JOURNEY THROUGH ART

Prod No.	99290
Date	15.05.18
Supplier	Leo Paper Products UK
T.P.S	260 x 205mm portrait
Extent	144pp printed 4/4 (CMYK)
Papers INT	140gsm uncoated woodfree paper
PLC	Printed 4/4 (CMYK) on 128gsm gloss art + matt lamination
Binding	Sewn in 16s, over 2.5mm greyboards to overhang bookblock by 2mm.
Ends	Printed 1/1 solid Pantone 115U yellow on 140gsm woodfree , + machine varnish
H&T Bands	GF ref 166 blue

세계
예술 지도

예술과 **역사**가 함께하는
청소년 인문 교양

세계
예술 지도

애런 로즌 지음 | **루시 달젤** 그림
신소희 옮김

북스토리

차례 CONTENTS

격동하는 근대와 파격적인 현대의 미술

전 세계 미술 여행을 시작하며

자, 이제부터 모험을 시작해봅시다. 이 책은 시간을 달리고 전 세계를 지나는 여행이 될 겁니다. 수만 년 전 오스트레일리아 북부에서 출발해 오늘날의 브라질 리우데자네이루에서 끝나는 여행이지요. 도중에 (남극을 제외한) 세계의 모든 대륙을 통과하게 될 거예요. 여행하면서 여러분은 정글을 헤치며 나아가고, 대상(隊商)을 따라 사막을 통과하고, 돛대 꼭대기에서 바다를 내다보는 자신의 모습을 상상할 수 있을 겁니다.

하지만 무엇보다도, 이 여행은 사람들에 관한 것이 될 거예요. 우리는 너무 자주 미술작품을 마치 보물처럼, 혹은 미술관의 하얀 벽에 걸려 있기 위해 생겨난 것처럼 여기곤 합니다. 그래서 미술작품 뒤에 있는 문화에 관해선 잊어버리지요. 미술은 단순히 아름다움의 문제가 아닙니다. 종교와 정치, 사람들의 생활 방식 등 이 세상 모든 것을 반영하고 또 그것들에 영향을 미치니까요.

이 책에서 선택된 장소와 시대는 각기 다른 문화권의 놀라운 순간들을 잘 보여줍니다. 그렇다고 해서 이 장소들이 선택된 시대 이전에는 흥미롭지 않았다거나 그 이후로 별 볼 일 없어졌다는 이야기는 아닙니다. 사람들은 종종 모든 국가에는 황금기가 있다고 말하지요. 하지만 그건 사실 너무 단순한 표현이에요. 모든 문화는 어느 시대든 연구할 가치가 있습니다. 문화를 서로 경쟁하는 것으로 생각해선 안 됩니다. 북아메리카의 카호키아에 있는 대형 고분부터 그리스 아테네의 아크로폴리스까지, 모든 장소에는 그곳만의 사연과 흥미진진한 수수께끼가 존재한답니다.

이 책이 여러분에게 각자 나름의 미술 여행을 시작하는 계기가 되어주길 바랍니다. 내가 이 책에 그려 넣은 경로마다 여러분이 직접 천 개를 더 그려 넣을 수 있을 겁니다. 아프가니스탄의 헤라트에서 터키의 이스탄불까지, 혹은 과테말라의 티칼에서 페루의 쿠스코까지 말이죠.

– 애런 로즌

북대서양

북태평양

• 테오티우아칸
(300년)

남태평양

남대서양

선사 시대와
고대 미술의
발자취

데비(900년)

로마
(기원후 1년)

아테네
(기원전 450년)

니네베(기원전 700년)

예루살렘(700년경)

테베(기원전 1250년)

아잔타(500년)

나왈라 가반뭉
(기원전 35000년경)

인도양

남극해

나왈라 가반뭉(기원전 35000년경)

동굴 속의 궁전

오스트레일리아 원주민인 애버리지니는 약 5만 년 전부터 이 대륙 전역을 돌아다니며 살아왔습니다. 원주민 사회가 남긴 가장 오래된 자취 일부는 오스트레일리아 북부 나왈라 가반뭉의 사암 동굴에서 발견되었습니다. 이곳에서 작업하던 고고학자들은 최근 35000년이나 된 돌도끼를 발견했답니다. 같은 형태의 도끼로는 세계에서 가장 오래된 유물이지요. 나왈라 가반뭉은 '바위 속의 구멍'이라는 뜻입니다. 자오인 족의 한 여성 장로가 설명한 것처럼 이 외진 동굴은 한마디로 '궁전 같은 곳'이었어요. 천장과 벽, 기둥에는 온갖 그림들이 그려져 있었습니다. 세계 창조부터 원주민들이 사냥했던 거대한 동물, 유럽인들의 도

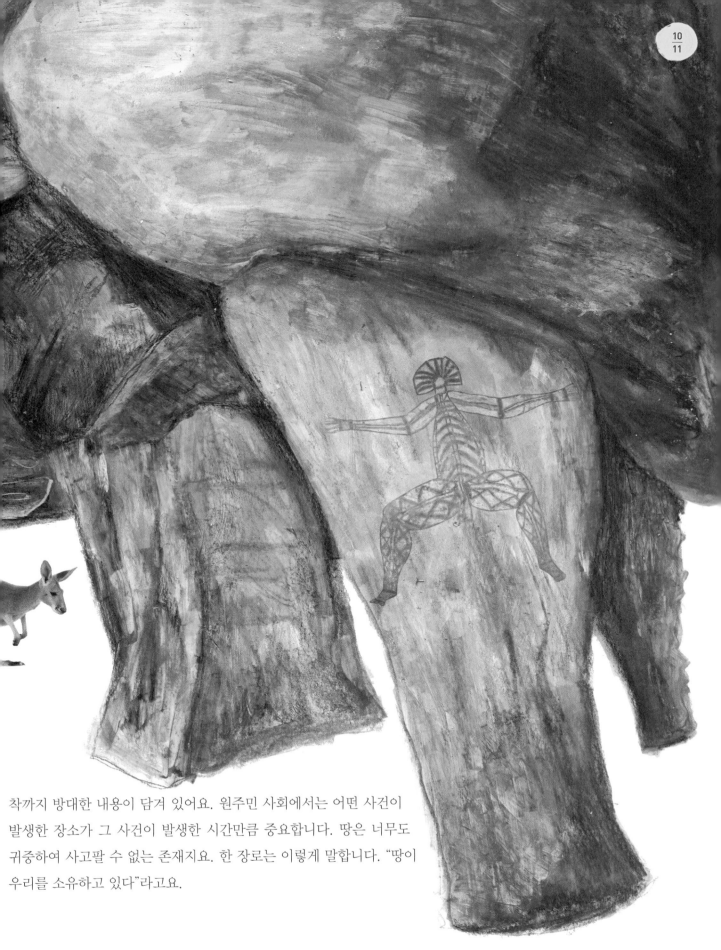

착까지 방대한 내용이 담겨 있어요. 원주민 사회에서는 어떤 사건이
발생한 장소가 그 사건이 발생한 시간만큼 중요합니다. 땅은 너무도
귀중하여 사고팔 수 없는 존재지요. 한 장로는 이렇게 말합니다. "땅이
우리를 소유하고 있다"라고요.

미술작품을 넘어 꿈을 그리다

애버리지니에게 미술은 단순한 장식이 아니라 종교 의식과 전설, 역사에 관한 주요 지식을 계승하고 전수하는 방식이었지요. 원주민 사회에서 지식은 큰 존경과 권위의 이유가 되었습니다. 미술 창작에 쓰이는 전설, 상징, 기법들은 올바른 방식으로 터득해 적용해야 했습니다. 예를 들어 어느 문화 집단에서는 어떤 동물을 그릴 권리를 특정한 사람들이 독점했지요. 심지어 직선을 교차시켜 긋는 소묘의 한 기법을 특별한 집단이 독점하기도 했습니다. 또한 다른 사람의 그림을 따라 그리는 건 심각한 불법 행위로 여겨졌답니다.

바라문디는 바위그림에 흔히 등장하는 소재입니다. 지금도 오스트레일리아의 강과 호수에 서식하는 이 물고기는 인기 있는 식재료이기도 하지요. 이 그림에서 엄마와 아이는 바라문디와 함께 헤엄치며 바위 표면을 떠다니는 것처럼 보이네요.
〈바위그림 : 여자와 아이와 물고기〉, 작자 미상, 아넘랜드

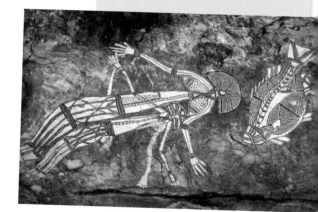

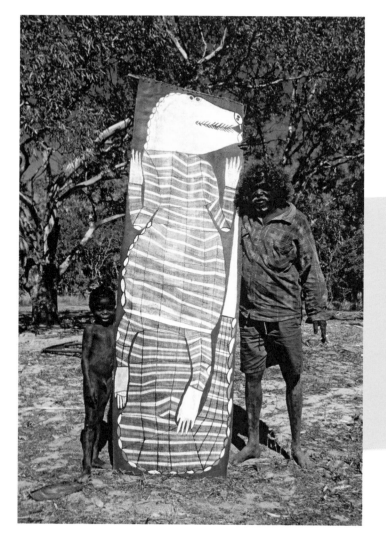

지미 은지미누마(사진 속 오른쪽)는 다른 여러 애버리지니 예술가들처럼 바위뿐만 아니라 나무껍질에도 그림을 그렸습니다. 이 나무껍질 그림은 강과 시냇물을 창조했다는 신성한 무지개 뱀을 묘사한 것입니다. 원주민 사회에서도 아주 존경받는 사람들만이 이 뱀을 그릴 수 있었답니다.
〈무지개 뱀〉, 지미 은지미누마, 아넘랜드

유럽인들은 질병을 비롯한 온갖 골칫거리들을 오스트레일리아로 가져왔지요. 애버리지니는 어려운 결정을 내려야만 했습니다. 그들은 전통문화를 이어가기 위해 미술을 필요로 했지만, 그들의 전통이 잘못된 방식으로 사용되는 건 바라지 않았거든요. 애버리지니 미술작품들은 흔히 두 가지의 의미를 갖고 있습니다. 그들의 공동체 안에서만 적용되는 내적 의미와 모든 사람들을 위한 외적 의미지요.

아넘랜드의 노울랜지 암벽에서 발견된 이 캥거루 그림은 마치 엑스레이 사진처럼 보입니다. 이 그림은 애버리지니가 사냥한 동물들의 내장 기관을 얼마나 잘 파악하고 있었는지, 그리고 그들이 동물을 어떤 방법으로 죽였는지 생생히 보여줍니다.
〈캥거루 바위그림〉, 작가 미상, 아넘랜드

애버리지니 종교의 중심은 과거와 현재를 이어주는 꿈입니다. 이 세상이 시작될 때 위대한 창조자들은 땅과 그 위의 모든 것을 만들었습니다. 그런 다음 스스로 산, 나무, 강 등 풍경의 일부가 되었지요. 미술과 노래와 춤은 모두 꿈 이야기를 전하는 데 쓰인답니다.

데이비드 말랑기는 애버리지니 미술가 중에서도 가장 유명한, 그리고 가장 먼저 미술관에 작품이 전시된 사람입니다. 말랑기의 그림은 오스트레일리아 1달러짜리 지폐에 (본인의 허가 없이) 인쇄된 적도 있다고 하네요. 이 사진 속에서 그는 나무껍질 그림에 쓸 천연 황토 물감을 섞고 있습니다.
〈물감을 섞는 데이비드 말랑기〉

빛바랜 도시, 테베 (기원전 1250년)

파라오들이 세운 도시

테베는 이집트 종교와 문화의 핵심이었습니다. 유명한 나일 강이 테베의 유적을 둘로 가르며 흐릅니다.
동쪽 강변에는 파라오들이 지은 궁전과 성역이 있습니다. 서쪽 강변은 죽은 자들의 도시로 왕들의 무덤과
사원이 있지요. 많은 파라오들이 웅장한 건물을 계속 지었습니다.
하지만 가장 인상적인 랜드마크를 남긴 것은
제19왕조의 람세스 2세였지요.
그는 67년간 통치하면서 많은 돈을 들여 여러
대형 기념물을 세웠는데, 대부분 자신을
기념하기 위한 것이었습니다. 그의
유산이 얼마나 장엄했던지 이후로도

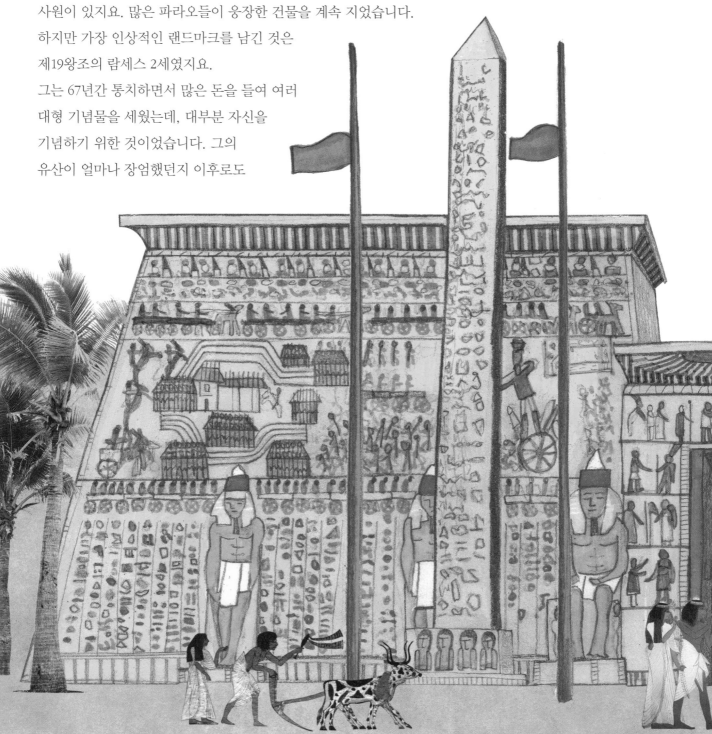

아홉 명의 이집트 왕들이 그와 같이 람세스라는 이름을 썼답니다. 다만 문제는 람세스가 너무 많은 돈을 쓴 나머지 이집트가 파산의 위기를 맞았다는 것이지요.

람세스는 모든 사람들이 영원히 자신의 위대함 앞에 무릎 꿇기를 바랐지만, 이 세상에 영원한 건 없지요. 현재로부터 2천 년 전 로마 제국 시대에도 이미 테베의 폐허는 관광지로 유명했습니다. 그 전에는 고대 그리스의 역사가들이 테베의 빛바랜 영광을 찬양했지요. 이 도시의 이름은 이집트어로 '와셋'이었고, 테베라는 이름은 그리스인들이 새로 지은 것이랍니다.

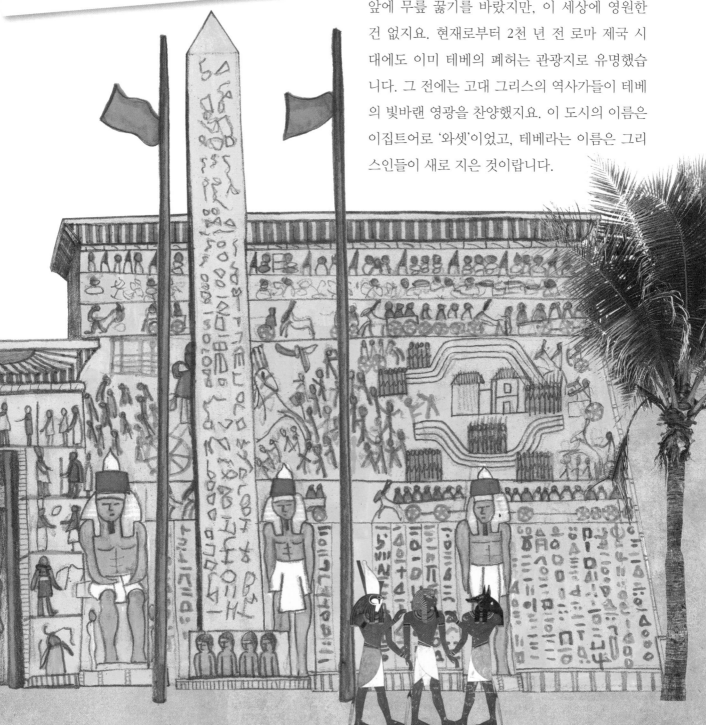

이집트 사원에는 보통 높이 솟은 대문과 그 양옆으로 높고 비스듬한 탑문이 있었습니다. 이 사원에는 람세스 2세의 거대한 석상과 오벨리스크라고 불리는 높은 돌기둥 두 개가 있었지요. 두 기둥 중 하나는 현재 파리에 있답니다.
〈룩소르 사원의 탑문〉, 기원전 13세기

종교와 함께 꽃핀 이집트 미술

이집트의 종교의식은 파라오와 귀족들이 엄격히 지켜온 비밀이었습니다. 하지만 이집트 왕국이 가장 강성했던 기원전 16세기 이후로는 종교의식이 좀 더 공개적으로 변했답니다. 테베에서는 매년 수십 가지의 대중 축제가 열렸습니다. 모든 축제의 중심은 태양신 '아문-라'였지요. 여러 의식 동안 '아문-라'의 신성한 초상이 여러 사원들로 옮겨지며 나일 강을 여러 차례 건너갔답니다.

람세스 2세는 많은 아내와 백 명 이상의 자식을 두었습니다. 하지만 그의 첫 번째 왕비였던 네페르타리는 특별한 존재였지요. 그녀의 무덤은 여왕의 빰과 옷 주름에 명암을 넣는 등 당시의 최신 기법이 사용된 벽화들로 가득하답니다.
〈'여왕의 계곡'에 있는 네페르타리 무덤〉, 기원전 13세기

라메세움은 람세스 2세를 위한 신전입니다. 그는 자신의 가장 위대한 승리였던 시리아 카데시에서의 전투를 기념하여 거대한 조각을 제작하게 했습니다. 이집트 군대는 히타이트 왕국의 기습을 받았지만, 람세스와 그의 경비병들이 용감히 적군을 물리쳤답니다.
〈라메세움의 카데시 전투 부조〉, 기원전 1274년

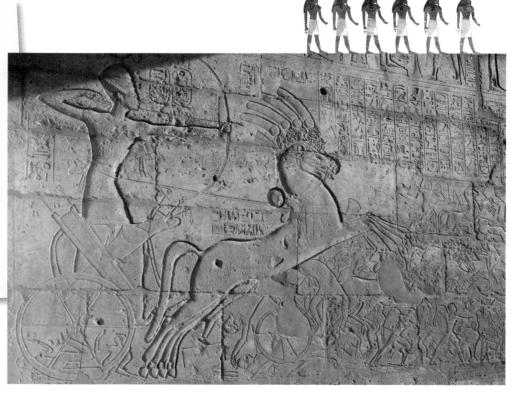

히에로글리프

히에로글리프는 본래 상형문자, 즉 각각 하나의 단어나 음절, 혹은 글자를 나타내는 단순한 형태의 그림을 뜻합니다. 고대 이집트인들에게 히에로글리프는 '신의 언어' 였답니다. 1799년에 같은 문장이 각각 이집트 상형문자와 그리스어로 새겨진 돌 하나에서 발견될 때까지 히에로글리프 해석은 수수께끼로 남아 있었습니다. '로제타 스톤'으로 알려진 이 돌 덕분에 마침내 전문가들이 이집트 상형문자를 해독할 수 있었지요.

이 그림은 신문의 풍자만화처럼 유머러스한 의미를 담고 있습니다. 사자가 가젤을 잡아 먹기는커녕 둘이 함께 이집트에서 인기 있던 보드게임인 '세넷'을 하고 있어요. 그리고 고양이는 거위 떼를 죽이는 대신 마치 거위 지기처럼 몰고 가는 중입니다.
〈풍자적 파피루스〉, 기원전 1250년

테베의 성직자들은 보통 건축가이면서 미술가이기도 했습니다. 이집트 미술은 종종 비현실적이라고 이야기하지요. 하지만 당시의 미술가들은 그림이 완벽하여 실제로 살아 움직이길 바랐습니다. 조각품들을 깨워 일으키기 위해 '입 열어주기'라는 특별한 의식을 거행하기도 했지요. 거의 모든 그림이 히에로글리프를 새겨야만 완성된다고 여겨졌습니다. 언어에는 미술적 힘이 있다는 믿음 때문이었지요. 우리는 이집트 미술이 평면적이며 밋밋하다고 생각하지만, 이집트인들은 전혀 그렇게 생각하지 않았답니다!

람세스 2세와 그의 아버지가 만든 이 방에는 기둥이 무려 134개나 세워져 있습니다. 지붕을 받치는 데 필요한 수를 훨씬 넘어서지요. 이것은 방문객들이 마치 장엄하고 신비로운 숲 속에 들어온 것처럼 느끼게 하려는 의도였습니다. 히에로글리프로 뒤덮인 이 기둥들은 본래 화려하게 채색되어 있었다고도 해요.
〈카르나크의 대열주실〉,
기원전 1280~1270년

호사스러운 니네베 [기원전 700년]

아시리아 왕국의 웅장한 수도

아시리아 왕국은 지구에서 가장 먼저 문명이 발생한 지역 중 하나인 메소포타미아를 장악했습니다. 기원전 9세기부터 기원전 7세기까지, 아시리아 왕국은 그때까지 세상에 존재했던 가장 강력한 세력이라고 할 수 있었지요. 그들의 군대는 세계 최고로 거대하고 복잡한 조직이었습니다. 아시리아 군인들은 중동 지역을 휩쓸었고 심지어 강대한 이집트 왕국마저도 정복했답니다. 성경에 등장하는 예언자 이사야는 무시무시한 광경을 다음과 같이 묘사합니다.

"보라 그들이 빨리 달려올 것이로되/ 그중에 곤핍하여 넘어지는 자도 없을 것이며 조는 자나 자는 자도 없을 것이며…… 그들의 화살은 날카롭고…… 그들의 소리 지름은 어린 사자들과 같을 것이라." (이사야서 5장 26~29절)

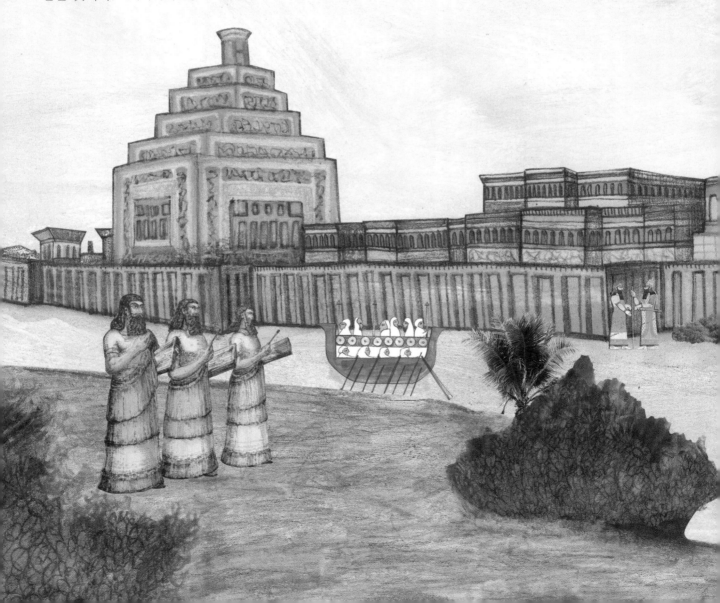

니네베는 두께가 15미터에 이르는 성벽으로 둘러싸여 있고, 수문 15개와 운하를 통해 티그리스 강의 지류로 이어져 있었습니다. 센나케리브 왕이 지은 궁전은 너무나 호화로웠기에 왕은 그곳을 '무적의 궁전'이라고 불렀습니다. 궁전 내부는 왕 자신의 위대한 승리를 묘사한 조각들로 가득했지요. 이후에 아슈르바니팔 왕 또한 선조와 경쟁할 만큼 호화로운 궁전을 지었는데, 그곳에는 세계 최초이자 최대의 도서관이 있었습니다. 아시리아의 군사적 승리도 놀라웠지만, 이 제국이 세계 역사에 남긴 가장 큰 공헌은 무엇보다 미술과 문학에 관련된 것이랍니다.

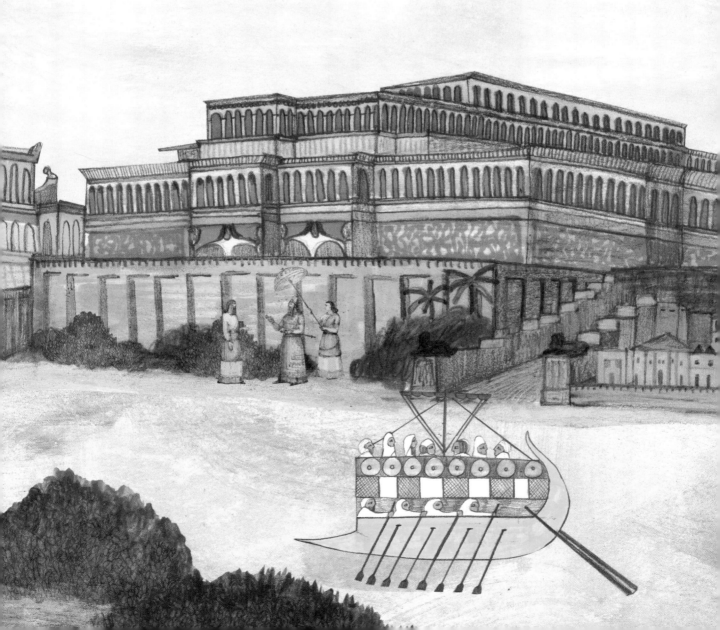

역사 기록의 수단이 된 미술

아시리아인들은 기록을 남기길 좋아했습니다. 미술은 그들에게 전투에서의 승리를 자세히 기록할 좋은 수단이 되었지요. 높이가 2미터인 돌덩이에 새겨진 부조들이 그 사실을 잘 보여줍니다. 얼핏 보기에는 단조로운 조각들이지만, 찬찬히 들여다보면 각 조각마다 아주 다양한 내용이 담겨 있음을 알 수 있습니다. 이 부조들은 기습 공격과 포위, 항복 등 수백 가지의 역사적 사건들을 묘사했으며, 본래는 더욱 실감이 나도록 화려하게 채색되어 있었지요. 아시리아인들은 또한 글쓰기도 좋아했습니다. 파피루스나 종이가 없었던 시대라 그들은 대체로 점토판에 글을 썼습니다. 서기들은 쐐기문자를 사용했는데, 이것은 갈대를 깎아 만든 펜을 부드러운 점토판에 눌러 생기는 작은 쐐기 자국들로 이루어진 문자 체계였습니다. 니네베에 있던 아슈르바니팔 왕의 도서관에는 군사 전략, 마술, 설화 등 내용별로 분류된 수만 개의 점토판이 있었답니다.

길가메시 서사시는 세계에서 가장 오래된 전래 설화 중 하나입니다. 길가메시가 현자 우트나피쉬팀을 찾기 위해 떠난 모험을 다루었지요. 우트나피쉬팀은 길가메시의 가족과 가축들을 대홍수로부터 구해줍니다. 이 서판이 발견되었을 때 사람들은 성경 내용과 너무나 비슷한 설화가 아시리아에 존재했다는 사실에 깜짝 놀랐답니다.
〈길가메시 서사시가 기록된 홍수 서판〉, 기원전 7세기

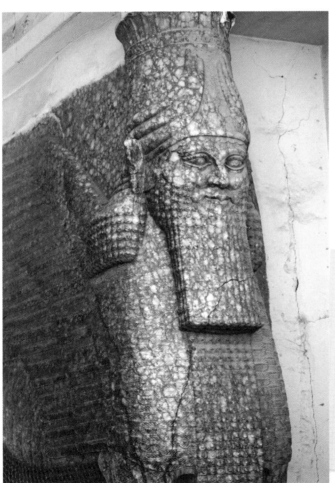

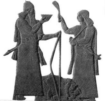

라마수는 외부 방문객을 두렵게 만들기 위해 니네베 성문에 세운 거대 석상입니다. 사람 머리에 독수리 날개, 황소의 몸을 하고 있지요. 안타깝게도 이 사진이 촬영된 후 2015년에 IS가 석상의 얼굴 부분을 훼손했습니다.
〈니네베 네르갈 성문의 라마수 석상〉, 기원전 8세기

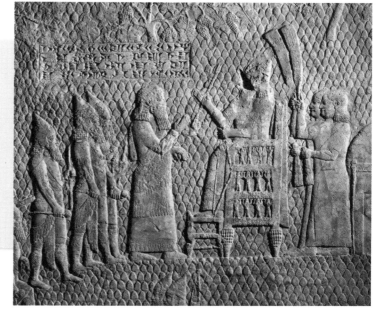

이 부조는 유대 왕국의 포로들과 함께 있는 아시리아의 왕을 묘사한 것입니다. 아시리아의 왕은 자신이 예루살렘의 왕을 '새장에 갇힌 새처럼' 가두어놓았다고 자랑스럽게 적어두었습니다. 하지만 성경에 기록된 내용은 다릅니다. 성경에는 신이 예루살렘을 구해주었다고 적혀 있거든요!

〈니네베 남서 궁전의 라키시 부조〉
기원전 700~692년

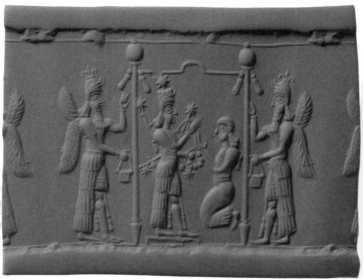

원통형 인장을 부드러운 점토판에 굴리면 하나의 그림을 찍어낼 수 있습니다. 이 인장은 별의 여신 이시타르를 숭배하기 위해 무릎을 꿇은 아시리아인의 모습을 담고 있어요. 인장은 서명으로 쓰였지만 한편으로 마술적인 방어력이 깃들어 있다고도 여겨졌습니다.

〈신 아시리아 왕국의 원통형 인장〉,
기원전 8~7세기

니네베의 유적은 매우 위태로운 상황에 직면해 있습니다. 2014년에 이슬람 무장 테러 단체인 IS가 이라크의 도시 모술을 점령한 뒤 니네베로 옮겨갔기 때문이에요. 이로 인해 라마수 석상을 비롯하여 수천 년 넘게 보존되어온 유적들이 파괴되었습니다. 고대 아시리아인들은 도시를 악의 세력으로부터 보호하기 위해 이 거대한 석상들을 만들었지만, 유감스럽게도 석상들의 힘으로 이러한 현대의 위협을 막아낼 수는 없었지요.

도시국가, 아테네 [기원전 450년]

민주주의의 기원

고대 그리스인들은 여러 면에서 현대 세계를 형성한 민족이었습니다. 오늘날 서구의 언어와 정치 체계, 건축에는 그들의 흔적이 뚜렷이 남아 있지요. 그리스에는 아테네 외에도 스파르타, 코린트, 테베 등 여러 도시국가들이 있었습니다. 그리스어로 도시국가는 폴리스(polis)라고 했는데, 이는 영어로 '정치'를 뜻하는 politics의 기원이 되었지요. 아테네 시민들은 정치적 결정을 내려야 할 때마다 한자리에 모였고, 자신들이 도시에 거주하는 모든 사람들을 대표한다고 여겼습니다. 그리스어로 '민중'은 demos라고 했는데 이로부터 영어로 '민주주의'를 뜻하는 democracy가 나왔답니다.

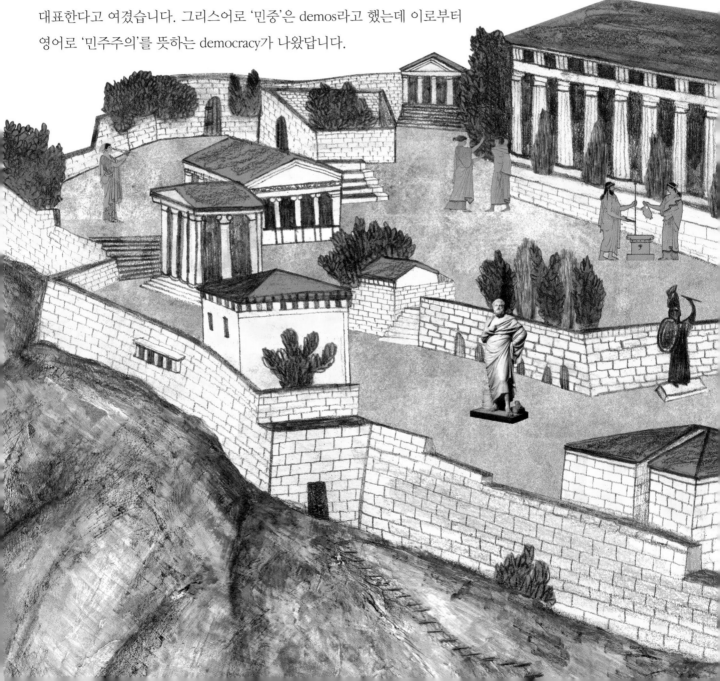

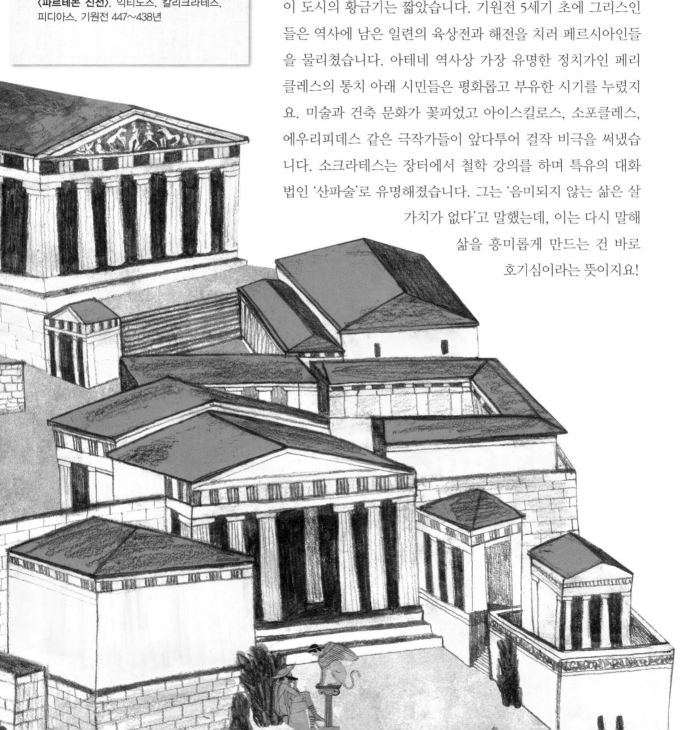

파르테논 신전의 기단은 가운데가 살짝 위로 솟아 있고, 기둥들 또한 살짝 중간 부분이 굵으며 안쪽으로 기울어져 있습니다. 이는 실수가 아니라 건축가들의 의도였는데, 이처럼 교묘한 처리로 착시 현상이 나타나 건물 전체가 완벽하게 균형 잡힌 것처럼 보인답니다.

〈파르테논 신전〉, 익티노스, 칼리크라테스, 피디아스, 기원전 447∼438년

고대 그리스에서는 부유한 남성에게만 투표권이 있었습니다. 반면 오늘날 우리는 정치적 결정을 내릴 때면 모든 사람들의 목소리가 반영되어야 한다고 생각하지요. 민주주의의 의미는 시대가 지나면서 바뀌었으나, 서구 문명에서 중요한 여러 개념과 제도가 그러하듯 민주주의 또한 고대 그리스로부터 기원한 것입니다. 아테네의 유산은 이후로 수천 년간 이어졌지만, 이 도시의 황금기는 짧았습니다. 기원전 5세기 초에 그리스인들은 역사에 남은 일련의 육상전과 해전을 치러 페르시아인들을 물리쳤습니다. 아테네 역사상 가장 유명한 정치가인 페리클레스의 통치 아래 시민들은 평화롭고 부유한 시기를 누렸지요. 미술과 건축 문화가 꽃피었고 아이스킬로스, 소포클레스, 에우리피데스 같은 극작가들이 앞다투어 걸작 비극을 써냈습니다. 소크라테스는 장터에서 철학 강의를 하며 특유의 대화법인 '산파술'로 유명해졌습니다. 그는 '음미되지 않는 삶은 살 가치가 없다'고 말했는데, 이는 다시 말해 삶을 흥미롭게 만드는 건 바로 호기심이라는 뜻이지요!

건축이 빛나는 그리스 미술

아크로폴리스는 아테네 전체에서 가장 높은 곳에
위치했습니다. 아테네 사람들은 그곳이 도시를 대
표하는 신전을 짓기에 최적의 장소라고 생각했지
요. 방어하기 편리했고 멀리서부터 오는 적군을 관
측하기에도 좋았기 때문입니다. 하지만 이 신전들은
페르시아인들이 아크로폴리스를 약탈했을 때 파괴되어
슬픈 기념물처럼 도시 위로 솟은 채 남아 있었습니다. 아크로
폴리스를 재건하고 예전보다 더욱 근사하게 만들 필요가 있었지요.
아테네 사람들은 지혜와 전쟁의 여신 아테나와의 특별한 관계를 드러
내고 싶었습니다. 아테나는 이 도시의 수호신이자 아테네라는 이름의
유래이기도 했거든요. 파르테논은 아크로폴리스에서 가장 중요한 신
전이었는데, 피디아스는 이 신전을 위해 황금과 상아로 장엄한 여신
상을 제작했습니다. 또한 상징적 의미에서 페르시아 군의 무기를 녹
여 전사 복장을 한 또 하나의 아테나 여신상을 만들었지요. 아쉽게도
이제는 두 여신상 모두 사라졌지만, 로마 예술가들이
만든 복제품들은 아직 남아 있답니다.

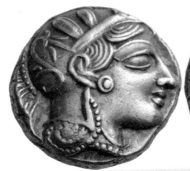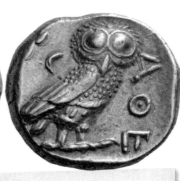

은광이 있었던 아테네에서는 고대 세계를 통
틀어 가장 정확한 중량의 은화가 만들어졌습
니다. 은화 앞면에는 지혜의 여신 아테나가,
뒷면에는 아테나를 상징하는 올빼미가 새겨
져 있지요. 그리스의 여러 도시에서는 고유의
주화를 만들었는데, 승리의 여신 니케나 미노
타우로스 등 다양한 도상을 새겼습니다.
〈아테네의 4드라크마 은화〉, 기원전 5세기

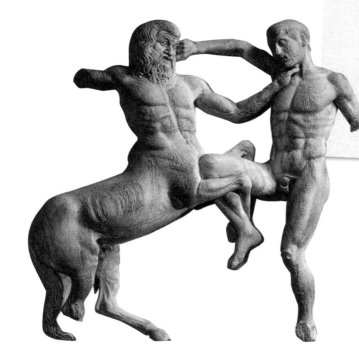

피디아스와 그의 일꾼들은 파르테논 신전의 기둥머리
에 모두 92개의 부조를 남겼습니다. 이 조각은 그리스
신화의 내용을 묘사하고 있는데, 상반신은 인간이고
하반신은 말인 켄타우로스의 무리가 결혼식장에서 싸
움을 시작하는 장면입니다. 라피트족 사람 하나가 술
취한 켄타우로스를 물리치고 있습니다.
〈남쪽 소간벽(小間壁) 31번 부조〉, 피디아스,
기원전 447~438년

아크로폴리스에는 에렉테움 신전도 있습니다. 신화에 따르면 바다의 신 포세이돈과 전쟁의 여신 아테나는 둘 다 아테네가 자신에게 봉헌되길 원했습니다. 그래서 둘 중 누가 더 아테네에 근사한 선물을 줄 수 있는지 겨루기로 했지요. 포세이돈은 샘 하나가 솟아나게 했고, 아테나는 올리브나무 한 그루가 자라나게 했습니다. 승리는 아테나에게 돌아갔지만, 아테네 사람들은 에렉테움에 성소를 두 곳 만들어 두 신 모두를 기념했답니다.

〈에렉테움〉, 므네시클레스, 기원전 421~405년

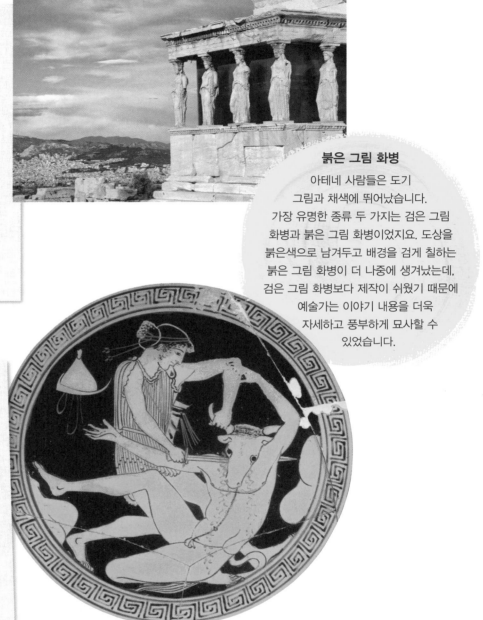

붉은 그림 화병

아테네 사람들은 도기 그림과 채색에 뛰어났습니다. 가장 유명한 종류 두 가지는 검은 그림 화병과 붉은 그림 화병이었지요. 도상을 붉은색으로 남겨두고 배경을 검게 칠하는 붉은 그림 화병이 더 나중에 생겨났는데, 검은 그림 화병보다 제작이 쉬웠기 때문에 예술가는 이야기 내용을 더욱 자세하고 풍부하게 묘사할 수 있었습니다.

아테네에 내려오는 전설에 따르면 예전에 이 도시에서는 젊고 아름다운 남녀를 크레타 왕국에 바쳐야 했습니다. 그들은 미노타우로스라는 무시무시한 짐승의 희생물로 바쳐졌지요. 반은 인간이고 반은 황소인 이 짐승은 복잡한 미로 안에 가두어져 있었습니다. 테세우스는 영리하게도 실뭉치를 써서 미로를 빠져나가는 길을 찾아냈고 미노타우로스를 죽인 뒤 아테네로 돌아왔답니다.

〈테세우스와 미노타우로스〉, 도키마시아의 화가, 기원전 480년

오늘날 파르테논의 모습은 처음 지어졌을 때와는 아주 다르게 보입니다. 원래는 화려하게 채색되어 있었지만 지금은 눈부시게 흰 대리석 신전으로 알려져 있지요. 하지만 이 신전의 놀라운 규모와 뛰어난 설계는 예나 지금이나 그대로입니다. 파르테논은 현대 건축가들에게도 많은 영감을 주었고, 영국박물관이나 미국 대법원 건물에도 파르테논의 영향이 드러난답니다.

새로운 시대, 로마 (기원후 1년)

벽돌의 도시에서 대리석의 도시로

기원전 1세기 로마는 파멸의 위기에 처했습니다. 수 세기를 이어져온 로마 공화국이 혼란에 빠진 것입니다. 율리우스 카이사르는 로마의 권력을 손에 넣었지만 얼마 뒤인 기원전 44년에 친구였던 브루투스와 여러 원로원 의원들에게 암살당했습니다. 카이사르가 죽자 그의 지지자들은 그의 적들과 싸웠습니다. 지지자들 쪽이 이기자 이젠 그들 사이에서 싸움이 일어났지요. 결국 카이사르의 조카뻘인 젊은 옥타비아누스가 일인자 자리에 올랐습니다. 기원전 27년에 원로원은 옥타비아누스에게 아우구스투스라는 이름을 주었고, 로마는 공화국이 아닌 제국이 되었습니다. 아우구스투스는 모든 권력을 손에 쥐었지만 카이사르와 달리 현명하게도 '민중의 하인'을 자처하기로 했습니다. 그는 자신을 황제가 아닌 '제1시민'으로 불렀습니다.

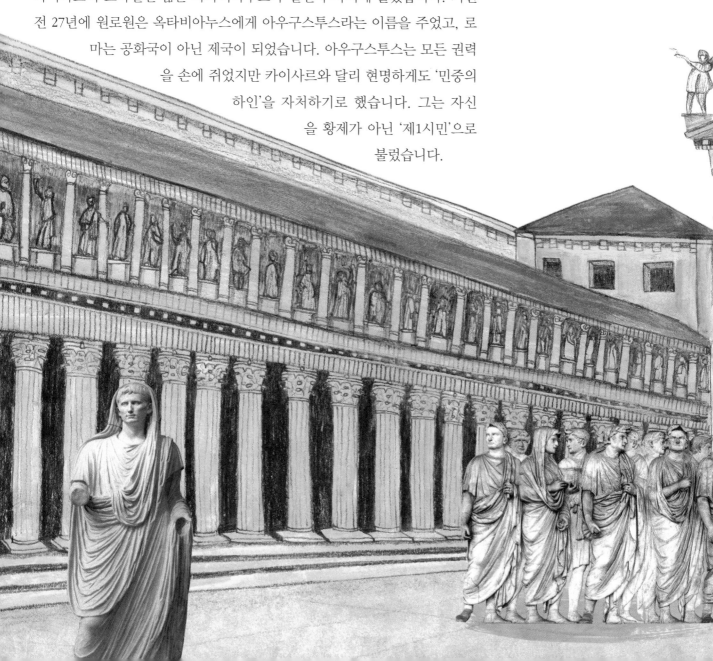

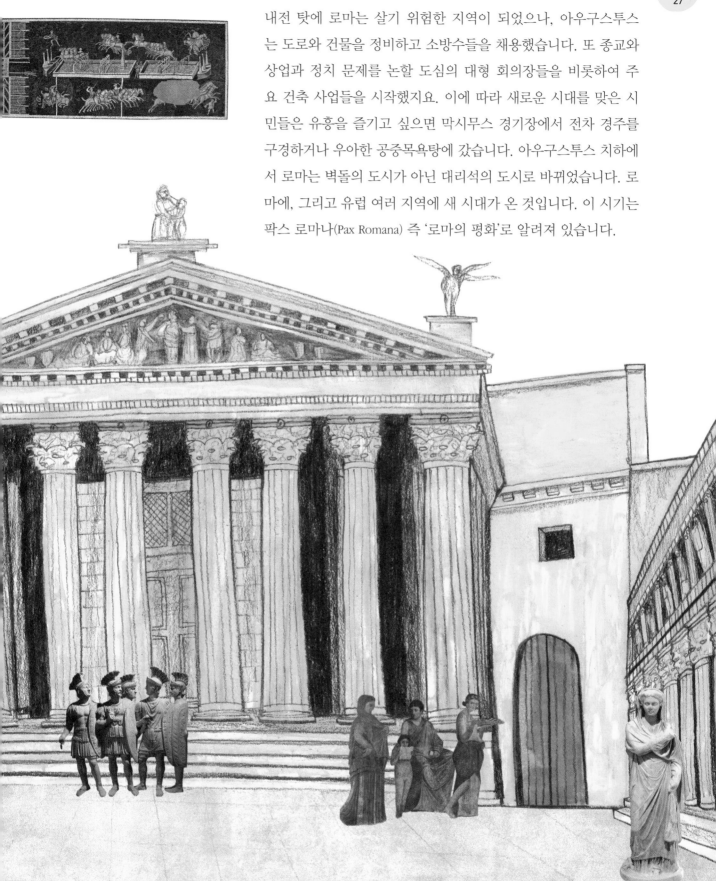

내전 탓에 로마는 살기 위험한 지역이 되었으나, 아우구스투스는 도로와 건물을 정비하고 소방수들을 채용했습니다. 또 종교와 상업과 정치 문제를 논할 도심의 대형 회의장들을 비롯하여 주요 건축 사업들을 시작했지요. 이에 따라 새로운 시대를 맞은 시민들은 유흥을 즐기고 싶으면 막시무스 경기장에서 전차 경주를 구경하거나 우아한 공중목욕탕에 갔습니다. 아우구스투스 치하에서 로마는 벽돌의 도시가 아닌 대리석의 도시로 바뀌었습니다. 로마에, 그리고 유럽 여러 지역에 새 시대가 온 것입니다. 이 시기는 팍스 로마나(Pax Romana) 즉 '로마의 평화'로 알려져 있습니다.

제국의 전성기를 기념하다

아우구스투스는 예술이 제국의 성공에 중요하다는 것을 잘 알았습니다. 그는 호라티우스와 베르길리우스 같은 시인들을 지원하여 로마의 위대함을 찬양하는 서정시와 서사시를 쓰게 했습니다. 조각가들은 로마와 고대 그리스 역사의 중대한 순간들을 묘사했습니다. 그리스 걸작들을 본떠서 정교한 복제품을 만들기도 했지요. 로마의 조각가들은 초상 분야에 특히 뛰어났습니다. 아우구스투스는 항상 완벽하고 젊은 얼굴로 묘사되었고, 이후에도 여러 로마 황제들은 그의 초상을 본보기 삼아 자신의 초상을 제작했습니다. 실제로는 전혀 다르게 생긴 경우에도 말이지요.

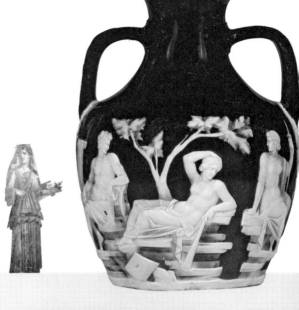

포틀랜드 화병은 카메오 기법을 사용했습니다. 유리를 한 층 깎아내 그 아래 새겨진 문양이 드러나게 하는 기법이지요. 18세기 중 영국에 들어온 이 화병은 위대한 도공 조사이어 웨지우드에게 영감을 주었고, 그는 이 화병의 기법을 오랫동안 연구하여 복제품을 만들었습니다. 이 화병은 19세기에 파손되었지만 다행히도 웨지우드의 정교한 복제품 덕분에 복원이 가능했습니다.
〈포틀랜드 화병〉, 1〜25년

아라 파치스, 즉 '평화의 제단'은 아우구스투스 치하의 새로운 전성기를 기념한 작품입니다. 신성한 행렬을 묘사한 이 조각은 파르테논 신전의 조각들과 달리 사실적으로 표현되었기에 로마의 실제 정치인들을 알아볼 수 있습니다.
〈아라 파치스의 황가 행렬 부조〉, 기원전 13〜9년

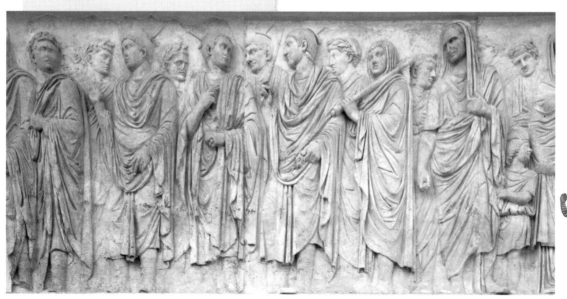

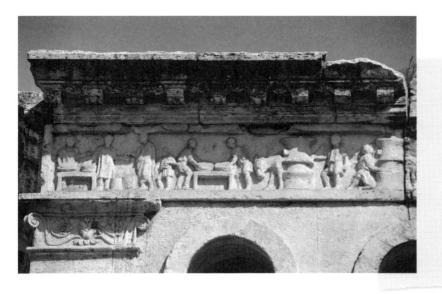

로마 제국에서는 점점 더 많은 시민들이 신분 상승을 시도할 수 있게 되었습니다. 부유한 제빵사였던 에우리사케스는 자신의 직업을 자랑스러워했고, 건축가를 고용하여 자신의 웅장하고 개성적인 무덤을 설계하게 했습니다. 사진에 보이는 구멍들은 빵을 보관하는 용기와 비슷한 모양을 하고 있습니다.
〈제빵사 에우리사케스의 무덤〉, 기원전 30년경

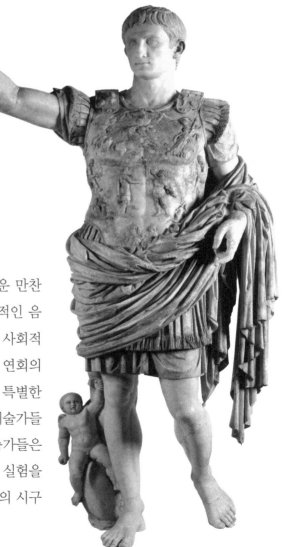

아우구스투스의 자세는 그리스 조각가 폴리클레이토스의 〈창을 든 남자〉에서 따온 것입니다. 아우구스투스는 창을 드는 대신 자신의 군대에게 연설할 때처럼 한쪽 팔을 치켜든 모습을 하고 있습니다. 갑옷에는 그의 군사적·외교적 승리들을 상징하는 그림들이 새겨져 있지요.
〈프리마 포르타의 아우구스투스상〉, 1세기

부유한 로마인들이 무엇보다도 좋아한 것은 친구들과의 사치스러운 만찬이었습니다. 그들은 긴 의자에 기대 누워 공작새나 가재처럼 이국적인 음식을 먹으며 음악가와 곡예사의 공연을 구경했습니다. 이런 연회는 사회적 신분을 과시하고 공고히 할 기회였습니다. 식기 하나에 이르기까지 연회의 모든 세부 사항이 손님들을 감동시켜야 했지요. 고급 유리그릇은 특별한 자랑거리였습니다. 유리에 공기를 불어넣는 새로운 기법 덕분에 예술가들은 전에 없던 형태와 색조의 그릇을 만들 수 있었습니다. 또한 건축가들은 대리석 같은 전통적 소재 외에도 콘크리트 같은 신소재를 도입하는 실험을 했습니다. 무한한 가능성의 시대였고, 로마인들은 시인 호라티우스의 시구절인 '오늘을 즐겨라(carpe diem)'에 따를 준비가 되어 있었습니다.

신비로운 테오티우아칸 (300년)

신들의 도시

메소아메리카(고대에 공통된 문화를 지녔던 멕시코와 중앙아메리카 일부 지역)에 있었던 이 신비로운 도시의 본래 이름이 무엇이었는지 우리는 영원히 알 수 없을 것입니다. 도시가 파괴된 지 한참 뒤에 폐허를 발견한 아즈텍 사람들은 크게 감동해서 이곳에 '테오티우아칸'이라는 이름을 지어주었습니다. '신들이 태어난 장소'라는 뜻이지요. 전성기의 테오티우아칸은 세계 최대의 도시 중 하나로 인구가 20만에 달했습니다. 상업으로 부유해진 이 도시는 중앙아메리카 전역의 미술과 건축에 영향을 미쳤답니다.

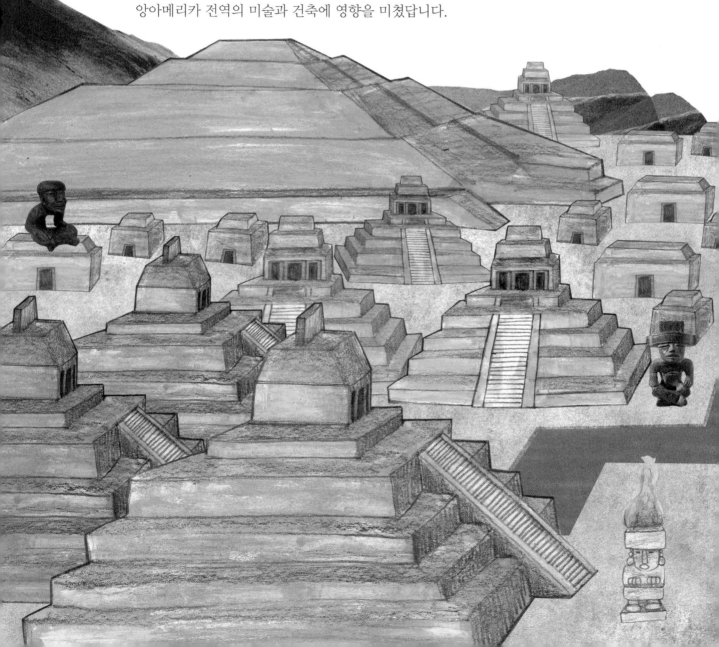

도로들은 정확한 격자 형태로 배치되었습니다. '죽은 자의 거리'는 도시 한 가운데를 관통하는데, 이 무시무시한 이름은 길 양쪽의 건축물들이 무덤으로 추측되었기 때문에 지어진 것이지요. 이후에 고고학자들은 이 수백 개의 건축물이 사실 가정집이었음을 알게 되었습니다. 여러 가족들이 연결된 아파트에 살면서 마당을 공유했던 것이지요. 이는 현대의 아파트 단지와 크게 다르지 않았어요. 심지어 하수도로 쓰이거나 식수를 공급할 도랑들도 갖춰져 있었습니다. 테오티우아칸 사람들은 문자 기록을 전혀 남기지 않았지만, 그들이 놀라운 도시 계획의 본보기를 남긴 것은 확실합니다. 아즈텍 사람들이 이곳을 신들에게 어울릴 도시라고 생각했던 것도 당연한 일이지요.

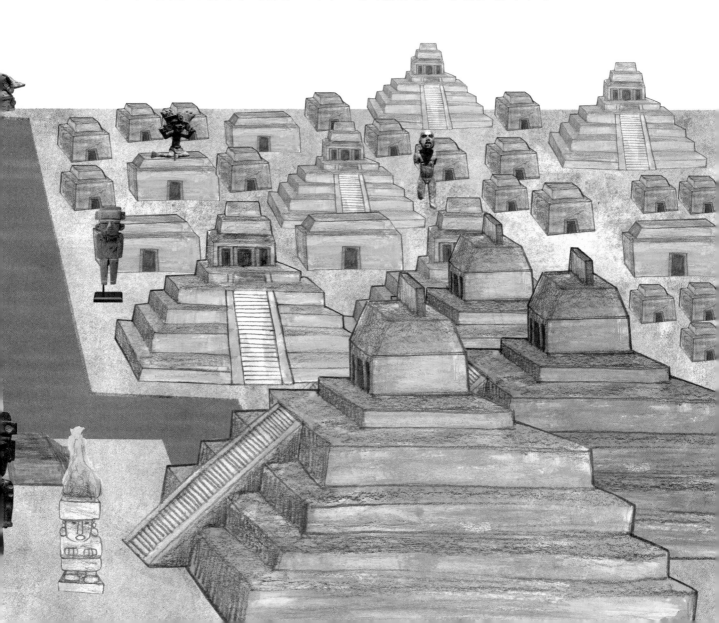

깃털 달린 뱀이 지배하는 곳

테오티우아칸 사람들은 자연 풍광에 영감을 받았습니다. '죽은 자의 거리'는 신성한 산 세로 고르도(Cerro Gordo)를 향해 직선으로 뻗어 있습니다. 태양의 피라미드와 달의 피라미드는 그 뒤에 있는 산비탈들과 닮았습니다. 도시를 설계한 사람들은 별과 행성의 위치에 따라 신성한 건축물들의 자리를 정했습니다. 초기의 고고학자들은 이 도시의 종교생활을 평화로운 사제들이 주관하는 점잖은 것이었으리라 상상했습니다. 하지만 최근의 발견에 따르면 테오티우아칸 사람들은 깃털 달린 뱀의 신전에서 인간 제물을 바쳤던 것으로 보입니다.

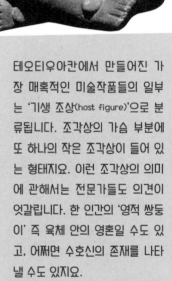

태양의 피라미드는 고대 아메리카 문명이 남긴 최대의 건축물 중 하나입니다. 본래는 회반죽을 바르고 붉게 채색했던 것으로 추측되며, 천연 동굴 위에 지어져 있습니다. 테오티우아칸 사람들은 바로 이곳에서 최초의 생명이 나왔다고 믿었습니다. 마치 아즈텍 사람들이 그들의 신 케찰코아틀이 생명을 창조했다고 믿었듯 말이지요.
〈태양의 피라미드〉, 200년경

테오티우아칸에서 만들어진 가장 매혹적인 미술작품들의 일부는 '기생 조상(host figure)'으로 분류됩니다. 조각상의 가슴 부분에 또 하나의 작은 조각상이 들어 있는 형태지요. 이런 조각상의 의미에 관해서는 전문가들도 의견이 엇갈립니다. 한 인간의 '영적 쌍둥이' 즉 육체 안의 영혼일 수도 있고, 어쩌면 수호신의 존재를 나타낼 수도 있지요.
〈테오티우아칸 조상〉, 1~750년

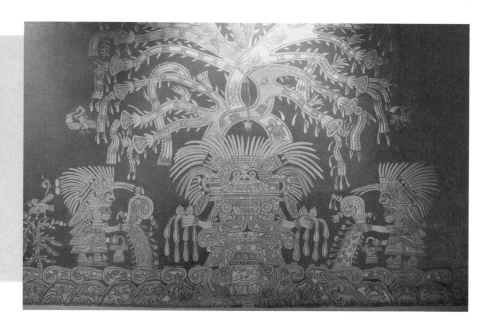

테오티우아칸에서 발견된 이 벽화의 주제는 폭풍의 신과 풍요의 여신입니다. 몇몇 고고학자들은 이 여신이 테오티우아칸의 종교에서 가장 중심적인 존재였다고 믿는답니다.
〈위대한 여신 벽화〉, 200년경

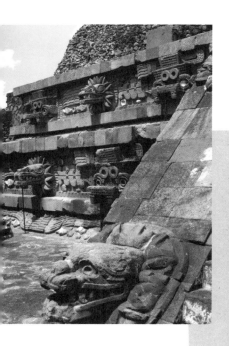

깃털 달린 뱀의 무시무시한 얼굴은 이 도시의 전사들에게 중요한 상징물이었습니다. 신전의 선반 형태 구조는 이후의 여러 문명에서 모방되었지요. 최근에 고고학자들은 신전 아래 수은이 고여 있는 것을 발견했습니다. 어쩌면 테오티우아칸 사람들은 이 은빛 액체 금속을 신비의 호수로 여겼을지도 모릅니다.
〈깃털 달린 뱀 신전의 석조 두상〉, 200년경

깃털 달린 뱀은 고대 메소아메리카의 여러 지역에서 발견되는 상징물입니다. 이 수수께끼의 존재에 대한 숭배는 테오티우아칸에서 시작된 것으로 보입니다. 아즈텍 사람들은 테오티우아칸 유적을 탐사하면서 발견한 깃털 달린 뱀 조각을 그들의 신 케찰코아틀과 연관 지었습니다. 케찰코아틀이 자신의 피를 뿌려 고대 유적의 뼈들을 되살린 다음 인류를 창조했다고 믿었던 것이지요. 어쩌면 테오티우아칸 사람들도 이와 비슷한 믿음을 가졌을 수도 있습니다. 수 세기 동안 중앙아메리카 전역의 사람들은 이 신전에서 거행된 극적인 의식을 보기 위해 테오티우아칸을 찾아왔습니다.

숲 속의 거대한 아잔타 (500년)

정글 깊이 숨겨진 사원

19세기 초에 어느 영국 군인들이 인도 중부의 숲 속으로 호랑이 사냥을 떠났습니다. 그때 갑자기 그들의 눈앞에 말발굽처럼 강줄기를 에워싸며 구부러진 가파른 절벽이 나타났지요. 군인들은 바위 위로 우거진 덤불과 뿌리를 제거하며 나아간 끝에 우연히 고대의 동굴 수십 곳으로 이어지는 입구를 발견했습니다. 이곳은 바로 거대한 아잔타 석굴이었습니다. 바위벽을 파내서 만든 방과 사원들이 30여 개에 이르렀지요. 불교 승려들이 아잔타에서 살기 시작한 것은 기원전 2세기였다고 하는데, 그들은 인도에서 불교가 쇠락할 때까지 900년 넘게 이곳에 머물렀습니다. 아잔타의 전성기는 500년 무렵이었는데, 그 당시 고대 인도에서 강성했던 굽타 왕조의 수도 파탈리푸트라로 이어지는 교역로와 가까웠던 덕분이었지요.

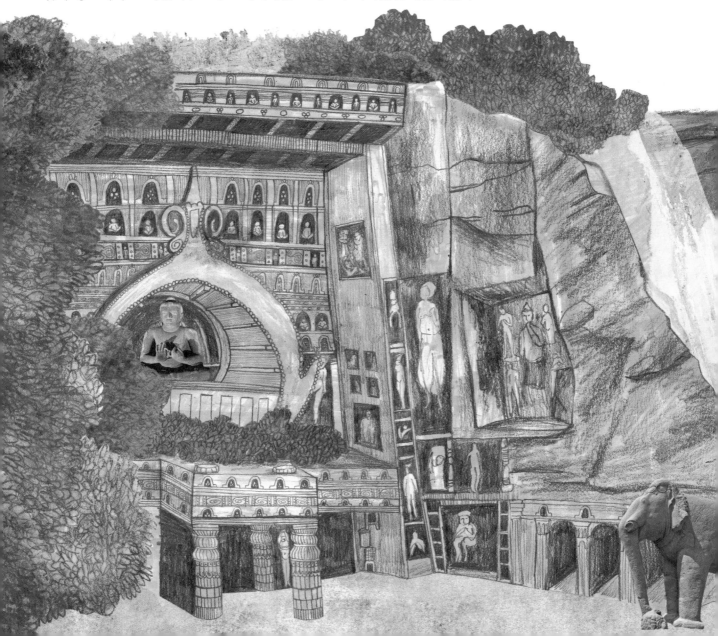

태풍이 오는 우기가 되면 승려들은 동굴 안에 머물며 명상하고 학문을 닦았습니다. 이 지역에 비가 어찌나 거세게 내렸는지 동굴 밖에는 18미터 높이의 폭포가 생겨났습니다. 다행히 동굴 벽화는 햇빛과 빗물로부터 안전했기에 지금까지 남게 되었지요. 동굴들 중 24곳은 승려들이 잠자는 기숙사였고, 5곳은 사원이었답니다.

〈아잔타 석굴〉, 인도, 500년

승려들은 근처 마을까지 걸어가서 주민들과 상인들을 만나곤 했습니다. 사람들은 승려들이 기도와 학문에 전념할 수 있도록 시주를 했지요. 아잔타에는 학문을 가르치는 교사도 있었고 배우는 학생도 있었습니다. 일부 학생들의 이름은 동굴 벽에 새겨져서 지금 우리에게도 알려져 있지요. 그들은 열심히 일하고 종교와 철학, 수학, 천문학 책을 읽었으며 돌 위에서 잠자는 등 소박하게 생활했답니다. 하지만 그들이 사는 곳은 놀라운 미술작품과 아름다운 자연 풍광으로 가득했지요. 아잔타 석굴에서는 인도에 남아 있는 가장 오래된 그림들, 그리고 인도 최고의 바위 조각과 건축을 볼 수 있습니다.

불교

불교는 아시아에서 2천 년도 더 전에 싯다르타라는 사람에 의해 시작되었습니다. 그는 이후 부처라는 이름으로 알려지게 되었지요. 그는 고귀한 가문 출신이었으나 성장하면서 인간의 삶이 얼마나 고통스러운 것인지 깨달았습니다. 이후 싯다르타는 영혼의 평화, 즉 '열반'에 이르는 길을 깨닫고 이를 다른 사람들에게도 가르쳤습니다.

바위 동굴 속의 불교 걸작품들

남아시아 전역의 예술가들이 아잔타 석굴의 미술을, 특히 그림들을 모방했습니다. 이곳에 있는 그림들 상당수는 동굴 속 깊은 곳에 그려져 불을 밝혀야만 볼 수 있었습니다. 아잔타의 화가들은 현대의 미술가들과 달리 작품에 서명을 남기지 않았습니다. 여러 미술가들이 각각의 동굴에서 공동 작업하며 다양한 기법과 양식으로 하나의 그림을 만들어냈습니다. 작업은 고되었으며 채색할 물감을 준비하는 데만도 여러 날이 걸렸습니다. 미술가들은 노란색과 붉은색 흙을 땅에서 파냈고, 검은색과 푸른색 물감을 만들기 위해 난로에서 검댕을 모으고 라피스라줄리(청금석)라는 푸른 보석을 캐냈답니다.

이 조각은 어찌나 입체적인지 마치 돌덩어리를 깎아 만든 것처럼 보입니다. 하지만 실은 바위벽을 안으로 파낸 것입니다. 아주 힘든 작업이었겠지요. 조각 뒤쪽으로 돌아가 작업할 수 없었기에, 조각가는 손이 잘 닿지 않는 부분에 이르면 옆으로 비스듬히 돌을 쪼아야 했습니다. 왕의 머리 위로 코브라 일곱 마리가 보이는군요. 왕과 여왕은 왕족에게만 허용된 느긋한 자세로 앉아 있습니다. 그 아래 계층 사람들은 절대로 이렇게 편히 앉아 있을 수 없었지요.
〈나가 왕과 여왕, 19번 동굴〉, 5세기 말

아잔타 석굴에서 가장 후기에 만들어졌고 가장 화려하게 장식된 기도실 중 하나입니다. 뒤쪽으로 불교의 성물들이 보관된 스투파라는 구조물이 있고 앞쪽으로는 부처의 부조가 보입니다. 부처는 종종 한 손을 쳐들고 축복을 내리거나 설법하는 모습으로 묘사됩니다.
〈기도실, 26번 동굴〉, 5세기 말

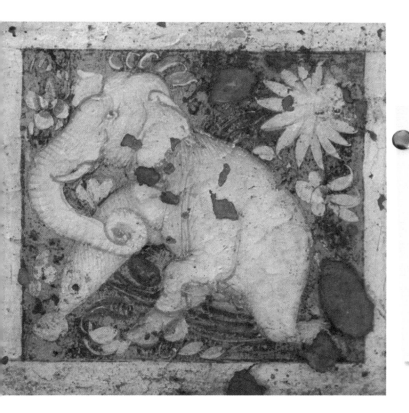

인도의 호수와 연못에 서식하는 연꽃은 불교도들에게 특별한 꽃입니다. 피어나는 연꽃은 열반을 상징하며, 따라서 아래 그림의 보살도 손가락 끝으로 연꽃을 잡고 있습니다. 흰 코끼리는 종종 부처와 연관되는 동물로, 이 그림 속에서는 연꽃 핀 연못에서 목욕한 후 물을 털어내고 있습니다. 〈천장화 세부, 1번 동굴〉, 5세기 말

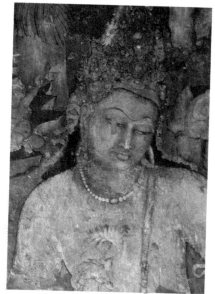

불교도들은 이번 삶에서의 행동이 다음 삶에 영향을 준다고 믿습니다. 어떻게 사는지에 따라 동물에서 신까지 온갖 존재로 환생하며 윤회하게 된다는 것입니다. 이 그림에 묘사된 보살은 윤회의 고리를 거의 깨고 열반에 가까워진 존재이지요. 〈연화수 보살, 1번 동굴〉, 5세기 말

아잔타 이전에도 승려들은 동굴 벽화를 그렸지만, 그리기 전 벽면에 점토와 회반죽을 칠한 뒤 돌가루와 풀을 발라야 했습니다. 하지만 그들의 노고는 그만한 가치가 있었지요. 세부 묘사와 명암 처리가 놀랍도록 섬세한 덕에 그림 속 인간과 동물의 얼굴들은 살아 있는 것처럼 보입니다. 벽화 속에서 부처가 자신의 여러 전생들에 관해 이야기하며 제자들을 가르치는 모습을 종종 볼 수 있습니다. 부처는 미술이 사람들을 현혹하여 자신의 메시지에 집중하지 못하게 만들까 봐 우려했습니다. 하지만 부처의 제자들 일부는 그의 메시지가 아름다운 미술 작품으로 만들어질 가치가 있다고 믿었습니다. 미술은 때로는 글보다 더욱 효과적으로 메시지를 전달할 수 있으니까요.

치열한 성지, 예루살렘(700년경)

누구의 땅인가?

예루살렘만큼 치열하게 뺏고 빼앗긴 도시도 드물 것입니다. 유대인과 기독교인, 무슬림들은 각각 자기들에게 가장 중요한 역사적 사건이 이 도시에서 일어났다고(혹은 일어날 것이라고) 주장합니다. 최초의 유대교 성전은 3천 년 전 예루살렘에 세워졌습니다. 유대인들에게는 세계에서 가장 거룩한 장소지요. 천 년 뒤 헤롯 왕이 같은 자리에 더욱 장엄한 성전을 지었지만 이곳도 훗날 파괴되었습니다. 유대교 성전에서 남은 것이라곤 서쪽 벽면뿐인데, 유대인들은 지금도 이곳에서 옛 성전을 기억하며 기도합니다. 한편 기독교인들은 예수가 자신을 희생해 인간들을 구원했기 때문에 형식적인 건물뿐인 유대교의 성지는 더 이상 의미가 없다고 여겨서 성전산(Temple Mount)을 정복한 뒤 쓰레기장으로 방치하였지요.

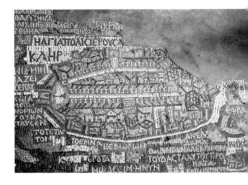

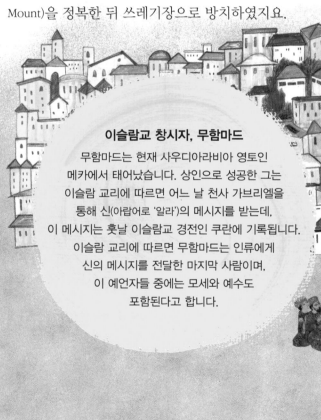

이슬람교 창시자, 무함마드

무함마드는 현재 사우디아라비아 영토인 메카에서 태어났습니다. 상인으로 성공한 그는 이슬람 교리에 따르면 어느 날 천사 가브리엘을 통해 신(아랍어로 '알라')의 메시지를 받는데, 이 메시지는 훗날 이슬람교 경전인 쿠란에 기록됩니다. 이슬람 교리에 따르면 무함마드는 인류에게 신의 메시지를 전달한 마지막 사람이며, 이 예언자들 중에는 모세와 예수도 포함된다고 합니다.

왼쪽 그림은 비잔틴 교회 바닥의 모자이크로, 현존하는 가장 오래된 중동 지도입니다. 아래에 그려진 부분은 예루살렘을 나타내는데, 그리스어 설명이 붙어 있고 가운데에는 성묘 교회의 황금 돔이 보이지요. 이 지도의 놀랍도록 정확한 묘사 덕에 고고학자들은 주요 유적들의 위치를 한눈에 파악할 수 있었답니다.

〈마다바 지도〉 세부, 요르단 마다바의 성 조지 교회, 6세기 중반

기독교인들은 성전산 가까이에 성묘 교회(Holy Sepulchre)를 지었습니다. 예수가 태어났고 이후 부활했다고 여겨진 자리였지요. 638년에 예루살렘은 무슬림들의 손에 들어갔습니다. 그들의 우두머리는 성묘 교회에 참배한 뒤 성전산으로 가서 쓰레기장을 치우도록 명령한 후, 이 자리에 무슬림 최초의 주요 기념물인 '바위의 돔'을 짓게 했습니다. 유대교 사원이나 기독교의 성묘 교회보다도 더욱 장엄한 건물이었지요.

신의 모습이 없는 종교 미술

아라비아 반도에서 온 무슬림 군대는 700년 무렵 중동과 북아프리카를 지나 남유럽 일부를 점령하기에 이르렀습니다. 무함마드의 죽음으로 이들의 승리는 70년도 채 못 되어 막을 내렸지만, 이 기간에 무슬림들은 갑자기 여러 다른 문화권의 미술을 접하고 그 영향을 받게 되지요. 무함마드는 미술에 관해 언급하지 않았기 때문에, 초기의 무슬림들은 이슬람교 미술의 방향을 직접 결정해야 했습니다. 그들은 특히 예루살렘 성묘 교회의 돔 지붕을 비롯한 비잔틴 건축에 깊은 인상을 받았기 때문에 예루살렘을 정복한 뒤 비슷한 형태로 '바위의 돔'을 만들어 그 내부를 섬세한 모자이크로 장식했습니다.

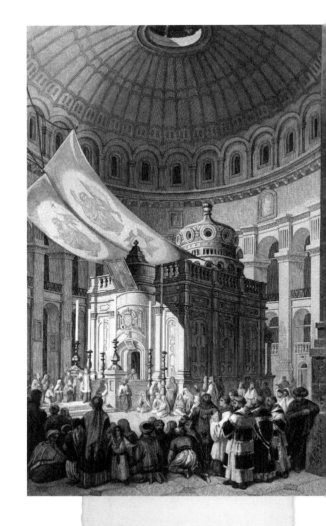

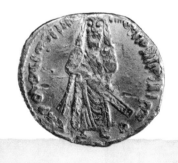

무슬림 군대는 기독교 문화권을 점령하면 그곳의 도상을 자기들의 신앙에 맞게 바꾸었습니다. 기독교도들의 주화에 황제 대신 무슬림 통치자인 칼리프 아브드 알말리크(위쪽 사진)가 새겨졌지요. 주화 뒷면에는 기독교의 십자가 대신 기둥이 새겨졌고요. 이후에 칼리프는 일체의 도상을 없애고 그 대신 쿠란의 인용문을 넣었습니다.
〈디나르 금화〉, 695~96년

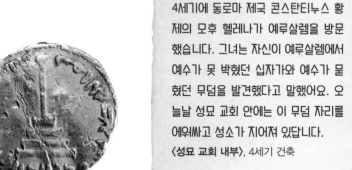

4세기에 동로마 제국 콘스탄티누스 황제의 모후 헬레나가 예루살렘을 방문했습니다. 그녀는 자신이 예루살렘에서 예수가 못 박혔던 십자가와 예수가 묻혔던 무덤을 발견했다고 말했어요. 오늘날 성묘 교회 안에는 이 무덤 자리를 에워싸고 성소가 지어져 있답니다.
〈성묘 교회 내부〉, 4세기 건축

'바위의 돔'을 지은 건축가들은 단순히 기독교 미술을 모방하지 않았고 이슬람교 신앙에 적합한 도상들을 꼼꼼히 골라냈지요. 무함마드는 알라 외에 어떤 사람이나 물건도 숭배하지 말라고 경고했기에, '바위의 돔'을 장식한 미술가들 역시 혼란이 생기지 않도록 인간이나 동물의 도상은 피했습니다. 다른 시대와 지역의 무슬림들은 이와 조금 다른 그들 나름의 미술 법칙을 만들기도 했지만, 한 가지만은 모두 의견이 일치했습니다. 바로 신의 모습을 묘사해서는 안 된다는 점이지요.

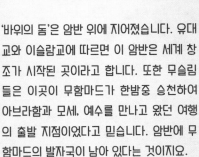

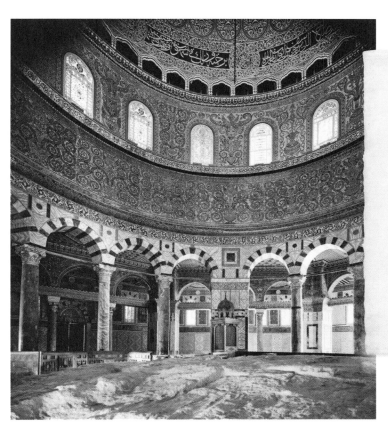

'바위의 돔'은 암반 위에 지어졌습니다. 유대교와 이슬람교에 따르면 이 암반은 세계 창조가 시작된 곳이라고 합니다. 또한 무슬림들은 이곳이 무함마드가 한밤중 승천하여 아브라함과 모세, 예수를 만나고 왔던 여행의 출발 지점이었다고 믿습니다. 암반에 무함마드의 발자국이 남아 있다는 것이지요.
〈바위의 돔〉, 691년 완공

돔 지붕은 오랜 세월 납이 씌워져 있다가 1960년대에 처음 지어졌을 때처럼 금으로 복원되었습니다. 이곳의 벽은 12세기 터키에서 만든 아름다운 푸른색 타일로 덮여 있는 것으로 유명합니다. 이곳은 기독교 십자군에 점령당한 뒤 얼마 동안 교회로 개조되기도 했지요.
〈바위의 돔〉, 691년 완공

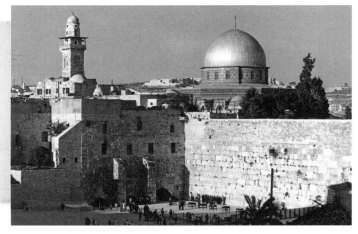

바이킹의 무역항, 헤데비 (900년)

바이킹의 요새

바이킹이란 북해 연안에 살았던 전사 민족의 명칭입니다. 옛 스칸디나비아어 비킹그(vikingr)에서 온 말이지요. 이 북유럽 사람들은 8세기부터 11세기까지 바다를 지배했습니다. 덴마크, 스웨덴, 노르웨이를 넘어 종종 영국과 아일랜드까지도 습격했지요. 아이슬란드와 그린란드에 정착지를 만들었고, 심지어 크리스토퍼 콜럼버스보다 5세기 먼저 북미 대륙에도 갔답니다!

바이킹들은 먼 나라들로 대담한 원정을 떠났던 것으로 유명하지만, 그들의 고향 땅에도 번성한 마을들이 있었습니다.

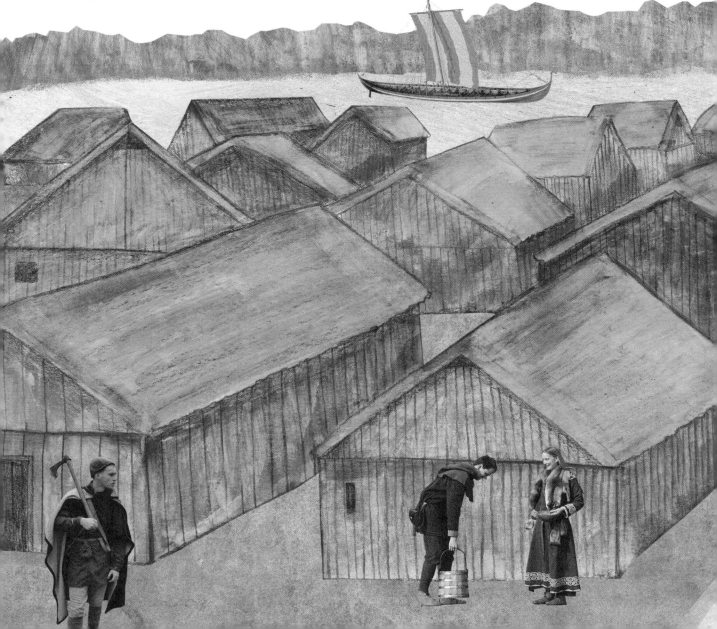

헤데비는 바이킹 영토에서 최초로 고유의 주화를 만든 곳이었습니다. 이 주화들은 화폐일 뿐만 아니라 미술작품이기도 했지요. 스웨덴의 바이킹 무덤에서는 헤데비 주화를 꿰어 만든 목걸이들이 발견되었어요. 이 은화에 그려진 배는 전형적인 바이킹 범선으로, 바다와 강을 모두 다닐 수 있어 남쪽으로 진출하기에 편리했답니다.
〈헤데비에서 주조된 은화〉, 10세기

덴마크의 고트프리트 왕은 헤데비를 바이킹의 요새로 만들었지요. 헤데비는 현재 독일 땅인 유틀란트 반도에 있습니다. 두 바다 사이에 위치한 덕에 완벽한 무역항이 되었지요. 장인들은 유리를 불고, 양털로 실을 자았으며, 좁고 긴 범선을 제작했습니다. 헤데비 여성들은 당시 세계 어느 곳의 여성들보다도 독립적으로 살았습니다. 부동산을 소유했고 남편과 이혼할 수도 있었지요. 일부 여성들은 마법사로 크게 존경받았고 남성들은 그들의 조언을 들으러 오곤 했습니다. 바이킹의 폭력적인 악명은 그들 역사의 일부분에 불과하답니다.

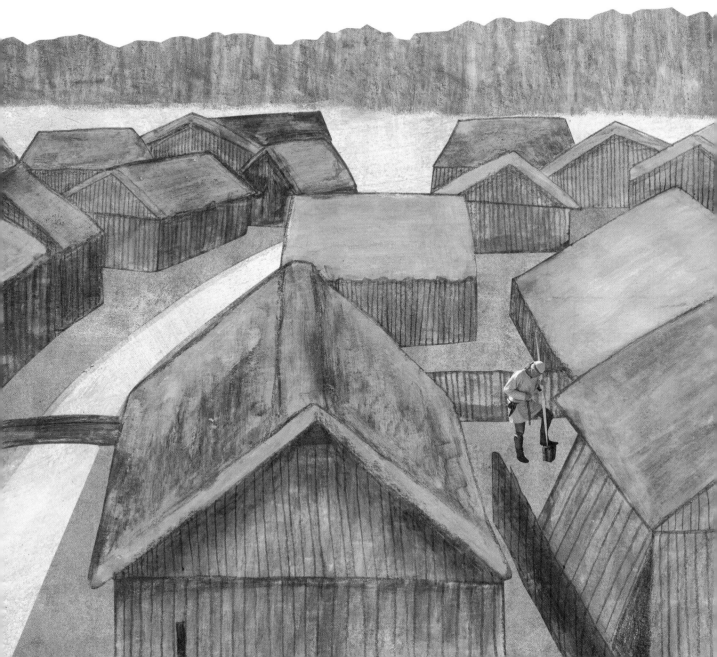

바이킹들의 흔적을 찾아서

바이킹의 유물을 찾기란 쉽지 않은 일입니다. 그들의 훌륭한 공예품 상당
수는 나무로 만들어져서 오래전에 썩어 없어졌지요. 다행히도 고고학자
들은 헤데비에서 꽤 많은 유물을 발견할 수 있었습니다. 그중에는 항구의
진흙 바닥 속에 묻혀 있던 대형 선박의 잔해도 있었지요. 또 다른 주요 유
물들은 저장된 보물 속에서 발견되었습니다. 귀금속으로 만든 이 보물들
은 당시 사람들이 안전히 보관하려고 땅속에 묻었지만 다시 파내지 못한
것들입니다. 소유자들이 보관 장소를 잊어버렸거나 미처 파내기 전에 사
고를 당했던 것이겠지요. 오늘날에도 사람들은 여전히 금속 탐지기를 들
고 다니며 땅속의 보물을 찾고 있답니다.

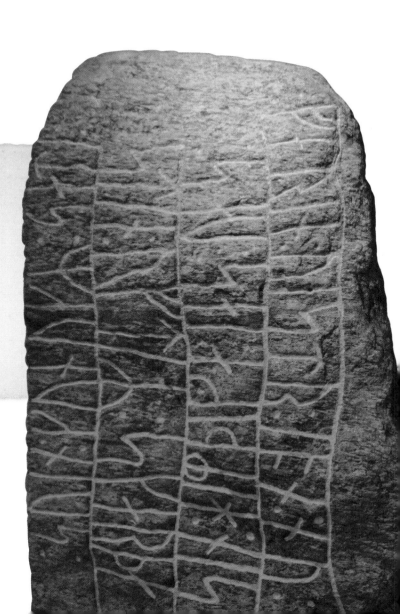

이 화강암 기념비에는 고대의 룬 문자가 새겨져
있습니다. 삐죽삐죽한 형태가 마치 화살표나 갈지
자처럼 보이는 룬 문자는 나무나 돌, 뼈에 메시지
를 새기는 데 주로 사용했지요. 여기 새겨진 메시
지는 다음과 같습니다. '스벤 왕이 스카르티를 기
념하여 이 돌을 세웠다. 왕의 충실한 신하였던 그
는 서쪽으로 떠났으나 헤데비 근처에서 죽음을 맞
이했도다.'
〈스카르티 룬 문자석〉, 982년경

바이킹 미술은 장식적이면서도 실용적입니다. 현존하는 금속 공예 품들은 바이킹 장인들이 물건의 표면 전체에 장식을 새기곤 했음을 보여줍니다. 동물들이 리본처럼 엮이고 꼬이거나, 긴 발톱으로 서로 움켜잡고 있는 복잡한 문양도 종종 눈에 띕니다. 바이킹 미술가들은 사람을 묘사할 때면 종종 신화 내용에서 영감을 얻었습니다. 하지만 바이킹들이 기독교로 개종하면서 북유럽 신화의 많은 부분이 잊혀졌습니다. 지금까지 전해지는 일화들 중 하나는 최고신 오딘이 싸우다 죽은 전사들을 발할라 궁전에서 맞아준다는 것입니다. 죽은 전사들은 함께 모여 언젠가 일어날 신화적 전투이자 세상의 종말이 될 라그나로크를 준비한다고 하지요. 바이킹 시대는 오래전에 끝났지만, 이 전사들은 미술작품을 통해 살아남았답니다.

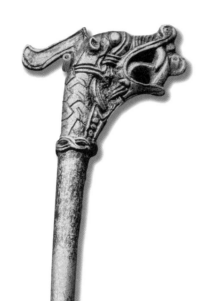

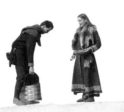

이 조그만 핀의 복잡한 세부 문양은 바이킹 예술가의 솜씨를 잘 보여줍니다. 용은 바이킹들이 애용한 도상입니다. 바이킹 문화에서 용이 얼마나 중요한 상징이었는지는 900년 뒤 근대 스칸디나비아 예술가들이 고대 문양에서 영감을 얻어 만든 양식을 드라게슈틸(dragestil, 용 스타일)이라고 불렀던 것만 봐도 알 수 있지요.
〈용머리가 새겨진 금속 핀〉, 950~1000년경

이 칼자루 장식은 바이킹 미술에서 흔히 볼 수 있는 무늬와 형태가 연결되고 맞물려 있습니다. 바이킹이 정복하고 정착한 지역마다 이런 문양들이 전파되었답니다.
〈칼자루〉, 9세기

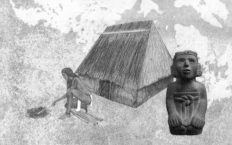

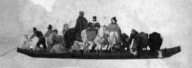

• 카호키아
(1100년)

북대서양

그
(1

팀북투

북태평양

남태평양

남대서양

중세와
근세 미술의
찬란한 업적

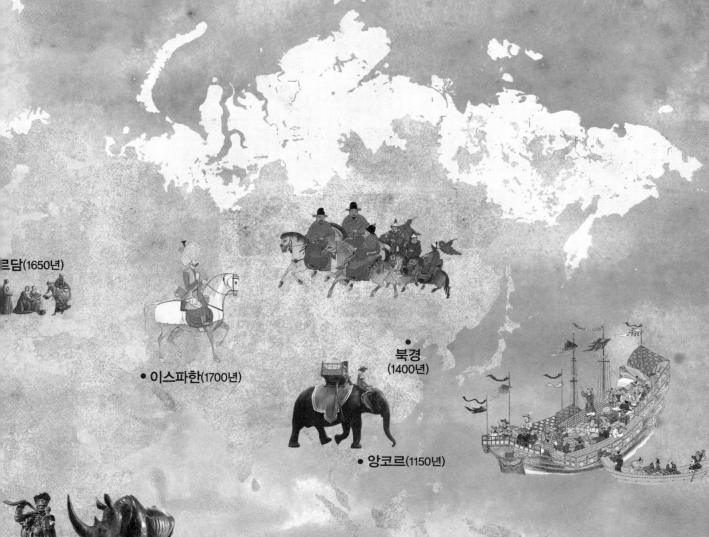

르담(1650년)

이스파한(1700년)

북경
(1400년)

앙코르(1150년)

그레이트 짐바브웨
(1300년)

인도양

남극해

부유한 도시, 카호키아 (1100년)

아메리카 원주민 문명 최대의 도시

'신세계'에 도착한 유럽인들은 이곳에서 만난 사람들을 원시인이나 야만인이라고 불렀습니다. 하지만 사실 아메리카 대륙에는 그보다 수천 년 전부터 수백만 명에 이르는 다양한 부족들이 살아가고 있었습니다. 일부 도시들은 그보다 훨씬 오래전에 전성기를 지났기에 그 후손인 원주민들에게도 잊힌 상태였지요. 우리는 고대 도시 카호키아에 관해 오직 고고학 유적을 통해서만 알고 있지만, 지금껏 알게 된 것들만 해도 충분히 놀랍습니다. 이 도시는 미시시피 강과 미주리 강, 일리노이 강이 만나는 지점 가까이 있었습니다. 카호키아 사람들은 비옥한 땅에 옥수수를 재배했지요. 인구가 많았지만 수확량이 풍부해서 이들 모두에게 다 식량을 공급할 수 있었습니다. 카호키아는 멕시코 북부 최대의 도시로 성장했습니다. 전성기의 도시 인구는 2만 명으로 당시의 런던과 같은 규모였지요.

이 도시의 당시 이름이 무엇이었는지 우리는 모릅니다. 카호키아는 이후 프랑스인들이 이곳을 식민지로 삼았을 때 살고 있던 부족 이름이지요. 도시 중심의 거대한 언덕은 '몽크스 마운드(Monk's Mound)'라고 불렸는데, 이는 19세기에 기독교 선교사들이 이 언덕에서 살았기 때문이랍니다. 현재 카호키아는 일리노이 주의 도시 세인트루이스 동부에 속합니다.

〈몽크스 마운드〉, 카호키아

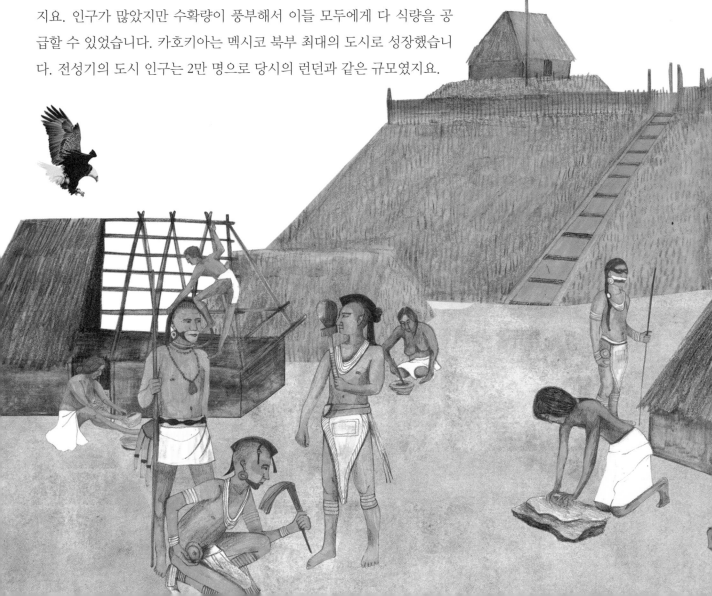

부유한 도시 카호키아는 미 대륙 전역과 교역했습니다. 카호키아 사람들은 오대호의 구리, 멕시코 만의 조개껍질, 로키 산맥의 회색 곰 이빨(장신구 재료였지요)을 구할 수 있었습니다. 물품 거래를 통해 종교적·정치적·예술적 아이디어들도 전파되었습니다. 카호키아가 1400년대 이후 버림받은 도시가 된 이유는 아무도 모릅니다. 하지만 이 도시가 남긴 전통은 이후로도 수 세기 동안 아메리카 원주민들의 삶에 영향을 미쳤답니다.

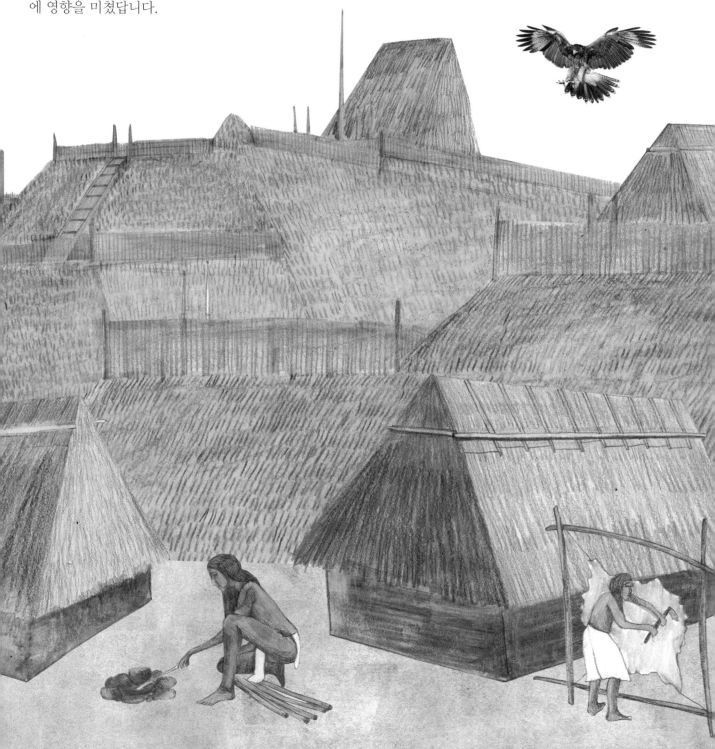

거대한 조각품, 언덕의 도시

카호키아와 도시 주변의 비옥한 농지를 관리하고 방어하려면 고도로 조직된 공동체가 필요했습니다. 귀족들은 카호키아를 다스리고 교외 거주민들에게 세금을 거두었습니다. 종교가 귀족들의 권력을 뒷받침해주었지요. 도기, 돌, 조개껍질에 남겨진 도상을 살펴보면 카호키아의 지배자들은 그들이 태양에서 내려왔으며 생명을 주는 힘을 부여받았다고 여긴 듯합니다. 그들은 도시 중심에 자기들의 권력을 나타내는 거대한 언덕을 쌓았답니다.

이 조각은 세상을 떠난 족장을 묘사한 것으로 보입니다. 족장은 황홀경에 빠져 종교적 환영을 보고 있는 듯한 모습입니다. 머리 장식, 망토, 조개껍질 목걸이와 귀걸이로 카호키아 사람들의 복식을 추측해볼 수 있습니다. 이 작품은 카호키아 근처에서 제작되어 이 도시 문화의 영향을 받은 다른 도시로 팔려간 것입니다.

〈보크사이트를 깎아 만든 '빅보이' 모형 담뱃대〉, 1200~1350년경

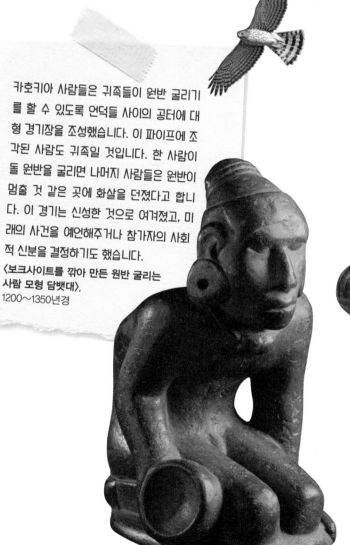

카호키아 사람들은 귀족들이 원반 굴리기를 할 수 있도록 언덕들 사이의 공터에 대형 경기장을 조성했습니다. 이 파이프에 조각된 사람도 귀족일 것입니다. 한 사람이 돌 원반을 굴리면 나머지 사람들은 원반이 멈출 것 같은 곳에 화살을 던졌다고 합니다. 이 경기는 신성한 것으로 여겨졌고, 미래의 사건을 예언해주거나 참가자의 사회적 신분을 결정하기도 했습니다.

〈보크사이트를 깎아 만든 원반 굴리는 사람 모형 담뱃대〉, 1200~1350년경

샤먼

여러 문화권에서 그랬듯 카호키아에서도 샤먼들이 중요한 역할을 했습니다. 그들은 탄생, 결혼, 죽음에 관련된 종교의식을 거행했지요. 또한 질병 치유와 부족의 역사를 기념하는 데도 관여했습니다. 샤먼은 성직자, 예언자, 의사, 역사가를 합친 존재라고 할 수 있었답니다.

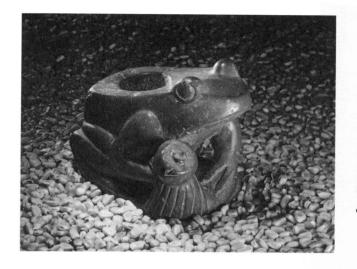

카호키아의 조각품은 담뱃대 형태로 만들어진 것이 많습니다. 담배 피우는 것은 여러 문화권에서 영혼 세계와의 교류이자 신성한 행위로 여겨졌답니다. 이 개구리는 종교의식 도구인 듯한 딸랑이를 들고 있는데, 동물의 영혼이 깃든 샤먼을 나타냈는지도 모릅니다.

〈딸랑이를 든 개구리 담뱃대〉, 1250년경

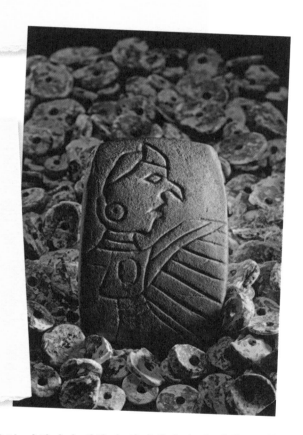

카호키아의 종교에서 맹금류, 특히 독수리와 매는 특별한 힘이 있다고 여겨졌습니다. 카호키아 사람들은 이런 새들과 비슷한 차림을 하고 춤추며 의식을 거행했을지도 모릅니다. 이 석판에 새겨진 그림처럼 말이지요. 이는 전사 한 명이 매장된 자리 주변에 거대한 매 형태로 조개껍질이 놓여 있었던 것을 보고 추측할 수 있답니다.

〈조개껍질 구슬과 함께 놓인 '버드맨' 사암 석판〉, 1200~1350년경

일 년에 두 번, 춘분과 추분 아침이면 태양이 언덕에서 솟아 나와 그 꼭대기의 신전에 불을 밝히는 것처럼 보였습니다. 언덕 자체가 흙으로 만들어진 하나의 거대한 조각품이었지요. 언덕은 10층 높이로 이루어졌고 넓이는 축구 경기장 12개를 합친 것과 같았습니다. 카호키아의 족장들은 신전 안에 귀한 미술품들로 에워싸여 매장되었습니다. 신전은 종종 불타서 재로 뒤덮였고, 그 자리에 다시 새로운 신전이 세워졌습니다. 신전이 재건될 때마다 언덕은 더 높아졌고 신전 안의 보물들도 늘어났지요.

황금빛 수도, 앙코르 (1150년)

크메르 왕국의 천상의 수도

앙코르의 고대 유적은 논으로 둘러싸인 캄보디아의 열대림 속에 있습니다. 앙코르에서 출발한 크메르 왕국은 캄보디아 전체를 정복하고 현재의 태국, 라오스, 베트남까지 확장되었습니다. 하지만 앙코르는 단지 크메르 왕국의 수도만이 아니었지요. 크메르의 왕들은 앙코르가 정말로 우주의 중심이며 자기들이 신들에게 특별히 선택받았다고 믿었습니다. 크메르의 왕 수리야바르만 2세는 1116년부터 30년 후 사망할 때까지 힌두교 사원 앙코르와트의 건설을 감독했습니다. 이 사원은 지금까지도 세계 최대의 종교 건축물로 꼽힐 정도로 거대하지요. 앙코르와트의 대규모 수도원은 신들에겐 현세의 집이며 왕들에게는 천상의 궁전이라고 여겨졌답니다.

수리야바르만 왕이 죽은 후 왕국은 쇠퇴하기 시작했습니다. 한동안 분쟁과 반란이 이어졌고 크메르 왕가는 앙코르의 지배권을 잃었습니다. 하지만 12세기 후반에 왕위에 오른 자야바르만 7세가 앙코르를 되찾았습니다. 왕은 이를 축하하기 위해 수백 곳의 사원과 병원, 휴게소 등 대규모 건설 계획에 착수했지요. 그가 가난한 자들에게 베푼 친절은 전설로 남아 있습니다. 자야바르만 7세 시대의 한 조각에는 '왕을 슬프게 하는 것은 바로 백성의 슬픔이다'라고 새겨져 있지요. 그는 새로운 수도 앙코르톰을 세우는 것으로 시작하여 왕국 전체에 불교를 전파했습니다. 앙코르와트처럼 앙코르톰도 영원히 존재할 수 있도록 만들어진 곳이었답니다.

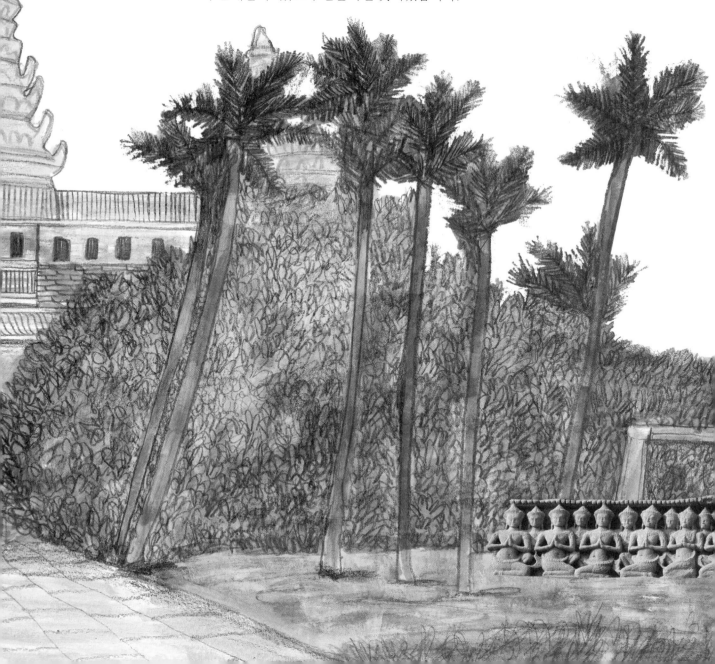

밀림 속의 완전한 천상의 왕국

위에서 내려다본 앙코르의 모습은 땅에서 올려다본 모습만큼 인상적입니다. 가장 먼저 눈에 띄는 것은 이곳의 기하학적 구조입니다. 사원 건물들은 천상의 완벽함을 나타내듯 완전한 대칭을 이루고 있습니다. 기둥과 창문들은 태양과 달과 별들의 위치에 부합하게 만들어졌지요. 힌두교와 불교의 신들은 세계의 중심이자 대양 한가운데에 있는 메루 산(Mount Meru)에 산다고 합니다. 앙코르 사원의 탑들은 메루 산에 있는 천상의 봉우리를 나타내며, 탑들을 둘러싼 넓은 해자는 우주의 바다를 상징한답니다.

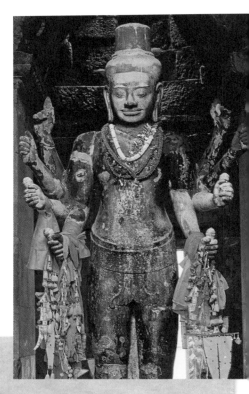

힌두교

힌두교의 기원은 수천 년 전으로 거슬러 올라갑니다. 여러 다양한 신앙과 관습들이 어우러져 이 종교를 형성했지요. 힌두교에는 수많은 신들이 있지만, 힌두교도들은 대부분 최고신은 오직 하나뿐이라고 생각합니다. 오늘날 세계에는 약 10억 명의 힌두교도가 있는데, 그 대다수는 남아시아에 산답니다.

'수리야바르만'이라는 이름은 '태양의 수호자'를 뜻합니다. 수리야바르만 2세는 앙코르와트 사원을 세계의 수호신 비슈누에게 바쳤습니다. 사원 입구의 이 조각상은 비슈누의 모습을 한 왕을 나타낸 것으로 보입니다. 오늘날에도 승려들은 이 조각상을 장식하고 공물을 바치며 경의를 표합니다.
〈비슈누 상〉, 앙코르와트, 12세기

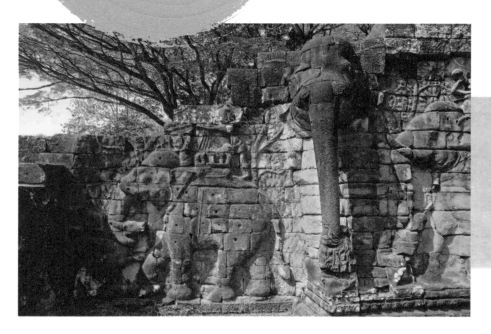

기둥 여러 개를 코끼리의 코 모양으로 파낸 이 조각품은 크메르 예술가들의 창의성을 잘 보여줍니다.
〈코끼리 테라스〉, 앙코르톰, 12세기 말

자야바르만 7세는 앙코르 지역을 불교 사원들로 채웠습니다. 그중 가장 중요한 곳은 바욘 사원으로, 불교 신앙의 영향을 뚜렷이 드러냅니다. 이곳의 석탑에서는 아잔타 석굴에 있는 것과 비슷한 거대 보살 두상 부조를 볼 수 있습니다.
〈바욘 사원의 돌탑〉, 앙코르톰, 12세기 말~13세기 초

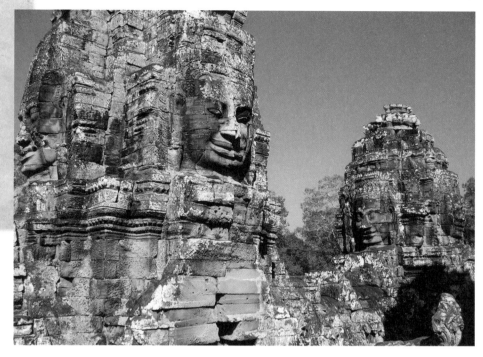

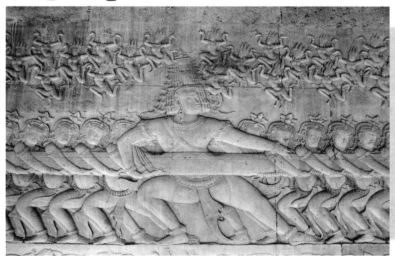

앙코르와트의 종교적 부조들은 천 제곱미터 이상의 크기를 자랑합니다. 이 부조는 세상의 시초에 관한 힌두교 신화를 묘사한 것입니다. 신들과 악마들이 양쪽에서 뱀 한 마리를 밧줄처럼 잡아당기고 있습니다. 이들은 우유로 가득한 우주의 바다를 휘젓고 있는데, 이렇게 하여 영생의 묘약인 신들의 음료가 만들어졌다고 합니다.
〈우유 바다를 휘젓다〉 세부, 앙코르와트, 12세기

크메르 왕들은 완벽한 직사각형 저수지를 지었습니다. 바라이(baray)라고 불리는 이 저수지들은 수 킬로미터에 달하는 뛰어난 관수 시설로, 논에 물을 대어 수십만 백성을 먹이는 데 큰 도움을 주었지요. 물은 실용적인 동시에 신성한 존재였습니다. 성직자들은 신에게 공물을 바치는 일을 매우 진지하게 여겼으며, 신들이 먹고 마실 꿀과 우유, 당밀부터 모기장으로 쓸 비단실 그물까지 신들에게 필요한 일체의 물품 목록을 만들었습니다. 크메르의 사원들은 왕에게 적합한 만큼 신들에게도 적합한 곳이어야 했답니다.

그레이트 짐바브웨(1300년)

석조의 승리

'짐바브웨'라는 말은 돌로 만든 집을 뜻합니다. 하지만 그레이트 짐바브웨는 단순히 돌집 여러 채가 모인 곳이 아니었지요. 이곳은 철기 시대에 쇼나족의 수도였습니다. 짐바브웨와 모잠비크에서는 지금까지 150곳 이상의 석조 유적이 발견되었는데, 그중 가장 규모가 큰 곳이 그레이트 짐바브웨입니다. 14세기에 이 도시는 수 제곱킬로미터 의 넓이를 자랑했습니다. 두께가 3미터를 넘는 돌벽에 둘러싸인 도시는 가파른 언덕 꼭대기의 왕궁에서 언덕 아래의 대광장(Great Enclosure)에 이르렀지요. 1만 명 이상의 주민이 인도양 너머까지 금을 수출했답니다. 고고학자들은 쇼나족이 페르시아나 중 국의 도자기와 같은 사치품을 수집했다는 사실을 알아냈습니다. 도시가 폐허로 변한 지 한참 뒤에도 탐험가들은 이곳의 전설들을 이야기하곤 했지요. 사람들은 이곳이 성 경 속 솔로몬 왕의 비밀 금광, 혹은 시바의 여왕이 살던 궁전이었다고 상상했답니다.

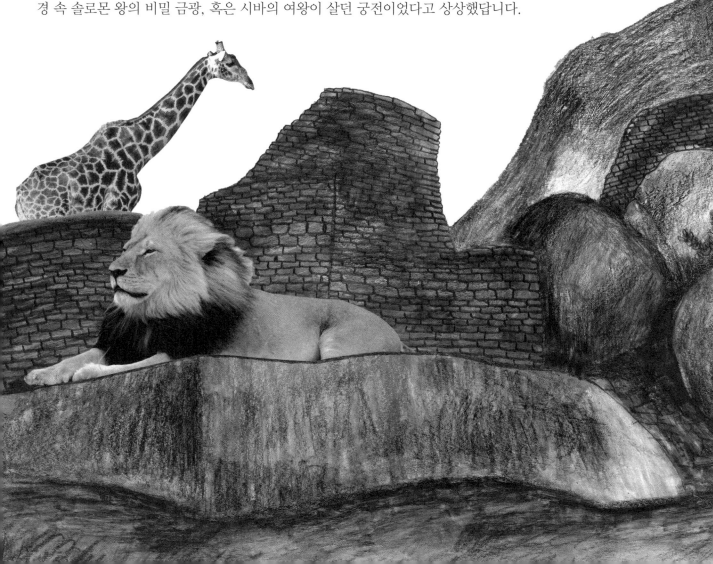

이 도시를 처음 발굴한 고고학자들은 멋대로 이야기를 지어냈습니다. 그들은 부당하게도 아프리카 사람들이 이렇게 훌륭한 건축물을 설계하고 지었을 리 없다고 생각했던 것이지요. 오늘날 짐바브웨 국민들은 선조의 업적을 무척 자랑스럽게 여기고 있으며, 그레이트 짐바브웨의 유적은 그들에게 확고한 독립의 상징이 되었답니다.

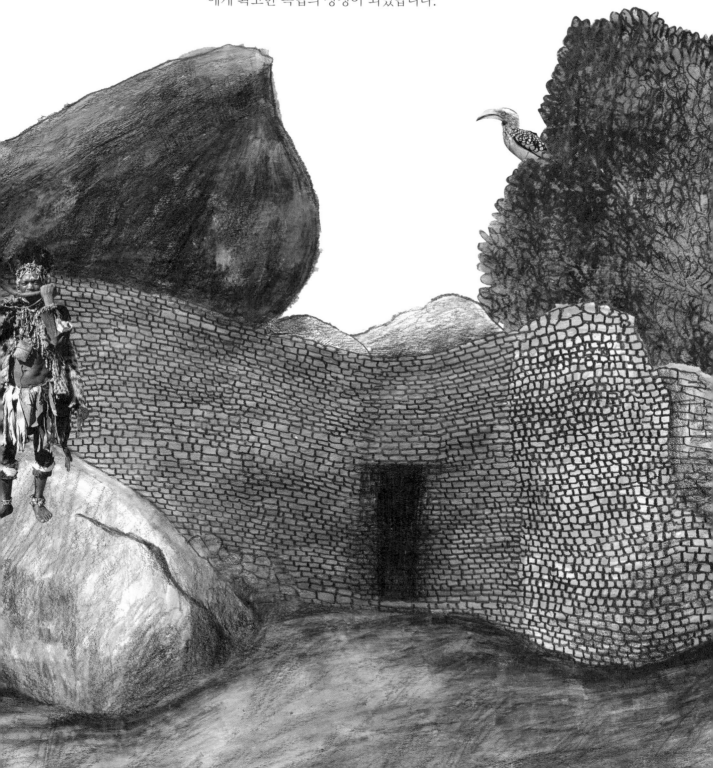

영혼을 담아 만든 새 조각들

그레이트 짐바브웨의 돌벽은 실용적인 만큼이나 장식적입니다. 건축가들은 돌을 쌓아 오랜 세월을 이겨낼 만큼 견고하고도 아름다운 문양을 만들었지요. 과거 이 도시의 성벽 안에 있었을 수많은 건축물들에 관해서는 그저 짐작해볼 수 있을 뿐이지만, 고고학자들은 주로 진흙을 손으로 다져서 쌓은 오두막이 존재했을 거라고 말합니다. 도시의 장인들은 섬세한 철사로 공예품을 만들었습니다. 이곳에서 발견된 가장 흥미로운 미술작품은 비눗돌로 조각한 새들입니다. 한때는 성문 기둥 위에서 도시로 들어오는 사람들을 반겨주던 조각들이지요.

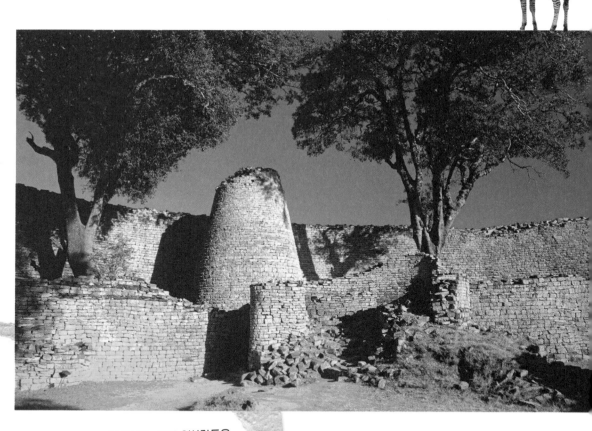

이 인상적인 탑이 지어진 이유는 불명확합니다. 일부 역사가들은 이 탑이 대형 곡물 보관소였을 거라고 생각하지요. 어쩌면 백성에게 식량을 공급하고 신들과 소통할 수 있는 왕의 권력을 상징하는 존재였을지도 모릅니다.
〈대광장의 원뿔 탑〉

이 새들은 사실적으로 묘사되었지만 한편으로 상징적이기도 합니다. 발톱 대신 발가락을 가졌고, 한 마리는 부리 대신 입이 있지요. 쇼나족은 새들이 특별한 힘을 지녔고 영적 세계의 메시지를 전해준다고 믿었답니다.

〈비눗돌 새 조각〉, 13~15세기

대광장은 사하라 사막 이남 아프리카에 현존하는 최대 규모의 고대 유적입니다. 건축가들은 돌을 정확히 똑같은 크기로 잘라서 시멘트나 모르타르 없이도 틈새가 생기지 않게 반듯이 쌓아 올렸지요. 높이 11미터의 외벽 안에 또 하나의 높은 벽이 있어서 원뿔 탑까지 이어지는 구부러진 통로를 이룬답니다.

〈대광장의 좁은 통로〉

다른 어느 곳에서도 이와 같은 건축물을 찾을 수 없습니다. 하나하나 다르게 생긴 새 조각들은 이 도시를 다스렸던 여러 왕들의 영혼을 나타내는 것으로 보입니다. 일부 전문가들은 서 있는 새들은 왕을, 앉아 있는 새들은 주요 여성 통치자들을 상징한다고 주장합니다. 이곳의 예술, 종교, 권력은 아주 긴밀하게 연결되어 있었기에 그 경계를 구분하기란 어렵답니다.

명나라의 수도, 북경 [1400년]

황제가 사는 금단의 도시

중국 땅에는 세계 역사상 가장 크고 강성한 제국이 있었습니다. 13세기에 몽골 전사 칭기즈 칸은 이후 동유럽까지 뻗어 나간 제국을 건설했습니다. 몽골이 세운 원나라가 멸망한 뒤 명나라가 중국을 통일합니다. 15세기 초에 명나라는 스스로 영락제(永樂帝), 즉 '영원한 평화의 황제'라고 칭했던 주체(朱棣)의 통치하에 있었습니다. 그는 수도를 대도(大都)로 옮기고 북경(北京, 베이징)이라는 이름을 붙였습니다. 평화는 오래가지 못했지만, 영락제가 중국에 미친 영향은 지금까지 이어집니다. 그가 북경에 지은 자금성은 광대한 정원과 드높은 성벽, 만 개 이상의 방이 있는 궁궐로 이루어졌습니다.

중국 땅 전체에 공무를 집행하려면 수천 명의 관료가 필요했습니다. 그래서 황제는 과거 시험을 통해 최고의 인재들을 뽑았지요.

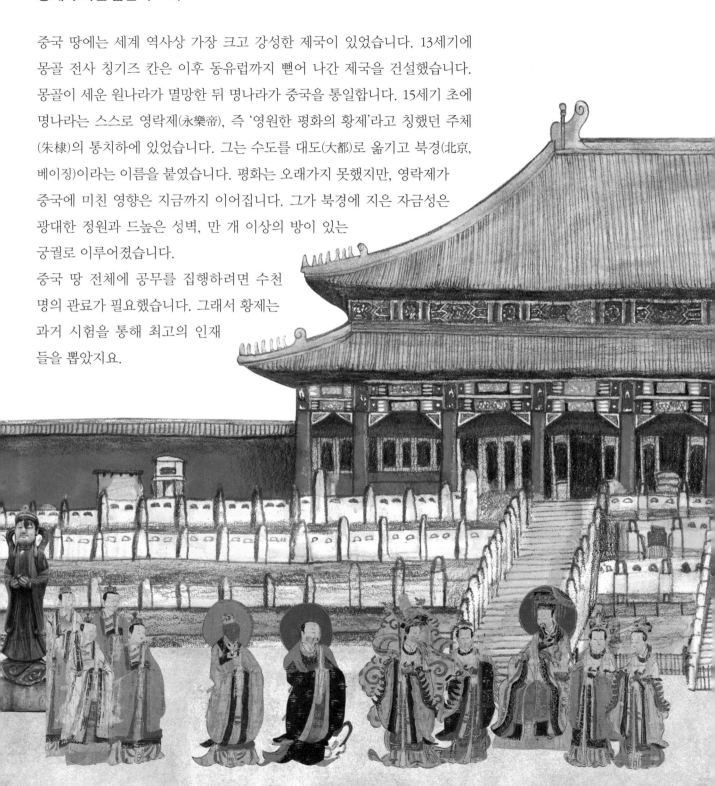

자금성(紫禁城)이라는 이름은 황제의 허락 없이는 출입이 금지되었기에 붙여졌습니다. 성 안의 모든 것은 황제의 권력을 강조하기 위해 만들어졌지요. 심지어 건물도 중심부에 가까워질수록 더 높아집니다. 모든 방문자는 황제에게 머리가 땅에 닿도록 절하여 경의를 표해야 했습니다.
〈태화전(太和殿)〉, 15세기 초

학문을 좋아했던 영락제는 관료들에게 중국의 모든 서책들이 수록된 방대한 백과사전을 편찬하도록 지시했습니다. 완성된 『영락대전』은 거의 2만 2천 권에 달했답니다! 영락제는 불교 신자였지만 세계의 여러 종교와 문화에 관심을 보였습니다. 이슬람교 연구를 통해 북경에서 최초의 중국어 쿠란이 출간되기도 했습니다. 그는 또 환관 정화에게 300척 이상의 배를 주고 세계를 탐사하게 했지요. 정화의 원정과 비교하면 크리스토퍼 콜럼버스의 탐험대는 초라해 보일 지경이에요!

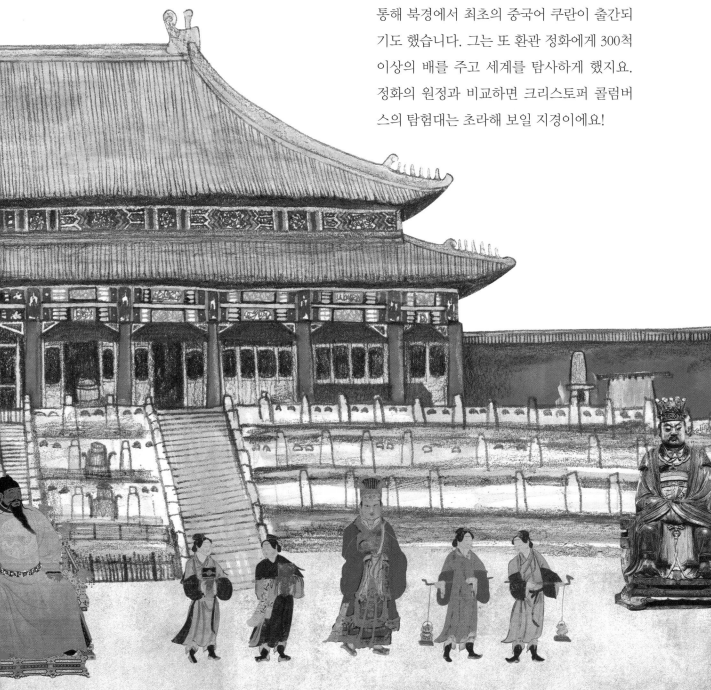

호사의 극치, 명나라의 미술품

15세기 북경에서는 수만 명의 장인들이 활동했습니다. 점점 더 많은 사람들이 미술품을 구입하게 되었지요. 중국인들은 특히 서예 작품을 높이 평가했답니다. 도자기나 칠기 같은 사치품도 귀하게 여겼지요. 명나라 사람들은 고품질을 추구했고, 국가가 운영하는 공방의 생산품에는 특별한 표식이 찍혔습니다. 일부 공방은 사람들이 물건을 더 구하고 싶어 할 경우를 위해 자기네 주소까지 표시했지요. 미술 시장이 커질수록 가짜 미술품도 늘어나 구매자들은 전문적인 지식을 갖추어야 했습니다.

이 족자는 사환이라는 거장의 조수가 그린 것입니다. 사환의 원작을 모방했을 확률이 높지요. 1427년 북경의 주요 문관들이 로를 방문한 모습을 담았습니다. 저택 주인은 붉은 옷을, 손님들은 푸른 옷을 입었습니다. 인물들이 그림 한가운데 위치한다는 것은 그들의 중요성을 나타내며, 주변의 사치스러운 세간들은 그들의 높은 취미를 드러냅니다.

〈행원아집도(杏園雅集圖)〉, 사환(謝環)의 모사, 1437년경

이 탁자는 매우 희귀하고 값진 미술품입니다. 독이 있는 옻나무 수액을 짜내서 가공한 다음 목제 가구에 칠한 것이지요. 한 번 칠하고 말리려면 하루가 꼬박 걸리는데 이를 여러 번 반복합니다. 이 탁자의 경우 백 번을 칠했다고 하네요. 옻칠이 마르면 용과 꽃 등의 문양을 세공해 넣습니다.

〈옻칠 탁자〉, 명, 1426~35년

명 시대의 중국은 청화백자로 세계에 명성을 떨쳤습니다. 이탈리아 르네상스 시대 그림에서도 청화백자 그릇을 볼 수 있지요. 중국 도예가들은 도자기에 담청색 도료로 그림을 그린 뒤 투명한 유약을 덧칠했습니다.

〈청화백자 화병〉, 명, 1464~87년

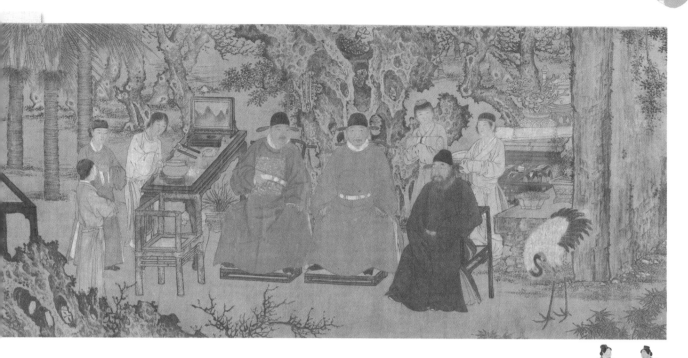

족자는 흔히 그림과 서예가 결합된 형태였으며 선물로 인기가 있었습니다. 소유자는 족자를 조심스럽게 펼쳐 책을 읽듯 각 부분을 차례로 감상하곤 했지요. 서구에서는 보통 그림을 벽에 붙박이로 걸어두지만, 중국에서는 족자를 보관해두었다가 특별한 경우에만 꺼내서 펼쳐 보았지요. 소유자가 내밀하고 차분하게 미술작품을 감상할 수 있게 말이지요.

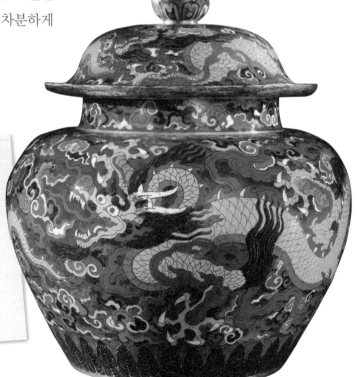

중국에서 처음으로 칠보 기법이 사용된 것은 15세기였습니다. 금속 배경에 금속 줄을 붙여 복잡한 문양을 만든 다음 열을 가해 녹인 채색 유리로 각각의 구역을 채워 넣습니다. 이 단지는 황궁에서 쓰기 위해 만든 것으로, 용은 황제의 권력을 상징한답니다.
〈칠보 단지〉, 명. 1426~35년

찬란한 왕국, 그라나다 (1450년)

지상의 천국

1450년 스페인의 그라나다 왕국에서 가장 아름다운 곳은 시에라네바다 산맥 아래 있던 도시 알람브라였습니다. 아라비아에는 이런 속담이 있었지요. '천국이란 그라나다 위에 있는 하늘나라의 한 부분이다.' 두꺼운 성벽과 여러 개의 탑, 묵직한 성문이 이 도시를 보호하고 있었습니다.

'알람브라'라는 이름은 9세기의 요새 '칼라 알함라(붉은 성)'에서 비롯되었습니다. 11세기에는 유대인 궁정 관료가 이곳에 살았지요. 이 궁전의 가장 장엄한 건물들은 14세기에 술탄 유수프 1세와 그의 아들 무함마드 5세가 지은 것입니다.
〈알람브라 궁전〉, 그라나다

성벽 안에는 여섯 개의 찬란한 궁전이 세워졌습니다. 세계 최고의 이슬람 미술과 건축 작품들이 이곳에 있지요. 무슬림, 유대인, 기독교인들은 관용과 창의성의 시대를 만끽했답니다. 중세 스페인에서는 유대인들이 번성했습니다. 그들은 아랍어로 글을 썼고 알람브라 요새에 영감을 받은 시나고그(유대교 회당)를 설계했지요. '불운한 보압딜'이라고 불리는 술탄 무함마드 12세는 1492년에 기독교도인 페르난도 왕과 이사벨라 여왕에게 항복합니다. 이때 유대인들도 스페인을 떠나야 했지요. 그라나다 왕국의 멸망은 7세기 이상 이어져온 스페인 이슬람 문명의 종말을 의미했습니다. 이는 무슬림들에게 황금기의 종말이기도 했지요. 아랍 철학, 시, 과학 분야 최고의 걸작들이 이 시대에 완성되었답니다.

에메랄드 사이의 진주, 알람브라

작열하는 스페인의 햇볕 아래에서 건축가들은 정원과 안뜰에 세심하게 그늘을 드리워 궁전 안을 서늘하게 유지했습니다. 궁전 곳곳에서는 분수가 물을 뿜었고, 바닥을 따라 난 수로에는 물줄기가 듣기 좋은 소리를 내며 흘러 열기를 쫓았습니다. 자연은 일종의 예술처럼 다루어졌지요. 창문과 발코니는 주변의 산과 정원 가운데 엄선된 전망이 보이는 위치와 방향에 놓았습니다. 장미와 은매화 관목, 오렌지나무와 석류나무에서 향긋한 냄새가 풍겨왔지요. 쿠란에서 천국은 하나의 호사스러운 정원으로 묘사됩니다. 알람브라를 설계한 사람들은 그들 나름의 지상 천국을 창조하려고 했고, 작은 부분 하나도 주의 깊게 검토하여 결정했던 것입니다.

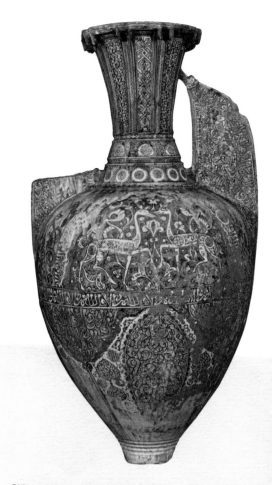

알람브라 궁전의 화병들은 무척 큽니다. 높이가 1미터 이상인 화병도 적지 않고, 거의 사람의 키만 한 것도 있지요. 알람브라의 벽에 새겨진 시구절에서 이들은 아름다운 신부에 비교됩니다. 반짝이는 푸른빛으로 채색된 이 화병들은 눈부신 빛깔과 날개가 달린 독특한 형태로 전 세계 사람들의 찬사를 받아왔답니다.
〈알람브라 화병〉, 1400년경

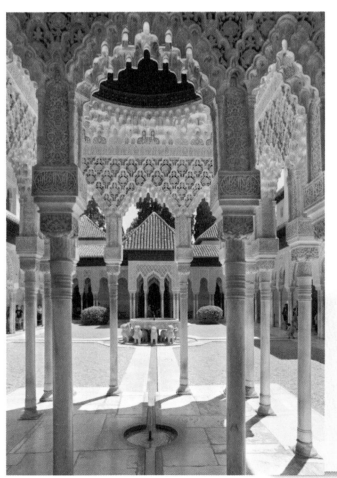

스페인과 북아프리카의 여러 이슬람 건축물들과 마찬가지로, 알람브라는 대칭을 이루는 직사각형 정원들로 구성되었습니다. 그늘진 회랑에 둘러싸인 이 정원은 술탄이 은밀하게 여흥을 즐기는 공간이었습니다. 입에서 물을 뿜어내는 특이한 사자 조각들은 앞서 11세기에 세워진 다른 궁전에 있던 것들입니다.
〈사자의 안뜰〉, 1375년경

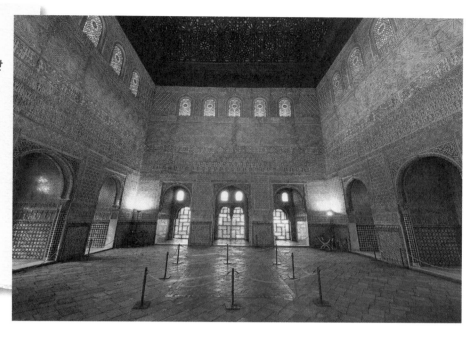

이 방은 도시를 내려다보는 거대한 탑 안에 있습니다. 별들이 그려진 천장은 이슬람의 일곱 낙원을 상징합니다. 술탄은 천상에서의 신의 권력과 지상에서의 술탄의 통치를 연결해주는 이 별들 아래의 왕좌에 앉았다고 합니다. 20세기에 화가 M.C. 에셔는 이 천장과 벽의 복잡한 문양에서 영감을 받은 그림들을 그렸습니다.
〈대사의 방〉, 1350년경

고도로 숙련된 장인들이 벽과 천장에 복잡한 문양을 새겨 넣었습니다. 시 한 편 전체를 정교한 글씨로 써넣기도 했지요. 통치자들은 궁전의 실내 장식을 이 지역의 도예가와 직조공에게 맡겼습니다. 그들의 훌륭한 직물과 화병은 귀한 보물로 대우받았고 심지어 기독교 유럽 전역에서도 신분의 상징처럼 여겨졌습니다. 이슬람 스페인 세력은 사라졌지만, 그 찬란함은 그들이 남긴 미술품들을 통해 여전히 살아 있답니다.

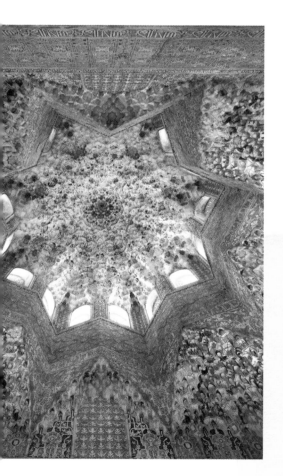

이 돔은 500개 이상의 작은 아치로 이루어져 마치 거대한 벌집이나 동굴 천장처럼 보입니다. 궁전 벽에는 이 천장에 관한 이븐 잠락의 시구절이 남아 있습니다. '이곳의 아름다움은 숨겨져 있는 한편 뚜렷이 보이니/ 천상의 별들을 능가하는 아름다움이라네.'
〈두 자매의 방에 있는 돔 천장〉, 1380년경

르네상스의 도시, 피렌체(1500년)

문화 부흥의 르네상스

'르네상스'라는 말은 '재탄생'을 뜻합니다. 하지만 이 시대에 재탄생이란 정확히 어떤 것이었을까요? 답은 여러 가지입니다. 사람들은 사고하고 창조하고 발견할 수 있는 인간 고유의 능력을 확신하게 되었지요. 이 새로운 관점을 인본주의라고 합니다. 인본주의는 현재 이탈리아에 있는 도시 피렌체에서 은행업을 통해 부유하고 강력해진 메디치 가문의 후원을 받았습니다. 로렌초 데 메디치는 보티첼리나 미켈란젤로 같은 예술가와 피코 델라 미란돌라 같은 철학자를 후원하여 '위대한 로렌초'라고도 불렸습니다. 재산을 잃은 뒤에도 그는 여전히 뛰어난 예술가와 사상가들을 격려하는 일을 중요하게 여겼지요. 당시 피렌체에서는 '훌륭한 지도자의 자질은 무엇인가'라는 문제를 놓고 뜨거운 논쟁이 벌어졌습니다.

1490년대에는 성직자인 지롤라모 사보나롤라가 권력을 잡고 종교를 피렌체 생활의 중심에 돌려놓겠다고 선언했습니다. 하지만 결국엔 메디치 가문이 도시의 패권을 되찾았지요. 1513년에 니콜로 마키아벨리는 유명한 저서 『군주론』을 로렌초의 증손자에게 헌정합니다. 마키아벨리는 좋은 목적을 위해서라면 지도자의 악하거나 이기적인 행동도 감수해야 한다고 썼습니다. 오늘날까지도 이 책의 독자들은 마키아벨리가 지도자로서 메디치 가문 사람들을 비판한 것인지, 찬양한 것인지에 대해 논쟁합니다. 우리가 확실히 알 수 있는 것은 단지 마키아벨리를 비롯한 여러 유명한 르네상스 사상가들이 거리낌 없이 어려운 질문들을 던질 수 있었다는 사실뿐입니다.

완벽함을 추구했던 예술가들

역사상 가장 위대한 예술가들로 손꼽히는 레오나르도 다빈치
와 미켈란젤로는 오랫동안 피렌체를 떠나 있다가 1501년에 돌
아왔습니다. 레오나르도가 더 손위였지만, 두 사람은 서로 맹
렬한 경쟁자였습니다. 둘 다 이 시기에 최고의 걸작을 만들었
지요. 레오나르도는 〈모나리자〉를 그렸고 미켈란젤로는 거대
한 〈다비드〉를 조각했습니다. 두 사람은 성격이 매우 달랐지
만, 미술은 과학이기도 하다고 확신한다는 점에선 같았습니
다. 그들은 인체 구조를 이해하기 위해 시체를 세심하게 해부
하기도 했습니다. 레오나르도는 대중이 해부 실험에 분노하리
라는 걸 알고 있었습니다. 종교적 이유에서도 그랬지만, 그냥
보기에도 끔찍한 일이었으니까요. 그는 여러 권의 노트에 인
체 스케치 수천 장을 남겼습니다. 임신 기간의 태아 발달 과정
에 매혹된 그는 여성의 몸이야말로 탐구해야 할 최고의 수수
께끼라고 말했답니다.

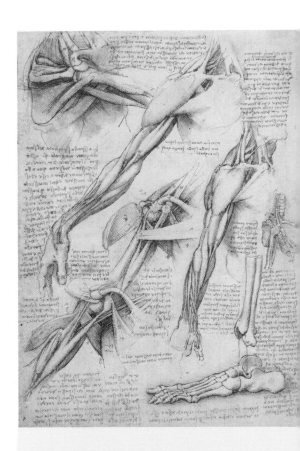

레오나르도는 노트에 이렇게 기록했습니다. "오, 우리
의 몸이라는 기계를 사색하는 자여, 타인의 죽음을 통
해서만 이에 관한 지식을 얻을 수 있다는 점에 괴로워
하지 말라. 오히려 창조주께서 우리의 지성을 이처럼
뛰어난 통찰에 이를 수 있도록 만드셨음에 기뻐하라."
〈해부학 스케치〉, 레오나르도 다빈치, 1510~12년경

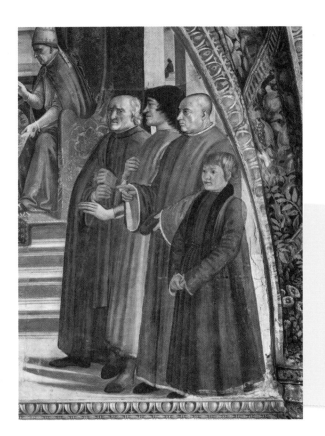

이 프레스코 벽화의 오른쪽 구석에는 어른 셋
과 아이 하나가 그려져 있습니다. 한 손을 내민
검은 머리 남자는 로렌초 데 메디치이고 그 옆
의 붉은 옷을 입은 남자는 로렌초의 은행 지점
장 프란체스코 사세티입니다.
〈성 프란치스코 수도회를 인준하는 교황 호노리
오 3세〉 세부, 도메니코 기를란다요, 피렌체 산타
트리니타 성당 부속 사세티 예배당, 1483~86년

미술가들은 새로운 기법을 찾아내려 했던 한편 고대 그리스와 로마 미술가들이 만든 규범을 따르려고도 했습니다. 특히 고대 조각에 나타난 비례와 균형미를 숭배했지요. 건축가들 또한 고대 건축을 본보기 삼았습니다. 레온 바티스타 알베르티는 로마 건축가 비트루비우스의 저술을 열심히 연구했습니다. 비트루비우스는 레오나르도의 유명한 스케치 〈비트루비우스의 인체비례〉에도 영향을 미쳤습니다. 이 그림은 원과 정사각형 안에 완벽히 맞춰지도록 두 팔과 두 다리를 뻗고 있는 인체의 모습을 표현한 것이지요.

후원 제도

후원자가 된다는 것은 예술가를 경제적으로 지원한다는 뜻이에요. 하지만 로렌초 데 메디치는 거기서 한 발 더 나아갔습니다. 그는 미켈란젤로를 초청해 자기 집에서 함께 살았고 식사도 자기 가족과 같이하게 했답니다. 르네상스 시대에는 귀족과 교회가 예술가의 가장 큰 후원자였습니다.

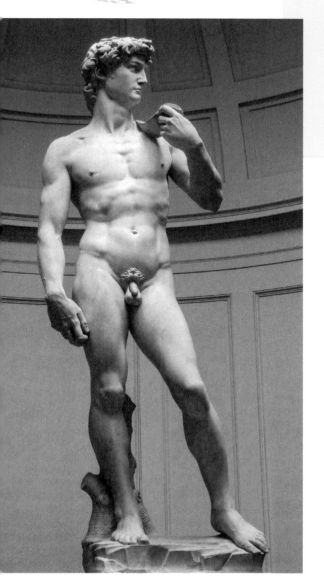

16세기에 이탈리아 미술사 조르조 바사리는 이렇게 적었습니다. "미켈란젤로의 〈다비드〉를 본 사람이라면 과거에서 현재까지 통틀어 다른 어느 작가의 어떤 조각도 볼 필요가 없다." 하지만 모두가 바사리처럼 이 작품에 열광한 것은 아니었지요. 〈다비드〉가 처음 공개되었을 때 피렌체 사람들 몇몇은 조각상에 돌을 던졌으니까요!
〈다비드〉, 미켈란젤로 부오나로티, 1501~4년

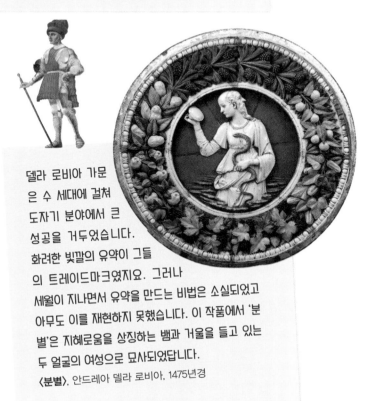

델라 로비아 가문은 수 세대에 걸쳐 도자기 분야에서 큰 성공을 거두었습니다. 화려한 빛깔의 유약이 그들의 트레이드마크였지요. 그러나 세월이 지나면서 유약을 만드는 비법은 소실되었고 아무도 이를 재현하지 못했습니다. 이 작품에서 '분별'은 지혜로움을 상징하는 뱀과 거울을 들고 있는 두 얼굴의 여성으로 묘사되었답니다.
〈분별〉, 안드레아 델라 로비아, 1475년경

전설의 대학 도시, 팀북투(1550년)

책들의 도시

수백 년 동안 팀북투는 전설 속의 장소로만 남아 있었습니다. 오늘날에도 영어로 머나먼 신비의 장소를 가리킬 때 '여기부터 팀북투까지 (from here to Timbuktu)'라고 말하지요. 팀북투는 사하라 사막 남단이 나이저 강의 북쪽 굽이와 만나는 지점에 세워졌습니다. 낙타나 카누를 타고 온 여행자들은 이곳에서 금과 소금을 거래했고, 1550년에 팀북투는 서아프리카 최대의 도시이자 가장 부유한 도시가 되었습니다.

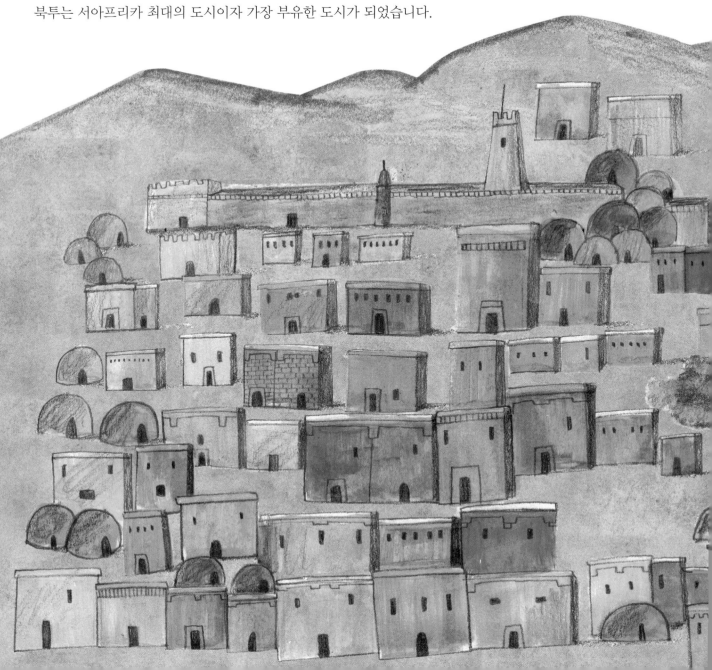

하지만 팀북투의 가장 큰 자랑거리는 이곳이 배움의 중심지라는 것이었지요. 외교관이자 학자였던 레오 아프리카누스는 16세기에 이 도시를 여행한 뒤 이렇게 전했습니다. "팀북투에는 수많은 재판관, 학자, 성직자들이 살고 있다. 이곳의 왕은 지식인들을 매우 아끼기에 이들 모두에게 후한 봉급을 지불한다. 이곳에서는 필사본들이 다른 어떤 상품보다도 많이 팔린다." 송가이 제국 치하에서 팀북투는 무슬림 학자들의 중심지가 되었습니다. 2만 명의 학생들이 쿠란에서 의학, 천문학까지 다양한 분야를 공부했지요. 서기들은 이 도시의 역사를 상세히 적어두었고 후손들은 그 기록들을 도서관에 세심하게 보관했습니다.

시간을 초월하는 대학 건축물

그때나 지금이나 팀북투는 대학 도시입니다. 16세기에 이곳은 서아프리카 전역에서 유명했습니다. 마치 현재 영국에서 옥스퍼드나 케임브리지가 유명하듯이 말이지요. 도시는 대학들로 넘쳐났고, 10년씩 머물면서 공부하는 학생들도 있었습니다. 팀북투에서 가장 크고 오래된 대학들은 가장 중요한 모스크 세 곳 주위에 지어졌습니다. 징게르베르, 상코레, 시디 야히아 모스크에는 각각 미너렛이 하나씩 있습니다. 미너렛은 무슬림들이 하루 다섯 번 하는 기도 시간을 알리는 탑이지요. 미너렛의 형태와 양식, 규모는 아주 다양합니다. 팀북투의 미너렛은 특히 고슴도치 가시처럼 측면에 삐죽 튀어나온 막대들이 개성적입니다. 팀북투의 건축가들은 방코라는 고유의 진흙 혼합물을 회반죽처럼 펼쳐서 건물에 두드려 붙였습니다. 방코는 뜨거운 햇볕을 받으면 금이 가고 부서지므로 매년 새로 한 겹 덧붙여야 하지요. 수백 년 동안 팀북투 시민들은 한데 모여 똑같은 방식으로 모스크와 대학 건물들을 보수해왔습니다. 어디까지가 고대의 건물이고 어디부터가 새로운 건물인지 구별하기 어렵기에, 이 도시는 말 그대로 시간을 초월한 곳이라고 할 수 있답니다.

해마다 모스크는 보수 주간을 거칩니다. 이 한 주는 축제인 동시에 작업 기간이지요. 지역민들이 보수에 참여합니다. 미너렛의 측면에 삐져나온 나무 막대들은 단순한 장식이 아니라 사람들이 기어올라 작업할 수 있는 사다리 구실도 한답니다.
〈상코레 모스크의 공동 보수〉, 2000년경 촬영

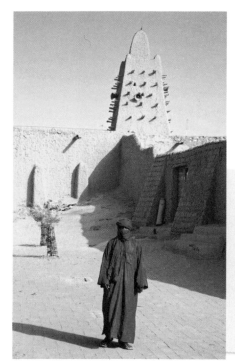

14세기에 만사 무사가 순례를 마치고 돌아온 기념으로 건설한 모스크입니다. 주요 증축은 16세기의 종교 지도자들이 했지요. 이 모스크에는 여러 무슬림 성인들의 묘가 있는데, 이 때문에 팀북투는 종종 '성인 333명의 도시'라고도 불린답니다.
〈징게르베르 모스크〉, 1327년 건설

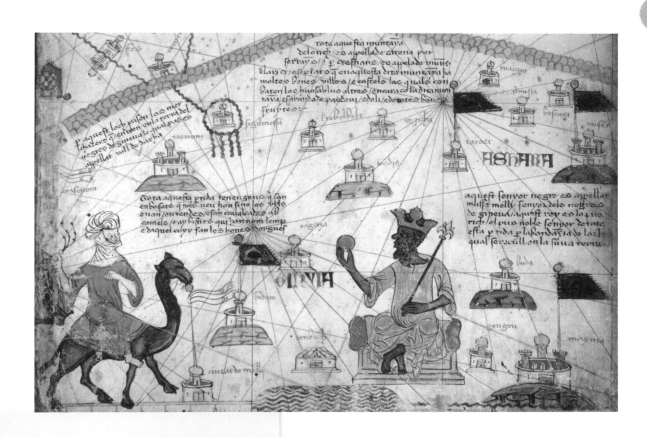

팀북투가 유명해진 것은 14세기에 말리의 왕 만사 무사(이 그림에서 황금 왕관을 쓴 인물)가 아프리카에서 아라비아로 순례를 떠나면서였습니다. 무사가 여행 길에 얼마나 많은 금을 뿌렸는지, 사람들은 팀북투 같은 도시들이 말 그대로 금으로 만들어진 곳이라고 믿게 되었답니다.
〈카탈루냐 아틀라스〉 세부, 아브라함 크레스크, 1375년

현재 팀북투에서 나무는 무척 귀한 소재입니다. 한 팀북투 주민은 이렇게 말합니다. "기후가 변해서 보라수스 야자나무는 더 이상 여기서 자라지 않아요. 하지만 우리 전통 건축물의 기둥과 문은 조상님 들이 예멘에서 들여온 설계에 따라 그 나무의 단단한 목재로 만들어졌지요. 이제 우리는 활엽수 목재를 수입해와야 한답니다."
〈시디 야히아 모스크〉, 1440년경 건설

자유의 도시, 암스테르담 (1650년)

관용의 도시

16세기부터 17세기까지 유럽은 전쟁에 휩쓸렸습니다. 네덜란드와 스페인 간의 80년 전쟁은 종교와 정치 문제로 일어난 것이었지요. 스페인은 가톨릭 국가였지만 네덜란드 국민의 다수는 개신교도였고 마음대로 신앙생활을 할 자유를 원했습니다. 마침내 1648년에 두 국가는 평화협정을 맺었고 네덜란드는 독립국가가 되었습니다. 그리고 그 중심에 암스테르담이 있었지요.

개신교

수백 년 동안 유럽의 기독교도들은 단일한 집단에 속했습니다. 교황이라는 개인이 이끄는 로마 가톨릭 교회였지요. 그러나 16세기에 종교개혁가 마르틴 루터가 교회의 변화를 요구했습니다. 평범한 사람들도 직접 성경을 읽고 다양한 방식으로 신을 섬길 수 있어야 한다는 생각이었지요. 이러한 개혁으로 개신교가 생겨났습니다.

프랑스의 개신교도들, 포르투갈과 스페인의 유대인들이 암스테르담으로 모여
들었습니다. 고국에서는 자신의 종교를 포기하거나 숨기도록 강요당했던 사람
들이었지요. 암스테르담의 유대인 주민들이 가졌던 자부심은 포르투갈 시나고
그의 위풍당당한 전면에 잘 드러납니다. 이곳은 당시 암스테르담 최고의 교회
와 맞먹을 만큼 화려하게 설계되었지요. 암스테르담에는 단순히 종교의 자유뿐
만 아니라 종교에 관한 자유로운 사상이 있었답니다. 철학자 스피노자는 성경의
저자가 누구인지, 신과 세상의 관계는 무엇인지에 관한 전통적 사고에 도전했지
요. 과학 분야에서도 암스테르담은 새로운 발견의 중심지였습니다. 과학자들은
현미경으로 박테리아를 관찰했고, 망원경의 개량은 머나먼 위성들의 발견으로
이어졌지요. 전 세계 사람들이 암스테르담을 통해 세상을 보는 관점을 달리하게
되었답니다.

상업의 발달과 예술의 황금기

네덜란드의 황금기는 상업으로 정의됩니다. 네덜란드 동인도회사는 전 세계로 선박을 보내 인도네시아에서 일본까지 다양한 나라의 국민들과 거래했습니다. 일본의 경우 유럽 국가들 중에 오직 네덜란드에만 교역을 허락했지요. 상인들이 네덜란드로 가져온 물건들은 의복, 회화, 도자기 분야에서 새로운 양식을 낳았습니다. 델프트 근교의 장인들이 명나라 도자기에 영감을 받아 만들어 낸 청화백자 타일과 도자기는 유럽 전역에서 사랑받았습니다. 또한 상인들이 터키에서 들여온 튤립이 엄청난 인기를 끌자 사람들은 마치 주식시장에 투자하듯 튤립 구근에 돈을 쏟아붓기 시작했습니다. 결국 튤립 시장이 붕괴하자 구근을 너무 많이 사둔 나머지 파산한 사람들까지 생겼지요!

암스테르담에서 유대인들은 자유롭게 그들의 예배당을 지을 수 있었습니다. 이 그림 속의 포르투갈 시나고그는 당시 세계 최대의 시나고그였으며, 이로 인해 암스테르담은 유럽 유대인 세계의 중심으로 자리 잡았습니다. 이곳은 예루살렘에 있던 고대 성전과 비슷하게 설계되었답니다.
〈포르투갈 시나고그의 내부〉, 에마뉘엘 더비터, 1680년

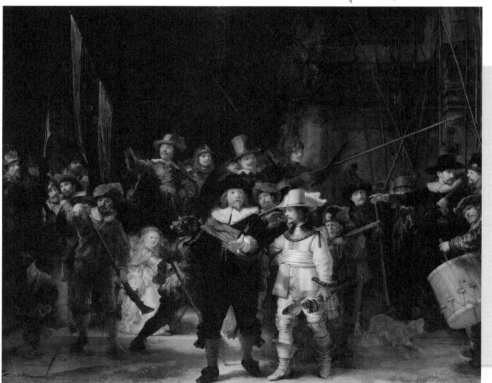

부자들은 화가에게 집단 초상화를 의뢰하곤 했습니다. 이 그림 속의 대장과 부관은 정면에 그려지는 대가로 군인들 중에서 가장 많은 돈을 지불했을 것입니다. 다른 화가라면 그냥 군인들이 테이블 주위에 둘러앉은 모습을 그렸을 수도 있겠지만, 렘브란트는 생동감 넘치는 분위기와 극적인 명암으로 특별한 장면을 창조해냈지요.
〈야경〉, 렘브란트 반 레인, 1642년

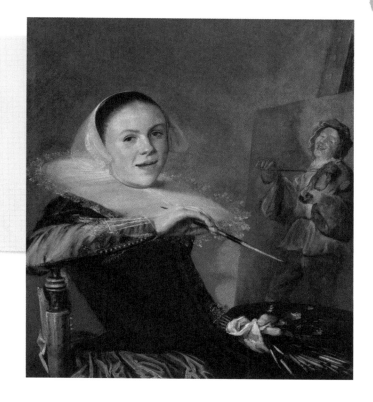

레이스터는 평생 동안 자신의 일상 속 장면들을 그렸으며 특히 음악가들을 다룬 그림들로 유명했습니다. 이 그림 속의 그녀는 여유롭고 편안한 모습으로 걸작으로 평가받은 〈즐거운 사람들〉의 바이올린 연주자를 그리고 있습니다. 하지만 레이스터는 죽은 후 수백 년 동안 거의 잊혀졌고, 사람들은 그녀의 그림들을 프란스 할스의 그림으로 오해했지요.

〈자화상〉, 유디트 레이스터, 1630년경

이 피라미드만큼 네덜란드 황금기의 이국 취향과 부를 잘 보여 주는 미술품도 없을 것입니다. 불교 사원의 탑 형태에 중국풍 문양을 그리고 유약을 칠했으며, 주둥이마다 튤립을 한 송이씩 꽂았지요. 당시에는 튤립이 비쌌기 때문에 다발이 아니라 한 송이씩 사야 했답니다.

〈델프트 공방의 그리스인이 만든 꽃 피라미드〉, 1695년경

모든 상업 분야에는 물건의 판매 장소와 방식을 통제하는 길드가 있었습니다. 화가들에게도 고유의 길드가 있었지요. 유디트 레이스터 같은 여성 화가들이 최초로 길드에 받아들여진 것도 이 시대였습니다. 길드를 비롯한 여러 집단들은 회의 장소에 모인 자신들의 초상화를 의뢰하곤 했습니다. 이런 집단 초상화 중 최고의 걸작은 렘브란트의 〈야경〉입니다. 이 그림은 자경단이 행진하기 위해 모여 있는 모습을 담았지요. 이 그림 속에서 깃발을 들고 북을 치는 군인들처럼, 암스테르담 시민들은 온갖 가능성이 넘치는 도시에서 산다는 것을 자랑스러워했답니다.

지상의 천국, 이스파한 (1700년)

황제의 새 도읍

16세기 말에 사파비 왕국의 아바스 1세는 수도를 이스파한으로 옮겼습니다. 자신의 권력을 가장 잘 드러낼 방법은 화려한 건물들을 설계하고 짓는 것이라 생각했기 때문이지요. 아바스 1세는 이 도시를 완전히 새롭게 변신시켰습니다. 17세기 중반에 이르자 이스파한은 50만 인구와 150곳 이상의 모스크, 수천 개의 가게와 수백 개의 공중목욕탕이 있는 대도시가 되었습니다. 도시 중앙에는 마이단이라는 광장이 있었습니다. 유럽 어느 도시의 광장보다도 크고 화려한 곳이었지요. 당시 이곳을 방문한 누군가의 기록처럼, 마이단은 '의심할 여지없이 우주의 어느 곳보다도 드넓고 유쾌하며 향기로운 장터'였답니다.

시아파

이슬람교는 크게 수니파와 시아파 두 가지 종파로 나뉩니다. 시아파는 전 세계의 무슬림 중에서도 소수를 차지하지요. 이들은 예언자 무함마드의 진정한 후계자가 그의 사위였던 알리라고 믿습니다. 알리가 죽은 지 수백 년 뒤 사파비 왕국에서는 시아파 이슬람교를 국교로 정했습니다. 오늘날에도 이란 국민의 대다수는 시아파 신자랍니다.

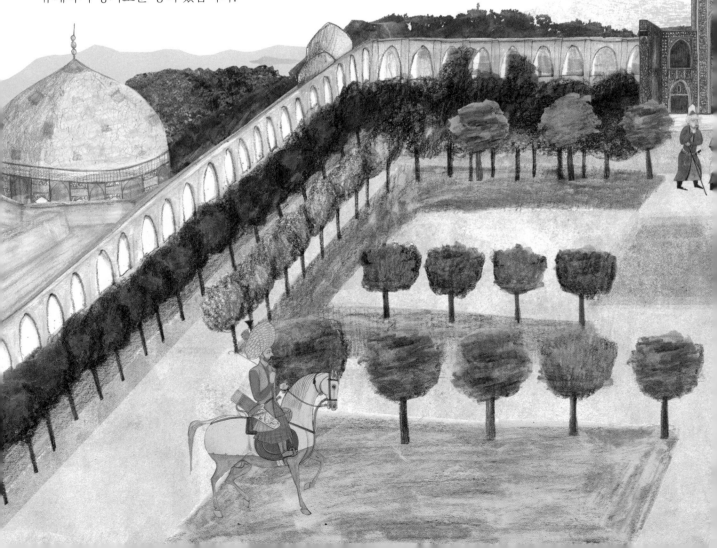

도시의 중앙 광장인 마이단 주위에는 왕궁과 시장, 모스크가 완벽한 대칭 형태로 배치되었습니다. 광장 뒤쪽에는 학교, 주택, 공방들이 있었지요. 낙타를 타고 대상을 이루어 다녔던 수천 명의 상인들을 위한 여관도 수백 개나 있답니다. 이들은 아시아와 유럽을 오가는 도중에 이스파한에 들르곤 했지요.

〈마이단〉, 이스파한

광장은 상업의 중심일 뿐만 아니라 샤(페르시아의 왕)가 종교적·예술적·신체적 우월함을 과시하는 장소이기도 했습니다. 순례 행렬을 할 때든 말을 타고 공을 칠 때든, 사파비 왕국의 샤들은 완벽한 통제력을 보여주려 했지요. 그들은 외국에서 온 상인들에게 관대했고 기독교인, 유대인, 고대 페르시아에서 전해진 조로아스터교 신자와 힌두교도 등 다양한 신앙을 지닌 모든 사람들이 이스파한에 살 수 있게 했습니다. 하지만 샤의 신성한 통치권에는 의문의 여지가 없었습니다. 그들은 자신이 신의 대리인이며 이스파한이 지상의 천국이라고 굳게 믿었답니다.

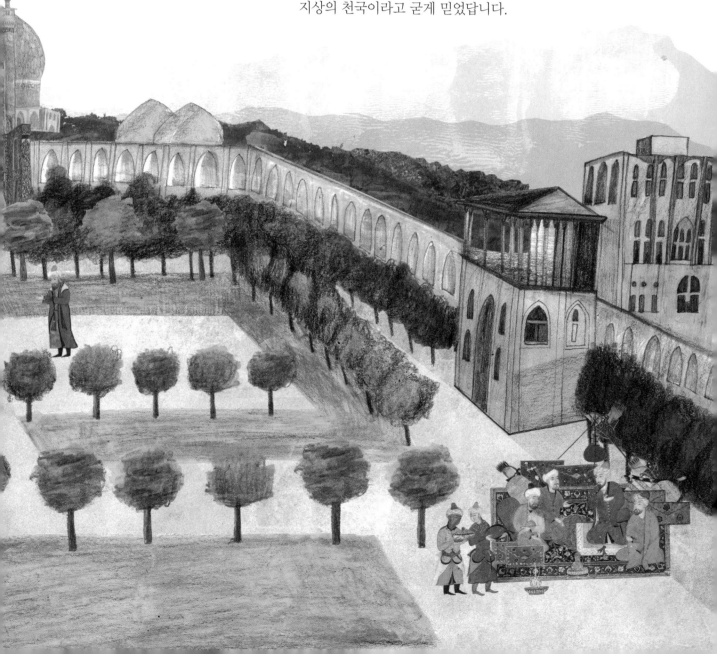

이스파한의 크고 작은 걸작들

이스파한이 점점 커지면서 페르시아에는 이런 속담이 생겼습니다. '이스파한이 세상의 절반이다.'

사파비 왕국의 샤들은 웅장한 건물을 신속하게 짓고 싶어했습니다. 해결책은 돔이나 탑, 아치 등 기본 형태를 다양하게 조합하는 것이었지요. 거기에 화려한 타일들을 붙이면 건물들은 각각 독특하면서도 호화롭게 보였습니다. 샤들은 다른 미술 분야에서도 이와 비슷한 접근 방식을 택하여 양탄자를 짜고 필사본에 채색 세밀화를 그리는 장인들의 대규모 공방을 만들었습니다. 페르시아 양탄자는 종종 이스파한 주변의 정원과 분수, 돔들을 담은 지도처럼 보입니다. 특히 재능 있는 삽화가들이 높이 평가받았고, 어떤 샤는 심지어 직접 삽화를 그리기도 했지요. 미술가들은 고대 페르시아의 유명한 전설들이 담긴 『왕들의 서』 같은 거대한 책을 공동 제작했답니다.

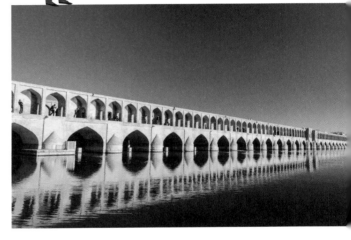

이 다리는 알라베르디 칸이라는 기독교인의 이름을 따왔습니다. 그는 전투에서 패배해 노예로 팔려왔지만 이후 이슬람교로 개종하여 샤의 신임을 받는 장군이 되었지요. 이 거대한 다리는 33개의 아치로 이루어져 있으며 무거운 물건의 운송로이자 강변 전망대, 수량 조절까지 다양한 용도로 쓰였답니다.

〈알라베르디 칸 다리〉, 1602년 건설 시작

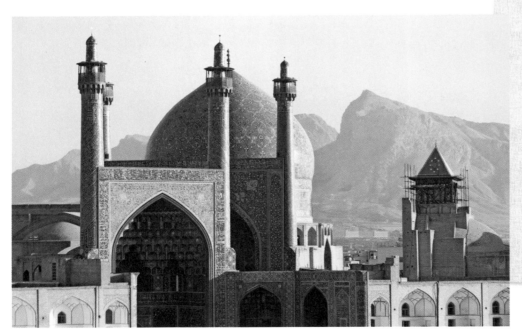

이 모스크의 특이한 형태는 한 가지 문제점을 해결하기 위한 것이었습니다. 건축가들은 모스크의 정면이 마이단을 마주 보도록 설계했지요. 그런 다음 건물의 나머지 부분을 45도 돌려놓아 그 안의 예배자들이 무함마드의 탄생지인 메카를 향해 기도할 수 있게 했답니다.

〈마스지드 이맘 모스크〉, 이스파한, 1611~38년

모든 화가에게는 서예부터 인물 묘사, 귀금속 세공 등 각
자의 전문 분야가 있었습니다. 화가들은 페르시아고양이
의 털로 만든 붓을 가지고 수백 시간 작업하여 필사본을
하나의 작은 미술관으로 바꿔놓았지요. 샤들은 자신의
권세가 화가들을 통해 영원히 살아남길 바랐지만, 오늘
날 우리가 기억하는 것은 왕들의 이름이 아니라 그들이
고용했던 레자와 무인 같은 화가들의 이름입니다.

이 같은 대형 페르시아 양탄자는 수천만 개의 매
듭으로 이루어져 있습니다. 겨우 몇 제곱센티미
터 넓이에 수천 개의 매듭이 들어가지요. 페르시
아뿐만 아니라 유럽의 귀족들도 이 양탄자에 감
탄했습니다. 양탄자 가운데에는 연못 안을 헤엄
치는 화려한 빛깔의 생물들이 보이는데, 용의 존
재는 중국 미술의 영향을 보여줍니다.
〈정원 양탄자〉, 케르만 지역, 1625년경

17세기 말이 되자 페르시아 화가들은
세밀화보다도 각자의 개성이 드러나는
단독 회화를 더욱 많이 그리게 됩니다.
그 전환점이 된 것은 일상 속의 인물들
에 주목했던 화가 레자 아바시의 작품
들이었지요. 이 그림은 레자의 가장 뛰
어난 제자였던 무인이 작업 중인 스승
의 모습을 묘사한 것입니다.
〈레자 아바시의 초상〉, 무인 무사비르,
1673년

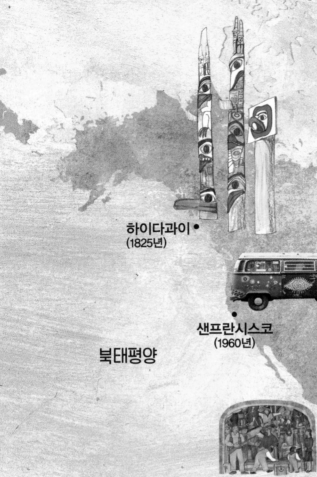

하이다과이 •
(1825년)

런던(18
파리

북대서양

• 뉴욕(1950년)

샌프란시스코
(1960년)

북태평양

• 멕시코시티(1930년)

남태평양

• 리우데자네이루
(2020년)

남대서양

**격동하는
근대와
파격적인
현대의 미술**

● 모스크바(1920년)

베를린(1990년)
● 빈(1890년)

● 서울
(2000년)

● 에도(1800년)

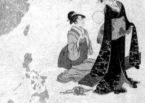

인도양

남극해

쇼군을 위한 도시, 에도 (1800년)

쇼군과 일왕의 대립

19세기의 일본 사람들은 엄격히 자신의 계급에 맞게 살았습니다. 하지만 그들의 계급 제도는 우리가 생각하는 것과 크게 달랐답니다. 예를 들어 일본의 왕은 나라를 다스리지 않았습니다. 진정한 권력자는 군사 독재자인 쇼군이었지요. 17세기 초에는 도쿠가와 가문이 새로이 쇼군 자리를 손에 넣었습니다. 그들은 왕으로부터의 독립성을 과시하기 위해 일본의 수도를 전통적인 왕도(王都) 교토에서 현재의 도쿄인 에도로 옮겼습니다. 쇼군은 지역 귀족들을 통제할 효과적 방법들을 고안해냈습니다. 귀족들이 반드시 일정 기간 에도에 머물게 하여 그들을 감시했지요. 일본의 지방 귀족들은 사무라이라는 전사 집단을 거느렸습니다.

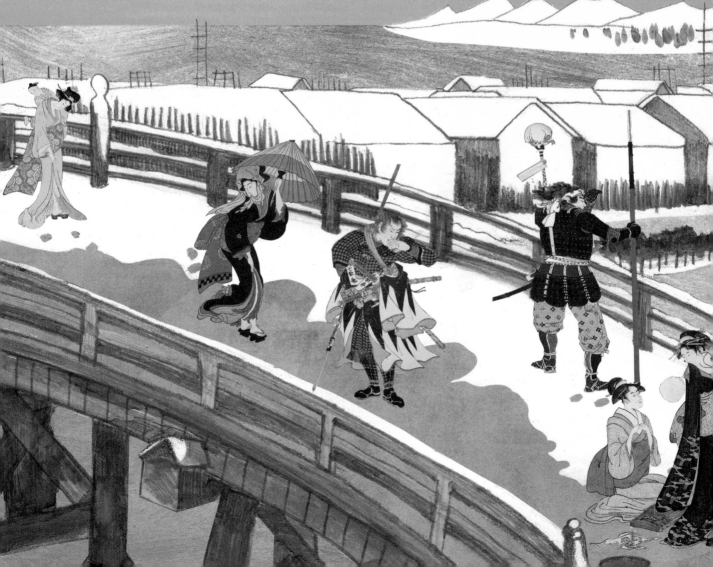

사무라이 아래 계급은 농부, 장인, 그리고 최하층인 상인이었답니다. 19세기 일본의 상인들은 불행했습니다. 돈은 많이 벌었지만 여전히 최하층 계급으로 여겨졌으니까요. 그렇다고 다른 나라에 가서 일자리를 찾을 수도 없었습니다. 일본인들에게는 출국이 허용되지 않았기 때문입니다. 외국인들에게도 입국이 허용되지 않았습니다. 중국과 한국, 네덜란드의 배들만이 특정한 항구에 한하여 입항할 수 있었답니다. 하지만 19세기 중반이 되자 쇼군은 더 이상 쇄국 정책을 고수할 수 없게 되었지요. 그들이 엄격하게 통제해왔던 일본 사회에도 어쩔 수 없이 변화의 흐름이 나타난 것입니다. 얼마 지나지 않아 일본에서는 쇼군이라는 직책 자체가 없어지게 되었습니다.

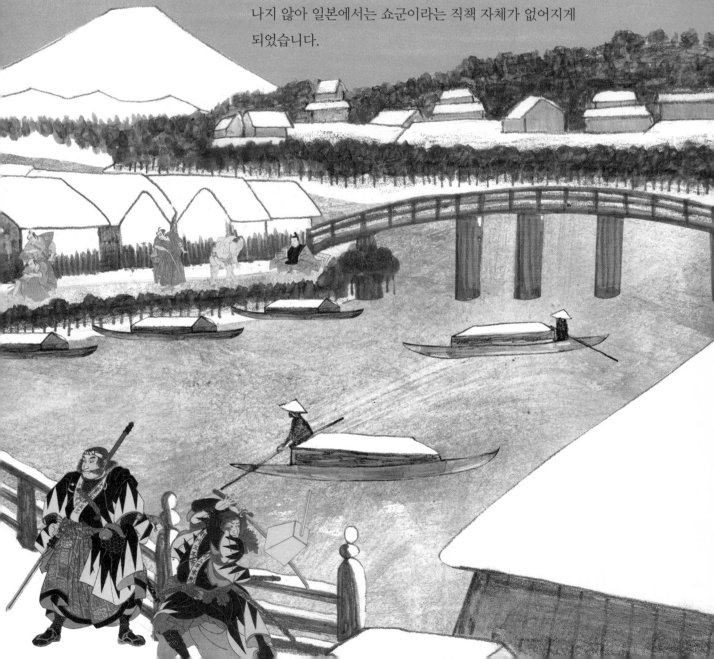

도쿠가와 가문의 쇼군들은 에도를 수도로 삼고 자신들의 편의에 맞추어 설계했습니다. 외부에서 공격해오기 어렵도록 나선형 구조로 만든 것이지요. 주민들은 계급별로 각각 다른 구역에 살게 되었습니다.
〈에도 지도〉, 1849년

뜬구름 같은 세상을 찍어내다

쇼군의 군사 독재하에서 사람들의 생활은 엄격하게 통제받았습니다. 긴장을 풀고 즐길 방법이 필요했지요. 사람들의 도피처는 유흥가였습니다. 에도의 사무라이와 상인 모두 요시와라에서 많은 시간을 보냈습니다. 이 구역에서는 사람들이 성별과 계급을 가리지 않고 뒤섞이곤 했습니다. 눈부신 옷을 걸친 여성들이 노래하고 춤추고 뛰어난 화술을 구사했지요. 가부키라는 새로운 연극이 대담한 의상과 뻔뻔한 유머로 인기를 끌었고, 가부키 배우들은 유명 인사 취급을 받게 되었습니다. 무법 지대였던 유흥가는 '뜬구름 같은 세상(우키요)'이라고 불리곤 했습니다. 예술가들은 이러한 세계관을 나타낼 새로운 양식을 만들었는데, 바로 목판을 이용해 여러 장 찍을 수 있는 화려한 다색판화인 우키요에였지요.

일본에 총이 도입되면서 사무라이들도 방탄 판갑을 착용하게 되었습니다. 에도 시대는 비교적 평화로웠기 때문에 갑옷은 주로 의식에서만 착용되었습니다. 갑옷 장인은 무척 오랜 시간을 들여 기술을 갈고닦아야 했지요.
〈에도 시대의 갑옷〉, 18세기 말

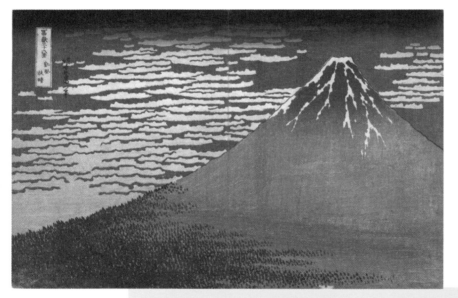

호쿠사이가 신성한 후지 산을 묘사한 이 그림을 그린 것은 70세가 넘어서였습니다. 그는 예술적 재능이란 나이 들수록 원숙해진다고 믿었습니다. "100세에 나는 진정으로 놀라운 예술가가 될 것이며, 110세에는 내가 찍는 점과 선 하나하나가 고유의 생명을 지니게 될 것이다." 그러나 호쿠사이는 유감스럽게도 89세에 세상을 떠났답니다.
〈'후지 산 36경' 중 개풍쾌청(凱風快晴)〉, 가츠시카 호쿠사이, 1830~32년

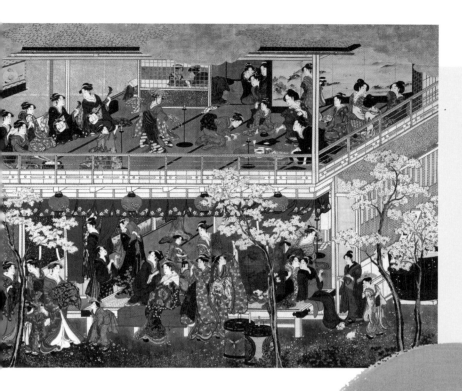

우타마로는 에도 유흥가의 인기 있는 여성들을 그려 유명해진 화가입니다. 이 족자 그림은 벚나무 아래 모인 요시와라의 여성들을 담았습니다. 피어나는 벚꽃을 감상하는 것은 지금까지도 일본의 특별한 관습으로 남아 있답니다.

〈요시와라의 벚꽃〉, 기타가와 우타마로, 1793년경

사무라이

사무라이가 되려면 신체적·정신적으로 엄격한 수련을 거쳐야 했습니다. 사무라이들은 검도와 불교의 가르침을 공부했으며 남녀를 불문하고 명예와 복종의 엄격한 규칙에 따랐습니다.

에도 사람들은 긴 가운 형태의 옷을 입었습니다. 그래서 이처럼 네쓰케라는 작은 함을 이용해 허리띠에 쌈지를 달았답니다. 이 조각상들은 실용적인 동시에 아름다운 작품이기도 하지요. 높이 4센티미터의 이 조각상은 중국 전설 속의 원숭이 손오공을 묘사한 것입니다. 그는 삼장법사의 모험에 따라가겠다고 동의할 때까지 오행산 밑에 갇혀 있었다고 합니다.

〈손오공 모양의 상아 네쓰케〉, 슈교쿠, 19세기

일본이 문호를 개방하면서 우키요에는 세계적으로 유명해졌습니다. 심지어 머나먼 파리의 예술가들도 그 영향을 받았지요. 하지만 소박한 의식 또한 사치스러움만큼 에도 시대의 삶을 이루는 중요한 요소였습니다. 당시 녹차를 준비하고 마시는 일은 19세기부터 중요한 의식이 되었으며 오늘날까지도 그러합니다. 작고 단순한 다실 안에 앉는 방식부터 손으로 만든 비대칭 형태의 찻잔을 잡는 방식에 이르기까지, 일본의 다도는 소박한 기쁨을 찬미하는 행위이며 불완전한 것도 완전한 것만큼 아름답다는 교훈을 전합니다.

푸르른 섬, 하이다과이(1825년)

하이다 민족의 섬

태평양 북서 연안은 지금까지도 신비의 지역입니다. 북부 캘리포니아에서 캐나다를 지나 알래스카까지 2,400킬로미터의 이 바위 해변은 춥고 척박하게만 보입니다. 하지만 사실은 비교적 온난하고 비도 자주 내려 지구상에서 가장 푸르른 지역 중 하나지요. 과학자들은 이런 기후 지역을 온대강우림이라고 부른답니다. 태평양 연안의 캐나다 원주민들은 독특한 기후 덕분에 수천 년 동안 이 지역에서 살아올 수 있었습니다. 그들은 연어를 잡고 곰을 사냥하고 고유의 주택을 지었으며 거대한 붉은 삼나무를 깎아 카누를 만들었답니다. 이 같은 자원들 덕에 태평양 북서 연안 원주민들은 작은 해안 마을에서도 고도의 사회 조직을
형성할 수 있었지요.

하이다 사람들은 수천 년 동안 그들이 사는 지역을 '하이다과이'라고 불러왔습니다. '하이다 민족의 섬들'이라는 뜻이지요. 19세기에 천연두를 비롯한 서구의 전염병들이 덮쳐오자 하이다 사람들은 죽은 이들을 기리기 위해 집 앞에 더욱더 많은 토템 기둥을 세웠답니다.
《하이다의 주택과 토템 기둥》, 하이다과이

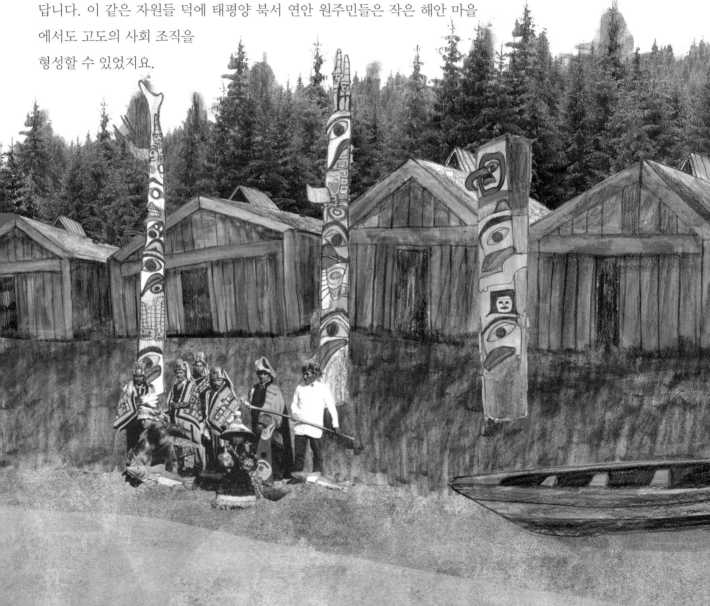

하이다 사람들은 태평양 북서 연안의 여러 민족 중 하나입니다. 그들은 아직도 캐나다 본토에서 떨어진 여러 섬에 살지요. 이 같은 섬들 중에 하이다과이, 영어로는 퀸샬럿 제도가 있습니다. 하이다 사람들은 까마귀 부족과 독수리 부족 두 갈래로 나뉩니다. 한 부족 사람은 무조건 다른 부족 사람과 결혼합니다. 까마귀 부족 남자가 독수리 부족 여자와 결혼하면 독수리 부족 사람이 되어 아내의 씨족과 함께 삽니다. 이 같은 씨족의 유대를 미술로 풀어내는 일은 무척 중요하게 여겨집니다. 태평양 북서 연안 문화에서 미술은 여러 목적을 갖지만, 가장 중요한 목적은 바로 모두가 볼 수 있도록 사실을 기록하는 것이지요.

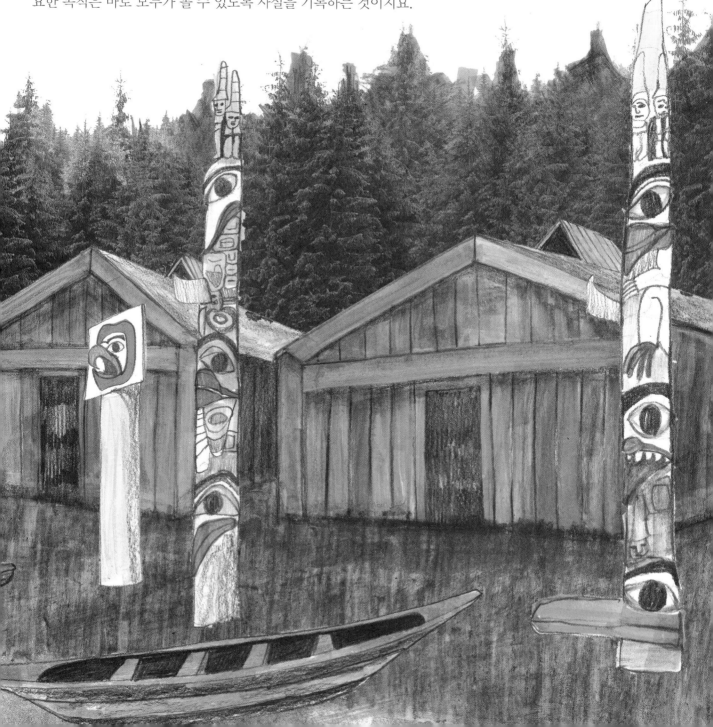

정체성 선언을 위한 장식미술

태평양 북서 연안 미술의 도상과 상징은 수수께끼처럼 보입니다. 하지만 캐나다 원주민에게 이런 장식들은 거리의 표지판만큼이나 쉽고 명백하지요. 하이다 사람들이 조각하는 유명한 토템 기둥도 마찬가지입니다. 꼭대기에 장식을 새겨 넣은 이 기둥들은 귀족 가문의 문장처럼 씨족의 역사와 소유물, 권리 등 중요한 정보를 알립니다. 토템 기둥에 새겨지는 장식의 대다수는 실제로 존재하거나 신화적인 동물들입니다. 태평양 북서 연안의 씨족들은 그들의 정체성을 확인하기 위해 고대의 선조에게 특별한 힘을 주었다는 수호 동물로까지 거슬러 올라가곤 합니다. 그들은 포틀래치 축제에서 정교한 가면과 춤, 노래로 씨족의 설화를 구현하지요.

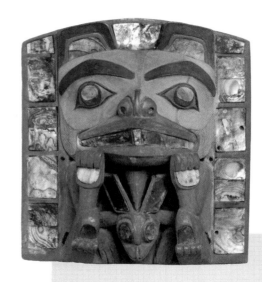

하이다 문화에서 미술품 제작은 고귀한 특권이었습니다. 여러 위대한 족장들은 뛰어난 예술가이기도 했지요. 최고의 하이다 미술가 중 하나인 찰스 에덴쇼는 족장이었던 삼촌 밑에서 수련했답니다. 가면의 일부인 이 머리 장식은 모기 위로 구부린 곰을 묘사한 것입니다.
〈머리 장식〉, 찰스 에덴쇼, 1880년경

원주민들이 그들의 가장 좋은 의식용 복장을 착용하고 있습니다. 부족 여성들이 산양 털과 삼나무 껍질로 짠 화사한 빛깔의 담요를 걸치고 있고, 남성들은 가면과 북과 까마귀처럼 생긴 신성한 딸랑이를 든 모습입니다. 머리 장식은 특별히 중요했는데, 이 사진에서는 조각한 쓰개와 원뿔 모자가 눈에 띕니다.
〈포틀래치 의식 동안 전통 의상을 입고 에드윈 스콧의 독피시 하우스 앞에 모인 사람들〉, 클링콴, 1901년

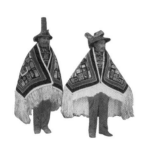

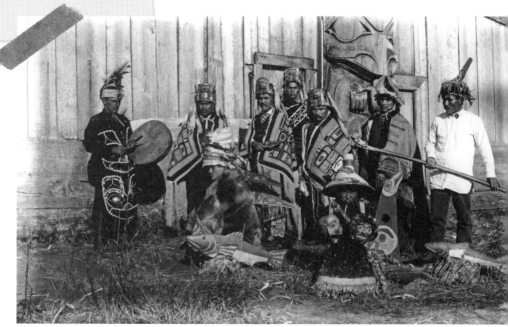

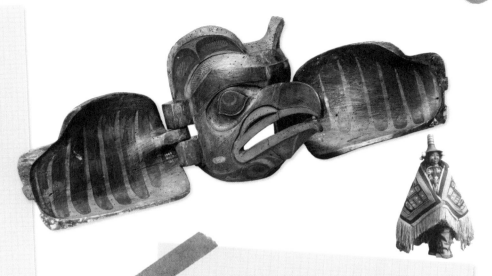

19세기에 태평양 북서 연안 원주민들은 더 복잡한 가면들을 만들기 시작했습니다. 의식용 춤을 출 때 일부분을 움직일 수 있는 가면도 많았지요. 이 가면은 곰의 얼굴을 펼치면 새의 머리가 나오게 되어 있습니다. 동물이나 인간, 신들 간의 변신은 태평양 북서 연안의 신화와 전설에서 중요한 요소였습니다.
〈변신 가면〉, 1850년경

빌 리드는 찰스 에덴쇼의 증손자로, 에덴쇼의 조각을 연구하여 하이다의 전통 조각 기술을 터득했습니다. 이 작품은 하이다 창조 신화의 한 장면입니다. 꾀 많은 까마귀가 홍합 껍데기 속에 갇힌 최초의 인간들을 발견하고 이 세상으로 나오라며 설득하는 모습을 담았지요.
〈까마귀와 최초의 인간들〉, 빌 리드, 1983년

포틀래치는 흡사 거꾸로 된 생일잔치와 같습니다. 의식을 주최한 씨족이 모든 손님에게 선물을 주니까요! 손님들은 선물을 받음으로써 주최 측인 씨족의 위대한 역사를 인정하는 것입니다. 이미 상당수의 유럽인들이 와 있던 1825년에도 이 관습은 여전히 지켜지고 있었습니다. 하지만 1860년대에 이르자 유럽에서 전파된 여러 질병 때문에 원주민들이 10명 중 8명꼴로 죽고 말았습니다. 새로 제정된 법률에서 1884년부터 1951년까지 포틀래치 의식을 금지한 탓에 태평양 북서 연안의 원주민 문화는 큰 타격을 입었지요. 오늘날에는 다시 포틀래치 의식이 주최되고 있으며 이 지역의 원주민 미술도 새롭게 주목받고 있답니다.

포틀래치

높은 신분의 씨족들은 아기의 이름을 지어주거나 족장의 죽음을 애도하는 등 특별한 경우에 포틀래치 축제를 열었습니다. 신성한 춤을 추었고, 연회를 열어 선물을 뿌리며 손님들을 아낌없이 대접했지요. 포틀래치는 미술과 종교, 정치가 결합된 복잡한 관습이었습니다.

변화하는 도시, 런던 (1850년)

긍지와 빈곤

런던 사람들에게 1850년대는 최고의 시기이자 최악의 시기였습니다. 런던은 (에도를 제외하면) 세계 그 어디보다도 심각한 인구 과밀을 겪었습니다. 가난한 사람들은 빈민가에 살았고 집세를 제때 내지 않으면 바로 감방에 들어가야 했습니다. 이 시대에는 어린이들도 살기가 힘들었답니다. 찰스 디킨스를 비롯해 많은 사람들이 학업을 몇 년 만에 중단하고 일하러 가야 했지요. 소설가가 된 뒤 디킨스는 『크리스마스 캐럴』의 이기적인 고용주 스크루지와 같은 인물을 만들어 불우한 사람들을 도와줄 것을 촉구했답니다. 런던 생활은 힘겨웠습니다. 하지만 당시는 큰 변화의 시대였으며 그중에는 모든 사람들에게 도움이 되는 변화도

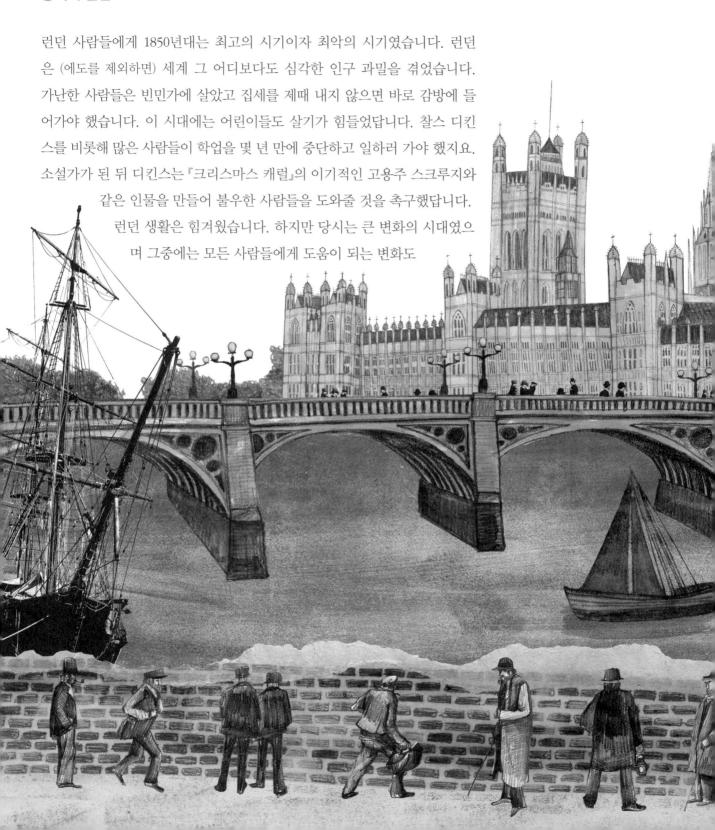

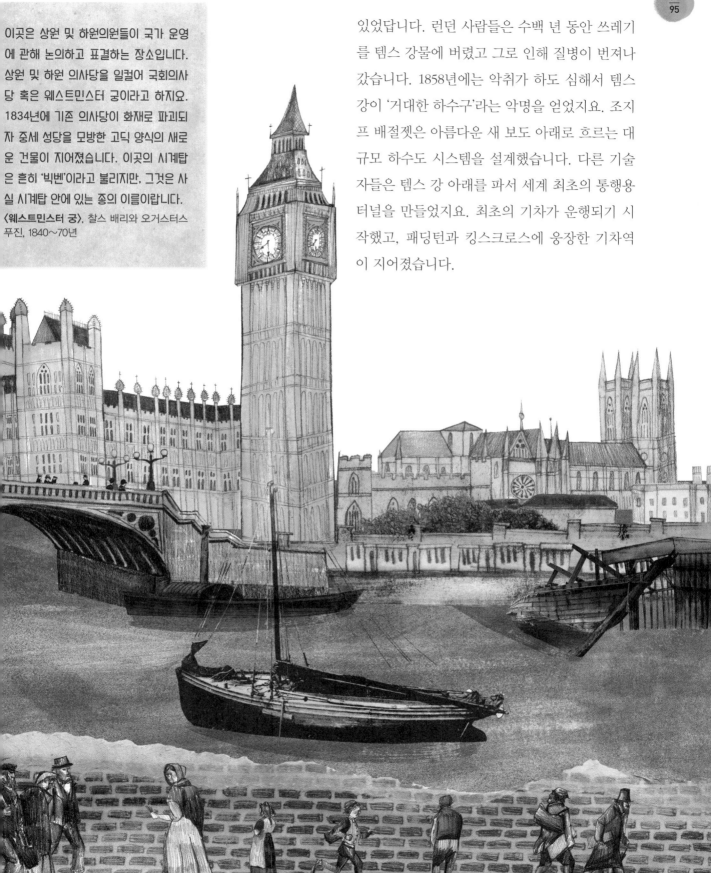

이곳은 상원 및 하원의원들이 국가 운영에 관해 논의하고 표결하는 장소입니다. 상원 및 하원 의사당을 일컬어 국회의사당 혹은 웨스트민스터 궁이라고 하지요. 1834년에 기존 의사당이 화재로 파괴되자 중세 성당을 모방한 고딕 양식의 새로운 건물이 지어졌습니다. 이곳의 시계탑은 흔히 '빅벤'이라고 불리지만, 그것은 사실 시계탑 안에 있는 종의 이름이랍니다.

〈웨스트민스터 궁〉, 찰스 배리와 오거스터스 푸진, 1840~70년

있었답니다. 런던 사람들은 수백 년 동안 쓰레기를 템스 강물에 버렸고 그로 인해 질병이 번져나갔습니다. 1858년에는 악취가 하도 심해서 템스 강이 '거대한 하수구'라는 악명을 얻었지요. 조지프 배절젯은 아름다운 새 보도 아래로 흐르는 대규모 하수도 시스템을 설계했습니다. 다른 기술자들은 템스 강 아래를 파서 세계 최초의 통행용 터널을 만들었지요. 최초의 기차가 운행되기 시작했고, 패딩턴과 킹스크로스에 웅장한 기차역이 지어졌습니다.

혁신의 온상이 된 만국박람회

이 시대에는 시각미술 또한 일상생활만큼이나 빠르게 변화했습니다. 미술가들은 자연을 새로운 관점으로 보기 시작했습니다. J.M.W. 터너는 소용돌이치는 구름, 몰아치는 파도, 타오르는 석양을 그렸습니다. 존 에버릿 밀레를 비롯한 '라파엘 전파(前派)'는 자연에 색다르게 접근하여 주변 세계를 세밀하고 보석같이 반짝이는 이미지들로 묘사했습니다. 장신구와 도자기, 가구 등의 장식미술도 황금기를 맞았습니다. 1851년 만국박람회에서는 이러한 공예품들을 비롯하여 세계에서 가장 큰 다이아몬드가 전시되었습니다. 모든 사람들이, 심지어 빅토리아 여왕과 앨버트 공을 비롯한 왕족들도 박람회에 열광했습니다. 여왕 부부는 박람회 계획에 직접 참여했을 뿐만 아니라 박람회장을 40번 이상 방문했다고 합니다.

만국박람회가 열린 수정궁은 마치 온실처럼 생겼는데, 이는 우연의 일치가 아니었습니다. 수정궁을 설계한 조지프 팩스턴은 건축가인 동시에 정원사였으니까요. 이 건물을 짓는 데 90만 장 이상의 유리가 사용되었습니다. 수정궁은 이후 화재로 파괴되었지만, 만국박람회의 입장권 수익 덕분에 런던 최고의 박물관들이 지어질 수 있었답니다.
〈수정궁〉, 조지프 팩스턴, 1851년

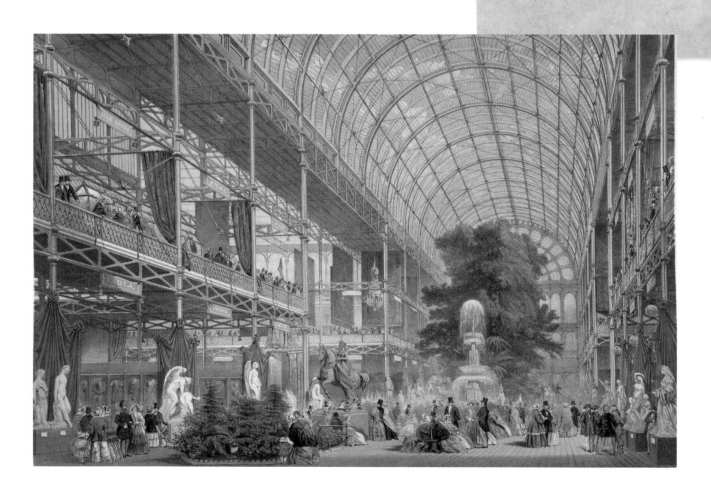

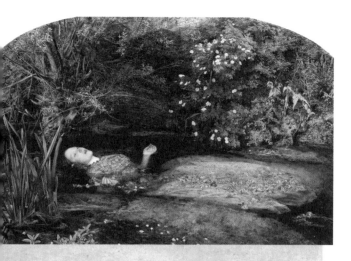

소설가 윌리엄 새커리는 이렇게 적었습니다. "런던의 휘황한 거리에서 수많은 국가들이 조우한다." 런던은 완벽함과는 거리가 먼 곳이었지만, 만국박람회를 보러 온 수백만 명의 사람들에게 이 도시는 정말로 세상의 중심처럼 느껴졌겠지요.

...익스피어의 비극 <햄릿>에 영감을 받은 그림입니다. 여주인공 오...리어는 햄릿 왕자와의 결혼을 앞두고 시냇가에서 익사하지요. 밀...는 이 장면을 사실적으로 묘사하려고 런던의 강둑에 자라는 식물...들을 연구했고, 물에 뜬 오필리어의 머리칼과 옷자락을 생생하게 그...기 위해 모델이 욕조에서 포즈를 취하게 했습니다. 이 여성은 너...무 오래 물속에 있었던 탓에 독감에 걸리고 말았습니다.
<오필리어>, 존 에버릿 밀레, 1851~52년

숭고

미술은 여러 가지 이유로 기분 좋은 것입니다. 우리는 흔히 아름답고 마음을 진정시킨다는 이유로 미술을 좋아합니다. 하지만 때로는 무시무시한 롤러코스터처럼 걷잡을 수 없이 내면을 뒤흔들기에 좋아하기도 하지요. 이처럼 오싹하면서도 황홀한 감정을 숭고함이라고 합니다. 마치 터너의 그림들이 주는 것과 같은 감정이지요.

터너는 이 그림을 준비하는 과정에서 실제로 폭풍이 심한 날 배 돛대에 자신의 몸을 묶어달라고 요구했답니다. 비평가들은 터너의 그림이 '흐릿하다'고 비난했지만, 그것이야말로 그가 표현하고 싶었던 느낌이었습니다. 터너는 자연을 실제 우리의 경험대로 묘사하려면 때로는 빠르고 거칠며 흐린 붓질이 필요하다고 생각했지요.
<눈보라: 항구를 떠나는 증기선>, J.M.W. 터너, 1842년

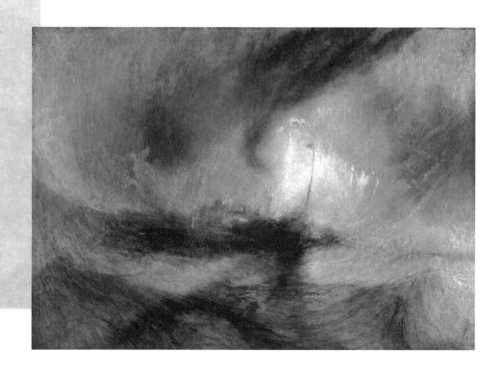

새로 설계된 도시, 파리 (1875년)

철거와 새 출발

19세기 초의 파리는 과거 수백 년과 거의 비슷한 모습이었습니다. 많은 건물들이 중세로 거슬러 올라갈 만큼 오래되었기 때문이지요. 어둡고 좁고 구불구불한 골목길이 수천 개나 있었고, 방 하나를 여남은 사람이 함께 써야 하는 경우도 많았습니다. 하지만 1875년 무렵의 파리는 널따란 거리, 많은 공원, 환한 가로등과 개선된 하수도를 갖춘 현대적인 수도가 되었답니다.

이 국립 오페라 극장은 상류층 사교생활의 중심이었습니다. 파리의 부자들이 오페라 극장에 가는 것은 공연을 보는 만큼 자신의 모습을 보이기 위해서이기도 했답니다. 에드가 드가, 메리 커셋 같은 화가들은 배우뿐만 아니라 관객들도 그림에 담곤 했지요.
〈팔레 가르니에〉, 샤를 가르니에, 1875년

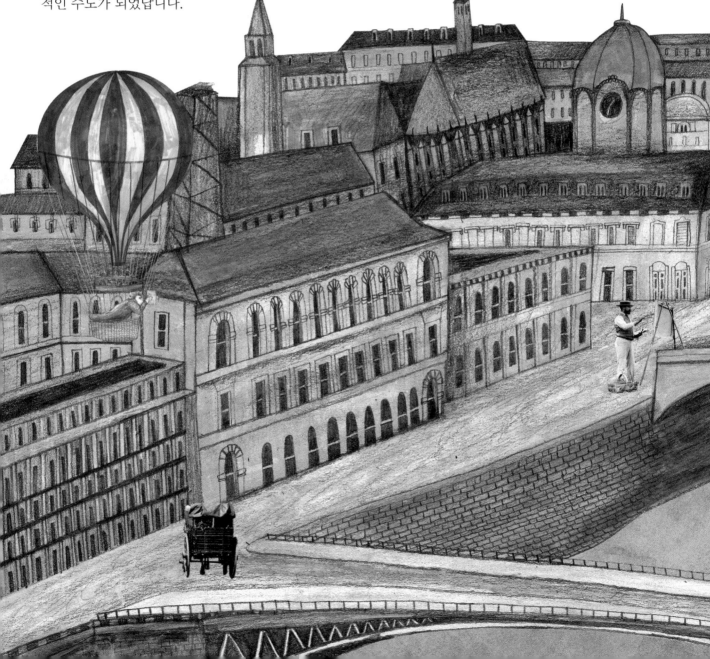

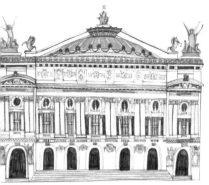

이 같은 혁신 뒤에는 '파괴자'라 불렸던 도시 계획가 조르주 외젠 오스만이 있었습니다. 오스만의 파리에서 핵심은 루브르 미술관에서 샤를 가르니에가 화려하게 설계한 새 오페라 극장까지 이어지는 오페라 대로였습니다. 1830년대에 발명된 사진술이 빠르게 발전한 덕분에 당시 파리의 철거와 건설은 생생히 기록될 수 있었습니다. 미술가들은 발아래서 급변해가는 도시 광경을 포착하기 위해 새로운 높이에 도전했고, 심지어 완벽한 사진 한 장을 찍으러 열기구에 오르기도 했답니다.

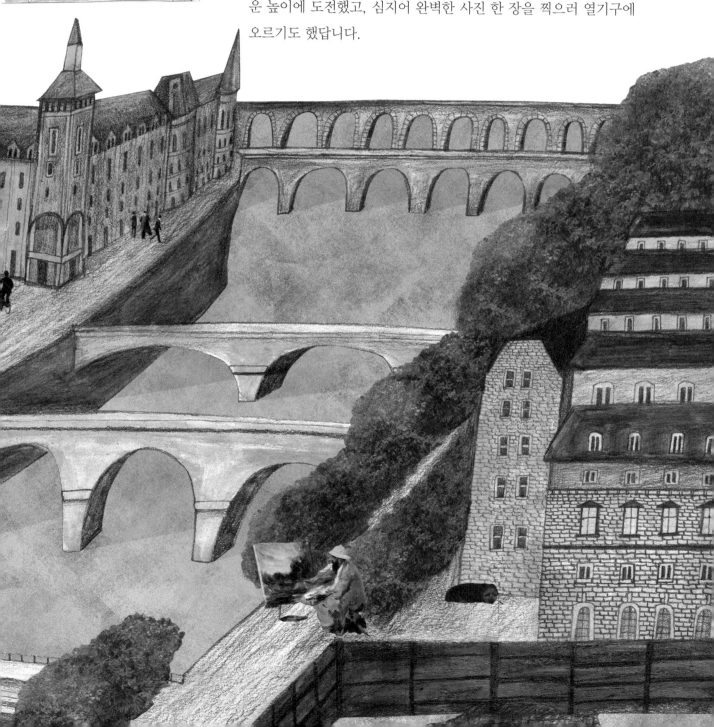

참신한 시선의 인상주의 출현

19세기 중반에 파리에서 미술가로 성공하려면 확고한 규정을 따라야 했습니다. 미술학교인 에콜 데 보자르에서 공부하고, 역사나 신화 속의 한 장면을 그려 대규모 연례 전시회인 살롱전에 출품해야 했지요. 하지만 1860년대에 이르자 이런 규칙이 깨지기 시작했습니다. 오귀스트 로댕은 고대 그리스와 로마 미술품의 우아한 포즈를 모방하는 대신 실제 사람들의 움직임을 보여주는 조각을 만들었지요. 하지만 많은 비평가들은 이런 사실주의가 부적절하다고 생각했습니다.

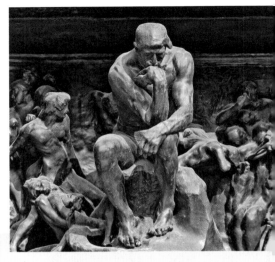

로댕은 죽을 때까지 37년에 걸쳐 〈지옥의 문〉을 작업했습니다. 14세기 단테 알리기에리의 걸작 서사시 『신곡』 중 가상의 지옥 여행을 담은 「지옥 편」에서 영감을 받은 작품이지요. 사진은 지옥의 문간에 앉아 있는 단테를 보여주는데, 이 인물상은 로댕의 가장 유명한 조각이자 그의 무덤 옆에 놓인 작품 〈생각하는 사람〉의 원형이 되었답니다.

〈**지옥의 문**〉 세부, 오귀스트 로댕, 1880~1917년

인상주의

인상주의는 세상을 묘사하는 새로운 방식을 찾으려 했던 미술 유파였습니다. 화가들은 자연의 빛과 색채를 좀 더 충실하게 담기 위해 화실 대신 야외에서 작업하기 시작했지요. 빛의 효과는 시간에 따라 신속하게 변했기 때문에 화가들은 급히 그림을 그려야 했고 그로 인해 빠르고 자유로운 붓질을 구사하게 되었습니다. 그들의 화풍은 처음엔 조롱당했지만 시간이 지나면서 미술에 관한 대중의 생각을 크게 바꾸어놓았답니다.

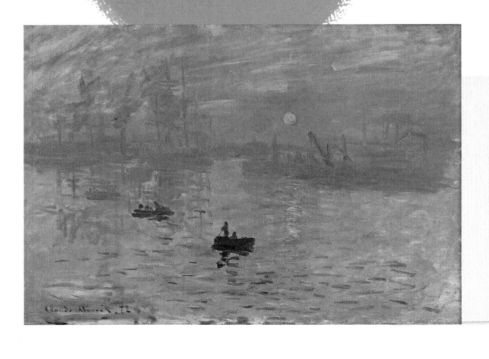

이 그림이 처음 전시되었을 때 많은 관람객들은 그림의 느슨한 붓질과 흐릿한 형체에 질색했습니다. 한 비평가는 제목인 〈인상〉에서 착안해 모네와 동료들을 '인상주의자들'이라며 비웃었지요. 따라서 인상주의란 본래 그들을 욕하는 말이었지만, 화가들은 이 말을 받아들여 당당히 '인상주의자'로 자칭하게 되었답니다.

〈**인상, 해돋이**〉, 클로드 모네, 1872년

'인상주의자'라는 새로운 화가 집단은 사실주의에 있어 독자적 관점을 드러냈습니다. 사람과 물체를 정확하게 복제하는 대신 눈앞에서 일어나는 빛과 색채의 변화를 포착하려 했지요. 살롱전에서 이 새로운 화파의 그림을 전시하지 않으려 하자 클로드 모네, 에드가 드가, 피에르 오귀스트 르누아르를 비롯한 화가들은 1874년에 그들만의 전시회를 개최했습니다. 이 화파에서는 여성들도 화가이자 취향 선도자로 중요한 역할을 했는데, 미국에 인상주의를 전파하는 데 공헌한 메리 커셋이 그 예입니다. 아름다움에 관한 생각은 급속도로 변화했습니다. 1889년에 기술자 귀스타브 에펠은 만국박람회를 위해 거대 철제 구조물을 세웠습니다. 파리의 많은 사람들은 이 탑이 흉하다고 생각했지만, 얼마 지나지 않아 에펠 탑은 파리의 찬란함을 상징하는 존재가 되었답니다.

메리 커셋은 파리에 사는 미국인 화가였습니다. 당시에는 직업적 여성 미술가는커녕 혼자 카페에 오는 여성조차도 드물었지요. 커셋은 이탈리아 르네상스 미술과 일본 판화를 좋아했고, 후자의 화사한 색채와 문양에서 영감을 받았습니다. 남성 미술가들과 달리 그녀는 집에서 느긋한 자세를 취한 여성과 아이들을 즐겨 그렸답니다.
〈푸른 소파에 앉은 소녀〉, 메리 커셋, 1878년

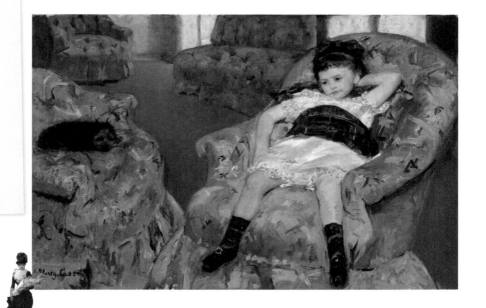

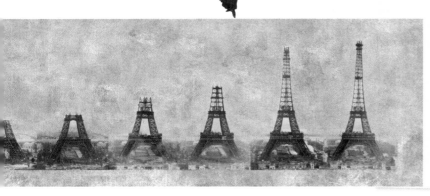

에펠 탑은 당시 세계에서 가장 큰 인공 구조물이었습니다. 1930년대 뉴욕에 크라이슬러 빌딩이 세워지기 전까지는 말이지요. 이 탑은 본래 20년 정도만 유지될 예정이었지만 건설에 도입된 놀라운 공학 기술 덕에 지금까지 그대로 남아 있답니다. 날씨가 추우면 크기가 15센티미터나 수축하고, 강풍이 불면 유연하게 몇 센티미터 굽어지면서도 끄떡없이 자리를 지키고 있지요.
〈에펠 탑의 건설 과정〉, 귀스타브 에펠, 1888년

예술가들의 감성 도시, 빈 (1890년)

감상을 위한 공간

20세기로의 전환기에 유명해지고 싶은 사람이라면 빈을 찾아가야 했습니다. 오스트리아 헝가리 제국의 수도였던 이 도시는 미술가, 음악가, 작가, 철학자와 혁명가들을 끌어당겼습니다. 빈의 카페에서는 유럽 전역의 지성인들이 신문을 읽고 슈트루델(오스트리아의 대표적 패스트리 – 옮긴이)을 씹으며 휘핑크림이 얹힌 이 도시 특유의 커피를 음미하는 모습을 볼 수 있었습니다. 빈에서는 새로운 사상들이 활발히 논의되었습니다. 테오도어 헤르츨은 유대인을 위한 국가를 만들려고 계획했습니다. 지크문트 프로이트는 인간의 마음을 연구하는 정신분석학 분야에서 새로운 접근법을 개발했습니다. 꿈의 내용이나 농담, 심지어 말실수도 사람들의 숨은 욕망을 드러낸다는 것이었지요. 한편 빈의 신세대 예술가와 사상가들도 전성기에 도달하고 있었는데, 그중에는 20세기 최고의 철

이 건물은 단순한 전시 공간을 넘어 분리파 운동의 상징이 되었습니다. 입구 위에는 분리파의 좌우명이 금으로 새겨져 있습니다. '모든 시대에 고유한 예술을. 모든 예술에 각자의 자유를.' 이 호화로운 장소의 건축비를 후원한 사람은 루트비히 비트겐슈타인의 아버지인 카를이었습니다.

〈분리파 건물〉, 요제프 마리아 올브리히, 1898년

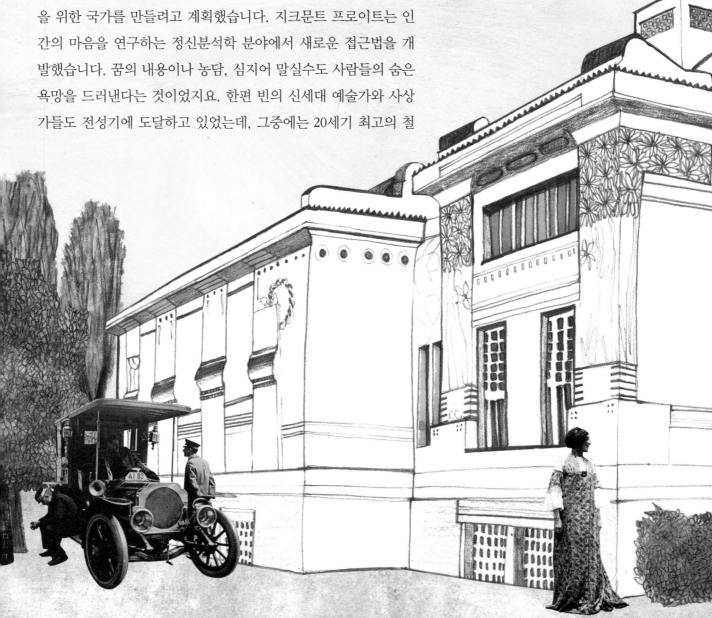

학자로 꼽히는 루트비히 비트겐슈타인도 있었답니다.

빈은 파리와 비슷하게 당대에 새로이 설계된 도시였습니다. 중세의 성벽이 파괴되고 그 자리에 옛 도심을 에워싸는 장엄한 대로가 생겼지요. 새로운 철도 시스템은 이후로 백 년간 시민들에게 봉사했습니다. 하지만 이 모든 화려한 성취로도 오스트리아 헝가리 제국의 쇠퇴를 숨길 순 없었지요. 통치자였던 합스부르크 가문은 연달아 큰 정치적 실수를 저질렀습니다. 이러한 오류들은 결국 제1차 세계대전으로 이어졌고, 위대했던 제국은 결국 산산조각 나고 말았습니다.

거대한 총체예술의 집합체, 빈

우리는 흔히 각각의 예술 분야가 완전히 별개라고 생각합니다. 연극은 극장에서, 미술은 전시회장에서, 음악은 연주회장에서 감상하는 것으로 여기지요. 19세기 말의 예술가들은 이런 선입견을 뒤집고 싶었습니다. 그들은 각자의 재능을 결합하여 종합 예술작품을 창조할 방법을 모색했지요. 이를 총체예술(Gesamtkunstwerk)이라고도 합니다. 이러한 관점은 특히 빈에서 큰 반응을 얻었습니다. 수백 년 동안 루트비히 반 베토벤을 비롯한 최고의 클래식 음악가들은 이 도시를 보금자리로 삼아 왔습니다. 1890년대에 빈 궁정 오페라단은 구스타프 말러를 지휘자로 지명했지요. 말러는 자연 음향과 민요를 최초로 클래식 음악에 도입한 선구적 작곡가였습니다. 음악은 빈의 미술가들에게 중요한 영감의 원천이었습니다. 1897년에는 구스타프 클림트를 비롯한 여러 미술가들이 빈의 기존 미술가협회에서 탈퇴하여 빈 분리파를 결성했습니다. 그들의 가장 인기 있었던 전시회는 베토벤에 헌정되었으며 회화와 조각 등 여러 분야의 미술품들로 구성되었습니다.

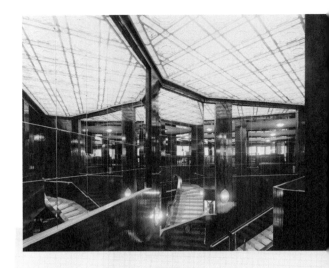

사실 아돌프 로스는 분리파 건축을 좋아하지 않았습니다. 너무 장식적이라고 생각했기 때문이지요. 그는 장식이 '범죄'라고까지 말했지만, 그럼에도 불구하고 로스가 만든 여러 건물들의 내부도 값비싼 목재와 석재의 자연무늬를 강조하여 화려하게 꾸며져 있답니다.
〈미하엘러플라츠의 로스 저택〉, 아돌프 로스, 1909~10년

구스타프 클림트는 제14회 분리파 전시회를 위해 길이 30미터 이상의 벽화를 그렸습니다. 그리스 신화에서 따온, 유혹하는 악마와 괴물들과 싸우는 기사를 묘사한 벽화였지요. 벽화의 마지막 부분에는 합창단이 그려져 있는데, 관람객들에게 베토벤 9번 교향곡의 일부인 〈환희의 송가〉를 상기시키기 위해서였습니다. 클림트는 무엇보다도 특유의 금빛 채색과 화려하고 복잡한 문양으로 유명했지요.
〈베토벤 프리즈〉 세부, 구스타프 클림트, 1902년

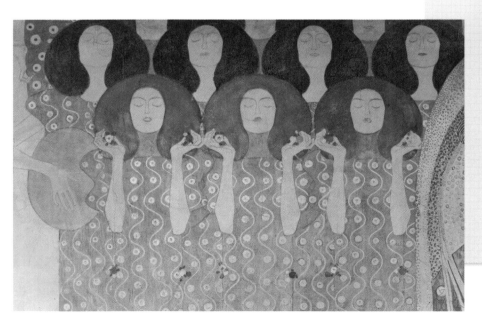

분리파 미술가들은 다양한 양식을 구사했습니다. 상징주의에 집중하는 사람들도 있었고 자연이나 일본 미술에서 영감을 구하는 사람들도 있었지요. 한편 패션 디자이너들도 고전적 형태와 당대의 복잡한 장식에 고루 영감을 받아 실험적 시도에 나섰습니다. 에밀리 플뢰게는 대담한 문양이 있는 직물로 현대 여성들에게 필요한 의상을 몸에 편하게 맞도록 제작했지요. 빈 자체가 하나의 거대한 총체예술이 되어가고 있었답니다.

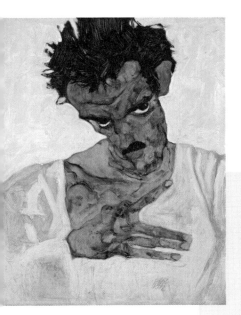

클림트는 젊은 화가 에곤 실레의 후원자가 되었습니다. 실레는 요절했음에도 확고한 자기만의 양식을 만들어 냈지요. 그의 그림은 주로 자화상과 누드인데, 길고 울퉁불퉁한 손가락에 얼룩진 피부, 야위고 어색한 신체 표현이 인상적입니다.
〈고개 숙인 자화상〉, 에곤 실레, 1912년

요제프 마리아 올브리히보다 윗세대였던 오토 바그너는 여러 후배 분리파 건축가들에게 멘토 역할을 했습니다. 그는 사진과 같은 기차역부터 은행과 아파트, 가톨릭 성당까지 고향인 빈에 분리파 양식을 전파하는 데 공헌했답니다.
〈카를스플라츠 전차역〉, 오토 바그너, 1898년

혁신의 도시, 모스크바 (1920년)

혁명의 문화

역사상 그 어떤 국가도 20세기 초의 러시아만큼 빠르고 극적으로 변화하진 않았을 것입니다. 러시아 제국은 수백 년 동안 차르의 절대왕정 아래 있었지요. 국민의 대부분은 가난했고 권리라고는 거의 누리지 못했습니다. 1905년 반란이 일어나면서 궁지에 몰린 차르 니콜라이 2세는 의회를 개설하고 헌법을 만들 수밖에 없었습니다. 약간의 변화가 일어나긴 했으나 국가의 본질적 문제가 해결된 것은 아니었지요. 제1차 세계대전 동안 혼란은 점점 커져갔고, 극좌 정당인 볼셰비키는 이 혼란을 기회 삼아 1917년에 권력을 잡았습니다. 그들의 수장은 블라디미르 레닌이었습니다.

모스크바에는 독창적 구조물들이 세워졌습니다. 블라디미르 슈코프의 라디오 전송탑(왼쪽)이나 콘스탄틴 멜니코프의 노동자회관(아래) 등이지요. 엘 리시츠키의 수평 구조 마천루처럼 (맨 오른쪽) 설계되었지만 건축되지 ○한 작품도 있었습니다. 블라디미○ 타틀린의 나선형 철탑, 카지미르 레비치의 플라스틱 블록 건축물. ○코프 체르니코프의 '건축적 환상○을 통해 러시아는 지면에서부터 이 상상되고 구현되었습니다.

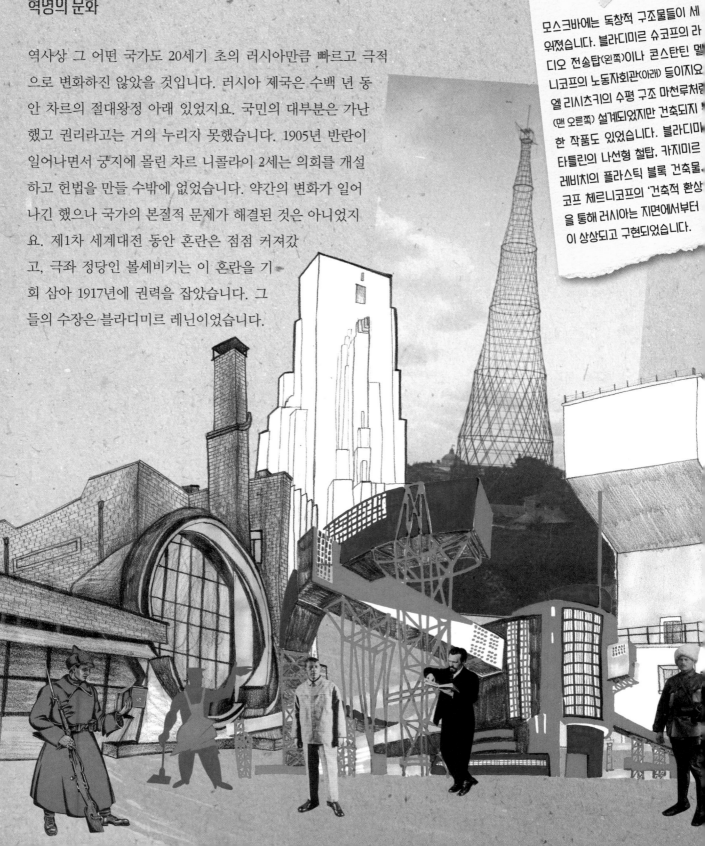

레닌은 러시아가 노동자 계급이 다스리는 공산주의 국가라고 선언했습니다. 처음에는 러시아 내외에서 레닌에게 대항하는 집단들도 있었습니다. 하지만 1920년대에 이르자 볼셰비키가 대부분의 적수를 무너뜨렸지요. 이후로 그들은 건축과 상업, 언론, 교육까지 일상생활을 온전히 통제하게 되었습니다. 후에 레닌이 죽고 이오시프 스탈린이 권력을 쥐면서 소비에트 연방공화국은 점점 더 억압적 국가로 변했습니다. 하지만 1920년대 초의 소련은 아직 낙관적 분위기였답니다. 화가, 건축가, 작가, 영화감독 등 모든 예술가가 새로운 주제와 양식을 발견했습니다. 예술이 새로운 사회를, 나아가 새로운 세계를 구현하는 데 공헌하는 것처럼 보였지요.

공산주의

공산주의는 계급 구분뿐만 아니라 부동산이나 기업 등 일체의 사적 소유를 없애는 것을 목표로 하는 정치체제입니다. 공산주의 사상은 19세기에 카를 마르크스가 수립한 것이며, 20세기 들어 레닌은 이를 현실 정치에서 구현하려고 했습니다.

심장의 열기가 타오르는 곳

러시아 예술가들은 그들도 프랑스와 독일에서 싸우는 군인들만큼 용감할 수 있다는 것을 증명하고 싶었습니다. 1910년에 모스크바 미술가들은 '다이아몬드의 잭'이라는 단체를 만들었습니다. 나탈리아 곤차로바를 비롯한 여성 미술가들도 회원으로서 전시에 참여했지요. 시인 안나 아흐마토바와 같은 여성들은 예술계 전반에서 지도적 역할을 했습니다. 예술가들은 재주를 모아 전 세계에서 공연하던 무용단 '발레 뤼스'의 무대 배경과 의상을 디자인하기도 했지요. 모스크바 예술극장의 연출가 콘스탄틴 스타니슬랍스키는 작가와 디자이너, 특히 배우들에게 새로운 사실주의 규범을 따르게 했습니다. 모스크바 국립 유대 극장도 번성했지요. 러시아 유대인 대부분이 사용한 언어인 이디시어로 된 연극, 마르크 샤갈의 몽환적 벽화가 인기를 끌었습니다. 또한 참신하고 대담한 그래픽 디자인이 발달했는데, 〈전함 포템킨〉 같은 영화 포스터들이 대표적이랍니다.

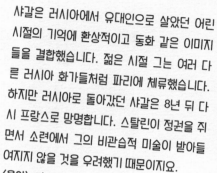

샤갈은 러시아에서 유대인으로 살았던 어린 시절의 기억에 환상적이고 동화 같은 이미지들을 결합했습니다. 젊은 시절 그는 여러 다른 러시아 화가들처럼 파리에 체류했습니다. 하지만 러시아로 돌아갔던 샤갈은 8년 뒤 다시 프랑스로 망명합니다. 스탈린이 정권을 쥐면서 소련에서 그의 비관습적 미술이 받아들여지지 않을 것을 우려했기 때문이지요.
〈음악〉, 마르크 샤갈, 1920년

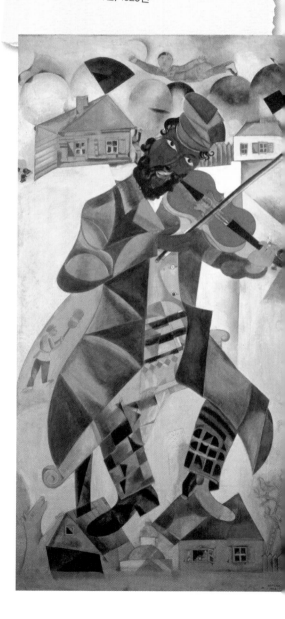

이 영화는 1905년 반란을 일으킨 러시아 해병들의 이야기를 다루었습니다. 오데사 시민들도 반란에 참여했지만 차르가 보낸 군인들의 총에 맞고 도시의 계단에 쓰러졌지요. 뛰어난 영화감독 에이젠슈타인은 다양한 시점에서 촬영한 영상들을 잘라 붙여 관객에게 강렬한 인상을 주는 장면을 만들어냈습니다. 이 장면에서 어머니가 쓰러지며 놓친 유모차는 아기가 안에 누운 채로 계단을 굴러 내려가 비극적 결말을 맞습니다.
〈전함 포템킨〉, 세르게이 에이젠슈타인의 영화, 1925년

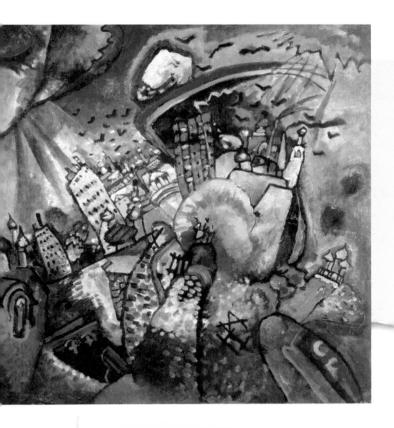

이 그림은 유명한 성 바실리 성당의 양파 모양 돔을 담고 있습니다. 하지만 당시 모스크바의 실제 모습을 표현했다기보다는 그곳의 분위기를 표현한 그림이었지요. 칸딘스키는 이렇게 적었습니다. "태양은 모스크바 전체를 녹여 하나의 점(돔)에 응축하고, 그 점은 광란하는 금관악기처럼 모든 심장과 영혼을 전율시킨다."

〈모스크바 1〉, 바실리 칸딘스키, 1916년

카지미르 말레비치는 회화를 가장 단순한 형태로 정제하려 했습니다. 사진 속 전시장의 벽 한구석에는 그의 대표작 〈검은 사각형〉(1915년)이 보입니다. 이 구석 자리에 그림을 건다는 것은 충격적인 일이었습니다. 러시아 정교도 가정에서 이 자리는 '이콘'이라고 불리는 지극히 신성한 종교화를 거는 곳이었으니까요. 말레비치는 공산주의 시대의 새로운 이콘을 창조한 것입니다.

〈0, 10: 최후의 미래파 회화전〉, 페트로그라드(현재 상트페테르부르크), 1915년

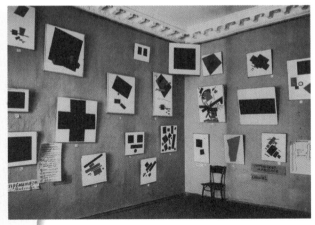

미술과 건축은 떼어놓기 어려운 관계가 되었습니다. 당대의 중요한 두 가지 실험적 사조는 구성주의와 절대주의였지요. 블라디미르 타틀린은 산업 자재로 구성주의 조각을 만들었고, 카지미르 말레비치는 단순한 기하학 형태로 절대주의 회화를 그렸습니다. 처음에 소련 정부는 이러한 혁신적 미술가들을 찬양했지만, 얼마 지나지 않아 실험과 의문 제기가 공산주의 실현에 방해되는 행위라고 단정하게 되었습니다.

투쟁과 혁명, 멕시코시티 (1930년)

독수리와 뱀의 도시

고대 예언에 따르면 아즈텍, 혹은 다른 이름으로 멕시카 민족은 독수리가
입에 뱀을 물고 선인장 위에 앉아 있는 장소에 도시를 세워야 했습니다. 이
곳이 바로 웅장한 도시 테노치티틀란이 되었답니다. 16세기에 스페인 사람
들이 테노치티틀란을 파괴하고 그 자리에 멕시코시티를 세웠지요. 19세기
들어 멕시코시티는 새로이 독립한 국가 멕시코의 수도가 되었답니다.
오늘날 독수리와 뱀은 멕시코 국기 한가운데에서 자랑스럽게
이 도시의 기원을 상기시켜주고 있지요.

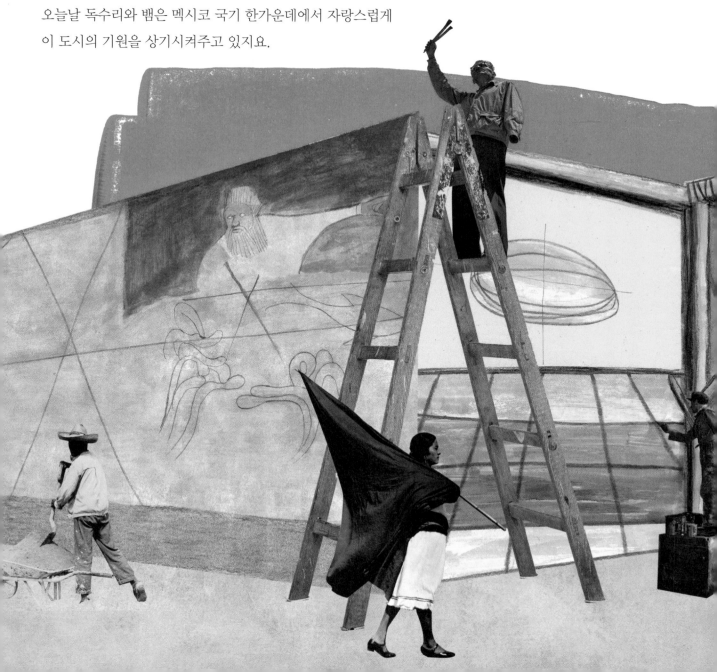

20세기 초 멕시코는 포르피리오 디아스 대통령이 통치하고 있었습니다. 디아스는 국가를 발전시키긴 했지만 그 이득의 대부분은 상류층에게만 돌아갔지요. 1910년 무렵 다수의 멕시코 사람들은 디아스를 물러나게 하기로 결심하고 기나긴 투쟁을 시작했습니다. 여러 저항 세력들은 무정부주의에서 공산주의까지 각각 다른 사상과 목표를 가지고 있었지요. 디아스를 쫓아낸 이후로도 일부 세력들은 서로 계속 맞서 싸웠습니다. 1917년에 새로 작성된 멕시코 헌법은 공교육, 노동자의 권리, 농부들에게 이로운 토지 개혁 등의 내용을 포함했습니다. 갈등은 사그라졌고, 1930년대에 이르자 멕시코는 현대 국가의 형태를 갖추게 되었지요.

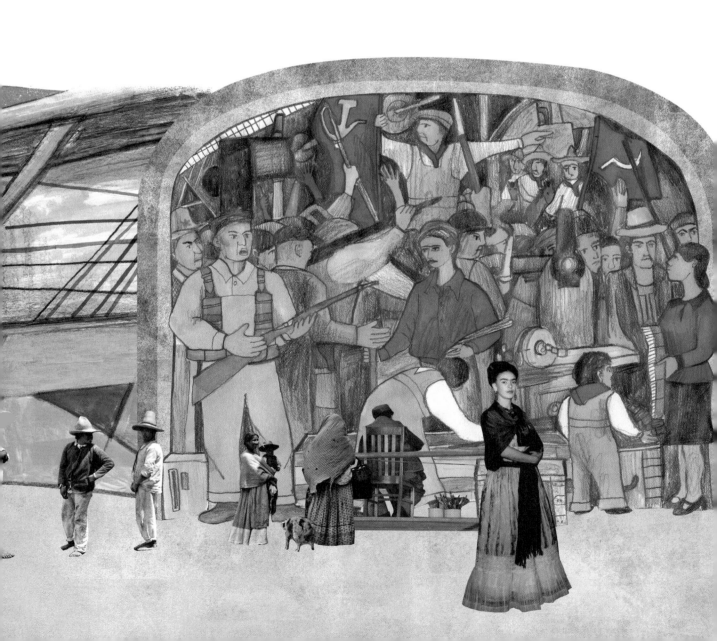

정치 혁명을 담은 멕시코 미술

멕시코 혁명이 끝나자 새로운 국가의 사상을 표현하고 전파할 방법들이 요구되었습니다. 미술은 강력한 수단이 되었지요. 멕시코 최고의 미술가 몇몇은 파리에서 유학했고 파블로 피카소를 비롯한 현대 미술 거장들에게 배웠습니다. 그들은 모스크바에서 전해진 공산주의를 비롯한 급진적 정치사상과 최신 미술 사조를 결합시켰지요. 벽화야말로 이런 사상들을 퍼뜨리기에 완벽한 방식이었습니다. 호세 클레멘테 오로스코, 디에고 리베라, 다비드 알파로 시케이로스는 멕시코시티와 교외의 공공건물에 거대한 벽화를 그렸습니다. 그들은 멕시코 역사, 특히 아즈텍 같은 토착 민족들의 미술에서 영감을 얻곤 했지요. 그들의 작품은 멕시코뿐만이 아니라 해외에도 영향을 미쳤습니다. 특히 뉴욕의 미술가들은 멕시코 벽화의 규모와 역동성, 상징주의에 감탄했지요.

이곳은 디아스 집권기에 건설되기 시작했습니다. 원래 디아스가 지으려 한 것은 의회 건물이었지만, 혁명 이후 정부는 이곳을 혁명을 기념하는 구조물로 바꾸기로 했습니다. 판초 비야를 비롯하여 유명한 여러 혁명가들의 유해가 이곳에 묻혔답니다.
⟨혁명 기념탑⟩, 1938년

1932년에 프리다 칼로는 디트로이트에서 벽화 작업을 하던 남편 디에고 리베라와 함께 지냈습니다. 그녀는 불행했고 고국 멕시코를 그리워했지요. 칼로는 미국을 공해와 기술의 영역으로, 멕시코를 자연과 전통문화의 영역으로 묘사했습니다. 멕시코 쪽에 그려진 유적은 앞서 이 책에서도 살펴본 테오티우아칸을 연상시킵니다.
⟨멕시코와 미국의 국경선에 선 자화상⟩, 프리다 칼로, 1932년

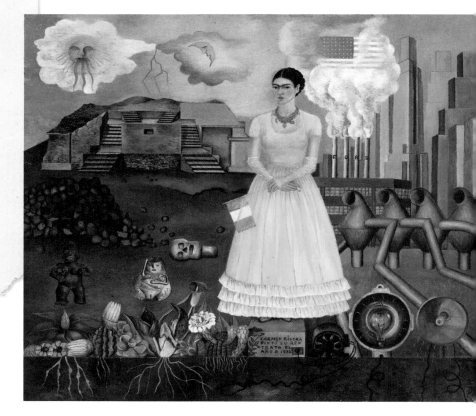

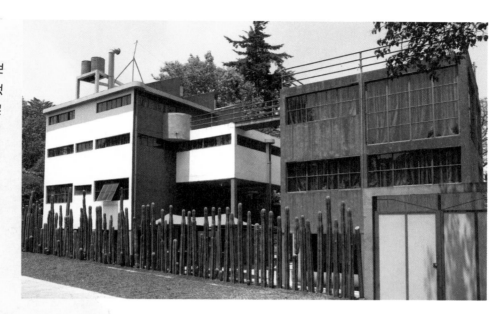

리베라와 칼로에게 이곳은 완벽한 보금자리였습니다. 두 사람은 종종 싸웠는데, 이 집은 각자의 공간이 다리로 연결되어 있는 구조였지요. 당시의 최첨단 건축 디자인과 멕시코 특유의 화사한 색채가 만난 집입니다. 오고르만은 이후 멕시코시티 대학교 도서관을 건설하면서 정면에 테노치티틀란의 풍경을 담은 거대 모자이크를 만들기도 했습니다.
〈디에고 리베라와 프리다 칼로의 집〉, 후안 오고르만, 1932년

대통령 궁에 있는 이 벽화 중심에는 독수리가 뱀을 물고 앉아 있습니다. 고대 도시 테노치티틀란과 현대 멕시코시티의 공통된 상징이지요. 벽화 속에는 리베라의 아내 프리다 칼로를 비롯하여 우리가 알아볼 수 있는 인물들 여럿이 그려져 있습니다.
〈멕시코의 역사〉, 디에고 리베라, 1930년경

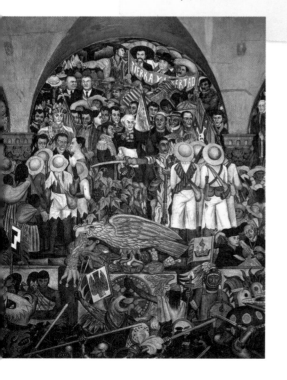

1930년대 멕시코 미술가들 모두가 정치성 높은 대규모 미술작품을 만들려고 한 것은 아닙니다. 예를 들어 프리다 칼로는 국가적 충돌보다도 내면의 갈등을 탐색한 소형 회화들을 그렸습니다. 하지만 칼로 역시 또 다른 방식으로 멕시코 문화를 그림에 담았습니다. 그녀는 종종 멕시코 고유의 가톨릭 종교화처럼 작은 주석판에 그림을 그렸고, 다산을 기원하는 토착 인형의 이미지를 그려 넣기도 했습니다. 미술작품의 규모나 공공성 여부를 떠나서, 당시의 멕시코 미술가들은 모두 진정으로 현대적인 미술을 하려면 그들의 역사를 온전히 포용해야 한다고 믿었답니다.

예술가들의 천국, 뉴욕 (1950년)

'쿨함'의 탄생

1950년에 재즈 음악가 마일스 데이비스는 명반 〈쿨의 탄생(Birth of the Cool)〉을 녹음합니다. '쿨'이란 재즈의 한 형태를 가리키는 말이었지만, 당시 뉴욕의 분위기를 완벽하게 묘사하는 단어이기도 했지요. 1950년대에 세계 최대의 도시가 된 뉴욕은 전 세계 예술가들에게 가장 매력적이고 영감을 주는 도시 중 하나이기도 했답니다. 파리와 빈 같은 유럽 도시의 현대적 예술가들이 카페에 모였듯이, 뉴욕의 예술가들은 담배 연기 자욱한 바와 재즈 클럽에서 만났지요. 그리니치빌리지와 바워리 가를 따라 이런 장소들이 빽빽이 들어서 있었답니다.

이 지역에는 이제 맨해튼에서도 가장 비싼 레스토랑과 아파트가 가득하지요. 하지만 1950년대에 이곳은 가난한 예술가들의 천국이었답니다. 몇 달러의 방세만 내면 이 도시의 창조적 심장에서 지내면서 작업할 수 있었지요. 모든 예술 분야에 있어 실험적인 시기였고, 음악가, 작가, 미술가가 두루 어울리며 영향을 주고받았답니다. 마일스 데이비스나 디지 길레스피 같은 재즈 거장들의 절규하는 트럼펫 소리, 앨런 긴즈버그의 자유시 낭독을 듣는 한편 뉴욕에서 샌프란시스코에 이르는 잭 케루악의 기이한 도로 여행기를 읽을 수 있었지요. 거리는 자유롭고 즉흥적인 분위기로 가득했습니다.

고정관념을 탈피한 도시의 추상

제2차 세계대전 이전 유럽에는 폴 세잔에서 파블로 피카소까지 최고의 현대 미술가들이 있었습니다. 미국인들은 자기들도 고유한 미술 양식을 만들 수 있다는 걸 보여주려고 애썼지요. 1950년대 뉴욕 미술가들은 세계 최대의 도시에 어울리는 대형 회화를 그리기 시작했는데, 그들 주위의 세계를 묘사하기보다도 사상과 감정을 포착하는 추상 이미지에 관심을 가졌답니다. 이러한 창작 행위는 단색 사각형들을 꼼꼼하게 그리는 것이 되기도 했고, 때로는 캔버스 전체에 물감을 확 뿌려 불규칙한 형태로 흘리거나 튀기는 것이기도 했습니다.

추상표현주의

잭슨 폴락의 어지러운 물감 흘리기는 바넷 뉴먼의 깔끔하게 측정된 '지퍼'나 헬렌 프랑켄탈러의 화사한 색채 얼룩과는 전혀 다르게 보입니다. 추상표현주의 미술가들은 색채와 형태 자체에 표현력이 있다고 믿었습니다. 이들의 그림은 알아볼 수 있는 인물과 장소와 물체를 묘사하지 않고서도 관람자에게 강렬한 체험을 선사했지요.

어떤 이들은 폴락을 '잭 더 드리퍼'라고(19세기 런던의 살인마 '잭 더 리퍼'를 따옴 – 옮긴이) 불렀습니다. 폴락이 캔버스를 이젤 위가 아닌 바닥에 놓고 그 주위로 춤추듯 돌아다니며 이리저리 물감을 뿌렸기 때문이지요. 폴락의 그림들을 자세히 들여다보면 그의 걸음을 되짚어볼 수 있고, 때로는 그가 남긴 발자국까지도 볼 수 있답니다.
〈회화 작업 중인 잭슨 폴락〉

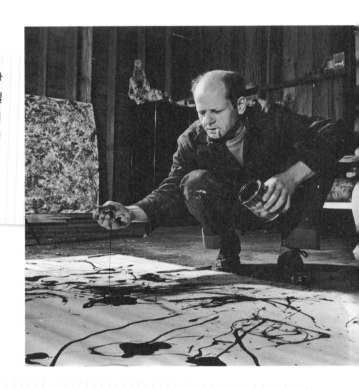

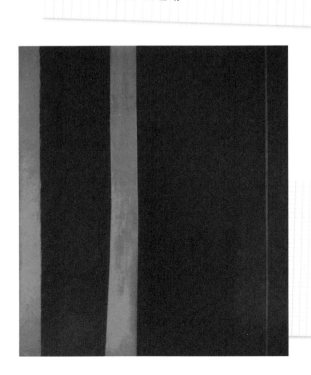

폴락과 달리 뉴먼은 단정하고 정밀한 추상회화를 남겼습니다. 그는 1948년부터 1970년에 사망할 때까지 스스로 '지퍼'라고 칭한 수직선만을 그렸답니다. 뉴먼은 그의 지퍼들이 관람자를 그림 가까이 끌어당기길 원했습니다. 관람자가 그림을 들여다보며 마치 색채로 에워싸인 것처럼 느끼게 될 때까지 말이지요.
〈아담〉, 바넷 뉴먼, 1951~52년

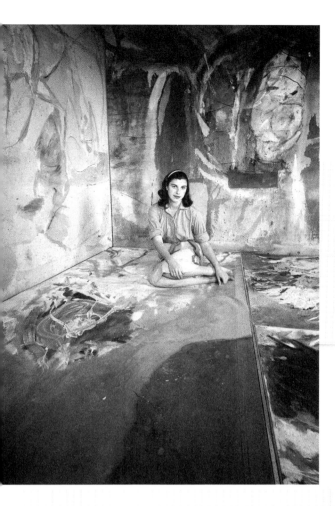

여성들은 뉴욕 창작 세계의 중심에 있었습니다. 헬렌 프랑켄탈러는 물감을 희석해 캔버스에 붓고 스며들게 하는 새로운 회화 기법을 만들어냈지요. 그녀의 그림을 보면 깊은 푸른색에 잠겨 헤엄칠 수 있을 것처럼 느껴진답니다.
〈화실의 헬렌 프랑켄탈러〉, 〈라이프〉 잡지 화보, 1957년

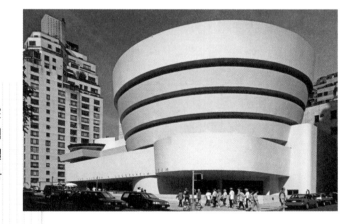

화려한 크라이슬러 빌딩과 웅장한 엠파이어스테이트 빌딩 같은 마천루가 가득한 뉴욕에서, 프랭크 로이드 라이트는 깔때기처럼 땅으로 감겨 내려가는 건물을 설계했습니다. 관람객들은 에스컬레이터를 타고 돔 꼭대기까지 올라간 다음 건물 내부의 긴 경사로를 내려가며 미술품을 관람하게 되지요.
〈솔로몬 R. 구겐하임 미술관〉, 프랭크 로이드 라이트, 1959년 개관

새로운 미술에는 사각형 방이 차례로 이어지는 기존의 전시장과 전혀 다른 새로운 건물이 필요했습니다. 구겐하임 미술관을 설계한 라이트는 관람객들이 나선 통로를 따라 내려오며 예상치 못한 각도에서 미술품을 볼 수 있도록 했습니다. 뉴욕의 여러 위대한 음악가, 작가, 미술가들처럼 라이트 또한 그 무엇보다도 중요한 한 가지를 자문해보았던 것이지요. '어떻게 하면 고정관념을 벗어날 수 있을까?'

열광의 샌프란시스코 (1960년)

'프리덤, 베이비!'

"시대가 변해가고 있어." 1964년에 밥 딜런은 이렇게 노래했습니다. 미국 전역에서 엄청난 변화들이 일어나고 있었지만, 캘리포니아 주의 샌프란시스코 만 주변만큼 변화가 컸던 곳은 없었지요. 히피들은 더욱 자유롭고 개방적인 삶을 찾아 헤이트애시베리 구역에 모여들었습니다. 그들은 집단을 이루어 큰 폐가에서 살며 최대한 돈을 쓰지 않는 삶을 지향했지요. 또한 주민들에게 필요한 무료 진료소와 무료 상점을 세웠습니다. 근처의 카스트로 구역에서는 동성애자들이 하비 밀크와 같은 사회 운동가들의 지휘로 이성애자와 동등한 권리를 얻기 위해 싸우고 있었습니다. 만 건너편 오클랜드에서는 아프리카계 미국인들도 경찰과 건물주에게 정당한 대우를 받을 수 있도록 블랙팬서 당이 투쟁하는 중이었습니다.

한편 바다에서는 아메리카 원주민들이 앨커트래즈 섬의 오래된 교도소를 점령하고 그들의 선조가 빼앗긴 땅에 대한 관심을 촉구했습니다. 이 같은 사회 운동들에서는 학생들이 중요한 역할을 했습니다. 캘리포니아 대학 버클리 캠퍼스에서는 학생들이 자유 언론 운동의 일환으로 건물을 점거했지요. 베트남 전쟁에 반대하는 학생들은 캠퍼스에서 대규모 자체 강의를 열고 왜 미국의 무장 세력이 베트남을 떠나야 하는 지, 젊은이들에게 전쟁터로 나가라고 강요하는 것을 멈춰야 하는지 설명했습니다. 행사 동안 3천 명 이상의 사람들이 캠퍼스로 와서 강의와 반전 가요를 듣고 시위에 참여했지요. 미국 전역의 젊은이들은 샌프란시스코로부터 전해지는 평화와 사랑의 메시지에 점점 더 귀 기울이게 되었습니다.

반드시 머리에 꽃을 꽂으세요

당시에 샌프란시스코로 가려는 사람은 가수 스콧 매켄지의 충고를 따라야 했습니다. "반드시 머리에 꽃을 꽂으세요." 전국에서 수만 명의 '꽃의 아이들'이 그의 부름에 응하여 히치하이크를 하며 캘리포니아로 왔습니다. 1967년 1월에 미술가들과 음악가들은 골든게이트 공원에서 '휴먼 비인(Human Be-In)'이라는 행사를 개최했습니다. 제퍼슨 에어플레인과 그레이트풀 데드 등 샌프란시스코 록 밴드들의 공연이 펼쳐졌지요. 그해 6월의 전설적인 몬터레이 팝 페스티벌에서는 재니스 조플린이 블루스를 열창했고, 지미 헨드릭스는 기타를 맹렬히 연주한 끝에 기타에 불까지 붙였습니다. 열광적인 '사랑의 여름'이 시작된 것입니다.

릭 그리핀은 그레이트풀 데드, 더 도어즈, 지미 헨드릭스를 비롯한 유명 뮤지션들의 음반 표지와 포스터를 디자인했습니다. 캘리포니아의 서핑 선수들을 다룬 만화로 경력을 시작한 그리핀은 훗날 샌프란시스코에서 시작된 음악 잡지 『롤링스톤』의 유명한 로고를 만들었답니다.
〈그레이트풀 데드의 음반 '아옥소목소아' 표지〉, 릭 그리핀, 1969년

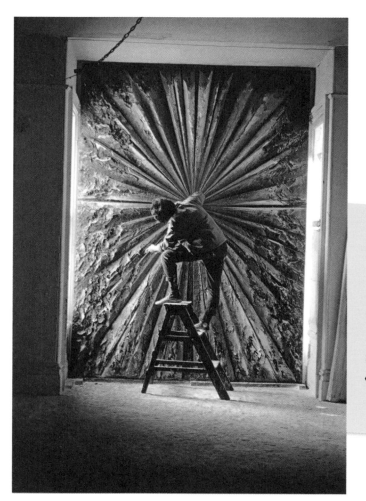

제이 드페오는 샌프란시스코의 자기 아파트에서 8년간 이 그림을 작업했습니다. 어찌나 물감을 많이 썼는지 그림의 무게가 1톤 가까이 되었지요. 그녀는 결국 집세를 못 내 아파트에서 쫓겨나게 되었는데, 이 그림을 떼어가기 위해 벽 일부를 함께 뜯어내야만 했습니다.
〈장미〉, 제이 드페오, 1958~66년

'제스'라는 이름으로만 알려진 이 화가는 샌프란시스코의 미션 구역에서 파트너인 시인 로버트 던컨과 함께 살았습니다. 이 초상화는 집에 있는 던컨을 그린 것인데, 두 사람이 함께 살았던 집은 샌프란시스코 부흥기의 시인들에게 중요한 만남의 장소가 되었지요.
〈매혹당한 마법사〉, 제스, 1965년

로버트 크럼은 축하 카드에 그림을 그리는 일로 경력을 시작했습니다. 그의 만화가 한동안은 잘 팔리지 않았기 때문이지요. 초창기에 그는 자신의 만화를 유모차에 싣고 거리를 다니며 팔곤 했지만 이후 자신의 잡지 『위어도(Weirdo)』를 펴내기 시작했답니다.
〈'미스터 내추럴' 엽서〉, 로버트 크럼, 1967년

'샌프란시스코 사운드'에는 그에 어울리는 고유의 이미지가 있었습니다. 릭 그리핀은 이런 음반들을 위해 이상하고 비밀스러운 상징과 현란하고 변화무쌍한 색채로 이루어진 환각적 디자인들을 제공했지요. 로버트 크럼은 새로운 언더그라운드 만화 운동의 대표적 존재가 되었습니다. 그의 전위만화(comix)는 기존의 만화(comics)와 달리 성인들을 위한 것이었지요. 크럼은 히피 문화를 찬양하면서 동시에 풍자할 줄 알았습니다. 무의미한 충고를 하며 돌아다니는 '미스터 내추럴' 같은 캐릭터는 이런 크럼의 특성을 잘 보여줍니다. 그 밖에도 여러 미술가들이 새로운 기법을 실험했습니다. 제스는 회화 표면을 단색의 작고 질척한 얼룩들로 세심하게 채웠고, 제이 드페오는 매우 거대하고 무거워 거의 조각에 가까운 회화를 만들었지요. 음악가 동료들처럼 미술가들 역시 기존의 관습을 깨뜨리며 나아가는 길고 이상한 여행을 시작한 것입니다.

장벽을 넘은 베를린 (1990년)

분단된 도시

베를린 장벽을 쌓는 작업은 1961년의 한밤중에 시작되었습니다. 처음에 동서 베를린을 갈라놓은 것은 가벼운 블록과 철조망뿐이었죠. 그냥 뛰어넘어 건너간 사람들도 있었습니다. 하지만 곧 단단한 콘크리트 장벽이 세워졌습니다. 군인들은 서베를린으로 가는 사람이 있으면 무조건 발포하라는 명령에 따랐지만, 그럼에도 여전히 넘어가려고 시도하는 사람들이 있었습니다. 열기구부터 터널 파기까지 온갖 방법을 다 써서 말이지요. 동독의 공산당 지도자는 적들을 쫓기 위해 장벽을 만든 것이라고 했지만 사실은 국민들을 가둬두기 위한 것이었습니다. 동독은 '스타지'라는 비밀경찰을 통해 국민의 일상생활을 엄격히 통제했습니다. 민주주의 국가 서독의 일부인 서베를린은 여러 동독 사람들에게 자유로운 작은 섬과도 같았지요. 바로 코앞에 있었지만 실제로 닿을 가능성은 거의 없는 곳이었습니다.

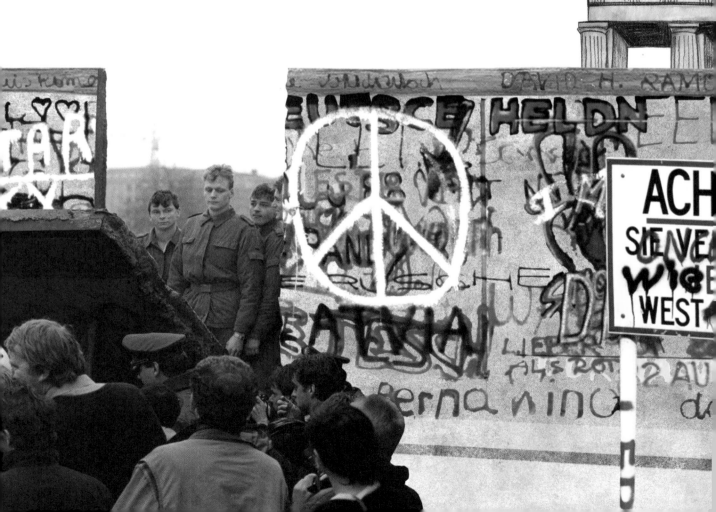

장벽은 결국 무너졌지만, 이는 사실 우연한 사고 때문이었습니다. 1989년 기자 회견에서 동독의 공직자가 실수로 여행 제한이 풀렸다고 발표했습니다. 이 소식이 퍼져나가자 동독 국민들은 떼 지어 검문소를 통과하기 시작했습니다. 군인들도 총을 쏘지 않았지요. 사람들은 갑자기 자유로이 서베를린으로 넘어갈 수 있게 된 것입니다. 공산당 정부는 곧 붕괴되었습니다. 1990년 독일은 제2차 세계대전에서 패배한 이후 처음으로 하나의 국가가 되었습니다. 통일 과정에서 모든 일이 매끄럽게 진행된 것은 아니지만, 독일은 사람들이 장벽보다 강하다는 사실을 세계에 증명해 보였답니다.

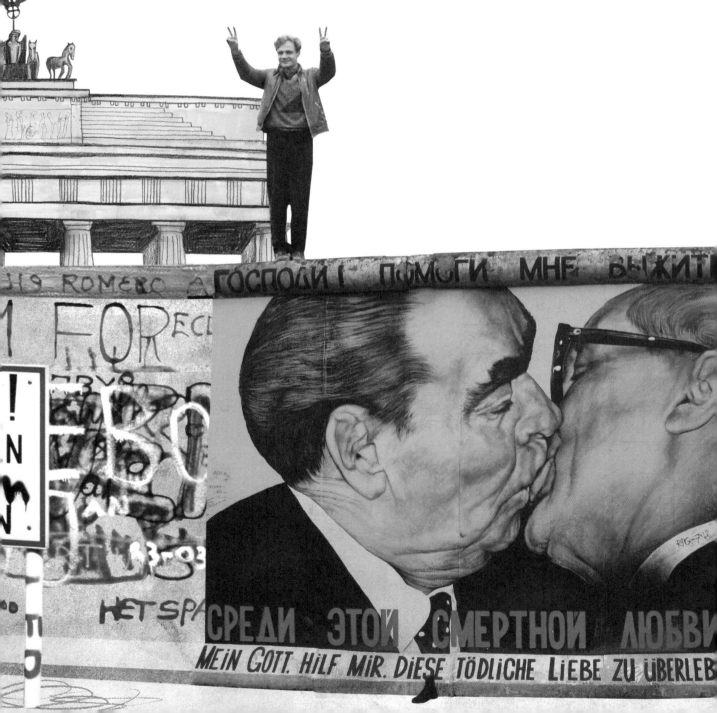

강력한 메시지를 담은 작품들

동서 독일의 통일은 쉽지 않았습니다. 특히 베를린에서는 난관들이 극명하게 드러났지요. 양쪽을 갈라놓는 베를린 장벽은 없어졌지만, 동·서독 사람들은 수십 년의 분단을 겪은 후 서로가 너무 달라졌음을 깨달았습니다. 동독보다 서독에 돈이 많은 것은 물론이고, 양쪽의 목표와 기대도 서로 달랐지요. 동서 독일은 힘을 합쳐 경제적 균형을 맞추고 도시를 다시 설계하며 새로운 법 조항들을 통과시켜야 했습니다. 나아가 독일인의 정체성에 관해 새삼 고민해보아야 했지요. 이 과정에서 미술가와 건축가들이 중요한 역할을 했습니다. 미술가들은 베를린 장벽이 무너지고 남은 1.5킬로미터 정도의 콘크리트 벽에 그림을 그렸는데 이곳은 '이스트사이드 갤러리'로 알려지게 되었습니다. 저항적 낙서인 그래피티는 벽 위를 넘어 베를린 전역으로 퍼져 나갔고, 지금도 베를린 사람들에게 자유의 상징으로 여겨진답니다.

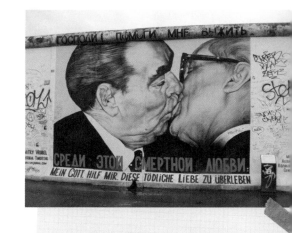

브루벨은 동독과 서독의 국경이 열린 직후 베를린 장벽에 이 유명한 벽화를 그렸습니다. 1979년에 소련 공산당 서기장 레오니드 브레즈네프와 동독 수상 에리히 호네커가 만나서 포옹했던 장면을 담았지요. 이 그림은 두 공산국가의 유사성을 풍자하는 한편, 공포와 증오의 상징이던 장벽을 '사랑'의 이미지로 덮었습니다.
〈주여, 이 치명적인 사랑을 이겨내게 도와주소서〉, 드미트리 브루벨, 1990년

독일 제국 시대에 세워진 국회의사당은 복잡한 사연을 지닌 건물입니다. 1933년에 아돌프 히틀러가 권력을 차지한 결정적 사건이 바로 국회의사당 테러와 그로 인한 화재였으니까요. 동서 독일이 통일된 후 부부 미술가 크리스토와 잔클로드는 건물 전체를 너비 30만 제곱미터 이상의 은빛 천으로 씌웠습니다. 건물을 뒤덮어버리자 사람들은 새삼 이곳이 어떤 의미를 갖는지 생각해보게 되었지요. 이곳은 지금도 국회의사당으로 쓰인답니다.
〈포장된 독일 국회의사당〉, 크리스토와 잔클로드, 1971~95년

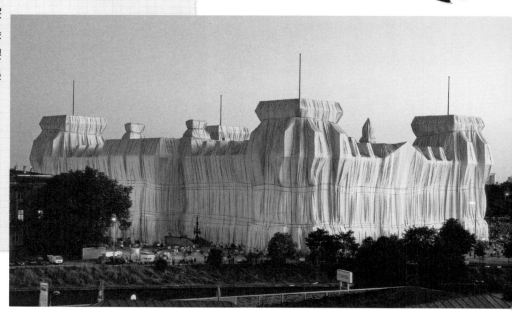

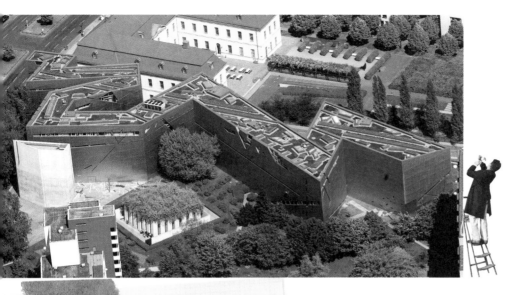

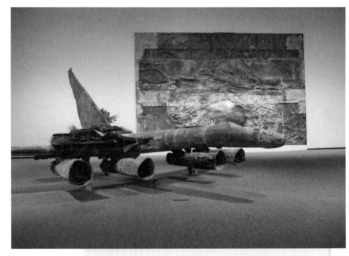

건축가 다니엘 리베스킨트는 이렇게 말했습니다. "내 설계가 지나치게 미래적이거나 나아가 부조화적으로 보인다면, 이는 기억이란 것 자체가 매우 과격한 방식으로 일깨워져야 하는 존재이기 때문이다." 그의 유대 박물관 설계는 낯설게 느껴지고 어떤 부분에서는 황량한 느낌마저 줍니다. 이 건물은 관람객이 홀로코스트 학살로 죽어간 베를린 출신 유대인들의 빈 공간에 관해 생각하도록 강력히 촉구합니다.
〈베를린 유대 박물관〉, 다니엘 리베스킨트, 1999년

안젤름 키퍼를 비롯한 몇몇 미술가들은 독일의 어두운 역사를 한층 더 깊이 뒤돌아보기 시작했습니다. 그들은 공산주의의 잔재뿐만 아니라 나치즘의 사악함을 다루었지요. 건축가들은 나치가 유대인 600만 명을 비롯해 여러 소수자 집단을 살해한 홀로코스트를 기억하기 위해 새로운 유형의 박물관과 기념물이 필요하다는 것을 깨달았습니다. 독일인들은 과거를 직면하는 일의 중요성을 인식하게 되었습니다. 설사 그 과정이 무척 고통스러울지라도 말이지요.

제2차 세계대전이 끝날 무렵 독일에서 태어난 안젤름 키퍼는 폭격에 파괴된 건물의 잔해에서 뛰어놀던 일을 기억합니다. 그의 작품들은 어떻게 하면 역사를 재건하는 동시에 잊지 않을 수 있을지를 질문합니다. 1989년에 독일 역사의 새로운 페이지가 열렸지만 키퍼는 여전히 과거를 성찰하기를 그치지 않았습니다. 그의 '천사'는 철로 만들어진 묵직한 책들을 양 날개에 가득 실은 낡은 비행기의 모습입니다.
〈역사의 천사〉, 안젤름 키퍼, 1989년

하이테크의 중심, 서울 (2000년)

맹렬한 호랑이의 도시

20세기 전반에 한국은 일본의 지배를 받았습니다. 일본이 제2차 세계대전에서 패배한 뒤 소련은 재빨리 움직여 한국의 북쪽을 손에 넣은 한편 미국은 남쪽을 원조했습니다. 1950년부터 1953년까지 계속된 6.25 전쟁에서 남과 북은 둘로 갈라져 싸웠습니다. 이후로 북한은 쭉 가혹한 독재 체제하에 있지요. 남한 역시 수십 년의 군사정권을 비롯하여 나름의 시련들을 극복해야 했습니다. 경제학자들은 남한의 맹렬하게 빠른 경제 성장 속도 때문에 이 나라를 '호랑이'라고 불렀습니다. 한국의 복잡한 역사를 고려하면 이 같은 변화는 한층 더 인상적이지요.

1988년 서울에서 열린 하계 올림픽은 한국의 세계무대 데뷔로 여겨졌습니다. 국민들이 새롭게 일궈낸 민주주의뿐만 아니라 경제와 문화 발전도 조명되었지요. 이후로 서울은 세계적 경제 침체 속에서도 쭉 성장해왔습니다. 한국의 수도인 서울은 최첨단 기술로 유명하며 세계에서 인터넷 속도가 가장 빠른 곳이기도 하죠. 고속열차는 시속 300킬로미터 이상으로 달려 서울과 국토 전체를 연결해줍니다. 서울의 신규 개발 지역 디지털미디어시티는 혁신에의 열정을 상징적으로 보여주는 장소입니다. 한때 거대한 쓰레기 매립장이었던 이곳은 이제 하이테크 산업의 중심으로 변신했답니다.

한류와 창의적 디자인의 나라

서울에는 한국에서 가장 큰 회사들이 위치해 있습니다. 그중에는 세계 최대의 휴대전화 생산 기업인 삼성도 포함되지요. 한국의 회사들이 세계적 인지도를 얻은 만큼 국가적 브랜드도 발전했습니다. 한국의 대중음악은 가까운 중국과 일본에서 크게 인기 있을 뿐 아니라 세계적으로도 점점 더 유명해지고 있습니다. 케이팝(k-pop) 가수들은 한국어와 영어로 된 쉽고 경쾌한 가사, 특유의 춤 동작들과 시각효과가 넘치는 공연으로 알려져 있지요. 서울의 부유한 지역에서 제목을 따온 싸이의 히트곡 〈강남스타일〉은 유튜브에서 수십억 번의 조회 수를 기록했습니다. 한국의 텔레비전 드라마 또한 전 세계에서 시청됩니다. 드라마의 특정 에피소드는 아예 팬들의 요구에 맞추어 쓰이기도 하지요. 소형 디지털 기기에서 주요 건축 프로젝트까지, 한국은 창의적 디자인의 나라로 인식되고 있습니다. 한강에 떠 있는 인공 섬인 새빛둥둥섬처럼 호평받는 경우도 있고, 옛 시청 건물 위로 반짝이는 파도같이 솟아오른 서울의 새 시청사처럼 찬반이 엇갈리는 경우도 있습니다.

이지영의 작품은 포토샵으로 합성한 것처럼 보이지만 사실 서울의 작은 스튜디오에서 일일이 손으로 그려진 것입니다. 그녀는 꿈속에만 존재할 수 있을 듯한 드넓고 열린 공간들을 상상합니다. 이 작품은 최고의 가상현실이란 비디오게임 속이 아니라 우리의 상상속에 있음을 암시합니다.
〈게이머〉, 이지영, 2011년

새빛둥둥섬은 공원과 영화관, 전시장 등이 합쳐진 복합 문화공간입니다. 세 개의 건물은 함께 어우러져 씨앗, 봉오리, 피어난 꽃이라는 식물의 세 성장 단계를 상징합니다. 밤이면 모든 건물에 조명이 밝혀져 근처의 반포대교에서 쏘아 올리는 달빛무지개분수와 조화를 이룹니다.
〈새빛둥둥섬〉, 해안건축, 2011년

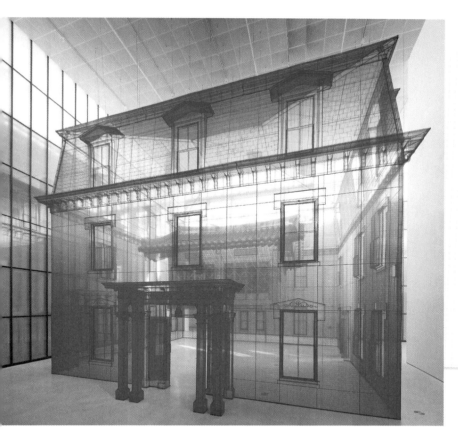

이 조각을 이루는 두 집은 실물 크기이며 투명하게 비치는 천으로 만들어졌습니다. 큰 건물은 서도호가 미국에 와서 처음 살았던 집이고, 그 안에 매달린 작은 건물은 그가 자랐던 서울의 집이지요. 작가는 두 가지 문화 사이에서 살아가는 느낌을 표현하려고 했습니다.
〈집 속의 집 속의 집 속의 집 속의 집〉, 서도호, 2013년

고정관념을 깨기 위해 꼭 최신 기술을 사용해야 하는 것은 아닙니다. 서도호, 이지영, 최정문 등의 미술가들이 선보인 작품들은 마치 컴퓨터로 생성한 듯 보이지만 실제로는 모두 공들여 손으로 만든 것입니다. 한국 사회는 빠르게 변화하고 있지만, 많은 미술가들은 신기술과 옛 전통을 연계할 새로운 방식을 찾으려고 노력합니다.

레이저 빔이나 컴퓨터 시뮬레이션처럼 보이는 이 선들은 사실 색 있는 실에 자외선을 비춘 것입니다. 작가의 관심사는 우리가 사물에 경계를 긋는 방식이라고 합니다. "남한과 북한의 경계선에 이런 설치작업을 하는 것이야말로 가장 화려하고 극적인 프로젝트가 되겠지요."
〈Out of Sight〉, 최정문, 2009년

내일의 리우데자네이루 (2020년)

미래에의 전망

리우데자네이루는 세계에서 가장 특색이 뚜렷한 도시 중 하나입니다. 만 위로 우뚝 솟은 슈거로프 산이 방문객들을 반겨주고, 구세주 그리스도의 상이 코르코바두 산에서 도시를 내려다보고 있지요. 하지만 이런 광경도 리우의 복잡성을 다 드러내진 못합니다. 이곳은 18세기에 포르투갈의 식민지였던 브라질의 수도가 되었습니다. 그리고 건축가 오스카 니마이어가 새로운 수도 브라질리아를 설계한 1960년까지 그 자리를 지켰지요. 리우는 이제 정치적 수도가 아니지만 여전히 문화적 중심입니다. 문화는 결코 정치와 동떨어져 있지 않으며 특히 브라질에선 더욱 그렇답니다. 브라질은 1970년대와 1980년대 내내 군사정권하에 있었고 1990년대와 2000년대에는 여러 정치적 추문에 시달렸지만, 미술가들은 브라질의 문제점과 가능성을 창의적으로 표현해왔습니다.

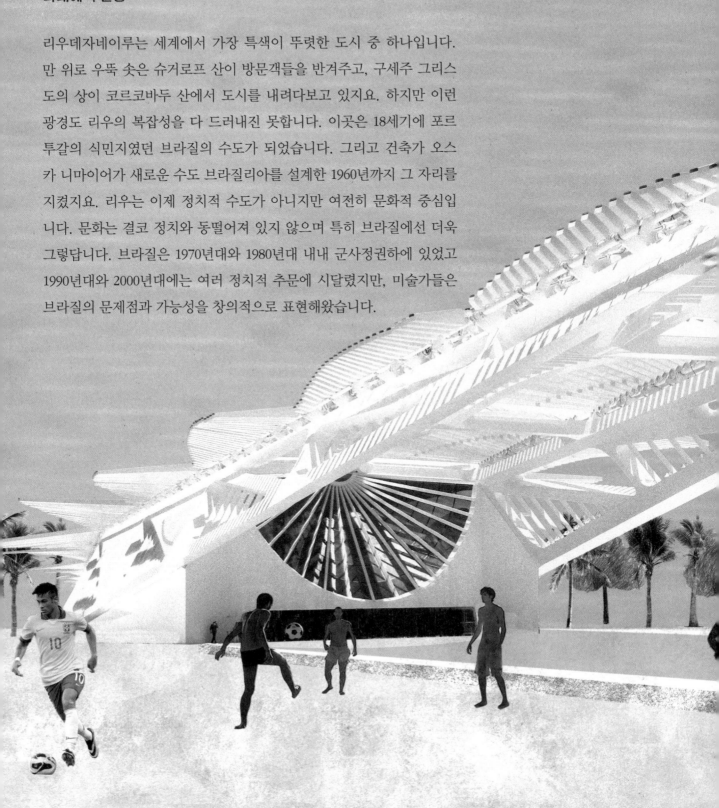

이 나라에는 토착 민족을 비롯하여 아프리카와 유럽의 여러 혈통을 지닌 국민들의 놀라운 다양성이 있습니다. 하지만 한편으로는 여전히 심각한 경제적 난관이 존재하지요. 리우의 산등성이마다 '파벨라'로 불리는 빈민촌들이 빼곡히 들어서 있습니다. 리우는 세계 여러 지역들처럼 미래를 바라보고 있지만, 과거의 유산을 기념하는 동시에 현재의 난관에 대처하는 최선의 방법은 무엇일지 고민하는 중입니다.

이 박물관은 미래의 바다로 뛰어들려는 호버크라프트처럼 보입니다. 하지만 미래는 흥미진진한 만큼 걱정스러운 것이기도 하지요. 이곳은 관람객이 지구온난화, 삼림 파괴 등 브라질뿐만 아니라 전 세계가 직면한 문제들에 관해 생각해보도록 촉구합니다. 또한 그러한 역할에 맞게 태양열 에너지를 사용하며 만에서 온 물을 재활용하고 있지요.

〈내일의 박물관〉, 산티아고 칼라트라바, 2015년

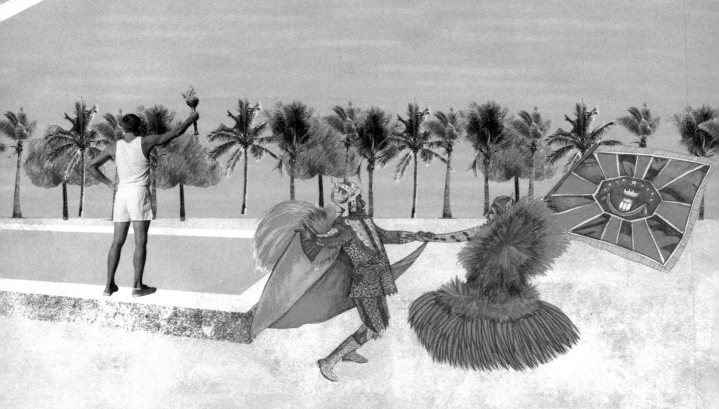

차이에도 불구하고 우리는 하나

2016년 리우데자네이루에서 열린 하계 올림픽은 도시 전체를 무대로 삼았습니다. 코파카바나 해변의 비치발리볼 시합부터 언덕들을 오르내리는 자전거 경주, 과나바라 만을 가로지르는 수영 경기까지 말이지요. 하지만 리우에서 대규모 축제가 주최되는 것이 생소한 일은 아니었습니다. 이곳에서 매년 열리는 주요 이벤트가 바로 카니발이니까요. 전 세계의 기독교인들은 전통적으로 사순절, 즉 부활절 직전의 금욕 기간에 들어가기 앞서 축제를 벌입니다. 리우는 이 축제를 완전히 새로운 경지로 끌어올린 곳이지요. 시내 여러 지역의 삼바 학교들이 몇 달에 걸쳐 현란한 의상과 무대 차량, 대규모 퍼레이드를 위한 춤을 준비합니다. 퍼레이드의 경로는 오스카 니마이어가 이 장관을 보여주기 위해 설계한 삼바 드롬을 통과하지요. 삼바의 유래는 브라질 역사의 초창기까지 거슬러 올라갑니다. 아프리카 출신 노예들이 들여온 춤에 시간이 지나면서 아프리카와 라틴아메리카 고유의 리듬이 더해져 삼바가 완성되었다고 하지요.

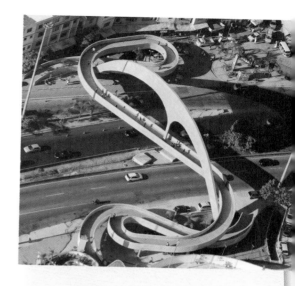

니마이어는 이 육교를 설계했을 때 백 살이 넘었다고 합니다. 평생 동안 대담한 곡선 형태의 탐구에 관심을 두었던 작가다운 작품이지요. 그는 이렇게 적었습니다. "나는 인공적인 직각이나 직선에는 매력을 못 느낀다. 자유롭게 흐르는 관능적 곡선이 좋다. 내 조국의 산자락과 강줄기, 해변의 파도에서 보이는 곡선 말이다."
〈호시냐 빈민촌의 육교〉, 오스카 니마이어, 2010년

아드리아나 바레자우는 리우 올림픽 수영 경기장 벽화 작업을 하면서 브라질이 포르투갈의 식민지였던 시절 전해진 희고 푸른 타일에 영감을 받았습니다. 그녀는 낡고 부서지고 짝이 안 맞는 타일들을 모아 파도 문양을 만들었는데, 남아메리카의 해변에 부서져 오는 역사의 파도를 상징적으로 나타낸 것이지요.
〈수영 경기장〉, 아드리아나 바레자우, 2016년

에르네스토 네토는 사람들이 쳐다볼 뿐만 아니라 만지고 냄새 맡게 되는 조각을 만듭니다. 그의 물렁물렁하고 축 늘어진 형태들은 인체와 자연을 연상시키지요. <문화는 우리를 갈라놓지만 자연은 우리를 결합시킨다>라는 네토의 한 작품 제목은 인류애에 대한 그의 희망을 보여줍니다.
<경관 속에 매달린 벌레>, 에르네스토 네토, 2012년

브라질의 창의성은 항상 여러 문화의 융합으로 정의되어왔습니다. 리우의 해변에서 연인을 찾는 내용을 재즈와 삼바가 어우러진 경쾌한 리듬에 담아낸 1960년대의 세계적인 히트곡 <이파네마에서 온 소녀>처럼 말이지요. 오늘날 브라질의 힙합 뮤지션들은 남북 아메리카의 음악적 영향을 결합시키고 있습니다. 이 같은 '퓨전'은 시각미술에도 흔히 나타납니다. 에르네스토 네토나 아드리아나 바레자우 같은 리우 미술가들의 작품은 문화적으로뿐만 아니라 미술 분야에 있어서도 복합적이지요. 현대 브라질의 다양성은 여러 면에서 우리의 세계사 미술여행에 어울리는 마지막 장면이라고 할 수 있겠네요. 온 세상 사람들의 다양한 얼굴들을 담아낸 에두아르도 코브라의 벽화가 그 좋은 예지요. 이 모든 차이와 다양성은 결국, 그럼에도 불구하고 우리는 모두 하나라는 사실을 깨닫게 해주니까요.

에두아르도 코브라는 상파울루 출신의 거리 미술가입니다. 코브라와 그의 조수들은 올림픽을 위해 지구촌 사람들의 다양한 모습이 담긴 세계 최대의 벽화를 그렸지요. "우리는 갈등이 넘쳐나는 매우 혼란스러운 시대를 살아가고 있습니다. 나는 그럼에도 모든 사람이 연결되어 있다는 걸, 우리는 하나로 이어져 있다는 걸 보여주고 싶었습니다."
<우리는 모두 하나>, 에두아르도 코브라, 2016년

자, 이렇게 여러분은 여행의 첫걸음을 내디뎠습니다.
이젠 어디로 가고 싶은가요?

미술을 깨우치는 가장 좋은 방법은 작품을 직접 마주하는 것입니다. 다시 말해 미술관이나 전시장에 직접 가봐야 한다는 것이지요. 혹은 지금 여러분 주변에 있는 것들에 대해 면밀하게 주의를 기울여야 한다는 의미이기도 합니다. 기념물, 만화책, 심지어 벽에 휘갈겨진 그래피티에도요. 실제로 미술관이나 전시장에 가게 된다면 두려워하지 말고 궁금한 걸 질문해보세요. 그곳의 도우미들이 미술작품과 그것이 유래된 문화에 관해 차근차근 설명해줄 테니까요.
미술작품은 과거에만 살아 있었던 게 아니라 우리가 그것을 생각하거나 화제로 삼을 때마다 되살아난답니다. 특히 다른 사람과 그렇게 한다면요.

여행을 갈 때면 항상 연필과 스케치북을 가져가세요. 그리고 보이는 것들을 그려봅시다.

이 책에서 공부한 여러 미술가들은 과거의 거장들에 대해 공부함으로써 스스로도 거장이 되었답니다. 뉴욕의 추상표현주의 미술가들은 멕시코시티 화가들의 벽화를 연구하여 훌륭한 그림을 그릴 수 있었죠. 멕시코 화가들은 이탈리아 르네상스 화가들의 기법과 조형을 연구했고요. 르네상스 미술가들은 고대 로마 조각에서, 고대 로마 조각가들은 고대 그리스 미술에서 배웠어요.

연필을 잡고 스케치를 시작할 때마다 여러분은 시간을 거슬러 여행을 하게 된답니다. 지나간 과거에 흠뻑 빠져보세요. 아주 놀라운 여행이 될 거예요!

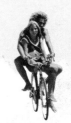

쉽게 이해하는 용어 설명

고고학
인간의 유물과 유적을 통해 역사를 연구하는 학문 분야입니다. 고고학자들은 과거의 생활을 알아보기 위해 유물과 유적을 발견하고 조사하지요.

고딕 양식
중세 유럽의 건축 양식으로 뾰족한 수직 아치형 지붕. 이무깃돌과 추상적·장식적 문양 등이 특징입니다.

공화국
국민들이 그들을 대표할 공직자를 투표로 선출하는 국가 형태를 말합니다.

교역로
물건을 사고파는 배나 상인 집단이 여러 국가를 오가는 경로를 말합니다. 장거리에 걸친 교역로는 필수품뿐만 아니라 예술적 사상의 교환 경로이기도 했지요.

기원전/기원후
'기원전'이라는 말이 붙는 연도는 서구에서 사용하는 기독교식 원년, 즉 예수가 탄생한 것으로 추정되는 해의 이전을 가리킵니다. '기원후'라는 말도 예수 탄생 이후를 뜻하는 기독교식 원년 이후를 뜻하지요.

나치즘
독일의 독재자 아돌프 히틀러가 이끌었던 나치 정당의 신조를 말합니다. 히틀러는 인종주의와 유대인, 집시, 장애인에 대한 편견을 퍼뜨렸으며 이를 구실로 수백만 명을 학살했습니다.

독재자
한 나라에서 절대적 권력을 행사하며 국민에게 자신의 생각을 강제하는 사람을 말합니다. 무력으로 그 자리를 차지하는 경우가 많습니다.

라파엘 전파
19세기 영국에서 생긴 회화 유파입니다. 이탈리아 르네상스 이전 시기의 미술에서 영향을 받았으며, 자연 혹은 자연적 형태의 세밀한 묘사가 특징적입니다.

르네상스
프랑스어로 '재탄생'이라는 뜻입니다. 이탈리아 르네상스가 시작된 것은 14세기에 사람들이 고대 그리스와 로마의 미술품들에서 미학적 영감을 얻게 되면서였지요.

무정부주의
정부는 불필요하며 사람들이 자유로이 공동체를 조직할 수 있어야 한다는 신념입니다.

부조
배경인 벽이나 표면을 깎아서 형상을 드러내되 그것이 그 표면의 일부로 남아 있는 형태의 조각을 말합니다.

비잔틴 제국
동로마 제국, 즉 이탈리아에서의 서로마 제국이 멸망한 뒤로도 동유럽에서 천 년 동안 지속된 제국을 말합니다. 비잔틴 제국의 미술과 건축은 경건하고 영적인 주제를 잘 표현한 것으로 유명합니다.

사실주의
이 말에는 다양한 의미와 양식이 포함됩니다. 하지만 '사실주의자'로 칭해지는 미술가들은 넓은 의미에서 세상을 있는 그대로 보여주려 했다는 공통점을 갖습니다.

서기
기록을 하는 사람입니다. 특히 인쇄가 발명되기 이전시기에 원고나 자료를 손으로 베껴 쓰던 사람을 가리킵니다.

서예
두꺼운 붓이나 펜 등으로 쓰는 장식적 글씨. 서구에서는 캘리그래피라고도 합니다.

쇠퇴
특정 문화나 국가의 정치적·경제적 침체와 불안한 상태를 말합니다.

수도원
승려들이 생활하며 예배를 드리는 건물을 말합니다.

순례
종교적·영적으로 중요한 특정 장소로 직접 찾아가는 여행을 말합니다.

식민주의
한 나라가 더 많은 토지와 자원을 얻기 위해 다른 나라의 전체 혹은 일부를 장악하고 지배하는 것을 가리킵니다.

신화
특정 문화와 연결된 신성한 이야기의 모음. 주로 과거의 사건들과 자연을 설명하고 이해하기 위해 만들어집니다.

오벨리스크 이집트의 돌기둥으로 보통 정사각형이나 직사각형인 단에서부터 위로 갈수록 좁아지는 형태입니다.

왕조 장기간 국가의 최고 권력을 쥐고 세습하는 하나의 가문을 가리킵니다.

의식 인물이나 사물을 기리기 위해, 혹은 사람들에게 위로와 안정감을 주기 위해 특정한 방식으로 이루어지는 일련의 행위를 말합니다. 흔히 종교성을 띕니다.

인구 특정 장소에 사는 사람들의 수효를 말합니다.

저수지 물을 모아두는 큰 호수로, 자연적일 수도 있고 인공적으로 만들 수도 있습니다.

제국 한 사람이나 집단이 다스리는 여러 지역의 집합을 말합니다.

조각가 조각, 즉 3차원적인 미술작품을 창작하는 미술가를 말합니다.

즉흥 준비 없이 즉석에서 상상력으로 뭔가를 드러내는 것을 말합니다.

천문학 행성과 별, 우주를 다루는 학문 분야입니다.

철기 시대 인류가 청동 대신 철로 도구를 만들고 사용하는 기술을 익힌 시대를 말합니다. 아프리카 대부분의 지역에서는 석기 시대에 뒤이어 바로 철기 시대가 시작되었습니다.

초상화 개인 혹은 집단의 모습을 담은 그림을 말합니다.

캐나다 원주민 이누이트와 메티스족을 제외한 캐나다 토착 종족들을 말합니다.

토착 애버리지니, 아메리카 원주민 등(주로 서구 중심적 시각에서) 특정 지역이나 국가에 본래 존재했던 민족이나 문화를 일컫는 말입니다.

파라오 고대 이집트의 통치자로 황제와 비슷한 위상을 지녔습니다.

혁명 특정한 체제, 보통 국가나 정부에 있어 집단이 일으키는 대규모의 변화를 말합니다. 현재의 체제에 대한 신뢰를 잃은 사람들이 혁명을 선두에서 이끌게 되지요.

황금기 개인, 문화, 국가 등의 역사에서 가장 뛰어난 업적을 성취한 시기를 말합니다.

희생 종교적·영적 신앙의 일환으로 인간이나 동물의 생명을 버리거나 바치는 행위이며 흔히 의식의 일부로 이루어집니다. 비유적으로는 가치 있는 무언가를 포기하는 행위를 가리킵니다.

히피 1960년대 미국에서 기존 사회의 가치를 거부하고 좀 더 자연 친화적인 삶을 지향한 사람들, 혹은 그런 문화를 말합니다.

이 책에 쓰인 도판의 저작권

78 상 : 〈포르투갈 시나고그의 내부〉, 에마뉘엘 더 비터, 1680년. 암스테르담 국립미술관.
하 : 〈야경〉, 렘브란트 반 레인, 1642년. 암스테르담 국립미술관

79 상 : 〈자화상〉, 유디트 레이스터, 1630년경. 워싱턴 국립미술관.
하 : 〈델프트 공방의 그리스인이 만든 꽃 피라미드〉, 1695년경. 암스테르담 국립미술관

82 상 : 〈알라베르디 칸 다리〉, 1602년 건설 시작. Jorge Fernandez/Alamy Stock Photo
하 : 〈마스지드 이맘 모스크〉, 이스파한, 1611~38년. dbimages/Alamy Stock Photo

83 상 : 〈정원 양탄자〉, 케르만 지역, 1625년경. 자이푸르 앨버트 홀 박물관.
하 : 〈레자 아바시의 초상〉, 무인 무사비르, 1673년. 프린스턴 대학교 도서관 개릿 컬렉션

86 〈에도 지도〉, 1849년. Geographic Rare Books & Maps

88 상 : 〈에도 시대의 갑옷〉, 18세기 말. 런던 대영박물관.
하 : 〈'후지 산 36경' 중 개풍쾌청(凱風快晴)〉, 가쓰시카 호쿠사이, 1830~32년. 뉴욕 메트로폴리탄 미술관

89 상 : 〈요시와라의 벚꽃〉, 기타가와 우타마로, 1793년경. Allen Philips/하트퍼드 워즈워스 아테니움 미술관.
하 : 〈손오공 모양의 상아 네쓰케〉, 슈교쿠, 19세기. 런던 대영박물관

92 상 : 〈머리 장식〉, 찰스 에덴쇼, 1880년경. 뉴욕 브루클린 미술관.
하 : 〈포틀래치 의식 동안 전통 의상을 입고 에드워드 스콧의 독피시 하우스 앞에 모인 사람들〉, 클링콴, 1901년. 알래스카 주립 도서관 윈터 앤드 폰드 컬렉션

93 상 : 〈변신 가면〉, 1850년경. 런던 대영박물관.
하 : 〈까마귀와 최초의 인간들〉, 빌 리드, 1983년. 밴쿠버 브리티시컬럼비아 대학교 인류학 박물관. © Bill Reid

96 상 : 〈수정궁〉, 조지프 팩스턴, 1851년. 런던 대영도서관

97 상 : 〈오필리어〉, 존 에버릿 밀레, 1851~52년. 런던 테이트 미술관.
하 : 〈눈보라: 항구를 떠나는 증기선〉, J.M.W. 터너, 1842년. 런던 테이트 미술관

100 상 : 〈지옥의 문〉 세부, 오귀스트 로댕, 1880

~1917년. 파리 로댕 미술관.
하 : 〈인상, 해돋이〉, 클로드 모네, 1872년. 파리 마르모탕 모네 미술관

101 상 : 〈푸른 소파에 앉은 소녀〉, 메리 커셋, 1878년. 워싱턴 국립 미술관.
하 : 〈에펠 탑의 건설 과정〉, 귀스타브 에펠, 1888년. 파리 카르나발레 박물관

104 상 : 〈미하엘러플라츠의 로스 저택〉, 아돌프 로스, 1909~10년. akg-images/Erich Lessing
하 : 〈베토벤 프리즈〉 세부, 구스타프 클림트, 1902년. Imagno/Getty Images

105 상 : 〈고개 숙인 자화상〉, 에곤 실레, 1912년. 빈 레오폴트 미술관.
하 : 〈카를스플라츠 전차역〉, 오토 바그너, 1898년. Graphiapl/Dreamstime.com

108 좌 : 〈전함 포템킨〉, 세르게이 에이젠슈타인의 영화, 1925년. Universal History Archive/UIG via Getty Images
우 : 〈음악〉, 마르크 샤갈, 1920년. akgimages. Chagall ®/© ADAGP, Paris and DACS, London 2018

109 상 : 〈모스크바 1〉, 바실리 칸딘스키, 1916년. 모스크바 트레티야코프 미술관.
하 : 〈0, 10: 최후의 미래파 회화전〉, 페트로그라드, 1915년. 상트페테르부르크 러시아 미술관

112 상 : 〈혁명 기념탑〉, 1938년. imageBROKER/Alamy Stock Photo
하 : 〈멕시코와 미국의 국경선에 선 자화상〉, 프리다 칼로, 1932년. Christie's Images, London/Scala, Florence. © Banco de México Diego Rivera Frida Kahlo Museums Trust, Mexico, D.F./DACS 2018

113 상 : 〈디에고 리베라와 프리다 칼로의 집〉, 후안 오고르만, 1932년. Neil Setchfield/Alamy Stock Photo
하 : 〈멕시코의 역사〉, 디에고 리베라, 1930년경. Photo Art Resource/Bob Schalkwijk/Scala, Florence. © Banco de México Diego Rivera Frida Kahlo Museums Trust, Mexico, D.F./DACS 2018

116 상 : 〈회화 작업 중인 잭슨 폴락〉, Martha Holmes/The LIFE Picture Collection/Getty Images © The Pollock-Krasner Foundation ARS, NY and DACS, London 2018
하 : 〈아담〉, 바넷 뉴먼, 1951~52년. 런던 테이트 미술관. © The Barnett Newman Foundation, New York / DACS, London 2017

117 상 : 〈화실의 헬렌 프랑켄탈러〉, 『라이프』 잡지 화보. Gordon Parks/The LIFE Picture Collection/Getty Images © Helen Frankenthaler Foundation,

Inc./ARS, NY and DACS, London 2018
하 : 〈솔로몬 R. 구겐하임 미술관〉, 프랭크 로이드 라이트, 1959년 개관. Interfoto/Alamy Stock Photo

120 상 : 〈그레이트풀 데드의 음반 '아옥소목소아' 표지〉, 릭 그리핀, 1969년. © Rick Griffin
하 : 〈장미〉, 제이 드페오, 1958~66년. Burt Glinn/Magnum

121 상 : 〈매혹당한 마법사〉, 제스, 1965년. © the Jess Collins Trust, used by permission
하 : 〈'미스터 내추럴' 엽서〉, 로버트 크럼, 1967년. © Robert Crumb

124 상 : 〈주여, 이 치명적인 사랑을 이겨내게 도와주소서〉, 드미트리 브루벨, 1990년. 베를린 이스트 사이드 갤러리.
하 : 〈포장된 독일 국회의사당〉, 크리스토와 잔클로드, 1971~95년. © Wolfgang Volz/LAIF, Camera Press

125 상 : 〈베를린 유대 박물관〉, 다니엘 리베스킨트, 1999년. Michael Kappeler/ Getty Images
하 : 〈역사의 천사〉, 안젤름 키퍼, 1989년. © Anselm Kiefer

128 상 : 〈게이머〉, 이지영, 2011년. © JeeYoung Lee
하 : 〈새빛둥둥섬〉, 해안건축, 2011년. Yooniq Images/Alamy Stock Photo

129 상 : 〈집 속의 집 속의 집 속의 집 속의 집〉, 서도호, 2013년. © Do Ho Suh
하 : 〈Out of Sight〉, 최정문, 2009년. © Jeong-moon Choi

132 상 : 〈호시냐 빈민촌의 육교〉, 오스카 니마이어, 2010년. Yann Arthus-Bertrand/Getty Images
하 : 〈수영 경기장〉, 아드리아나 바레자우, 2016년. © Adriana Varejão

133 상 : 〈경관 속에 매달린 벌레〉, 에르네스토 네토, 2012년. Photo by Eduardo Ortega, Courtesy the artist and Tanya Bonakdar Gallery, New York
하 : 〈우리는 모두 하나〉, 에두아르도 코브라, 2016년. Brazil Photos/Getty Images

한눈에 용어 찾아보기 INDEX

작가 소개

애런 로즌 지음

케임브리지 대학교에서 박사 학위를 받았고, 버클리 대학교에서 객원 연구원으로 있었다. 예일, 옥스퍼드, 컬럼비아 대학교에서 강의했고, 런던 킹스칼리지에서 부교수로 종교 전통과 예술에 관해 가르쳤다. 현재는 미국 로키마운틴 대학교의 종교학 교수로 학생들을 가르치며 다양한 분야의 학문적·대중적 저술을 발표하고 있다. 저서로 『유대교 미술 상상하기』 『21세기의 미술과 종교』 등이 있으며, 『나의 창의성은 어디 있을까?』를 공동 저술했다.

루시 달젤 그림

런던에 기반을 둔 일러스트 작가 겸 아티스트이다. 2006년 영국 플리머스 대학 디자인학과에서 일러스트레이션을 전공한 후 출판, 광고, 편집 분야에서 일하며 전속작가로도 활동했고 현재는 외부에서 의뢰받은 일과 개인적인 예술 작업을 병행하고 있다. 변화하는 주변의 도시 환경에서 영감을 받는다.

신소희 옮김

서울대학교 국어국문과를 졸업하고 출판 편집자 및 번역가로 일해 왔다. 옮긴 책으로 『위험한 독서의 해』 『분리된 평화』 『아웃사이더』 『안달루시아의 낙천주의자』 『소로와 함께 강을 따라서』 『그린 맨션』 『르네상스의 비밀』 등이 있다.

지은이의 말

나를 전 세계로 데리고 다니셨던
친아버지 클리퍼드 로즌에게.
내가 미술에 눈을 뜨게 해주신
양아버지 제임스 해먼드에게.
그리고 친할아버지와 외할아버지의 기억에 바칩니다.

학자로서 우리는 자신의 전문 영역을 찾아내 거기에 집중하라고 배웁니다. 그리하여 결국 깊지만 좁은 구덩이를 파게 되지요. 이 책을 쓰는 동안 나의 전문 영역을 한참 벗어나는 분야들을 얕고 넓게 파는 일이 얼마나 즐거운지 새삼 다시 느낄 수 있었습니다. 이 책에서 다룬 장소에 머물며 공부한 적이 있는 친구들에게도 많은 정보를 얻었지요. 특별히 다음 친구들에게 감사하고 싶습니다. 필립 섀퍼, 키르티 바스카르 우파디아야, 레나타 호멤, 김현영, 아나이린 엘리스에반스, 게리 워딩엄, 나우시카 엘메키, 지브란 칸, 레이철 펜들러, 자일스 월러, 데이비드 더브라윈. 이 책의 도판들을 찾아준 샐리 니컬스는 작업 과정에서 노련한 조언들을 제공했습니다. 템스 & 허드슨 출판사의 로저 소프, 애나 리들리, 루시 브라운리지는 각각 다른 단계에서 현명하게 작업을 이끌어주었고, 조애나 니마이어의 능숙한 디자인도 큰 도움이 되었습니다. 하지만 이 책이 실현될 수 있었던 것은 그 무엇보다도 루시 달젤의 놀랍도록 섬세하고 뛰어난 일러스트 덕분이었죠. 이 책을 쓰면서 과거의 나 자신이, 그리고 언제나 날카로운 호기심과 끝없는 관대함으로 내게 영감을 주는 아내 캐럴라인이 조숙했던 청소년 시절에 어떤 책을 읽고 싶었을지 마음속에 그려보곤 했답니다.

맺음말을 쓰다 보니 11시 11분이군요. 내 동생 휘트니가 소원을 빌곤 하던 시각입니다. 내가 비는 소원은 항상 똑같답니다. 휘트니, 네가 지금 여기 있다면 얼마나 좋을까. 너무도 짧았던 너의 삶에서 넌 그 누구보다도 큰 용기와 사랑을 보여주었단다.

세계 예술 지도(원제 : A Journey Through Art)

1판 1쇄 2018년 9월 5일
　　2쇄 2019년 9월 5일

지 은 이 애런 로즌
그 린 이 루시 달첼
옮 긴 이 신소희

발 행 인 주정관
발 행 처 북스토리㈜
주　　　소 경기도 부천시 길주로 1 한국만화영상진흥원 311호
대표전화 032-325-5281
팩시밀리 032-323-5283
출판등록 1999년 8월 18일 (제22-1610호)
홈페이지 www.ebookstory.co.kr
이 메 일 bookstory@naver.com

ISBN 979-11-5564-168-2 03600

Handbook of

METALLOPROTEINS

Volume 5

Handbook of

METALLOPROTEINS

Editor:

Albrecht Messerschmidt
Max-Planck-Institut für Biochemie, Martinsried bei München,
Germany

Series Editors:

Albrecht Messerschmidt
Wolfram Bode
Mirek Cygler
Robert Huber
Thomas Poulos
Karl Wieghardt

WILEY

British Library Cataloguing in Publication Data

A catalogue record for this book is available from the British Library

ISBN 978-0-470-71199-6

Typeset in 9.5/12pt Sabon by Laserwords Private Limited, Chennai, India
Printed and bound in Spain by Grafos S.A., Barcelona, Spain.

Preface

The *Handbook of Metalloproteins* has become a standard reference work for the scientific community working in this field, which includes bioinorganic chemistry, biophysics, structural biology, and molecular medicine. The first two volumes, which were published in 2001, contain entries on metalloproteins of redox-active metals (iron, nickel, manganese, cobalt, molybdenum, tungsten, copper, vanadium). In 2004 Volume 3 was published, which was dedicated to proteins found in the redox-inactive ions of zinc and calcium. The field has been rapidly developing ever since. This provoked the decision of the Publisher to launch the *Handbook of Metalloproteins* as an online version with 15 to 20 new entries per year. Within the last 4 years, a total of 72 entries have been collected and edited, which have been presented online and will now be provided in print form in these Volumes 4 and 5. Most of the contributions have been compiled in the same style as in the previous volumes, with the 3D Structure of the protein appearing on the first page of each contribution followed by several mandatory sections detailing the biological function, occurrence, amino acid sequence, spatial structure, and functional properties of the protein. Furthermore, a detailed presentation and discussion of the metal site(s) is given. Several contributions are reviews summarizing whole protein or domain families while others deal with special aspects of metal transport or homeostasis.

The volumes retain the same sectioning as used in Volumes 1 to 3 but hold new sections for magnesium, sodium/potassium and mercury. The new contributions are dedicated to many highly relevant topics like photosynthesis (cytochrome b_6f complex, photosystem I and II), respiratory chain (complex I and II), Alzheimer's disease (amyloid precursor protein), magnesium channels and transporting, and sodium/potassium (sodium potassium ATPase, potassium channels, nucleobase-cation-symport-1 family of membrane transport proteins).

This new batch of contributions presented in print form will hopefully be accepted with the same interest by inorganic and bioinorganic chemists, biochemists, biophysicists, microbiologists, structural biologists, and students and researchers from molecular medicine.

The Editor is indebted to all authors for delivering such excellent contributions and thanks Martin Röthlisberger, Elizabeth Grainge, and David Hughes for their advice and support as well as Kerry Powell for her highly appreciated assistance throughout the project.

Albrecht Messerschmidt

Contents

Volume 4

Volume 5

MANGANESE

Manganese catalase

Vladimir V Barynin* and James W Whittaker†

*The Krebs Institute, Department of Molecular Biology and Biotechnology, University of Sheffield, Firth Court, Western Bank, Sheffield S10 2TN, UK
†Department of Science and Engineering, Oregon Health and Science University, 20000 N.W. Walker Road, Beaverton, OR 97006, USA

FUNCTIONAL CLASS

Enzyme; hydrogen peroxide oxidoreductase; EC 1.11.1.6; a manganoprotein containing two manganese ions per molecule; functionally related to heme-dependent catalases[1–6] but structurally related to oxygen-activating metalloenzymes, for example, ferritin and Class II ribonucleotide reductases, known as *manganese catalase* (*MNC*). They are also known as *pseudocatalase* or *non-heme catalase*.

MNC catalyzes the two-electron redox disproportionation of hydrogen peroxide into its reaction products, water and dioxygen (Equation (1)):

$$2H_2O_2 \longrightarrow O_2 + 2H_2O \qquad (1)$$

No other donor or acceptor substrates are required for this reaction to occur, and each of the two protein-bound manganese ions undergo a one-electron oxidation/reduction cycle during turnover. MNC can also oxidize a variety of small molecules including hydroxylamine.

OCCURRENCE

MNC was first identified as a cyanide-resistant catalase in mesophilic eubacteria (pediococci and lactobacilli)[7–11] evolved to living in 'total iron abstinence' or severe iron limitation.[12] The enzyme has subsequently been found in both thermophilic eubacteria (*Thermus thermophilus*[13] and *Thermoleophilum album*[14]) and hyperthermophilic crenarchae (e.g., *Pyrobaculum calidifontis*[15]), reflecting a broad distribution over prokaryotic life. Characteristic sequence elements in the MNC protein associated with the dinuclear metal cluster binding motif have allowed putative MNC homologs to be identified *in silico* in genomic databases.

BIOLOGICAL FUNCTION

Catalases are a critical component of the antioxidant defense shield of cells exposed to dioxygen. While oxygen

3D Structure Schematic representations of the monomer structures for MNC from *L. plantarum* (left, PDB code: 1JKU) and *T. thermophilus* (right, PDB code: 2V8U), showing the monomer plus metal ions (manganese, red; calcium, blue; and lithium, white). Prepared with the programs MOLSCRIPT[49] and RASTER3D.[50]

is itself a relatively innocuous species, toxic by-products of dioxygen reduction threaten the metabolic stability of cells in aerobic environments. Reactive oxygen species (ROS) including superoxide free radical (O_2^-), hydrogen peroxide (H_2O_2), and hydroxyl free radical (HO) are generated *in vivo* by one-, two-, and three-electron reduction of O_2, respectively, by the auto-oxidation of cell components, such as flavoprotein and metalloprotein complexes. These ROS are capable of oxidizing a wide variety of biomolecules, damaging enzymes, and introducing mutagenic lesions in the DNA. Protection against this damage is quite literally a matter of life and death. Catalases and peroxidases play an essential role, detoxifying metabolically generated hydrogen peroxide by catalytic decomposition. The biological importance of this reaction may be gauged by the observation that at least three families of enzymes (two heme-dependent and one non-heme manganese-dependent) have evolved to perform this function.

The protective function of MNC has been demonstrated experimentally *in vivo*. Catalase-positive strains of pediococci (expressing MNC) show a growth advantage when cultivated in glycerol media under aerobic conditions.[16] The physiological role of MNC has also been investigated experimentally by comparing the behavior of catalase-negative and -positive strains of *Lactobacillus plantarum*.[17] In contrast to the catalase-positive strain, the catalase-negative strain accumulates H_2O_2 in the late log and stationary phases, reflected in a lower survival rate. Chemical inactivation of the intracellular MNC also results in an increased sensitivity to H_2O_2.

Antisense RNA strategies have been used to investigate the physiological role of MNC in *T. thermophilus*.[18] Cells transformed with an MNC antisense expression vector exhibit an approximately 90% decrease in viability under aerobic conditions and become hypersensitive to hydrogen peroxide stress, demonstrating that in this organism MNC is essential for aerobic life.

In addition to endogenously formed ROS, living cells must protect themselves from hydrogen peroxide in the environment. Hydrogen peroxide is a well-known antimicrobial compound that is released as a chemical warfare agent by living cells. For example, neutrophils and macrophages release ROS, including hydrogen peroxide, during the respiratory burst immune response, and prokaryotes that contain a membrane-bound NADH oxidase excrete hydrogen peroxide into their environment as a selective agent to increase their competitive advantage. Catalases also provide defense against the toxicity of this environmental H_2O_2. Because the formation of ROS is an important part of the immune response to microbial pathogens, catalases may contribute to the survival and virulence of pathogens. In particular, MNC may contribute and provide an essential antioxidant defense within the Fe-limited environment of a host organism, reflecting the importance of manganese for bacterial survival.[19]

AMINO ACID SEQUENCE INFORMATION

For crystallographically defined proteins,

- *T. thermophilus* HB8, 302 AA, chemical sequencing of the polypeptide amino acid (AA) sequence analysis,[20] translation of genomic DNA sequence [gi:34556035], and atomic resolution protein structure[20] [gi:15843 1099].
- *L. plantarum*, 266 AA residues, translation of genomic DNA sequence[21] [gi:42558946].

For related proteins that have been biochemically characterized but are not yet crystallographically defined,

- *Thermus* sp. YS 8–13, 302 AA, translation of genomic DNA sequence[22] [gi:4519429].
- *P. calidifontis* VA1, 298 AA, translation of genomic DNA sequence[15] [gi: 21321250].
- *Salmonella enterica*, 292 AA, translation of genomic DNA sequence[23] [gi:16765075].

PROTEIN PRODUCTION, PURIFICATION, AND MOLECULAR CHARACTERIZATION

The most straightforward preparation of the MNC protein involves isolation from its natural source. Thus, *T. thermophilus* catalase (TTC) and *L. plantarum* catalase (LPC) have been isolated from the corresponding organism grown under aerobic conditions to enhance the MNC expression level,[11,24–26] a method that is generally adequate for basic biochemical characterization. However, for overexpression of the protein or for preparation of mutational variants, recombinant techniques are required. Production of both recombinant TTC and recombinant LPC in their respective homologous expression hosts has been reported,[27–29] as well as the expression of TTC in a heterologous host (*Escherichia coli*).[30] In the latter case, coexpression with protein folding chaperones permits the isolation of the soluble and folded but metal-free apoprotein.

The protein is purified from cell extracts using standard chromatographic methods. Quantitation of the purified protein is conveniently performed by measuring the UV absorption ($E_{280\ nm}^{1\%} = 9.5$ (TTC)[26] or 10.7 (LPC)[11]). In solution, both TTC and LPC are hexameric proteins formed from six identical subunits, having monomer masses of 33.201 kDa (TTC) and 29.743 kDa (LPC), respectively. A tetrameric MNC has also been described.[15]

METAL CONTENT AND COFACTORS

MNC contains two manganese ions per monomer, based on the atomic absorption spectrometric analysis. While substoichiometric Mn content may be observed in some

samples, other metal ions do not appear to substitute for Mn in the active site. In addition to the active site metal ions, LPC contains a calcium ion (one Ca per monomer). In the crystals, TTC is associated with lithium ions derived from the precipitation salt ($LiSO_4$).

ACTIVITY TESTS

A catalase activity may be qualitatively detected in biological materials by the effervescence of a dilute (3%) hydrogen peroxide solution. This qualitative test has been used to identify strains of catalase-positive lactic acid bacteria, which are potential sources of MNC.[7–10] Standard enzyme activity measurements are based on the decrease in UV absorption of a 20 mM solution of hydrogen peroxide[31,32] ($\varepsilon_{240} = 39.4\,M^{-1}\,cm^{-1}$) in 50 mM phosphate buffer, pH 7, or by the detection of dioxygen formed during catalatic decomposition using a Clark oxygen electrode. Specific activity is defined in units per milligram protein. One unit of catalase activity is defined as the reaction yielding decomposition of 1 μmol of hydrogen peroxide to O_2 and water in 1 min at pH 7. Purified preparations of MNC exhibit a specific activity of 8900 U mg^{-1} (LPC, 25 °C) or 8000 U mg^{-1} (TTC, 65 °C).

SPECTROSCOPY

The spectroscopic properties of MNC provide important information on the nature and interactions of the manganese ions that form the catalytic active site. In particular, spectroscopy can be used to define the oxidation state of the metal ions and provides a probe of electronic interactions within the binuclear Mn cluster. In general, Mn^{2+}, Mn^{3+}, and Mn^{4+} oxidation states may all be accessible within a biological complex. Both metal ions are redox active in MNC, and complexes have been prepared in the following oxidation states (the valence of each of the Mn ions being indicated in brackets): fully reduced, (2,2); mixed-valent, (2,3); fully oxidized, (3,3); and hyperoxidized mixed valent (3,4). The enzyme cycles between (2,2) and (3,3) states during turnover.[33]

Optical absorption

Optical spectroscopy may be used to determine the oxidation state of the Mn cluster based on the weak ligand field (d–d) transitions in the visible absorption spectrum. These features are both spin- and orbitally (Laporte-) forbidden for a Mn^{2+} (d^5) ion, resulting in vanishingly small intensities in the visible spectrum ($\varepsilon \sim 1\,M^{-1}\,cm^{-1}$), but the d–d spectra are spin allowed and are thus much more intense for Mn^{3+} (d^4) and Mn^{4+} (d^3) ions. Qualitatively, fully reduced MNC is colorless, whereas the oxidized

Table 1 Spectroscopic data for MNC

MNC	Oxidation state	ABS		CD	
		λ (nm)	ε ($M^{-1}\,cm^{-1}$)	λ (nm)	$\Delta\varepsilon_{CD}$ ($M^{-1}\,cm^{-1}$)
LPC	(3,3)	475	330	460	0.72
				552	−0.53
TTC	(3,3)	492	360	452	−1.1
				530	0.8

(3,3) form is pink (Table 1). Coordination of exogenous ligands (fluoride, azide, or other anions) is reflected in a perturbation of the electronic spectra.

Circular dichroism

Ligand field absorption bands typically exhibit a strong optical rotation (ellipticity) as a consequence of the relatively large magnetic dipole contribution to the transition. The circular dichroism CD spectra of MNC (3,3) complexes clearly reflect this behavior, with strong resolved CD features assigned to $^4A \rightarrow {}^4E$ transitions of the two distorted octahedral Mn^{3+} ions.

Electron paramagnetic resonance

Transition metal ions (including manganese ions) have unpaired electrons in their valence shells that may be sensitively detected by electron paramagnetic resonance (EPR) methods. The metal ions in MNC are both high spin and usually accessible by these techniques, but electronic interactions mediated by ligands bridging between the two metal ions in the cluster stabilize the antiferromagnetically coupled ground states. In homovalent states for which both ions have the same spin, antiferromagnetic coupling produces a total spin $S_T = 0$ state at the lowest energy that is nondegenerate and EPR silent. However, the electronic interactions result in a ladder of spin states, defined by the characteristic splitting J, at higher energies. These states (ranging in spin from $S_T = |S_1 - S_2|$ to $S_T = S_1 + S_2$) have a multiplicity of ($2S_T + 1$) and will give rise to EPR signals with an intensity proportional to the population if the resonance condition is met. As the sample temperature is raised, thermal population over the spin ladder results in temperature-dependent EPR signals that may be deconvoluted to estimate the Heisenberg exchange coupling constant (J) for the complex.[34–37] For LPC, $J = 4\,cm^{-1}$, assuming all substates contribute to the observed spectra.

Additional splittings in the EPR spectra arise from electron–nuclear hyperfine interactions with the ^{55}Mn ($I = 5/2$) nucleus (100% n.a.). For an isolated Mn ion, a simple sextet splitting is predicted. For a pair of interacting

Mn ions, the splitting is more complex. For example, a 14-line hyperfine pattern multiline signal is associated with an antiferromagnetically mixed valent (3,4) state of the cluster.[38,39] This signal dominates the EPR spectrum of the as-isolated MNC enzyme at low temperature even though it actually represents a very small fraction (<10%) of the sample, because the majority of the protein complexes have EPR-silent ground states. At higher temperatures, signals arising within paramagnetic excited states of the cluster appear and may be assigned to coupled spin systems based on the multiplicity and the magnitude of the splitting patterns.

EPR spectra arising from integer-spin states may be detected with greater sensitivity using parallel polarization techniques, where the microwave oscillating magnetic field is aligned, rather than perpendicular to the applied magnetic field. This approach has been successfully applied to integer-spin states of LPC.[27] Advanced techniques, including electron–nuclear double resonance (ENDOR),[40] high field EPR,[41] and pulsed EPR[42] spectroscopies, have also been used to probe the electronic ground state in the metal cluster and to define the electronic coupling to ligand nuclei.

Magnetic circular dichroism

Magnetic circular dichroism (MCD) spectroscopy permits the sensitive detection of paramagnetic metalloprotein complexes and can provide information on the electronic ground state complementing that is available from EPR methods. MCD measures circular polarization induced in optical absorption bands by a longitudinal magnetic field arising from the Zeeman splitting of electronic states. MCD spectroscopy is most sensitive to complexes having paramagnetic ground states ($S > 0$), since both the Zeeman splitting and differential population at low temperature contribute to the intensity. Diamagnetic ground states ($S = 0$) are much less sensitively detected. Because of this difference in sensitivity, MCD spectra for MNC complexes[26,27,42] are dominated by features arising from components that are ferromagnetically or weakly coupled ($J < 0$, $J \approx 0$) or are mixed–valent complexes having half-integer spin ground states.

Magnetic susceptibility

Magnetic susceptibility methods are sensitive to the total magnetization of the sample, including all paramagnetic components. The magnetic response is temperature-dependent, reflecting population of the spin ladder. However, there is no requirement for resonance excitation, and all populated states contribute to the observed signal. Susceptibility measurements on TTC[43,44] and LPC[45] have been used to estimate the Heisenberg exchange splitting in the electronic ground state (J) as $5.0\,cm^{-1}$ (TTC) and $5.3\,cm^{-1}$ (LPC) for the (2,2) state.

X-ray absorption spectroscopy

The X-ray absorption spectroscopy (XAS) and the extended X-ray absorption fine structure (EXAFS) have been used to assign the manganese oxidation state and estimate the metric parameters of the metal cluster for comparison with crystallographic data.[33] The metal ions appear to be reduced by photoelectrons produced by synchrotron radiation required for X-ray absorption measurements, so the structural data available from XAS experiments (e.g., Mn–Mn separation, 3.53 Å) are expected to correspond to the reduced (2,2) complex.

X-RAY STRUCTURE OF NATIVE MNC

Crystallization

Crystals of TTC[20,46,47] were grown in 0.05 M N-(1,1-dimethyl-2-hydroxyethyl)-3-amino-2-hydroxypropanesulfonic acid (AMPSO) buffer, pH 9.0, at 37–45 °C, using ammonium sulfate (0.7–1.4 M) as a precipitant. The crystals exhibit a rhombohedral habit based on a cubic lattice, space group P2₁3, with unit cell parameters $a = b = c = 134.3$ Å. The asymmetric unit contains one-third of the hexameric protein (two subunits). Crystals were flash-frozen in a cryostabilizer solution containing 0.1 M AMPSO buffer pH 8.5, 0.36 M lithium sulfate, and 30% polyethylene glycol 400 Da (PEG400).

Crystals of LPC[48] were grown in 0.1 M N-tris(hydroxymethyl)methyl-3-aminopropanesulfonic acid (TAPS) buffer pH 8.7, containing 25% polyethylene glycol 8000 Da (PEG8000) as a precipitant. Two crystal forms have been prepared, using PEG from difference sources. The first is monoclinic, space group P2₁, with unit cell parameters $a = 74$–76 Å, $b = 96$–98 Å, $c = 107$–108 Å, $\alpha = 90°$, $\beta = 107.2°$, and $\gamma = 90°$. The second crystal form is orthorhombic, space group P2₁2₁2₁, with unit cell dimensions $a = 85.3$ Å, $b = 124.1$ Å, and $c = 146.1$ Å. The asymmetric unit contains one hexameric protein molecule for both crystal forms.

Overall description of the structure

TTC and LPC are homohexamers with subunits arranged in 32- point symmetry, forming compact globular structures. The organization of individual TTC and LPC subunits (SCOP ID: a.25.1.3, ferritin-like fold) is shown in the 3D Structure. For TTC [PDB code: 2V8U], each subunit of 302 residues is composed of three regions: an N-terminal polypeptide, a central barrel-shaped four-helix

bundle domain that contains the catalytic core (CATH classification: 1.20.1260.10.14), and a C-terminal tail (CATH classification: 3.30.1530.10). The central domain is all-α-helical and well organized. In contrast, the N- and C-terminal regions, which contain all of the β-strands, have an extended conformation that is low in well-defined secondary structure elements. The N-terminal region includes a short β-strand (residues 2–4) that forms an antiparallel sheet with the corresponding element from a neighboring subunit at the interface, and a second β-strand (residues 7–8) that forms an antiparallel sheet with a β-strand (residues 269–270) located in the C-terminal polypeptide. A region of parallel β-sheet (residues 259–263; 232–235) is also present in the C-terminal polypeptide, together with four helixes, which are loosely organized over the four-helix bundle core. The core domain is formed from four antiparallel α-helices of similar length (residues 19–50, 56–86,143–167, and 172–201) with an unusually long, left-handed crossover connection between helices 2 and 3 (residues 87–142), which fills the central region of the assembled hexamer. The antiparallel α-hairpins are arranged in a coiled coil with a left-handed twist. Helix 1 is broken in the middle by a short loop (residues 32–34) that locally disrupts the helical packing, creating a solvent-filled channel into the protein interior. A topology diagram for the TTC subunit architecture is shown in Figure 1.

For LPC [PDB code: 1JKU], each subunit of 266 residues is, like TTC, composed of three regions. A short segment of β-strand (residues 2–4) in the N-terminal region links adjacent subunits through a symmetric antiparallel β-sheet motif. The central domain of the LPC subunit (residues 18–164) is similarly formed from a pair of antiparallel α-hairpins, but the left-handed crossover connection between helices 2 and 3 (residues 87–131) is slightly shorter than in the TTC structure. A loop in the middle of helix 1 (residues 28–32) forms a bulge and creates a channel into the core of the four-helix bundle. Overall, the coiled–coiled central domains of TTC and LPC are very similar and are superimposable with a Cα atoms rmsd of 1.42 Å (excluding the crossover connection). Unlike the TTC structure, the C-terminal region of LPC contains a calcium binding loop associated with an α/β sandwich structure, stretching away from the central domain and filling in the clefts between subunits. A topology diagram for the LPC subunit architecture is shown in Figure 2.

Manganese coordination

The two manganese are bound on the axis of the four-helix bundle by a cluster of AA side chains in both LPC (Figure 3) and TTC (Figure 4), including two histidines (His73 and His188 in TTC; His69 and His181 in LPC) and three glutamates (Glu36, Glu70, and Glu155 in TTC; Glu35, Glu66, and Glu148 in LPC). In both cases, the cluster is spanned by a μ-1,3 bridging carboxylate (Glu70 in TTC and Glu66 in LPC) and two single-atom solvent bridges (μ-1,1 bridging oxo, hydroxo, or aquo). Metric

Figure 1 Topology diagram for MNC from *T. thermophilus* HB8 (PDB code: 2V8U) with the assignment of secondary structural elements. The figure was prepared with the program TOPDRAW.[51]

Figure 2 Topology diagram of domain architecture for MNC from *L. plantarum* (PDB code: 1JKU) with an assignment of secondary structural elements. The figure was prepared with the program TOPDRAW.[51]

Figure 3 The dinuclear manganese site in LPC. Based on a 1.8 Å crystal structure of *L. plantarum* MNC (PDB code: 1JKU). A single conformation of each of the ligands is shown. The figure was prepared using the program MOLSCRIPT.[49]

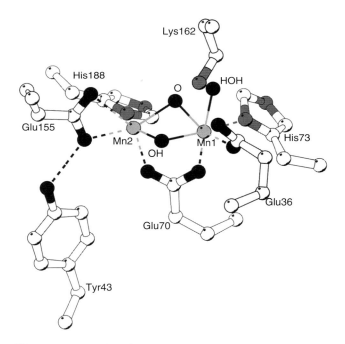

Figure 4 The dinuclear manganese site in TTC. Based on a 1.1 Å crystal structure of *T. thermophilus* HB8 MNC (PDB code: 2V8U). A single conformation of each of the ligands is shown. The figure was prepared using the program MOLSCRIPT.[49]

Table 2 Comparison of manganese–manganese and manganese–ligand distances in manganese catalases

Atom1	LPC		TTC	
	Atom2	**Distance (Å)[a]**	**Atom2**	**Distance (Å)[b]**
Mn1	Mn2	3.03	Mn2	3.13
Mn1	W1	1.92	W1	2.03
Mn1	W2	2.06	W2	2.07
Mn1	W3	2.10	W3	2.27
Mn1	OE1Glu35	1.85	OE1Glu35	2.05
Mn1	OE2Glu35	3.35	OE2Glu35	3.39
Mn1	NDHis69	2.17	NDHis89	2.22
Mn1	OE1Glu66	2.11	OE1Glu86	2.14
Mn2	W1	1.98	W1	2.12
Mn2	W2	2.23	W2	2.18
Mn2	OE2Glu66	2.10	OE2Glu86	2.12
Mn2	OE1Glu148	2.38	OE1Glu148	2.17
Mn2	OE2Glu148	2.42	OE2Glu148	2.64
Mn2	NDHis181	2.16	NDHis181	2.26

[a] Data given for the A subunit conformer having six-coordination at Mn1 (PDB code: 1JKU).
[b] Data given for the K subunit conformer having six-coordination at Mn1 (PDB code: 2V8U).

complexes, including ferritin and ribonucleotide reductase, which catalyze the multielectron reduction of dioxygen.

Active site environment

The manganese binding site is embedded in an extended hydrogen bond network in the interior of the four-helix bundle that may provide a mechanism for rapid electrostatic compensation by the protein to changes in charge distribution in the active site during redox catalysis. An Arg–Glu salt bridge in the outer sphere of the cluster that is conserved over MNC structures (Arg184–Glu69, TTC; Arg177–Glu65, LPC) serves as an anchor for metal-coordinating side chains on the histidine side of the cluster. The noncoordinating NE nitrogens of both ligating histidine residues are hydrogen bonded to the carboxylate oxygens of the salt bridge.

A second arginine side chain (Arg147) lies on the opposite side of the cluster in LPC, forming hydrogen bonds with the terminal glutamates at Mn1 and Mn2 as well as an outer sphere tyrosine. This arginine is not present in the outer sphere of the TTC cluster.

A noncoordinating glutamate (Glu178, LPC), corresponding to one of the metal ligands in the di-iron motif, lies above the solvent-bridged diamond core of the cluster in LPC, buttressed by the polypeptide backbone. This feature is absent in TTC, where the corresponding residue is a glycine (Gly185), and the glutamate appears to be functionally replaced by a lysine residue (Lys162) arising from a different region of secondary structure.

parameters for the two active site complexes are compared in Table 2. The pattern of metal coordination is very similar to the metal binding motif in other four-helix bundle di-iron

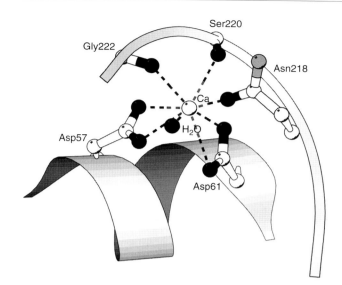

Figure 5 The calcium binding site in LPC domain 2. Based on a 1.8 Å crystal structure of *L. plantarum* MNC (PDB code: 1JKU). Helix and loop peptides are associated with two different subunits. The figure was prepared using the program MOLSCRIPT.[49]

Calcium coordination

The unique calcium ion in LPC is bound at an unsymmetrical subunit interface formed from a turn within the α/β structure in the C-terminal tail of one polypeptide chain and the first helix within the four-helix bundle core of the other. The metal ion is eight-coordinate and effectively cross-links the protein, with three neutral protein ligands arising from one subunit (including the side chain carbonyl of Asn218 and peptide carbonyls of Ser220 and Gly222) and two chelating carboxylate ligands (Asp57 and Asp61) from the other subunit. The coordination sphere is capped by a single solvent molecule. The structure of the LPC calcium binding site is shown in Figure 5.

FUNCTIONAL ASPECTS

Interconversion of oxidation states

Methods have been developed to interconvert these forms of MNC by treating the enzyme with redox agents that are small enough to access the metal centers.[26,33,52] Treatment of LPC (3,3) with 0.5 equivalents of hydroxylamine (based on manganese content) under anaerobic conditions results in reduction to homogeneous (2,2) state, interpreted as a two-electron oxidation process (Equation (2)):

$$NH_2OH + 2Mn^{3+} \longrightarrow 1/2N_2O + 1/2H_2O + 2Mn^{2+}$$

(2)

Conversely, incubation under an atmosphere of pure O_2 permits conversion to a homogeneous (3,3) state. Reaction with a mixture of hydroxylamine and hydrogen peroxide

results in the conversion to a superoxidized (3,4) state of the cluster. Similar transformations may be performed on TTC, yielding these redox forms as wells as a mixed-valent (2,3) state.

Steady-state kinetics

Steady-state kinetics have been measured for both TTC and LPC (TTC: $k_{cat} = 2.6 \times 10^5\,s^{-1}$, $K_m = 83\,mM$; LPC: $k_{cat} = 2.0 \times 10^5\,s^{-1}$, $K_m = 350\,mM$). In contrast, heme catalases exhibit rapid, nonsaturating kinetics ($k_{cat} = 1 \times 10^7\,s^{-1}$). However, while MNC enzymes are relatively slow, they compensate by forming stable turnover intermediates, in contrast to the heme catalases that generate a highly reactive metalloradical complex (Compound I) during catalysis. This may allow them to function efficiently at lower substrate concentrations, where catalytic half-reaction intermediates may be required to persist for extended periods.

Inhibition kinetics have been reported for a steady-state turnover of LPC.[5] Compared to heme catalases, MNCs are relatively insensitive to anion inhibition. At neutral pH, the K_i for azide is 80 mM and $K_i = 5\,mM$ at pH 5.5. Inhibition by fluoride appears to be complex, with the enzyme being trapped in the reduced (2,2) state when the fluoride is present during turnover. TTC is sensitive to inhibition by a wider variety of anions, including nitrate, oxalate, and phosphate, which is consistent with the more open access to the active site.

Coordination chemistry

Interactions between the binuclear Mn active site and exogenous ligands can be detected through the perturbation of spectra associated with the complex. Using these approaches, perturbation of the Mn spectra has permitted the measurement of dissociation constants for small-molecule binding. In general, the affinity for small anions is pH dependent, consistent with a proton-coupled association reaction. For example, fluoride binding to the oxidized (3,3) form of LPC yields $K_d = 0.5\,mM$ at pH 5.5, but $K_d = 14\,mM$ at pH 7. Fluoride binding to the reduced (2,2) form of LPC, two distinct titration steps are resolved with $K_{d,1} = 12\,\mu M$ and $K_{d,2} = 140\,\mu M$ (pH 5.5). The significantly higher affinity of fluoride for the reduced complex is the reverse of the ordering normally observed in Mn coordination chemistry and may reflect the accessibility of alternative binding modes in the (2,2) complex.

FUNCTIONAL DERIVATIVES

General remarks

The binuclear Mn clusters in LPC and TTC interact with a variety of small molecules that perturb the structures and affect the activity of the sites. Transformation of the active

site by small redox-active molecules (e.g., hydroxylamine) and the inhibitory effect of some anions (e.g., fluoride) have been noted above. The relatively open access to the cluster in TTC supports a broad range of interactions with ions as large as phosphate, whereas access to the active site of LPC appears to be relatively restricted. However, the availability of an efficient homologous expression system for the production of recombinant LPC has allowed a number of mutational variants of that protein to be prepared.

X-ray structure of anion complexes (PDB code: 1JKV)

Azide may be viewed as an electronic structural analog hydrogen peroxide analog in terms of valence molecular orbitals and interactions with metal ions. Azide is a competitive inhibitor of MNC (see above) and the structure of a complex of LPC with azide bound has been determined by X-ray crystallography[48] (Figure 6). In this structure, azide is terminally bound to Mn1, in the position occupied by the nonbridging solvent in the native enzyme structure. This binding mode may be expected to mimic the binding of hydrogen peroxide to the oxidized Mn(3,3) form of the enzyme.

Mutational variants LPC Y42F (PDB code: 1O9I)

The role of conserved outer sphere residues in the structure and function of the MNC active site has been investigated by site-directed mutagenesis. A conserved tyrosine residue

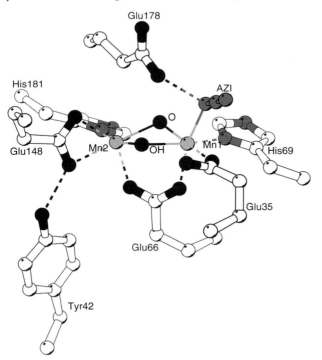

Figure 6 The azide complex of LPC. Based on a 1.4 Å crystal structure of *L. plantarum* MNC (PDB code: 1JKV). A single conformation of each of the ligands is shown. The figure was prepared using the program MOLSCRIPT.[49]

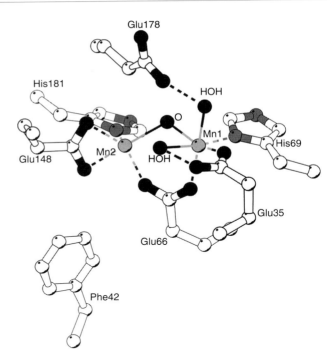

Figure 7 The dinuclear manganese site in the Y42F variant of LPC. Based on a 1.3 Å crystal structure of *L. plantarum* MNC Y42F variant (PDB code: 1O9I). A single conformation of each of the ligands is shown. The figure was prepared using the program MOLSCRIPT.[49]

(Tyr42 in the LPC sequence) has been shown to form a hydrogen bond to one of the metal ligands (Glu148). This feature bears an uncanny resemblance to motifs involving a conserved tyrosine residue found in a wide range of other metalloenzymes. For example, in ribonucleotide reductase, a redox-active tyrosine (Tyr122) is closely associated with the binuclear Fe active site. Similarly, in the oxygen-evolving complex (OEC) of green plants, a redox-active tyrosine in the outer sphere of the water splitting complex functions in the electron transfer pathway coupling the OEC to the photooxidation of the chlorophyll special pair.

Substitution of the outer sphere tyrosine (Tyr42) by phenylalanine in LPC results in a marked perturbation of the Mn cluster[27] (Figure 7). Displacement of Mn2 toward the chelating Glu carboxyate appears to reflect an increased basicity of the carboxylate headgroup when the phenolic hydrogen bond is lost. As a result of this displacement, one of the solvent bridges is broken, leaving a single μ-bridging solvent molecule. The singly bridged cluster exhibits strong EPR and MCD signals characteristic of a ferromagnetically coupled binuclear complex. Although both metal ions are bound in the active site, the open cluster is unable to support a complete catalytic cycle.

X-ray structure of the metal-free form of MNC (PDB code: 2CWL)

A crystal structure of metal-free apoprotein form of TTC has been solved at a 1.65 Å resolution (Figure 8).

Figure 8 Cluster ligands in metal-free apo-TTC. Based on a 1.6 Å crystal structure of *T. thermophilus* HB8 MNC apoprotein (PDB code: 2CWL). The figure was prepared using the program MOLSCRIPT.[49]

Interestingly, the metal ligands are organized in the apoprotein in the same geometry as they are found in the Mn-containing holoenzyme, but with solvent molecules occupying the position of the cluster. Thus, the protein structure templates the binding of the binuclear Mn cluster.

CATALYTIC MECHANISM

The catalase turnover cycle supported by MNC is predicted to involve two distinct half-reactions, with the cycling of the dinuclear metal center between the (2,2) and (3,3) oxidation states coupled to changes in the protonation state of the bridging ligands (in square brackets):

$$H_2O_2 + (3,3)[O,OH] \longrightarrow O_2 + (2,2)[OH,OH_2] \quad (3)$$

$$H_2O_2 + (2,2)[OH,OH_2] \longrightarrow 2\,H_2O + (3,3)[O,OH] \quad (4)$$

In the oxidative half-reaction (Equation (3)), the substrate peroxide may bind terminally to Mn1, displacing the non bridging solvent (Figure 9). The bridging solvent oxygens are assigned μ-oxo and μ-hydroxo protonation states in this complex. A pendant hydrogen-bonding residue lying above the cluster (Glu178 in LPC and Lys162 in TTC) could serve to facilitate the proton transfer between the coordinated substrate and the bridging oxygens during the reduction of the two metal ions. Upon reduction of the cluster from (3,3) to (2,2), the basicity of the bridging solvent atoms is expected to significantly increase, enhancing their ability to serve as proton acceptor sites. Protonation of the two solvent bridges through the transfer of the two solvent-derived protons creates μ-hydroxo and μ-aquo bridges in the reduced complex. The lability of the μ-bridging water in this complex could allow for the insertion of a second molecule of hydrogen peroxide (Equation (4)) into the bridging position in the reductive half-reaction in μ-1,1 bridging geometry. Reductive cleavage of the O–O bond would then regenerate the (3,3) state of the cluster. This scheme, involving the sequential binding of two molecules of hydrogen peroxide in a two-state cycle, generates active site species that are

Figure 9 Hypothetical turnover cycle for MNC peroxide disproportionation mechanism.

indefinitely stable in both oxidized and reduced complexes. This is very different from the catalatic cycle supported by heme catalases, where the reactivity of one of the turnover complexes (the oxidized oxyferryl Compound I) makes it very unstable and might point toward an evolutionary adaptation of the MNC family of antioxidant metalloenzymes to protect against a low steady-state level of hydrogen peroxide.

ACKNOWLEDGEMENTS

Support for this research from the National Institutes of Health (GM042680 to J.W.W.) is gratefully acknowledged.

REFERENCES

1 PC Loewen, MG Klotz and DJ Hassett, *ASM News*, **66**, 76–82 (2000).

2 M Zamocky, PG Furtmüller and C Obinger, *Antioxid Redox Signal*, **10**, 1527–48 (2008).

3 MG Klotz, GR Klassen and PC Loewen, *Mol Biol Evol*, **14**, 951–58 (1997).

4 P Chelikani, I Fita and P Loewen, *Cell Mol Life Sci*, **61**, 192–08 (2004).

5 DW Yoder, J Hwang and JE Penner-Hahn, *Met Ions Biol Syst*, **37**, 527–57 (2000).

6 AJ Wu, JE Penner-Hahn and VL Pecoraro, *Chem Rev*, **104**, 903–38 (2004).

7 MA Johnston and EA Delwiche, *J Bacteriol*, **90**, 347–51 (1965).

8 EA Delwiche, *J Bacteriol*, **81**, 416–18 (1961).

9 MA Johnston and EA Delwiche, *J Bacteriol*, **83**, 936–38 (1962).

10 MA Johnston and EA Delwiche, *J Bacteriol*, **90**, 352–56 (1965).

11 Y Kono and I Fridovich, *J Biol Chem*, **258**, 6015–19 (1983).

12 ED Weinberg, *Perspect Biol Med*, **40**, 578–83 (1997).

13 VV Barynin and AI Grebenko, *Dokl Akad Nauk USSR*, **286**, 461–64 (1986) (In Russian).

14 GS Allgood and JJ Perry, *J Bacteriol*, **168**, 563–67 (1986).

15 T Amo, H Atomi and T Imanaka, *J Bacteriol*, **184**, 3305–12 (2002).

16 Y Kono and I Fridovich, *J Bacteriol*, **155**, 742–46 (1983).

17 AA Yousten, JL Johnson and M Salin, *J Bacteriol*, **123**, 242–47 (1975).

18 R Moreno, A Hidalgo, F Cava, R Fernandez-Lafuente, JM Guisan and J Berenguer, *J Bacteriol*, **186**, 7804–06 (2004).

19 NS Jakubovics and HF Jenkinson, *Microbiology*, **147**, 1709–18 (2001).

20 SV Antonyuk, VR Melik-Adamyan, AN Popov, VS Lamzin, PD Hempstead, PM Harrison, PJ Artymyuk and VV Barynin, *Crystallogr Rep*, **45**, 105–16 (2000).

21 T Igarashi, Y Kono and K Tanaka, *J Biol Chem*, **271**, 29521–24 (1996).

22 M Kagawa, N Murakoshi, Y Nishikawa, G Matsumoto, Y Kurata, T Mizobata, Y Kawata and J Nagai, *Arch Biochem Biophys*, **362**, 346–55 (1999).

23 V Robbe-Saule, C Coynault, M Ibanez-Ruiz, D Hermant and F Norel, *Mol Microbiol*, **39**, 1533–45 (2001).

24 VV Barynin and AI Grebenko, *Dokl Akad Nauk SSSR*, **286**, 461–64 (1986).

25 VV Barynin, AA Vagin, WR Melik-Adamyan, AI Grebenko, SV Khangulov, AN Popov, ME Adnrianova and BK Vainshtein, *Sov Phys Dokl*, **31**, 457–59 (1986).

26 MM Whittaker, VV Barynin, SV Antonyuk and JW Whittaker, *Biochemistry*, **38**, 9126–36 (1999).

27 MM Whittaker, VV Barynin, T Igarashi and JW Whittaker, *Eur J Biochem*, **270**, 1102–16 (2003).

28 T Rochat, J.-J Gratadoux, A Gruss, G Corthier, E Maguin, P Langella and M van de Guchte, *Appl Envir Microbiol*, **72**, 5143–49 (2006).

29 A Hidalgo, L Betancor, R Moreno, O Zafra, F Cava, R Fernandez-Lafuente, JM Guisan and J Berenguer, *App Environ Microbiol*, **70**, 3839–44 (2004).

30 T Mizobata, M Kagawa, N Murakoshi, E Kusaka, K Kameo, Y Kawata and J Nagai, *FEBS J*, **267**, 4264–71 (2000).

31 RF Beers Jr and IW Sizer, *J Biol Chem*, **195**, 133–40 (1952).

32 DP Nelson and LA Kiesow, *Anal Biochem*, **49**, 474–78 (1972).

33 GS Waldo and JE Penner-Hahn, *Biochemistry*, **34**, 1507–12 (1995).

34 AE Meier, MM Whittaker and JW Whittaker, *Biochemistry*, **35**, 348–60 (1996).

35 SV Khangulov, PJ Pessiki, VV Barynin, DE Ash and GC Dismukes, *Biochemistry*, **34**, 2015–25 (1995).

36 SV Khangulov, VV Barynin, NV Voevodskaya and AI Grebenko, *Biochim Biophys ACTA*, **1020**, 305–10 (1990).

37 SV Khangulov, MG Goldfeld, VV Gerasimenko, NE Andreeva, VV Barynin and AI Grebenko, *J Inorg Biochem*, **40**, 279–92 (1990).

38 M Zheng, SV Khangulov, GC Dismukes and VV Barynin, *Inorg Chem*, **33**, 382–87 (1994).

39 S Khangulov, M Sivaraja, VV Barynin and GC Dismukes, *Biochemistry*, **32**, 4912–24 (1993).

40 C Teutloff, KO Schafer, S Sinnecker, V Barynin, R Bittl, K Wieghardt, F Lendzian and W Lubitz, *Magn Reson Chem*, **43**, S51–64 (2005).

41 A Ivancich, VV Barynin and JL Zimmermann, *Biochemistry*, **34**, 6628–39 (1995).

42 DR Gamelin, ML Kirk, TL Stemmler, S Pal, WH Armstrong, JE Penner-hahn and EI Solomon, *J Am Chem Soc*, **116**, 2392–99 (1994).

43 L Jacquamet, I Michaud-Soret, N Debaecker-Petit, J.-M Latour, VV Barynin and JL Zimmermann, *Ang Chem Int Ed*, **36**, 1626–28 (1997).

44 I Michaud-Soret, L Jacquamet, N Debaecker-Petit, L Le Pape, VV Barynin and JM Latour, *Inorg Chem*, **37**, 3874–76 (1998).

45 L Le Pape, E Perret, I Michaud-Soret and J.-M Latour, *J Biol Inorg Chem*, **7**, 445–50 (2004).

46 BK Vainshtein, WR Melik-Adamyan, VV Barynin and AA Vagin, in YA Ovchinnikov (ed.), *Progress in Bioorganic Chemistry and Molecular Biology*, Elsevier, Amsterdam, New York, Oxford, pp 117–26 (1984).

47 VV Barynin, PD Hempstead, AA Vagin, SV Antonyuk, WR Melik-Adamyan, VS Lamzin, PM Harrison and PJ Artymiuk, *J Inorg Biochem*, **67**, 196 (1997).

48 VV Barynin, MM Whittaker, SV Antonyuk, VS Lamzin, PM Harrison, PJ Artymiuk and JW Whittaker, *Structure (Camb)*, **9**, 725–38 (2001).

49 P Kraulis, *J Appl Crystallogr*, **24**, 946–50 (1991).

50 EA Merrit and MEP Murphy, *Acta Crystallogr*, **D50**, 869–73 (1994).

51 CS Bond, *Bioinformatics*, **19**, 311–12 (2003).

52 Y Kono and I Fridovich, *J Biol Chem*, **258**, 13646–48 (1983).

Human cytosolic X-prolyl aminopeptidase

Xin Li[†], Mark Bartlam[†] and Zihe Rao[†,‡]

[†] Tianjin Key Laboratory of Protein Science, College of Life Sciences, Nankai University, Tianjin 300071, China
[‡] National Laboratory of Biomacromolecules, Institute of Biophysics, Chinese Academy of Sciences, Beijing 100101, China

FUNCTIONAL CLASS

Enzyme; human cytosolic X-prolyl aminopeptidase (XPNPEP1); EC 3.4.11.9; double-manganese ion-dependent aminopeptidase.

X-prolyl aminopeptidase catalyzes the removal of N-terminal amino acid that is linked to prolyl residue from a peptide, according to Equation (1):

$$(H_2N)X_1-P-X-X-\ldots + H_2O \rightarrow (H_2N)X_1(COOH)$$
$$+ (H_2N)P-X-X-\ldots \quad (1)$$

The substrate peptide can be a large protein or even a dipeptide or tripeptide.[1] The human cytosolic X-prolyl aminopeptidase contains two Mn^{2+} ions in the active site per subunit and its functional form is dimer.[1-3]

OCCURRENCE

X-prolyl aminopeptidases, also known as *aminopeptidase P* or *AP-P*, are found in a variety of organisms including mammals, yeasts, and bacteria. In mammalian cells, two forms of X-prolyl aminopeptidases have been discovered: one is the membrane-bound form and the other the cytosolic form. The mammalian cytosolic form of AP-P has been purified from human leukocytes,[1] human platelets,[4] rat brain,[5] and guinea pig brain.[6] Among the mammalian isoforms, the human cytosolic X-prolyl aminopeptidase (XPNPEP1) has been the most extensively studied. Compared with the previously well-characterized *Escherichia coli* aminopeptidase P,[7-10] XPNPEP1 belongs to a new class of X-prolyl aminopeptidases, though they share the same catalytic activity.[3]

BIOLOGICAL FUNCTION

The activity of X-prolyl aminopeptidase is implicated in the degradation and maturation of many biologically active peptides, including coagulants, enzymes, growth factors, hormones, kinins, neurotransmitters, and toxins.[11] In particular, one biologically active peptide, the vasodilatory hormone bradykinin, is known to be directly regulated by mammalian X-prolyl aminopeptidases.[12] The X-prolyl aminopeptidases catalyze the first step in the degradation of bradykinin. Inhibition of human X-prolyl aminopeptidases

3D Structure Ribbon representation of the dimeric dinuclear manganese human cytosolic X-prolyl aminopeptidase (PDB code: 3CTZ). The two subunits are colored green and yellow, and the manganese ions are colored light grey. Structural pictures were prepared using PyMOL (DeLano Scientific, San Carlos, CA).

with the specific inhibitor apstatin can reduce the severity of myocardial infarction, and may be a promising cardio-vascular therapeutic method.[13–16] The XPNPEP1 enzyme is also able to metabolize bradykinin and other biologically active peptides and the dinuclear manganese active site is required for its catalytic activity.[2,3]

AMINO ACID SEQUENCE INFORMATION

XPNPEP1 consists of 623 amino acids (GenBank: CAG33203). Because of their similar catalytic activities and specificities, it had been suggested that XPNPEP1 and human membrane-bound X-prolyl aminopeptidase (XPNPEP2) are products of variant splicing of the same gene.[17] However, later cDNA cloning studies showed that the two X-prolyl aminopeptidases are encoded by genes of independent entities. The gene encoding XPNPEP1 was reported to sublocalize on chromosome 10q25.3.[18]

PROTEIN PRODUCTION AND PURIFICATION

Before recombinant enzymes were more routinely prepared, XPNPEP1 was originally extracted from various organs. In 1992, XPNPEP1 was reported to be purified from human mononuclear white cells. In that study, polyethylene glycol precipitation, diethylaminoethyl (DEAE) cellulose chromatography, and hydrophobic chromatography were performed for purification. For very high purity enzymes, a hydroxyapatite chromatography was also reported to be required.[1] Recombinant XPNPEP1 was also shown to be expressed in either eukaryotic or prokaryotic cells. In 2000, XPNPEP1 was both expressed in COS-1 (CV-1 (simian) in Origin, and carrying the SV40 genetic material) cells, similar to the eukaryotic expression of XPNPEP2,[19] and *E. coli* as a C-terminal hexahistidine tagged protein. Ni–NTA (nitrilotriacetic acid) affinity chromatography on the enzyme expressed from either source yielded purified XPNPEP1.[2]

For crystallization quality *E. coli* expressed recombinant XPNPEP1, an anion ion exchange chromatography step is normally required, in addition to the Ni–NTA affinity chromatography step. Notably, since XPNPEP1 is a dinuclear manganese enzyme, a large amount of additional manganese chloride should be added to the Luria–Bertani (LB) media to prevent manganese ion depletion when expressed in *E. coli*.

MOLECULAR CHARACTERIZATION

The molecular weight of each XPNPEP1 monomer is about 70 kDa as determined by denatured gel electrophoresis.[1] Under nondenaturing conditions, XPNPEP1 exists as a dimer with molecular weight of 140 kDa, as can be demonstrated by either size-exclusion high-performance liquid chromatography (HPLC)[1] or analytical ultra-centrifugation.[3] Compared to the well-characterized *E. coli* aminopeptidase P, the molecular weight of XPNPEP1 is significantly larger. Structural analysis of XPNPEP1 showed that the enzyme uniquely contains three domains, rather than two domains as in other X-prolyl aminopep-tidases with known stuctures.[3] Sequence alignment of the catalytic domain regions of XPNPEP1 and XPNPEP2 and other X-prolyl peptidases (*E. coli* aminopeptidase P, proli-dase from *Pyrococcus furiosus*, prolidase from *Pyrococcus horikoshii* OT3, and human prolidase) with known struc-tures revealed only 11% identity and 38% similarity, though the residues for chelating metal ions are absolutely conserved.

METAL CONTENT

XPNPEP1 used to be considered as a single Mn(II) dependent enzyme.[2] Recent studies have clarified that the enzyme actually contains two metal ions in each monomer. Together with activity studies, only manganese and no other metal ions were shown to be required for the activity of XPNPEP1,[2,3] and therefore the enzyme was confirmed as double Mn(II) dependent. A recent study showed that purified recombinant XPNPEP1 contains 1.79 mol M manganese ions per molar protein, as determined by inductively coupled plasma mass spectrometry (ICP-MS).[3] Interestingly, recombinant XPNPEP1 may also chelate iron or magnesium ions under depleted manganese conditions, but this portion of the enzyme shows much lower activity than with sufficient manganese ions.

ACTIVITY AND INHIBITION TEST

Classically, the activity assay performed for XPNPEP1 relies on the measurement of the quantity of the substrate and products. A most classical method to monitor the amount of substrate and product is to use reverse-phase HPLC.[2,12,19] This method is quite slow and arduous. An alternative method for activity assay is to use a *o*-phthalaldehyde, 2-mercaptoethanol reagent fluorescence assay.[3,20–22] *o*-Phthalaldehyde is able to inter-react with both the substrate and amino acid product, but with much higher fluorescent yield of the free amino acid product compared to the peptide substrate. By adding *o*-phthalaldehyde, 2-mercaptoethanol reagent to the termi-nated enzyme reaction system and measuring the fluo-rescence, the enzyme activity can be rapidly calculated. Recently, a highly efficient method was developed for assaying the activity of X-prolyl aminopeptidases by using an internally quenched peptide substrate.[9,23] The substrate peptide is fused with a fluorogenic group and its quencher of fluorescence at the N- and C-terminals, respectively.

With the activity of the enzymes, the fluorogenic group can be released from the quencher and fluorescence can be detected. Examining the fluorescence intensity will lead to the resultant enzyme activity.

Regarding substrate preference, XPNPEP1 shows different catalytic activity toward peptides with proline in the penultimate position, but of different sequences and lengths. Bradykinin is usually used as a standard peptide substrate for activity assays. Although XPNPEP1 recognizes the penultimate proline in a peptide, polyproline is not hydrolysable, and the penultimate proline is not replaceable by hydroxyproline. Xaa–Pro dipeptides can be cleaved by the enzyme, although at a slower rate than longer peptides.[1]

Inhibitors of XPNPEP1 were evaluated by incubating the enzyme on ice with different compounds for 30 min before activity assays were performed.[2] The chelating agents ethylenediaminetetraacetic acid (EDTA) and 1,10-phenanthroline were both identified to be able to inhibit the enzyme. However, even at a concentration of 1 mM, EDTA caused only 49% inhibition, while 1,10-phenanthroline completely inhibited XPNPEP1 at a concentration of only 100 μM. The specific X-prolyl aminopeptidase inhibitor apstatin also completely inhibited the hydrolysis of bradykinin at 100 μM.

X-RAY STRUCTURE

Crystallization

Initial XPNPEP1 crystals were yielded from the Crystal Screen kit (Hampton Research, Aliso Viejo, CA) by

Figure 1 Ribbon representation and topology of the XPNPEP1 subunit. (a) Ribbon representation of the XPNPEP1 monomer (PDB code: 3CTZ). Domain I, II, and III are colored yellow, green, and blue, respectively. (b, c, d) topology diagram for domain I, II, and III, respectively. Secondary structure elements in each domain are defined in reference 3.

the hanging-drop vapor-diffusion method. The optimized reservoir solution for 1.6 Å resolution diffracting crystals contained 20% (v/v) polyethylene glycol (PEG) 400, 0.15 M CaCl₂, and 100 mM 4-(2-hydroxyethyl)-1-piperazineethanesulfonic acid (HEPES), pH 7.5. Notably, low concentrations of calcium chloride caused crystals to become twinned. A typical hanging drop consisted of 2 μL of protein solution (20 mg mL⁻¹) mixed with 2 μL of the reservoir solution. The growth of the crystals required a constant temperature of 16 °C for the duration of 1 week. The crystals were block or rod shaped and large (over 0.5 mm). Although the enzyme contains metal ions, the crystals were colorless. Selenomethionyl-labeled protein crystallized under near-identical conditions as described for the wild-type protein, with the only difference being a longer duration for crystal growth.

Diffraction data analysis showed that the XPNPEP1 crystallized with an orthorhombic lattice in space group C222₁ and the following unit cell parameters; $a = 71.4$ Å, $b = 131.4$ Å, $c = 169.1$ Å, $\alpha = \beta = \gamma = 90°$. XPNPEP1 crystallized with one molecule per asymmetric unit.

Overall description of XPNPEP1

To date, besides XPNPEP1, several structures of X-prolyl aminopeptidases or prolidases have been determined. Although they all share a similar C-terminal domain and conserved active site, XPNPEP1 uniquely consists of three domains rather than the two observed for other X-prolyl aminopeptidases/prolidases. Furthermore, XPNPEP1 forms a novel dimer. The overall structure of the XPNPEP1 monomer is a relatively large 'C'-shaped molecule with dimensions of about 70 Å long, 60 Å wide, and 35 Å high. The XPNPEP1 dimer is formed by the lengthways stacking of two 'C'-shaped monomers such that the height of the dimer is twice that of the monomer. When stacked to form a dimer, the mouths of each monomer face opposite directions. (3D structure).

The crystal structure of the XPNPEP1 monomer includes an N-terminal domain (domain I, residues 1–161), a middle domain (domain II, residues 162–322), and a C-terminal domain (domain III, residues 323–623) as shown in Figure 1(a). Domain I is composed of a six-stranded (β1–β6) mixed β-sheet flanked by six α-helices (α1–α6). The topological order of the β-sheet is β4-β3-β2-β1-β5-β6, where strand β2 points in the direction opposite to the rest. Four of the helices (α1, α2, α3, and α6) are localized on one side of the β-sheet, and the remaining two (α4 and α5) on the other (Figure 1(b)). The structure of domain II is similar to that of domain I, as shown in Figure 1(c) and Figure 2(a). In domain II, on taking off the linking region to domain I, the remainder is also made up of a six-stranded (strands β8 and β10–β14) mixed β-sheet flanked by six α-helices (helices α8–α13). The topological order of each secondary structure in this portion is the same as that of domain I. The linking region only consists of a short α-helix (α7) and forms a small antiparallel β-sheet (β7 and β9) with the peptide region between β8 and β10 (Figure 1(c), boxed region). Domain III exhibits a conserved 'pita-bread' fold as observed in other X-prolyl aminopeptidases, prolidases, methionine aminopeptidases, and creatinase.[3,24–28] The domain contains one strongly curved five-stranded antiparallel β-sheet (sheet I, β16-β17-β20-β26-β25), and two additional antiparallel β-sheets (sheet II, β15-β18-β19, and sheet III, β23-β22-β24-β27-β28-β21). On the outer face of the three sheets lie six α-helices (α14–α19). Of these, helices α14–α17 are oriented roughly parallel to the strands in sheet I, and α18 and α19 are near-perpendicular to the former helices. Strands α27 and α28 form a short hairpin structure that protrudes from the core (Figure 1(d)).

In the homodimer, the two XPNPEP1 molecules interact primarily through hydrophobic interactions. The hydrophobic residues include Tyr439, Phe459, Pro460, Leu468, Phe471, Trp477, Leu481, Leu484, Tyr526, Tyr549, and Phe551. These residues form a hydrophobic belt around each XPNPEP1 molecule, and the two belts

(a) (b) (c)

Figure 2 Domain comparison. (a) comparison of domain I (yellow) and domain II (green) from XPNPEP1 (PDB code: 3CTZ). (b) Comparison of domain I (yellow) from XPNPEP1 and the N-terminal domains from *E. coli* aminopeptidase P (green, PDB code: 1A16) and human prolidase (blue, PDB code: 2iw2). (c) Comparison of domain I (yellow) from XPNPEP1 and the N-terminal domains from *P. furiosus* (green, PDB code: 1pv9) and *P. horikoshii* OT3 (blue, PDB code: 1wy2).

contact each other via a dyad symmetry relationship in the homodimer. Among the residues listed above, Trp477 plays a vital role in dimerization. Mutating this tryptophan to a charged glutamate residue abolishes the capability of the enzyme to form a native dimer.[3] Besides hydrophobic interactions, there are also hydrogen bonds and charged interactions that help to stabilize the dimer interaction. Glu442 and Tyr549 from each molecule form two hydrogen bonds. Leu467 and Ser470 from the two subunits form another two hydrogen bonds. Glu442 and Lys548 and their symmetric counterparts yield two salt bridges. All of the residues involved in the dimer interactions are localized in domain III. Approximately 1600Å^2 of the solvent-accessible surface area from each subunit is buried upon dimer formation.

Dinuclear manganese active site structure

The carboxylate-bridged dinuclear manganese active site is located in the inner (concave) surface of the curved β-sheets of domain III. According to the distances between electron donor atoms and the metal ions, the two Mn^{2+} ions are speculated to be coordinated by four acidic residues (Asp415, Asp426, Glu523, and Glu537), one basic residue (His489), and three water molecules, as shown in Figure 3 and Table 1. The two Mn^{2+} ions show different coordination numbers. As shown in Figure 3, the coordination number of Mn1 is 5, while the coordination number of Mn2 is 6. Water molecule W1 and the carboxylate groups of Asp426 and Glu537 act as bridges between the two Mn^{2+} ions. Besides the bridging residues or water molecules, Mn2 is additionally coordinated by Glu523, His489, and the water molecule W3. The coordinating ligands for Mn1 form an approximate trigonal bipyramidal coordination geometry, with the Oδ1 atoms of the two aspartate residues (Asp415 and Asp426) and W1

Figure 3 Dinuclear manganese active site of XPNPEP (PDB code: 3CTZ). Residues are colored by atom type (carbon in green, oxygen in red, and nitrogen in blue). Mn^{2+} ions and water molecules are shown as gray and red spheres, respectively. Coordination bonds are presented in pink broken lines.

in the equatorial plane, and the Oε1 atom of the glutamate residue (Glu537) and W2 on the axis. The coordination sphere of Mn2 forms a distorted octahedral coordination geometry, with the Oδ2 atom of Asp426, the Oε2 atoms of Glu523 and Glu537, Nε-2 atom of residue His489, and two water molecules (W1 and W3) acting as the vertexes. All residues involved in metal coordination, as well as their 3D structures, are thoroughly conserved in X-prolyl aminopeptidases and prolidases, suggesting the importance of the active site metal coordination geometries. In the study of *E. coli* aminopeptidase P, which shares the same active site structure with XPNPEP1, mutating any of the manganese-coordinating residues can cause a complete loss of catalytic activity.[9]

Table 1 Coordination bond distances in the dinuclear manganese active site of the 1.6 Å resolution XPNPEP1 structure (PDB code: 3CTZ)

Atom	Atom/residue	Distance (Å)
Mn1	Oδ1, Asp415	2.15
Mn1	Oδ1, Asp426	2.14
Mn1	Oε1, Glu537	2.19
Mn1	W1	2.23
Mn1	W2	2.27
Mn2	Oδ2, Asp426	2.37
Mn2	Oε2, Glu537	2.26
Mn2	Oε2, Glu523	2.27
Mn2	Nε2, His489	2.27
Mn2	W1	2.31
Mn2	W3	2.17

In the outer shell of the XPNPEP1 metal coordination site, there also lie three important histidine residues: His395, His485, and His498. These three imidazole-containing residues are also conserved among the X-prolyl peptidases. Notably, in the study of the catalytic mechanism of *E. coli* aminopeptidase P, mutating His361 (equivalent to His498 in XPNPEP1) to alanine led to the loss of a water molecule, which is equivalent to W3 in XPNPEP1.[9] This observation, together with structural evidence that the distance between the water molecule and the Nε2 atom of His361 (2.53 Å) is smaller than that between the water molecule and the metal ion (2.84 Å), suggests that the solvent molecule only forms a hydrogen bond with His361 but does not coordinate a metal ion in *E. coli* aminopeptidase P. However, in the structure of XPNPEP1, the distance between W3 and the metal ion (2.17 Å) is much smaller than that between W3 and the Nε2 atom of His498 (2.66 Å), suggesting that although no structure of XPNPEP1 with a His498 mutation is available, the water molecule W3 is still more likely to coordinate with Mn2 in XPNPEP1 rather than be localized merely by a hydrogen bond in substrate-free state. Mutation of any of the three equivalent histidine residues in *E. coli* aminopeptidase P also stripped the enzyme of its activity.[9] These data provide evidence for the importance of His395, His485, and His498 in XPNPEP1.

Figure 4 Proposed catalytic mechanism for XPNPEP1.

CATALYTIC MECHANISM

Several similar mechanisms have been proposed for the 'pita-bread' metalloenzymes aminopeptidase P and metalloaminopeptidases.[7,9,26,28] Of these, the mechanism of *E. coli* aminopeptidase P has been extensively studied via detailed mutagenesis and structural analysis.[9] On the basis of the almost identical dinuclear manganese active site structure between XPNPEP1 and *E. coli* aminopeptidase P, and their common substrate selectivity, XPNPEP1 was proposed to share a similar catalytic mechanism with *E. coli* aminopeptidase P, as shown in Figure 4. In the process of removing the Xaa from a substrate Xaa–Pro-peptide, His485, and Arg535 form a hydrophobic pocket, which allows the penultimate proline residue in the substrate to bind in, thus localizing the substrate in a suitable orientation for catalysis. Although the position of His395 in substrate-free XPNPEP1 is only slightly different from the equivalent His243 in *E. coli* aminopeptidase P, the role of this histidine residue was still understood to be the same as its counterpart when XPNPEP1 binds with a substrate.[3] The $N_{\varepsilon}2$ atom of residue His395 was considered to form a hydrogen bond with the oxygen atom of the penultimate

proline residue of the substrate, which helps to stabilize the substrate complex. The amino group of the Xaa residue in the substrate takes the place of solvent molecule W2 (as shown in Figure 3) and coordinates to Mn1, which is localized by Asp415, Asp426, and Glu537. The carbonyl oxygen atom of the substrate Xaa residue, taking the place of the W3 molecule, binds to Mn2, which is localized by Asp426, His489, Glu523, and Glu537. Thus the carbonyl bond is polarized and facilitates nucleophilic attack. Glu523, not only coordinates to Mn2 but also abstracts a proton from the bridging water molecule W1, thus initiating a nucleophilic attack on the carbonyl bond mentioned above. The conserved His498 residue is proposed to stabilize the gem-diol intermediate that is formed following the nucleophilic attack.[7,29] This histidine residue has also been implicated in modulation of the Lewis acidity of the active site metal(s).[27] Glu41, whose side chain forms a hydrogen bond with the $N_{\delta}1$ atom of His498, was considered to stabilize the orientation of the imidazole ring but was demonstrated to play only a negligible role in catalysis.[3] In the final step of catalysis, collapse of this intermediate to products is facilitated by donation of the abstracted proton from Glu523 to the propeptide amine leaving group.

Figure 5 Overall structural comparison of XPNPEP1 (PDB code: 3CTZ), *E. coli* aminopeptidase P (PDB code: 1A16), prolidase from *P. furiosus* (PDB code: 1PV9), prolidase from *P. horikoshii* OT3 (PDB code: 1WY2), and human prolidase (PDB code: 2iw2). (a) Subunit comparison. (b) Dimer comparison. The two subunits are colored in green and yellow, respectively. In (a) and the upper panel of (b), the catalytic domains in the green subunits are all oriented the same way. The catalytic domains of the five green subunits in (b) lower panel are oriented the same way. The five structures from left to right are XPNPEP1, *E. coli* aminopeptidase P, prolidase from *P. furiosus*, prolidase from *P. horikoshii* OT3, and human prolidase.

COMPARISON WITH RELATED STRUCTURES

Monomer comparison

Although XPNPEP1 shares a conserved catalytic C-terminal domain with 'pita-bread' fold and active site with other X-prolyl aminopeptidases and prolidases, it was identified as a member of a new class of X-prolyl peptidases by its overall structure.[3] Unlike all other X-prolyl peptidases with known structure that contain two domains (an N-terminal domain and a C-terminal domain) in each monomer, XPNPEP1 is unique in containing three domains (domain I, domain II, and domain III) in each monomer (Figure 1). Comparing the structure of XPNPEP1 monomer with the subunits of the other X-prolyl peptidases, domain II and domain III of XPNPEP1 are equivalent to the N-terminal domain and C-terminal domain, respectively, in the previously reported X-prolyl peptidase structures (Figure 5(a)). However, XPNPEP1 has an additional N-terminal domain, domain I. In domain I, the only residue that is close to the active site is Glu41, which forms a hydrogen bond with the active site residue His498 in the same subunit. However, evidence has shown that this residue is not important for catalysis,[3] so there is no evidence to support that domain I directly participates in catalysis. However, domain I truncation experiments demonstrated the importance of the domain.[3] Putting the evidence together, domain I

was considered to play a structural role in XPNPEP1 rather than contributing anything directly toward catalysis. Comparing the XPNPEP1 subunit and the dimers of the other X-prolyl peptidases, the position of domain I of XPNPEP1 is comparable with the positions of neighboring N-terminal domains in the two-domain X-prolyl peptidase dimers, and is particularly similar to the two prolidases from archaeobacteria species (Figure 5(a) and 5(b), upper panel). Further superposition of domain I and the N-terminal domains of other X-prolyl peptidase revealed structural and topological similarity (Figure 2(b) and (c)), suggesting similar functions. Combined with evidence that the structures of domain I and domain II in XPNPEP1 are similar, domain I and domain II can be considered as two repetitive domains. On the basis of the fact that the two domains are related by a rotation of 150°, which is close to the dyad symmetry relationship displayed between the two N-terminal domains in the two-domain X-prolyl peptidase dimers, it was speculated that the role of domain I in XPNPEP1 is to mimic the neighboring N-terminal domains in two-domain X-prolyl peptidases dimers, so that the enzyme can maintain its active site pocket.[3]

Dimer comparison

All of the known X-prolyl peptidases, including XPNPEP1,[2,3] are able to form symmetrical homodimers.[7,20,30–32]

Some can even form tetramers[7,20,31] or predicted trimers.[5] However, comparing the XPNPEP1 dimer and the dimers of the other X-prolyl peptidases reveals significant structural differences (Figure 5(b)). As previously described, the XPNPEP1 homodimer is composed of two 'C'-shaped subunits. In the homodimer, the planes of the two 'C'-shaped molecules are arranged parallel to each other. In the homodimers of other X-prolyl peptidases, however, the two subunits are nearly perpendicular to each other (Figure 5(b)). These two different modes of dimer interaction result in significant differences between the entrances of their respective active site pockets. In the homodimers of the two-domain X-prolyl peptidases, each active site pocket is directly open toward the solvent. In the XPNPEP1 dimer, the active site pocket in each protomer is opened toward the neighboring protomer (as shown in Figure 5(b), lower panel, all of the active site pockets of the green subunits are opened to the right side). Thus, in the case of XPNPEP1, the peptide substrate cannot easily access the active site, as in the cases of other two-domain X-prolyl peptidases. This feature of XPNPEP1 was predicted to be linked with its substrate selectivity. An experiment in which XPNPEP1 exhibited a K_m for bradykinin almost fourfold lower than the K_m for the N-terminal tripeptide of bradykinin (Arg-Pro-Pro), which should be more efficient in diffusion, provided hints that the stronger binding for the longer peptide substrate may be linked with additional binding sites in XPNPEP1 that help the N-terminus of the bradykinin to access the active site.[3]

Besides the role in substrate selectivity, the dimerization of XPNPEP1 was also speculated to play a structural stabilization role. Structural comparison between an XPNPEP1 subunit and other X-prolyl peptidase dimers suggests an isolated XPNPEP1 subunit should have full activity (Figure 5), or even higher activity since the active site becomes more accessible. However a dimer-blocking mutant of XPNPEP1, W477E, was reported to have little catalytic activity, indicating the importance of dimerization. Since there is no structural evidence that dimerization directly participates in catalysis, a possible explanation is that the dimerization of XPNPEP1 stabilizes the organization of the three domains in each subunit.

Although the role of the additional N-terminal domain and the novel dimeric organization of XPNPEP1 have not thoroughly been elucidated, the unique features of the enzyme make it the first member of a new class of X-prolyl peptidases bearing a dinuclear metal active site.

REFERENCES

1　I Rusu and A Yaron, *Eur J Biochem*, **210**, 93–100 (1992).

2　GS Cottrell, NM Hooper and AJ Turner, *Biochemistry*, **39**, 15121–28 (2000).

3　X Li, Z Lou, X Li, W Zhou, M Ma, Y Cao, Y Geng, M Bartlam, XC Zhang and Z Rao, *J Biol Chem*, **283**, 22858–66 (2008).

4　G Vanhoof, I De Meester, F Goossens, D Hendriks, S Scharpe and A Yaron, *Biochem Pharmacol*, **44**, 479–87 (1992).

5　HT Harbeck and R Mentlein, *Eur J Biochem*, **198**, 451–58 (1991).

6　L Gilmartin and G O'Cuinn, *Neurosci Res*, **34**, 1–11 (1999).

7　MC Wilce, CS Bond, NE Dixon, HC Freeman, JM Guss, PE Lilley and JA Wilce, *Proc Natl Acad Sci U S A*, **95**, 3472–77 (1998).

8　SC Graham, MJ Maher, WH Simmons, HC Freeman and JM Guss, *Acta Crystallogr D Biol Crystallogr*, **60**, 1770–79 (2004).

9　SC Graham, PE Lilley, M Lee, PM Schaeffer, AV Kralicek, NE Dixon and JM Guss, *Biochemistry*, **45**, 964–75 (2006).

10　SC Graham and JM Guss, *Arch Biochem Biophys*, **469**, 200–8 (2008).

11　A Yaron, *Biopolymers*, **26**, S215–22 (1987).

12　GS Lloyd, J Hryszko, NM Hooper and AJ Turner, *Biochem Pharmacol*, **52**, 229–36 (1996).

13　C Ersahin, DE Euler and WH Simmons, *J Cardiovasc Pharmacol*, **34**, 604–11 (1999).

14　S Kitamura, LA Carbini, WH Simmons and AG Scicli, *Am J Physiol*, **276**, H1664–71 (1999).

15　MM Prechel, AT Orawski, LL Maggiora and WH Simmons, *J Pharmacol Exp Ther*, **275**, 1136–42 (1995).

16　S Wolfrum, G Richardt, P Dominiak, HA Katus and A Dendorfer, *Br J Pharmacol*, **134**, 370–74 (2001).

17　RC Venema, H Ju, R Zou, VJ Venema and JW Ryan, *Biochim Biophys Acta*, **1354**, 45–48 (1997).

18　TJ Sprinkle, C Caldwell and JW Ryan, *Arch Biochem Biophys*, **378**, 51–56 (2000).

19　RJ Hyde, NM Hooper and AJ Turner, *Biochem J*, **319**, 197–201 (1996).

20　WH Simmons and AT Orawski, *J Biol Chem*, **267**, 4897–903 (1992).

21　S Taylor and AL Tappel, *Anal Biochem*, **56**, 140–48 (1973).

22　M Roth, *Anal Chem*, **43**, 880–82 (1971).

23　A Stockel-Maschek, B Stiebitz, R Koelsch and K Neubert, *Anal Biochem*, **322**, 60–67 (2003).

24　JF Bazan, LH Weaver, SL Roderick, R Huber and BW Matthews, *Proc Natl Acad Sci U S A*, **91**, 2473–77 (1994).

25　WT Lowther and BW Matthews, *Biochim Biophys Acta*, **1477**, 157–67 (2000).

26　WT Lowther and BW Matthews, *Chem Rev*, **102**, 4581–608 (2002).

27　AJ Copik, SI Swierczek, WT Lowther, M D'souza, BW Matthews and RC Holz, *Biochemistry*, **42**, 6283–92 (2003).

28　AJ Copik, BP Nocek, SI Swierczek, S Ruebush, SB Jang, L Meng, M D'souza, JW Peters, B Bennett and RC Holz, *Biochemistry*, **44**, 121–29 (2005).

29　WT Lowther, Y Zhang, PB Sampson, JF Honek and BW Matthews, *Biochemistry*, **38**, 14810–19 (1999).

30　F Endo and I Matsuda, *Mol Biol Med*, **8**, 117–27 (1991).

31　T Yoshimoto, N Murayama, T Honda, H Tone and D Tsuru, *J Biochem*, **104**, 93–97 (1988).

32　MJ Maher, M Ghosh, AM Grunden, AL Menon, MW Adams, HC Freeman and JM Guss, *Biochemistry*, **43**, 2771–83 (2004).

The Mre11 nuclease complex

Karl-Peter Hopfner, Derk Bemeleit and Katja Lammens

Gene Center and Center for Integrated Protein Science, Department of Chemistry and Biochemistry,
Ludwig-Maximilians-University Munich, Feodor-Lynen-Str. 25, 81377 Munich, Germany

FUNCTIONAL CLASS

Mre11 (Meiotic recombination 11): Enzyme; metallo-dependent phosphatase; hydrolytic DNA single-strand endonuclease, hydrolytic DNA 3′->5′ exonuclease activity, and hydrolytic DNA hairpin opening activity. Manganese-dependent nuclease.

Rad50 (Radiation sensitivity 50): Enzyme (EC 3.6.1.3.); ATP binding cassette (ABC) type P-loop containing adenosine nucleoside triphosphate hydrolase, magnesium dependent. Additional forward and reverse adenylate kinase activity, magnesium dependent. Zinc dependent DNA tethering function (3D Structure).

OCCURRENCE

Homologs for Mre11 and Rad50 are found in all kingdoms of life[1] (Figure 1). In humans, the highest levels of Mre11 are found in proliferating tissues, but it is also detected in nonproliferating tissues.[2] Archaeal proteins are denoted as Mre11 and Rad50, whereas eubacterial homologs are known as SbcC (Rad50) and SbcD (Mre11).[3] The term 'Sbc' was introduced in 1970 where a set of genes which, when mutant, was suggested to suppress certain mutated recombination genes (*RecB* and *RecC*). Certain bacteriophages (T4 and T5)

3D Structure Schematic representation of the Mre11$_2$:Rad50$_2$ heterotetramer. Annotated ribbon models of three crystallized domains: the Rad50 ATPase domain (PDB code 1I8) is shown in yellow/orange; the Rad50 coiled-coil apex (PDB code 1I8d) is shown in yellow/orange with gray zinc ion; the Mre11 dimer (PDB code 1I7) is shown in light and dark blue with magenta manganese ions. Metal ions are depicted as spheres. Produced using the program PyMOL.[89]

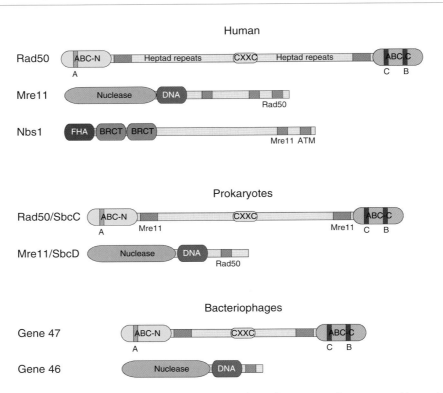

Figure 1 Domain structure of the Mre11, Rad50, and Nbs1 polypeptides in humans, prokaryotes, and bacteriophages with annotated known functional domains. Known binding sites for other subunits are shaded gray and annotated. Functional ATP binding motifs are: A: Walker A motif or P-loop; B: Walker B motif; C: signature or C motif.

that replicate by a recombination like replication initiation also contain Mre11 and Rad50 homologs, denoted gene 47 and gene 46, respectively.[4] The eukaryotic Mre11–Rad50 complex often contains a third polypeptide, which is denoted by X-ray radiation sensitivity (Xrs2) in *Saccharomyces cerevisiae* and Nijmegen breakage syndrome (Nbs1) in other eukaryotes. Nbs1 homologs are found in most but not all eukaryotic genomes. For instance, it is not detected in the microsporidium *Encephalitozoon cuniculi*. The *in vivo* function of the Mre11–Rad50–Nbs1/Xrs2 complexes have been studied in several organisms including *S. cerevisiae*,[5,6] *Schizosaccharomyces pombe*,[7,8] *Drosophila melanogaster*,[9] *Coprinus cinereus*,[10,11] *Caenorhabditis elegans*,[12,13] mice[14,15] as well as in human cells.[2,16,17] Prokaryotic SbcC and SbcD were analyzed in *Escherichia coli*,[18,19] *Deinococcus radiodurans*,[20] and *Bacillus subtilis*.[21] Biochemical data are available for *E. coli*[22,23] and *Pyrococcus furiosus* SbcC/Rad50 and SbcD/Mre11 proteins,[24,25] as well as yeast and human Mre11, Rad50, and Xrs2/NBS1 proteins and their complexes.[26–28] Furthermore, biochemical activities were analyzed in *Xenopus laevis* egg extracts.[29] While high-resolution structural information is up to now limited to archaeal Mre11 and Rad50 domains,[25,30–33] archaeal and eukaryotic complexes were analyzed by electron microscopy and atomic force microscopy.[30,31,34–36]

BIOLOGICAL FUNCTION

The eukaryotic Mre11–Rad50–Nbs1/Xrs2 complex is involved in most, if not all, aspects of the eukaryotic cellular response to DNA double-strand breaks (DSBs) and is a key factor in the maintenance of genome stability. It serves as one of the primary sensors for DNA DSBs[37] and is involved in pre-recombinational processing of DNA,[38–42] homologous recombination and meiosis,[43–48] nonhomologous end joining (NHEJ),[49–52] telomere maintenance,[53–58] and the DSB-activated cell cycle checkpoint response.[14,16,59–61] Null mutations in yeast are viable but defective for DSB repair, sporulation, chromosome pairing, formation and processing of DNA DSBs in meiosis, and recombination. Null mutations in vertebrates are embryonic lethal,[9,45,62,63] while hypomorphic mutations result in complete hematopoietic failure in mice and are linked to human cancer susceptibility syndromes such as Nbs1 and ataxia telangiectasia variant.[15,16,64–66] Current data suggest that the physiological complex contains two Mre11 polypeptides, two Rad50 polypeptides, and one or two Nbs1 polypeptides. The prokaryotic complex is involved in the repair of DNA DSBs, hairpin processing, and palindrome instability in *E. coli*, repair of cross-links in *B. subtilis*, and X-ray resistance in *D. radiodurans*.[19–21,67–69] A unifying mechanistic basis explaining these diverse functional implications still needs to be developed. However,

some of these multiple roles of the Mre11 complex can be attributed to its dual structural and nucleolytic activities (see below).

AMINO ACID SEQUENCE INFORMATION

Homo sapiens: Mre11: 708 amino acid residues AA (Swiss-Prot entry P49959); Rad50: 1312 AA (Q92878); NBS1: 754 AA (O60934).

Saccharomyces cerevisiae: Mre11: 692 AA (P32829); Rad50: 1312 AA (P12753); Xrs2: 854 AA (P33301).

Schizosaccharomyces pombe: Rad32 (Mre11 homolog): 649 AA (Q09683); Rad50: 1290 AA (Q9UTJ8); Nbs1: 613 AA (O43070).

Encephalitozoon cuniculi: Rad32 (Mre11 homolog): 567 AA (Q8SRV0); Rad50: 1247 AA (Q8SRK6).

Escherichia coli: SbcD (Mre11 homolog): 408 AA (P0AG76); SbcC (Rad50 homolog): 1048 AA (P13458).

Pyrococcus furiosus: Mre11: 426 AA (Q8U1N9); Rad50: 882 AA (P58301).

Bacteriophage T4: gene 46 (Rad50 homolog): 560 AA (P04522); gene 47 (Mre11 homolog): 339 AA (P04521).

PROTEIN PRODUCTION, PURIFICATION, AND CHARACTERIZATION

Biochemical and structural approaches typically use recombinant proteins. Owing to their low abundance, natively purified Mre11 and Rad50 are not generally used, but the human Mre11 complex purified from Burkitt's lymphoma cells is used.[40] Recombinant eubacterial SbcC and SbcD as well as archaeal Mre11 and Rad50 can be produced to substantial amounts by bicistronic coexpression of the corresponding genes from a single plasmid in *E. coli* BL21.[24,70] Cells are opened by sonication or high-pressure shearing, and protein purification typically includes an ammonium sulfate precipitation step to reduce bound nucleic acids. The complex is further purified by metal-chelate affinity chromatography step on nickel–nitrilotriacetic acid, utilizing an added 6xHis tag on one of the two polypeptides. Additional purification steps include ion exchange chromatography and gel filtration. Yeast Mre11 complex proteins can be obtained from *S. cerevisiae* overexpression systems.[71,72] Human Mre11, Rad50, and Nbs1 are produced in a baculovirus derived expression system in insect cells.[26,27,73]

In gel filtration, the Mre11–Rad50 or SbcC–SbcD complexes elute with an apparent hydrodynamic radius corresponding to a megadalton molecular weight, much larger than the anticipated molecular weight of an Mre11$_2$–Rad50$_2$ complex (~300 kDa for the archaeal complex). This large apparent hydrodynamic radius is due to the long, nonglobular coiled-coil domains of Rad50. Ultracentrifugation of SbcC–SbcD, however, resulted in a molecular weight of ~600 kDa, perhaps indicating hetero-octameric multimers.[70]

METAL CONTENT

Metal binding by the Mre11 complex is inferred from the requirement for different metal ions for the various enzymatic and structural activities. At least three different metal binding sites have been identified in the Mre11 complex. Mre11 requires manganese for its nucleolytic activities.[24,40,70,74] The manganese ions are directly involved in catalysis by coordinating ligand and hydrolytic water.[31] The P-loop ATPase domain of Rad50 contains a magnesium binding site.[32] Here, the magnesium ion coordinates β- and γ-phosphates of ATP and is critically involved in the ATP hydrolysis and adenylate kinase reactions. A second metal binding site in Rad50 is found at the apex of the coiled-coil domain. The physiological metal for this site is unclear, but its cysteine coordination cluster, as well as some biochemical data, argues for a zinc ion binding site.[29,30] In contrast with the manganese and magnesium binding sites, the site in the coiled-coil domain has not been associated with a catalytic activity but could be important in structural functions of the Mre11 complex in DNA cross-linking.

ACTIVITY ASSAYS

The Mre11 complex has several demonstrated biochemical activities. These are ATP hydrolysis and ATP-stimulated endo and exonuclease activities, a DNA cross-linking activity as well as an adenylate kinase activity. Biochemical approaches to study these activities include the following.

Nuclease assays

Mre11 is an endo- as well as an exonuclease. Latter requires or is stimulated by ATP. The endonuclease acts on single-strand (ss) DNA and hairpins, while the exonuclease degrades various types of double-strand (ds) DNA ends.[24,25,27,40,70,75] With the exception of gene products 46/47, the bacteriophage T4 homologs of Mre11 and Rad50, all Mre11 complexes assayed in these studies degrade dsDNA in the 3′->5′ direction. This proofreading-like nuclease activity argues that the Mre11 complex is not directly involved in the formation of 3′-tails in homologous recombination but is most likely involved in the processing of DNA secondary structures and misfolded DNA ends.[22,26,76–78] Furthermore, *E. coli* SbcCD, can

directly remove covalently attached proteins from DNA ends,[22] an activity that could explain the function of the Mre11 complex in the removal of covalently attached sporulation 11 (Spo11) from meiotic DSBs.[48,79,80] The processing of protein-bound DNA ends requires ATP and proceeds by introducing a DSB close to the end. It appears that the Mre11 complex can process virtually all types of DNA ends and hairpins in an ATP-stimulated manner, resulting in a clean 3'-OH for subsequent DNA synthesis steps in HR.

Nuclease activity assays are typically performed using DNA substrates, which have been marked with radioactive phosphate (end labeled by T4 polynucleotide kinase and γ^{32}-ATP). The degradation and cleavage products are separated by denaturing acrylamide gel electrophoresis and quantitated by phosphor imaging. This method allows assessing the precise site for endonucleolytic cleavage and hairpin opening. A different type of assay was based on fluorescence quenching. 2-Aminopurine (a fluorescent base analog that base-pairs with thymine) containing dsDNA oligonucleotides were exonucleolytically degraded by the archaeal Mre11–Rad50 complex in the presence and absence of ATP or 5'-adenylyl imidodiphosphate (AMP-PNP) (a nonhydrolyzable ATP analog).[31] The fluorescence of 2-aminopurine is quenched in the base-stacking context of DNA. Nucleolytic release results in a change of fluorescence intensity, which can be monitored in a spectrofluorometer ($\lambda_{ex} = 295$ and $\lambda_{em} = 335$). Latter method allows for a continuous measurement of activity. Using this method, it has been shown that both ATP and AMP-PNP stimulate exonuclease activity; thus, ATP binding, and not ATP hydrolysis, is critically required. Analysis of k_{cat} and K_m values for dsDNA cleavage by the Mre11 complex in the presence of ATP ($K_m = 4.7 \, \mu M$ (± 0.7); k_{cat} $0.0062 \, s^{-1}$ (± 0.0004)) or AMP-PNP ($K_m = 5.0 \, \mu M$ (± 0.6) and k_{cat} $0.0016 \, s^{-1}$ (± 0.0008)) suggest that ATP hydrolysis appears to accelerate k_{cat} without altering K_m.

ATP hydrolysis assays

ATP hydrolysis by the Rad50 ABC type ATPase domain is typically studied by analyzing hydrolysis products of γ-^{32}P containing ATP with a thin layer chromatography and phosphor imaging (for example, see references 81 and 82). This method is very sensitive, a required feature because the turnover number for ATP by Rad50 is very slow. One microliter of the hydrolysis reaction mixture is spotted on polyethyleneimine-(PEI-)cellulose plates. The plates are developed in 0.5 M LiCl and 1 M formic acid, dried, and analyzed by phosphor imager. Data from archaeal Rad50 show a rate of ATP hydrolysis around 0.1 min^{-1} indicating a switch rather than a motor function.[24,32] However, these data were obtained at subphysiological temperature. Yeast Rad50p had a $K_m = 1.1 \times 10^{-9}$ M and

$V_{max} = 1.8 \times 10^{-6} \, mol^{-1} \, l^{-1} \, min^{-1}$ for the ATP hydrolysis reaction.[83] The K_m for ATP of the human Mre11–Rad50 complex was 33 nM and its turnover number was 0.026 min^{-1}.[84] No substantial allosteric activator of this poor ATP hydrolysis activity has been identified; in particular, DNA had no activating effect. A different way to analyze ATP hydrolysis is on the basis of the photometric detection of liberated phosphate by malachite green.[85] The photometric analysis can be done in a standard spectrophotometer or microplate reader. Care needs to be taken to avoid phosphate in the preparations and more protein material is required compared to the radioactivity-based assays.

Adenylate kinase assays

Recently, adenylate kinase activity, associated with Rad50, has been observed.[28] In the reversible adenylate kinase activity, the γ-phosphate of ATP is transferred onto AMP, producing two ADP molecules. In contrast with ATP hydrolysis, this activity does not release free energy and is reversible. The reverse reaction produces ATP and AMP out of two ADP molecules. Adenylate kinase activity is, similar to ATP hydrolysis activity, often measured by using α- or γ-^{32}P-containing ATP. Educts and products are separated by thin layer chromatography and analyzed by phosphor imaging and image quantification. Adenylate kinase activity is abrogated by a signature motif mutation and is magnesium dependent, indicating that it involves active site motifs that are also important for the ATP hydrolysis activity.[28] Molecular details of the adenylate kinase activity need to be revealed. However, adenylate kinase activity has also been previously demonstrated for another ABC type ATPase, the cystic fibrosis transmembrane regulator (CFTR).[86] For both CFTR and Rad50, the requirement of an energy-dependent step in the form of ATP hydrolysis in the functional cycle is not clear.

DNA tethering assays

On the basis of the crystallographic and atomic force microscopic observation of a zinc-dependent joining of two Rad50 coiled-coil domains, a tethering assay was developed to follow cross-linking of DNA segments by Mre11 complexes in *Xenopus laevis* egg extracts.[29] In these assays, control extracts and Mre11-depleted extracts were incubated with ^{32}P-labeled 131-bp linear DNA fragments. The extracts were then applied onto a gel filtration column and the collected fragments analyzed by scintillation counting. In these assays, Mre11 was required for DNA to form large molecular weight assemblies. These assemblies can be precipitated by antibodies against Mre11 or against a biotin tag on the linear DNA fragments and therefore contain both components.

STRUCTURE OF THE COMPLEX

Our understanding of the functional architecture of the Mre11 complex is based on low-resolution electron and atomic force microscopies, and high-resolution X-ray crystal structures of several domains in different conformational states.

Electron microscopy and atomic force microscopy

The architectures of Mre11 complexes from all kingdoms of life were analyzed through electron microscopy and atomic force microscopy.[18,24,30,31] In the electron micrographic samples, rotary shadowing and negative stain techniques were applied to enhance the image contrast, and these images were at relatively low resolution. Up to now, cryoelectron microscopy and single particle reconstructions to obtain higher resolution images have not been done, perhaps because of the low contrast and flexibility of the complex. Atomic force microscopy allowed assessing flexibility of Mre11 complex domains, most prominently the Rad50 coiled-coil domains.[34,35,84] With this method, mesoscale conformational changes were detected upon interaction of the human Mre11 complex with DNA plasmids.[36]

For both methods, a distinct, biologically highly significant shape for the $Mre11_2–Rad50_2$ was observed. The complex consists of a globular 'head' with a diameter of $\sim 100\,\text{Å}$ and two tails with a length of $200–600\,\text{Å}$ (depending on organisms). Main features of this architecture are similar in pro and eukaryotes. The head is composed of two ATPase domains of Rad50 and an Mre11 nuclease dimer. The location of the eukaryotic Nbs1/Xrs2 subunit is still unclear, but since it interacts with Mre11, it is likely part of the head. The two tails of the macromolecular assembly are protruding coiled-coil domains for each of the two Rad50 subunits. The apices of these coiled-coil domains contain a zinc-binding site, a key functional motif that is important for higher oligomer formation and DNA cross-linking of the Mre11 complex.

Higher oligomers of Mre11 complexes are frequently found in electron micrographs and atomic force images, and two modes of oligomer formation have been detected.[30,36] A clustering and aggregation of the complex are observed at DNA ends in atomic force images. The molecular and mechanistic natures of this clustering are unclear. Upon addition of zinc, specific and distinct heterooctameric $Mre11_2–Rad50_2:Mre11_2–Rad50_2$ complexes are formed.[30] In this particular architecture, coiled coils from two different $Mre11_2–Rad50_2$ complexes are joined by zinc-mediated hook association (intermolecular joining). This zinc hook intramolecular joining of two $Mre11_2–Rad50_2$ complexes is associated with DNA binding and involves a conformational change, resulting in a more parallel orientation of the two coiled-coil domains.[36]

In the absence of DNA, atomic force images often show an intramolecular joining, i.e. the apices of both coiled coils of a single $Mre11_2–Rad50_2$ complex are joined in a ring-like structure. The biological function of these two conformational forms is unclear but may have implications in DNA tethering.

X-RAY STRUCTURES

The Mre11 nuclease

The catalytic nuclease domain of Mre11 from the hyperthermophile *P. furiosus* was crystallized in space group $P2_12_12_1$ with cell dimensions $a = 72.9$, $b = 87.0$, $c = 146.4\,\text{Å}$ and two molecules in the asymmetric unit at $4\,°C$ in $100\,\text{mM}$ 2-(*N*-cyclohexylamino)ethane sulfonic acid (CHES) (pH 9.5), $400\,\text{mM}$ ammonium sulfate, and 35% polyethylene glycol (PEG). Its structure was determined by multiple anomalous diffraction phasing to $2.6\,\text{Å}$ resolution.[31] A complex with deoxy-adenosine monophosphate (dAMP represents a product of an exonucleolytically cleaved DNA end) and manganese was determined to $2.1\,\text{Å}$ resolution. This Mre11 structure comprised residues 1–342 and lacked 82 C-terminal residues, which did not affect endonucleolytic activity but contained a Rad50 binding site. The crystal form contained an Mre11 dimer in the asymmetric unit, consistent with Mre11–Mre11 interactions in yeast two-hybrid experiments, as well as particle sizes in electron micrographs and atomic force micrographs.

The Mre11 comprises two domains that interact near the active site (Figure 2). Domain I has two central parallel mixed β-sheets flanked by several α-helices. It possesses five conserved phosphodiesterase motifs, which form the nuclease active site.[87,88] The phosphodiesterase motifs are situated in loops connecting the core β-strands with their flanking α-helices and place the active site at the center of a shallow surface depression on domain I. Domain I in fold and active site location resembles the catalytic domain of calcineurin like Ser/Thr phosphatases (Figure 2(a)). Mre11 tightly coordinates two Mn^{2+} ions, closely resembling the di-metal (Fe/Zn) binding motifs of Ser/Thr phosphatases. Domain II, which consists of a five-stranded β-sheet and two α-helices, may play a role in DNA binding.

Two Mn^{2+} ions are octahedrally coordinated by seven conserved residues of the phosphodiesterase motifs (Asp8, His10, Asp49, Asn84, His173, His206, and His208) and by a bridging water molecule (Figure 2(b)). Soaking *P. furiosus* Mn^{2+}-Mre11 with dAMP shows that the two manganese ions coordinate the phosphate moiety, which is also liganded to Asn84 and His85.[31] Analysis of a mutant derivative (H85L) confirmed the importance of this residue for the catalysis.[25] The double coordination of the dAMP phosphate by both active site metals resembles the binding of phosphorylated protein residues in Ser/Thr phosphatases.

Figure 2 (a) Comparison of the two-domain structure of the catalytic nuclease fragment of *P. furiosus* Mre11 (PDB code 1II7) with calcineurin protein phosphatase (PDB code 2P6B). Metals (magenta spheres) and coordinating residues (orange) are shown as sticks. (b) Stereo image of the active site of *P. furiosus* Mre11 (color-coded sticks) with bound manganese (magenta spheres), phosphate (PO$_4$), and annotated coordination residues. Metal–ligand distances are indicated in angstrom. (c) Proposed nuclease mechanism. Metal coordinates the attacking hydroxide (red). His52 and His85 could stabilize the negative charge of the transition state and donate a proton for the leaving group in catalysis. Structure figures were produced using the program PyMOL.[89]

From interaction studies with dAMP as well as from biochemical data, it is likely that Mre11 cleaves the sugar-3'-O-phosphate bond of DNA. The conserved phosphodiesterase residue His85 is critical for catalysis[25,87] and arguably acts in transition state stabilization possibly by donating a proton to the leaving DNA 3'-OH. The protonated state of His85 is probably stabilized through a charge relay system with the adjacent and conserved His52. Mn^{2+} ion number 1 in Figure 3 likely binds the attacking hydroxide ion as proposed for protein phosphatases.[90] Collinear nucleophilic attack of the phosphoester by this hydroxide would result in the crystallographically observed product with both Mn^{2+} ions coordinating the dAMP phosphate.

The active site of Mre11 is situated in a shallow groove. Without significant conformational changes in either protein or dsDNA, normal duplex DNA cannot reach the metal ions. This steric exclusion may be a structural mechanism to prevent endonucleolytic cleavage of DNA duplexes. DNA ends, single-stranded DNA as well

as hairpins might reach the active site metals, explaining the suitability as substrates. The precise mode of interaction of Mre11 with different DNA substrates as well as the mechanism of cleavage requires further experiments.

The Rad50 ATPase

For structural studies on Rad50, it was necessary to truncate the long, flexible coiled-coil insertion and coexpress the coding sequences for the N- and C-terminal part of the bipartite ATPase domain.[32] Three crystal structures along with a derivative are available of the ATPase domain of Rad50: a 1.5-Å resolution structure of ATPase domain without any coiled coil.[32] A 3.0-Å resolution structure with a ~70 amino acid long coiled-coil fragment that contains the Mre11 binding site,[31] a 2.1-Å resolution structure of the ATPase domain in the dimeric ATP-bound form,[31] and a signature motif mutation of the ATPase domain.[33]

Figure 3 Mechanism of ATP hydrolosis by the ABC ATPase Rad50. (a) ATP binding engages two Rad50 ABC ATPase domains (orange *N*-terminal segment and yellow *C*-terminal segment) and is sandwiched in the Rad50–Rad50 dimer interface by binding to opposing P-loop and signature motifs. Disengagement is promoted by ATP hydrolysis. This functional cycle drives the powerstroke of ABC ATPases in general, including ABC transporters. (b) Stereo image of the active site shown as zoom into the 'right' active site of the right panel in (a) of the *P. furiosus* Rad50 ATPase dimer (color-coded sticks) with sandwiched ATP molecule (cyan), bound magnesium (gray sphere). Selected active residues and water molecules are shown as ball and sticks and annotated. Metal–ligand distances are indicated in angstrom. (c) Model for the hydrolysis reaction with highlighted selected motifs. P-loop and signature motifs are located at the *N*-terminus of long α-helices, which may contribute a partial positive charge to compensate the negative charges on phosphates. Structure figures were produced using the program PyMOL.[89]

Cosynthesized *P. furious* Rad50 residues 1–152 (N-terminal half ATPase) and residues 735–882 (C-terminal half ATPase) resulted in a stable domain with two copurifying polypeptide chains that possesses magnesium-dependent ATP hydrolysis activity.[32] The Rad50 ATPase was crystallized in space group $P2_12_12_1$ with cell dimensions $a = 66.6$, $b = 67.1$, and $c = 70.1\,\text{Å}$ by sitting drop vapor diffusion in 200 mM ammonium acetate, 50 mM cacodylate (pH 6.5), 10 mM $MgCl_2$, and 10% PEG4000. Experimental phases to 2.0 Å were obtained by multiple isomorphous replacement and anomalous scattering (MIRAS). The final structure was determined to 1.5 Å resolution. AMP-PNP- and Mg^{2+}-bound Rad50cd was crystallized in space group $P2_12_12_1$ with cell dimensions $a = 79.9$, $b = 82.6$, and $c = 106.0\,\text{Å}$, and two molecules in the asymmetric unit by the sitting drop method by adding 2.5 mM ATP or 2.5 mM AMP-PNP plus 10 mM $MgCl_2$ to the Rad50 ATPase domain. Crystals formed in 0.1 M 4-(2-hydroxyethyl)-piperazine-1-ethane sulfonic acid (pH 7.5), 17% PEG 3350, 8.5% isopropanol, and 15% glycerol and diffracted to 2.1-Å resolution.

The ATPase domain of Rad50 has overall dimensions of $70 \times 40 \times 25\,\text{Å}$, formed by two lobes that fold into a single ellipsoidal domain with convex and concave sides (Figure 3(a)).[32] The core of this fold is the prototypic recombination protein A (RecA)/F1 type P-loop ATPase. Lobe I consists primarily of residues from the N-terminal segment of the ATPase domain and forms an α/β roll by the packing of the P-loop containing helix against an antiparallel β sheet. Lobe II is a β-α-β sandwich and contains the root of the coiled coil. It consists primarily of residues from the C-terminal ATPase fragment. The two lobes are joined into a single folded domain by a central β sheet II that contains β strands from both N- and C-terminal segments of the ATPase domain. The nucleotide binding site, formed by the Walker A motif (P-loop) and Walker B motif, is located in the interface of both lobes. It also contains the metal coordinating residues. The overall structure of Rad50 is related to that of the ATPase domains of ABC transporters.

In the presence of AMP-PNP, the two Rad50 ATPase domains dimerize in a 'head-to-tail' orientation, where each lobe II mutually binds to lobe I of the opposing ATPase domain.[32] The overall shape of the ATPase domain dimer is that of a shallow ellipsoid bowl of $95 \times 60 \times 40\,\text{Å}$. The dimer interface runs diagonally to the ellipsoid axes. Both ATP molecules are buried in the dimer interface, sandwiched between the P-loop (Walker A motif) of one Rad50cd and the conserved signature motif from the opposing Rad50cd. In subsequent years, it has been established that this intriguing ATP-binding conformation is a hallmark of the ABC ATPase family and that this ATP binding induced engagement of two ABC ATPase domains and its ATP hydrolysis-mediated disengagement drives the powerstroke of ABC transporters.[91,92]

The signature motif binds to an ATP γ-phosphate O *via* the Ser793 side chain Oγ and the Gly795 main chain N, explaining the conservation of these residues in ABC ATPase sequences. Thus, the signature motif is a 'sensor' for an ATP γ-phosphate in the opposing molecule, and controls ATP-dependent engagement and disengagement of two Rad50 domains, as shown by biochemical analysis. The active site Mg^{2+} ion binds to ATP β- and γ-phosphate Os and to Ser37 and Gln140 side chain Os, plus two water molecules, one of which binds to Asp822 and Glu823 in the Walker B motif. A water molecule near the ATP γ-phosphate, almost collinear with the scissile bond, is a putative attacking nucleophile. In other ABC ATPase structures, the Walker B motif residue (Glu823 in Rad50) as well as a main chain carbonyl oxygen of the opposing ATPase domain is implicated in positioning and polarizing the attacking water,[82,93] explaining why hydrolysis of ATP seems to require ABC ATPase domain dimer formation.

The Rad50 coiled coil

The most intriguing feature of Rad50 is the 200–600-Å-long (depending on organisms) coiled-coil domain, which protrudes from the helical lobe II of the ABC ATPase domain.[31] The apex of the coiled coil, as inferred from the heptad repeat sequence, contains a conserved Cys-X-X-Cys (CXXC) motif that is suggested to form a protein interaction motif.[22] Analytic ultracentrifugation revealed that a peptide containing pfRad50-CXXC motif forms monomers when demetalated, and that the monomers form dimers upon addition of Zn^{2+}.[30] Isothermal titration calorimetry resulted in a stoichiometry of 0.4:1 zinc:peptide with an apparent dissociation constant of 8.5 μM for the *P. furiosus* protein. The pfRad50-CXXC (comprising residues 396–506) was crystallized in space group $P2_1$ with cell dimensions $a = 32.0$, $b = 78.0$, $c = 53.3\,\text{Å}$, $β = 91.6°$ and two molecules in the asymmetric unit in 100 mM phosphate/citrate (pH 4.2), 40% ethanol, 10% glycerol, and 20 mM Zn-acetate. Zn^{2+}- and Hg^{2+}-bound structures were determined to 2.6 and 2.2 Å resolution, respectively.

Rad50-CXXC forms a remarkable partial metal binding site in the form of a molecular hook structure at the apex of the Rad50 coiled coil (Figure 4).[30] Two of these hooks create a composite Zn^{2+} binding site that links two Rad50 coiled coils. The central hook structure consists of only 14 nonhelical residues (440–453), which form an antiparallel extension at the coiled-coil apex that protrudes 15 Å, perpendicular to the flat side of the coiled coil.

Each hook motif of the two Rad50-CXXC molecules contributes two cysteine residues (Cys444 and Cys447) to the metal binding site, which together tetrahedrally coordinate the Zn^{2+} ion. The metal site contributes ~70 Å² of the ~1200 Å² of the buried surface at the interface between the two interlocking hook extensions of

Figure 4 (a) Ribbon model of the crystal structure of two tethered coiled-coil apices, forming a composite zinc (gray sphere) binding site. Zinc-coordinating cysteines are shown as sticks. One coiled-coil apex and hook is shown in red, the other in yellow. (b) Stereo image (zoom of (a)) of the composite zinc coordination site with highlighted coordinating cysteine residues. Metal–ligand distances are indicated in angstrom for the mercury bound structure. (c) Zinc-dependent intramolecular and intermolecular tethering of Mre11 complexes *via* the hook structures at the end of the Rad50 coiled coils, as observed by electron and atomic force microscopy. Structure figures were produced using the program PyMOL.[89]

the Rad50-CXXC dimer. The dimer assembly is further stabilized by a conserved hydrophobic interface. Most CXXC contain a proline in position 2, presumably to stabilize the hook motif by rigidifying the sharp turn at the tip of the hook.

The structure of the Rad50-CXXC dimer has important consequences for the structure and biological function of the Mre11 complex. It shows that the coiled-coil arms of Rad50 are large protein–protein cross-linking extensions. Atomic force microscopy data indicate that the coiled coils are flexible, with preferred kink sites that co-localize with predicted regions of low coiled-coil propensities.[34–36]

Deletion of the hook motifs phenocopies Rad50 deficiency, highlighting the essential nature of this metal binding site for the physiological function of the Mre11 complex.[94] Replacing the hook protein–protein interaction domain with a ligand-inducible FK506 binding protein (FKBP) dimerization domain can partially rescue the hook-deletion phenotypes in a ligand-dependent manner. This substantial rescue indicates that the essential functional role of the apex of coiled coil is predominantly to join two coiled-coil domains, although it remains to be shown if it serves additional mechanistic functions such as interaction with other molecular partners.

ROLE IN DNA DOUBLE-STRAND BREAK REPAIR

DNA DSBs are arguably among the most cytotoxic forms of DNA damage and can lead to gross chromosomal aberrations and disruption of the genomic integrity, processes that are linked to cell aberration and cancer development.[16,63,64,95,96] Although DSBs can arise from many exogenous and endogenous sources, their predominant cause in proliferating cells are errors in DNA replication.[79,97–101] DSBs can be repaired by two major DSBs repair pathways, homologous recombination (HR), and NHEJ. In HR, the DSBs are resected into 3' ssDNA tails. These tails pair with the homologous DNA segment of the sister chromatid by formation of a D-loop structure and repair proceeds by DNA synthesis essentially without loss of genetic information.[102,103] In NHEJ, the two broken ends are aligned, may be processed, and directly re-ligated. This process is potentially mutagenic.[104–106]

The nature of DNA DSBs necessitates that these repair pathways contain a structural as well as an enzymatic component. The structural activities need to capture and align the broken DNA ends. In the case of homologous recombination, cohesion between the broken chromatid and the sister-chromatid repair template must be maintained and reestablished, a process that has been recently attributed to new cohesin complex loading.[107,108] The enzymatic activity processes the ends to enable subsequent repair steps. Here, degradation in 5'->3' direction creates the 3' single-strand tail that is used for Rad51 filament assembly and pairing with the sister chromatid. Limited processing of the 3' end, however, may also be needed in some instances, e.g. to remove damaged nucleotides so that the 3' tail can prime the repair synthesis by DNA polymerases.

The Mre11 complex combines structural and enzymatic activities in a remarkable manner. Its multifunctional architecture provides a basis to understand its multifaceted role in virtually all aspects of DNA end metabolism, such as DSB detection,[37] DSB processing,[38–42] homologous recombination and meiosis,[43–46] NHEJ,[49–52] telomere maintenance,[53–58] and the DSB-activated cell cycle checkpoint response.[16,59,60] Combining current functional and structural aspects, one can draw a hypothetical model for the function of this complex in DSB repair (Figure 5). The head, consisting of the Rad50 ATPase and Mre11, form the main DNA binding subunit. DNA binding can occur at an internal site of duplex DNA and could for instance, involve lateral movement of the complex toward a DNA end. DNA binding and DNA end recognition have two structural consequences in atomic force microscopic images. Conformational changes within the head parallelize the coiled coils, thereby unhooking the intramolecular joining between the two coiled-coil domains. At ends, Mre11 complexes cluster to form large proteinaceous aggregates. The local concentration of exposed hooks at DNA ends

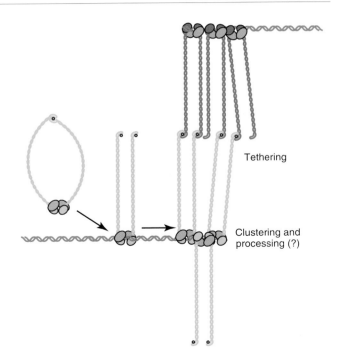

Figure 5 Speculative model for the role of the Mre11 nuclease complex in DNA end detection, cross-linking and DNA end processing (see text).

might form large 'baits' that can tether with similar structures, e.g. at the other end of the broken chromatid.

In the presence of ATP, the head begins to process the ends. This might clear ends from covalent proteins in meiosis or from damaged bases or DNA backbone structures. The intrinsic degradation is 3'->5', thus creating appropriate 3' OH termini to serve as primer in strand extension by DNA synthesis. The nature of 5'->3' resection of the ends to create the recombinogenic tails remains to be shown. However, additional factors were identified that promote homologous recombination and end resection, and add an additional magnesium-dependent nuclease activity.[13,109–112] These new data add a novel layer of complexity to the DNA-processing function of the Mre11 complex at recombinogenic ends. Numerous additional functional partners of the Mre11 are known, including nucleases, helicases, kinases, and checkpoint proteins. It is still a long way to go to understand fully the mechanistic functions of the Mre11 complex in DNA end metabolism.

REFERENCES

1 L Aravind, DR Walker and EV Koonin, *Nucleic Acids Res*, **27**, 1223–42 (1999).

2 JH Petrini, ME Walsh, C DiMare, XN Chen, JR Korenberg and DT Weaver, *Genomics*, **29**, 80–86 (1995).

3 GJ Sharples and DR Leach, *Mol Microbiol*, **17**, 1215–17 (1995).

4 VM Blinov, EV Koonin, AE Gorbalenya, AV Kaliman and VM Kryukov, *FEBS Lett*, **252**, 47–52 (1989).

5 M Ajimura, SH Leem and H Ogawa, *Genetics*, **133**, 51–66 (1993).

6 H Ogawa, K Johzuka, T Nakagawa, SH Leem and AH Hagihara, *Adv Biophys*, **31**, 67–76 (1995).

7 S Wilson, N Warr, DL Taylor and FZ Watts, *Nucleic Acids Res*, **27**, 2655–61 (1999).

8 E Hartsuiker, E Vaessen, AM Carr and J Kohli, *Embo J*, **20**, 6660–71 (2001).

9 MM Gorski, RJ Romeijn, JC Eeken, AW De Jong, BL Van Veen, K Szuhai, LH Mullenders, W Ferro and A Pastink, *DNA Repair (Amst)*, **3**, 603–15 (2004).

10 ST Merino, WJ Cummings, SN Acharya and ME Zolan, *Proc Natl Acad Sci USA*, **97**, 10477–82 (2000).

11 EE Gerecke and ME Zolan, *Genetics*, **154**, 1125–39 (2000).

12 GM Chin and AM Villeneuve, *Genes Dev*, **15**, 522–34 (2001).

13 A Penkner, Z Portik-Dobos, L Tang, R Schnabel, M Novatchkova, V Jantsch and J Loidl, *Embo J*, **26**, 5071–82 (2007).

14 TH Stracker, M Morales, SS Couto, H Hussein and JH Petrini, *Nature*, **447**, 218–21 (2007).

15 CF Bender, ML Sikes, R Sullivan, LE Huye, MM Le Beau, DB Roth, OK Mirzoeva, EM Oltz and JH Petrini, *Genes Dev*, **16**, 2237–51 (2002).

16 JP Carney, RS Maser, H Olivares, EM Davis, M Le Beau, JR Yates III, L Hays, WF Morgan, and JH Petrini, *Cell* **93**, 477–86 (1998).

17 GM Dolganov, RS Maser, A Novikov, L Tosto, S Chong, DA Bressan and JH Petrini, *Mol Cell Biol*, **16**, 4832–41 (1996).

18 JC Connelly, LA Kirkham and DR Leach, *Proc Natl Acad Sci USA*, **95**, 7969–74 (1998).

19 DR Leach, EA Okely and DJ Pinder, *Mol Microbiol*, **26**, 597–606 (1997).

20 E Bentchikou, P Servant, G Coste and S Sommer, *J Bacteriol*, **189**, 4784–90 (2007).

21 J Mascarenhas, H Sanchez, S Tadesse, D Kidane, M Krisnamurthy, JC Alonso and PL Graumann, *BMC Mol Biol*, **7**, 20 (2006).

22 JC Connelly, ES de Leau and DR Leach, *DNA Repair (Amst)*, **2**, 795–807 (2003).

23 JC Connelly, ES de Leau and DR Leach, *Nucleic Acids Res*, **27**, 1039–46 (1999).

24 KP Hopfner, A Karcher, D Shin, C Fairley, JA Tainer and JP Carney, *J Bacteriol*, **182**, 6036–41 (2000).

25 LM Arthur, K Gustausson, KP Hopfner, CT Carson, TH Stracker, A Karcher, D Felton, MD Weitzman, J Tainer and JP Carney, *Nucleic Acids Res*, **32**, 1886–93 (2004).

26 TT Paull and M Gellert, *Genes Dev*, **13**, 1276–88 (1999).

27 TT Paull and M Gellert, *Mol Cell*, **1**, 969–79 (1998).

28 V Bhaskara, A Dupre, B Lengsfeld, BB Hopkins, A Chan, JH Lee, X Zhang, J Gautier, V Zakian and TT Paull, *Mol Cell*, **25**, 647–61 (2007).

29 V Costanzo, T Paull, M Gottesman and J Gautier, *PLoS Biol*, **2**, E110 (2004).

30 KP Hopfner, L Craig, G Moncalian, RA Zinkel, T Usui, BA Owen, A Karcher, B Henderson, JL Bodmer, CT McMurray, JP Carney, JH Petrini and JA Tainer, *Nature*, **418**, 562–66 (2002).

31 KP Hopfner, A Karcher, L Craig, TT Woo, JP Carney and JA Tainer, *Cell*, **105**, 473–85 (2001).

32 KP Hopfner, A Karcher, DS Shin, L Craig, LM Arthur, JP Carney and JA Tainer, *Cell*, **101**, 789–800 (2000).

33 G Moncalian, B Lengsfeld, V Bhaskara, KP Hopfner, A Karcher, E Alden, JA Tainer and TT Paull, *J Mol Biol*, **335**, 937–51 (2004).

34 J van Noort, T van Der Heijden, M de Jager, C Wyman, R Kanaar and C Dekker, *Proc Natl Acad Sci USA*, **100**, 7581–86 (2003).

35 M de Jager, J van Noort, DC van Gent, C Dekker, R Kanaar and C Wyman, *Mol Cell*, **8**, 1129–35 (2001).

36 F Moreno-Herrero, M de Jager, NH Dekker, R Kanaar, C Wyman and C Dekker, *Nature*, **437**, 440–43 (2005).

37 OK Mirzoeva and JH Petrini, *Mol Cell Biol*, **21**, 281–88 (2001).

38 S Moreau, JR Ferguson and LS Symington, *Mol Cell Biol*, **19**, 556–66 (1999).

39 JC Connelly and DR Leach, *Genes Cells*, **1**, 285–91 (1996).

40 KM Trujillo, SS Yuan, EY Lee and P Sung, *J Biol Chem*, **273**, 21447–50 (1998).

41 C Mickelson and JS Wiberg, *J Virol*, **40**, 65–77 (1981).

42 LK Lewis, F Storici, S Van Komen, S Calero, P Sung and MA Resnick, *Genetics*, **166**, 1701–13 (2004).

43 E Alani, R Padmore and N Kleckner, *Cell*, **61**, 419–36 (1990).

44 DA Bressan, BK Baxter and JH Petrini, *Mol Cell Biol*, **19**, 7681–87 (1999).

45 Y Yamaguchi-Iwai, E Sonoda, MS Sasaki, C Morrison, T Haraguchi, Y Hiraoka, YM Yamashita, T Yagi, M Takata, C Price, N Kakazu and S Takeda, *Embo J*, **18**, 6619–29 (1999).

46 H Tauchi, J Kobayashi, K Morishima, DC van Gent, T Shiraishi, NS Verkaik, D vanHeems, E Ito, A Nakamura, E Sonoda, M Takata, S Takeda, S Matsuura and K Komatsu, *Nature*, **420**, 93–98 (2002).

47 SM Cherry, CA Adelman, JW Theunissen, TJ Hassold, PA Hunt and JH Petrini, *Curr Biol*, **17**, 373–78 (2007).

48 V Borde, W Lin, E Novikov, JH Petrini, M Lichten and A Nicolas, *Mol Cell*, **13**, 389–401 (2004).

49 Y Tsukamoto, J Kato and H Ikeda, *Genetics*, **142**, 383–91 (1996).

50 GT Milne, S Jin, KB Shannon and DT Weaver, *Mol Cell Biol*, **16**, 4189–98 (1996).

51 JK Moore and JE Haber, *Mol Cell Biol*, **16**, 2164–73 (1996).

52 D Udayakumar, CL Bladen, FZ Hudson and WS Dynan, *J Biol Chem*, **278**(43), 41631–35 (2003).

53 M Chamankhah, T Fontanie and W Xiao, *Genetics*, **155**, 569–76 (2000).

54 KM Kironmai and K Muniyappa, *Genes Cells*, **2**, 443–55 (1997).

55 SJ Boulton and SP Jackson, *Embo J*, **17**, 1819–28 (1998).

56 SC Teng, J Chang, B McCowan and VA Zakian, *Mol Cell*, **6**, 947–52 (2000).

57 XD Zhu, B Kuster, M Mann, JH Petrini and T de Lange, *Nat Genet*, **25**, 347–52 (2000).

58 V Lundblad, *Oncogene*, **21**, 522–31 (2002).

59 D D'Amours and SP Jackson, *Genes Dev*, **15**, 2238–49 (2001).

60 S Zhao, YC Weng, SS Yuan, YT Lin, HC Hsu, SC Lin, E Gerbino, MH Song, MZ Zdzienicka, RA Gatti, JW Shay, Y Ziv, Y Shiloh and EY Lee, *Nature*, **405**, 473–77 (2000).

61 J Falck, J Coates and SP Jackson, *Nature*, **434**, 605–11 (2005).

62 J Zhu, S Petersen, L Tessarollo and A Nussenzweig, *Curr Biol*, **11**, 105–9 (2001).

63 G Luo, MS Yao, CF Bender, M Mills, AR Bladl, A Bradley and JH Petrini, *Proc Natl Acad Sci USA*, **96**, 7376–81 (1999).

64 GS Stewart, RS Maser, T Stankovic, DA Bressan, MI Kaplan, NG Jaspers, A Raams, PJ Byrd, JH Petrini and AM Taylor, *Cell*, **99**, 577–87 (1999).

65 R Varon, C Vissinga, M Platzer, KM Cerosaletti, KH Chrzanowska, K Saar, G Beckmann, E Seemanova, PR Cooper, NJ Nowak, M Stumm, CM Weemaes, RA Gatti, RK Wilson,

M Digweed, A Rosenthal, K Sperling, P Concannon and A Reis, *Cell*, **93**, 467–76 (1998).

66 S Matsuura, H Tauchi, A Nakamura, N Kondo, S Sakamoto, S Endo, D Smeets, B Solder, BH Belohradsky, VM Der Kaloustian, M Oshimura, M Isomura, Y Nakamura and K Komatsu, *Nat Genet*, **19**, 179–81 (1998).

67 GA Cromie and DR Leach, *Mol Microbiol*, **41**, 873–83 (2001).

68 X Pan and DR Leach, *Nucleic Acids Res*, **28**, 3178–84 (2000).

69 GA Cromie, CB Millar, KH Schmidt and DR Leach, *Genetics*, **154**, 513–22 (2000).

70 JC Connelly, ES de Leau, EA Okely and DR Leach, *J Biol Chem*, **272**, 19819–26 (1997).

71 KM Trujillo, DH Roh, L Chen, S Van Komen, A Tomkinson and P Sung, *J Biol Chem*, **278**, 48957–64 (2003).

72 WE Raymond and N Kleckner, *Nucleic Acids Res*, **21**, 3851–56 (1993).

73 M de Jager, ML Dronkert, M Modesti, CE Beerens, R Kanaar and DC van Gent, *Nucleic Acids Res*, **29**, 1317–25 (2001).

74 M Furuse, Y Nagase, H Tsubouchi, K Murakami-Murofushi, T Shibata and K Ohta, *Embo J*, **17**, 6412–25 (1998).

75 K Ohta, A Nicolas, M Furuse, A Nabetani, H Ogawa and T Shibata, *Proc Natl Acad Sci USA*, **95**, 646–51 (1998).

76 JA Farah, E Hartsuiker, K Mizuno, K Ohta and GR Smith, *Genetics*, **161**, 461–68 (2002).

77 KS Lobachev, DA Gordenin and MA Resnick, *Cell*, **108**, 183–93 (2002).

78 KM Trujillo and P Sung, *J Biol Chem*, **276**, 35458–64 (2001).

79 S Keeney, *Curr Top Dev Biol*, **52**, 1–53 (2001).

80 MJ Neale, J Pan and S Keeney, *Nature*, **436**, 1053–57 (2005).

81 N Assenmacher, K Wenig, A Lammens and KP Hopfner, *J Mol Biol*, **355**, 675–83 (2006).

82 A Lammens, A Schele and KP Hopfner, *Curr Biol*, **14**, 1778–82 (2004).

83 G Ghosal and K Muniyappa, *J Mol Biol*, **372**, 864–82 (2007).

84 M de Jager, C Wyman, DC van Gent and R Kanaar, *Nucleic Acids Res*, **30**, 4425–31 (2002).

85 RD Henkel, JL VandeBerg and RA Walsh, *Anal Biochem*, **169**, 312–18 (1988).

86 C Randak and MJ Welsh, *Cell*, **115**, 837–50 (2003).

87 DA Bressan, HA Olivares, BE Nelms and JH Petrini, *Genetics*, **150**, 591–600 (1998).

88 H Tsubouchi and H Ogawa, *Mol Cell Biol*, **18**, 260–8 (1998).

89 W DeLano, *The PyMOL Molecular Graphics System* (2002). On World Wide Web http://www.pymol.org.

90 F Rusnak, in A Sigel and H Sigel (eds.) *Metal Ions in Biological Systems*, Marcel Dekker, Basel (2000).

91 KP Hopfner and JA Tainer, *Curr Opin Struct Biol*, **13**, 249–55 (2003).

92 KP Locher, AT Lee and DC Rees, *Science*, **296**, 1091–98 (2002).

93 LW Hung, IX Wang, K Nikaido, PQ Liu, GF Ames and SH Kim, *Nature*, **396**, 703–7 (1998).

94 JJ Wiltzius, M Hohl, JC Fleming and JH Petrini, *Nat Struct Mol Biol*, **12**, 403–7 (2005).

95 JC Game, *Semin Cancer Biol*, **4**, 73–83 (1993).

96 MZ Zdzienicka, *Cancer Surv*, **28**, 281–93 (1996).

97 V Costanzo, K Robertson, M Bibikova, E Kim, D Grieco, M Gottesman, D Carroll and J Gautier, *Mol Cell*, **8**, 137–47 (2001).

98 A Kuzminov, *Proc Natl Acad Sci USA*, **98**, 8461–68 (2001).

99 JF Ward, *Prog Nucleic Acid Res Mol Biol*, **35**, 95–125 (1988).

100 M Gellert, *Annu Rev Biochem*, **71**, 101–32 (2002).

101 JE Haber, *Annu Rev Genet*, **32**, 561–99 (1998).

102 LH Thompson and D Schild, *Mutat Res*, **509**, 49–78 (2002).

103 JE Haber, *Curr Opin Cell Biol*, **12**, 286–92 (2000).

104 MR Lieber, Y Ma, U Pannicke and K Schwarz, *Nat Rev Mol Cell Biol*, **4**, 712–20 (2003).

105 LK Lewis and MA Resnick, *Mutat Res*, **451**, 71–89 (2000).

106 JM Daley, PL Palmbos, D Wu and TE Wilson, *Annu Rev Genet*, **39**, 431–51 (2005).

107 L Strom, C Karlsson, HB Lindroos, S Wedahl, Y Katou, K Shirahige and C Sjogren, *Science*, **317**, 242–45 (2007).

108 E Unal, JM Heidinger-Pauli and D Koshland, *Science*, **317**, 245–48 (2007).

109 C Uanschou, T Siwiec, A Pedrosa-Harand, C Kerzendorfer, E Sanchez-Moran, M Novatchkova, S Akimcheva, A Woglar, F Klein and P Schlogelhofer, *Embo J*, **26**, 5061–70 (2007).

110 S Takeda, K Nakamura, Y Taniguchi and TT Paull, *Mol Cell*, **28**, 351–52 (2007).

111 AA Sartori, C Lukas, J Coates, M Mistrik, S Fu, J Bartek, R Baer, J Lukas and SP Jackson, *Nature*, **450**, 509–14 (2007).

112 O Limbo, C Chahwan, Y Yamada, RA de Bruin, C Wittenberg and P Russell, *Mol Cell*, **28**, 134–46 (2007).

Metal ions in cyanobacterial photosystem II

Bernhard Loll[t,‡], Jacek Biesiadka[t] and Wolfram Saenger[t]

[t]Institut für Chemie und Biochemie–Kristallographie, Freie Universität Berlin, Takustrasse 6, 14195 Berlin, Germany
[‡]Max-Planck Institute for Medical Research, Department of Biomolecular Mechanisms, Jahnstrasse 29, 69120 Heidelberg, Germany

FUNCTIONAL CLASS

Enzyme: water: plastoquinone oxidoreductase that is driven by sunlight, also known as *photosystem II* (PSII), a multisubunit protein complex decorated by cofactors and one of the key players in oxygenic photosynthesis.

Photosynthesis is one of the most fundamental bioenergetic processes on our planet. At the heart of oxygenic photosynthesis is PSII, which catalyzes the thermodynamically most demanding reaction in biological systems, the splitting of water into oxygen, protons and electrons (reducing equivalents). This process is driven by solar energy, which is captured by pigments (chlorophyll *a* and carotenoids) embedded within PSII. Oxygenic photosynthesis developed first in cyanobacteria, the ancestors of higher plants, and is thought to have been the reason why the oxygen level in the primeval earth's reducing atmosphere rose to the point at which higher forms of life could develop about 2 billion years ago. Additionally, the reducing equivalents are necessary to fix carbon dioxide to organic molecules that lie at the basis of nearly all food chains, and the electrochemical gradient generated across the thylakoid membrane powers the production of the energy-storing molecule adenosine triphosphate (ATP).[1,2]

OCCURRENCE

PSII is located in the thylakoid membrane of higher plants, algae and cyanobacteria (3D structure). Oxygenic photosynthesis was extended into eukaryotes according to the endosymbiotic theory, whereby cyanobacteria-like cells were incorporated into the eukaryotic systems and evolved to the plastids of algae and higher plants.[3,4]

The main subunits of the PSII core complex are highly conserved between prokaryotes and eukaryotes. Significant differences are observed for the outer antenna system. In prokaryotic PSII the hydrophilic phycobilisomes are attached on the cytoplasmic side to the PSII core complex. This is in contrast to plants where the outer antenna system is embedded in the thylakoid membrane and is composed of light harvesting complexes II, CP24, CP26, and CP29 that are closely associated with the PSII core complexes. Further differences are found in the equipment

3D Structure View of dimeric PSII (PDB entry 2AXT) looking along the membrane plane.[18] Membrane-intrinsic subunits: RC subunits D1 (yellow) and D2 (orange), antenna subunits CP43 (magenta) and CP47 (red), α- and β-chains of cyt *b*-559 (green and cyan), low molecular weight subunits (gray) and membrane-extrinsic (lumenal) subunits: PsbO (green), PsbU (pink) and PsbV (blue). Cofactors in green (Chl*a*), yellow (Pheo), red (Car), blue (heme), violet (quinone), cyan (lipids), brown (detergent and unassigned alkyl chains). The non-heme Fe^{2+} (blue) and putative Ca^{2+} (yellow) are shown as spheres. All figures were prepared with the program PYMOL.[106]

Figure 1 Dimeric PSII (a) View on the membrane plane. The local pseudo-C2 axis relating the two monomers is indicated by a black ellipse at the center. Different structural elements are shown in the two monomers (I and II) separated by a dashed black line. Monomer I, α-helices are indicated as spirals, membrane-extrinsic subunits are not drawn and cofactors are omitted. Reaction center (RC) subunits D1 (yellow) and D2 (orange), antenna subunits CP43 (magenta) and CP47 (red), α- and β-chains of cyt b-559 (green and cyan), low-molecular-weight subunits (gray). Unassigned transmembrane α-helices (TMHs) are labeled X1–X3. Monomer II, Subunits are only shown by their TMH (cylinders) colored as in I. Cofactors in green (Chla), yellow (Pheo), red (Car), blue (heme), violet (quinone), cyan (lipids), brown (detergent and unassigned alkyl chains). The nonheme Fe^{2+} (blue) and putative Ca^{2+} (yellow) are shown as spheres. (b) Side view of PSII looking along the membrane plane. Color code for subunits and cofactors as in (a). Membrane-extrinsic subunits are drawn: PsbO (green), PsbU (pink) and PsbV (blue). α-helices are drawn as cylinders and β-strands as arrows.

of membrane-extrinsic subunits. Whereas PsbO is found in all organisms, the cyanobacterial subunits PsbU and PsbV are replaced in eukaryotes by PsbQ and PsbP.

BIOLOGICAL FUNCTION

In all photosynthetic oxygenic organisms two large pigment– protein complexes, PSII (Figure 1) and photosystem I (PSI) are responsible for light-driven charge separation. PSII captures sunlight by two antenna proteins CP47 and CP43, which transfer the excitation energy to the photochemical reaction center (RC) with primary electron donor P680 formed by chlorophyll a (Chla) molecules.[5–7] The primary electron donor is oxidized to $P680^{+•}$ with the highest electrochemical potential (1.2 V) found in nature,[8] and the released electron travels along the electron transfer

Figure 2 Z-scheme of cyanobacterial photosynthesis: Energy diagram of light-reactions of oxygenic photosynthesis. The axis on the left side gives the electrochemical potential in V. All cofactors involved in electron transfer reactions are indicated according to their redox-potentials. The reduction potentials decrease downward so that electrons flow spontaneously in this direction. Protein–pigment complexes involved are, from the left to the right side: PSII, cyt b_6f, and PSI. Absorption of one photon by P680 ejects an electron that travels along the ETC to the final electron acceptor Q_B. At P680 the electron-gap (after release of an electron) is filled by an electron derived via Tyr_Z from the Mn_4Ca-cluster catalyzing the oxidation of two water molecules to oxygen and four protons. Plastoquinone Q_B is reduced to plastoquinol that diffuses through the thylakoid membrane and in turn reduces the cyt b_6f complex, with the concomitant translocation of protons into the thylakoid lumen. Cyt b_6f then transfers the electrons to PC, and the electron from PC regenerates photooxidized P700 in PSI. The electron ejected from P700 after excitation by a photon travels along the ETC to the electron-acceptors (A_X) and then to the iron–sulfur clusters (F_X, F_A, F_B). The electron carrier FD transfers the electrons to FD:$NADP^+$ reductase, which catalyzes the reduction of $NADP^+$ to NADPH in noncyclic electron transport. Alternatively, the electron may return to the cyt b_6f complex in a cyclic process that translocates additional protons into the thylakoid lumen, dotted arrow.

chain (ETC) featuring two pairs of Chla, one pair of pheophytin a (Pheo) and two plastoquinones (PQ, Q_A and Q_B). $P680^{+\bullet}$ is re-reduced via redox-active tyrosine Tyr_Z[9] by an electron from a unique metal cluster composed of 4Mn and 1Ca (hereafter Mn_4Ca-cluster) where the oxidation of two water molecules to atmospheric oxygen, $4H^+$ and $4e^-$ is catalyzed. This occurs in four steps, at each of which the Mn_4Ca-cluster (the oxygen evolving complex (OEC)) is oxidized to a higher oxidation state and after the fourth step, molecular O_2 is released. The electrons are transferred from the Mn_4Ca-cluster through redox-active Tyr_Z to $P680^{+\bullet}$, which is reduced to P680 for another photosynthetic cycle. Doubly reduced and protonated Q_B is released as plastoquinol Q_BH_2 into the plastoquinone pool in the thylakoid membrane and oxidized at the membrane-intrinsic cytochrome (cyt) b_6f complex to Q_B. The electrons from Q_BH_2 are transferred at the lumenal side of the membrane to soluble cyt c_6 (plants) or plastocyanin (PC) (cyanobacteria) and conveyed to PSI. Here the electrons are donated at the cytoplasmic side to soluble ferredoxin (FD) that brings them to ferredoxin-oxidized nicotinamide adenine dinucleotide phosphate ($NADP^+$) reductase where the reducing equivalents finally convert $NADP^+$ to reduced nicotinamide adenine dinucleotide phosphate (NADPH).

This process is associated with formation of a proton gradient across the membrane that drives the synthesis of ATP which, together with NADPH, serves to reduce CO_2 to carbohydrates.[1,2] The electron transport across the thylakoid membrane by membrane-embedded cofactors in PSII, cyt b_6f and PSI can be best described by the so-called Z-scheme, an energy diagram (Figure 2) first suggested by Hill and Bendall.[10]

AMINO ACID SEQUENCE INFORMATION

The entire genome of the cyanobacterium *Thermosynechococcus elongatus* BP-1, was sequenced.[11] Below we provide the gene and trivial names of the polypeptide chains that are widely used in the literature and the presently accepted components of cyanobacterial PSII, the number of amino acids (aa) and the SWISSPROT codes.

- *T. elongatus*, PsbA1, RC protein D1, 345 aa, SWISSPROT Id code P0A444.
- *T. elongatus*, PsbB, antenna subunit CP47, 510 aa, SWISSPROT Id code Q8DIQ1.
- *T. elongatus*, PsbC, antenna subunit CP43, 573 aa, SWISSPROT Id code Q8DIF8.

- *T. elongatus*, PsbD1, RC protein D2, 352 aa, SWISSPROT Id code Q8CM25.
- *T. elongatus*, PsbE, α-chain of cyt *b*-559, 84 aa, SWISSPROT Id code Q8DIP0.
- *T. elongatus*, PsbF, β-chain of cyt *b*-559, 45 aa, SWISSPROT Id code Q8DIN9.
- *T. elongatus*, PsbH, 66 aa, SWISSPROT Id code Q8DJ43.
- *T. elongatus*, PsbI, 38 aa, SWISSPROT Id code Q8DJZ6.
- *T. elongatus*, PsbJ, 40 aa, SWISSPROT Id code P59087.
- *T. elongatus*, PsbK, 35 aa, SWISSPROT Id code Q9F1K9.
- *T. elongatus*, PsbL, 37. aa, SWISSPROT Id code Q8DIN8.
- *T. elongatus*, PsbM, 36. aa, SWISSPROT Id code Q8DHA7.
- *T. elongatus*, PsbO, manganese stabilizing protein, 256 aa, SWISSPROT Id code P0A431.
- *T. elongatus*, PsbT, 32 aa, SWISSPROT Id code Q8DIQ0.
- *T. elongatus*, PsbU, 104 aa, SWISSPROT Id code Q9F1L5.
- *T. elongatus*, PsbV, cyt *b*-550, 137 aa, SWISSPROT Id code P0A386.
- *T. elongatus*, PsbX, 40 aa, SWISSPROT Id code Q8DHE6.
- *T. elongatus*, PsbY, 44 aa, SWISSPROT Id code Q8DKM3.
- *T. elongatus*, PsbZ, ycf9, 62 aa, SWISSPROT Id code Q8DHJ2.

PROTEIN PRODUCTION, PURIFICATION, AND MOLECULAR CHARACTERIZATION

PSII was isolated from the thermophilic unicellular cyanobacterium *T. elongatus*. The organism is photoautotrophic, has an optimum growth temperature of $56\,^{\circ}C$ and naturally inhabits hot springs. In the laboratory, *T. elongatus* cells were grown at $56\,^{\circ}C$ in a PBR25 photobioreactor (IGV Potsdam, Germany and Sartorius-BBI Systems, Melsungen, Germany) using a volume of 32-l Castenholz Medium D under continuous circulation.[12] The culture was illuminated by lamps (Fluora 550 Im L18W/77, Osram, Germany) and adjusted to pH 7.8 by automatically adding CO_2. The flow rate and light intensity were adjusted according to the cell density in the culture. After lysozyme digestion followed by disruption of *T. elongatus* cells, the thylakoid membranes were centrifuged, and PSII complexes were solubilized using 0.6% *n*-dodecyl-β-D-maltoside (β-DM) and separated from membrane fragments by centrifugation. All further purification steps were conducted at $6\,^{\circ}C$ in the dark or under dim green light. In the first purification step, the PSII extract was loaded on an anion exchange column packed with Toyo

Pearl diethylaminoethyl (DEAE) 650S (TosoHas, Japan). Three main fractions were obtained with increasing salt gradient: (1) phycobilisomes, (2) PSII, contaminated with traces of PSI and ATP-synthetase, and (3) PSI. In the second purification step, the fractions containing PSII were loaded on an anion exchange column with different geometry and packed with DEAE 650S. In this purification step, peaks were separated into phycobilisomes and ATP-synthase, monomeric PSII, dimeric PSII and PSI. Fractions containing dimeric PSII were pooled and concentrated. After two precipitation steps with 15% (w/w) PEG 2000, microcrystals were obtained which were redissolved in 100 mM Piperazine-1,4-bis(2-ethanesulfonic acid) (PIPES)-NaOH, pH 7.0, 5 mM $CaCl_2$, 0.03% (w/w) β-DM.[13]

The subunit composition of our dimeric PSII samples was investigated using SDS-PAGE, MALDI-TOF mass spectrometry and N-terminal sequencing (J. Kern personal communication). The presence of 19 protein subunits has been confirmed for dimeric PSII and is listed in the previous paragraph.

The PSII samples were characterized by various biophysical methods. Reverse phase high-performance liquid chromatography (HPLC) identified ∼35 Chl*a*, ∼8.3 carotenoids (Car) and ∼2.3 plastoquinone (PQ) molecules.[13] Flash-induced fluorescence measurements of functional plastoquinone in the Q_B site revealed only an occupancy of 50%,[14] indicating that the Q_B site indicated that it is merely half occupied. The lipid and detergent composition of dimeric PSII was analyzed by thin layer chromatography, resulting in about 145 β-DM and 10 lipid molecules per monomer.[13] The intactness of the Mn_4Ca-cluster was probed by atom absorption spectroscopy revealing a Mn content of 3.7 per PSII monomer.[13]

ACTIVITY TESTS

The activity of PSII can be measured by oxygen evolution that is detectable by a Clark type electrode.[15] Excitation of PSII was either performed with repetitive 1-Hz flashes from a xenon flash lamp or with saturating continuous white light from a tungsten lamp passed through a heat filter. The buffer used contained 20 mM MES–NaOH, pH 6.4, 5 mM $CaCl_2$, and the sample concentration was adjusted to 20–50 μM Chl*a*. Artificial electron acceptors added were either 2 mM $K_3[Fe(CN)_6]$ and 0.2 mM phenyl-*p*-benzoquinone or 2 mM 2,6-dichloro-*p*-benzoquinone. The electrode was calibrated using air-saturated and nitrogen-saturated water at atmospheric pressure.

The PSII samples are highly active with 2200–3700 μmol O_2 (mg Chl*a* h)$^{-1}$; 37–70 Chl*a* (0.25 O_2 flash)$^{-1}$. Redissolved crystals showed the same oxygen evolution activity as dimeric PSII prior to crystallization.[16] These results indicated that the overall structure of the water-oxidizing center was not altered during protein isolation, purification, and crystallization.

Table 1 Overview about structural studies on PSII complexes

Origin	Complex	Method	Resolution	PDB entry	References
S. oleracea	Monomeric D1/D2/CP47 PSII subcomplex	EM	8–6 Å		24–26
T. elongatus	Cyanobacterial PSII core complex	X ray	3.8 Å	1FE1	27
T. elongatus	Cyanobacterial PSII core complex	X ray	3.8 Å	1ILX	28
T. vulcanus	Cyanobacterial PSII core complex	X ray	3.7 Å	1IZL	29
T. elongatus	Cyanobacterial PSII core complex	X ray	3.5 Å	1S5L	23
T. elongatus	Cyanobacterial PSII core complex	X ray	3.2 Å	1W5C	30
T. elongatus	Cyanobacterial PSII core complex	X ray	3.0 Å	2AXT	18

X-RAY STRUCTURE OF PHOTOSYSTEM II AT 3.0-Å RESOLUTION

Crystallization

PSII crystals were grown from a solution containing 3–10% (w/w) PEG-2000, 100 mM PIPES-NaOH, pH 7.0, 5 mM $CaCl_2$, 0.03% (w/w) β-DM using the batch method.[13,17] It should be noted that the crystallization setups were prepared and subsequently stored at 20 °C in the dark. The crystals grew within 3–5 days to a size of about 500 μm and were suitable for X-ray diffraction experiments. The advantage of the batch method compared with other crystallization techniques is the larger size of the obtained crystals. The crystals belong to the orthorhombic space group $P2_12_12_1$, and cell parameters are $a = 127.7$ Å, $b = 225.4$ Å, $c = 306.1$ Å with one dimeric PSII molecule per asymmetric unit.[18] The PSII crystals retain an unrestricted and highly active water-oxidizing capacity as they evolve oxygen bubbles when they are excited by light.[19] Successful crystallization of PSII from plant and cyanobacteria has been reported by different groups using different crystallization setups.[20–23]

Overall description of the structure

During the last decade there have been extensive efforts to obtain structural information on plant and cyanobacterial PSII.[18,23–30] The first crystal structure of PSII published in 2001 revealed the overall arrangement of the PSII complex.[27] The diffraction quality of the crystals was gradually improved by this[18,30] and other groups with PSII isolated from T. elongatus[23] and from the related T. vulcanus.[29] The obtained structures (Table 1) differ mainly in terms of completeness of the model and interpretation of the electron density.

The crystal structure of dimeric PSII from the cyanobacterium T. elongatus discussed here presents the highest resolution (3.0 Å) structure of cyanobacterial PSII[18] presently available. The structure shows the architecture of 38 protein subunits in the PSII homodimer, the monomers being symmetry related by a pseudo-C2 axis normal to the membrane plane (Figure 1). The longest dimensions of PSII measure 200×100 Å2. The membrane-integral part is 40 Å thick and extends above the cytoplasmic side of the membrane surface by no more than 20 Å. The extended loop domains of CP47, CP43 and the membrane-extrinsic subunits PsbO, PsbU, and PsbV extend by around 78 Å into the lumen, the longest extension being formed by PsbO. Each PSII monomer with a molecular mass of 375 kDa is composed of 19 different subunits, 16 forming a field of 36 transmembrane spanning α-helices (TMHs). The 22 TMHs of the central RC subunits D1 and D2 as well as the antenna subunits CP43 and CP47 are related by a local pseudo-C2(Fe^{2+}) symmetry axis (Figure 1). This axis is orientated parallel to the local pseudo-C2 axis that relates the two monomers of the PSII dimer and passes through the nonheme iron (Fe^{2+}) located near the cytoplasmic side of the membrane. The pseudo-C2(Fe^{2+}) axis relates D1 and D2 that form the core of the complex (2×5 TMHs) and the antenna subunits CP47 and CP43 (2×6 TMHs). The low molecular weight subunits are located at the periphery and at the dimer interface. The three membrane-extrinsic and the low molecular weight membrane-intrinsic subunits break the pseudo-C2(Fe^{2+}) symmetry of the monomer. In addition, the electron density revealed the location and coordination of organic cofactors and metal ions including 35 Chla, 11 carotenoids (Car), 2 Pheo, 2 PQ, 2 heme, bicarbonate, 14 lipid, 3 detergent molecules (β-DM), 4 Mn-atoms, 2 Ca^{2+}, and Fe^{2+}.[18]

Internal antenna system

The energy required for charge separation at the special Chla pair P680 is provided by sunlight. If sunlight is converted to electrochemical energy by charge separation, this is termed 'trapping' of light energy. The absorption of a photon and the transfer of excitation energy to the RC is performed via the antenna pigments located in the outer (phycobilisomes) and inner (CP43, CP47) antenna system.

The principal photoreceptor of photosynthetic organisms is chlorophyll, a tetrapyrrol derivative. The main differences to the heme group are (1) the central metal ion is Mg^{2+}, (2) pyrrol-ring III has an additional cyclopentanone-ring (pyrrol-ring IV), (3) pyrrol-ring IV is partially reduced, (4) the propionate group of pyrrol-ring IV is esterified

with a long phytol group. The conjugated π-system absorbs sunlight efficiently. Small differences in the protein-surrounding modulate the spectral properties of Chl*a*, the exclusive chlorophyll derivative so far identified in PSII from *T. elongatus*. Because Chl*a* molecules are the most abundant cofactors of PSII, Mg^{2+} cations are in consequence the most abundant metal ions observed in the internal antenna system and in the ETC.

The main purpose of all antenna systems is the optimal trapping of radiation energy over a broad wavelength range that is subsequently converted to electrochemical work. These systems have to transfer energy faster than the natural lifetime of the excited state over long distances from the peripheral antenna pigments to the ETC via several intermediate steps. Crucial for efficient energy transfer between pigments are the interpigment distances and the orientations of the pigment dipoles, rather than the overall supramolecular structure of the antenna.

The light-absorbing pigments are localized in transmembrane regions of CP47 and CP43. One PSII monomer harbors 29 Chl*a* molecules in its antenna system (13 in CP47 and 16 in CP43), arranged in two layers near the cytoplasmic and lumenal sides of the membrane (Figure 3). The cytoplasmic layers of both subunits contain nine Chl*a* molecules each (numbered Chl*a*21 to Chl*a*29 in CP47 and Chl*a*41 to Chl*a*49 in CP43) that are related by the local pseudo-$C2(Fe^{2+})$ symmetry axis passing through the non-heme Fe^{2+} (Figures 1 and 3).[18,30,31] By contrast, the lumenal layer contains seven Chl*a* in CP47 (Chl*a*11 to

Table 2 Overview of the ligation of the central Mg^{2+} of Chl*a* molecules by protein residues, acylcarbonyl function (ac.) of digalactosyldiacylglycerol (CP43) or monogalactosyldiacylglycerol (CP47). For four central Mg^{2+} cations, no direct ligands have been identified (unassigned), the interactions being probably mediated by a water molecule to the protein

	His	Asn	Backbone	ac.	Unassigned	Sum
All	27	1	1	2	4	35
PsbA, D1	2				1	3
PsbB, CP47	13		1	1	1	16
PsbC, CP43	10	1		1	1	13
PsbD, D2	2				1	3

Chl*a*17), but only four in CP43 (Chl*a*33 to Chl*a*35 and Chl*a*37).

The central Mg^{2+} of the Chl*a* are mostly coordinated by histidine imidazoles (Table 2). Other ligands are observed as well, one Chl*a* (Chl*a*47) in CP43 being coordinated by Asn, and for four additional Chl*a* no direct ligand could be identified. Most likely these Mg^{2+} are indirectly coordinated by water molecules which could not be resolved at 3.0-Å resolution. Interestingly, not only amino acids serve as ligands to Mg^{2+}. In CP43 the acylcarbonyl of the lipid digalactosyldiacylglycerol is at 3.2 Å distance to the central Mg^{2+} of Chl*a*37, and Chl*a*17 located in CP47 is at 3.9-Å distance to the acylcarbonyl function of monogalactosyldiacylglycerol.[18,32] Similar lipid–chlorophyll binding interactions have been described for PSI[33] and LHCII[34,35] but in these cases the central Mg^{2+} of Chl*a* is directly coordinated by a free oxygen of the phosphodiester group of phosphatidylglycerol and not by the acylcarbonyl.

Of particular interest are Chl*a* molecules that may connect the inner antenna system and the ETC. Two Chl*a* molecules (Chl*a*21 in CP47 and Chl*a*41 in CP43) fulfill this function in cyanobacterial PSII as they are closest (about 20 Å) to Pheo$_{D1/D2}$ in the ETC. The clear separation of antenna and ETC cofactors has two advantages, first that the antenna cofactors are protected from harmful oxidation by P680$^+$ and second that fast excitation energy transfer to the ETC is still efficient as the transfer rate has been estimated to be approximately 20 ps. The exact nature of this kinetics is still under debate.[36]

Cytoplasm

Lumen

Figure 3 Side view of monomeric PSII showing the arrangement of the antenna Chl*a* as well as the ETC. All protein subunits are shown in gray. Cofactors in green (Chl*a*), yellow (Pheo), blue (heme), violet (quinone) drawn in stick representation. For clarity Car, lipid and detergent molecules are not drawn. The non-heme Fe^{2+} (blue), the putative Ca^{2+} (yellow) as well as the Mn_4Ca-cluster (red–yellow) are shown as spheres.

Reaction center

The primary function of the ETC is the charge separation and the stabilization of two radical species. The ETC is embedded in the RC formed by subunits D1 (PsbA) and D2 (PsbD) and isolated from the protein matrix of other subunits. This spatial separation protects the protein-surrounding from the highly reactive radicals formed during

Figure 4 View along the membrane plane. The cofactors of the ETC (P_{D1}/P_{D2}, $Chl_{D1/D2}$, $Pheo_{D1/D2}$, and $Q_{A/B}$) are related by the pseudo-$C2$(Fe^{2+}) axis (arrow), Fe (blue), Mn (red), and Ca (yellow) are shown as spheres. Selected distances (in Å) are drawn between cofactor centers (black lines) or edges (red dotted lines).

the photosynthetic cycle and reduces possible energy-wasting side reactions.

The five TMH (a–e) of D1 and D2 are arranged in semicircles related by the local pseudo-$C2$(Fe^{2+}) axis (Figure 1a, molecule II) similar as in the well resolved (2.3 Å) purple bacterial reaction center (PbRC).[37] The D1 and D2 subunits bind all cofactors of the ETC, from the lumenal to the cytoplasmic side: Mn_4Ca-cluster, Chla of the photochemical RC P680 ($P_{D1/D2}$), two accessory Chla ($Chl_{D1/D2}$), two pheophytin a ($Pheo_{D1/D2}$), two carotenoid molecules, nonheme Fe^{2+} and two plastoquinones (Q_A and Q_B), of which Q_B is finally reduced. Except for the Mn_4Ca-cluster and the two bound Car molecules, the cofactors of the ETC are arranged in two branches related by the local pseudo-$C2$(Fe^{2+}) axis (Figure 4), similar as in PbRC[37] and PSI.[33] The symmetric arrangement is reflected in nearly equal distances between corresponding cofactors of each branch (Figure 4). Although the arrangement and orientation of the cofactors constituting the two branches of the ETC are similar in PSII and PbRC,[37] there are some notable differences.

Chla molecules P_{D1} and P_{D2} coordinated by D1-His198 and D2-His197 form the special pair P680 in PSII in analogy to P700 in PSI and P960 in PbRC. A notable differences is that the $Mg^{2+} \cdots Mg^{2+}$ distance of $P_{D1/D2}$ in PSII, 8.3 Å, is only 0.7 Å longer than that of the two bacteriochlorophyll b of P960, 7.6 Å[37] in PbRC, suggesting that P680 could likewise act as a special Chla pair. Contradictory to the special pair model, the observed excitonic coupling between P_{D1} and P_{D2} is much smaller than expected and this led to the multimer model.[38,39] According to the multimer model, the excited singlet state $^1P680^*$ is delocalized over all four Chla ($P_{D1/D2}$, $Chl_{D1/D2}$),

and possibly includes the two Pheo molecules that act as a collective state, thereby promoting fast and efficient charge separation.[5,6] In addition the increased distance between P_{D1} and P_{D2} reduces electronic coupling, which in turn probably contributes to the higher midpoint redox-potential for the primary electron donor in PSII compared with PbRC (1.17 V in $P680^{+\bullet}/P680$ vs 0.52 V in $P960^{+\bullet}$/P960),[40,41] finally allowing electron abstraction from Tyr_Z and from the Mn_4Ca-cluster.

Chl_{D1} and Chl_{D2} are found in positions equivalent to the two accessory bacteriochlorophyll b in PbRC. In contrast to PbRC, they are not coordinated by histidines, but probably by water molecules hydrogen bonded to D1-Thr179Oγ and to the backbone oxygen of D2-Val175, respectively. (Table 2). This coordination is similar to the situation described in PSI, where accessory chlorophyll molecules eC-A2 and eC-B2 are coordinated via water to the protein backbone.[33] Chl_{D1} is the closest to $Pheo_{D1}$ and most likely the initial electron donor to form the radical pair $Chl^{\bullet+}_{D1}$ $Pheo^{\bullet-}$.[42,43] This intermediate pairing is short lived, and the electron travels within a few milliseconds along the ETC to Q_B. After double reduction of Q_B and protonation to plastoquinol, Q_BH_2 leaves PSII by diffusion through an internal channel into the thylakoid membrane.

Both peripheral $Chlz_{D1/D2}$ are most likely not involved in primary charge separation and they show slow energy transfer to P680.[44,45] Accordingly it was suggested that these two Chlz could be of importance in energy transfer from the inner antenna system (CP47 and CP43) to the ETC,[46,47] but their location is too distant to the cofactors of the ETC and certainly not optimized for energy transfer.[28,48] The closest cofactors to $Chlz_{D1/D2}$ are either Car_{D1} or Car_{D2} (Figure 4). $Chlz_{D2}$ as well as cyt b-559 and Car_{D2} could act as alternate electron donors that are possibly involved in secondary electron transfer when the Mn_4Ca-cluster is damaged.[49]

The non-heme Fe^{2+}

The non-heme iron resides close to the cytoplasmic side of PSII right on the pseudo-$C2$(Fe^{2+}) axis and is flanked by primary quinone Q_A and secondary quinone Q_B. Compared to PbRC, the nonheme iron in PSII has a noticeably lower redox-potential which is pH dependent.[50,51] Under physiological conditions, the role of the nonheme iron in electron transfer reactions at the acceptor side is probably of minor relevance. Under stress conditions, i.e. damage of the electron donor side or the electron acceptor Q_B side, the nonheme iron could have a protective function. The non-heme iron is coordinated by four histidines (D1-His215, D1-His272, D2-His214, D2-His268) provided by the four-helix bundle formed by TMH-**d** and -**e** of D1 and D2 (Figures 1a, molecule II, and 5). Four sequentially and structurally homologous histidines and bidentate glutamate (GluM232) provide the ligands for the non-heme iron

D1-Glu 244

D2-Tyr 244

D1-Tyr 246

3.3
3.3

D1-Ser 268

2.8 2.7

2.8

D2-Lys 264 2.6

2.3 D1-His 272

3.0 2.1

2.2

D2-His 268 2.2

D1-His 215 D2-His 214

Figure 5 Coordination of the nonheme Fe^{2+} by residues of the RC subunits D1 and D2 as well as bicarbonate are drawn as gray sticks. All other amino acid residues as well as cofactors are not drawn for clarity. Red dashed lines indicate hydrogen bonds and Fe^{2+} coordination. All distances are given in Å.

in PbRC.[52] Whereas, the four hisitidines are conserved, there is, however, no equivalent of Glu M232 in PSII. On the basis of Fourier transform infrared (FTIR) spectroscopy data,[53] a peak in the F_o-F_c electron density was interpreted as bicarbonate coordinated to Fe^{2+} that is additionally hydrogen bonded by D1-Tyr246-OH and D2-Tyr244-OH. The properties of bicarbonate could explain the specific properties of the quinone–iron electron acceptor side in PSII.[54] Bicarbonate has a strong influence on the electron transfer rates between the quinones[55] and influences the midpoint potential of the non-heme Fe^{2+}. D1-Glu244 that ligates bicarbonate is held in position by a salt bridge to D2-Lys264. Interestingly, D1-His215 and D2-His214 may serve dual functions. They coordinate with their unprotonated Nε to Fe^{2+}, while the Nδ-H groups could form hydrogen bonds with Q_A and Q_B, thereby facilitating electron transfer between them.

The Mn_4Ca-cluster

Without doubt the catalytic site of PSII, the oxygen evolving complex (OEC), is the holy grail for many scientists and has been investigated by a wide array of spectroscopic and biochemical methods. It is composed of four mixed-valence Mn cations, a Ca^{2+} cation and a chloride.[56] After four single light flashes, one molecule of oxygen evolves with a peculiar oscillatory pattern. The third flash results in the maximum oxygen yield. Thereafter, the amount of produced oxygen peaks with every fourth flash until the oscillation damps out to a steady state, thus showing

that the OEC must undergo four light-dependent reactions before the release of oxygen. The OEC cycles through five different states, named S_0 to S_4,[57] during which the Mn cations change their oxidation states. Oxygen is released between cycles S_4 and S_0. S_1 seems to be the most stable state as oxygen is first released at the third and thereafter at each fourth flash. During water oxidation, a total of four protons are released to the lumen. Since the E_m of O_2/H_2O was measured to be 0.815 V,[1] the five S-states have to have a very high redox-potential. Furthermore the OEC has to stabilize highly reactive intermediates in a protein environment.

Electron paramagnetic resonance (EPR) and X-ray spectroscopic measurements on PSII and metallo-organic model compounds provided many insights into the structure of the Mn_4Ca-cluster.[58–63] Extended X-ray absorption fine structure (EXAFS) at the Mn absorption edge is used to study the arrangement of the Mn cations, and the proposed topologically consistent models can be reconciled with several different structures where the four Mn cations are possibly organized.[64] EPR studies indicate that the four Mn cations are arranged in a structure with three strongly exchange-coupled Mn cations that are coupled more weakly to the fourth Mn. The proposed model consists of two or three di-μ-oxo-bridged binuclear Mn units with strongly coupled Mn–Mn distances of about 2.7 Å that are linked to each other by a mono-μ-oxo bridge with a Mn–Mn separation of about 3.3 Å and with Ca^{2+} at a distance of 3.4 Å to one of the Mn.[63–66] The Mn–Mn distances are largely invariant in the native S_1 and S_2 states.[64] EXAFS experiments on the S_3 and S_0 states have been difficult to perform on PSII samples using single flashes. The fewer number of studies on the Ca^{2+} cofactor have sometimes relied on substituting the native cofactor with Sr^{2+} or other metals[67,68] and have stirred some debate about the structure of the binding site. Sr^{2+} has a similar ionic radius as Ca^{2+} as well as a pK_a of its aqua ion that is close to that of Ca^{2+} and therefore can functionally substitute for Ca^{2+}. Efforts using Mn EXAFS on Sr^{2+} substituted PSII[69] and Sr^{2+} EXAFS[66,70,71] have indicated a close link between the Mn cluster and Sr^{2+}, within 3.5 Å. Nevertheless, other experiments have given contradicting results.[72]

The cluster of 4Mn cations is located at the lumenal side of D1 and surrounded mostly by residues from this subunit and side chains from CP43 (Figure 6). The shape of the electron density of the Mn_4Ca-cluster can be best approximated by four Mn atoms arranged as a 'hook' (Figure 6).[18] Single-wavelength anomalous scattering was exploited to confirm the positions of the Mn cations by collecting anomalous diffraction data at the absorption edge of Mn (1.88 Å) and for the Ca cation by collecting data beyond the Mn-edge (1.91 Å). Making use of anomalous difference electron density maps, the four Mn cations were modeled in a 'hook'-like arrangement, and Ca^{2+} was localized between the Mn cluster and Tyr_Z (D1-Tyr161). The Mn cations are numbered Mn1 to Mn4, starting from

Figure 6 View of the Mn₄Ca-cluster along the membrane plane. (a) Surrounding amino acids of D1 (yellow) and CP43 (magenta) are indicated, Mn (red) and Ca (yellow) are shown as spheres and numbered. Electron density is contoured at 1.2σ level. (b) Schematic view of the Mn₄Ca-cluster, distances (Å) between Mn (red) and Ca (yellow) are indicated by colors of connecting lines (blue, 2.7 Å; magenta, 3.3 Å; green, 3.4 Å). Amino acids of first coordination sphere are shown in black; those of the second sphere in gray, ligand–metal distances are given in Å.

the highest electron density at the bend of the 'hook'. Mn1–Mn2 and Mn2–Mn3 are 2.7 Å apart and probably connected by di-μ-oxo bridges, while Mn1–Mn3 and Mn3–Mn4 are at 3.3 Å, suggesting mono-μ-oxo bridges. This arrangement is compatible with the '3 + 1' models suggested for the Mn cations.[73] Ca^{2+} forming the vertex of a trigonal pyramid is equidistant (\sim3.4 Å) to Mn1, 2, and 3 (Figure 6). Whereas the distances between the metal centers derived from the electron density[18] agree with EXAFS studies, the number of short and long Mn–Mn and of Mn–Ca interactions is different compared to those derived by EXAFS measurements.[63,74] The medium resolution (3.0 Å) of the X-ray diffraction data may account for atomic coordinate errors, and possible radiation damage is indicated by weaker electron density observed for Ca^{2+} and Mn4.

The coordination of Mn by amino acids was extensively studied by a combination of mutational and spectroscopic studies (for reviews see references 75–78). The amino acids directly coordinating Mn and Ca^{2+} are depicted in Figure 6. In addition there are further amino acid residues that are not directly ligating the metal sites but could form a second coordination sphere. These residues might interact through water molecules or they may provide ligation in different S-states of the Mn₄Ca-cluster. Five carboxylates (Figure 6) act as bidentate ligands bridging different cations. The combination of bidentate ligands and mono- or di-μ-oxo bridges could enhance the stability of the cation arrangement and facilitate rearrangement of μ-oxo bridges during the S-state cycle. Mutational studies of ligating residues[75,76] showed that, except for D1-Glu333 and D1-Asp342, replacement of a ligating group with a group that cannot ligate metal

ions still leads to a (partially) functional cluster. The PSII structure[18] shows that in most cases a second ligating group is present, which could hold the cations in place, even when the exchanged residue cannot coordinate them. Ca^{2+} is coordinated by D1-Glu189 and D1-Ala344, with the former also ligating Mn1 and the latter Mn2. Taking into consideration the positional error of Ca^{2+} and results from FTIR spectroscopy indicating that D1-Ala344 should ligate Mn[79] but not Ca^{2+},[80] it is likely that Ca^{2+} is only coordinated by D1-Glu189. The Mn high affinity binding site during assembly of the cluster[76,81,82] is formed by D1-Asp170 and D1-Glu333 ligating Mn4 that is more distinct from the other three Mn. The 3.0-Å resolution structure[18] did not provide any hints for modeling additional molecules like bicarbonate, water or chloride in the direct vicinity of the Mn₄Ca-cluster as reported in the 3.5-Å resolution structure.[23]

Assuming an oxidation state distribution of Mn(III)₂(IV)₂ for the S₁-state of the Kok-cycle,[60,83] localization of oxidation states on individual metal ions of the cluster was proposed on the basis of results from FTIR studies.[79,84,85] Mn1 and Mn3 can either attain oxidation state III or IV in the S₁ state. Mn4, ligated by Asp170, is not oxidized during S₀-S₁-S₂-S₃ transitions,[84] and therefore likely present as Mn(IV) whereas, Mn2, ligated by the C-terminal carboxylate of Ala344, changes from Mn(III) to Mn(IV) in the S₁–S₂ transition[79] and can be considered as the site of first oxidation during the catalytic cycle of water splitting.

The structure of the Mn₄Ca-cluster differs considerably from the postulated cubane-like model as derived from the 3.5-Å resolution structure[23] because the Mn–Mn distances

within the pyramid formed by the three Mn are not equal and the pyramid is connected asymmetrically to Mn4 (for detailed comparison of both structures see Supplementary Material in references 18, 78). In addition there are differences observed in the coordination of metal ions. i.e. in the assignment of the ligands to certain metal ions as well as in the number of bridging ligands that were reported in the 3.5-Å resolution structure.[18,23]

The exposure of PSII crystals to X rays during data collection leads to radical formation in the protein and in solvent channels, and the radicals destroy PSII and, above all, they reduce the Mn ions.[86] This is associated with changes in the Mn–Mn distances and the geometry of the Mn_4-cluster and could thereby affect its coordination sphere and the protein environment. Using X-ray absorption spectroscopy (13.3 keV at 100 K) on single crystals, it was shown that Mn(III) and Mn(IV) of the Mn_4Ca-cluster are rapidly reduced to Mn(II) when a radiation dose equivalent to the dose required for collecting even a partial X-ray diffraction data set is applied to PSII crystals.[86] At lower energies (6.6 keV) used for the anomalous diffraction studies at the Mn edge, an even higher radiation damage was found because the harmful absorption of X rays by the crystals increases with longer wavelengths (lower energy). Structural changes accompanying Mn reduction in solution were monitored by Mn-EXAFS spectra.

This study revealed dramatic changes in the characteristic pattern of the Fourier transform of the Mn_4Ca-cluster EXAFS spectra (three peaks representing Mn–O interactions at 1.8 Å, and Mn–Mn interactions at 2.7 Å, and 3.3 Å as well as Mn–Ca interactions at 3.4 Å) upon increasing the dose, associated with disruption of μ-oxo bridges and changes in the Mn–ligand interactions.[86] Dichroic X-ray absorption and EXAFS spectra from the OEC in the dark adapted S_1 state were collected recently using polarized X-ray spectroscopy on oriented single crystals of T. elongatus PSII, and a structural model for the Mn_4CaO$_X$ cluster was derived.[87] Notably both structures of the Mn_4Ca-cluster[18,23] as determined by X-ray crystallography failed to reproduce the calculated dichroism of the experimental EXAFS spectra.

The electron density for the Mn_4Ca-cluster possibly represents a mixture of all kind of S-states, the native dark adapted S_1 state of the Mn_4Ca as well as stepwise reduced states. One symptom of such damage could be the reported uneven distribution of electron density within the cluster.[18] The highest peak in the electron density of 8.4σ is located within the Mn1–Mn2 pair; it decreases to 7.0σ at Mn3 and to 4.4σ around Mn4. The electron density of the Ca^{2+} cation is only 2σ. Decreased electron density levels may be interpreted as indicator for disorder, directly or indirectly induced by X-ray radiation. One cannot also entirely exclude the possibility that positions and coordination modes of cations as well as amino acid ligands are altered by radiation.

Membrane-intrinsic cyt b-559

Cyt b-559 is composed of two heme-bridged subunits α (PsbE) and β (PsbF) located at the periphery of PSII and close to D2 in a hydrophobic environment (Figure 1). A characteristic property of cyt b-559 is the occurrence of two forms with high- and low-midpoint potentials (+390 mV and +275 mV, respectively, at pH 6.5). Compared with other b-type cyt the high-midpoint redox-potential of cyt b-559 is unusual. The function of high-potential cyt b-559 in PSII is still under debate. It was proposed to be involved in proton translocation and secondary electron transfer processes that may play a protective role under intensive light-stress conditions and, in the absence of a functional Mn_4Ca-cluster, it could transfer electrons to P680+•.[88] Even though cyt b-559 is not crucial for O_2 activity, it is important for the assembly of stable PSII.[89]

The heme of cyt b-559 is located near the cytoplasmic side of PSII, the normal of the heme plane being tilted by 86° to the normal of the membrane plane. α-His23 and β-His24 coordinate the central Fe^{2+} with their Nε atoms (Figure 7). Their NδH groups form hydrogen bonds to peptide oxygen α-Tyr19O and β-Trp20O (3.2 Å). This unique coordination of the heme group in a heterodimeric, hydrophobic protein matrix and with hydrogen bonds formed by both of the coordinating imidazoles to peptide oxygens is most likely the reason for the unusual redox properties. FTIR spectroscopic studies showed that in the low-potential form one of the hydrogen bonds is possibly broken.[90,91] Additionally, α-His23 imidazole π-stacks with the aromatic ring of α-Tyr19, and β-His24 imidazole π-stacks with the indole group of β-Trp20.

Figure 7 Binding niche of heme in cyt b-559 close to the cytoplasmic side of the membrane. View along the membrane plane. Cyt b-559 α-chain is in green and β-chain in cyan. The heme (gray sticks) and coordinating histidines (α-His23 and β-His24) are shown. Dashed red lines indicate hydrogen bonds and Fe^{2+} coordination. All distances are given in Å.

Figure 8 Representation of membrane-extrinsic cyt *c*-550 (PsbV) (blue): The heme and coordinating histidines are shown. All other subunits and cofactors of PSII are omitted. Cyt *c*-550 is coordinated by PsbV-His67 and PsbV-His118. A thioether bond is formed within the heme vinyl group C3^1 of the heme and PsbV-Cys63 (black bar). Dashed red lines indicate hydrogen bonds and Fe^{2+} coordination.

Membrane-extrinsic cyt *c*-550

Cyt *c*-550 is present only in cyanobacterial and algal-type PSII but absent in higher plant PSII. Recent biochemical and EPR studies revealed that the redox potentials and the EPR characteristics of the isolated, soluble and PSII-bound forms of *T. elongatus* cyt *c*-550 are markedly different,[91,93] −80 mV and −240 mV, respectively, at pH 6.0.[92]

In cyanobacteria, cyt *c*-550 is lumenally associated with PSII where it appears to stabilize the OEC[94] and it is close to cyt *b*-559, CP43 and PsbU (Figure 1(b)). The heme group is well defined in the electron density,[18] tilted by about 60° to the membrane plane (the angle between the normal to the heterocycle plane and the pseudo-C2(Fe^{2+}) axis) and shielded from the solvent by hydrophobic residues of cyt *c*-550 and by the extended lumenal domain of CP43. The Fe^{2+} is coordinated by PsbV-His67Nε (2.1 Å) and by PsbV-His118Nε (2.2 Å) (Figure 8). PsbV-His67NδH is hydrogen bonded to PsbV-Ile71O (2.7 Å) and to PsbV-Thr72Oγ1 (3.2 Å) whereas, PsbV-His118 NδH is stabilized by a hydrogen bond to the backbone carbonyl of PsbV-Pro119O (2.8 Å). Only OE1 of one of the two propionate heme carboxy groups is in direct contact with the protein backbone (PsbV-Asp79O, 3.1 Å), whereas the other one is probably hydrated. The hydrophobic environment of the heme and the close π-stacking interaction of PsbV-Tyr101Oη⋯Fe^{2+}, 5.0 Å, could modulate the heme redox

properties. The redox-potential difference between bound and isolated cyt *c*-550[91] could be caused by shielding of the heme group from CP43 in the bound state and by a different protonation pattern of the protein-surrounding.[95] PsbV-Cys63 of the ^{63}CysXXCysHis67 motif,[96] a common feature of *c*-type cytochromes, forms a thioether bond with the heme vinyl group C3^1, whereas PsbV-Cys66 is close enough to vinyl group C8^1 to also form a thioether bond, but there is no connecting electron density. This could be explained by radiation damage as the MALDI-TOF mass spectrum showed the mass for cyt *c*-550 with covalently attached heme group (Jan Kern personal communication). The structure of free cyt *c*-550 (PDB entry 1MZ4)[97] superimposes on PsbV associated to PSII with an rmsd of 0.3 Å for 131 Cα atom pairs. Major conformational changes upon binding to PSII, which might influence the redox properties of cyt *c*-550, seem not to occur.

Putative Ca^{2+} binding sites

Spherical electron density on the lumenal side of PsbK was interpreted as putative Ca^{2+} (Figures 1 and 3) according to the acidic protein-surrounding and contents of the crystallization buffer. This Ca^{2+} could be coordinated by side chains of PsbK-Asp19, PsbK-Asp23 and a residue from unassigned TMH X1. The location of this cation, distant from the OEC, suggests that it is not involved in the catalytic cycle.[18] Most likely the Ca^{2+}-binding site provides structural stabilization for the low-molecular-weight subunits or is a low affinity binding site.

Another possible Ca^{2+}-binding site on the surface of the membrane-extrinsic PsbO subunit is under debate. On the basis of anomalous X-ray diffraction data, Ferreira *et al.*[23] reported a weak binding site for Ca^{2+}.[98] The ligands of this Ca^{2+}-binding site are PsbO-Glu54, PsbO-Glu114, and PsbO-His231. It should be noted that only PsbO-Glu114 is highly conserved, whereas PsbO-His231 is a lysine in most organisms. The electron density calculated from anomalous X-ray diffraction data at 3.0-Å resolution[18] did not show a peak at this position and therefore cannot support this binding site. In addition spectroscopic Ca^{2+} binding studies on heterologously expressed *T. elongatus* PsbO protein provided no evidence for a Ca^{2+} binding site.[99]

Comparison with related structures

Bacterial photosynthetic systems can be divided in two distinct groups, classified by the terminal electron acceptor of the ETC. PSII belongs to the type-II (quinone-type) characterized by a quinone-type terminal electron acceptor. Other members of this group are RC of green filamentous bacteria and PbRC.[100,101] For type-I RC with Fe$_4$S$_4$ clusters as terminal electron acceptors, see the chapter on cyanobacterial PSI by Saenger, Biesiadka, and Loll. In

addition, the RC polypeptide chains D1 and D2 of PSII have structural homology to the PbRC subunits L and M, and on this basis, corresponding functional regions had already been suggested for PSII in 1988.[102] Furthermore, amino acid sequences of D1 and D2 show homology to the RC domain of PsaA and PsaB of PSI, suggesting that gene duplications from a common ancestor gave rise to these subunits in PSII and PSI,[103] and likewise the core antenna proteins CP47 and CP43 show high homology to the antennae domains of PsaA and PsaB, respectively, of PSI.[103,104] Additionally, superposition of the chromophore structure in CP43 and CP47 of PSII[18,30,31] and in the corresponding antenna domains of PsaA and PsaB in PSI[33] reveals relatively high conservation with respect to the location of the Chl*a* heterocycles and analogous manner of coordination.[31,105]

REFERENCES

1 B Ke, *Photosynthesis – Photobiochemistry and Photobiophysics*, Vol. 295, Kluwer Academic Publishers, Dordrecht, The Netherlands (2001).

2 T Wydrzynski and K Satoh, *Photosystem II: The Light-Driven Water: Plastoquinone Oxidoreductase, Advances in Photosynthesis and Respiration Series, Vol. 22*, Springer, Dordrecht, The Netherlands (2005).

3 L Margulis, *Symbiosis in Cell Evolution*, W. H. Freeman and Company, San Francisco, CA (1981).

4 JW Stiller and BD Hall, *Proc Natl Acad Sci U S A*, **94**, 4520–4525 (1997).

5 EJG Peterman, H van Amerongen, R van Grondelle and JP Dekker, *Proc Natl Acad Sci U S A*, **95**, 6128–6133 (1998).

6 LM Barter, JR Durrant and DR Klug, *Proc Natl Acad Sci U S A*, **100**, 946–951 (2003).

7 H Ishikita, B Loll, J Biesiadka, W Saenger and EW Knapp, *Biochemistry*, **44**, 4118–4124 (2005).

8 F Rappaport, M Guergova-Kuras, PJ Nixon, BA Diner and J Lavergne, *Biochemistry*, **41**, 8518–8527 (2002).

9 BA Barry, *Photochem Photobiol*, **57**, 179–188 (1993).

10 R Hill and F Bendall, *Nature*, **186**, 136–137 (1960).

11 Y Nakamura, T Kaneko, S Sato, M Ikeuchi, H Katoh, S Sasamoto, A Watanabe, M Iriguchi, K Kawashima, T Kimura, Y Kishida, C Kiyokawa, M Kohara, M Matsumoto, A Matsuno, N Nakazaki, S Shimpo, M Sugimoto, C Takeuchi, M Yamada and S Tabata, *DNA Res*, **9**, 123–130 (2002).

12 RW Castenholz. *Methods Enzymol*, 68–100 (1988).

13 J Kern, B Loll, C Lüneberg, D DiFiore, J Biesiadka, K-D Irrgang and A Zouni, *Biochim Biophys Acta*, **1706**, 147–157 (2005).

14 K Zimmermann, M Heck, J Frank, J Kern, I Vass and A Zouni, *Biochim Biophys Acta*, **1757**, 106–114 (2006).

15 LC Clark, *Trans Am Soc Artif Intern Organs*, **2**, 41 (1956).

16 J Kern, B Loll, A Zouni, W Saenger, K-D Irrgang and J Biesiadka, *Photosynth Res*, **84**, 153–159 (2005).

17 A Zouni, C Lüneberg, P Fromme, WD Schubert, W Saenger and HT Witt, in G Garab (ed.), *Photosynthesis: Mechanisms and Effects*, Kluwer Academic, Dordrecht, The Netherlands, pp 925–928 (1998).

18 B Loll, J Kern, W Saenger, A Zouni and J Biesiadka, *Nature*, **438**, 1040–1044 (2005).

19 A Zouni, R Jordan, E Schlodder, P Fromme and HT Witt, *Biochim Biophys Acta*, **1457**, 103–105 (2000).

20 C Fotinou, M Kokkinidis, G Fritzsch, W Haase, H Michel and DF Ghanotakis, *Photosynth Res*, **37**, 41–48 (1993).

21 N Adir, *Acta Crystallogr D Biol Crystallogr*, **55**, 891–894 (1999).

22 H Kuhl, J Kruip, A Seidler, A Krieger-Liszkay, M Bunker, D Bald, AJ Scheidig and M Rögner, *J Biol Chem*, **275**, 20652–20659 (2000).

23 KN Ferreira, TM Iverson, K Maghlaoui, J Barber and S Iwata, *Science*, **303**, 1831–1838 (2004).

24 EP Morris, B Hankamer, D Zheleva, G Friso and J Barber, *Structure*, **5**, 837–849 (1997).

25 KH Rhee, EP Morris, D Zheleva, B Hankamer, W Kühlbrandt and J Barber, *Nature*, **389**, 522–526 (1997).

26 KH Rhee, EP Morris, J Barber and W Kühlbrandt, *Nature*, **396**, 283–286 (1998).

27 A Zouni, HT Witt, J Kern, P Fromme, N Krauss, W Saenger and P Orth, *Nature*, **409**, 739–743 (2001).

28 S Vasil'ev, P Orth, A Zouni, TG Owens and D Bruce, *Proc Natl Acad Sci U S A*, **98**, 8602–8607 (2001).

29 N Kamiya and JR Shen, *Proc Natl Acad Sci U S A*, **100**, 98–103 (2003).

30 J Biesiadka, B Loll, J Kern, K-D Irrgang and A Zouni, *Phys Chem Chem Phys*, **6**, 4733–4736 (2004).

31 B Loll, J Kern, A Zouni, W Saenger, J Biesiadka and K-D Irrgang, *Photosynth Res*, **86**, 175–184 (2005).

32 B Loll, J Kern, W Saenger, A Zouni and J Biesiadka, *Biochim Biophys Acta*, **1767**, 509–519 (2007), doi:10.1016/j.bbabio.2006.12.009.

33 P Jordan, P Fromme, HT Witt, O Klukas, W Saenger and N Krauss, *Nature*, **411**, 909–917 (2001).

34 Z Liu, H Yan, K Wang, T Kuang, J Zhang, L Gui, X An and W Chang, *Nature*, **428**, 287–292 (2004).

35 J Standfuss, AC Terwissscha van Scheltinga, M Lamborghini and W Kuehlbrandt, *EMBO J*, **24**, 919–928 (2005).

36 BA Diner and F Rappaport, *Annu Rev Plant Biol*, **53**, 551–580 (2002).

37 J Deisenhofer, O Epp, K Miki, R Huber and H Michel, *Nature*, **318**, 618–624 (1985).

38 VL Tetenkin, BA Gulyaev, M Seibert and A Rubin, *FEBS Lett*, **250**, 459–463 (1989).

39 B Hillmann, K Brettel, F van Mieghem, A Kamlowski, AW Rutherford and E Schlodder, *Biochemistry*, **34**, 4814–4827 (1995).

40 Z Adam and O Ostersetzer, *Biochem Soc Trans*, **29**, 427–430 (2001).

41 J Barber and MD Archer, *J Photochem Photobiol, A*, **142**, 97–106 (2001).

42 VI Prokhorenko and AR Holzwarth, *J Phys Chem*, **104**, 11563–11578 (2000).

43 JP Dekker and R Van Grondelle, *Photosynth Res*, **63**, 195–208 (2000).

44 JPM Schelvis, PI van Noort, TJ Aartsma and HJ van Gorkom, *Biochim Biophys Acta*, **1184**, 242–250 (1994).

45 A Holzwarth, M Muller, M Reus, M Nowaczyk, J Sander and M Rogner, *Proc Natl Acad Sci U S A*, **103**, 6895–6900 (2006).

46 MT Lince and W Vermaas, *Eur J Biochem*, **256**, 595–602 (1998).

47 S Vasil'ev and D Bruce, *Biochemistry*, **39**, 14211–14218 (2000).

48 FL de Weerd, IH van Stokkum, H van Amerongen, JP Dekker and R van Grondelle, *Biophys J*, **82**, 1586–1597 (2002).

49 CA Tracewell, JS Vrettos, JA Bautista, HA Frank and GW Brudvig, *Arch Biochem Biophys*, **385**, 61–69 (2001).

50 V Petrouleas and BA Diner, *Biochim Biophys Acta*, **849**, 264–275 (1986).

51 R Hienerwadel and C Berthomieu, *Biochemistry*, **34**, 16288–16297 (1995).

52 J Deisenhofer, O Epp, I Sinning and H Michel, *J Mol Biol*, **246**, 429–457 (1995).

53 C Berthomieu and R Hienerwadel, *Biochemistry*, **40**, 4044–4052 (2001).

54 J Govindjee and JJS van Rensen, in J Deisenhofer and J Norris (eds.), *The Photosynthetic Reaction Center*, Academic Press, San Diego, CA, pp 357–389 (1993).

55 JJS van Rensen, *Photosynth Res*, **73**, 185–192 (2002).

56 RJ Debus, *Biochim Biophys Acta*, **1102**, 269–352 (1992).

57 B Kok, B Forbush and M McGloin, *Photochem Photobiol*, **11**, 457–475 (1970).

58 VK Yachandra, K Sauer and MP Klein, *Chem Rev*, **96**, 2927–2950 (1996).

59 RD Britt, JM Peloquin and KA Campbell, *Annu Rev Biophys Biomol Struct*, **29**, 463–495 (2000).

60 H Dau, L Iuzzolino and J Dittmer, *Biochim Biophys Acta*, **1503**, 24–39 (2001).

61 TG Carrell, AM Tyryshkin and GC Dismukes, *J Biol Inorg Chem*, **7**, 2–22 (2002).

62 RD Britt, KA Campbell, JM Peloquin, ML Gilchrist, CP Aznar, MM Dicus, J Robblee and J Messinger, *Biochim Biophys Acta*, **1655**, 158–171 (2004).

63 J Yano, Y Pushkar, P Glatzel, A Lewis, K Sauer, J Messinger, U Bergmann and V Yachandra, *J Am Chem Soc*, **127**, 14974–14975 (2005).

64 VJ DeRose, I Mukerji, MJ Latimer, VK Yachandra, K Sauer, JC Andrews and MP Klein, *J Am Chem Soc*, **116**, 5239–5249 (1994).

65 VK Yachandra, VJ DeRose, MJ Latimer, I Mukerji, K Sauer and MP Klein, *Science*, **260**, 675–679 (1993).

66 RM Cinco, JH Robblee, J Messinger, C Fernandez, KL McFarlane Holman, K Sauer and VK Yachandra, *Biochemistry*, **43**, 13271–13282 (2004).

67 DF Ghanotakis, GT Babcock and CF Yocum, *Biochim Biophys Acta*, **809**, 173–180 (1985).

68 A Boussac, JJ Girerd and AW Rutherford, *Biochemistry*, **35**, 6984–6989 (1996).

69 MJ Latimer, VJ DeRose, I Mukerji, VK Yachandra, K Sauer and MP Klein, *Biochemistry*, **34**, 10898–10909 (1995).

70 RM Cinco, JH Robblee, A Rompel, C Fernandez, VK Yachandra, K Sauer and MP Klein, *J Phys Chem B*, **102**, 8248–8256 (1998).

71 RM Cinco, KL McFarlane Holman, JH Robblee, J Yano, SA Pizarro, E Bellacchio, K Sauer and VK Yachandra, *Biochemistry*, **41**, 12928–12933 (2002).

72 PJ Riggs-Gelasco, R Mei, DF Ghanotakis, CF Yocum and JE Penner-Hahn, *J Am Chem Soc*, **118**, 2400–2410 (1996).

73 JM Peloquin and RD Britt, *Biochim Biophys Acta*, **1503**, 96–111 (2001).

74 K Sauer, J Yano and VK Yachandra, *Photosynth Res*, **85**, 73–86 (2005).

75 BA Diner, *Biochim Biophys Acta*, **1503**, 147–163 (2001).

76 RJ Debus, *Biochim Biophys Acta*, **1503**, 164–186 (2001).

77 RJ Debus, in T Wydrzynski and K Satoh (eds.), *Photosystem II: The Light Driven Water: Plastoquinone Oxidoreductase*, Springer, Dordrecht, The Netherlands, pp 261–284 (2006).

78 J Kern, J Biesiadka, B Loll, W Saenger and A Zouni, *Photosynth Res*, (2007), doi:10.1007/s11120-007-9173-1.

79 Y Kimura, N Mizusawa, T Yamanari, A Ishii and TA Ono, *J Biol Chem*, **280**, 2078–2083 (2005).

80 MA Strickler, LM Walker, W Hillier and RJ Debus, *Biochemistry*, **44**, 8571–8577 (2005).

81 KD Campbell, DA Force, PJ Nixon, F Dole, B Diner and RD Britt, *J Am Chem Soc*, **122**, 3754–3761 (2000).

82 RO Cohen, PJ Nixon and BA Diner, *J Biol Chem*, **282**, 7209–7218 (2007).

83 TA Roelofs, W Liang, MJ Latimer, RM Cinco, A Rompel, JC Andrews, K Sauer, VK Yachandra and MP Klein, *Proc Natl Acad Sci U S A*, **93**, 3335–3340 (1996).

84 RJ Debus, MA Strickler, LM Walker and W Hillier, *Biochemistry*, **44**, 1367–1374 (2005).

85 Y Kimura, A Ishii, T Yamanari and TA Ono, *Biochemistry*, **44**, 7613–7622 (2005).

86 J Yano, J Kern, K-D Irrgang, MJ Latimer, U Bergmann, P Glatzel, J Biesiadka, B Loll, K Sauer, J Messinger, A Zouni and VK Yachandra, *Proc Natl Acad Sci U S A*, **102**, 12047–12052 (2005).

87 J Yano, J Kern, K Sauer, MJ Latimer, Y Pushkar, J Biesiadka, B Loll, W Saenger, J Messinger, A Zouni and VK Yachandra, *Science*, **314**, 821–825 (2006).

88 DH Stewart and GW Brudvig, *Biochim Biophys Acta*, **1367**, 63–87 (1998).

89 F Morais, K Kuhn, DH Stewart, J Barber, GW Brudvig and PJ Nixon, *J Biol Chem*, **276**, 31986–31993 (2001).

90 C Berthomieu, A Boussac, W Mantele, J Breton and E Nabedryk, *Biochemistry*, **31**, 11460–11471 (1992).

91 M Roncel, A Boussac, JL Zurita, H Bottin, M Sugiura, D Kirilovsky and JM Ortega, *J Biol Inorg Chem*, **8**, 206–216 (2003).

92 JA Navarro, M Hervas, B De la Cerda and MA De la Rosa, *Arch Biochem Biophys*, **318**, 46–52 (1995).

93 JS Vrettos, MJ Reifler, O Kievit, KV Lakshmi, JC de Paula and GW Brudvig, *J Biol Inorg Chem*, **6**, 708–716 (2001).

94 Y Nishiyama, H Hayashi, T Watanabe and N Murata, *Plant Physiol*, **105**, 1313–1319 (1994).

95 H Ishikita and EW Knapp, *FEBS Lett*, **579**, 3190–3194 (2005).

96 PD Barker and SJ Ferguson, *Structure Fold Des*, **7**, 281–290 (1999).

97 CA Kerfeld, MR Sawaya, H Bottin, KT Tran, M Sugiura, D Cascio, A Desbois, TO Yeates, D Kirilovsky and A Boussac, *Plant Cell Physiol*, **44**, 697–706 (2003).

98 JW Murray and J Barber, *Biochemistry*, **45**, 4128–4130 (2006).

99 B Loll, G Gerold, D Slowik, W Voelter, C Jung, W Saenger and K Irrgang, *Biochemistry*, **44**, 4691–4698 (2005).

100 W Nitschke and AW Rutherford, *Trends Biochem Sci*, **16**, 241–245 (1991).

101 RE Blankenship, *Photosynth Res*, **33**, 91–111 (1992).

102 H Michel and J Deisenhofer, *Biochemistry*, **27**, 1–7 (1988).

103 WD Schubert, O Klukas, W Saenger, HT Witt, P Fromme and N Krauss, *J Mol Biol*, **280**, 297–314 (1998).

104 P Fromme, HT Witt, WD Schubert, O Klukas, W Saenger and N Krauss, *Biochim Biophys Acta*, **1275**, 76–83 (1996).

105 JW Murray, J Duncan and J Barber, *Trends Plant Sci*, **11**, 152–158 (2006).

106 WL DeLano, The Py MOL Molecular Graphics System on World Wide Web http://www.pymol.org, (2002).

COBALT

Corrinoid Adenosyltransferases

Paola E Mera, Ivan Rayment† and Jorge C Escalante-Semerena**

*Department of Bacteriology, University of Wisconsin, Madison, WI 53706, USA
†Department of Biochemistry, University of Wisconsin, Madison, WI 53706, USA

FUNCTIONAL CLASS

ATP:Corrinoid adenosyltransferases (ACA) enzymes catalyze the transfer of the adenosyl moiety from ATP to the β axial ligand position of cob(I)alamin, generating the unique organometallic bond of the coenzyme B_{12} (adenosylcobalamin, AdoCbl) (Figure 1). AdoCbl has a Co^{3+} ion coordinated equatorially by four nitrogens of a tetrapyrrole macrocycle, known as the *corrin ring* and by two axial ligands (α and β). The α axial (lower) ligand is the base 5,6-dimethylbenzimidazole (DMB), and the β axial (upper) ligand is the adenosyl moiety.

The properties of the organometallic cobalt–carbon bond attaching the β ligand to the ring lie at the heart of the reactivity of this coenzyme. Most of the work published to date about ACA function has been performed with Cbl or its precursor cobinamide (Cbi). However, since almost all of the structural work on ACA enzymes has been done with Cbl as substrate, we focus our discussion on Cbl adenosylation.

ACA enzymes have three distinct tasks in the biosynthesis of AdoCbl. First, ACA enzymes bring the substrates into close proximity for catalysis. The Co^{1+} ion of cob(I)alamin is the nucleophile that attacks (S_N2) the 5′C of ATP

during catalysis. However, synthesis of cob(I)alamin is thermodynamically challenging to all cells given the low redox potential of the Co^{2+}/Co^{1+} couple ($-670\,mV$).[1] Cells solve this conundrum by using ACA enzymes. Therefore, the second function of ACA enzymes is to facilitate this unfavorable reduction by bringing the reduction potential of the cob(II)alamin/cob(I)alamin couple to within physiological range.[2–5] Thirdly, once AdoCbl is generated, ACA enzymes have been proposed to chaperone the coenzyme to AdoCbl-dependent enzymes.[6] Thus, ACAs are multifunctional enzymes that properly orient the substrates for catalysis, facilitate the generation of the corrinoid nucleophile (cob(I)alamin), and may deliver the product AdoCbl.

OCCURRENCE

Cells of all domains of life synthesize ACA enzymes. Three types of ACA enzymes are known (i.e., CobA (cobalamin biosynthesis protein A), PduO (propanediol utilization protein O), and EutT (ethanolamine utilization

3D Structure Ribbon and surface representation of a PduO-type ACA enzyme. In its biologically active form, PduO (PDB 3CI1) is a trimer with the active site located at the subunit interface. Each subunit of PduO is colored in cyan, light blue, and yellow. For the sake of clarity, the substrates cob(II)alamin (pink) and ATP (brown) are shown only in one of the three active sites. Figure generated with program PyMOL.[47]

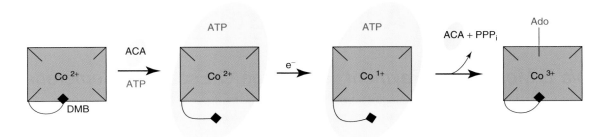

Figure 1 Proposed mechanism for the reduction and adenosylation of cobalamin. The cobalt ion of cob(III)alamin is reduced to cob(II)alamin inside the reducing environment of the cell. ACA enzymes (cyan oval) bind cob(II)alamin and displace the lower ligand DMB (black diamond) generating a four-coordinate cob(II)alamin intermediate. The latter facilitates the transfer of the second electron resulting in the super nucleophile cob(I)alamin, which reacts with ATP to generate coenzyme B_{12} (AdoCbl).

protein T)), all of which were first described as part of metabolic processes in the facultative anaerobe *Salmonella enterica* servovar Typhimurium LT2. The *S. enterica* CobA (*Se*CobA) is the housekeeping ACA enzyme involved in the anaerobic *de novo* biosynthesis of AdoCbl.[7] PduO and EutT are more specialized ACA enzymes involved in the catabolism of 1,2-propanediol and ethanolamine, respectively.[8,9] All ACA enzymes identified belong to one of these types. The PduO-type ACA enzyme is the most widely distributed among species, and it is the human type.[10,11]

BIOLOGICAL FUNCTION

In mammals, AdoCbl is an essential coenzyme for the catabolism of amino acids (AA), cholesterol, and odd-chain fatty acids.[12–14] Although humans cannot synthesize AdoCbl *de novo*, they have evolved a complex and highly specific system for the internalization of Cbl from their diet[15,16] and rely on ACA enzymes to convert nonadenosylated Cbl to its biologically active coenzymic form, AdoCbl. Malfunctioning of the human ACA enzyme leads to methylmalonic aciduria, a fatal disorder associated with developmental retardation and infant mortality.[17–20]

In prokaryotes, ACA enzymes are involved at several stages of AdoCbl biosynthesis. In AdoCbl-synthesizing prokaryotes, corrinoid adenosylation is required for *de novo* synthesis of the corrin ring, for salvaging incomplete and complete corrinoids from the environment and for the regulation of genes encoding AdoCbl biosynthetic genes and outer membrane corrinoid transporters.[7,21–25]

AMINO ACID SEQUENCE INFORMATION

Although the CobA, PduO, and EutT enzymes catalyze the same reaction, they do not share homology at the nucleotide or AA level.

- *S. enterica*, CobA, 196 AA, Swiss-Prot: P31570.
- *Thermoplasma acidophilum*, PduO, 177 AA, TrEMBL: Q9HIA7.

- *Homo sapiens*, PduO, 250 AA, TrEMBL: Q96EY8.
- *Lactobacillus reuteri*, PduO, 188 AA, TrEMBL: Q50EJ2.
- *Sulfolobus tokodaii*, PduO, 177 AA, TrEMBL: Q970Z7.
- *S. enterica* EutT, 267 AA, no structure available at the time of this writing.

PROTEIN PRODUCTION, PURIFICATION, AND MOLECULAR CHARACTERIZATION

All three types of ACA enzymes have been expressed in *Escherichia coli* using T7 expression vectors. CobA-type enzymes are soluble proteins that have been purified with tags or in their native form.[26,27] Most PduO-type enzymes known are soluble when purified, except for the *S. enterica* PduO (*Se*PduO).[28] The insolubility of *Se*PduO is probably due to the last 150 residues, which are unique to the *S. enterica* enzyme and whose function is still unknown.[28] Homogeneous *Se*PduO protein was isolated from inclusion bodies.[28] The purification of the EutT-type enzymes, on the other hand, has been more difficult. The EutT from *S. enterica*, the only EutT-type ACA enzyme analyzed, is insoluble but can be enriched to 70% homogeneity in the presence of detergents.[29] Owing to the sensitivity of this enzyme to oxygen, the purification is performed inside anoxic chambers. EutT-type ACA enzyme is the least understood of the three types of ACA enzymes due to its problematic purification.

METAL CONTENT AND COFACTORS

Each monomer of PduO-type enzyme contains a corrinoid with a low-spin cobalt ion and one Mg^{2+} ion in the active site. Under conditions used to crystallize CobA, the dimer contained two Mg^{2+} ions but only one corrinoid. There are no coordination bonds between the cobalt ion and the enzyme. In *Se*CobA, Mg^{2+} is coordinated octahedrally by two nonbridging phosphate oxygen atoms from the α and β phosphates of ATP, the side-chain hydroxyl of

Thr42, a carboxylate oxygen of Glu128, and two water molecules[30] (Figure 2(a) and Table 1). Similarly, in PduO Mg^{2+} is coordinated to nonbridging oxygen atoms from all phosphate groups of ATP, a carbonyl oxygen from asparagine (Asn214 hATR, Asn156 LrPduO), and two water molecules[11,31] (Figure 2(b) and Table 1). Notably, the structure of *L. reuteri* PduO (LrPduO) revealed an additional K^+ ion in the active site.[32] In the PduO-type human adenosyltransferase (referred to in the literature as $hATR$), electron density was observed at this location, and a Mg^{2+} ion was modeled.[31] The physiological relevance of this second metal in PduO-type ACA enzymes is unclear because the crystallographic conditions in LrPduO and hATR contained high concentrations of KCl and $MgSO_4$, respectively. However, a twofold increase in the specific activity of LrPduO was observed when 100 mM KCl was added to the reaction mixture (Mera, P, Escalante-Semerena, JC, *unpublished results*).

As mentioned earlier, the EutT-type ACA enzymes are less well studied. Previously reported work showed that SeEutT exhibits sensitivity to the iron chelator

Table 1 Mg^{2+} coordinations and ligand bond distances in the active site of ACA enzymes

ACA enzyme	Coordination ligand	Distance (Å)
SeCobA	Thr42 ($O_{\gamma 1}$)	2.0
	Glu128 ($O_{\varepsilon 2}$)	2.1
	Wat1331 (OH)	2.2
	Wat1332 (OH)	2.3
	ATP ($PO_{4\alpha}$)	2.3
	ATP ($PO_{4\beta}$)	2.2
LrPduO	Asn156 ($O_{\delta 1}$)	2.0
	Wat1080 (OH)	2.1
	Wat1079 (OH)	2.3
	ATP ($PO_{4\alpha}$)	2.1
	ATP ($PO_{4\beta}$)	2.1
	ATP ($PO_{4\gamma}$)	2.0

bathophenanthroline,[33] and evidence obtained more recently suggests that SeEutT may contain an oxygen-sensitive Fe/S cluster (Mera, P, Escalante-Semerena, JC, *unpublished results*). SeEutT contains a C–C–X–X–C motif, whose Cys residues are important for activity.[29] Efforts are ongoing to crystallize SeEutT under anoxic conditions.

SPECTROSCOPY

Cob(II)alamin is a paramagnetic species ($S = 1/2$) that exhibits a temperature-dependent magnetic circular dichroism (MCD) spectrum.[2,3] The MCD spectrum is sensitive to subtle changes in electronic structure accompanying changes in the coordination environment of Co^{2+}. Studies using MCD spectroscopy revealed how ACA enzymes facilitate the unfavorable reduction of cob(II)alamin to cob(I)alamin.[3,4] The reduction midpoint potential of the cob(II)alamin/cob(I)alamin couple is significantly lower than that of physiological reducing agents.[34] To catalyze the reduction of cob(II)alamin, ACA enzymes displace the lower axial ligand of cob(II)alamin (cob(II)alamin does not have an upper ligand), generating a four-coordinate square-planar intermediate that lacks axial ligands[2–5] (Figure 1). The loss of axial ligands stabilizes the Co^{2+} $d_{z^2}^2$ orbital raising its reduction potential to within physiological range.[4] By generating cob(I)alamin inside the controlled environment of the enzyme active site, ACA enzymes protect this highly reactive molecule from adventitious side reactions.

The low-energy region (11 000–21 000 cm^{-1}) of the cob(II)alamin MCD spectrum is dominated by $d \rightarrow d$ transitions of the cobalt center. Specifically, the appearance of a new feature at ~12 400 cm^{-1} that becomes evident when cob(II)alamin binds the enzyme in complex with MgATP reflects the presence of a square-planar four-coordinate cob(II)alamin species.[2–5]

EPR (electron paramagnetic resonance) has also been used to probe lower ligand substitutions of cob(II)alamin.

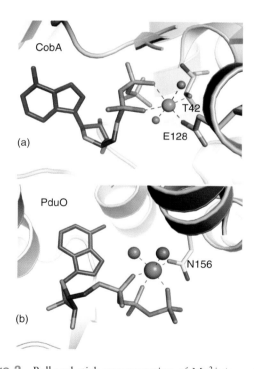

Figure 2 Ball-and-stick representation of Mg^{2+} (green) coordination in the active site of SeCobA and LrPduO. (a) In SeCobA (PDB 1G64), Mg^{2+} is octahedrally coordinated by two nonbridging phosphate oxygen atoms from the α and β phosphates of ATP, the side-chain hydroxyl of Thr42, a carboxylate oxygen of Glu128, and two water molecules (red). (b) The Mg^{2+} ions in LrPduO (PDB 3CI1) are, similarly to CobA, coordinated in a bi-pyramidal form, except the nonbridging phosphate oxygen atoms of ATP provide three coordination bonds. Two highly ordered water molecules (red) along with the carbonyl oxygen of Asn156 complete the coordination sphere. Figure generated with program PyMOL.

The EPR g values and ^{59}Co hyperfine parameters significantly change with different lower ligands. Broad features near 2600 g are characteristic of cob(II)alamin in the base-off conformation with a water molecule as the lower axial ligand.[35] Resonances covering the wide range of EPR values characterize the four-coordinate cob(II)alamin, requiring unusually large g_\perp values and ^{59}Co hyperfine coupling constants to be simulated.

The use of UV–visible spectroscopy to probe changes of cob(II)alamin upon binding to ACA enzymes is the least sensitive methodology for this analysis. Since corrin-based $\pi \rightarrow \pi^*$ transitions dominate the UV–visible spectra, they are hardly affected by the lower axial ligand transitions.[2] However, the presence of ACA enzymes in complex with ATP causes a blue-shift of the band near $21\,010\,\text{cm}^{-1}$ (476 nm) in the absorbance spectrum of cob(II)alamin by $470\,\text{cm}^{-1}$ (\sim10 nm).[2–5]

X-RAY STRUCTURE OF CobA-TYPE ACA ENZYMES

Crystallization

Three structures of CobA isolated from *S.enterica* have been reported: (i) Apo-CobA at 2.1 Å; (ii) CobA/ATP at 1.8 Å; and (iii) CobA/ATP/Cbl at 2.1 Å[30] (Figure 3). Apo-CobA crystallizes in the hexagonal space group P6$_5$22

with the unit cell dimensions $a = b = 49.4\,\text{Å}$, $c = 250.2\,\text{Å}$, and with one subunit in the asymmetric unit. CobA/ATP crystals belong to space group P6$_5$22 with $a = b = 49.5\,\text{Å}$, $c = 249.7\,\text{Å}$, whereas CobA/ATP/Cbl crystals belong to space group P4$_1$2$_1$2, with two subunits per asymmetric unit, and $a = b = 79.4\,\text{Å}$, $c = 141.7\,\text{Å}$ unit cell dimensions. The structure of the CobA/ATP complex was obtained by soaking the apo-CobA crystals in 1 mM ATP.[30] Crystals of the CobA/ATP/Cbl complex were obtained by co-crystallization. These crystals contained one dimer of CobA in the asymmetric unit, where only one of the active sites was occupied by ATP and Cbl.

Apo-CobA-type ACA enzyme

CobA is a homodimer with each subunit consisting of an α/β structure.[30] This structure consists of a six-stranded parallel β-sheet and five α-helices connecting the strands on both sides of the sheet. The strand order of the parallel sheet is 324516. This topology is similar to the one seen in the P-loop containing family proteins RecA (recombinase A), F$_1$ATPase, helicase core domain, and adenosylcobinamide guanylyltransferase.[36–39] The N- and C-terminus of apo-CobA are disordered.

ATP binds the P-loop in the active site with a unique conformation

The topology of CobA belongs to the P-loop containing family of nucleotide (NTD) hydrolases.[40] The structure of the *Se*CobA in complex with ATP at 1.8 Å resolution unveiled the unique form of binding of ATP to the P-loop. First, CobA contains a P-loop motif of only seven residues (GNGKGKT), instead of the 8-AA consensus **GXXXXGKT/S** motif. Secondly, ATP is bound to this P-loop in an orientation opposite to the one observed with NTP hydrolases. Lastly, the conformation of ATP is not extended, as it is observed in other P-loops, instead the nucleotide is folded back onto itself. This unique conformation of ATP in the P-loop of CobA has functional implications since it leaves the 5'C of ATP exposed, facilitating the nucleophilic attack by the cobalt ion of cob(I)alamin during catalysis.

CobA binds hydroxocobalamin in the base-on conformation

The structure of the *Se*CobA in complex with ATP and hydroxocobalamin was solved to 2.1 Å resolution.[30] Notably, the N- and C-terminal regions of the protein become ordered upon ATP and Cbl binding. The active site of CobA is found at the C-terminal end of the β-sheet of one subunit capped by the N-terminal helix

Figure 3 Ribbon representation of *Se*CobA with ATP and HOCbl bound in the active site. CobA (PDB 1G64) is a homodimer with the individual subunits colored green and brown. The substrates, ATP and Cbl, are depicted in ball-and-stick representation. The active site is formed by the loops at the C-terminal end of the β-sheets of one subunit and is capped by the N-terminal helix from the adjacent subunit. Cob(III)alamin is bound with its α-ligand 'on', that is, as a five-coordinate species. Figure generated with program PyMOL.

from the adjacent subunit (Figure 3). This N-terminal helix interacts predominantly with the nucleotide loop of Cbl. The flexibility of this helix is likely to give CobA its broad corrinoid substrate specificity. This helix, however, is not conserved in all CobA-type enzymes. The corrin ring is bound perpendicular to the β-sheet with only a few direct interactions with the protein. The functional groups of two conserved residues Trp93 and Arg161 hydrogen bond with amide groups of the corrin ring.

The fact that Cbl is bound in the active site of CobA with the lower ligand base in the 'on' conformation is intriguing for two reasons. First, CobA-type enzymes adenosylate Cbl *via* a four-coordinate intermediate, which lacks both axial ligands.[4] Second, the cobalt ion of Cbl is 6.1 Å away from 5′C of ATP, a much larger distance for the nucleophilic attack to take place. These results suggest that a structural rearrangement must occur during the reduction of the Co^{3+} to Co^{1+} so that the four-coordinate cob(II)alamin intermediate can be generated. The nature of this anticipated rearrangement is unknown.

FUNCTIONAL ASPECTS OF CobA-TYPE ACA ENZYMES

FldA, the electron-transport protein, recognizes structural components of CobA

In vitro, the flavin mononucleotide (FMN)-dependent electron transfer protein (FldA) is the electron donor for the reduction of cob(II)alamin when bound in the active site of CobA.[41] Site-directed mutagenesis analysis of the CobA and FldA interactions revealed critical residues that participate in the docking of these two enzymes.[26] Two arginine residues of the *Se*CobA (Arg9 and Arg165) are critical for CobA–FldA docking. Interestingly, these residues are only critical for docking and do not play an essential role in catalysis.

X-RAY STRUCTURE OF PduO-TYPE ACA ENZYMES

Crystallization

The X-ray structure of the archaeal PduO in its apo form from *T. acidophilum* was solved at 1.5 Å resolution.[42] These crystals belong to space group P23, with the unit cell parameters $a = b = c = 89.1$ Å, and with a single molecule in each asymmetric unit. Two structures of PduO-type ACA enzymes with ATP bound in the active site (hATR at 2.5 Å resolution and *L. reuteri* at 1.7 Å resolution) are available.[11,31] Both crystals were grown by vapor diffusion at room temperature. The crystals from the human PduO (hATR) belong to space group P321, with cell dimensions of $a = b = 111.2$ Å, $c = 115.5$ Å, and have three molecules

in the asymmetric unit. The *L. reuteri* PduO (*Lr*PduO) crystals were cubic shaped with space group I23, cell parameters $a = b = c = 110.6$ Å, and with one subunit in the asymmetric unit.

In 2008, the structures of *Lr*PduO/ATP/cob(II)alamin, *Lr*PduO/ATP/cob(I)inamide, and *Lr*PduO/PPP$_i$/AdoCbl were solved at 1.9, 2.0, and 1.1 Å resolution, respectively.[32] These crystals were grown using the vapor diffusion method in an anoxic chamber with a reducing system designed to reduce hydroxocobalamin (Co(III)) to cob(II)alamin. All crystals were brown-colored cubic belonging to the space group R3 with one subunit in the asymmetric unit. Unit cell parameters $a = b = 67.8$ Å, $c = 111.2$ Å. Using the same crystallization method, two sets of *Lr*PduO variants were reported in 2007 and 2009.[43,44] *Lr*PduOD35N (2.6 Å) and *Lr*PduOR132K (2.6 Å) belong to the space group P6$_3$ with two monomers in the asymmetric unit. *Lr*PduOF112A (1.5 Å), *Lr*PduOF112H (1.2 Å), and *Lr*PduO$^{\Delta 183}$ (1.4 Å) crystals belong to the space group R3 with one subunit in the asymmetric unit.

Apo-PduO-type ACA enzymes

Even though CobA and PduO ACA enzymes catalyze the same reaction, the structure of PduO is strikingly different (compare Figure 3 vs 4). PduO is a trimer with each subunit composed of a right-handed twist five-helix bundle.[42,45]

Figure 4 Ribbon representation of *Lr*PduO with ATP and cob(II)alamin bound in the active site. In its biologically active form, PduO (PDB 3CI1) is a trimer with the individual subunits colored light blue, cyan, and yellow. The substrates, ATP (brown) and cob(II)alamin (pink) represented with sticks, are bound at the subunit interface. The lower ligand DMB of Cbl lies outside of the active site, and the corresponding density is disordered. Therefore, cob(II)alamin is bound as a four-coordinate species. Figure generated with program PyMOL.

The topology of the bundle is 12354. Helices α2 and α5 contain kinks. Mostly hydrophobic interactions are present between helices α1 and α2 and between helices α4 and α1. Ionic interactions are predominantly found between helices α2 and α3 and polar interactions between helices α5 and α4. The first 22 AAs at the N-terminal domain and the last 7 AAs at the C-terminal domain are disordered in the apo structure; however, they become ordered when both substrates are bound in the active site.

PduO-type ACA enzymes have a unique ATP-binding motif

The active site of PduO-type ACA enzymes is located at the interface of two adjacent subunits formed by the interaction of helix α2 from one subunit and helix α4 from the adjacent subunit.[11,31] Binding of ATP to the active site promotes the ordering of 23 AAs at the N-terminus of each subunit. Aside from the ordering of this N-terminal loop, no significant conformational changes in the helix bundle accompany ATP binding. PduO-type enzymes lack any of the classical nucleotide binding motifs. The conserved ATP-binding motif (Thr–(Lys/Arg)–X–Gly–Asp–X–Gly–X–(Thr/Ser)) is unique to PduO-type ACA enzymes. Most of these residues interact with the phosphate groups of ATP.

Aside from the extensive interactions of the protein with the phosphate groups, there are numerous interactions between PduO and the adenosine moiety. Some of these interactions are critical for catalysis others are responsible for the differing affinity of PduO for nucleotide triphosphates. An arginine residue (Arg190 in hATR and Arg132 in LrPduO) hydrogen bonds with two bridging oxygen atoms, one from the ribose and one from the α phosphate; this arginine residue is conserved in all PduO-type enzymes (Figure 5). The function of this arginine is discussed below. The interactions of two functional groups on ATP (the C6 amino group and the nitrogen at the N7 position of the adenosine base) explain the reduced ability of LrPduO to use other nucleoside triphosphates in place of ATP.[43] In hATR, the C6 amino group of ATP hydrogen bonds with the carbonyl oxygen of Glu135 (Glu193 hATR). Loss of this interaction significantly affects the enzymes affinity to nucleotides like ITP. The nitrogen at the N7 position of ATP coordinates to a water molecule that helps position the Mg^{2+} ion in the active site. Loss of this interaction affects the enzyme's affinity for nucleotides and its ability to catalyze the reaction.

Structural evidence of the four-coordinate cob(II)alamin intermediate

Like CobA, LrPduO facilitates the reduction of cob(II) alamin by generating a base-off four-coordinate cob(II) alamin intermediate.[3,5,46] The first structural evidence of

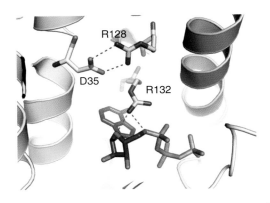

Figure 5 Interactions between ATP and two conserved arginine residues in the active site of LrPduO (PDB 2NT8). Residue Arg132 forms a salt bridge with Asp35 from the adjacent subunit. Modifications of this salt bridge affect the 'on' rate of ATP binding. Arg132 hydrogen bonds with two oxygen of ATP but plays no significant role in locking ATP in the proper orientation for catalysis. Instead, Arg132 is predicted to stabilize the developing negative charge of the transition state. Figure generated with program PyMOL.

this intermediate was seen in the X-ray structure of the LrPduO/ATP/cob(II)alamin complex at 1.9 Å resolution.[32] In this complex, cob(II)alamin is bound in the active site with its lower axial ligand DMB pushed out of the active site (3D Structure and Figure 4). The density of the DMB ligand was not modeled because it is disordered and may be solvent exposed. Importantly, the environment around the vacant α-ligand of Cbl consists of several hydrophobic and bulky residues (Phe112, Phe163, Phe187) (Figure 6).

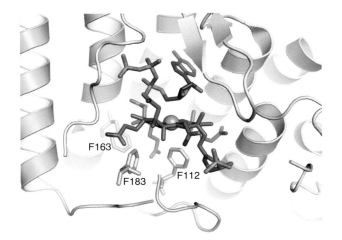

Figure 6 Structural overview of the hydrophobic environment of LrPduO around cob(II)alamin. Individual subunits of LrPduO (PDB 3CI1) are colored light blue and cyan. The hydrophobic environment around cob(II)alamin constitutes of residues from the C-terminal domain and a loop connecting helices 3 and 4 of the same subunit. Phe112 is positioned directly below the cobalt ion of cob(II)alamin serving a critical role in the displacement of the lower ligand. Figure generated with program PyMOL.

Upon Cbl binding, two significant conformational changes take place in the active site of *Lr*PduO. First, the last six residues in the C-terminus become ordered, and secondly, the loop connecting helices 3 and 4 clamps down over Cbl acting like a hinged lid. Upon closure of this loop, a conserved phenylalanine residue (Phe112 in *Lr*PduO) moves to within 3.8 Å away from the Co ion (Figure 6). This loop is anchored by two conserved Pro residues and locked into a close conformation by two hydrogen bonds between Ile113 and an amide group of the corrin ring of cob(II)alamin. This closed conformation was also seen in the structure of PduO from *S. tokodaii* where a polypropylene glycol 400 was bound in the active site.[48]

The corrin ring is held in place by additional hydrogen bonding interactions with residues from the two adjacent subunits of the active site. *Lr*PduO also interacts with amide hydrogen and carbonyl groups of the corrin ring. Interestingly, the overall structure of the *Lr*PduO/ATP/cobinamide complex is indistinguishable from the structure of *Lr*PduO/ATP/Cbl (rmsd = 0.07 Å for all main chain atoms), suggesting that the presence or the absence of the nucleotide loop does not affect the structure of the protein.

The structure of the *Lr*PduO/AdoCbl/PPP$_i$ complex was obtained from a crystal that was incubated for 65 days with cob(II)alamin and MgATP in an anoxic chamber.[32] Over this prolonged incubation, *Lr*PduO slowly generated AdoCbl and PPP$_i$. This crystal was partially occupied by cob(II)alamin and PPP$_i$ and partially occupied by AdoCbl and PPP$_i$. Owing to the C–Co bond sensitivity to X-rays, the electron density of AdoCbl between the carbon and cobalt was incomplete. Notably, there were no significant changes between the structure of *Lr*PduO with substrates and *Lr*PduO with products, except for a rearrangement of the 5′C of the ribosyl moiety of Ado. In the structure of the *Lr*PduO/ATP/cob(II)alamin complex, the 5′C of ATP is positioned at a 153° angle from the Co ion of cob(II)alamin, aligned for the subsequent S_N2 nucleophilic attack. In the structure of *Lr*PduO/AdoCbl/PPP$_i$ complex, one can see that the 5′C of Ado is aligned at a distance and angle consistent with a covalent C–Co bond, and AdoCbl remains in the base-off conformation.

FUNCTIONAL ASPECTS OF THE PduO-TYPE ACA ENZYMES

Characterization of residues found mutated in patients with methylmalonic aciduria

Several mutations of conserved residues in the active site of the human ACA enzyme (hATR) have been identified in patients with methylmalonic aciduria. A mutation of a conserved arginine residue (Arg186 in hATR and Arg128 in *Lr*PduO) to a tryptophan has been identified as the most common mutation, and it is associated with an early onset of the disease.[49] Structural and kinetic analysis revealed that this residue influences the rate of ATP binding by forming a salt bridge in the active site (Figure 5). The side chain of this arginine residue also interacts with an amide from the corrin ring. It is not surprising then that the substitution of this residue with a bulky and hydrophobic tryptophan residue inactivates the enzyme. A tryptophan residue at this position eliminates the critical Asp35–Arg128 salt bridge (in *Lr*PduO) affecting the rate of ATP binding and impairing the binding of Cbl.[42,50]

Substitutions of Arg190 (Arg132 in *Lr*PduO) to histidine or cysteine have also been identified in human patients. Owing to its proximity to the 5′C carbon of ATP, this arginine residue was hypothesized to properly orient ATP in the active site[11,31] (Figure 5). However, structural and kinetic analysis of *Lr*PduO variants revealed that the loss of these interactions with ATP did not affect the conformation of ATP in the active site. Instead, it was proposed that this arginine residue may stabilize the developing negative charge of the transition state.[11]

Mechanism for the generation of the cob(II)alamin four-coordinate intermediate

Even though *Se*CobA and PduO-type ACA enzymes exhibit no similarities at the structural or AA levels, the strategy used to facilitate the reduction of cob(II)alamin to cob(I)alamin is strikingly similar. That is, the PduO-type enzyme also generates the four-coordinate intermediate when it binds cob(II)alamin.[3,5,32]

The structure of *Lr*PduO in complex with ATP and Cbl unveiled a hydrophobic environment around Cbl with Phe112 positioned only 3.8 Å away from the Co ion[32] (Figure 6). In a random mutagenesis analysis of hATR and in the model of the Cbl-binding site of hATR, Phe112 was predicted to be involved in Cbl binding.[31,51] Phe112, a conserved residue in all PduO-type ACA enzymes, is critical for the displacement of the lower ligand of cob(II)alamin to generate the four-coordinate state.[44] Furthermore, Phe112 stabilizes the four-coordinate cob(II)alamin by preventing the cobalt ion from interacting with other potential ligands. Strikingly when Phe112 is modified, the conformation of Cbl-bound is also altered significantly. For example, if Phe112 is changed to an alanine residue, Cbl binds with the lower ligand DMB coordinated to the cobalt ion of Cbl (Figure 7(a)). This Cbl confirmation is known as the *base-on* conformation. The wild-type *Lr*PduO protein binds Cbl in the 'base-off' conformation, where DMB is not coordinated to the cobalt ion of cob(II)alamin. The *Lr*PduOF112A variant no longer facilitates the reduction of cob(II)alamin because it cannot generate the four-coordinate state. If Phe112 is changed to a histidine residue, Cbl binds in a 'base-off' conformation, but one can see that histidine interacts with the Co ion mimicking a 'base-on' conformation; this conformation is known as

the *base-off/His-on* (Figure 7(b)). *Lr*PduOF112H retains very low activity. Notably, the rest of the hydrophobic residues in the Cbl-binding pocket do not play a significant role in the generation of the four-coordinate intermediate.

CONCLUDING REMARKS

In the last decade, much has been learned about the mechanism of ACA enzymes. However, there are remaining questions, specifically with the mechanism of EutT. For instance, what is the function of the predicted Fe/S cluster in EutT? Does EutT use a different strategy to facilitate the unfavorable reduction of cob(II)alamin compared to CobA and PduO? Is the Fe/S cluster involved in this reduction?

Together, the enzymological, spectroscopic, and crystallographic analyses of CobA and PduO revealed how cells overcome the thermodynamic challenging reduction of cob(II)alamin by generating the unprecedented four-coordinate cob(II)alamin intermediate and provided mechanistic insights into the function of this family of enzymes. Ongoing studies of ACA enzymes will continue to unveil details of their mechanism of catalysis.

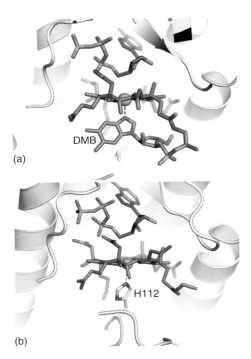

Figure 7 Crystal structure of active-site *Lr*PduO variants. Individual subunits of *Lr*PduO are colored light blue and cyan. (a) The variant *Lr*PduOF112A (PDB 3GAI) binds cob(II)alamin in a five-coordinate conformation with DMB-on. (b) Cob(II)alamin in variant *Lr*PduOF112H (PDB 3GAH) is bound in the active site with the lower ligand DMB displaced similarly to wild type; however, cob(II)alamin is in a five-coordinate conformation because His112 is positioned in close proximity to the cobalt ion to serve as the lower ligand. Figure generated with program PyMOL.

ACKNOWLEDGEMENTS

This work was supported by PHS grant AR35186 (to Ivan Rayment) and R01-GM40313 (to Jorge C. Escalante-Semerena) from the National Institutes of Health. P. E. Mera was supported in part by PHS grant F31-GM081979. We thank K. Park for critical reading of the manuscript.

REFERENCES

1 D Lexa, JM Saveant and J Zickler, *J Amer Chem Soc*, **99**, 2786–90 (1977).

2 TA Stich, NR Buan and TC Brunold, *J Am Chem Soc*, **126**, 9735–49 (2004).

3 TA Stich, M Yamanishi, R Banerjee and TC Brunold, *J Am Chem Soc*, **127**, 7660–61 (2005).

4 TA Stich, NR Buan, JC Escalante-Semerena and TC Brunold, *J Am Chem Soc*, **127**, 8710–19 (2005).

5 K Park, PE Mera, JC Escalante-Semerena and TC Brunold, *Biochemistry*, **47**, 9007–15 (2008).

6 D Padovani, T Labunska, BA Palfey, DP Ballou and R Banerjee, *Nat Chem Biol*, **4**, 194–96 (2008).

7 JC Escalante-Semerena, SJ Suh and JR Roth, *J Bacteriol*, **172**, 273–80 (1990).

8 TA Bobik, GD Havemann, RJ Busch, DS Williams and HC Aldrich, *J Bacteriol*, **181**, 5967–75 (1999).

9 DE Sheppard, JT Penrod, T Bobik, E Kofoid and JR Roth, *J Bacteriol*, **186**, 7635–44 (2004).

10 NA Leal, SD Park, PE Kima and TA Bobik, *J Biol Chem*, **278**, 9227–34 (2003).

11 M St Maurice, PE Mera, MP Taranto, F Sesma, JC Escalante-Semerena and I Rayment, *J Biol Chem*, **282**, 2596–605 (2007).

12 R Banerjee and M Vlasie, *Biochem Soc Trans*, **30**, 621–24 (2002).

13 R Banerjee and S Chowdhury, in R Banerjee (ed.), *Chemistry and Biochemistry of B12*, John Wiley & Sons, Inc., New York, pp 707–29 (1999).

14 DS Rosenblatt and WA Fenton, in R Banerjee (ed.), *Chemistry and Biochemistry of B₁₂*, John Wiley & Sons, New York, pp 367–84 (1999).

15 DH Alpers and GJ Russell-Jones, R Banerjee (ed.), *Chemistry and Biochemistry of B₁₂*, John Wiley & Sons, New York (1999).

16 SP Rothenberg, EV Quadros and A Regec, in R Banerjee (ed.), *Chemistry and Biochemistry of B₁₂*, John Wiley & Sons, New York (1999).

17 CM Dobson, T Wai, D Leclerc, H Kadir, M Narang, JP Lerner-Ellis, TJ Hudson, DS Rosenblatt and RA Gravel, *Hum Mol Genet*, **11**, 3361–69 (2002).

18 WA Fenton and LE Rosenberg, *Arch Biochem Biophys*, **189**, 441–47 (1978).

19 F Ciani, MA Donati, G Tulli, GM Poggi, E Pasquini, DS Rosenblatt and E Zammarchi, *Crit Care Med*, **28**, 2119–21 (2000).

20 C Cavicchi, MA Donati, S Funghini, G la Marca, S Malvagia, F Ciani, GM Poggi, E Pasquini, E Zammarchi and A Morrone, *Clin Genet*, **69**, 72–76 (2006).

21 S Ravnum and DI Andersson, *Mol Microbiol*, **39**, 1585–94 (2001).

22 AA Richter-Dahlfors and DI Andersson, *Mol Microbiol*, **6**, 743–49 (1992).

23 AA Richter-Dahlfors, S Ravnum and DI Andersson, *Mol Micro-biol*, **13**, 541–53 (1994).

24 X Nou and RJ Kadner, *Proc Natl Acad Sci U S A*, **97**, 7190–95 (2000).

25 A Nahvi, JE Barrick and RR Breaker, *Nucleic Acids Res*, **32**, 143–50 (2004).

26 NR Buan and JC Escalante-Semerena, *J Biol Chem*, **280**, 40948–56 (2005).

27 S Suh and JC Escalante-Semerena, *J Bacteriol*, **177**, 921–25 (1995).

28 CL Johnson, ML Buszko and TA Bobik, *J Bacteriol*, **186**, 7881–87 (2004).

29 NR Buan and JC Escalante-Semerena, *J Biol Chem*, **281**, 16971–77 (2006).

30 CB Bauer, MV Fonseca, HM Holden, JB Thoden, TB Thompson, JC Escalante-Semerena and I Rayment, *Biochemistry*, **40**, 361–74 (2001).

31 HL Schubert and CP Hill, *Biochemistry*, **45**, 15188–96 (2006).

32 M St Maurice, P Mera, K Park, TC Brunold, JC Escalante-Semerena and I Rayment, *Biochemistry*, **47**, 5755–66 (2008).

33 NR Buan, SJ Suh and JC Escalante-Semerena, *J Bacteriol*, **186**, 5708–14 (2004).

34 MV Fonseca and JC Escalante-Semerena, *J Bacteriol*, **182**, 4304–9 (2000).

35 S Van Doorslaer, G Jeschke, B Epel, D Goldfarb, RA Eichel, B Krautler and A Schweiger, *J Am Chem Soc*, **125**, 5915–27 (2003).

36 TB Thompson, MG Thomas, JC Escalante-Semerena and I Rayment, *Biochemistry*, **37**, 7686–95 (1998).

37 RM Story, IT Weber and TA Steitz, *Nature*, **355**, 318–25 (1992).

38 HS Subramanya, AJ Doherty, SR Ashford and DB Wigley, *Cell*, **85**, 607–15 (1996).

39 JP Abrahams and AGW Leslie, *Acta Crystallogr D Biol Crystallogr*, **52**, 30–42 (1996).

40 CA Smith and I Rayment, *Biophys J*, **70**, 1590–602 (1996).

41 MV Fonseca and JC Escalante-Semerena, *J Biol Chem*, **276**, 32101–8 (2001).

42 V Saridakis, A Yakunin, X Xu, P Anandakumar, M Pennycooke, J Gu, F Cheung, JM Lew, R Sanishvili, A Joachimiak, CH Arrowsmith, D Christendat and AM Edwards, *J Biol Chem*, **279**, 23646–53 (2004).

43 PE Mera, MS Maurice, I Rayment and JC Escalante-Semerena, *Biochemistry*, **46**, 13829–36 (2007).

44 P Mera, M St Maurice, I Rayment and JC Escalante-Semerena, *Biochemistry*, **48**, 3138–45 (2009).

45 F Forouhar, A Kuzin, J Seetharaman, I Lee, W Zhou, M Abashidze, Y Chen, W Yong, H Janjua, Y Fang, D Wang, K Cunningham, R Xiao, TB Acton, E Pichersky, DF Klessig, CW Porter, GT Montelione and L Tong, *J Struct Funct Genomics*, **8**, 37–44 (2007).

46 M Yamanishi, T Labunska and R Banerjee, *J Am Chem Soc*, **127**, 526–27 (2005).

47 WL Delano, *The Pymol Molecular Graphics System* (2002).

48 Y Tanaka, T Sasaki, I Kumagai, Y Yasutake, M Yao, I Tanaka and K Tsumoto, *Proteins*, **68**, 446–57 (2007).

49 JP Lerner-Ellis, AB Gradinger, D Watkins, JC Tirone, A Villeneuve, CM Dobson, A Montpetit, P Lepage, RA Gravel and DS Rosenblatt, *Mol Genet Metab*, **87**, 219–25 (2006).

50 J Zhang, CM Dobson, X Wu, J Lerner-Ellis, DS Rosenblatt and RA Gravel, *Mol Genet Metab*, **87**, 315–22 (2006).

51 C Fan and TA Bobik, *Biochemistry*, **47**, 2806–13 (2008).

MOLYBDENUM/TUNGSTEN

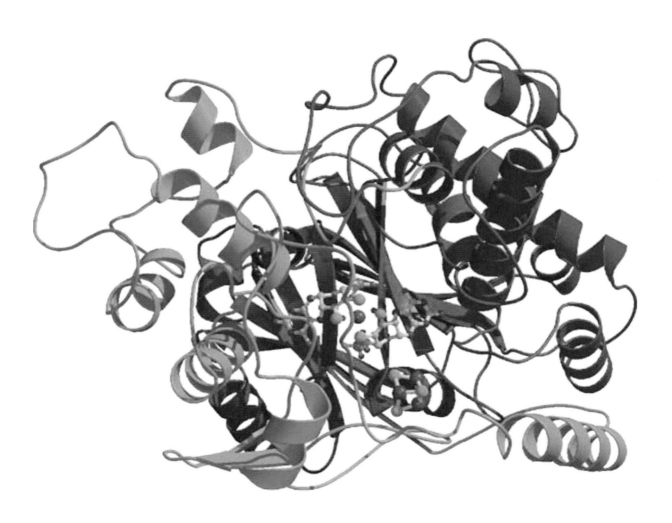

Nitrogenase: recent advances

Susana LA Andrade[†], Yilin Hu[‡], Markus W Ribbe[‡] and Oliver Einsle[†]

[†] Institut für Mikrobiologie und Genetik, Georg-August-Universität Göttingen, Göttingen, Germany
[‡] Department of Molecular Biology and Biochemistry, University of California, Irvine, CA, USA

FUNCTIONAL CLASS

Enzyme; two-component system; EC 1.18.6.1; component I – nitrogenase molybdenum – iron (MoFe) protein; component II – nitrogenase iron (Fe) protein.

Nitrogenase catalyzes the adenosine triphosphate (ATP)-dependent reductions of dinitrogen to ammonia and protons to dihydrogen as a two-component enzymatic machinery. The constituents of nitrogenase are the MoFe protein (or component I, 'dinitrogenase') and the Fe protein (or component II, 'dinitrogenase reductase'). This enzyme has been the subject of an article in volume I of the *Handbook of Metalloproteins*,[1] and the intention of the present addendum is to outline new achievements in nitrogenase research in the years 2000–2007. Several aspects, for which additional data have led to a refined understanding of the architecture and action of nitrogenase, are discussed here.

Reduction of dinitrogen (and presumably other substrates of nitrogenase) occurs at the FeMo cofactor, following multiple rounds of electron transfer (ET) from the P-cluster that in turn receives electrons from a [4Fe–4S] cluster in the Fe protein. The term *cofactor* (in contrast to 'cluster') implies that the FeMo cofactor is assembled *ex situ* through the catalytic action of multiple biosynthetic enzymes and subsequently transferred intact to apo-MoFe protein, while the clusters are synthesized *in situ* at their functional sites. The cofactor itself is a rigid and highly symmetrical structure, whose architecture was recently revised, possibly with fundamental consequences for our understanding of its function. Finally, a series of studies have addressed the structural details of complex formation and ET between MoFe protein and Fe protein. They concern the stoichiometry of ATP hydrolysis and ET, as well as the complex and flexible protein–protein interactions involved.

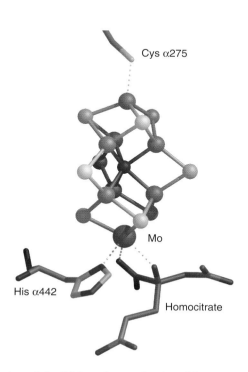

Cys α275

Mo

His α442

Homocitrate

3D Structure Ball-and-stick representation of the FeMo cofactor, the site of dinitrogen reduction to ammonia in the MoFe protein of nitrogenase of *Azotobacter vinelandii*. Redetermination of the crystal structure at atomic resolution revealed the presence of a central ligand in this largest and most complex iron–sulfur cluster known in a biological system. The coordinates were obtained from PDB entry 1M1N. Figures were prepared using MOLSCRIPT,[96] BOBSCRIPT,[97] RASTER3D,[98] and PyMOL.[99]

New findings on nitrogenase can thus be grouped into three major areas, concerning (i) the mechanistic details of dinitrogen reduction by the MoFe protein, (ii) the biogenesis of the component proteins of nitrogenase and their three metal clusters, and (iii) the interplay of MoFe protein and Fe protein in ET and ATP hydrolysis. All these aspects are tightly interwoven and contribute to the overall picture of nitrogenase action, which still remains far from being complete.

STRUCTURE AND REACTIVITY OF THE FeMo COFACTOR

Chatt-type reactions on molybdenum and iron

Although a chemical model system for the catalytic reduction of dinitrogen to ammonia under mild conditions was not available at the time, the laboratories of Chatt and Hidai had recognized the principles of this reactivity by Mo^0 and W^0 already more than 40 years ago.[2,3] However, their compounds catalyzed the reduction only stoichiometrically with a single turnover per metal rather than in a catalytic manner.

Chatt and coworkers also proposed a generalized catalytic mechanism for dinitrogen reduction on molybdenum,[4] but only two experimental realizations of this mechanism are known to date. Shilov and coworkers achieved catalytic reduction of dinitrogen, with the products hydrazine and ammonia in an approximate 10:1 ratio.[5] More recently, in 2003, Schrock and coworkers were able to achieve catalytic reduction with ammonia as an almost exclusive product using a Mo complex with a $[(HIPTNCH_2CH_2)_3N]^{3-}$ ligand with hexa-isopropyl terphenyl for HIPT.[6] Subsequently, Peters and coworkers showed that analogous chemistry based on iron is possible.[7] It remains unclear whether mechanistic similarities exist with biological nitrogen fixation on the FeMo cofactor.

A central atom in the FeMo cofactor

The intricate structure of the FeMo cofactor, the largest and most complex metal cluster known in biology, has remained highly enigmatic even after high-resolution crystal structures became available. In spite of the presence of six coordinatively unsaturated iron atoms at its center, the cofactor of isolated MoFe protein remained fully inert *in vitro*, toward not only its substrates but also various other, more reactive compounds. This seeming contradiction was partially resolved when an improved crystal structure of the *Azotobacter vinelandii* MoFe protein at a resolution of 1.16 Å was presented. Here, an additional light atom, most likely nitrogen, was detected in the central cavity of the FeMo cofactor.[8] This atom completed a tetrahedral geometry for the six iron atoms previously considered to be unsaturated. It thus simplified the explanation of the cofactor's extraordinary stability, as it removed the requirement for auxiliary constructions such as metal–metal bonding to rationalize its structural integrity. Before addressing the chemical nature of the central atom and its implications for nitrogenase mechanism, the fact that this ligand has evaded detection during decades of work on nitrogenase – including high-resolution crystal structures – should be addressed.

From the perspective of structural biochemistry, the most striking feature of the FeMo cofactor is its high degree of intrinsic symmetry, unrivaled by any other biological metal center: six iron atoms form a trigonal prism, each of them equidistant to the center of the cofactor at a distance of 2.0 Å. These iron atoms are bridged by a total of nine sulfur atoms that also link the prism to the apical iron and molybdenum atoms (Figure 1). The FeMo cofactor thus has an internal, threefold symmetry axis (Figure 1(a)) and all sulfur atoms are again equidistant from the center, placing them on the surface of a sphere with a radius of 3.3 Å (Figure 1(c)). X-ray structures of MoFe proteins from *A. vinelandii* (2.0 Å resolution),[9] *Clostridium pasteurianum* (2.2 Å),[10] and *Klebsiella pneumoniae* (1.6 Å)[11] consistently

(a) (b) (c)

Figure 1 Architecture and symmetry properties of the FeMo cofactor. (a) A threefold symmetry is found along the longitudinal axis of the FeMo cofactor. (b) Basic building blocks of the cofactor are two cubane units fused through the central ligand (blue) and bridged by three sulfur atoms (yellow). One of the apical positions is occupied by iron (gray), the other by molybdenum (orange). (c) The position of the central atom in FeMo cofactor is equidistant from six of the seven iron atoms at 2.0 Å, and also from all nine sulfur atoms, which are found on the surface of a sphere with a radius of 3.3 Å.

showed a highly conserved architecture of the cofactor with an empty center, evidenced by the absence of any maximum in a $2F_o–F_c$ electron density map. However, a corresponding $F_o–F_c$ difference electron density map does show a significant (>6σ) peak, and this observation motivated a closer inspection of the scattering properties of the FeMo cofactor.

A known issue in Fourier applications such as the calculation of electron density maps is with periodic artifacts introduced by series termination errors, i.e. by an insufficient number of terms in the Fourier summation in the discrete case of X-ray diffraction. While normally minor, such errors – or 'ripples' – can frequently be observed in the immediate vicinity of strong scatterers, in particular, metal ions. Their severity increases reciprocally to the limit of summation (or integration), which in turn corresponds to decreasing resolution in X-ray crystallography. The effects of such errors on a structural model are, in most cases, negligible, but can amount to a distortion of distances between very heavy metals (Mo, W) and lighter ligands. In the FeMo cofactor, however, the situation is unique in that the very center of the metal cluster is surrounded by two shells of scattering atoms, where termination effects are amplified sixfold for the iron atoms and ninefold for the sulfur atoms, respectively (Figure 1(c)). It is possible to quantify these termination effects for the given geometry of the cofactor, resulting in a resolution-dependent diffraction profile for the center of the cluster that depicts the artifactual density alterations induced exclusively by the concerted action of the surrounding atoms. Even when assuming a light atom to be present at this position, it is evident that in a resolution range between 2.3 and 1.55 Å the electron density in the center of the FeMo cofactor is negative. This effect disappears both at lower resolutions, where electron density maps no longer provide sufficient detail to discern individual atoms, and at very high resolutions. It was overcome by a redetermination of the structure of the MoFe-protein to atomic resolution (Figure 2). In a structure solved at a resolution of 1.16 Å, an additional electron density maximum was indeed found at the central position (3D Structure).[8]

The resolution-dependent electron density profile (Figures 2 and 3) clarified that at this resolution, no effects originating from cofactor geometry distorted the observed electron density. Electron density maps using structure factors calculated from a geometrical model of the cofactor (including a central nitrogen) illustrate this effect (Figure 3); if the high-resolution limit falls into the critical range of the electron density profile, the density peak of the central ligand disappears, although it was included in all calculations. It is thus solely the architecture of the FeMo cofactor that obscured the central interstitial atom in all previous structures and, given the degree of conservation of bond lengths and angles in all cofactor models from different organisms, it can be assumed that this atom was present in all crystal structures solved to date.[12]

Figure 2 Resolution-dependent electron density profile of the FeMo cofactor. Owing to Fourier series termination effects, the individual components of the FeMo cofactor produce artifactual ripples at the cofactor center, independent of the presence of a central atom. (Above) These ripples are minor for the distant Mo and Fe_1 atoms, but add up substantially for nine sulfur and six iron atoms. (Below) The sum of the individual curves shown above depicts the actual resolution-dependent electron density profile, the magnitude of the electron density artifact versus resolution of the calculated electron density map. In a resolution range between 1.55 and 2.3 Å, this results in negative density at the cofactor center, sufficient in magnitude to conceal the presence of a light atom.

The chemical identity of the central atom

The electron density observed in the central cavity of the cofactor as well as the distances to the surrounding iron atoms could only be reasonably modeled with the elements C, N, or O. It is difficult to discriminate between these atom types solely on the basis of observed electron density, but given the high quality of the diffraction data and the fact that the unit cell of these crystals contained four independent copies of the FeMo cofactor, careful data analysis pointed toward nitrogen as the most likely candidate.[8] For this analysis, the resolution-dependent electron density profile of the cofactor was subtracted from the actually observed electron density in its center and the remaining electron density displayed as a now undistorted profile (Figure 4). One of the elements C, N, or O was included into the model, positional, and B-factor refinement were carried out, and the resulting electron density at the cofactor center was plotted against resolution. After refinement, an increase in B factors was observed from C < N < O, and the resulting electron density peak was of similar magnitude in all three cases.

Figure 3 Calculated electron densities for the FeMo cofactor. On the basis of the coordinates of the cofactor from PDB entry 1M1N, F_{calc}/φ_{calc} electron density maps were calculated at various points along the resolution-dependent electron density profile (upper left). Although in each case the interstitial atom was included in the calculation, no electron density is visible at resolutions lower than 1.6 Å, due to the onset of Fourier series termination errors that interfere negatively in the cofactor center.

Figure 4 Experimentally observed electron density in the center of the FeMo cofactor. After subtraction of the resolution-dependent electron density profile induced by the Fourier series termination effect of the cofactor, no remaining electron density should be observed. Instead, experimental maps show a clear peak that increases in intensity with resolution, as expected for an atom located at this position (black dots). In order to estimate the identity of this central atom, refinements were carried out with C, N, and O as a central ligand (green, blue, and red dots, respectively). After positional and B-factor refinement, the resulting density profiles were very similar for all three elements. Comparison with the calculated electron density profile for the three elements shows that the experimental data is best explained by nitrogen as a central ligand.

This density corresponded best to the one expected for nitrogen (Figure 4). These experiments remain the only direct observation and quantification of the central atom in the FeMo cofactor to date. The discovery of a central atom subsequently triggered a series of computational studies, mostly density functional calculations that tried to assess the nature of this ligand by theoretical means.[13–16] Overall, these works report a preference of N over C over O.

However, the hypothesis of a central nitrogen atom was challenged by Hoffman, Dean, Seefeldt and coworkers, who presented data from [14]N/[15]N ENDOR (electron nuclear double resonance) and ESEEM (electron spin echo envelope modulation) studies where they were unable to detect any nitrogen atoms directly associated with the FeMo-cofactor core or exchangeable with [15]N. Experiments were carried out under turnover conditions as well as in the resting state, and initially led to the conclusion that a central N atom is nonexchangeable,[17] and (in a subsequent publication) that the central atom is not a nitrogen at all.[18] These results were based on the absence of a detectable signal, and no evidence was presented to identify the central atom as either C or O. The history of nitrogenase research may be taken as a warning that the complexity of the FeMo cofactor and the strong interaction of its constituent elements may well lead to effects that mask the presence of the central atom. Lovell and coworkers presented density functional calculations wherein the interstitial atom is assigned a spin density of only −0.02 of an electron.[15] In this case, it is well conceivable that weak interactions such as spin coupling with the nucleus, as it is relevant in ENDOR, would be difficult to detect. Recently, the same authors together with Hoffman and coworkers reassessed their data and no longer

rule out N or C as possible central ligands of the FeMo cofactor.[19]

The nature of the core atom in the FeMo cofactor thus remains under debate. More direct, experimental evidence will be required, and it can be expected that the answer to this question will be crucial for our understanding of the mechanistic details of nitrogen fixation.

Mechanistic implications

The discovery of an interstitial atom in the trigonal prism of iron atoms at the heart of the FeMo cofactor simplifies explaining its extraordinary stability, including the fact that the entire cofactor can be extracted from MoFe protein and used to activate apo-MoFe protein to a functional state (see below). The central ligand completes the coordination environment of all atoms in the cluster. In this position its role might merely be structural, conveying rigidity and stability to the cofactor, whose dinitrogen binding site(s) should then be located on the surface. Alternatively, if the central atom indeed is nitrogen, it may represent a functional intermediate of dinitrogen fixation, formally a nitrido species (N^{3-}) at a point in the reaction cycle where three electrons have been transferred and the first nitrogen atom has left as a fully reduced ammonia molecule.[8,16] However, as pointed out by density functional studies, the insertion and removal of the central atom would require a major structural rearrangement of the entire FeMo cofactor during the reaction cycle that would be energetically and logistically demanding. The feasibility of such rearrangements has indeed been suggested on the basis of calculations by Blöchl and coworkers[20,21] as well as by Ahlrichs, Coucouvanis and coworkers,[22,23] but within the enzyme one would expect to see such movements reflected

in substantial conformational changes of the protein itself, and no experimental evidence has been provided in support of this hypothesis to date.

Progress in understanding the mechanism of nitrogenase is further complicated by the fact that the various different substrates may not all be converted along the same mechanistic pathway. They are likely to differ in their binding mode, in the number of reduction steps that the cofactor has to undergo before the substrate can bind, and even in the pathways within the MoFe protein that a substrate has to follow in order to access the active site. At present, interaction of substrate with the iron atoms of the cofactor seems to be the favored model, but even so various possibilities ranging from end-on coordination to a single iron atom to side-on coordination on one of the four-iron faces of the cofactor can be imagined.

A further interesting aspect was most recently pointed out by Howard and Rees[24]: In the FeMo cofactor, as in all iron–sulfur clusters, iron is commonly described as a cationic form (+I through +III or mixed valence) and sulfur is considered to be in the sulfido state (−II). For the interactions of possible substrates with such clusters, the actual ionic radii should be considered rather than van der Waals radii of the uncharged species, and here the radius for S^{2-} (1.84 Å) is more than twice that for Fe^{2+} (0.76 Å)/Fe^{3+} (0.64 Å) or Mo^{4+} (0.68 Å). Depicting the cofactor in such an 'accessible surface representation' (Figure 5) emphasizes that the sulfur atoms and cluster ligands effectively shield the metals (both Fe and Mo) from approaching substrate and would not allow sufficiently close contact for coordination. Notably, Howard and Rees point out that in catalytic iron–sulfur clusters, such as the one of aconitase,[25] one cysteine ligand is absent to enable direct access for substrate to one of the iron atoms. This view of a sterical restriction of iron-based catalysis

Figure 5 Stereo image of the FeMo cofactor in space-filling representation with realistic ionic radii. The positively charged iron and molybdenum ions have significantly smaller radii than the S^{2-} sulfurs. Access to the metal ions is therefore sterically restricted, and this may, in part, explain the chemical inertness of the FeMo cofactor.

on biological iron–sulfur clusters may, furthermore, be of high relevance for understanding the functionality of other complex metal clusters in biology, such as the cluster C in Ni,Fe carbon monoxide dehydrogenase[26,27] or the clusters of Ni,Fe- and Fe-only hydrogenases.[28]

A different source of information on the possible modes of substrate binding and the mechanisms of substrate reduction at the FeMo cofactor is the study of variants of MoFe protein generated by site-directed mutagenesis. An Ala α70 point mutant was created, wherein alanine replaced a valine positioned above one of the 4Fe-faces of the FeMo cofactor, and binding of propargyl alcohol to the cofactor was observed.[29] In further studies, particularly the variants Gln α195 and Ala α70 were used to alter the putative substrate access pathways within the MoFe protein and to allow for the *in vitro* binding of various compounds to the FeMo cofactor, as observed using EPR (electron paramagnetic resonance) and ENDOR spectroscopies[30–33] and rationalized through density functional studies.[34] A methyldiazene adduct of the Gln α195 variant of *A. vinelandii* MoFe protein was found to have the ligand bound end-on through an $[-NH_x]$ fragment.[35] The authors concluded that this should support a mechanism of alternating proton and ET to the proximal and distal nitrogen atoms of methyldiazene, respectively, rather than a Chatt/Schrock-type mechanism, where electrons and protons are added sequentially to the distal nitrogen atom.[4,6] While providing interesting insights, such studies on variant proteins do face the challenge to prove their relevance for substrate reduction in the wild-type MoFe protein under turnover conditions. If indeed the protein environment of FeMo cofactor limits access of substrate to the active site, the requirement of a structural rearrangement of MoFe protein in the course of the reaction cycle of dinitrogen reduction is implied, and as in the case of a rearrangement of the cofactor itself, such evidence has not been presented so far.

Model compounds

Before and, in particular, since high-resolution crystal structures of the MoFe protein have become available, its two metal clusters have been the focus of intensive synthetic work that aimed at obtaining structural models in order to elucidate the biosynthesis and functionality of the P-cluster and the FeMo cofactor. Typical synthetic strategies started from preassembled cubane subunits of composition [4Fe–4S] or [M–3Fe–4S], which were then fused by substitution and displacement of terminal ligands. Coucouvanis and coworkers[36,37] and Holm and coworkers[38,39] produced various compounds of increasing complexity, and recently the latter group presented a series of MoFeS-containing clusters that represented topological analogs to the P-cluster.[40–43] Furthermore, after the discovery of the central atom in the FeMo cofactor, the

topological equivalence of P-cluster and FeMo cofactor became evident. In the P-cluster, the two cubane-type subclusters are bridged by cysteine sulfurs from the MoFe protein, while the analogous position in the FeMo cofactor is taken by the equatorial, bridging sulfides. The FeMo cofactor also contains a terminal molybdenum atom in place of iron, but the crucial difference apart from these is the central atom. Being a light atom in the cofactor, it allows for short bond distances to the surrounding iron atoms (2.0 Å), while the central sulfur atom in the P^N state of the P-cluster necessitates longer bonds (~2.3 Å) and thus distorts the entire cluster. Independent of these variations, the topology of both clusters is identical although the biosynthesis of each cluster obviously proceeds along a very different pathway (see below). On the synthetic side, this equivalence has been explicitly pointed out by Tatsumi and coworkers, who achieved the synthesis of a compound that does not only present a topological link between FeMo cofactor and P-cluster but was also obtained via a fundamentally different route.[44] Synthesis started with a [2Fe–2S] compound with bulky ligands, $[(TipS)Fe(\mu\text{-}SDmp)]_2$ (Tip = 2,4,6-iPr$_3$C$_6$H$_2$, Dmp = 2,6-(mesityl)$_2$C$_6$H$_3$), in order to avoid the spontaneous formation of [4Fe–4S] units. Addition of elemental sulfur then led to the one-step formation of complex clusters, two of which were shown to be equivalents of the P^N-cluster.[44] The implication of this work is that the formation of structures as complex as the clusters of MoFe protein may be favorable and occur in a straightforward and concerted step that might also play a role in the biological assembly pathway.

ASSEMBLY OF THE MoFe PROTEIN

Assembly of MoFe protein is arguably among the most complex processes in the field of bioinorganic chemistry, requiring, at least, the participation of the *nifS*, *nifU*, *nifB*, *nifE*, *nifN*, *nifV*, *nifQ*, *nifZ*, *nifH*, *nifD*, and *nifK* gene products of the *nif* (nitrogen fixation) system.[45] Multiple events occur during this process, including (i) the *ex situ* assembly of FeMo cofactor on NifEN, (ii) the incorporation of FeMo cofactor into the MoFe protein, (iii) the *in situ* assembly of the P-cluster on the MoFe protein, and (iv) the stepwise assembly of MoFe protein (Figure 6).

Ex situ assembly of FeMo cofactor

Biosynthesis of FeMo cofactor occurs independently of the production of MoFe protein polypeptides (hence the term *ex situ*, which refers to the biosynthesis of FeMo cofactor outside of the target MoFe protein).[46] On the basis of genetic evidence, biosynthesis of FeMo cofactor commences with NifS and NifU, which mobilize iron and sulfur for the assembly of small FeS fragments.

Figure 6 Model of the assembly of nitrogenase MoFe protein: ① the *ex situ* assembly of FeMo cofactor on NifEN, which involves a series of events leading to the conversion of precursor (as in NifEN) to 'FeMo cofactor' (as in NifEN[complete]) upon addition of Mo and homocitrate by Fe protein/MgATP (as in Fe protein[complete]); ② the insertion of FeMo cofactor into MoFe protein, which involves the concomitant conversion of FeMo-cofactor binding site to an accessible conformation upon P-cluster formation, the direct transfer of FeMo cofactor from NifEN to MoFe protein by protein–protein interactions, and the insertion of FeMo cofactor into its binding site through a positively charged funnel; ③ the *in situ* assembly of P-cluster on MoFe protein and ④ the concurrent stepwise assembly of MoFe protein, which involve the sequential conversion of paired [4Fe–4S]-like clusters to [8Fe–7S] P-clusters – one at a time, and the concomitant assembly of MoFe protein upon P-cluster formation and FeMo-cofactor insertion – one αβ-subunit half prior to the other. Maturation of P-cluster involves the processing of the [4Fe–4S]-like clusters (as in Δ*nifH* MoFe protein) into a more reduced form (as in Δ*nifH* MoFe protein[PI]) by Fe protein/MgATP before the formation of the first P-cluster (as in Δ*nifZ*Δ*nifB* MoFe protein) through coupling of [4Fe–4S]-like clusters. The second pair of [4Fe–4S]-like clusters is forced into an unfavorable conformation for coupling by the assembly of the first P-cluster and requires the sequential actions of NifZ and Fe protein/MgATP for maturation. At this point, depending on the availability of FeMo cofactor and the rate at which FeMo cofactor is inserted, the second P-cluster is formed either before (as in Δ*nifB* MoFe protein) or after (as in Δ*nifZ* MoFe protein) the insertion of FeMo cofactor into the first αβ-subunit half.

These small FeS fragments are subsequently transferred to NifB and further processed into a FeMo-cofactor 'core' that potentially contains all necessary Fe and S for the generation of a mature cofactor.[45,46] The FeMo-cofactor 'core' is then transferred to NifEN, where it undergoes additional rearrangements before its delivery to the MoFe protein.[45,47,48] While the exact points of Mo and homocitrate incorporation are unclear, it is known that NifV acts as a homocitrate synthase and NifQ is involved in molybdenum mobilization. In addition, NifH, the Fe protein, is also required for FeMo-cofactor maturation, although its function in the process is not yet understood.[45]

The participation of NifU, NifS, and NifB in the early assembly steps of FeMo cofactor was originally established by deletion analyses of the respective genes encoding for these proteins. Recently, it was reported that FeMo cofactor could be synthesized *in vitro* in an assay containing purified NifB and NifEN, and that NifB might be an *S*-adenosyl-methionine-dependent enzyme.[49,50] Although these observations are consistent with the model derived from genetic studies and sequence-based predictions, there is no spectroscopic or structural evidence that is indicative of the nature of cluster species rendered during the process and, therefore, the unambiguous assignment of

the functions of these proteins in FeMo-cofactor assembly has not been possible. Nevertheless, NifB undoubtedly plays a considerable role in synthesizing a FeMo-cofactor 'core' either prior to its transfer to NifEN or upon its interaction with NifEN, as NifEN isolated from a *nifB*-deletion background is free of any biosynthetic intermediate of FeMo cofactor, whereas NifEN isolated from *nifB*-intact background contains a distinct FeMo-cofactor-like cluster.[51] The eventual result of *nifB*-deletion is the accumulation of a FeMo-cofactor-deficient form of the MoFe protein (designated Δ*nifB* MoFe protein). Such a MoFe protein has an 'open' FeMo-cofactor site that is readily accessible to FeMo cofactor and, therefore, can be used for *in vitro* reconstitution assays (see below).

The function of NifEN as a scaffold protein for further processing of the FeMo-cofactor 'core' was initially proposed on the basis of a significant level of sequence homology between NifEN and MoFe protein, which has led to the hypothesis that NifEN contains cluster-binding regions that are analogous to the P-cluster and FeMo-cofactor sites in the MoFe protein. While the P-cluster analog in NifEN was established earlier as a cluster of [4Fe–4S] type,[48] the FeMo-cofactor counterpart in the protein has remained unidentified until the recent characterization of a NifEN complex isolated from *nifB*-intact yet *nifHDK*-deficient background. Deletion of *nifDK*-encoded MoFe protein (the terminal acceptor of FeMo cofactor) and *nifH*-encoded Fe protein (as an essential maturation factor) allows the accumulation of a precursor form of the FeMo cofactor on NifEN. This NifEN-bound precursor contains no Mo and exhibits a unique $g = 1.92$ EPR signal in the indigodisulfonate (IDS)-oxidized state.[51] More excitingly, Fe K-edge XAS (X-ray absorption spectroscopy) analysis reveals that the precursor is a Mo-free analog of FeMo cofactor and not one of the more commonly suggested cluster types based on the standard [4Fe–4S] architecture.[52] Both the 8Fe-model (Figure 7(a)) and the 7Fe-model (Figure 7(b)) of the precursor resemble FeMo cofactor with slightly elongated interatomic distances.[52] This finding suggests that, instead of following the previously postulated mechanism that involves the coupling of [4Fe–3S] and [Mo–3Fe–3S] subclusters, FeMo cofactor is assembled by the formation of an iron–sulfur core prior to the insertion of molybdenum. As in the fully assembled wild-type MoFe protein, a central atom in the NifEN-bound cofactor precursor could not be identified in these XAS-studies. Its presence is strongly suggested by the otherwise unchanged cofactor geometry, although the slightly elongated distances between atoms do not rule out a structural difference between this state and the fully assembled cofactor.

The precursor on NifEN undergoes further transformation upon incubation with Fe protein, MgATP, MoO_4^{2-} and homocitrate.[46] NifEN reisolated after such treatment (designated NifENcomplete) contains Mo, as opposed to

Figure 7 Putative biosynthetic precursors of the FeMo cofactor as identified by Fe-edge XAS.[52] An 8Fe model (a) as well as a 7Fe model (b) were suggested to fit the experimental data. Both models strongly resemble FeMo cofactor, but do not contain a molybdenum atom and are predicted to have slightly elongated interatomic distances.

the untreated NifEN, and it no longer exhibits the IDS-oxidized, $g = 1.92$ feature that is characteristic of the Mo-free precursor.[46] Furthermore, NifEN, thus treated, can serve as a FeMo-cofactor donor that directly activates the FeMo-cofactor-deficient Δ*nifB* MoFe protein, suggesting that (i) both Mo and homocitrate are inserted into the precursor while it is still bound to NifEN and (ii) the resulting, fully complemented cluster is transferred from NifEN to the MoFe protein by direct protein–protein interactions. Fe and Mo K-edge XAS/EXAFS (extended X-ray absorption fine structure) studies show that the processed cluster on NifEN closely resembles the FeMo cofactor on MoFe protein, except for a significant amount of disorder in the Mo environment that likely results from an asymmetric coordination of Mo in NifEN as compared to that in MoFe protein.[46]

The observation that cofactor biogenesis is completed on NifEN not only allows for an accurate assessment of the biosynthetic events hosted by NifEN but also suggests a significant role of the Fe protein in this process. Fe protein reisolated after incubation with MgATP, MoO_4^{2-}, homocitrate and NifEN (designated Fe proteincomplete) is capable of activating the Δ*nifB* MoFe protein in combination with NifEN.[53] This indicates that Fe protein can be 'charged' with Mo and homocitrate, which are subsequently inserted into the precursor on NifEN for the formation of a fully complemented cluster. The concomitant hydrolysis of MgATP is absolutely required for the 'loading' of Mo and homocitrate onto the Fe protein, as replacement of ATP by adenosine diphosphate (ADP) or by nonhydrolyzable ATP analogs, or of wild-type Fe protein by variant Fe proteins defective in MgATP

hydrolysis, results in the inability of Fe protein to deliver Mo and homocitrate to NifEN. Comparative Mo K-edge XAS analyses of the 'charged' Fe protein and the free molybdate show an edge shift of ~2.3 eV, indicating that the Mo associated with the Fe protein is modified from its supplied form. Furthermore, there is an ~0.5 eV difference between the Mo K edges of Fe proteins 'loaded' with Mo in the presence and absence of homocitrate, suggesting that homocitrate can be associated with the Fe protein along with Mo.[53]

Incorporation of FeMo cofactor into the MoFe protein

Upon completion of its assembly on NifEN, FeMo cofactor is transferred to and inserted into the MoFe protein through a complex mechanism. It has been suggested earlier that the delivery of FeMo cofactor is mediated by a carrier protein, such as NifX, NifY, or NafY.[45] However, the absolute requirement of such a FeMo-cofactor carrier was precluded by the previously mentioned observation of unaffected nitrogen-fixing ability of the host upon deletions of carrier-encoding genes and the recent finding of direct FeMo-cofactor transfer between NifEN and MoFe protein upon protein–protein interactions.[46] Sequence comparisons between NifEN and MoFe protein reveal that certain residues that either provide a covalent ligand for or pack tightly to FeMo cofactor within the polypeptide matrix of the MoFe protein are not duplicated in the corresponding NifEN sequence. It is, therefore, possible that the respective cluster sites in NifEN and MoFe protein are brought into close vicinity, which would allow for the subsequent transfer of FeMo cofactor from its low-affinity, biosynthetic site in NifEN to the final, high-affinity binding site in the MoFe protein. On the other hand, although the transfer of FeMo cofactor can occur without a carrier protein, it may involve accessory factors that further improve the efficiency of this process. A recent report suggests that NifX, one of the previously proposed carrier proteins, may participate in FeMo-cofactor assembly in a chaperone-like function.[19,54] In addition to the *nif*-specific accessory proteins, the well-established chaperone GroEL has also been shown to facilitate FeMo-cofactor insertion, although it is not clear whether GroEL works alone or in concert with GroES in this process.[55]

Upon its delivery to the MoFe protein, FeMo cofactor interacts with a number of protein residues *en route* to its target site within the protein. Identification of these residues was assisted by studies of Δ*nifB* MoFe protein, a P-cluster-intact yet cofactor-deficient form of MoFe protein that can be readily reconstituted with isolated FeMo cofactor.[56] Comparison of the crystal structures of Δ*nifB* and wild-type MoFe proteins has led to the discovery of a positively charged 'funnel' in the αIII domain of Δ*nifB* MoFe protein that allows for the access of the negatively charged FeMo

cofactor (Figure 8). A closer inspection of the 'funnel' reveals three distinct regions that are potentially important for cofactor insertion: (i) the 'lid loop' (residues α353 through α364), which potentially guides the FeMo cofactor to the insertion funnel. Among them, His α362, which is located at the tip of the loop, could serve as a transient ligand for FeMo cofactor at the entrance of the funnel, (ii) the 'His triad' (His α274, His α442, and His α451), which may provide a histidine-enriched, intermediary docking point for the cofactor during its journey through the funnel, and (iii) the 'switch/lock' (His α442 and Trp α444), which could secure the FeMo cofactor in its binding site by the bulky side chain of Trp α444 following a swap in position between Trp α444 and His α442 at the bottom of the funnel (Figure 8(a)).[56] Participation of these residues in FeMo cofactor insertion has been confirmed by mutational analyses that demonstrate a specific and substantial reduction of cofactor incorporation upon removal of the positive charge, liganding capacity, or steric effect at the respective positions.[57–59] Furthermore, FeMo-cofactor insertion is accompanied by structural rearrangements of the MoFe protein (Figure 8(b) and (c)). Consistent with the structurally confirmed, open conformation of the αIII domain of Δ*nifB* MoFe protein,[56] the SAXS (small angle X-ray scattering)-derived R_g value of the Δ*nifB* MoFe protein (42.4 Å) is slightly, yet reproducibly larger than that of the wild-type MoFe protein (40.2 Å).[60] Considering that Δ*nifB* MoFe protein supposedly represents a biosynthetic intermediate immediately prior to the fully assembled MoFe protein, these data suggest a compacting effect on MoFe-protein conformation upon FeMo-cofactor insertion, i.e. the 'closing of the lid'.

In situ assembly of P-cluster

Biosynthesis of P-cluster, similar to that of FeMo cofactor, also begins with the action of NifS and NifU. However, further processing of the small, NifSU-generated Fe/S fragments into a mature P-cluster takes place within the MoFe protein (hence the term *in situ*). There is evidence that Fe protein is involved in P-cluster formation, but the exact function of Fe protein in the process, as well as the nature of the biosynthetic intermediate of P-cluster, has remained largely unknown.

Recently, a MoFe protein isolated from a *nifH*-deletion background (designated Δ*nifH* MoFe protein) was characterized. As in the case of Δ*nifB* MoFe protein, Δ*nifH* is FeMo-cofactor deficient due to the absence of *nifH*-encoded Fe protein that is required for FeMo-cofactor maturation. However, in contrast to Δ*nifB* MoFe protein, Δ*nifH* MoFe protein contains an unusual 'P-cluster', displaying an $S = 1/2$ EPR signal in the dithionite-reduced state that is characteristic of [4Fe–4S] clusters.[61]

Figure 8 Comparison of NifB$^-$-MoFe protein with wild-type MoFe protein. (a) Within the open funnel (blue circle, see (b)), several conserved residues are presumed to play a role in guiding the FeMo cofactor to its final position. These include His362 as a primary point of contact, a characteristic His triad composed of histidines 274, 442, and 451 (red circle) and the His442/Trp444 switch region (orange circle). All residues belong to the α subunit. Depicted below are electrostatic surface representation of the Δ*nifB* MoFe protein (b) and MoFe protein (c) in identical orientations.[56] The stereo images emphasize the deep, open funnel in the Δ*nifB* variant that forms a final intermediate of MoFe-protein assembly, an apo form ready to accept cofactor assembled on NifEN.

Fe K-edge XAS/EXAFS analysis revealed that the metal center at the P-cluster site in Δ*nifH* MoFe protein is composed of paired [4Fe–4S]-like clusters, either separated or bridged.[62] VTVH-MCD (variable-temperature, variable-field magnetic circular dichroism) analysis provided further support for the model of separated [4Fe–4S] centers, showing that each [4Fe–4S] pair contains a [4Fe–4S]$^{+1}$ cluster and a diamagnetic [4Fe–4S]-like cluster which, upon IDS oxidation, becomes paramagnetic.[63]

The paired [4Fe–4S] clusters in Δ*nifH* MoFe protein represents a physiologically relevant precursor to P-cluster, as Δ*nifH* MoFe protein can be fully activated, in crude extract, upon incubation with Fe protein, MgATP and isolated FeMo cofactor.[64] Given that Δ*nifH* MoFe

protein contains precursors in place of the fully assembled P-clusters, it could represent an intermediate that occurs earlier than $\Delta nifB$ MoFe protein along the biosynthetic pathway. Comparative SAXS analyses of $\Delta nifH$, $\Delta nifB$, and wild-type MoFe proteins show that the $\Delta nifH$ MoFe protein exists in the most extended conformation ($R_g = 45.7$ Å), followed by the $\Delta nifB$ MoFe protein ($R_g = 42.4$ Å), and then the wild-type MoFe protein ($R_g = 40.2$ Å).[60] The increase in size of $\Delta nifH$ MoFe protein is correlated with an increase in the solvent accessibility of the P-cluster precursor Fe atoms and can be best modeled by a 6 Å gap at the α/β-subunit interface that is absent from the structure of either $\Delta nifB$ or wild-type MoFe protein.[60] These results suggest that coupling of the P-cluster subclusters is accompanied by a conformational change of MoFe protein that brings its α and β subunits together. Furthermore, maturation of P-cluster not only affects the α/β-subunit interface, it also has an impact on the FeMo-cofactor binding site within the α subunit of MoFe protein. Upon incubation with Fe protein, MgATP and reductant, not only is the P-cluster precursor in $\Delta nifH$ MoFe protein further processed,[65] the protein (designated $\Delta nifH$ MoFe protein[PI], where PI = preincubated) can also be activated to ~10% of its maximal activity, suggesting that, concomitant with the formation of P-cluster, the FeMo-cofactor site is partially opened up, possibly upon conformational changes induced by the Fe protein.

Stepwise assembly of the MoFe protein

One important aspect of MoFe-protein assembly is the coordination of multiple events that occur during the process, including the timing of cluster synthesis/insertion and the order of subunit folding/rearrangement. Recently, a semi-assembled form of the tetrameric $(\alpha\beta)_2$ MoFe protein was isolated from a $nifZ$-deletion background (designated $\Delta nifZ$ MoFe protein), which contained a P-cluster and a FeMo cofactor in one $\alpha\beta$-subunit dimer, and a P-cluster precursor plus a vacant FeMo-cofactor site in the other.[66] The P-cluster species in the second half comprised two [4Fe–4S]-like clusters, as indicated by an $S = 1/2$ EPR signal highly similar to the one seen in the $\Delta nifH$ MoFe protein.[61,66] These observations suggest that (i) MoFe protein is assembled in a stepwise fashion, (ii) completion of the first $\alpha\beta$ half forces the second half into a conformation that does not allow proper coupling of the two [4Fe–4S] fragments into a mature P-cluster, and (iii) NifZ is specifically required at this point for the formation of the second P-cluster.

Subsequent studies of the MoFe protein isolated from $nifZ/nifB$-double-deletion background (designated $\Delta nifZ\Delta nifB$ MoFe protein) allowed investigation of the maturation of the second P-cluster without the interference of FeMo cofactor. EPR analysis suggested that such

a MoFe protein is cofactor deficient and contains one P-cluster in one $\alpha\beta$ half and one paired [4Fe–4S]-like clusters in the other.[66] Consistent with the presence of a fully assembled P-cluster in the first half, $\Delta nifZ\Delta nifB$ MoFe protein can be activated, without additional factors, to ~50% of the activity of the fully reconstituted $\Delta nifB$ MoFe protein.[66] Upon incubation with NifZ and Fe protein/MgATP, $\Delta nifZ\Delta nifB$ MoFe protein can be further activated to ~86% of the maximal activity. The additional ~36% increase in activation suggests the conversion of a major portion of precursor to mature P-cluster in the second half of the protein,[67] which is further backed up by EPR analysis that showed a decrease in the intensity of the precursor-associated $S = 1/2$ signal and a concurrent increase in the magnitude of the P^{2+}-associated $g = 11.8$ signal. Furthermore, the action of NifZ precedes that of Fe protein/MgATP in this process, as $\Delta nifZ\Delta nifB$ MoFe protein reisolated after incubation with NifZ alone can be activated by Fe protein/MgATP, whereas $\Delta nifZ\Delta nifB$ MoFe protein reisolated after incubation with Fe protein/MgATP cannot be activated by NifZ.[67] The fact that $\Delta nifZ\Delta nifB$ MoFe protein cannot be activated fully suggests that additional factors may be required along with NifZ for P-cluster formation. Such factors could be the products of $nifW$ and $nifM$ genes, both of which are juxtaposed with $nifZ$ gene on the chromosome and are believed to be implicated in earlier steps of MoFe-protein assembly.

ELECTRON TRANSFER AND PROTEIN INTERACTIONS

The [4Fe–4S]⁰ redox state of the Fe protein

Nitrogenase Fe protein is a functional homodimer that is grouped with the extensive family of nucleotide-switch proteins based on its architecture and functional properties.[1] It binds a cubane-type [4Fe–4S] cluster at the dimer interface, with Cys97 and Cys132 of each monomer acting as ligands.[68,69] ATP binding and hydrolysis leads to a complex series of conformational changes in the dimer that drastically alter both the surface exposure and redox potential of the cluster, making Fe protein the only agent, known to date, that is able to transfer electrons to the FeMo cofactor of the MoFe protein.[1,12,70] The [4Fe–4S] cluster of Fe protein has a canonical structure and undergoes a transition from the [4Fe–4S]$^{+2}$ to the [4Fe–4S]$^{+1}$ state upon reduction with dithionite that is typically found in this type of metal center.[71,72] In addition, in the cluster of the Fe protein a unique, further reduction step can be achieved when using titanium citrate, yielding a [4Fe–4S]⁰ state.[73] Physiological electron donors to the Fe protein are typical one-electron carriers, such as flavodoxins[74–77] or ferredoxins.[78–80] However, as the isoalloxazine group is able to hold up to two electrons, a two-electron transfer from a flavodoxin in the hydroquinone (HQ) state could

also result in a $[4Fe-4S]^0$ cluster. The $[4Fe-4S]^0$ state was previously not considered to be of physiological relevance, due to the extremely negative redox potential estimated for the $+1/0$ redox couple of $-790\,mV$ (compared to a midpoint potential of $-460\,mV$ using methyl viologen as a reductant).[81] ET to the MoFe protein was therefore considered to occur in single electron steps, resulting in an ATP/electron ratio of 2 and the hydrolysis of 16 mol ATP per mol $N_2 + H_2$.

This canonical stoichiometry of the nitrogenase reaction has recently been challenged by Watt and coworkers, based on evidence that the *Azotobacter* flavodoxin hydroquinone form can indeed produce the all-ferrous Fe protein.[82,83] This state is distinct from the $[4Fe-4S]^0$ form of Fe protein obtained after reduction with Ti(III) citrate; while the latter was found to have an $S = 4$ spin state and a characteristic EPR signal at $g = 16.4$,[84] reduction with the flavodoxin hydroquinone resulted in a $S = 0$ spin state and absence of the $g = 16.4$ EPR signal.[82] A direct consequence of the transfer of two electrons onto the Fe protein would be a change in the overall stoichiometry, such that only one molecule of ATP had to be hydrolyzed for each electron transferred to the MoFe protein, when a flavodoxin is the redox partner of the Fe protein. Notably, the downstream redox partner of the Fe protein, the P-cluster of the MoFe protein, has also been characterized in two distinct states, the P^N state and the two-electron oxidized P^{Ox} state, supporting the possibility of two-electron transfer steps during nitrogen fixation. The significance of this finding for nitrogenase action *in vivo* remains unclear, and it seems likely that both modes of ET, single- and two-electron, may be relevant under various conditions within the cell, depending on the ratios of ATP/ADP, Fe protein/MoFe protein, or flavodoxin/Fe protein.

Complex formation between MoFe protein and Fe protein

A structure of a complex of MoFe protein and Fe protein was first obtained with the *A. vinelandii* system, using $ADP\cdot AlF_4^-$ bound to Fe protein as a transition-state analog of ATP hydrolysis.[85,86] Its crystal structure revealed two Fe-protein homodimers binding to one MoFe protein, with the $[4Fe-4S]$ cluster of the former positioned directly above the P-cluster of the MoFe protein, suggesting a functional arrangement for ET (Figure 9(a)).[1,87] Beyond this general mode of interaction of the two-component proteins of nitrogenase, more recent studies on complex formation have led to a refined understanding of the process.

In 1989, Howard and coworkers obtained a covalently cross-linked complex of Fe and MoFe protein using *N*-(3-(dimethylamino)propyl)*N*-ethylcarbodiimide (EDC). Turnover of the nitrogenase system in the presence of EDC led to a covalent amide bond formation between the side chains of Glu112 of the Fe protein and Lys β400 of

MoFe protein.[90,91] The specificity of this bond formation is surprising, not only because in the $ADP\cdot AlF_4^-$ complex structure the Oε2 atom of Glu112 and the Nζ atom of Lys β400 are at a distance of 12 Å, but also because Glu112 is located in a negatively charged surface patch of the Fe protein that consists of no less than 11 aspartic acid or glutamic acid residues. Out of all these, only Glu112 has been found to form an EDC-induced cross-link with the MoFe protein (Figure 9(b)), indicative of a highly specific interaction of the two-component proteins of nitrogenase. In the $ADP\cdot AlF_4^-$ complex structure, however, the Oδ2 atom of Asp69 is at a distance of only 3 Å from the Nζ atom of Lys β400 and yet no cross-link between these residues was observed under turnover conditions. A crystal structure of the EDC-cross-linked complex, solved at a resolution of 3.2 Å, subsequently showed the exact covalent link that had previously been identified.[89] However, while a single MoFe-protein heterotetramer was found to be covalently linked to two Fe-protein homodimers as was the case in the $ADP\cdot AlF_4^-$ complex structure, the Fe proteins were not docked onto the MoFe-protein surface as in the latter case. The covalent amide link formed the only connection between the two proteins, and the Fe proteins were located lateral to the MoFe protein, at a distance far too large to consider the possibility of ET between their metal centers.[89] EDC-induced complex formation under turnover condition thus did not lead to a stabilized complex as did blocking of the Fe protein with the transition-state analog $ADP\cdot AlF_4^-$, although the Fe proteins in the cross-linked complex were found to be in a closed conformation similar to the one observed in the first complex structure. While not completing the picture of the complex interplay of the two-component proteins of nitrogenase, the EDC-cross-linked structure did emphasize the important role of the significant flexibility of the Fe-protein homodimer during ATP hydrolysis and ET to the MoFe protein.

A crucial contribution toward understanding this flexibility was the subsequent determination of three complex structures between the Fe protein and the MoFe protein under near-physiological conditions of protein concentration and ionic strength in the absence of a nucleotide bound to the Fe protein as well as in the presence of ADP and of the nonhydrolyzable ATP analog AMP-PCP.[88] While the latter complex yielded a binding mode very similar to the one observed for the $ADP\cdot AlF_4^-$ complex,[87] the other two showed clearly distinct binding sites for the Fe protein on the MoFe protein. In particular, this resulted in $[4Fe-4S]$ cluster to P-cluster distances that were approximately 5 Å longer for the nucleotide-free and ADP-bound complexes (22 Å) than for the ones with AMP-PCP or $ADP\cdot AlF_4^-$ (17 Å), presumably with strong consequences for ET efficiency. Moreover, the nucleotide-free complex remains the only nitrogenase complex observed to date that shows a 1:1 stoichiometry of both component proteins rather than the usually observed binding of two Fe proteins to one

Figure 9 Complexes of MoFe protein and Fe protein. In all panels, MoFe protein is colored in red (α subunits) and blue (β subunits) and Fe protein in green and yellow. (a) The AMPPCP-stabilized complex,[88] where complex formation occurs in a manner similar to the original, ADP·AlF$_4^-$-stabilized complex.[87] (b) Crystal structure of EDC-cross-linked MoFe protein with Fe protein.[89] The conformation of the Fe proteins is due to crystal packing interactions and does not explain the formation of the highly specific cross-link. (c) Details of the interaction of MoFe protein and Fe protein in the nucleotide-free complex structure.[88] Solely here, both proteins were found in a complex that readily explains the specific formation of an EDC-mediated cross-link between E112 and K400. (d) Three different complexes obtained under near-physiological conditions of protein concentration and ionic strength show specific, but different binding patches for Fe protein on the surface of MoFe protein. While the nucleotide-free structure explains the formation of the EDC-cross-link, only the AMP-PCP (adenylylmethylenediphosphate)-bound form brings the [4Fe–4S] cluster of Fe protein sufficiently close to the P-cluster of MoFe protein to allow for efficient electron transfer.

MoFe protein. The binding patch of the Fe protein here was shifted from the pseudo-twofold symmetry axis of the α and β subunits of the MoFe protein toward the β subunit, and in this conformation the Oε2 atom of Glu112 in the Fe protein and the Nζ atom of Lys β400 of the MoFe protein were directly juxtaposed, at a distance of only 2.9 Å (Figure 9(c)).[88] This finding helps to rationalize the specificity of the EDC-induced cross-linking reaction[90,91] and it may shed light on the conformation of a resting state of the complex, inactive in ET, but nonetheless of high specificity, such as to enable a faster formation of the ET-competent complex upon nucleotide binding. On the other hand, the ADP-bound complex observed in this work shows a similar degree of displacement of the Fe protein from the optimal position for ET, but in this case the

Fe protein is shifted in the opposite direction, toward the α-subunit. Specific binding is observed, albeit with a smaller buried surface area (1600–2000 Å2) than in the nucleotide-free (2800 Å2) or AMP-PCP-bound complexes (3700 Å2).[88] The MoFe protein thus seems to provide several distinct binding patches for the Fe protein, all of which are specific and possibly functionally relevant (Figure 9(d)). Viewing the Fe protein as a nucleotide-switch protein, one could expect the action of Fe protein – hydrolysis of ATP – to be assisted by two factors, an activating protein (AP) that induces ATP hydrolysis and a nucleotide exchange factor (EF) that triggers exchange of ADP for ATP, such as they are commonly part of the regulatory cycles of G proteins.[92,93] In the nitrogenase system, Fe protein is only able to hydrolyze ATP after complex formation with the

MoFe protein,[94] and both components possibly dissociate after each transfer cycle,[95] making MoFe protein the AP for Fe protein. In addition, the various complex structures of nitrogenase suggest that upon ATP hydrolysis the two proteins do not fully dissociate, but merely rearrange to yield a further specific complex, wherein the Fe protein is able to release ADP and regain competence for a further round of reduction and ATP binding. In this line of thought, MoFe protein acts as an EF for Fe protein. However, one might then assume that the nucleotide-free complex represents this state of the reaction cycle of the Fe protein, with ADP dissociated and the Fe protein ready for reduction by flavodoxin of ferredoxin. The occurrence of a stable ADP-bound complex is more difficult to align with this scheme, unless it is assumed that the reduction step has to take place before nucleotide exchange.

REFERENCES

1 B Schmid, HJ Chiu, V Ramakrishnan, JB Howard and DC Rees, in A Messerschmidt, R Huber, K Wieghardt and T Poulos (eds.), *Handbook of Metalloproteins*, Vol. 2, John Wiley & Sons, New York, pp. 1025–36 (2001).

2 M Hidai and Y Mizobe, *Chem Rev*, **95**, 1115–33 (1995).

3 J Chatt and GJ Leigh, *Chem Soc Rev*, **1**, 121–36 (1972).

4 J Chatt, JR Dilworth and RL Richards, *Chem Rev*, **78**, 589–625 (1978).

5 AE Shilov, *J Mol Catal*, **41**, 221–34 (1987).

6 DV Yandulov and RR Schrock, *Science*, **301**, 76–78 (2003).

7 TA Betley and JC Peters, *J Am Chem Soc*, **126**, 6252–54 (2004).

8 O Einsle, FA Tezcan, SLA Andrade, B Schmid, M Yoshida, JB Howard and DC Rees, *Science*, **297**, 1696–700 (2002).

9 JW Peters, MHB Stowell, SM Soltis, MG Finnegan, MK Johnson and DC Rees, *Biochemistry*, **36**, 1181–87 (1997).

10 JT Bolin, N Campobasso, SW Muchmore, TV Morgan and LE Mortenson, in EI Stiefel, D Coucouvanis and WE Newton (eds.), *Molybdenum Enzymes, Cofactors and Model Systems*, Vol. 535, American Chemical Society, Washington, DC, pp. 186–95 (1993).

11 SM Mayer, DM Lawson, CA Gormal, SM Roe and BE Smith, *J Mol Biol*, **292**, 871–91 (1999).

12 DC Rees, FA Tezcan, CA Haynes, MY Walton, S Andrade, O Einsle and JB Howard, *Philos Trans R Soc London, Ser A*, **363**, 971–84 (2005).

13 V Vrajmasu, E Munck and EL Bominaar, *Inorg Chem*, **42**, 5974–88 (2003).

14 B Hinnemann and JK Norskov, *J Am Chem Soc*, **125**, 1466–67 (2003).

15 T Lovell, TQ Liu, DA Case and L Noodleman, *J Am Chem Soc*, **125**, 8377–83 (2003).

16 I Dance, *Chem Commun*, 324–25 (2003).

17 HI Lee, PMC Benton, M Laryukhin, RY Igarashi, DR Dean, LC Seefeldt and BM Hoffman, *J Am Chem Soc*, **125**, 5604–5 (2003).

18 TC Yang, NK Maeser, M Laryukhin, HI Lee, DR Dean, LC Seefeldt and BM Hoffman, *J Am Chem Soc*, **127**, 12804–5 (2005).

19 D Lukoyanov, V Pelmenschikov, N Maeser, M Laryukhin, TC Yang, L Noodleman, DR Dean, DA Case, LC Seefeldt and BM Hoffman, *Inorg Chem*, **46**, 11437–49 (2007).

20 J Kästner and PE Blöchl, *J Am Chem Soc*, **129**, 2998–3006 (2007).

21 J Kästner, S Hemmen and PE Blöchl, *J Chem Phys*, **123**, 74306 (2005).

22 U Huniar, R Ahlrichs and D Coucouvanis, *J Am Chem Soc*, **126**, 2588–601 (2004).

23 D Coucouvanis, JH Han, R Ahlrichs, P Nava and U Huniar, *J Inorg Biochem*, **96**, 19 (2003).

24 JB Howard and DC Rees, *Proc Natl Acad Sci USA*, **103**, 17088–93 (2006).

25 H Beinert, MC Kennedy and CD Stout, *Chem Rev*, **96**, 2335–73 (1996).

26 H Dobbek, V Svetlitchnyi, L Gremer, R Huber and O Meyer, *Science*, **293**, 1281–85 (2001).

27 JH Jeoung and H Dobbek, *Science*, **318**, 1461–64 (2007).

28 JC Fontecilla-Camps, A Volbeda, C Cavazza and Y Nicolet, *Chem Rev*, **107**, 5411 (2007).

29 HI Lee, RY Igarashi, M Laryukhin, PE Doan, PC Dos Santos, DR Dean, LC Seefeldt and BM Hoffman, *J Am Chem Soc*, **126**, 9563–69 (2004).

30 BM Barney, TC Yang, RY Igarashi, PC Dos Santos, M Laryukhin, HI Lee, BM Hoffman, DR Dean and LC Seefeldt, *J Am Chem Soc*, **127**, 14960–61 (2005).

31 BM Barney, M Laryukhin, RY Igarashi, HI Lee, PC Dos Santos, TC Yang, BM Hoffman, DR Dean and LC Seefeldt, *Biochemistry*, **44**, 8030–37 (2005).

32 PC Dos Santos, RY Igarashi, HI Lee, BM Hoffman, LC Seefeldt and DR Dean, *Acc Chem Res*, **38**, 208–14 (2005).

33 RY Igarashi, M Laryukhin, PC Dos Santos, HI Lee, DR Dean, LC Seefeldt and BM Hoffman, *J Am Chem Soc*, **127**, 6231–41 (2005).

34 I Dance, *J Am Chem Soc*, **126**, 11852–63 (2004).

35 BM Barney, D Lukoyanov, TC Yang, DR Dean, BM Hoffman and LC Seefeldt, *Proc Natl Acad Sci USA*, **103**, 17113–18 (2006).

36 PR Challen, SM Koo, CG Kim, WR Dunham and D Coucouvanis, *J Am Chem Soc*, **112**, 8606–7 (1990).

37 KD Demadis, CF Campana and D Coucouvanis, *J Am Chem Soc*, **117**, 7832–33 (1995).

38 C Goh, BM Segal, JS Huang, JR Long and RH Holm, *J Am Chem Soc*, **118**, 11844–53 (1996).

39 JS Huang, S Mukerjee, BM Segal, H Akashi, J Zhou and RH Holm, *J Am Chem Soc*, **119**, 8662–74 (1997).

40 YG Zhang, JL Zuo, HC Zhou and RH Holm, *J Am Chem Soc*, **124**, 14292–93 (2002).

41 YG Zhang and RH Holm, *J Am Chem Soc*, **125**, 3910–20 (2003).

42 JL Zuo, HC Zhou and RH Holm, *Inorg Chem*, **42**, 4624–31 (2003).

43 Y Zhang and RH Holm, *Inorg Chem*, **43**, 674–82 (2004).

44 Y Ohki, Y Ikagawa and K Tatsumi, *J Am Chem Soc*, **129**, 10457–65 (2007).

45 PC Dos Santos, DR Dean, YL Hu and MW Ribbe, *Chem Rev*, **104**, 1159–73 (2004).

46 YL Hu, MC Corbett, AW Fay, JA Webber, KO Hodgson, B Hedman and MW Ribbe, *Proc Natl Acad Sci USA*, **103**, 17119–24 (2006).

47 JT Roll, VK Shah, DR Dean and GP Roberts, *J Biol Chem*, **270**, 4432–37 (1995).

48 PJ Goodwin, JN Agar, JT Roll, GP Roberts, MK Johnson and DR Dean, *Biochemistry*, **37**, 10420–28 (1998).

49 L Curatti, JA Hernandez, RY Igarashi, B Soboh, D Zhao and LM Rubio, *Proc Natl Acad Sci USA*, **104**, 17626–31 (2007).

50 L Curatti, PW Ludden and LM Rubio, *Proc Natl Acad Sci USA*, **103**, 5297–301 (2006).

51 YL Hu, AW Fay and MW Ribbe, *Proc Natl Acad Sci USA*, **102**, 3236–41 (2005).

52 MC Corbett, YL Hu, AW Fay, MW Ribbe, B Hedman and KO Hodgson, *Proc Natl Acad Sci USA*, **103**, 1238–43 (2006).

53 YL Hu, MC Corbettt, AW Fay, JA Webber, KO Hodgson, B Hedman and MW Ribbe, *Proc Natl Acad Sci USA*, **103**, 17125–30 (2006).

54 JA Hernandez, RY Igarashi, B Soboh, L Curatti, DR Dean, PW Ludden and LM Rubio, *Mol Microbiol*, **63**, 177–92 (2007).

55 MW Ribbe and BK Burgess, *Proc Natl Acad Sci USA*, **98**, 5521–25 (2001).

56 B Schmid, MW Ribbe, O Einsle, M Yoshida, LM Thomas, DR Dean, DC Rees and BK Burgess, *Science*, **296**, 352–56 (2002).

57 AW Fay, Y Hu, B Schmid and MW Ribbe, *J Inorg Biochem*, **101**, 1630–41 (2007).

58 Y Hu, AW Fay and MW Ribbe, *J Biol Inorg Chem*, **12**, 449–60 (2007).

59 YL Hu, AW Fay, B Schmid, B Makar and MW Ribbe, *J Biol Chem*, **281**, 30534–41 (2006).

60 MC Corbett, YL Hu, AW Fay, H Tsuruta, MW Ribbe, KO Hodgson and B Hedman, *Biochemistry*, **46**, 8066–74 (2007).

61 MW Ribbe, YL Hu, ML Guo, B Schmid and BK Burgess, *J Biol Chem*, **277**, 23469–76 (2002).

62 MC Corbett, YL Hu, F Naderi, MW Ribbe, B Hedman and KO Hodgson, *J Biol Chem*, **279**, 28276–82 (2004).

63 RB Broach, K Rupnik, YL Hu, AW Fay, M Cotton, MW Ribbe and BJ Hales, *Biochemistry*, **45**, 15039–48 (2006).

64 S Tal, TW Chun, N Gavini and BK Burgess, *J Biol Chem*, **266**, 10654–57 (1991).

65 YL Hu, MC Corbett, AW Fay, JA Webber, B Hedman, KO Hodgson and MW Ribbe, *Proc Natl Acad Sci USA*, **102**, 13825–30 (2005).

66 Y Hu, AW Fay, PC Dos Santos, F Naderi and MW Ribbe, *J Biol Chem*, **279**, 54963–71 (2004).

67 Y Hu, AW Fay, CC Lee and MW Ribbe, *Proc Natl Acad Sci USA*, **104**, 10424–29 (2007).

68 RP Hausinger and JB Howard, *J Biol Chem*, **257**, 2483–90 (1982).

69 MM Georgiadis, H Komiya, P Chakrabarti, D Woo, JJ Kornuc and DC Rees, *Science*, **257**, 1653–59 (1992).

70 JB Howard and DC Rees, *Chem Rev*, **96**, 2965–82 (1996).

71 CW Carter, J Kraut, ST Freer, RA Alden, LC Sieker, E Adman and LH Jensen, *Proc Natl Acad Sci USA*, **69**, 3526–29 (1972).

72 H Beinert, RH Holm and E Munck, *Science*, **277**, 653–59 (1997).

73 GD Watt and KRN Reddy, *J Inorg Biochem*, **53**, 281–94 (1994).

74 MG Yates, *FEBS Lett*, **27**, 63–67 (1972).

75 MG Duyvis, H Wassink and H Haaker, *Biochemistry*, **37**, 17345–54 (1998).

76 LT Bennett, MR Jacobson and DR Dean, *J Biol Chem*, **263**, 1364–69 (1988).

77 GD Watt, *Anal Biochem*, **99**, 399–407 (1979).

78 DC Yoch and DI Arnon, *J Bacteriol*, **121**, 743–45 (1975).

79 MP Golinelli, J Gagnon and J Meyer, *Biochemistry*, **36**, 11797–803 (1997).

80 Y Jouanneau, C Meyer, I Naud and W Klipp, *Biochim Biophys Acta: Bioenerg*, **1232**, 33–42 (1995).

81 ML Guo, F Sulc, MW Ribbe, PJ Farmer and BK Burgess, *J Am Chem Soc*, **124**, 12100–1 (2002).

82 TJ Lowery, PE Wilson, B Zhang, J Bunker, RG Harrison, AC Nyborg, D Thiriot and GD Watt, *Proc Natl Acad Sci USA*, **103**, 17131–36 (2006).

83 JA Erickson, AC Nyborg, JL Johnson, SM Truscott, A Gunn, FR Nordmeyer and GD Watt, *Biochemistry*, **38**, 14279–85 (1999).

84 HC Angove, SJ Yoo, BK Burgess and E Munck, *J Am Chem Soc*, **119**, 8730–31 (1997).

85 KA Renner and JB Howard, *Biochemistry*, **35**, 5353–58 (1996).

86 MG Duyvis, H Wassink and H Haaker, *FEBS Lett*, **380**, 233–36 (1996).

87 N Schindelin, C Kisker, JL Sehlessman, JB Howard and DC Rees, *Nature*, **387**, 370–76 (1997).

88 FA Tezcan, JT Kaiser, D Mustafi, MY Walton, JB Howard and DC Rees, *Science*, **309**, 1377–80 (2005).

89 B Schmid, O Einsle, HJ Chiu, A Willing, M Yoshida, JB Howard and DC Rees, *Biochemistry*, **41**, 15557–65 (2002).

90 AH Willing, MM Georgiadis, DC Rees and JB Howard, *J Biol Chem*, **264**, 8499–503 (1989).

91 A Willing and JB Howard, *J Biol Chem*, **265**, 6596–99 (1990).

92 A Wittinghofer and P Gierschik, *Biol Chem*, **381**, 355 (2000).

93 IR Vetter and A Wittinghofer, *Science*, **294**, 1299–304 (2001).

94 RV Hageman and RH Burris, *Biochemistry*, **17**, 4117–24 (1978).

95 RV Hageman and RH Burris, *Proc Natl Acad Sci USA*, **75**, 2699–702 (1978).

96 P Kraulis, *J Appl Crystallogr*, **24**, 946–50 (1991).

97 RM Esnouf, *J Mol Graph*, **15**, 132–34 (1997).

98 EA Merritt and DJ Bacon, *Methods Enzymol*, **277**, 505–24 (1997).

99 WL DeLano, *The PyMOL Molecular Graphic System*, DeLano Scientific, San Carlos, CA (2002).

Xanthine oxidoreductase

Takeshi Nishino[†] and Emil F Pai[‡,§]

[†]Department of Biochemistry and Molecular Biology, Nippon Medical School, Tokyo, Japan
[‡]Departments of Biochemistry, Medical Biophysics, and Molecular Genetics, University of Toronto, Toronto, Ontario, Canada
[§]Division of Cancer Genomics & Proteomics, Ontario Cancer Institute, Princess Margaret Hospital, Toronto, Ontario, Canada

FUNCTIONAL CLASS

Enzyme – purine (hypoxanthine/xanthine/pterin) : nicotin-amide adenine dinucleotide (NAD)[+] oxidoreductase; EC 1.17.1.4 (xanthine dehydrogenase (XDH)) or purine (hypoxanthine/xanthine/pterin) : oxygen oxidoreductase; EC 1.17.3.2 (xanthine oxidase (XO)) – contains a molybdenum–pterin cofactor and two Fe_2S_2 clusters plus flavin adenine dinucleotide (FAD).

Xanthine oxidoreductase (XOR) catalyzes the hydroxylation of a wide variety of purine, pyrimidine, pteridine, and aldehyde substrates.[1,2] In mammals and birds, the physiologically relevant catalyzed reactions are the oxidation of hypoxanthine to xanthine and of xanthine to uric acid. In mammals, with the exception of primates,[3] uric acid is further oxidized to allantoin for secretion in the urine. XDH transfers electrons from the reducing substrate via a pterin-liganded Mo center, two iron–sulfur centers, and FAD to the oxidizing substrate NAD[+] whereas oxygen acts as the final electron-accepting substrate in XO.[4,5] In addition, many dyes such as methylene blue, 2,6-dichlorophenol indophenol, triphenyl tetrazolium chloride, and phenazine methosulfate can act as acceptors of electrons via various redox sites.[6–8]

OCCURRENCE

XOR activity has been identified in a wide range of organisms, from bacteria and fungi to plants, birds, and mammals;[1,9] at the cellular level, the enzyme is located in the cytoplasm[10,11] although there have been reports that the enzymes in pea leaf[12] and in the parenchymal cells of liver associate with peroxisomes.[13] In mammals, XOR can be detected in endothelial cells and is also found in large amounts in the liver, small intestine, and milk lipid globules.[14]

BIOLOGICAL FUNCTION AND MEDICAL IMPORTANCE

Milk XO, first described as aldehyde oxidase in 1902 by Schardinger,[15] became a benchmark enzyme for the whole

3D Structure 1 Schematic representation of the dimer structure of XDH showing the two monomers related by a twofold rotation plus the cofactors, Mo–pterin, two Fe_2S_2 clusters, and FAD. PDB code: 1FO4. Prepared with the program PyMOL.[81]

class of complex flavoproteins.[16] Historically, XDH and XO have been studied as distinct enzymes.[1] The enzyme was isolated as the XO form from mammalian sources such as cow's milk,[15] while it was always purified in its XDH form from other organisms such as chicken[17] or insects.[18] It is becoming clear, however, that mammalian XORs, as synthesized on the ribosome, are in the XDH form. In some cases, XDH can be subsequently converted to the XO form, either irreversibly by proteolysis or reversibly by oxidation of cysteine residues to disulfide bridges.[19–23] As the XO form produces reactive oxygen species such as superoxide and hydrogen peroxide, the enzyme has been postulated to play a role in the pathology of postischemic reperfusion injury.[24–27] In fruit flies and silkworm larvae, XDH is synthesized in fat bodies or Malpighian tubules.[28] In Drosophila, the enzyme itself is then transported to the eye where it is part of the biosynthetic pathway of the eye pigment drosopterin.[28] In the silkworm larvae, it is the product uric acid that is transported to and accumulated in the hypodermis, giving the larval skin an opaque white appearance.[29] The important physiological role of mammalian XOR in milk secretion has been demonstrated by gene knockout experiments.[30] In humans, the enzyme is the target of therapeutic drugs against hyperuricemia or gout.[31,32]

AMINO ACID SEQUENCE INFORMATION

All amino acid sequences listed below have been annotated as XOR and deposited in the NCBI Entrez Protein Database. Their respective accession codes are given immediately following the source. The microbial sequences are only examples of the large and fast-growing number of such sequences in the database.

- *Homo sapiens* (man), NP_000370, 1333 amino acid (AA) residues, translation of cDNA sequence[33]
- *Pan troglodytes* (chimpanzee), XP_525729, 1333 AA, genome sequence[34]
- *Bos taurus* (cow), NP_776397, 1332 AA, translation of cDNA sequence[35]
- *Syncerus caffer* (African buffalo), AAD17937, 1328 AA, translation of cDNA sequence[36]
- *Tragelaphus oryx* (eland), AAD17938, 1332 AA, translation of cDNA sequence[37]
- *Equus caballus* (horse), XP_001501608, 1333 AA, genome sequence[38]
- *Capra hircus* (goat), ABL96618, 1333 AA, translation of cDNA sequence[39]
- *Canis lupus familiaris* (dog), XP_540143, 1333 AA, genome sequence[40]
- *Felis silvestris catus* (cat), NP_001009217, 1333 AA, translation of cDNA sequence[41]
- *Rattus norvegicus* (rat), NP_058850, 1331 AA, translation of cDNA sequence[42]
- *Mus musculus* (mouse), NP_035853, 1335 AA, translation of cDNA sequence[43]
- *Monodelphis domestica* (gray short-tailed opossum), XP_001380730, 1356 AA, genome sequence[44]
- *Ornithorhynchus anatinus* (duck-billed platypus), XP_001509432, 1297 AA, genome sequence[45]
- *Gallus gallus* (chicken), NP_990458, 1358 AA, translation of cDNA sequence[46]
- *Danio rerio* (zebrafish), CAK04749, 1241 AA, genome sequence[47]
- *Poecilia reticulate* (guppy), AAK59699, 1331 AA, translation of cDNA[48]
- *Strongylocentrotus purpuratus* (purple sea urchin), XP_001193570, 1243 AA, genome sequence[49]
- *Bombyx mori* (domestic silkworm), NP_001037325, 1356 AA, translation of cDNA sequence[50]
- *Apis mellifera* (honey bee), XP_001119950, 1356 AA, genome sequence[51]
- *Nasonia vitripennis* (jewel wasp), XP_001606866, 1359 AA, genome sequence[52]
- *Drosophila melanogaster* (fruit fly), P10351, 1335 AA, translation of cDNA sequence[53,54]
- *Ceratitis capitata* (Mediterranean fruit fly), AAG47345, 1347 AA, translation of cDNA sequence[55]
- *Calliphora vicina* (blowfly), P08793, 1353 AA, translation of cDNA sequence[56]
- *Anopheles gambiae* (African malaria mosquito), AAO14865, 1325 AA, genome sequence[57]
- *Aedes aegypti* (yellow fever mosquito), XP_001662131, 1348 AA, genome sequence[58]
- *Lutzomyia longipalpis* (sand fly), CAP08999, 1331 AA, translation of cDNA sequence[59]
- *Tribolium castaneum* (red flour beetle), XP_968229, 1363 AA, genome sequence[60]
- *Neurospora crassa* (bread mold), EAA27223, 1375 AA, genome sequence[61]
- *Dictyostelium discoideum* (slime mold), XP_635420, 1358 AA, translation of cDNA sequence[62]
- *Aspergillus nidulans* (filamentous fungus), CAA58034, 1363 AA, translation of cDNA sequence[63]
- *Neosartorya fischeri* (thermotolerant soil fungus), XP_001261698, 1404 AA, genome sequence[64]
- *Ajellomyces capsulatus* (mycoplasma-spiro-plasma), EDN09700, 1386 AA, genome sequence[65]
- *Arabidopsis thaliana* (thale cress), CAB80207, 1364 AA, genome sequence[66]
- *Trichomonas vaginalis* (flagellated protozoan), EAY13869, 1374 AA, genome sequence[67]
- *Myxococcus xanthus* (δ proteobacterium), ABF87994, 1273 AA, genome sequence[68]
- *Rhodobacter capsulatus* (phototrophic purple bacterium), CAA04469, Chain A 462 AA; CAA04470, Chain B 777 AA, translation of gene sequence[69]
- *Delftia* (formerly *Comamonas*) *acidovorans*, AAL92571, Chain A 536 AA; AAL92572, Chain B 808 AA, translation of gene sequence[70]

Figure 1 Representation of the three binding domains of bovine XDH. The color scheme is the same as in 3D Structure. (a) Schematic representation of the amino acid sequence. The numbers refer to the residues that form the beginning and end of the domains. Labeled cysteine residues are involved in the oxidative conversion to the XO form; (b) Fe/S cluster binding domain; (c) the FAD binding domain, which also harbors the NAD(H) binding site; (d) the Mo–pterin binding domain, which includes the binding site of purine substrates. Parts a, b, and c prepared with the program PyMOL.[81]

PROTEIN PRODUCTION, PURIFICATION, AND MOLECULAR CHARACTERIZATION

The most popular source of XOR is bovine milk. After the cream has been collected, it is separated into fat and aqueous components. The solution is treated with porcine pancreatin and contaminants are removed by $CaCl_2$ precipitation, followed by ammonium sulfate fractionation.[71] To obtain fully active enzyme, however, two runs on a folate affinity column have to be added. While the first of these contributes to the removal of impurities, the second is performed with the enzyme preincubated with allopurinol, which reacts only with the active sulfide form of the Mo center preventing folate from binding. This step selects for fully active Mo centers. Gel chromatography provides the final purification step.[72] To purify the XDH form, pancreatin treatment is replaced by incubation with lipase, followed by ammonium sulfate fractionation and the folate chromatography described above.[73]

Recombinant expression of a partially active form of the *Delftia acidovorans* XDH has been reported in *Escherichia coli*;[74] a fully active enzyme could be produced in *Pseudomonas aeruginosa*.[56] *E. coli* could also be engineered to synthesize relatively large amounts of the *R. capsulatus* enzyme.[75] *D. melanogaster* XDH is expressed not only in *D. melanogaster* itself[76] but also in *A. nidulans*.[77] Rat[78] and bovine[79] enzymes were obtained as mixtures of active, demolybdo and desulfo forms in the baculovirus/Sf9 insect cell system. Recently, Yamaguchi *et al.* described their success in producing functional human XDH in *E. coli* cells.[80]

In solution, eukaryotic XDH exists as a homodimer of $M_r \approx 290\,000$.[1] In the XO form generated by proteolysis of mammalian XOR, the two pieces of polypeptide chain of each subunit stay together tightly; they can be dissociated into the fragments in the presence of denaturants such as sodium dodecyl sulfate (SDS) or guanidine-HCl.[42] Prolonged incubation of chicken XDH with proteases leads to the separation of the FAD domain from the complex of the Mo and Fe binding domains (see Figure 1).[46]

While most XORs have similar molecular weights, subunit composition, and cofactor requirements, the enzymes from bacterial sources display a much larger variability. *D. acidovorans*[82] and *R. capsulatus* B10S[69] contain XORs composed of two smaller and two larger subunits; *Pseudomonas* species seem to represent the most diverse group with $\alpha_4\beta_4$ and homotrimeric arrangements reported, too.[83–86] For the enzymes from *Veillonella atypica*,[87] *Eubacterium barkeri*,[88] and *Clostridium purinolyticum*,[89] $(\alpha\beta\gamma)_2$ and $(\alpha\beta\gamma)_4$ structures have been described. Interestingly, some probacteria seem to combine all subunits in a single chain.[68]

METAL CONTENT AND COFACTORS

Each catalytically competent unit of XORs from most sources, in both its XDH and XO form, contains a molybdenum–pterin complex (see Figure 2), two Fe_2S_2 centers, and one FAD cofactor.[1] In contrast to all other analyzed XORs, which employ the mononucleotide Mo–pterin, a rather unusual trait for bacterial enzymes, the *E. barkeri* protein binds the dinucleotide form of the Mo

Figure 2 Mo–pterin cofactor in its oxidized form. The double-bonded oxygen ligand assumes the apical position.

cofactor.[88] Selenium has been reported as being essential for the catalytic activity of a clostridial and a eubacterial enzyme;[88,89] the latter also contains tungsten.[88]

ACTIVITY ASSAY

XDH and XO activities are measured in a manner similar to that described by Avis *et al.*[90] At 25 °C, 50 mM potassium phosphate buffer, pH 7.8, in a final volume of 1 ml contains 0.4 mM ethylenediaminetetraacetic acid (EDTA) and 0.15 mM xanthine. When determining dehydrogenase activity, NAD^+ is added to the mixture to 500 mM and the change in absorption at 340 nm is recorded; when measuring oxidase activity, the buffer is saturated with air and the conversion of xanthine to uric acid is monitored at 295 nm. Enzyme concentrations are determined from the absorbance at 450 nm using an extinction coefficient of 35.8 mM^{-1} cm^{-1} for rat XOR[91] and 37.8 mM^{-1} cm^{-1} for bovine milk XO.[90] The activity-to-flavin ratio (AFR), a measure of purity and catalytic competence of XOR,[1] is obtained by dividing the absorbance change/minute at 295 nm by the absorbance at 450 nm of the enzyme at 25 °C. For fully active bovine XOR, the AFR value is ca. 200.[92–94]

SPECTROSCOPY

While the Mo cofactor adds a broad but minor absorbance to the UV/visible spectra of XOR, the main contributions are made by the flavin cofactor and the two iron–sulfur centers. Slight differences are observed among XORs from various sources; they are probably due to differences in the protein environments around the flavin cofactors because spectra of the de-flavo forms of chicken and bovine milk enzymes are essentially the same.

Although preliminary experiments have been performed using Mössbauer[95] and circular dichroism[96] spectroscopy, the majority of spectroscopic characterization has been done with the help of electron paramagnetic resonance (EPR). The Mo ion in its +V oxidation state gives rise to the so-called rapid EPR signal, while the 'slow' signal is attributed to the inactive desulfo form. The 'rapid' signal has been further divided into 'type 1' and

'type 2' categories depending on the nature of the proton hyperfine splitting.[97,98] Although the two [Fe$_2$–S$_2$] clusters are indistinguishable in terms of their visible absorption spectra, they display quite distinct EPR spectra. On the basis of their spectroscopic character, the two centers are named Fe/S-I and Fe/S-II. The midpoint redox potential of the Fe/S-II center is more positive than that of the Fe/S-I center. It should be noted that these EPR signals are commonly observed in XORs and in related mononuclear Mo-containing hydroxylases with two iron–sulfur centers. The Fe/S-I center exhibits a rhombic EPR signal ($g = 2.02$, 1.93, and 1.90 ± 0.01), which is similar to those observed in regular plant-type [Fe$_2$–S$_2$] ferredoxins and can be observed at temperatures up to 40 K. On the other hand, the Fe/S-II center exhibits an unusually broad EPR signal ($g = 2.10 \pm 0.02$, 1.98 ± 0.015, and 1.91 ± 0.01) that can be only recorded below 22 K.[6] Sequence comparisons of XOR proteins show eight strictly conserved cysteine residues, assembled in two motives, both contained in the N-terminal 20 kD domain. Their arrangement reflects their spectroscopic features with the first motif, the one closest to the N-terminus, adopting the structural fold of regular plant-type ferredoxins, while the more C-terminally located one is unique to the two iron center Mo-containing hydroxylase family. Site-directed mutagenesis assigned the N-terminal motif to Fe/S-II and the C-terminal one to Fe/S-I.[99]

A magnetic circular dichroism study of the Mo(V) species, which is formed when a substrate is covalently bound to the Mo complex at high pH, addressed the location of its oxygen and sulfur ligands, placing the double-bonded oxygen in the apical and the Mo=S group in an equatorial position.[100] Near-edge X-ray absorption spectroscopy then identified the remaining Mo ligand as an OH group.[101] Raman spectroscopy showed that the double-bonded oxygen is not exchangeable during turnover.[102]

X-RAY STRUCTURES OF XANTHINE OXIDOREDUCTASES

Crystallization

The first small crystals of bovine XO were reported in 1954[103]; however, almost half a century passed before diffraction-quality crystals were obtained. Both XDH and XO crystallized in buffer with close to neutral pH that contained 5 mM dithiothreitol (DTT), 1 mM sodium salicylate, 0.2 mM EDTA, and 20–30% glycerol to stabilize the enzyme against oxidation and degradation. Polyethylene glycol (PEG) 4000 was used as precipitant.[73] The XO crystals belonged to space group C222$_1$ with unit cell parameters $a = 116.3$ Å, $b = 164.4$ Å, and $c = 152.2$ Å, whereas XDH crystals grew in space group C2 with $a = 169.9$ Å, $b = 124.8$ Å, $c = 148.6$ Å, and $\beta = 90.9°$. Various complexes of bovine XDH with covalent[104,105]

and noncovalent[106,107] inhibitors crystallized under very similar conditions and in the same space group. More recently, however, crystals of bovine XO in space group $P2_1$ with $a = 133.2$ Å, $b = 73.8$ Å, $c = 146.5$ Å, and $\beta = 98.9°$ have also been described.[108]

For the rat enzyme, crystals have been reported for a double (W335A/F336L)[109] and a triple (C535A/C992R/C1324S) mutant.[110] Although both proteins could be crystallized under very similar conditions at pH 6.2, ca. 10% PEG 8000, 0.6 M LiSO$_4$, DTT, salicylate, and EDTA, they displayed different crystallographic characteristics: the parameters for the former mutant were $P2_12_12_1$, $a = 101.1$ Å, $b = 139.5$ Å, and $c = 223.3$ Å while the latter assumed space group $I4_122$ with unit cell axes $a = b = 134.3$ Å and $c = 523.3$ Å.

The human enzyme could be induced to form crystals of limited resolution when exposed to 0.1 M sodium acetate/0.25 M ammonium acetate buffer, pH 6.0 containing 26% PEG 4000, 10 mM DTT, and 10% (w/v) glucose. They adopted space group $P3_121$ with $a = b = 197.7$ Å and $c = 285.5$ Å.[111] The E803V mutant of human XDH was also crystallized.[80]

The only prokaryotic XOR whose crystallization has been described is the protein from *R. capsulatus* in its native and alloxanthine-inhibited form.[112] Both crystals could be grown under identical conditions: 0.1 M Tris, pH 8.0, 8% PEG 8000, 7.5 mM BaCl$_2$, 25 mM DTT, and 3% isopropanol and they both assumed space group P1. The unit cell parameters for the native enzyme were $a = 92.9$ Å, $b = 141.1$ Å, $c = 158.1$ Å, $\alpha = 109.5°$, $\beta = 105.8°$, and $\gamma = 101.3°$.

Researchers have taken full advantage of the various crystals described above and elucidated the following crystal structures, which have been deposited in the RCSB Protein Data Bank (PDB):

- *Bos taurus* (cow), XDH form, PDB-ID: 1FO4[113]; XO form, PDB-IDs: 1FIQ[113] and 3B9J[108]

 XDH in complex with the xanthine-competitive inhibitor Febuxostat[R], 1N5X[106]

 XDH in complex with the xanthine-competitive inhibitor Y-700, 1VDV[107]

 XDH in complex with the covalent inhibitor FYX-051, 1V97[104]

 XO in complex with the slow substrate 2-hydroxy-6-methylpurine, 3B9J[108]

- *Homo sapiens* (man), XDH, 2CKJ[111]
 E803V mutant form of XDH, 2E1Q[80]

- *Rattus norvegicus* (rat), W335A/F336L double mutant of XO form (demolybdo enzyme), 2E3T[109]
 C535A/C992R/C1324S triple mutant of XDH form (demolybdo enzyme), 1WYG[110]

- *Rhodobacter capsulatus* (phototrophic purple bacterium), apo enzyme 1JRO, alloxanthine-inhibited form 1JRP.[112]

Figure 3 Folding diagrams of the six subdomains of XDH as defined by the SCOP (Structural Classification of Proteins) database.[114] Subdomains 1 ((a), a.a. 3–92) and 2 ((b), a.a. 93–165) form the Fe/S binding domain, subdomains 3 ((c), a.a. 192–414) and 4 ((d), a.a. 415–528) generate the FAD binding domain, and subdomains 5 ((e), a.a. 537–694) and 6 ((f), a.a. 695–1332) together represent the large Mo–pt binding domain. All six subdomains are contained in the single chain monomers of the dimeric enzymes of higher animals[94] In contrast, the bacterial enzyme from *R. capsulatus* assembles into an $\alpha_2\beta_2$ heterotetramer with the smaller subunit generated by subdomains 1–4 and the larger one consisting of subdomains 5 and 6.[69,112] Figure based on the output of the web program TOPS.[115]

Overall structure

In all mammalian XOR crystals published so far, the protein subunits are arranged in dimers, the oligomeric state they also assume in solution. The dimers display a distinct butterfly shape with the interface formed between the narrower sides of the elongated subunits.[113] The crystal structure of bovine XOR is used as a guide for discussion; its fold is shown in the 3D Structure and in a more schematic representation in Figure 3. Numbering of amino acid residues will be according to the bovine sequence unless stated otherwise. The dimensions of the whole enzyme molecule are 155 Å × 90 Å × 70 Å; single subunits are 100 Å × 90 Å × 70 Å. No atom of any cofactor bound to one subunit approaches a cofactor atom in the second subunit closer than 50 Å; this allows electron

flow only within subunits. Each monomer can be divided into three subdomains. The small N-terminal domain (amino acids 1–165) contains both iron–sulfur cofactors and is connected to the second, FAD binding domain (a.a. 226–531) by a long segment consisting of residues 166–225. For the first part of this linker region (a.a. 166–191), no electron density could be observed in the corresponding map. The FAD domain is connected to the third domain by another extended segment (a.a. 532–589), which is also partially disordered; residues 532–536 could not be seen in the crystal structure. The large third domain (a.a. 590–1332) sequesters the Mo–pterin cofactor (Mo–pt) close to the interfaces of the Fe/S- and FAD binding domains. The C-terminal residues 1310–1331 are disordered in some crystal structures but visible in others.

The SCOP database[114] subdivides bovine XDH into six subdomains, with three consecutive pairs constituting the Fe/S-, FAD-, and Mo–pt binding domains defined in Figure 1. The N-terminal subdomain (a.a. 3–92) folds as a ubiquitin-like β-Grasp and belongs to the 2Fe–2S-ferredoxin-like superfamily. The next one (a.a. 93–165), a 4-helix bundle, represents the only all α-helical domain whereas the other five subdomains all belong to the α + β classes of proteins. The fold of subdomain 2 is classified as CO dehydrogenase ISP C-domain-like. Subdomain 3 (a.a. 192–414) assumes a general FAD binding fold and is matched with a sandwich (a.a. 415–528) special to flavin-containing Mo–pterin proteins and named after the CO dehydrogenase flavoprotein C-terminal domain. Amino acids 537–694 form an α/β hammerhead fold and together with subdomain 6 (a.a. 695–1332), a member of the Mo cofactor binding domain family, complete the complex arrangement.

Despite the enzyme's heterotetrameric nature, the crystal structure of *R. capsulatus* XDH, the only bacterial structure determined, proved to be similar enough to its mammalian counterpart that it could be solved by molecular replacement techniques.[112] The smaller α-subunit contains the Fe/S domain (a.a. A1–153), which is connected to the FAD domain (a.a. A185–462) by a 31 amino acid peptide linker. The β-subunit comprises the molybdenum cofactor domain (a.a. B1–777). Although the polypeptide composition is different in mammalian and bacterial enzymes, the spatial arrangement of the four redox centers is very similar in all XORs (see Figure 4).

For several mammalian XORs, reversible and irreversible transitions between the XDH and XO forms have been described.[5] The global folds of XDH and XO, however, remain very similar and no significant changes at or around the two Fe/S centers and the Mo–pt center are observed. The rms deviation in C_α positions between the combined Fe/S domains and Mo–pt domains of XDH and XO of bovine XOR is only 0.34 Å for 889 corresponding atoms. In contrast, the polypeptide loop composed of the residues between Gln423 and Lys433 in the FAD domain (loop A) undergoes a dramatic conformational change upon the

Figure 4 Three-dimensional arrangement of the four cofactors bound to XORs. The electrons are transferred from the 'bottom' (Mo–pt) to the 'top' (FAD). It is based on PDB-ID 1FO4 and prepared with the program PyMOL.[81]

XDH to XO transition, drastically changing the chemical environment of the flavin ring.[113] Other differences between XDH and XO include the location of the C-terminal peptide, which can insert close to the FAD active site or be mobile in solution,[110] as well as changes in the packing arrangement of a unique amino acid cluster connecting loop A with the chain linking the FAD and Mo–pt domains.[79]

The various domains and their cofactors

In the following, we discuss the three major folding domains of mammalian XORs, not in the more conventional N- to C-terminal order but according to the actual progress of the catalytic reaction: first, the C-terminal, Mo–pt-binding domain, followed by the N-terminal Fe/S-cluster-containing domain, and finally the FAD-binding domain, which is located in the middle of the sequence.

The molybdopterin domain

A relatively narrow channel leads from the surface of XOR to the rather large Mo–pt active site, buried in the protein's interior, where hypoxanthine, xanthine, and related substrates are oxidized.[5,6] When the crystal structures of the bovine enzyme in both its XDH and XO forms, and later that of the bacterial enzyme from *R. capsulatus*, were reported the resolution of the analyses was not high enough to allow an unequivocal assignment of all the ligands of the Mo ion.[112,113] On the basis of spectroscopic and mechanistic evidence, these had previously been postulated to consist of two thiolene sulfurs (−S−) from the pteridine moiety, one sulfo (=S), one oxo (=O), and one hydroxo (OH) group or water.[1,116,117]

Owing to the lack of independent information, the Mo ligands were originally placed in analogy to the Mo center geometry reported for *Desulfovibrio gigas* aldehyde oxidase.[118,119]

When improved methods allowed the preparation of fully active bovine XDH in its reduced state, incubation of this sulfo form with the heterocyclic slow substrate 4-[5-pyridin-4-yl-1H-[1,2,4]triazol-3-yl]pyridine-2-carbonitrile (FYX-051) resulted in a covalent complex that produced crystals, which provided much better diffraction data. The resulting electron density map clearly showed that the Mo=S group found in oxidized enzyme was protonated to Mo—SH upon reduction of the Mo center and that this sulfur, too, occupied an equatorial position in the square-pyramidal metal coordination sphere, not the apical position it was originally assigned and which was taken by a double-bonded oxygen atom instead.[104] The singly bound oxygen, which is resupplied to the Mo center from solvent water and also located in the equatorial plane, had formed a bond with a carbon atom of the substrate (see Figure 5). This assignment also completely supported the results of magnetic circular dichroism[100] and X-ray absorption spectroscopy, including the refined values of the bond lengths.[101,116] Further corroboration (Table 1) comes from a crystal structure at 1.7 Å resolution.[120]

Further structural analyses addressed bovine XOR in complex with salicylate,[113] 2-(3-cyano-4-isobutoxyphenyl)-4-methyl-5-thiazolecarboxylic acid (TEI-6720),[106] and 1-[3-cyano-4-(2,2-dimethylpropoxy)phenyl]-1H-pyrazole-4-carboxylic acid (Y-700).[107] The latter two compounds are tight binding inhibitors, similar to the suicide inhibitor FYX-051 but interact noncovalently.

Table 1 Distances between the Mo ion of the Mo–pterin cofactor and its ligands as measured from a highly refined 1.7 Å electron density map of the oxidized form of bovine XDH.[120] Atom positions were unrestrained during refinement; values are the average of the two subunits in the asymmetric unit

Equatorial ligands		Apical ligand	
Mo—S1 of pterin	2.37 Å	Mo=O	1.69 Å
Mo—S2 of pterin	2.38 Å		
Mo=S	2.12 Å		
Mo—OH	2.00 Å		

When salicylate is bound to the oxidized form of bovine XDH, both carboxylate atoms of the inhibitor interact with the guanidinium group of Arg880 and also bind to the hydroxyl side chain of Thr1010 and via a water molecule to the carboxylate of Glu1261. This glutamic acid–water pair is near the Mo ion, and mutation of the residue results in complete loss of enzymic activity.[80,121] The aromatic ring of the inhibitor is aligned parallel to the ring of Phe914 at a distance of 3.5 Å, but the two aromatic rings overlap only slightly.[113] At the same time, the phenyl ring of Phe1009 interacts edge-on with the center of the salicylate ring with a closest approach of 3.7 Å (see Figure 6).

These kinds of interactions are observed in all structures of XDH in complex with aromatic compounds.[104,106,107,113] With the inhibitors TEI-6720 or FYX-051, which contain two and three aromatic rings, respectively, the side chain of Glu802 forms a hydrogen bond with a nitrogen atom of the five-membered ring found in each of the inhibitors, a thiazole in TEI-6720 and a triazole ring in FYX-051,

Figure 5 (a) Electron density corresponding to the Mo–pterin–FYX-051 complex of reduced bovine XDH. The covalent bond between the inhibitor and one of the oxygen ligands of the Mo ion is clearly visible. (b) Detail with bond lengths and the angle enclosed by Mo-bridging oxygen–ring carbon of inhibitor indicated. (c) Schematic of Mo center reduction and covalent attack. The hydroxy ligand of the Mo ion is deprotonated by the catalytic base Glu1261 generating an oxyanion, which in turn undergoes a nucleophilic attack on the closest ring carbon forming a covalent intermediate. The surplus proton is transferred to the double-bonded sulfur generating an —SH ligand.[104] Prepared with the program PyMOL.[81]

Figure 6 Sketch of the Mo–pterin active site of oxidized bovine XDH with a salicylate molecule bound between the two aromatic rings of Phe914 and Phe1009. The two aromatic amino acids engage the ring of the inhibitor in the two energetically most suitable kinds of contacts: stacking (Phe1009) and edge-on to center (Phe914). Arg880 and the two acidic residues Glu802 and 1261 are also shown; they are important in substrate binding and in catalysis.[104] Prepared with the program PyMOL.[81]

whereas Glu1261 binds to the nitrogen atom of the FYX-051 ring approaching the Mo center. In the latter structure, Glu802 is considered to be obligatorily protonated, so it can form hydrogen bonds with two nitrogen atoms.[104,106] Arg880, associated with the carboxylate of the substrate in the salicylate-bound structure, binds to the oxygen atom of the 6-position of oxypurinol (corresponding to the 2-position of the xanthine substrate) in the crystal structure of the oxypurinol-bound form of reduced XDHs from *R. capsulatus*[112] and bovine milk.[105] The mutation of the human enzyme at residues Glu803 (corresponding to Glu802 in the bovine sequence) and Arg880 resulted in significant decreases in the enzymatic activity against purine substrates.[80] The analysis of a natural mutant of *Drosophila* XDH[122] and mutation experiments with *R. capsulatus* XDH[123] confirmed the importance of this arginine residue for xanthine turnover.

The iron/sulfur domain

As pointed out above, the N-terminal domain of XDH consists of two Fe/S cluster binding subdomains. With its two clusters, it serves as a conduit for the flow of electrons from the Mo center to the flavin ring. The clusters are of the Fe_2–S_2 type; each of the two iron atoms is also bound to the $S\gamma$ atoms of two cysteine residues (see Table 2). Folds and structural arrangement are very similar to those found in other members of the XOR family including bacterial XDH,[112] *D. gigas* aldehyde oxidase,[118] and *Oligotropha carboxidovorans* CO dehydrogenase.[124]

The shortest distances between the various cofactors are listed in Table 3. The entry for Mo ion to nearest iron atom in the Fe/S-I cluster at 14.7 Å agrees very

Table 2 Distances between the Fe ions and their ligands in clusters Fe/S-I and Fe/S-II. Distances as measured from a highly refined 1.7 Å electron density map of the oxidized form of bovine XDH.[120] Positions of iron and inorganic sulfur atoms were unrestrained during refinement; values are the average of the two subunits in the asymmetric unit

Cluster Fe/S-I		Cluster Fe/S-II	
Cys113–Fe1	2.31 Å	Cys43–Fe1	2.38 Å
Cys150–Fe1	2.41 Å	Cys48–Fe1	2.30 Å
Cys116–Fe2	2.23 Å	Cys51–Fe2	2.29 Å
Cys148–Fe2	2.37 Å	Cys73–Fe2	2.33 Å
S1–Fe1	2.26 Å	S1–Fe1	2.20 Å
S2–Fe1	2.25 Å	S2–Fe1	2.23 Å
S1–Fe2	2.23 Å	S1–Fe2	2.25 Å
S2–Fe2	2.23 Å	S2–Fe2	2.31 Å

Table 3 Shortest distances between atoms of the various cofactors in oxidized bovine XDH

Mo–Fe/S-I	14.7 Å
Fe/S-I–Fe/S-II	12.4 Å
Fe/S-II–7a-methyl of flavin	7.8 Å

well with the estimate of 14 Å based on the measurement of the dipolar interaction between the two paramagnetic centers.[125] In terms of their visible absorption spectra, the two clusters are indistinguishable but they differ in their respective midpoint redox potentials.[126] When Cys43, one of the ligands of iron atom Fe1 in Fe/S center II, was changed to a serine, both redox potential and spectrum of this cluster changed. The equivalent mutation of Cys51, which binds to iron atom Fe2 in the same cluster, had no measurable effect. The distances between the latter iron and the nearest atoms in the FAD and Fe/S-I cofactors are 8.1 and 14.1 Å, respectively, which are significantly longer than the corresponding values for the Cys43-liganded iron (7.8 and 12.4 Å, respectively). For enzymatic activity, this would suggest the interesting conclusion that only the Cys43-bound iron atom is catalytically competent.[127]

The van der Waals contact between the 2-amino substituent of the pterin Mo ligand and $S\gamma$ of Cys150 is the only potential 'through bond' path; no other bond-mediated interactions are obvious. The distances between the centers, however, are certainly suitable to support an 'electron tunneling' mechanism.[128]

The FAD domain

The three-dimensional fold of the FAD domain (Figure 3) makes it a member of the so-called PCMH family of flavoproteins[129] named after the enzyme p-cresol methylhydroxylase;[130] other related proteins include the UDP-N-acetylenolpyruvyl-glucosamine reductase MurB and vanillyl-alcohol oxidase.[131] FAD binds in an extended

conformation in a deep cleft, and the *si* face of its isoalloxazine ring is easily accessible to solvent. This space also provides the opportunity for the nicotinamide ring of the NAD substrate to approach and align itself in a parallel fashion to the flavin ring. In contrast to the open access available to the *si* side of the isoalloxazine, the *re* side of the flavin cofactor is tightly covered by protein residues. One of these amino acids, Phe337 in the bovine milk enzyme, is completely conserved in all known XOR sequences; its side chain engages in a π–π stacking interaction with the pyrimidine part of the isoalloxazine ring. The phenylalanine, however, is mutated to nonaromatic residues in several oxidases, e.g. to a leucine in bovine aldehyde oxidase. This phenyl–isoalloxazine pair could potentially play a role in the determination of the cofactor's redox potential and contribute to the relative preference of dehydrogenase versus oxidase catalysis displayed by the various enzymes.

Structural changes during the transition from XDH to XO

All animal XORs are synthesized as the XDH form but, with the exception of avian enzymes, can be converted to their XO form, either reversibly by formation/reduction of disulfide bridges between cysteine residues[21,110] or irreversibly by proteolysis.[6,20] Bacterial XORs are also resistant to such a conversion.

As crystal structures of both the XDH and XO forms have been determined, one can identify how these functional changes are reflected in the underlying three-dimensional structures.[113] The long linker peptide connecting the FAD and Mo–pt domains contains not only the prevalent proteolytic cleavage site but also one of the cysteine residues involved in the XDH–XO transition. One can, therefore, safely assume that major changes in the arrangement of amino acids in this stretch of peptide chain can act as a trigger for the transformation. A rather unique cluster formed by the four residues Arg335, Trp336, Arg427, and Phe549 (bovine milk enzyme) and held together mostly via π-cation interactions seems to be at the center of a relay system.[79] Tight interactions between the amino acid residues of the cluster seem to be crucial for the stabilization of the XDH form of the enzyme. Proteolysis, leading to drastically increased mobility of the linker peptide, or disulfide formation, causing conformational strain, breaks Phe549 out of this tight arrangement. Mutating Trp336 creates an equivalent effect.[109] During these conformational transitions, the cluster acts not only as a transmitter of modification on the linker peptide but also as a solvent gate.[79]

The dissolution of the cluster is transmitted to loop A (Gln423–Lys433), which closely approaches the *si* side of the FAD cofactor. In fact, the largest difference between the crystal structures of bovine XDH and XO is the change in the location of loop A (Figure 7).[113] In XDH, the side chain of Asp429, at a distance of 3.6 Å, is very close to atom C_6 of the flavin ring and, with no charge compensation nearby, the major contributor to negative charge at the flavin site. When loop A assumes its XO position, this residue moves away from FAD and is replaced by the guanidinium group of Arg426 as the flavin ring's nearest neighbor; the distances between the closest atoms is now 6.3 Å. This reversal of the electrostatic potential surrounding the redox-active part of the FAD cofactor has been suggested to modulate the latter's reactivity. Equivalent changes were observed when the crystal structures of two mutants of the rat

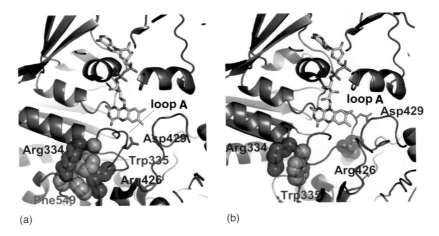

(a) (b)

Figure 7 The environment of the FAD active site of rat XOR. Although the overall structure does not change at all, there are distinct differences between the XDH and XO forms of the enzyme. (a) In the XDH form, the tight cluster of residues Arg334, Trp335, Arg426, and Phe549 is undisturbed. Any disruption, either by proteolysis, mutation, or strain caused by disulfide formation between cysteines, triggers a large movement of loop A. (b) In the XO form, the tight cluster has been destroyed; the loop A residues Arg426 and Asp429 are now at very different locations, thereby drastically changing the electrostatic environment of the flavin ring. Prepared with the program PyMOL.[81]

enzyme were compared. The triple C535A/C992R/C1324S mutant is stably locked in the XDH form,[110] while the double W335A/F336L mutant is locked in its XO form.[109] Consequently, in the former the carboxyl carbon of Asp428 (corresponds to Asp429 in the bovine enzyme) is located 4.2 Å away from the C_6 carbon of FAD and is replaced by the guanidinium group of Arg425 (Arg426 in the bovine enzyme) in the latter. While drastic conformational changes are happening at the *si* side of the isoalloxazine ring, the only difference that can be observed at the *re* side is a rather minor shift in the position of Phe337.

The dislocation of loop A not only influences the electrostatics in the potential NAD binding site but also blocks the approach of NAD molecules to the FAD cofactor preventing the reduction of NAD^+ in the XO form.[113] In addition, the C-terminal peptide also seems to play an indirect role in the creation or at least stabilization of the NAD binding pocket. This peptide is inserted into the FAD domain pointing in the direction of the NAD binding pocket and makes contact with the loop Leu494–Met504 that seems to be important for binding the NAD cofactor. In the crystals of rat XDH, the N-terminal tail re-inserts into the FAD domain of its own polypeptide chain,[109] whereas in bovine XDH crystals, it extends outward interacting in an equivalent manner with a neighboring molecule in the crystal lattice. In the case of bovine XO, no corresponding density can be observed at all, that is, the peptide is highly mobile.[113] As a consequence, the potential NAD^+ binding site is not properly formed preventing the passing of reducing equivalents to the dinucleotide and diverting them to oxygen instead.

FUNCTIONAL ASPECTS

Redox potential of cofactors

The redox potentials of the various redox-active centers of XOR are shown in Table 4. Those of the Fe/S-I and Fe/S-II clusters of mammalian XORs at physiological temperature are reported as ca. −235 and −310 mV, respectively. Potentials measured for the Mo cofactor are lower and close to that of the xanthine/urate couple (−360 mV at pH 7.0).

The geometrical arrangements and redox potentials of the centers (Table 4) indicate that electrons are transferred from Mo to the two Fe/S centers in a thermodynamically favorable process. However, the redox potential of the FAD/FADH· couple is −270 mV, whereas that of FADH·/FADH$_2$ is as low as −410 mV in milk XDH[126] and −377 mV in chicken XDH.[132] The corresponding values for XO are approximately −320 and −235 mV, respectively. Thus, the flavin semiquinone is thermodynamically much more stable in XDH than in XO. This is consistent with experiments that found relatively large amounts of the flavin semiquinone during reductive titration as well as during xanthine–oxygen turnover in XDHs.[133–136]

REACTION MECHANISM

Mo-dependent hydroxylation

In the oxidized form of XORs, the Mo ion is in the +VI oxidation state, surrounded by an oxo- (=O), one hydroxo (−OH), and a sulfido (=S) ligand, in addition to the two sulfur ligands contributed by the pterin group.[2] The double-bonded oxygen ligand occupies the apical position in the square-pyramidal metal coordination sphere; the other four lie in the equatorial plane.[100,104] In the course of a single turnover, one of the ligands of the Mo ion, the 'labile oxygen', is transferred to the substrate. The Mo ion's coordination sphere is regenerated through the addition of an oxygen atom derived from the solvent, as shown by experiments in ^{18}O-labeled water[137] and by resonance Raman studies.[102] There is general agreement that it is the Mo−OH ligand rather than the Mo=O ligand that is involved in this process. Maybe not surprisingly, stopped-flow studies indicated that the rate-limiting step of the reductive half-reaction is not the electron transfer from the xanthine substrate to the Mo center but the release of the product urate.[5,136]

The crystal structure of bovine XOR with a trapped intermediate of the hydroxylation of the slow-reacting substrate FYX-051 revealed a covalent bond between the hydroxyl oxygen and a carbon atom of the aromatic substrate.[104] This finding fully supports the mechanistic

Table 4 Midpoint potentials of the redox centers of XO and XDH

	MoVI/MoV (mV)	MoV/MoIV (mV)	Fe/S-I (mV)	Fe/S-II (mV)	FAD/FADH· (mV)	FADH·/FADH$_2$ (mV)
Milk XO[a]	−345	−315	−310	−217	−301	−237
Milk XO[b]	−373	−377	−310	−255	−332	−234
Milk XDH[c]	nd	nd	−310	−235	−270	−410
Chicken XDH[d]	−357	−337	−280	−275	−345	−377

nd: not determined.
[a] In 0.1 M potassium N, N-bis(2-hydroxyethyl)glycine, pH 7.7, at 25 °C.[143]
[b] In 50 mM bicine, 1 mM EDTA, pH 7.7, at 25 °C.[144]
[c] In 0.1 M pyrophosphate, 0.3 mM EDTA, pH 7.5, at 25 °C.[126]
[d] In 50 mM phosphate, pH 7.8, 0.1 mM EDTA at 173 K and 25 K.[132]

proposal that it is Glu1261, located near the Mo—OH in the apo form of the enzyme,[113] that acts as an active-site base initiating the catalytic reaction by abstracting a proton from the Mo—OH group,[104,121] which then undergoes a nucleophilic attack on the substrate's carbon atom to be hydroxylated. The newly protonated Glu1261 is stabilized by hydrogen bond formation with the N-1 nitrogen of the substrate. In addition, upon reduction of the molybdenum center, the Mo=S, which, in its equatorial location, is appropriately positioned for hydride transfer from the reactive carbon atom, is protonated to afford Mo—SH. The mutation of Glu1261 in the human enzyme[80] and of the corresponding Glu730 in *R. capsulatus* XDH resulted in complete loss of hydroxylation activity.[121]

In contrast to Glu1261, the side chain of another glutamic acid residue seems to be intimately involved in the binding, and potentially the hydroxylation catalysis, of heterocyclic substrates. Glu802 forms hydrogen bonds to nitrogen atoms of the competitive inhibitors Y-700[107] and TEI-6720,[106] which both bind in and block the narrow channel leading from the protein's surface to the Mo center. This residue, in its protonated form, also interacts with the slow substrate FYX-051.[104] Changing the corresponding Glu803 to valine in human XDH almost completely abrogated catalytic activity with hypoxanthine as substrate but still allowed some turnover for xanthine.[80]

Arg880 is the third residue that has been assigned a role in the hydroxylation of aromatic substrates at the Mo—pt active site. In several complexes, the guanidinium group interacts with carboxylate groups of the bound inhibitors.[106,107,113] When Arg881 in human XDH was replaced by a methionine, the effects were the reverse of the Glu803 to valine mutation mentioned above: now xanthine hydroxylation was abolished with hypoxanthine still converted, albeit with much reduced efficiency.[80] Mutational and kinetic analyses of Arg310, the equivalent amino acid in *R. capsulatus* XDH, have shown that this residue not only supports the binding of substrates but also contributes to catalysis by stabilizing the negative charge developing in the transition state.[123]

Fe/S clusters: an electron sink

The crystal structures of XDH and XO from bovine milk revealed the location of the two iron centers; placed between the Mo—pt and the flavin ring of FAD, they connect the reductive and oxidative sites.[113] This finding nicely fits with earlier kinetic and thermodynamic studies that had defined the clusters as conduits of reducing equivalents but also pointed out that they should be considered as electron sinks. As such, they serve to remove electrons from Mo—pt to allow further reaction with substrate, whereas in the case of oxidation they regenerate fully reduced flavin for further reaction with NAD^+ or oxygen, respectively, the final electron acceptor substrates. The latter process is thermodynamically controlled by way of the one-electron-reduced or fully reduced FAD state.[138,139]

Enzyme reoxidation at the FAD active site

Both XO and XDH catalyze the reduction of oxygen at their FAD sites. However, only XDH is capable of converting NAD^+ to NADH. It is the ratio between the rates for oxidase and dehydrogenase activity that determines the actual nature of catalysis.[140,141] One-electron transfer from flavin semiquinone to oxygen will generate superoxide anion; in addition, fully reduced FAD is able to engage in two-electron transfer to form H_2O_2.[135,139] Rapid kinetics showed that the flavin semiquinone is thermodynamically much more stable in XDH than in XO. This is due to a major change in the flavin's environment, especially the electrostatics, which is experienced when one form of the enzyme is converted into the other.[113] The rate of the one-electron transfer reaction, however, is slower than that of the two-electron transfer reaction, explaining, in part, the fact that xanthine–oxygen activity is lower in XDH than in XO. Another factor to consider is the reduced ease of oxygen supply to the flavin. In XDH, the cluster of tightly packed amino acids, identified as the core of a relay system governing the structural changes during the XDH/XO transition, also locks the solvent gate that provides improved access to the isoalloxazine ring in the XO form of the enzyme.[79]

A loop near the flavin ring undergoes a major structural rearrangement when XDH is converted to XO.[113] In its XO conformation, it prevents NAD^+ from approaching the flavin cofactor for steric reasons, a simple but convincing explanation of XO's inability to function as a dehydrogenase. These same changes also seem to interfere with the insertion of the C-terminal tail into the FAD domain, which causes smaller conformational shifts necessary to generate the actual pyridine dinucleotide binding site. The complex of NADH and bovine XDH shows the pyrimidine ring of the dinucleotide molecule placed parallel to the flavin ring,[120] in a fashion very similar to the one originally described for glutathione reductase.[142] This interaction also explains how binding of NAD^+ to XDH could shift the redox potential of the FAD/FADH couple, destabilizing the flavin semiquinone and making it thermodynamically more favorable for the flavin to reduce NAD^+.[140]

REFERENCES

1 RC Bray, PD Boyer (ed.), *The Enzymes*, Vol. 12, Academic Press, New York, pp 299–419 (1975).

2 R Hille and V Massey, in TG Spiro (ed.), *Molybdenum Enzymes*, Wiley-Interscience, New York, pp 443–518 (1985).

3 TB Friedman, GE Polanco, J Apold and JE Mayle, *Comp Biochem Physiol*, **81B**, 653–659 (1985).

4 T Nishino, *J Biochem*, **116**, 1–6 (1994).

5 R Hille and T Nishino, *FASEB J*, **9**, 995–1003 (1995).

6 R Hille, *Chem Rev*, **96**, 2757–2816 (1996).

7 H Komai, V Massey and G Palmer, *J Biol Chem*, **244**, 1692–1700 (1969).

8 M Kanda, FO Brady, KV Rajagopalan and P Handler, *J Biol Chem*, **247**, 765–770 (1972).

9 GD Vogels and C van der Drift, *Bacteriol Rev*, **40**, 403–468 (1976).

10 M Ichikawa, T Nishino and A Ichikawa, *J Hist Cytochem*, **40**, 1097–1103 (1992).

11 Y Hattori, *Acta Histochem Cytochem*, **22**, 617–624 (1989).

12 J Nguyen, *Physiol Veg*, **24**, 163–281 (1986).

13 WM Frederiks and H Vreeling-Sindelarova, *Acta Histochem*, **104**, 29–37 (2002).

14 ED Jarasch, C Grund, G Bruder, HW Heid, TW Keenan and WW Franke, *Cell*, **25**, 67–82 (1981).

15 F Schardinger, *Z Untersuch Nahrungs Genussmittel*, **5**, 1113–1121 (1902).

16 V Massey and CM Harris, *Biochem Soc Trans*, **25**, 750–755 (1997).

17 KV Rajagopalan and P Handler, *J Biol Chem*, **242**, 4097–4107 (1967).

18 D Barrett and NA Davidson, *J Insect Physiol*, **21**, 1447–1452 (1975).

19 ED Corte and F Stirpe, *Biochem J*, **108**, 349–351 (1968).

20 F Stirpe and ED Corte, *J Biol Chem*, **244**, 3855–3863 (1969).

21 ED Corte and F Stirpe, *Biochem J*, **126**, 739–745 (1972).

22 WR Waud and KV Rajagopalan, *Arch Biochem Biophys*, **172**, 354–364 (1976).

23 M Nakamura and I Yamazaki, *J Biochem*, **92**, 1279–1286 (1982).

24 JM McCord and RS Roy, *Can J Physiol Pharmacol*, **60**, 1346–1352 (1982).

25 JM McCord, *N Engl J Med*, **312**, 159–163 (1985).

26 OD Saugstad, *Pediatr Res*, **23**, 143–150 (1988).

27 CE Berry and JM Hare, *J Physiol*, **555**, 589–606 (2004).

28 AG Reaume, SH Clark and A Chovnick, *Genetics*, **123**, 503–509 (1989).

29 Y Hayashi, *Nature*, **186**, 1053–1054 (1960).

30 C Vorbach, A Scriven and MR Capecchi, *Gene Dev*, **16**, 3223–3235 (2002).

31 GB Elion, *Science*, **244**, 41–47 (1989).

32 MA Becker, R Schumacher Jr, RL Wortmann, PA MacDonald, D Eustace, WA Palo, J Streit and N Joseph-Ridge, *N Engl J Med*, **353**, 2450–2461 (2005).

33 K Ichida, Y Amaya, K Noda, S Minoshima, T Hosoya, O Sakai, N Shimizu and T Nishino, *Gene*, **133**, 279–284 (1993).

34 NCBI Genome Annotation Project, *NCBI Entrez Protein Database*, accession code XP_525729, (2006).

35 L Berglund, JT Rasmussen, MD Andersen, MS Rasmussen and TE Petersen, *J Dairy Sci*, **79**, 198–204 (1996).

36 J Wang, SJ Black and N Murphy, *NCBI Entrez Protein Database*, accession code AAD17937, (1999).

37 J Wang, SJ Black and N Murphy, *NCBI Entrez Protein Database*, accession code AAD17938, (1999).

38 Broad Institute of MIT/Harvard Genome Sequencing Platform, *NCBI Entrez Protein Database*, accession code XP_0015016081, (2007).

39 HJ Wu, J Luo and LJ Zhang, *NCBI Entrez Protein Database*, accession code ABL96618, (2006).

40 Broad Institute of MIT/Harvard Genome Sequencing Platform and Agencourt Bioscience, *NCBI Entrez Protein Database*, accession code XP_540143, (2005).

41 S Tsuchida, R Yamada, S Ikemoto and M Tagawa, *J Vet Med Sci*, **63**, 353–355 (2001).

42 Y Amaya, K Yamazaki, M Sato, K Noda, T Nishino and T Nishino, *J Biol Chem*, **265**, 14170–14175 (1990).

43 M Terao, G Cazzaniga, P Ghezzi, M Bianchi, F Falciani, P Perani and E Garattini, *Biochem J*, **283**, 863–870 (1992).

44 Broad Institute of MIT/Harvard Genome Sequencing Platform, *NCBI Entrez Protein Database*, accession code XP_001380730, (2007).

45 Washington University Genome Sequencing Center, *NCBI Entrez Protein Database*, accession code XP_001509432, (2007).

46 A Sato, T Nishino, K Noda, Y Amaya and T Nishino, *J Biol Chem*, **270**, 2818–2826 (1995).

47 Wellcome Trust Sanger Institute, *NCBI Entrez Protein Database*, accession code CAK04749, (2007).

48 J Ben, T.-M Lim, VPE Phang and W.-K Chan, *Mar Biotechnol*, **5**, 568–578 (2003).

49 Baylor College of Medicine Human Genome Sequencing Center, *NCBI Entrez Protein Database*, accession code XP_001193570, (2006).

50 Y Yasukochi, T Kanda and T Tamura, *Genet Res*, **71**, 11–19 (1998).

51 Baylor College of Medicine Human Genome Sequencing Center, *NCBI Entrez Protein Database*, accession code XP_001119950, (2006).

52 Baylor College of Medicine Human Genome Sequencing Center, *NCBI Entrez Protein Database*, accession code XP_001606866, (2007).

53 CS Lee, D Curtis, M McCarron, C Love, M Gray, W Bender and A Chovnick, *Genetics*, **116**, 55–66 (1987).

54 TP Keith, MA Riley, M Kreitman, RC Lewontin, D Curtis and G Chambers, *Genetics*, **116**, 67–73 (1987).

55 RJ Pitts and LJ Zwiebel, *Genetics*, **158**, 1645–1655 (2001).

56 M Houde, MC Tiveron and F Brégegère, *Gene*, **85**, 391–402 (1989).

57 NJ Besansky, M Krzywinski, M Kern, O Mukabayire, D Fontenille, Y Toure and N Sagnon, *NCBI Entrez Protein Database*, accession code AAO14865 (2003).

58 V Nene, JR Wortman, D Lawson, B Haas, C Kodira, Z Tu, B Loftus, Z Xi, K Megy, M Grabherr, Q Ren, EM Zdobnov, NF Lobo, KS Campbell, SE Brown, MF Bonaldo, J Zhu, SP Sinkins, DG Hogenkamp, P Amedeo, P Arensburger, PW Atkinson, S Bidwell, J Biedler, E Birney, RV Bruggner, J Costas, MR Coy, J Crabtree, M Crawford, B deBruyn, D DeCaprio, K Eiglmeier, E Eisenstadt, H El-Dorry, WM Gelbart, SL Gomes, M Hammond, LI Hannick, JR Hogan, MH Holmes, D Jaffe, JS Johnston, RC Kennedy, H Koo, S Kravitz, EV Kriventseva, D Kulp, K LaButti, E Lee, S Li, DD Lovin, C Mao, E Mauceli, CFM Menck, JR Miller, P Montgomery, A Mori, AL Nascimento, HF Naveira, C Nusbaum, S O'Leary, J Orvis, M Pertea, H Quesneville, KR Reidenbach, Y.-H Rogers, CW Roth, JR Schneider, M Schatz, M Shumway, M Stanke, EO Stinson, JMC Tubio, JP VanZee, S Verjovski-Almeida, D Werner, O White, S Wyder, Q Zeng, Q Zhao, Y Zhao, CA Hill, AS Raikhel, MB Soares, DL Knudson, NH Lee, J Galagan, SL Salzberg, IT Paulsen, G Dimopoulos, FH Collins, B Birren, CM Fraser-Liggett and DW Severson, *Science*, **316**, 1718–1723 (2007).

59 MR Sant' Anna, B Alexander, PA Bates and RJ Dillon, *NCBI Entrez Protein Database*, accession code CAP08999, (2007).

60 Baylor College of Medicine Human Genome Sequencing Center, *NCBI Entrez Protein Database*, accession code XP_968229, (2006).

61 JE Galagan, SE Calvo, KA Borkovich, EU Selker, ND Read, D Jaffe, W FitzHugh, LJ Ma, S Smirnov, S Purcell, B Rehman, T Elkins, R Engels, S Wang, CB Nielsen, J Butler, M Endrizzi, D Qui, P Ianakiev, D Bell-Pedersen, MA Nelson, M Werner-Washburne, CP Selitrennikoff, JA Kinsey, EL Braun, A Zelter, U Schulte, GO Kothe, G Jedd, W Mewes, C Staben, E Marcotte, D Greenberg, A Roy, K Foley, J Naylor, N Stange-Thomann, R Barrett, S Gnerre, M Kamal, M Kamvysselis, E Mauceli, C Bielke, S Rudd, D Frishman, S Krystofova, C Rasmussen, RL Metzenberg, DD Perkins, S Kroken, C Cogoni, G Macino, D Catcheside, W Li, RJ Pratt, SA Osmani, CP DeSouza, L Glass, MJ Orbach, JA Berglund, R Voelker, O Yarden, M Plamann, S Seiler, J Dunlap, A Radford, R Aramayo, DO Natvig, LA Alex, G Mannhaupt, DJ Ebbole, M Freitag, I Paulsen, MS Sachs, ES Lander, C Nusbaum and B Birren, *Nature*, **422**, 859–868 (2007).

62 L Eichinger, JA Pachebat, G Glöckner, MA Rajandream, R Sucgang, M Berriman, J Song, R Olsen, K Szafranski, Q Xu, B Tunggal, S Kummerfeld, M Madera, BA Konfortov, F Rivero, AT Bankier, R Lehmann, N Hamlin, R Davies, P Gaudet, P Fey, K Pilcher, G Chen, D Saunders, E Sodergren, P Davis, A Kerhornou, X Nie, N Hall, C Anjard, L Hemphill, N Bason, P Farbrother, B Desany, E Just, T Morio, R Rost, C Churcher, J Cooper, S Haydock, N van Driessche, A Cronin, I Goodhead, D Muzny, T Mourier, A Pain, M Lu, D Harper, R Lindsay, H Hauser, K James, M Quiles, M Madan Babu, T Saito, C Buchrieser, A Wardroper, M Felder, M Thangavelu, D Johnson, A Knights, H Loulseged, K Mungall, K Oliver, C Price, MA Quail, H Urushihara, J Hernandez, E Rabbinowitsch, D Steffen, M Sanders, J Ma, Y Kohara, S Sharp, M Simmonds, S Spiegler, A Tivey, S Sugano, B White, D Walker, J Woodward, T Winckler, Y Tanaka, G Shaulsky, M Schleicher, G Weinstock, A Rosenthal, EC Cox, RL Chisholm, R Gibbs, WF Loomis, M Platzer, RR Kay, J Williams, PH Dear, AA Noegel, B Barrell and A Kuspa, *Nature*, **435**, 43–57 (2005).

63 A Glatigny and C Scazzocchio, *J Biol Chem*, **270**, 3534–3555 (1995).

64 WC Nierman, Neosartorya fischeri Genome Project, The Institute for Genomic Research, *NCBI Entrez Protein Database*, accession code XP_001261698, (2006).

65 B Birren, E Lander, J Galagan, C Nusbaum, K Devon, L.-J Ma, M Henn, D Jaffe, J Butler, P Alvarez, S Gnerre, M Grabherr, M Kleber, E Mauceli, W Brockman, S Rounsley, S Young, K LaButti, V Pushparaj, D DeCaprio, M Crawford, M Koehrsen, R Engels, P Montgomery, M Pearson, C Howarth, L Larson, S Luoma, J White, C Yandava, C Kodira, Q Zeng, S Oleary, L Alvarado, J Taylor, A Sil and B Goldman, The Broad Institute Genome Sequencing Platform, NCBI Entrez Protein database, accession code EDN09700, (2007).

66 EU Arabidopsis sequencing project, *NCBI Entrez Protein Database*, accession code CAB80207, (2006).

67 JM Carlton, RP Hirt, JC Silva, AL Delcher, M Schatz, Q Zhao, JR Wortman, SL Bidwell, UC Alsmark, S Besteiro, T Sicheritz-Ponten, CJ Noel, JB Dacks, PG Foster, C Simillion, Y Van de Peer, D Miranda-Saavedra, GJ Barton, GD Westrop, S Müller, D Dessi, PL Fiori, Q Ren, I Paulsen, H Zhang, FD Bastida-Corcuera, A Simoes-Barbosa, MT Brown, RD Hayes, M Mukherjee, CY Okumura, R Schneider, AJ Smith, S Vanacova, M Villalvazo, BJ Haas, M Pertea, TV Feldblyum, TR Utterback, CL Shu, K Osoegawa, PJ de Jong, I Hrdy, L Horvathova, Z Zubacova, P Dolezal, SB Malik, JM Logsdon Jr, K Henze, A Gupta, CC Wang, RL Dunne, JA Upcroft, P Upcroft, O White, SL Salzberg, P Tang, CH Chiu, YS Lee, TM Embley, GH

Coombs, JC Mottram, J Tachezy, CM Fraser-Liggett and PJ Johnson, *Science*, **315**, 207–212 (2007).

68 BS Goldman, WC Nierman, D Kaiser, SC Slater, AS Durkin, JA Eisen, CM Ronning, WB Barbazuk, M Blanchard, C Field, C Halling, G Hinkle, O Iartchuk, HS Kim, C Mackenzie, R Madupu, N Miller, A Shvartsbeyn, SA Sullivan, M Vaudin, R Wiegand and HB Kaplan, *Proc Natl Acad Sci USA*, **103**, 15200–19205 (2006).

69 S Leimkühler, M Kern, PS Solomon, AG McEwan, G Schwarz, R Mendel and W Klipp, *Mol Microbiol*, **27**, 853–869 (1998).

70 NV Ivanov, F Hubalek, M Trani and DE Edmondson, *Eur J Biochem*, **270**, 4744–4754 (2003).

71 EG Ball, *J Biol Chem*, **128**, 51–67 (1939).

72 T Nishino, T Nishino and K Tsushima, *FEBS Lett*, **131**, 369–372 (1981).

73 BT Eger, K Okamoto, C Enroth, M Sato, T Nishino, EF Pai and T Nishino, *Acta Cryst D*, **56**, 1656–1658 (2000).

74 NV Ivanov, M Trani and DE Edmondson, *Protein Expr Purif*, **37**, 72–82 (2004).

75 S Leimkühler, R Hodson, GN George and KV Rajagopalan, *J Biol Chem*, **278**, 20802–20811 (2003).

76 WA Doyle, JF Burke, A Chovnick, FL Dutton, C Russell, JR Whittle and RC Bray, *Biochem Soc Trans*, **24**, 31S (1996).

77 B Adams, DJ Lowe, AT Smith, C Scazzochio, S Demais and RC Bray, *Biochem J*, **362**, 223–229 (2002).

78 T Nishino, Y Amaya, S Kawamoto, Y Kashima, K Okamoto and T Nishino, *J Biochem*, **132**, 597–606 (2002).

79 Y Kuwabara, T Nishino, K Okamoto, T Matsumura, BT Eger, EF Pai and T Nishino, *Proc Natl Acad Sci USA*, **100**, 8170–8175 (2003).

80 Y Yamaguchi, T Matsumura, K Ichida, K Okamoto and T Nishino, *J Biochem*, **141**, 513–524 (2007).

81 WL Delano, *The PyMol Molecular Graphics System*, Delano Scientific, Palo Alto, CA, (2002), http://www.pymol.org.

82 Q Xiang and DE Edmondson, *Biochemistry*, **35**, 5441–5450 (1996).

83 D Hettrich and F Lingens, *Biol Chem Hoppe Seyler*, **372**, 203–211 (1991).

84 T Sakai and H.-K Jun, *Agric Biol Chem*, **43**, 753–760 (1979).

85 K Koenig and JR Andreesen, *J Bacteriol*, **172**, 5999–6009 (1990).

86 CA Woolfolk, *J Bacteriol*, **163**, 600–609 (1985).

87 L Gremer and O Meyer, *Eur J Biochem*, **238**, 862–866 (1996).

88 T Schräder, A Rienhöfer and JR Andreesen, *Eur J Biochem*, **264**, 862–871 (1999).

89 WT Self and TC Stadtman, *Proc Natl Acad Sci USA*, **97**, 7208–7213 (2000).

90 PG Avis, F Bergel and RC Bray, *J Chem Soc (London)*, **1955**, 1100–1107 (1955).

91 JL Johnson, WR Waud, HJ Cohen and KV Rajagopalan, *J Biol Chem*, **249**, 5056–5061 (1974).

92 V Massey, PE Brumby, H Komai and G Palmer, *J Biol Chem*, **244**, 1682–1691 (1969).

93 V Massey and D Edmondson, *J Biol Chem*, **245**, 6595–6598 (1970).

94 T Nishino and K Tsushima, *J Biol Chem*, **261**, 11242–11246 (1986).

95 R Hille, WR Hagen and WR Dunham, *J Biol Chem*, **260**, 10569–10575 (1985).

96 G Palmer and V Massey, *J Biol Chem*, **244**, 2614–2620 (1969).

97 RC Bray and T Vänngård, *Biochem J*, **114**, 725–734 (1969).

98 RC Bray, *Q Rev Biophys*, **21**, 299–329 (1988).

99 T Iwasaki, K Okamoto, T Nishino, J Mizushima, H Hori and T Nishino, *J Biochem*, **127**, 771–778 (2000).

100 RM Jones, FE Inscore, R Hille and ML Kirk, *Inorg Chem*, **38**, 4963–4970 (1999).

101 CJ Doonan, A Stockert, R Hille and GN George, *J Amer Chem Soc*, **127**, 4518–4522 (2005).

102 NC Maiti, T Tomita, T Kitagawa, K Okamoto and T Nishino, *J Biol Inorg Chem*, **8**, 327–333 (2003).

103 PG Avis, F Bergel, RC Bray and KV Shooter, *Nature*, **173**, 1230–1231 (1954).

104 K Okamoto, K Matsumoto, R Hille, BT Eger, EF Pai and T Nishino, *Proc Natl Acad Sci USA*, **101**, 7931–7936 (2004).

105 K Okamoto, BT Eger, T Nishino, EF Pai and T Nishino, *Nucleos Nucleot Nucl*, in press.

106 K Okamoto, BT Eger, T Nishino, S Kondo, EF Pai and T Nishino, *J Biol Chem*, **278**, 1848–1855 (2003).

107 A Fukunari, K Okamoto, T Nishino, BT Eger, EF Pai, M Kamezawa, I Yamada and N Kato, *J Pharmacol Exp Ther*, **311**, 519–528 (2004).

108 JM Pauff, J Zhang, CE Bell and R Hille, *J Biol Chem*, (2007), http://www.jbc.org/cgi/doi/10.1074/jbc.M707918200.

109 R Asai, T Nishino, T Matsumura, K Okamoto, K Igarashi, EF Pai and T Nishino, *J Biochem*, **141**, 525–534 (2007).

110 T Nishino, K Okamoto, Y Kawaguchi, H Hori, T Matsumura, BT Eger, EF Pai and T Nishino, *J Biol Chem*, **280**, 24888–24894 (2005).

111 AR Pearson, BLJ Godber, R Eisenthal, GL Taylor and R Harrison, *RCSB/Protein Data Bank*, accession code 2CKJ, (2007).

112 JJ Truglio, K Theis, S Leimkühler, R Rappa, KV Rajagopalan and C Kisker, *Structure*, **10**, 115–125 (2002).

113 C Enroth, BT Eger, K Okamoto, T Nishino, T Nishino and EF Pai, *Proc Natl Acad Sci USA*, **97**, 10723–10728 (2000).

114 AG Murzin, SE Brenner, T Hubbard and C Chotia, *J Mol Biol*, **247**, 536–540 (1995).

115 I Michalopoulos, GM Torrance, DR Gilbert and DR Westhead, *Nucleic Acid Res*, **32**, D251–D254 (2004), http://www.tops.leeds.ac.uk.

116 SP Cramer and R Hille, *J Am Chem Soc*, **107**, 8164–8169 (1985).

117 R Hille, GN George, MK Eidsness and SP Cramer, *Inorg Chem*, **28**, 4018–4022 (1989).

118 MJ Romao, M Archer, I Moura, JJ Moura, J LeGall, R Engh, M Schneider, P Hof and R Huber, *Science*, **270**, 1170–1176 (1995).

119 R Huber, P Hof, RO Duarte, JJ Moura, I Moura, MY Liu, J LeGall, R Hille, M Archer and MJ Romao, *Proc Natl Acad Sci USA*, **93**, 8846–8851 (1996).

120 BT Eger, K Okamoto, T Nishino, T Nishino and EF Pai, to be published.

121 S Leimkühler, AL Stockert, K Igarashi, T Nishino and R Hille, *J Biol Chem*, **279**, 40437–40444 (2004).

122 A Glatigny, P Hof, MJ Romao, R Huber and C Scazzocchio, *J Mol Biol*, **278**, 431–438 (1989).

123 JM Pauff, CF Hemann, N Junemann, S Leimkühler and R Hille, *J Biol Chem*, **282**, 12785–12790 (2007).

124 H Dobbek, L Gremer, O Meyer and R Huber, *Proc Natl Acad Sci USA*, **96**, 8884–8889 (1999).

125 RE Coffman and GR Buettner, *J Phys Chem*, **83**, 2392–2400 (1979).

126 J Hunt, V Massey, WR Dunham and RH Sands, *J Biol Chem*, **268**, 18685–18691 (1993).

127 T Nishino and K Okamoto, *J Inorg Biochem*, **82**, 43–49 (2000).

128 CC Page, CC Moser, X Chen and LP Dutton, *Nature*, **402**, 47–52 (1999).

129 O Dym and D Eisenberg, *Protein Sci*, **10**, 1712–1728 (2001).

130 LM Cunane, ZW Chen, N Shamala, FS Mathews, CN Cronin and WS McIntire, *J Mol Biol*, **295**, 357–374 (2000).

131 A Mattevi, MW Fraaije, A Mozzarelli, L Olivi, A Coda and WJ van Berkel, *Structure*, **5**, 907–920 (1997).

132 MJ Barber, MP Coughlan, M Kanda and KV Rajagopalan, *Arch Biochem Biophys*, **201**, 468–475 (1980).

133 T Saito and T Nishino, *J Biol Chem*, **264**, 10015–10022 (1989).

134 J Hunt and V Massey, *J Biol Chem*, **267**, 21479–21485 (1992).

135 CM Harris and V Massey, *J Biol Chem*, **272**, 8370–8379 (1997).

136 LM Schopfer, V Massey and T Nishino, *J Biol Chem*, **263**, 13528–13538 (1989).

137 M Xia, R Dempski and R Hille, *J Biol Chem*, **274**, 3323–3330 (1999).

138 JS Olson, DP Ballou, G Palmer and V Massey, *J Biol Chem*, **249**, 4363–4382 (1974).

139 T Nishino, T Nishino, LM Schopfer and V Massey, *J Biol Chem*, **264**, 2518–2527 (1989).

140 CM Harris, SA Sanders and V Massey, *J Biol Chem*, **274**, 4561–4569 (1999).

141 CM Harris and V Massey, *J Biol Chem*, **272**, 28335–28341 (1997).

142 EF Pai and GE Schulz, *J Biol Chem*, **258**, 1752–1757 (1983).

143 AG Porras and G Palmer, *J Biol Chem*, **275**, 11617–11626 (1982).

144 MJ Barber and LM Siegel, *Biochemistry*, **21**, 1638–1647 (1982).

4-Hydroxybenzoyl-coenzyme A reductase

Matthias Boll

Institute of Biochemistry, University of Leipzig, Leipzig, Germany

FUNCTIONAL CLASS

Enzyme; 4-hydroxybenzoyl-coenzyme-A (HBCoA) :ferredoxin oxidoreductase; EC 1.3.99.20; a molybdenum, FAD, and iron−sulfur clusters containing reductase; belongs to the xanthine oxidase (XO) family of molybdenum cofactor containing enzymes; known as 4-hydroxybenzoyl-CoA reductase (HBCR).

HBCR catalyzes the irreversible removal of the phenolic hydroxyl group from 4- HBCoA by two-electron reduction yielding benzoyl-Coenzyme A (BCoA).[1] A 2[4Fe−4S] cluster containing ferredoxin serves as natural electron acceptor.[2] The enzyme may use 3,4- or 2,4-di HBCoA as substrate[3]; a mechanism *via* radical intermediates has been proposed (3D Structure).[4,5]

OCCURRENCE

HBCR is predicted to occur in all anaerobic bacteria that use phenol, 4-hydroxybenzoate, 4-cresol (4-methylphenol), tyrosine, protocatechuate, or 4-hydroxyphenyl acetic acid as carbon source. It has so far only been isolated from the denitrifying Betaproteobacterium *Thauera aromatica*.[1] *In vitro* HBCR activities have also been determined in other denitrifying *Thauera* and *Azoarcus* strains,[1,7,8] in the phototrophic *Rhodopseudomonas palustris*[9] as well as in the obligately anaerobic Deltaproteobacteria *Desulfobacterium cetonicum* (sulfate reducing),[10] and *Geobacter metallireducens* [Fe(III)-respiring].[11,12] Genes of HBCR are present in species of the aromatic compounds degrading genera *Magnetospirillum, Thauera, Azoarcus, Geobacter*, and *Rhodopseudomonas*.[2,9,12]

BIOLOGICAL FUNCTION

A large portion of the naturally occurring aromatic compounds contain phenolic hydroxyl groups, which derive mainly from plant secondary metabolism (e.g., lignin, flavonoids, or tannins). Many phenolic compounds are also produced to a great extent by human activities (e.g., solvents, preservatives, etc.) and are of environmental concern. In anaerobic bacteria that degrade aromatic compounds all oxygen-dependent reactions catalyzed by oxygenases are replaced by alternative enzymatic processes, many of which have so far exclusively been found in the anaerobic aromatic metabolism and follow unprecedented biochemical principles.[13–17] HBCR plays a crucial role in the anaerobic degradation of phenolic compounds and catalyzes the removal of a phenolic hydroxyl group by reduction (Figure 1).[1,4,5] To date, HBCR is the only enzyme described that catalyzes such a reaction type. Notably, in case of *ortho-* or *meta*-hydroxylated BCoA analogs no dehydroxylating enzyme has been identified so far. This

3D Structure Schematic representation of the $(\alpha\beta\gamma)_2$ structure of HBCR. The α-subunits (red color tones) harbor the Mo-cofactor, the β-subunits (blue color tones) two [2Fe–2S] clusters, and the γ-subunit (green color tones) one FAD and one [4Fe-4S] cluster. The cofactors are presented as spheres. PDB code 1SB3. Produced using the program PyMOL.[6]

Figure 1 Role of HBCR in the anaerobic degradation of aromatic compounds. The reaction of HBCR is highlighted by a frame. The next step in the degradation pathway is catalyzed by dearomatizing BCR.

finding can be rationalized by the substrate specificity of the dearomatizing benzoyl-CoA reductase (BCR), catalyzing the next step in the degradation pathway (Figure 1). BCR dearomatizes 2- or 3-HBCoA to the corresponding hydroxylated dienoyl-CoA compounds, but it does not accept the *para*-hydroxylated analog because of mechanistic reasons.[18–20] Thus, the para-positioned hydroxyl functionality has to be removed by the dehydroxylating HBCR prior to the dearomatization reaction.

AMINO ACID SEQUENCE INFORMATION

The genes coding for the three subunits of HBCR are located in a cluster and are termed *hba*BCD (*R. palustris*, *hbc* = hydroxybenzoic acid),[9] *hcr*ABC (*T. aromatica*, *hcr* = hydroxybenzoyl-CoA reductase),[2] or *pcm*RST (*G. metallireducens, pcm* = *p*-cresol metabolism).[12] HBCR shares amino acid (AA) sequence similarities to members of the XO family.[2,9] For this reason, the genes of true HBCRs cannot be determined unambiguously by simple AA sequence alignments. AA sequences of HBCRs that have been verified by additional experimental evidence (crystal structure, gene induction/disruption experiments) are listed below.

- *T. aromatica*: α-subunit, 769 AA residues; β-subunit, 324 AA; γ-subunit, 161 AA; accession numbers CAA5038-5040 *R. palustris*: α-subunit, 774 AA; β-subunit, 327 AA; γ-subunit, 163 AA; accession numbers CAE26114-26116.

- *Aromatoleum aromaticum*: α-subunit, 761 AA; β-subunit, 294 AA; γ-subunit, 163 AA; accession numbers CAI8160-8162.
- *G. metallireducens*: α-subunit, 762 AA; β-subunit, 289 AA; γ-subunit, 171 AA; accession numbers YP_385088-90.

All accession numbers refer to the NCBI protein database.

PROTEIN PRODUCTION AND PURIFICATION

HBCR has so far only been purified from extracts of *T. aromatica* cells grown on 4-hydroxybenzoate as carbon source and nitrate as electron acceptor.[1] Because of the oxygen sensitivity (half life on air is about 30 min), HBCR has to be purified in an anaerobic glove box. The purification typically starts from 200-g cells (wet mass) that were cultivated in a 200-L fermenter. Cell disruption is carried out by a French press and after ultracentrifugation HBCR is purified from the soluble protein fraction. The purification protocol established consists of the following three chromatographic steps using 20 mM triethanolamine/HCl buffer at pH 7.8: (i) diethylaminoethyl anion exchange chromatography (elution at 190 mM KCl), (ii) Q-sepharose anion-exchange chromatography (elution at 250 mM KCl), and (iii) Cibacron Blue affinity chromatography (elution either between 0.5 and 1 M KCl or with 0.2 mM 4-HBCoA). If necessary, an additional gel filtration step may be carried out. From 1 g of cells (wet mass), approximately

0.25 mg of purified HBCR can be obtained.[1,21] Heterologous expression of the structural genes has not yielded an active enzyme, so far.

MOLECULAR CHARACTERIZATION

HBCR from *T. aromatica* has a molecular mass of 270 kDa and consists of three subunits of 82 (α), 35 (β), and 17 kDa (γ) suggesting an ($\alpha\beta\gamma)_2$ composition.[1,2] AA sequence comparisons indicate that HBCR from other organisms have a highly similar composition[2], which is also typical for many members of the XO family of molybdenum enzymes.[22–24] The α-subunit harbors the active site cytosine molybdopterin cofactor. The γ-subunit binds two [2Fe-2S] clusters which are both coordinated by conserved cysteines. The β-subunit binds one FAD and a [4Fe-4S] cluster.

METAL CONTENT

The metal content of HBCR from *T. aromatica* was determined by colorimetric assays and by inductively coupled plasma mass spectrometry. It contained 15 Fe and 1.8 Mo per ($\alpha\beta\gamma)_2$-unit; the amount of other metals was negligible.[2] In accordance, the crystal structure revealed 16 Fe and 2 Mo per ($\alpha\beta\gamma)_2$-unit.[25]

ACTIVITY ASSAYS

There are two assays for the determination of HBCR activity. In the continuous spectrophotometric assay, reduced viologens are used as electron donors and the time-, protein-, and HBCoA-dependent decrease in absorption due to viologen oxidation can be followed at 600 nm. In the original descriptions, reduced benzyl viologen served as an artificial electron donor[1,26]; however, in further studies, the use of reduced methyl viologen resulted in more reliable measurements.[2,21] Although the time-dependent oxidation of the natural electron donor ferredoxin can be monitored spectrophotometrically at 415 nm, this assay is not used for routine purposes as it requires the purification of the ferredoxin from *T. aromatica* and as it only allows to monitor the consumption of a small amount of substrate.[2] In the discontinuous assay, the formation of BCoA from HBCoA is determined by reversed phase HPLC analysis of the substrate consumed and the product formed.[1,7,12]

SPECTROSCOPY AND ELECTROCHEMISTRY

UV/Vis spectroscopy

The UV/Vis spectrum of oxidized HBCR exhibits complex features between 350 and 600 nm due to the presence of the FeS clusters and FAD.[1] The extinction coefficients determined were $\varepsilon_{278} = 270\,mM^{-1}\,cm^{-1}$ and $\varepsilon_{420} = 45\,mM^{-1}\,cm^{-1}$. Reduction by dithionite or HBCoA bleached the spectrum.[1]

EPR spectroscopy

The redox centers of HBCR were studied in detail by electron paramagnetic resonance (EPR) spectroscopy.[21] An overview of the EPR properties of the individual cofactors is presented in Table 1. In the thionine-oxidized state, no EPR signal was observed, indicating that all redox centers were in the diamagnetic state. Upon reduction with dithionite, the $[2Fe-2S]^{+1}$ clusters and the FADH semiquinone radical exhibited typical $S = 1/2$ EPR signals. The paramagnetic Mo(V) species was also observed in the dithionite reduced state of the enzyme and showed a strong hyperfine coupling with one or more proton(s) (Figure 2(a)).[27] Like other members of the XO family, HBCR was inhibited by cyanide that was accompanied by a loss of a cyanolyzable sulfur ligand from the Mo atom. In the cyanide-inhibited state, an altered Mo(V) EPR signal was observed. This signal is referred to as the desulfo-inhibited state, which is also typical for other XO family enzymes.[28] It was also present to a minor extent in the as-isolated, native HBCR, suggesting that a portion (<10%) of HBCR has lost the sulfur ligand during the purification procedure. In D_2O, the hyperfine splitting of the Mo(V) EPR signal was lost, suggesting that solvent-exchangeable protons induced this splitting.[28]

Table 1 EPR spectroscopic and electrochemical properties of the redox centers of HBCR[21]

Redox center	Redox transition	E'_0	g-Values	EPR conditions
[2Fe–2S] I	$[2Fe-2S]^{1+/+2}$	−205 mV	2.04, 1.995, 1.964	40–100 K, 0.2 mW
[2Fe–2S] II	$[2Fe-2S]^{+1/+2}$	−255 mV	2.02, 1.977, 1.961	40 K, 2 mW
[4Fe–4S]	$[4Fe-4S]^{+1/+2}$	−465 mV	2.06, 1.954, 1.934	
FAD	FAD/FADH$^\bullet$	~−250 mV	2.008	200 K, 0.2 mW
	FADH$^\bullet$/FADH$_2$	~−470 mV		
Mo (rapid signal)	Mo(VI)/Mo(V)	−380 mV	1.99, 1.965, 1.965 A_{x-z}: 0.4–0.8 mT	120 K, 2 mW
	Mo(V)/Mo(IV)	~−500 mV		

Figure 2 EPR spectra of HBCR.[21] (a) 180 K EPR spectra of the Mo(V) signal. For better presentation the flavin semiquinone signal at g = 2.008 was subtracted from all spectra.[21] EPR spectra of dithionite-reduced HBCR (a) as isolated in H_2O, (b) as isolated in D_2O, (c) as isolated in D_2O after subtraction of the spectrum of cyanide-treated HBCR in D_2O (×0.15), as shown in (e), (e) cyanide-treated HBCR in D_2O. (d) and (f) are simulations of the spectra in (c) and (e), respectively. The three lines in (a) point to the split g_z-component of the Mo(V)-signal. (b) 40 K EPR spectra of the two $[2Fe–2S]^{+1}$ and the $[4Fe–4S]^{+1}$ cluster at different redox potentials. The numbers at the spectra refer to g-values. The g = 2.06 feature is assigned to the $[4Fe–4S]^{+1}$ cluster; the features at g = 2.04 and 1.971 to the two $[2Fe–2S]^{+1}$ clusters. Features below g = 1.94 newly developed upon [4Fe–4S] cluster reduction.

HBCR is the only member of the XO family that carries a $[4Fe–4S]^{+1/+2}$ cluster.[21] At redox potentials, where this low-potential cluster was diamagnetic the overlaying S = 1/2 signals of the two $[2Fe–2S]^{+1}$ clusters can be detected (Figure 2(b)). However, at potentials below −420 mV the [4Fe–4S] cluster became paramagnetic and a complex low-spin EPR signal was observed. Reduction of the [4Fe–4S] cluster resulted in marked effects on the EPR properties of all other paramagnetic redox centers. For instance, the typical features of the S = 1/2 EPR signals of the $[2Fe–2S]^+$ cluster disappeared and the S = 1/2 Mo(V) species showed an increased relaxation behavior (Figure 2(b)). As the distance between the [4Fe–4S] cluster and the Mo(V) species is about 40 Å, such a long range magnetic coupling is remarkable and appears to be mediated by the other paramagnetic species (see below).

EPR redox titrations studies revealed that the redox potentials of the $[2Fe–2S]^{+1/+2}$ clusters of HBCR are in the range of other XO family members ($E'^\circ \sim$ −200 mV to −300 mV, Table 1).[21–23,29,30] In contrast, the midpoint potentials of the FADH/FADH•, (−470 mV), and Mo(V)/(IV), (−500 mV), couples were exceptionally low; they are in the range of the additional $[4Fe–4S]^{+1/+2}$ cluster (−465 mV; Table 1).

Mössbauer spectroscopy

For Mössbauer spectroscopy studies, HBCR was purified from extracts of *T. aromatica* grown anaerobically with ^{57}Fe as the sole source of iron.[21] High ^{57}Fe enrichment was achieved (>90%) as estimated from the resonance absorption effect of each subspectrum of the oxidized

sample. In Figure 3, the Mössbauer spectra of the thionine oxidized ^{57}Fe-labeled HBCR taken at 4.2 K in external fields of 20 mT ⊥ γ (a) and 7 T || γ (b) are shown. Spectrum A consists of two doublets with an area ratio of 1:1. One of the doublets exhibits parameters typical of delocalized mixed-valence high-spin iron sites ($Fe^{2.5+}$) with tetrahedral sulfur-coordination ($\delta = 0.44$ mm s^{-1}; $\Delta E_Q = 1.12$ mm s^{-1}; $\Gamma = 0.33$ mm s^{-1}; dotted line in Figure 3(a)) as in $[4Fe–4S]^{2+}$ and in $[3Fe–4S]^0$ clusters.[31] The second doublet is characteristic of high-spin Fe^{3+} sites tetrahedrally coordinated with sulfur ligands ($\delta = 0.29$ mm s^{-1}; $AE_Q = 0.61$ mm s^{-1}; $\Gamma = 0.27$ mm s^{-1}; dashed line in Figure 3(a)). Such Fe^{3+} sites are present in $[2Fe–2S]^{1+/2+}$ and $[3Fe–4S]^0$ clusters. Applying a high external field (Figure 3(b)) demonstrates the presence of $[4Fe–4S]^{2+}$ clusters and $[2Fe–2S]^{2+}$ clusters in a ratio of 1:2.

The Mössbauer spectra of dithionite-reduced HBCR showed a superposition of several subspectra including subspectra characteristic of diamagnetic and paramagnetic [4Fe–4S] and [2Fe–2S] clusters. The simulations revealed the following cluster stoichiometry: $[4Fe–4S]^{2+}$: $[4Fe–4S]^{1+}$: $[2Fe–2S]^{2+}$: $[2Fe–2S]^{1+}$ equal to 1:1:1:3. Thus, 50% of the $[4Fe–4S]^{2+}$ clusters and 75% of the $[2Fe–2S]^{2+}$ clusters were reduced by dithionite. This result is in agreement with the finding that the redox potential of the $[4Fe–4S]^{+1/+2}$ cluster is substantially more negative than that of the $[2Fe–2S]^{+1/+2}$ clusters.

Mössbauer spectra of dithionite-reduced HBCR in the presence of excess substrate (HBCoA) revealed a cluster stoichiometry of $[4Fe–4S]^{+2}$: $[2Fe–2S]^{+1}$: $[2Fe–2S]^{+2}$ 2:1:3. Thus, in the steady state of HBCoA turnover, all [4Fe–4S] clusters were in the oxidized state, whereas 75% of the [2Fe–2S] clusters were in the reduced state.

Figure 3 Mössbauer spectra of ^{57}Fe-enriched HBCR (650 µM) in the thionine oxidized state. (a) Spectrum taken at 4.2 K in an applied field of 20 mT ⊥ γ. (b) Spectrum taken at 4.2 K in an applied field of 7 T ‖ γ. The solid lines are the sum of two subspectra.

Obviously, the [2Fe–2S] clusters were either not oxidized at all or the reduction of these clusters (by excess of dithionite present in the sample) was much faster than their substrate-dependent oxidation.

X-RAY STRUCTURE

Crystallization

HBCR was anaerobically crystallized in a glove box under a nitrogen/hydrogen atmosphere (95% N_2, 5% H_2 by volume), using the hanging drop vapor diffusion method.[32] The reddish crystals formed at room temperature after 3–4 weeks in a drop containing 2.5 µL enzyme solution (20 mg mL^{-1}) and 2.5 µL 100 mM N-(2-hydroxyethyl)-piperazine-N'-2-ethanesulfonic acid pH 7.5, 10% polyethylene glycol (PEG) 4000, 15% 2-methyl-2,4-pentanediol reservoir buffer. HBCR crystallized in two closely related forms both adopting the space group P2$_1$2$_1$2$_1$. The unit cell parameters of crystal form 1 and 2 were determined to be $a = 116.6$ Å, $b = 150.2$ Å, $c = 175.3$ Å and $a = 112.9$ Å, $b = 152.3$ Å, $c = 174.6$ Å, respectively. They diffracted to a resolution of about 2 and 1.6 Å, respectively. Assuming that one hexamer is present in the asymmetric unit, a volume of mass ratio is V_M of 2.8 Å3 Da^{-1} and the corresponding solvent content was 56%. All measurements were achieved under flash-freezing conditions after soaking the crystals in a cryoprotectant solution containing 6% PEG 4000, 0.1-M NaCl, 0.1 M sodium acetate, pH 4.8, and 25% glycerol.

Overall structure

In agreement with the native composition, HBCR was crystallized as a dimer of a trimer, (αβγ)$_2$, and the structure was solved at 1.6 Å.[25,32] The butterfly-shaped overall architecture was similar to those of other structurally characterized members of the XO family[33–37]; each αβγ unit is proposed to function independently (3D Structure). The α-subunit contains the molybdenum cofactor containing active site and the β-subunit contains FAD and a [4Fe–4S] cluster, whereas the γ-subunit harbors two [2Fe–2S] clusters. Substantial global differences, in particular, between HBCR and the structurally characterized oxidizing enzymes of the XO family are observed in the relative arrangement of the two αβγ units within the protein complex. Compared to other XO family members, the angle between the two αβγ units is reduced by about 25°. The more closed state results from an additional interface between two subunits γ of the (αβγ)$_2$ heterohexamer.

Alpha-subunit and active site

Because of the high resolution, the ligation of the redox-active molybdenum in the α-subunit could be accurately analyzed (Figure 4(a)). The molybdenum cofactor was identified as molybdopterin-cytosine dinucleotide (Figure 4(b)). Two coordinating oxo and a hydroxyl or water ligand were clearly identified showing distances to the molybdenum atom of 2.0, 2.0, and 2.2 Å, respectively. Together with the two dithiolene sulfur atoms, they form a distorted square pyramidal coordination geometry around the central atom. An electron density peak located in trans to the apical Mo=O position could not be confirmed in all crystals and its nature remains unclear. A glutamate residue (E^{726} in Figure 4(a)) that is conserved in all XO family enzymes is considered to act as proton acceptor/donor during hydroxylation/dehydroxylation of the substrate in XO family enzymes.

Substrate-binding channel

Attempts to soak the substrate HBCoA into HBCR crystals damaged the crystals immediately, indicating a

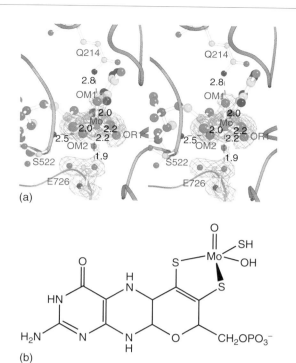

(a)

(b)

Figure 4 Active site structure of HBCR and the typical molybdenum cofactor of the XO family. (a) The ligation of the molybdenum atom. The electron density at a contour level of 1.2σ is shown in green and that of 5σ is shown in brown. Molybdenum is coordinated by the two thiolene sulfurs, two oxo, and one hydroxyl group. Additionally, an extra electron density was observed between the molybdenum and Gluα726. Produced using the program MOLSCRIPT.[38] (b) Typical structure of the native Mo-cofactor of XO family members. In HBCR, the typical sulfur ligand in the equatorial position is exchanged by an oxo-ligand during the purification procedure. In HBCR, the cofactor additionally carries a cytidylate residue bound to the phosphate residue.

substrate-induced conformational change; cocrystallization with the nonhydrolyzable 4-hydroxyphenacyl-CoA failed due to poor binding of the analog. Therefore, binding of HBCoA was modeled taking into account that in XO-like enzymes the hydroxyl group of the substrate

replaces a hydroxyl/water ligand from the molybdenum. The substrate-binding site is located in a 18-Å long and 6-Å wide channel whose size is well compatible with the spatial requirements of the bulky HBCoA (Figure 5). The modeled phenolic ring is surrounded by several aromatic AA residues including Tyrα319, Tyrα326, Hisα360, and Tyrα521, which are perfectly suited for binding it by van der Waals and probably π–π interactions; as a result, it can be optimally positioned relative to the molybdenum. The aromatic residues involved in substrate binding are conserved in HBCR-like proteins but not in other members of the XO family.

Beta- and gamma-subunits

The γ-subunit harboring the two 2[Fe–2S] clusters shows the highest similarities to other members of the XO family (with a root mean square deviation (rmsd) of 1.1 and 1.7 Å). The clusters are coordinated by conserved cysteines that are present in all members of the XO family. In contrast, the FAD and the [4Fe–4S] cluster binding β-subunit contains the most striking difference between HBCR and other XO family enzymes: the insertion of a [4Fe–4S] cluster binding, 40 AA residue long polypeptide segment (Thrβ118–Thrβ158), which is absent in all other XO family enzymes (Figure 6(a)). The cluster is coordinated to Cysβ123, Cysβ138, Cysβ146, and Cysβ155 with distances of about 2.3 Å between the sulfhydryl sulfurs and the iron atoms (Figure 6(a)).

Role of the [4Fe–4S] cluster

In common XO family enzymes, the electrons derived from substrate oxidation are usually transferred via the [2Fe–2S] clusters and the flavin cofactor to external acceptors such as NAD^+ or O_2. Therefore, the involvement of the additional [4Fe–4S] cluster in the electron transfer chain from the external donor ferredoxin to the active site of HBCR was at issue. Figure 6(b) shows the [4Fe–4S] cluster of

Figure 5 Substrate-binding channel in HBCR. HBCoA is modeled into a 6 Å wide channel in a way that the Mo-ligated water is replaced by the hydroxy group of 4-HBCoA. The benzoyl moiety is flanked by four aromatic residues comprising Tyrα319, Tyrα326, Hisα360, and Tyrα521. Produced using the program MOLSCRIPT.[38]

Figure 6 Structure of the [4Fe–4S] cluster insertion segment and proposed electron transfer chain of HBCR. (a) The [4Fe–4S] cluster binding insertion segment of HBCR (orange) is composed of 40 AAs from Cysβ118 to Tyrβ158 and wraps the [4Fe–4S] cluster. The distances between the irons and the cysteine sulfurs are between 2.2 and 2.4 Å. The omit density in green is at 5.5σ level. The superimposed structures of HBCR and aerobic carbon monoxide dehydrogenase from *Oligotropha carboxidovorans*,[34,39] an XO family enzyme lacking the cluster insertion segment, are shown in red and blue with the 'shortcut' from Ala C117 to Pro C121 shown in green for the latter. Produced using the program MOLSCRIPT.[38] (b) Electron transfer chain from reduced ferredoxin to the substrate at an overall distance of 55 Å. Electron transfer calculations revealed an unidirectional electron transfer *via* the [4Fe-4S] cluster as presented.[25] The numbers refer to distances between the redox centers (Å) or to midpoint potentials (mV) of redox centers. In the case of FAD and Mo, the redox potential values for the two redox transitions are presented [FAD/FADH*/FADH2; Mo(VI/V/IV)].

the donor-reduced ferredoxin positioned to HBCR at its closest approach at a minimum distance of 10 Å to the extra [4Fe–4S] cluster of HBCR. In alternative modeling, the minimized modeled distance between the [4Fe–4S] cluster of ferredoxin and the flavin cofactor is approximately 19 Å. A simple calculation estimated a difference in tunneling rate between the two cases of >105-fold, strongly favoring initial electron transfer from ferredoxin to the extra [4Fe–4S] and, hence, mandating inclusion of the cluster as a linear member of the cofactor chain to the catalytic site.[40]

In comparison to other XO family enzymes, the redox properties and proposed molecular architecture of the cofactors in HBCR suggest an inverted electron transfer chain from reduced ferredoxin *via* the [4Fe–4S] cluster, the FAD, the two [2Fe–2S] clusters, and Mo-cofactor to the substrate. The overall reduction of HBCoA to BCoA and H_2O (E'° is approximately $-100\,mV$ for the free acids)[21,41] by reduced ferredoxin is considered to be an irreversible process. However, to accomplish reduction of the kinetically inert aromatic substrate at physiological rates, electrons on extremely low potentials are required. Therefore, the unusual low redox potential for the Mo(IV)/Mo(V) couple of $-500\,mV$ has been suggested as essential for the first electron transfer to the substrate.[21] An active role in this process for the extra $[4Fe–4S]^{+1/+2}$ cluster and for FAD is supported by the data obtained from EPR and Mössbauer spectroscopy studies, which revealed that the reduced $[4Fe–4S]^+$ cluster is oxidized by addition of the substrate.[21]

COMPLEX STRUCTURES

Next to cyanide, a typical inhibitor of XO family enzymes,[42] oxygen as well as the reducing agents Ti(III)-citrate and dithionite, readily inactivated HBCR.[11] Inactivation and reactivation of HBCR by these compounds followed a complex pattern. Cyanide-inhibited, reduced HBCR was reactivated by simple oxidation, whereas reactivation from the cyanide-inhibited oxidized state was only achieved in the presence of sulfide. Dithionite-inhibited HBCR was also reactivated by oxidation, whereas inhibition by Ti(III)-citrate was irreversible. Surprisingly, azide protected the enzyme from inactivation by Ti(III)-citrate. The structures of dithionite- and azide-bound HBCR were solved at 2.1 and 2.2 Å, respectively (Figure 7). Both dithionite and azide bound directly to equatorial ligation sites of the Mo atom. This binding may explain the reversible inhibitory effect of dithionite and the protective effect of azide. Obviously, binding of dithionite prevented substrate binding, and the oxidation of dithionite to sulfite upon oxygen exposure reactivated HBCR. Binding of azide to the Mo-cofactor was obviously strong enough to prevent the inhibition by Ti(III)-citrate. In contrast, azide was obviously readily displaced by HBCoA as azide itself had no inhibitory effect on HBCR activity.

Figure 7 Mo ligation in structures of HBCR soaked with dithionite and azide. (a) Native structure of oxidized HBCR showing the ligation pattern of Mo. The contour level of the electron density map was 3σ (in red) and 1.5σ (in light red); (b and c) HBCR structure with dithionite (b) and azide (c) modeled as indicated. In both the cases, the $2F_{obs}-F_{calc}$ and $F_{obs}-F_{calc}$ electron density maps (in light red and green) were calculated without dithionite (b) and without azide (c). The corresponding contour levels were 1.5σ and 3σ, respectively. In approximately 50% of the active sites of dithionite- or azide-treated HBCR crystals, the Mo atom is equatorially coordinated by an oxo and a water ligand as indicated by the gray balls. Produced using the program MOLSCRIPT.[38]

CATALYTIC MECHANISM

HBCR is the only member of the XO family using a thiol ester substrate.[22,23] This finding suggests that the mechanism differs from that of other molybdenum-containing hydroxylases. Buckel and Keese[43] were first who discussed the essential role of the thiol ester functionality for the reductive dehydroxylation reaction. In analogy to the related process of reductive benzene ring reduction,[44] they suggested that a ketyl radical anion is transiently formed (Figure 8). Such a species has a low-redox potential; however, in comparison to a benzene radical anion its formation is largely facilitated. The electrochemical properties of the redox centers of HBCR also appear to be suited for a low-potential redox chemistry: a low-potential reduced ferredoxin ($E'^{\circ} = -585\,mV$ for one of the [4Fe–4S] clusters)[45] serves as electron donor; in

addition, the unique [4Fe–4S] cluster and an Mo-cofactor with an unusually low-redox potential ($-500\,mV$ for the Mo(V)/(IV)-transition)[21] are present. However, a one-electron chemistry is in contrast to the general assumption, that catalysis of Mo-containing hydroxylases usually involves two-electron transitions between a substrate and spatially separated one-electron carriers, thereby avoiding the transient formation of reactive oxygen species.[22,23] Thus, in spite of the similarities in AA sequence and in the overall fold, HBCR appears to catalyze a unique reaction among all members of the XO family of molybdenum-containing hydroxylases.

The proposed catalytic cycle of HBCR runs counter clockwise to the one of XO family members (Figure 8).[21] An additional major difference is that single electron transfer steps to the substrate occur. The reaction starts

Figure 8 Proposal for a catalytic cycle of HBCR. Reaction steps: I, replacement of a Mo-bound water molecule by the substrate; II, charge transfer from Mo(IV) to the Mo-bound substrate; III, protonation of the radical anion to the free radical; IV, homolytic cleavage of C–O-bond resulting in rearomatized BCR; and V, rereduction of the enzyme by two single electrons.

with binding of the substrate to the Mo(IV) center *via* the hydroxyl group, thereby replacing the bound water or hydroxyl ligand. This water ligand has unambiguously been identified in the crystal structure of the enzyme. Binding will induce at least a partial charge transfer from the Mo(IV) to the substrate. The radical anion formed is stabilized by the thiol ester functionality. The highest electron density is located at the *para*-carbon atom, at this site the irreversible protonation to the free radical should occur. Finally, the mechanistically most demanding step takes place, the homolytic splitting of the C_4–O-bond. This difficult process will be largely driven by the rearomatization to the product BCoA. The enzyme will be in the oxidized Mo(VI) state and has to be regenerated to the Mo(IV) state by two single electron transfer steps to the active site from the donor reduced ferredoxin.

By coupling electrochemistry and steady-state kinetics, mechanistic information for HBCR catalysis was obtained.[26] In this study, a theory was developed that was able to distinguish between single two-electron transfer mechanisms from one involving two one-electron transfers. HBCR was found to involve two successive one-electron transfer steps, which is consistent with the mechanism proposed in Figure 8.

REFERENCES

1 R Brackmann and G Fuchs, *Eur J Biochem*, **213**, 563–71 (1993).

2 K Breese and G Fuchs, *Eur J Biochem*, **251**, 916–23 (1998).

3 B Ding, S Schmeling and G Fuchs, *J Bacteriol*, **190**, 1620–30 (2008).

4 M Boll, *Biochim Biophys Acta*, **1707**, 34–50 (2005).

5 M Boll and G Fuchs, *Biol Chem*, **386**, 989–97 (2005).

6 W DeLano, *The PyMOL User's Manual*, DeLano Scientific, San Carlos, CA, (2002).

7 R Glöckler, A Tschech and G Fuchs, *FEBS Lett*, **251**, 237–40 (1989).

8 J Heider, M Boll, K Breese, S Breinig, C Ebenau-Jehle, U Feil, N Gad'on, D Laempe, B Leuthner, ME Mohamed, S Schneider, G Burchhardt and G Fuchs, *Arch Microbiol*, **170**, 120–31 (1998).

9 J Gibson, M Dispensa and CS Harwood, *J Bacteriol*, **179**, 634–42 (1997).

10 JA Müller, AS Galushko, A Kappler and B Schink, *J Bacteriol*, **183**, 752–57 (2001).

11 J Johannes, MC Unciuleac, T Friedrich, E Warkentin, U Ermler and M Boll, *Biochemistry*, **47**, 4964–72 (2008).

12 F Peters, D Heintz, J Johannes, A van Dorsselaer and M Boll, *J Bacteriol*, **189**, 4729–38 (2007).

13 M Boll, G Fuchs and J Heider, *Curr Opin Chem Biol*, **6**, 604–11 (2002).

14 M Carmona, MT Zamarro, B Blazquez, G Durante-Rodriguez, JF Juarez, JA Valderrama, MJ Barragan, JL Garcia and E Diaz, *Microbiol Mol Biol Rev*, **73**, 71–133 (2009).

15 E Diaz, *Microbiology*, **7**, 173–80 (2004).

16 J Gibson and CS Harwood, *Annu Rev Microbiol*, **56**, 345–69 (2002).

17 B Schink, B Philipp and J Müller, *Naturwissenschaften*, **87**, 12–23 (2000).

18 M Boll, *J Mol Microbiol Biotechnol*, **10**, 132–42 (2005).

19 M Boll and G Fuchs, *Eur J Biochem*, **234**, 921–33 (1995).

20 H Möbitz, T Friedrich and M Boll, *Biochemistry*, **43**, 1376–85 (2004).

21 M Boll, G Fuchs, C Meier, A Trautwein, A el Kasmi, SW Ragsdale, G Buchanan and DJ Lowe, *J Biol Chem*, **276**, 47853–62 (2001).

22 CD Brondino, MJ Romao, I Moura and JJ Moura, *Curr Opin Chem Biol*, **10**, 109–14 (2006).

23 R Hille, *Arch Biochem Biophys*, **433**, 107–16 (2005).

24 DJ Lowe, *Met Ions Biol Syst*, **39**, 455–79 (2002).

25 MC Unciuleac, E Warkentin, CC Page, M Boll and U Ermler, *Structure*, **12**, 2249–56 (2004).

26 A el Kasmi, R Brackmann, G Fuchs and SW Ragsdale, *Biochemistry*, **34**, 11668–77 (1995).

27 MP Coughlan, JL Johnson and KV Rajagopalan, *J Biol Chem*, **255**, 2694–99 (1980).

28 RC Bray, *Adv Enzymol Relat Areas Mol Biol*, **51**, 107–65 (1980).

29 C Canne, I Stephan, J Finsterbusch, F Lingens, R Kappl, S Fetzner and J Hüttermann, *Biochemistry*, **36**, 9780–90 (1997).

30 R Hille, *Chem Rev*, **96**, 2757–816 (1996).

31 E Mulliez, S Ollagnier-de Choudens, C Meier, M Cremonini, C Luchinat, AX Trautwein and M Fontecave, *J Biol Inorg Chem*, **4**, 614–20 (1999).

32 MC Unciuleac, M Boll, E Warkentin and U Ermler, *Acta Crystallogr D Biol Crystallogr*, **60**, 388–91 (2004).

33 I Bonin, BM Martins, V Purvanov, S Fetzner, R Huber and H Dobbek, *Structure*, **12**, 1425–35 (2004).

34 H Dobbek, L Gremer, O Meyer and R Huber, *Proc Natl Acad Sci U S A*, **96**, 8884–89, 1999.

35 K Okamoto, K Matsumoto, R Hille, BT Eger, EF Pai and T Nishino, *Proc Natl Acad Sci U S A*, **101**, 7931–36 (2004).

36 MJ Romao, M Archer, I Moura, JJ Moura, J LeGall, R Engh, M Schneider, P Hof and R Huber, *Science*, **270**, 1170–76 (1995).

37 JJ Truglio, K Theis, S Leimkühler, R Rappa, KV Rajagopalan and C Kisker, *Structure*, **10**, 115–25 (2002).

38 PJJ Kraulis, *J Appl Cryst*, **24**, 946–50 (1991).

39 H Dobbek, L Gremer, R Kiefersauer, R Huber and O Meyer, *Proc Natl Acad Sci U S A*, **99**, 15971–76 (2002).

40 CC Page, CC Moser, X Chen and PL Dutton, *Nature*, **402**, 47–52 (1999).

41 RK Thauer, K Jungermann and K Decker, *Bacteriol Rev*, **41**, 100–80 (1977).

42 RC Wahl and KV Rajagopalan, *J Biol Chem*, **257**, 1354–59 (1982).

43 W Buckel and R Keese, *Angew Chem*, **107**, 1595–98 (1995).

44 M Boll, D Laempe, W Eisenreich, A Bacher, T Mittelberger, J Heinze and G Fuchs, *J Biol Chem*, **275**, 21889–95 (2000).

45 M Boll, G Fuchs, G Tilley, FA Armstrong and DJ Lowe, *Biochemistry*, **39**, 4929–38 (2000).

The membrane-bound nitrate reductase A from *Escherichia coli*: NarGHI

Michela Bertero

Centre for Genomic Regulation, Barcelona, Spain

FUNCTIONAL CLASS

Enzyme; membrane-bound quinol:nitrate oxidoreductase A; EC 1.7.99.4; a prokaryotic quinol:nitrate oxidoreductase containing three subunits (NarG, NarH, and NarI) and eight redox centers (one molybdenum cofactor, five iron–sulfur clusters, and two heme groups); known as *NarGHI*.

Bacterial nitrate reduction can be catalyzed by three classes of nitrate reductases: assimilatory nitrate reductases (NASs), periplasmic nitrate reductases (NAPs), and membrane-bound respiratory reductases (NARs).[1] These enzymes differ in their cellular location, function, subunit composition, and number and identity of their redox centers. NAS is formed by one subunit, located in the cytoplasm and is involved in nitrogen assimilation. NAP is a two-subunit complex in the periplasm and presents functional flexibility, involved in nitrate respiration or energy dissipation according to the organism. NAR is a three-subunit enzyme located in the membrane exposed to the cytoplasm and participates in anaerobic nitrate respiration.

NarGHI belongs to the NAR class and comprises three subunits with distinct functionalities: NarI (the membrane anchor subunit), NarH (the electron transfer subunit) and NarG (the catalytic subunit). NarGHI catalyzes electron transfer from the quinol oxidation site, located in NarI in the membrane, through the redox cofactors, embedded in the enzyme, to the molybdo-bis(molybdopterin) guanine dinucleotide (Mo-bisMGD) cofactor located in the cytoplasmic NarG, where nitrate is reduced to nitrite. The overall reaction is a two-electron and two-proton process. NarGHI can accept electrons from both menaquinol (MQH_2) and ubiquinol (UQ_2) as physiological reductants.[2] In addition to nitrate, other substrates can be reduced, such as Cl^-, F^-, NO_2^-, ClO_4^-, and BrO_4^-.[3]

OCCURRENCE

The membrane-bound nitrate reductases have been described among different bacterial species, both gram

(a)　　　　　　　　　(b)

3D Structure　　Ribbon representation of NarGHI as a monomer (a) and as a dimer (b). NarG is in green, NarH in red, and NarI in blue. NarGHI monomer is rotated approximately 90° around the vertical axis compared to the right NarGHI in the dimer. Cofactors are represented as sticks. PDB code is 1Q16. All the 3D structures presented in this manuscript were created using PyMOL.[19]

negative and gram positive. The enzymes have been reported also in a few obligate aerobic bacteria, such as *Mycobacterium tuberculosis* and *Streptomyces coelicolor*.[1] Interestingly, operons encoding NAR enzymes have been reported in hyperthermophilic[4] and halophilic Archaea.[5]

In a few species, such as *E. coli*, a second membrane-bound nitrate reductase has been discovered, known as *NarZYW*.[6] This is expressed at cryptic levels and may assist the bacterium in the transition from aerobic to anaerobic respiration.

BIOLOGICAL FUNCTION

Anaerobic conditions and the presence of nitrate are signals for *E. coli* to activate the synthesis of a respiratory chain, which is initiated by the membrane-bound formate dehydrogenase, FdnGHI, and terminated by the membrane-bound nitrate reductase, NarGHI. Electrons are transferred from the formate oxidation site in FdnGHI to the nitrate reduction site in NarGHI, *via* a plethora of redox prosthetic groups and the lipid soluble quinol pool (Figure 1). Electron transfer is coupled to proton translocation across the membrane, generating a proton motive force by a redox loop mechanism as proposed by the chemiosmotic theory of Mitchell.[7] In physiological terms, the production of a proton motive force results in conservation of the free energy derived from the catalytic reactions.

AMINO ACID SEQUENCE INFORMATION

The three distinct subunits of NarGHI are encoded by the *narGHJI* operon. NarJ is not part of the final enzyme but is required as a specific chaperone for the correct assembly of the enzyme.[8,9]

- *Escherichia coli*: NarG subunit, 1246 AA (amino acid) residues, P09152 (UniProtKB/Swiss-Prot entry); NarH, 512 AA, P11349; NarI, 225 AA, P11350.

PROTEIN PRODUCTION, PURIFICATION, AND MOLECULAR CHARACTERIZATION

E. coli NarGHI can be purified from a recombinant system.[10] The enzyme is overexpressed in the engineered *E. coli* LCB2048 strain that carries a deletion of two endogenous operons, *narGHJI* and *narZYWV* (Δ*narGHJI*, Δ*narZYWV*).[9] The pVA700 expression vector encodes the entire *narGHJI* operon under the control of the hybrid *trp* (tryptophan) – *lac* (lactose) *tac* promoter and upon isopropyl-thio-galactoside (IPTG) induction. Bacterial cells are lysed through a French press cell, the membranes are purified by sucrose step-gradient centrifugation, and the enzyme is extracted with the detergent polyoxyethylene 9-dodecyl ether (Thesit). NarGHI is purified by two consecutive anion exchange chromatographic steps at pH 6.0 and 8.0 (diethylaminoethyl-dextran DEAE-sepharose) and a final gel filtration experiment (Superdex 200).

As judged by light scattering analyses, the purified form of NarGHI is a dimer of heterotrimers with a total molecular weight of ~500 kDa, and it is likely (see below) that this is the form of the enzyme that occurs *in situ* in the inner membrane of *E. coli*.[10] The membrane anchor subunit NarI (26 kDa) contains two *b*-type hemes, whose coordination and redox properties were previously determined by the use of optical and electron paramagnetic resonance (EPR) spectroscopy in combination with site-directed mutagenesis and redox potentiometry.[11] The electron transfer subunit NarH (58 kDa) contains four ferredoxin-type [4Fe–4S] and one [3Fe–4S] clusters, already recognized in the 1970s[12] and further characterized by EPR spectroscopy.[13] The catalytic subunit NarG (139 kDa) hosts the complex molybdenum cofactor, Mo-bisMGD, identified by sequence alignment comparison and spectroscopy studies, as well as a novel [4Fe–4S] cluster.[13,14]

ACTIVITY

Quinol:nitrate oxidoreductase activity is determined using a spectrophotometric protocol. Measurements are based on the absorption changes produced by oxidation of reduced quinol and menaquinol analogs, such as tetramethyl-*p*-benzoquinol (duroquinol) or 2-methyl-1,4-napthoquinol (menadiol), and plumbagin.[3,15] A stock ethanolic solution of each quinone analog is reduced by metallic zinc in acidified ethanol. The assay is initiated by addition of nitrate to the degassed assay buffer containing NarGHI (either enriched membranes or the purified enzyme) and the electron donors. The use of quinol analogs as

Figure 1 Schematic representation of the nitrate respiratory chain. Black arrows indicate electron transfer and red arrow proton translocation.

substrates tests the entire electron transfer relay of NarGHI. Alternative assays use reduced viologens as electron donors. Typically, a compound such as benzyl viologen is reduced with excess dithionite and its enzyme-catalyzed nitrate-dependent oxidation is followed spectrophotometrically.[16] Because viologens donate electrons nonspecifically, they are used to measure activities in variants of NarGHI in which the electron transfer relay is 'broken'.

X-RAY STRUCTURE OF THE COMPLEX

Crystallization

Crystallization of membrane proteins is extremely challenging and one of the critical parameters is the choice of the appropriate detergent. Key to the successful crystallization of NarGHI was the presence of 0.7 mM Thesit in the protein solution.[10] First crystals were obtained by the vapor diffusion method with sitting drops equilibrated against a reservoir solution containing 100 mM 4-(2-hydroxyethyl)-1-piperazineethanesulfonic acid (HEPES), pH 7.0, 20% (w/v) poly ethylene glycol (PEG 3000), 200 mM sodium acetate, 200 mM KCl, and 5 mM ethylene diamine tetraacetic acid (EDTA). Crystals were orthorhombic and belonged to the space group $C222_1$ with unit cell dimension $a = 154.175$ Å, $b = 241.376$ Å, and $c = 139.494$ Å. Only one complex was present per asymmetric unit. Optimization of the cryoprotectant solution (100 mM HEPES, pH 7.0, 35% (w/v) PEG 3000, 300 mM sodium acetate, 200 mM KCl, 5 mM EDTA, and 0.7% Thesit) allowed crystal diffraction to 1.9 Å resolution. Selemethionine-substituted crystals were obtained following the same protocol. Similar experimental conditions were used to obtain several NarGHI crystal structures, containing single point mutations or in complex with the quinol inhibitor pentachlorphenol (PCP).

Overall architecture of NarGHI

The three subunits of NarGHI form a highly stable heterotrimer with dimensions of $90 \times 128 \times 70$ Å (3D Structure). The cytoplasmic NarG and NarH interact through extensive interfaces (~ 11.452 Å2) and are anchored to the membrane by NarI, predominantly through hydrophobic surfaces. In particular, the positively charged 'stop-transfer' sequences of NarI[17] interact with NarGH, suggesting that the latter subunits are exposed toward the cytoplasm, as supported previously by chemical labeling studies.[18]

One of the most striking features of NarGHI structure is revealed by the high-quality experimental electron density map: eight redox centers aligned on a single chain that runs like an electrical wire inside the enzyme for a total length of ~ 98 Å (Figure 2). Following the chain from the periplasm to the cytoplasm, we encounter heme b_D (distal), heme

Figure 2 Redox centers within NarGHI (similar orientation as in 3D Structure). Edge-to-edge distances are shown by dotted lines.

b_P (proximal), one [3Fe–4S] cluster (FS4), four [4Fe–4S] clusters (FS3, FS2, FS1, and FS0), and the Mo-bisMGD cofactor. Edge-to-edge distances between the redox centers are well within the 14-Å limit observed for physiological electron transfer.[20]

The heterotrimer NarGHI forms butterfly-shaped dimers in the crystals with dimensions $143 \times 128 \times 90$ Å and a twofold symmetry axis approximately perpendicular to the membrane. An extensive buried surface area ($\sim 12\,374$ Å2) exists between the two NarGHI heterotrimers in the complex, suggesting that the dimeric 'butterfly' is likely to be the physiologically relevant form of the enzyme. This is supported by the observation of the 'swapping' of a NarH helix-turn domain into the symmetry-related NarGHI and the identification of a phospholipid molecule at the interface between the two NarIs of one dimer. However, the distances between the redox centers belonging to the two symmetry-related complexes are too long to allow electron transfer, precluding kinetically competent electron transfer between the individual heterotrimers.

In the following paragraphs, each subunit is described in more detail following the same order in which the electrons travel through the enzyme.

NarI

NarI is the enzyme membrane anchor where quinol binds and is oxidized (the so-called Q site) initiating the journey

(a)

(b)

Figure 3 Ribbon representation of NarI (a) and close view to the hemes b_D and b_P (b). The helices have been removed and the coordinating histidine residues are shown.

of the electrons to nitrate within the complex. NarI contains five transmembrane helices (TM, I–V) that are tilted approximately $30°$ to the membrane normal (Figure 3(a)). Two short helices, one α and one 3_{10}, connect TM IV and V, and a C-terminal tail extends toward the cytoplasm to interact with NarGH. TM I, the first N-terminal helix, is involved in dimerization; TM II–V form a four-helix bundle that contains two heme groups, b_D and b_P. Each heme is oriented approximately parallel to the membrane normal and presents a Fe atom coordinated by two histidines: His66 and His187 coordinate b_D and His56 and His205 coordinate b_P, confirming previous functional studies (Figure 3(b)).[21]

NarH

The electron transfer subunit NarH contains four ferredoxin-type iron–sulfur clusters: three [4Fe–4S] referred to as *FS1*, *FS2*, and *FS3* and one [3Fe–4S] as *FS4*.[10] The redox potentials of the iron–sulfur clusters were previously determined by electrochemical methods: FS1 +130 mV, FS2 −420 mV, FS3 −55 mV, and FS4 +180 mV.[13] The NarH core is constituted by two domains, A and B, each holding two iron–sulfur centers and related to each other by twofold rotational symmetry (Figure 4). The fold of A and B is similar to the fold of bacterial 2 × [4Fe–4S] ferredoxins with two clusters sandwiched between two helices and one β-sheet.[22] Extra ordered motifs decorate

the protein surface (AA 46–174, 272–341, 357–509) and provide subunit–subunit interactions as well as shielding for the clusters.

Figure 4 Ribbon representation of NarH. Dark red indicates the 'core' and light red the nonconserved motives. The positions of the FS are indicated by arrows.

NarG

NarG belongs to the dimethyl sulfoxide (DMSO) reductase family containing the Mo-bisMGD cofactor. Several structures from this family have emerged in the recent years,[23–27] showing a common architecture. NarG 'core' presents the four conserved α–β domains organized around the catalytic center where nitrate is reduced to nitrite (Figure 5). Domains II and III form a cleft where the Mo-bisMGD cofactor is located. As observed previously in NarH, several extra motifs are present (AA 1–40, 115–150, 339–472, 616–638, 667–690, and 843–990) and mostly located at the surface of the enzyme toward the cytoplasm. These extra motifs decorate the narrow funnel also, which leads to the active site.

Unexpectedly, NarG contains an additional [4Fe–4S] cluster that was not detected by EPR spectroscopy prior to the determination of the structure.[13] This cluster, known as *FS0*, is coordinated by three cysteines (Cys54, Cys58, and Cys93) and one histine (His50). In the light of this finding, FS0 has been restudied and characterized by EPR spectroscopy and redox potentiometry, revealing an EPR

spectrum typical of a species with an $S = 3/2$ ground state and a redox potential of -55 mV.[14]

The molybdenum catalytic center

The Mo-bisMGD cofactor elongates to 34 Å within NarG, with one half, MGD-P (nomenclature as in Schindelin *et al.*),[24] coordinated by domain II and the other half, MGD-Q, coordinated by domain III. During the catalytic cycle, the Mo metal center cycles through the +4, +5, and +6 oxidation states. The NarGHI crystals[10] were obtained aerobically and most likely Mo is in the +6 oxidated state. In the structure, Mo is coordinated by six ligands: four *cis*-thiolate sulfur atoms (Mo–S distance ~2.4 Å) belonging to the two halves MGD-P and MGD-Q and both side-chain oxygens of the residue Asp222 (Mo-OD1 1.9 Å and Mo-OD2 2.4 Å). Aspartic acid coordination is observed for the first time in a Mo-bisMGD enzyme, where only serine, cysteine, or selenocysteine were previously reported.[28] Asp222 is absolutely conserved among NarG of gram-positive and gram-negative bacteria and Archaea.[29] The crystal structure of the soluble *E. coli* NarGH domain revealed ASP coordination.[29] However, the coordination sphere around the Mo center shows significant differences (Figure 6): the bidentate Asp222 interaction is substituted by the interaction of only one carboxylate oxygen of Asp222 and an additional oxo group (Mo–oxo 1.8 Å). The second carboxylate oxygen of Asp222 is hydrogen bonded to His546. The authors suggest an 'Asp pendulum hypothesis': ASP could oscillate between single and bidentate interactions with Mo, according to the protonation state of His546. It was previously shown that the enzyme activity is pH dependent and controlled by pK of ~8.[12,30] The observed differences might also be because of structural flexibility at the active site or different oxidation states in the two structures. Further investigation is required to gain deeper insight into the molecular details of nitrate reduction.

An additional peculiarity revealed by the NarGHI structure[10] is the novel bicylic dihydropterin structure of MGD-Q, rather than the typical tricyclic pyranopterin structure of MGD-P, as well as all of other MGD moieties in the solved crystal structures (Figure 6). The authors speculate a possible involvement in the catalytic mechanism. The following point mutations were introduced in NarGHI: NarG-S719A, NarG-H1163A, and the double mutation (RA Rothery, *personal communication*, 2008). Both residues are in the proximity of MGD-Q and in particular His1163 is hydrogen bonded to the oxygen in the open ring of MGD-Q. In NarGHI carrying H1163A and the double mutation, a drop in the overall enzyme potential is observed: from about +135 mV, which is the average value of the Mo (+6/+5) and Mo (+5/+6) conversions, to approximately +50 mV. A concomitant drop in

(a)

(b)

Figure 5 Structure of NarG and its domain organization. (a) Ribbon representation and (b) topology diagram. Each β-strand is represented by an arrow and each α-helix by a cylinder.

Figure 6 Ball-and-stick representation of the active site of NarGHI (blue) superimposed on FdnGHI (yellow). Red arrows indicate the dihydropterin form observed in MGD-Q.

the enzyme activity is also observed. An attractive explanation for these observations is that MGD-Q is in the closed pyranopterin state in a NarG-H1163A mutant and its enzyme activity is retained at reduced level (RA Rothery, *personal communication*, 2008).

FUNCTIONAL ASPECTS

The reaction catalyzed by NarGHI is a quinol:nitrate oxidoreduction. Quinone is oxidized and the redox cofactors (two *b*-hemes and five iron–sulfur clusters) transfer electrons across a potential range from −100 and +100 mV, depending on the reductant quinone, menaquinol, or ubiquinol respectively, to +420 mV (nitrate/nitrite at pH 7.0) for the final reduction of nitrate.

The two sites catalyzing these substrate redox reactions are connected by a series of prosthetic groups with potentials not consistently organized in a thermodynamically 'downhill' direction. For example, a fairly large thermodynamic barrier exists for electron transfer between the FS3 cluster ($E_m = -55$ mV) and FS2 ($E_m = -420$ mV), with ΔE_m of −365 mV. Such large energy barriers are also observed in other respiratory chain enzymes, including succinate: ubiquinone oxidoreductase (complex II) and the membrane-bound *E. coli* DMSO reductase (DmsABC). The presence of such energy barriers in electron transfer relays remains unexplained.

Another intriguing aspect of the electron transfer relay of NarGHI is its length. The membrane-extrinsic NarH subunit coordinates a chain of four [Fe–S] clusters (FS4–FS1) that is supplemented by a fifth cluster in NarG (FS0). It represents an archetype of a subunit architecture found in a large family of prokaryotic enzymes. Amongst the other well characterized [Fe–S] cluster containing electron transfer relays, most contain only three clusters (e.g. complex II). The prominent exception to this simplifying trend is exemplified by the membrane-extrinsic arm of the *Thermus thermophilus* nicotinamide adenine dinucleotide (NADH): ubiquinone oxidoreductase (complex I), whose electron transfer relay comprises nine [Fe–S] clusters, seven of which appear to be on a logical electron transfer relay connecting its NADH-binding active site to the as yet structurally uncharacterized membrane-intrinsic arm of complex I.[31]

The precise mechanism of nitrate reduction has confounded oversimplification. For example, a simplified redox cycle for the enzyme would envision an oxo-transfer reaction in which an oxo group on the oxidized Mo +6 metal center is lost as OH^-/H_2O when the cofactor is reduced to the Mo +4 state. Nitrate would then bind to the reduced state and is reduced to nitrite, which is released leaving behind a nitrato oxygen to regenerate the oxo group on the Mo +6 species.

Recent protein film voltammetry studies have indicated that while the oxo-transfer aspects of this mechanism are valid, substrate binding appears to occur to the intermediate Mo +5 state of the cofactor, and that this binding is enhanced by the protonation of an ionizable moiety within the protein with a pK_a of approximately 7.8.[32] Interestingly, with low-nitrate concentrations (<250 μM), increasing the thermodynamic driving force (more negative electrode potentials) *decreases catalytic activity*. These results suggest that a redox transition (a reduction) occurring in the vicinity of the cofactor inhibits nitrate reduction. It is tempting to speculate that the 'regulating' species undergoing reduction is the FS0 cluster of NarG, but it could also represent an as-yet-uncharacterized redox transition associated with one of the pterins of the cofactor.

The Mo center of NarGHI was scrutinized extensively by EPR, ranging from studies carried out in the 1970s[12] to more recent studies that also incorporated site-directed mutants and enzymology.[33] In each case, a common theme is the observation of hyperfine splittings in the Mo +5 EPR associated with a pK_a very similar to that discussed above. A strong correlation exists between catalytic activity and protonation of the enzyme. Furthermore, at pH 5.85, it was observed that Mo (+5/+6) transition is not readily observed in potentiometric titrations,[33] increasing the availability of the catalytically competent Mo +5 state at high redox

potentials. It should be noted that both the protonated and unprotonated forms of the enzyme active site appear to be catalytically competent, with catalysis being quicker *via* the protonated form.

The precise details of the protonation and the functionality responsible for it will likely be delineated by mutagenesis of conserved residues within the enzyme active site. An obvious candidate is His546 identified by Moura and coworkers[28] as important in the 'Asp pendulum' hypothesis.

FUNCTIONAL DERIVATIVES

The X-ray structure of NarGHI in complex with PCP

Previous biochemical, kinetic, and biophysical studies showed the presence of at least one quinol binding and oxidation site (Q-site) in NarI, in proximity to the periplasm and the distal heme b_D (Q_D).[21,34–37] These data were further supported by the 2.0-Å resolution structure of NarGHI in complex with the quinol binding inhibitor PCP.[38] PCP is structurally related to the physiological quinol substrates of NarGHI and it was shown to strongly inhibit the enzyme activity and to alter the spectroscopic properties of the heme b_D.[38] PCP binds into a small hydrophobic pocket delimited by helices II and III and located in proximity to the periplasmic side of the membrane (Figure 7). Most of the residues lining the pocket (Gly65, Gly69, Ala90, and Gly94) are highly conserved among the diverse bacterial NarI subunits. The hydroxyl group of PCP forms two hydrogen bonds, with one of the propionate groups of

b_D (2.8 Å) and with the Nε of His66, which coordinates b_D (2.8 Å). The edge-to-edge distance between PCP and b_D is 2.8 Å, which is well within the physiological limit for electron transfer.[20] In light of the structure and further modeling and mutagenesis investigation, it was proposed that the PCP pocket mimics the physiological Q_D-site. The conserved Lys86 was suggested to be an essential residue in defining the Q_D-site and in facilitating the binding of the electron donors.[38] A recent study has supported this hypothesis, showing that Lys86 is required for the stabilization of a semiquinone radical which is located at the Q_D site and most likely involved in the catalytic mechanism.[39] Although the crystal structures of Q sites characterized to date show no structural similarities, two other respiratory enzymes, the b_D quinol oxidase[40,41] and the *E. coli* fumarate reductase,[42,43] possess a lysine residue involved in quinol oxidation.

Quinol oxidation is coupled to proton translocation.[21] Does the NarGHI-PCP crystal structure suggest a possible proton pathway from the Q site to the periplasm? A network of water molecules can be observed in the 9-Å path between the propionate groups of b_D and the perisplasmic space. The four water molecules are the only ones buried within NarI; they are highly ordered and stabilized by extensive hydrogen bonding among themselves and the surrounding residues. 'Proton wires' formed by water molecules were already proposed in the *E. coli* FdnGHI[27,44] and the yeast cytochrome bc_1 complex.[44]

ATOMIC SNAPSHOTS OF THE FdnGHI/NarGHI REDOX LOOP

The *E. coli* nitrate respiratory chain is formed by two membrane-bound enzymes, FdnGHI and NarGHI. This respiratory chain is the paradigm for the 'proton motive force redox loop', which was proposed by Mitchell in his chemiosmotic theory.[7] Proton movement across the membrane, which generates proton motive force, is driven by a redox loop between the two distinct enzymes. Now the high-resolution crystal structures of the two protein complexes have been resolved as well as their functional derivatives. FdnGHI (1.6-Å resolution)[27] and its redox counterpart NarGHI (1.9-Å resolution)[10] are highly similar. They are both formed by three subunits with a soluble domain, FdnGH and NarGH, and a TM anchor, FdnI, and NarI. Despite differences in the fold of the TM subunits, NarI and FdnI, NarG superimposes on FdnG with root-mean-square (rms) deviation of 2.46 Å over 634 Cα atoms and NarH superimposes on FdnH with an rms deviation of 1.8 Å over 158 Cα atoms. Both enzymes form oligomers, trimers of FdnGHI, and dimers of NarGHI, which are oriented in opposite directions with respect to the membrane: toward the periplasm FdnGHI and toward the cytoplasm NarGHI. Their different topology is the key

Figure 7 A detailed view of PCP binding to NarI. Hydrogen bonds are indicated in red.

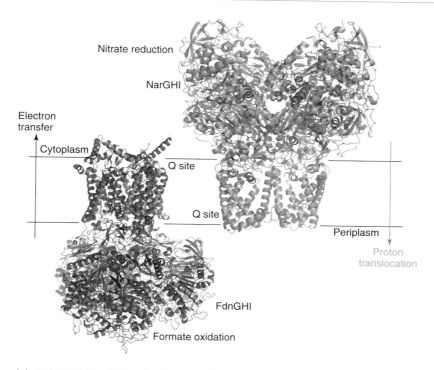

Figure 8 Atomic view of the FdnGHI–NarGHI redox loop and formation of proton motive force across the membrane.

for energy-efficient proton motive force generation. Fdn and Nar possess eight redox cofactors: two *b*-type hemes, five iron–sulfur clusters, and one Mo-bisMGD. By X-ray crystallography, the Q sites in FdnGHI and NarGHI were characterized, located at the cytoplasmic and periplasmic sides of the membrane, respectively.[10,27] Functional and structural information provide today an atomic framework of the nitrate redox loop (Figure 8). Formate is oxidized in the periplasm by FdnGHI to CO_2 and H^+, releasing two electrons, which are channeled through the redox cofactors to the Q site, where menaquinone is reduced to menaquinol taking up two protons from the cytoplasm. Then, the menaquinol diffuses within the lipid bilayer and binds to the NarGHI Q site, where it undergoes oxidation, releasing two protons in the periplasm and transferring two electrons to the nitrate reduction site in NarGHI. Nitrate is reduced to nitrite in the cytoplasm, consuming two cytoplasmic protons. Energy is conserved and proton motive force is generated.

ACKNOWLEDGEMENTS

I thank R. A. Rothery for critical reading and scientific discussions. I thank N. C. Strynadka for great supervision and support when I solved the NarGHI structure in her lab at University of British Columbia, Vancouver, Canada.

REFERENCES

1　DJ Richardson, BC Berks, DA Russell, S Spiro and CJ Taylor, *Cell Mol Life Sci*, **58**, 165–78 (2001).

2　BJ Wallace and IG Young, *Biochim Biophys Acta*, **461**, 84–100 (1977).

3　GN George, RC Bray, FF Morpeth and DH Boxer, *Biochem J*, **227**, 925–31 (1985).

4　Y Kawarabayasi, Y Hino, H Horikawa, S Yamazaki, Y Haikawa, K Jin-No, M Takahashi, M Sekine, S Baba, A Ankai, H Kosugi, A Hosoyama, S Fukui, Y Nagai, K Nishijima, H Nakazawa, M Takamiya, S Masuda, T Funahashi, T Tanaka, Y Kudoh, J Yamazaki, N Kushida, A Oguchi, K Aoki, K Kubota, Y Nakamura, N Nomura, Y Sako and H Kikuchi, *DNA Res*, **6**, 83–101, 145–52 (1999).

5　B Lledo, RM Martinez-Espinosa, FC Marhuenda-Egea and MJ Bonete, *Biochim Biophys Acta*, **1674**, 50–59 (2004).

6　F Blasco, C Iobbi, J Ratouchniak, V Bonnefoy and M Chippaux, *Mol Gen Genet*, **222**, 104–11 (1990).

7　P Mitchell, *J Theor Biol*, **62**, 327–67 (1976).

8　F Blasco, JP Dos Santos, A Magalon, C Frixon, B Guigliarelli, CL Santini and G Giordano, *Mol Microbiol*, **28**, 435–47 (1998).

9　F Blasco, J Pommier, V Augier, M Chippaux and G Giordano, *Mol Microbiol*, **6**, 221–30 (1992).

10　MG Bertero, RA Rothery, M Palak, C Hou, D Lim, F Blasco, JH Weiner and NC Strynadka, *Nat Struct Biol*, **10**, 681–87 (2003).

11　A Magalon, D Lemesle-Meunier, RA Rothery, C Frixon, JH Weiner and F Blasco, *J Biol Chem*, **272**, 25652–58 (1997).

12　SP Vincent and RC Bray, *Biochem J*, **171**, 639–47 (1978).

13　F Blasco, B Guigliarelli, A Magalon, M Asso, G Giordano and RA Rothery, *Cell Mol Life Sci*, **58**, 179–93 (2001).

14　RA Rothery, MG Bertero, R Cammack, M Palak, F Blasco, NC Strynadka and JH Weiner, *Biochemistry*, **43**, 5324–33 (2004).

15　G Unden and A Kroger, *Methods Enzymol*, **126**, 387–99 (1986).

16 J Buc, CL Santini, F Blasco, R Giordani, ML Cardenas, M Chippaux, A Cornish-Bowden and G Giordano, *Eur J Biochem*, **234**, 766–72 (1995).

17 G von Heijne, *J Mol Biol*, **225**, 487–94 (1992).

18 RW Jones and PB Garland, *Biochem J*, **164**, 199–211 (1977).

19 W DeLano, *The PyMOL Molecular Graphics System* (2002), On World Wide Web http://www.pymol.org.

20 CC Page, CC Moser, X Chen and PL Dutton, *Nature*, **402**, 47–52 (1999).

21 RA Rothery, F Blasco, A Magalon and JH Weiner, *J Mol Microbiol Biotechnol*, **3**, 273–83 (2001).

22 LC Sieker, E Adman and LH Jensen, *Nature*, **235**, 40–42 (1972).

23 JM Dias, ME Than, A Humm, R Huber, GP Bourenkov, HD Bartunik, S Bursakov, J Calvete, J Caldeira, C Carneiro, JJ Moura, I Moura and MJ Romao, *Structure*, **7**, 65–79 (1999).

24 H Schindelin, C Kisker, J Hilton, KV Rajagopalan and DC Rees, *Science*, **272**, 1615–21 (1996).

25 F Schneider, J Lowe, R Huber, H Schindelin, C Kisker and J Knablein, *J Mol Biol*, **263**, 53–69 (1996).

26 PJ Ellis, T Conrads, R Hille and P Kuhn, *Structure*, **9**, 125–32 (2001).

27 M Jormakka, S Tornroth, B Byrne and S Iwata, *Science*, **295**, 1863–68 (2002).

28 JJ Moura, CD Brondino, J Trincao and MJ Romao, *J Biol Inorg Chem*, **9**, 791–99 (2004).

29 M Jormakka, D Richardson, B Byrne and S Iwata, *Structure*, **12**, 95–104 (2004).

30 GN George, NA Turner, RC Bray, FF Morpeth, DH Boxer and SP Cramer, *Biochem J*, **259**, 693–700 (1989).

31 LA Sazanov and P Hinchliffe, *Science*, **311**, 1430–36 (2006).

32 SJ Elliott, KR Hoke, K Heffron, M Palak, RA Rothery, JH Weiner and FA Armstrong, *Biochemistry*, **43**, 799–807 (2004).

33 A Magalon, M Asso, B Guigliarelli, RA Rothery, P Bertrand, G Giordano and F Blasco, *Biochemistry*, **37**, 7363–70 (1998).

34 RA Rothery, F Blasco, A Magalon, M Asso and JH Weiner, *Biochemistry*, **38**, 12747–57 (1999).

35 A Magalon, RA Rothery, D Lemesle-Meunier, C Frixon, JH Weiner and F Blasco, *J Biol Chem*, **273**, 10851–56 (1998).

36 Z Zhao, RA Rothery and JH Weiner, *Biochemistry*, **42**, 14225–33 (2003).

37 Z Zhao, RA Rothery and JH Weiner, *Biochemistry*, **42**, 5403–13 (2003).

38 MG Bertero, RA Rothery, N Boroumand, M Palak, F Blasco, N Ginet, JH Weiner and NC Strynadka, *J Biol Chem*, **280**, 14836–43 (2005).

39 P Lanciano, A Savoyant, S Grimaldi, A Magalon, B Guigliarelli and P Bertrand, *J Phys Chem B*, **111**, 13632–37 (2007).

40 SF Hastings, TM Kaysser, F Jiang, JC Salerno, RB Gennis and WJ Ingledew, *Eur J Biochem*, **255**, 317–23 (1998).

41 T Mogi, S Akimoto, S Endou, T Watanabe-Nakayama, E Mizuochi-Asai and H Miyoshi, *Biochemistry*, **45**, 7924–30 (2006).

42 E Maklashina, P Hellwig, RA Rothery, V Kotlyar, Y Sher, JH Weiner and G Cecchini, *J Biol Chem*, **281**, 26655–64 (2006).

43 TM Iverson, C Luna-Chavez, LR Croal, G Cecchini and DC Rees, *J Biol Chem*, **277**, 16124–30 (2002).

44 C Hunte, J Koepke, C Lange, T Rossmanith and H Michel, *Structure*, **8**, 669–84 (2000).

Arsenite oxidase

Russ Hille

Department of Biochemistry, University of California, Riverside, CA 92521, USA

FUNCTIONAL CLASS

Enzyme; arsenite:acceptor oxidoreductase (EC 1.20.98.1). Arsenite oxidase catalyzes the two-electron oxidation of arsenite to arsenate, according to Equation (1):

$$AsO_2^- + H_2O \longrightarrow AsO_3^- + 2[e^-] + 2H^+ \qquad (1)$$

The enzyme is a member of the dimethyl sulfoxide (DMSO) reductase family of molybdenum-containing enzymes, with two equivalents of a pyranopterin cofactor common to all mononuclear molybdenum (and tungsten) enzymes coordinated to the metal *via* enedithiolate side chains.[1,2] The molybdenum coordination sphere of the oxidized enzyme is completed by an Mo=O group and, unusually, a second and longer Mo=O (or possibly a Mo–OH)[3] rather than an amino acid residue (such as serine, cysteine, selenocysteine, or aspartate) as found in other members of this family (Figure 1). The enzyme is an inducible,[4] αβ heterodimer of ~113 kDa molecular weight, with large and small subunits of 97 and 16 kDa, respectively (see below).

In organisms such as *Alcaligenes faecalis*, the reducing equivalents generated by the reaction are passed into the respiratory electron transfer chain for energy conservation.[1,4]

There is some question as to whether this energy conservation is sufficient to sustain growth,[5,6] although the most recent evidence suggests that it may well be, at least under certain conditions.[7] The fact that in organisms such as *Chloroflexus aurantiacus* the photosynthetic reaction center can oxidize arsenite oxidase further suggests a link between arsenite oxidase and energy conservation.[8] The best characterized form of the enzyme is that from the β-proteobacterium *A. faecalis*,[1–3] but the enzyme has also been characterized to a varying degree from *Hydrogenophaga* sp. str. NT-14,[9] *Rhizobium* sp. str. NT-26[10] and *C. aurantiacus*.[11]

OCCURRENCE

Arsenite oxidase is a broadly distributed and apparently ancient enzyme.[12] Genes encoding the two subunits of arsenite oxidase, annotated variously by the mnemonics *aro*, *aso*, and *aox*, have been identified in a wide variety of organisms, and on the basis of phyolgenetic analysis, it has been concluded that arsenite oxidase activity arose very early in the course of evolution, prior to the divergence of the archaeal and eubacteria domains[12] (although this conclusion has been the subject of active discussion in the

3D Structure The overall structure of arsenite oxidase from *A. faecalis*. The larger, catalytic subunit is in yellow, and the smaller Rieske subunit in blue, with the iron–sulfur centers rendered in space-filling mode. The figure was constructed using PyMOL (www.pymol.sourceforge.net) on the basis of the PDB file 1G8K.

Figure 1 The active site molybdenum center of arsenite oxidase from *A. faecalis*. In the protein, the pterin cofactor is elaborated as the dinucleotide of guanosine, as shown.

literature[13–15]). The larger, catalytic subunit possessing the active site molybdenum center is a member of the DMSO reductase family of molybdenum-containing enzymes, and the smaller subunit, with a characteristic [2Fe–2S] cluster having two cysteines coordinating one iron and two histidines the other, is a member of the diverse Rieske family of redox-active proteins.[1] Phylograms of both molybdenum and Rieske proteins place the respective subunits of arsenite oxidase in clearly distinct subtrees; the roots of these lie intermediate between archaeal and bacterial representatives.[12] These phylograms are also otherwise consistent with those based on the sequences of 16S RNAs, lending further support to the conclusion. It is on the basis of these observations that arsenite oxidase is considered to have arisen prior to the divergence of archaea and bacteria, and was present in the last universal common ancestor of life, having been assembled from progenitor proteins possessing various redox-active centers as building blocks.[12]

BIOLOGICAL FUNCTION

Arsenite oxidase catalyzes the oxidation of arsenite to the less toxic arsenate, with water presumably being the source of the oxygen atom incorporated into the product. Formally, the reaction is considered an oxygen atom transfer, since it has been demonstrated for members of this family of molybdenum-containing enzymes that a catalytically labile Mo=O group constitutes the proximal oxygen atom donor to the arsenite lone pair.[16] The reducing equivalents thus obtained by the enzyme in the course of this reaction are passed on to the respiratory electron transfer chain of the organism (*via* the Type 1 copper protein azurin or a *c*-type cytochrome) for energy conservation.[1] The enzyme is related to, but distinct from, the respiratory arsenate reductase (product of the *arr* gene) of, for example *C. arsenatis* and *Bacillus selenitireducens*, which is also a molybdenum-containing enzyme and which under at least certain conditions is also able to function as an

arsenite oxidase[17,18]; it is unrelated altogether from the plasmid-encoded *arsC* arsenate reductase from *Escherichia coli*, *Staphylococcus aureus* and yeasts that function in conjunction with an arsenite-specific ATPase to detoxify arsenate.[5]

AMINO ACID SEQUENCE INFORMATION

The genes encoding the two subunits of the bacterial and archaeal arsenite oxidases are variously annotated *aro*, *aso*, and *aox* in the literature. They encode an αβ heterdimeric protein, for example, AsoAB, with a catalytic large subunit (typically asoA, etc., but aoxB in the case of the arsenite oxidase from *Cenibacterium arsenoxidans*[19] and *Agrobacterium tumefaciens*[20]) and a small subunit possessing a Rieske-type iron–sulfur center.[12] The *Rhizobium* protein appears to be unusual in forming an $\alpha_2\beta_2$ tetramer.[10]

- *A. faecalis*: large subunit (asoA; SWISS-PROT accession number Q6WB60), 826 AA; small subunit (asoB; SWISS-PROT accession number Q6WB59), 175 AA. The amino acid sequence was initially reported on the basis of the protein crystal structure, which appeared prior to any protein or genetic sequencing work [SWISS-PROT accession numbers Q7SIF4 and Q7SIF3 for the aoxB (large subunit) and aoxA (small subunit), respectively]. A comparison with the amino acid sequence inferred from the unpublished sequence of the genes encoding the two subunits indicates that the crystallographic sequence for the large subunit was ~90% correct and for the small subunit 97%. A-42 residue sequence at the N-terminus is either unresolved in the crystal structure or cleaved from the protein.
- *Herminiimonas arsenicoxydans*: large subunit (aoxB; SWISS-PROT accession number Q8GGJ6), 826 AA; small subunit (aoxA; SWISS-PROT accession number Q8GGJ7), 173 AA.
- *Pyrobaculum calidifontis*: large subunit (Pcal-1369; SWISS-PROT accession number A3MVX3), 1026 AA; small subunit (Pcal-1370; SWISS-PROT accession number A3MVX4), 199 AA.
- *Vibrio splendidus*: large subunit (V12B01_14570; SWISS-PROT accession number A3UWX8), 908 AA; small subunit (V12B01_14575; SWISS-PROT accession number A3UWX9), 194 AA.
- *Xanthobacter autotrophicus*: large subunit (Xaut_3950; SWISS-PROT accession number A7IMD1), 820 AA; small subunit (Xaut_3949; SWISS-PROT accession number A7IMD0), 173 AA.
- *C. aurantiacus*: large subunit (Caur-1209; SWISS-PROT accession number A9WJY7), 836 AA; small subunit (Caur-1210; SWISS-PROT accession number A9WJY8), 217 AA.
- *Chloroflexus aggregans*: large subunit (Cagg_0377; SWISS-PROT accession number B8G319), 861 AA;

small subunit (Cagg_0378; SWISS-PROT accession number B8G320), 168 AA.

- *Burkholderia multivorans*: large subunit (asoA; SWISS-PROT accession numbers A9AS22 (829), A9AS22 (829)); small subunit (asoB; SWISS-PROT accession numbers B3DAM2 (172 AA), B3DAP3 (168 AA)).
- *Chlorobium phaeobacteroides*: large subunit (Cphamn1_2365; SWISS-PROT accession number B3EPM6), 853 AA; small subunit (Cphamn1_2364; SWISS-PROT accession number B3EPM5), 165 AA.
- *Chlorobium limicola*: large subunit (Clim_0382; SWISS-PROT accession number B3EFU2), 854 AA; small subunit (Clim_0383; SWISS-PROT accession number B3EFU3), 163 AA.
- *Thermus aquaticus*: large subunit (TaqDRAFT_3247; SWISS-PROT accession number B7AAY6), 861 AA; small subunit (TaqDRAFT_3248; SWISS-PROT accession number B7AAY7), 160 AA.
- *Thermus thermophilus*: large subunit (TTHB127; SWISS-PROT accession number Q53W39), 861 AA; small subunit (TTHB128; SWISS-PROT accession number Q53W38), 160 AA.
- *Hydrogenobaculum* sp. 3684: large subunit (aoxB; SWISS-PROT accession number C5H9R1), 861 AA; small subunit (aoxA; SWISS-PROT accession number C5H9R0), 160 AA.
- *Rhizobium* NT-26: large subunit (aroA; SWISS-PROT accession number Q6VAL8), 845 AA; small subunit (aroB; SWISS-PROT accession number Q6VAL9), 175 AA.
- *Ochrobactrum tritici*: large subunit (aoxB; SWISS-PROT accession number B7UB94), 846 AA; small subunit (aoxA; SWISS-PROT accession number B7UB93), 175 AA.

PROTEIN PRODUCTION, PURIFICATION, AND MOLECULAR CHARACTERIZATION

The literature protocol[1] for the purification of arsenite oxidase is from *A. faecalis* (NCIB 8687), with the organism grown to late log phase on rich medium at 30 °C in the presence of 0.1% (w/v) sodium arsenite. Cells are then filter-harvested, centrifuged and washed with a purification buffer (20 mM Tris–HCl, 0.67 mM phenylmethylsulfonylfluoride (PMSF), 0.6 mM EDTA, pH 8.4 containing 0.9% NaCl). After treatment with lysozyme, DNase, and RNase, the cells are disrupted by sonication and heated to 60 °C for 1 min, then cooled immediately to 4 °C and centrifuged to remove cell debris. The crude extract thus obtained is then subjected to gradient DEAE-Sepharose, Sepharose S-200, and phenyl-Sepharose chromatography. On SDS-PAGE chromatography, the protein shows a single band at 97 kDa due to the catalytic large subunit and a band running near the front attributable to the smaller 16 kDa Rieske-containing subunit.

ACTIVITY ASSAY

The standard assay for arsenite oxidase utilizes the dye 2,4-dichloorphenolindophenol (DCPIP) as an artificial acceptor, taking advantage of the large absorbance change ($\varepsilon = 23\,\mathrm{mM^{-1}\,cm^{-1}}$) at 600 nm seen upon reduction of the dye.[1] Standard conditions are 50 mM 2-(4-morpholino)-ethane sulfonate (MES) buffer, pH 6.0, 25 °C, and 200 μM sodium arsenite. The specific activity is defined as micromole DCPIP consumed per minute milligram protein, and the purified enzyme has a specific activity of 2.88.

METAL CONTENT AND COFACTORS

The arsenite oxidase from *A. faecalis* and related organisms possesses a molybdenum center of the type found in DMSO reductases[2] (but with an −OH ligand rather than the serinate found in these other enzymes[3]) and a [3Fe–4S] iron–sulfur cluster in its large subunit, and a Rieske-type [2Fe–2S] cluster in its small subunit. The molybdenum center has the metal coordinated by two equivalents of the pyranopterin cofactor common to all mononuclear molybdenum and tungsten enzymes, coordinated to the metal *via* an enedithiolate side chain. This cofactor is present in arsenite oxidase as the dinucleotide of guanosine.[2] The enzyme is, to date, unique among the DMSO reductase family of enzymes in lacking a protein ligand to the metal, instead having an Mo–OH ligand in place of the serinate or cysteinate ligand seen in other members of this family. The molybdenum center is the site of arsenite oxidation, and on the basis of the crystal structure (see below), the reducing equivalents thus obtained are passed first to the [3Fe–4S] cluster of the large subunit, then to the [2Fe–2S] cluster of the small subunit before being passed on to the physiological oxidant of the enzyme, the Type 1 copper-containing protein azurin or a *c*-type cytochrome.[1]

X-RAY STRUCTURE

Crystallization

The X-ray crystal structure of the arsenite oxidase from *A. faecalis* has been determined using multiple isomorphous replacement with anomalous scattering and multiple-wavelength anomalous dispersion methods to solve the phase (3D Structure).[2] Structures have been obtained from two crystal forms of arsenite oxidase, one in space group P1 with four molecules per asymmetric unit (1.64 Å resolution) and the other in space group P2$_1$ with two molecules per asymmetric unit (2.03 Å resolution). Both were obtained by the vapor diffusion method, the P1 crystals using a reservoir solution of 12% polyethylene glycol (PEG) 17 500 and 0.1 M MES, pH 6.4, the P2$_1$ crystals one of 15%

PEG 6000 and 0.1 M Tris–HCl, pH 8.5. $HgCl_2$ derivatives of the P1 crystal form were obtained by making the enzyme solution 0.25 mM in $HgCl_2$ and equilibrating against a reservoir solution of 9% PEG 10 000, 10 mM $CaCl_2$ and 0.1 M MES, pH 6.4. An ethylmercurisalicylate (EMTS) derivative was also obtained by making the enzyme solution 2 mM in EMTS and equilibrating against a reservoir of 10 PEG 17 500, 0.4 M $CaCl_2$ and 0.1 M MES, pH 6.4. The P1 crystals had unit cell dimensions $a = 90.7\,\text{Å}$, $b = 109.5\,\text{Å}$, $c = 117.6\,\text{Å}$, $\alpha = 97.7°$, $\beta = 90°$, and $\gamma = 96.4°$. For the $P2_1$ crystals, the unit cell dimensions were $a = 96.7\,\text{Å}$, $b = 114.3\,\text{Å}$, $c = 109.0\,\text{Å}$, and $\beta = 112.4°$.

Overall description of the structure

Despite the rather different crystallization conditions used to obtain the two types of crystal, and the significantly different crystal packing interactions in the two crystal forms, the overall structures obtained are remarkably similar; excluding the N- and C-termini, the root mean square deviation (rmsd) for backbone atoms is only 0.7 Å. The two subunits of the heterodimer are very tightly associated, with a subunit interface of 3790 Å². The dimer is stabilized by 31 hydrogen bonds (four of which are backbone–backbone). The irregularly shaped dimer has approximate dimensions of $75\,\text{Å} \times 75\,\text{Å} \times 50\,\text{Å}$.

A comparison of the sequence deduced from the crystallographic structure with that inferred from the sequences of the genes encoding the two subunits (SWISS-PROT accession numbers Q7SIF4 and Q7SIF3) indicates that an N-terminal methionine of the large subunit is not seen in the crystal structure, but that the crystallographically determined sequence is remarkably accurate as compared to that inferred from the gene sequences: ca. 90% for the large subunit, and 97% for the small subunit. More importantly, a 42-amino acid stretch at the N-terminus of the small subunit is also missing, presumably due to disorder in the crystal. This stretch includes the twin-arginine targeting sequence in the first 12 residues that marks the (prefolded) protein for export to the periplasm via the TAT system, along with a presumed membrane-anchoring α-helix. In the discussion of the crystal structure that follows, all amino acid residue numbers are those based on the full-length sequences of the two subunits and differ from those given in the original report of the crystal structure by 1 (for the large subunit) and 42 (for the small subunit).

The large subunit

Like other members of the DMSO family of molybdenum enzymes, the overall architecture of the large subunit of arsenite oxidase is divided into four domains, and like other members of this family that possess an iron–sulfur cluster,

the [3Fe–4S] cluster is found in the N-terminal Domain I (Figure 2).[2] This domain, made up of residues 2–120, 533–559, and 623–658, consists of three antiparallel β sheets and six α helices. The [3Fe–4S] cluster is coordinated by Cys22, 25, and 29; Ser100 occupies the position that would otherwise constitute a fourth cysteine coordinating the 'missing' iron in the cluster. The [3Fe–4S] cluster is deeply buried (>10 Å from the protein surface). Domain II of the large subunit consists of residues 121–196, 425–532, and 560–622, and Domain III of residues 197–425 and 659–683 have similar αβα sandwich topologies, with a (principally) parallel β sheet flanked by several α helices on each side that resembles the classic nucleotide-binding fold. As in the similar DMSO reductase, Domains II and III are related in the structure by a pseudo twofold axis of symmetry. Domain IV, residues 684–826, is a six-stranded β-barrel with flanking α helices.

The molybdenum center lies at the interface of Domains I–III at the bottom of a wide funnel-shaped depression in the protein surface. The two equivalents of the pterin cofactor are, according to the convention established with the structure of DMSO reductase,[21,22] designated P and Q. The P pterin lies at the interface between Domains II and IV and the Q pterin between Domains III and IV (Figure 2). The overall coordination geometry of the molybdenum is approximately square pyramidal, with the four sulfurs contributed by the two equivalents of the pterin cofactor occupying the equatorial plane and a single terminal Mo=O the apical position. The structure was

Figure 2 The structure of the large (asoA) catalytic subunit. The perspective is looking down the broad funnel that provides solvent access to the active site. The four domains are depicted in separate colors, with Domain I, which possesses the [3Fe–4S] cluster of the subunit on top, Domains II and III to the left and right, respectively, of the active site, and domain IV behind and to the bottom of the active site. The P pterin lies below the molybdenum and extends to the left toward Domain II, and the Q pterin above the molybdenum, extending to the right and Domain III.

interpreted as representing that of the reduced enzyme, as suggested by shifts in the iron X-ray absorption edge in the course of data acquisition, an interpretation consistent with subsequent X-ray absorption spectroscopic studies of the oxidized enzyme, which clearly indicated a pair of oxygen atoms in the molybdenum coordination sphere (an Mo=O at 1.70 Å and an Mo–OH at a longer 1.83 Å) in addition to the four pterin sulfurs (at a common distance of 2.47 Å). By analogy to the coordination geometry seen in the closely related DMSO reductase from *Rhodobacter sphaeroides*, the presumed coordination geometry in oxidized arsenite oxidase is trigonal prismatic. Arsenite oxidase is unique among members of the DMSO reductase family of molybdenum enzymes in lacking a protein ligand to the metal, the position equivalent to the serine ligand in the *R. sphaeroides* DMSO reductase (Ser147) is Ala200 in the structure of arsenite oxidase. In the absence of this interaction with the metal, the peptide loop containing Ala200 lies further away from the molybdenum than is seen in the structures of related enzymes, making the active site even more exposed than would otherwise be the case.

The small subunit

The small subunit of arsenite oxidase consists of an incomplete, six-stranded antiparallel β barrel, with the Rieske-type iron–sulfur cluster in an extruded loop, itself consisting of a four-stranded antiparallel β sheet (Figure 3). These two subdomains are connected by a disulfide bond (between Cys65 and 80) that is conserved among the true Rieske proteins (those otherwise similar proteins, with a pair of histidine ligands rather that cysteines but without the disulfide bond, are referred to as *Rieske-type*).[23] This disulfide bond is not universally conserved among the arsenite oxidases from a variety of organisms, however (the enzymes from the archaea *Aeropyrum pernix* and *Sulfolobus tokodaii*, for example, lack it[24]), creating the unfortunately confusing situation that, from the standpoint of their Rieske subunits, the arsenite oxidases are split between the two subclasses of Rieske proteins – that is, some are considered 'genuine' Rieske proteins, while others are merely 'Rieske-type'. With regard to the structure of the cluster itself, one iron of the [2Fe–2S] cluster is coordinated by Cys60 and Cys78, the other by His62 and His81; the latter iron is the redox-active iron of the cluster, and lies nearer to the redox-active centers of the large subunit. Of the four ligands to the Rieske center, only His81 is solvent exposed and presumably marks the general site of interaction with the physiological oxidant. Absent in the structure of the small subunit is the 42-amino acid stretch at the N-terminus, as referred to above, that is encoded by the *asoB* gene of *A. faecalis* and possesses the twin-arginine periplasm targeting sequence marking the protein

Figure 3 The structure of the small (asoB) Rieske subunit. The amino terminus, in the absence of the putative membrane-anchoring helix (see text), is shown at the top. The [2Fe–2S] cluster lies in a separate subdomain at the extreme left, adjacent to the subunit interface in the intact heterodimer and with the redox-active iron (that coordinated by the two histidine residues) proximal to the redox-active centers of the large subunit. The disulfide bond conserved among all proper Rieske proteins lies immediately in front of the [2Fe–2S] cluster in the orientation as shown. Histidine 81, at the lower left of the cluster, is solvent exposed, but histidine 22 is buried at the subunit interface.

for export, presumably as the intact heterodimer, *via* the TAT system. It has been suggested that this missing N-terminal sequence also constitutes a transmembrane helical anchor that is either disordered in the crystal or (more likely) cleaved off, either physiologically or in the course of purification. This membrane anchor would be analogous to that seen in the Rieske subunit of cytochrome bc_1, although it appears that the bulk of the subunits have a rather different orientation relative to the plane of the membrane. In the case of the arsenite oxidase from *C. aurantiacus*, the angular dependence of the amplitude of the g_x and g_y features of the Rieske electron paramagnetic resonance (EPR) signal in partially oriented membrane samples, suggests that the Fe–Fe vector lies approximately 45° to the membrane plane.[11] This and the known location of the putative membrane anchor limits the possible orientations to just two configurations for the protein relative to the surface of the membrane. Largely on the basis of phylogenetic and physiological arguments, it has been hypothesized that all arsenite oxidases are expected to be membrane anchored.[12]

SPECTROSCOPY AND ELECTROCHEMISTRY

The UV–visible absorption spectrum of the arsenite oxidase from *A. faecalis* exhibits the broad long-wavelength

absorption at ~700 nm that is characteristic of *bis*(enedithiolate) molybdenum centers, and additionally the absorption in the 440–490-nm region characteristic of iron–sulfur centers (by analogy to the absorption characteristics of the DMSO reductase from *R. capsulatus* or *R. sphaeroides*, which lack other redox-active centers, it is expected that the molybdenum center of arsenite oxidase also contributes to the observed absorption in this region, albeit to a lesser degree than the iron–sulfur clusters of the enzyme).[1] Prominent bands at 490, 570, and 690 nm are evident in the circular dichroism of the oxidized enzyme (the first two presumably principally due to the iron–sulfur centers, the last to the molybdenum center).[1] Absorption throughout the visible region is significantly bleached upon reduction of the enzyme either by substrate or by sodium dithionite. The oxidized enzyme exhibits a rhombic EPR signal attributable to the [3Fe–4S] cluster, with $g_{1,2,3} = 2.03$, 2.01, and 2.00; this signal disappears in the course of reductive titrations with substrate or sodium dithionite and is subsequently replaced by a second, much broader EPR signal typical of Rieske centers, with $g_{1,2,3} = 2.03$, 1.89, and 1.76.[1] Disappointingly, but consistent with the electrochemistry described below, no EPR signal attributable to the molybdenum center of arsenite oxidase in the paramagnetic Mo(V) oxidation state has been reported to date.

Using 647-nm excitation, the resonance Raman (rR) spectrum of oxidized arsenite oxidase exhibits a band at $822\,cm^{-1}$ that is shifted to $783\,cm^{-1}$ upon turning the enzyme over in [18-O]-labeled water, and which has been interpreted as an Mo=O.[3] This band is lost upon reduction of the enzyme. The other prominent modes seen in the rR are at 1525 and $1598\,cm^{-1}$, and by analogy to work done with DMSO reductase,[25] have been assigned to the enedithiolate C=C stretching modes of the P and Q pterins, respectively, of the molybdenum center.[3]

The electrochemistry of arsenite oxidase has been examined by protein film voltammetry (PFV) and spectroelectrochemical titration.[26] Using the latter method, the reduction potentials for the [3Fe–4S] and Rieske centers are estimated to be +260 and +130 mV *vs* the standard hydrogen electrode, respectively. Using PFV, the midpoint potential for the Mo(VI/IV) couple is determined to be +292 mV at pH 5.9 (+210 mV at pH 7.0); both oxidative and reductive peaks of the voltammogram exhibit a narrowness consistent with an obligatory two-electron process, which explains the failure to observe a Mo(V) EPR signal under either catalytic conditions or in the course of reductive titrations. This potential is extremely pH dependent with a linear 59 mV drop per pH unit in the pH 5–10 range, consistent with a double protonation on taking up a pair of electrons. In the presence of substrate, a catalytic wave is seen in the voltammogram that correlates well with the midpoint potential of the molybdenum center, demonstrating that this is indeed the active site of the enzyme.

INTRAMOLECULAR ELECTRON TRANSFER AND CATALYTIC MECHANISM

Electrons enter arsenite oxidase at the molybdenum center, reducing it from the Mo(VI) to the Mo(IV) oxidation state. On the basis of the crystal structure of the protein (Figure 4), it appears most likely that reducing equivalents then pass individually on to the [3Fe–4S] cluster of the large subunit, over a distance of 9.9 Å (from the molybdenum atom the sulfur of Cys24 that coordinates one of the [3Fe–4S] irons) then to the [2Fe–2S] Rieske center of the small subunit (13.0 Å iron to iron) prior to being passed on to azurin or a *c*-type cytochrome. It is the redox-active (histidine-coordinated) iron of the Rieske center that lies nearer the two redox-active centers of the large subunit. It is recognized that this pathway is uphill thermodynamically, since the Rieske center has the lowest reduction potential of the three centers. Still, at neutral pH, the distribution of a *pair* of reducing equivalents in the two-electron-reduced enzyme generated after reaction with a first equivalent of arsenite is approximately 50 : 50 Mo(IV) and oxidized Fe/S centers on the one hand, and Mo(VI) and reduced Fe/S centers on the other (this is because the average of the reduction potentials for the two iron–sulfur clusters is approximately equal to the midpoint potential for the Mo(VI/IV) couple at pH 7.0). From a structural standpoint, this pathway is certainly reasonable given the shorter jumps involved – the distance from the molybdenum atom to the nearer iron of the Rieske cluster, at 24.7 Å, far too long for effective electron transfer.[27] Having said this, it is to be noted that the Q pterin of the molybdenum center intervenes between the molybdenum atom and the Rieske cluster, and the distance between its distal amino group and the nearer iron of the Rieske center is much shorter, approximately 14.3 Å. This span is bridged by just two amino acid residues, Gln704 of the large subunit and Glu97 of the small subunit. Were the Q pterin to be electronically coupled to the molybdenum to the same degree as is seen, for example, the porphyrin to the iron in a heme group, then the effective distance would be effectively reduced – it is uncertain, however, as to whether this is indeed the case. In the case of xanthine oxidase, another molybdenum-containing enzyme, albeit having a significantly different molybdenum center than is seen in arsenite oxidase, the single pterin cofactor seen in the molybdenum center clearly spans the space between the molybdenum atom and the nearest redox-active center in the protein, a [2Fe–2S] ferredoxin site; the distal amino group of the pterin in fact hydrogen bonds to one of the coordinating cysteine residues of the iron–sulfur center. Nevertheless, the electron transfer from the molybdenum to the iron–sulfur cluster is not exceptionally fast, some $8500\,s^{-1}$ over a distance of 14.5 Å (metal to metal), and it is evident that the pterin does not provide an unusually effective electron transfer pathway within the enzyme.[28] Further, the magnetic circular dichroism spectrum of the

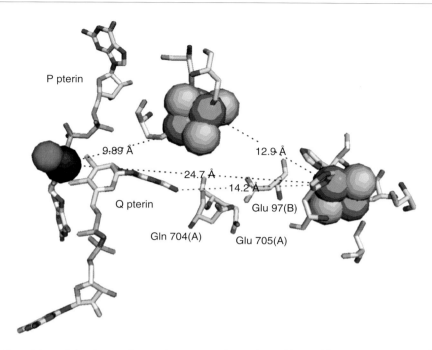

Figure 4 The spatial disposition of the three redox-active centers of arsenite oxidase with respect to one another.

Mo(V) state of xanthine oxidase has been interpreted in the context of a molecular orbital picture in which the interaction between the molybdenum and pterin ligand that is principally σ rather than π in nature,[29] making it less likely that the (limited) π conjugation of the pterin ring plays a significant role in shortening the effective distance from the molybdenum to a redox partner. Still, the overall structure of arsenite oxidase is suggestive, and in light of the failure to detect a Mo(V) intermediate in the reoxidation of the Mo(IV) state on even the shortest timescales experimentally accessible (*ca.* 10 ms) it may be that a first reducing equivalent leaves for the [3Fe–4S] cluster and the second concomitantly for the Rieske center *via* a spatially distinct pathway. It remains for future work to determine whether such a bifurcated electron transfer pathway (such as is thought to operate in the case of ubiquinol oxidation by cytochrome bc_1[30]) in fact operates in arsenite oxidase.

A specific proposal for the chemical course of the reaction for arsenite oxidase has been proposed. Formally, the reductive half of the catalytic cycle (i.e., the reaction of oxidized enzyme with arsenite) is thought to involve the oxygen atom transfer from the molybdenum coordination sphere to substrate in the course of oxidation, initiated by

the attack of the substrate lone pair on an antibonding Mo=O orbital according to Figure 5.[2]

The above chemistry is consistent with the known susceptibility of the $Mo^{VI}O_2$ unit to a nucleophilic attack by compounds with lone pairs of electrons,[31] and also with the observed involvement of two protons in the two-electron reduction of the enzyme (in the noncatalytic electrochemical reduction, the departing M=O oxygen must be doubly protonated to H_2O).[26] Furthermore, studies of a model compound having the general structure $Mo^{VI}O_2(bdtCl_2)_2$ ($bdtCl_2$ = dichlorobenzenedithiolate) have demonstrated that the reaction proceeds as shown, specifically demonstrating the oxygen atom transfer in ^{18}O labeling experiments.[32] Interestingly, a discrete $Mo^{V}O(OH)$ $(bdtCl_2)_2$ species was observed in the oxidation of the $Mo^{IV}O(bdtCl_2)_2$ model, which was subsequently oxidized to the $Mo^{VI}O_2(bdtCl_2)_2$ species. A comparable intermediate was not observed with the nonchlorinated benzenedithiolate ligand itself, demonstrating the extent to which subtle changes in the electronic structure of the enedithiolate ligand could influence the chemistry of the model.

Figure 5 The proposed reaction mechanism for arsenite oxidase.

REFERENCES

1 GL Anderson, J Williams and R Hille, *J Biol Chem*, **267**, 23674–82 (1992).

2 PJ Ellis, T Conrads, R Hille and P Kuhn, *Structure*, **9**, 125–32 (2001).

3 T Conrads, C Hemann, GN George, IJ Pickering, RC Prince and R Hille, *J Am Chem Soc*, **124**, 11276–77 (2002).

4 FH Osborne and HL Erlich, *J Appl Bacteriol*, **41**, 295–305 (1976).

5 R Mukhipadhyay, BP Rosen, LT Phung and S Silver, *FEMS Microbiol Rev*, **26**, 311–25 (2002).

6 S Silver and LT Phung, *Appl Env Microbiol*, **2005**, 599–608 (2005).

7 GL Anderson, M Love and BK Zeider, *J Phys IV France*, **107**, 49–52 (2003).

8 TR Kulp, SE Hoeft, M Asao, MT Madigan, JT Hollibaugh, JC Fischer, JF Stolz, CW Clubertson, LG Miller and RS Oremland, *Science*, **321**, 967–70 (2008).

9 RH vanden Hoven and JM Santini, *Biochim Biophys Acta*, **1656**, 148–55 (1004).

10 JM Santini and RH vanden Hoven, *J Bacteriol*, **186**, 1614–19 (2004).

11 D Zannoni and WJ Ingledew, *FEBS Lett*, **193**, 93–98 (1985).

12 E Lebrun, M Brugna, F Baymann, D Muller, D Lièvremont, C.-M Lett and W Nitschke, *Mol Biol Env*, **20**, 686–93 (2003).

13 C Richey, P Chovanec, SE Hoeft, RS Oremland, P Basu and JF Stolz, *Biochem Biophys Res Commun*, **382**, 298–302 (2009).

14 B Schoepp-Cothenet, S Duval, JM Santini and W Nitschke, *Science*, **323**, 583 (2009).

15 RS Oremland, JF Stolz, M Madigan, JT Hollibaugh, TR Kulp, SE Hoeft, J Fischer, LG Miller, CW Culbertson and M Asao, *Science*, **323**, 583 (2009).

16 BE Schultz, R Hille and RH Holm, *J Am Chem Soc*, **117**, 827–28 (1995).

17 T Krafft, JM Macy, T Krafft and JM Macy, *Eur J Biochem*, **255**, 647–53 (1998).

18 JF Stolz, P Basu, JM Santini and RS Oremland, *Annu Rev Microbiol*, **60**, 107–30 (2006).

19 D Muller, D Lièvremont, DD Simeonova, JC Hubert and MC Lett, *J Bacteriol*, **185**, 135–41 (2003).

20 DR Kashyap, LM Botero, WL Franck, FJ Hassett and TR McDermott, *J Bacteriol*, **188**, 1081–88 (2006).

21 H Schindelin, C Kisker, J Hilton, KV Rajagopalan and DC Rees, *Science*, **272**, 1615–21 (1996).

22 H.-K Lei, C Temple, KV Rajagopalan and H Schindelin, *J Am Chem Soc*, **122**, 7673–80 (2000).

23 CL Schmidt and L Shaw, *J Bioenerget Biomembr*, **33**, 9–26 (2001).

24 E Lebrun, JM Santini, M Brugna, A.-L Ducluzeau, S Ouchane, B Schoepp-Cothenet, F Baymann and W Nitschke, *Mol Biol Evol*, **23**, 1180–91 (2006).

25 SD Garton, J Hilton, H Oku, BR Crouse, KV Rajagopalan and MK Johnson, *J Am Chem Soc*, **119**, 12906–16 (1997).

26 KR Hoke, N Cobb, FA Armstrong and R Hille, *Biochemistry*, **43**, 1667–74 (2004).

27 CC Moser, CC Page, R Farid and PL Dutton, *J Bioenerget Biomembr*, **27**, 263–74 (1995).

28 R Hille and RF Anderson, *J Biol Chem*, **266**, 5608–15 (1991).

29 RM Jones, FE Inscore, R Hille and ML Kirk, *Inorg Chem*, **38**, 4963–70 (1999).

30 A Osyczka, CC Moser and PL Dutton, *Trends Biochem Sci*, **30**, 176–82 (2005).

31 M Pietsch and MB Hall, *Inorg Chem*, **35**, 1273–78 (1996).

32 H Sugimoto, M Tarumizu, H Miyake and H Tsukube, *Eur J Inorg Chem*, **2006**, 4494–97 (2006).

Acetylene hydratase

Grazyna B Seiffert[†], Dietmar Abt[†], Felix tenBrink[†], David Fischer[†], Oliver Einsle[‡] and Peter MH Kroneck[†]

[†] Universität Konstanz, Konstanz, Germany
[‡] Institut für Mikrobiologie und Genetik, Georg-August-Universität Göttingen, Göttingen, Germany

FUNCTIONAL CLASS

Enzyme; acetylene hydratase; EC 4.2.1.112; a tungsten protein containing a $W(MGD)_2$ (MGD, molybdopterin guanine dinucleotide) center and one [4Fe–4S] cluster per molecule, member of the DMSO-reductase family; known as *acetylene hydratase (AH)*.

Acetylene hydratase (AH) belongs to the group of hydrolyases. It catalyzes the addition of one molecule of water to the C≡C bond of ethine (trivial name, acetylene) forming acetaldehyde, a reaction distinct from the reduction of ethine to ethylene by nitrogenase.[1] The addition of one H_2O molecule to the C≡C bond – formally a nonredox reaction – requires a strong reductant, such as Ti(III) citrate or sodium dithionite, and the presence of chemically complex metal centers. Cyanide as well as nitric oxide are inhibitors, both organic nitriles (R–CN) and isonitriles (R–NC) do not react with AH.

OCCURRENCE

So far, AH activity has been only detected in bacteria. The strictly anaerobic fermenting bacterium *Pelobacter acetylenicus* can grow with acetylene as single carbon and energy source. The first step in the fermenting pathway is the transformation of acetylene to acetaldehyde which is then converted to acetate and ethanol.[2] The aerobic, acetylene-degrading bacteria *Mycobacterium lacticola*, *Norcadia rhodochrous*, *Rhodococcus* strain A1, and *Rhodococcus rhodochrous* have been reported to convert acetylene to acetaldehyde. Yet, AH activity could be demonstrated in crude extracts of *Rhodococcus* strain A1 only when the assay was performed under anoxic conditions.[3] Thus, acetylene appears to be the only hydrocarbon that is converted in the presence and absence of dioxygen by the same type of enzyme. Currently, only AH of *P. acetylenicus* has been purified to homogeneity and structurally and

3D Structure Three-dimensional structure of AH from *Pelobacter acetylenicus*.[4] Tungsten is shown as a blue sphere; iron and sulfide atoms of the [4Fe–4S] cluster are shown as gray and yellow spheres. The two MGD ligands of tungsten are shown as sticks (sulfur = yellow). Produced with the program PyMOL.[20] PDB code: 2E7Z.

functionally characterized.[4,5] Enzyme activity was located exclusively in the soluble fraction of the cell extract.

BIOLOGICAL FUNCTION

AH appears to be highly specific toward its substrate acetylene as no other substrates could be detected so far. Acetylene is well known to react with nitrogenase where it is reduced to ethylene, and it acts as an inhibitor for numerous metal-dependent enzymes.[6] AH catalysis is rather unique in the sense that two redox-active metal sites and the presence of a strong reductant are required to perform a nonredox reaction, i.e. the addition of water to a $C\equiv C$ bond. As the process depends on tungsten, and as most tungsten enzymes described to date have been purified from strictly anaerobic, thermophilic, or extremely thermophilic bacteria, one could speculate that metabolism of acetylene might represent an early form of life.[7] Given the hot, anoxic conditions under which life probably arose, tungsten might have been essential. Low-valent tungsten sulfides are more soluble in aqueous solution than their molybdenum counterparts and thus would be more available in the mostly reducing environment of the early earth. However, *P. acetylenicus* is a mesophilic organism, and the temperature optimum of AH has been determined to 55 °C.[8] Note that a molybdenum-dependent AH can be obtained from *P. acetylenicus* cultivated on molybdate (2 μM) in the presence of nanomolar concentrations of tungstate,[5] as reported for DMSO reductase from *Rhodobacter capsulatus*.[9] Furthermore, there exist several iron–sulfur proteins that do not catalyze redox reactions but hydration reactions, with aconitase being among the first discovered examples.[10] It had also been suggested that the physiological function of AH might be the hydrolysis of toxic substances, such as cyanide, or organic nitriles. In summary, a possible physiological function of AH beyond the conversion of acetylene to acetaldehyde cannot be defined at present.

AMINO ACID SEQUENCE INFORMATION

P. acetylenicus, 730 amino acid (AA) residues; GenBank accession # gi:33325844; molecular mass 81.85 kDa; theoretical pI 5.4, experimental pI 4.2; the *N*-terminal amino acid sequence, reported earlier,[1] had to be corrected at position 11, i.e. cysteine had to be exchanged against serine according to the nucleotide sequence. BLASTP searches show that *P. acetylenicus* AH has the highest similarity to a putative molybdopterin oxidoreductase of the hyperthermophilic archaeon *Archaeoglobus fulgidus*, with a sequence identity of about 35%; the five best matches of the search are representatives of three of the seven subfamilies of the DMSO-reductase family, indicating the unique status of AH. Five of the 15 cysteines of AH are highly conserved,

with four of them forming a typical [4Fe–4S] sequence motif $(C-X-X-C-X-X-X-C-(X)_n-C)$.[8]

PROTEIN PRODUCTION, PURIFICATION, AND MOLECULAR CHARACTERIZATION

AH has been isolated and characterized from the anaerobic bacterium *P. acetylenicus* grown in a medium containing tungstate.[1,4,5] Best results were obtained under the exclusion of dioxygen, in an atmosphere of 94% N_2/6% H_2. Recently, AH has been expressed in *Escherichia coli* and active enzyme could be obtained.[11]

The purification procedure consists of the preparation of the crude extract from *P. acetylenicus* grown with acetylene and tungstate in 20-liter bottles, at pH 6.7–7.0. After ammonium sulfate precipitation, three chromatographic steps (Resource 30Q, Resource 15Q, and Superdex S200) led to pure AH.[4] In solution, AH exists as a monomer of M_r of approximately 73 (SDS polyacrylamide gel electrophoresis), and 81.3 (AA sequence).

Most recently, the aerobically living bacteria *Gordonia rubripertincta* and *Gordonia alkanivorans*[12] have been investigated in the context of AH activity. In the latter case, active enzyme with so far unknown molecular properties has been isolated and purified to near homogeneity (criteria SDS gel electrophoresis). Note that this enzyme purified from an aerobe seems not to require protection against dioxygen; furthermore, the addition of a strong reductant is not needed to achieve activity.

METAL CONTENT AND COFACTORS

AH preparations obtained from *P. acetylenicus* grown on tungstate[1,4,5,8] have 4.4 ± 0.4 mol Fe, 0.5 ± 0.1 mol W, 3.9 ± 0.4 mol acid labile sulfur, and 1.3 ± 0.1 mol molybdopterin guanine dinucleotide (MGD) per mol enzyme; Selenium was absent.[5] Cultivation of *P. acetylenicus* on molybdate leads to an Mo-enriched AH, which does not contain tungsten but approximately 0.5 mol of Mo and 3.1 mol of Fe. Usually, metal content is assessed by inductively coupled plasma mass spectrometry (ICP-MS), acid labile sulfur by the method of Beinert,[13] and MGD by fluorimetry.[14]

ACTIVITY TEST

Enzyme activity is determined in a coupled test with yeast alcohol dehydrogenase following the rate of NADH oxidation at 365 nm under anoxic conditions, at 30 and 50 °C.[1,4,5,8] Specific activity is defined in units per milligram protein. One unit activity corresponds to the amount of protein that converts 1 μmol of acetylene to acetaldehyde per minute, under standard assay conditions. The purest

preparations from the usual source *P. acetylenicus* grown on tungstate exhibit activities of about 15 units (30 °C) *versus* 42 units mg^{-1} protein (50 °C); the specific activity of AH obtained from molybdate grown cells comes to 17 units mg^{-1} protein (50 °C).[8] Since BLASTP searches revealed a relatively high similarity between AH and an unknown molybdopterin oxidoreductase from *A. fulgidus*, AH activity was tested at 80 °C using *Sulfolobus solfataricus* alcohol dehydrogenase and *A. fulgidus* cells. Neither in the crude extracts nor in partially purified fractions, AH activity was higher than the background level without protein.[8]

SPECTROSCOPY

Pure AH (as isolated) shows a greenish-yellow color. The UV–vis spectrum reveals a shoulder around 375 nm typical for iron-sulfur clusters, and a broad maximum around 590 nm resulting from the W(MGD)$_2$ center. The room-temperature circular dichroism (CD) spectrum of AH (as isolated) shows a negative band at 435 nm and positive shoulders at 320 and 540 nm. The positive shoulder around 320 nm can be assigned to the [4Fe–4S] cluster as reported for ferredoxins I and II.[15]

The electron paramagnetic resonance (EPR) spectrum of AH (as isolated in the presence of dioxygen) may show a weak signal of a truncated [3Fe–4S] cluster, at $g_{av} = 2.02$. Upon reduction with dithionite, a rhombic signal appears, with *g* values at 2.048, 1.934, and 1.920 ($g_{av} = 1.97$). The line shape and *g* values indicate that this EPR signal results from a low-potential ferredoxin type [4Fe–4S] center.[16] When oxidized by [FeIII(CN)$_6$]$^{3-}$, a new EPR signal arises, with resonances at $g = 2.048$, 2.015, and 2.005 ($g_{av} = 2.022$) which is assigned to the tungsten center in the W(V) redox state.[5,8] The EPR spectrum of dithionite reduced AH from molybdate grown *P. acetylenicus* shows the same rhombic signal of the [4Fe–4S] cluster observed for the tungsten enzyme. However, the enzyme as isolated in the absence of dioxygen, exhibits a rhombic signal with *g* values at 2.023, 1.99, and 1.978 ($g_{av} = 1.997$) resulting from the corresponding Mo(V) center.

X-RAY CRYSTALLOGRAPHY

Crystallization

The first crystals of AH were grown by Einsle *et al.* under N$_2$/H$_2$ (94%/6%), in a final 0.1 M morpholinoethane sulfonic acid (MES) buffer, pH 6.5, containing 21% polyethylene glycol 8000, 0.2 M Mg(Ac)$_2$, and Na$^+$ dithionite, or Ti(III) citrate, as reductant;[17] crystals were flash-frozen at 100 K using 25% 2-methylpentane-2,4-diol (MPD) as cryoprotectant. They belonged to space group C2 with unit cell dimensions of $a = 120.7$ Å, $b = 70.5$ Å, $c = 106.5$ Å, $\beta = 124°$, (1 Å = 0.1 nm), and one monomer per

asymmetric unit. Single-wavelength anomalous dispersion data (W absorption edge) were collected at the European Synchrotron Radiation Facility (Grenoble, France). The quality of these data, however, did not allow obtaining a reasonably well-resolved three-dimensional structure.[18]

In a second attempt, crystals were grown by Seiffert *et al.* under N$_2$/H$_2$ (94%/6%), at 20 °C, using the sitting drop vapor diffusion method;[4] they formed over a period of 1–3 weeks, from 10 mg protein mL^{-1}, in 5 mM 4-(2-hydroxyethyl)-1-piperazine ethanesulfonic acid (HEPES)/NaOH, pH 7.5, containing 5 mM of Na$^+$ dithionite. A protein solution of 2 μL was mixed with 2.2 μL of 0.1 M Na$^+$ cacodylate, pH 6.5, containing 0.3 M of Mg(Ac)$_2$, 21% of polyethylene glycol (PEG) 8000 and 0.04 M Na$^+$ azide. 2-methyl-2,4-pentanediol (MPD) 15% was added as a cryoprotectant and the crystals were flash-frozen in liquid nitrogen. These plate-shaped crystals had a yellow–brown color and belonged again to space group C2; $a = 120.8$ Å, $b = 72.0$ Å, $c = 106.8$ Å, one monomer per asymmetric unit. The native structure was solved by SAD (Fe absorption edge) and has been refined to 1.26 Å resolution.[4] The model consists of 730 amino acid residues, 880 water molecules, two molybdopterin guanine dinucleotide (MGD) cofactor molecules, and one [4Fe–4S] cluster. Additionally, two MPD molecules, one acetate molecule, and one sodium ion have been identified in the crystal structure of AH.

Overall description of the structure

AH from *P. acetylenicus* consists of a single peptide chain (730 amino acid residues, molecular mass 81.85 kDa) and contains two MGD cofactors (MGD, designated P and Q, following the DMSO-reductase nomenclature).[19] Furthermore, it carries two metal sites, a tungsten center, and a cubane-type [4Fe–4S] cluster (3D structure). AH shares the general structural features of a member of the DMSO-reductase family of molybdenum and tungsten proteins (Figure 1; Table 1).

The peptide chain folds into a tertiary structure with four domains that are related by an internal pseudo-twofold axis and bury all cofactors deep inside the protein (Figure 1). Domain I (residues 4–60) holds the [4Fe–4S] cluster bound to Cys9, Cys12, Cys16, and Cys46. The subsequent domains II (residues 65–136 and 393–542) and III (residues 137–327) display an α, β, α-fold, with homologies to the NAD binding fold observed in dehydrogenases,[21] providing multiple hydrogen-bonding interactions to one of the MGD cofactors each, mediated by the variable loop regions at the C-termini of the strands of a parallel ß-sheet. The final domain IV (residues 590–730) is dominated by a seven-stranded β-barrel structure and participates in the coordination of both MGD ligands. The overall arrangement of cofactors is similar to the one observed in other members of the DMSO-reductase family, with the

Figure 1 View of the four domains of AH from *P. acetylenicus*. Domain I (blue) with the [4Fe–4S] cluster; domain II (dark green) with MGD$_P$; domain III (light green) with MGD$_Q$; domain IV (red). Produced with the program PyMOL.[20]

Table 1 Comparison of active site bond distances in AH, nitrate reductase (NR; PDB code 2NAP), and formate dehydrogenase (FDH; PDB code 2IV2)

Atom 1	Atom 2	Distance (Å)		
		AH	**NR**	**FDH**
Mo/W	S12 (P-MGD)	2.34	2.36	2.27
Mo/W	S13 (P-MGD)	2.52	2.19	2.23
Mo/W	S12 (Q-MGD)	2.40	2.40	2.49
Mo/W	S13 (Q-MGD)	2.28	2.39	2.29
Mo/W	S (4Fe–4S)	11.16	12.19	12.37
Mo/W	S (SG-Cys[a])	2.32[a]	2.59[a]	2.07
N19 (Q-MGD)	NZ (Lys[b])	3.00	3.01	3.26
S (4Fe–4S)	NZ (Lys[b])	4.23	4.28	3.76
W	O (HOH893)	2.04		
W	OD2 (Asp13)	3.91		
O (HOH893)	OD2 (Asp13)	2.41		
O (HOH893)	O (HOH426)	2.84		

[a] SG-Cys141 in AH (*P. acetylenicus*) and SG-Cys140 in NR (*Desulfovibrio desulfuricans* ATCC 27774).

[b] NZ Lys48 in AH, NZ Lys49 in NR (*D. desulfuricans* ATCC 27774) and NZ Lys44 in FDH (*E. coli*).

MGD molecules in an elongated conformation and the [4Fe–4S] cluster in close proximity to Q$_{MGD}$.

The secondary structure of AH has 46% α-helical (40 helices; 338 residues) and 15% ß-sheet (27 strands; 115 residues) character. The result of a multiple alignment of AH with structurally homologous enzymes, such as formate dehydrogenase (FDH), nitrate reductase (NR), and transhydroxylase (TH) documents four highly similar secondary structure elements (Figure 2).

Active site access

In the structures of proteins of the DMSO-reductase family, available to date, access to the active center is provided through a funnel-like entrance whose position is conserved in enzymes such as DMSO and trimethylamine-*N*-oxide (TMAO) reductases, as well as in formate and nitrate reductases (Figure 3). It aligns well with the pseudo-twofold axis between domains II and III that passes the active site metal ion. In AH, however, the entire region connecting domains II and III (residues 327–393) has been completely rearranged. This leads to a tight sealing of the substrate funnel and in a shift of the loop region ranging from residues 327–335 by more than 15 Å toward the protein surface. In formate and nitrate reductases, this loop separates the Mo/W center from the [4Fe–4S] cluster,

PDB	Domain I	Domain II	Domain III	Domain II	Domain IV
2e7z (A)	___Ss–Sh	------ssHs– Hhhs–	shShShHsh-------	hhShhsh------hhhhSh–hSh –Shshhhhs---------	shhshshSsshhs
2iv2 (X)	___Ss–Sh	------ Hs– Hhhs–	hhShShHhh --------	hShhs------- hhhSh–hSh –Ssshhh--------------	shshSsssh-
2nap (A)	___Ss–Sh	------hHs– Hshh–	shhShShHsh-------	hShsh--------- hhSh–hSh –Shsshhh--------	sshhshSsshs-
1h0h (K)	___Ss–Shh	----- sHsssHhhh–	shhShShHhh -----	hhShshh------ hhhSh –hShh Shsshhhsshh--- hhhsssshhsSsshs-	
1ogy (G)	___Ss–Sh	------ Hs– Hshhh –	shhShShHsh-------	hhShhs------- hhhSh–hSh –Shsshhh----------	hhsshshSsshs-
1vld (U)	Ss–SsshhshhsHs– Hshhhh	shhShShHhh --------	hShhhhh ----shssSh–hSh –Shshshhhs---------hhhshshSsshs-		

Figure 2 Comparison of the secondary structures of AH and members of the DMSO-reductase family. Multiple alignment of AH (*P. acetylenicus*, PDB code 2E7Z) with FDH (*E. coli*, PDB code 2IV2), NR (*D. desulfuricans* ATCC 27774, PDB code 2NAP), FDH (*Desulfovibrio gigas*, PDB code 1H0H), NR (*Rhodobacter sphaeroides*, PDB code 1OGY), and TH (*Pelobacter acidigallici*, PDB code 1VLD) are shown.

(a)　　　　　　　　　　(b)　　　　　　　　　　(c)

Figure 3 Schematic view of active site access and surface representation of the domain structure of AH from *P. acetylenicus*. (a) Red cone, usual active site access of enzymes of the DMSO-reductase family (red cone), with the exception of AH which uses the black cone. (b) View of the four-domain structure typically found for members of the DMSO-reductase family. (c) View of the access to the catalytic site of AH. Produced using the program PyMOL.[20]

and its displacement in AH opens up a new face of the protein surface at the intersection of domains I, II, and III, providing access to the active site from a very different angle (Figure 3).

Active site tungsten center

The major rearrangement within an otherwise conserved protein fold has marked consequences for the architecture of the catalytic site of AH. The tungsten center, most likely W(IV) in the active state, is bound to the four sulfur atoms of the dithiolene moieties of the P_{MGD} and Q_{MGD} cofactors. As in dissimilatory nitrate reductase, this coordination is completed by a cysteine residue (Cys141) from the protein. Finally, the 6th ligand of the tungsten center shows a bond length of 2.04 Å, indicating a tightly coordinated water molecule (Figure 4). The active site geometry in this class of enzymes is commonly either described as square pyramidal or trigonal prismatic.[22] In AH, a slight rotation of the P-MGD cofactor leads to a more octahedral, or trigonal *anti*prismatic geometry. As a result of the displacement of the loop region 325–335 from the active site, the substrate acetylene can access the tungsten ion through a channel approximately 17-Å deep and 6–8-Å wide, close to the N-terminal domain that harbors the [4Fe–4S] cluster. Within

this domain, a very important residue, namely Asp13, is then positioned in such a way as to interact closely with the water bound to the tungsten ion, forming a short hydrogen bond of 2.4 Å (Figure 4).

Substrate binding

Above the metal and the coordinated water molecule, the substrate access funnel ends in a ring of hydrophobic residues, built by residues Ile14, Ile113, Ile142, Trp179, Trp293, and Trp472 (Figure 5). These residues, originating from domains I, II, and III, build a small binding cavity with dimensions that make it a perfect mold for binding acetylene. Pressurization of crystals of AH with acetylene as well as soaking of crystals of AH with acetylene or the inhibitor propargyl alcohol failed so far to produce a crystalline adduct. However, docking of an acetylene molecule at this position is possible and results in a perfect fit, positioning the two carbon atoms of the substrate exactly above the water molecule coordinated to tungsten. Through shape complementarity, the residues of the hydrophobic ring are a key determinant for the enzyme's substrate specificity (Figure 5).

Figure 4 Active site structure of AH from *P. acetylenicus*. The tungsten center is coordinated to Q-MGD and P-MGD via four dithiolene sulfur atoms, one cysteine thiolate sulfur, and one oxygen from H_2O/OH^-. Asp13 provides a direct linkage to the [4Fe–4S] cluster via its ligand Cys12. Dithiolene sulfur atoms of MGD and sulfide atoms of [4Fe–4S] cluster are shown as orange spheres, cysteine sulfur as yellow, tungsten as green, and iron atoms as brown spheres, respectively. Produced using the Program PyMOL.[20]

(a) (b)

Figure 5 View of the active site channel of AH from *P. acetylenicus*. (a) Cartoon and (b) surface presentation of the ring of hydrophobic residues. Electrostatic surface potential colored in blue for a positive and in red for negative potential (cutoff +10 and −10, respectively). The distances between hydrophobic residues and tungsten are in the range between 4.41 and 6.20 Å, and 2.4 Å between Asp13 and water coordinated to tungsten. Produced with the program PyMOL.[20]

Function-based modifications

Caught in its active redox state and defined at very high resolution, the crystal structure of AH provides insight required to unravel the unique chemistry of this enzyme. The formation of acetaldehyde is not accomplished via an organometallic intermediate as described in organic chemistry textbooks, but rather by activation of a water ligand of the active site tungsten ion interacting with the nearby Asp13. While such an activating residue should be a Lewis-base by nature, aspartate is–in aqueous solution–indeed the most acidic amino acid, with a pK_a of 3.83. The solution to this problem is provided by the [4Fe–4S] cluster, one of whose ligands, Cys12, is an immediate neighbor of Asp13. While in other members of the DMSO-reductase family this cluster is involved in electron transfer, such functionality is obviously not required in AH. Note that Lys48, generally considered to be essential for electron transfer from the [4Fe–4S] cluster to Q_{MGD}, is conserved.[22] In AH, however, the active site is found at a different side of the W ion, closer to the iron–sulfur cluster, and redox chemistry is not taking place. Instead, a significant increase in pK_a for Asp13 is caused by the desolvation of this residue compared to the free acid in aqueous solution. Furthermore, the nearby [4Fe–4S] cluster appears to push electrons toward Asp13 and thus helps to increase its proton affinity. Density functional theory (DFT)-based atomic charges have been calculated and used to derive pK_a values for all protonable residues.[4] The entire protein contains 34 Asp and 58 Glu residues, and in the calculations only three of these reveal highly aberrant titration behavior, Asp298, Glu494, and Asp13. Asp298 shows a pK_a of 11.99 ± 1.53, while both Glu494 and Asp13 remain fully protonated, indicating a substantial increase of pK_a by more than 20 units. Consequently, Asp13 can act as a base in the activation of water bound to the tungsten center. The increased specific activity of AH under reducing conditions is, in part, explained by this finding, as the inductive effect and therefore the shift in pK_a and the degree of activation

of 1.6 Å showed a markedly shortened W–O distance of only 1.7 Å, indicative of an oxo ligand, while the rest of the structure remained essentially unchanged.[23]

The biomimetic complex, $[Et_4N]_2[W^{IV}O(mnt)_2]$ (Et, ethyl; mnt, maleonitrile dithiolate), has been reported earlier to catalyze the same reaction as AH, while the corresponding oxidized W(VI) complex is inactive, but can be reactivated by the addition of strong reductants.[24]

MECHANISM OF ACETYLENE HYDRATION

Independent of the fact that the structure of AH in complex with its substrate acetylene, or structural analogs, has not been achieved so far, a crucial question for unraveling the mechanism by which AH hydrates the C≡C bond of acetylene concerns the nature of the oxygen ligand (H_2O or OH^-) bound to tungsten. Owing to the proximity of the heavy scatterer tungsten, the W–O distance derived from the crystal structure may be distorted by Fourier series termination effects. At 1.26 Å resolution, a bond distance of 2.04 Å is observed for a true ligand distance of 2.25 Å. For the mechanism, this value is crucial, as the distance of 2.04 Å falls right between the values expected for a hydroxo ligand (1.9–2.1 Å) and a coordinated water (2.0–2.3 Å). Thus, two different mechanistic scenarios can be formulated: (1) the OH^- ligand will constitute a strong nucleophile and will yield a vinyl anion with acetylene[25] of sufficient basicity to deprotonate aspartate 13 to give the vinyl alcohol. A second water molecule can then bind to tungsten and will be deprotonated by the basic Asp13, thereby regenerating the hydroxo ligand for the next reaction cycle; (2) the bound H_2O molecule will gain a partially positive net charge via the proximity of the protonated Asp 13, making it an electrophile that, in turn, will directly attack the C≡C bond in a Markovnikov-type addition reaction with a vinyl cation intermediate.[25]

$$OH^{\ominus} + HC{\equiv}CH \longrightarrow HOHC{=}C^{\ominus}H + H^{\oplus} \longrightarrow H_2C{=}CHOH \rightleftharpoons H_3C{-}CHO$$

Nucleophile · · · · · · · · · · · Vinyl anion · · · · · · · · · · · Vinyl alcohol · · · · Acetaldehyde · · · · · · · · · · (1)

$$HOH + HC{\equiv}CH \longrightarrow H_2C{=}C^{\oplus}H + OH^{\ominus} \longrightarrow H_2C{=}CHOH \rightleftharpoons H_3C{-}CHO$$

Electrophile · · · · · · · · · · · Vinyl cation · · · · · · · · · · · Vinyl alcohol · · · · Acetaldehyde · · · · · · · · · · (2)

of the water ligand will be stronger in a reduced [4Fe–4S] cluster that carries an extra negative charge. As a second effect, both W and Mo in the (VI) state have been shown to bind oxygen preferentially in the oxo form, while the metals in the reduced +IV state favor water which, in AH, is required for reactivity. Determination of a structure of AH oxidized with 2 mM of $K_3[Fe(III)(CN)_6]$ at a resolution

In this reaction scheme, Asp13 will remain protonated. A definitive distinction between both mechanisms will require further studies, but we observe that our DFT calculations only converge for a water ligand in the reduced state and only for a hydroxo ligand in the oxidized state. This can be rationalized considering that the central metal ion is surrounded by five negative charges from its five thiolate

ligands, yielding a total charge of $(+1)$ in the oxidized *versus* (-1) in the reduced state, complementary to that of the respective ligand found to be stable in the calculations. As a consequence, and in accordance with the observed bond distances, the active W(IV) state should favor a water ligand and therefore the electrophilic addition mechanism.

Both mechanisms require the modified architecture of the enzyme, with a relocated substrate access pathway as well as with the ring of hydrophobic residues to guide and orient the substrate. A molecule of acetylene modeled into its putative binding site will be positioned right above the H_2O/OH^- ligand and fixed in place by hydrophobic interactions with the surrounding residues. The first product of acetylene hydration will be the vinyl alcohol, $H_2C=CHOH$, which will then undergo spontaneous tautomerization to acetaldehyde, CH_3CHO. With the product bound in this manner at the active tungsten center, the hydrophobic constriction may present a barrier for the access of water from the side of the substrate channel, the final step required to replenish the coordination of the tungsten atom and complete the reaction cycle. However, the structure shows that water can instead be taken out of a big pool of at least 16 well-defined water molecules in a pocket next to the active site. This arrangement offers an elegant solution to the problem of a possible product inhibition by association of the enol or aldehyde to tungsten.

Clearly, AH represents a highly sophisticated catalyst, equipped with the molecular toolbox of a regular tungsten-dependent redox enzyme, which has been intricately modified for an entirely different function.

REFERENCES

1 BM Rosner and B Schink, *J Bacteriol*, **177**, 5767–72 (1995).

2 B Schink, *Arch Microbiol*, **142**, 295–301 (1985).

3 JAM de Bont and MW Peck, *Arch Microbiol*, **127**, 99–104 (1980).

4 GB Seiffert, MG Ullmann, A Messerschmidt, B Schink, PMH Kroneck and O Einsle, *Proc Natl Acad Sci USA*, **104**, 3073–77 (2007).

5 RU Meckenstock, R Krieger, S Ensign, PMH Kroneck and B Schink, *Eur J Biochem*, **264**, 176–82 (1999).

6 MR Hyman and DJ Arp, *Anal Biochem*, **173**, 207–20 (1988).

7 R Hille, *Trends Biochem Sci*, **27**, 360–67 (2002).

8 D Abt, *Tungsten-Acetylene Hydratase from Pelobacter acetylenicus and Molybdenum-Transhydroxylase from Pelobacter acidigallici: Two Novel Molybdopterin and Iron-Sulfur Containing Enzymes* Dissertation, Universität Konstanz (2001).

9 LJ Stewart, S Bailey, B Bennett, JM Charnock, CD Garner and AS McAlpine, *J Mol Biol*, **299**, 593–600 (2000).

10 H Beinert, MC Kennedy and CD Stout, *Chem Rev*, **96**, 2335–74 (1996).

11 F ten Brink, unpublished data.

12 BM Rosner, FA Rainey, RM Kroppenstedt and B Schink, *FEMS Microbiol Lett*, **148**, 175–80 (1997).

13 H Beinert, *Anal Biochem*, **131**, 373–78 (1983).

14 JL Johnson, KV Rajagopalan, S Mukund and MWW Adams, *J Biol Chem*, **268**, 4848–52 (1993).

15 KS Yoon, C Bobst, CF Hemann, R Hille and FR Tabita, *J Biol Chem*, **276**, 44027–36 (2001).

16 R Cammack, DS Patil and VM Fernandez, *Biochem Soc Trans*, **13**, 572–78 (1985).

17 O Einsle, H Niessen, DJ Abt, G Seiffert, B Schink, R Huber, A Messerschmidt and PMH Kroneck, *Acta Crystallogr*, **F61**, 299–301 (2005).

18 H Raaijmakers, S Maciera, JM Dias, S Teixeira, S Bursakov, R Huber, JJG Moura, I Moura, and MJ Romao, *Structure*, **10**, 1261–72 (2002).

19 H Schindelin, C Kisker, J Hilton, KV Rajagopalan and DC Rees, *Science*, **272**, 1615–21 (1996).

20 WL DeLano, The PyMOL Molecular Graphic System, DeLano Scientific, San Carlos (2002).

21 AM Lesk, *Curr Opin Struct Biol*, **5**, 775–83 (1995).

22 H Dobbek and R Huber, *Molybdenum and Tungsten: Their Roles in Biological Processes*, Metal Ions in Biological Systems A Sigel and H Sigel (eds.), Marcel Dekker, New York, Basel Vol. 39, pp. 227–63 (2002).

23 PMH Kroneck and O Einsle, unpublished data.

24 J Yadav, SK Das and S Sarkar, *J Am Chem Soc*, **119**, 4315–16 (1997).

25 P Yurkanis Bruice, *Organic Chemistry*, Pearson Prentice Hall, Upper Saddle River (2004).

Mo–Se-containing nicotinate dehydrogenase

Holger Dobbek[t,§] *and Antonio J Pierik*[‡]

[t] Institut für Biologie, Strukturbiologie/Biochemie, Humboldt-Universität zu Berlin, Berlin, Germany
[§] Labor für Proteinkristallographie/Biochemie, Universität Bayreuth, Germany
[‡] Institut für Zytobiologie, Philipps-Universität Marburg, Marburg, Germany

FUNCTIONAL CLASS

Enzyme; nicotinate:NADP+ 6-oxidoreductase (hydroxylating); EC 1.17.1.5; a molybdenum hydroxylase containing molybdenum, iron–sulfur clusters and flavin adenine dinucleotide (FAD); is related to xanthine oxidoreductase (xanthine oxidase/dehydrogenase).

OCCURRENCE

Nicotinate dehydrogenases (NDHs), closely related to the well-characterized soluble *Eubacterium barkeri* four-subunit enzyme, are present in the genomes of two other clostridial species (*Anaerotruncus colihominis* DSM 17241 and *Natranaerobius thermophilus* JW/NM-WN-LF) and in *Bacteroides capillosus* ATCC 29799. NDH has been detected in many pseudomonads and other proteobacteria, on the basis of growth, enzyme activity, purification,[1–7] and/or genomic information.[8,9] NDH is also present in Gram-positive bacteria like *Bacillus niacini* and the sulfate reducer *Desulfobacterium niacini*.[10–12] The only eukaryote for which NDH has been described is

Aspergillus nidulans.[13] Characterization showed that the enzyme, which is also called *purine hydroxylase II*, has molybdopterin.[14] It is different from the α-ketoglutarate-dependent mononuclear iron-containing xanthine dioxygenase of *A. nidulans*.[15] The discovery of the latter enzyme shows that there might be other classes of NDH in nature, which could have been missed in screens based on amino acid sequence identity or activity measurements in the absence of added cosubstrate.

BIOLOGICAL FUNCTION

In all organisms NDH is the first enzyme that labelizes the pyridine moiety of nicotinate by hydroxylation to 6-hydroxynicotinate. This process is reversible with an equilibrium on the side of the products, 6-hydroxynicotinate and NADPH.[16] Further catabolism invariably involves a complex series of other enzymes, which vary depending on the type of organism and availability of oxygen in the environment.[17] Under fermentative[18] or microaerobic[19] conditions, 6-hydroxynicotinate is reduced to 1,4,5,6-tetrahydro-6-oxonicotinate (THON). After cleavage of the ring and elimination of ammonia, 2-formylglutarate

3D Structure Schematic presentation of the homodimeric NDH structure (PDB-Id: 3HRD). Each subunit has a different color. The dimer is presented with the twofold rotation axis relating the two monomers lying within the plane of the picture. Subunits are labeled. The cofactors (FAD, two [2Fe–2S]-clusters, and Mo–MCD) are shown as spheres. All figures were prepared using PyMOL.[43]

is formed, which in *E. barkeri*, is converted to acetate, propionate, and CO_2 in six further steps.[8] In *Azorhizobium caulinodans* and various other proteobacteria, 2-formylglutarate is presumably degraded via glutaryl- and crotonyl-CoA to acetate. Nothing is known on the pathway in the sulfate-reducing organism *D. niacini*.[10]

In organisms living in an aerobic habitat, 6-hydroxynicotinate is subjected to a second hydroxylation yielding 2,6-dihydroxynicotinate[12] or oxidatively decarboxylated to 2,5-dihydroxypyridine.[20] The latter pathway has recently been completely elucidated.[9] Nicotinate degradation is not only of environmental significance but its conversion has also found application in the industrial production of hydroxylated nicotinate derivatives by Lonza in Visp, Switzerland.[21–24] Their patented applications employ 'resting' cell suspensions of the aerobic nicotinate-catabolizing bacterium *Achromobacter xylosoxidans* LK1 as source of NDH. Production of ton-scale quantities of 6-hydroxynicotinate is carried out in volumes of up to 12 000 L. The high 6-hydroxynicotinate concentration in the medium inhibits further catabolism by consecutive enzymes. After optimization, *Pseudomonas fluorescens* TN5 cells produced 191 g L^{-1} [25] and *Serratia marcescens* IFO12648 yielded 301 g L^{-1} 6-hydroxynicotinate.[26] Many other hydroxylations have been described (see reference [27] for a review): *Comamonas testosteroni* hydroxylates 3-cyanopyridine to 3-cyano-6-hydroxypyridine[28] and *Agrobacterium* sp. DSM6336 produces 5-hydroxypyrazine-2-carboxylate from 2-cyanopyrazine.[29] These hydroxylations are thought to be carried out by NDH, though this has not been proven.

AMINO ACID SEQUENCE INFORMATION

In *E. barkeri*, the nicotinate fermentation gene cluster encodes 17 genes such as *ndhF*, *ndhS*, *ndhL*, and *ndhM*.[8] These partially overlapping genes code for the four subunits of the NDH: NdhF, the F subunit binding the flavin adenine dinucleotide (FAD) cofactor, NdhS, the S (small) subunit coordinating the two [2Fe–2S] clusters, NdhL and NdhM, the molybdopterin cytosine dinucleotide (MCD) binding L (large) and M (medium) subunits, respectively. The presence of two subunits is highly unusual for enzymes binding MCD and similar cofactors. N-terminal amino acid sequencing of the subunits of the purified enzyme,[30] the presence of a consensus Shine–Dalgarno sequence at appropriate distance before the start codon of NdhM,[31] bioinformatic analysis (see supplement of reference [32]), and the X-ray crystallographic density[32] corroborate the presence of separate subunits. Independent evidence is supplied by the genomic sequence of *N. thermophilus* JW/NM-WN-LF, which shows that this organism has a nicotinate fermentation gene cluster with an NDH, with two MCD binding subunits. In the genome of *A. colihominis* DSM 17241 and *B. capillosus* ATCC 29799, otherwise very similar NDHs

are found (amino acid sequence identities of 50–86%). They have a 'regular' single MCD binding subunit, which corresponds to a fusion of NdhL and NdhM. Accessory genes relating to MCD biosynthesis and selenium insertion were not found in the vicinity of the structural subunits or the entire gene cluster in the aforementioned organisms. The NDHs from proteobacteria have lower amino acid sequence identities for the NdhS and NdhL/NdhM subunits (17–46% [8]). Absence of NdhF homologs in the gene clusters and presence of three CXXCH cytochrome *c* binding motifs at the C-terminus of the NdhLM homolog[8,9] indicates that electron acceptors other than NAD(P)$^+$ and membrane-associated electron carriers are involved[5]. Owing to the divergent character and lack of structural and biochemical information, these NDHs are not included in the overview below. Sequences accession codes are from Swiss-Prot (*E. barkeri*) and TrEMBL databases.

- *Eubacterium barkeri* (DSMZ 1223): F subunit, 296 amino acid residues (AA) (acc. Q0QLF4); S-subunit, 157 A (acc. Q0QLF3); L-subunit, 424 AA (corrected for removal of the N-terminal methionine) (acc. Q0QLF2); M-subunit, 330 AA (acc. Q0QLF1).[8,30]
- *Natranaerobius thermophilus* JW/NM-WN-LF: F subunit, 292 AA (acc. B2A7L0); S-subunit, 164 AA (acc. B2A7K9); L-subunit, 424 AA (acc. B2A7K8); M-subunit, 328 AA (acc. B2A7K7).
- *Anaerotruncus colihominis* DSM 17241: F-subunit, 289 AA (acc. B0PCM5); S-subunit, 166 AA (acc. B0PCM4); L-subunit, 772 AA (acc. B0PCM3).
- *Bacteroides capillosus* ATCC 29799: F-subunit, 289 AA (acc. A6NVP1); S-subunit, 161 AA (acc. A6NVP2); L-subunit, 772 AA (acc. A6NVP3).

PROTEIN PRODUCTION, PURIFICATION, AND MOLECULAR CHARACTERIZATION

The presence of several labile cofactors has hampered purification and characterization of NDHs. Published protocols all use nicotinate-grown cells as source and require three to five purification steps. Particularly for the well-characterized *E. barkeri* enzyme, a rapid purification, anaerobicity, and maintenance of a protein concentration above 5 mg mL^{-1} is essential to obtain a high specific activity, selenium occupancy, and a crystallizable preparation.[16,30,32] With successive Source 30Q anion exchange, hydroxyapatite and gel filtration chromatography, NDH suitable for crystallization was obtained.[32] Analytical gelfiltration showed a slightly nonsymmetrical peak of apparent molecular mass of ~400 kDa. Native polyacrylamide electrophoresis of the same preparation exhibited multiple bands with mobilities corresponding to 120, 160, and 400 kDa.[30] In the crystalline state, the native enzyme is a dimer of heterotetramers (calculated molecular mass of 260.4 kDa).[32]

METAL AND COFACTOR CONTENT

Corrected for the molecular mass of the subunits obtained by sequencing of the genes,[8] Holcenberg and Stadtman[16] obtained a preparation with 4.7 Fe, 2.7 acid-labile sulfide, and 0.65 FAD (mol/mol heterotetramer of 130.2 kDa). They stated that these values were undoubtedly minimal values since dialysis had led to activity losses of 30–45%. We can now appreciate their accurate observations: FAD and acid-labile sulfide were partially lost and the iron of the two [2Fe–2S] clusters remained associated. The presence of molybdenum and selenium became apparent a decade later.[33,34] Only 0.05–0.25 Se mol/mol tetramer was found based on the radioactivity of the ^{75}Se isotope.[35] The growth of cells with Difco yeast supplemented with selenium, higher contents (0.4–0.8 mol Se/mol tetramer) were obtained.[36] An improved purification[30] gave (recalculated) average contents (in mol/mol heterotetramer) of 0.81 molybdenum, 0.42 Se, and 5.7 Fe. The selenium remained associated with the fluorescent molybdopterin cofactor in the dinucleotide form,[30,34] which was identified as cytosine.[37]

ACTIVITY AND INHIBITION TESTS

NDH from *E. barkeri* has a specific activity of 25–40 U mg^{-1} and exhibits a K_m for its physiological substrate nicotinate of 0.11 mM.[16,30] For the crystallized enzyme with a selenium occupancy of 0.8, a specific activity of 12–20 U mg^{-1} was found.[32] Exposure to air after dithionite or nicotinate reduction inactivates NDH.[36] Gladyshev and Stadtman investigated the stability of NDH activity in the presence of different compounds[30] and showed that glycerol and potassium chloride have mild activity-preserving properties. Attempts to reactivate the enzyme by treatment with sulfide, selenide, or selenophosphate under anaerobic conditions led to the complete inactivation of NDH. Treatment of NDH with selenite had no effect on the reactivity.[30] Contrary to xanthine dehydrogenase and other molybdopterin-containing enzymes,[38] NDH is not inactivated by cyanide treatment.[30]

The enzyme is specific for NADP$^+$ ($K_m = 28\,\mu$M) and has a maximal activity and stability at pH 8.0–8.5. Diaphorase activity with NADPH as substrate and oxygen as acceptor is 50–104% of the nicotinate hydroxylation activity.[16,30] Dyes like 2,3,5-triphenyltetrazolium or methylene blue are better acceptors and lead to diaphorase activity that is approximately fivefold higher than nicotinate hydroxylation.[16,30] A specific loss of nicotinate hydroxylation relative to diaphorase activity is observed upon heat denaturation,[16] purification, freezing/thawing,[35] storage,[30] or when Se has not been supplemented to the growth medium.[36] These observations show that the labile part of NDH resides in the selenium-substituted MCD cofactor.

NDH is an enzyme highly specific for nicotinate, since, of several analogs, only 2-pyrazinecarboxylate served as an equally efficient substrate, albeit with a seven times higher K_m value (0.83 mM).[16,30] Other nicotinate analogs hydroxylated by NDH with low specific activities are 2,3-pyrazinecarboxylate, 3,5-pyridinedicarboxylate, trigonelline, and 6-methylnicotinate.[30] Studies with a variety of other analogs showed that hydroxylation only occurs if a carboxylate moiety is present at position 3, and the pyridine nitrogen and carbon-5 are unsubstituted. Inhibitors of nicotinate hydroxylation are 3-pyridinesulfonate, 6-chloronicotinate, 6-methylnicotinate, and the physiological product of the NDH reaction, 6-hydroxynicotinate, which strongly inhibits activity.[30]

SPECTROSCOPY

The presence of FAD, MCD, and two [2Fe–2S] cofactors allows application of several spectroscopic techniques. Visible and electron paramagnetic resonance (EPR) spectroscopies have been used for the discovery and characterization of the reactivity and structure of the Mo–pyranopterin active site. Mössbauer and pulsed EPR spectroscopic studies have not been published. In the visible spectrum of purified *E. barkeri* NDH, the contributions of the 360 and 450 nm bands of oxidized FAD and 420 and 550 nm bands of the two [2Fe–2S]$^{2+}$ clusters appear as a broad hump centered at 450 nm. Upon treatment with sodium dithionite, a featureless spectrum resulted, which indicated that the cofactors were reduced to the [2Fe–2S]$^{1+}$ state and to the FAD hydroquinone form.[16] Similar observations were made upon anaerobic reduction with nicotinate.[30]

EPR spectroscopy has been used to characterize all four cofactors of the *E. barkeri* NDH.[30,36] Upon NADPH reduction of NDH, an FAD semiquinone EPR signal appeared at $g = 2.003$. Curiously, NADH also reduced FAD to the semiquinone form, although NAD$^+$ does not support catalysis. Reduction with sodium dithionite or nicotinate only reduced [2Fe–2S] cluster-I, which exhibits an EPR signal with g-values of 2.041, 1.946, and 1.899 detectable at temperatures below 60 K. Dithionite reduction in the presence of methylviologen also led to reduction of [2Fe–2S] cluster-II with a superimposing EPR signal with g-values of 2.054, 1.945, and 1.897. Several Mo(V)-based EPR signals were detected. The most relevant species ('resting') exhibits an axial signal with g-values of 2.067, 1.982, and 1.974 and is assigned to catalytically competent NDH. Its intensity showed a linear correlation with NDH hydroxylase activity in six preparations and the EPR signal decreased in parallel with activity upon heat treatment. The selenium content and the double-integrated EPR intensity (0.36 spin/heterotetramer) were similar. Addition of azide, glycerol, or cyanide, or short-time incubation with nicotinate (analogs) influenced the lineshape and position of the g_z component (2.070–2.062).

Many studies were performed with NDH isolated after growth on medium enriched with ^{95}Mo ($I = 5/2$) or ^{77}Se ($I = 1/2$). In both cases, a dramatic change of the 'resting' EPR spectrum invoked by the changed nuclear spin in comparison with Mo or Se at natural abundance provided conclusive evidence that active NDH contained a Mo(V)–Se substructure. Other sharper and less anisotropic Mo(V) EPR signals centered around $g = 1.97$ were seen in selenium-deficient inactive NDH preparations, upon reduction with sodium dithionite and after prolonged incubation (1–3 h) of active NDH at 4 $^\circ$C or at room temperature. No difference in spectral shapes of these signals was found between ^{77}Se-enriched NDH and enzyme with Se at natural abundance. Thus (irreversible) breakage of the Mo–Se bond could have occurred in such forms. However, highly active Se-dependent *Clostridium purinolyticum* purine hydroxylase also had no detectable magnetic interaction between ^{77}Se and Mo(V) as judged by EPR spectroscopy.[39] No selenium has been detected for the NDH (purine hydroxylase II) of *A. nidulans*, which has Mo(V) EPR signals similar to Se-dependent *C. purinolyticum* purine hydroxylase.[40] It is clear that care has to be taken with interpretation of the physiological relevance and presence of Mo–Se bond for the less anisotropic $g = 1.97$ Mo(V) EPR signals of NDH.

X-RAY STRUCTURE OF NATIVE NDH

Crystallization

NDH from *E. barkeri* was crystallized under anaerobic conditions using the vapor-diffusion method.[32] The specific activity of the enzyme used for crystallization was 11–20 U mg^{-1}. Crystallization drops consisted of a 1:1 mixture of NDH at 10 mg mL^{-1} with reservoir solution containing 18–20% polyethylene glycol (PEG) 3350, 100 mM tris(hydroxymethyl)amino-methane (Tris)*HCl (pH 7.5), 75 mM NaNO$_3$, 5% glycerol, or alternatively 1% 2,4-methyl-pentane-diol. For harvesting and freezing, crystals were transferred to a solution containing reservoir solution supplemented with 15% (vol/vol) (2R,3R)-butanediol.[32] Crystals were monoclinic with space group P2$_1$ and $a = 97.1$ Å, $b = 71.7$ Å, $c = 214.5$ Å, and $\beta = 90.2^\circ$. The asymmetric unit of the crystal contained one dimer with the complete ($\alpha\beta\gamma\delta$)$_2$ subunit composition.[32] The structure has been refined to a resolution of 2.2 Å. At the time of writing the review, only one crystal structure of a NDH has been published.

Overall description of the structure

The eight subunits of the homodimer are arranged with C2 symmetry and show the typical butterfly shape of molybdenum hydroxylases (3D Structure).[41,42] The dimer

has overall dimensions of 148 Å × 100 Å × 70 Å, a van der Waals radius of 84 Å around its center of mass and has a solvent-accessible surface area of 75 770 Å2. Each $\alpha\beta\gamma\delta$-monomer is relatively tightly packed, whereas the contact area between the two monomers covers only 1365 Å2.

The NDH structure contains three different types of spatially separated cofactors (Figure 1), each of which is bound by a different subunit. The FAD cofactor, the terminal acceptor of the electrons within the protein and likely donor of the hydride transferred to NADP$^+$, is bound by the F subunit (296 residues) (Figure 2). The F subunit consists of three domains, all having a mixed α/β-fold. The N-terminal domain (residues 1–57) is formed by a small three-stranded parallel β-sheet, which is flanked by two α-helices. The N-terminal and middle domain (residues 58–178) are held together by the adenosine and ribityl moiety of the FAD. The cofactor is held within a cleft containing two glycine-rich binding motifs, AGGTN and TIGGN, which are typical for the flavoenzyme family of the vanillyl-alcohol oxidases.[44–46] The middle domain consists of a five-stranded antiparallel β-sheet with six small α-helices. The C-terminal domain (residues 179–291) is formed by a three-stranded antiparallel β-sheet flanked by a bundle of three α-helices. The C-terminal domain interacts with FAD by a single hydrogen bond between the O(4) atom of the isoalloxazine ring and the side chain of Lys187$_F$. In all structurally characterized molybdenum hydroxylases studied, the C-terminal domain of the F subunit (or

Figure 1 Architecture of the electron transfer chain connecting the two active sites of NDH. Two electrons are transferred from the substrate to Mo during hydroxylation of the nicotinate, which are sequentially transferred via the [2Fe–2S] cluster to the isoalloxazin ring of FAD. The electrons are finally taken up by NADP$^+$ that is reduced to NADPH.

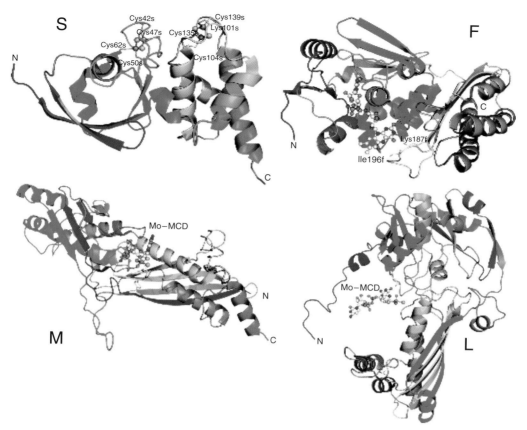

Figure 2 Cartoon presentation of the four individual subunits. N- and C-termini are labeled. S, F, M, and L mark the cartoon of the S-, F-, M-, and L-subunits, respectively. The cofactors are shown as ball-and-stick models.

analogous parts) contributes to shield the isoalloxazine ring from the bulk solvent. As in the bovine and bacterial xanthine oxidoreductases, the side chain of an isoleucine residue partially shields the reactive N5 atom of the flavin cofactor (Figure 2). The fold of the N-terminal and the middle domain is similar to two domains of members of the vanillyl-alcohol oxidase family.[47]

The S-subunit (157 residues) harbors two conserved cysteine motifs to bind two [2Fe–2S] clusters (Figures 2 and 3). The N-terminal domain of the-S subunit (residues 1–79) is similar to plant-type ferredoxins,[48] which show the β-grasp motif consisting of a mixed four-stranded β-sheet and a long α-helix. The four cysteinyl sulfurs coordinating the [2Fe–2S]-cluster originate from a $CX_4CX_2CX_{11}C$ binding motif (Figure 3) and position the cluster at a distance of 7.8 Å from the flavin cofactor (Figure 1). The C-terminal domain (residues 80–157) shows a unique fold, found only in molybdenum hydroxylases, consisting of a bundle of four α-helices with an approximately twofold symmetry. The [2Fe–2S] cluster (cluster-I) is coordinated by four cysteines, which are part of two loop regions (Figures 2 and 3). The cysteines coordinating cluster-I are part of a $CX_2CX_{31}CXC$ binding motif (Figure 3). While cluster-I is deeply buried within the protein matrix at the interface of the S- and L-subunit cluster-II is more solvent exposed and is near

the subunit interface between the S- and F-subunits.[32] The arrangement of the [2Fe–2S] clusters as well as the fold of the S-subunit is similar for all structurally characterized molybdenum hydroxylases.[41,42,47,49–52]

The Mo-bound pyranopterin cofactor is harbored between the L-subunit (424 residues) and the M-subunit (330 residues). The two subunits are extended and are oriented like two crossed swords (3D Structure). The M-subunit can be divided into two domains with similar topology both consisting of mixed four-stranded β-sheets and three α-helices (Figure 2). The L-subunit has an N-terminal extension (residues 1–28) engulfing the C-terminal domain of the S-subunit. The middle domain of the L-subunit (residues 29–129 and 181–277) is connected to the N-terminal extension by three α-helices and contains two antiparallel β-sheets of two and seven strands. The C-terminal domain of the L-subunit has, as a main structural element, a mixed five-stranded β-sheet flanked on one side by two α-helices that continue into an antiparallel two-stranded β-sheet and a C-terminal α-helix. The presence of two individual subunits to take up the pyranopterin cofactor is a unique feature of the NDH structure and has so far not been observed in other structures of molybdenum hydroxylases. However, bioinformatic analysis revealed that split pyranopterin

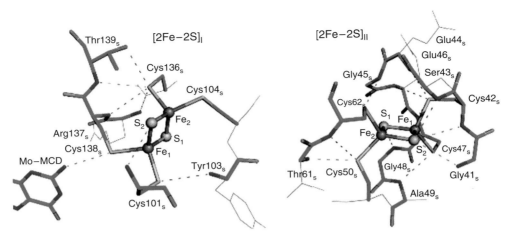

Figure 3 Interaction of the two [2Fe–2S]-clusters with the protein matrix. Possible hydrogen-bonding interactions are indicated by dotted lines.

binding subunits exist in other bacterial enzymes of unknown function, which are homologous to NDH from *E. barkeri*.[32]

Structure of the [2Fe–2S] clusters

The two [2Fe–2S] clusters act as a one-electron transfer chain between the two electron acceptors/donors Mo–MCD and FAD (Figure 1). The Fe–Fe distances in both clusters are about 2.7 Å and the µS–µS distances are about 3.6 Å long. The µS–Fe bond lengths are between 2.15 and 2.25 Å, while the bond length of the cysteinyl sulfur–Fe bonds are between 2.3 and 2.4 Å. The shortest Fe–Fe distance between the two clusters is 12.4 Å, while the shortest S–S distance is 9.0 Å. The two [2Fe–2S] clusters are clearly different in their interaction with the protein environment. Upon reduction of iron–sulfur clusters, a large part of the additional charge is located at the coordinating sulfur atoms and, therefore, hydrogen bonds to the sulfur atoms help stabilize negative charge and increase the reduction potential of the [2Fe–2S]$^{2+/+}$ couple.[53] Seven hydrogen bonds are possible for the type-I [2Fe–2S] cluster of which one would be between the amide proton of Cys101$_S$ and the bridging sulfido ligand (S2) and the other six are directed toward the cysteinyl sulfurs (Figure 3). A remarkable hydrogen-bonding interaction is found between the exocyclic NH$_2$-group of the MCD cofactor and the cysteinyl sulfur of Cys138$_S$. A much higher number of hydrogen bonds are possible for the type-II [2Fe–2S] cluster. Four hydrogen bond donors are correctly positioned and oriented to share a hydrogen bond with the µ-sulfido ligands of the cluster core and six further hydrogen bonds are possible for the cysteinyl sulfurs (Figure 3). Only main-chain amide protons act as possible hydrogen-bond donors for the type-II [2Fe–2S] cluster.

The Mo–Se active site

The L- and M-subunits form a substrate channel, which ends at the Mo–MCD complex. The Mo-site has a distorted square-pyramidal coordination. One hydroxo, one selenido, and the two enedithiolate sulfurs form the square-pyramidal base and an oxo-ligand is found in the apical position (Figure 4). The stereochemistry of the ligands is similar to the structurally characterized xanthine oxidoreductase[54] and Mo-containing carbon monoxide dehydrogenases,[55] with the major difference that NDH contains a selenido ligand instead of the sulfido ligand found in the other molybdenum hydroxylases. The presence of selenium in NDH had been shown to be essential for reactivity by the group of Jan Andreesen.[33] The localization of selenium within the active site near Mo had been established by EPR studies of NDH with the ^{77}Se isotope, which showed that the nuclear spin of ^{77}Se couples to the Mo(V) electron spin,[36] suggesting that the ^{77}Se serves as a ligand of Mo. Both observations made it the first nonselenocysteine selenium-containing enzyme. The observed Mo–Se bond length of 2.3 Å is in agreement with a selenido ligand at this position. The NDH bound selenium has been shown to be labile[30] and the strength of the electron density, the Debye–Waller (B) factor and the anomalous scattering contribution allowed to estimate the selenium content within the active site to be approximately 80%. Two oxo-ligands of the Mo-ion have bond lengths of 1.7–1.8 Å, while the two Mo–S bond lengths to the enedithiolate group are 2.4–2.5 Å long.

Several residues are found within the second coordination sphere of Mo. Direct contacts with the Mo-ligands are established by Glu289$_M$ in trans to the apical oxo-group, which is in hydrogen-bonding distance to the equatorial hydroxo-ligand and Gln208$_L$, which is in hydrogen bonding distance to the apical oxo-group (Figure 4). Residues that most likely contribute to binding and

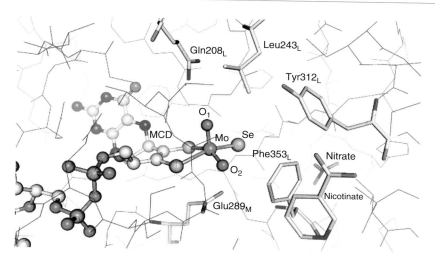

Figure 4 Active site environment of NDH. Atoms of the Mo–pyranopterin cofactor are shown as balls and sticks, whereas the side chains of amino acids implicated in substrate binding and hydroxylation are shown as sticks. All other residues are shown as lines using the color code of the 3D structure.

stabilization of the substrate are $Phe353_L$, $Tyr13_M$, and $Tyr312_L$. An anion binding pocket is located approximately 8 Å from the Mo and is most likely occupied by a nitrate molecule (Figure 4).

CATALYTIC MECHANISM AND INTRAMOLECULAR ELECTRON TRANSFER

Soaking of NDH crystals with nicotinate resulted in the appearance of additional electron density near, but not in the actives site. The nicotinate molecule modeled in the electron density is not in a productive position as the distance between the reactive equatorial hydroxyl group and the C-6 atom to be hydroxylated is too long for the reaction to proceed.[32] The reason for the unproductive binding mode is probably the orientation of the phenyl ring of $Phe353_L$, which prevents access to the equatorial Mo-ligands. Modeling of a possible productive substrate–enzyme complex therefore needs an adjustment of $Phe353_L$ and allows to position nicotinate in an orientation bringing the C-6 carbon atom to a distance of approximately 2 Å from the hydroxyl group. Increasing evidence on the mechanism of molybdenum hydroxylases suggests that substrate hydroxylation proceeds by a base-assisted nucleophilic attack of the equatorial Mo-OH group on the substrate, with a concomitant hydride transfer from the substrate to the Mo(+VI)=S group resulting in the formation of Mo(+IV)–SH.[56] In the case of NDH, we assume a similar reaction mechanism with the difference that the hydride acceptor is not a sulfido ligand, but a selenido ligand. The model complex has a distance of 2.5 Å between C-6 and the selenido ligand allowing hydride transfer between the two atoms.

The principal advantage of employing selenium instead of sulfur as Mo-ligand is likely related to the weaker double-bond character in Mo=Se compared to Mo=S. As the hydride transfer can be described as a nucleophilic attack of the hydride on the antibonding (π^*) orbital of Mo=Se, a weaker π-interaction leads to a less destabilized antibonding orbital and therefore, a lower activation barrier. Model calculations with small substrates indicated an approximate stabilization of the transition state of $3.1–3.4 \, kcal \, mol^{-1}$ upon substitution of Mo=S for Mo=Se, which corresponds to a factor of 200–300 in rate acceleration for this step (Figure 5).[32]

The intramolecular electron transfer from Mo(+IV) to NADP$^+$ is facilitated by a chain of redox-active cofactors (Figure 1). Electron transfer between Mo(+IV) and the type-I [2Fe–2S] cluster may be mediated by the pyranopterin cofactor, however, Hille and Anderson showed that the presence of the pyranopterin cofactor between Mo(+IV) and the type-I [2Fe–2S] cluster of xanthine oxidase does not result in an exceptionally effective electron transfer between the two centers.[57] The short metal–metal distances of 12.4 Å between the type-I [2Fe–2S] cluster and the type-II [2Fe–2S] cluster and of 6.4 Å between the type-II [2Fe–2S] cluster and FAD indicate that electron transfer may proceed efficiently between all redox cofactors of NDH.[58]

COMPARISON WITH RELATED STRUCTURES

NDH shows distinct sequence homology to other members of the molybdenum hydroxylase family and has the same cofactor composition and overall architecture as carbon monoxide dehydrogenase,[41,47] xanthine oxidoreductase,[50] and quinoline oxidoreductase.[52] It differs slightly from

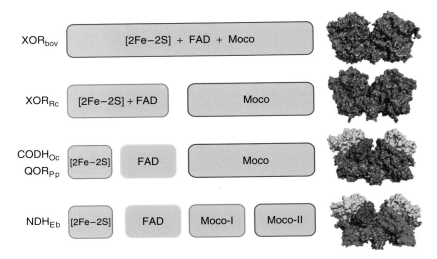

Figure 5 Catalytic mechanism. The mechanism of NDH has been formulated in analogy to that of xanthine oxidoreductase,[56] with which it shares several parallels in the active site architecture.

XOR_bov	[2Fe–2S] + FAD + Moco		
XOR_Rc	[2Fe–2S] + FAD	Moco	
CODH_Oc QOR_Pp	[2Fe–2S]	FAD	Moco
NDH_Eb	[2Fe–2S]	FAD	Moco-I Moco-II

Figure 6 Comparison of the subunit compositions of bovine xanthine oxidoreductase (XOR_bov; PDB-Id: 1FO4),[50] xanthine oxidoreductase from *Rhodobacter capsulatus* (XOR_Rc; PDB-Id: 1JRO),[59] quinoline 2-oxidoreductase from *Pseudomonas putida* 86 (QOR_Pp; PDB-Id: 1T3Q)[52] and NDH (NDH_Eb; PDB-Id: 3HRD).[32]

the Mop protein of *Desulfovibrio gigas*[49] by having a flavoprotein subunit and from 4-hydroxybenzoyl-CoA reductase by lacking the additional [4Fe–4S] cluster found in this enzyme.[51] The decisive structural difference on the atomic scale is the presence of the selenido ligand, while, on the nanoscale, the structure is unique by having four subunits. The different number of subunits, however, has no obvious influence on the architecture of the electron transport chain or the principal orientation of individual domains (Figure 6).

REFERENCES

1 EJ Behrman and RY Stanier, *J Biol Chem*, **228**, 923–45 (1957).

2 EJ Behrman and RY Stanier, *J Biol Chem*, **228**, 947–53 (1957).

3 MV Jones, *FEBS Lett*, **32**, 321–24 (1973).

4 DE Hughes, *Biochem J*, **60**, 303–10 (1955).

5 AL Hunt, *Biochem J*, **72**, 1–7 (1959).

6 AL Hunt, A Rodgers and DE Hughes, *Biochim Biophys Acta*, **34**, 354–72 (1959).

7 R Thacker, O Rørvig, P Kahlon and IC Gunsalus, *J Bacteriol*, **135**, 289–90 (1978).

8 A Alhapel, DJ Darley, N Wagener, E Eckel, N Elsner and AJ Pierik, *Proc Natl Acad Sci U S A*, **103**, 12341–46 (2006).

9 JI Jimenez, B Minambres, JL Garcia and E Diaz, *Environ Microbiol*, **4**, 824–41 (2002).

10 D Imhoff-Stuckle and N Pfennig, *Arch Microbiol*, **136**, 194–98 (1983).

11 M Nagel and JR Andreesen, *FEMS Microbiol Lett*, **59**, 147–52 (1989).

12 M Nagel and JR Andreesen, *Arch Microbiol*, **154**, 605–13 (1990).

13 C Scazzocchio, *Mol Gen Genet*, **125**, 147–55 (1973).

14 RK Mehra and MP Coughlan, *Arch Biochem Biophys*, **229**, 585–95 (1984).

15 GM Montero-Moran, M Li, E Rendon-Huerta, F Jourdan, DJ Lowe, AW Stumpff-Kane, M Feig, C Scazzocchio and RP Hausinger, *Biochemistry*, **46**, 5293–304 (2007).

16 JS Holcenberg and ER Stadtman, *J Biol Chem*, **244**, 1194–203 (1969).

17 S Fetzner, *Appl Microbiol Biotechnol*, **49**, 237–50 (1998).

18 JS Holcenberg and L Tsai, *J Biol Chem*, **244**, 1204–11 (1969).

19 CL Kitts, LE Schaechter, RS Rabin and RA Ludwig, *J Bacteriol*, **171**, 3406–11 (1989).

20 H Nakano, M Wieser, B Hurh, T Kawai, T Yoshida, T Yamane and T Nagasawa, *Eur J Biochem*, **260**, 120–26 (1999).

21 HG Kulla, *Chimia*, **45**, 81–85 (1991).

22 R Gloeckler and JP Roduit, *Chimia*, **50**, 413–15 (1996).

23 WJMM Hoeks, HP Meyer, D Quarroz, M Helwig and P Lehky, *Opportunities in Biotransformations*, 67–71 (1990).

24 U Schmid, KL Schimz and H Sahm, *Anal Biochem*, **180**, 17–23 (1989).

25 T Nagasawa, B Hurh and T Yamane, *Biosci Biotech Biochem*, **58**, 665–68 (1994).

26 B Hurh, M Ohshima, T Yamane and T Nagasawa, *J Ferment Bioeng*, **77**, 382–85 (1994).

27 T Yoshida and T Nagasawa, *J Biosci Bioeng*, **89**, 111–18 (2000).

28 M Yasuda, T Sakamoto, R Sashida, M Ueda, Y Morimoto and T Nagasawa, *Biosci Biotechnol Biochem*, **59**, 572–75 (1995).

29 M Wieser, K Heinzmann and A Kiener, *Appl Microbiol Biotechnol*, **48**, 174–76 (1997).

30 VN Gladyshev, SV Khangulov and TC Stadtman, *Biochemistry*, **35**, 212–23 (1996).

31 A Alhapel, DJ Darley, N Wagener, E Eckel, N Elsner and AJ Pierik, *Proc Natl Acad Sci U S A*, **103**, 12341–46 (2006).

32 N Wagener, AJ Pierik, A Ibdah, R Hille and H Dobbek, *Proc Natl Acad Sci U S A*, **106**, 11055–60 (2009).

33 D Imhoff and JR Andreesen, *Fems Microbiol Lett*, **5**, 155–58 (1979).

34 GL Dilworth, *Arch Biochem Biophys*, **221**, 565–69 (1983).

35 GL Dilworth, *Arch Biochem Biophys*, **219**, 30–38 (1982).

36 VN Gladyshev, SV Khangulov and TC Stadtman, *Proc Natl Acad Sci U S A*, **91**, 232–36 (1994).

37 VN Gladyshev and P Lecchi, *Biofactors*, **5**, 93–97 (1995).

38 MP Coughlan, JL Johnson and KV Rajagopalan, *J Biol Chem*, **255**, 2694–99 (1980).

39 WT Self, MD Wolfe and TC Stadtman, *Biochemistry*, **42**, 11382–90 (2003).

40 MP Coughlan, RK Mehra, MJ Barber and LM Siegel, *Arch Biochem Biophys*, **229**, 596–03 (1984).

41 H Dobbek, L Gremer, O Meyer and R Huber, *Handbook of Metalloproteins*, Vol. 1, John Wiley Interscience (2001).

42 H Dobbek and R Huber, *Met Ions Biol Syst*, **39**, 227–63 (2002).

43 WL DeLano, *The PyMol Molecular Graphics System*, DeLano Scientific, San Carlos, CA (2002).

44 MW Fraaije, WJH van Berkel, JAE Benen, J Visser and A Mattevi, *Trends Biochem Sci*, **23**, 206–07 (1998).

45 L Gremer, S Kellner, H Dobbek, R Huber and O Meyer, *Flavins Flavoproteins*, Berlin, 759–66 (1999).

46 L Gremer, S Kellner, H Dobbek, R Huber and O Meyer, *J Biol Chem*, **275**, 1864–72 (2000).

47 H Dobbek, L Gremer, O Meyer and R Huber, *Proc Natl Acad Sci U S A*, **96**, 8884–89 (1999).

48 J Meyer, *J Biol Inorg Chem*, **13**, 157–70 (2008).

49 MJ Romao, M Archer, I Moura, JJ Moura, J LeGall, R Engh, M Schneider, P Hof and R Huber, *Science*, **270**, 1170–76 (1995).

50 C Enroth, T Eger Bryan, K Okamoto, T Nishino and F Pai Emil, *Proc Natl Acad Sci U S A*, **97**, 10723–28 (2000).

51 M Unciuleac, E Warkentin, CC Page, M Boll and U Ermler, *Structure*, **12**, 2249–56 (2004).

52 I Bonin, BM Martins, V Purvanov, S Fetzner, R Huber and H Dobbek, *Structure (Camb)*, **12**, 1425–35 (2004).

53 PJ Stephens, DR Jollie and A Warshel, *Chem Rev*, **96**, 2491–513 (1996).

54 K Okamoto, K Matsumoto, R Hille, BT Eger, EF Pai and T Nishino, *Proc Natl Acad Sci U S A*, **101**, 7931–36 (2004).

55 H Dobbek, L Gremer, R Kiefersauer, R Huber and O Meyer, *Proc Natl Acad Sci U S A*, **99**, 15971–76 (2002).

56 R Hille, *Arch Biochem Biophys*, **433**, 107–16 (2005).

57 R Hille and RF Anderson, *J Biol Chem*, **276**, 31193–201 (2001).

58 CC Page, CC Moser, X Chen and PL Dutton, *Nature*, **402**, 47–52 (1999).

59 JJ Truglio, K Theis, S Leimkühler, R Rappa, KV Rajagopalan and C Kisker, *Structure*, **10**, 115–125 (2002).

COPPER

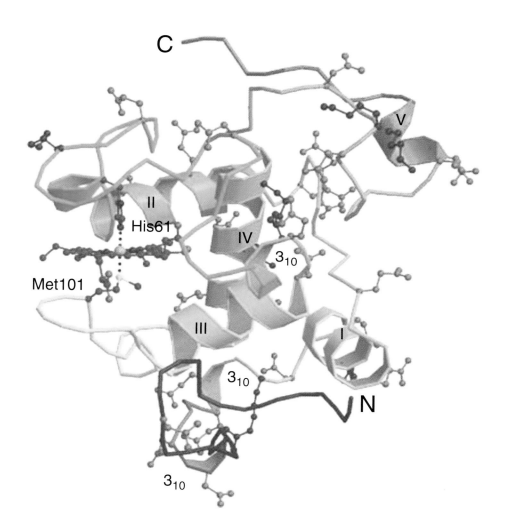

Type-2 Copper Enzymes

Peptidylglycine α-hydroxylating monooxygenase (PHM)

Katarzyna Rudzka[†], Eduardo E Chufán[†], Betty Eipper[§], Richard Mains[§] and Mario L Amzel[†]

[†] Department of Biophysics and Biophysical Chemistry, Johns Hopkins School of Medicine, Johns Hopkins University, Baltimore, MD 21205, USA
[§] Neuroscience and Molecular, Microbial, and Structural Biology, University of Connecticut Health Center, Farmington, CT 06030, USA

FUNCTIONAL CLASS

Peptidylglycine α-hydroxylating monooxygenase (PHM; EC 1.14.17.3) is the N-terminal domain of the bifunctional enzyme peptidylglycine α-amidating monooxygenase (PAM), which is classified as a copper type II, ascorbate-dependent monooxygenase.[1] Other members of the family include dopamine β-monooxygenase (DBM; EC 1.14.17.1) and monooxygenase X (MOX, unknown function).[2] Tyramine β-monooxygenase (TBM), which produces octopamine by hydroxylating tyramine, replaces DBM in *Caenorhabditis elegans* and *Drosophila*.[2–5] Family members share considerable sequence similarity within the catalytic domain (e.g. human PHM exhibits 28% sequence identity with hDBM and 25% identity with hMOX).[2] A fourth member of this family, dopamine β-hydroxylase-like enzyme (DBHL), is found in the mouse genome.[2] The enzymes that have been studied require molecular oxygen as well as copper and reduced ascorbate as an electron donor in order to perform their catalytic reactions.

OCCURRENCE

A gene encoding PAM has not been identified in prokaryotes, but a monofunctional PHM gene has been identified in *Planaria* and in *Cnidarians*, creatures with the most primitive type of nervous system. In mammals, PAM activity has been quantified in most tissues, although

3D Structure A diagram of the catalytic core of rat peptidylglycine α-hydroxylating monooxygenase, (PHMcc). Protein Data Bank accession code 1PHM.[21] The protein backbone is shown in cyan. Ligands of the metal centers are shown in green with atoms highlighted in blue and yellow (nitrogen and sulfur atoms, respectively). Catalytic copper ions are represented by gold color spheres and the water molecule ligand is shown in red. The two nine-stranded domains of PHMcc are both folded as a β-sandwich. They are separated by ∼8 Å of solvent accessible interdomain space. The figure was created using PyMOL.[49]

levels vary widely. Particularly high levels of PAM have been found in endocrine cells and in neurons, where amidated peptides are stored, but PAM is also expressed in atrial myocytes, where amidated peptides are not a major product. PAM is expressed at lower levels in brain ependymal cells and astrocytes.[6,7] Elimination of PHM expression in *Drosophila* and PAM expression in mice is not compatible with life.[8,9]

BIOLOGICAL FUNCTION

Conversion of hormone precursors into mature peptides is a multistep process that requires cleavage of large prohormone molecules by proteolytic enzymes. These processes expose a terminal glycine residue resulting in the formation of a glycine-extended intermediate.[9] The penultimate amino acid residue of the intermediate becomes amidated, as a result of PAM activity. PAM has broad substrate specificity and virtually any amino acid can be amidated, although neutral and hydrophobic residues predominate.[10,11] This seemingly subtle structural modification has a significant impact on biological properties of peptides. Modified peptides tend to be less susceptible to the cleavage by carboxypeptidases and have far better binding affinity for their receptors. As a consequence, an amidated form of peptide can be even up to a 1000 times more potent than its unmodified analog (e.g. corticotrophin-releasing hormone).[12,13] PAM is the sole enzyme known to carry out this reaction. It has been shown that deletion of this gene in mouse model was lethal for the embryos.[9]

AMINO ACID SEQUENCE INFORMATION

Peptide amidation is a widespread posttranslation modification that occurs in species ranging from humans to *C. elegans* and *Schistosoma mansoni*. In all species, the reaction is carried out by similar enzymes. The sequence of PHM has been determined for the following species:

- *Homo sapiens* (*Human*), AMD_HUMAN, 973 amino acids (AA) PAM, 494 AA PHM (residues 1–494), 4 isoforms produced by alternative splicing, Swiss-Prot ID code (SWP) P19021.[14–17]
- *Bos taurus* (*Bovine*), AMD_BOVIN, 972 AA PAM, 494 AA PHM (residues 1–494), SWP P10731.[18,19]
- *Rattus norvegicus* (*Rat*), AMD_RAT, 976 AA Pam, 497 AA PHM (residues 1–497), 7 isoforms produced by alternative splicing, SWP P14925.[20–23]
- *Mus musculus* (*Mouse*), AMD_MOUSE, 979 AA Pam, 497 AA PHM (residues 1–497), SWP P97467.[24]
- *Xenopus laevis* (*African clawed frog*), AMD1_XENLA, 935 AA Pam-a, 390 AA PHM (residues 1–390), 2 isoforms produced by alternative splicing, SWP P08478.[25]

- *Xenopus laevis* (*African clawed frog*), AMD2_XENLA, 875 AA Pam-b, 392 AA PHM (residues 3–394), SWP P12890.[26]
- *Lymnaea stagnalis* (*Great pond snail*), Q9Y1M5_LYMST, 1951 AA L-PAM, SWP Q9Y1M5.[27]
- *Drosophila melanogaster* (*Fruit fly*), PHM_DROME, 365 AA, SWP O01404.[8,28,29]
- *Schistosoma mansoni* (*Blood fluke*), Q86QQ6_SCHMA, 350 AA, SWP Q86QQ6.[30]
- *Caenorhabditis elegans*, AMDL_CAEEL, 663 AA PAM, 300 AA PHM (residues 1–300), SWP P83388.[31,32]
- *Caenorhabditis elegans*, PHM_CAEEL, 324 AA, SWP Q95XM2.[31,32]
- *Dugesia japonica* (*Planarian*), PHM_DUGJA, 382 AA, SWP Q4W7B5.[33]

PROTEIN PRODUCTION, PURIFICATION, AND CHARACTERIZATION

The catalytic core of peptidylglycine α-hydroxylating monooxygenase (PHMcc), which was defined by limited trypsin digestion of PAM and by expression of N- and C-terminally truncated PAM proteins, is overexpressed in stably transfected Chinese hamster ovary (CHO) cells using the pCIS vector system.[34,35] PHMcc is secreted into the medium and concentrated by precipitation with $(NH_4)_2SO_4$. After resuspension, PHM is purified by hydrophobic interaction chromatography followed by anion exchange chromatography.[36] Purified enzyme contains substoichiometric amounts of copper and requires addition of exogenous metal for maximal activity.[37] Initial velocity measurements performed with purified PHMcc, as a function of Ac-Tyr-Val-Gly substrate concentration yielded the following kinetic parameters (pH 5.5): $K_m = 6.3$ (± 1.4) μM, $k_{cat} = 15.0\,s^{-1}$.[38] Optimum activity is observed at pH 5.5. Increasing the pH of the reaction mixture to 7 causes an approximately fivefold decrease in the K_m value and the effect on V_{max} is even more significant (~25-fold decrease).[38] The observed pH dependence may reveal important aspects of the catalytic mechanism. It has been proposed that elevated pH strengthens the salt bridge through which the peptidylglycine C-terminus interacts with the guanidinium group of Arg240, locking the substrate in a position incompatible with hydrogen atom abstraction and causing a decrease in K_m and V_{max}.

METAL CONTENT OF PAM

Copper is the only metal that supports PHM activity. Treatment of PHM with metal chelators resulted in the loss of enzymatic activity and, from several metals tested, only copper restored enzymatic function.[37,39] Although the active site is binuclear, the distance that separates the two metal centers does not allow any bridging ligation. As a

consequence, each copper ion shows features consistent with an isolated metal center (Cu(II), $S = 1/2$). The resting state of the enzyme contains Cu(II), but the catalytic activity requires both coppers to cycle between Cu(II) and Cu(I) redox states.[40] These two copper centers have different geometries as well as different sets of ligands and play distinct roles in the catalytic mechanism. Cu_M is responsible for oxygen reactivity (hydrogen abstraction and hydroxylation of the Cα of substrate) and Cu_H supplies an electron for oxygen reduction by long-range electron transfer.

X-RAY STRUCTURES

Information about the overall structure came mainly from X-ray diffraction studies of PHMcc ((rat PAM-1)(42–356)).[21,41–43] Among the structures deposited in the Protein Data Bank (PDB), there are both oxidized and reduced forms of enzyme complexed with substrate (PDB codes: 1PHM, 3PHM, 1OPM) as well as the ternary complex (reduced enzyme with bound O_2 and a slowly reacting substrate) in the precatalytic state (PDB code 1SDW). In contrast, a wide variety of techniques have been used to study the structure of the PHM active site. From Fourier transform infrared spectroscopy (FTIR),[44–46] circular dichroism/magnetic circular dichroism (CD/MCD),[47] electron paramagnetic resonance (EPR),[36,40,47] and other spectroscopic methods to X-ray absorption spectroscopy (XAS)[36,45,46,48] and X-ray diffraction, these different techniques have provided information about the coordination of both copper centers in the reduced and oxidized states, alone and when complexed with substrates, inhibitors, and small-molecule copper ligands.

Crystallization

Two crystal forms of wt PHMcc have been deposited in the PDB. Both belong to the orthorhombic space group $P2_12_12_1$. The first crystal form (PDB code 1PHM) was grown in the presence of the salts of transition metals (Ni^{2+}, Co^{2+} or Cu^{2+}) in cacodylate buffer pH 5.5 (unit cell dimensions $a = 69.4$ Å, $b = 68.8$ Å, $c = 81.0$ Å, and $\alpha = \beta = \gamma = 90°$).[21] The second crystal form was obtained in the presence of Tris buffer pH 8.5 with the addition of PEG-4000 (polyethylene glycol) and $MgCl_2$ salt (PDB code 1YIP) and has unit cell dimensions $a = 58.5$ Å, $b = 65.7$ Å, $c = 69.9$ Å, and $\alpha = \beta = \gamma = 90°$.[43] The PHMcc-substrate complex was produced by soaking protein crystals in mother liquor containing substrate (N-α-acetyl-3,5-diiodotyrosylglycine). Crystals of the reduced form of PHMcc were prepared by adding 5 mM ascorbic acid to the crystallization solution. In order to capture the copper-dioxygen precatalytic complex, protein crystals were soaked with a slow substrate analog (N-acetyl-diiodotyrosyl-D-threonine, IYT) and ascorbic acid in the presence of oxygen.

Overall structure

PHMcc is composed of two domains of ~150 residues, each folded as a nine-strand β-sandwich. The two domains have similar topologies: an eight-stranded antiparallel jelly-roll motif (3D Structure). The N- and C-terminal domains interact through a hydrophobic interface in the loop-linking area, while the remaining interdomain space forms an ~8 Å wide solvent-filled cleft. One copper ion is bound to each domain: Cu_H to the N-terminal and Cu_M to the C-terminal domain. There is no evidence that the copper centers approach each other during the catalytic cycle.

(a) (b)

Figure 1 The structures of the two PHMcc copper centers (Cu_M (a), Cu_H (b)). Copper ions are represented by gold color spheres, carbons are colored green, sulfur yellow, nitrogens blue, and the ligand water is shown as a red sphere. Protein Data Bank accession code 1PHM.[21]

Figure 2 A representation of the active site of the precatalytic complex of PHMcc with slowly reacting substrate analog and dioxygen. Copper ions are represented by gold color spheres, carbons are colored green, sulfur yellow, nitrogens blue, and oxygen red. The side chain of the D-threonine is shown at the R-side of the α-carbon. Protein Data Bank accession code 1SDW.[41]

Catalytic site

Cu_H is coordinated by three histidine residues (His107, His108, and His172) with two short bond distances (His107 and His108, 1.9–2.0 Å) and the third slightly

elongated bond distance (His172, 2.1–2.4 Å) (Figure 1). Overall, Cu_H presents a distorted T-shaped geometry. Cu_M is coordinated by two histidines (His242, His244, ~2 Å), one methionine residue (Met314, 2.5 Å), and one solvent molecule, forming a distorted tetrahedral geometry. Displacement of the solvent ligand at Cu_M opens a coordination site for the binding of molecular oxygen in the precatalytic complex. Crystallographic studies of the ternary precatalytic complex of enzyme, O_2, and a slow substrate revealed end-on binding of oxygen to the reduced Cu_M site, with an O–O distance of 1.23 Å and a copper–O–O angle of 110° (Figure 2). This precatalytic complex is stabilized by the use of a slowly reacting substrate analog containing a C-terminal D-amino acid (N-acetyl-diiodo-tyrosyl-D-threonine, IYT). Binding of substrate close to the Cu_M site positions the terminal Cα in close proximity to the two oxygen atoms.

CATALYTIC MECHANISM

In the resting state, both PHM copper ions are oxidized to Cu(II). To start the catalytic cycle, each copper ion must undergo one-electron reduction to Cu(I). Under physiological conditions, each of the two electrons is provided by ascorbate, resulting in the conversion of two molecules

Scheme 1 Reaction catalyzed by peptidylglycine α-hydroxylating monooxygenase (PHM).

Scheme 2 Proposed mechanism for PHM-catalyzed reaction.[41]

of ascorbate into two molecules of semidehydroascorbate. Crystallographic data suggest that the reduced Cu_M site is capable of binding molecular oxygen only in the presence of peptide substrate. Formation of the Cu_M–dioxygen complex is followed by the transfer of a single electron from each copper center to the oxygen atoms. Considering the long distance that separates the metal sites (11 Å), the pathway of the electron transfer from Cu_H to Cu_M–O_2 remains one of the most puzzling mechanistic questions in this system. Several mechanisms have been proposed.[21,41,50–53] One hypothesis suggests that the substrate provides a path for the electron transfer. Simultaneous reduction of dioxygen and binding of substrate could ensure their immediate reaction and prevent the release of harmful reactive oxygen species. Alternative proposals suggest a role for the interdomain protein network in electron transfer or use of superoxide ion.[44,42] Once the reduced oxygen species is formed, the distal oxygen atom needs to be positioned in a proper orientation for abstraction of the *pro-S* hydrogen from the C-terminal glycine residue. This could be achieved by the rotation of the distal oxygen atom by ~110° around the Cu_M–O_2 complex. The hydrogen abstraction initially generates an alkyl radical and eventually leads to hydroxylation of the substrate.

REFERENCES

1 C Southan and LI Kruse, *FEBS Lett*, **255**, 116–20 (1989).

2 X Xin, RE Mains and BA Eipper, *J Biol Chem*, **279**, 48159–67 (2004).

3 CR Hess, JP Klinman and NJ Blackburn, *J Biol Inorg Chem.*, In press. [published ahead of print].

4 KJ Chambers, LA Tonkin, E Chang, DN Shelton, MH Linskens and WD Funk, *Gene*, **218**, 111–20 (1998).

5 AK Knecht and M Bronner-Fraser, *Dev Biol*, **234**, 365–75 (2001).

6 RS Klein and LD Fricker, *Brain Res*, **596**, 202–8 (1992).

7 CH Rhodes, RY Xu and RH Angeletti, *J Histochem Cytochem*, **38**, 1301–311 (1990).

8 AS Kolhekar, MS Roberts, N Jiang, RC Johnson, RE Mains, BA Eipper and PH Taghert, *J Neurosci*, **17**, 1363–76 (1997).

9 TA Czyzyk, Y Ning, MS Hsu, B Peng, RE Mains, BA Eipper and JE Pintar, *Dev Biol*, **287**, 301–13 (2005).

10 AF Bradbury and DG Smyth, *Physiol Bohemoslov*, **37**, 267–74 (1988).

11 PP Tamburini, BN Jones, AP Consalvo, SD Young, SJ Lovato, JP Gilligan, LP Wennogle, M Erion and AY Jeng, *Arch Biochem Biophys*, **267**, 623–31 (1988).

12 F Cuttitta, *Anat Rec* **236**, 87–93, 172–73 (1993) discussion 93–5.

13 W Vale, J Spiess, C Rivier and J Rivier, *Science*, **213**, 1394–97 (1981).

14 J Glauder, H Ragg, J Rauch and JW Engels, *Biochem Biophys Res Commun*, **169**, 551–58 (1990).

15 K Tateishi, F Arakawa, Y Misumi, AM Treston, M Vos and Y Matsuoka, *Biochem Biophys Res Commun*, **205**, 282–90 (1994).

16 M Satani, K Takahashi, H Sakamoto, S Harada, Y Kaida and M Noguchi, *Protein Expr Purif*, **28**, 293–302 (2003).

17 HY Yun, HT Keutmann and BA Eipper, *J Biol Chem*, **269**, 10946–55 (1994).

18 BA Eipper, LP Park, IM Dickerson, HT Keutmann, EA Thiele, H Rodriguez, PR Schofield and RE Mains, *Mol Endocrinol*, **1**, 777–90 (1987).

19 AG Katopodis, DS Ping, CE Smith and SW May, *Biochemistry*, **30**, 6189–94 (1991).

20 BA Eipper, CB Green, TA Campbell, DA Stoffers, HT Keutmann, RE Mains and L Ouafik, *J Biol Chem*, **267**, 4008–15 (1992).

21 ST Prigge, AS Kolhekar, BA Eipper, RE Mains and LM Amzel, *Science*, **278**, 1300–305 (1997).

22 DA Stoffers, CB Green and BA Eipper, *Proc Natl Acad Sci U S A*, **86**, 735–39 (1989).

23 DA Stoffers, L Ouafik and BA Eipper, *J Biol Chem*, **266**, 1701–707 (1991).

24 J Villen, SA Beausoleil, SA Gerber and SP Gygi, *Proc Natl Acad Sci U S A*, **104**, 1488–93 (2007).

25 Y Iwasaki, T Kawahara, H Shimoi, K Suzuki, O Ghisalba, K Kangawa, H Matsuo and Y Nishikawa, *Eur J Biochem*, **201**, 551–59 (1991).

26 K Ohsuye, K Kitano, Y Wada, K Fuchimura, S Tanaka, K Mizuno and H Matsuo, *Biochem Biophys Res Commun*, **150**, 1275–81 (1988).

27 S Spijker, AB Smit, BA Eipper, A Malik, RE Mains and WP Geraerts, *FASEB J*, **13**, 735–48 (1999).

28 MD Adams, SE Celniker, RA Holt, CA Evans, JD Gocayne, PG Amanatides, SE Scherer, PW Li, RA Hoskins, RF Galle, RA George, SE Lewis, S Richards, M Ashburner, SN Henderson, GG Sutton, JR Wortman, MD Yandell, Q Zhang, LX Chen, RC Brandon, YH Rogers, RG Blazej, M Champe, BD Pfeiffer, KH Wan, C Doyle, EG Baxter, G Helt, CR Nelson, GL Gabor, JF Abril, A Agbayani, HJ An, C Andrews-Pfannkoch, D Baldwin, RM Ballew, A Basu, J Baxendale, L Bayraktaroglu, EM Beasley, KY Beeson, PV Benos, BP Berman, D Bhandari, S Bolshakov, D Borkova, MR Botchan, J Bouck, P Brokstein, P Brottier, KC Burtis, DA Busam, H Butler, E Cadieu, A Center, I Chandra, JM Cherry, S Cawley, C Dahlke, LB Davenport, P Davies, B de Pablos, A Delcher, Z Deng, AD Mays, I Dew, SM Dietz, K Dodson, LE Doup, M Downes, S Dugan-Rocha, BC Dunkov, P Dunn, KJ Durbin, CC Evangelista, C Ferraz, S Ferriera, W Fleischmann, C Fosler, AE Gabrielian, NS Garg, WM Gelbart, K Glasser, A Glodek, F Gong, JH Gorrell, Z Gu, P Guan, M Harris, NL Harris, D Harvey, TJ Heiman, JR Hernandez, J Houck, D Hostin, KA Houston, TJ Howland, MH Wei, C Ibegwam, M Jalali, F Kalush, GH Karpen, Z Ke, JA Kennison, KA Ketchum, BE Kimmel, CD Kodira, C Kraft, S Kravitz, D Kulp, Z Lai, P Lasko, Y Lei, AA Levitsky, J Li, Z Li, Y Liang, X Lin, X Liu, B Mattei, TC McIntosh, MP McLeod, D McPherson, G Merkulov, NV Milshina, C Mobarry, J Morris, A Moshrefi, SM Mount, M Moy, B Murphy, L Murphy, DM Muzny, DL Nelson, DR Nelson, KA Nelson, K Nixon, DR Nusskern, JM Pacleb, M Palazzolo, GS Pittman, S Pan, J Pollard, V Puri, MG Reese, K Reinert, K Remington, RD Saunders, F Scheeler, H Shen, BC Shue, I Siden-Kiamos, M Simpson, MP Skupski, T Smith, E Spier, AC Spradling, M Stapleton, R Strong, E Sun, R Svirskas, C Tector, R Turner, E Venter, AH Wang, X Wang, ZY Wang, DA Wassarman, GM Weinstock, J Weissenbach, SM Williams, T Woodage, KC Worley, D Wu, S Yang, QA Yao, J Ye, RF Yeh, JS Zaveri, M Zhan, G Zhang, Q Zhao, L Zheng, XH Zheng, FN Zhong, W Zhong, X Zhou, S Zhu, X Zhu, HO Smith, RA Gibbs, EW Myers, GM Rubin and JC Venter, *Science*, **287**, 2185–95 (2000).

29 M Han, D Park, PJ Vanderzalm, RE Mains, BA Eipper and PH Taghert, *J Neurochem*, **90**, 129–41 (2004).

30 GR Mair, MJ Niciu, MT Stewart, G Brennan, H Omar, DW Halton, R Mains, BA Eipper, AG Maule and TA Day, *FASEB J*, **18**, 114–21 (2004).

31 R Ainscough, S Bardill, K Barlow, V Basham, C Baynes, L Beard, A Beasley, M Berks, J Bonfield, J Brown, C Burrows, J Burton, C Chui, E Clark, L Clark, G Colville, T Copsey, A Cottage, A Coulson, M Craxton, A Cummings, P Cummings, S Dear, T Dibling, R Dobson, J Doggett, R Durbin, J Durham, A Ellington, D Evans, K Fleming, J Fowler, A Fraser, D Frame, A Gardner, J Garnett, I Gray, J Gregory, M Griffiths, S Hall, B Harris, T Hawkins, C Hembry, S Holmes, B Jassal, M Jones, S Jones, A Joy, P Kelly, J Kershaw, A Kimberley, Y Kohara, N Laister, D Lawson, N Lennard, J Lightning, S Limbrey, S Lindsay, C Lloyd, S Margerison, A Marrone, L Matthews, P Matthews, R Mayes, K McLay, A McMurray, M Metzstein, S Miles, N Mills, M Mohammadi, B Mortimore, M O'Callaghan, A Osborn, S Palmer, C Percy, A Pettett, E Playford, M Pound, R Rocheford, J Rogers, D Saunders, M Searle, K Seeger, R Shownkeen, M Sims, N Smaldon, A Smith, M Smith, M Smith, R Smye, E Sonnhammer, R Staden, C Steward, J Sulston, J Swinburne, R Taylor, L Tee, J Thierry-Mieg, K Thomas, J Usher, M Wall, J Wallis, A Watson, S White, A Wild, J Wilkinson, L Williams, J Winster, I Wragg *Science* **282**, 2012–18 (1998).

32 H Kaji, J Kamiie, H Kawakami, K Kido, Y Yamauchi, T Shinkawa, M Taoka, N Takahashi and T Isobe, *Mol Cell Proteomics*, **6**, 2100–109 (2007).

33 A Asada, H Orii, K Watanabe and M Tsubaki, *FEBS J*, **272**, 942–55 (2005).

34 AS Kolhekar, HT Keutmann, RE Mains, AS Quon and BA Eipper, *Biochemistry*, **36**, 10901–909 (1997).

35 FA Tausk, SL Milgram, RE Mains and BA Eipper, *Mol Endocrinol*, **6**, 2185–96 (1992).

36 BA Eipper, AS Quon, RE Mains, JS Boswell and NJ Blackburn, *Biochemistry*, **34**, 2857–65 (1995).

37 R Kulathila, AP Consalvo, PF Fitzpatrick, JC Freeman, LM Snyder, JJ Villafranca and DJ Merkler, *Arch Biochem Biophys*, **311**, 191–95 (1994).

38 J Bell, R El Meskini, D D'Amato, RE Mains and BA Eipper, *Biochemistry*, **42**, 7133–42 (2003).

39 AS Murthy, RE Mains and BA Eipper, *J Biol Chem*, **261**, 1815–22 (1986).

40 JC Freeman and JJ Villafranca, *J Am Chem Soc*, **115**, 4923–24 (1993).

41 ST Prigge, BA Eipper, RE Mains and LM Amzel, *Science*, **304**, 864–67 (2004).

42 ST Prigge, AS Kolhekar, BA Eipper, RE Mains and LM Amzel, *Nat Struct Biol*, **6**, 976–83 (1999).

43 X Siebert, BA Eipper, RE Mains, ST Prigge, NJ Blackburn and LM Amzel, *Biophys J*, **89**, 3312–19 (2005).

44 S Jaron and NJ Blackburn, *Biochemistry*, **38**, 15086–96 (1999).

45 FC Rhames, NN Murthy, KD Karlin and NJ Blackburn, *J Biol Inorg Chem*, **6**, 567–77 (2001).

46 S Jaron, RE Mains, BA Eipper and NJ Blackburn, *Biochemistry*, **41**, 13274–82 (2002).

47 P Chen, J Bell, BA Eipper and EI Solomon, *Biochemistry*, **43**, 5735–47 (2004).

48 NJ Blackburn, FC Rhames, M Ralle and S Jaron, *J Biol Inorg Chem*, **5**, 341–53 (2000).

49 WL DeLano, *The PyMOL Molecular Graphics System*, DeLano Scientific LLC San Carlos, CA (2002).

50 WA Francisco, NJ Blackburn and JP Klinman, *Biochemistry*, **42**, 1813–19 (2003).

51 A Crespo, MA Marti, AE Roitberg, LM Amzel and DA Estrin, *J Am Chem Soc*, **128**, 12817–28 (2006).

52 JP Klinman, *J Biol Chem*, **281**, 3013–16 (2006).

53 ST Prigge, RE Mains, BA Eipper and LM Amzel, *Cell Mol Life Sci*, **57**, 1236–59 (2000).

Type-3 Copper Enzymes

Structure, spectroscopy, and function of tyrosinase; comparison with hemocyanin and catechol oxidase

Armand WJW Tepper[†], Emanuela Lonardi[†],
Luigi Bubacco[‡] and Gerard W Canters[†,§]

[†]Leiden Institute of Chemistry, Leiden University, Gorlaeus Laboratories, Einsteinweg 55, 2333 CC Leiden, The Netherlands
[‡]Department of Biology, University of Padova, Via Ugo Bassi 58b, 35121, Padova, Italy
[§]Leiden Institute of Physics, Leiden University, Huygens Laboratory, Niels Bohrweg 2, 2333 CA Leiden, The Netherlands

FUNCTIONAL CLASS

The protein is a monophenol monooxygenase enzyme (EC 1.14.18.1) and belongs to the class of oxidoreductases (EC 1).

OCCURRENCE

The enzyme tyrosinase (E.C. 1.14.18.1) has been identified in almost every large taxon. More generally described as *poly phenol oxidases* (PPOs), tyrosinases can be found in both Gram-positive and Gram-negative bacteria (recently reviewed in reference[1]), fungi and plants (see references [2,3] for recent reviews), invertebrates,[4-7] and vertebrates.[8-11] Table 1 contains examples of organisms in which tyrosinases have been identified.

BIOLOGICAL FUNCTION

Tyrosinase is commonly described as an enzyme able to catalyze the oxidation of both monophenols and

3D Structure The structure of *Streptomyces castaneoglobisporus* tyrosinase in complex with its caddie protein coded by ORF378 (PDB accession code 1WX4). The helices of the 4-helix bundle donating the six Cu_2 coordinating His residues (sticks) have been colored shades of blue (for CuA) or green (for CuB). The caddie protein and Tyr98 occupying the substrate-binding pocket (see also Figure 3) are shown in yellow. The copper atoms and coordinated O_2 are shown as spheres. The graphic was generated using Discovery Studio 1.5 (Accelrys, San Diego, USA).

Table 1 Examples of known tyrosinases. Accession codes for the UniprotKB database are provided. Number of aa refers to the total length of the primary sequence, if not otherwise specified. Molecular weight and isoelectric point were calculated from the whole primary sequence obtained from the database, if not otherwise specified. For more details on bacterial tyrosinase, refer to Claus and Decker[1]; for more information on plant and fungal tyrosinases, valid reviews include van Gelder[12] and Halalouli.[2] A sequence alignment of these tyrosinases is provided in Table 2

Scientific name/Common name	Uniprot accession code	Number aa	Mw (kDa)	Computed pI	Reference
Homo sapiens	P14679	529	60.4	5.7	13
Human	–	–	–	–	–
Mus musculus	P11344	533	60.6	5.7	9
Domestic mouse	–	–	–	–	–
Rana nigromaculata	Q04604	532	60.1	5.1	11
Black spotted frog	–	–	–	–	–
Oryzias latipes	P55025	540	61.3	6.0	14
Rice fish	–	–	–	–	–
Agaricus bisporus	O42713	556	64	5.9	15
Button mushroom	–	–	47[a]	5.1[a]	–
Neurospora crassa	P00440	685	75.9	6.0	16
Filamentous fungus	–	407[a]	45.8[a]	8.3[a]	–
Lycopersicon esclentum	Q08303	585–630[b]	70.5[c]	7.2[c]	17
Tomato	–	–	–	–	–
Streptomyces antibioticus	P07524	272	30.5	7.2	18
Bacteria Gram+	–	–	–	–	–
Rhizobium melitoti	P33180	494	54	4.65	19
Bacteria Gram-	–	–	–	–	–
Ipomea batatas	Q9ZP19	496	39[a]	3.6[a]	20
Sweet potato	–	345[a]	–	–	–

[a] Active form; values taken from reference.
[b] Depending on isoforms.
[c] Relative to isoform A.

o-diphenols to the corresponding *o*-quinones. Highly reactive *o*-quinones can then polymerize, thereby incorporating other compounds present in solution. Tyrosinase is therefore the catalyst in the rate-limiting step of a large variety of cascade reactions that have quinones as initial reagents, as in the case of melanin formation but also as in the case of secondary metabolite formation in plants.

Melanins are heterogeneous phenolic polymers, with colors ranging from yellow to brown and black. Tyrosinase is directly involved in the biosynthesis of two of the three major categories of melanins: eumelanins (brown to black) and pheomelanins (yellow to reddish–brown). The third group, allomelanins, consists of polymers of DHN (dihydroxynaphthalene)-derivatives and generally do not contain nitrogen.[21] During melanogenesis (see Scheme 1), tyrosinase hydroxylates tyrosine to 3,4-dihydroxyphenylalanine (L-DOPA), and then oxidizes this to DOPAquinone. DOPAquinone spontaneously converts into L-DOPAchrome, which evolves into brown or black eumelanins via indole quinones.[22] The cysteinyl and glutathionyl conjugates of L-DOPA and dopamine form pheomelanins through oxidative polymerization.

Melanins have a specific range of chemical properties[23]; their high degree of conjugation makes them absorb over a wide spectral range, which confers protection against ultraviolet light and prevents photoinduced damage to

the cell; the comproportionation between orthoquinone and catechol forms of the polymer generates semiquinone radicals, conferring marked redox properties to melanins and enabling one- and two-electron redox reactions. Carboxylic and deprotonated hydroxyl groups, finally, give the molecule its powerful cation-chelating properties. These chemical properties translate into a wide range of biological functions carried out within an even wider range of taxons.

The ability to produce melanin is widespread among microorganisms and is associated with tyrosinase activity as well as laccase activity. In *bacteria*, melanins are formed mainly extracellularly and as such can provide a particular microenvironment for the organism. Their ambivalent nature as both donor and acceptor of electrons makes melanins valuable for anaerobic as well as aerobic microorganisms. In the case of anaerobic bacteria, melanins can replace the electron acceptor at the end of the electron transfer chain, similar to the use of humic substances.[24] In the case of the nitrogen-fixating bacterium *Azotobacter chroococcum* it has been shown that melanins, by taking away oxygen, can provide the reducing environment necessary for nitrogen assimilation.[25] Under aerobic conditions, melanins can act as a trap for peroxide radicals and hydrogen peroxide as well as for the highly reactive hydroxyl radical.[26] Microbial melanization has also been associated with enhanced virulence of certain pathogens, as

Scheme 1 Schematic representation of the melanogenesis pathways from tyrosine to eumelanins and pheomelanins. For clarity, the reactions leading to DOPAchrome, 1,4 benzthiazinyl-alanine, and eumelanins have been substituted by double arrows. DHI, 5,6-dihydroxyindole; DHICA, 5,6-dihydroxyindole-2-carboxylic acid; TRP1 and TRP2, tyrosinase-related protein 1 and 2. Adapted from reference 21.

demonstrated for the fungus *Cryptococcus neoformans*[27]: melanin provides protection against the oxidative burst of activated host effector cells, reduces the susceptibility to phagocytosis and phagocytic killing, and offers resistance to antimicrobial compounds.[27]

In the case of *Streptomyces* spp., melanin formation is one of the phenotypic characteristics used in classification. As streptomycetes produce a large variety of secondary metabolites, it has been recently suggested that some of the tyrosinase homologs, with a different substrate specificity, might be responsible for the formation of phenoxazinone chromophores.[28] The homolog would act as an *o*-aminophenol oxidase.

In the case of *plant and fungi* tyrosinases, the denomination PPO is preferred for consistency with the body of literature covering the subject. Plant PPOs tend to be present in each species in multiple isoforms, possibly activated and upregulated at different development stages. *Plant* PPOs are localized on the thylakoids of chloroplasts and in vesicles or other bodies in nongreen plastid types, and are generally anchored to the membrane in nonsenescing tissues,[29] while the possible substrates are

kept separated in the vacuole. As the tissue ages, or after damage induced by pathogens or by wounding, the enzyme becomes more soluble, possibly because of the breakdown of membrane integrity. The location of PPO in *fungi* is yet not completely clear, but the enzyme appears to be located mostly in the cytoplasm.[29] Browning of fruits, vegetables, and mushrooms is one of the most common outcomes of tyrosinase-mediated melanization after tissue damage.

It has been suggested that melanization elicits a defense role against pathogens and insects for *higher plants*, where a scab of melanin can act as barrier against further attacks.[12] More recently, the level of expression of PPOs in tomato plants has been related to the susceptibility of the plant to the pathogen *Pseudomonas syringae*,[30,31] although an explanation of the resistance mechanism has still to be found: it possibly relies on the oxidation of phenolic compounds as well as on the generation of reactive oxygen species (ROS) by PPOs. It has been proven also[32] that PPO does play a role in the defense against herbivores but the mechanisms regarding gene expression,[33] enzyme formation and activation, as well as substrate formation, appear complex. A role for PPOs

as oxygen scavenger within chloroplasts has also been suggested.[34] Finally, tyrosinase has been linked to the biosynthesis of betalains,[35–37] water-soluble red pigments present in plants of the order caryophyllales.

Melanin production is part of the defense system in *invertebrates*. In case of mechanical injuries or invasion by foreign objects, microorganisms or pathogens, localized deposition of melanin around the damaged tissue or intruding object will occur. Melanins act as a mechanical shield[38] against the intruder, blocking or retarding its growth, as well as a chemical shield.[39] The latter is achieved by the formation of reactive and toxic quinone intermediates characteristic of the melanization process, which is controlled by the enzyme phenoloxidase (PO),[40] in turn highly regulated by a complex activation mechanism. In invertebrates, prophenoloxidase (proPO) is produced by hemocytes, stocked in the endoplasmic reticulum of hemocytes, and is thought to be released upon damage to the cell membrane. Activation of proPO is controlled by the so-called proPO-activating system and consists of proteins capable of binding to polysaccharides and other compounds typically associated with microorganisms, proteinases that become active in the presence of such microbial products, and other factors (proteinase inhibitors) able to regulate the system.[4] The localization of tyrosinase in its inactive form inside hemocytes does not explain cuticular melanization, for which it has been suggested that proPO, originating inside hemocytes, might be actively transported across the epidermis and into the cuticular matrix.[38]

In *mammals*, melanins have an important role in protective coloration (mimetism) and social behavior within species, but they still elicit a very important defensive role, absorbing free radicals generated within the cytoplasm and shielding the host from various types of ionizing radiations, including UV light. In mammals, melanin production is absolutely dependent on tyrosinase activity, but the modulation of pigmentation relies on various melanogenic factors,[8] acting at different levels.[41] Melanogenesis takes place in specialized dendritic cells called *melanocytes*, located mainly in skin, hair bulbs, and eyes. Melanocytes migrate from the neural crest during embryo development, and the final distribution is responsible for the characteristic patterns found in the mantle of some animals.[8] Melanin synthesis is confined to specialized organelles within the melanocytes, called *melanosomes*, which can be produced in varying sizes, numbers, and densities. Distribution of melanosomes from melanocytes to the surrounding keratinocytes (skin cells) through an exocytosis/phagocytosis mechanism also plays an important role in pigmentation. Lastly, melanogenesis is regulated at the subcellular level by regulating the enzymatic activity not only of tyrosinase but also of tyrosinase-related protein 1 (TRP 1, or DHICA oxidase) and tyrosinase-related protein 2 (TRP 2, or dopachrome tautomerase). These enzymes seem to form a membrane-bound melanogenic complex inside the melanosome.[42]

AMINO ACID SEQUENCE INFORMATION

The recent advancements in sequencing and annotation of entire genomes has considerably expanded the number of tyrosinase sequences available for analysis. The tyrosinase sequences known at the moment range from bacteria to higher eukaryotes (see Table 2 for examples). Although all tyrosinases share common structural and sequence features, the homology is high only within the same taxon. Furthermore, tyrosinase can be present in the cell as monomer (like most bacterial tyrosinases as well as human tyrosinase) or multimer (fungal tyrosinase); in the case of plant and fungal tyrosinases, it is not uncommon to find multiple isoforms of the enzyme (tomato tyrosinase, sweet potato catechol oxidase (CO)).

All tyrosinases belong to the type-3 copper protein family and as such contain an active site consisting of two clusters of three histidines each that ligate two copper ions (see Figure 1). The active site is located in the central domain (when more domains are present). The first three histidine residues are part of a cluster constituting the so-called CuA site and the following three histidines belong to the CuB site. The length of the sequence upstream of CuA varies, as well as the sequence between CuA and CuB (for further structural details see the section "X-Ray structure"). As a normal rule for metalloenzymes, metal ions bind at high hydrophobicity contrast centers.[43] In the case of tyrosinase, the shell of hydrophilic atomic groups (six N) is embedded in a larger hydrophobic shell, corresponding mainly to the pattern $Fxx\Phi$ $H_3Rx\Phi$ around CuA and $FxxHH_3$ around CuB, where Φ indicates an aromatic residue (F, Y, W) and H_3 is the third ligand in each cluster (see Table 2).[44]

Bacterial tyrosinases are monomeric and do not undergo posttranslation modifications. The signal peptide for export to the extracellular environment is carried on the chaperone protein, which is coded within the same operon (this is true for all *Streptomyces* tyrosinases and has been proven for *Marinomonas mediterranea* tyrosinase). *Plant* and *fungal* PPOs are encoded in the nucleus. In the case of *plants*, the N-terminal part of the sequence contains a transit peptide to direct the protein to the lumen of plastidial thylakoids,[45] where tyrosinase is supposed to be soluble or loosely associated with the membrane. In the case of *fungal* PPOs, there is no transit peptide and tyrosinase is therefore thought to be cytoplasmic, possibly bound to organelles or other structures.[46,47] Both classes of PPOs consist of a 55–70 kD latent enzyme form, which is activated upon photolytic cleavage of a C-terminal fragment.[12] *Mammalian* tyrosinase also contains a signal peptide at the N-terminus, which targets the protein to the endoplasmatic reticulum for subsequent folding, modification, and sorting.[46] The C-terminal tail contains a short transmembrane region (TM) followed by a short peptide. While the TM region anchors the protein to the membrane of the melanosome, this short peptide

Table 2 Sequence alignment of the CuA and CuB regions for 9 tyrosinases, one plant catechol oxidase, and one Hc. Coordinating histidines are highlighted in gray. The sequences aligned here correspond to the tyrosinase examples listed in Table 1: HCYG_OCTDO, *Octopus dofleini* hemocyanin subunit G; CO_IPOBA, *Ipomoea batatas* Catechol oxidase; TYRO-, tyrosinase; HUMAN, *Homo sapiens*; MOUSE, *Mus musculus*; RANNI, *Rana nigromaculata*; ORYLA, *Oryzias latipes*; LYCES, *Lycopersicon esclentum*; AGABI, *Agaricus bisporus*; NEUCR, *Neurospora crassa*, STRAT, *Streptomyces antibioticus*, RHIME, *Rhizobium melitoti*. Under the alignment, the pattern of hydrophobic residues around the third histidine of each cluster is indicated. In yellow, the cysteine involved in a thioether bridge with the second histidine of the CuA cluster. In red, residues involved in the "tyrosine motif" interactions. In magenta, the gate residue (for those cases that have been identified). In green, the conserved Asn residue which hydrogen-bonds one of the His ligands

```
CuA

HCYG_OCTDO    HGFQTIASYHG-STLCPSP---EE-PKY------ACCLHGMPVFPHWHRVYLLHFEDSMR
CO_IPOBA      RNFYQQALVHCAYCNGGYDQVNFP-DQ--------EIQVHNSWLFFPFHRWYLYFYERILG
TYRO_AGABI    SSFFQLAGIHGLPFTEWAKERPSMNLY------KAGYCTHGQVLFPTWHRTYLSVLEQILQ
TYRO_NEUCR    DSYYQVAGIHGMPFKPWAGVPSDTDWSQPGSSGFGGYCTHSSILFITWHRPYLALYEQALY
TYRO_HUMAN    NIYDLFVWMH--YYVSMDALLGG-SEIW-----RDIDFAHEAPAFLPWHRLFLLRWEQEIQ
TYRO_MOUSE    NIYDLFVWMH--YYVSRDTLLGG-SEIW-----RDIDFAHEAPGFLPWHRLFLLLWEQEIR
TYRO_RANNI    SAYDLFVWIH--YYASRDAFLED-GSVW-----ADIDFAHEAPGFLPWHRFYLLLWEREIQ
TYRO_ORYLA    NTYDLFVWIH--YYVSRDTFLGGPGNVW-----RDIDFAHESAAFLPWHRVYLLHWEQEIR
TYRO_STRAT    GRYDAFVTTHN-AFILGDTDNGER-----------TGHRSPSFLPWHRRFLLEFERALQ
PPOA_LYCES    IGFKQQANIHCAYCNGGYSIDGK-----------VLQVHNSWLFFPFHRWYLYFYERILG
TYRO_RHIME    RNWYRNGFIH----------------------LMDCPHGDWWFTSWHRGYLGYFEETCR

                                                    FxxΦHRxΦ
```

```
CuB

HCYG_OCTDO    -EVVHNSIHYLVGG-HQKY---------AMSSIVYSSFDPIFYVHHSMVDRLWAIW[53]GYKY
CO_IPOBA      ETSPHIPIHRWVGDPRNTN--------NEDMGNFYSAGRDIAFYCHHSNVDRMWTIW[40]GYKY
TYRO_HUMAN    QSSMHNALHIYMNG--------------TMSQVQGSANDPIFLLHHAFVDSIFEQW[45]GYDY
TYRO_MOUSE    QSSMHNALHIFMNG--------------TMSQVQGSANDPIFLLHHAFVDSIFEQW[45]GYDY
TYRO_RANNI    QSSMHNSLHVFLNG--------------SMSSVQGSANDPIFVLHHAFVDSLFEQW[45]GYDY
TYRO_ORYLA    QSTMHNALHVFMNG--------------SMSSVQGSANDPIFLLHHAFIDSIFERW[44]GYEY
PPOA_LYCES    ENIPHSPVHIWVGTRRGSVLPVGKISNGEDMGNFYSAGLDPLFYCHHSNVDRMWNEW[43]GYDY
TYRO_AGABI    LESVHDDIHVMVGYGKIEG---------HMDHPFFAAFDPIFWLHHTNVDRLLSLW[55]GYSY
TYRO_NEUCR    LEDVHNEIHDRTGG---NG---------HMSSLEVSAFDPLFWLHHVNVDRLWSIW[55]GYAY
TYRO_STRAT    ---LHNRVHVWVGG--------------QMATG-VSPNDPVFWLHHAYIDKLWAEW[40]GYTF
TYRO_RHIME    EGQPHNRVHMSVGGQSAPY---------GLMSQNLSPLDPIFFLHHCNIDRLWDVW[52]DYDY

                                          FxxHH
```

Figure 1 (adapted from references [3,12]). Domain organization in the tyrosinase family. Dark gray circles represent the Cu binding regions. Light gray highlights the N-terminal globular domain of tyrosinases. The globular central domain is delimited, at the C-term, by the tyrosine motif (YY). The black arrow indicates the site of proteolysis which generates the active form of the enzyme. Higher eukaryotes and plants have an N-terminal signal peptide (checkered), which in the case of bacterial tyrosinase is carried by the specific chaperone. Fungal tyrosinases lack the signal peptide and are therefore thought to be cytoplasmatic. Tyrosinases from higher eukaryotes have a transmembrane domain (black).

(exposed to the cytosol) contains sorting/trafficking signals (see Figure 1).

The primary sequences of some bacterial tyrosinases and those of the central domain of plant and fungal PPOs have

features in common with some of the other members of the type-3 copper protein family (mainly the CO of *Ipomoea batatas* and various hemocyanins (Hcs), like the one from *Octopus dofleini*). In particular, this applies to (i) the

presence of a cysteine in the CuA region, which forms a thioether bridge with one of the coordinating histidines,[48,49] putatively adding a structural restraint (see also section "X-Ray structure"), and (ii) the presence of a so-called gate residue, which is placed above the active site and partially prevents access to it (see Table 2).[50] In the case of plant tyrosinases, this residue is a phenylalanine, while fungal PPOs have a leucine or proline in this location.[3] Many tyrosinases share a so-called "tyrosine motif" (Y/FxY) downstream of the CuB region Table 2), which has been thought to interact with a conserved aspartate located after the third coordinating histidine of CuB to structurally restrain the end of the amino acid sequence forming the globular N-terminal domain.[3] The linker region between the N-terminal active globular domain and the C-terminal domain (proteolytically cleaved for activation) is variable in length.[3] The C-terminal domain seems to have a beta sandwich configuration, similar to that of *O. dofleini* Hc,[51] although this cannot be stated with certainty for all available mushroom sequences.

GENETIC INFORMATION AND GENE ORGANIZATION

In the case of *bacteria*, it is not uncommon for tyrosinase to be encoded by a polycistronic operon (see Figure 2); this applies to both Gram-negative (as *Streptomyces* spp.) and Gram-positive (for example, *M. mediterranea*) organisms. In the case of *Streptomyces antibioticus*, the *melC* operon contains two structural genes under the control of one promoter (Figure 2). The first open reading frame (ORF438, *melC1*, 438 bp) codes for the protein MelC1 (M_r

14 754), and the second gene (ORF816, *melC2*, 816 bp) encodes the apo-form of tyrosinase (M_r 29 500).[18] MelC1 forms a heterodimer with tyrosinase (MelC2), which is essential for the correct folding and copper uptake into the active site.[52] MelC1 carries the signal peptide responsible for translocation of the heterodimer via interaction with the Tat (twin arginine translocation) machinery.[53] This so-called hitchhiker mechanism guarantees the secretion of active tyrosinase into the medium.[52,54,55] In the case of *M. mediterranea* a two-cistron operon has been identified, *ppoB*.[56] The *ppoB1* codes for apo-tyrosinase and *ppoB2* for a chaperone, responsible for incorporating copper ions into the active site. The *ppoB2* product does not show any homology with MelC1. PpoB2 contains six transmembrane helices and is not secreted, unlike its functional counterpart in *Streptomycetes*. This protein-specific chaperone for copper uptake seems characteristic of bacteria, since higher organisms rely on general homeostasis systems.[57,58]

The genetic organization of *plant* PPOs (Figure 2) is more complicated and often reveals the presence of multiple gene copies in the genome. They generally do not present introns. In the case of tomato PPOs, a cluster of seven copies of the gene was mapped on chromosome 8. The genes show a high degree of homology (70–91% at the nucleic acid level, 64–88% at the amino acid level), while their flanking regions show a high degree of divergence, which might be responsible for tissue-specific expression of otherwise similar proteins.[17]

Fungal PPOs (Figure 2) can also be present in multiple copies: in *Agaricus bisporus*, the genes AbPPO1 and AbPPO2 share 46% of homology at the nucleic acid level and 34–52% at the amino acid level (identical and

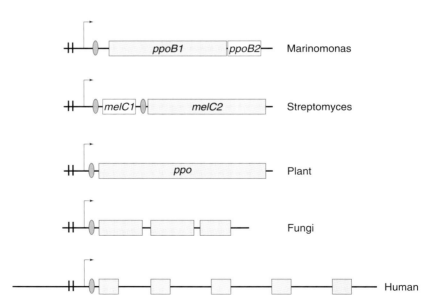

Figure 2 Schematic representation (not drawn to scale) of the genetic organization of tyrosinase in different taxa. Vertical black stripes represent the promoter region. Bent arrow indicates the beginning of transcription. The gray circle represents the ribosome binding sequence. In the case of fungi and human tyrosinase, the presence of exons (gray squares) is indicated. See text for further details.

equivalent amino acids, respectively). It seems, therefore, that the two genes correspond to two separate loci, rather than to two alleles. Both genes present at least 400 bp introns. It has been suggested that AbPPO1 and AbPPO2 might have different roles: AbPPO1 is expressed constitutively, while the expression of AbPPO2 is induced by stress.[15]

While tyrosinase isoforms are more common among plants and fungi, the organization in introns and exons is a general feature for many higher eukaryotic organisms: in the case of *human* tyrosinase (Figure 2), the gene (around 2.4 kb) spans 65 kb on chromosome 11 and consists of five exons and four introns, the 2000 bp upstream of the gene being an important target for both tissue-specific and multiple regulatory elements.[59]

PROTEIN PRODUCTION, PURIFICATION AND CHARACTERIZATION

The purification of active tyrosinase has to deal with the problem of the high melanin contents in the crude extract, which affects binding to ion-exchange material. For this reason, over the years, a number of methods have been developed to remove, at least partially, the pigments: salt fractionation and ultra filtration, among others. Historically, the first tyrosinase to be purified to homogeneity was obtained from mushrooms of the Agaricus genus.[60,61] *Neurospora crassa* tyrosinase has been isolated in the past by salt fractionation and a combination of ion-exchange and hydroxyapatite chromatography.[62]

The first *bacterial* tyrosinases were isolated from cell extracts of *Streptomyces* spp.[63,64] Extracellular forms of the enzyme were purified much later from the supernatant of cell cultures.[18,65] A first homologous expression system was based on the multicopy plasmid pIJ702, harboring the *melC* operon.[18] In all cases, the intracellular form of the protein was identical to the extracellular form in molecular mass and sequences. An over expression system for *S. antibioticus* tyrosinase, based on both chromosomal and plasmid contributions, has been designed.[66] Purification relies in all cases on sequential chromatography steps.[66] Recently, *Streptomyces castaneoglobisporus* tyrosinase has been efficiently over expressed in *Escherichia coli* by coexpression with the chaperone protein MelC1, while the His-tagged tyrosinase could be purified on a Ni(II)-bound affinity column.[67] In the case of the Gram-negative bacterium, *M. mediterranea*, tyrosinase has been extensively studied after extraction from the intracellular component of the cell culture.[56,68]

While bacterial tyrosinases do not undergo posttranslational processes, like glycosylation or proteolytic activation, the choice of a possible host for expression of *eukaryotic* tyrosinases must be well pondered. *Plant* and *fungal*

tyrosinases were originally (and in most cases still are) purified starting from crude cell extracts, but nowadays, the development of cDNA libraries can facilitate the cloning of the appropriate genetic material to be expressed heterologously, like in the case of *Pycnoporus sanguineus* tyrosinase, obtained by over expression in *Aspergillus niger*.[69]

METAL CONTENTS AND NATURE OF THE COFACTOR

The maturation of Ty requires the insertion of two copper ions in the active site of tyrosinase. Since copper is a very cytotoxic and genotoxic element, and its cytosolic levels are extremely low,[70] all types of organism have developed chaperone-based homeostatic mechanisms for the uptake of this ion and its incorporation into specific proteins. In the case of *bacterial* tyrosinase, the best example comes from the *Streptomyces* family where the MelC1 protein is coexpressed with apo-Ty (MelC2). The interaction MelC1:MelC2 is very specific and depends on His residues in both proteins.[52,55,71] As most eukaryotic tyrosinases are larger than those of bacteria, it has been argued that an internal domain may be responsible for the copper incorporation in the eukaryotic species.[44] The uptake of copper by *eukaryotic* cells and the subsequent transfer to target proteins takes place in different compartments,[72] although the details of this mechanism in the case of *fungal* and *plant* Ty are not yet clear. For *mammalian* Ty, it is assumed that copper incorporation takes place in the trans-Golgi network,[73] where copper is delivered to two P-type ATPases (Menkes and Wilson disease proteins[74]), both containing six domains with the typical copper-chaperone CxxC motif[75] at the N-terminus.

X-RAY STRUCTURE

Crystallization

In spite of the importance of tyrosinase and of the numerous attempts to determine its structure, it was only very recently that crystal structures were obtained for the enzyme from *S. castaneoglobisporus*[18,67] in complex with its so-called "caddie protein", the gene product of ORF378. ORF378 is located in the same operon upstream of the tyrosinase gene, analogous to MelC1 in the case of *S. antibioticus* (see the section "Genetic Information and Gene Organization"). The Ty and the caddie protein were coexpressed, a *conditio sine qua non* for obtaining catalytically active enzyme from the *E. coli* expression system. Crystallization appeared possible only for the protein complex Ty-ORF378 in the apo-form.[76] Subsequent soaking of crystals in Cu-containing buffer generated first the metI and metII forms

(i.e. the fully oxidized [Cu(II)–Cu(II)] protein with one and two Cu–Cu bridging water molecules, respectively) and then the deoxy [Cu(I)–Cu(I)] and the oxy forms [Cu(II)–O$_2$$^{2-}$–Cu(II)].[76]

Crystals were grown using a precipitant solution containing 20% polyethylene glycol 3350, 0.2 M sodium nitrate, and 0.1 M 4-(2-hydroxyethyl)-1-piperazineethanesulfonic acid (HEPES) at pH 6.5. The crystals were orthorhombic with space group P2$_1$2$_1$2 ($a = 64.7$, $b = 96.7$, and $c = 54.6$ Å) with one protein complex per asymmetric unit. The structure of the Ty–Caddie complex was solved for the following states: reduced or "deoxy" (PDB: 2ZMZ, 2AHL), oxygenated or "oxy" (PDB: 1WX2, 1WX4), oxidized with one (PDB: 2ZMX) and with two (PDB: 2ZMY, 2AHK) Cu–Cu bridging water molecules, and copperfree apo (PDB: 1WX5, 1WXC). The structures were determined with resolutions in the range 1.2–1.8 Å.

Structure

The overall structure of the protein is mainly α-helical with a core of four helixes (α2, α3, α6, and α7) that provide the histidine ligands for the binuclear copper center (3D Structure and Figure 3). These are, His38, His54, and His63 as ligands of CuA and His190, His194, and His216 as ligands of CuB. The distances from the coordinating His Nε atoms to the nearby copper as well as the Cu–Cu distances have been collected in Table 3 for the four states for which the 3D Structure was reported. The active site is placed at the bottom of a large cavity that defines the substrate-binding region (Figure 3). In the crystal structure of the complex, Tyr98 from the caddie protein is placed in the substrate-binding pocket (3D Structure and Figure 3). This residue is stacked with the imidazole ring of CuB ligand His194, a configuration that is supposed to be similar to the substrate-binding mode (Figure 3; see also below).

Figure 3 Three different views of the active site of *Streptomyces castaneoglobisporus* Ty (PDB accession code 1WX4). The histidine ligands and Tyr98 of the caddie protein (ORF378) are shown in stick representation. Molecular oxygen (red spheres) coordinates to the two copper ions (orange spheres) in a side-on bridging geometry. The substrate-binding pocket is shown as a yellow to red surface and has been calculated after removal of the caddie protein and the bound O$_2$. It can accommodate phenolic molecules with the aromatic ring approximately perpendicular to the Cu–Cu axis. The graphic was generated using Discovery Studio 1.5 (Accelrys, San Diego, USA).

Table 3 Distances from the coordinating His Nε atoms to the nearby copper and Cu–Cu distances in the various forms of *Streptomyces* tyrosinase. All distances in angstrom. Data from reference [76]

Form	MetI	MetII	MetII	oxy	red
PDB entry	2ZMX	2AHK[a]	2ZMY[a]	1WX4	2ZMZ
His38	1.98	2.10	2.2	2.08	1.86
His54	1.98	2.26	6.05[b]	2.16	2.12
His63	2.40	2.44	2.37	2.37	2.16
His190	2.00	2.05	2.06	2.06	2.01
His194	2.01	2.16	2.09	2.09	1.98
His216	2.10	2.19	2.18	2.18	2.01
Cu–Cu	3.72	3.32	3.55	3.55	4.07

[a] There are two data files for the MetII form, 2AHK and 2ZMY, with different coordination geometries around the Cu$_2$ site; in particular, the position of His54 appears different. The methods of preparation of the two MetII forms are probably different, but no information (experimental data or literature reference) is at hand for the MetII form of the 2ZMY PDB file.

[b] Does not coordinate to copper.

COMPARISON WITH HEMOCYANINS AND CATECHOL OXIDASES

As mentioned earlier, tyrosinase is a member of the family of the type-3 Cu proteins which also contains CO and the respiratory pigment Hc.[77] In all structures, each copper ion is coordinated by three histidines. Of the two copper ions in the dinuclear site, the CuB ion exhibits a conserved coordination geometry that is characterized by the respective perpendicular position of the π molecular orbital of the two imidazolates that coordinate the copper ion in the equatorial position. (Figure 4)

A less coherent picture emerges for the coordination geometry of the CuA ion (Figure 4) where the histidine ligands belong to different secondary structural elements (3D Structure). This has been considered an indication that the CuA site is the result of convergent evolution.[78] Since, at least for CuB, the coordination geometry of the imidazolate ligands is highly conserved, one may expect that the structural elements that define this coordination geometry should be conserved, also. In fact, both the Nδ's of the imidazolate equatorial CuB ligands are involved in conserved H-bonds. The first equatorial imidazolate ligand, His194, of CuB is bound to the backbone oxygen of Met201 in *Streptomyces* Ty. The second equatorial imidazolate ligand, His190, is oriented by a strong H-bond to the backbone oxygen of a conserved Asn residue, Asn191, that occurs right after the His ligand in the primary sequence of all type-3 proteins (Table 2). A feature that may play a similar histidine ligand-orienting role is the thioether bond already mentioned in the section "Amino Acid Sequence Information", that has been observed for the His ligand of CuA of mollusc Hc, CO, and *N. crassa* Ty but is absent in bacterial and mammalian Ty.[79]

Although the amino acid sequence of bacterial tyrosinase exhibits only around 25% identity with those of *I. batatas* CO and the *odg* domain of the *O. dofleini* Hc, the overall structures are rather similar. The root mean square difference between the positions of the main chain atoms of Ty and CO is 0.94 Å for 138 matched residues, and of Ty and Octopus Hc is 1.34 Å for 172 residues.[76] Among these three proteins, the highest degree of structural conservation is observed between the core domains that define the superimposable oxygen binding sites.

The measure of accessibility of the active site for bulky substrates is one of the distinctive features among type-3 proteins. While bacterial Ty shows an active site cleft that directly exposes the metal ions in the reaction center to the solvent, both arthropod and mollusc Hcs have a protein domain that shields the active site allowing efficient diffusion of molecular oxygen into the active site but preventing the access for monophenol or diphenol substrates. A second feature that has been considered a determinant for the reactivity of the type-3 site is the presence of a bulky residue in the substrate-binding pocket. In the case of *Limulus polyphemus*, Hc Phe49 occupies the same position as Tyr98 (of the caddie protein) in the structure of the bacterial complex of Ty plus the caddie protein, preventing binding of substrate. In the case of CO, Phe260 is present in the proximity of CuA and this has been proposed to be the structural feature responsible for the lack of the hydroxylation activity in COs.[49]

SPECTROSCOPIC STUDIES

Before the crystal structure of bacterial Ty was reported in 2006,[76] spectroscopic techniques provided the only tools to investigate the structural basis of the complex enzymatic activity of tyrosinases.

Optical spectroscopy

All available crystal structures of oxygenated type-3 sites show that oxygen binds in a $\mu-\eta^2 : \eta^2$–peroxodicopper(II) binding mode (Figure 5(a)). The absorption spectra of oxygenated type-3 sites (Figure 5(b)) exhibit a very intense transition at 350 nm ($\varepsilon \sim 15$–$20 \text{ mM}^{-1} \text{ cm}^{-1}$) and a weak feature at 550 nm ($\varepsilon \sim 1000 \text{ M}^{-1} \text{ cm}^{-1}$). Both transitions are assigned to $O_2^{2-} \rightarrow$ Cu charge transfer (CT) transitions. The doubly degenerate π* HOMOs of the peroxide are split in energy upon interaction with the binuclear copper site. The absorption band at higher energy is assigned as the $\pi_\sigma^* \rightarrow$ Cu(II) and the lower energy as the $\pi_v^* \rightarrow$ Cu(II) CT transition where π_σ^* is the peroxide orbital in the Cu_2O_2 plane (σ-bonding to the Cu(II) centers) and the π_v^* is orthogonal (vertical) to the plane[80] (Figure 5(c)). The resonance Raman spectrum exhibits an extremely low O–O stretch vibration at 750 cm^{-1}, which indicates a very

Figure 4 Superposition of the copper binding residues of type-3 copper proteins: *Limulus polyphemus* Hc (light blue), *Octopus dofleini* Hc subunit G (orange), *Panulirus interruptus* Hc (red), *Ipomoea batatas* Catechol oxidase (yellow). The graphic was generated using Swiss PDB viewer software (Swiss Institute of Bioinformatics, Lausanne Switzerland).

Figure 5 Electronic structure and optical spectroscopy of the oxygenated type-3 copper site. (a) Oxygen binds to the reduced Cu_2 center as the peroxide in a $\mu-\eta^2 : \eta^2$ side-on bridging mode, providing a formal charge of $+2$ to each of the Cu ions. (b) Absorption spectra of oxytyrosinase and oxyhemocyanin. (c) Geometric and electronic structure of a model of the oxygenated type-3 site showing the contours of the HOMO and LUMO orbitals from broken-symmetry SCF-Xα-SW calculations. Figures adapted from reference.[77]

weak O–O bond, a feature that is explained by invoking back-bonding from the copper centers into the σ^* LUMO of the peroxide.[80]

Deoxy-Ty, that has a dinuclear center containing closed shell d^{10} Cu(I) ions shows no marked optical properties. The oxygen bound to the dinuclear center in bacterial Ty_{oxy} can be flash photolyzed by 355 nm pulse irradiation.[81] Using the absorbance change of Ty_{oxy} at 345 nm under O_2 it appeared not possible to observe geminate recombination (within tens of microseconds) but the experiment proved very effective in the determination of rate constants for oxygen binding ($k_{on} = 13 \,\mu M^{-1}s^{-1}$, $k_{off} = 3 \times 10^2 \, s^{-1}$).

EPR, ESEEM, and HYSCORE

The controlled reduction of the EPR (Electron Paramagnetic Resonance) silent Ty_{met} to the EPR visible half-met

[Cu(I)–Cu(II)] form (Figure 6) provided a sensitive paramagnetic probe for the investigation of the interaction between the paramagnetic half of the dinuclear site and substrates or transition-state analog inhibitors of *S. antibioticus* tyrosinase.[82,83] Indicators of structural effects are the hyperfine coupling constants from the noncoordinating histidyl nitrogens. These have been obtained from simulations of the electron spin echo envelope modulation (ESEEM) spectra and hyperfine sublevel correlation (HYSCORE) spectra of half-met-Ty (Figure 6(b)). The structural model that emerged implies the CuB as the paramagnetic center with the unpaired electron occupying a $d_{x^2-y^2}$ orbital and the Cu tetracoordinated by the three His ligands and one equatorial water molecule. The identification of CuB and not CuA as the paramagnetic center in the half-met-Ty was based on the observation that only this assignment gave consistent results in the

Figure 6 (a, b) EPR spectra ($T = 77$ K) of frozen solutions of (a) half-met tyrosinase, (b) half-met tyrosinase with L-mimosine. The copper hyperfine splitting is 13.76 mT for (a) and 15.32 mT for (b). The $g_{//}$ values are 2.296 and 2.305 for (a) and (b). (c, d) Proton regions of HYSCORE spectra for frozen solutions of (c) half-met tyrosinase and (d) half-met tyrosinase with L-mimosine.

simulation of the nitrogen quadrupole data for the histidine Nδ atoms.

Two classes of competitive inhibitors have been considered, monodentate (such as p-nitrophenol (pnp)) and bidentate (Kojic acid and L-mimosine). In the first case, the presence of a nitro substituent in the para position of pnp results in a very poor substrate that in the native protein acts as a competitive inhibitor of L-DOPA oxidation with an inhibition constant of 0.7 mM.[82,83] Binding to the cupric center is demonstrated by the changes in the lineshape of the continuous wave EPR spectrum (Figure 6(a)) as well as by the disappearance of the contribution from the bound water molecule to the HYSCORE spectrum of the pnp-bound form of half-met-Ty (Figure 6(b)).[82] The Cu(II) remains four-coordinated and the coordination geometry is not significantly modified upon pnp binding. A more complex effect was observed upon binding of bidentate hydroxyquinones,[82,83] which are among the strongest competitive inhibitors of bacterial tyrosinase with inhibition constants in the range 4–30 μM.[84] In this case, the disappearance of the signal of the bound water molecule was accompanied by a significant change in the EPR parameters of the Cu(II). The EPR spectrum was indicative of pentacoordination, and this could be rationalized by assuming that both oxygen atoms of the inhibitors coordinate to the Cu(II).[82,83] This view has been corroborated by the paramagnetic NMR (nuclear magnetic resonance) studies discussed in the section "NMR".

Indirect evidence that bidentate ligands bind with both oxygen atoms to Cu(II) is found in the analysis of the half-met-Ty complex with toluic acid.[83] In hydroxyquinones, the ligand oxygens conjugated to the aromatic ring are 2.7 Å apart, while in the carboxylic group of toluic acid the two oxygen ligands are 2.3 Å apart. The structural consequence of this, assuming bidentate ligation, is a more distorted coordination that results in a weaker inhibition. However, no simple correlation can be made between the observed inhibition constant and the structure of the inhibitors, although, in general, bidentate hydroxyquinone ligands seem to bind stronger than both bidentate carboxyl inhibitors and monodentate inhibitors.

XAS

Pulsed EPR experiments (see above) provided the angular orientation of the imidazole rings with respect to the d-orbital of the oxidized copper ion and the strength of the interaction with the water ligands, but no direct information could be obtained on bond lengths in the active site. This gap can be filled, in principle, by X-ray absorption spectroscopy (XAS). The more recent minute X-Ray absorption near edge structure (MXAN) analysis[85] also provides structural models of the coordination shells of the metal ions.

The first XAS studies available in the literature on Tys date back to the 1980s. One is related to the fully oxidized Ty from N. crassa[86] and another to the deoxygenated and oxygenated forms of A. bisporus Ty.[87] More recently, an XAS analysis[88] provided new insights starting from a comparison of the results of the MXAN analysis of S. antibioticus Ty and the crystal structure of S. castaneoglobisporus Ty in a complex with ORF378 (the caddie),[76] its chaperone protein (see the sections "Amino Acid Sequence Information" and "Genetic Information and Gene Organization" for more details). As mentioned above, the met-forms of Cu(II)-bound Ty complexed with ORF378 can be obtained by soaking crystals of the apo-protein in a CuSO$_4$ solution and this led to the identification of two met forms, the first (MetI) with one, the second (MetII) with two bridging water molecules between the copper ions in the active site. The XAS analysis of Ty$_{met}$ allowed the identification of the MetII form as the solution form of the protein.[88] Furthermore, it was reported that in solution, ORF378 is liberated from the complex by the addition of Cu(II), while in the crystalline state, it is not.[76] The presence of residue Tyr98 of the caddie protein in close proximity of the active site of Ty in the crystal structure may be responsible for the small differences observed between the crystalline and solution forms.

A structural feature that has been recurrently proposed as a determining factor in Ty activity is the Cu–Cu distance. The solution structure of Ty$_{met}$ from S. antibioticus with two water (hydroxyl) molecules bridging the metal ions, shows a distance of 3.36 ± 0.08 Å in the MXAN analysis[88] in good agreement with the value obtained in the only other X-ray absorption study on Ty$_{met}$ (N. crassa) where it amounted to about 3.4 Å.[86] The Cu–Cu distance in the crystal structure of S. castaneoglobisporus Ty MetII, that is, with two water molecules bridging the copper ions, is 3.32 Å.[76] A different structural model of the dinuclear site has been proposed for the met-derivative of I. batatas CO. Both the XAS and the crystal structure indicate that the copper ions are tetracoordinated with only one bridging atom and also a shorter Cu–Cu distance of 2.89 Å (from EXAFS (X-ray absorption fine structure) spectroscopy)[20] and 2.87 Å (in the crystal structure).[49]

NMR

In the met-form of Ty (Ty$_{met}$), the Cu ions in the dinuclear site are in the oxidized Cu(II) form, each with an electronic spin of $S = 1/2$. Antiferromagnetic coupling between the two spins leads to a diamagnetic $S = 0$ ground state and a paramagnetic $S = 1$ (triplet) state at a distance of $-2J$ above the $S = 0$ state. At the low temperatures where EPR spectra are usually recorded, only the diamagnetic $S = 0$ state is populated, hence the statement often encountered in the literature that "the Ty$_{met}$-form is EPR-silent" (e.g. 49, 89).

However, when the singlet–triplet energy separation ($-2J$) amounts to a few hundred wavenumbers as in the case of Ty, the paramagnetic excited state is partially populated at room temperature where $k_B T$ is in the order of ~200 wavenumbers.[66,90,91] In the NMR spectrum of Ty_{met}, this paramagnetism induces large shifts and relaxation enhancements of signals deriving from nuclei close to the paramagnetic center.[66,91] Shifts and relaxation enhancements both contain information about the structure of and the spin distribution in the active site.[92] In fact, the signals shifted outside the (crowded) diamagnetic envelope provide a useful fingerprint, for example, to follow ligand binding.

Compared to mononuclear copper systems, oxidized tyrosinase or binuclear copper systems, in general, display remarkably sharp paramagnetically shifted signals. The sharpness of the signals is related to the electronic structure of the Cu_2 center.[91] The magnetic coupling between the two copper ions provides electronic relaxation pathways that are unavailable to isolated Cu^{2+} ions. This causes a decrease in the electronic relaxation time τ_S with respect to mononuclear Cu systems. While the latter typically exhibit τ_S values in the order of 10^{-8}–10^{-9} s, the τ_S of Ty_{met} is in the order of 10^{-11} s.[91] The fast electronic relaxation in the type-3 center and other Cu_2 systems is thought to be due to the modulation of the zero-field splitting (ZFS) splitting of the $S = 1$ level[90] and/or thermal motion affecting the Cu–X–Cu bridging angle and, thereby, the magnitude of the exchange parameter $-2J$.[91]

The paramagnetic NMR spectrum of chloride-bound Ty_{met} displays a rich fine structure originating from the protons of the coordinated amino acid residues (Figure 7). The shifted resonances could partly be assigned on the basis of H_2O/D_2O exchange experiments, intraresidue NOE (nuclear Overhauser effect) patterns and T_1 relaxation data.[66] The sharp solvent exchangeable signals, marked with an asterisk in Figure 7, were assigned to the His–Nδ protons, while the broader signals could be assigned to the His–Cϵ and His–Cδ protons of the coordinating histidines. Furthermore, the observed NOE patterns allowed to relate each of the six sharp Nδ proton signals with a broader Cϵ signal, thereby identifying each histidine residue in the six-coordinate ligand sphere of the Cu_2 site. This provided the first unequivocal proof that Ty contains a "classical" type-3 copper center, whereby each Cu is coordinated by three His residues.

Paramagnetic nuclear magnetic resonance (pNMR) has also been used to study the interaction of Ty_{met} with inhibitors. It was shown that halide ions can replace a Cu-bridging hydroxide causing large changes in the NMR spectra.[93] The magnitude of the antiferromagnetic coupling constant, $-2J$, for the three halide-bound Ty_{met} forms follows the order Ty_{met}F ($260\,cm^{-1}$) > Ty_{met}Cl ($200\,cm^{-1}$) > Ty_{met}Br ($162\,cm^{-1}$).[91] This has been rationalized in terms of the Cu–X$^-$–Cu bridging angle, with larger angles inducing stronger couplings. The same order was

Figure 7 Paramagnetic ^1H NMR spectrum of chloride-bound oxidized [Cu^{2+}–Cl^-–Cu^{2+}] tyrosinase at pH 6.8 and 4 °C. Owing to the paramagnetism of the Cu ions, the signals originating from the protons of coordinated His residues are shifted outside of the crowded diamagnetic window (between −1 and 12 ppm). The sharp signals labeled with an asterisk belong to His Nδ protons, while the broader signals originate from the His Cδ and Cϵ protons. The drawn lines indicated by capitals A–F represent NOE connectivities between His Nδ and Cϵ protons, thereby identifying each of the six His ligands in the type-3 coordination sphere.

observed in the electronic relaxation times (τ_S) as estimated from proton relaxation data.[91] It was also shown that the halide-bridging ligands are displaced when bidentate transition-state analog inhibitors (e.g. mimosine) bind to Ty_{met}, indicating that one of the oxygens on the inhibitor occupies the Cu-bridging position,[93] consistent with the picture emerging from the spectroscopic analysis of Ty in the half-met form discussed above (see section "EPR, ESEEM, and HYSCORE").

The binding of *pnp* to Ty_{met} and its halide-bound derivatives has been studied in detail by pNMR spectroscopy.[96] The monophenolic substrate analog forms a ternary complex with halide-bound Ty_{met}, showing that the phenolic oxygen does not displace the Cu-bridging ligand. Furthermore, all six histidine ligands remain bound to Cu, excluding the possibility that phenols displace a coordinating His residue, again consistent with the studies on $Ty_{half-met}$ (see the section "EPR, ESEEM, and HYSCORE"). In the case of native Ty_{met} as well as of Ty_{met}Cl, the paramagnetic shift of one coordinated histidine was shown to be noticeably affected by *pnp* binding. This could be the result of a change in coordination geometry of this His residue upon *pnp* binding or it could be due to a direct interaction of *pnp* with the ring of a coordinated histidine analogous to His244 of CO that interacts with the aromatic ring of the inhibitor phenylthiourea. From the crystal structure of *Streptomyces* Ty, His194 has been suggested as a possible candidate for this role.[95]

For Ty_{met}Cl, it was established that the magnetic exchange parameter $-2J$ shifts from $200\,cm^{-1}$ in the absence to about $150\,cm^{-1}$ in the presence of *pnp*.[96] This was rationalized by assuming that the Cu–X$^-$–Cu bridging angle decreases, which would mean that the

Cu ions are pulled together upon *pnp* binding. A similar event might be important in the activation of the peroxide upon monophenol binding to Ty_{oxy}. By evaluating the T_1 values of the aromatic ring protons of Ty_{met}-bound *pnp*, a structural model of monophenol coordination could be derived.[96] In this model, the phenol is axially coordinated to one copper with its aromatic ring tilted toward the noncoordinating copper, which later proved very similar to the orientation of Tyr98 in the Ty X-ray structure (Figure 3). In this orientation, the ortho protons of the bound phenol are oriented toward the bound peroxide in Ty_{oxy}, allowing for the hydroxylation of the phenol. In CO, instead, a similar orientation of phenol is prevented by Phe261 that shields the active site and locks the substrate in place.[49,95,97] This would explain the absence of monophenolase activity in CO.

ENZYME MECHANISM

Over the years, attempts to fit the Ty-catalyzed reactions into a single mechanistic scheme have proved a formidable challenge. The Ty reaction scheme must allow for monophenolase and diphenolase activities, as well as for the lag phase observed in the conversion of monophenolic compounds, the suicide inactivation upon the conversion of monophenols and the inhibition by monophenolic substrates.[98,99] Furthermore, kinetic schemes have to take in account the side reactions in which quinone products may engage (see section "Biological Function"). These often lead to the formation of diphenolic compounds which are themselves Ty substrates, and this complicates analysis. Several kinetic schemes have been proposed.[98,99] The consensus mechanism consistent with kinetic analyses and structural studies is presented in Scheme 2.

The monophenolase pathway starts with the binding of O_2 to Ty_{red} to render Ty_{oxy} (step 1) in a fast reversible step. The O_2 binds to both copper atoms as the peroxide in a side-on μ-η^2 : η^2 bridging mode, with each Cu carrying a formal charge of +2.[77] Phenolic substrate then binds to one of the type-3 coppers of Ty_{oxy} (step 2) with the aromatic ring oriented toward the bound peroxide. In this step, the phenol may transfer a proton to a base "B". From the structure of CO and from sequence homology, a role for proton uptake has been suggested for the conserved Glu residue that is present in the CuB site of most COs and Tys.[49] In *Streptomyces* Ty, a similar base is not present, however, leaving the bound peroxide itself[76,100] or the noncoordinating His215 residue located at 4.5 Å from CuB and close to His194[76] as possible candidates.

Whether the phenol binds to CuA or CuB has been a matter of debate. The coordination to CuA in Ty has been suggested on the basis of modeling studies using the X-ray structures of *Limulus* Hc and CO,[95,97] while the picture emerging from spectroscopic studies is more consistent with phenol binding to CuB (see the section "EPR, ESEEM, and

HYSCORE").[83] Also the X-ray structure of *Streptomyces* Ty[76] does not unambiguously resolve the issue. In the structure, a tyrosine (Tyr98) from the caddie protein (ORF378) extends into the substrate-binding pocket, much like a potential substrate. The hydroxyl moiety of this tyrosine is centrally located between the copper ions at a distance of 4 Å from both Cu atoms (Figure 3), which is too large to be compatible with a direct coordination to type-3 Cu. This would explain why the residue is not hydroxylated in the structure. A free phenolic substrate, however, can directly approach the Cu_2O_2 core, where it could coordinate, in principle, to either CuA or CuB.

The binding of the phenol is followed by the selective ortho hydroxylation of the substrate (step 3). Attempts to directly trap an intermediate of the Ty hydroxylation reaction and uncover the details of the hydroxylation reaction on a structural level have been unsuccessful so far. Studies on small inorganic model compounds mimicking the Ty hydroxylation chemistry have provided new insights, however. An important step forward was the demonstration of the side-on peroxo binding mode of O_2 in a Cu_2O_2 complex.[101] Following this, similar complexes have been described, many of which appeared capable of aromatic ligand hydroxylation (e.g. [102–106]). In most of these systems, the hydroxylation proceeds through an electrophilic aromatic substitution, the rate of which scales with the electron donor capability of the para substituents of the phenol substrate. The negative Hammett parameter, which is diagnostic for this type of reaction, lies around −2 in these complexes.[107,108] This is similar to the value of −2.4 determined recently for the hydroxylation reaction of mushroom Ty.[109]

An important question is at which stage of the reaction the O–O bond of the bound peroxide is broken.[77,110,111] The type of reaction catalyzed and the electronic properties of the Cu_2O_2 core suggest that it occurs concomitant with or after hydroxylation. Yet, in one case, the coordination of phenolate to a synthetic Cu_2O_2 complex induced scission of the peroxo bond to render a bis-μ-oxo dicopper(III)–phenolate complex[112] which closely reproduced the spectroscopic features of the bis-μ-oxo complexes synthesized earlier by Tolman and coworkers.[113] This O–O bond scission was followed by the hydroxylation of the bound phenolate. In the complex, the phenolate oxygen coordinates in plane with the Cu_2O_2 core to one of the coppers in an equatorial fashion, which optimally orients the aromatic ring for electrophilic attack on the Cu_2O_2 core. In Ty_{oxy}, a similar orientation seems to be precluded due to the rigid protein scaffold constraining the phenol to an axial position with the phenolic oxygen perpendicular to the Cu_2O_2 plane (see Figure 3). It has been suggested, however, that the bound peroxide may rotate around the Cu–Cu axis prior to hydroxylation of the substrate so that one of the oxygens points toward the aromatic ring,[95] in which case, such a mechanism could occur.

Scheme 2 Schematic overview of the Ty-catalyzed mono- and diphenolase pathways. See text for details.

After oxygen transfer the diphenol product is bound to Ty_{met}. In most models, the diphenol is coordinated in a "bridging" bidentate fashion with the phenolic hydroxo moieties coordinating to different Cu atoms, but experimental evidence for this has been lacking. This orientation requires a large reorganization of the substrate in the active site as well as of active-site residues during or after the hydroxylation reaction. Spectroscopic studies of complexes of Ty_{met} and $Ty_{half-met}$ with bidentate inhibitors have shown (see the sections "EPR, ESEEM, and HYSCORE" and "NMR") that one of the phenolic oxygens displaces the bridging ligand between the Cu(II) ions in Ty_{met}, and that bidentate inhibitors bind with both oxygens to a single type-3 copper in half-met Ty, observations incompatible with the proposed diphenol binding mode. The spectroscopic data are consistent, therefore, with the diphenol orientation as drawn in Scheme 2

in which one phenolic oxygen bridges two Cu ions. This would require little or no reorganization of the diphenol in the active site and the His copper ligands after the hydroxylation has occurred.

The diphenol bound to Ty_{met} can be oxidized further to produce the quinone and Ty_{red} (step 4). Alternatively, the diphenol may dissociate from the complex,[99,100] leaving the enzyme in the oxidized met-form. Since Ty_{met} is the dead end in the conversion of monophenols, this dissociation causes an apparent suicide inactivation of the enzyme. Ty_{met} can only be revived through reduction by a diphenol substrate, and this is only efficient at relatively high diphenol concentrations because of the relatively low affinity of Ty_{met} for diphenolic substrates.[98–100] The failure of Ty_{met} to react with monophenols also causes the characteristic lag phase in the conversion of monophenols. In the "resting" or "as isolated" state, a major fraction

of the tyrosinase is in the Ty_{met} form. Thus, only the small percentage of the enzyme in the Ty_{oxy} state is able to react with monophenolic compounds at the onset of catalysis resulting in a low rate of conversion. The buildup of diphenolic compounds in the reaction medium eventually results in the conversion of Ty_{met} into Ty_{red}, thus directing this enzyme to the monophenolase pathway and raising the observed catalytic rate. In the conversion of tyrosine, for example, the diphenolic activator is formed by the disproportionation of orthoquinone into DOPAchrome and DOPA. A further factor in the lag-phase kinetics is due to substrate inhibition that arises from the binding of monophenol to Ty_{met} (step 8) resulting in a dead-end complex. The occurrence of this binding step had been inferred from kinetic studies and now has been proven by the pNMR studies[96] described in the section "NMR".

The diphenolase cycle involves the conversion of two diphenol molecules into the corresponding quinones. In the first step, a diphenol molecule binds to Ty_{oxy} (step 5) and transfers two electrons to the peroxide in Ty_{oxy} converting it to water. After dissociation of the quinone product, the enzyme is left in the met-form (step 6). The second diphenol molecule then binds to Ty_{met} (step 7) and donates electrons to the Cu(II) ions producing the reduced form, Ty_{red} (step 4). The binding of the diphenol to Ty_{met} may involve the transfer of a proton from the diphenol to an OH^--bridging ligand and the concomitant dissociation of the resulting water molecule from its bridging position. The pK_a of this bridging OH^- lies around 4.5 in *Streptomyces* Ty as inferred from rapid kinetic studies.[94] The diphenolase pathway is blocked when the OH^- is replaced by the more electronegative fluoride ion,[94] the latter being more difficult to protonate.

REFERENCES

1 H Claus and H Decker, *Syst Appl Microbiol*, **29**, 3–14 (2006).

2 S Halaouli, M Asther, JC Sigoillot, M Hamdi and A Lomascolo, *J Appl Microbiol*, **100**, 219–32 (2006).

3 CM Marusek, NM Trobaugh, WH Flurkey and JK Inlow, *J Inorg Biochem*, **100**, 108–23 (2006).

4 L Cerenius and K Soderhall, *Immunol Rev*, **198**, 116–26 (2004).

5 R Waterston, C Martin, M Craxton, C Huynh, A Coulson, L Hillier, R Durbin, P Green, R Shownkeen and N Halloran, *Nat Genet*, **1**, 114–23 (1992).

6 M Hall, T Scott, M Sugumaran, K Soderhall and JH Law, *Proc Natl Acad Sci USA*, **92**, 7764–68 (1995).

7 K Fujimoto, N Okino, S Kawabata, S Iwanaga and E Ohnishi, *Proc Natl Acad Sci USA*, **92**, 7769–73 (1995).

8 VJ Hearing and K Tsukamoto, *FASEB J*, **5**, 2902–9 (1991).

9 BS Kwon, M Wakulchik, AK Haq, R Halaban and D Kestler, *Biochem Biophys Res Commun*, **153**, 1301–9 (1988).

10 M Mochii, A Iio, H Yamamoto, T Takeuchi and G Eguchi, *Pigment Cell Res*, **5**, 162–67 (1992).

11 M Takase, I Miura, A Nakata, T Takeuchi and M Nishioka, *Gene*, **121**, 359–63 (1992).

12 CW van Gelder, WH Flurkey and HJ Wichers, *Phytochemistry*, **45**, 1309–23 (1997).

13 LB Giebel and RA Spritz, *Am J Hum Genet*, **49**, 406 (1991).

14 H Inagaki, Y Bessho, A Koga and H Hori, *Gene*, **150**, 319–24 (1994).

15 HJ Wichers, K Recourt, M Hendriks, CE Ebbelaar, G Biancone, FA Hoeberichts, H Mooibroek and C Soler-Rivas, *Appl Microbiol Biotechnol*, **61**, 336–41 (2003).

16 U Kupper, DM Niedermann, G Travaglini and K Lerch, *J Biol Chem*, **264**, 17250–58 (1989).

17 SM Newman, NT Eannetta, H Yu, JP Prince, MC de Vicente, SD Tanksley and JC Steffens, *Plant Mol Biol*, **21**, 1035–51 (1993).

18 V Bernan, D Filpula, W Herber, M Bibb and E Katz, *Gene*, **37**, 101–10 (1985).

19 J Mercadoblanco, F Garcia, M Fernandezlopez and J Olivares, *J Bacteriol*, **175**, 5403–10 (1993).

20 C Eicken, F Zippel, K Buldt-Karentzopoulos and B Krebs, *FEBS Lett*, **436**, 293–99 (1998).

21 PM Plonka and M Grabacka, *Acta Biochim Pol*, **53**, 429–43 (2006).

22 AJ Nappi and E Ottaviani, *Bioessays*, **22**, 469–80 (2000).

23 PA Riley, *Int J Biochem Cell Biol*, **29**, 1235–39 (1997).

24 JD Coates, KA Cole, R Chakraborty, SM O'Connor and LA Achenbach, *Appl Environ Microbiol*, **68**, 2445–52 (2002).

25 S Shivprasad and WJ Page, *Appl Environ Microbiol*, **55**, 1811–17 (1989).

26 G Sichel, C Corsaro, M Scalia, AJ Di Bilio and RP Bonomo, *Free Radic Biol Med*, **11**, 1–8 (1991).

27 JD Nosanchuk and A Casadevall, *Cell Microbiol*, **5**, 203–23 (2003).

28 H Suzuki, Y Furusho, T Higashi, Y Ohnishi and S Horinouchi, *J Biol Chem*, **281**, 824–33 (2006).

29 AM Mayer, *Phytochemistry*, **67**, 2318–31 (2006).

30 P Thipyapong, J Melkonian, DW Wolfe and JC Steffens, *Plant Sci*, **167**, 693–703 (2004).

31 L Li and JC Steffens, *Planta*, **215**, 239–47 (2002).

32 J Wang and CP Constabel, *Planta*, **220**, 87–96 (2004).

33 ME Christopher, M Miranda, IT Major and CP Constabel, *Planta*, **219**, 936–47 (2004).

34 K Vaughn, A Lax and S Duke, *Physiol Plant*, **72**, 659–65 (1988).

35 U Steiner, W Schliemann, H Böhm and D Strack, *Planta*, **208**, 114–24 (1999).

36 F Gandia-Herrero, J Escribano and F Garcia-Carmona, *Plant Physiol*, **138**, 421–32 (2005).

37 D Strack, T Vogt and W Schliemann, *Phytochemistry*, **62**, 247–69 (2003).

38 M Ashida and PT Brey, *Proc Natl Acad Sci USA*, **92**, 10698–702 (1995).

39 AJ Nappi and E Vass, *Pigment Cell Res*, **6**, 117–26 (1993).

40 K Soderhall and L Cerenius, *Curr Opin Immunol*, **10**, 23–28 (1998).

41 H Watabe, JC Valencia, K Yasumoto, T Kushimoto, H Ando, J Muller, WD Vieira, M Mizoguchi, E Appella and VJ Hearing, *J Biol Chem*, **279**, 7971–81 (2004).

42 A Chakraborty and J Pawelek, *J Cell Physiol*, **157**, 344–50 (1993).

43 MM Yamashita, L Wesson, G Eisenman and D Eisenberg, *Proc Natl Acad Sci USA*, **87**, 5648–52 (1990).

44 JC Garcia-Borron and F Solano, *Pigment Cell Res*, **15**, 162–73 (2002).

45 JC Steffens, E Harel, and MD Hunt, Polyphenol oxidase, in SE Ellis, GW Kuroki and HA Stafford (eds.), *Genetic Engineering of Plant Secondary Metabolism*, Plenum Press, New York, pp 275–312 (1994).

46 A Helenius, T Marquardt and I Braakman, *Trends Cell Biol*, **2**, 227–31 (1992).

47 S Jolivet, N Arpin, HJ Wichers and G Pellon, *Mycol Res*, **102**, 1459–83 (1998).

48 ME Cuff, KI Miller, KE van Holde and WA Hendrickson, *J Mol Biol*, **278**, 855–70 (1998).

49 T Klabunde, C Eicken, JC Sacchettini and B Krebs, *Nat Struct Biol*, **5**, 1084–90 (1998).

50 C Gerdemann, C Eicken and B Krebs, *Acc Chem Res*, **35**, 183–91 (2002).

51 C Gerdemann, C Eicken, A Magrini, HE Meyer, A Rompel, F Spener and B Krebs, *Biochim Biophys Acta*, **1548**, 94–105 (2001).

52 LY Chen, WM Leu, KT Wang and YH Lee, *J Biol Chem*, **267**, 20100–7 (1992).

53 K Schaerlaekens, M Schierova, E Lammertyn, N Geukens, J Anne and L Van Mellaert, *J Bacteriol*, **183**, 6727–32 (2001).

54 LY Chen, MY Chen, WM Leu, TY Tsai and YH Lee, *J Biol Chem*, **268**, 18710–16 (1993).

55 WM Leu, LY Chen, LL Liaw and YH Lee, *J Biol Chem*, **267**, 20108–13 (1992).

56 D Lopez-Serrano, F Solano and A Sanchez-Amat, *Gene*, **342**, 179–87 (2004).

57 D Lopez-Serrano, F Solano and A Sanchez-Amat, *Microbiology*, **153**, 2241–49 (2007).

58 TV O'Halloran and VC Culotta, *J Biol Chem*, **275**, 25057–60 (2000).

59 S Ponnazhagan, L Hou and BS Kwon, *J Invest Dermatol*, **102**, 744–48 (1994).

60 MF Mallette, S Lewis, SR Ames, JM Nelson and CR Dawson, *Arch Biochem*, **16**, 283–89 (1948).

61 D Keilin and T Mann, *Proc Roy Soc (London) B* **125**, 187–204 (1938).

62 K Lerch, *FEBS Lett*, **69**, 157–60 (1976).

63 K Lerch and L Ettinger, *Eur J Biochem*, **31**, 427–37 (1972).

64 AM Nambudiri and JV Bhat, *Biochem J*, **130**, 425–33 (1972).

65 R Crameri, L Ettlinger, R Hutter, K Lerch, MA Suter, and JA Vetterli, *J Gen Microbiol*, **128**, 371–79 (1982).

66 L Bubacco, J Salgado, AWJW Tepper, E Vijgenboom and GW Canters, *FEBS Lett*, **442**, 215–20 (1999).

67 PY Kohashi, T Kumagai, Y Matoba, A Yamamoto, M Maruyama and M Sugiyama, *Protein Expr Purif*, **34**, 202–7 (2004).

68 D Lopez-Serrano, A Sanchez-Amat and F Solano, *Pigment Cell Res*, **15**, 104–11 (2002).

69 S Halaouli, E Record, L Casalot, M Hamdi, JC Sigoillot, M Asther and A Lomascolo, *Appl Microbiol Biotechnol*, **70**, 580–89 (2006).

70 SJ Lippard, *Science*, **284**, 748–49 (1999).

71 LL Liaw and YH Lee, *Biochem Biophys Res Commun*, **214**, 447–53 (1995).

72 MD Harrison, CE Jones, M Solioz and CT Dameron, *Trends Biochem Sci*, **25**, 29–32 (2000).

73 G Negroiu, N Branza-Nichita, GE Costin, H Titu, AJ Petrescu, RA Dwek and SM Petrescu, *Cell Mol Biol (Noisy-le-Grand)*, **45**, 1001–10 (1999).

74 M Schaefer and JD Gitlin, *Am J Physiol*, **276**, G311–14 (1999).

75 SM Petrescu, N Branza-Nichita, G Negroiu, AJ Petrescu and RA Dwek, *Biochemistry*, **39**, 5229–37 (2000).

76 Y Matoba, T Kumagai, A Yamamoto, H Yoshitsu and M Sugiyama, *J Biol Chem*, **281**, 8981–90 (2006).

77 EI Solomon, UM Sundaram and TE Machonkin, *Chem Rev*, **96**, 2563–605 (1996).

78 H Decker and N Terwilliger, *J Exp Biol*, **203**, 1777–82 (2000).

79 C Gielens, K Idakieva, M De Maeyer, V Van den Bergh, NI Siddiqui and F Compernolle, *Peptides*, **28**, 790–97 (2007).

80 M Metz and EI Solomon, *J Am Chem Soc*, **123**, 4938–50 (2001).

81 S Hirota, T Kawahara, E Lonardi, E de Waal, N Funasaki and GW Canters, *J Am Chem Soc*, **127**, 17966–67 (2005).

82 M van Gastel, L Bubacco, EJJ Groenen, E Vijgenboom, and GW Canters, *FEBS Lett*, **474**, 228–32 (2000).

83 L Bubacco, M van Gastel, EJJ Groenen, E Vijgenboom and GW Canters, *J Biol Chem*, **278**, 7381–89 (2003).

84 L Bubacco, E Vijgenboom, C Gobin, AWJW Tepper, J Salgado and GW Canters, *J Mol Catal B-Enzym*, **8**, 27–35 (2000).

85 S della Longa, A Arcovito, M Girasole, JL Hazemann, and M Benfatto, *Phys Rev Lett 87* **155501**, (2001).

86 S DellaLonga, I Ascone, A Bianconi, A Bonfigli, AC Castellano, O Zarivi and M Miranda, *J Biol Chem*, **271**, 21025–30 (1996).

87 GL Woolery, L Powers, M Winkler, EI Solomon, K Lerch and TG Spiro, *Biochim Biophys Acta*, **788**, 155–61 (1984).

88 L Bubacco, R Spinazze, S della Longa and M Benfatto, *Arch Biochem Biophys*, **465**, 320–27 (2007).

89 RH Holm, P Kennepohl and EI Solomon, *Chem Rev*, **96**, 2239–314 (1996).

90 I Bertini, O Galas, C Luchinat, G Parigi and G Spina, *J Magn Reson*, **130**, 33–44 (1998).

91 AWJW Tepper, L Bubacco and GW Canters, *Chem-A Eur J*, **12**, 7668–75 (2006).

92 I Bertini, C Luchinat and S Aime, *Coord Chem Rev*, **150**, R7 (1996).

93 AWJW Tepper, L Bubacco and GW Canters, *J Biol Chem*, **277**, 30436–44 (2002).

94 AWJW Tepper, L Bubacco and GW Canters, *J Biol Chem*, **279**, 13425–34 (2004).

95 H Decker, T Schweikardt and F Tuczek, *Angew Chem Int Ed*, **45**, 4546–4550 (2006).

96 AWJW Tepper, L Bubacco and GW Canters, *J Am Chem Soc*, **127**, 567–575 (2005).

97 H Decker and F Tuczek, *Trends Biochem Sci*, **25**, 392–97 (2000).

98 A Sanchezferrer, JN Rodriguezlopez, F Garciacanovas and F Garciacarmona, *Biochim Biophys Acta-Protein Struct Mol Enzymol*, **1247**, 1–11 (1995).

99 LG Fenoll, MJ Penalver, JN Rodriguez-Lopez, R Varon, F Garcia-Canovas and J Tudela, *Int J Biochem Cell Biol*, **36**, 235–46 (2004).

100 LG Fenoll, JN Rodriguez-Lopez, F Garcia-Sevilla, PA Garcia-Ruiz, R Varon, F Garcia-Canovas and J Tudela, *Biochim Biophys Acta-Protein Struct Mol Enzymol*, **1548**, 1–22 (2001).

101 N Kitajima, T Koda, and Y Morooka, *Chem Lett*, 347–50 (1988).

102 KD Karlin, PL Dahlstrom, SN Cozzette, PM Scensny, and J Zubieta, *J Chem Soc Chem Commun*, 881–82 (1981).

103 L Santagostini, M Gullotti, E Monzani, L Casella, R Dillinger and F Tuczek, *Chem-A Eur J*, **6**, 519–22 (2000).

104 S Itoh, H Kumei, M Taki, S Nagatomo, T Kitagawa and S Fukuzumi, *J Am Chem Soc*, **123**, 6708–9 (2001).

105 LM Mirica, M Vance, DJ Rudd, B Hedman, KO Hodgson, EI Solomon and TDP Stack, *J Am Chem Soc*, **124**, 9332–33 (2002).

106 L Casella, M Gullotti, R Radaelli, and P Digennaro, *J Chem Soc Chem Commun*, 1611–12 (1991).

107 S Itoh and S Fukuzumi, *Acc Chem Res*, **40**, 592–600 (2007).

108 S Palavicini, A Granata, E Monzani and L Casella, *J Am Chem Soc*, **127**, 18031–36 (2005).

109 S Yamazaki and S Itoh, *J Am Chem Soc*, **125**, 13034–35 (2003).

110 EI Solomon, P Chen, M Metz, SK Lee and AE Palmer, *Angew Chem Int Ed*, **40**, 4570–90 (2001).

111 EI Solomon, AJ Augustine and J Yoon, *Dalton Trans*, 3921–32 (2008).

112 LM Mirica, M Vance, DJ Rudd, B Hedman, KO Hodgson, EI Solomon and TDP Stack, *Science*, **308**, 1890–92 (2005).

113 S Mahapatra, JA Halfen, EC Wilkinson, GF Pan, XD Wang, VG Young, CJ Cramer, L Que and WB Tolman, *J Am Chem Soc*, **118**, 11555–74 (1996).

Multicopper Enzymes

Two-domain multicopper oxidase

Thomas J Lawton and Amy C Rosenzweig

Departments of Biochemistry, Molecular Biology, and Cell Biology and of Chemistry, Northwestern University, Evanston, IL, USA

FUNCTIONAL CLASS

Enzyme; benzenediol oxygen oxidoreductase and ferricytochrome oxygen oxidoreductase; EC 1.10.3.2; a 'blue' multicopper oxidase with two cupredoxin domains closely related to copper nitrite reductase and other multicopper oxidases; known as 2dMCO.

OCCURRENCE

Gene sequences predicted to encode two-domain multicopper oxidases (2dMCOs) are found in the genomes of bacterial and archaeal species and frequently occur in gene clusters with proteins involved in metabolism or metal homeostasis.[2,3] The 2dMCO amino acid sequences are classified as type A, B, or C based on which domain(s) provide(s) the conserved type-1 (T1) copper center ligands (Figure 1). 2dMCOs have been isolated from cultures of *Nitrosomonas europaea* (3D structure), *Sinorhizobium meliloti*, and a number of *Streptomyces* species.[4–7] In addition, 2dMCOs from several *Streptomyces* species and a metagenomic library have been cloned and expressed.[8–10] There is also some evidence that 2dMCOs are present in fungi.[11]

BIOLOGICAL FUNCTION

The physiological function of 2dMCOs has been investigated in *N. europaea* (NeMCO, also known as blue copper oxidase) and *Streptomyces griseus* (SgMCO, also known as EpoA). The 2dMCOs from *Streptomyces* have received much attention because their broad working pH range and remarkable stability may be useful for biotechnological applications.[5,8,9] Although 2dMCOs from *Streptomyces* have generally been regarded as laccases because of their broad substrate range,[8,9] studies on SgMCO indicate that it may play a role in the onset of cell morphogenesis.[8]

The 2dMCO from *N. europaea* is of interest because of its role in nitrifier denitrification. The gene encoding NeMCO is found in an operon with two cytochromes and a CuNIR that is regulated by a nitrite sensor, NsrR. Disruption of the gene encoding NeMCO results in cells with an increased sensitivity to nitrite, indicating that NeMCO plays a supporting role in nitrite reduction.[12,13] Biochemical data show that NeMCO is capable of accepting electrons from reduced ferricytochromes.[4] Given the presence of 2dMCOs in the genomes of many unrelated species,[11] it is likely that they have diverse functions.

3D Structure Crystal structures of 2dMCOs from *Nitrosomonas europaea* (a, PDB code: 3G5W) and *Streptomyces coelicolor* (b, PDB code: 3CG8). T1 copper sites are shown in dark blue and T2/T3 copper sites are shown in light blue. The three monomers are shown in gray, green, and pink, with the two domains of the pink monomer shown in dark pink and light pink. All figures were produced with the program PyMOL.[1]

Figure 1 MCO classification scheme. Three cyan circles indicate the location of the T2/T3 copper site. Single dark blue circles indicate the location of the T1 copper site. The CuNIR domain structure is shown for comparison. Crystallographically characterized examples are listed below each cartoon.

AMINO ACID SEQUENCE INFORMATION

- *Nitrosomonas europaea* (NeMCO); UniProtKB/TrEMBL: Q82VX3; PDB code: 3G5W; 363 amino acid residues (AA); also known as BCO (blue copper oxidase)
- *Streptomyces coelicolor* (ScMCO); UniProtKB/TrEMBL: Q9XAL8; PDB code: 3GC8; 343 AA; also known as SLAC (small laccase)
- *Arthrobacter* sp. (strain FB24) (AsMCO); UniProtKB/TrEMBL: A0AW19; PDB code: 3GDC; 376 AA
- *Uncultured bacteria* (MgMCO); UniProtKB/TrEMBL: C0STU6; PDB code: 2ZWN; 359 AA
- *Streptomyces griseus* (SgMCO); UniProtKB/TrEMBL: Q93HV5; 348 AA; also known as EpoA (extracytoplasmic phenol oxidase)

A BLAST[14] search using any of these genes reveals many more putative 2dMCOs. For a review of 31 sequences, see reference[11] and for a review of 7 sequences from archaeal sources, see reference.[3]

PROTEIN PRODUCTION, PURIFICATION, AND MOLECULAR CHARACTERIZATION

The first reported 2dMCO isolation was that of *N. europaea* (NeMCO) by ammonium sulfate precipitation followed by isoelectric focusing and size exclusion chromatography.[4] The molecular masses based on size exclusion chromatography and sodium dodecyl sulfate polyacrylamide gel electrophoresis were estimated to be 127.5 and 40.1 kDa, respectively, consistent with a trimer. Electron paramagnetic resonance (EPR) spectroscopic data indicated the presence of T1 and type-2 (T2) copper, and optical spectroscopy revealed an absorption maximum at 605 nm with an extinction coefficient of $6.0\,cm^{-1}\,mM^{-1}$. Although NeMCO was the first purified 2dMCO, it was not recognized as a 2dMCO until its sequence from the *N. europaea* genome was analyzed.[2,15] In more recent protocols, the isoelectric focusing step is replaced with hydrophobic interaction chromatography.[16]

The 2dMCOs from *Streptomyces* are the most studied to date. Most of this work has focused on the 2dMCO from *S. coelicolor* (ScMCO). The first characterization of ScMCO involved expression in *E. coli* and purification by anion exchange chromatography.[9] EPR and optical spectroscopy revealed typical MCO spectroscopic properties. Isoelectric focusing indicated that the oxidized form of ScMCO has a pI of 8.2, whereas the reduced form has a pI of 7.3. In-gel sodium dodecyl sulfate polyacrylamide gel electrophoresis activity assays demonstrated that the enzyme is tolerant of sodium dodecyl sulfate and active as an oligomer. On the basis of in-gel activity assays and gel filtration chromatography, ScMCO was predicted to be a dimer, but was later shown to be a trimer.[17] This study also

showed that active ScMCO is secreted to the media by *S. coelicolor*.[9]

The highest yields obtained for a 2dMCO, 350 mg L^{-1}, have been for ScMCO expressed in *Streptomyces lividans*.[18] The advantage of this expression system is that ScMCO is secreted to the media and does not require extensive purification. Although native *Streptomyces* 2dMCOs are usually secreted, the yields are much lower.[5,6,8] Besides ScMCO, other *Streptomyces* 2dMCOs have been purified from both native and recombinant sources using a variety of methods.[5,6,8,19] In general, *Streptomyces* 2dMCOs are very stable and are active in the presence of detergent as well as at high temperatures. Optimal activities have been obtained at unusually alkaline pH values.[8,9] Several halotolerant *Streptomyces* 2dMCOs have been isolated as well.[5,19] Owing to their stability, a number of studies have been performed to determine if *Streptomyces* 2dMCOs have uses in the biotechnology industry.[6,18–22]

METAL CONTENT

2dMCOs contain 12 copper ions per functional trimer, arranged in three T1 sites and three trinuclear (T2/T3) sites. The copper content of 2dMCOs has been determined by inductively coupled plasma optical emission spectroscopy,[16] bicinchoninic acid assays,[9] and atomic absorption spectroscopy.[8]

ACTIVITY TEST

Given the broad substrate specificity of 2dMCOs, many different substrates can be used to measure activity. A number of aromatic compounds such as *p*-phenylenediamine and 2,6-dimethoxyphenol have been used to spectrophotometrically detect activity.[4,8,9] In addition, 2,2′-azinobis-(3-ethyl benzthiazoline-6-sulphonate) and Fe(CN)$_6^{4-}$ have been used.[9,16]

X-RAY STRUCTURES

Crystallization

The first crystals of a 2dMCO were those of ScMCO reported in 2007 by Skálová *et al.*[23] These crystals were obtained by hanging-drop vapor diffusion by mixing 1 μL of 7 mg mL^{-1} ScMCO in 0.05 M H$_3$BO$_3$–NaOH, pH 9.0, with 1 μL 30% Jeffamine ED-2001, pH 7.0. The crystals belonged to space groups P4$_1$2$_1$2 or P4$_3$2$_1$2 with unit cell dimensions $a = b = 179.8$ Å and $c = 175.3$ Å. The 2.7-Å resolution structure of ScMCO was reported in 2008 using crystals belonging to space group P4$_3$2$_1$2 and grown with polyethylene glycol 550 monomethyl ether as the precipitant.[17]

The 1.9-Å resolution structure of NeMCO in space group P1 and the 1.7-Å resolution structure of a 2dMCO from a metagenome (MgMCO) in the space group P2$_1$2$_1$2$_1$ were reported in early 2009.[16,24] The sequence similarity between mature (lacking an N-terminal signal sequence) NeMCO and MgMCO proteins is 62%, whereas they are 22% and 17% similar to ScMCO, respectively. In early 2010, the 1.8-Å resolution crystal structure of the *Arthrobacter* sp. (strain FB24) 2dMCO (AsMCO) in the space group C2 was released to the PDB. Given that a literature report for this structure has not yet appeared, only structural aspects of AsMCO will be discussed in comparison to other 2dMCOs.

Overall architecture

The architecture of 2dMCOs resembles a cylindrical homotrimer very similar to that of CuNIRs (Figure 2). The monomers are composed of two cupredoxin domains (domain 1 and domain 2) with trinuclear copper clusters located at each of the monomer–monomer interfaces. The T1 copper site in MgMCO, AsMCO, and NeMCO is located in the first domain (type C), whereas the T1 site in ScMCO is located in the second domain (type B) (Figure 1). There are no crystal structures of type A 2dMCOs.

An N-terminal signal sequence of ~40 residues is not present in any of the 2dMCO structures. In ScMCO, MgMCO, and NeMCO, the N-terminus forms the first β strand of domain 1. The two domains are connected by a short linker approximately 12 amino acids in length. The C-termini of NeMCO, MgMCO, and AsMCO are well ordered and almost entirely modeled. The 25 C-terminal residues are not present in the structure of ScMCO. In NeMCO and MgMCO, the ~40 C-terminal amino acids wrap around the outside of each monomer into the crevice that is formed between the two domains (Figure 2). The C-terminus contacts the first β strand of the domain 2 and the third β strand of domain 1. In contrast, the N-terminus of AsMCO occupies the crevice between the two domains, similar to what is observed in CuNIRs[25] and there is no C-terminal extension past the second cupredoxin domain (Figure 2(b)).

The ScMCO structure contains two unique extended loops termed the "trimerization loops" which are not found in the other structurally characterized 2dMCOs or CuNIRs (Figure 2(c)).[17] The first loop is composed of amino acids 135–147 from domain 1. These residues interact with the second trimerization loop, formed by residues 243–254 of domain 2 from the adjacent monomer. In the other structurally characterized 2dMCOs, these loops are truncated and bear a closer resemblance to CuNIRs. The termini, trimerization loops, and tower loops (discussed below) appear to be the least conserved structural features among 2dMCOs. These elements likely influence stability and/or function.

Figure 2 Comparison of 2dMCOs with *Alcaligenes faecalis* CuNIR (AfNIR, gray, PDB code: 1AS7). T2/T3 copper ions are shown in light blue and 2dMCO T1 copper ions are shown in dark blue. (a) Superposition of NeMCO (pink, PDB code: 3G5W) and AfNIR (gray) looking down the trimer threefold axis. (b) NeMCO monomer (pink) superposed on AfNIR (gray) and AsMCO (green, PDB code: 3GDC) viewed perpendicular to the threefold axis. (c) Superposition of ScMCO (pink, PDB code: 3GC8) with AfNIR (gray). The ScMCO trimerization loops are shown in dark pink. Domain 1 from one monomer is on the left and domain 2 from a second monomer is on the right. (d) NeMCO (pink) with tower loop highlighted in green. Domain 1 (right) and domain 2 (left) of the same monomer are displayed.

Copper coordination

The trinuclear T2/T3 copper clusters are composed of a single T2 copper ion and a pair of T3 copper ions located at the monomer–monomer interfaces (Table 1 and Figure 3). The T2/T3 copper site is coordinated by eight histidine residues. Four of these histidines are derived from domain 1 and four come from domain 2 of the adjacent monomer. This arrangement is analogous to three-domain MCOs (3dMCOs), in which four ligands are provided by domain 1 and four ligands are provided by domain 3.[26–28] Similar

to 3dMCOs, the T3 copper ions are bridged by a hydroxyl group and each coordinated by three histidine nitrogen atoms. The T2 site is coordinated by two histidine nitrogen atoms with the third ligand being either hydroxide or water. This T2 coordination environment is virtually identical to that in 3dMCOs.[26–28]

The specific details of T3 coordination in ScMCO and AsMCO differ from what is observed in MgMCO and NeMCO. In MgMCO, NeMCO, and all structurally characterized 3dMCOs, one of the T3 copper ions is coordinated by three Nε2 atoms and a bridging oxygen

Table 1 Crystallographically determined metal-ligand distances in 2dMCOs. Corresponding amino acids are shown in Figure 3

	NeMCO	MgMCO	AsMCO	ScMCO
Resolution of structure	1.9 Å	1.7 Å	1.8 Å	2.7 Å
Copper–copper				
Cu(3a)–Cu(3b)	5.04 ± 0.03	4.97 ± 0.02	5.65 ± 0.04	5.00 ± 0.05
Cu(2)–Cu(3b)	4.05 ± 0.04	3.91 ± 0.02	4.01 ± 0.05	3.68 ± 0.35
Cu(2)–Cu(3a)	4.06 ± 0.02	4.11 ± 0.02	4.39 ± 0.06	3.75 ± 0.20
Copper 3b (T2/T3 site)				
Ligand 1 (His Nε2, Nδ1)	2.00 ± 0.05	2.00 ± 0.02	2.02 ± 0.05	1.93 ± 0.01
Ligand 2 (His Nε2)	2.07 ± 0.02	2.04 ± 0.02	2.04 ± 0.06	2.07 ± 0.06
Ligand 3 (His Nε2)	2.18 ± 0.05	2.15 ± 0.01	2.11 ± 0.03	2.00 ± 0.12
Ligand 4 (O, bridging)	2.88 ± 0.15	2.61 ± 0.03	2.96 ± 0.10	2.51 ± 0.20
Copper 3a (T2/T3 site)				
Ligand 1 (His Nε2)	2.10 ± 0.06	2.10 ± 0.01	2.05 ± 0.02	2.28 ± 0.07
Ligand 2 (His Nε2)	2.01 ± 0.02	2.02 ± 0.02	1.98 ± 0.05	2.10 ± 0.03
Ligand 3 (His Nε2)	2.05 ± 0.04	2.02 ± 0.03	2.00 ± 0.09	2.37 ± 0.04
Ligand 4 (O, bridging)	2.20 ± 0.13	2.36 ± 0.01	2.70 ± 0.09	2.54 ± 0.17
Copper 2 (T2/T3 site)				
Ligand 1 (His Nε2)	2.00 ± 0.03	1.89 ± 0.02	1.86 ± 0.03	1.84 ± 0.09
Ligand 2 (His Nε2)	1.94 ± 0.02	1.87 ± 0.02	1.86 ± 0.04	1.95 ± 0.06
Ligand 3 (OH)	2.75 ± 0.04	2.98 ± 0.06	3.19 ± 0.13	2.83 ± 0.01
Bridging O	3.50 ± 0.08	3.15 ± 0.03	3.12 ± 0.20	2.66 ± 0.06
Copper 1 (T1 site)				
Ligand 1 (His Nδ1)	2.20 ± 0.04	2.09 ± 0.01	2.12 ± 0.07	2.00 ± 0.02
Ligand 2 (His Nδ1)	2.11 ± 0.03	2.02 ± 0.04	2.15 ± 0.07	1.91 ± 0.02
Ligand 3 (Met S, Leu Cδ1)	2.79 ± 0.05	2.75 ± 0.05	3.24 ± 0.01	3.42 ± 0.03
Ligand 4 (Cys S)	2.13 ± 0.05	2.25 ± 0.02	2.14 ± 0.05	2.18 ± 0.02

atom and the other is coordinated by two Nε2 atoms, one Nδ1 atom, and a bridging oxygen. Both the T3 copper ions in ScMCO and AsMCO are coordinated by three Nε2 atoms and a bridging oxygen, similar to the six-domain MCO (6dMCO) ceruloplasmin.[29] For ScMCO, this difference was suggested to be the result of a π–π interaction between His104 which provides the Nε2 (the analogous residue provides the coordinated Nδ1 in other 2d and 3dMCOs) and His154.[17] In 3dMCOs, MgMCO, and NeMCO, the equivalent residue to ScMCO His154 is a tryptophan. The corresponding residue in AsMCO is a leucine, suggesting the absence of a tryptophan instead of the presence of histidine gives rise to the alternative coordination. It is not immediately clear if this difference has any effect on oxygen binding by or reactivity of the T2/T3 site.

In ScMCO, MgMCO, and AsMCO, the distance from the T3 bridging oxygen to the T2 copper ion is relatively short in comparison to other MCOs (Table 1). In the crystal structures of ScMCO, AsMCO, and MgMCO, the T2 copper centers are modeled with occupancies of 0.4, 0.4, and 0.7, respectively. These partial occupancies may explain the varying position of the bridging oxygen atom. Partial depletion of the T2 center has been reported in some 3dMCO isolations.[30,31] In addition, modeling of the bridging oxygen in ScMCO is based on a difference density

map, and after refinement, the oxygen atom is not well defined in the $2F_o–F_c$ map, suggesting it may not be well ordered.[17] In NeMCO, the copper sites are fully occupied and the 3.5-Å distance from the T3 bridging oxygen to the T2 copper ion is consistent with that observed in other MCOs.

The T1 copper centers of all structurally characterized 2dMCOs (Table 1 and Figure 3) except for AsMCO strongly resemble the T1 copper centers in ascorbate oxidase[32,33] and CuNIR.[25,34–36] The T1 centers in ScMCO, MgMCO, and NeMCO are distorted trigonal pyramidal with coordination by two Nδ1 atoms from histidines, one cysteine, and a more distant axial methionine. In MgMCO and NeMCO, the axial methionine sulfur atom is ~2.8 Å from the copper ion, whereas in ScMCO the Cu–S distance is 3.4 Å (Table 1).

Similar to several fungal 3dMCOs and ferrous transport 3 protein (Fet3p),[37] the T1 axial methionine is replaced with leucine in AsMCO. In T1 copper centers, the axial residue plays a major role in tuning the reduction potential, with hydrophobic axial residues correlated with a much higher reduction potential than methionine.[37] Thus, a comparison of AsMCO biochemical data with that obtained for the other 2dMCOs will be of particular interest. Notably, sequence analysis of 2dMCOs indicates that many variants probably have hydrophobic residues in this position.[37]

Figure 3 Ligands to the copper centers in the four structurally characterized 2dMCOs.

COMPARISON TO OTHER STRUCTURES

Comparison to CuNIRs

The trimeric architecture of 2dMCOs results in a domain arrangement that is virtually identical to that found in CuNIRs (Figure 2). CuNIRs contain two mononuclear copper centers, a T1 site within domain 1 and a T2 site, which is the site of nitrite reduction, at the monomer–monomer interface (Figure 1). Secondary structure matching of the individual monomers of ScMCO and NeMCO to five different CuNIRs gives average root mean square deviation (r.m.s.d.) values of 1.9 and 2.3 Å, respectively, with an average of 78 and 68% of the secondary structure of the MCOs matched to CuNIRs.[16] The similar architecture places the CuNIR T2 site in the same location as one of the 2dMCO T3 copper ions. The CuNIR residues that correspond to the T2 ligands in 2dMCOs are replaced by two conserved residues, a histidine and an aspartate, which are essential for CuNIR activity.[38–40] The CuNIR residues equivalent to the second T3 copper ion ligands in 2dMCOs are hydrophobic residues. The T1 sites in MgMCO and NeMCO occupy the same location as the T1 site in CuNIRs, and are coordinated by similar ligands with nearly identical distances.

An interesting feature of NeMCO and MgMCO is the presence of a "tower loop" between β strands 1 and 2 of domain 2. This loop extends over the top of the first domain (Figure 2(d)). In CuNIR, the tower loop plays a role in positioning proteinaceous electron donors near the T1 site.[41,42] The presence of a tower loop in NeMCO likely gives rise to its cytochrome oxidase activity.[16] The ability of other 2dMCOs to accept electrons from proteinaceous electron donors has not yet been studied.

Despite the similarities between 2dMCOs and CuNIRs, there are significant differences at the termini (Figure 2(b)). In all currently characterized CuNIRs, the N-terminal residues extend from the first cupredoxin domain into the crevice between domains 1 and 2, whereas the C-terminal β-strand hydrogen bonds with domain 1 of the adjacent monomer. In contrast, the C-termini of 2dMCOs either occupy the space between domains 1 and 2 (NeMCO and MgMCO) or do not extend into the neighboring monomer (AsMCO). In AsMCO, the domain–domain interface is filled by the N-terminus, similar to CuNIRs, but in a slightly different fashion. It is important to note that a significant portion of the N-terminus of AsMCO is not modeled.

The difference in C-termini between 2dMCOs and CuNIRs is interesting because truncations of the C-terminal extensions in *Achromobacter cycloclastes* CuNIR (AcNIR) result in structural changes and significant loss of activity.[43,44] In the crystal structure of truncated AcNIR, the metal-ligand distances at the T1 copper center change

drastically, suggesting alterations to the domain–domain interface can affect the distant T1 site.[44] It was also suggested that truncation enhances the role of the T2 site in trimer stabilization.

Comparison to 3dMCOs

The trimeric structure of 2dMCOs results in a domain arrangement that is surprisingly similar to the domain arrangement of 3dMCOs (Figure 4). Secondary structure matching of ScMCO and NeMCO models containing one monomer and domain 2 of the adjacent monomer (Figure 4(a)) to 13 different 3dMCOs gave average r.m.s.d. values of 2.3 and 1.8 Å, respectively, with averages of 87 and 81% of the secondary structure of the 2dMCOs matched to the 3dMCOs.[16] The lowest r.m.s.d. value in this study was 1.4 Å between NeMCO and ascorbate oxidase. These superpositions indicate that the overall fold and orientations of the domains in 2dMCOs and 3dMCOs are extremely well conserved.

Structural conservation is especially evident at the 2dMCO monomer–monomer interface and the analogous interface between domains 1 and 3 in 3dMCOs (Figure 4(a) and (c)). This similarity results in the T2/T3 site being coordinated in the same way in 2dMCOs and 3dMCOs (Figure 4(b)) and suggests that formation of the T2/T3

site is dependant on precise positioning of the domains. Thermal denaturation studies on Fet3p, a 3dMCO involved in iron metabolism, show that binding of the T2/T3 copper ions decreases the stability of domains 1 and 3. It was suggested that domain 2 compensates for this effect by reducing the degrees of freedom for domains 1 and 2.[45] Thus, domain 2 likely plays a large role in positioning and stabilizing the interface between domain 1 and 3 in 3dMCOs. In 2dMCOs, this interface forms as a result of trimerization. Therefore, oligomerization in 2dMCOs and the presence of an additional domain in 3dMCOs likely serve a similar purpose.

Given the structural homology at the T2/T3 copper site, it is likely that 2dMCOs follow the same general mechanism as the well-studied 3dMCOs.[46] Extensive studies on yeast Fet3p indicate that a conserved aspartate, Asp94, is essential for the formation of a μ_3-1,2,2 peroxy intermediate.[46,47] An aspartate occupies the same position as Fet3p Asp94 in all four 2dMCO crystal structures. In NeMCO, ScMCO, and AsMCO, this aspartate adopts a similar rotamer as in Fet3p pointing toward the T2 copper ion and within hydrogen bonding distance of the histidine residue equivalent to Fet3p His418 and the water ligand to the T2 site. In ScMCO, this aspartate adopts a different position. In Fet3p, NeMCO, and MgMCO, this portion of the protein backbone is structurally similar, whereas differences are observed for ScMCO and AsMCO.

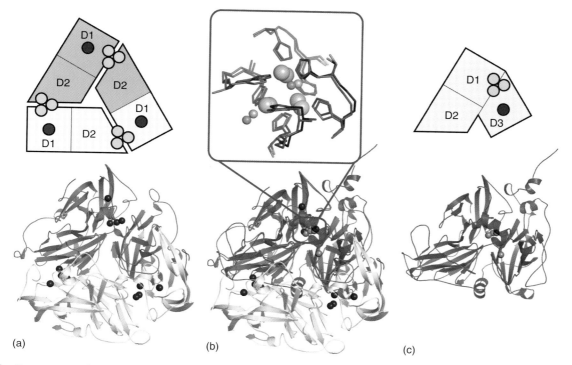

Figure 4 Comparison of NeMCO to ascorbate oxidase. (a) Domains of NeMCO (PDB code: 3G5W) used for superposition are highlighted dark pink in schematic (top) and ribbon (bottom) diagrams. (b) Superposed structures of NeMCO (dark pink) and ascorbate oxidase (gray, PDB code: 1AOZ). Inset shows a close up view of the T2/T3 site. Copper ions are shown as large spheres and solvent ligands are shown as small spheres. (c) Domains of ascorbate oxidase used for superposition are shown in gray in schematic (top) and ribbon (bottom) diagrams.

In ScMCO, a tyrosine residue is within hydrogen bonding distance of the T2 water ligand and close to the position of Asp94 in Fet3p. Interestingly, a radical intermediate was detected by electron paramagnetic resonance (EPR) spectroscopy for ScMCO, which would be consistent with a tyrosyl radical.[48] It may be that ScMCO differs mechanistically from MgMCO, AsMCO, and NeMCO.

Another important residue in Fet3p is Glu487, which acts as a proton donor and is responsible for the pH dependent decay of the peroxy intermediate.[46,47] Surprisingly, this residue is not strictly conserved in the 2dMCOs that have been characterized to date. In NeMCO and MgMCO, the residue corresponding to Glu487 is an aspartate residue (Asp298 and Asp256, respectively) which could act as a proton donor in a similar way. In ScMCO and AsMCO, Glu487 is substituted with a glutamine (Gln291) and threonine (Thr284), respectively. The Gln291 substitution in ScMCO is intriguing given that its activity has a different pH profile than other MCOs.[9]

PLACEMENT IN THE EVOLUTION OF MULTICOPPER BLUE PROTEINS

Several models for the evolution of multicopper blue proteins from single cupredoxin domains to 3d/6dMCOs have been proposed.[49–51] In all these models, there is consensus that MCO evolution began with a single domain duplication, followed by a trimerization event and metal binding at the monomer–monomer interfaces. The existence of functional 2dMCOs confirms the plausibility of these models. In light of the conserved domain placement between 2dMCOs and 3d/6dMCOs (Figure 4), it is extremely likely that modern day 2dMCOs and 3d/6dMCOs share a common 2dMCO ancestor.

In addition, the 2dMCO structures highlight their similarities to CuNIRs. Strikingly, the only major difference between CuNIR and the type-C 2dMCOs NeMCO and ScMCO is the presence of the T3 copper ions. Two pathways for CuNIR evolution have been proposed: the first involves evolution of CuNIR following the initial domain duplication event[11,52] and the second involves evolution of CuNIR from a type-C 2dMCO.[11] Current structural and sequence analysis cannot exclude either of these possibilities and it is possible both pathways may be relevant to multicopper blue protein evolution.

In recent years, the sizes of protein sequence databases have increased rapidly. The relatively recent discovery of 2dMCOs underscores that we have just begun to realize the diversity of the MCO and CuNIR families.[11,52] Additional sequences and structures of 2dMCOs as well as of other multicopper blue proteins are required to understand and construct their evolutionary relationships.

ACKNOWLEDGEMENTS

The work in the Rosenzweig laboratory on 2dMCOs is supported by the Agriculture and Food Research Initiative competitive grant no. 2010-65115-20380 from the USDA National Institute of Food and Agriculture.

REFERENCES

1 WL Delano, *The PyMOL Molecular Graphics System*, DeLano Scientific, San Carlos, CA (2002).

2 K Nakamura, T Kawabata, K Yura and N Go, *FEBS Lett*, **553**, 239–44 (2003).

3 K Sharma and R Kuhad, *Indian J Microbiol*, **49**, 142–50 (2009).

4 AA DiSpirito, LR Taaffe, JD Lipscomb and AB Hooper, *Biochim Biophys Acta*, **827**, 320–26 (1985).

5 KN Niladevi, N Jacob and P Prema, *Process Biochem.*, **43**, 654–60 (2008).

6 ME Arias, M Arenas, J Rodríguez, J Soliveri, AS Ball and M Hernández, *Appl Environ Microbiol*, **69**, 1953–58 (2003).

7 F Rosconi, LF Fraguas, G Martinez-Drets and S Castro-Sowinski, *Enzyme Microbiol Technol*, **36**, 800–807 (2005).

8 K Endo, Y Hayashi, T Hibi, K Hosono, T Beppu and K Ueda, *J Biochem*, **133**, 671–77 (2003).

9 MC Machczynski, E Vijgenboom, B Samyn and GW Canters, *Protein Sci*, **13**, 2388–97 (2004).

10 H Komori, K Miyazaki and Y Higuchi, *Acta Cryst*, **F65**, 264–66 (2009).

11 K Nakamura and N Go, *Cell Mol Life Sci*, **62**, 2050–66 (2005).

12 HJ Beaumont, SI Lens, WN Reijnders, HV Westerhoff and RJ van Spanning, *Mol Microbiol*, **54**, 148–58 (2004).

13 HJ Beaumont, SI Lens, HV Westerhoff and RJ van Spanning, *J Bacteriol*, **187**, 6849–51 (2005).

14 SF Altschul, TL Madden, AA Schaffer, J Zhang, Z Zhang, W Miller and DJ Lipman, *Nucleic Acids Res*, **25**, 3389–402 (1997).

15 P Chain, J Lamerdin, F Larimer, W Regala, V Lao, M Land, L Hauser, A Hooper, M Klotz, J Norton, L Sayavedra-Soto, D Arciero, N Hommes, M Whittaker and D Arp, *J Bacteriol*, **185**, 2759–73 (2003).

16 TJ Lawton, L Sayavedra-Soto, DJ Arp and AC Rosenzweig, *J Biol Chem*, **284**, 10174–80 (2009).

17 T Skálová, J Dohnálek, LH Østergaard, PR Østergaard, P Kolenko, J Dusková, A Stepánková and J Hasek, *J Mol Biol*, **385**, 1165–78 (2009).

18 E Dube, F Shareck, Y Hurtubise, C Daneault and M Beauregard, *Appl Microbiol Biotechnol*, **79**, 597–603 (2008).

19 JM Molina-Guijarro, J Pérez, J Muñoz-Dorado, F Guillén, R Moya, M Hernández and ME Arias, *Int Microbiol*, **12**, 13–21 (2009).

20 E Dube, F Shareck, Y Hurtubise, M Beauregard and C Daneault, *J Ind Microbiol Biotechnol*, **35**, 1123–29 (2008).

21 J Gallaway, I Wheeldon, R Rincon, P Atanassov, S Banta and SC Barton, *Biosens Bioelectron*, **23**, 1229–35 (2008).

22 R Moya, M Hernández, AB Garcia-Martin, AS Ball and ME Arias, *Bioresour Technol*, **101**, 2224–29 (2010).

23 T Skálová, J Dohnálek, LH Østergaard, PR Østergaard, P Kolenko, J Dusková and J Hasek, *Acta Cryst*, **F63**, 1077–79 (2007).

24 H Komori, K Miyazaki and Y Higuchi, *FEBS Lett*, **583**, 1189–95 (2009).

25 ET Adman, JW Godden and S Turley, *J Biol Chem*, **270**, 27458–74 (1995).

26 P Giardina, V Faraco, C Pezzella, A Piscitelli, S Vanhulle and G Sannia, *Cell Mol Life Sci*, **67**, 369–85 (2010).

27 D.J Kosman, J Peisach and WB Mims, *Biochem*, **19**, 1304–308 (1980).

28 NE Ahukhlistova, YN Zhukova, AV Lyashenko, VN Zaitsev and AM Mikhailov, *Struct Macromol Compd*, **53**, 92–110 (2008).

29 I Zaitseva, V Zaitsev, G Card, K Moshkov, B Bax, A Ralph and P Lindley, *J Biol Inorg Chem*, **1**, 15–23 (1996).

30 V Ducros, AM Brzozowski, KS Wilson, SH Brown, P Østergaard, P Schneider, DS Yaver, AH Pederson and GJ Davies, *Nature Struct Biol*, **5**, 310–16 (1998).

31 A Messerschmidt, W Steigemann, R Huber, G Lang and PM Kroneck, *Eur J Biochem*, **209**, 597–602 (1992).

32 A Messerschmidt, A Rossi, R Ladenstein, R Huber, M Bolognesi, G Gatti, A Marchesini, R Petruzzelli and A Finazzi-Agró, *J Mol Biol*, **206**, 513–29 (1989).

33 A Messerschmidt, R Ladenstein, R Huber, M Bolognesi, L Avigliano, R Petruzzelli, A Rossi and A Finazzi-Agró, *J Mol Biol*, **224**, 179–205 (1992).

34 MJ Boulanger and ME Murphy, *J Mol Biol*, **315**, 1111–27 (2002).

35 T Inoue, M Gotowda, Deligeer, K Kataoka, K Yamaguchi, S Suzuki, H Watanabe, M Gohow and Y Kai, *J Biochem*, **124**, 876–79 (1998).

36 M Kukimoto, M Nishiyama, ME Murphy, S Turley, ET Adman, S Horinouchi and T Beppu, *Biochemistry*, **33**, 5246–52 (1994).

37 T Sakurai and K Kataoka, *Cell Mol Life Sci*, **64**, 2642–56 (2007).

38 ME Murphy, S Turley and ET Adman, *J Biol Chem*, **272**, 28455–60 (1997).

39 MJ Boulanger, M Kukimoto, M Nishiyama, S Horinouchi and ME Murphy, *J Biol Chem*, **275**, 23957–64 (2000).

40 K Kataoka, H Furusawa, K Takagi, K Yamaguchi and S Suzuki, *J Biochem*, **127**, 345–50 (2000).

41 MD Vlasie, R Fernández-Busnadiego, M Prudêncio and M Ubbink, *J Mol Biol*, **375**, 1405–15 (2008).

42 M Nojiri, H Koteishi, T Nakagami, K Kobayashi, T Inoue, K Yamaguchi and S Suzuki, *Nature*, **462**, 117–20 (2009).

43 WC Chang, JY Chen, T Chang, MY Liu, WJ Payne and J LeGall, *Biochem Biophys Res Commun*, **250**, 782–85 (1998).

44 HT Li, T Chang, WC Chang, CJ Chen, MY Liu, LL Gui, JP Zhang, XM An and WR Chang, *Biochem Biophys Res Commun*, **338**, 1935–42 (2005).

45 E Sedlak, L Ziegler, DJ Kosman and P Wittung-Stafshede, *Proc Natl Acad Sci USA*, **105**, 19258–63 (2008).

46 EI Solomon, AJ Augustine and J Yoon, *Dalton Trans*, 3921–32 (2008).

47 J Yoon and EI Solomon, *J Am Chem Soc*, **129**, 13127–36 (2007).

48 AW Tepper, S Milikisyants, S Sottini, E Vijgenboom, EJ Groenen and GW Canters, *J Am Chem Soc*, **131**, 11680–82 (2009).

49 LG Rydén and LT Hunt, *J Mol Evol*, **36**, 41–66 (1993).

50 ME Murphy, PF Lindley and ET Adman, *Protein Sci*, **6**, 761–70 (1997).

51 AJ Terzulli and DJ Kosman, *J Biol Inorg Chem*, **14**, 315–25 (2009).

52 MJ Ellis, JG Grossmann, RR Eady and SS Hasnain, *J Biol Inorg Chem*, **12**, 1119–27 (2007).

Nitrous oxide reductase

Robert R Eady, Svetlana V Antonyuk and S Samar Hasnain

Molecular Biophysics Group, Daresbury Laboratory, Warrington, Cheshire WA4 4AD, UK

FUNCTIONAL CLASS

Enzyme: 1.7.99.6 is generally a periplasmic, occasionally membrane-bound, copper-containing enzyme using cytochromes or reduced viologens as electron donors for the reduction of N_2O to dinitrogen.

Nitrous oxide reductase (N_2OR) catalyzes the strongly exergonic two-electron reduction of N_2O to N_2 according to Equation (1):

$$N_2O + 2e^- + 2H^+ \longrightarrow N_2 + H_2O \qquad (1)$$

$$[E_{o\,(pH\,7)}' = +135\,mV \,:\, \Delta G_o' = -339.5\,kJ\,mol^{-1}]$$

This reaction represents difficult chemistry although it is thermodynamically favorable; N_2O is kinetically inert and as a result is a long-lived greenhouse gas ($\tau_{1/2}$ 100 yr). N_2O is a poor ligand for transition metals. Since the publication of the first crystal structure revealed the active site to be a novel tetranuclear Cu center, the mechanism by which N_2O binds, is activated and reduced at this center has been the subject of extensive theoretical analysis. However, experimental kinetic and mechanistic data are limited in scope, and understanding the mechanism of action continues to be a challenge.

OCCURRENCE AND BIOLOGICAL FUNCTION

N_2OR is a component of the denitrification system, a process in which some micro-organisms conserve energy by coupling respiratory ATP synthesis to the reduction of nitrate and nitrite through the gaseous N-oxide intermediates NO and N_2O, to N_2 (see Scheme 1).

The individual reactions of this important sector of the biological N_2 cycle are catalyzed by distinct reductases that variously contain Mo, Fe, and Cu or heme centers.[1-3] The chemistry is that of small molecule binding and activation coupled to electron–proton transfer in one- or two-electron reactions. Unlike other nitrogen oxides, N_2O is a major greenhouse gas and is thought to be some 300 times more potent than CO_2 in promoting global warming and is the main natural regulator of levels of stratospheric ozone.

Denitrification is widespread, with representative organisms among *Archaea*, *Bacteria*, and *Eukarya* (where it is restricted to a few fungi). Some organisms, such as in the fungi, terminate the pathway to produce N_2O as the product of denitrification. However, in most denitrifiers, N_2OR catalyzes the terminal step in the unabridged denitrification process, the two-electron reduction of N_2O to N_2. In gram-negative bacteria, nitrite reductase and N_2OR are soluble periplasmic enzymes, in contrast to gram-positive organisms where they are membrane-bound. N_2OR activity

3D Structure Schematic representation of the N_2OR structure showing the dimeric arrangement of the molecule. Each of the monomers is shown in a different color. The domains belonging to the same monomer are shown as different shades of the same color. The Cu_A dinuclear cluster, located in the cupredoxin domain, is shown as dark blue spheres. The tetra-nuclear Cu_Z cluster, located in the β-propeller domain is shown in light blue with the inorganic S atom as a yellow sphere. PDB code 2iwf. All structural figures were produced with program PyMOL(superscript figure of the reference) (http://www.pymol.org).

$$NO^{3-} \rightarrow NO^{2-} \rightarrow NO \rightarrow N_2O \rightarrow N_2$$

Scheme 1 The denitrification reaction.

is also found in nondenitrifying microorganisms such as *Wolinella succinogenes* that respire N_2O. The enzyme was first isolated as a Cu-containing protein of unknown function in 1972,[4] before its unambiguous identification in 1982 as a multicopper-containing enzyme[5] that catalyzed the reduction of N_2O.

The robust nature of N_2O respiration is indicated by the extremes of habitat range shown by organisms with this ability, e.g. a temperature range of $-1\,^\circ C$ (*Colwellia psychrerythraea*) to $+104\,^\circ C$ (*Pyrobaculum aerophilum*), pressures up to 20 MPa (*Photobacterium profundum*), and a salinity of 30% NaCl (*Salinibacter ruber*) (see Zumft and Kroneck[6]).

When purified from a wide range of bacteria of diverse metabolic groups, N_2ORs have very similar properties. They generally contain only Cu as the metal constituent, and are homodimers with two distinct multinuclear Cu centers per subunit, a binuclear Cu_A electron transfer (ET) site and a catalytic Cu_Z center, a novel μ_4-sulfide-bridged tetranuclear Cu cluster. To date, only N_2OR from *W. succinogenes* has been shown to contain an additional *c*-type heme domain fused to the Cu_A domain.

Over 50 genes involved in denitrification have been identified and classified, of these, 10 *nos* genes have a specific involvement in the use of N_2O.[6,7] The current view is that the ability to respire N_2O was an early evolutionary event and arose before the separation of the domains *Archaea* and *Bacteria*.[6]

In common with other metalloenzymes containing novel redox and catalytic centers such as nitrogenase and hydrogenase, the formation of an active N_2OR requires not only the structural gene *nosZ* but also involves a number of ancillary genes involved in the processing and maturation of the apo-protein. In the case of N_2OR, this maturation process results in the insertion of the Cu_A center and the catalytic Cu_Z center. To address the question as to which *nos* genes are involved in this process, Zumft and colleagues transferred the *nosRZDFY* genes to the nondenitrifying bacterium *Pseudomonas putida*. They established that these genes conferred the ability to synthesize active N_2OR *in vitro*[8] and identified these as the minimal set of genes allowing synthesis of an active enzyme in *P. putida*, although no enzyme activity was detectable *in vivo*. It was also shown that apo-N_2OR is exported to the periplasm, a location where it undergoes Cu-dependent activation.[9] In constructs carrying only the *nosRZ* genes encoding the membrane-bound iron-sulfur flavoprotein regulator NosR[10] and the structural gene for N_2OR, the inactive enzyme exhibited the spectral properties of Cu_A-containing protein, and contained only ~4 Cu ions–dimer. The assembly of active enzyme required coexpression of

nosDFY with a presumed role in providing an appropriate sulfur source, allowing synthesis of the Cu_Z center. NosD is a periplasmic protein, NosF is a cytoplasmic ATPase, and NosY is a six-helix integral membrane protein. These are thought to comprise an ABC-type transporter.[11] A discussion of the distribution, organization and regulation of the *nos* genes is outside the scope of this contribution and the reader is directed to a recent comprehensive review.[6]

Despite their overall similarity, N_2ORs with different activities and spectroscopic properties are found and this depends on the organism from which the enzymes are isolated and the extent of exposure to dioxygen (O_2) during purification. The enzymes from *P. stutzeri* and *Pantotrophica denitrificans* have been studied extensively and are the best characterized at the biochemical, biophysical, and genetic level, but no structures of these N_2ORs are currently available. Crystal structures of aerobically purified N_2ORs from *Marinobacter hydrocarbonoclasticus*[6] (formerly *Pseudomonas nautica*),[12,13] *Paracoccus denitrificans*,[14] and, more recently, *Achromobacter cycloclastes*[15] have been determined.

The global structures of these enzymes are very similar with each having two domains, an N-terminal seven-bladed β-propeller domain that contains the Cu_Z catalytic center and a C-terminal domain containing the Cu_A center with a cupredoxin fold that is homologous to this domain of bovine cytochrome *c* oxidase (COX) (see 3D Structure Figure).

AMINO ACID SEQUENCE INFORMATION

The paradigm organisms for studies of N_2O metabolism are *P. stutzeri* and *P. denitrificans* where an extensive body of information on the organization of the 10 *nos* genes, regulation of their expression by environmental signals such as nitrate, nitrite, NO, dissolved oxygen tension, and Cu availability is complemented by the biochemical characterization of their N_2ORs.

The recent rapid expansion in the number of sequenced bacterial genomes has revealed that *nos* genes are widespread, and are usually chromosomally encoded. It has been noted that 10–15% of taxa occupying a range of extreme environments have the potential for N_2O respiration. The genes are clustered and the strongest conserved pattern is the location of *nosDFY* downstream from *nosZ* and the location of *nosL* downstream from *nosY*. These genes are present in all denitrifiers but the other genes *nosC*, *nosH*, *nosG*, *nosR*, and *nosX* have a more variable distribution (see Zumft & Kroneck[6]).

The comparison of a large number of *nosZ* gene [SWISSPROT database: /nosZ *P. stutzeri*/ Accession number AY957390 (protein ID AA243126.1); /nosZ *P. denitrificans*/ Accesssion number X74792 (protein ID CAA52797.1) & /nosZ *Achromobacter cycloclastes*/ Accession number AF047429 (protein ID AAD09157.1)]

sequences shows them to encode a highly conserved enzyme family. The phylogenetic tree for *nosZ* shows a strong correlation with the nucleotide sequences of 16S rRNA, suggesting that Nos appeared early in evolution. Consistent with this, the congruent relationships of the accessory *nos* genes involved in N_2OR maturation are consistent with them having coevolved with *nosZ*.[6]

In terms of functionality, the primary structure of NosZ shows an *N*-terminal sequence encoding a signal peptide containing a S-R-R-x-F-L-K motif characteristic of the Tat translocase system involved in the export of folded proteins across the cytoplasmic membrane.[16] N_2OR was one of the first enzymes in which this motif was recognized. Subsequently, it was demonstrated that metal cofactor insertion into the folded protein before export into the periplasm was not essential, in contrast to most Tat-dependent proteins.[17]

The deduced sequence of *nosZ* gene also showed that the *C*-terminal domain of N_2ORs was homologous to the Cu_A-binding domain of COX, although in other respects these enzymes do not show any sequence similarity.[18,19] Multifrequency EPR data of N_2OR proved to be consistent with the presence of a dinuclear mixed valence Cu_A center similar to that observed in COX,[20,21] a finding subsequently confirmed by structure determination of both enzymes.[13,22]

PROTEIN PRODUCTION AND PURIFICATION

N_2OR has been purified from a wide variety of gram-negative bacteria, but, to date, none have been characterized from a gram-positive organism, although sequence data clearly predict that the enzymes will have very similar properties.[6] The gram-negative bacteria from which N_2OR has been isolated and characterized include *Achromobacter cycloclastes*, *Alcaligenes xylosoxidans*, *Paracoccus denitrificans*, *Pseudomonas stutzeri*, *Pseudomonas aeruginosa*, *Rhodobacter capsulatus*, *Rhodobacter sphaeroidies*, *Thiobacillus denitrificans*, and *Hyphomicrobium denitrificans*. When isolated from their native source, organisms are grown under anoxic or O_2-limiting conditions in the presence of nitrate, conditions resulting in the denitrification process supporting energy generation. Under these conditions, N_2OR comprises up to 2–3% of the total soluble protein. Using a homologous expression system, the recombinant enzyme from *P. stutzeri* has been purified and shown to be indistinguishable from the native enzyme.[23] The purification of various N_2ORs involves the application of standard techniques including ultracentrifugation, DEAE-anion exchange, gel filtration, Q-anion exchange, preparative isoelectric focusing, and hydrophobic interaction chromatography. Despite the almost universal periplasmic location of these enzymes, pressure disruption is used routinely in the preparation of crude extracts due to the relatively large cell mass used (~200–600 g). In the

case of PnN_2OR, the enzyme copurified with a chaperonin of the GroES family but this precipitated under conditions in which crystals were grown.[12]

It has been clear for many years that the most important factor that results in variation in enzymatic activity and color between preparations is the extent to which O_2 is excluded during purification. When enzymes are not purified under air, exclusion is usually achieved by degassing and sparging buffers used with N_2 or argon and collecting column fractions under an inert atmosphere. Less frequently, more rigorous exclusion of O_2 is achieved by using anaerobic chambers during purification. In a comparative study of the effects of O_2 on N_2OR from *P. pantotropha*, a 12-h exposure of frozen cell paste to air at $-80\,^{\circ}C$ before subsequent anaerobic purification in an anaerobic chamber was sufficient to produce significant differences in the spectroscopic properties of the catalytic Cu center[24] and led to the assignment of two forms of this center, Cu_Z and Cu_Z^* (see below).

The differences in color (purple form isolated anoxically; pink form isolated aerobically, or the blue form, obtained on reduction of both purple and pink forms) and the spectroscopic properties of these different forms of N_2OR from *P. stutzeri* have been reviewed in detail.[6] All the published crystallographic information was obtained from preparations of N_2ORs purified aerobically, although both blue (*Pn*, *Pc*) and pink (*Ac*) crystals were analyzed. In addition to the differences in color as a consequence of purification conditions, pink preparations can become blue after freeze thawing associated with storage of the sample.

MOLECULAR CHARACTERIZATION

With the exception of the enzyme from *W. succinogenes*, which contains an additional *c*-heme-binding domain,[25] all N_2ORs that have been characterized are homodimers of 120 kDa. Mutational and biochemical studies have shown that the physiological electron donor partners to N_2OR in different organisms are periplasmic *c*-type cytochromes or the cupredoxins azurin and pseudoazurin. These small ET proteins are also competent in shuttling electrons from the $cytbc_1$ complex to nitrite and nitric oxide reductases, posing interesting questions regarding the nature of their specificity in forming ET complexes. The interaction of these donors with N_2OR has been modeled for $cytc_{550}$ and pseudoazurin using the crystal structures of the three proteins.[26] The analysis suggested that both $cytc_{550}$ and pseudoazurin interacted with the same hydrophobic patch on N_2OR, providing a specific ET pathway to the Cu_A center of the enzyme. A number of lysine side chains were positioned to interact electrostatically with side-chain carboxylates of N_2OR.

The N_2OR structures show that, within each monomer, the distance between the Cu_Z and Cu_A centers is greater than $40\,\text{Å}$, which is too far for effective ET. However,

Figure 1 A comparison of the 20 Å resolution molecular structure of AxN$_2$OR in solution with the 1.86 Å resolution crystallographic structure of AcN$_2$OR. The two monomers are shown in a similar color scheme as in the 3D structure. Solution structure is from reference 27. PDB code 2iwf.

the dimers are arranged such that the Cu$_A$ center of one monomer is only 10 Å from the Cu$_Z$ center of the second monomer, indicating that intrasubunit ET occurs during catalysis; see 3D Structure figure. We note that the first 20 Å resolution three-dimensional model for an N$_2$OR was deduced from solution X-ray scattering data of the enzyme from *A. xylosoxidans*.[27] This low-resolution model had shown the existence of the dimeric structure, consistent with the crystal structure, where two monomers were arranged in a twofold symmetry unit around a central axis (Figure 1).

METAL AND ACID-LABILE SULFIDE CONTENT

Until recently, the Cu content of a number of N$_2$OR preparations isolated from different organisms corresponded to an upper limit of ~8 Cu–dimer.[7] Subsequently, the Cu content reported by different groups has increased to ~12 Cu–dimer, a value consistent with the presence of fully metallated Cu centers as revealed by the crystal structures. Illustrative values are PaN$_2$OR[28] 10.5 ± 2.6, PsN$_2$OR[23,28] 9.9 ± 1.7, and PnN$_2$OR[12] 10.7 ± 1.7. In the case of PsN$_2$OR, the higher Cu content of the isolated enzyme was a result of increasing the Cu content of the growth medium from 1 mM to 5 mM.

The presence of inorganic or acid-labile sulfide in N$_2$ORs was unsuspected. Its discovery arose from an investigation to rationalize MCD and EPR data that indicated substantial metal–ligand covalency in the Cu$_Z$ center.[29–31] This property is more typical of S rather than oxygen and histidine ligation. In the first 2.4 Å crystallographic structure of PnN$_2$OR, the bridging ligand was modeled as water or hydroxide. Biochemical analysis established that no significant acid-labile sulfide was associated with a mutant form of PsN$_2$OR lacking Cu$_Z$ centers, in contrast to the holoenzyme which contained

1.6 ± 0.2 S^{2-}/dimer. PaN$_2$OR was also shown to contain 1.7 ± 0.4 S^{2-}/dimer giving in both cases a Cu/S ratio of 6.2. Additionally, resonance Raman (RR) spectra of reduced PsN$_2$OR, where only vibrational modes coupled to electronic transitions arising from the Cu$_Z$ center of enzyme occur, showed a prominent band at 382 cm^{-1} that was sensitive to isotopic substitution of ^{32}S with ^{34}S. This provided definitive evidence that the Cu$_Z$ center has an acid-labile sulfur ligand.[28] Subsequent reexamination of PnN$_2$OR structure and a higher resolution structure determination of PdN$_2$OR[14] at 1.6 Å resolution showed a bridging inorganic sulfur in place of oxygen in the Cu$_Z$ cluster. This is the first example of a biological copper sulfide cluster.

ACTIVITY ASSAY

Activity assays based on both gas chromatographic and amperometric measurement of N$_2$O formation, or reductant utilization has been described.[32,33] The assay of N$_2$OR activity is most conveniently measured spectrophotometrically by monitoring absorbance changes associated with the oxidation of the electron donor. Methyl viologen (MV) is the most commonly used donor and the high affinity of the enzyme allows linear rates to be measured over the accessible range of absorbance values. It is important when dithionite is used as reductant that the concentration does not exceed that of the MV in the assay, otherwise activity is inhibited.[33] A typical reaction mixture in 1 mL stoppered cuvettes flushed extensively with high purity N$_2$ contains 0.85 mL of 10 mM phosphate buffer, pH 7.1, 0.05 mL of 10 mM MV, and a suitable volume of 1 mM sodium dithionite to give an A$_{600}$ of 1–1.5. An aliquot of enzyme solution is then injected into the cuvette using a microsyringe and the contents mixed using a small magnetic stirrer before the A$_{600}$ is measured for a few

minutes to measure the slow background rate of oxidation. The reaction is initiated by injection of 0.08 mL of N_2O-saturated buffer and mixing of the contents before the A_{600} is measured. The solubility of N_2O in water is taken to be 25 mM at 25 °C and the extinction coefficient of MV as $11\,400\,M^{-1}\,cm^{-1}$. The specific activity of N_2OR is expressed as µmol of N_2O reduced·min.(mg of protein)$^{-1}$.

In addition to the spectroscopic differences noted above, the specific activity of enzyme preparations purified under anoxic conditions is higher than preparations purified in air. Typical values for anoxic preparations range from 60 to 122 µmol of N_2O reduced·min.(mg of protein)$^{-1}$ and for aerobic preparations 6–55 µmol of N_2O reduced·min.(mg of protein)$^{-1}$.

The activity of the enzyme is also increased upon preincubation of the enzyme with reductant, or upon preincubation at high pH values (pH 9–10) or high temperatures (40 °C – 70 °C). The twofold activation resulting from temperature and base treatment are transient under assay conditions and the increased activity relaxes during the assay period to attain the value of the untreated enzyme. Such behavior is consistent with an equilibrium of two forms of the enzyme, which have different activities with the more active form favored at high pH or high temperature. Reductant activation using MV increases the specific activity sixfold to 125 µmol of N_2O reduced·min.(mg of protein)$^{-1}$, and, as described below, is associated with the super reduction of the Cu_Z to the all-cupric $[4Cu^IS]^{2+}$ state.

METAL CENTERS

Early spectroscopic studies of N_2ORs suggested the presence of novel complex metallocenters, and, before the availability of crystallographic data, the focus of the large body of work in this area was to assign structures to these centers. In this review, discussion of the spectroscopy is necessarily limited, and is restricted to how these data have complemented crystallographic data and to what extent insight can be gained on the roles of these metallocenters in N_2O activation and reduction events.

In anaerobically purified highly active N_2OR, multi-frequency EPR,[21,29,34–36] ENDOR,[37] 1H NMR,[38] Cu extended X-ray absorption fine structure (EXAFS),[23,39,40] RR,[41,42] and CD/MCD[31,39,40,43] spectroscopic data were interpreted in terms of two distinct multinuclear Cu sites, designated Cu_A and Cu_Z. In order to deconvolute the contribution of these centers, studies were focused on three oxidation states of the enzyme, native as-isolated, semireduced, and reduced. Such studies were facilitated by the availability of mutant forms of N_2OR that contained only the Cu_A site (designated form V) isolated from a *nos* mutant defective in Cu assembly for the Cu_Z center, and a species containing only Cu_Z, formed by mutation of one of the Cys residues involved in binding the Cu_A center.[6,7]

THE ELECTRON TRANSFER Cu_A CENTER

The Cu_A centers of the three structurally characterized N_2ORs[12–15] are very similar to the Cu_A centers of CCO[22,44] and menaquinol: nitric oxide reductase of *Bacillus azotoformans*[44] (see below). The structure of the Cu_A center of N_2OR as a dinuclear dithiolate-bridged cluster and identification of the amino acid residues involved in ligation of the center to the protein were correctly assigned before the crystal structure was determined. This was achieved by extensive spectroscopic analysis including EXAFS investigation involving comparison with CCO, and the use of site-directed mutagenesis of *nosZ*, targeting sequence encoding potential Cu_A site liganding residues.[6,45]

The spectroscopic properties of the Cu_A site of N_2OR are relatively well understood from a theoretical and structural perspective. Cu_A sites are binuclear with the two Cu ions bridged by two cysteinyl thiolates. Each copper ion is also bound by a His residue and a weaker axial ligand, a methioninyl thioether sulfur for one Cu ion and a backbone carbonyl to the other. The Cu–Cu separation is extremely short at 2.47 Å, suggesting some Cu–Cu bonding interactions as has been shown from EXAFS and MCD studies for CCO and inorganic Cu_A models.[46,47] Density-functional-theory (DFT) calculations indicate that the center is characterized by low reorganizational energy attributed to the flexibility of the bonding of the axial ligands to the Cu ions and to the delocalization of charge from Cu onto the sulfur atoms of the bridging cysteinyl residues.[48]

In the as-isolated N_2OR, the Cu_A center is predominantly in the mixed valence $S = 1/2$ state, which gives rise to the distinctive purple–pink color of the enzyme arising from intense $S(Cys) \rightarrow Cu^{II}$ charge transfer bands plus some intervalence Cu absorption. The absorbance bands at 480, 540, and 790 nm, which are characteristic of one-electron oxidized Cu_A, dominate the spectrum of ferricyanide-oxidized N_2OR. The EPR spectrum recorded at 9.30 GHz and 10 K shows a characteristic 7-line hyperfine structure in the g_{II} region around 2.18. Analysis of the EPR data is consistent with 15–20% spin density on each of the Cu ions and a high degree of covalent delocalization of the unpaired spin in the direction of the S ligands.

During redox cycling, the site alternates between the fully reduced all-cupric state and the (Cu^I–Cu^{II}) mixed-valence state where the unpaired electron is delocalized between the two Cu ions. On reduction by one electron, the Cu_A site becomes diamagnetic and colorless. Anaerobic potentiometric titration of both pink and purple forms of PsN_2OR gave a midpoint potential[32] $E_{0,540}$ of $+260 \pm 5$ mV *versus* SHE and $n = 0.95$, and EPR measurements of both forms of PnN_2OR and the aerobic–anaerobic forms of PpN_2OR gave a midpoint potential[12,28] +260 mV. Further oxidation to the all-cuprous state has not been observed.

A number of variants of the Cu_A center of PsN_2OR have been characterized in which the ligating or bridging residues were substituted.[23] Biochemical and Cu-EXAFS studies of

these mutants allowed the correct assignment of the residues involved in binding the Cu_A center and provided metrical information on atoms in the first coordination sphere of the Cu ions. A surprising finding from these studies was the observation that the ligand-exchange Cu_A mutations C622D and H583G did not result in the loss of Cu from the Cu_A site but nevertheless resulted in demetallation of the Cu_Z site, despite translocation of the enzyme to the periplasm being unaffected. The mutated species were shown to retain the dimeric structure of the native enzyme and the effect on Cu_Z was attributed to intersubunit or interdomain long-range interaction between the two Cu sites.[23]

THE CATALYTIC Cu_Z CENTER

On the basis of the analysis of EPR, optical, and MCD data, the catalytic Cu_Z center was proposed to be a second binuclear Cu center with cystine ligation.[30,31] When *nosZ* DNA sequences revealed that there were an insufficient number of conserved Cys residues to bind two thiolate-bridged centers, ligation by a set of conserved histidine residues was suggested.[23,31,38] This suggestion was subsequently confirmed by the crystal structures of N_2OR. What was completely unexpected was the tetranuclear nature of the Cu_Z site,[12,13] which had remained undiscovered despite extensive spectroscopic study.

The recognition of the tetranuclear structure of the Cu_Z center provided a framework for the interpretation of the spectroscopic data, which revealed the unusual electronic[12,28] and vibrational[49] spectral features of the center. It also facilitated the application of computational methods of analysis to the problem of how N_2O is bound and activated.[50–52] Considerable insight into the electronic and redox properties of the Cu_Z site has also been gained from studies of oxidized N_2OR (ferricyanide-treated), semireduced (ascorbate-reduced), reduced (excess dithionite), and super-reduced (dithionite plus excess MV).

A relatively recent development is the recognition of two forms of the catalytic center, designated Cu_Z and Cu_Z^*. These appear to be present in all enzyme preparations but in PpN_2OR the Cu_Z^* species predominates when the enzyme is purified from cells previously exposed to air. Both the Cu_Z and Cu_Z^* species are active, but differ in their spectroscopic and redox behavior.[28,53] In anaerobic preparations, the oxidized form of Cu_Z has a peak at 560 nm ($\varepsilon \sim 5000 \, M^{-1} \, cm^{-1}$), which on reduction with dithionite converts to a peak at 670 nm ($\varepsilon \sim 4400 \, M^{-1} \, cm^{-1}$) associated with an E_m of $+60$ mV in the oxidative direction. In aerobic preparations, this redox process is not observed, suggesting the E_m is shifted to $> +400$ mV. Additionally, the absorption peak is at 650 nm ($\varepsilon \sim 3800 \, M^{-1} \, cm^{-1}$) with a broad band at 960 nm ($\varepsilon \sim 1600 \, M^{-1} \, cm^{-1}$). These differences are designated as properties of the modified catalytic center Cu_Z^*. EPR and

MCD studies are consistent with the retention of the $\{Cu_4S\}$ structure because the enzyme in which Cu_Z^* is the predominant form is active.[24]

Initially it was thought that the Cu_Z^* species was generated as a consequence of exposure of the enzyme to air during purification or interaction with the exogenous ligands[54] CO, SCN^-, or NCO^- but it is now apparent that it is also formed when *nosR* is mutated.[10] As already mentioned, in *P. stutzeri* NosR, a membrane-bound iron–sulfur flavoprotein is required both for transcription of *nosZ* and for N_2OR activity *in vivo*. It is proposed that the latter effect of NosR involves interaction with mature NosZ. Depending on the mutations introduced in NosR, anaerobic purification of N_2OR resulted in the isolation of an enzyme with a 637 nm peak, which was redox inert with dithionite or ferricyanide, a characteristic of the Cu_Z^* center.

The reduction with dithionite of a number of N_2ORs is biphasic. The Cu_A center is rapidly reduced and then more slowly, on a timescale of minutes, a blue species with a peak at 640 nm appears.[27,35,49,55] This $\{Cu_A^{red}-Cu_Z^{red}\}$ species is characterized by an $S = 1/2$ EPR spectrum with $g_{II} = 2.16$ and a complicated hyperfine-coupling pattern.[12,30,49] Although possibly a nonphysiological oxidation state,[56] it has been pivotal in allowing the identification of the all-cupric $[4Cu^IS]^{2+}$ state as the catalytically competent species in N_2O reduction (see below).

The use of ascorbate, which only reduces the Cu_A center, provides a better tool to study the reductive processes undergone by the Cu_Z center.[24] The range of observed oxidation and spin states of Cu_Z center[24,52,53] are shown in Scheme 2.

For many years, mechanistic studies of N_2OR were hindered by the sluggish redox response of the Cu_Z center in the dithionite-reduced enzyme species $\{Cu_A^{red}-Cu_Z^{red}\}$ and the lack of a spectroscopic fingerprint for substrate or inhibitor binding. This problem was resolved in studies

MV reduced	$[4Cu^I S]^{2+}$	EPR silent
	$+e^- \uparrow\downarrow -e^-$	
Dithionite reduced	$[3Cu^I \, 1 \, Cu^{II}S]^{3+}$	$S = 1/2$ ground state
$E_m + 60$ mV	$+e^- \uparrow\downarrow -e^-$	
As isolated anaerobically	$[2Cu^{II} \, 2Cu^{II}S]^{4+}$	EPR silent

Scheme 2 Redox and spin states of the Cu_Z center of N_2OR relevant to enzyme turnover. The reduction of the $S = 1/2$ ground state to the $[4Cu^IS]^{2+}$ state is associated with activation of enzymatic activity.[57,58]

of the reductive activation of the enzyme seen both under assay conditions or preincubation of enzyme with dithionite and MV.[21,27,33] Parallel measurements of the EPR spectra and the enzymatic activity of PnN_2OR as a function of the length of incubation with excess MV and dithionite showed similar kinetics of increasing activity and loss of the S = 1/2 EPR signal over a 40-min period.[57] The rate of reaction ($k = 0.07\,s^{-1}$) for the reduction of the $[3Cu^I 1Cu^{II}S]^{3+}$ is too slow for this species to be involved in turnover but provided the first indication that the $[4Cu^IS]^{2+}$ was present in the reductively activated enzyme. DFT calculations showed the lowest energy structures to be end-on N-ligation of N_2O to Cu1 of the $[3Cu^I 1Cu^{II}S]^{3+}$ state, in contrast to the μ-1,2-N_2O-bridging mode in the $[4Cu^IS]^{2+}$-activated state. The bent geometry in this binding mode was shown to make the ligated N_2O a better electron acceptor, and Cu1 and Cu4 were poised to serve as efficient two-electron reducing agents. The direct interaction of N_2O with the $[4Cu^IS]^{2+}$ activated state of AcN_2OR has been reported.[58] In this case, reductant activation took ~8 h for completion, and the time course correlated with the loss of the absorbance bands at 640 and 680 nm of the dithionite-reduced enzyme. Following the addition of N_2O, substantial changes in the absorption spectrum occurred, indicative of the transfer of two electrons to form the $\{Cu_A^{ox}-Cu_Z^{red}\}$ species. GC-MS using ^{15}N-labelled N_2O confirmed that N_2 was formed in amounts that correlated with the specific activity of the enzyme, confirming the involvement of the $[4Cu^IS]^{2+}$ in catalysis.

Once activation has occurred, the higher activity is maintained during enzyme turnover, suggesting that subsequent cycling of the $[3Cu^I1Cu^{II}S]^{3+}/[4Cu^IS]^{2+}$ redox couple is fast, or that catalysis involves the $[2Cu^I2Cu^{II}S]^{2+}/[4Cu^IS]^{2+}$ redox couple and that the $[3Cu^I1Cu^{II}S]^{3+}$ species is not significantly populated in turnover. How this may be achieved when reduced cytochrome is the electron donor is discussed below, but it must also occur when chemical reductants are employed. The slow rate of the activation process is suggestive of a kinetic barrier to form the $[4Cu^IS]^{2+}$ state, as it also occurs under assay conditions and is clearly not accelerated by the presence of N_2O. This might occur if some modification of the site were required, possibly ligand exchange at the Cu1−Cu4 edge of the Cu_Z center.

INTERMOLECULAR ELECTRON TRANSFER WITH CYTOCHROME c

The use of dithionite-MV as a reductant in the assay for N_2OR is a matter of convenience rather than the requirement for a very low potential donor, and evidence is accumulating that this chemical reductant bypasses the natural pathway for ET. The first evidence is the lack of whole-cell N_2OR activity in *nosR* mutants of *P. stutzeri* despite the presence of enzyme that is active with dithionite-MV as a reductant.[8] The second piece of evidence is the presteady state kinetic studies described below, which demonstrate altered kinetics for intermolecular ET between Cu_A and Cu_Z centers in the presence of an effective cytochrome donor.[56]

In the presteady state studies, reduced horse heart (HH) cytochrome *c* (used as a cyt c_{550} homolog) was reacted with anaerobically prepared PpN_2OR in the ferricyanide-oxidized $\{Cu_A^{ox}-Cu_Z^{ox}\}$, one-electron ascorbate reduced $\{Cu_A^{red}-Cu_Z^{ox}\}$, and the two-electron dithionite-reduced states $\{Cu_A^{red}-Cu_Z^{red}\}$.[56] These studies showed that on reduction of oxidized N_2OR only the Cu_A center was reduced by one electron ($k_{obs} = 150\,s^{-1}$) transferred from HH cytochrome *c*, where the E_m of the *c*-heme had decreased by $27\,mV$, attributed to protein–protein interaction.

In the reverse reaction, where oxidized HH cytochrome *c* was mixed with two-electron reduced N_2OR in which both Cu_A and Cu_Z are each reduced by one electron, a biphasic rate of ET was observed. The rapid phase ($k_{obs} = 150\,s^{-1}$) corresponded to ET from Cu_A to cytochrome *c*; the 1000-fold slower rate ($k_{obs} = 0.1 - 0.4\,s^{-1}$) corresponded to internal ET from Cu_Z to Cu_A, the likely rate-limiting reaction in turnover.

EFFECT OF SUBSTRATE ON INTERNAL ELECTRON TRANSFER

There were no spectroscopic changes upon incubation of oxidized or one-electron-reduced N_2OR with substrate, and only very slow oxidation occurred with two-electron-reduced enzyme $\{Cu_A^{red}-Cu_Z^{red}\}$, despite the species having sufficient electrons for catalysis. In contrast, when reduced HH cytochrome *c* was mixed with an excess of one-electron-reduced N_2OR $\{Cu_A^{red}-Cu_Z^{ox}\}$, in the presence of N_2O a single turnover occurred, with concomitant oxidation of Cu_A and HH cytochrome *c*. The time course of this reaction showed a short lag phase. A proposed ET scheme is shown in Scheme 3, in which two separate ET events from reduced HH cytochrome *c* to Cu_A, occur. N_2O is proposed to bind to reduced Cu_Z, of uncomplexed N_2OR in which the Cu_A center is oxidized, and following the transfer of a second electron, reduction occurs at the super-reduced center. The authors note that in the dithionite-reduced enzyme the one-electron-reduced species $\{Cu_A^{ox}-Cu_Z^{red}\}$ is not populated, thereby preventing interaction with substrate, and that the $\{Cu_A^{red}-Cu_Z^{red}\}$ species, formed in the presence of dithionite, is probably not biologically significant. Computer simulation of the experimental data using Scheme 3 suggests that during turnover the redox potential of the Cu_Z center must be $150\,mV$, an increase of $90\,mV$ from that of the isolated protein, and presumably arises from changes in the environment of Cu_Z consequent upon complex formation with the cytochrome.

Scheme 3 Proposed cytochrome *c*-dependent catalytic cycle for N$_2$OR of *P. pantotropha*.[56] The cytochrome in the complex with N$_2$OR (shown in green) has undergone a conformational change.

Clearly, events that occur in dithionite-MV dependent assays must be different, as despite the population of different oxidation states, i.e. the formation of the apparently redox-trapped, {Cu$_A$red–Cu$_Z$red} species, activity is observed, albeit at nonactivated levels. The inability of the dithionite ion alone to access more reduced states of Cu$_Z$ is reminiscent of its inability to reduce the [4Fe4S] center of the Fe protein of nitrogenase to the super reduced form. In the presteady state assays described above, the predominant form of the catalytic center would have been Cu$_Z$. This suggests the possibility that similar studies with the Cu$_Z$* species, which does have altered redox properties, may provide additional insight into these processes.

X-RAY STRUCTURES OF N$_2$OR

All the structures determined to date are those of 'as-isolated' aerobically purified N$_2$OR, although depending on the source of the enzyme, species with both oxidized or reduced forms of Cu$_A$ have been characterized. The structures of *Pn*N$_2$OR and *Pd*N$_2$OR in which Cu$_A$red was present, the catalytic cluster was in the Cu$_Z$* form, whereas in the crystal structure of *Ac*N$_2$OR, where Cu$_A$ox was present, the catalytic center was in the Cu$_Z$ form.

Crystallization of *Pn*N$_2$OR and *Pd*N$_2$OR

Crystals of *Pn*N$_2$OR were grown[2,13] by vapor diffusion using a well solution of 100 mM bicine, pH 9.5, containing 600 mM NaCl, 15% (v/v) isopropanol, 10 mM spermidine, and 18% (w/v) PEG-4000. The 6 µL drop was 3 µL of well solution and 3 µL of stock N$_2$OR (5 mg protein mL^{-1}). Blue crystals were formed and 10% (w/v) ethylene glycol was used as a cryoprotectant. The structure was solved by multiple-wavelength anomalous dispersion (MAD) phasing, using the Cu anomalous signal. Single-crystal microspectroscopy exhibited a dominant band at 635 nm and a shoulder at 740 nm, typical of reduced N$_2$OR with Cu$_Z$ in the 3CuI/1CuII state. The absence of bands at 540 and 800 nm indicate that the ET cluster Cu$_A$ is reduced, in contrast to the situation with the crystals of *Ac*N$_2$OR described below. The spectroscopic and redox properties of *Pn*N$_2$OR used in this structural study indicate that the catalytic center was in the Cu$_Z$* form.

Crystals of *Pd*N$_2$OR were grown using vapor diffusion at 4 °C using a well solution of 80 mM Na cacodylate, pH 6.5, containing 160 mM MgCl$_2$, 16% (w/v) PEG-8000. The 4-mL drop comprised 2 µL of well solution and 2 µL of stock N$_2$OR (14 mg protein mL^{-1}), with blue plate-like crystals appearing within 3 weeks.[14] A cryoprotectant of 20% (w/v) glycerol in well solution was used and crystals were flash-cooled in liquid N$_2$. The structure was solved using molecular replacement techniques using *Pn*N$_2$OR as a search model. Although the optical data for these crystals was not reported, the properties of the preparation used indicate that the catalytic center was predominantly in the Cu$_Z$* form.[14]

Crystallization of *Ac*N$_2$OR

Crystals of *Ac*N$_2$OR were grown[15] by vapor diffusion at 21 °C using a well solution of 100 mM bis-tris propane,

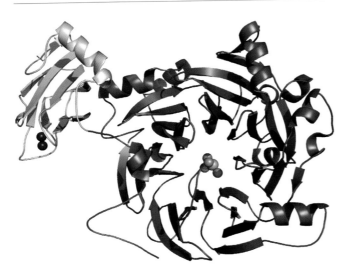

Figure 2 Overall schematic representation of a monomer of AcN_2OR from showing two domains a C-terminal cupredoxin domain (left, in lighter shade) carrying the Cu_A center (dark blue spheres) and the N-terminal β-propeller domain (right, darker shade) with the catalytic Cu_Z center in which copper and inorganic S ions are shown as light blue and dark yellow spheres. PDB code 2iwf.

pH 6.5 containing 200 mM KSCN and 20%(w/v) PEG-3350. The 3-μL drop comprised 1 μL of well solution and 2 μL of stock N_2OR (6 mg protein mL^{-1} in 10 mM tris-HCl pH 8). Pink–purple rhombohedral plate-like crystals grew within 2 days. Seeding with crystals obtained using a crystallization robot and a Molecular Dimensions PACT Premier screen was used to obtain diffraction-quality crystals. Parartone oil was used as a cryoprotectant before flash cooling to 100 K. The structure was solved using molecular replacement techniques using PnN_2OR as the search model. Single-crystal microspectroscopy exhibited main peaks at 480, 540, and 800 nm ascribed to $Cu_A{}^{ox}$ and a minor peak at 650 nm arising from the catalytic center in the 3CuI/1CuII state. The catalytic cluster in this AcN_2OR structure[15] was assigned as to the Cu_Z species.

Crystallization of inhibitor-bound AcN_2OR

It has been shown that the inhibitor iodide has a high affinity for N_2OR and binding results in the loss of spectral features of Cu_A and the formation of a blue adduct.[55] Incubation of native AcN_2OR with NaI resulted in complete loss of features associated with Cu_A resulting from the reduction of this center and the emergence of a strong 650 nm peak, consistent with Cu_Z cluster remaining in the 3CuI/1CuII state.[15] Subsequent oxidation with $K_3Fe(CN)_6$ results in partial restoration of the Cu_A features of the oxidized center while retaining the 650-nm peak associated with the 3CuI/1CuII state of the Cu_Z cluster.

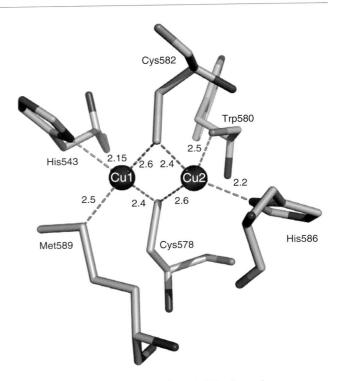

Figure 3 The Cu_A center of AcN_2OR where the two copper atoms share two bridging cysteinyl S atoms, a feature analogous to cytochrome c oxidase. PDB code 2iwf.

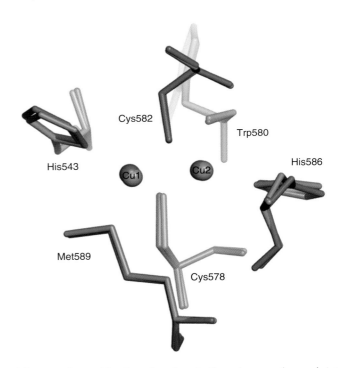

Figure 4 Oxidized and reduced Cu_A site as observed in AcN_2OR (pink) and PdN_2OR (green), respectively. PDB code 2iwf and 1fwx, respectively.

Crystals of iodide-bound AcN_2OR were obtained using similar procedure to those used for the oxidized protein.

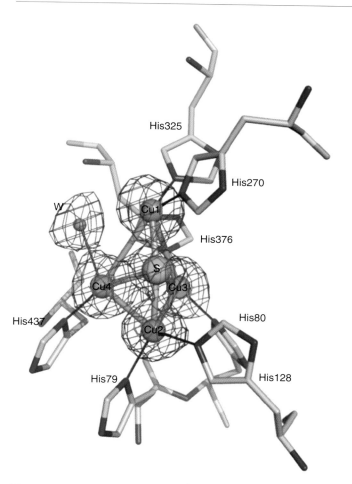

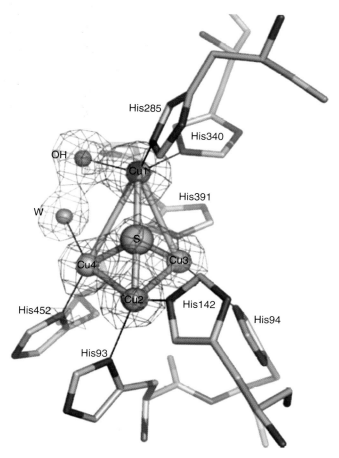

Figure 5 The Cu_Z site of the 1.6 Å structure of PdN_2OR (PDB code: 1fwx) with electron density at 2σ level for the Cu and S atoms. Water is drawn at 1σ level. Sequence numbering is that of PdN_2OR. This cluster was classed as a $Cu_Z{}^*$ species of the catalytic cluster.

Figure 6 Cu_Z cluster of the native as isolated AcN_2OR. The electron density map is shown, contoured at 2σ level. Copper atoms are shown in cyan and the bridging sulfur atom in yellow. The Cu1 and Cu4 atoms, constituting the catalytic edge of the Cu_Z cluster are ligated by OH^- and water, respectively, which are contoured at the 1σ level. This cluster was classed as a Cu_Z species. PDB code 2iwf.

except 200 mM NaI replaced KSCN in the crystallization solutions.[15] In this case, the crystals formed were light blue in color.

OVERALL STRUCTURE OF THE ENZYME

Structures of all of the N_2ORs published to date show a very similar organization. Each monomer is comprised of two distinct domains, an N-terminal seven-bladed β-propeller domain and a C-terminal domain with a cupredoxin fold containing Cu_A cluster. Figure 2 shows an overall view of the N_2OR monomer from the top side of the propeller domain where the Cu_Z cluster is located some 40 Å from the Cu_A cluster.

In the dimeric structure, 3D Structure Figure, the two domains of each monomer pack antiparallel to each other so that the cupredoxin-like domain of one monomer is in contact with the β-propeller domain of the other monomer. The result is a tightly packed globular structure with an

extensive monomer–monomer interface. These structures confirm that the dimeric assembly is the functional unit of the enzyme because within each monomer the separation between the Cu_A and Cu_Z centers is 40 Å, which is too far for effective rates of ET. However, the arrangement of the dimers is such that the Cu_A center of one monomer is some 10 Å from the Cu_Z center of the second monomer, indicating that ET between the centers of neighboring monomers occurs during catalysis.

The dimeric structure is stabilized by a combination of polar and nonpolar interactions over a large dimer interface area covering some 26% of the total solvent-accessible surface area of the monomer corresponding to ~6270 Å2. In addition, two calcium ions in each monomer are tightly bound in the monomer–monomer interface and may contribute to dimer stabilization (see below for further discussion on role of Ca^{2+}).

Figure 7 Superposition of the novel μ4-sulfide-bridged tetranuclear Cu cluster from as-isolated *Ac*N2OR (shown in magenta) and *Pd*N2OR (shown in green). These represent CuZ and CuZ* species of the cluster, respectively. PDB code 2iwf and 1fwx, respectively.

Figure 8 CuZ cluster of the inhibitor-bound *Ac*N2OR structures. The electron density map is shown, contoured at 2σ level. The Cu1 and Cu4 atoms of the CuZ cluster are bridged by an iodide atom, which has been shown to be an inhibitor. PDB code 1iwk.

THE CuA SITE AND THE CUPREDOXIN DOMAIN

The CuA center (see Figure 3) is located in the loop region connecting two of the β strands of the β-sandwich region of the cupredoxin fold near the C-terminus. The sequence identity of this domain is low when compared to other cupredoxin domains.[59] The structure of the site shows a strong similarity to the CuA site of bovine[60] and *P. denitrificans* COXII[22] and BA3COX[59] (r.m.s. deviation of 1–1.8 Å), consisting of two copper ions bridged by the Sγ atoms of two Cys residues. Cu1 has additional His Met ligands and Cu2 His Trp ligands. The CuA site in the structure of *Ac*N2OR was that of the oxidized center, whereas in all other N2OR structures the dinuclear site

is in the reduced state. A comparison of the sites in 'as-isolated' *Ac*N2OR and *Pd*N2OR structures at 1.86 Å and 1.6 Å resolution, respectively, reveal that subtle changes as expected are observed upon reduction (see Figure 4). In particular, both Cu atoms move as well as Cys 578 and the two His ligands. A similar difference is observed between the 'as-isolated' and iodide-bound *Ac*N2OR structures because in the iodide-bound structure CuA is in the reduced state.

THE CuZ SITE AND THE β-PROPELLER CATALYTIC DOMAIN

The first crystal structure of *Pn*N2OR at 2.4 Å resolution showed that the CuZ center is located nearly in the middle of the central channel of the β-propeller domain. It revealed

Table 1 Copper ligand distances for Cu_Z for the known crystal structures of N_2ORs. PdN_2oR structure has four molecules in the A.U. A/B (B-factor − 18.9/17.3) C/D (B-factor 23.4/30.1); PnN_2OR structure has six molecules in the A.U. A/B have lower B-factor then all other molecules: A/B(52.9/52.4), C/D(61/59), and E/F(55/57)

Bond Distances	Blue N_2OR A/B	Pink N_2OR A/B	Pd N_2OR A/B	Pn N_2OR A/B
Cu_Z1-His285 $N^{\varepsilon 2}$(Å)	2.1/2.1	2.2 /2.0	2.0/2.0	
Cu_Z1-His340 $N^{\varepsilon 2}$(Å)	2.1/2.1	2.2/2.1	2.1/2.0	2.1/2.2
Cu_Z2-His142 $N^{\varepsilon 2}$(Å)	2.2/2.1	2.2/2.2	2.0/2.0	2.1/2.1
Cu_Z2-His93 $N^{\delta 1}$(Å)	2.4/2.2	2.2/2.3	2.1/2.1	1.9/2.1
Cu_Z3-His94 $N^{\varepsilon 2}$(Å)	2.6/2.4	2.5/2.3	2.1/2.0	2.2/2.2
Cu_Z3-His391 $N^{\varepsilon 2}$(Å)	2.1/2.1	2.2/2.1	2.1/2.1	2.1/2.2
Cu_Z4-His452 $N^{\delta 1}$(Å)	2.3/2.2	2.1/2.1	2.0/1.9	2.1/2.1
Cu_Z1-S(Å)	2.6/2.4	2.5/2.7	2.3/2.3	2.0/1.9
Cu_Z2-S(Å)	2.3/2.2	2.1/2.1	2.2/2.2	2.3/2.7
Cu_Z3-S(Å)	1.9/2.0	2.1/2.6	2.2/2.3	2.2/1.9
Cu_Z4-S(Å)	2.4/2.1	2.1/2.1	2.2/2.2	2.2/2.1
Cu_Z1-Cu_Z3(Å)	3.6/3.3	3.4/3.6	3.4/3.4	2.1/2.4
Cu_Z1-Cu_Z4(Å)	3.2/3.0	3.7/3.7	3.3/3.4	3.4/3.4
Cu_Z2-Cu_Z3(Å)	2.6/2.7	2.6/2.6	2.6 /2.6	3.3/3.3
Cu_Z2-Cu_Z4(Å)	2.3/2.6	2.4/2.5	2.6/2.6	2.6/2.6
Cu_Z3-Cu_Z4(Å)	2.7/2.8	3.0/2.9	3.0/2.6	2.5/2.6
Cu_Z1-W1(Å)	–	2.2/2.2	2.8/2.7	3.0/3.0
Cu_Z4-W1(Å)	–	4.0/4.1	2.5/2.7	2.6/2.4
Cu_Z4-W2	–	2.5/2.6		2.5/2.3
Cu_Z1-IOD(Å)	2.4/2.5	–	–	–
Cu_Z4-IOD(Å)	2.9/2.8	–	–	–
PDB (resolution(Å))	1iwk (1.7)	1iwf (1.86)	1fwx (1.6)	1qni (2.4)
Average B-factor (Å²)	22.7/22.6	22.0/24.6	18.9/17.3	52.9/52.4

the novel nature of the Cu_Z site in which four Cu ions were ligated by seven His residues.[13] In this structure, the Cu coordination was completed by a bridging oxygen moiety, and two other hydroxide ligands. As described above, elemental analysis combined with spectroscopic data subsequently indicated that the center was a μ_4-sulfide-bridged tetra-nuclear Cu center. This assignment was confirmed from a high-resolution 1.6 Å structure of PdN_2OR and a reanalysis of the original PnN_2OR structure introducing a bridging inorganic sulfur[13,14] (see Figure 5). In the case of PnN_2OR and PdN_2OR, the Cu_A center was reduced and the Cu_Z cluster was assigned to the Cu_Z* species.

The 1.86 Å resolution structure of AcN_2OR, for which the crystals were pink-purple as opposed to the blue crystals of PdN_2OR and PnN_2OR, revealed that, again, the copper atoms are ligated to the protein by seven histidine residues namely, His93, His94, His142, His285, His340, His391, and His452. In addition, an inorganic S bridges the Cu atoms forming the novel μ_4-sulfide-bridged tetranuclear Cu cluster. In contrast to other structures, clear electron density is observed for two oxygen atoms in the AcN_2OR structure (Figure 6). Oxygen 1 is ligated to Cu1 and oxygen 2 to Cu4 at 2.2 Å and 2.5 Å, respectively (see Table 1). It has been suggested that this structure represents the Cu_Z species of the catalytic cluster,[15] and that the longer O distance of 2.5 Å arises from a H_2O molecule while the shorter distance is more compatible with it being

an OH^-. On the basis of computational methods, this structure of the Cu_Z cluster has also been predicted to be a stable structure, whereas the structure with two water molecules ligated to these Cu atoms was shown to be unstable.[61]

A comparison of the structures of the two forms of the catalytic center, Cu_Z in AcN_2OR at 1.86 Å resolution, and Cu_Z* in PdN_2OR at 1.6 Å resolution reveals close correspondence in the positions of the copper atoms and their corresponding protein ligands (Figure 7 and Table 1). However, a number of significant differences are observed. In particular, the imidazole ring of His452 (AcN_2OR numbering) has been rotated by ~30° toward His93 with a small increase in its distance from Cu4 (2.04 instead of 2.25 Å). In this structure, the position of the bridging sulfide ion connecting the four copper atoms of the catalytic cluster shows a concerted shift together with Cu4 and His452. Differences are observed for all four Cu–S bond lengths (Table 1).

INHIBITOR- AND SUBSTRATE-BOUND STRUCTURES

Exposure of the as-isolated AcN_2OR to sodium iodide led to reduction of the electron-donating Cu_A site and the formation of a blue species. Structure determination of this adduct at 1.7 Å resolution showed that iodide was bound at

the Cu$_Z$ site bridging the Cu1 and Cu4 ions (Figure 8). This structure represents the only example of an inhibitor bound to the Cu1-Cu4 edge of the catalytic cluster, providing clear evidence for the proposal that this forms the catalytic edge of the Cu$_Z$ cluster.[13] The position of iodide is somewhat asymmetrical with respect to Cu1 and Cu4, which are located at 2.5 Å and 2.8 Å, respectively. The single OH$^-$ observed in PdN$_2$OR is also asymmetrically bound but with a distance of 2.8 Å and 2.5 Å to Cu1 and Cu4, respectively (see Table 1).

A comparison of these structures enabled the development of a model for substrate binding.[15] In the as-isolated AcN$_2$OR structure, the molecular envelope of the two O-donating ligands to Cu1 and Cu4 was such that N$_2$O could be modeled as shown in Figure 9. The observed distance between the two oxygen atoms is 2.3 Å, a distance able to accommodate an O−N−N molecule where Cu4 would ligate to the O atom, whereas Cu1 would ligate to the terminal N atom of the substrate. This results in a bent configuration of bound N$_2$O, as suggested by the DFT calculations,[52,61] with an angle of 150° (see Figure 9).

Figure 9 The substrate N$_2$O is modeled onto the Cu$_Z$ cluster (see Figure 6) where the O atom of O−N−N is ligated to Cu4 and the terminal N atom is ligated to Cu1.

Recent DFT calculations have shown that the binding of N$_2$O to the [3CuI1CuIIS]3 state of the catalytic cluster is unfavorable compared to the 'super- reduced' [4CuIS]$^{2+}$ state due to the effective competition by H$_2$O for the site.[61] Binding of N$_2$O in the μ-1,4 bridging mode to the [4CuIS]$^{2+}$ state makes N$_2$O a very good electron acceptor and allows the high activation energy barrier for N$_2$O reduction to be overcome.[57] This enables a fast two-ET process with electrons donated from Cu1 and Cu4. Therefore, the catalytic center cycles between the [4CuIS]$^{2+}$ state and the oxidized [2CuI2CuIIS]$^{3+}$ state during catalysis. Following N−O bond cleavage and the release of N$_2$ from the catalytic center, the 'O' bound intermediate (O derived from N$_2$O) is formed. It has been suggested[15] that the position of iodide bound in a bridging mode as observed in the inhibitor-bound structure, Figure 8, represents the position of the 'O' in this intermediate.

CALCIUM IN N$_2$OR : IS THERE MORE TO IT THAN MEETS THE EYE?

As mentioned above, a number of calcium atoms have been found in all of the N$_2$OR structures determined so far. Their role in terms of dimer stability has been realized and discussed. Two of these calcium atoms are invariant in all of the structures, and are tightly bound at or near the monomer–monomer interface. One of these calcium ions (1606 AcN$_2$OR numbering) is bound to a number of residues, namely Met129, Tyr230 (through their main chain carbonyl groups) and to the side-chain oxygen atoms of Glu222, Asp236, and Asn283. The interaction with Asn283 in particular (through its O$^{\delta 1}$) stabilizes the side chain to enable it to hydrogen bond to Glu580 (through its O$^{\varepsilon 2}$ atom). The other Ca ion (1605) is located close to the interface but is coordinated by two protein residues of the same monomer (called *monomer 1*) (Figure 10). It coordinates to both oxygen atoms of Glu427 and also to the backbone O of Lys412 as well as four solvent molecules. One of these waters is in turn hydrogen-bonded to N$^{\varepsilon 2}$ of Trp580, which is one of the Cu$_A$ ligands from monomer 2. Trp580 coordinates Cu2 of Cu$_A$. Therefore, Ca 1605 occupies a central position with respect to the Cu$_A$ and Cu$_Z$ clusters (Figure 10), as if it is there to orchestrate the 'communication' between the two clusters located in the neighboring monomers of the functional dimer. Ca 1605 is located 9.3 Å from the Cu$_2$ of Cu$_A$ cluster and 11.2 Å from Cu$_4$ of the Cu$_Z$ cluster. Lys412, which coordinates through the backbone to this Ca (1605), also provides its amide N$_2$ to the water coordinating to Cu$_4$ of the catalytic cluster. The distance of this amide N$_2$ from Cu$_4$ is 2.9 Å, which is ideal for anchoring the asymmetrically bidentate-bound substrate as modeled in Figure 10. These observations are consistent with other structures of N$_2$OR as well as DFT calculations.[13,14,61] The DFT calculations have indicated a more favorable binding of N$_2$O in competition with H$_2$O to

the super-reduced state compared with the $\{Cu_A^{red}-Cu_Z^{red}\}$ species. A bent μ-1,4 bridging mode of substrate binding mimicking the transition state with the terminal N atom coordinating Cu1 and the O atom coordinating to Cu4 was proposed. This binding mode is stabilized by the potential for H-bond formation with the side chain of a conserved lysine residue and following ET from Cu_Z to the bound N_2O the substrate is activated for both direct and proton-assisted N–O bond cleavage.[61] Following bond cleavage, the Cu_Z center is in the $[2Cu^I2Cu^{II}S]^{3+}$ redox state and requires two one-electron and protonation events to re-establish the catalytically active super-reduced state.

PERSPECTIVE

It is clear that during the last 5 years major progress has been made toward our understanding of N_2OR. Major discoveries have been made including the discovery of a new and novel Cu cluster where activation and reduction of this inert substrate takes place. The structural results have provided a platform from which one can begin to address the detailed mechanism using an integrated structural biology approach combining site-directed mutagenesis with well-defined kinetic studies, together with high-resolution structures and computational studies. The big

challenge remains in terms of how this unique Cu_Z cluster catalyzes the conversion of this potent greenhouse gas to N_2. The discovery of this novel cluster in biology has posed a challenge to biomimic such a Cu cluster in the laboratory.

REFERENCES

1 RR Eady and SS Hasnain, *Compr Coord Chem*, **8**, 759–786 (2003).

2 S Suzuki, K Kataoka and K Yamaguchi, *Acc Chem Res*, **33**, 728–735 (2000).

3 WG Zumft, *Microbiol Mol Biol Rev*, **61**, 533–616 (1977).

4 T Matsubara and H Iwasaki, *J Biochem*, **71**, 747–750 (1972).

5 WG Zumft and T Matsubara, *FEBS Lett*, **148**, 107–112 (1982).

6 WG Zumft and PMH Kroneck, *Adv Microb Physiol*, **53**, 107–227 (2007).

7 WG Zumft, *J Mol Microbiol Biotechnol*, **10**, 154–166 (2005).

8 P Wunsch, M Herb, SH Wieland, UM Schiek and WG Zumft, *J Bacteriol*, **185**, 887–896 (2003).

9 MP Heikkilä, U Honisch, P Wunsuch and WG Zumft, *J Bacteriol*, **183**, 1663–1671 (2001).

10 P Wunsuch and WG Zumft, *J Bacteriol*, **187**, 1992–2001 (2005).

11 U Honisch and WG Zumft, *J Bacteriol*, **185**, 1895–1902 (2003).

12 M Prudêncio, AS Pareira, P Tavares, S Besson, I Cabrito, K Brown, B Samyn, B Devreese, JF Beeumen, F Rusnak, G Fauque, JJG Moura, M Tegoni, C Cambillau and I Moura, *Biochemistry*, **39**, 3899–3907 (2000).

13 K Brown, M Tegoni, M Prudêncio, AS Pareira, S Besson, JJG Moura, I Moura and C Cambillau, *Nat Struct Biol*, **7**, 191–195 (2000).

14 T Halitia, K Brown, M Tegoni, C Cambillau, M Saraste, K Mattila and K Djinovic-Carugo, *Biochem J*, **269**, 77–88 (2003).

15 K Paraskevopoulos, SV Antonyuk, RG Sawers, RR Eady and SS Hasnain, *J Mol Biol*, **362**, 55–65 (2006).

16 T Palmer and BC Berks, *Microbiology*, **149**, 547–556 (2003).

17 MP Heikkilä, U Honisch, P Wunsuch and WG Zumft, *J Bacteriol*, **183**, 1663–1671 (1989).

18 A Viebrock and WG Zumft, *J Bacteriol*, **170**, 4658–4668 (1998).

19 WG Zumft, A Dreusch, S Löchelt, H Cuypers, B Friedrich and B Schneider, *Eur J Biochem*, **208**, 31–40 (1992).

20 PMH Kroneck, WA Antholine, J Riester and WG Zumft, *FEBS Lett*, **242**, 70–74 (1988).

21 WE Antholine, DHW Kastrau, GCM Steffens, G Buse, WG Zumft and PMH Kroneck, *Eur J Biochem*, **209**, 875–881 (1992).

22 S Iwata, C Ostermeier, B Ludwig and H Michel, *Nature*, **376**, 660–669 (1995).

23 JM Charnock, A Dreusch, H Korner, F Neese, J Nelson, A Kannt, H Michel, CD Garner, PMH Kroneck and WG Zumft, *Eur J Biochem*, **267**, 1368–1381 (2000).

24 T Rasmussen, BC Berks, JN Butt and AJ Thompson, *Biochem J*, **364**, 807–815 (2002).

25 S Teraguchi and TC Hollacher, *J Biol Chem*, **264**, 1972–1979 (1989).

26 K Mattila and T Haltia, *Proteins Struct Func Bioinform*, **59**, 708–722 (2005).

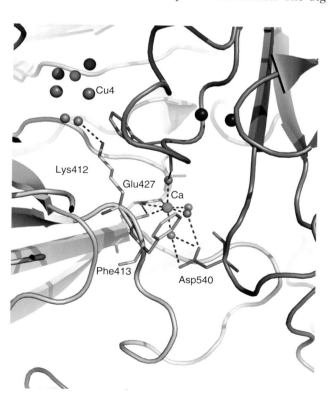

Figure 10 The Ca 1605 coordination and its linkage to Cu_A and Cu_Z clusters belonging to different monomers is shown (see text for more details). PDB code 2iwf.

27 S Ferretti, JG Grossmann, SS Hasnain, RR Eady and BE Smith, *Eur J Biochem*, **259**, 651–659 (1999).

28 T Rasmussen, BC Berks, J Sanders-Loehr, DM Dooley, WG Zumft and AJ Thomson, *Biochemistry*, **39**, 12753–12756 (2000).

29 J Riester, WG Zumft and PMH Kroneck, *Eur J Biochem*, **78**, 751–762 (1989).

30 JA Farrar, AJ Thomson, MR Cheesman, DM Dooley and WG Zumft, *FEBS Lett*, **294**, 11–15 (1991).

31 JA Farrar, WG Zumft and AJ Thompson, *Proc Natl Acad Sci U S A*, **95**, 9891–9896 (1998).

32 CL Coyle, WG Zumft, PMH Kroneck, H Körner and W Jacob, *Eur J Biochem*, **153**, 459–467 (1985).

33 BC Berks, D Barratta, DJ Richardson and SJ Ferguson, *Eur J Biochem*, **212**, 467–476 (1993).

34 F Neese, WG Zumft, WE Antholine and PMH Kroneck, *J Am Chem Soc*, **118**, 8692–8699 (1996).

35 JA Farrar, WG Zumft and AJ Thompson, *FEBS Lett*, **294**, 11–15 (1991).

36 PMH Kroneck, WE Antholine, J Riester and WG Zumft, *FEBS Lett*, **242**, 70–74 (1988).

37 F Neese, R Kappl, J Hünttermann, WG Zumft and PMH Kroneck, *J Biol Inorg Chem*, **3**, 53–67 (1998).

38 RC Holz, ML Alvarez, WG Zumft and DM Dooley, *Biochemistry*, **38**, 11164–11171 (1999).

39 RA Scott, WG Zumft, CL Coyle and DM Dooley, *Proc Natl Acad Sci U S A*, **86**, 4082–4086 (1989).

40 DM Dooley, MA McGuirl, AC Rosenzweig, JA Landin, RA Scott, WG Zumft, F Devlin and PJ Stephens, *Inorg Chem*, **30**, 3006–3011 (1991).

41 DM Dooley, RS Moog and WG Zumft, *J Am Chem Soc*, **109**, 6730–6735 (1987).

42 CR Andrew, J Han, S de Vries, J vas der Oost, BA Averill, TM Loehr and J Sanders-Loehr, *J Am Chem Soc*, **116**, 10805–10806 (1994).

43 JA Farrar, F Neese, P Lappalainen, PMH Kroneck, M Saraste, WG Zumft and AJ Thomson, *J Am Chem Soc*, **118**, 11501–11514 (1996).

44 Suharti, MJF Strampraad, I Schröder and S deVries, *Biochemistry*, **40**, 2632–2639 (2001).

45 PMH Kroneck, in A Messerschmidt, R Huber, T Poulos and K Wieghardt (eds.), *Handbook of Metalloproteins*, Vol. 2, John Wiley & Sons, New York, pp 1333–1341 (2001).

46 KR Williams, DR Gamelin, LB LaCroix, R Houser, WB Tollman, S deVries, B Hedman, KO Hodgson and EI Solomon, *J Am Chem Soc*, **119**, 613–614 (1997).

47 DR Gamelin, DW Randall, M Hay, R Houser, TC Mulder, GW Canters, S deVries, WB Tollman, Y Lu and EI Solomon, *J Am Chem Soc*, **120**, 5246–5263 (1998).

48 MHM Olsson and U Ryde, *J Am Chem Soc*, **123**, 7866–7876 (2001).

49 ML Alvarez, JY Ai, WG Zumft, J Sanders-Loehr and DM Dooley, *J Am Chem Soc*, **123**, 576–587 (2001).

50 P Chen, SD George, I Cabrito, WE Antholine, JJG Moura, I Moura, B Hedman, KO Hodgson and EI Solomon, *J Am Chem Soc*, **124**, 744 (2002).

51 P Chen, I Cabrito, JJG Moura, I Moura and EI Solomon, *J Am Chem Soc*, **124**, 10497–10507 (2002).

52 P Chen, SI Gorelsky, S Ghosh and EI Solomon, *Angew Chem Int Ed*, **43**, 4132–4140 (2004).

53 VS Oganesyan, T Rasmussen, S Fairhurst and AJ Thompson, *Chem Soc Dalton Trans*, 996–1002 (2004).

54 J Riester, WG Zumft and PMH Kroneck, *Eur J Biochem*, **178**, 751–762 (1989).

55 F Neese, Electronic structure and spectroscopy of novel copper chromophores in biology, PhD Dissertation, University of Konstanz, Germany, (1997).

56 T Rasmussen, T Brittain, BC Berks, NJ Watmough and AJ Thompson, *J Chem Soc Dalton Trans*, 3501–3506 (2005).

57 S Ghosh, SI Gorelsky, P Chen, I Cabrito, JJG Moura, I Moura and EI Soloman, *J Am Chem Soc*, **125**, 15708–15709 (2003).

58 JM Chan, JA Bollinger, CL Grewell and DM Dooley, *J Am Chem Soc*, **126**, 3030–3031 (2004).

59 PA Williams, NJ Blackburn, D Sanders, H Bellamy, EA Stura, JA Fee and DE McRee, *Nat Struct Biol*, **6**, 509–516 (1999).

60 T Tsukihara, H Aoyama, E Yamashita, T Tomizaki, H Yamaguchi, K Shinzawa-Itoh, R Nakashima, R Yaono and S Yoshikawa, *Science*, **269**, 1069–1074 (1995).

61 SI Gorelsky, S Ghosh and EI Soloman, *J Am Chem Soc*, **128**, 278–290 (2006).

Particulate methane monooxygenase

Amy C Rosenzweig

Departments of Biochemistry, Molecular Biology and Cell Biology and Chemistry, Northwestern University, Evanston, IL, USA

FUNCTIONAL CLASS

Enzyme; EC 1.14.13.25; methane, NAD(P)H: oxygen oxidoreductase (hydroxylating); membrane-bound form of methane monooxygenase; known as *particulate methane monooxygenase* (pMMO).

OCCURRENCE

pMMO is found in methanotrophic bacteria. Methanotrophs, eubacteria that grow only on C1 compounds, are widely distributed in nature, including extreme environments.[1,2] All methanotroph strains except one produce pMMO,[3] which is housed in intracytoplasmic membranes.[1] Several methanotrophs can express an alternative soluble methane monooxygenase (sMMO)[4] under conditions of copper starvation,[5,6] but pMMO is the predominant form in nature. pMMO has been studied from the type X organism *Methylococcus capsulatus* (Bath), the type II organisms *Methylosinus trichosporium* OB3b and *Methylocystis* sp. strain M, and the type I organism *Methylomicrobium album* BG8.[7–10] The three types of methanotrophs are all proteobacteria and are classified on the basis of various physiological characteristics.[1] Acidic methanotrophs that belong to the phylum *Verrucomicrobia* have also been identified, but little is known about their pMMO.[11]

BIOLOGICAL FUNCTION

Methanotrophs utilize methane as their sole source of carbon and energy. The pMMO enzyme converts methane to methanol in the first step of methanotroph metabolism. In the overall reaction, one atom of dioxygen is transferred

3D Structure Schematic representation of pMMO from *M. capsulatus* (Bath). The pmoB subunits are shown in purple, the pmoA subunits are shown in blue, and the pmoC subunits are shown in light green. Copper ions are shown as cyan spheres and zinc ions are shown as gray spheres. PDB code: 1YEW. Produced using the program PyMOL.[58]

Scheme 1

to methane and the other to water. Methanol is then further converted to formaldehyde, formate, and carbon dioxide, with biomass assimilation occurring via formaldehyde (Scheme 1). The pMMO reaction in methanotrophs impacts the global carbon cycle by controlling the amount of methane, a potent greenhouse gas, that reaches the atmosphere.[2] There is much interest in adapting the biological function of pMMO for bioremediation applications[12,13] as well as in developing biomimetic catalysts that can selectively oxidize methane under mild conditions.[14]

AMINO ACID SEQUENCE INFORMATION

The genes for pMMO are encoded by the *pmoCAB* operon, which is present as two full copies in *M. capsulatus* (Bath),[15] *M. trichosporium* OB3b, and *Methylocystis* sp. strain M.[16] A third copy of the *pmoC* gene is found in *M. capsulatus* (Bath).[17] The proteins encoded by these genes are the pmoB or α, pmoA or β, and pmoC or γ subunits of pMMO. The genome for *M. capsulatus* (Bath) has been completed.[18] Because the *pmoA* gene is widely used as an environmental probe for methanotrophs,[19] a large number of *pmoA* sequences are available.

- *M. capsulatus* (Bath): pmoB (UniProtKB/TrEMBL Q49104), 414 amino acid residues (AA); pmoA (UniProtKB/TrEMBL Q607G3), 247 AA; pmoC (UniProtKB/TrEMBL O05111), 289 AA.
- *M. trichosporium* OB3b: pmoB (UniProtKB/TrEMBL Q9KX50), 431 AA; pmoA (UniProtKB/TrEMBL Q50541), 252 AA; pmoC (UniProtKB/TrEMBL Q9KX51), 256 AA.
- *Methylocystis* sp. strain M: pmoB (UniProtKB/TrEMBL Q9KX36), 419 AA; pmoA (UniProtKB/TrEMBL O06122), 252 AA; pmoC (UniProtKB/TrEMBL Q9KX37), 256 AA.
- *Methylomicrobium* sp. N1: pmoB (UniProtKB/TrEMBL Q25BV2), 414 AA; pmoA (UniProtKB/TrEMBL Q25BV3), 247 AA; pmoC (UniProtKB/TrEMBL Q25BV4), 250 AA.
- *Methylocaldum* sp. T-025: pmoB (UniProtKB/TrEMBL A4PDX8), 418 AA; pmoA (UniProtKB/TrEMBL A4PDX7), 247 AA; pmoC (UniProtKB/TrEMBL A4PDX6), 262 AA.
- *Verrucomicrobia bacterium* SolV: pmoB (UniProtKB/TrEMBL A9Q6C7), 436 AA; pmoA (UniProtKB/TrEMBL A9Q6C3), 245 AA; pmoC (UniProtKB/TrEMBL A9Q6C5), 289 AA.

PROTEIN PRODUCTION, PURIFICATION, AND MOLECULAR CHARACTERIZATION

All pMMO samples are isolated from native methanotrophs. A suitable recombinant expression system has not yet been developed, although some expression in *Rhodococcus erythropolis* has been reported.[20] Methanotrophs are typically cultivated at 30–45 °C in a nitrate mineral salts medium.[1,21] pMMO has been purified from *M. capsulatus* (Bath) and *M. trichosporium* OB3b. If ~30–60 μM CuSO₄ is included in the culture medium, pMMO is abundant in the membranes.[22–24] Cells are harvested, lysed by French press,[22,24–29] sonication,[23,30–35] or a cell disruptor,[36] cell debris pelleted, and the membranes isolated by ultracentrifugation. The membranes are then washed, and pMMO is solubilized with the detergent dodecyl-β-D-maltoside (DDM). Most purification schemes are conducted using DDM, although undecyl-β-D-maltoside (UDM)[37] and Brij-58[30,35] have also been used. Purification is typically accomplished by a combination of anion exchange and gel filtration chromatography.[10]

The pMMO complexes from *M. capsulatus* (Bath), *M. trichosporium* OB3b, and *Methylocystis* sp. strain M are 300-kDa α₃β₃γ₃ trimers with three copies each of the pmoB, pmoA, and pmoC subunits. This polypeptide arrangement was determined from crystallographic[35,38] and cryoelectron microscopic[39,40] data. According to sodium dodecyl sulfate-polyacrylamide gel electrophoresis (SDS-PAGE) analysis, the molecular masses of the subunits are 43–47 kDa for pmoB, 24–27 kDa for pmoA, and 22–25 kDa for pmoC.[10] The pmoB subunit contains a 33-residue membrane-targeting sequence that is cleaved *in vivo*.[27,29]

METAL CONTENT

The metal content of pMMO is typically reported per 100-kDa αβγ protomer and depends on the source organism and the laboratory conducting the purification (Table 1). Inductively coupled plasma atomic emission spectroscopy or atomic absorption spectroscopy have been used to obtain values of 2,[36] 2–3,[23] 8–10,[22] and 15–20[24,27] copper ions per purified *M. capsulatus* (Bath) protomer. In some cases, a portion of the copper is associated with methanobactin, a

Table 1 Metal content of purified pMMO

Laboratory	M. capsulatus (Bath)		M. trichosporium OB3b	
	Mol Cu/ 100 kDa	Mol Fe/ 100 kDa	Mol Cu/ 100 kDa	Mol Fe/ 100 kDa
Rosenzweig (refs. 23, 35)	2–3	0.4–1	0.8–2	0
Dalton (ref. 36)	2	1	–	–
DiSpirito (refs. 22, 29)	2 (+6–8 mb)	2	–	–
Chan (refs. 24, 27)	12–15	0	–	–
Okura (ref. 30)	–	–	2	0

1217-kDa Cu(I) chelator of unknown function.[41] Purified *M. trichosporium* OB3b pMMO contains ~2 copper ions per protomer.[30,35] A number of preparations also contain 0.75–2.5 iron ions per protomer,[22,23,36] some of which derive from heme contaminants.[23,42] The zinc content of purified pMMO has been measured and is negligible.[24,37]

ACTIVITY AND INHIBITION TESTS

The activity of pMMO is measured by monitoring the epoxidation of propylene to propylene oxide by gas chromatography.[43] Either NADH or duroquinol[44] is added to the assay as a reductant. Specific activities of ~10–200 nmol propylene oxide (milligrams protein × min)$^{-1}$ for membrane-bound pMMO and 2–126 nmol propylene oxide (milligrams protein × min)$^{-1}$ for purified pMMO have been reported for *M. capsulatus* (Bath).[10] The activity is much lower for purified *M. trichosporium* OB3b pMMO.[30,35] Additional components such as a type 2 NADH:quinone oxidoreductase[22,45] or methanol dehydrogenase[36] have been proposed to be important for pMMO activity, but the actual physiological reductant has not been identified. Other factors influencing the activity include the growth conditions, the solubilization procedure, and the presence of oxygen during purification.[9] Known inhibitors include carbon monoxide, azide, cyanide, and acetylene.[29] In studies using radiolabeled acetylene to probe the active site location, the pmoA subunit was labeled primarily, with some labeling of pmoB as well.[29,46,47]

SPECTROSCOPY

Optical and EPR spectroscopy

The optical spectrum of purified pMMO exhibits a band at 410 nm that results from cytochrome impurities.[27] Electron paramagnetic resonance (EPR) spectra of pMMO typically show a type 2 Cu(II) signal. This signal has similar parameters for purified *M. capsulatus* (Bath) pMMO[22,23,29,36] and purified *M. trichosporium* OB3b

pMMO[30,35] as well as membrane-bound and whole cell samples from *M. capsulatus* (Bath), *M. album* BG8,[48–50] and *M. capsulatus* strain M.[51] Integration of this type 2 signal indicates that 40–85% of the copper in pMMO is EPR active.[23,35,36] According to electron spin echo modulation spectroscopic (ESEEM) data, three or four histidine imidazoles coordinate the type 2 copper.[48,51,52] Electron nuclear double resonance (ENDOR) data indicate that solvent ligands are also present.[51] In some pMMO preparations, a broad isotropic signal at $g \sim 2.1$ is also observed and is attributed to a trinuclear copper center.[25,26,53,54] Treatment with dithionite significantly decreases the EPR signal intensity.[23,25,26,55] EPR signals arising from rhombic iron[23,26,29,31,36] as well as high spin heme[42] have also been observed.

X-ray absorption spectroscopy

The X-ray absorption near edge spectra (XANES) for purified pMMO from *M. capsulatus* (Bath) and *M. trichosporium* OB3b exhibit features at 8984 eV due to Cu(I) 1s → 4p transitions.[23,35,42] The intensity of this feature increases upon dithionite treatment, indicating that some, but not all, of the copper in purified pMMO is reduced. Oxidation of *M. capsulatus* (Bath) pMMO with hydrogen peroxide diminishes this peak, but complete oxidation to Cu(II) does not occur. The first shell Cu extended X-ray absorption fine structure (EXAFS) data for *M. capsulatus* (Bath) pMMO are best fit with two Cu–O/N ligand environments with distances of 1.93–2.22 Å, depending on the oxidation state. A second shell of backscatterers is best fit with a 2.51 Å Cu–Cu interaction that increases to 2.65 Å upon dithionite reduction.[23,42] The EXAFS for *M. trichosporium* OB3b pMMO are similar with O/N ligands at 1.97 Å and a Cu–Cu interaction at 2.52 Å.[35] A camelback beat pattern characteristic of imidazole ligation is detected for both pMMO samples. The iron in *M. capsulatus* (Bath) pMMO has also been investigated by X-ray absorption spectroscopy (XAS).[42] The XANES spectrum indicates that the iron is present as Fe(III), and the EXAFS fitting indicates a mixed Fe–O/N coordination environment with Fe-ligand distances of 1.97 and 2.12 Å. Long-range scattering is also observed and is best fit with carbon ligands. The Fe data are similar to XAS of heme proteins and thus consistent with the presence of cytochrome contaminants. The absence of Fe-metal scattering at 2.5–2.65 Å confirms that the 2.5 Å interaction in the Cu EXAFS is due to a Cu–Cu, rather than a Cu–Fe, interaction.

Mössbauer spectroscopy

Mössbauer spectroscopy has been used to probe the nature of the iron in both whole cell and purified preparations of *M. capsulatus* (Bath) pMMO.[56] pMMO purified from

Figure 1 Topology diagrams of the pMMO subunits produced using PDBSUM (http://www.ebi.ac.uk/thornton-srv/databases/pdbsum/) and PDB code 1YEW.

cells grown with ^{57}Fe exhibits a Mössbauer spectrum with two doublets. The first doublet has $\Delta E_Q(1) = 1.05$ mm s^{-1} and $\delta(1) = 0.5$ mm s^{-1} and is assigned to a di-iron(III) center like that in sMMO.[4] The second doublet has $\Delta E_Q(2) = 2.65$ mm s^{-1} and $\delta(2) = 1.25$ mm s^{-1}, parameters characteristic of high spin Fe(II). Additional features in the spectrum are consistent with mineralized Fe(III) nanoparticles. Doublet 1 is also observed in whole cells. On the basis of these spectra, iron quantitation, and activity measurements, the proposed di-iron(III) center is ~11% occupied in purified pMMO.

X-RAY STRUCTURE

Crystallization

The first pMMO crystals were from *M. capsulatus* (Bath). Purified pMMO in 50 mM 4-(2-hydroxyethyl)-1-piperazineethanesulfonic acid (HEPES) pH 7.5 containing 0.12% cyclohexyl-1-pentyl-β-D-maltoside (Cymal-5) was crystallized from a precipitant solution containing 0.2 M zinc acetate and 8–12% polyethylene glycol (PEG) 8000.[37] The zinc acetate was essential for crystallization. Crystals were also obtained using UDM as the detergent. The

best crystals were $0.1 \times 0.1 \times 0.4$ mm and diffracted to 2.8 Å resolution. The lattice was tetragonal, space group $P4_22_12$ with unit cell dimensions $a = b = 264.1$ Å and $c = 150.0$ Å. The structure was solved by Cu single wavelength anomalous dispersion (SAD) phasing using a highly redundant data set.[37,38] Crystals of *M. trichosporium* OB3b pMMO were also obtained. Purified *M. trichosporium* OB3b pMMO in 50 mM Tris pH 8.5 containing 0.03% UDM was crystallized from solutions containing 100 mM cacodylate pH 6.5, 20% PEG 3000, and 250 mM magnesium formate or manganese chloride. These crystals belonged to space group $P2_12_12_1$ with unit cell dimensions $a = 113.8$, $b = 184.1$, and $c = 203.9$. The 3.9 Å resolution structure was solved by molecular replacement using *M. capsulatus* (Bath) pMMO as a starting model.[35]

Overall structure of pMMO

The cylindrical pMMO trimer (3D structure) is ~105 Å long and ~90 Å in diameter.[37,38] The protomers are related by a noncrystallographic threefold axis. A soluble region comprises six cupredoxin-like, β-barrel structures, two from each pmoB subunit. These domains are predicted to reside in the periplasm. The transmembrane region consists of 15 α helices from each protomer. An opening at the

Figure 2 Locations of metal centers and potential metal centers in the *M. capsulatus* (Bath) pMMO structure. The pmoB subunit is shown as a purple surface, the pmoA subunit is shown as a blue surface, and the pmoC subunit is shown as a light green surface. Figure generated with PyMOL.[58]

Figure 3 The pmoB mononuclear copper center in the *M. capsulatus* (Bath) pMMO structure. Bond distances are not well determined at 2.8 Å resolution. Figure generated with PyMOL.[58]

Figure 4 The pmoB dinuclear copper center in the *M. capsulatus* (Bath) pMMO structure. Bond distances are not well determined at 2.8 Å resolution, but the Cu–Cu distance is consistent with that determined by EXAFS. Figure generated with PyMOL.[58]

center of the trimer is ~11 Å in diameter in the soluble region and widens to ~22 Å within the membrane. The N-terminal β barrel in pmoB (Figure 1, pmoB domain 1) is connected to the C-terminal β barrel (Figure 1, pmoB domain 3) via a β hairpin, two transmembrane helices, and

Figure 5 The zinc site in the *M. capsulatus* (Bath) pMMO structure. Ligands are derived from both the pmoA and pmoC subunits. This site contains copper in the *M. trichosporium* OB3b structure. Bond distances are not well determined at 2.8 Å resolution. Figure generated with PyMOL.[58]

Figure 6 Candidate for additional metal binding site in the *M. capsulatus* (Bath) pMMO structure. Hydrophilic residues from both pmoA and pmoC are potential ligands. Figure generated with PyMOL.[58]

a loop (Figure 1, pmoB domain 2). The combination of a C-terminal β barrel and two transmembrane (TM) helices is also found in subunit II of cytochrome *c* oxidase.[57] There is an acidic patch on the outer surface of pmoB that could serve as a docking site for partner proteins such as reductases. Both pmoA and pmoC are primarily α helical (Figure 1). An additional TM helix was modeled in the

M. trichosporium OB3b structure, but, at 3.9 Å resolution, it was not possible to connect it definitively to pmoA or pmoC.[35]

Metal centers in the pMMO structure

The identities of metal ions in the pMMO crystal structures were determined by the analysis of anomalous data collected at the Cu, Zn, and Fe absorption edges.[59] Two copper centers are housed in the N-terminal β barrel of the pmoB subunit (Figure 2).[37,38] The first site is located ~25 Å above the membrane interface and contains a single copper ion ligated by two histidine residues, His48 and His72 in *M. capsulatus* (Bath) pMMO (Figure 3). A glutamine, Gln404, is also nearby. The coordination is similar to that of the type 2 site in multicopper oxidases.[60] This mononuclear site is not occupied in *M. trichosporium* OB3b pMMO, consistent with the replacement of His48 with an asparagine.[35] The second copper center is located ~10 Å from the membrane and 21 Å from the mononuclear site. This site is dinuclear with a Cu–Cu distance of 2.6 Å, consistent with EXAFS analysis (Figure 4).[42] One copper ion is coordinated by His33, which is the N-terminal residue in pmoB. Both the side chain nitrogen and the amino terminal nitrogen appear to be ligands. The second copper ion is ligated by His137 and His139. Exogenous ligands are not observed at 2.8 Å resolution, but are likely to be present. The dinuclear site is conserved in *M. trichosporium* OB3b pMMO. This site is significantly different from other structurally characterized di-copper centers, including the active sites of tyrosinase and catechol oxidase[61] and the electron transfer Cu$_A$ site of cytochrome *c* oxidase and nitrous oxide reductase.[62] The C-terminal β barrel does not contain any metal ions in the crystal structures, but has been suggested to house ~10 additional copper ions.[63]

In the *M. capsulatus* (Bath) pMMO structure, a third metal center located within the membrane 19 Å from the di-copper site is occupied by a zinc ion (Figure 2).[37,38] Coordinating ligands include Asp156, His160, and His173 from pmoC and Glu195 from pmoA (Figure 5). Since purified pMMO does not contain zinc, this zinc ion is likely to be an artifact of the 0.2 M zinc acetate required for crystallization. In the *M. trichosporium* OB3b pMMO structure, the zinc ion is replaced by copper, although any related changes in coordination cannot be discerned at 3.9 Å resolution.[35] The presence of multiple histidine and carboxylate residues near this site has led to the proposal that a di-iron center could be present at this location *in vivo*.[37,56] Finally, an adjacent patch of conserved hydrophilic residues in the membrane is a candidate for another metal binding site (Figures 2 and 6). Although this site contains no metal ions in the crystal structures, it has been proposed to house a trinuclear copper center.[54]

Much discussion has focused on reconciling the spectroscopic and crystallographic data, determining the oxidation

states of the pMMO copper ions, and identifying the active site.[7,38,54] The oxidation states of the mononuclear and dinuclear copper centers in the crystal structures are not clear, although several scenarios have been considered. Since the mononuclear copper center in the *M. capsulatus* (Bath) structure is not conserved, it is unlikely to be critical for activity. The di-copper center, the mononuclear zinc or copper site, a di-iron center, and a tri-copper center have all been considered as possible sites for catalysis. Resolution of these issues awaits functional derivatives and mutagenesis studies.

CATALYTIC MECHANISM

Despite the uncertainty regarding the pMMO active site, some mechanistic studies have been conducted using *M. capsulatus* (Bath) membrane preparations. Both chiral ethane and chiral butane are hydroxylated with retention of configuration.[64,65] These data combined with experiments using alkene substrates are consistent with a proposed mechanism involving concerted oxene addition across the C–H bond.[66] No carbon kinetic isotope effect is observed for propane oxidation, suggesting little structural change at the carbon atom in the rate-limiting step.[67] Oxidation of multicarbon compounds by pMMO is regioselective with the C-2 position preferentially oxidized.[68] The pMMO mechanism has additionally been investigated by DFT calculations. Mechanisms involving a Cu(III)-oxo species have been computed using both mononuclear and dinuclear copper centers as active site models.[69]

REFERENCES

1 J Bowman, *Prokaryotes*, **5**, 266–89 (2006).

2 RS Hanson and TE Hanson, *Microbiol Rev*, **60**, 439–71 (1996).

3 MG Dumont and JC Murrell, *Methods Enzymol*, **397**, 413–27 (2005).

4 DA Whittington, SJ Lippard, A Messerschmidt, R Huber, K Weighardt and T Poulos (eds.), *Handbook of Metalloproteins*, John Wiley & Sons, New York, pp. 712–24 (2001).

5 SD Prior and H Dalton, *J Gen Microbiol*, **131**, 155–63 (1985).

6 SH Stanley, SD Prior, DJ Leak and H Dalton, *Biotechnol Lett*, **5**, 487–92 (1983).

7 R Balasubramanian and AC Rosenzweig, *Acc Chem Res*, **40**, 573–80 (2007).

8 SI Chan, KH-C Chen, SS-F Yu, C-L Chen and SS-J Kuo, *Biochemistry*, **43**, 4421–30 (2004).

9 AS Hakemian and AC Rosenzweig, *Annu Rev Biochem*, **76**, 223–41 (2007).

10 RL Lieberman and AC Rosenzweig, *Crit Rev Biochem Mol Biol*, **39**, 147–64 (2004).

11 JD Semrau, AA Dispirito and JC Murrell, *Trends Microbiol*, **16**, 190–93 (2008).

12 JP Sullivan, D Dickinson and CA Chase, *Crit Rev Microbiol*, **24**, 335–73 (1998).

13 S Lontoh and JD Semrau, *Appl Environ Microbiol*, **64**, 1106–14 (1998).

14 RA Periana, G Bhalla, WJ Tenn III, KJH Young, XY Liu, O Mironov, CJ Jones and VR Ziatdinov, *J Mol Catal A*, **220**, 7–25 (2004).

15 JD Semrau, A Chistoserdov, J Lebron, A Costello, J Davagnino, E Kenna, AJ Holmes, R Finch, JC Murrell and ME Lidstrom, *J Bacteriol*, **177**, 3071–79 (1995).

16 B Gilbert, IR McDonald, R Finch, GP Stafford, AK Nielsen and JC Murrell, *Appl Environ Microbiol*, **66**, 966–75 (2000).

17 S Stolyar, AM Costello, TL Peeples and ME Lidstrom, *Microbiology*, **145**, 1235–44 (1999).

18 N Ward, O Larsen, J Sakwa, L Bruseth, H Khouri, AS Durkin, G Dimitrov, L Jiang, D Scanlan, KH Kang, M Lewis, KE Nelson, B Metheacute, M Wu, JF Heidelberg, IT Paulsen, D Fouts, J Ravel, H Tettelin, Q Ren, T Read, rT DeBoy, R Seshadri, SL Salzberg, HB Jensen, NK Birkeland, WC Nelson, RJ Dodson, SH Grindhaug, I Holt, I Eidhammer, I Jonason, S Vanaken, T Utterback, TV Feldblyum, CM Fraser, JR Lillehaug and JA Eisen, *PLoS Biol*, **2**, e303 (2004).

19 IR McDonald, L Bodrossy, Y Chen and JC Murrell, *Appl Environ Microbiol*, **74**, 1305–15 (2008).

20 Z Gou, X-H Xing, M Luo, H Jiang, B Han, H Wu, L Wang and F Zhang, *FEMS Microbiol Lett*, **263**, 136–41 (2006).

21 R Whittenbury, KC Phillips and JF Wilkinson, *J Gen Microbiol*, **61**, 205–18 (1970).

22 DW Choi, RC Kunz, ES Boyd, JD Semrau, WE Antholine, JI Han, JA Zahn, JM Boyd, AM de la Mora and AA DiSpirito, *J Bacteriol*, **185**, 5755–64 (2003).

23 RL Lieberman, DB Shrestha, PE Doan, BM Hoffman, TL Stemmler and AC Rosenzweig, *Proc Natl Acad Sci USA*, **100**, 3820–25 (2003).

24 SS-F Yu, KH-C Chen, MY-H Tseng, Y-S Wang, C-F Tseng, Y-J Chen, DS Huang and SI Chan, *J Bacteriol*, **185**, 5915–24 (2003).

25 H-HT Nguyen, KH Nakagawa, B Hedman, SJ Elliott, ME Lidstrom, KO Hodgson and SI Chan, *J Am Chem Soc*, **118**, 12766–76 (1996).

26 H-HT Nguyen, AK Shiemke, SJ Jacobs, BJ Hales, ME Lidstrom and SI Chan, *J Biol Chem*, **269**, 14995–5005 (1994).

27 HH Nguyen, SJ Elliott, JH Yip and SI Chan, *J Biol Chem*, **273**, 7957–66 (1998).

28 DDS Smith and H Dalton, *Eur J Biochem*, **182**, 667–71 (1989).

29 JA Zahn and AA DiSpirito, *J Bacteriol*, **178**, 1018–29 (1996).

30 A Miyaji, T Kamachi and I Okura, *Biotechnol Lett*, **24**, 1883–87 (2002).

31 M Takeguchi, K Miyakawa and I Okura, *J Mol Catal A*, **132**, 145–53 (1998).

32 M Takeguchi, K Miyakawa and I Okura, *Biometals*, **11**, 229–34 (1998).

33 GM Tonge, DEF Harrison and IJ Higgins, *Biochem J*, **161**, 333–44 (1977).

34 J-Y Xin, J-R Cui, X-X Hu, S-B Li, C-G Xia, L-M Zhu and Y-Q Wang, *Biochem Biophys Res Commun*, **295**, 182–86 (2002).

35 AS Hakemian, KZ Bencze, J Telser, BM Hoffman, TL Stemmler and AC Rosenzweig, *Biochemistry*, **47**, 6793–801 (2008).

36 P Basu, B Katterle, KK Andersson and H Dalton, *Biochem J*, **369**, 417–27 (2003).

37 RL Lieberman and AC Rosenzweig, *Nature*, **434**, 177–82 (2005).

38 RL Lieberman and AC Rosenzweig, *Dalton Trans*, **21**, 3390–96 (2005).

39 A Kitmitto, N Myronova, P Basu and H Dalton, *Biochemistry*, **44**, 10954–65 (2005).

40 VL Tsuprun, NP Akent'eva, IV Tagunova, EV Orlova, AN Grigoryan, RI Gvozdev and NA Kiselev, *Dokl Akad Nauk SSSR*, **292**, 490–93 (1987).

41 R Balasubramanian and AC Rosenzweig, *Curr Opin Chem Biol*, **12**, 245–49 (2008).

42 RL Lieberman, KC Kondapalli, DB Shrestha, AS Hakemian, SM Smith, J Telser, J Kuzelka, R Gupta, AS Borovik, SJ Lippard, BM Hoffman, AC Rosenzweig and TL Stemmler, *Inorg Chem*, **45**, 8372–81 (2006).

43 J Colby, DI Stirling and H Dalton, *Biochem J*, **165**, 395–402 (1977).

44 AK Shiemke, SA Cook, T Miley and P Singleton, *Arch Biochem Biophys*, **321**, 421–28 (1995).

45 AK Shiemke, DJ Arp and LA Sayavedra-Soto, *J Bacteriol*, **186**, 928–37 (2004).

46 SA Cook and AK Shiemke, *J Inorg Biochem*, **63**, 273–84 (1996).

47 SD Prior and H Dalton, *FEMS Microbiol Lett*, **29**, 105–09 (1985).

48 SS Lemos, MLP Collins, SS Eaton, GR Eaton and WE Antholine, *Biophys J*, **79**, 1085–94 (2000).

49 H Yuan, MLP Collins and WE Antholine, *J Am Chem Soc*, **119**, 5073–74 (1997).

50 H Yuan, MLP Collins and WE Antholine, *Biophys J*, **76**, 2223–29 (1999).

51 B Katterle, RI Gvozdev, N Abudu, T Ljones and KK Andersson, *Biochem J*, **363**, 677–86 (2002).

52 SJ Elliott, DW Randall, RD Britt and SI Chan, *J Am Chem Soc*, **120**, 3247–48 (1998).

53 S-C Hung, C-L Chen, KH-C Chen, SS-F Yu and SI Chan, *J Chin Chem Soc*, **51**, 1229–44 (2004).

54 SI Chan, VCC Wang, JCH Lai, SSF Yu, PPY Chen, KHC Chen, CL Chen and MK Chan, *Angew Chem Int Ed*, **46**, 1992–94 (2007).

55 H Yuan, MLP Collins and WE Antholine, *J Inorg Biochem*, **72**, 179–85 (1998).

56 M Martinho, DW Choi, AA DiSpirito, WE Antholine, JD Semrau and E Münck, *J Am Chem Soc*, **129**, 15783–85 (2007).

57 S Iwata, C Ostermeier, B Ludwig and H Michel, *Nature*, **376**, 660–69 (1995).

58 WL Delano, *The PyMOL Molecular Graphics System*, DeLano Scientific, San Carlos, CA (2002).

59 M Sommerhalter, RL Lieberman and AC Rosenzweig, *Inorg Chem*, **44**, 770–78 (2005).

60 EI Solomon, UM Sundaram and TE Machonkin, *Chem Rev*, **96**, 2563–605 (1996).

61 AC Rosenzweig and MH Sazinsky, *Curr Opin Struct Biol*, **16**, 729–35 (2006).

62 H Beinert, *Eur J Biochem*, **245**, 521–32 (1997).

63 SSF Yu, CZ Ji, YP Wu, TL Lee, CH Lai, SC Lin, ZL Yang, VCC Wang, KHC Chen and SI Chan, *Biochemistry*, **46**, 13762–74 (2007).

64 B Wilkinson, M Zhu, ND Priestley, H-HT Nguyen, H Morimoto, PG Williams, SI Chan and HG Floss, *J Am Chem Soc*, **118**, 921–22 (1996).

65 SS-F Yu, L-Y Wu, KH-C Chen, W-I Luo, D-S Huang and SI Chan, *J Biol Chem*, **278**, 40658–69 (2003).

66 K-Y Ng, L-C Tu, Y-S Wang, SI Chan and SSF Yu, *ChembioChem*, **9**, 1116–23 (2008).

67 DS Huang, SH Wu, YS Wang, SS Yu and SI Chan, *ChembioChem*, **3**, 760–65 (2002).

68 SJ Elliott, M Zhu, L Tso, H-H Nguyen, JH-K Yip and SI Chan, *J Am Chem Soc*, **119**, 9949–55 (1997).

69 K Yoshizawa and Y Shiota, *J Am Chem Soc*, **128**, 9873–81 (2006).

Copper Storage and Transport

Copper transporters and chaperones

Fabio Arnesano[†] and Lucia Banci[‡]

[†]Department of Pharmaceutical Chemistry, University of Bari, Bari, Italy
[‡]Magnetic Resonance Center (CERM) and Department of Chemistry, University of Florence, Florence, Italy

FUNCTIONAL CLASS

Copper is an essential element for many cellular processes,[1] such as free radical detoxification,[2] mitochondrial respiration,[3] iron metabolism,[4] neuropeptide maturation,[5] connective tissue formation,[6] and pigmentation.[7] In each of these processes, one or more copper-binding proteins and enzymes are involved, and their copper centers may have either an electron transfer or a catalytic role or both. The involvement of copper in these processes derives from its ability to assume different oxidation states, the two most common being reduced Cu(I) and oxidized Cu(II). The redox properties of copper, however, are also responsible for its cellular toxicity. Indeed, free copper ions catalyze Fenton reactions, which produce highly reactive oxygen species (ROS) that may damage cell membranes, proteins, and nucleic acids.[8]

To supply copper to proteins and enzymes, avoiding damage caused by free copper ions, cells have developed mechanisms for copper transport and homeostasis, which maintain the cellular concentration of copper within narrow limits and prevent the occurrence of free copper ions in the cytosol,[9] and also make the needed copper ions available in concentrations suitable for proper protein metalation. The tight control exerted by these cell machineries regulates copper levels via uptake and efflux, mediated by high-affinity *membrane transporters*, as well as

guarantees copper delivery to the appropriate target proteins and compartments.[10,11] This latter task is fulfilled by *soluble copper chaperones*, which provide an efficient system of copper distribution to specific cellular pathways and of copper incorporation into designated cuproenzymes.[12,13]

The class of copper transporters encompasses proteins with very different architectures and functional mechanisms. Nonetheless, some features are conserved among different subclasses. Membrane copper transporters contain intramembrane copper-binding site(s) and soluble copper-binding domains, while soluble copper chaperones are characterized by exposed metal sites, and thermodynamic stability and kinetic lability of copper binding, which ensure tight binding as well as fast copper transfer.[14] A classification of copper transporters and chaperones can be made on the basis of the functional pathway in which they are involved. So far, three well-characterized trafficking pathways (Figure 1) have been studied: (1) copper transport into the Golgi/thylakoid compartment and incorporation into multicopper oxidases/plastocyanin and other cuproenzymes as well as excess copper excretion from the cell, (2) copper incorporation into Cu,Zn-superoxide dismutase (Cu,Zn-SOD1) in the cytosol and in mitochondria, (3) copper delivery to mitochondria/periplasm and incorporation into specific subunits of cytochrome *c* oxidase (COX).

3D Structure Schematic representation of the solution structure of the complex between the yeast metallochaperone Atx1 (in blue) and the first soluble domain of the copper-transporting P-type ATPase Ccc2 (in yellow), with the Cu(I) ion shown as a green sphere. PDB code: 2GGP. Prepared with the program MOLMOL.[175]

OCCURRENCE

Copper chaperones and copper-transporting P-type adenosine triphosphatases (ATPases) delivering copper to the Golgi/thylakoid compartment in eukaryotes and cyanobacteria, respectively, have homologues in numerous bacteria, reflecting a highly conserved mechanism of copper transport, adapted among different phyla and cellular organizations.[15] Copper chaperones for P-type ATPases are located in the cytoplasm, while the ATPases are either anchored to the plasma/outer membrane or to the Golgi/thylakoid membrane.

Cu,Zn-SOD1 and its copper chaperone (called copper chaperone for superoxide dismutase (CCS), hereafter) are present both in the cytoplasm and in the mitochondrial intermembrane space (intermembrane space (IMS)).[16] Both yeast and human CCS proteins have been characterized[17] and have homologues in plants[18,19] and other eukaryotic organisms.[20,21] The bacterial Cu,Zn-SOD1 enzymes[22] acquire copper through a different mechanism, which is not yet known. This diversity among phyla may be related to the different Cu,Zn-SOD1 subcellular location, as in bacteria it is present in the periplasmic space, an oxidizing environment where copper availability may not be limited in normal conditions,[9] at variance with eukaryotic organisms.[23]

The same considerations on the cellular location hold for the COX enzyme, which is located in the mitochondrial inner membrane (IM) in eukaryotes, and in the periplasmic or outer membrane in bacteria. Several proteins are needed to incorporate the copper ions in COX.[24] In eukaryotes, they are located in the cytoplasm and/or in the mitochondrial IMS, while those already identified in prokaryotes[25–28] are located in the periplasm.

BIOLOGICAL FUNCTION

Studies on copper homeostasis received a further impulse when it was discovered that the yeast protein antioxidant1 (Atx1) functions as a Cu(I) chaperone, and that its physiological partner was the yeast ATPase cross-complements Ca^{2+}-sensitive phenotype of csg1 mutant 2 (Ccc2), which pumps Cu(I) into a subcellular organelle, the trans-Golgi network.[29] It was suggested that, during this transfer, Cu(I) is oxidized to Cu(II), due to the more oxidizing environment of the Golgi.[30] Copper is then loaded onto ferrous transport 3 (Fet3), a multicopper-ferroxidase essential for high-affinity iron uptake.[31] When loaded with copper, Fet3 makes a complex with the iron transporter Ftr1 and, together, they move to the cell membrane,[32] where Fet3 catalyzes the oxidation of Fe(II) to Fe(III), which is then bound by Ftr1. This pathway (Figure 1) is one example of the tight interplay between copper and iron metabolisms.[33] Humans possess a somehow similar, though more complex, pathway, where a soluble copper chaperone, Hah1 (the

homologue to Atx1, also called Atxo1),[34] delivers Cu(I) to two different, but highly similar in sequence, Cu(I)-binding P-type ATPases, ATP7A, and ATP7B (both homologous to Ccc2). Mutations on human ATP7A and ATP7B are implicated in Menkes (MNK) and Wilson (WND) diseases, respectively, and hence these proteins are often referred to as the MNK[35] and the WND[36,37] proteins. MNK protein is expressed in most tissues (muscle, kidney, lung, and brain, but only a trace amount in the liver), while WND protein is expressed mainly in the liver, kidney, and placenta. The key role of MNK and WND proteins in copper homeostasis is strongly determined by their intracellular trafficking and localization, depending on the copper levels.[30,38] At low copper concentrations, both proteins are localized in the Golgi, where MNK protein transfers copper to cuproenzymes, among which lysyl oxidase, which is responsible for cross-linking collagen and elastin.[39–42] At high copper concentrations, MNK protein moves to the external cell membrane and pumps copper out of the cell. In intestinal cells, MNK protein moves to the basolateral membrane and releases copper into the blood circulation,[30] which allows the distribution of copper to other cell types. When the intracellular copper levels are reduced, the protein returns to the Golgi membrane. WND protein, also located in the Golgi membrane, incorporates copper (at low concentrations) into ceruloplasmin, a multicopper oxidase similar to Fet3.[43] At high copper concentrations, WND protein moves from the Golgi membrane to a vesicular compartment where it releases copper. The copper-loaded vesicles are then discharged into the bile.[38] This copper-induced trafficking of both ATPases shows their dual functional role.

Plants also need copper for a variety of functions. One of these functions is unique to this kingdom of life and involves binding of ethylene, an important endogenous plant hormone, affecting many aspects of growth and development. In *Arabidopsis thaliana*, a copper pathway similar to that of yeast was identified.[44] Copper is shuttled by a soluble protein copper chaperone (CCH), the homologue of Atx1,[45] to a copper ATPase responsive-to-antagonist 1 (RAN1), which resides in the Golgi compartment, like Ccc2.[46] Here, the ATPase delivers one copper ion to the ethylene receptors (ETR1 family), which thus become functional and move to the external cell membrane to sense ethylene concentrations.[47] Ccc2 and Atx1 homologues are also widespread in the bacterial world,[15] where they regulate intracellular concentrations of copper with Ccc2 acting as exporter at high Cu(I) concentration in order to avoid its toxic effects.[48] The pumping process is such that Cu(I) is transferred from the cytoplasm to either the extracellular environment or intracellular compartments. An exception to this rule is provided by cyanobacteria, which contain two copper-transporting ATPases, namely CtaA and PacS.[49] The former is located on the external cellular membrane and is involved in copper uptake, whereas the latter is on the thylakoid

Figure 1 Copper trafficking pathways in yeast. Abbreviations: Ctr = copper transporter; Fre = ferrireductase-encoding; SOD = superoxide dismutase; CCS = copper chaperone for SOD; Atx = antioxidant; Ccc2 = cross-complements Ca²⁺-sensitive phenotype of csg1 mutant 2; Fet = ferrous transport; Ftr = Fe transporter; Cox = cytochrome *c* oxidase; Sco = suppressor of cytochrome *c* oxidase deficiency; MT = metallothionein; IMS = intermembrane space.

membrane and transports copper inside this organelle for its delivery to copper requiring proteins. Copper is shuttled between these two ATPases by a soluble copper chaperone, similar to Atx1 in sequence and structure, which is able to interact with the soluble copper-binding domains of both CtaA and PacS.[50] The phenotypes of *CtaA* and *PacS* mutants of *Synechocystis* PCC 6803 are consistent with both ATPases transporting copper in an inward direction, one into the cytosol and the other into the thylakoid lumen,[50] while the mechanisms of copper export from cyanobacterial cells, and the proteins involved, remain elusive.

Cu,Zn-SOD1 is a ubiquitous component of the cellular antioxidant system, which catalyzes the disproportionation of the superoxide anion to oxygen and hydrogen peroxide.[2] Cu,Zn-SOD1 is an extremely stable protein which, in the mature form, is present as a dimer, each subunit binding one copper and one zinc ion, which share a bridging histidine ligand. Eukaryotic Cu,Zn-SOD1 can obtain copper posttranslationally, both in the cytosol (Figure 1) and in the IMS, and CCS is essential for this process.[16] SOD1 has an intramolecular disulfide bond between Cys57 and Cys146, which is fully conserved in all eukaryotic Cu,Zn-SOD1.[51] On the contrary, in the immature, apo form of SOD1, these cysteines are in the reduced state. Absence of the metal ions and breaking of this disulfide bond induce protein monomerization.[52,53] CCS docks with and transfers the copper ion to the latter form of SOD1.[54] Several studies showed that CCS might also catalyze the oxidation of these two cysteines in SOD1 to form a disulfide bond.[52,53,55]

COX is a key component of the respiratory chain that reduces oxygen to water and generates the proton gradient driving ATP synthesis, a crucial step in cellular energy metabolism. Mammalian COX consists of a 13-subunit complex embedded in the mitochondrial IM.[3] The first three core subunits of the complex are encoded by mitochondrial genes, whereas the remaining ten subunits are nuclear encoded.[56] Copper ions are present in two COX subunits where they are located in one center each, designated Cu_A (a dicopper cluster in the Cox2 subunit) and Cu_B (constituted by a single copper ion, forming a binuclear site with one of the two heme *a* cofactors, in Cox1 subunit)[3] (Figure 2). Copper metalation of COX involves a number of accessory proteins: up to now, the essential requirement for this process was found for Cox17, Cox19, Cox23, Cox11, Sco1, and Sco2 (Sco2 is not required in yeast)[24] (Figure 1). Cox17 is a key copper metallochaperone within the IMS[57] acting as the donor of Cu(I) to both Sco1 and Cox11.[58] Like Cox17, Cox19[59] and Cox23[60] exhibit dual localization in the cytoplasm and IMS, but their function remains to be elucidated, even if it has been recently shown that Cox19 has copper-binding ability.[61] Sco1 is essential for Cu(I) transfer from Cox17 to the Cu_A site,[62] while Cox11 is involved in Cu_B site assembly.[63] Pathogenic mutations in Sco1 and its paralog, Sco2, which determine partial or incorrect COX assembly,[64] were described in several cases of fatal infantile encephalo-, cardio-, or hepato-pathy, and ketoacidotic coma. Sco1 and Sco2 are highly similar proteins with nonoverlapping but cooperative functions.[65] However, a physiological role for Sco2 remains undefined.

AMINO ACID SEQUENCE INFORMATION

Here we report specific information on the sequences of those proteins that are more extensively discussed in the

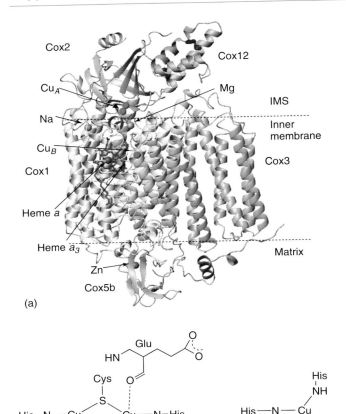

Figure 2 Structure and metal cofactors of COX subunits. (a) Crystal structure of subunits 1, 2, 3, 5b, and 12 of a monomer of bovine COX (PDB code 1OCR) represented as ribbons. The other peripheral subunits were removed to allow the metal cofactors which are indicated with arrows, to be seen, (b) Schematic drawing of the metal coordination in Cu_A and Cu_B of bovine COX. Prepared with the program MOLMOL.[175]

text. For a complete list of sequences of all the isoenzymes in the available genomes see http://www.ncbi.nlm.nih.gov/entrez/query.fcgi?db=Genome and http://www.ebi.uniprot.org/index.shtml

Atx1-like copper chaperones:

- *Homo sapiens*, (human), ATOX1 (HAH1), 68 amino acids (AA), determined from the circular deoxyribonucleic acid (cDNA) sequence. SWISSPROT Id code (SWP) O00244.[34]
- *Arabidopsis thaliana*, (thale cress), CCH, 121 AA, determined from the cDNA sequence. SWP O82089.[45]
- *S. cerevisiae*, (Baker's yeast), ATX1, 73 AA, determined from the cDNA sequence. SWP P38636.[66]
- *Synechocystis* sp. *strain* PCC 6803 (cyanobacterium), SSR2857, 64 AA, determined from DNA. SWP P73213.[67]

- *Bacillus subtilis*, COPZ, 69 AA, determined from DNA. SWP O32221.[68]

Copper-transporting P-type ATPases:

- *H. sapiens*, (human), ATP7A (MNK, Menkes disease-associated protein), 1500 AA, determined from the cDNA sequence. SWP Q04656.[35]
- *H. sapiens*, (human), ATP7B (WND, Wilson disease-associated protein), 1465 AA, determined from the cDNA sequence. SWP P35670.[69]
- *A. thaliana*, (thale cress), RAN1, 1001 AA, translation of mRNA sequence. SWP Q9S7J8.[46]
- *S. cerevisiae*, (Baker's yeast), CCC2, 1004 AA, determined from the cDNA sequence. SWP P38995.[70]
- *Synechocystis* sp. *strain PCC 6803* (cyanobacterium), PACS, 745 AA, determined from DNA. SWP P73241.[67]
- *B. subtilis*, COPA, 803 AA, determined from DNA. SWP O32220.[68]

Copper chaperones for superoxide dismutase:

- *Homo sapiens*, (human), CCS, 274 AA, determined from the cDNA sequence. SWP O14618.[17]
- *Drosophila melanogaster*, (Fruit fly), CCS, 264 AA, determined from DNA. SWP Q9BLY4.[71]
- *A. thaliana*, (thale cress), CCS1, 256 AA, determined from DNA. SWP O65325.[72]
- *Solanum lycopersicum*, (tomato), CCS, 256 AA, determined from the cDNA sequence. SWP Q9ZSC1.[18]
- *S. cerevisiae*, (Baker's yeast), CCS1 (LYS7), 249 AA, determined from the cDNA sequence. SWP P40202.[73]

Cox17-like copper chaperones:

- *H. sapiens*, (human), COX17, 63 AA, determined from the cDNA sequence. SWP Q14061.[74]
- *Sus scrofa*, (pig), COX17 (Dopuin), 62 AA, determined from protein. SWP P81045.[75]
- *Plasmodium falciparum*, (malaria parasite), COX17, 67 AA, determined from DNA. SWP Q8IJE6.[76]
- *A. thaliana*, (thale cress), COX17, 72 AA, determined from DNA. SWP Q8LFR7.[72]
- *S. cerevisiae*, (Baker's yeast), COX17, 69 AA, determined from the cDNA sequence. SWP Q12287.[77]
- *H. sapiens*, (human), COX19, 90 AA, translation of mRNA sequence. SWP Q49B96.[78]
- *S. cerevisiae*, (Baker's yeast), COX19, 98 AA, determined from the cDNA sequence. SWP Q3E731.[59]
- *S. cerevisiae*, (Baker's yeast), COX23, 151 AA, determined from the cDNA sequence. SWP P38824.[60]

Sco1-like copper chaperones:

- *H. sapiens*, (human), SCO1, 301 AA, determined from the cDNA sequence. SWP O75880.[79]
- *H. sapiens*, (human), SCO2, 266 AA, determined from the cDNA sequence. SWP O43819.[80]
- *S. cerevisiae*, (Baker's yeast), SCO1, 295 AA, determined from the cDNA sequence. SWP P23833.[81]
- *S. cerevisiae*, (Baker's yeast), SCO2, 301 AA, determined from the cDNA sequence. SWP P38072.[82]

- *B. subtilis*, YPMQ, 193 AA, determined from DNA. SWP P54178.[68]

Cox11-like copper chaperones:

- *H. sapiens*, (human), COX11, 276 AA, determined from the cDNA sequence. SWP Q9Y6N1.[79]
- *S. cerevisiae*, (Baker's yeast), COX11, 300 AA, determined from the cDNA sequence. SWP P19516.[83]
- *Sinorhizobium meliloti*, CTAG (COX11), 198 AA, determined from DNA. SWP Q92RG6.[84]
- *Rhodobacter sphaeroides*, CTAG (COX11), 191 AA, determined from the cDNA sequence. SWP P56940.[25]
- *B. subtilis*, CTAG (COX11), 297 AA, determined from DNA. SWP O34329.[68]

PROTEIN PRODUCTION, PURIFICATION, AND MOLECULAR CHARACTERIZATION

For copper chaperones and transporters, *Escherichia coli* was normally used as the host cell for cloning, plasmid propagation, and protein expression in constructs aimed at cytoplasmic, periplasmic, and/or fusion protein expression. Protein purification was normally carried out using affinity tags, like the commonly used His-tag.[85] Dealing with copper proteins, as histidines can bind copper, the His-tag needs to be proteolytically removed. Whenever the gene of interest contained transmembrane segments, as for P-type ATPases, Sco1, and Cox11, several possible constructs were designed to obtain the soluble part(s).[86–89] Also, the entire protein was expressed for a P-type ATPase, and a functional reconstituted form.[90] In some cases, the fold packing was optimized through single amino acid mutations, designed on the basis of sequence analysis and structure prediction.[91]

The exposed location of the metal ligands might lead, in the case of cysteines, to the formation of intermolecular disulfide bridges responsible for protein aggregation and protein precipitation. To avoid cysteine oxidation to disulfide forms, samples need to be prepared under strictly reducing conditions.

Protein metalation was usually carried out in diluted solutions to avoid copper-induced aggregation, by adding either a stable Cu(I) complex ($[Cu(I)-(CH_3CN)_4]PF_6$)[12] or Cu(II) salts with or without thiol reductants (e.g. dithiothreitol (DTT) (DTT, CAS 3483-12-3) or tris(2-carboxyethyl)phosphine (TCEP, CAS 51805-45-9)), depending on the desired oxidation state of the copper ion inside the protein. The aggregation state of the proteins was checked through gel filtration chromatography, sodium dodecyl sulphate-polyacrylamide gel electrophoresis (SDS–PAGE), or ultracentrifugation procedures. Interactions of the protein molecules slow down the rate of molecular tumbling in solution, thus broadening nuclear magnetic resonance (NMR) signals.[92] Therefore, NMR linewidth and heteronuclear spin relaxation measurements were also performed to detect copper-mediated aggregation phenomena.[93–95]

In addition to the standard methods for protein characterization, these proteins should be analyzed with respect to the metal content and oxidation state of cysteine residues. The metal content was usually determined by inductively coupled plasma atomic emission spectrometry (ICP-AES), atomic absorption measurements, or colorimetric assays using chelating agents, such as bathocuproine disulfonate (BCS, CAS 52698-84-7).[96] The latter has a very high, selective affinity for Cu(I), whose complex gives characteristic absorption bands. Also, electrospray ionization mass spectra (ESI-MS), recorded in nondenaturing, mild acidic conditions (e.g. 5 mM ammonium acetate buffer, pH 6), were used to monitor both the number of metal ions and the occurrence of disulfide bonds.[97] The presence of the latter was also checked through the selective reaction of the free thiol groups with 4-acetamido-4'-maleimidylstilbene-2,2'-disulfonic acid (AMSCAS 118121-38-3), which adds ~500 Da per reactive thiol to the total mass, thus shifting the mobility of the protein on a denaturing SDS–PAGE and changing the total mass in the mass spectra.

METAL CONTENT AND COFACTORS

In copper chaperones and transporters, the apo and the metal-bound states are both functionally relevant. The metal-binding sites, characterized by specific metal-binding consensus motifs,[98] contain cysteines as preferential Cu(I) ligands, sometimes with the presence of a third ligand such as histidine.[15,27] Common ligands for Cu(II) are histidines, cysteines, and, to a lesser extent, acidic residues.

Atx1 binds a single Cu(I) ion through a CXXC motif that is fully conserved in all the Atx1-like proteins from bacteria to mammals.[15] The same motif is also found in the copper-binding soluble domains of Cu(I)-transporting P-type ATPases, and more peculiarly also in Co(II), Zn(II), Cd(II), and Pb(II)-transporting P-type ATPases[99–101] and in soluble Hg(II) transporters.[102] Metal specificity in these systems is dictated by specific sequence and structural variations in the proximity of the exposed metal-binding site.[15,103] Specifically, it has been observed that the presence or not of an acidic residue in the binding site discriminates between mono- and divalent metal ions.[104] Furthermore, its location either adjacent to one cysteine of the CXXC consensus motif or in a different loop makes the protein discriminate between the first- and second-row transition metal ions.[105]

The nature of the residues in the metal-binding site also affects their interactions with the solvent as well as the metal complex stability. While mononuclear Cu(I) coordination complexes are usually not stable in aqueous solution, and typically undergo auto-oxidation or disproportionation reactions to give Cu(II) and metallic copper, Cu(I)-Atx1 at millimolar concentrations is stable in air at a neutral pH, suggesting that the coordination environment in Atx1 stabilizes the Cu(I) state and suppresses disproportionation.[12]

The dissociation constant K_D of 10^{-19} M for binding of Cu(I) to Atx1 and to the N-terminal domain of Ccc2 was estimated through competition binding with the ligand BCS ($K_D \sim 10^{-20}$ M).[96] The human homologues of Ccc2, the MNK and WND proteins, contain six soluble Cu(I)-binding domains at the N-terminal region, each containing a CXXC motif. The entire N-terminal soluble segment is therefore capable of binding up to six copper ions.[106,107] The equilibrium constant K_{ex} for the metal exchange process between yeast Atx1 and the soluble domain of Ccc2 is 1.4 ± 0.2,[14] while for the human copper chaperone Hah1 and the individual N-terminal domains of MNK protein it ranges between 5 and 10, but in the case of the third domain K_{ex} is 0.06 ± 0.03, indicating that Hah1 has a higher affinity for Cu(I) than MNK3.[108]

CCS proteins are formed by three domains with quite different sizes and properties. The N-terminal domain I has a fold and contains a fully conserved CXXC motif similar to Atx1. Domain II has a sequence similar to that of its SOD1 target, while domain III is constituted by only \sim30 residues and contains two conserved cysteine residues in a CXC copper-binding motif.[109] Both the CXXC and CXC metal-binding motifs are fully conserved in the known CCS.[109] Human CCS, when expressed in the presence of $CuSO_4$ and $ZnSO_4$, contains approximately two Cu(I) ions and one Zn(II) ion per protein.[110] Zinc binding occurs in the SOD1-like domain of human CCS, which contains four histidines, while the yeast protein does not have the putative zinc-binding site, due to the different spacing between these histidines, which therefore do not form a metal-binding site. Isolated domains I and III of CCS are each capable of binding one Cu(I) ion, while the full-length human protein shows a binuclear Cu(I) cluster bound to four cysteine residues, two of which are provided by the CXXC motif of domain I and two by the CXC motif of domain III, thus suggesting simultaneous involvement of both domains in Cu(I) binding for some states of the protein.[111] While domain III is essential for CCS activity in vivo, the requirement for domain I is only apparent under copper-limiting conditions.[109] If, in the assay solutions, the copper concentration is decreased to $\sim$$10^{-17}$ M by the addition of BCS, Cu(I)-CCS still metalates apoSOD1.[13] As the level of intracellular free copper available to SOD1 was suggested to be low (less than one free atom per yeast cell),[13] domain I in CCS could ensure that the metallochaperone recruits the needed metal ions. Domain II is proposed to participate in target recognition rather than in direct transfer of copper.[109] Domain III is involved in both metal incorporation in SOD1 and disulfide bond formation. Indeed, single cysteine to serine mutations in the CXC motif have a dramatic effect on CCS activity and the mutants fail to activate the SOD1 enzyme, affecting both SOD1 metalation[109] and intramolecular disulfide bond formation.[55]

For copper incorporation in COX, a few proteins have been characterized in some detail.[24] Cox17 contains two CX$_9$C motifs in addition to two other conserved cysteines located in a CCXC motif, where its last C is the first of the first CX$_9$C motif. The three cysteines of the CCXC motif are essential for in vivo function.[24,112] Recombinant yeast Cox17 forms two distinct Cu(I) adducts, depending on the oxidation state of cysteines.[113,114] The partially oxidized Cox17 with two disulfide bonds ($Cox17_{2S-S}$) binds a single Cu(I) ion, giving rise to the (Cu_1-$Cox17_{2S-S}$) species. The fully reduced protein binds up to four Cu(I) ions in a polycopper–thiolate solvent shielded cluster, giving rise to protein oligomerization with a dimer–tetramer equilibrium.[113] The fully oxidized form of Cox17, with three disulfide bonds, is unable to bind Cu(I). Competition experiments for Cu(I) between Cox17 and the Cu(I) chelator DTT ($K_D = 6.3 \times 10^{-12}$ M), carried out with ESI-MS,[113] showed that Cu_1-$Cox17_{2S-S}$ binds the Cu(I) ion with a $K_D = 6.4 \times 10^{-15}$ M, while an apparent $K_D = 1.3 \times 10^{-14}$ was estimated for Cu_4-$Cox17$.[113] Like Cox17, Cox19 is a Cu(I) binding protein.[59,61] As a recombinant protein, Cox19 exists as a stable dimeric species and binds one Cu(I) ion per protein monomer.[61] Cu(I) coordination involves thiolate ligands, although the identity of the coordinating cysteines has not been determined yet.

Recombinant forms of Sco1,[115] Sco2,[116] and Cox11[117] bind one Cu(I) ion per protein monomer. Bacterial[89] and mammalian[117] Cox11 dimerize upon Cu(I) binding to form a binuclear Cu(I) thiolate cluster at the dimer interface, which involves two CFCF copper-binding motifs. In Sco1 and Sco2,[118] a conserved pair of cysteine residues within a CX$_3$C motif and a conserved histidine residue are essential for copper binding. These residues are spatially close in the apoSco1 structure and located in a solvent-exposed pocket.[119–121] The presence of three ligands, one being a histidine residue on a flexible loop, also makes the site suitable for the binding of divalent metal ions. Indeed, Cu(II),[88,118,120] Ni(II),[120] and Zn(II)[122] can bind at the same site in Sco1. The coordination can be completed by an additional exogenous ligand, for example, H_2O, or by a protein carboxylate. The latter hypothesis is supported by the observation that the affinity of Sco1 for the Cu(II) ion is reduced if Asp259 in human Sco1 and Asp238 in yeast Sco1 are mutated.[118] The equilibrium constant K_{ex} for exchange of Cu(I) between Cu_1-$Cox17_{2S-S}$ and apoSco1 is 10^2. Taking into account the latter value and the K_D of Cu_1-$Cox17_{2S-S}$, K_D of Cu(I)-Sco1 is estimated to be 10^{-17} M.[123] Interestingly, the K_D of the pathogenic P174L Sco1 mutant is 3.2×10^{-13} M, indicating a lower affinity of P174L Sco1 for Cu(I) compared to the WT protein and to Cu_1-$Cox17$.[123]

SPECTROSCOPY

The spectroscopic tools, which can be applied to copper proteins to characterize the metal-binding site quite depend

on the oxidation state of the copper ion. Cu(I) is diamagnetic and electronic and electron paramagnetic resonance (EPR) spectra are silent. Copper has two magnetically active isotopes, ^{63}Cu and ^{65}Cu, and is therefore NMR active, but, due to the quadrupolar moments of these isotopes, they are not suitable for NMR measurements on slow tumbling molecules such as proteins. On the other hand, the binding of the diamagnetic metal ion essentially does not perturb the detectability of other NMR amenable nuclei in its surrounding.[124] Therefore, homonuclear and heteronuclear NMR spectroscopy can be used to characterize Cu(I) binding to these proteins as well as to solve their structures in solution with standard approaches. Still, with these measurements, no direct information on the copper ion can be obtained. In principle, Cu(I) can be replaced by Ag(I), which is NMR amenable, and NMR experiments can be carried out directly on the metal.[125] However, as the coordination properties of Cu(I) and Ag(I) are different, these measurements are usually not used. X-ray absorption spectroscopy (XAS) has been particularly suitable for identifying the number and the nature of the copper donor atoms.[126] The XAS technique can be applied to both Cu(I) and Cu(II). On the latter, EPR measurements[127] and electronic spectroscopy,[128] in the visible region and in the near ultraviolet (UV), can be used to characterize the coordination sphere of the metal ion. A metal ion bearing unpaired electrons affects, even dramatically particularly for Cu(II), the NMR spectra. These effects can be translated in paramagnetism-based structural restraints, originating from pseudocontact and contact shifts on the other nuclei, nuclear spin relaxation enhancements, cross correlation between Curie and dipole–dipole relaxation, and magnetic alignment,[124] which all contain structural information to define the copper-binding site. These data are also potentially useful in investigating protein–protein interactions, especially when the paramagnetic metal site is located on the protein surface, as in the case of Cu(II) transporters.

X-RAY AND NMR STRUCTURES

Crystallization versus solution NMR

Crystallization of copper-trafficking proteins has been a difficult task, even if now several structures of the copper bound form are available (see below). Some early attempts used nonnative metal ions (i.e. Hg(II) and Ag(I)) for successful crystallization. In some cases, oxidation of the cysteines also occurred, giving rise to the oxidized, nonfunctional form. Finally, the exposed location of the metal sites in Cu(I) transporters may lead to the formation of intermolecular disulfide bridges, giving rise to protein dimerization.

In several cases, the solution structure determination of copper trafficking proteins by NMR was successful. Protein oxidation and aggregation was prevented by keeping the

Cu(I)–Atx1

Cu(I)–Ccc2a

Atx1–Cu(I)–Ccc2a

Figure 3 Solutions structures of Cu(I)-Atx1 and Cu(I)-Ccc2a from *S. cerevisiae* and their copper complex. The cysteines of CXXC motifs are shown in green and the Cu(I) ion is represented as a green sphere. PDB codes: Cu(I)-Atx1 (1FD8); Cu(I)-Ccc2 (1FVS); Atx1-Cu(I)-Ccc2a (2GGP). Prepared with the program MOLMOL.[175]

samples under nitrogen atmosphere and adding a thiol reductant (e.g. DTT), with the NMR tubes closed airtight.

Overall description of the structures and copper site geometries

The available structures of copper chaperones and transporters, and of their complexes with physiological partners are reported in Table 1.

The structures of reduced and oxidized yeast *S. cerevisiae* apoAtx1 were solved by NMR[129] and X ray,[130] respectively. Both apoAtx1 structures exhibit a ferredoxin-like βαββαβ fold.[129,130] The absence of the disulfide bond between the two cysteines of the conserved CXXC motif (located between loop 1 and helix α1) in the reduced form causes some conformational disorder.[129] The solution structure of Cu(I)-Atx1 (Figure 3) shows the Cu(I) ion coordinated by the two cysteines of the CXXC motif, with an average S–Cu–S angle of $120 \pm 40°$ suggesting that Cu(I) is three coordinate,[129] which is indeed the preferred coordination for Cu(I).[131] Extended X-ray absorption fine

structure (EXAFS) analyses of Cu(I)-Atx1[12] and of its homologous protein, CopZ from *B. subtilis*,[132] showed that a third sulfur or an oxygen atom from the reductant completes the coordination sphere of Cu(I), confirming its three coordination (Figure 4). *In vivo*, the reductant is likely to be replaced by glutathione (CAS 70-18-8), which is present at high concentration in the cytoplasm. Crystal structures of the metal-bound form of Atx1 were possible

Table 1 Structures of copper chaperones and transporters and of their complexes with physiological partners

Protein	PDB ID	Metal site(s)	Experimental method	References
Copper chaperones				
Human Hah1	1FEE	Cu(I)-bound	X ray	134
	1FE4	Hg(II)-bound		
	1FE0	Cd(II)-bound		
Human Hah1	1TL5	Apo-form	NMR	133
	1TL4	Cu(I)-bound		
S. cerevisiae Atx1	1FES	Apo-form	NMR	129
	1FD8	Cu(I)-bound		
S. cerevisiae Atx1	1CC7	Apo Cys-oxidized	X ray	130
	1CC8	Hg(II)-bound		
Synechocystis Sp. Atx1	1SB6	Apo-form	NMR	136
B. subtilis CopZ	1P8G	Apo-form	NMR	173
	1K0V	Cu(I)-bound		
E. hirae CopZ	1CPZ	Apo-form	NMR	93
H. pylori CopP	1YG0	Apo-form	NMR	Lee, B.J., Park, S.J., unpublished
P1-type ATPases				
Human Menkes	1KVI	Apo-form	NMR	143
First soluble domain	1KVJ	Cu(I)-bound		
Human Menkes	1S6O	Apo-form	NMR	144
Second soluble domain	1S6U	Cu(I)-bound		
Human Menkes	1Q8L	Apo-form	NMR	145
Second soluble domain				
Human K46V	2G9O	Apo-form	NMR	108
Third soluble domain	2 GA7	Cu(I)-bound		
Human Menkes	1AW0	Apo-form	NMR	146
Fourth soluble domain	2AW0	Ag(I)-bound		
Human Menkes	1Y3K	Apo-form	NMR	147
Fifth soluble domain	1Y3J	Cu(I)-bound		
Human Menkes	1YJU	Apo-form	NMR	148
Sixth soluble domain	1YJV	Cu(I)-bound		
Human A629P	1YJR	Apo-form	NMR	148
Sixth soluble domain	1YJT	Cu(I)-bound		
Human Wilson	2EW9	Apo-form	NMR	87
Fifth and sixth soluble domains				
S. cerevisiae Ccc2a	1FVQ	Apo-form	NMR	142
	1FVS	Cu(I)-bound		
Synechocystis Sp. PacS	2GCF	Apo-form	NMR	165
B. subtilis S46V CopA	1OQ3	Apo-form, a domain	NMR	91
	1OQ6	Cu(I)-bound, a domain		
	1JWW	Apo-form, b domain		174
	1KQK	Cu(I)-bound, b domain		
	1P6T	Apo-form, a and b domains		149
A. fulgidus CopA actuator domain	2HC8	Apo-form	X ray	141
A. fulgidus CopA ATP-binding domain	2B8E	Apo-form	X ray	140
Copper chaperones for superoxide dismutase				
Human CCS Domain II	1DO5	Zn(II)-bound	X ray	151
S. cerevisiae CCS	1QUP	Apo-form	X ray	150
S. cerevisiae CCS Domain II	1EJ8	Apo-form	X ray	152

Table 1 *(continued)*

Protein	PDB ID	Metal site(s)	Experimental method	References
		Cytochrome *c* oxidase copper incorporation proteins		
S. cerevisiae Cox17	1Z2G	Apo Cys-oxidized	NMR	114
S. cerevisiae Cox17	1U97	Apo Cys-reduced	NMR	153
	1U96	Cu(I)-bound		
Human Sco1 soluble domain	1WP0	Apo-form	X ray	119
Human Sco1 soluble domain	2GVP	Apo-form	NMR	120
	2GT5			
	2GT6	Cu(I)-bound		
	2GQM			
	2GQL	Ni(II)-bound		
	2GQK			
Human Sco1 soluble domain	2GGT	Ni(II)-bound, Cys-oxidized	X ray	120
Human P174L Sco1 soluble domain	2HRF	Cu(I)-bound	NMR	123
	2HRN			
S. cerevisiae Sco1 soluble domain	2B7K	Apo-form	X ray	121
	2BTJ	Cu(I)-bound		
B. subtilis Sco1-like soluble domain	1ON4	Apo-form	NMR	88
B. subtilis Sco1-like soluble domain	1XZO	Apo-form	X ray	156
S. meliloti Cox11-like soluble domain	1SP0	Apo-form	NMR	89
	1SO9			
D. radiodurans DR1885 (hypothetical bacterial COX chaperone)	1X7L	Apo-form	NMR	28
	1X9L	Cu(I)-bound		
		Protein−protein complexes		
S. cerevisiae Atx1/Ccc2a	2GGP	Cu(I) bound to both Atx1 and Ccc2a	NMR	95
S. cerevisiae CCS/Zn-SOD1 H48F	1JK9	Zn(II) bound to SOD1	X ray	159

only for the Hg(II) derivative,[130] with the Hg(II) ion also coordinated by the two cysteines of the CXXC motif, but with a linear digonal geometry. Comparison of the Cu(I)- and apo-conformations of the protein reveals that, upon metal binding, the cysteines move from a solvent-exposed conformation to a more buried one. Concomitantly, helix α1 becomes longer by one helical turn in the Cu(I)-bound form and the side chain of the conserved Lys65 moves toward the metal site.[129]

The structure of Hah1, the human homologue of Atx1, has been solved as well, both by NMR in the apo and Cu(I)-bound forms,[133] and by X-ray crystallography in the Cu(I)-, Hg(II)-, and Cd(II)-bound forms.[134] The solution structures are similar to the crystal ones; however, in the latter case,

the protein is in a dimeric state, with a single metal ion coordinated by cysteine residues from two different Hah1 molecules.[134] The apo and Cu(I)-Hah1 solution structures show only minor structural rearrangements upon Cu(I) binding. As in the yeast protein, a movement of Lys60 (corresponding to Lys65 in yeast Atx1) toward the metal site in Cu(I)-Hah1 helps neutralize the overall − 1 charge of the Cu(I)-bis-thiolate center.[133] The NMR structure of human Cu(I)-Hah1 suggests that Cu(I) has a lower tendency to expand the coordination number from two to three, at variance with yeast and bacterial Cu(I)-Atx1, taking a coordination geometry closer to the linear one.[133] This is confirmed by EXAFS data that could be fit to two Cu–S interactions at 2.16 Å, a distance typical of digonal Cu(I) coordination[135] (Figure 4).

A peculiar copper site for this class of proteins is observed in the Atx1 homologue from the cyanobacterium *Synechocystis Sp.* This copper chaperone possesses a histidine residue on a loop in the position corresponding to Lys60 in Hah1. The imidazole ring of histidine protrudes from this loop, thus providing a third ligand, which coordinates copper through its Nε2, as established by NMR[136] (Figure 4). This coordinated histidine residue was proposed to influence the direction of metal transfer in the interaction of this chaperone with the N-terminal domains

Figure 4 Coordination geometries and bond distances of copper-binding sites of three copper chaperone homologues. The metal–donor bond distances (in angstrom) were obtained from EXAFS data.[12,135,176]

of the two Cu(I)-binding ATPases present in this organism, PacS and CtaA.[50]

P-type ATPases are responsible for transporting copper to enzymes in the trans-Golgi network, in eukaryotic organisms, or to excrete copper from the cell, in both eukaryotic and prokaryotic organisms.[137–139] These copper-transporting P-type ATPases contain eight transmembrane helices, one of which, helix six, contains a copper-binding Cys-Pro-Cys (CPC) motif, an ATP-binding/-phosphorylation domain (between helices six and seven), and a phosphatase (or actuator) domain (between helices four and five). Copper ATPases also possess a variable number of N-terminal soluble copper-binding domains of about 70 amino acids, each containing a CXXC motif. The structures of the ATP-binding[140] and of the actuator[141] domains of the copper-transporting ATPase, CopA, from *Archaeoglobus fulgidus* were determined by X-ray diffraction, which, on the basis of sequence analysis, are predicted to be similar to the corresponding domains of other P-type ATPses. The structure of the first of the two soluble, copper-binding domains, present in the Ccc2 ATPase from yeast *S. cerevisiae*,[43] Ccc2a, was solved by NMR spectroscopy, and exhibits the same ferredoxin-like βαββαβ fold of its partner Atx1, which remains essentially unchanged upon copper loading.[142] Unlike Atx1, very minor conformational changes are observed in Ccc2a upon copper release. The metal-binding region (including the conformation of the metal-binding cysteines) is well defined in both apo and holo forms, suggesting that the metal site in apoCcc2a is preorganized at some extent to receive the copper ion. The structure indicates that the copper environment is three coordinate (S–Cu–S average angle $120 \pm 30°$)[142] (Figure 3).

As already discussed, the human homologues of Ccc2 are the ATP7A and ATP7B ATPases, also indicated as MNK and WND proteins, respectively. Both proteins have, in addition to the fully conserved CPC copper-binding site in the transmembrane helix six, six soluble Cu(I)-binding domains at the N-terminal region, each containing a CXXC motif.[30,38] The six metal-binding domains of MNK and WND proteins are connected by linkers of different length, with the longest linker separating domains one to four from five and six, in both MNK and WND proteins.[30,38] The structures of all the isolated metal-binding domains of MNK protein (MNK1,2,3,4,5,6)[108,143–148] and of domains five and six of WND protein (WND5-6)[87] were solved by NMR. All these domains share the same βαββαβ fold, shown by Ccc2, but display different electrostatic surface charges and have different affinity for Cu(I), the MNK3 domain being the most different. This domain shows a different conformation of the last β-strand with respect to the other MNK domains[108] and has a much weaker affinity for the Cu(I) ion.[108] The solution structure of WND5-6 consists of two copper-binding domains, each again with the same ferredoxin-like fold, connected by a short linker, and behaving as a single unit in solution[87] (Figure 5(a)).

Figure 5 Solution structures of a two-domain construct of human WND protein and *B. subtilis* CopA ATPases. The cysteines of CXXC motifs are shown in green. PDB codes: WND5-6 (2EW9); CopAab (1P6T). Prepared with the program MOLMOL.[175]

The spatial arrangement of the two-domain WND5-6 construct is evolutionarily conserved from bacteria to yeast to humans. The metal-binding sites of the two domains are far from each other, and copper binding does not alter the protein structure.[87] A structurally characterized two-domain construct of CopA of *B. subtilis*, denoted CopAab, has a linker shorter than WND5-6, thus keeping the two domains closer to each other such that a hydrogen-bonding network at the interdomain interface can be formed[149] (Figure 5(b)).

CCS is the largest copper chaperone identified to date. It is formed by three domains with quite different structural properties.[109] The X-ray structures of the three domains of yeast CCS[150] (Figure 6(a)) and of human CCS domain II[151] were determined. Domain II of both proteins fold into an eight-stranded 'Greek key' β-barrel that is similar to that of the physiological target, Cu,Zn-SOD1. In both yeast and human structures, the protein is a homodimer with a dimer interface very similar to that in SOD1, where similar interactions are also conserved[150–152] (Figure 6(a)). The similar pattern of interactions at the dimer interfaces could facilitate target recognition between the two proteins by allowing the formation of heterodimers. However, the metal-binding properties of this domain are different for proteins from different organisms, and different from SOD1. Domain II of yeast CCS lacks the two loops forming the active site channel in Cu,Zn-SOD1, as well as six of the seven metal ligands present in SOD1. Consequently,

domain II in yeast CCS is unable to bind metal ions.[150] By contrast, the two active site channel loops are structurally conserved in the human CCS domain II, and two potential metal-binding sites are present. However, in the crystal structure, only the zinc site is occupied by a Zn(II) ion, while the copper site is empty.[151] The substitution of one of the copper-binding histidines with an aspartate might account for this difference. XAS data indicate that copper can actually bind to histidines of domain II of human CCS in solution, but only in the absence of Zn(II), suggesting that the two metal ions bind at the same site. It is, however, important to stress that metal binding to this domain has no functional role.

Domain I of CCS has a ferredoxin-like fold, similar to that of the soluble domains of Cu(I)-binding ATPases and their chaperones, including an exposed loop containing

the CXXC motif, which is the functionally relevant metal-binding site. In the crystal, the two cysteines are oxidized (Figure 6(a)), forming a disulfide bond, similar to what is observed in oxidized apoAtx1.[150] Domain III is disordered in the yeast CCS crystal structure; this domain is predicted to lie in the vicinity of the N-terminal domain I.[150]

Although the structure of copper-bound CCS has not yet been reported, the available biochemical and spectroscopic data suggest that the functional copper-binding site includes cysteine ligands. Spectroscopic data for human and tomato CCS[18] in the presence of Co(II) are consistent with coordination through three or four cysteines. Since tomato CCS only contains four cysteines, two in the CXXC motif of domain I and the others in the CXC motif of domain III, these data suggest that the metal-binding site is jointly formed by the two domains. Furthermore, XAS data on the copper derivative of human CCS indicate the presence of a second metal-binding site. XAS data indicate a Cu–Cu moiety with the two copper at 2.7 Å apart and three sulfur ligands at 2.2 Å per each copper ion.[111] From this analysis, a cysteine-bridged dinuclear copper cluster coordinated by the four cysteines from domains I and III was proposed[111] (Figure 6(b)).

Cox17 from *S. cerevisiae* (69 amino acids) was characterized in various states,[114,153] that is, Cys-reduced apo, partially oxidized apoCox17$_{2S-S}$ and Cu1-Cox17$_{2S-S}$, and Cys-reduced Cu$_4$(I) oligomer. The NMR structure of apoCox17$_{2S-S}$ showed that it assumes a hairpin conformation, with two-helices stabilized by two disulfide bonds between the two pairs of cysteines of the CX$_9$C motif, present in each helix[114] (Figure 7). This arrangement is remarkably similar to that of the Cox12 subunit of COX.[154] Cox12 docks to Cox2 and forms interactions at the dimer interface of the COX enzyme complex (Figure 2). Partially oxidized Cox17$_{2S-S}$ binds one Cu(I) ion.[113] Full reduction of the two disulfide bonds leads to apoCox17, which is in a molten globule state capable of binding a cluster of four Cu(I) ions with trigonal coordination (Figure 8); in this form, the protein is in equilibrium between dimeric and tetrameric species.[113,114,155]

Sco1, Sco2, and Cox11 are anchored, through a single transmembrane helix in the N-terminal segment, to the inner mitochondrial membrane. Only the structures of the soluble IMS-projecting domains of Sco1[88,119–121] and Cox11[89] were solved up to now. Sco1 has a thioredoxin-like fold, with eight β strands and four α helices[88,119–121] (Figure 7). The consensus metal-binding motif, CX$_3$C, is located in a loop region between β4 and α1, which is far in sequence but structurally close to the loop between α3 and β7 containing a conserved histidine residue, which acts as the third copper ligand (Figure 8). Sco1 is able to bind both Cu(I) and Cu(II).[88,118,120,122] The solution structure of the human protein was solved for both the Cu(I) and the Ni(II) derivatives,[120] the latter mimicking the divalent Cu(II) ion, whose similarity in the coordination properties has been

(a)

(b)

Figure 6 Crystal structures of CCS from *S. cerevisiae* and its complex with Zn(II)-SOD1. (a) Homodimeric structure of CCS and heterodimeric structure of CCS–Zn(II)-SOD1 complex, with domain II of CCS shown in the same orientation. The metal-binding cysteines of the CXXC and CXC motifs of CCS, the metal-binding histidines of SOD, and the cysteines involved in disulfide bonds are shown in green. The Zn(II) ion is represented as a gray sphere. PDB codes: CCS (1QUP); CCS–Zn(II)-SOD1 (1JK9). (b) Coordination geometry and bond distances of the dinuclear copper-binding site of human CCS. The metal–donor bond distances (in angstrom) were obtained from EXAFS data.[111] Prepared with the program MOLMOL.[175]

Cox17$_{2S-S}$

Cu(I)–Sco1

Cox11

Figure 7 Solution structures of proteins involved in copper delivery to COX. The metal-binding cysteines and histidine residues and the cysteines involved in disulfide bonds are shown in green. The Cu(I) ion is represented as a green sphere. PDB codes: *S. cerevisiae* Cox17$_{2S-S}$ (1Z2G); human Cu(I)-Sco1 (2GT6); *S. meliloti* Cox11 (1SP0). Prepared with the program MOLMOL.[175]

shown through spectroscopic characterization (Figure 8). Structures are also available for the apo form of Sco1, both in solution and in the crystal, for the human[119,120] and for the yeast[121] protein as well as for a bacterial homologue (Sco1 from *B. subtilis*).[88,156] The thioredoxin fold allowed the authors to suggest another function for Sco1 as a thioreductase, in addition to that of a copper transporter. Furthermore, the peculiar structure of the Ni(II) adduct of oxidized Sco1 suggested a possible mechanism for copper transfer to the Cu$_A$ site in Cox2, where these two possible functions of Sco1 play a role.

Some missense mutations identified in SCO1 (P174L) and SCO2 patients (E140K and S240F) are located near the conserved CX$_3$C and the histidine residue, suggesting that the loss of function in mutants of both proteins may

relate to alteration in the copper-binding properties. The solution structure of the P174L mutant in its Cu(I) form showed that Leu174 prevents the formation of a well packed hydrophobic region around the metal-binding site, causing a reduction of the affinity of Cu(I) for the protein.[123]

Formation of the Cu$_B$ site is dependent on Cox11. Only the structure of the soluble portion of Cox11 from *S. meliloti* has been solved so far by NMR.[89] This protein has an immunoglobulin-like fold, consisting of 10 β strands organized into two β sheets (Figure 7). The consensus motif for copper binding, CFCF, is located in a loop between two short β strands on one side of the barrel.[89] In the presence of Cu(I) ions and in the absence of DTT, commonly used as reducing agent, Cox11 dimerizes. EXAFS data are consistent with a binuclear Cu(I) cluster, where the two copper(I) ions are 2.7 Å apart and are coordinated by three sulfur atoms[117] (Figure 8). Therefore, most likely, a cysteine residue of the CFCF motif of one protein acts as the third, bridging ligand of the Cu(I) ion, coordinated by two cysteines of the other molecule.[89]

STRUCTURES OF PROTEIN COMPLEXES

The soluble Atx1-like metallochaperones shuttle Cu(I) to the soluble domains of the copper-transporting ATPases.[29] The copper ion then translocates through the membrane and metalates secretory cuproenzymes within the trans-Golgi compartment. The formation of a transient complex between the two partner proteins is an initial event in Cu(I) translocation (see 3D Structure). The interaction between the two proteins is metal mediated,[95] that is, the metal is necessary for the interaction between the donor and the acceptor proteins. This behavior also has a physiological relevance, as it prevents unproductive binding between the apo forms. Addition of Cu(I) to an equimolar mixture of Atx1 and Ccc2a in their apo forms leads to the formation of a new species in fast chemical exchange on the NMR timescale ($>10^3$ s^{-1}) with the free proteins.[94,95] The interaction between Atx1 and Ccc2a was initially demonstrated by NMR chemical shift mapping[94] and docking[157] approaches. More recently, the structure characterization of the Atx1–Cu(I)–Ccc2a complex was determined in solution through NMR in combination with site-directed mutagenesis experiments to assess the role of specific cysteines in the metal binding to the complex.[95] Twenty-five intermolecular nuclear overhauser effect (NOEs) (experimental distance constraints) in the Atx1–Cu(I)–Ccc2a complex were detected. These data provided the relative orientation of Atx1 and Ccc2a molecules: helix α1 of one protein is nearly orthogonal to helix α2 of the partner and in contact with a loop between α2 and β4[95] (Figure 3). The CXXC motifs of Atx1 and Ccc2a are spatially close in the complex and form the Cu(I)-binding site. The metal ion is three coordinate, and two adduct forms are in equilibrium, one where two ligands are

Figure 8 Coordination geometries and bond distances of copper-binding sites of proteins involved in copper delivery to COX. The metal coordination environment was determined through NMR and/or X ray, while the metal–donor bond distances (in angstrom) were obtained from EXAFS[88,117,122,155] and X-ray diffraction data.[120] The copper ligands to Cox11 are provided by two protein molecules (A and B). (Reproduced from L Banci *et al.*, *Proc Natl Acad Sci USA*, **103**, 8595–600 (2006).)

provided by Atx1 (lower percentage) and another when two ligands are provided by Ccc2a[95] The N-terminal cysteines of the CXXC motifs (Cys15 of Atx1 and Cys13 of Ccc2a) are essential for complex formation, as it results from site directed mutagenesis studies.[95]

While metal ion binding is the driving force for complex formation, the latter is stabilized by an extended network of intermolecular interactions: close to the Cu(I)-binding site, the interprotein contacts involve mainly hydrophobic residues, whereas further away contacts between complementarily charged side chains are present.[95] Atx1 possesses multiple positively charged residues on its surface, while Ccc2 possesses multiple negatively charged residues. Most of them are strictly conserved in all the eukaryotic homologues of the yeast proteins.[15] Mutation of Lys24 and Lys28 to glutamates in Atx1 dramatically reduces its activity, while mutations of Lys61 and Lys62 have a lower effect on the function.[158]

The complex between SOD1 and its copper chaperone, CCS, was also structurally characterized[159] (Figure 6). The heterodimeric CCS–Zn(II)-SOD1 complex was crystallized for the yeast proteins (using the H48F variant of SOD1).[159] The most striking feature of the structure of the CCS–Zn(II)-SOD1 complex is the presence of an intermolecular disulfide bond between Cys229 of CCS domain III and Cys57 of SOD1 (Figure 6), which replaces the intramolecular disulfide bond of native SOD1. The new disulfide bond alters the conformation of loop IV and opens up the SOD1 active site. Domain II of CCS interacts with one SOD1 monomer similar to what occurs in homodimeric SOD1, with a very similar interface.[159] Furthermore, the two proteins are held together by four strong backbone hydrogen bonds, in addition to a number of hydrophobic

interactions involving conserved residues. Domain I changes its position in the heterodimer with respect to that in the homodimer (Figure 6), and domain III becomes ordered, forming a 10-residue α-helix at the C-terminus.[159]

To date, there are no available structures of complexes involving proteins responsible for copper delivery to the COX enzyme. However, the interaction of Cox17 with Sco1 and Cox11 has been studied in solution. *In vitro* studies showed Cu(I) transfer from Cox17 to either Sco1[58,123] or Cox11.[58] In addition, the C57Y yeast Cox17 mutant fails to transfer Cu(I) to Sco1, but it is competent for Cu(I) transfer to Cox11, suggesting that Cox17 may have different interaction interfaces for Sco1 and Cox11. In particular, the C-terminal amphipathic helix containing Cys57 may be an important interface for Sco1, but not Cox11.[58]

Cu_1-$Cox17_{2S-S}$ is the functional form, which is able to transfer Cu(I) to apoSco1 through a transient complex that can be detected through ESI-MS spectra.[123] The latter also showed that apoCox17$_{2S-S}$ and apoSco1 do not form any complex, while addition of one equivalent of Cu(I) produces, in addition to formation of Cu(I)-Sco1, two low intensity twin peaks corresponding to molecular masses of Sco1-Cu_1-$Cox17_{2S-S}$ and Sco1–Cu_2-$Cox17_{2S-S}$ complexes,[123] which constitute very low populated states. From the NMR analysis, it appears that a few resonances of Sco1 close to the CX_3C copper-binding site are perturbed when Cu_1-$Cox17_{2S-S}$ is added to apoSco1.[123] These observations were supported by a recently reported computational prediction of the protein–protein adducts involved in copper incorporation in Sco1.[160]

FUNCTIONAL ASPECTS

Copper transfer and metal-dependent interactions for copper chaperones and transporting ATPases

The copper coordination geometry in most Atx1-like domains and soluble domains of P-type ATPases, where the metal is bound through the conserved CXXC motif, deviates from linear digonal bonding. Cu(I) coordination in Cu(I)-Atx1 takes a trigonal geometry with the participation of an exogenous ligand (Figure 4), making it ideally poised for ligand–exchange reactions.[12] The Cu(I)-binding site is located near the surface of the protein, but is partially solvent shielded, allowing access for the target molecule, yet protecting the copper ion from spurious ligand–exchange reactions.[129] Moreover, the location of the metal site in a surface loop between a β-strand and an α-helical element (Figure 3) provides some flexibility, which allows copper to expand its coordination sphere, thus becoming three coordinate.[95] In these proteins, a 15-member chelate ring is formed on copper by the two cysteines. The strength of the chemical bonds between the soft sulfur atoms and highly polarizable d^{10} centers, such as Cu(I), is typically so large that it is difficult to measure, which has led to the belief that Cu(I) exchange from thiolate-rich coordination sites should be slow. However, in these systems, the third exogenous ligand can be easily displaced by an incoming ligand from the receiving protein. In this way, copper can

Figure 9 Proposed mechanisms of copper trafficking. (a) Copper transfer between Atx1 and Ccc2a.[95] The Cu(I) ion is represented as a green sphere, (b) copper insertion into SOD1 by its metallochaperone, CCS,[55] (c) copper transfer from Sco1 to Cu_A center of Cox2.[120] (Reproduced from L Banci *et al.*, *Proc Natl Acad Sci USA*, **103**, 8595–600 (2006).)

be transferred from one protein to another through a series of three-coordinate intermediates[12] (Figure 9(a)).

During the copper transfer process, the third exogenous copper ligand in Cu(I)-Atx1 is displaced by one cysteine of the CXXC motif on the partner molecule, to form a three-coordinate intermediate.[95] When a second cysteine of Ccc2 binds Cu(I), one cysteine of Atx1 is detached, thus weakening the interaction of Cu(I) with Atx1. In the final step, the second cysteine of Atx1 is detached, (probably) replaced by an exogenous ligand, and the metallochaperone leaves in its apo form. The juxtaposition of the sulfur atoms of two CXXC metal-binding motifs around the Cu(I) ion is determined by backbone torsions, side chain reorientations, hydrogen bonding, and electrostatic and hydrophobic interactions.[95] These structural changes are accompanied by an increase in mobility of residues at the interface.[94] Structural studies and site-directed mutagenesis help in understanding the role of individual residues. When each of the Cu(I)-binding cysteines of both Atx1 (Cys15 and Cys18) and Ccc2a (Cys13 and Cys16) are individually mutated to alanine, complex formation in the presence of Cu(I) is observed only for the C18A Atx1 mutant and, to a very small extent, for the C16A Ccc2a mutant.[95] Thus, Cys15 of Atx1 and Cys13 of Ccc2a are essential for complex formation, while the other two are not. In a three-coordinate model, coordination of Cu(I) involves a rapid equilibrium of various species. The identification of one dominant tricoordinate species, involving Cys15 of Atx1 together with Cys13 and Cys16 of Ccc2a, shows that Cu(I) transfer involves ligand-exchange reactions (Figure 9(a)),[95] as previously predicted.[12]

These three-coordinate intermediates can be considered as low energy states in the copper transfer process and these chaperones for metal ions can be considered to act as enzymes, lowering the energetic barriers along a specific reaction pathway and making the copper transfer process fast.[14,95]

The Ccc2 human homologues, MNK and WND ATPases, can interact with Cu(I)-Hah1, the homologue of Atx1, through their six soluble metal-binding domains, all of which can bind a single Cu(I) ion.[106,107] Despite the role of each individual domain in the overall process has not been elucidated yet, it has been reported that isolated domains of MNK (MNK2,3,5,6) do exchange Cu(I) with Hah1, but little (if any) complex formation occurs.[108,147,148] In the MNK4-6 triple domain construct of MNK, Cu(I)-Hah1 preferentially donates its cargo to domain 4, as shown by NMR titrations.[86] When the interaction of the entire N-terminal tail (MNK1-6) with Cu(I)-Hah1 is investigated, both domains 1 and 4 form a metal-mediated adduct with Hah1 whereas domain 6 is simultaneously able to partly remove Cu(I) from Hah1.[161] In the case of WND ATPase, it has been shown that WND4 forms a complex with the chaperone in vitro (in fast exchange on the NMR time scale with the isolated

Figure 10 Electrostatic surface potential of the six soluble copper-binding domains of WND and MNK ATPases and of the human copper chaperone Hah1. The positively charged, negatively charged, and neutral amino acids are represented in blue, red, and white respectively. The figure was generated with the program MOLMOL[175] using the experimental structures, when available, or the theoretical models.[15]

proteins), and is able to transfer Cu(I) to WND5-6, which on the contrary does not interact with Hah1.[87]

The preferential interaction of Cu(I)-Hah1 with domains 1 and 4 of MNK and with WND4 could be correlated with the electrostatic complementarity between these domains and the chaperone,[15,134] the Atx1-Cu(I)-Ccc2a complex serving as a paradigmatic structural model of the interaction, even if the factors modulating this interaction have not yet been rationalized. In Figure 10 the surface potentials of the six metal binding domains of the MNK and WND proteins are reported. All the structures are showing the side which is predicted to interact with the soluble chaperone, with the charged residues located at the interface in the Atx1-Cu(I)-Ccc2a complex.

The soluble metal-binding domains of copper-ATPases were suggested to be involved in the copper-dependent regulation of the ATP-dependent pump.[162] Indeed, the copper-metalated N-terminal WND1-6 domains interact with the ATP-binding domain less tightly than their apo forms, thus favoring the interaction of the ATP binding domain with ATP, when they are metalated.[162] However, only binding of copper to the intramembrane CPC binding site is essential for the copper-dependent catalytic activity of the ATPase.[163] A unique feature of mammalian copper-ATPases is their ability to undergo copper-dependent intracellular trafficking.[30,38] NMR titration data, together with available in vivo studies, suggest that the subcellular localization of ATPases may be regulated by the accumulation of the adducts of Cu(I)-Hah1 with domains 1–4 under copper excess, whereas the main role of domains 5–6 is to

assist copper translocation.[161,162] When copper concentration is increasing the conformation of the N-terminal region might change, thus inducing the trafficking of the protein from the Golgi to the external cell membrane or to a vesicular compartment, where they pump excess copper out of the cytoplasm.[30,38] Conformational characterization and interaction pathways of the full MNK and WND proteins still represents a challenging problem whose solution will contribute to unravel the complex mechanism of action of copper pumps.

The complementary charge distribution in Atx1-like copper chaperones and soluble Cu(I)-binding domains of ATPases as well as the metal-binding properties are conserved not only in eukaryotes but also in bacteria, strongly supporting an evolutionarily conserved mechanism of interaction between physiological partners.[15] Studies of *B. subtilis* CopZ and its interaction with the second N-terminal domain of CopA also revealed the formation of a protein–protein complex, again mediated by Cu(I) binding and favored by the interaction of the acidic surface of CopZ with a basic patch on the ATPase domain.[164] Cu(I)-mediated complex formation has also been detected between a cyanobacterial Atx1 chaperone and the N-terminal domain of PacS ATPase.[165]

Copper chaperones for superoxide dismutase: a key role for disulfide formation

In the CCS–SOD1 copper transfer pathway, Cu(I) bound to the CXXC motif of domain I and/or to the CXC motif of domain III of CCS is transferred to a buried site with four histidyl ligands in SOD1. The transfer of copper from CCS into SOD1 implies its change in coordination and its insertion in a position deep inside the enzyme. The three domains of CCS might each have a specific role in this process: the Cu(I)-binding domain I, homologous to Atx1, is involved in copper capture at low metal concentrations, the SOD1-like domain II is involved in target recognition, and the C-terminal domain III is responsible for copper insertion.[109]

SOD1 maturation is likely initiated by the formation of a heterodimer between domain II of CCS and one subunit of disulfide-reduced Zn(II)-SOD1[54] (Figure 9(b)). Domain I of CCS obtains Cu(I) from an unknown source (most likely the Ctr membrane transporters) and transfers the metal ion to domain III. This latter process may occur via a three coordinate model, where the Cu(I) ion in CCS can undergo direct intramolecular ligand exchange between the CXXC motif of domain I and the CXC motif of domain III.[111] In the absence of domain I and at high copper concentrations, domain III could acquire copper directly.[109] Domain III then changes its position to deliver copper to the SOD1 active site. This transfer is oxygen dependent[55]: the oxidizing equivalents are employed in disulfide formation, leading to an intermolecular disulfide linking Cys229 in

domain III of CCS with Cys57 of SOD1, which opens up the SOD1 active site to facilitate metal ion insertion.[159] In the crystal structure of the CCS–Zn(II)-SOD1 complex, this disulfide bond brings Cys229 from CCS domain III within $10\,\text{Å}$ of SOD1 copper ligand His120[159] (Figure 6). In a subsequent step, this intermolecular disulfide bond can be converted to the intramolecular disulfide bond between Cys57 and Cys146, characteristic of the mature SOD1 form (Figure 9(b)). The latter disulfide bond plays both structural and functional roles, including affecting the quaternary structure of SOD1.[52,53] The reduced protein favors the monomeric state in the absence of metal ions, which is the form of SOD1 capable of being imported into the IMS of mitochondria.[166]

Cytochrome *c* oxidase metalation: interplay between copper binding and redox processes

Cox17, like SOD1, exhibits a dual localization in the cytosol and the IMS,[57] but its function is performed in the latter compartment. Cox17 import in IMS is dependent on the protein Mia40, located within the IMS and anchored to the mitochondrial IM.[167] During import, Mia40 forms a transient disulfide-linked intermediate with Cox17.[167] Cox17 and Mia40 share a twin CX_9C sequence motif, which is also found in Cox19[59] and Cox23.[60]

Recent studies have shown that mitochondria contain a pool of nonproteinaceous copper ions localized within the matrix as a soluble, anionic, low molecular weight complex[168] (Figure 1). A reduction of the levels of this copper complex in the matrix also attenuates the activation of COX and SOD1 within the IMS.[169] This suggests that Cox17 is metalated within the IMS, using the matrix copper pool as Cu(I) source. The access routes for copper to the mitochondrial matrix and to the IMS are still not known.

Once Cox17 is imported in the IMS, cysteine oxidation modulates the folding and Cu(I)-binding properties of Cox17. Oxidized yeast Cox17 contains two disulfide bonds ($Cox17_{2S-S}$), one involving Cys26 and Cys57 and the other involving Cys36 and Cys47 of the twin CX_9C motif.[114] $Cox17_{2S-S}$ binds a single Cu(I) ion.[113] The fully reduced apoCox17 is in a molten globule state, capable of binding a cluster of up to four Cu(I) ions,[114] thereby inducing protein oligomerization. Human Sco1 binds Cu(I) and Cu(II) with the same ligands (Cys169 and Cys173 of the conserved CX_3C motif, and His260).[120] Also, bacterial[88,122] and yeast[118] Sco1 proteins are able to bind both Cu(I) and Cu(II), even if at substoichimetric ratios. Therefore, the Sco1 thioredoxin fold has evolved to bind metal ions via the CX_3C motif. A very peculiar finding was that cysteine-oxidized Sco1 ($Sco1_{S-S}$) is also able to interact with metal ions. In the crystal structure of Ni(II)-Sco1$_{S-S}$, Ni(II) has a quite unprecedented coordination environment.[120] The two cysteines of the CX_3C motif are oxidized and form a disulfide bond and are therefore not capable of binding

the Ni(II) ion as thiolates. Still, the metal ion remains in contact with the disulfide bond with a Ni–S distance of 2.0–2.2 Å, suggesting the formation of bonds with the available lone pairs of sulfur atoms. The coordination sphere of Ni(II) is completed by His260 and a fourth exogenous ligand arranged in a distorted square planar geometry[120] (Figure 8).

On the basis of the structural characterization of various states of the protein, it was suggested that Sco1 could transfer copper ions, reduce disulfide bonds, or both. Furthermore, the structure of oxidized Sco1 bound with Ni(II), (Ni(II)-Sco1$_{S-S}$) suggested a possible process of copper transfer from Sco1 to Cu$_A$, where Sco1 plays a dual role[120] (Figure 9(c)). In the first step of the copper transfer mechanism, copper loaded Sco1 interacts with the oxidized Cu$_A$ site of the Cox2 subunit of COX and reduces the cysteine residues of the Cu$_A$ site, acting as a thioredoxin. Subsequently, the CX$_3$C motif of Sco1 becomes oxidized to disulfide, but is still able to interact with copper. The copper ion is then transferred to the reduced Cu$_A$ site, and the oxidized apoSco1 species is obtained.[120] Within this model, Sco1 would have a dual functional role similar to that of CCS. Consistent with these suggestions, the X-ray structure of Sco1 from *B. subtilis* identified a disulfide switch, demonstrating that Sco1 has redox capabilities.[156]

The nature of Sco1 as a multifunctional protein is further supported by genome-wide searches in prokaryotic genomes, which showed that multiple Sco1-like sequences are present in a single organism in different genomic contexts.[27,170] In particular, Sco1 is often close, in the operons, to copper-requiring proteins and/or is fused to a cytochrome c domain, consistent with its potential redox mechanism.[27,170]

At this stage of knowledge, the oxidization state of copper during the metal transfer cannot be assessed. The Cu$_A$ site can indeed accept both Cu(I) and Cu(II) ions from Sco1. This metal center is binuclear and, therefore, once Sco1 has provided one Cu(I), it is possible that Cu(II) enters the second site of Cu$_A$, forming binuclear mixed-valence units.[28] Consistent with this scheme, kinetic- and copper-binding studies on a Cu$_A$ center engineered into an azurin have shown that the formation of a Cu(I)-thiolate center is observed and that, following the addition of Cu(II), the mononuclear intermediate converts into the final Cu$_A$ center.[171] Another hypothesis[118] is that Sco1 and Sco2 work as a unit to transfer two copper equivalents to form the Cu$_A$ site in a single step. Although the soluble domains of each isolated protein are monomers, the full-length proteins are homodimers *in vivo* and are tethered to the mitochondrial IM by a transmembrane helix[118] The Sco1–Sco2 complex could both transfer the metal ion and reduce the metal-receiving cysteines.

The insertion of a copper ion in the Cu$_B$ center of Cox1 appears to be a particularly challenging problem, as this site is buried 13 Å below the membrane surface (Figure 2). Evidence of the association of Cox11 with mitochondrial

ribosomes[172] recently provided a clue toward the understanding of this process. The Cu$_B$ site might be cotranslationally formed by a transient interaction between Cox11 and the nascent Cox1 in the IMS. Upon transfer of the copper ion, the nascent Cox1 is pushed further into the IM and the Cu$_B$ site moves into the lipid bilayer. The dimeric state of Cox11 may be disrupted during the interaction with Cox1, and a Cox11–Cox1 heterodimer may be formed.

REFERENCES

1 A Messerschmidt, R Huber, TL Poulos and K Wieghardt (eds.), *Handbook of Metalloproteins*, John Wiley & Sons, Chichester, UK (2001).

2 I Fridovich, *Annu Rev Biochem*, **64**, 97–112 (1995).

3 S Yoshikawa, *Adv Protein Chem*, **60**, 341–395 (2002).

4 A Dancis, DS Yuan, D Haile, C Askwith, D Elde, C Moehle, J Kaplan and RD Klausner, *Cell*, **76**, 393–402 (1994).

5 ST Prigge, RE Mains, BA Eipper and LM Amzel, *Cell Mol Life Sci*, **57**, 1236–1259 (2000).

6 HA Lucero and HM Kagan, *Cell Mol Life Sci*, **63**, 2304–2316 (2006).

7 Y Matoba, T Kumagai, A Yamamoto, H Yoshitsu and M Sugiyama, *J Biol Chem*, **281**, 8981–8990 (2006).

8 I Fridovich, *Science*, **201**, 875–879 (1978).

9 LA Finney and TV O'Halloran, *Science*, **300**, 931–936 (2003).

10 MMO Pena, J Lee and DJ Thiele, *J Nutr*, **129**, 1251–1260 (1999).

11 J Camakaris, I Voskoboinik and JF Mercer, *Biochem Biophys Res Commun*, **261**, 225–232 (1999).

12 RA Pufahl, CP Singer, KL Peariso, S-J Lin, PJ Schmidt, CJ Fahrni, V Cizewski Culotta, JE Penner-Hahn and TV O'Halloran, *Science*, **278**, 853–856 (1997).

13 T Rae, PJ Schmidt, RA Pufahl, VC Culotta and TV O'Halloran, *Science*, **284**, 805–808 (1999).

14 DL Huffman and TV O'Halloran, *J Biol Chem*, **275**, 18611–18614 (2000).

15 F Arnesano, L Banci, I Bertini, S Ciofi-Baffoni, E Molteni, DL Huffman and TV O'Halloran, *Genome Res*, **12**, 255–271 (2002).

16 LA Sturtz, K Diekert, LT Jensen, R Lill and VC Culotta, *J Biol Chem*, **276**, 38084–38089 (2001).

17 VC Culotta, LW Klomp, J Strain, RL Casareno, B Krems and JD Gitlin, *J Biol Chem*, **272**, 23469–23472 (1997).

18 H Zhu, E Shipp, RJ Sanchez, A Liba, JE Stine, PJ Hart, EB Gralla, AM Nersissian and JS Valentine, *Biochemistry*, **39**, 5413–5421 (2000).

19 CC Chu, WC Lee, WY Guo, SM Pan, LJ Chen, HM Li and TL Jinn, *Plant Physiol*, **139**, 425–436 (2005).

20 SD Moore, MM Chen and DW Cox, *Cytogenet Cell Genet*, **88**, 35–37 (2000).

21 A Southon, R Burke, M Norgate, P Batterham and J Camakaris, *Biochem J*, **383**, 303–309 (2004).

22 L Banci, I Bertini, V Calderone, F Cramaro, R Del Conte, A Fantoni, S Mangani, A Quattrone and MS Viezzoli, *Proc Natl Acad Sci U S A*, **102**, 7541–7546 (2005).

23 GN Landis and J Tower, *Mech Ageing Dev*, **126**, 365–379 (2005).

24 PA Cobine, F Pierrel and DR Winge, *Biochim Biophys Acta*, **1763**, 759–772 (2006).

25 J Cao, J Hosler, J Shapleigh, A Revzin and S Ferguson-Miller, *J Biol Chem*, **267**, 24273–24278 (1992).

26 NR Mattatall, J Jazairi and BC Hill, *J Biol Chem*, **275**, 28802–28809 (2000).

27 F Arnesano, L Banci, I Bertini and M Martinelli, *J Proteome Res*, **4**, 63–70 (2005).

28 L Banci, I Bertini, S Ciofi-Baffoni, E Katsari, N Katsaros, K Kubicek and S Mangani, *Proc Natl Acad Sci U S A*, **102**, 3994–3999 (2005).

29 SJ Lin, R Pufahl, A Dancis, TV O'Halloran and VC Culotta, *J Biol Chem*, **272**, 9215–9220 (1997).

30 I Voskoboinik and J Camakaris, *J Bioenerg Biomembr*, **34**, 363–371 (2002).

31 C Askwith, D Eide, A Van Ho, PS Bernard, L Li, S Davis-Kaplan, DM Sipe and J Kaplan, *Cell*, **76**, 403–410 (1994).

32 R Stearman, D Yuan, Y Yamaguchi-Iwan, RD Klausner and A Dancis, *Science*, **271**, 1552–1557 (1996).

33 AB Taylor, CS Stoj, L Ziegler, DJ Kosman and PJ Hart, *Proc Natl Acad Sci U S A*, **102**, 15459–15464 (2005).

34 LW Klomp, SJ Lin, D Yuan, RD Klausner, VC Culotta and JD Gitlin, *J Biol Chem*, **272**, 9221–9226 (1997).

35 CD Vulpe, B Levinson, S Whitney, S Packman and J Gitschier, *Nat Genet*, **3**, 7–13 (1993).

36 PC Bull, GR Thomas, JM Rommens, JR Forbes and DW Cox, *Nat Genet*, **5**, 327–337 (1993).

37 RE Tanzi, K Petrukhin, I Chernov, JL Pellequer, Wasco W, B Ross, DM Romano, E Parano, L Pavone, LM Brzustowicz, M Devoto, J Peppercorn, AI Bush, I Sternlieb, M Pirastu, JF Gusella, O Evgrafov, GK Penchaszadeh, B Honig, IS Edelman, MB Soares, IH Scheinberg and C Gilliam, *Nat Genet*, **5**, 344–350 (1993).

38 S Lutsenko, RG Efremov, R Tsivkovskii and JM Walker, *J Bioenerg Biomembr*, **34**, 351–362 (2002).

39 PM Royce, J Camakaris and DM Danks, *Biochem J*, **192**, 579–586 (1980).

40 L Peltonen, H Kuivaniemi, A Palotie, N Horn, I Kaitila and KI Kivirikko, *Biochemistry*, **22**, 6156–6163 (1983).

41 S Gacheru, C McGee, JY Uriu-Hare, T Kosonen, S Packman, D Tinker, SA Krawetz, K Reiser, CL Keen and RB Rucker, *Arch Biochem Biophys*, **301**, 325–329 (1993).

42 R Kemppainen, ER Hamalainen, H Kuivaniemi, G Tromp, T Pihlajaniemi and KI Kivirikko, *Arch Biochem Biophys*, **328**, 101–106 (1996).

43 DS Yuan, R Stearman, A Dancis, T Dunn, T Beeler and RD Klausner, *Proc Natl Acad Sci U S A*, **92**, 2632–2636 (1995).

44 E Himelblau and RM Amasino, *Curr Opin Plant Biol*, **3**, 205–210 (2000).

45 E Himelblau, H Mira, SJ Lin, VC Culotta, L Penarrubia and RM Amasino, *Plant Physiol*, **117**, 1227–1234 (1998).

46 T Hirayama, JJ Kieber, N Hirayama, M Kogan, P Guzman, S Nourizadeh, JM Alonso, WP Dailey, A Dancis and JR Ecker, *Cell*, **97**, 383–393 (1999).

47 T Hirayama and JM Alonso, *Plant Cell Physiol*, **41**, 548–555 (2000).

48 ZH Lu and M Solioz, *Adv Protein Chem*, **60**, 93–121 (2002).

49 S Tottey, PR Rich, SAM Rondet and NJ Robinson, *J Biol Chem*, **276**, 19999–20004 (2001).

50 S Tottey, SA Rondet, GP Borrelly, PJ Robinson, PR Rich and NJ Robinson, *J Biol Chem*, **277**, 5490–5497 (2002).

51 D Bordo, K Djinovic and M Bolognesi, *J Mol Biol*, **238**, 366–386 (1994).

52 F Arnesano, L Banci, I Bertini, M Martinelli, Y Furukawa and TV O'Halloran, *J Biol Chem*, **279**, 47998–48003 (2004).

53 PA Doucette, LJ Whitson, X Cao, V Schirf, B Demeler, JS Valentine, JC Hansen and PJ Hart, *J Biol Chem*, **279**, 54558–54566 (2004).

54 TD Rae, AS Torres, RA Pufahl and TV O'Halloran, *J Biol Chem*, **276**, 5166–5176 (2001).

55 Y Furukawa, AS Torres and TV O'Halloran, *EMBO J*, **23**, 2872–2881 (2004).

56 A Barrientos, MH Barros, I Valnot, A Rotig, P Rustin and A Tzagoloff, *Gene*, **286**, 53–63 (2002).

57 J Beers, DM Glerum and A Tzagoloff, *J Biol Chem*, **272**, 33191–33196 (1997).

58 YC Horng, PA Cobine, AB Maxfield, HS Carr and DR Winge, *J Biol Chem*, **279**, 35334–35340 (2004).

59 MP Nobrega, SCB Bandeira, J Beers and A Tzagoloff, *J Biol Chem*, **277**, 40206–40211 (2002).

60 MH Barros, A Johnson and A Tzagoloff, *J Biol Chem*, **279**, 31943–31947 (2004).

61 K Rigby, L Zhang, PA Cobine, GN George and DR Winge, *J Biol Chem*, **282**, 10233–10242 (2007).

62 A Lode, M Kuschel, C Paret and G Rodel, *FEBS Lett*, **485**, 19–24 (2000).

63 L Hiser, M Di Valentin, AG Hamer and JP Hosler, *J Biol Chem*, **275**, 619–623 (2000).

64 EA Shoubridge, *Am J Med Genet*, **106**, 46–52 (2001).

65 SC Leary, BA Kaufman, G Pellecchia, GH Guercin, A Mattman, M Jaksch and EA Shoubridge, *Hum Mol Genet*, **13**, 1839–1848 (2004).

66 SJ Lin and VC Culotta, *Proc Natl Acad Sci U S A*, **92**, 3784–3788 (1995).

67 T Kaneko, S Sato, H Kotani, A Tanaka, E Asamizu, Y Nakamura, N Miyajima, M Hirosawa, M Sugiura, S Sasamoto, T Kimura, T Hosouchi, A Matsuno, A Muraki, N Nakazaki, K Naruo, S Okumura, S Shimpo, C Takeuchi, T Wada, A Watanabe, M Yamada, M Yasuda, S Tabata, *DNA Res*, **3**, 109–136 (1996).

68 F Kunst, N Ogasawara, I Moszer, AM Albertini, G Alloni, V Azevedo, MG Bertero, P Bessières, A Bolotin, S Borchert, R Borriss, L Boursier, A Brans, M Braun, SC Brignell, S Bron, S Brouillet, CV Bruschi, B Caldwell, V Capuano, NM Carter, SK Choi, JJ Codani, IF Connerton, NJ Cummings, RA Daniel, F Denizot, KM Devine, A Düsterhüft, SD Ehrlich, PT Emmerson, KD Entian, J Errington, C Fabret, E Ferrari, D Foulger, C Fritz, Y Fujita, Y Fujita, S Fuma, A Galizzi, N Galleron, SY Ghim, P Glaser, A Goffeau, EJ Golightly, G Grandi, G Guiseppi, BJ Guy, K Haga, J Haiech, CR Harwood, A Hénaut, H Hilbert, S Holsappel, S Hosono, MF Hullo, M Itaya, L Jones, B Joris, D Karamata, Y Kasahara, M Klaerr-Blanchard, C Klein, Y Kobayashi, P Koetter, G Koningstein, S Krogh, S Kumano, K Kurita, A Lapidus, S Lardinois, J Lauber, V Lazarevic, SM Lee, A Levine, H Liu, S Masuda, C Mauël, C Médigue, N Medina, RP Mellado, M Mizuno, D Moesti, S Nakai, M Noback, D Noone, M O'Reilly, K Ogawa, A Ogiwara, B Oudega, SH Park, V Parro, TM Pohl, D Portetelle, S Porwollik, AM Prescott, E Presecan, P Pujic, S purnelle, G Rapoport, M Rey, S Reynolds, M Rieger, C Rivolta, E Rocha, B Roche, M Rose, Y Sadaie, T Sato, E Scalan, S Schleich, R Schroeter, F Scoffone, J Sekiguchi, A Sekowska, SJ Seror, P Serror, BS Shin, B Soldo, A Sorokin, E Tacconi, T Takagi, H Takahashi, K Takemaru, M Takeuchi, A Tamakoshi, T Tanaka, P Terpstra, A Tognoni, V Tosato, S Uchiyama, M Vandenbol, F Vannier, A Vassarotti, A Viari, R Wambutt, E Wedler, T Weitzenegger, P Winters, A Wipat, H Yamamoto, K Yamane, K Yasumoto, K Yata, K Yoshida, HF Yoshikawa, E

Zumstein, H Yoshikawa and A Danchin, *Nature*, **390**, 249–256 (1997).

69 K Petrukhin, SG Fischer, M Pirastu, RE Tanzi, I Chernov, M Devoto, LM Brzustowicz, E Cavanis, E Vitale and JJ Russo, *Nat Genet*, **5**, 338–343 (1993).

70 D Fu, TJ Beeler and TM Dunn, *Yeast*, **11**, 283–292 (1995).

71 MD Adams, SE Celniker, RA Holt, CA Evans, JD Gocayne, PG Amanatides, SE Scherer, PW Li, RA Hoskins, RF Galle, RA George, SE Lewis, S Richards, M Ashburner, SN Henderson, GG Sutton, JR Wortman, MD Yandell, Q Zhang, LX Chen, RC Brandon, YH Rogers, RG Blazej, M Champe, BD Pfeiffer, KH Wan, C Doyle, EG Baxter, G Helt, CR Nelson, GL Gabor Miklos, JF Abril, A Agbayani, HJ An, C Andrews-Pfannkoch, D Baldwin, RM Ballew, A Basu, J Baxendale, L Bayraktaroglu, EM Beasley, KY Beeson, PV Benos, BP Berman, D Bhandari, S Bolshakov, D Borkova, MR Botchan, J Bouck, P Brokstein, P Brottier, KC Burtis, DA Busam, H Butler, E Cadieu, A Center, I Chandra, JM Cherry, S Cawley, C Dahlke, LB Davenport, P Davies, B de Pablos, A Delcher, Z Deng, AD Mays, I Dew, SM Dietz, K Dodson, LE Doup, M Downes, S Dugan-Rocha, BC Dunkov, P Dunn, KJ Durbin, CC Evangelista, C Ferraz, S Ferriera, W Fleischmann, C Fosler, AE Gabrielian, NS Garg, WM Gelbart, K Glasser, A Glodek, F Gong, JH Gorrell, Z Gu, P Guan, M Harris, NL Harris, D Harvey, TJ Heiman, JR Hernandez, J Houck, D Hostin, KA Houston, TJ Howland, MH Wei, C Ibegwam, M Jalali, F Kalush, GH Karpen, Z Ke, JA Kennison, KA Ketchum, BE Kimmel, CD Kodira, C Kraft, S Kravitz, D Kulp, Z Lai, P Lasko, Y Lei, AA Levitsky, J Li, Z Li, Y Liang, X Lin, X Liu, B Mattei, TC McIntosh, MP McLeod, D McPherson, G Merkulov, NV Milshina, C Mobarry, J Morris, A Moshrefi, SM Mount, M Moy, B Murphy, L Murphy, DM Muzny, DL Nelson, DR Nelson, KA Nelson, K Nixon, DR Nusskern, JM Pacleb, M Palazzolo, GS Pittman, S Pan, J Pollard, V Puri, MG Reese, K Reinert, K Remington, RD Saunders, F Scheeler, H Shen, BC Shue, I Siden-Kiamos, M Simpson, MP Skupski, T Smith, E Spier, AC Spradling, M Stapleton, R Strong, E Sun, R Svirskas, C Tector, R Turner, E Venter, AH Wang, X Wang, ZY Wang, DA Wassarman, GM Weinstock, J Weissenbach, SM Williams, T Woodage, KC Worley, D Wu, S Yang, QA Yao, J Ye, RF Yeh, JS Zaveri, M Zhan, G Zhang, Q Zhao, L Zheng, XH Zheng, FN Zhong, W Zhong, X Zhou, S Zhu, X Zhu, HO Smith, RA Gibbs, EW Myers, GM Rubin and JC Venter, *Science*, **287**, 2185–2195 (2000).

72 Arabidopsis Genome Initiative, *Nature*, **408**, 796–815 (2000).

73 J Horecka, PT Kinsey and GF Sprague Jr, *Gene*, **162**, 87–92 (1995).

74 R Amaravadi, DM Glerum and A Tzagoloff, *Hum Genet*, **99**, 329–333 (1997).

75 ZW Chen, T Bergman, CG Ostenson, S Efendic, V Mutt and H Jornvall, *Eur J Biochem*, **249**, 518–522 (1997).

76 MJ Gardner, N Hall, E Fung, O White, M Berriman, RW Hyman, JM Carlton, A Pain, KE Nelson, S Bowman, IT Paulsen, K James, JA Eisen, K Rutherford, SL Salzberg, A Craig, S Kyes, MS Chan, V Nene, SJ Shallom, B Suh, J Peterson, S Angiuoli, M Pertea, J Allen, J Selengut, D Haft, MW Mather, AB Vaidya, DM Martin, AH Fairlamb, MJ Fraunholz, DS Roos, SA Ralph, GI McFadden, LM Cummings, GM Subramanian, C Mungall, JC Venter, DJ Carucci, SL Hoffman, C Newbold, RW Davis, CM Fraser and B Barrell, *Nature*, **419**, 498–511 (2002).

77 DM Glerum, A Shtanko and A Tzagoloff, *J Biol Chem*, **271**, 14504–14509 (1996).

78 S Sacconi, E Trevisson, F Pistollato, MC Baldoin, R Rezzonico, I Bourget, C Desnuelle, R Tenconi, G Basso, S DiMauro and L Salviati, *Biochem Biophys Res Commun*, **337**, 832–839 (2005).

79 V Petruzzella, V Tiranti, P Fernandez, P Ianna, R Carrozzo and M Zeviani, *Genomics*, **54**, 494–504 (1998).

80 LC Papadopoulou, CM Sue, MM Davidson, K Tanji, I Nishino, JE Sadlock, S Krishna, W Walker, J Selby, DM Glerum, RV Coster, G Lyon, E Scalais, R Lebel, P Kaplan, S Shanske, DC De Vivo, E Bonilla, M Hirano, S DiMauro and EA Schon, *Nat Genet*, **23**, 333–337 (1999).

81 P Buchwald, G Krummeck and G Rodel, *Mol Gen Genet*, **229**, 413–420 (1991).

82 PH Smits, M de Hann, C Maat and LA Grivell, *Yeast*, **10**, 75–80 (1994).

83 A Tzagoloff, N Capitanio, MP Nobrega and D Gatti, *EMBO J*, **9**, 2759–2764 (1990).

84 D Capela, F Barloy-Hubler, J Gouzy, G Bothe, F Ampe, J Batut, P Boistard, A Becker, M Boutry, E Cadieu, S Dréano, S Gloux, T Godrie, A Goffeau, D Kahn, E Kiss, V Lelaure, D Masuy, T Pohl, D Portetelle, A Pühler, B Purnelle, U Ramsperger, C Renard, P Thébault, M Vandenbol, S Weidner and F Galibert, *Proc Natl Acad Sci U S A*, **98**, 9877–9882 (2001).

85 P Hengen, *Trends Biochem Sci*, **20**, 285–286 (1995).

86 L Banci, I Bertini, F Cantini, C Chasapis, N Hadjiliadis and A Rosato, *J Biol Chem*, **280**, 38259–38263 (2005).

87 D Achila, L Banci, I Bertini, J Bunce, S Ciofi-Baffoni and DL Huffman, *Proc Natl Acad Sci U S A*, **103**, 5729–5734 (2006).

88 E Balatri, L Banci, I Bertini, F Cantini and S Ciofi-Baffoni, *Structure*, **11**, 1431–1443 (2003).

89 L Banci, I Bertini, F Cantini, S Ciofi-Baffoni, L Gonnelli and S Mangani, *J Biol Chem*, **279**, 34833–34839 (2004).

90 YH Hung, MJ Layton, I Voskoboinik, JF Mercer and J Camakaris, *Biochem J*, **401**, 569–579 (2007).

91 L Banci, I Bertini, S Ciofi-Baffoni, L Gonnelli and XC Su, *J Mol Biol*, **331**, 473–484 (2003).

92 AG Palmer III, *Curr Opin Struct Biol*, **7**, 732–737 (1997).

93 R Wimmer, T Herrmann, M Solioz and K Wüthrich, *J Biol Chem*, **274**, 22597–22603 (1999).

94 F Arnesano, L Banci, I Bertini, F Cantini, S Ciofi-Baffoni, DL Huffman and TV O'Halloran, *J Biol Chem*, **276**, 41365–41376 (2001).

95 L Banci, I Bertini, F Cantini, IC Felli, L Gonnelli, N Hadjiliadis, R Pierattelli, A Rosato and P Voulgaris, *Nat Chem Biol*, **2**, 367–368 (2006).

96 Z Xiao, F Loughlin, GN George, GJ Howlett and AG Wedd, *J Am Chem Soc*, **126**, 3081–3090 (2004).

97 A Voronova, J Kazantseva, M Tuuling, N Sokolova, R Sillard and P Palumaa, *Protein Expr Purif*, **53**, 138–144 (2007).

98 C Andreini, I Bertini and A Rosato, *Bioinformatics*, **20**, 1373–1380 (2004).

99 JC Rutherford, JS Cavet and NJ Robinson, *J Biol Chem*, **274**, 25827–25832 (1999).

100 C Rensing, B Mitra and BP Rosen, *Proc Natl Acad Sci U S A*, **94**, 14326–14331 (1997).

101 G Nucifora, L Chu, TK Misra and S Silver, *Proc Natl Acad Sci U S A*, **86**, 3544–3548 (1989).

102 G Veglia, F Porcelli, T DeSilva, A Prantner and SJ Opella, *J Am Chem Soc*, **122**, 2389–2390 (2000).

103 TM DeSilva, G Veglia, F Porcelli, AM Prantner and SJ Opella, *Biopolymers*, **64**, 189–197 (2002).

104 L Banci, I Bertini, S Ciofi-Baffoni, LA Finney, CE Outten and TV O'Halloran, *J Mol Biol*, **323**, 883–897 (2002).

105 L Banci, I Bertini, S Ciofi-Baffoni, XC Su, R Miras, N Bal, E Mintz, P Catty, JE Shokes and RA Scott, *J Mol Biol*, **356**, 638–650 (2006).

106 S Lutsenko, K Petrukhin, MJ Cooper, CT Gilliam and JH Kaplan, *J Biol Chem*, **272**, 18939–18944 (1997).

107 M DiDonato, S Narindrasorasak, JR Forbes, DW Cox and B Sarkar, *J Biol Chem*, **272**, 33279–33282 (1997).

108 L Banci, I Bertini, F Cantini, N Della Malva, A Rosato, T Herrmann and K Wüthrich, *J Biol Chem*, **281**, 29141–29147 (2006).

109 PJ Schmidt, TD Rae, RA Pufahl, T Hamma, J Strain, TV O'Halloran and VC Culotta, *J Biol Chem*, **274**, 23719–23725 (1999).

110 JP Stasser, JF Eisses, AN Barry, JH Kaplan and NJ Blackburn, *Biochemistry*, **44**, 3143–3152 (2005).

111 JF Eisses, JP Stasser, M Ralle, JH Kaplan and NJ Blackburn, *Biochemistry*, **39**, 7337–7342 (2000).

112 D Heaton, T Nittis, C Srinivasan and DR Winge, *J Biol Chem*, **275**, 37582–37587 (2000).

113 P Palumaa, L Kangur, A Voronova and R Sillard, *Biochem J*, **382**, 307–314 (2004).

114 F Arnesano, E Balatri, L Banci, I Bertini and DR Winge, *Structure*, **13**, 713–722 (2005).

115 T Nittis, GN George and DR Winge, *J Biol Chem*, **276**, 42520–42526 (2001).

116 M Jaksch, C Paret, R Stucka, N Horn, J Muller-Hocker, R Horvath, N Trepesch, G Stecker, P Freisinger, C Thirion, J Muller, R Lunkwitz, G Rodel, EA Shoubridge and H Lochmuller, *Hum Mol Genet*, **10**, 3025–3035 (2001).

117 HS Carr, GN George and DR Winge, *J Biol Chem*, **277**, 31273–31242 (2002).

118 YC Horng, SC Leary, PA Cobine, FB Young, GN George, EA Shoubridge and DR Winge, *J Biol Chem*, **280**, 34113–34122 (2005).

119 JC Williams, C Sue, GS Banting, H Yang, DM Glerum, WA Hendrickson and EA Schon, *J Biol Chem*, **280**, 15202–15211 (2005).

120 L Banci, I Bertini, V Calderone, S Ciofi-Baffoni, S Mangani, M Martinelli, P Palumaa and S Wang, *Proc Natl Acad Sci U S A*, **103**, 8595–8600 (2006).

121 C Abajian and AC Rosenzweig, *J Biol Inorg Chem*, **11**, 459–466 (2006).

122 L Andruzzi, M Nakano, MJ Nilges and NJ Blackburn, *J Am Chem Soc*, **127**, 16548–16558 (2005).

123 L Banci, I Bertini, S Ciofi-Baffoni, I Leontari, M Martinelli, P Palumaa, R Sillard and S Wang, *Proc Natl Acad Sci U S A*, **104**, 15–20 (2007).

124 F Arnesano, L Banci and M Piccioli, *Q Rev Biophys*, **38**, 167–219 (2007).

125 GL Oz, DL Pountney and IM Armitage, *Biochem Cell Biol*, **76**, 223–234 (1998).

126 L Banci, I Bertini and S Mangani, *J Synchrotron Radiat*, **12**, 94 (2005).

127 M Ubbink, JAR Worrall, GW Canters, EJJ Groenen and M Huber, *Annu Rev Biophys Biomol Struct*, **31**, 393–422 (2002).

128 ABP Lever, *Inorganic Electronic Spectroscopy*, Elsevier, Amsterdam, NY (1984).

129 F Arnesano, L Banci, I Bertini, DL Huffman and TV O'Halloran, *Biochemistry*, **40**, 1528–1539 (2001).

130 AC Rosenzweig, DL Huffman, MY Hou, AK Wernimont, RA Pufahl and TV O'Halloran, *Structure Fold Des*, **7**, 605–617 (1999).

131 FA Cotton and G Wilkinson, *Advanced Inorganic Chemistry*, John Wiley & Sons, New York (1988).

132 L Banci, I Bertini, R Del Conte, S Mangani and W Meyer-Klaucke, *Biochemistry*, **8**, 2467–2474 (2003).

133 J Anastassopoulou, L Banci, I Bertini, F Cantini, E Katsari and A Rosato, *Biochemistry*, **43**, 13046–13053 (2004).

134 AK Wernimont, DL Huffman, AL Lamb, TV O'Halloran and AC Rosenzweig, *Nat Struct Biol*, **7**, 766–771 (2000).

135 M Ralle, S Lutsenko and NJ Blackburn, *J Biol Chem*, **278**, 23163–23170 (2003).

136 L Banci, I Bertini, GPM Borrelly, S Ciofi-Baffoni, NJ Robinson and XC Su, *J Biol Chem*, **279**, 27502–27510 (2004).

137 S Lutsenko and JH Kaplan, *Biochemistry*, **34**, 15607–15613 (1995).

138 M Solioz and CD Vulpe, *Trends Biochem Sci*, **21**, 237–241 (1996).

139 C Rensing, M Ghosh and BP Rosen, *J Bacteriol*, **181**, 5891–5897 (1999).

140 MH Sazinsky, AK Mandal, JM Arguello and AC Rosenzweig, *J Biol Chem*, **281**, 11161–11166 (2006).

141 MH Sazinsky, S Agarwal, JM Arguello and AC Rosenzweig, *Biochemistry*, **45**, 9949–9955 (2006).

142 L Banci, I Bertini, S Ciofi-Baffoni, DL Huffman and TV O'Halloran, *J Biol Chem*, **276**, 8415–8426 (2001).

143 TM DeSilva, G Veglia and SJ Opella, *Proteins*, **61**, 1038–1049 (2005).

144 L Banci, I Bertini, R Del Conte, M D'Onofrio and A Rosato, *Biochemistry*, **43**, 3396–3403 (2004).

145 CE Jones, NL Daly, PA Cobine, DJ Craik and CT Dameron, *J Struct Biol*, **143**, 209–218 (2003).

146 J Gitschier, B Moffat, D Reilly, WI Wood and WJ Fairbrother, *Nat Struct Biol*, **5**, 47–54 (1998).

147 L Banci, I Bertini, C Chasapis, S Ciofi-Baffoni, N Hadjiliadis and A Rosato, *FEBS J*, **272**, 865–871 (2005).

148 L Banci, I Bertini, F Cantini, M Migliardi, A Rosato and S Wang, *J Mol Biol*, **352**, 409–417 (2005).

149 L Banci, I Bertini, S Ciofi-Baffoni, L Gonnelli and XC Su, *J Biol Chem*, **278**, 50506–50513 (2003).

150 AL Lamb, AK Wernimont, RA Pufahl, VC Culotta, TV O'Halloran and AC Rosenzweig, *Nat Struct Biol*, **6**, 724–729 (1999).

151 AL Lamb, AK Wernimont, RA Pufahl, TV O'Halloran and AC Rosenzweig, *Biochemistry*, **39**, 1589–1595 (2000).

152 LT Hall, RJ Sanchez, SP Holloway, H Zhu, JE Stine, TJ Lyons, B Demeler, V Schirf, JC Hansen, AM Nersissian, JS Valentine and PJ Hart, *Biochemistry*, **39**, 3611–3623 (2000).

153 C Abajian, LA Yatsunyk, BE Ramirez and AC Rosenzweig, *J Biol Chem*, **279**, 53584–53592 (2004).

154 T Tsukihara, H Aoyama, E Yamashita, T Tomizaki, H Yamaguchi, K Shinzawa-Itoh, R Nakashima, R Yaono and S Yoshikawa, *Science*, **272**, 1136–1144 (1996).

155 DN Heaton, GN George, G Garrison and DR Winge, *Biochemistry*, **40**, 743–751 (2001).

156 Q Ye, I Imriskova-Sosova, BC Hill and Z Jia, *Biochemistry*, **44**, 2934–2942 (2005).

157 F Arnesano, L Banci, I Bertini and AMJJ Bonvin, *Structure*, **12**, 669–676 (2004).

158 ME Portnoy, AC Rosenzweig, T Rae, DL Huffman, TV O'Halloran and V Cizewski Culotta, *J Biol Chem*, **274**, 15041–15045 (1999).

159 AL Lamb, AS Torres, TV O'Halloran and AC Rosenzweig, *Nat Struct Biol*, **8**, 751–755 (2001).

160 AD van Dijk, S Ciofi-Baffoni, L Banci, I Bertini, R Boelens and AM Bonvin, *J Proteome Res*, **6**, 1530–1539 (2007).

161 L Banci, I Bertini, F Cantini, N Della-Malva, M Migliardi and A Rosato, *J Biol Chem* (2007), in press.

162 R Tsivkovskii, BC MacArthur and S Lutsenko, *J Biol Chem*, **276**, 2234–2242 (2001).

163 JR Forbes and DW Cox, *Am J Hum Genet*, **63**, 1663–1674 (1998).

164 L Banci, I Bertini, S Ciofi-Baffoni, R Del Conte and L Gonnelli, *Biochemistry*, **42**, 1939–1949 (2003).

165 L Banci, I Bertini, S Ciofi-Baffoni, NG Kandias, GA Spyroulias, XC Su, NJ Robinson and M Vanarotti, *Proc Natl Acad Sci U S A*, **103**, 8325 (2006).

166 LS Field, Y Furukawa, TV O'Halloran and VC Culotta, *J Biol Chem*, **278**, 28052–28059 (2003).

167 A Chacinska, S Pfannschmidt, N Wiedemann, V Kozjak, LK Sanjuan Szklarz, A Schulze-Specking, KM Truscott, B Guiard, C Meisinger and N Pfanner, *EMBO J*, **23**, 3735–3746 (2004).

168 PA Cobine, LD Ojeda, KM Rigby and DR Winge, *J Biol Chem*, **279**, 14447–14455 (2004).

169 PA Cobine, F Pierrel, ML Bestwick and DR Winge, *J Biol Chem*, **281**, 36552–36559 (2006).

170 L Banci, I Bertini, G Cavallaro and A Rosato, *J Proteome Res*, **6**, 1568–1579 (2007).

171 X Wang, MC Ang and Y Lu, *J Am Chem Soc*, **121**, 2947–2948 (1999).

172 O Khalimonchuk, K Ostermann and G Rodel, *Curr Genet*, **47**, 223–233 (2005).

173 L Banci, I Bertini and R Del Conte, *Biochemistry*, **42**, 13422–13428 (2003).

174 L Banci, I Bertini, S Ciofi-Baffoni, M D'Onofrio, L Gonnelli, FC Marhuenda-Egea and FJ Ruiz-Dueñas, *J Mol Biol*, **317**, 415–429 (2002).

175 R Koradi, M Billeter and K Wüthrich, *J Mol Graph*, **14**, 51–55 (1996).

176 GPM Borrelly, CA Blindauer, R Schmid, CS Butler, CE Cooper, I Harvey, PJ Sadler and NJ Robinson, *Biochem J*, **378**, 293–297 (2004).

Amyloid precursor protein

Su Ling Leong[†,§,*], Kevin J Barnham[†,§,*], Gerd Multhaup[¶] and Roberto Cappai[†,‡,§,*]

[†]Department of Pathology, University of Melbourne, Parkville, Victoria 3010, Australia
[‡]Centre for Neuroscience, University of Melbourne, Victoria 3010, Australia
[§]Bio21 Molecular Science and Biotechnology Institute, University of Melbourne, Victoria 3010, Australia
[*]Mental Health Research Institute of Victoria, Parkville, Victoria 3052, Australia
[¶]Freie Universitaet Berlin, Institut fuer Chemie/Biochemie, Thielallee 63, D-14195 Berlin, Germany

FUNCTIONAL CLASS

Type 1 transmembrane glycoprotein with a large ectodomain and a short cytoplasmic domain (Figure 1) that is commonly abbreviated to amyloid-precursor protein (APP). It contains three alternatively spliced exons that yield numerous isoforms. In mammals it has two paralogues termed amyloid-precursor like protein 1 (APLP1) and amyloid-precursor like protein 2 (APLP2). The ectodomain is cleaved close to the membrane by proteases termed α and β-secretase to release a soluble ectodomain and a membrane associated carboxy terminal fragment. The carboxy terminal fragment is then cleaved by the γ-secretase complex. The non-amyloidogenic pathway follows from the initial cleavage by α-secretases and subsequently γ-secretase, yielding a fragment known as p3, whose role remains unknown.[1] In the amyloidogenic pathway, β-secretase cleavage of APP is followed by γ-secretase and results in the release of the amyloid-β peptide (Aβ), which is the primary constituent of the amyloid plaques that characterize Alzheimer's disease.[2–4]

OCCURRENCE

APP orthologues and paralogues have been found in a variety of mammalian species including humans, rodents,

3D Structure NMR structure of the APP CuBD (PDB code: 1OWT). Highlighted are the residues implicated in the copper-binding site. His-147 and His-151 (red), Tyr-168 (yellow) and Met-170 (magenta). Disulfide bridges are shown in light blue. (Figure prepared using the program MOLMOL.[44])

Figure 1 Schematic of the APP domain structure. For simplicity of discussion, domains are numbered from the N-terminus to the C-terminus. The growth factor–like domain (GFLD – D1) and the copper-binding domain (CuBD – D2) is linked via the acidic region (D3) to the carbohydrate domain (D6), which contains the E2 domain (D6a) and the juxtamembrane domain (D6b). This is followed by the transmembrane (TM – D7) and the APP intracellular domain (AICD – D8). The amyloid-β region encompasses residues at the tail end of D6b and the first half of D7. The Kunitz protease inhibitor domain (KPI – D4) is found in APP_{751} and APP_{770}, while the OX-2 sequence (D5) is present only in APP_{770}.

dogs, and apes where three members of the gene family have been identified. Moreover, orthologues have been identified in the electric stingray, puffer fish, *Drosophila melanogaster*, and *Caenorhabditis elegans*. No orthologue has been identified from unicellular organisms such as yeast. In mammals, expression appears to be ubiquitous, with RNA and protein identified in most tissues.[5,6] In humans, the APP695 isoform is highly expressed on the cell surfaces of neurons, while the APP751 and APP770 isoforms are present in all adult tissues studied.[7,8] In mice, the homologues of the human isoforms have similar tissue specificity to that found in humans.[9,10]

BIOLOGICAL FUNCTION

The biological function of the APP family remains ill defined. Single APP, APLP1, and APLP2 knockout mice are all viable with no overt phenotype. Double knockout mice studies have identified APLP2 to be essential for survival as APLP2/APLP1 and APP/APLP2 double knocks die early postnatal.[11] The APP molecule, as the precursor to the Aβ peptide, is the most studied member of the APP family. A number of activities have been attributed to APP and are outlined below:

G protein coupled receptor

APP may function as a G protein coupled receptor. Reconstituted vesicles containing APP695 coupled to trimeric G proteins induced activation of G_0 after binding to an antibody based ligand mimic.[12,13] The antibody ligand mimic was the antibody, 22C11, which has the epitope of APP66–81.[14] G_0 activation typically leads to the initiation of downstream intracellular signalling pathways, such as apoptosis,[15] adenyl cyclase,[16] and phospholipase C.[17]

Neuritotropic activity

APP can promote neurite outgrowth. Rat neuroblastoma B103 cells transfected with soluble amyloid-precursor protein (sAPP), produced by the cleavage of APP within the amyloid-β sequence by α-secretase, can develop neurites faster than wildtype B103 cells.[18] It is proposed that this neuritotropic activity is mediated via the cell adhesion properties of APP.[18] Moreover, substratum-bound APP stimulates neurite outgrowth of cultured chick sympathetic neurons and mouse hippocampal neurons.[19] This activity is localized to N-terminal and C-terminal heparin-binding domains in the APP ectodomain.[19,20] The APLP2 ectodomain can also stimulate neurite outgrowth of chick sympathetic neurons with a similar activity to APP.[21]

Neuronal plasticity

In human cortical cell cultures APP can inhibit the influx of glutamate-induced Ca^{2+}, and thus attenuate neuronal excitability.[22] APP knockout mice have reactive gliosis and disrupted locomotor activity,[23] decreased levels of synaptophysin in the hippocampus,[24] impaired long-term potentiation (LTP)[25] and altered neuromuscular junctions,[26] implicating APP expression has an important role in neuronal function and synaptic plasticity.

Mitogen activated protein (MAP) kinase activation

APP can stimulate rat PC12 pheochromocytoma cells to upregulate activation of MAP kinase, thereby acting as a trophic factor for the phosphorylation of various cellular substrates.[27] The activation of MAP kinase by APP specifically phosphorylates the microtubule-associated protein, tau, a protein that is hyperphosphorylated in Alzheimer's disease as the neurofibrillary tangles.[27]

APP contains a phosphotyrosine-binding (PTB) motif, which is a sequence that interacts with Shc proteins.[28] This has led to the suggestion that APP could be involved in the modulation of cell survival, as Shc proteins are implicated in cellular and neuronal differentiation and proliferation through their involvement in the MAP kinase cascade.[29,30]

Copper chaperone

A significant body of data indicates APP and APLP2 have a physiological role in the modulation of copper homeostasis. APP has a copper-binding domain (CuBD; see 3D structure) located in the N-terminal cysteine-rich region[31,32] and the full-length protein as well as peptides derived from the CuBD, are able to coordinate

and reduce Cu^{2+} to Cu^{+}.[32–34] *In vivo*, APP and APLP2 knockout mice have significantly elevated copper levels in the cerebral cortex and liver.[35] Conversely, transgenic mice overexpressing APP have reduced copper levels in the brain.[36–38] These findings establish a role for APP in copper homeostasis. Moreover, the APP:Cu or APLP2:Cu complexes can regulate the metabolism of the heparin sulfate sidechains in the proteoglycan molecule glypican-1 both *in vitro* and *in vivo*.[39] This suggests glypican-1 is a molecular target for APP:Cu and APLP2:Cu. The tertiary structure of the APP CuBD is an α-helix packed over a triple strand β-sheet topology (PDB code: 1OWT).[40] This characteristic secondary structure is shared by three other proteins known to possess copper chaperone activity – the Menkes copper-transporting ATPase fragment (PDB code: 1AW0),[41] the metallochaperone Atx1 (PDB code: 1FES),[42] and the superoxide dismutase (SOD1) copper chaperone (PDB code 1QUP).[43]

AMINO ACID SEQUENCE INFORMATION

- *Homo sapiens* (human), APP, 695 aa[45,46] Primary accession number **Swiss-Prot accession number (SWP): P05067**

- *Homo sapiens* (human), APLP1, 650 aa[47] Primary accession number **SWP: P51693**

- *Homo sapiens* (human), APLP2, 763 aa[48–50] Primary accession number **SWP: Q06481**

- *Pan troglodytes* (chimpanzee), APP, 770 aa[51] Primary accession number **SWP: Q5IS80**

- *Caenorhabditis elegans* (worm), apl-1, 686 aa[52] Primary accession number **SWP: Q10651**

- *Drosophila melanogaster* (fruit fly), Appl, 887 aa[53] Primary accession number **SWP: P14599**

- *Mus musculus* (mouse), App, 770 aa[9] Primary accession number **SWP: P12023**

- *Rattus norvegicus* (rat), App, 770 aa[54] Primary accession number **SWP: P08592**

- *Narke japonica* (electric ray), el app, 699 aa[55] Primary accession number **SWP: O57394**

- *Fugu rubripes* (Japanese pufferfish), APP, 737 aa[56] Primary accession number **SWP: O93279**

PROTEIN PRODUCTION, PURIFICATION, AND MOLECULAR CHARACTERIZATION

APP has been purified from human cerebrospinal fluid (CSF) via ammonium sulfate fractionation,[57] and from human platelets, liver, spleen, kidney, heart, and adrenal using TS buffer (50 mM Tris, 150 mM sodium chloride), 5 mM ethylene diamine tetraacetic acid (EDTA), 2 mM phenylmethylsulfonylfluoride, 1 µg of leupeptin/ml, 10 µg of aprotinin/ml, 0.1 µg of pepstatin/ml, 1 µg of 7-amino-1-chloro-3-tosylamido-2-heptanone (TLCK)/ml, pH 7.6).[58] APP has been purified from rat brain using 1% Triton X-100 containing buffer.[59] APP has been extracted to varying levels from the cell culture media and lysates of human neuroblastoma (NB–SK–N–SH), human epithelial (HeLa),[60] rat chromaffin (C12),[60] and rat glial (C6) cells.[60] Recombinant APP has been expressed using adenovirus to infect rat cortical cultured neurons. Following adenoviral infection APP expression was high with no evidence of cell toxicity.[61] Structural and biophysical assays have used recombinant APP expressed in the methylotrophic yeast *Pichia pastoris*,[62] *Saccharomyces cerevisiae*,[63,64] *Escherichia coli*,[14,65] and *Spodoptera frugiperda* cells infected with recombinant APP- baculovirus.[66,67]

The longest APP isoform, APP770, has a calculated mass of 86 943 Da. In denaturing SDS-PAGE APP migrates at approximately 116 kDa.

APP has a multidomain structure (Figure 1). On the basis of structural-sequence predictions and alternative splicing APP consists of approximately nine domains and the domains have been named either numerically, or on the basis of their activity and sequence characteristics.[40,45,68] The N-terminal cysteine-rich domain (E1, D1–D2, (growth factor–like domain) GFLD–CuBD) region consists of the N-terminal GFLD and the adjacent CuBD and ZnBD (zinc-binding domain) (refer Figure 2).[19,40,69,70] This is followed by the acidic region, which is rich in glutamate and aspartate residues. Next are the alternatively spliced Kunitz protease inhibitor (KPI) and OX-2 domains followed by the E2/ central amyloid-precursor protein domain (CAPPD), which contains the RERMS sequence,[18,71,72] followed by the juxtamembrane domain, the transmembrane domain (TM) and finally the amyloid-precursor protein intracellular domain (AICD).[73,74] The amyloid-beta sequence is derived from the end of the juxtamembrane and into the transmembrane domain. These is a small cytoplasmic tail that contains a YENPTY sequence that corresponds to the NPXY motif commonly preferred by proteins with a PTB domain.[75,76] This motif forms a β-turn upon peptide binding, and is structurally favored by the groove located within PTB domains.[75] APP contains seven disulfide bonds all located in the N-terminal cysteine-rich region.

Activity and inhibition tests

Given the function of APP remains undefined, there are no established activity tests for APP, but various *in vitro* activities that can be used to assess these activities outlined above. These include neurite outgrowth,[19,21] cell adhesion, copper reduction[32,35] and inhibition of coagulation factors.[77]

Figure 2 X-ray structure of the GFLD domain (PDB code: 1MWP). Disulfide bridges are shown in light blue. (Figure prepared using the program MOLMOL.[44])

NMR AND X-RAY STRUCTURE

The structure of full-length APP has not been reported. Structural studies have mainly utilized isolated domains of APP to be solved by either NMR spectroscopy or X-ray crystallography. These domains are discussed from the N-terminus to the C-terminus of APP, with reference to Figure 2.

Growth factor–like domain (PDB code: 1MWP)

The crystal form of the GFLD of APP was generated from a construct consisting of residues 18–350 and expressed in *Pichia pastoris*.[69] This domain was crystallized by the hanging drop method at $22\,^{\circ}$C from 22% poly ethylene glycol (PEG) 10 000 and 0.1 M 4-(2-hydroxyethyl)-1-piperazineethanesulfonic acid (HEPES) at pH 7.5. Mass spectroscopy determined the crystals corresponded to a proteolytic-breakdown product consisting of residues 23–128. The crystals were of space group $P2_12_12_1$ with cell dimensions $a = 31.2\,\text{Å}$, $b = 48.6\,\text{Å}$, $c = 67.4\,\text{Å}$. The structure of the GFLD was calculated to 2.0 Å resolution.[69]

Copper-binding domain (PDB codes: 1OWT; 2FKZ)

NMR

The 3D structure of the CuBD was determined, and is shown in 3D structure (PDB code: 1OWT).[40] The region encompasses residues 124–189, and was expressed using *Pichia pastoris* as either uniformly ^{15}N-labeled or ^{15}N- and ^{13}C-labeled proteins.[40] The sample was made up of 0.5 mM protein in 20 mM phosphate buffer (pH 6.9) and 1 mM EDTA, and the spectra obtained at $30\,^{\circ}$C.[40] The final structure was based on the best 21 structures after energy minimization.

Crystallization

The APP CuBD has been crystallized and the structure solved (PDB code: 2FKZ). The domain encompassing residues 133–189 was expressed in *Pichia pastoris,* and crystallized by the hanging drop method at room temperature in 0.1 M HEPES at pH 8.0 and 28%–32% w/v PEG 10 000.[78,79] Data was collected at cryogenic temperatures to 1.6 Å resolution by cryoprotecting the crystals and the structure was determined by molecular replacement using the lowest-energy NMR structure (PDB code: 1OWT) as a probe model. The space group of the crystals was $P2_12_12_1$ with cell dimensions, $a = 31.3\,\text{Å}$, $b = 32.5\,\text{Å}$ and $c = 50.2\,\text{Å}$.

The Cu-bound form of the APP CuBD could not be co-crystallized, and therefore the structure was obtained by soaking Cu^{2+} ions into the apo APP CuBD crystals (PDB code: 2FK1). The apo CuBD crystals was soaked in 5 M NaCOOH, 100 mM $CuCl_2$ for 30 min, then back-soaked in 5 M NaCOOH with 12% (v/v) glycerol as a cryoprotectant and 200 mM $K_3Fe(CN)_6$ to ensure minimal reduction of Cu^{2+}. The structure of Cu^+ bound to APP CuBD was determined from crystals obtained as described for Cu^{2+}, but back-soaked in 5 M NaCOOH containing 10 mM ascorbate for 10 min to reduce the Cu^{2+} to Cu^+ (PDB code: 2FK2). The space group of the Cu-bound APP CuBD crystals was $P2_12_12_1$. Cu^{2+}-bound crystals had cell dimensions, $a = 31.4\,\text{Å}$, $b = 32.5\,\text{Å}$ and $c = 50.4\,\text{Å}$, while Cu^+-bound crystals were, $a = 31.4\,\text{Å}$, $b = 32.6\,\text{Å}$ and $c = 50.4\,\text{Å}$.

Kunitz protease inhibitor domain (PDB code: 1AAP)

The APP KPI domain was expressed in *E. coli* from a plasmid containing a synthetic gene corresponding to the KPI sequence. Crystals were grown via vapor diffusion at $20\,^{\circ}$C from a solution containing 10 mM sodium acetate at pH 6.5 and 25% magnesium sulfate. The space group of the KPI crystals was $P2_12_12_1$ with cell dimensions, $a = 35.6\,\text{Å}$, $b = 38.9\,\text{Å}$ and $c = 73.6\,\text{Å}$. Data was collected at 1.5 Å.[72]

E2 domain (PDB code: 1RW6)

The APP E2 domain corresponded to residues 346–551 cloned into the expression vector pET28a and was expressed in *E. coli*.[73] The E2 domain was crystallized by the hanging drop method at room temperature in a solution containing 2.0 M NaCl and 0.1 M sodium acetate at pH 4.5.[73] The E2 crystal had a space group of I422 with cell dimensions, $a = 84\,\text{Å}$, $b = 84\,\text{Å}$ and $c = 147\,\text{Å}$.

CAPPD (PDB code: 1TKN)

The region encompassed by residues 365–658, which corresponds to the CAPPD and overlaps with the E2

domain (PDB code: 1RW6), was solved by NMR spectroscopy. This region was expressed as either a uniformly [15]N-labeled or [15]N- and [13]C-labeled glutathione-s-transferase (GST) fusion protein in the pGEX-KG bacterial expression vector and following purification was cleaved from GST by thrombin cleavage.[74] NMR spectra was obtained with a sample containing 0.85 mM protein, 50 mM sodium phosphate (pH 6.4), 250 mM NaCl and 300 mM guanidinium chloride at 27 °C.[74]

Amyloid-β (PDB code: 1BA4)

The APP domain encompassing residues 681–715, which corresponds to residues 10–35 of the amyloid-beta peptide, has been ascertained by NMR. Synthetic peptides were used, prepared using the 9-fluorenylmethoxycarbonyl (Fmoc) strategy and labelled for spectra acquisition by substituting the corresponding isotopically labelled reagents during synthesis.[80] Samples were made up of 0.25 mM peptide in either 100% D_2O or 90% H_2O:10% D_2O, containing 0.5 mM trimethylsilyl propionate (TCP) at pH 7.4, and data acquired at 20 °C.[80]

Most solution structures have been determined using small fragments of the peptide and in acidic pH conditions to maintain solubility, making it difficult to assess the physiological relevance of the structures. To date the longest fragment of the peptide to be solved is Aβ1–40 in sodium dodecyl sulfate (SDS) micelles to mimic the physiological membrane environment and also to avoid aggregation.[81] 1 mM of peptide was prepared in a sample containing 100 mM SDS in 90% H_2O or 10% D_2O at pH 5.1 and NMR spectra were acquired at room temperature. This structure presents itself as two α-helices (Aβ residues 15–24 and residues 28–36) separated by a 'helix-breaker' region (residues 25–27) (Figure 3), similar to that resolved for Aβ1–40 in 40% trifluoroethanol (TFE) at pH 2.8 and Aβ1–28 in SDS micelles at pH 3[82] and pH 5–6.[83,84]

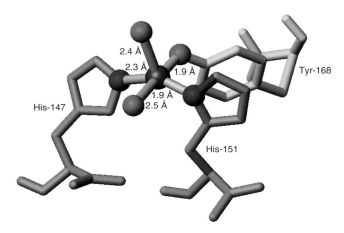

Figure 3 Cu^{2+} bound to APP CuBD with copper ligand bond distances. (Figure prepared using the program MOLMOL.[44])

OVERALL DESCRIPTION OF THE STRUCTURE

Growth factor–like domain

The GFLD domain (PDB code: 1MWP) consists of nine β-strands and one α-helix, which fold into a compact, globular domain of dimensions 45 Å × 30 Å × 30 Å (Figure 2).[69] This domain has three disulfide bridges that act to provide support to the structure. One disulfide bridge between Cys98 and Cys105 links the β6 and β7 strands to form a hairpin loop. This long and flexible loop is highly charged with basic residues, and is implicated in proteoglycan binding, not unlike similar regions found in other growth factors.[85,86] Interestingly, this domain also contains a large hydrophobic patch, which is conserved across the APP family and vital for protein–protein interaction, and suggests a role in binding to carbohydrates and proteoglycans.[69]

Copper-binding domain (CuBD)

The CuBD structure consists of an α-helix (corresponding to residues 147–159) supported by a triple-stranded β-sheet (corresponding to residues 133–139, 162–167, and 181–188) (see 3D structure).[40] Disulfide bridges link Cys133–Cys187, Cys158–Cys186, and Cys144–Cys174.[40] Cys133–Cys187 connects strands β1 to β3, while Cys158–Cys186 links the α-helix to β3. A hydrophobic core consisting of Leu136, Trp150, Val153, Ala154, Leu165, Met170, Val182, and Val185 act to stabilize the structure.[40] It was proposed that His147, His151, Tyr168, and Met170 were the ligands involved in metal-binding, corresponding to a tetrahedral coordination sphere, which is generally preferred by Cu^+ ions. The APP Cu coordination site is surface-exposed, and the domain bears strong overall structural similarities to that of other copper chaperones albeit containing a unique Cu-binding site, thus supporting APP having a role in copper homeostasis.

The crystal structure of the APP CuBD (PDB code: 2FK1) bound to Cu showed that Cu^{2+} binding involved His147, His151, Tyr168, an equatorial water molecule at 1.4 above the plane of the amino acids as well as an axially bound water (Figure 3).[78] This binding site resembles the classical square pyramidal geometry commonly adopted by five-coordinate Cu^{2+} typified by the Type 2 nonblue Cu center. The crystal structure of Cu^+ bound to APP CuBD was found to be similar to that of Cu^{2+}:CuBD, with the exception of the axial water, thus giving a distorted square-planar geometry.

Earlier NMR and EPR studies of the APP CuBD suggested that the S of Met170 was the fourth ligand coordinating Cu^{2+} in the binding site. However, the X-ray crystallography data indicated the $C^ε$ of Met170 to be

5.8 Å from the Cu metal-ion, while the S is 7 Å away and thus less favorable for Cu-binding.[79] It was proposed that instead of acting as a donor ligand, Met170 could act as an electron donor to Cu^{2+} by bringing the S physically closer to Cu^{2+} or by relaying the electron through S to Cu^{2+}. This phenomenon would resemble that of Cu^{2+} reduction by Aβ, whereby a methionine is proposed to provide the electron for Cu^{2+} reduction via a tyrosine ligand.[87,88] However, it is also likely that artifacts due to crystal packing could have influenced the coordination geometry about the metal.

Kunitz protease inhibitor domain

Kunitz inhibitors are characterized by their strong binding to proteases with an observed dissociation constant of 6×10^{-14} M for bovine pancreatic trypsin inhibitor (BPTI) trypsin binding.[89] The specificity of binding is governed by the two binding loops in the KPI sequence, corresponding to residues 297–305 and 320–325 (Figure 4).[72] These residues form the interface between these inhibitors and their protease targets, and Arg-301 has been identified as the primary determinant of KPI specificity.[72] Gly325 and Gly326 adopt a backbone dihedral angle conformation, while the side chain of Asn-327 forms H-bonds with Gln294 and Asn329.[72] This Gly–Gly–Asn motif is extremely conserved in the Kunitz inhibitor family of proteins,[90] and it is believed that Gly-326 and Asn-327 influence the specificity of binding by altering the geometry of Gly325. This KPI domain also contains a large hydrophobic patch, primarily involving Met303 and Phe320, further suggesting that ligand binding entails nonpolar residues.[72]

E2/CAPPD domain

The E2 domain is a highly conserved domain in the APP family. It is an independently folded structure, and contains two distinct coiled-coil substructures made up of six α-helices.[73] The N-terminal portion of this domain contains a double-stranded coiled-coil structure formed by αB and αC strands that bear no apparent helical twist. The C-terminal end consists of a triple-stranded antiparallel coiled-coil, with αC and αE in parallel and αD in the opposite orientation.[73] Unlike the N-terminal, this helical bundle contains a left-handed twist commonly found in coiled-coil structures. The N- and C-terminal helical substructures are linked by a continuous central helix consisting of 56 residues and a distance of 90 Å, and thus have no direct interactions. The unique fold of this E2 domain appears to be evolutionary conserved in the APP family, and intriguingly is similar to that of spectrin,[91] α-actinin[92] and the β-catenin binding domain of α-catenin.[93] In solution, as well as in the crystalline state, the E2 domain was dimeric. This dimerization appears to be driven by the packing of a cluster of 24 crucial residues, including 10 hydrophobic residues, at the interface where the αB and αC helices intersect with αD and αE of the dimeric partner. At the concave face of this dimer lies a patch of positively charged residues that form a groove, where it is postulated that proteoglycans could bind.[73]

The CAPPD domain is made up of four α-helices connected via short loops and turns (Figure 5).[74] The 3D structure had three helices (HA, HB, and HC) that form a tight elongated 'up-and-down' bundle with the fourth helix (HD) packed across the top of this bundle. Helix HC contains within the structure an N-glycosylation site that is conserved in the APP- superfamily of proteins.[74]

Amyloid-β

Aβ binds to Cu[94] and the Cu-binding site on Aβ coordinates the metal-ion via the imidazole rings of His6, His13, His14, and an as yet unidentified fourth ligand, possibilities include Tyr10, carboxylate sidechains of Glu1 and Glu11 or the N-terminal of the peptide (Figure 6).[95,96] In phosphate buffered saline (PBS) buffer there is strong data to support the role of bridging histidine residues in Cu-binding to generate a coordination environment similar to the active site of the SOD-1 protein (PDB code: 1SOS). The bridging histidines are also important in oligomerization and membrane penetration.[88,97] Binding of Cu to Aβ causes increased aggregation of Aβ, especially at below neutral pH levels, and chelation of Cu completely reverses this effect.[94] Cu-bound Aβ demonstrates redox activity, and the major residues implicated in the reduction of Cu^{2+} are the histidine residues, Tyr10 and Met35. The reduction of Cu^{2+} to Cu^+ by Met-35 leads to the release of hydroxyl radicals and formation of hydrogen peroxide (H_2O_2) This reaction is important for Aβ's neurotoxic activity.[98] The binding of Cu^{2+} via histidine residues coordinates Cu and brings it in close contact with Met35, thereby facilitating the reduction mechanism.

Figure 4 X-ray structure of the KPI domain (PDB code: 1AAP). (Figure prepared using the program MOLMOL.[44])

Figure 5 NMR structure of the CAPPD domain (PDB code: 1TKN). (Figure prepared using the program MOLMOL.[44])

To further characterize the Cu-binding properties of Aβ, NMR studies were carried out using synthetic Aβ1–16 peptides bound to Cu^{2+}.[99] Given the paramagnetism of Cu^{2+}, it is difficult to fully elucidate the structure of copper bound to the peptide. However, it was possible to determine the ligands that were directly involved in Cu-binding. It was shown that Aβ coordinates Cu^{2+} via Tyr10 and the imidazole rings of His6, His13, and His14 in a square-planar arrangement.[99] It is believed that the metal coordination geometry is heavily dependent on pH, as an increase in pH led to a gradual transition from a 3 N complex to that of 4 N at pH 9.0.[100]

The solution structure of Aβ1–42 in a mixture of (hexafluroisopropanol) HFIP/H_2O was determined (PDB code: 1ZOQ)[101] and it was found that HFIP (making up at least 20% of the mixture) was capable of retaining the

Figure 6 NMR structure of Aβ1–40 (PDB code: 1BA4). Highlighted are His-6, His-13 and His-14 (red), the proposed fourth ligand, Tyr-10 (yellow) and Met-35 (magenta) implicated in Cu^{2+} reduction. (Figure prepared using the program MOLMOL.[44])

α-helical conformation of the peptide in solution, and that decreasing the concentration of HFIP (less than 10% of mixture) led to the gradual transition to β-sheet. It was observed that Aβ1–42 contains two helical regions; a long one encompassing residues 8–25, and a shorter one between residues 28–38. The transition from an α-helix to that of β-sheet is indicative of aggregation and involved a loss of the β-turn structure around residues 25, 26, and also partially that of the C-terminal helix. This is in accordance with other findings that implicate the importance of residues 25–35.[102]

Aβ is capable of binding to Zn, and the formation of Aβ/Zn complexes promoted aggregation. The Zn-binding domain has been mapped to residues 6–28 of Aβ.[103,104] The solution structure of Zn-binding to Aβ1–16 has been solved and this peptide undergoes a conformational transformation upon binding Zn in a 1:1 ratio in 50 mM sodium phosphate buffer at pH 6.5 (PDB code: 1ZE7).[105] Upon Zn binding the Aβ1–16 structure became more compact, with His6, His13, His14, and Glu11 peaks broadening, indicative of their active involvement in the conformation change.[105] It was concluded that Zn(II) associates with the peptide in a tetrahedral coordination.[105]

APP ectodomain

Small angle X-ray scattering (SAXS) has been applied to the analysis of the two main APP ectodomains, sAPP695 and sAPP770. This has allowed *ab initio* reconstruction of molecular models to identify the overall shape of the APP ectodomain and the organization of distinct structural domains.[106] While both APP ectodomains exhibited an elongated shape, the two isoforms differed in their overall shape. The ectodomains have considerable conformational flexibility indicative of flexible regions connecting the structurally defined domains.[106–108] *Ab initio* modelling of the SAXS data and sedimentation velocity ultracentrifugation indicated the N-terminal cysteine-rich region, composed of

the growth factor–like domain and the CuBD, had an elongated dumbbell shape and the two domains are connected by a highly flexible linker.[106]

FUNCTIONAL ASPECTS

Growth factor–like domain

The N-terminal GFLD of APP has been implicated in the stimulation of neurite outgrowth,[19] the regulation of synaptogenesis[109] and synaptic transmission.[110] In line with this, several studies have suggested that APP was capable of binding to the extracellular matrix (ECM),[111] including components such as the basement membrane form of heparin sulfate proteoglycan (HSPG),[112] heparin,[113] laminin,[114] and collagen (IV).[115] The interaction of APP with these ECM proteins might be facilitated by the cysteine-rich GFLD, where a heparin-binding site has been postulated to reside.[19] The disulfide bridge formed between Cys98–Cys105 is critical in maintaining the conformation of the binding site, and preserves the mobility of the predominantly β-hairpin loop surface. It was proposed that this surface can accommodate an octasaccharide fragment of heparin, where the flexibility of this surface allows an induced-fit binding around the sulfate residues of the carbohydrate.[69] Adjoining this heparin-binding domain lies a large surface hydrophobic patch consisting of the residues Met36, Phe37, Ile69, Pro109, Phe111, Val112, Ile113, and Tyr115, which is conserved across the APP family.[69] This conservation points to an important function by this domain in the APP family and possibly involves the dimerization of APP either via a direct APP–APP interaction or in the presence of an ECM protein.[19,69,106]

APP CuBD

The APP family has a clear role in the binding and modulation of copper homeostasis. This activity is mediated via a CuBD located in the N-terminal cysteine-rich region.[32,35] Both full-length APP, as well as peptides to the CuBD, can bind and reduce Cu^{2+} to Cu^+.[32,34] Whilst the CuBD sequence is similar among the APP family paralogues and orthologues, this does not correlate with an overall conservation in its activity. Peptide sequences based on the human APP, Xenopus APP, and human APLP2 CuBDs can induce Cu-mediated toxicity.[34] This activity is dependent on the conservation of the histidine residues at positions corresponding to 147 and 151 of human APP. In contrast, APP orthologues with different amino acid residues at these positions had altered Cu phenotypes. The corresponding *C. elegans* APL-1 CuBD, which has tyrosine and lysine residues at positions 147 and 151, respectively, strongly protected against Cu-mediated neurotoxicity *in vitro*. Mutating the human APP CuBD histidines 147 and 151 with tyrosine and lysine residues conferred this neuroprotective Cu phenotype to human the APP, APLP2, and, Xenopus APP CuBD peptides. Conversely the APL-1 protective peptide could be converted into a toxic peptide by changing the tyrosine and lysine residues to histidines. The toxic and protective CuBD phenotypes are associated with differences in Cu-binding and reduction amongst the APP family paralogues and orthologues.[34,116] Therefore there is a significant evolutionary change in the function of the CuBD in modulating Cu metabolism.

APP and APLP2 expression has a clear physiological effect on Cu homeostasis *in vivo* since APP and APLP2 knockout mice have significantly elevated copper levels in the cerebral cortex and liver.[35] Conversely, APP overexpressing transgenic mice demonstrate significantly reduced copper levels in the brain.[36–38] *In vitro*, Cu homeostasis is also dependent upon APP/APLP2 expression levels since primary cortical neurons or embryonic fibroblasts derived from APP/APLP2 knockout mice have increased Cu levels when exposed to Cu.[117]

A molecular target for the APP:Cu or APLP2:Cu complexes is the proteoglycan molecule glypican-1 where both *in vitro* and *in vivo* APP and APLP2 can regulate the nonenzymatic metabolism of the glypican-1 heparin sulfate sidechains in a copper dependent manner.[39] Interestingly, APP but not APLP2 stimulates glypican-1 autodegradation in the presence of both Cu(II) and Zn(II) ions, whereas the Cu(I) form of APP and the Cu(II) and Cu(I) forms of APLP2 inhibit autodegradation.[39]

Importantly, Cu affects APP metabolism, where an increase in the Cu concentration results in a reduction in Aβ levels in cell culture.[118] This effect also occurs *in vivo* where increasing brain Cu levels by either diet (Cu feeding) or genetically (expressing a mutant ATPase7b transporter, which elevates Cu levels) reduced Aβ in the brain.[37,38] This suggests that altering Cu homeostasis has therapeutic potential by altering APP processing into Aβ.

E2, CAPPD, D6a domain

This domain of APP can bind HSPG with higher affinity than the GFLD.[73] This region is an independently folded structure, with a HSPG-binding site and the pentapeptide RERMS sequence, residues 384–388, implicated in the cell growth and differentiation of APP.[119,120] It forms an antiparallel dimer in crystalline and solution states, presumably because of the arrangement of a cluster of hydrophobic residues at the dimer interface, where the αB and αC helices of one monomer interacts with the αD and αE of the second monomer.[73] The residues at this hydrophobic dimeric interface appear to be remarkably conserved across the APP family of proteins, strongly implying the physiological existence of APP as dimers is mediated via the E2 domain.[40,69,72,73,121,122] On the

concave face of this dimer lies a groove consisting of positively charged residues. This groove may participate in HSPG and heparin-binding, with greater affinity to that of the GFLD. The HSPG-binding site appears to be structurally different to that of the GFLD, and the greater binding affinity can be attributed to the elongated concave surface that provides a larger protein surface for carbohydrate binding.[73] It was noted that while the residues for HSPG-binding in the E2 domain are conserved across the APP superfamily, those involved in the N-terminal domain are not.[73] An alternative ligand for this domain is the sorting receptor sorLA.[123,124] Plasmon surface resonance studies established a strong (300 nM) interaction between this domain of APP and the complement-type repeat domain of the sorLA protein.[124] This is a functionally important interaction since sorLA modulates APP trafficking and processing. A decrease in sorLA expression results in increased Aβ levels and sorLA expression is reduced in Alzheimer disease patient brains.[123,125]

Similar to the APP E2 domain, both spectrin and α-actinin exist as antiparallel dimers and have two coiled-coil helices that facilitates flexibility of the dimers.[91,93] A comparable function has also been observed in the APP E2 domain, where the coiled-coil helices are thought to provide support to the oligomeric structure of APP.[73] The presence of a unique helical hairpin in these structures lends further support to the notion that APP exists as a dimer in physiological conditions.[106,121,122] In α-catenin, this helical hairpin is shown to be involved in homodimerization or as a mode of interaction with β-catenin.[92] Moreover, the antiparallel triple-stranded helical coiled-coils present in the E2 domain of APP exists only in the spectrin family.[126] The hydrophobic patch present in this region could serve to stabilize the interaction of these coiled-coils.[126] The implications of these similarities have yet to be determined, and while it suggests a conserved function between these proteins, more studies need to be performed to elucidate the basis of this correlation.

Aβ peptide

The Aβ peptide can coordinate Cu, and Aβ–Cu^{2+} complexes are known to mediate the aggregation propensities of the peptide.[94,127] Copper is a redox active metal, and Aβ is capable of reducing Cu^{2+} to Cu^{+}, generating reactive oxygen species and hydroxyl radicals that are toxic to cells.[98] The Aβ:Cu complex can exist with a binuclear Cu^{2+} center, where the formation of histidine bridges facilitates the coupling of Cu^{2+} ions via dipolar interactions. The Cu^{2+}: Aβ molar ratio can affect Aβ aggregation where a ratio above 1:0.5, resulted in the parallel appearance of $g \sim 2$ and $g \sim 4$ resonances by EPR spectroscopy, indicative of the existence of a binuclear Cu^{2+} center.[97] On the basis of computer simulations, the two Cu^{2+} coordination geometries are structurally identical,

in a tetrahedrally distorted square-planar configuration.[128] The Cu^{2+} ions were determined to be 6.2 ± 0.2 Å apart, with the two ions bridged by histidines much like that observed in the active site of SOD 1.[129] The functional consequences of this structure is suggested by the formation of histidine bridges between Cu^{2+} ions correlating with toxicity.[97] Intriguingly, this correlation was independent of the formation of amyloid fibrils.

ELECTRON PARAMAGNETIC RESONANCE (EPR) STUDIES

The crystal structure of APP CuBD bound to Cu^{2+} implicates the involvement of two histidine, a tyrosine, and two water molecules.[79] This binding site was found to resemble a classical square pyramidal geometry favored by Type 2 nonblue Cu centers. Using EPR to further elucidate the coordination geometry of Cu^{2+} bound to the CuBD, a solution of 2 mM APP CuBD +1.2 mM $CuCl_2$ had only one type of Cu^{2+} binding site with Cu^{2+} coordinated by $2N_2O$. A high $g_{//}$ value of 2.296 (compared to ~ 2.25) suggests a square-planar coordination geometry in the equatorial plane, with a possible distortion of the equatorial ligands toward a more tetrahedral configuration with the presence of an apical ligand.[40,79] Using 0.3 mM $^{65}Cu^{2+}$ bound to 0.5 mM CuBD (residues 133–189) in 20 mM phosphate buffer pH 6.9 demonstrated a high affinity 2NSO coordination sphere, with a distortion away from the square-planar geometry toward a tetrahedral arrangement, suggesting a preference for Cu^{+} coordination.[40]

EPR has been used to study the coordination of Cu to Aβ1–16, Aβ1–28, Aβ1–40, and Aβ1–42 peptides. The ligand donor atom set to Cu is 3N1O, implicating His6, His13, His14, and possibly the Tyr10 in the binding of Cu.[88,130,131] However, the role of Tyr10 is still controversial, as EPR spectra of Cu-bound to an Aβ peptide with a Y10F mutation appeared to be similar to that of wild type Aβ peptides.[132] It was proposed that the O-atom donor ligand is from water, providing an equatorial coordination sphere for Cu-binding. However, it was observed that when fibrils were assembled in $H_2^{16}O$ or $H_2^{17}O$, the resulting EPR signal was not broadened.[132] This abrogates the involvement of water as the O-atom donor ligand, and leaves the identity of this ligand still unresolved. Truncation of the N-terminal residues changed the coordination geometry of Cu-bound to Aβ, implicating the importance of the N-terminus to Aβ Cu-binding, possibly involving a role for Asp1 or Glu3.[100,131,132]

Much of the controversy surrounding the coordination of Cu^{2+} to Aβ and subsequently the identity of the fourth ligand stems from the use of variable buffer conditions and Cu sources in the different studies.[97,133] The presence of NaCl has a profound effect on the oligomerization of Aβ,[134,135] while the use of phosphate buffers conferred

different results compared with ethylmorpholine and Tris-based buffers.[97,131,136] Being pleiomorphic in nature, the structural characteristics of Aβ largely depend on the environment to which it is exposed and thus caution is needed before obvious conclusions are drawn from experimental data.

CATALYTIC MECHANISMS

The redox chemistry associated with the coordination of Cu^{2+} to Aβ can lead to the formation of covalent dityrosine cross links between Aβ peptides to form soluble oligomeric structures, which may represent the toxic species in Alzheimer's disease.[87] A role for Tyr10 in Aβ/Cu redox chemistry has been implicated by density functional theory calculations that suggest a mechanism in which proton-coupled electron transfer from a reducing substrate to the side chain oxygen of Tyr10 causes the reduction of Cu^{2+} to Cu^+. Then, the dioxygen coordinates to Cu^+, reducing it to superoxide and subsequently Tyr10 donates a second electron from its side chain hydroxyl hydrogen atom to superoxide via hydrogen atom transfer. Concurrently, H_3O^+ donates its proton to superoxide via proton transfer and leads to the formation of Tyr10 radicals and H_2O_2.[87] Mutating Tyr10 to an alanine rendered the Aβ 42 mutant peptide nontoxic to primary cortical neurons.[87]

COMPARISON WITH RELATED STRUCTURES

The CuBD of APP shares a similar fold to that of other known copper chaperones. Figure 7 illustrates this by showing a comparison of the APP CuBD to that of a known metallochaperone, Hah1 (PDB code: 1TL4).[137] However, the sites of metal coordination differ significantly. The CuBD presents as an α-helix packed over three β-sheets. In most of the known copper chaperones, a consensus fold is observed as an 'open-faced β-sandwich', with metal-ion specificity dictated by the residues surrounding the metal-binding loop, which is capable of influencing the conformation and flexibility of this fold.

In Menkes disease, the copper chaperone for superoxide dismutase (CCS) coordinates copper using the conserved MXCXXC motif,[138–140] as occurs in other copper chaperones such as Atx1.[141] CCS functions to deliver copper to the Cu, Zn superoxide dismutase I (SOD1), a protein found to be inactivated in Menkes disease.[142,143] CCS exists as a homodimer, and has two functional domains.[43] Domain I consists of two α-helices and one four-stranded β-sheet arranged in a βαββαβ fold. Domain II consists of an antiparallel eight-stranded β-barrel, two α-helices, and five connecting loops.[43]

Atx1 is another copper chaperone implicated in the transport of copper to the Menkes and Wilson disease

Figure 7 Comparison of the APP CuBD fold to that of the copper chaperone Hah1 (PDB code: 1TL4). Both structures show an α-helix packed over a triple-stranded antiparallel β-sheet arrangement. (Figure prepared using the program MOLMOL.[44])

proteins. Atx1 contains one copy of the conserved MXCXXC sequence motif, and coordinates Hg(II) and Cu(I) in a similar manner. The X-ray crystal structure determined for Atx1 showed that the metal-binding site is surface-exposed, and the metal-ion is coordinated by two cysteine residues (Cys15 and Cys18) in a linear fashion.[144] The metal-binding site presents a similar βαββαβ fold, seen in the CCS protein, and also possesses a hydrophobic core as found in the CuBD of APP, believed to be important for electron transfer. A cluster of lysine residues residing on the surface of the protein could be involved in the interaction with its binding target, Ccc2.[144] Interestingly, the APP CuBD contains Lys155 and Lys158 that appear to lie in similar orientations to the Lys24 and Lys28 on Atx-1.[40] This could have important functional implications, but further studies are needed to establish this.

The CuBD of APP differs from other Cu chaperones in that Cu is coordinated via two histidines, a tyrosine, and a fourth ligand. The coordination of Cu by histidines is not unusual and occurs in blue copper proteins that coordinate copper in a tetrahedral arrangement via two histidines, a methionine, and a cysteine residue.[145,146] The Cu-binding site in the APP CuBD is surface-exposed,

a property that could ensure sequestration of Cu upon binding. This is rather unique, as Cu(I) binding sites are usually hidden in proteins to discourage the generation of reactive oxygen species upon exposure, and are only exposed upon metal-binding.[42] However, other copper chaperones also exhibit a similarly surface-exposed Cu(I) site and it is believed the chaperone forms an intermolecular complex with the target protein thus enabling a thermodynamically and kinetically favorable ligand exchange phenomenon.[147,148]

PROTEIN INTERACTION

The APP ectodomain interacts with a range of ligands, in particular HSPGs and sorLA as described in the preceding sections. There are a number of binding proteins that interact with the APP cytoplasmic domain (reviewed by Kerr and Small[149]) and are outlined below.

APP contains an internalization motif that is present in the C-terminal domain, known as the YENPTY motif. This sequence is essential for efficient sorting of APP along its processing pathway.[150] The YENPTY motif is of particular interest as it contains the conventional NPXpY sequence that functions as a ligand for interacting proteins containing the phosphotyrosine-binding (PTB) domain.[76]

Using co-immunoprecipitation, APP interacts with the neuronal adaptor proteins, X11 and Fe65, via their PTB domains although there was no evidence to suggest a need for tyrosine phosphorylation in the interaction.[151] However, X11 and Fe65 have different binding sites on the YENPTY motif, and while their target sites might overlap, their different binding specificities suggests a mechanism whereby interacting proteins compete to influence the path of APP processing.

Another APP interacting protein was discovered using the yeast two-hybrid method, known as the jun N-terminal kinase (JNK)-interacting protein-1 (JIP-1).[152] Similar to X11 and Fe65, JIP-1 also contains a PTB domain and thus Tyr682, Asn684, and Tyr687 were crucial to this interaction. Intriguingly, just like the interaction with X11 and Fe65, tyrosine phosphorylation did not seem to be required for binding. JIP-1 may function as a scaffold protein, linking APP to JNK, thus implicating a role for APP in the JNK–signal transducer and activator of trypsin (STAT) signalling pathway.[152] However, it also emerged that JIP-1 can modulate the processing and maturation of APP, independent of its role in JNK signalling regulation.[153]

Using co-immunoprecipitation and GST pulldown assays, the Shc A and Shc C proteins interacted with APP.[28] In these interactions, Tyr682 phosphorylation was necessary to facilitate binding, and may potentiate coupling of APP to the intricate network of intracellular signalling pathways.[28]

In a yeast two-hybrid screen the Dab1 protein from the *disabled (dab)* gene family interacted with APP.[154,155]

Dab1 contains a PTB domain, however unlike other PTB domains, phosphorylation of tyrosine is not essential in its interaction with APP.[155] In fact, tyrosine phosphorylation reduces the binding affinity of Dab1 to APP by 250-fold. This interaction may serve to facilitate regulation of trafficking and processing of APP.[155]

Besides the NPXY motif, APP also contains a basolateral sorting signal (KKKQYTSIHHG) in the juxtamembrane region of the cytoplasmic domain capable of interacting with other proteins.[156] A yeast two-hybrid assay yielded a novel protein termed PAT1 (Protein interacting with APP Tail 1) as a potential APP interactor.[157] PAT1 is a cytosolic protein involved in membrane trafficking and is also capable of binding microtubules. Accordingly, it is suggested that the interaction of APP with PAT1 could mediate the trafficking of APP along the microtubules and could trigger their inclusion in transport vesicles budding form the trans-Golgi network.[157]

The binding of these proteins to the cytoplasmic domain has particular importance as this domain is released following γ-secretase cleavage of APP.[158] The released domain, termed APP intracellular cytoplasmic domain (AICD), can migrate to the nucleus[159,160] where it can alter the transcription of target genes including it's own expression.[161] Therefore, these binding proteins could be important for the regulating transport and nuclear activity of the AICD.

REFERENCES

1 C Haass, MG Schlossmacher, AY Hung, C Vigo-Pelfrey, A Mellon, BL Ostaszewski, I Lieberburg, EH Koo, D Schenk, DB Teplow and DJ Selkoe, Nature, **359**, 322–325 (1992).

2 CL Masters, G Simms, NA Weinman, G Multhaup, BL McDonald and K Beyreuther, Proc Natl Acad Sci U S A, **82**, 4245–4249 (1985).

3 CL Masters, G Multhaup, G Simms, J Pottgiesser, RN Martins and K Beyreuther, EMBO J, **4**, 2757–2763 (1985).

4 D Allsop, M Landon and M Kidd, Brain Res, **259**, 348–352 (1983).

5 R Sandbrink, CL Masters and K Beyreuther, J Biol Chem, **269**, 14227–14234 (1994).

6 R Sandbrink, CL Masters and K Beyreuther, J Biol Chem, **269**, 1510–1517 (1994).

7 RE Tanzi, JF Gusella, PC Watkins, GA Bruns, P St George Hyslop, ML Van Keuren, D Patterson, S Pagan, DM Kurnit and RL Neve, Science, **235**, 880–884 (1987).

8 RL Neve, EA Finch and LR Dawes, Neuron, **1**, 669–677 (1988).

9 T Yamada, H Sasaki, H Furuya, T Miyata, I Goto and Y Sakaki, Biochem Biophys Res Commun, **149**, 665–671 (1987).

10 T Yamada, H Sasaki, K Dohura, I Goto and Y Sakaki, Biochem Biophys Res Commun, **158**, 906–912 (1989).

11 J Herms, B Anliker, S Heber, S Ring, M Fuhrmann, H Kretzschmar, S Sisodia and U Muller, EMBO J, **23**, 4106–4115 (2004).

12 T Okamoto, S Takeda, Y Murayama, E Ogata and I Nishimoto, J Biol Chem, **270**, 4205–4208 (1995).

3 I Nishimoto, T Okamoto, Y Matsuura, S Takahashi, Y Murayama and E Ogata, *Nature*, **362**, 75–79 (1993).

4 A Weidemann, G Konig, D Bunke, P Fischer, JM Salbaum, CL Masters and K Beyreuther, *Cell*, **57**, 115–126 (1989).

5 U Giambarella, T Yamatsuji, T Okamoto, T Matsui, T Ikezu, Y Murayama, MA Levine, A Katz, N Gautam and I Nishimoto, *EMBO J*, **16**, 4897–4907 (1997).

6 BD Carter and F Medzihradsky, *Proc Natl Acad Sci U S A*, **90**, 4062–4066 (1993).

7 TM Moriarty, E Padrell, DJ Carty, G Omri, EM Landau and R Iyengar, *Nature*, **343**, 79–82 (1990).

8 L Jin, H Ninomiya, J Roch, D Schubert, E Masliah, D Otero and T Saitoh, *J Neurosci*, **14**, 5461–5470 (1994).

9 DH Small, V Nurcombe, G Reed, H Clarris, R Moir, K Beyreuther and CL Masters, *J Neurosci*, **14**, 2117–2127 (1994).

20 HJ Clarris, R Cappai, D Heffernan, K Beyreuther, CL Masters and DH Small, *J Neurochem*, **68**, 1164–1172 (1997).

21 R Cappai, SS Mok, D Galatis, DF Tucker, A Henry, K Beyreuther, DH Small and CL Masters, *FEBS Lett*, **442**, 95–98 (1999).

22 MP Mattson, B Cheng, AR Culwell, FS Esch, I Lieberburg and RE Rydel, *Neuron*, **10**, 243–254 (1993).

23 H Zheng, M Jiang, ME Trumbauer, DJS Sirinathsinghji, R Hopkins, DW Smith, RP Heavens, GR Dawson, S Boyce, MW Conner, KA Stevens, HH Slunt, SS Sisodia, HY Chen and LH Van der Ploeg, *Cell*, **81**, 525–531 (1995).

24 JE Hamos, LJ DeGennaro and DA Drachman, *Neurology*, **39**, 355–361 (1989).

25 GR Dawson, GR Seabrook, H Zheng, DW Smith, S Graham, G O'Dowd, BJ Bowery, S Boyce, ME Trumbauer, HY Chen, LH Van der Ploeg and DJ Sirinathsinghji, *Neuroscience*, **90**, 1–13 (1999).

26 P Wang, G Yang, DR Mosier, P Chang, T Zaidi, YD Gong, NM Zhao, B Dominguez, KF Lee, WB Gan and H Zheng, *J Neurosci*, **25**, 1219–1225 (2005).

27 SM Greenberg, EH Koo, DJ Selkoe, WQ Qiu and KS Kosik, *Proc Natl Acad Sci U S A*, **91**, 7104–7108 (1994).

28 PE Tarr, R Roncarati, G Pelicci, PG Pelicci and L D'Adamio, *J Biol Chem*, **277**, 16798–16804 (2002).

29 M Rozakis-Adcock, J McGlade, G Mbamalu, G Pelicci, R Daly, W Li, A Batzer, S Thomas, J Brugge, PG Pelicci, J Schlessinger and T Pawson, *Nature*, **360**, 689–692 (1992).

30 G Pelicci, L Lanfrancone, F Grignani, J McGlade, F Cavallo, G Forni, I Nicoletti, T Pawson and PG Pelicci, *Cell*, **70**, 93–104 (1992).

31 L Hesse, D Beher, CL Masters and G Multhaup, *FEBS Lett*, **349**, 109–116 (1994).

32 G Multhaup, A Schlicksupp, L Hesse, D Beher, T Ruppert, CL Masters and K Beyreuther, *Science*, **271**, 1406–1409 (1996).

33 FH Ruiz, M Gonzalez, M Bodini, C Opazo and NC Inestrosa, *J Neurochem*, **73**, 1288–1292 (1999).

34 AR White, G Multhaup, D Galatis, WJ McKinstry, MW Parker, R Pipkorn, K Beyreuther, CL Masters and R Cappai, *J Neurosci*, **22**, 365–376 (2002).

35 AR White, R Reyes, JF Mercer, J Camakaris, H Zheng, AI Bush, G Multhaup, K Beyreuther, CL Masters and R Cappai, *Brain Res*, **842**, 439–444 (1999).

36 CJ Maynard, R Cappai, I Volitakis, RA Cherny, AR White, K Beyreuther, CL Masters, AI Bush and Q-X Li, *J Biol Chem*, **277**, 44670–44676 (2002).

37 AL Phinney, B Drisaldi, SD Schmidt, S Lugowski, V Coronado, Y Liang, P Horne, J Yang, J Sekoulidis, J Coomaraswamy, MA Chishti, DW Cox, PM Mathews, RA Nixon, GA Carlson, P St George-Hyslop and D Westaway, *Proc Natl Acad Sci U S A*, **100**, 14193–14198 (2003).

38 TA Bayer, S Schafer, A Simons, A Kemmling, T Kamer, R Tepest, A Eckert, K Schussel, O Eikenberg, C Sturchler-Pierrat, D Abramowski, M Staufenbiel and G Multhaup, *Proc Natl Acad Sci U S A*, **100**, 14187–14192 (2003).

39 R Cappai, F Cheng, GD Ciccotosto, BE Needham, CL Masters, G Multhaup, LA Fransson and K Mani, *J Biol Chem*, **280**, 13913–13920 (2005).

40 KJ Barnham, WJ McKinstry, G Multhaup, D Galatis, CJ Morton, CC Curtain, NA Williamson, AR White, MG Hinds, RS Norton, K Beyreuther, CL Masters, MW Parker and R Cappai, *J Biol Chem*, **278**, 17401–17407 (2003).

41 J Gitschier, B Moffat, D Reilly, WI Wood and WJ Fairbrother, *Nat Struct Biol*, **5**, 47–54 (1998).

42 F Arnesano, L Banci, I Bertini, DL Huffman and TV O'Halloran, *Biochemistry*, **40**, 1528–1539 (2001).

43 AL Lamb, AK Wernimont, RA Pufahl, VC Culotta, TV O'Halloran and AC Rosenzweig, *Nat Struct Biol*, **6**, 724–729 (1999).

44 R Koradi, M Billeter, K Wuthrich, *J Mol Graph*, **14**, 51–55, 29–32 (1996).

45 J Kang, HG Lemaire, A Unterbeck, JM Salbaum, CL Masters, KH Grzeschik, G Multhaup, K Beyreuther and B Muller-Hill, *Nature*, **325**, 733–736 (1987).

46 HG Lemaire, JM Salbaum, G Multhaup, J Kang, RM Bayney, A Unterbeck, K Beyreuther and B Muller-Hill, *Nucleic Acids Res*, **17**, 517–522 (1989).

47 K Paliga, G Peraus, S Kreger, U Durrwang, L Hesse, G Multhaup, CL Masters, K Beyreuther and A Weidemann, *Eur J Biochem*, **250**, 354–363 (1997).

48 W Wasco, S Gurubhagavatula, MD Paradis, DM Romano, SS Sisodia, BT Hyman, RL Neve and RE Tanzi, *Nat Genet*, **5**, 95–100 (1993).

49 CA Sprecher, FJ Grant, G Grimm, PJ O'Hara, F Norris, K Norris and DC Foster, *Biochemistry*, **32**, 4481–4486 (1993).

50 H von der Kammer, J Hanes, J Klaudiny and KH Scheit, *DNA Cell Biol*, **13**, 1137–1143 (1994).

51 S Dorus, EJ Vallender, PD Evans, JR Anderson, SL Gilbert, M Mahowald, GJ Wyckoff, CM Malcom and BT Lahn, *Cell*, **119**, 1027–1040 (2004).

52 I Daigle and C Li, *Proc Natl Acad Sci U S A*, **90**, 12045–12049 (1993).

53 DR Rosen, L Martin-Morris, L Luo and K White, *Proc Natl Acad Sci U S A*, **86**, 2478–2482 (1989).

54 BD Shivers, C Hilbich, G Multhaup, M Salbaum, K Beyreuther and PH Seeburg, *EMBO J*, **7**, 1365–1370 (1988).

55 K Iijima, DS Lee, J Okutsu, S Tomita, N Hirashima, Y Kirino and T Suzuki, *Biochem J*, **330**, 29–33 (1998).

56 L Villard, F Tassone, T Crnogorac-Jurcevic, K Clancy and K Gardiner, *Gene*, **210**, 17–24 (1998).

57 MR Palmert, MB Podlisny, DS Witker, T Oltersdorf, LH Younkin, DJ Selkoe and SG Younkin, *Proc Natl Acad Sci U S A*, **86**, 6338–6342 (1989).

58 DJ Selkoe, MB Podlisny, CL Joachim, EA Vickers, G Lee, LC Fritz and T Oltersdorf, *Proc Natl Acad Sci U S A*, **85**, 7341–7345 (1988).

59 A Potempska, J Styles, P Mehta, K Kim and D Miller, *J Biol Chem*, **266**, 8464–8469 (1991).

60 DK Lahiri and Y-W Ge, *Ann NY Acad Sci*, **1030**, 310–316 (2004).

61 A-F Macq, C Czech, R Essalmani, J-P Brion, A Maron, L Mercken, L Pradier and J-N Octave, *J Biol Chem*, **273**, 28931–28936 (1998).

62 I Ohsawa, Y Hirose, M Ishiguro, Y Imai, S Ishiura and S Kohsaka, *Biochem Biophys Res Commun*, **213**, 52–58 (1995).

63 H Zhang, H Komano, RS Fuller, SE Gandy and DE Frail, *J Biol Chem*, **269**, 27799–27802 (1994).

64 V Hines, W Zhang, N Ramakrishna, J Styles, P Mehta, KS Kim, M Innis and DL Miller, *Cell Mol Biol Res*, **40**, 273–284 (1994).

65 JM Roch, IP Shapiro, MP Sundsmo, DA Otero, LM Refolo, NK Robakis and T Saitoh, *J Biol Chem*, **267**, 2214–2221 (1992).

66 R Bhasin, WE Van Nostrand, T Saitoh, MA Donets, EA Barnes, WW Quitschke and D Goldgaber, *Proc Natl Acad Sci U S A*, **88**, 10307–10311 (1991).

67 J Knops, K Johnson-Wood, DB Schenk, S Sinha, I Lieberburg and L McConlogue, *J Biol Chem*, **266**, 7285–7290 (1991).

68 C Reinhard, SS Hebert and B De Strooper, *EMBO J*, **24**, 3996–4006 (2005).

69 J Rossjohn, R Cappai, SC Feil, A Henry, WJ McKinstry, D Galatis, L Hesse, G Multhaup, K Beyreuther, CL Masters and MW Parker, *Nat Struct Biol*, **6**, 327–331 (1999).

70 G Multhaup, H Mechler and CL Masters, *J Mol Recognit*, **8**, 247–257 (1995).

71 H Ninomiya, JM Roch, MP Sundsmo, DA Otero and T Saitoh, *J Cell Biol*, **121**, 879–886 (1993).

72 TR Hynes, M Randal, LA Kennedy, C Eigenbrot and AA Kossiakoff, *Biochemistry*, **29**, 10018–10022 (1990).

73 Y Wang and Y Ha, *Mol Cell*, **15**, 343–353 (2004).

74 I Dulubova, A Ho, I Huryeva, TC Sudhof and J Rizo, *Biochemistry*, **43**, 9583–9588 (2004).

75 EG Hutchinson and JM Thornton, *Protein Sci*, **3**, 2207–2216 (1994).

76 Z Songyang, B Margolis, M Chaudhuri, SE Shoelson and LC Cantley, *J Biol Chem*, **270**, 14863–14866 (1995).

77 JM Scandura, Y Zhang, WE Van Nostrand and PN Walsh, *Biochemistry*, **36**, 412–420 (1997).

78 GK Kong, D Galatis, KJ Barnham, G Polekhina, JJ Adams, CL Masters, R Cappai, MW Parker and WJ McKinstry, *Acta Crystallogr Sect F Struct Biol Cryst Commun*, **61**, 93–95 (2005).

79 GK Kong, JJ Adams, HH Harris, JF Boas, CC Curtain, D Galatis, CL Masters, KJ Barnham, WJ McKinstry, R Cappai and MW Parker, *J Mol Biol*, **367**, 148–161 (2007).

80 S Zhang, K Iwata, MJ Lachenmann, JW Peng, S Li, ER Stimson, Y Lu, AM Felix, JE Maggio and JP Lee, *J Struct Biol*, **130**, 130–141 (2000).

81 M Coles, W Bicknell, AA Watson, DP Fairlie and DJ Craik, *Biochemistry*, **37**, 11064–11077 (1998).

82 J Talafous, KJ Marcinowski, G Klopman and MG Zagorski, *Biochemistry*, **33**, 7788–7796 (1994).

83 H Sticht, P Bayer, D Willbold, S Dames, C Hilbich, K Beyreuther, RW Frank and P Rosch, *Eur J Biochem*, **233**, 293–298 (1995).

84 TG Fletcher and DA Keire, *Protein Sci*, **6**, 666–675 (1997).

85 H Zhou, MJ Mazzulla, JD Kaufman, SJ Stahl, PT Wingfield, JS Rubin, DP Bottaro and RA Byrd, *Structure*, **6**, 109–116 (1998).

86 WJ Fairbrother, MA Champe, HW Christinger, BA Keyt and MA Starovasnik, *Structure*, **6**, 637–648 (1998).

87 KJ Barnham, F Haeffner, GD Ciccotosto, CC Curtain, D Tew, C Mavros, K Beyreuther, D Carrington, CL Masters, RA Cherny, R Cappai and AI Bush, *FASEB J*, **18**, 1427–1429 (2004).

88 CC Curtain, F Ali, I Volitakis, RA Cherny, RS Norton, K Beyreuther, CJ Barrow, CL Masters, AI Bush and KJ Barnham, *J Biol Chem*, **276**, 20466–20473 (2001).

89 JP Vincent and M Lazdunski, *Biochemistry*, **11**, 2967–2977 (1972).

90 TE Creighton and IG Charles, *Cold Spring Harb Symp Quant Biol*, **52**, 511–519 (1987).

91 VL Grum, D Li, RI MacDonald and A Mondragon, *Cell*, **98**, 523–535 (1999).

92 K Djinovic-Carugo, P Young, M Gautel and M Saraste, *Cell*, **98**, 537–546 (1999).

93 S Pokutta and WI Weis, *Mol Cell*, **5**, 533–543 (2000).

94 CS Atwood, RD Moir, X Huang, RC Scarpa, NM Bacarra, DM Romano, MA Hartshorn, RE Tanzi and AI Bush, *J Biol Chem*, **273**, 12817–12826 (1998).

95 CS Atwood, RC Scarpa, X Huang, RD Moir, WD Jones, DP Fairlie, RE Tanzi and AI Bush, *J Neurochem*, **75**, 1219–1233 (2000).

96 T Miura, K Suzuki, N Kohata and H Takeuchi, *Biochemistry*, **39**, 7024–7031 (2000).

97 DP Smith, DG Smith, CC Curtain, JF Boas, JR Pilbrow, GD Ciccotosto, TL Lau, DJ Tew, K Perez, JD Wade, AI Bush, SC Drew, F Separovic, CL Masters, R Cappai and KJ Barnham, *J Biol Chem*, **281**, 15145–15154 (2006).

98 X Huang, CS Atwood, MA Hartshorn, G Multhaup, LE Goldstein, RC Scarpa, MP Cuajungco, DN Gray, J Lim, RD Moir, RE Tanzi and AI Bush, *Biochemistry*, **38**, 7609–7616 (1999).

99 QF Ma, J Hu, WH Wu, HD Liu, JT Du, Y Fu, YW Wu, P Lei, YF Zhao and YM Li, *Biopolymers*, **83**, 20–31 (2006).

100 T Kowalik-Jankowska, M Ruta, K Wisniewska and L Lankiewicz, *J Inorg Biochem*, **95**, 270–282 (2003).

101 S Tomaselli, V Esposito, P Vangone, NA van Nuland, AM Bonvin, R Guerrini, T Tancredi, PA Temussi and D Picone, *Chembiochem*, **7**, 257–267 (2006).

102 AM D'Ursi, MR Armenante, R Guerrini, S Salvadori, G Sorrentino and D Picone, *J Med Chem*, **47**, 4231–4238 (2004).

103 AI Bush, WH Pettingell, Jr., M de Paradis, RE Tanzi, W Wasco, *J Biol Chem*, **269**, 26618–26621 (1994).

104 AI Bush, G Multhaup, RD Moir, TG Williamson, DH Small, B Rumble, P Pollwein, K Beyreuther and CL Masters, *J Biol Chem*, **268**, 16109–16112 (1993).

105 S Zirah, SA Kozin, AK Mazur, A Blond, M Cheminant, I Segalas-Milazzo, P Debey and S Rebuffat, *J Biol Chem*, **281**, 2151–2161 (2006).

106 M Gralle, CL Oliveira, LH Guerreiro, WJ McKinstry, D Galatis, CL Masters, R Cappai, MW Parker, CH Ramos, I Torriani and ST Ferreira, *J Mol Biol*, **357**, 493–508 (2006).

107 MG Botelho, M Gralle, CL Oliveira, I Torriani and ST Ferreira, *J Biol Chem*, **278**, 34259–34267 (2003).

108 M Gralle, MM Botelho, CL de Oliveira, I Torriani and ST Ferreira, *Biophys J*, **83**, 3513–3524 (2002).

109 T Morimoto, I Ohsawa, C Takamura, M Ishiguro and S Kohsaka, *J Neurosci Res*, **51**, 185–195 (1998).

110 T Morimoto, I Ohsawa, C Takamura, M Ishiguro, Y Nakamura and S Kohsaka, *J Neurosci*, **18**, 9386–9393 (1998).

111 DH Small, V Nurcombe, R Moir, S Michaelson, D Monard, K Beyreuther and CL Masters, *J Neurosci*, **12**, 4143–4150 (1992).

112 S Narindrasorasak, D Lowery, P Gonzalez-DeWhitt, RA Poorman, B Greenberg and R Kisilevsky, *J Biol Chem*, **266**, 12878–12883 (1991).

113 D Schubert, M LaCorbiere, T Saitoh and G Cole, *Proc Natl Acad Sci U S A*, **86**, 2066–2069 (1989).

114 S Narindrasorasak, DE Lowery, RA Altman, PA Gonzalez-DeWhitt, BD Greenberg and R Kisilevsky, *Lab Invest*, **67**, 643–652 (1992).

115 KC Breen, *Mol Chem Neuropathol*, **16**, 109–121 (1992).

116 A Simons, T Ruppert, C Schmidt, A Schlicksupp, R Pipkorn, J Reed, CL Masters, AR White, R Cappai, K Beyreuther, TA Bayer and G Multhaup, *Biochemistry*, **41**, 9310–9320 (2002).

117 SA Bellingham, GD Ciccotosto, BE Needham, LR Fodero, AR White, CL Masters, R Cappai and J Camakaris, *J Neurochem*, **91**, 423–428 (2004).

118 T Borchardt, J Camakaris, R Cappai, CL Masters, K Beyreuther and G Multhaup, *Biochem J*, **344**(Pt 2), 461–467 (1999).

119 SS Mok, G Sberna, D Heffernan, R Cappai, D Galatis, HJ Clarris, WH Sawyer, K Beyreuther, CL Masters and DH Small, *FEBS Lett*, **415**, 303–307 (1997).

120 LW Jin, H Ninomiya, JM Roch, D Schubert, E Masliah, DA Otero and T Saitoh, *J Neurosci*, **14**, 5461–5470 (1994).

121 D Beher, L Hesse, CL Masters and G Multhaup, *J Biol Chem*, **271**, 1613–1620 (1996).

122 S Scheuermann, B Hambsch, L Hesse, J Stumm, C Schmidt, D Beher, TA Bayer, K Beyreuther and G Multhaup, *J Biol Chem*, **276**, 33923–33929 (2001).

123 OM Andersen, J Reiche, V Schmidt, M Gotthardt, R Spoelgen, J Behlke, CA von Arnim, T Breiderhoff, P Jansen, X Wu, KR Bales, R Cappai, CL Masters, J Gliemann, EJ Mufson, BT Hyman, SM Paul, A Nykjaer and TE Willnow, *Proc Natl Acad Sci U S A*, **102**, 13461–13466 (2005).

124 OM Andersen, V Schmidt, R Spoelgen, J Gliemann, J Behlke, D Galatis, WJ McKinstry, MW Parker, CL Masters, BT Hyman, R Cappai and TE Willnow, *Biochemistry*, **45**, 2618–2628 (2006).

125 CR Scherzer, K Offe, M Gearing, HD Rees, G Fang, CJ Heilman, C Schaller, H Bujo, AI Levey and JJ Lah, *Arch Neurol*, **61**, 1200–1205 (2004).

126 B Lovejoy, S Choe, D Cascio, DK McRorie, WF DeGrado and D Eisenberg, *Science*, **259**, 1288–1293 (1993).

127 PW Mantyh, JR Ghilardi, S Rogers, E DeMaster, CJ Allen, ER Stimson and JE Maggio, *J Neurochem*, **61**, 1171–1174 (1993).

128 U Sakaguchi and AW Addison, *J Am Chem Soc*, **99**, 5189–5190 (1977).

129 HE Parge, RA Hallewell and JA Tainer, *Proc Natl Acad Sci U S A*, **89**, 6109–6113 (1992).

130 X Huang, MP Cuajungco, CS Atwood, MA Hartshorn, JD Tyndall, GR Hanson, KC Stokes, M Leopold, G Multhaup, LE Goldstein, RC Scarpa, AJ Saunders, J Lim, RD Moir, C Glabe, EF Bowden, CL Masters, DP Fairlie, RE Tanzi and AI Bush, *J Biol Chem*, **274**, 37111–37116 (1999).

131 CD Syme, RC Nadal, SE Rigby and JH Viles, *J Biol Chem*, **279**, 18169–18177 (2004).

132 JW Karr, H Akintoye, LJ Kaupp and VA Szalai, *Biochemistry*, **44**, 5478–5487 (2005).

133 ON Antzutkin, *Magn Reson Chem*, **42**, 231–246 (2004).

134 X Huang, CS Atwood, RD Moir, MA Hartshorn, JP Vonsattel, RE Tanzi and AI Bush, *J Biol Chem*, **272**, 26464–26470 (1997).

135 S Narayanan and B Reif, *Biochemistry*, **44**, 1444–1452 (2005).

136 JW Karr, LJ Kaupp and VA Szalai, *J Am Chem Soc*, **126**, 13534–13538 (2004).

137 I Anastassopoulou, L Banci, I Bertini, F Cantini, E Katsari and A Rosato, *Biochemistry*, **43**, 13046–13053 (2004).

138 J Chelly, Z Tumer, T Tonnesen, A Petterson, Y Ishikawa-Brush, N Tommerup, N Horn and AP Monaco, *Nat Genet*, **3**, 14–19 (1993).

139 C Vulpe, B Levinson, S Whitney, S Packman and J Gitschier, *Nat Genet*, **3**, 7–13 (1993).

140 JF Mercer, J Livingston, B Hall, JA Paynter, C Begy, S Chandrasekharappa, P Lockhart, A Grimes, M Bhave, D Siemieniak and T Glover, *Nat Genet*, **3**, 20–25 (1993).

141 PC Bull, GR Thomas, JM Rommens, JR Forbes and DW Cox, *Nat Genet*, **5**, 327–337 (1993).

142 VC Culotta, LW Klomp, J Strain, RL Casareno, B Krems and JD Gitlin, *J Biol Chem*, **272**, 23469–23472 (1997).

143 F Gamonet and GJ Lauquin, *Eur J Biochem*, **251**, 716–723 (1998).

144 AC Rosenzweig, DL Huffman, MY Hou, AK Wernimont, RA Pufahl and TV O'Halloran, *Structure*, **7**, 605–617 (1999).

145 ET Adman, *Adv Protein Chem*, **42**, 145–197 (1991).

146 EN Baker, *J Mol Biol*, **203**, 1071–1095 (1988).

147 RA Pufahl, CP Singer, KL Peariso, SJ Lin, PJ Schmidt, CJ Fahrni, VC Culotta, JE Penner-Hahn and TV O'Halloran, *Science*, **278**, 853–856 (1997).

148 TL Poulos, *Nat Struct Biol*, **6**, 709–711 (1999).

149 ML Kerr and DH Small, *J Neurosci Res*, **80**, 151–159 (2005).

150 A Lai, SS Sisodia and IS Trowbridge, *J Biol Chem*, **270**, 3565–3573 (1995).

151 J Borg, J Ooi, E Levy and B Margolis, *Mol Cell Biol*, **16**, 6229–6241 (1996).

152 S Matsuda, T Yasukawa, Y Homma, Y Ito, T Niikura, T Hiraki, S Hirai, S Ohno, Y Kita, M Kawasumi, K Kouyama, T Yamamoto, JM Kyriakis and I Nishimoto, *J Neurosci*, **21**, 6597–6607 (2001).

153 H Taru, Y Kirino and T Suzuki, *J Biol Chem*, **277**, 27567–27574 (2002).

154 M Trommsdorff, JP Borg, B Margolis and J Herz, *J Biol Chem*, **273**, 33556–33560 (1998).

155 BW Howell, LM Lanier, R Frank, FB Gertler and JA Cooper, *Mol Cell Biol*, **19**, 5179–5188 (1999).

156 C Haass, E Koo, A Capell, D Teplow and D Selkoe, *J Cell Biol*, **128**, 537–547 (1995).

157 P Zheng, J Eastman, S Vande Pol and SW Pimplikar, *Proc Natl Acad Sci U S A*, **95**, 14745–11450 (1998).

158 J Walter, C Kaether, H Steiner and C Haass, *Curr Opin Neurobiol*, **11**, 585–590 (2001).

159 WT Kimberly, JB Zheng, SY Guenette and DJ Selkoe, *J Biol Chem*, **276**, 40288–40292 (2001).

160 X Cao and TC Sudhof, *J Biol Chem*, **279**, 24601–24611 (2004).

161 RC von Rotz, BM Kohli, J Bosset, M Meier, T Suzuki, RM Nitsch and U Konietzko, *J Cell Sci*, **117**, 4435–4448 (2004).

ZINC

Hydrolases: Acting on Ester Bonds

Phosphotriesterase

Andrew N Bigley and Frank M Raushel

Department of Chemistry, Texas A&M University, College Station, TX, USA

FUNCTIONAL CLASS

Enzyme; organophosphate hydrolase; EC 3.1.8.1; binuclear zinc containing hydrolase specific for phosphotriesters; commonly known as *phosphotriesterase* (*PTE*); also known as *organophosphate hydrolase* (*OPH*).

PTE is a member of the amidohydrolase superfamily that catalyzes the hydrolysis of phosphoester bonds in a wide variety of substrates. The best known substrate is the insecticide paraoxon, the catalytic efficiency of which approaches the limits of diffusion (Figure 1).[4] Various

3D Structure Ribbon diagram of PTE from *Pseudomonas diminuta*. The top and bottom subunits of the dimer are colored red and blue, respectively. Metals bound in the active sites are shown as green spheres, and the substrate analog diethyl 4-methylbenzylphosphonate n the active site is shown in yellow. The picture was prepared using the programs Chimera from UCSF, MolScript, and Raster3D from the pdb file 1DPM.[1-3]

Figure 1 Substrates of PTE. (a) General reaction catalyzed by PTE where L can be an ester, thioester, or halide. In the case of the phosphonate and phosphinate substrates, one or both of the ester linkages (OX, OY) are replaced by direct carbon phosphorus linkage. (b) Examples of insecticide substrates of PTE with phosphotriester (paraoxon), thiophosphotriester (diazinon), and thiophosphorothioester (phosalone) classes shown. (c) Nerve agent substrates of PTE with the phosphohalides (sarin and soman) and phosphonothioester (VX) shown.

other compounds containing phosphotriester, phosphorothioester, and thiophosphoester moieties are known to be hydrolyzed by PTE.[4–6] In addition, PTE is catalytically active against various phosphonate and phosphinate compounds including compounds that contain phosphorus–halide bonds.[7–10]

OCCURRENCE

The gene for PTE was originally identified on large plasmids isolated from two soil bacteria, *Flavobacterium* sp. and *Pseudomonas diminuta*.[11,12] The plasmid from *Flavobacterium* was isolated from cultured bacteria, originally identified in soil known to be contaminated with organophosphate insecticides.[13] The *Pseudomonas* isolate was identified from a mixed culture of environmental bacteria selectively enriched for the ability to degrade pesticides.[14] The two plasmids containing the gene for PTE were found to be unique, but the genes associated with the plasmid-borne PTE activity were of identical sequence.[11] The gene for PTE (organophosphate-degrading; opd) codes for a proenzyme that contains a leader peptide believed to specify the enzyme for localization to the membrane.[15] The enzyme isolated from cultures of *Flavobacterium* was

found to be associated with the membrane, and N-terminal sequencing of the protein showed that the mature enzyme lacked the first 29 residues coded by the gene sequence. Other bacterial species have now been found to have related enzymes capable of hydrolyzing phosphotriesters including *Agrobacterium radiobacter* and two species of *Sulfolobus*.[16,17] The gene from *Agrobacterium* was more than 90% identical to PTE and, like PTE, was associated with mobile DNA elements in bacteria known to be able to degrade pesticides.[16] The *Sulfolobus* proteins were identified from genome sequencing projects shared 34% identity with PTE and possess relatively little phosphotriesterase activity.[17]

BIOLOGICAL FUNCTION

Biologically, PTE appears to function in the scavenging of resources from the environment. Organophosphates are synthetic compounds with no natural occurrence, and were first synthesized in the 1950s. Following their introduction, these compounds quickly became widespread because of their insecticidal properties.[18] These compounds serve mainly as agricultural pesticides where they are applied in millions of tons per year.[19] Organophosphates potentially

provide a rich supply of both phosphorus and carbon to fuel bacterial growth. The ability of soil bacteria to utilize these compounds for energy and as a nutrient source provides the organism a significant evolutionary advantage. It is quite remarkable that bacteria could evolve an enzyme that approaches the theoretical limit of efficiency in such a short period of evolutionary time, but to date no other physiological role has been identified. The rapid evolution of activity may have been facilitated by the incorporation of the gene on extrachromosomal elements as is seen for the three most active PTE enzymes.[11,12,16] Other soil bacteria have more recently been identified that can utilize organophosphate insecticides as the sole source of both carbon and phosphorus. These bacteria have been shown to possess enzyme systems unrelated to PTE but with similar ability to degrade insecticides. These findings indicate that the ability to scavenge nutrients from pesticides has evolved redundantly in bacterial organisms since the introduction of organophosphates.[20] Interestingly, in these other systems there is evidence of horizontal gene transfer between species, which may account for how these activities have become widespread in such a short period of time.

AMINO ACID SEQUENCE INFORMATION

The opd gene (Gen Bank #M20392) for PTE was identified on the plasmid pCMS1 isolated from *Pseudomonas diminuta*.

- *Pseudomonas diminuta/Flavobacterium* sp.: 365 amino acid residues, translation of open reading frame in plasmid DNA, UniProt ID code P0A434.[12]

PROTEIN PRODUCTION, PURIFICATION, AND MOLECULAR CHARACTERIZATION

PTE has been purified as the proenzyme containing the 29 amino acid N-terminal signal peptide or more commonly as the mature enzyme lacking this peptide.[15] The N-terminal peptide is thought to be involved in the targeting of the protein to the membrane in native bacteria and is cleaved during processing to form the mature enzyme, but common expression systems lack the ability to process this leader sequence.

The proenzyme form has been purified to homogeneity by expression in insect cells using a baculovirus infection system.[5] In this expression system, PTE is expressed as a soluble cytosolic protein. Cellular disruption is achieved by sonication followed by centrifugation to remove cellular debris. The supernatant is slurried with diethylaminoethyl (DEAE) anion exchange resin to remove a portion of the contaminating proteins. The DEAE resin is removed via filtration and the filtrate applied to a Green A dye affinity chromatography column. The fractions with the

most activity are then subjected to phenyl-Sepharose chromatography to obtain pure protein. The proenzyme was found to have a molecular weight of 39 kDa and appeared monomeric in solution. Isoelectric focusing gave an estimated isoelectric point of pH 8.3.

The more commonly utilized form of PTE is achieved via *E. coli* expression of the gene lacking the leader peptide.[21] The direct expression of the mature enzyme in *E. coli*, which lacks the machinery to process the leader peptide, yields a cytosolic enzyme with higher activity.[15] Growth is typically conducted at 30 °C for 36–40 h in Terrific Broth supplemented with metal.[21] Cellular disruption is achieved via sonication and followed by centrifugation to remove cellular debris. DNA contamination is removed from the supernatant via protamine sulfate precipitation followed by centrifugation. The supernatant is further subjected to ammonium sulfate fractionation, and the precipitated protein is resuspended and separated via size exclusion chromatography. The protein is further purified to homogeneity using DEAE chromatography (at pH 8.5) to preferentially bind contaminating proteins. The purified protein has a molecular mass of approximately 36 kDa per monomer and appears as a dimer in solution.[15] The native active site metals are zinc, and it has been found that purification of fully active enzyme requires the inclusion of metal in both the growth media and the purification buffers. Efficient substitution of the active site metal has been achieved by inclusion of alternate metals in the growth medium and purification buffers, or alternately by reconstitution of apoenzyme with the metal of interest.[21] Fully active enzyme has been achieved with the substitution of Co^{2+}, Ni^{2+}, Cd^{2+}, and Mn^{2+}.

ACTIVITY TESTS AND INHIBITION

The catalytic activity of PTE is typically assayed using the substrate paraoxon. The activity is followed by observing the release of the product *p*-nitrophenol under basic conditions at 400 nm ($E_{400} = 17\,000\,M^{-1}\,cm^{-1}$).[21] Reaction conditions are typically 30 °C in 50–150 mM 2-(cyclohexylamino)ethanesulfonic acid (CHES) buffer (pH 9) supplemented with 100 µM metal. Various other substrates with aromatic leaving groups can be followed similarly at different wavelengths.[6] Cleavage of phosphorothiol bonds is followed by inclusion of 5,5′-dithiobis(2-nitrobenzoic acid) (DTNB), which reacts with the free thiol released as the product. The reaction is followed by absorbance at 412 nm ($E_{412} = 14\,150\,M^{-1}\,cm^{-1}$) at pH 8.[22] Typical reaction conditions for phosphorothiolate bond cleavage are 30 °C in 50 mM 4-(2-hydroxyethyl)piperazine-1-ethanesulfonic acid (HEPES) (pH 8), with 0.3 mM DTNB and 100 µM metal. The catalytic activity using compounds that release fluoride has successfully been monitored with the use of a fluoride-sensitive electrode.[7,23]

Known inhibitors of PTE include the substrate analogs di-isopropyl methyl phosphonate (DIMP), diethyl 4-methyl benzyl phosphonate, and triethyl phosphate (TEP).[24] Other competitive inhibitors include various thiols, the most effective being dithiolthreitol (DTT) and β-mercaptoethanol (BME).[5] Metal chelators such as ethylenediaminetetraacitic acid (EDTA), 1,10-phenanthroline, and 8-hydroxyquinoline-5-sulfonic acid (HQSA) also inhibit PTE via sequestration of the required active site metals.[5,21] Inactivation of the enzyme can be achieved by reaction with the histidine-modifying reagent diethyl pyrocarbonate (DEPC)[25] and the mechanism-based inhibitors 1-bromovinyl and 4-(bromomethyl)-2-nitrophenyl phosphate esters.[26]

SPECTROSCOPY

UV–visible

PTE absorbs at 280 nm with an extinction coefficient of $29\,000 \, M^{-1} \, cm^{-1}$, which is in good agreement with theoretical calculations based on amino acid composition.[22] The metal center of PTE substituted with Co as the active site metal has a very broad, weak absorbance in the range of 450–650 nm ($E \approx 100 \, M^{-1} \, cm^{-1}$).[27] Variants of PTE with perturbed metal site ligands show more distinct peaks in this region giving rise to enzymes with visible color.[27,28]

^{113}Cd NMR

The ability to purify or reconstitute PTE with various active site metals has allowed the probing of the active site via the incorporation of the NMR active metal ^{113}Cd.[21,29] The NMR spectra of Cd-substituted PTE shows two distinct peaks at 116 and 212 ppm relative to $Cd(ClO_4)_2$. The presence of two peaks in the NMR spectrum indicates that the metal center in PTE is made up of two distinct metal-binding sites with different coordination environments, termed the α- and β- sites.[29] Enzyme reconstituted with equal amounts of Zn and Cd gave only a single resonance corresponding to the β-site demonstrating that the two sites have different metal preferences with the α-site binding Zn, while the β-site preferred Cd. Reconstitution experiments with less than stoichiometric metal demonstrated that the spectra maintained equality intensity of the α and β peaks indicating that metal binding occurred in either a highly cooperative or random manner. Later kinetic experiments have shown the former to be the case.[30]

Electron paramagnetic resonance spectroscopy

PTE reconstituted with manganese allowed for the probing of the metal site structure via electron paramagnetic resonance (EPR).[31] Both X-band and Q-band EPR experiments demonstrated a diminished signal intensity relative to free Mn with a large number of hyperfine splittings at 45-G intervals. This finding indicated that PTE possesses an antiferromagnetically spin-coupled binuclear center with shared ligands. EPR studies with Cu substituted PTE provided similar results and indicated the presence of at least three nitrogen ligands to the metal center.[32] More detailed EPR analysis of Mn-substituted PTE revealed the presence of 11 line splittings at $g = 2.2$ and the presence of downfield peaks at $g = 14.6$, 5.8, and 3.7.[33] Studies with the inhibitors DIMP and TEP demonstrated pronounced effects on the EPR signal indicating that these inhibitors interacted directly with the metal center of PTE.[34] Both inhibitors were found to reduce the spin-coupled signal at $g = 2.2$ with a concomitant increase in a mononuclear signal at $g = 2$. DIMP caused the appearance of an 11 line pattern separated by 45 G at $g = 4.3$ indicative of a coupled system as well as a rise in a mononuclear 90-G splitting at $g = 3.8$. TEP caused a similar splitting at $g = 4.3$, but did not alter the signal at $g = 3.8$. These experiments have demonstrated that the substrate analogs bind directly to the metal center and alter the environment, but do not disrupt the coupled nature of the system. Similar experiments with the product diethyl phosphate (DEP) demonstrated a loss of the coupled binuclear signal at $g = 2.2$ along with a rise in the mononuclear signal at $g = 2$, but unlike the substrate analogs, no new spin-coupled signals were detected at the other resonances in the spectra. The loss of coupling indicates that a common ligand through which the binuclear system is spin coupled is displaced on binding of the product.[34]

X-RAY STRUCTURE

Crystallization conditions

PTE has been crystallized via the hanging drop method using polyethyleneglycol (PEG) as the precipitant under various conditions with numerous metals and inhibitors bound to the active site. The first structure of PTE was solved by heavy metal replacement from crystals grown in 9% PEG 8000, 0.1 M Bicine (pH 9), 5 mM NaN_3, and 1 M LiCl.[35] Crystals grown under these conditions have a space group $P2_12_12$ with dimensions $a = 80.3$ Å, $b = 93.4$ Å, and $c = 44.8$ Å. These crystals diffracted to 2.0 Å resolution with the protein dimer constituting the asymmetric unit, but no metal was found in the structure, and crystal-soaking experiments to introduce the metal were found to disrupt the crystal lattice. Changing the crystallization conditions and utilizing Cd as an alternate active site metal were required to get the first metal-containing structure. The Cd-reconstituted enzyme was crystallized using 10% PEG 8000, 5 mM NaN_3, 50 mM CHES (pH 9) and gave crystals with a C2 space group ($a = 129.5$ Å, $b = 91.4$ Å, $c = 69.4$ Å, $\beta = 91.1°$) that diffracted to 2 Å.[36] Like the

apoenzyme, the dimer was the asymmetric unit, but the structure had two Cd ions in each active site allowing the first definitive determination of the metal ligands. The first Zn-containing enzyme structure was obtained from crystals grown in 13% PEG 8000, 0.1 M CHES (pH 9), 5 mM NaN$_3$, and 1% of the substrate analog diethyl 4-methylbenzylphosphonate.[37] These crystals diffracted to 2.1 Å with a C2 space group ($a = 129.6$ Å, $b = 91.4$ Å, $c = 69.4$ Å, $\beta = 91.9°$) and the dimer as the asymmetric unit. The inhibitor was found in the active site, but it was not directly coordinated to the metal center. Other inhibitor-bound structures were determined with DIMP and TEP bound in the active site. These crystals were grown in 7% PEG 8000, 100 mM NaCl, 0.5% 2-phenylethanol by seeding with Zn-containing PTE crystals grown under the same conditions.[24] Inhibitor-bound forms were obtained by including the inhibitor at 3% concentration in the crystallization solution. Both inhibitor-bound structures diffracted to 1.9 Å. The DIMP structure had a C2 space group ($a = 128.6$ Å, $b = 91.0$ Å, $c = 69.2$ Å, $\beta = 91.6°$) with the dimer as the asymmetric unit. The TEP crystals had a C222$_1$ space group ($a = 128.6$ Å, $b = 92.3$ Å, $c = 69.8$ Å), but a single monomer was found in the asymmetric unit. The structure with the product analog cacodylate was solved using crystals of the G60A variant grown in 20% PEG 8000, 0.2 M magnesium acetate, and 0.1 M sodium cacodylate (pH 6.5).[38] These crystals have a P1 space group ($a = 55.29$ Å, $b = 68.30$ Å, $c = 90.03$ Å, $\alpha = 90.05°$, $\beta = 100.42°$, $\gamma = 89.96°$) and resolved to 1.95 Å with two protein dimers making up the asymmetric unit. Wild-type cobalt-containing enzyme with the product DEP was crystallized in 20% PEG-monoethyl ether 5000, 0.1 M bistris (pH 6.5) and 17 mM DEP.[38] The crystals diffracted to 1.83 Å with the P1 space group ($a = 43.29$ Å, $b = 45.34$ Å, $c = 78.91$ Å, $\alpha = 104.73°$, $\beta = 93.40°$, $\gamma = 97.65°$).

Overall description

Like all members of the amidohydrolase superfamily, the general structure of PTE is a $(\beta/\alpha)_8$ TIM-barrel fold (3D Structure, Figure 2a and b).[39,40] Somewhat surprisingly, the structure solved by crystallography identified the biological unit as a dimer rather than a monomer (Figure 2c).[35] The basic structural element in each monomer is a core of 8 parallel β-strands surrounded by 8 α-helices. The loops connecting each of the successive core structural units are themselves made up of various secondary structural elements including random coils, β-turns, and α-helices (Figure 2a and b). The N-terminus of the protein contains two parallel β-strands, while the C-terminus forms an additional α-helix. Each subunit is roughly globular with approximate dimensions of 51 Å × 55 Å × 51 Å.[35] The active site is located at the C-terminal end of the core barrel with the majority of the active site residues being found on the loops connecting the core elements.[36] The subunit interface is also made up of residues from the loops at the C-terminal end of the barrel. The interface involves numerous aromatic stackings and other hydrophobic interactions between residues 61–73 as well as 104, 138, and 149 from each subunit.[35] The axis of each barrel is rotated forward in relationship to the axis of the dimer so that the subunit interface is made up of residues along one lip of the core

(a) (b) (c)

Figure 2 $(\beta\alpha)_8$ TIM-barrel motif of PTE. Core β-strands are colored in green. Core α-helices are colored blue. Residues corresponding to the loops connecting the C-terminal ends of the core β-sheets to the following helix (C-terminal loops) are colored red. Residues connecting the C-terminal end of the core helices to the following β-strand (N-terminal loops) and the residues of the N- and C-termini of the protein are colored gray. Metals at active site are shown as spheres. The location of the subunit interface is marked by a line. (a) Top-down view of the core barrel structure from the C-terminal end of barrel. (b) Side view of the barrel structure. (c) Dimeric structure of PTE showing the relative orientation of the core barrels. The substrate analog 4-methylbenzylphosphonate is shown in yellow at the active site. Figure prepared from pdb entry 1dpm using the program Chimera from UCSF.[1]

barrels (Figure 2b and c). The two active sites appear on the same face of the dimer though the monomers are rotated approximately 88° with respect to each other (Figure 2c). The distance between the active sites is approximately 25 Å.[37] The loops connecting the N-terminal side of the core barrel tend to be shorter than their C-terminal counterparts with the two antiparallel β-sheets from the N-terminus and the long α-helix from C-terminus of the protein forming a base for the N-terminal end of the barrel.[35]

Metal site geometry

The crystallographic structures showed that the two metal-binding sites are unique and coupled through common ligands as expected from the NMR and EPR spectra (Figure 3).[29,31,32] Solving the structure of a PTE containing a hybrid metal center with both Cd and Zn present allowed the structural definition of the α and β sites that were previously identified by NMR.[41] It has since been recognized that the metal coordination pattern of PTE is typical of the Type I amidohydrolases.[40] The α-site metal is coordinated to the enzyme by His55 and His57 from the end of β-strand 1 as well as by Asp301 from strand 8 (Figure 3a). The β-site metal is coordinated through His201 from β-strand 5 and His230 from strand 6. In addition, the metals are coordinated through the bridging ligands identified as a carboxylated Lys169 from β-strand 4 and a hydroxide or water from solution.[36] The α-site is typically found in a trigonal bipyramidal geometry in the reported structures of PTE. This geometry has been observed at the α-site with various metals and substrate analogs bound in the

active site, although an iron-containing enzyme showed an additional water bound terminally, resulting in an octahedral coordination.[24,36,38,41,42] The geometry and final coordination state of the β-site shows a dependence on the identity of the active site metal and the presence of other ligands.[24,36-38,41,42] The axial ligands to the α-site in the resting state of the enzyme (without substrate or product bound) are Asp301 and the carboxylated Lys169, while His55 and His57, along with the bridging hydroxyl, serve as the equatorial ligands (Figure 3a).[41] The structure of the resting state of the enzyme has an average axial–equatorial bond angle of 90.3° (86.0°–100.2°) at the α-site and bond angles of 114.2° (His55–Zn–His57), 111.6° (His55–Zn–OH), and 134.2° (His57–Zn–OH) between the equatorial ligands. The β-metal site in the resting state of the enzyme exhibited a distorted trigonal bipyramidal geometry.[41] The axial ligands were determined to be the bridging hydroxyl and His201, while the equatorial ligands were the carboxylated Lys169, His230, and a solvent molecule. The average axial–equatorial angle was determined to be 90.9° (77.1°–99.2°). The equatorial ligands had bond angles of 110.0° (Lys169–Zn–H$_2$O), 111.3° (Lys169–Zn–His230), and 138.7° (His230–Zn–H$_2$O). The crystal structure of the Zn-containing PTE with the substrate analog DIMP bound at the active site had an average axial–equatorial bond angles of 90.2° (82.1°–102.3°) at the α-site, and equatorial bonds of 110.8° (His55–Zn–OH), 129.9° (His57–Zn–OH), and 117.5° (His55–Zn–His57).[24] The β-site with this substrate analog bound is also in a trigonal bipyramidal geometry with the free phosphoryl oxygen of the substrate analog replacing the water molecule of the resting enzyme as an equatorial ligand (Figure 3b).[24] The axial–equatorial bond

Figure 3 Metal site coordination in PTE. (a) Metal coordination of resting state of enzyme (pdb 1HZY). Bond distances from metal to ligand are D301–α = 2.2 Å, H57–α = 2.1 Å, H55–α = 1.8 Å, K169–α = 2.1 Å, K169–β = 2.0 Å, bridging OH–α = 2.0 Å, bridging OH–β = 2.0 Å, H$_2$O–β = 2.1 Å, H230–β = 2.1 Å, H201–β = 2.2 Å. (b) Metal center with bound substrate analog di-isopropyl methyl phosphonate (DIMP)(pdb 1ez2). Bond distances from metal to ligand are D301–α = 2.3 Å, H57–α = 2.0 Å, H55–α = 1.7 Å, K169–α = 2.3 Å, K169–β = 1.9 Å, bridging OH–α = 2.2 Å, bridging OH–β = 2.1 Å, DIMP–β = 2.5 Å, H230–β = 2.0 Å, H201–β = 2.3 Å. (c) Cobalt-containing metal center with product diethyl phosphate (DEP) bound (pdb 3cak). Bond distances from metal to ligand are D301–α = 2.5 Å, H57–α = 2.0 Å, H55–α = 2.1 Å, K169–α = 2.1 Å, K169–β = 1.9 Å, DEP–α = 2.0 Å, DEP–β = 2.2 Å, H230–β = 2.1 Å, H201–β = 2.2 Å. Figure prepared using program Chimera from UCSF.[1]

angles averaged 91.8° (71.6°–111.4°), and the equatorial bonds were found to be 99.4° (His230–Zn–Lys169), 132.7° (His230–Zn–DIMP), and 127.8° (Lys169–Zn–DIMP).

The geometry of the active site differs somewhat in the structure of PTE solved with the product DEP bound at the active site (Figure 3c).[38] The structure was solved with the active site metal being Co rather than Zn. The most striking difference is the lack of the bridging hydroxyl seen in the resting and substrate-bound structures. With DEP, one of the free phosphoryl oxygens of the product is bound to the α-metal, while the other is bound to the β-metal. The α-site remains in the trigonal bipyramidal geometry with axial–equatorial bond average of 90.0° (80.8°–99.7°) and equatorial bond angles of 116.7° (His55–Zn–His57), 119.6° (His57–Zn–DEP), and 119.6° (His55–Zn–DEP).[38] The β-site in this form of the enzyme is in a tetrahedral geometry, with the ligands being Lys169, His201, His230, and DEP. The average bond angle at the β-site with product bound is 109.3° (99.9°–124.8°).[38] This structure showed no other solvent molecules within bonding distance to the metals, and this active site coordination has been seen in multiple structures with product bound.

Substrate-binding site

Crystallographic structures of PTE with bound substrate analogs show that the active site sits above the core barrel structure of the enzyme (Figure 4).[24,37] The metals in the active site are coordinated to the ends of the core β-strands with substrate binding external to them. The majority of the active site residues are from the C-terminal loops that extend above the core barrel structure. Three distinct hydrophobic pockets are observed in the substrate-binding site termed the *leaving, large,* and *small* group pockets. Subsequent to the structure of PTE being solved, a series of site-directed mutants were constructed to identify the roles of the active site residues.[43] The leaving group pocket is made up of the aromatic residues Trp131, Phe132, Phe306, and Tyr309 (Figure 4). In crystal structures, these residues are poised to interact with the leaving group of the substrate, and kinetic analysis of variants of PTE confirmed the role of these residues in defining the leaving group specificity.[37,43] The remaining two pockets seen in the substrate-binding site interact with the side groups attached to the phosphoryl center. The larger pocket (large group pocket) is lined by the residues His254, His257, Leu271, and Met317, while the smaller pocket (small group pocket) is buried beneath the surface of the enzyme and lined by the residues Gly60, Ile106, Leu303, and Ser308.[37] Crystallographic structures indicate that some of these residues may interact with the leaving group, the side group, or both. However, kinetic work utilizing chiral substrates with variants at these positions has indicated that the side chains of these residues are responsible for selectivity with respect to the side groups of the substrate rather than the

leaving group.[43] Together, these 12 residues largely define the substrate preferences of PTE, and alterations to these residues has been shown to be effective in manipulating the substrate preferences.[43]

FUNCTIONAL ASPECTS

One of the most interesting aspects of PTE is its extremely broad substrate specificity. Unlike other enzymes that catalyze a single or at most a few reactions, PTE has measurable activity with dozens of structurally related substrates. This activity extends to at least four general classes of compounds, phosphotriesters (including some phosphonates and phosphinates), thiophosphotriesters, phosphorothioesters, and phosphohalide-containing esters

(a)

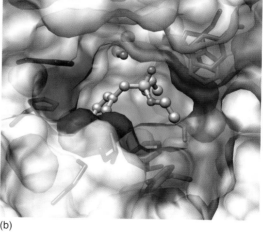

(b)

Figure 4 Active site binding pockets of PTE. Leaving group pocket (W131, F132, F306, Y309) is shown in red. Large group pocket (H254, H257, L271, M317) is shown in blue. Small group pocket (G60, I106, L303, S308) is shown in green. Metal site zinc ions are shown as magenta spheres with bridging hydroxyl as red ball. (a) Stick figure of active site with inhibitor bound. (b) Surface rendering of PTE active site with diethyl 4-methylbenzyl-phosphonate bound. Figure prepared from pdb 1DPM using the program Chimera from UCSF.[1]

Table 1 Activity of PTE against insecticide substrates

Compound	Insecticides				Reference
	Class[a]	k_{cat}(s^{-1})	K_m(mM)	k_{cat}/K_m(M^{-1}s.$^{-1}$)	
Paraoxon[b]	P	–	–	–	–
Zn/Zn	–	2430	0.091	2.7×10^7	29
Co/Co	–	6990	0.15	4.7×10^7	29
Parathion[b]	TP	–	–	–	–
Zn/Zn	–	450	0.04	1.1×10^7	29
Co/Co	–	500	0.025	2.0×10^7	29
Acephate[c]	PT	1.5	86	–	22
Methamidophos[c]	PT	0.1	88	–	22
Demeton-S[c]	PT	4.2	4.8	870	41
Azinophos[c]	TP/PT	0.4	–	–	43
Phosalone[c]	TP/PT	0.6	0.26	2.4×10^3	43
Oxydemeton[c]	P	1.0	47.6	21.0	42
Phorate[c]	TP/PT	0.2	0.5	310	42
Ethoprop[c]	PT	0.1	12	9.0	42
Azinphos methyl[c]	TP/PT	0.04	4	11	42
Terbufos[c]	TP/PT	0.02	0.03	620	42
Methidathion[c]	TP/PT	0.006	1.9	3.0	42
Phosmet[c]	TP/PT	0.004	0.3	13	42
Dimethoate[c]	TP/PT	0.003	1.0	4.0	42
Malathion[c]	TP/PT	0.003	0.9	3.0	42
Tribufos[c]	PT	0.0002	0.02	12	42
Diazinon[c]	TP	190	1.5	1.3×10^5	42
Methyl Parathion[c]	TP	380	1.0	1.03×10^5	42
Profenofos[c]	P	80	1.0	7.9×10^4	42
Fenitrothion[c]	TP	13	0.4	3.6×10^4	42
Pirimiphos methyl[c]	TP	1.9	0.2	9.1×10^3	42
Chlorpyrifos[c]	TP	1.3	0.03	4.5×10^4	42
Chlorpyrifos methyl[c]	TP	0.3	0.1	2.5×10^3	42
Propetamphos[c]	TP	3.8	0.2	1.7×10^4	42
Disulfton[c]	TP/PT	0.006	0.3	20	42

[a] P, phosphotriester; TP, thiophosphotriester; PT, phosphorothioester.

[b] Kinetic constants determined with multiple active site metals; kinetic constants for Zn and Co containing enzyme are given.

[c] Kinetic constants determined with Co as active site metal rather than native Zn.

(Figure 1a). PTE catalyzes ester bond cleavage for the first two classes of substrates and thioester or phosphohalide bond cleavage for the latter two.[6,10,22,23] Many of the compounds that are hydrolyzed by PTE are insecticides commonly used in agriculture (Table 1 and Figure 1b).[22,29,44–46] The activity of PTE against these compounds varies dramatically with compounds such as paraoxon or parathion displaying k_{cat} values in the hundreds to thousands per second and k_{cat}/K_m values approaching the limits of diffusion.[4,29] Other organophosphate insecticides are only marginal substrates for PTE such as turbufos or malathion, which show only one turnover per hundreds of seconds and have k_{cat}/K_m values reduced to greater than a millionfold compared to fast substrates.[45]

Also of interest, is the ability of PTE to degrade organophosphate nerve agents such as sarin, soman, and VX (Figure 1c and Table 2).[47,48] Sarin and soman are phosphohalide compounds, while VX and its related compound rVX (Russian VX) are phosphorothioesters.[47–49] These compounds are degraded with significantly less efficiency than that seen with the faster insecticide substrates. The nerve agents are all phosphonates, rather than phosphates more commonly used as insecticides. The alternate linkage to the phosphorus results in a chiral phosphoryl center with significant size differences in the large and small side groups. Analogs of sarin and soman have been developed to access the chiral preferences of PTE with these compounds.[9] The two enantiomers of the sarin analog demonstrate an order of magnitude difference in k_{cat}, but only about a twofold difference in K_m. Analogs of soman, which contain a stereo center at both the phosphorus and the ester carbon, show about 3 orders of magnitude difference in k_{cat} based on the phosphorus center, and 1 order of magnitude based on the carbon center. Significantly, less effect is seen on the substrate affinity. The K_m values for three of the four enantiomers are separated by only about twofold, while the maximal difference in binding affinity

Table 2 Activity of PTE against nerve agents and analogs

Compound	Nerve agents and analogs				Reference
	Class[d]	$k_{cat}(s^{-1})$	K_m(mM)	$k_{cat}/K_m(M^{-1}s^{-1})$	
Sarin[a]	PH	56	0.7	8×10^4	44
Soman[a]	PH	4.8	0.5	9.6×10^3	44
VX	PT	0.3	0.43	750	45,46
r-VX[b]	PT	0.5	0.47	–	46
DIFP[b]	PH	290	0.57	–	23
–	–	–	–	–	–
p-Nitrophenol sarin analog					
racemic[b]	P	1800	0.44	4.5×10^6	9
Rp[b]	P	2600	0.31	8.2×10^6	9
Sp[b]	P	299	0.72	4.1×10^5	9
–	–	–	–	–	–
p-Nitrophenol soman analog[c]					
racemic[b]	P	40	1.1	3.6×10^4	9
RpRc[b]	P	48	0.31	1.6×10^5	9
RpSc[b]	P	4.8	0.42	1.2×10^4	9
SpRc[b]	P	0.3	0.78	380	9
SpSc[b]	P	0.04	2.4	16	9
–	–	–	–	–	–
p-acetophenol VX analog[c]					
Sp[b]	P	670	–	1.2×10^6	47
Rp[b]	P	150	–	4.9×10^5	47
–	–	–	–	–	–
DEVX[b]	PT	0.8	0.8	1.0×10^3	48

[a] Kinetic constants determined with proenzyme containing leader sequence which is known to have reduced activity.
[b] Determined with Co as the active site metal.
[c] Compound contained phosphoryl center seen in nerve agent, but with fluoride leaving group replaced with p-nitrophenol or p-acetophenol.
[d] Classes of compounds are P, phosphotriester; PH, phosphohalide; PT, phosphorothioester.

is less than an order of magnitude between the best and worst soman analog. Similar studies with an analog of VX utilizing a *p*-acetophenol leaving group in place of the thioester demonstrated that there is relatively little selectivity based on the phosphoryl center, and the k_{cat} as well as k_{cat}/K_m are several orders of magnitude larger than those seen with authentic VX.[50] Recently, studies have focused on alternate analogs, diethyl-VX (DEVX) or the insecticide demeton-S, which contain the thioester leaving group and shows kinetics similar to the authentic nerve agent.[51]

CATALYTIC MECHANISM

The reaction catalyzed by PTE has been proposed to proceed via a nucleophilic attack on the phosphorus center in an S_N2-like mechanism.[52] Evidence supporting the nucleophilic attack on the phosphorus center has come from the analysis of products when the reaction was conducted in ^{18}O-labeled water.[52] The degradation of paraoxon yields diethyl phosphate and *p*-nitrophenol. When the reaction was carried out in labeled water, the label was found exclusively in the diethyl phosphate product, thereby verifying that the nucleophilic attack occurred at the phosphorus

center. This reaction was proposed to proceed via a direct attack on the substrate by water or through an enzyme intermediate. The phosphorus-containing product from the degradation of the insecticide EPN (O-ethyl O-(4-nitrophenyl) phenylphosphonothiolate) contains a chiral phosphorus center, and hydrolysis of a pure enantiomer of EPN by PTE yielded a product with an inversion of stereochemistry at the phosphorus center, thereby demonstrating that the reaction proceeds via a direct attack of the water nucleophile on the phosphorus in an S_N2 like mechanism.[52]

The specific chemical mechanism of the reaction catalyzed by PTE has been the subject of kinetic, computational, as well as structural studies. The mechanism proposed by Aubert *et al.* is shown in Figure 5.[53] The broad substrate specificity of PTE has allowed the use of Brønsted analysis to probe the catalytic mechanism. A series of substrates that differ in the pK_a of the leaving group has been developed.[4,6] The Brønsted plots are linear for the chemical hydrolysis of these compounds with KOH, but nonlinear for enzymatic hydrolysis.[6] The enzymatic rate is independent of the pK_a for the substrates with leaving group pK_a below 7 indicating that something other than bond cleavage is limiting the reaction.[6] The use of viscosity and solvent isotope effects demonstrated that this limit is

Figure 5 Proposed catalytic mechanism of PTE originally proposed by Aubert *et al.*[53] Distinct metal sites are designated α and β by convention. For the substrate paraoxon X and Y are ethanol groups in ester linkage to the phosphorus. Final step shown involves both the regeneration of the bridging hydroxyl and the binding of water in the open coordination site on the β-metal.

imposed by diffusion, and that some step after the bond cleavage is limiting, possibly product release or regeneration of the active site hydroxyl.[4,53] Contrary to what is seen with the fast substrates, there is a very strong dependence of the maximal rate of reaction on the pK_a of the leaving group in the substrates with pK_a above 8 ($\beta = -2.2$).[6]

Evidence for the interaction between the substrate and the active site metal has been observed by EPR which demonstrated that substrate analogs bound directly to the binuclear metal center as well as by structural work that showed analogs bound to the β-metal.[24,34] Kinetic evidence for direct interactions with the β-metal site during the course of the reaction has been achieved by Brønsted analysis of thiophosphate substrates with Zn/Zn, Cd/Cd, Mn/Mn, and Zn/Cd-substituted enzyme.[6] For fast substrates, these thiophosphate compounds are degraded more slowly than their phosphate counterparts, but for the group of slow substrates the thiophosphates are hydrolyzed faster. The Zn-containing enzyme gave a β-value from Brønsted analysis of -2.0, which is similar to the value measured with the phosphate series. The β-value for the thiophosphates was reduced to -1.4 in the Cd-containing enzyme, while the value for the phosphates increased to -3.0. The opposite trend was seen with the Mn-substituted enzyme where the β-values were -4.3 for the thiophosphates and -3.0 for the phosphates. The shift in β-values between the oxo and thio substrates indicates that significant alterations in the nature of the transition state are induced by the interaction between the substrate and active site metal. Cd, which prefers to bind to sulfur, appears to shift the late transition state with phosphate compounds to an early transition state with the thiophosphates. Mn, which prefers the harder oxygen, induces the opposite effect on the transition state. The identity of the metal site that is responsible for the coordination of the substrate during catalysis was verified using the hybrid enzyme containing both Zn and Cd.[6] It has been shown that Cd binds

preferentially to the β-site, and the Brønsted analysis of this hybrid is more reflective of the properties of the Cd/Cd enzyme indicating that the substrate interacts with the β-metal during catalysis.

It has been proposed that the metal-bridging hydroxyl seen in the crystal structure of PTE serves as the attacking nucleophile.[36,53] The pH rate profile for PTE indicates that a single group on the enzyme must be deprotonated for the reaction to proceed.[53] This ionizable group has been shown to have a pK_a of approximately 6, which is in rough agreement with what would be expected for water bound as a bridge between Zn ions.[54] It has been further demonstrated that the catalytic pK_a is dependent on the nature of the metals present in the active site with a larger contribution coming from the α-site metal.[53] EPR analysis of the pH-dependent coupling in the Mn-containing PTE demonstrated that the protonation of the bridging hydroxyl corresponds to the catalytic pK_a.[33] It has been alternately proposed that a water molecule bound terminally to the α-metal could be the attacking nucleophile. The finding that the catalytic pK_a is due to the deprotonation of the hydroxyl bridge, and the strong dependence of pK_a on the nature of the metal at the active site do not support the proposal of the nucleophile being a hydroxyl bound terminally to the α-site. In addition, a terminal hydroxyl bound to the α-metal is only seen structurally in enzymes containing alternate metals at the α-site, and it is doubtful that a Zn ion would accommodate the required octahedral coordination.[42]

Additional structural support for the proposed mechanism has been found in structures with product bound (Figure 3c). Unique to the proposed mechanism in Figure 5 is the appearance of a bivalent binding of product with one oxygen bound to each metal. This mode of binding has been seen with DEP bound in structures where the enzyme was cocrystallized with DEP and where the DEP was generated *in situ* from the degradation of substrate in the crystal.[38,42]

The catalytic mechanism of PTE has been probed theoretically by several computational methods.[55–58] While these studies have largely supported the proposed mechanism some differences have been noted. Quantum mechanical and molecular mechanical simulations supported a similar mechanism, but predicted that water binding and deprotonation would proceed product release in the mechanism.[55] This mechanism predicted a unique product complex that is not supported by current structural data.[38] Other computational studies have proposed that the mechanism with some substrates proceeds through two or more transition states with a relatively low energy barrier between them.[56,57] One interesting aspect of this work has been a proposal that substrates can bind initially in multiple orientations but must adopt the correct orientation for catalysis to occur, and that the initial approach of the phosphoryl center to the bridging hydroxyl could be rate limiting in some cases.[56,58]

ENZYME EVOLUTION WITH PTE

The broad substrate specificity of PTE is quite remarkable for an enzyme catalyst. However, PTE does demonstrate significant stereochemical preferences with substrates possessing chiral phosphorus centers.[10,43,59] This preference has been enhanced, reduced, and reversed by selective mutation of the active site residues.[43,60] The large and small pockets in the active site dictate the stereochemical preference of PTE.[43] Mutation of Gly60 to an alanine in the small group pocket enhances the enantiomeric preference of PTE.[43,60] This mutant has been shown to be able to enhance the stereochemical preference by up to 4 orders of magnitude with some substrates, and this large selectivity has allowed the use of PTE in both the isolation and synthesis of enantiomerically pure chiral organophosphates.[8,10,61,62] While G60A enhances the stereochemical preference already seen in wild-type PTE, other variants that simultaneously altered residues in the large and small binding pockets were able to reverse the preference and allow for the isolation of any enantiomer.[10,60] The issue of stereochemistry has been of particular interest in the development of PTE for the degradation of nerve agents. The nerve agents sarin, soman, and VX are all chiral compounds. The toxicity of enantiomers can vary significantly, and PTE has been shown to prefer the less toxic enantiomer for many organophosphates.[59] In the efforts to develop enzymes that could degrade the more toxic compound, the mutant I106A/F132A/H257Y was developed. This variant was shown to have a reversed stereochemical preference for analogs of both sarin and soman, and while the activity against the soman analogs was significantly reduced, the activity against the sarin analogs was enhanced compared to that of the wild-type enzymes.[9]

Other rational design studies have identified multiple mutants at positions His254 and His257 with improved ability to degrade phosphorothiolate compounds.[44] Similarly, alterations to residues Trp132 and Phe306 were shown to optimize the cleavage of phosphorus–fluoride bonds in the nerve agent analog diisopropylflurophosphate (DIFP) with the best mutant (F132H/F306H) showing a k_{cat} improved over an order of magnitude.[23] Studies that couple the modeling of desired substrates to the rational design of the active site have been able to identify mutants with enhanced ability to degrade specific insecticides. The mutant W131H/F132A of the *Agrobacterium* enzyme was identified using this method and demonstrated an improvement of 480-fold against the insecticide chlorfenvinphos.[63]

Numerous studies have expanded beyond typical rational design to identify variants of PTE with enhanced activity against desired compounds. The basis of most strategies is the generation of large numbers of genetic variants of PTE, and then screening them for activity against the compound of interest. The techniques utilized in generating variants has varied from randomization of one or two codons simultaneously, to random mutagenesis of the entire gene sequence, to shuffling of portions of the gene to generate random combinations of various favorable mutations previously identified.[28,64–67] Screening of libraries of mutants with multiple codons randomization allowed the isolation of H254G/H257W/L303T. This mutant has nearly 3 orders of magnitude improvement over the wild-type enzyme and with the opposite stereochemical preference for the degradation of soman analogs.[64] It has been possible to extend the search for beneficial variants to larger libraries by the development of plate-screening techniques. These techniques, in general, rely on the ability of bacterial colonies expressing PTE to either generate a chromogenic or fluorogenic product on a growth plate, or, in one case, deplete a colored substrate from the plate.[65–68] These techniques have been utilized to prescreen for improved activity prior to isolation of individual colonies for further analysis. These techniques, in combination with gene shuffling and random mutagenesis, have identified mutants with improved activity against various insecticides including some of the most commonly used insecticides and mutants that are expressed at much higher levels.[66,67]

UTILITY OF PTE AS AN ENZYME TOOL

Bioremediation and detection of organophosphates

The ability of PTE to degrade toxic compounds has led to much interest in it as an enzyme tool. Many of the substrates of PTE are highly toxic compounds that are applied in large amounts over vast areas of agriculture land.[19] It has been estimated that the majority of Americans are exposed to insecticides through food, water, and land contamination.[69] PTE was originally identified in studies of bacterial decontamination of insecticides,[14] and efforts have continued to develop PTE as a remediation tool. Many of these efforts have focused on the means of effectively immobilizing PTE for use in decontamination reactors. PTE has been successfully immobilized on trityl agarose resin to form fixed bed reactors that were able to decontaminate paraoxon, methyl parathion, parathion, DIPF, and coumaphos solutions that were flowed through the reactor with better than 90% decontamination.[70] Unfortunately, the inclusion of organic solvents is often required to achieve high solubility of organophosphates, and organic solvents dissociate the enzyme from the reactor. Better results were achieved with enzyme covalently immobilized onto nylon membranes and powders. While the enzymatic efficiency was reduced, the preparations proved to be stable for long periods of time and would withstand 40% MeOH without loss of activity.[71] Similarly, PTE has been covalently linked to sepharose beads for the development of flow systems that proved effective at decontaminating insecticide contamination in water.[72] PTE has also been immobilized by entrapment in meoporous silica beads with significant activity retained.[73] PTE has

been successfully expressed as a fusion to a cellulose binding domain protein to facilitate the rapid immobilization on cellulose columns that proved to be effective at the decontamination of solutions containing paraoxon.[74] PTE can also be expressed as a fusion to the ice nucleation protein, which targets it to the outer membrane in *E. coli* allowing the bacterial culture to be used as whole cell catalysts for the decontamination of pesticides.[75]

PTE has been successfully dispersed in fire-fighting foams to allow the decontamination of surfaces and soil contaminated with paraoxon.[76] This foam preparation proved to be more effective at decontaminating columns of sand containing paraoxon than the enzyme in solution. PTE has also been incorporated into latex paints to generate surfaces that are capable of decontaminating organophosphates that they come into contact with.[77]

Concerns over environmental contamination of organophosphates have also led to efforts to develop means to rapidly detect organophosphates. Multiple systems have been developed that incorporate immobilized PTE into various detection systems. One system immobilized PTE-expressing bacteria and followed the change in pH due to protons being released during the hydrolysis of organophosphates.[78] This scheme allowed detection of $1\,\mu M$ paraoxon but required 10–20 min. Other systems have utilized devices that measured a change in voltage potential associated with the proton released from the hydrolysis of various organophosphates with PTE immobilized on an electrode.[79,80] This methodology allowed detection down to $1\,\mu M$ paraoxon and was able to do so in only $10\,s$.[80] Immobilization of PTE or PTE-expressing cells onto electrodes has been utilized in several devices that measure a current flow generated from the release of *p*-nitrophenol during the degradation of select insecticides.[81–83] These devices have been able to detect concentrations of paraoxon down to $0.1\,\mu M$, and in some cases the electrodes have been shown to be stable for long periods of time.[81,82] One device that utilizes this methodology incorporated a PTE-coated gold electrode in a flow cell design that allowed for rapid testing of multiple samples.[83]

Traditionally, the activity of PTE has been followed spectrophotometrically, and numerous systems have been developed to utilize this technology to detect organophosphates. A fiber optic system was constructed to follow the hydrolysis of organophosphates by PTE immobilized on a nylon membrane attached to the end of the fiber optic cable.[84] This system was able to detect paraoxon down to $2\,\mu M$ and showed no interference from other common agricultural chemicals. Another system utilized PTE adsorbed onto bilayers of chitosa and poly(thiophene-3-acetic acid) on a quartz slide and the changes in fluorescence emission from the bilayers could be used to report on the binding of organophosphates to PTE.[85] The most sensitive system reported utilized PTE covalently linked to a pH-sensitive fluorophore and then encapsulated into a poly(ethylene glycol) hydrogel.[86] Following the changes in fluorescence

induced by proton released by hydrolysis, paraoxon could be detected down to a concentration of $16\,nM$.

Treatment of organophosphate poisoning

The toxicity of organophosphates is due to their ability to irreversibly inhibit acetylcholine esterase. Current treatments for organophosphate poisoning rely on compounds that themselves bind to acetylcholine esterase and prevent the organophosphate from binding or compounds that can reactivate acetylcholine esterase following exposure to organophosphates.[87] PTE has significant potential for the treatment of organophosphate poisoning because of its ability to directly degrade the toxin. Injection of PTE proved to increase the tolerance of mice to paraoxon poisoning by 33-fold.[88] It was found that PTE could protect to a limited degree against the inhibition of acetylcholine esterase by nerve agents in the brain despite not being able to enter the nervous system.[89] Other studies demonstrated that the treatment was more effective in combination with eptastigmine which prevents organophosphate binding to acetylcholine esterase.[90,91] This treatment was effective at speeding the recovery of acetylcholine esterase activity in the brain following exposure to DIFP.[90] The combination of PTE and pyridostigmine was shown to be able to increase the tolerance of test animals to sarin by four-fold and extend survival time from 20 min to over $2\,h$.[87] The closely related enzyme form Agrobacterium has shown to be effective at preventing mortality in rats treated with three times the LD_{50} values for the insecticides dichlorvos or parathion.[92]

REFERENCES

1 EF Petterson, TD Goddard, CC Huang, GS Couch, DM Greenblatt, EC Meng and TE Ferrin, *J Comput Chem*, **25**, 1605–12 (2004).

2 PJ Kraulis, *J Appl Crystallogr*, **24**, 946–50 (1991).

3 EA Merritt and MEP Murphy, *Acta Crystallogr*, **D50**, 869–73 (1994).

4 SR Caldwell, JR Newcomb, KA Schlecht and FM Raushe, *Biochemistry*, **30**, 7438–44 (1991).

5 DP Dumas, SR Caldwell, JR Wild and FM Raushel, *J Biol Chem*, **264**, 19659–65 (1989).

6 SB Bong and FM Raushel, *Biochemistry*, **35**, 10904–12 (1996).

7 DP Dumas, JR Wild and FM Raushel, *Biotechnol Appl Biochem*, **11**, 235–43 (1989).

8 WS Li, Y Li, CM Hill, KT Lum and FM Raushel, *J Am Chem Soc*, **124**, 3498–99 (2002).

9 WS Li, KT Lum, M Chen-Goodspeed, MA Sogorb and FM Raushel, *Bioorgan Medic Chem*, **9**, 2083–91 (2001).

10 C Nowlan, Y Li, JC Hermann, T Evans, J Carpenter, E Ghanem, BK Shoichet and FM Raushel, *J Am Chem Soc*, **128**, 15892–902 (2006).

11 LL Harper, CS McDaniel, CE Miller and JR Wild, *Appl Environ Microb*, **54**, 2586–89 (1988).

12 CS McDaniel, LL Harper and JR Wild, *J Bacteriol*, **170**, 2306–11 (1988).

13 KA Brown, *Soil Biol Biochem*, **12**, 105–12 (1980).

14 DM Munnecke and DPH Hsieh, *Appl Microbiol*, **28**, 212–17 (1974).

15 WW Mulbry and JS Karns, *J Bacteriol*, **171**, 6740–46 (1989).

16 I Horne, TD Sutherland, RL Harcourt, RJ Russell and JG Oakeshott, *Appl Environ Microb*, **68**, 3371–76 (2002).

17 E Porzio, L Merone, L Mandrich, M Rossi and G Manco, *Biochemie*, **89**, 625–36 (2007).

18 FM Raushel, *Curr Opin Microbiol*, **5**, 288–95 (2002).

19 T Kiely, D Donaldson, and A Grube, *Pesticide Industry Sales and Usage: 2000 and 2001 Market Estimates*. Biological and Economic Analysis Division, Office of Pesticide Programs, Office of Prevention, Pesticides, and Toxic Substances, U. S. Environmental Protection Agency (2004).

20 R Zhang, Z Cui, X Zhang, J Jiang, JD Gu and S Li, *Biodegradation*, **17**, 465–72 (2006).

21 GA Omburo, JM Kuo, LS Mullins and FM Raushel, *J Biol Chem*, **267**, 13278–83 (1992).

22 MY Chae, JF Postula and FM Raushel, *Bioorg Med Chem Lett*, **4**, 1473–78 (1994).

23 LM Watkins, HJ Mahoney, JK McCulloch and FM Raushel, *J Biol Chem*, **272**, 25596–601 (1997).

24 MM Benning, SB Hong, FM Raushel and HM Holden, *J Biol Chem*, **275**, 30556–60 (2000).

25 DP Dumas and FM Raushel, *J Biol Chem*, **265**, 21498–503 (1990).

26 SB Hong, LS Mullins, H Shim and FM Raushel, *Biochemistry*, **36**, 9022–28 (1997).

27 JM Kuo, MY Chae and FM Raushel, *Biochemistry*, **36**, 1982–88 (1997).

28 LM Watkins, JM Kuo, M Chen-Goodspeed and FM Raushel, *Prot Struct Func Gene*, **29**, 553–61 (1997).

29 GA Omburo, LS Mullins and FM Raushel, *Biochemistry*, **32**, 9148–55 (1993).

30 H Shim and FM Raushel, *Biochemistry*, **39**, 7357–64 (2000).

31 MY Chae, GA Omburo, PA Lindahl and FM Raushel, *J Am Chem Soc*, **115**, 12173–74 (1993).

32 MY Chae, GA Omburo, PA Lindahl and FM Raushel, *Arch Biochem Biophys*, **316**, 765–72 (1995).

33 CR Samples, T Howard, FM Raushel and VJ DeRose, *Biochemistry*, **44**, 11005–13 (2005).

34 SR Samples, FM Raushel and VJ DeRose, *Biochemistry*, **46**, 3435–42 (2007).

35 MM Benning, JM Kuo, FM Raushel and HM Holden, *Biochemistry*, **33**, 15001–7 (1994).

36 MM Benning, JM Kuo, FM Raushel and HM Holden, *Biochemistry*, **34**, 7973–78 (1995).

37 JL Vanhooke, MM Benning, FM Raushel and HM Holden, *Biochemistry*, **35**, 6020–25 (1996).

38 J Kim, PC Tsai, SL Chen, F Himo, SC Almo and FM Raushel, *Biochemistry*, **47**, 9497–504 (2008).

39 C Roodveldt and DS Tawfik, *Biochemistry*, **44**, 12728–36 (2005).

40 CM Seibert and FM Raushel, *Biochemistry*, **44**, 6383–91 (2005).

41 MM Benning, H Shim, FM Raushel and HM Holden, *Biochemistry*, **40**, 2712–22 (2001).

42 CJ Jackson, JL Foo, HK Kim, PD Carr, JW Liu, G Salem and DL Ollis, *J Mol Biol*, **375**, 1189–96 (2008).

43 M Chen-Goodspeed, MA Sogorb, F Wu, SB Hong and FM Raushel, *Biochemistry*, **40**, 1325–31 (2001).

44 B diSioudi, JK Grimsley, K Lai and JR Wild, *Biochemistry*, **38**, 2866–72 (1999).

45 B Zaitoun, *Kinetic Studies of the Hydrolysis of Organophosphate Insecticides by Phosphotriesterase*. Masters Thesis, Texas A&M University (2002).

46 K Lai, NJ Stolowich and JR Wild, *Arch Biochem Biophys*, **318**, 59–64 (1995).

47 DP Dumas, HD Durst, WG Landis, FM Raushel and JR Wild, *Arch Biochem Biophys*, **277**, 155–59 (1990).

48 K Lai, JK Grimsley, BD Kuhlmann, L Scapozza, SP Harvey, JJ DeFrank, JE Kolakowski and JR Wild, *Chimia*, **50**, 430–31 (1996).

49 VK Rastogi, JJ DeFrank, T Cheng and JR Wild, *Biochem Bioph Res Co*, **241**, 294–96 (1997).

50 PC Tsai, *Directed Evolution of Phosphotriesterase for Stereoselective Detoxification of Organophosphate Nerve Agents*. Doctoral Dissertation, Texas A&M University (2009).

51 EM Ghanem, *Directed Evolution of Phosphotriesterase for Detoxification of the Nerve Agent VX*. Doctoral Dissertation, Texas A&M University (2006).

52 VE Lewis, WJ Donarski, JR Wild and FM Raushel, *Biochemistry*, **27**, 1591–97 (1988).

53 SD Aubert, Y Li and FM Raushel, *Biochemistry*, **43**, 5707–15 (2004).

54 C He and SJ Lippard, *J Am Chem Soc*, **122**, 184–85 (2000).

55 KY Wong and J Gao, *Biochemistry*, **46**, 13352–69 (2007).

56 CJ Jackson, JW Liu, ML Coote and DL Ollis, *Org Biomol Chem*, **3**, 4343–50 (2005).

57 SL Chen, WH Fang and F Himo, *J Phys Chem B*, **111**, 1253–55 (2007).

58 X Zhang, R Wu, L Song, Y Lin, M Lin, Z Cao, W Wu and Y Mo, *J Comput Chem*, **30**, 2388–401 (2009).

59 SB Hong and FM Raushel, *Biochemistry*, **38**, 1159–65 (1999).

60 M Chen-Goodspeed, MA Sogorb, F Wu and FM Raushel, *Biochemistry*, **40**, 1332–39 (2001).

61 Y Li, SD Aubert and FM Raushel, *J Am Chem Soc*, **125**, 7526–27 (2003).

62 Y Li, SD Aubert, EG Maes and FM Raushel, *J Am Chem Soc*, **126**, 8888–89 (2004).

63 CJ Jackson, K Weir, A Herlt, J Khurana, TD Southerland, I Horne, C Easton, RJ Russell, C Scott and JG Oakeshott, *Appl Environ Microb*, **75**, 5153–56 (2009).

64 CM Hill, WS Li, JB Thoden, HM Holden and FM Raushel, *J Am Chem Soc*, **125**, 8990–91 (2003).

65 H Yang, SY McLoughlin, JW Liu, I Horne, X Qiu, CMJ Jeffries, RJ Russell, JG Oakeshott and DL Ollis, *Protein Eng*, **16**, 135–45 (2003).

66 C Roodveldt and DS Tawfik, *Protein Eng Des Sel*, **18**, 51–58 (2005).

67 CMH Cho, A Mulchandani and W Chen, *Appl Environ Microb*, **70**, 4681–85 (2004).

68 CMH Cho, A Mulchandani and W Chen, *Appl Environ Microb*, **68**, 2026–30 (2002).

69 DB Barr, R Allen, AO Olsson, R Bravo, LM Caltabiano, A Montesano, J Nguyen, S Udunka, D Walden, RD Walker, G Weerasekera, RD Whitehead, SE Schober and LL Needham, *Environ Res*, **99**, 314–26 (2005).

70 SR Caldwell and FM Raushel, *Biotechnol Bioeng*, **37**, 103–9 (1991).

71 SR Caldwell and FM Raushel, *Appl Biochem Biotech*, **31**, 59–73 (1991).

72 G Istamboulie, R Durbiano, D Fournier, JL Marty and T Noguer, *Chemosphere*, **78**, 1–6 (2010).

73 C Lei, Y Shin, J Liu and EJ Ackerman, *J Am Chem Soc*, **124**, 11242–43 (2002).

74 RD Richins, A Mulchandani and W Chen, *Biotechnol Bioeng*, **69**, 591–96 (2000).

75 C Yang, Y Zhu, J Yang, Z Liu, C Qiao, A Mulchandiani and W Chen, *Appl Environ Microb*, **74**, 7733–39 (2008).

76 KE LeJeune and AJ Russell, *Biotechnol Bioeng*, **62**, 659–65 (1999).

77 CS McDaniel, J McDaniel, ME Wales and JR Wild, *Prog Org Coat*, **55**, 182–88 (2006).

78 EI Rainina, EN Efremenco and SD Varfolomeyev, *Biosens Bioelectron*, **11**, 991–1000 (1996).

79 P Mulchandani, A Mulchandani, I Kaneva and W Chen, *Biosens Bioelectron*, **14**, 77–85 (1999).

80 AW Flounders, AK Singh, JV Volponi, SC Carichner, K Wally, AS Simonian, JR Wild and JS Schoeniger, *Biosens Bioelectron*, **14**, 715–22 (1999).

81 A Mulchandani, P Mulchandani, W Chen, J Wang and L Chen, *Anal Chem*, **71**, 2246–49 (1999).

82 P Mulchandani, W Chen, A Mulchandani, J Wang and L Chen, *Biosens Bioelectron*, **16**, 433–37 (2001).

83 J Wang, R Krause, K Block, M Musameh, A Mulchandani and MJ Schoning, *Biosens Bioelectron*, **18**, 255–60 (2003).

84 A Mulchandani, S Pan and W Chen, *Biotechnol Prog*, **15**, 130–34 (1999).

85 CA Constantine, SV Mello, A Dupont, X Cao, D Santos, ON Oliveira, FT Strixino, EC Pereira, TC Cheng, JJ DeFrank and RM Leblanc, *J Am Chem Soc*, **125**, 1805–9 (2003).

86 RJ Russell, MV Pishko, AL Simonian and JR Wild, *Anal Chem*, **71**, 4909–12 (1999).

87 K Tuovinen, E Kaliste-Korhonen, FM Raushel and O Hanninen, *Toxicology*, **134**, 169–78 (1999).

88 K Tuovinen, E Kaliste-Korhonen, FM Raushel and O Hanninen, *Fund Appl Toxicol*, **23**, 578–84 (1994).

89 K Tuovinen, E Kaliste-Korhonen, FM Raushel and O Hanninen, *Fund Appl Toxicol*, **31**, 210–17 (1996).

90 K Tuovinen, E Kaliste-Korhonen, FM Raushel and O Hanninen, *Toxicol Appl Pharm*, **141**, 555–60 (1996).

91 K Tuovinen, E Kaliste-Korhonen, FM Raushel and O Hanninen, *Toxicol Appl Pharm*, **140**, 364–69 (1996).

92 SB Bird, TD Sutherland, C Gresham, J Oakeshott, C Scott and M Eddleston, *Toxicology*, **247**, 88–92 (2008).

Hydrolases: Acting on Peptide Bonds

Glutamate carboxypeptidase II

Jeroen R Mesters and Rolf Hilgenfeld

Institute of Biochemistry, Center for Structural and Cell Biology in Medicine (CSCM), University of Lübeck, Ratzeburger Allee 160, Lübeck, Germany

FUNCTIONAL CLASS

Enzyme; glutamate carboxypeptidase II (GCP II); EC 3.4.17.21; glycosylated, membrane-bound dinuclear zinc exopeptidase; known as GCP II; formerly known as PSM/PSMA (prostate-specific membrane antigen), NAALADase (*N*-acetylated α-linked acidic dipeptidase; NAALAD 1) NAAG hydrolase (*N*-acetyl-L-aspartyl-α-L-glutamate hydrolase), mGCP (membrane glutamate carboxypeptidase), jejunal brush-border folate hydrolase/(de-)conjugase (FOLH 1), FGCP (folylpoly-γ-glutamate carboxypeptidase), and brush-border PPH (pteroylpoly-γ-glutamate hydrolase).

The type-II membrane glycoprotein GCP II is a homodimeric, dinuclear zinc carboxypeptidase that is known to catalyze the cleavage of at least two endogenous substrates carrying L-glutamate at the C-terminal P1' position, namely, α-NAAG and folylpoly-γ-L-glutamate (synonymous to folylpolyglutamate and pteroylpoly-γ-L-glutamate).[1–3] In addition, the enzyme is known to deconjugate methotrexatepoly-γ-L-glutamate.

The membrane-bound exopeptidase (PSMA; EC 3.4.17.21) is not to be confused with PSA (prostate-specific antigen; EC 3.4.21.77) or γ-GH (γ-glutamyl hydrolase; EC 3.4.19.9).

OCCURRENCE

At least one representative gene for GCP II can be found in amphibians, fish, birds, and mammals.[4] The exopeptidase is mainly located in prostate, virtually all types of glial cells, and, to a lesser extent, in kidney, liver, spleen, and rapidly regenerating tissues such as the bone marrow and the intestinal epithelium, i.e. the jejunal brush border.[5,6] Moreover, the enzyme is dramatically overproduced in endothelial cells of tumor-associated neovasculature[7] and prostate cancer tissue,[8–10] a fact that accounts for the widely used acronym in medicine, namely, PSMA. Expression of the carboxypeptidase in prostate tissue is hormonally downregulated by steroids such as 5α-dihydrotestosterone and testosterone.[11,12] Increased doses of vitamin D or the overexpression of the vitamin D receptor also downregulate the expression of the antigen.[13] The regulation by 1α,25-dihydroxyvitamin D_3 occurs at the level of the PSMA-enhancer element. Interestingly, the short cytoplasmic tail of the antigen is implicated in cell-surface localization and internalization, and thus involved in regulation of activity.[14,15] More specifically, the N-terminal tail of the protein contains an MXXXL motif that mediates the internalization of the antigen via clathrin-coated pits.[16]

N

3D Structure Schematic representation of homodimeric GCP II in complex with the potent inhibitor 2-phosphonomethyl-pentanedioic acid (2-PMPA), PDB ID-code 2JBJ.[74] One subunit is colored according to organization into domains: domain I, yellow; domain II, light blue; and domain III, brown. The inhibitor 2-PMPA, located in the S1' pocket, is shown as small beige spheres. The 'glutarate sensor' (domain III, residues 692–704), which probes the S1' site for bound glutamate, is shown in green. Zinc ions (active site) are shown as magenta spheres, Ca^{2+} (near the dimer interface) as a red sphere, and Cl^- (S1 pocket) as a cyan sphere. Carbohydrate chains are shown as colored lines. Many of the illustrations presented herein were prepared using MOLSCRIPT and RASTER3D.[97,98]

BIOLOGICAL FUNCTION

To evaluate the biological function(s) of GCP II, its two known endogenous substrates, namely, α-NAAG and folylpolyglutamate, require some introduction.

α-NAAG is the most abundant brain peptide (up to 1–2 mM) that can be found in a variety of neurons including γ-amino butyric acid excreting (i.e. GABAergic) hippocampus interneurons, motor neurons, and retinal ganglion cells.[6,17,18] It is synthesized by the enzyme NAAG synthase in neurons and glia directly from the two most abundant brain amino acids, glutamate and N-acetyl-aspartate,[18,19] and the acetylated dipeptide is ultimately released into the synaptic cleft for signaling. There, the neuropeptide acts as an agonist for the metabotropic (i.e. G-protein-coupled) glutamate receptor-3 (mGluR3)[6,20,21] and as a low-potency N-methyl-D-aspartate (NMDA) receptor mixed agonist/antagonist.[6,22–25] In the brain, the NAAG peptidase GCP II is mainly located at the astrocytic extensions surrounding the synaptic cleft (together forming the so-called tripartite synapse[26]), which is not surprising since the enzyme is responsible for switching off glutamatergic signaling triggered by the dipeptide. The products of the cleavage reaction, N-acetyl-L-aspartic acid and L-glutamic acid, act as neurotransmitters themselves that are ultimately removed from the synaptic cleft through active transport processes.[18] Very high concentrations of glutamic acid are excitotoxic and harm retina and brain,[27–29] which explains why α-NAAG (the main source of free L-glutamate in the synaptic cleft) is implicated in pain, amyotrophic lateral sclerosis (ALS), diabetic neuropathy, central nervous system injury, and schizophrenia.[29]

The principal folate-dependent reactions include nucleic-acid biosynthesis and amino acid interconversions.[30] During the homocysteine-to-methionine interconversion, a folate–vitamin B_{12}-dependent reaction, 5-methyl-tetrahydrofolate is demethylated to tetrahydrofolate, which in turn is further transformed to give 5,10-methylene-tetrahydrofolate, the essential cofactor for the enzyme thymidylate synthetase implicated in DNA (i.e. deoxythymidine monophosphate (dTMP)) biosynthesis. In our daily food and in blood plasma, pteroylmono-L-glutamate (i.e. folate) is mainly present in the form of folylpoly-γ-L-glutamate. Cell uptake (but also jejunal absorption) of the indispensable cofactor pteroylmono-L-glutamate can only occur after sequential hydrolysis (i.e. the stepwise removal of P1′ glutamates) of folylpoly-γ-L-glutamate by the carboxypeptidase GCP II. Folylpolyglutamate hydrolysis is reduced in conditions and diseases associated with folate deficiency such as chronic alcoholism, celiac disease, and tropical sprue.[30] As mentioned above, the enzyme is dramatically overproduced in tumor-associated neovasculature and prostate cancer tissue,[7–9] a fact that may be indicative of an increased folate demand of the rapidly proliferating cancer tissue. Nonetheless, the particular role of GCP II in cancer is poorly understood although it apparently plays a critical role in angiogenesis[31] and, unexpected for a transmembrane peptidase,[32] anti-invasiveness.[33]

It remains unclear whether the extracellular glycoprotein with its internalization signal sequence is able to bind and deliver a big macromolecular ligand to the cell,[3] as does the transferrin receptor (TfR).[34] In support of such a model, binding of antibodies to the ectodomain of the antigen increases its internalization.[14] In any case, GCP II could certainly act as an auxiliary folate shuttle.

Taken together, GCP II fulfills an essential function in NAAG and folate metabolism and, not unexpectedly, a homozygous null state may result in early embryonic death.[35]

AMINO ACID SEQUENCE INFORMATION

- *Homo sapiens* (human), 750 amino acid (AA) residues,[9] UniProtKB/Swiss-Prot (UPSP) ID code Q04609
- *H. sapiens* (human), 704 AA splice variant of GCP II termed PSM-E,[36] UPSP code A4UU12
- *Sus scrofa* (pig), 751 AA,[2] UPSP code O77564
- *Rattus norvegicus* (rat), 752 AA,[37] UPSP code P70627
- *Mus musculus* (mouse), 752 AA,[38] UPSP code O35409

Relationships

In descending order of the percentage of sequence identity, homologs of GCP II are PSMAL (prostate-specific membrane antigen-like protein; GCP III), NAALAD 2, NLDL (N-acetylated α-linked acidic dipeptidase-like protein), and NAALADL 2 (N-acetylated α-linked acidic dipeptidase-like 2).[39–41] Human GCP II shares 67% sequence identity with NAALAD 2 and 28% with the primary family representative TfR. The AAs that are involved in zinc and substrate binding in GCP II are poorly conserved in the TfR and, as a result, this functionality is lacking in the latter.[34,42] The enzymes GCP II and NAALAD 2 are thought to have arisen from a tandem gene duplication of an ancestral exopeptidase.[4] Each of these two enzymes catalyzes the hydrolysis of N-acetyl-L-aspartyl-α-L-glutamate and folylpoly-γ-L-glutamate. A representative of both GCP II and NAALAD 2 can be found in amphibians, birds, and mammals. Curiously, only one representative gene has been detected in fish so far, whereas three representatives are present in sea squirt and sea urchin.[4] The GCP II homologs PSMAL (GCP III) and NAALAD 2 are mainly found in ovary, testis, and in discrete brain areas.[39,40]

PROTEIN PRODUCTION, PURIFICATION, AND MOLECULAR CHARACTERIZATION

Initially, crude GCP II isolates were obtained from albino Sprague-Dawley rat forebrain and human jejunal

brush border.[43–45] The isolation from rat brain was optimized further employing sequential column chromatography on diethylaminoethyl-, carboxymethyl-, and lectin-sepharose (720-fold purification of the protein with a 1.6% yield).[46] The purified rat exopeptidase migrated as a single silver-stained band on a sodium-dodecyl-sulfate (SDS) gel with an apparent molecular weight of about 94 kDa. Successive immunocytochemical studies with guinea-pig polyclonal antibodies against rat GCP II revealed intense immunoreactivity in the cerebellar and renal cortices.[46] The rat protein is fairly temperature stable (up to 65 °C) and most active between pH 6.5 and 7.5 in the presence of calcium chloride.[44] Studies on human and pig jejunal brush-border FOLH 1 revealed a molecular weight of roughly 120 kDa for the denatured monomeric enzyme, which appeared to form homodimers under more native conditions.[30,47,48] Using an *in vitro* transcription–translation system and a plasmid containing the full-length 2.65-kb human PSMA cDNA, an unmodified 84-kDa protein was obtained that could be glycosylated employing pancreatic canine microsomes, thereby yielding the ~100 kDa glycoprotein.[11] Subsequent immunohistochemical analysis of three different prostate cancer cell lines employing the 7E11-C5.3 monoclonal antibody revealed high PSMA expression limited to androgen-sensitive lymph node carcinoma of the prostate (LNCaP) cells. These LNCaP cells are still being exploited as a source of native GCP II using conformational epitope-specific antibody-affinity chromatography.[49] Larger amounts of recombinant PSMA were produced successfully by utilizing insect cells.[50] For this particular approach, a recombinant baculovirus transfer vector was generated from which histidine-tagged GCP II was translated in insect cells and purified using cobalt-chelating affinity chromatography. The purified His$_6$-tagged antigen was used in the development of a novel protein biochip immunoassay for discriminating between benign and malignant prostate disease.[51] Also, a mammalian (i.e. Chinese hamster ovary DXB11) cell system has been used for the heterologous gene expression and translation of the extracellular part of the peptidase.[52] The protein was purified from the culture supernatant by ion exchange, hydrophobic interaction, and hydroxyapatite chromatography. For the large-scale expression of human GCP II required for crystallization trials, insect cells were applied successfully.[42,53] The extracellular portion of GCP II (residues 44–750) was subcloned into a baculovirus transfer vector and the peptidase overproduced by infecting *Trichoplusia* or *Drosophila* cells. The protein was subsequently purified utilizing the built-in cleavable His-tag or, employing the above-mentioned classical, sequential column-chromatography approach.

The extracellular portion of the exopeptidase (residues 44–750) harbors a total of 10 potential sites for N-glycoside linkage of carbohydrates, asparagine residues 51, 76, 121, 140, 153, 195, 336, 459, 476, and finally, 638. N-Glycosylation is important for folding, dimerization,

and activity of the antigen.[11,52,54,55] At position Asn638, the three-dimensional structure of the N-linked high-mannose (Man) carbohydrate chain (involved in homo-dimer formation) has been established up to a length of four sugar units: Asn638-GlnNAc β(1–4)-GlnNAc β(1–4)-Man α(1–3)-Man.[42] Markedly, the early and apparently immature high-mannose type, (chymo-)trypsin sensitive, GCPII becomes O-glycosylated as well.[55] This observation is of particular interest in view of the crucial role played by aberrant O-glycosylation in cancer.[56]

METAL CONTENT AND COFACTORS

Besides the two zinc ions located at the catalytic center of the active site, a single chloride and one calcium ion were located in the crystal structure of GCP II.[42] The latter two ions are required for the enzyme's hydrolytic activity[43,44]; Ca^{2+} appears to be critical for the formation of homodimers (the active form of GCP II)[48,52,57] and Cl$^-$ is located in the S1 pocket of the enzyme where it plays a role in substrate binding.[42] The enzyme does not require any coenzymes for its activity.

ACTIVITY TEST

GCP II activity was originally measured employing liquid chromatography, followed by radiodetection of the products of the cleavage reaction.[44] In brief, radiolabeled α-NAAG and enzyme were incubated at 37 °C in buffer, pH 7.4. The reaction was stopped by the addition of sodium phosphate and the mixture of substrate and products separated by ion-exchange chromatography. The separated, radiolabeled products of the reaction, either [3,4-^3H]-glutamate or [1-^{14}C]-acetyl-aspartate, were finally quantified by scintillation spectroscopy. An alternative, radiolabel-free assay utilizes methotrexate/pteroyl poly-γ-glutamate as a substrate.[52,58–60] Products were separated by either capillary electrophoresis[58,59] or by high-pressure liquid chromatography,[52] followed by detection at a wavelength of 300 nm (pteroyl moiety)[59] or 313 nm (methotrexate).[52] Finally, a simple colorimetric assay (based on formazan formation)[52] was employed that is highly specific for free (i.e. liberated) L-glutamate. A big advantage of the latter approach is that substrate and products do not need to be separated (commercially available kit, 'L-glutamic acid', cat. no. E 0139092, R-Biopharm GmbH, Darmstadt, Germany; lower detection limit of 0.2 µg ml^{-1}).

GCP II activity may be increased by Co^{2+} and other divalent metal ions substituting for Zn^{2+} while sulfate, phosphate, dithiothreitol, chelators, (such as ethylene-glycol tetraacetic acid, ethylene-diamine tetraacetic acid, and o-phenanthroline) and glutamate analogs (such as serine-O-sulfate, quisqualic acid, willardiine, and homoibotenate) inhibit substrate catabolism.[42,44,45,61]

X-RAY STRUCTURES

Crystallization

Crystals of PSMA (residues 44–750) were first reported by Davis *et al.* employing the vapor diffusion hanging-drop technique at 4 °C.[53] The crystallization droplets were prepared by mixing 0.8 μl of protein-stock solution (~10 mg ml^{-1} in 20 mM Tris (hydroxymethyl) aminomethane, pH 7.5) with 0.8 μl of reservoir solution consisting of 18% polyethylene glycol (PEG) 3350 in 0.2 mM thiocyanate. The crystals were then transferred to cryosolutions with increasing concentrations of glycerol and PEG. The final soaking solution contained 0.2 M sodium thiocyanate, 28% PEG 3350, and 20% glycerol. The crystals belonged to space group $P2_1$ with unit-cell dimensions $a = 75.8$ Å, $b = 159.5$ Å, $c = 134.4$ Å, $\beta = 93.2°$, and one dimer of the protein per asymmetric unit. Despite cryocooling to 100 K, the crystals decayed rapidly in the X-ray beam and, out of ~300 crystals screened, two partial datasets with a maximum Bragg spacing of 3.5 Å were collected and merged. Mesters *et al.* also prepared small crystals of GCP II by the vapor-diffusion hanging-drop technique.[42] The hanging drops were assembled by mixing 2-μl protein solution (10 mg ml^{-1} in 20 mM Tris, 100 mM sodium chloride, pH 8.0) with 2-μl well solution containing 20-mM 4-(2-hydroxyethyl)-1-piperazineethanesulfonic acid (HEPES), 200 mM sodium chloride, 5% (w/v) PEG 400, and 15% (w/v) PEG 1500. Large crystals of up to 0.6 × 0.25 × 0.2 mm^3 were obtained within a week or two only in the presence of inhibitors. They belonged to space group $I222$ with unit-cell dimensions $a = 103.1$ Å, $b = 131.2$ Å, $c = 161.2$ Å, and one molecule of GCP II in the asymmetric unit. Also, these crystals turned out to be very radiation-sensitive and, moreover, could not be satisfactorily and reproducibly flash-cooled. After many attempts, full-diffraction data sets (up to 2.0 Å) from single crystals mounted in short capillaries were easily obtained when collected at 263 K instead of at 277 or 100 K.[42] These crystals displayed mosaicity values smaller than 0.075°. The heavy N-glycosylation of the ectodomain of GCP II apparently does not interfere with crystal growth, contrary to common belief.[62] Finally, Barinka *et al.* succeeded in growing the $I222$ crystal form using well solutions containing 33% pentaerythritol propoxylate (5/4 PO/OH), 1–3% (w/v) PEG 3350 and 100 mM Tris, pH 8.0. These crystals could be directly transferred from the droplets to the cryostream (running at 100 K) and they displayed a maximum Bragg spacing of 1.5 Å.[63–65]

Overall description of structures

GCP II is a 750-residue, membrane-anchored dinuclear zinc peptidase (MEROPS peptidase database clan

MH, subfamily M28B)[66] of ~110-kDa molecular weight, including N-glycosylation at 10 sites.[54,67,68] Being a class-II membrane protein like the TfR,[34] GCP II has a short cytosolic amino-terminal region of approximately 19 residues and a single membrane-spanning segment (about 22 residues), with the bulk of the peptidase being located in the extracellular space.[69–72] Table 1 lists all GCP II structures deposited with the worldwide Protein Data Bank (wwPDB).[73] One more structure of inactive GCP II (Glu424 → Ala) in complex with NAAG is currently on hold (PDB ID code 3BXM).

The extracellular part of recombinant human GCP II folds into three distinct domains[42,53]: the carboxypeptidase domain (domain I, residues 57–116 and 352–590), the apical domain (domain II, residues 117–351), and the C-terminal helical domain (residues 591–750). The topology diagram in Figure 1 shows how strands and helices are organized within the three domains.

The fold of the carboxypeptidase domain (domain I) is most closely related to the protease-like domain of the TfR (PDB ID-code 1CX8[34]; root-mean-square deviation (rmsd) of 1.7 Å for 239 Cα pairs out of 300 compared) and the aminopeptidases of *Aeromonas proteolytica* (PDB ID code 1AMP[77]; rmsd of 2.0 Å for 239 Cα pairs out of 291 compared) and *Streptomyces griseus* (PDB ID code 1XJO[78]; rmsd of 2.1 Å for 243 Cα pairs out of 277). The main structural feature of this domain is a central seven-stranded

Table 1 Crystal structures of GCP II (PSMA) as listed in the Protein Data Bank (PDB; January 2008)

PDB ID code, year	Resolution (Å)	Inhibitor	References
1Z8L, 2005	3.5	None	53
2C6C, 2006	2.00	GPI-18431	42
2C6G, 2006	2.20	Glutamate	42
2C6P, 2006	2.39	Phosphate ion	42
2CIJ, 2006	2.40	Methionine	–
2JBJ, 2007	2.19	2-PMPA	74
2JBK, 2007	3.0	Quisqualate	74
2OOT, 2007	1.64	None	63
2OR4, 2007	1.62	Quisqualate	64
2PVV, 2007	2.11	L-SOS	64
2PVW, 2007	1.71	2-PMPA	64
3BHX, 2008	1.60	SPE	65
3BI0, 2008	1.67	EPE	65
3BI1, 2008	1.50	MPE	65

GPI-18431, (S)-2-(4-iodobenzylphosphonomethyl)-pentanedioic acid; 2-PMPA, 2-phosphonomethyl-pentanedioic acid; quisqualate, α-amino-3,5-dioxo-1,2,4-oxadiazolidine-2-propanoic acid; L-SOS, L-serine-O-sulfate; SPE, (2S)-2-{[(S)-(2-carboxyethyl)(hydroxy)phosphoryl]methyl}pentanedioic acid; EPE, (2S)-2-{[(S)-[(3S)-3-amino-3-carboxypropyl](hydroxy)phosphoryl]methyl}pentanedioic acid; MPE, (2S)-2-{[(R)-[(3R)-3-carboxy-3-{[(4-{[(2,4-diaminopteridin-6-yl)methyl](methyl)amino}phenyl]carbonyl]-amino}propyl](hydroxy)phosphoryl]methyl}pentanedioic acid.

Figure 1 Topology diagram for the ectodomain (residues 44–750) of GCP II,[42] redrawn after TOPS (topology of protein structure) server output.[75] Residue numbers are given for strands (β's) and helices (α's) defined according to the program DSSP (dictionary of protein secondary structure)[76]: α1, from 58 to 63; α2, 67 to 77; α3, 87 to 103; β1, from 107 to 119; β2, 127 to 131; β3, 137 to 140; β4, 171 to 176; α4, 182 to 190; β5, 200 to 204; α5, 210 to 219; β6, 224 to 228; α6, 231 to 234; β7, 294 to 297; α7, 299 to 307; β8, 341 to 345; β9, 349 to 362; β10, 367 to 377; α8, 389 to 407; β11, 414 to 421; α9, 429 to 445; β12, 447 to 451; β13, 461 to 466; α10, 471 to 479; α11, 493 to 500; α12, 521 to 526; β14, 532 to 538; α13, 559 to 565; α14, 571 to 589; α15, 597 to 615; α16, 619 to 625; α17, 630 to 652; α18, 658 to 673; β15, 692 to 695; β16, 699 to 704; α19, 706 to 712; α20, 720 to 744.

mixed β sheet flanked by 10 α helices. Domain I residues Glu433 (both Oε1 and Oε2) and Glu436 (Oε2), as well as domain II residues Thr269 (Oγ1 and main-chain O) and Tyr272 (main-chain O), coordinate the calcium ion (Figure 2). A water molecule completes its heptacoordination. The Ca^{2+} is too remote from the active site to be directly involved in the catalytic activity, but rather plays a crucial structural role in support of homodimer formation, the biologically active form of the exopeptidase.[48,52,57] It holds domains I and II together through coordinative interactions, thereby stabilizing the loop 272–279, which carries three tyrosine residues (272, 277, and 279) that form a hydrophobic pocket (Figure 2).[42] This pocket is entered by the side chain of Tyr733 of domain III of the other monomer in the homodimer. In addition, Tyr277 makes an intermolecular hydrophobic interaction with the N-acetyl group of the first N-acetylglucosamine sugar attached to side chain of Asn638 of the other monomer.[42]

Two water molecules and residues Asn451 (Nδ2), Asp453 (main-chain NH), Arg534 (Nε and Nη2 atoms), and Arg580 (Nη2), coordinate a Cl^- in a distorted octahedral manner (Figure 3).[42] The chloride ion holds S1-pocket-residue Arg534 in an 'all-gauche' conformation (Figure 3), which is energetically not the most favorable. Robinson *et al.* already observed an absolute dependence of GCP II activity on monovalent anions, with chloride being the most efficient; kinetic measurements revealed a clear increase in K_m in the absence of Cl^-, with little or

no change in V_{max}.[44] The side chains of Asn519, Arg534, and Arg536 play a role in the binding of the α-/γ-carboxyl group of the S1-bound penultimate AA.[42,65] In the absence of Cl^-, the side chain of Arg534 will most likely adopt a conformation not allowing it to productively interact with the substrate. It is worth noting that the catalytic activity of many carboxypeptidases depends on the presence of a chloride ion.[79]

Inserted between antiparallel strands β1 and β9, which are the first and second strands of the central mixed β-sheet of domain I, is the apical domain (domain II) that partly covers the active site, creating a deep substrate-binding funnel between domains I and II. The fold of the apical domain is most closely related to the TfR domain II (rmsd of 2.0 Å for 184 Cα pairs out of 228 compared).[34] The central seven-stranded (4 + 3) β sandwich of the apical domain is flanked by four α helices and harbors a perfect, solvent exposed, polyproline type 2 helix (Pro146–149). This structural motif usually mediates protein–protein interactions with Src homology 3 (SH3) domains implying that GCP II might be involved in other physiological processes such as signaling. Even though SH3 domains are mainly restricted to the cell cytoplasm, evidence suggests the presence of SH3-like modules in extracellular proteins.[80,81]

The main feature of domain III is an up-down-up-down four-helix bundle, most closely related to the fold of TfR domain III (rmsd of 2.9 Å for 137 Cα pairs

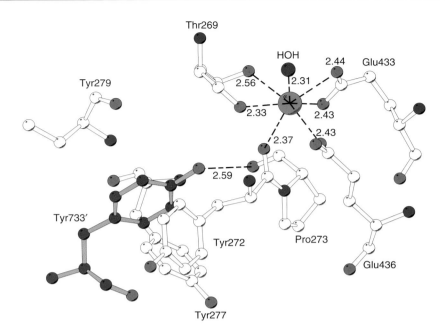

Figure 2 Schematic drawing of the heptacoordination sphere of bound Ca^{2+}. GCP II is most stable and active in the presence of $CaCl_2$, which plays an important role in dimer formation[42]: Tyr733' of the other monomer in the homodimer enters a hydrophobic pocket (shaped by tyrosine residues 272, 277, and 279) and forms a strong hydrogen bond with the main-chain carbonyl atom of Pro273. The calcium ion is shown as a green sphere. Distances are given in angstrom (Å). PDB ID code 2JBJ.[74]

Figure 3 Schematic drawing of the coordination geometry of bound Cl^- in the S1 pocket of GCP II. The chloride ion holds Arg534 (involved in substrate binding) in an 'all-gauche' conformation.[42] GCP II activity is strictly dependent on monovalent anions, with Cl^- being the most efficient. Distances are given in angstrom (Å). PDB ID code 2JBJ.[74]

out of 154 compared).[34] One α helix of the bundle is discontinuous (residues 658–673 and 706–712) and comprises two consecutive loops (residues 676–690 and 692–704),[42] both of which are located at the domain I–II interface. Moreover, residues Lys699 and Tyr700, at the tip of the second loop, are directly involved in the specific binding of the P1′ glutarate (i.e. pentanedioic acid) portion of bound substrates or inhibitors.[42,74] The two loops have

a significantly different conformation in the TfR, with the second of them being much shorter and unable to reach into the TfR domain I–II interface. In the dimerization interface of about 2457 Å2,[42] domain III of one GCP II monomer faces domains I and II of the other. Further, there are two intermolecular domain III–domain III salt bridges formed across the twofold axis of the homodimer between the side chains of Arg662 of one monomer and Asp666 of the other.

Catalytic-site zinc coordination geometry

To our knowledge, all metalloendoproteases and the majority of metallocarboxypeptidases contain a mononuclear-zinc active site. GCP II contains two zinc ions bound in its active site within a (μ-aquo)(μ-carboxylato)dizinc(II) core and a zinc–zinc distance of 3.3 Å.[42] Zn(1) is coordinated to His377, Asp453, and the bridging Asp387, and Zn(2) to Asp387, Glu425, and His553. In the substrate-free state of GCP II, the two metal ions are bridged in an asymmetric fashion by a bidentate water (or hydroxyl) ligand, which completes the tetrahedral coordination sphere of each of the zinc ions (Figure 4).

The main function of Zn(1) is to bind and activate a water molecule for the nucleophilic attack onto the scissile bond.[42,82] Zn(2) primarily polarizes the carbonyl group of the scissile bond for this reaction and compensates for the absence of an oxyanion hole in GCP II. Both metal ions

stabilize the *gem*-diol transition state. In complexes with transition-state-analog inhibitors, the distance between the zinc ions increases from 3.3 to 3.6–3.8 Å,[42,74] a scenario that may also apply to the *gem*-diol transition state of bound substrates (Figure 5). The distances between the zinc ions and their ligands changes by less than 0.2 Å. Glu424 is the acid/base of GCP II that abstracts a proton from the zinc-bound catalytic water and, during or after substrate cleavage, transfers it to the leaving group, the amino moiety of glutamate.[42,71,82]

Although GCP II is very active in the presence of cobalt chloride,[44] the naturally bound Zn^{2+} atoms, unlike most other transition metal ions, contain a filled d orbital that makes them redox-stable in the complex biological environment.[83] In addition, its ligand-field stabilization energy is about zero and thus no Zn^{2+} coordination geometry is more stable than the other.

Conformational variations

Substrate binding to the active site of GCP II obeys an induced-fit mechanism as opposed to a lock-and-key principle.[42] Residues Lys699 and Tyr700 of the so-called glutarate sensor (residues 692–704 of domain III),[42] are directly involved in the specific binding of the P1′ glutarate portion of bound substrates or inhibitors. Thus, not only domains I and II but also domain III is directly involved

Figure 4 Schematic drawing of the catalytic-site zinc coordination geometry of GCP II with a bound hydroxyl ion. Glu424 is the acid/base of GCP II that transfers a proton from the zinc-bound catalytic water to the amino moiety of S1′-bound glutamate. Zinc ions are shown as purple spheres. Distances are given in angstrom (Å). PDB ID code 2C6G.[42]

Figure 5 Schematic drawing of the catalytic-site zinc coordination geometry of GCP II with bound 2-phosphonomethyl-pentanedioic acid (2-PMPA; see also Figure 7). For transparency, only the O3P atom of bound 2-PMPA is shown. Zinc ions are shown as purple spheres. Distances are given in angstrom (Å). PDB ID code 2JBJ.[74]

in substrate binding. In the free state, the glutarate sensor is withdrawn from the active site, thereby allowing the substrate access to the S1′ pocket. Conversely, the sensor must give way in order to release S1′-bound product (i.e. glutamic acid). Between the two states, the hydroxyl group of Tyr700 undergoes a positional shift of up to 4.7 Å.[42] Further, in order to accommodate the folylpolyglutamate mimetic MPE (with a nonconforming 'D-glutamate' in the P1 position; see footnote to Table 1), the mobile loop Trp541-Gly548 (located at the entrance of the substrate-binding funnel) seems to adopt a different conformation in GCP II as compared to crystal-complex structures with smaller substrates.[65]

FUNCTIONAL ASPECTS

The S1′ pocket of GCP II has a clear preference for glutamic acid residues ($K_i = 0.46\,\mu M$).[43] In contrast, the type of peptide bound, either α- or γ-linked, seems to be less important for substrate catabolism although, β-NAAG has been reported to act as an inhibitor.[84] However, we were not able to obtain a crystal structure of GCP II with bound β-NAAG. Rather, we ended up with a bound glutamate in the S1′ site, which is a product of the cleavage reaction (PDB ID code 2C6G).[42] We conclude that GCP II is ultimately able to cleave β-NAAG, albeit slowly, and that S1-bound N-acetyl-aspartate is able to escape from the active site

while the L-glutamate stays trapped inside the S1′ pocket. This would imply that (small) domain rearrangements, which are prevented within the crystal, precede glutarate-sensor withdrawal and glutamate release. In support of this model, starting from a complex between N-acetyl-L-aspartyl-L-methionine ($K_m = 25\,\mu M$)[85] and GCP II, we ended up with L-methionine firmly locked up in the S1′ pocket of crystalline GCP II (PDB ID code 2CIJ; Figure 6) despite the fact that its side chain is unable to form an ionic interaction with Lys699 (of the glutarate sensor), which is a requirement for high-affinity binding.[74]

Compared to the S1′ site, the S1 pocket of the enzyme is clearly less specific, easily accessible, and able to accommodate a variety of molecules such as aspartate, glutamate, pteridine, and methotrexate.[86] The limited specificity of the S1 pocket is underscored by the apparent failure to increase the affinity of 2-phosphonomethyl-pentanedioic acid (2-PMPA) (Figure 7), the best inhibitor to date, by addition of a P1 probing moiety.[65,87]

The overall shape of funnel and active site together resemble a boot. Evidently, the boot shape allows for the productive binding of α-NAAG or of poly-γ-glutamate. In contrast to γ-linked Glu–Glu (see PDB ID code 3BI0),[65] we infer that the free amino group of α-linked Asp–Glu (based on 3BHX)[65] does not point toward (i.e. into) the shaft of the boot, but rather points in the direction of the heel of the boot (Figure 8, residue 454) with space to accommodate solely an N-acetyl moiety. In support of this observation,

Figure 6 Schematic drawing of an L-methionine (product of N-acetyl-L-aspartyl-L-methionine hydrolysis; see text) trapped in the S1′ site of GCP II. Zinc ions are shown as purple spheres. Distances are given in angstrom (Å). PDB ID-code 2CIJ.

Figure 7 Schematic drawing of 2-phosphonomethyl-pentanedioic acid (2-PMPA) bound to the S1′ site of GCP II. In the free state, Lys699 and Tyr700 (of the so-called glutarate sensor) are withdrawn from the active site. Between the two states, the hydroxyl group of Tyr700 undergoes a positional shift of up to 4.7 Å.[42] Zinc ions are shown as purple spheres. Distances are given in angstrom (Å). PDB ID code 2JBJ.[74]

α-linked oligopeptides (e.g. Val-Gly-Asp-Glu or Glu-Glu-Glu) bind less well to GCP II by about two orders of magnitude than γ-linked Glu–Glu.[43,46] We reason that the decrease in affinity for α-linked oligopeptides is caused by an unorthodox binding of the P1 moiety in the S1 pocket,

as compared to α-NAAG, in order for the chain to continue into the funnel.

COS-7 cells (derived from CV-1 simian cells transformed by an origin-defective mutant of simian virus 40) transfected with a polymorph of GCP II, harboring a C → T

Figure 8 Schematic drawing of the active site of GCP II with bound SPE, and with EPE superimposed (see footnote, Table 1).[65] SPE (an NAAG transition-state mimetic) is shown in yellow and EPE (a γ-linked Glu–Glu transition-state analog) is shown in gray. The amino group of bound γ-Glu–Glu (i.e. EPE, see 'hash') points into the funnel and can thus be easily extended with yet another γ-linked glutamate. The amino group of a bound α-Asp–Glu (based on SPE) would point in the direction of Ser454 and can therefore not be easily extended with yet another residue. The space between Ser454 and the C5 atom of SPE (indicated by a 'star') is rather limited, but evidently large enough to accommodate an *N*-acetyl-amino moiety. Zinc ions are shown as purple spheres. Distances are given in angstrom (Å). PDB ID codes 3BHX and 3BI0.[65]

exchange at codon 475 (His475 → Tyr), display a clearly lowered folate hydrolase activity when compared to COS-7 cells expressing wild-type GCP II.[88] It is not clear from the crystal structures how the amino acid substitution, located far away from the active site, could affect the hydrolytic activity of GCP II. Nevertheless, in persons concerned, the 1561C → T polymorphism is associated with higher plasma folate levels and lower total homocysteine concentrations.[89] It is still a matter of debate whether this polymorphism is the root of neural tube defects, cognitive deficits, and an increased risk of cardiovascular disease. Besides the 1561C → T polymorphism, a number of splice variants of GCP II have been reported, of which PSMA′ is the most prominent.[36,90–92] PSMA′ (exon-1 deletion splice variant) misses the first 59 AAs and thus lacks its membrane anchor.[91]

Last but not the least, since GCP II has been substantiated as a promising target for the treatment of a number of neurological disorders and for prostate tumor imaging/treatment,[29,93] the discovery of therapeutic and imaging compounds continues to attract considerable research interest.[94–96]

REFERENCES

1 RE Carter, AR Feldman and JT Coyle, *Proc Natl Acad Sci USA*, **93**, 749–53 (1996).

2 CH Halsted, EH Ling, R Luthi-Carter, JA Villanueva, JM Gardner and JT Coyle, *J Biol Chem*, **273**, 20417–24 (1998).

3 AK Rajasekaran, G Anilkumar and JJ Christiansen, *Am J Physiol Cell Physiol*, **288**, C975–81 (2005).

4 LA Lambert and SL Mitchell, *J Mol Evol*, **64**, 113–28 (2007).

5 WR Fair, RS Israeli and WD Heston, *Prostate*, **32**, 140–48 (1997).

6 JH Neale, T Bzdega and B Wroblewska, *J Neurochem*, **75**, 443–52 (2000).

7 SS Chang, DS O'Keefe, DJ Bacich, VE Reuter, WD Heston and PB Gaudin, *Clin Cancer Res*, **5**, 2674–81 (1999).

8 JS Horoszewicz, E Kawinski and GP Murphy, *Anticancer Res*, **7**, 927–35 (1987).

9 RS Israeli, CT Powell, WR Fair and WD Heston, *Cancer Res*, **53**, 227–30 (1993).

10 A Ghosh and WD Heston, *J Cell Biochem*, **91**, 528–39 (2004).

11 RS Israeli, CT Powell, JG Corr, WR Fair and WD Heston, *Cancer Res*, **54**, 1807–11 (1994).

12 GL Wright Jr, BM Grob, C Haley, K Grossman, K Newhall, D Petrylak, J Troyer, A Konchuba, PF Schellhammer and R Moriarty, *Urology*, **48**, 326–34 (1996).

13 RE Serda, M Bisoffi, TA Thompson, M Ji, JL Omdahl and LO Sillerud, *Prostate*, **68**, 773–83 (2008).

14 H Liu, AK Rajasekaran, P Moy, Y Xia, S Kim, V Navarro, R Rahmati and NH Bander, *Cancer Res*, **58**, 4055–60 (1998).

15 G Anilkumar, SA Rajasekaran, S Wang, O Hankinson, NH Bander and AK Rajasekaran, *Cancer Res*, **63**, 2645–48 (2003).

16 SA Rajasekaran, G Anilkumar, E Oshima, JU Bowie, H Liu, W Heston, NH Bander and AK Rajasekaran, *Mol Biol Cell*, **14**, 4835–45 (2003).

17 JT Coyle, *Neurobiol Dis*, **4**, 231–38 (1997).

18 MH Baslow, *J Neurochem*, **75**, 453–59 (2000).

19 LM Gehl, OH Saab, T Bzdega, B Wroblewska and JH Neale, *J Neurochem*, **90**, 989–97 (2004).

20 B Wroblewska, JT Wroblewski, S Pshenichkin, A Surin, SE Sullivan and JH Neale, *J Neurochem*, **69**, 174–81 (1997).

21 B Wroblewska, MR Santi and JH Neale, *Glia*, **24**, 172–79 (1998).

22 GL Westbrook, ML Mayer, MA Namboodiri and JH Neale, *J Neurosci*, **6**, 3385–92 (1986).

23 M Sekiguchi, K Okamoto and Y Sakai, *Brain Res*, **482**, 87–96 (1989).

24 PS Puttfarcken, JS Handen, DT Montgomery, JT Coyle and LL Werling, *J Pharmacol Exp Ther*, **266**, 796–803 (1993).

25 HM Valivullah, J Lancaster, PM Sweetnam and JH Neale, *J Neurochem*, **63**, 1714–19 (1994).

26 A Araque, V Parpura, RP Sanzgiri and PG Haydon, *Trends Neurosci*, **22**, 208–15 (1999).

27 JW Olney, *Retina*, **2**, 341–59 (1982).

28 A Doble, *Pharmacol Ther*, **81**, 163–221 (1999).

29 JH Neale, RT Olszewski, LM Gehl, B Wroblewska and T Bzdega, *Trends Pharmacol Sci*, **26**, 477–84 (2005).

30 CH Halsted, *West J Med*, **155**, 605–9 (1991).

31 RE Conway, N Petrovic, Z Li, W Heston, D Wu and LH Shapiro, *Mol Cell Biol*, **26**, 5310–24 (2006).

32 B Bauvois, *Oncogene*, **23**, 317–29 (2004).

33 A Ghosh, X Wang, E Klein and WD Heston, *Cancer Res*, **65**, 727–31 (2005).

34 CM Lawrence, S Ray, M Babyonyshev, R Galluser, DW Borhani and SC Harrison, *Science*, **286**, 779–82 (1999).

35 G Tsai, KS Dunham, U Drager, A Grier, C Anderson, J Collura and JT Coyle, *Synapse*, **50**, 285–92 (2003).

36 KY Cao, XP Mao, DH Wang, L Xu, GQ Yuan, SQ Dai, BJ Zheng and SP Qiu, *Prostate*, **67**, 1791–800 (2007).

37 T Bzdega, T Turi, B Wroblewska, D She, HS Chung, H Kim and JH Neale, *J Neurochem*, **69**, 2270–77 (1997).

38 DJ Bacich, JT Pinto, WP Tong and WD Heston, *Mamm Genome*, **12**, 117–23 (2001).

39 T Bzdega, SL Crowe, ER Ramadan, KH Sciarretta, RT Olszewski, OA Ojeifo, VA Rafalski, B Wroblewska and JH Neale, *J Neurochem*, **89**, 627–35 (2004).

40 MN Pangalos, JM Neefs, M Somers, P Verhasselt, M Bekkers, L van der Helm, E Fraiponts, D Ashton and RD Gordon, *J Biol Chem*, **274**, 8470–83 (1999).

41 ET Tonkin, M Smith, P Eichhorn, S Jones, B Imamwerdi, S Lindsay, M Jackson, TJ Wang, M Ireland, J Burn, ID Krantz, P Carr and T Strachan, *Hum Genet*, **115**, 139–48 (2004).

42 JR Mesters, C Barinka, W Li, T Tsukamoto, P Majer, BS Slusher, J Konvalinka and R Hilgenfeld, *EMBO J*, **25**, 1375–84 (2006).

43 KJ Koller and JT Coyle, *J Neurosci*, **5**, 2882–88 (1985).

44 MB Robinson, RD Blakely, R Couto and JT Coyle, *J Biol Chem*, **262**, 14498–506 (1987).

45 CJ Chandler, TT Wang and CH Halsted, *J Biol Chem*, **261**, 928–33 (1986).

46 BS Slusher, MB Robinson, G Tsai, ML Simmons, SS Richards and JT Coyle, *J Biol Chem*, **265**, 21297–301 (1990).

47 JF Gregory III, SL Ink and JJ Cerda, *Comp Biochem Physiol B*, **88**, 1135–41 (1987).

48 CJ Chandler, DA Harrison, CA Buffington, NA Santiago and CH Halsted, *Am J Physiol*, **260**, G865–72 (1991).

49 T Liu, Y Toriyabe and CE Berkman, *Protein Expr Purif*, **49**, 251–55 (2006).

50 Z Xiao, X Jiang, ML Beckett and GL Wright Jr, *Protein Expr Purif*, **19**, 12–21 (2000).

51 Z Xiao, BL Adam, LH Cazares, MA Clements, JW Davis, PF Schellhammer, EA Dalmasso and GL Wright Jr. *Cancer Res*, **61**, 6029–33 (2001).

52 N Schülke, OA Varlamova, GP Donovan, D Ma, JP Gardner, DM Morrissey, RR Arrigale, C Zhan, AJ Chodera, KG Surowitz, PJ Maddon, WD Heston and WC Olson, *Proc Natl Acad Sci USA*, **100**, 12590–95 (2003).

53 MI Davis, MJ Bennett, LM Thomas and PJ Bjorkman, *Proc Natl Acad Sci USA*, **102**, 5981–86 (2005).

54 C Barinka, P Sácha, J Sklenár, P Man, K Bezouska, BS Slusher and J Konvalinka, *Protein Sci*, **13**, 1627–35 (2004).

55 D Castelletti, G Fracasso, M Alfalah, S Cingarlini, M Colombatti and HY Naim, *J Biol Chem*, **281**, 3505–12 (2006).

56 I Brockhausen, *Biochim Biophys Acta*, **1473**, 67–95 (1999).

57 JK Troyer, ML Beckett and GL Wright Jr, *Int J Cancer*, **62**, 552–58 (1995).

58 WP Tong, S Lin, WW Li, M Waltham, E Goker and JR Bertino, *Proc Am Assoc Cancer Res*, **35**, 304 (1994).

59 JT Pinto, BP Suffoletto, TM Berzin, CH Qiao, S Lin, WP Tong, F May, B Mukherjee and WD Heston, *Clin Cancer Res*, **2**, 1445–51 (1996).

60 MC Waltham, S Lin, WW Li, E Göker, H Gritsman, WP Tong and JR Bertino, *J Chromatogr B Biomed Sci Appl*, **689**, 387–92 (1997).

61 BL Stauch, MB Robinson, G Forloni, G Tsai and JT Coyle, *Neurosci Lett*, **100**, 295–300 (1989).

62 JR Mesters and R Hilgenfeld, *Cryst Growth Des*, **7**, 2251–53 (2007).

63 C Barinka, J Starkova, J Konvalinka and J Lubkowski, *Acta Crystallogr Sect F Struct Biol Cryst Commun*, **63**, 150–53 (2007).

64 C Barinka, M Rovenská, P Mlcochová, K Hlouchová, A Plechanovová, P Majer, T Tsukamoto, BS Slusher, J Konvalinka and J Lubkowski, *J Med Chem*, **50**, 3267–73 (2007).

65 C Barinka, K Hlouchova, M Rovenska, P Majer, M Dauter, N Hin, YS Ko, T Tsukamoto, BS Slusher, J Konvalinka and J Lubkowski, *J Mol Biol*, **376**, 1438–50 (2008).

66 ND Rawlings, FR Morton, CY Kok, J Kong and AJ Barrett, *Nucleic Acids Res*, **36**, D320–25 (2008).

67 EH Holmes, TG Greene, WT Tino, AL Boynton, HC Aldape, SL Misrock and GP Murphy, *Prostate Suppl*, **7**, 25–29 (1996).

68 A Ghosh and WD Heston, *Prostate*, **57**, 140–51 (2003).

69 ND Rawlings and AJ Barrett, *Biochim Biophys Acta*, **1339**, 247–52 (1997).

70 D Mahadevan and JW Saldanha, *Protein Sci*, **8**, 2546–49 (1999).

71 HS Speno, R Luthi-Carter, WL Macias, SL Valentine, AR Joshi and JT Coyle, *Mol Pharmacol*, **55**, 179–85 (1999).

72 SB Rong, J Zhang, JH Neale, JT Wroblewski, S Wang and AP Kozikowski, *J Med Chem*, **45**, 4140–52 (2002).

73 H Berman, K Henrick, H Nakamura and JL Markley, *Nucleic Acids Res*, **35**, D301–3 (2007).

74 JR Mesters, K Henning and R Hilgenfeld, *Acta Crystallogr D Biol Crystallogr*, **63**, 508–13 (2007).

75 DR Westhead, TW Slidel, TP Flores and JM Thornton, *Protein Sci*, **8**, 897–904 (1999).

76 W Kabsch and C Sander, *Biopolymers*, **22**, 2577–637 (1983).

77 B Chevrier, C Schalk, H D'Orchymont, JM Rondeau, D Moras and C Tarnus, *Structure*, **2**, 283–91 (1994).

78 HM Greenblatt, O Almog, B Maras, A Spungin-Bialik, D Barra, S Blumberg and G Shoham, *J Mol Biol*, **265**, 620–36 (1997).

79 P Bünning and JF Riordan, *Biochemistry*, **22**, 110–16 (1983).

80 JC Lougheed, JM Holton, T Alber, JF Bazan and TM Handel, *Proc Natl Acad Sci USA*, **98**, 5515–20 (2001).

81 R Stoll, C Renner, M Zweckstetter, M Bruggert, D Ambrosius, S Palme, RA Engh, M Golob, I Breibach, R Buettner, W Voelter, TA Holak and AK Bosserhoff, *EMBO J*, **20**, 340–49 (2001).

82 RC Holz, KP Bzymek and SI Swierczek, *Curr Opin Chem Biol*, **7**, 197–206 (2003).

83 KA McCall, C Huang and CA Fierke, *J Nutr*, **130**, 1437S–46S (2000).

84 V Serval, L Barbeito, A Pittaluga, A Cheramy, S Lavielle and J Glowinski, *J Neurochem*, **55**, 39–46 (1990).

85 C Barinka, M Rinnová, P Sácha, C Rojas, P Majer, BS Slusher and J Konvalinka, *J Neurochem*, **80**, 477–87 (2002).

86 R Luthi-Carter, AK Barczak, H Speno and JT Coyle, *Brain Res*, **795**, 341–48 (1998).

87 PF Jackson, KL Tays, KM Maclin, YS Ko, W Li, D Vitharana, T Tsukamoto, D Stoermer, XC Lu, K Wozniak and BS Slusher, *J Med Chem*, **44**, 4170–75 (2001).

88 AM Devlin, EH Ling, JM Peerson, S Fernando, R Clarke, AD Smith and CH Halsted, *Hum Mol Genet*, **9**, 2837–44 (2000).

89 CH Halsted, DH Wong, JM Peerson, CH Warden, H Refsum, AD Smith, OK Nygård, PM Ueland, SE Vollset and GS Tell, *Am J Clin Nutr*, **86**, 514–21 (2007).

90 SL Su, IP Huang, WR Fair, CT Powell and WD Heston, *Cancer Res*, **55**, 1441–43 (1995).

91 LS Grauer, KD Lawler, JL Marignac, A Kumar, AS Goel and RL Wolfert, *Cancer Res*, **58**, 4787–89 (1998).

92 TD Schmittgen, S Teske, RL Vessella, LD True and BA Zakrajsek, *Int J Cancer*, **107**, 323–29 (2003).

93 MR Feneley, H Jan, M Granowska, SJ Mather, D Ellison, J Glass, M Coptcoat, RS Kirby, C Ogden, RT Oliver, DF Badenoch, FI Chinegwundoh, VH Nargund, AM Paris and KE Britton, *Prostate Cancer Prostatic Dis*, **3**, 47–52 (2000).

94 J Zhou, JH Neale, MG Pomper and AP Kozikowski, *Nat Rev Drug Discov*, **4**, 1015–26 (2005).

95 CA Foss, RC Mease, H Fan, Y Wang, HT Ravert, RF Dannals, RT Olszewski, WD Heston, AP Kozikowski and MG Pomper, *Clin Cancer Res*, **11**, 4022–28 (2005).

96 P Ding, P Helquist and MJ Miller, *Bioorg Med Chem*, **16**, 1648–57 (2008).

97 PJ Kraulis, *J Appl Crystallogr*, **24**, 946–50 (1991).

98 EA Merritt and DJ Bacon, *Meth Enzymol*, **277**, 505–24 (1997).

FtsH/HflB

Christoph Bieniossek[†,‡] and Ulrich Baumann[†]

[†]Departement für Chemie und Biochemie, Universität Bern, Berne, Switzerland
[‡]Institute of Biophysics and Molecular Biology, Swiss Federal Institute of Technology, Zurich, Switzerland

FUNCTIONAL CLASS

Enzyme; hydrolase; EC 3.4.24; an ATP-dependent membrane-standing Zn^{2+} metalloprotease belonging to the AAA+ family of energy-dependent proteases.

Filamentation temperature-sensitive locus H (FtsH)[1], synonymous for high frequency of lysogenization locus B (HflB) is an integral membrane protein belonging to the AAA+ proteases (AAA: adenosine triphosphatases associated with various cellular activities, reviewed in Refs. 2–5). These proteases control intracellular protein degradation and utilize the energy from ATP for protein unfolding and translocation into the interior of their sequestered proteolytic chambers. FtsH catalyzes the intracellular degradation of integral membrane proteins, e.g. it degrades the unassembled subunits such as SecY of the SecYEG translocon or the a-subunit of F_o ATPase.[6,7] FtsH also targets some soluble proteins, most notably the heat shock factor σ^{32}, the λ-phage transcriptional activator λ-CII, and LpxC, a key enzyme in lipid A biosynthesis.[8–11] FtsH cleaves its targets in a processive manner down to peptides of about 20 amino acids in length. FtsH is the only essential energy-dependent protease in *Escherichia coli* and its knockout shows generally severe phenotypes, for example, malfunctioning of paraplegin, a close homolog in human mitochondria, results in one form of spastic paraplegia.[12,13]

OCCURRENCE

FtsH is universally conserved in eubacteria, mitochondria, and chloroplasts. It occurs in Gram-positive bacteria as well as in the inner membrane of Gram-negative bacteria. Mitochondria possess at least two different homologs in their inner membrane (reviewed in Ref. 3), the i-AAA and m-AAA protease, the latter being composed of two different subunits. In the thylakoid membrane of chloroplasts there are about six different FtsH homologs present. In *E. coli* and presumably also in mitochondria, FtsH exists as a complex with its regulatory subunits (the HflKC complex in prokarya and the prohibitins in eukarya).[14] Little is known about the biological function of those regulators.

BIOLOGICAL FUNCTION

FtsH and homologs serve several purposes. First, they degrade damaged or not properly assembled membrane

3D Structure Ribbon representation of *T. maritima* FtsH (PDB code 2CE7). Zn^{2+} ions are shown as cyan spheres, ADP as stick representation with carbon atoms colored orange. The pore residues Phe234 are shown as gray sticks. View from the membrane down on the twofold symmetric AAA ring. Figure made with PYMOL (http://www.pymol.org).

proteins, e.g. the uncomplexed SecY subunit of the SecYEG translocon or the light-harvesting complex of photosystem II UV-B-damaged PSII reaction center subunits, D1 and D2.[15,16]

Secondly, they control the turnover of certain soluble targets, like λ-CII, σ[54], and the transacetylase LpxC. Here, FtsH is directly involved in the regulation of signaling and biosynthetic pathways by degrading key enzymes. The degradation of LpxC is essential for keeping a proper membrane composition: knockout of FtsH is lethal or accompanied in most bacteria by severe phenotypes due to the synthesis of too much lipopolysaccharide (LPS) due to the fact that LpxC levels are not properly balanced anymore.

These first two functions described above are accomplished by the complete degradation of the target proteins. Contrary to that, the yeast mitochondrial homologous m-AAA protease plays a key role in the processing of MrpL32, a conserved nuclear-encoded subunit of mitochondrial ribosomes where only the N-terminal mitochondrial targeting sequence is removed upon protein import.[17] Without this processing step, MrpL32 cannot be assembled into the large ribosomal subunit leading to impaired translation in mitochondria.

A third unexpected function of the m-AAA protease in yeast mitochondria has been published recently: the maturation of cytochrome c peroxidase (Ccp1) requires the subsequent action of two proteases: the m-AAA protease and *Pcp1*, a member of the rhomboid family. The actual proteolytic cleavage is solely carried out by *Pcp1* while the function of the m-AAA protease consists in translocation of Ccp1 from the membrane to position suitably for intramembrane cleavage by *Pcp1*.[18]

AMINO ACID SEQUENCE INFORMATION

There are several hundreds of sequences of FtsH homologs known. The following sequences are related to 3D structural entries are the following:

- *Thermotoga maritima*, 610 amino acids, DNA derived, UniProt Q9WZ49
- *Thermus thermophilus*, 624 amino acids, DNA, UniProt Q5SI82
- *Aquifex aeolicus*, 634 amino acids, DNA, UniProt O67077
- *Escherichia coli*, 644 amino acids, DNA, UniProt P0AAI3

Typical members from mitochondria and chloroplasts are

- Yta10 *Saccharomyces cerevisiae*, 761 amino acids, DNA, UniProt P39925
- Yta12 *S. cerevisiae*, 825 amino acids, DNA, UniProt P40341

- Paraplegin *Homo sapiens*, 795 amino acids, DNA, UniProt Q9UQ90
- FtsH1 *Arabidopsis thaliana*, 716 amino acids, DNA, UniProt Q39102

PROTEIN PRODUCTION, PURIFICATION, AND CHARACTERIZATION

For structural studies, all proteins are recombinantly expressed in *E. coli* utilizing pET vectors, e.g. pET-28 (Novagen), engineering a hexahistidine tag at the C-terminus, or pGEX vectors creating a C-terminal GST tag. Mitochondrial Yme1 and Yta10/Yta12 have been recombinantly expressed in yeast.[19] Full-length proteins containing the transmembrane domains have been functionally expressed[20] or been refolded from inclusion bodies.[21] Purification steps include usually immobilized metal ion affinity chromatography (IMAC) or similar affinity chromatography steps, ion exchange, and gel filtration. Cytosolic ΔTM constructs, i.e. lacking the N-Terminal transmembrane domains, have been expressed in soluble form in *E. coli* as well. Those ΔTM constructs derived from *T. maritima* and *T. thermophilus* were shown to be hexameric and functional in ATPase and proteolytic assays,[22,23] while the *E. coli* ΔTM construct was reported to be monomeric and inactive.[24] Constructs in which the TM-domains were substituted by leucine zippers, other transmembrane domains, or simply were preceded by glutathions–S–transferase or maltose-binding protein, were reported to be oligomeric and active – at least against soluble substrates.[24,25]

METAL CONTENTS AND COFACTORS

Each monomer contains one Zn^{2+} ion per subunit, bound to the HEXXH motif in the protease domain.

ATP is needed for the energy-dependent translocation of substrates from the membrane, unfolding and threading into the interior of the two-ring, self-compartmentalizing molecule, where the active sites are located. The nucleotide binds between the two subdomains of the AAA module of the molecule. Coordination occurs via the amino acids of the Walker A motif. A Mg^{2+} ion is bound between the β- and γ-phosphate groups and further coordinated by the aspartic acid of the Walker B motif.

ACTIVITY TEST

ATPase assays include malachite green,[26] radio-labelled [γ-[32]P]-ATP, and coupled assays.[27] Protease assays include colorimetric tests employing azocasein or resorufincasein,[22] and the degradation of casein, λ-CII or σ[32] monitored by SDS-PAGE or western blot.[23,24]

Table 1 FtsH X-ray structures in PDB

PDB Entry	Organism	Fragment	Mutant/Derivative	Resolution (Å)	R/Rfree (%)	Space group	References
2CE7	*T. maritima*	Cytosolic region	EDTA treated	2.44	22.3/26.9	$P4_12_12$	22
2CEA	*T. maritima*	Cytosolic region	–	2.75	21.6/26.2	$P4_12_12$	22
2DI4	*A. aeolicus*	Protease domain	–	2.79	25.4/29.9	$P6_3$	23
2DHR	*T. thermophilus*	Cytosolic region	G399L	3.90	30.1/34.2[a]	$P3_121$	23
1IXZ	*T. thermophilus*	AAA domain	–	2.20	19.6/23.8	$P6_5$	28
1IY0	*T. thermophilus*	AAA domain	AMPPNP	2.95	22.5/28.9	$P6_5$	28
1IY1	*T. thermophilus*	AAA domain	ADP	2.80	20.7/27.8	$P6_5$	28
1IY2	*T. thermophilus*	AAA domain	–	3.20	25.3/29.4	$C222_1$	28
1LV7	*E.coli*	AAA Domain	–	1.50	15.5/17.8	$P4_12_12$	29

[a]R-factors are not reproducible according to the EDS server (http://eds.bmc.uu.se/eds).[30]

FtsH is inhibited by the classic chelators like ethylene diamine tetra acetic (EDTA) or *ortho*-phenanthroline, with the latter being more potent than the former.

X-RAY STRUCTURES

Crystallization

Not quite unlike other AAA+ proteases, full-length FtsH is difficult to crystallize in a form suitable for high-resolution structural analysis. The first crystal structures available were from isolated AAA domain constructs. Recently, two structures of the whole cytosolic region became available, one at low and the other one at high resolution. Both structures are from thermophilic organisms. It appears that the reduced mobility of the molecules from those organisms is essential for growing suitable crystals. The currently available X-ray structures are summarized in Table 1.

Overall description of the structure

We will focus in the following on the X-ray structure of *T. maritima* FtsH since this is the only structure comprising the whole cytosolic region that has been solved at a reasonably high resolution.[22] *T. maritima* FtsH's polypeptide chain is 612 amino acids in length.

It contains two transmembrane helices at the N-terminus with a small periplasmic domain inserted in between. After the transmembrane domain follows the AAA and then the protease domain. The crystallographically determined structures encompass the AAA and protease domain, i.e. the cytosolic region in bacteria. The architecture of this cytosolic region consists of two rings stacked on each other (3D structure and Figure 1). The overall dimensions of this toroidlike structure are about 100 Å in diameter and 60 Å in height. The protease ring is a flat hexagon, which possesses perfect sixfold symmetry while the AAA ring exhibits only twofold symmetry. This very striking symmetry mismatch is caused by different angles in the monomers between the protease and the AAA domain: monomers located opposite to each other in the double-ring have the same angle and differ from the two other pairs (Figure 2).

Contrary to earlier reports, hexamerization takes place via the protease domain and not via the AAA domain. The latter do not form the frequently postulated sixfold symmetrical ring. The contacts between the AAA domains bury between 1350 and 2000 Å2 of the surface of a monomer, which is considerably less than that buried in a single protease monomer (about 4000 Å2).

The AAA domain

The AAA domain (Figure 2) resembles quite closely similar modules in other AAA proteins. It consists of two

(a) (b) (c)

Figure 1 Different views of the cartoon representation of *T. maritima* FtsH. (a) View from the membrane down on the twofold symmetric AAA ring. (b) Perpendicular view onto the two rings. The protease ring is at the bottom, the AAA ring on top. (c) View from the cytosolic side onto the protease ring. Figure made with PYMOL (http://www.pymol.org).

Figure 2 Monomer structure and overlay of the three independent subunits. (a) Cartoon representation of the monomer. The AAA domain is in green, the protease domain in yellow. ADP is shown in stick representation, Zn^{2+} in cyan. The coordinating residues His423, His427, Asp500, and the catalytic base Glu424 are shown as sticks. (b) Overlay of the three independent subunits in tube representation. The color coding is as in Figure 1. The tube radius is proportional to the temperature factor. The AAA domains and bound ADP were chosen as reference. There is no conformational difference in the angle between the two AAA subdomains. On the contrary, there is a large difference in the angles between AAA and the protease domain between the three monomers. Figure made with PYMOL (http://www.pymol.org).

subdomains, the N-terminal wedge-shaped αβα- and the C-terminal helical bundle subdomain. Nucleotides bind between these two subdomains and the inter-subdomain angle depends on the nature of the nucleotide, i.e. there is a hinge movement upon the hydrolysis of ATP to ADP and a further one upon ADP release.[31,32] It is believed that this movement is translated into a mechanical force via the pore residues Phe234 of the AAA domains that leads to mechanical unfolding and translocation of substrate polypeptide chains.[33]

The protease domain

The monomer shows a novel, essentially all-helical fold (Figure 2) where the first helix in this domain carries the metalloprotease fingerprint HEXXH motif. A characteristic feature of this domain is a long, slightly bent α-helix (α16, residues 547–574), which forms the base of the protease domain. This helix and the following helix α17 form the shape of an 'L' and are tethered to α11, α13, and α14 by means of a conserved leucine zipper motif consisting of residues 565, 568, 572, and 578.[25] Nonconservative substitution of these residues abolishes activity. Compared with other HEXXH proteases ('zincins'), the protease domain lacks a significant amount of β structure. The so-called 'edge strand', which is present in all other HEXXH proteases known so far and which functions to fix the substrate in a stretched conformation is completely absent. Two short β strands resemble slightly strands three and four of β sheet A in the metzincin clan of the zincins or the equivalent structures in thermolysin.

Protease active center and zinc geometry

The coordination of the zinc ion is such that the two histidines of the motif coordinate via their $N^{\epsilon 2}$ nitrogens of the imidazole side chains. A third ligand is provided by Asp50, which coordinates via its $O^{\delta 1}$ and makes some weak interactions via $O^{\delta 2}$. The fourth coordination site is filled by a water molecule (Figure 3(a)). This arrangement is similar to that of thermolysin or metzincins, with the difference that the third coordination place is occupied by the Asp residue mentioned above. Site-directed mutagenesis studies had initially assigned a glutamic acid instead of this aspartate to be the third zinc ligand,[34] but this was proved to be incorrect by the first crystal structure of the whole cytosolic region of FtsH.[22] Instead, this glutamic acid is an outer shell ligand (Figure 3(b)), which orients the imidazole sidechain of the first histidine in the HEXXH motif. This is in agreement with the approximate 5–10% of residual activity shown by a mutant where this glutamic acid is replaced by alanine. On the contrary, replacement of the true zinc ligand Asp by alanine abolishes activity completely.

The reaction mechanism is believed to follow the classical thermolysin-like mechanism where the carbonyl oxygen of the scissile peptide bond coordinates to the zinc.[35] The carbonyl carbon is attacked by the zinc-bound, acidified water molecule with Glu424 acting as catalytic base accepting a proton from this water molecule. In a next step, the tetrahedral intermediate collapses releasing the C-terminal part of the former peptide bond. The N-terminal part, still coordinating the Zn^{2+} via its newly formed carboxyl-terminus is replaced in the last step by a water molecule.

(a) (b)

Figure 3 The protease active site. (a) Zinc coordination geometry with distances in Å. These distances are not very accurate due to the limited resolution and imposing restraints during refinement. (b) Experimental electron density map contoured at 1 sigma above the mean (orange) and the anomalous map drawn at 12 sigma (magenta). The proposed third zinc ligand Glu489 stabilizes the conformation of His423 but does not bind to the zinc directly. Figure made with PYMOL (http://www.pymol.org).

Figure 4 Proposed ATPase cycle. The AAA ring is shown on top, the protease ring at the bottom. The pore residues Phe234 are colored yellow and magenta, nucleotides are shown in green and active site residues in blue. After binding of an apolar recognition tag by the hydrophobic patch formed by Phe234, ATP hydrolysis causes the inward movement of four of the pore residues and thereby pulling the target polypeptide toward the narrow entrance cleft. This leads under favorable circumstances to unfolding and subsequent power strokes translocate the substrate to the proteolytic centers in the interior of the FtsH hexamer. Figure made with DeepView.[38]

Derivatives

The crystal structure of the cytosolic part of FtsH from *T. thermophilus* has been published recently at 3.9 Å resolution.[23] That construct contained the mutation G399L (*T. thermophilus* numbering, the equivalent residue is Gly404 in *T. maritima*). This glycine is absolutely conserved in all FtsH sequences, however, the authors report that the mutant is as active as the wild type. The structures of *T. thermophilus* and *T. maritima* FtsH are similar with the major exception that the AAA ring in the *T. thermophilus* construct shows threefold symmetry.

FUNCTIONAL ASPECTS

AAA+ proteases are self-compartmentalizing enzymes, which utilize the energy from ATP for unfolding and translocating their substrates into the proteolytic chambers that are sequestered in the interior. In the *T. maritima*

structure, access to the active sites is granted by an S-shaped cleft, which is about 20 Å in width, hence allowing only unfolded substrates to enter (see Figure 4). An essential residue for substrate recognition is Phe234 located at the entrance pore (or entrance cleft). For ATP hydrolysis, Arg321 and possible Arg318 have been postulated to aid as so-called Arg-fingers, which sense the γ-phosphate and stabilize the surplus of negative charge in the transition state. Some AAA$^+$ proteins oligomerize only in the presence of ATP and mutation of the equivalent arginine residues abolished oligomerization and consequently activity.[36,37] A model with six ATP bound to the AAA domains and the 'Arg-fingers' inserted into the nucleotide binding site of a neighboring subunit was constructed, leading to a sixfold symmetric hexamer in the AAA and protease ring. In the experimental structure of *T. maritima*, all six subunits are loaded with ADP, i.e. this could represent the state after the power stroke. Interestingly, some of the pore residues have moved to the interior of the molecule, compared with the ATP-charged model. This movement could well represent the expected 'pull' on the substrate chain, leading to unfolding and translocation. Mutation of the aromatic pore residues in ClpB to Trp shows a clearly different fluorescence behavior in the ATP and ADP state.[33] A recent crystal structure from our laboratory confirms the presence of a C6 symmetric hexamer (Bieniossek and Baumann, unpublished).

REFERENCES

1 D Santos and DF De Almeida, *J Bacteriol*, **124**, 1502–1507 (1975).

2 K Ito and Y Akiyama, *Annu Rev Microbiol*, **59**, 211–231 (2005).

3 I Arnold, M Wagner-Ecker, W Ansorge and T Langer, *Gene*, **367**, 74–88 (2006).

4 TA Baker and RT Sauer, *Trends Biochem Sci*, **31**, 647–653 (2006).

5 RT Sauer, DN Bolon, BM Burton, RE Burton, JM Flynn, RA Grant, GL Hersch, SA Joshi, JA Kenniston, I Levchenko, SB Neher, ES Oakes, SM Siddiqui, DA Wah and TA Baker, *Cell*, **119**, 9–18 (2004).

6 Y Akiyama, A Kihara, H Tokuda and K Ito, *J Biol Chem*, **271**, 31196–31201 (1996).

7 Y Akiyama, A Kihara and K Ito, *FEBS Lett*, **399**, 26–28 (1996).

8 A Blaszczak, C Georgopoulos and K Liberek, *Mol Microbiol*, **31**, 157–166 (1999).

9 M Carmona and V de Lorenzo, *Mol Microbiol*, **31**, 261–270 (1999).

10 Y Shotland, A Shifrin, T Ziv, D Teff, S Koby, O Kobiler and AB Oppenheim, *J Bacteriol*, **182**, 3111–3116 (2000).

11 F Fuhrer, S Langklotz and F Narberhaus, *Mol Microbiol*, **59**, 1025–1036 (2006).

12 G Casari, M De Fusco, S Ciarmatori, M Zeviani, M Mora, P Fernandez, G DeMichele, A Filla, S Cocozza, R Marconi, A Durr, B Fontaine and A Ballabio, *Cell*, **93**, 973–983 (1998).

13 EI Rugarli and T Langer, *Trends Mol Med*, **12**, 262–269 (2006).

14 N Saikawa, Y Akiyama and K Ito, *J Struct Biol*, **146**, 123–129 (2004).

15 O Cheregi, C Sicora, PB Kos, M Barker, PJ Nixon and I Vass, *Biochim Biophys Acta*, **1767**, 820–828 (2007) [Epub ahead of print].

16 M Garcia-Lorenzo, A Zelisko, G Jackowski and C Funk, *Photochem Photobiol Sci*, **4**, 1065–1071 (2005).

17 M Nolden, S Ehses, M Koppen, A Bernacchia, EI Rugarli and T Langer, *Cell*, **123**, 277–289 (2005).

18 T Tatsuta, S Augustin, M Nolden, B Friedrichs and T Langer, *EMBO J*, **26**, 325–335 (2007).

19 R Tauer, G Mannhaupt, R Schnall, A Pajic, T Langer and H Feldmann, *FEBS Lett*, **353**, 197–200 (1994).

20 Y Akiyama and K Ito, *J Biol Chem*, **278**, 18146–18153 (2003).

21 RC Bruckner, PL Gunyuzlu and RL Stein, *Biochemistry*, **42**, 10843–10852 (2003).

22 C Bieniossek, T Schalch, M Bumann, M Meister, R Meier and U Baumann, *Proc Natl Acad Sci U S A*, **103**, 3066–3071 (2006).

23 R Suno, H Niwa, D Tsuchiya, X Zhang, M Yoshida and K Morikawa, *Mol Cell*, **22**, 575–585 (2006).

24 Y Akiyama and K Ito, *Biochemistry*, **40**, 7687–7693 (2001).

25 Y Shotland, D Teff, S Koby, O Kobiler and AB Oppenheim, *J Mol Biol*, **299**, 953–964 (2000).

26 AA Baykov, OA Evtushenko and SM Avaeva, *Anal Biochem*, **171**, 266–270 (1988).

27 MR Webb, *Proc Natl Acad Sci U S A*, **89**, 4884–4887 (1992).

28 H Niwa, D Tsuchiya, H Makyio, M Yoshida and K Morikawa, *Structure (Camb)*, **10**, 1415–1423 (2002).

29 S Krzywda, AM Brzozowski, C Verma, K Karata, T Ogura and AJ Wilkinson, *Structure (Camb)*, **10**, 1073–1083 (2002).

30 GJ Kleywegt, MR Harris, JY Zou, TC Taylor, A Wahlby and TA Jones, *Acta Crystallogr D Biol Crystallogr*, **60**, 2240–2249 (2004).

31 J Wang, *J Struct Biol*, **148**, 259–267 (2004).

32 J Wang, JJ Song, IS Seong, MC Franklin, S Kamtekar, SH Eom and CH Chung, *Structure (Camb)*, **9**, 1107–1116 (2001).

33 C Schlieker, J Weibezahn, H Patzelt, P Tessarz, C Strub, K Zeth, A Erbse, J Schneider-Mergener, JW Chin, PG Schultz, B Bukau and A Mogk, *Nat Struct Mol Biol*, **11**, 607–615 (2004).

34 N Saikawa, K Ito and Y Akiyama, *Biochemistry*, **41**, 1861–1868 (2002).

35 WR Kester and BW Matthews, *Biochemistry*, **16**, 2506–2516 (1977).

36 HK Song, C Hartmann, R Ramachandran, M Bochtler, R Behrendt, L Moroder and R Huber, *Proc Natl Acad Sci U S A*, **97**, 14103–14108 (2000).

37 Q Wang, C Song, L Irizarry, R Dai, X Zhang and CC Li, *J Biol Chem*, **280**, 40515–40523 (2005).

38 N Guex and MC Peitsch, *Electrophoresis*, **18**, 2714–2723 (1997).

VAP1 – snake venom homolog of mammalian ADAMs

Soichi Takeda

Department of Cardiac Physiology, National Cardiovascular Center Research Institute, Osaka, Japan

FUNCTIONAL CLASS

Enzyme; monozinc endopeptidase; a P-III class snake venom metalloproteinase (SVMP); a member of the reprolysin/adamalysin/ADAM (a disintegrin and metalloproteinase) family; clan MA(M) > family M12B > M12.186 (MEROPS classification, http://merops.sanger.ac.uk/).

OCCURRENCE

Vascular-apoptosis-inducing protein-1 (VAP1) is a P-III class SVMP that was isolated from western diamondback snake *Crotalus atrox* venom as a factor that induces apoptosis in cultured vascular endothelial cells (VECs).[1,2] Similar apoptotic SVMPs have been isolated from other hemorrhagic snake venoms.[3–8] SVMPs are classified into various groups (P-I to P-IV) according to their domain organization.[9,10] P-III SVMPs are composed of metalloproteinase (M), disintegrin-like (D), and cysteine-rich (C) domains, and display more potent hemorrhagic activity than P-I SVMPs, which contain only an M domain. In addition to apoptotic toxins, snake venoms contain a number of other SVMPs that play key roles in the pathologies associated with

(a)

(b)

3D Structure Ribbon diagram of VAP1, viewed from the dimer axis (a) and from the direction perpendicular to the dimer axis (b), PDB code 2ERO. The structural subsegments are represented in different colors as follows: the h0-helix, M domain, linker, D_s, D_a, C_w, C_h segments, and HVR are shown in red, yellow, gray, cyan, pink, gray, light green and blue, respectively. Carbohydrate moieties linked to Asn218 are in ball-and-stick representation. The catalytic zinc ions and the calcium ions are represented by red and black spheres, respectively. Figures were generated using the MOLSCRIPT[83] and RASTER3D[84] programs.

envenoming, such as hemorrhage, edema, inflammation, and necrosis.[9–11] Mammalian ADAM family proteins are phylogenically related to P-III SVMPs and have a homologous metalloproteinase/disintegrin/cysteine-rich (MDC) domain architecture.[10,12] ADAMs and SVMPs, together with ADAMTSs (ADAM with thrombospondin type-1 motif),[13,14] constitute the adamalysin/reprolysin/ADAM subgroup of the metzincin clan of zinc proteinases.[15,16] ADAMs are primary type-I transmembrane proteins. In addition to the amino-terminal MDC domains, ADAMs have a transmembrane segment and a cytoplasmic region in their carboxy terminus.[12,17,18] The canonical ADAMs (see below) also have an epidermal growth factor (EGF)-like domain between the C domain and the transmembrane segment. ADAMs are widely expressed in multicellular organisms, including humans, mice, *Drosophila melanogaster*, and *Caenorhabditis elegans*. ADAMs are also expressed in *Schizosaccharomyces pombe* (but not

in *Saccharomyces cerevisiae*).[19] Some ADAMs have alternatively spliced secreted forms in addition to the prototype transmembrane form.[20,21] There are 20 genes that encode human ADAMs and 37 genes that encode mouse ADAMs. The ADAMTS family is a branch of ADAMs, and constitutes a group of secreted proteinases that are expressed in a broad spectrum of species, ranging from humans to worms.[22] There are 19 known ADAMTS proteinases in vertebrates. A schematic representation of the domain structure of representatives of the adamalysin/reprolysin/ADAM family of proteins is shown in Figure 1.

BIOLOGICAL FUNCTION

SVMPs circulate within envenomed animals and are primarily responsible for local and systemic bleeding.

Figure 1 Schematic representation of the domain structures of ADAM/adamalysin/reprolysin family of proteins. Each domain or subsegment is colored as follows: the prodomain (Pro), transmembrane (TM), cytoplasmic region (CT), C-type lectin-like domain (CLP) thrombospondin type-1 domain (TS), and spacer (S) domain are in black, black, gray, brown, gray, and light green, respectively. The use of disintegrin-like (D) in the nomenclature of ADAMTS is a misnomer[23] as the D domain in ADAMTS-1 appears to be very similar in structure to the C_h segment of VAP1. Thus, the D domain of ADAMTSs is represented as the C_h segment. The C domain in ADAMTSs has no sequence homology to ADAMs, and is represented by a distinct color.

Some SVMPs do not possess hemorrhagic activity, but have other diverse functions attributable to them, such as fibrinogenase, prothrombin activating, or plate aggregation inhibitor activities.[10] VAP1 induces cell death in VECs in culture with the characteristic features of apoptosis, including fragmentation of cells and cleavage of DNA into a characteristic ladder pattern upon electrophoresis.[2] VAP1-induced apoptosis is dependent on its catalytic activity,[24] is inhibited by antibodies to integrins α3, α6, β1, and CD9 (cluster of differentiation antigen-9),[25] and involves activation of specific caspases.[26] However, the physiological target(s) of VAP1 and the underlying mechanism of VAP1-induced apoptosis remain elusive.

The first mammalian ADAMs, termed *fertilin* (hetero dimer of α- (ADAM1) and β-chain (ADAM2)), was identified in 1992 as surface molecules on sperm cells that are essential for fertilization.[27] Meltrins α (ADAM12), β (ADAM19), and γ (ADAM9) were isolated as molecules involved in myogenesis.[28] The best-characterized *in vivo* activity of mammalian ADAMs is their ectodomain sheddase activity. ADAM17 (tumor necrosis factor converting enzyme or TACE) was initially identified as the physiological convertase for tumor necrosis factor (TNF)-α.[29,30] ADAM10 (kuzbanian), which dictates the lateral inhibition of *Drosophila* neurogenesis,[31] releases Notch ligand delta[32] and Notch.[33] ADAM-mediated shedding can be activated by ligands for G-protein-coupled receptors (GPCRs). ADAMs have also been implicated in mitogenic events associated with EGF receptor transactivation by GPCRs.[34–36] However, in contrast to SVMPs and ADAMTSs, all of which are proteolytically active, only 60% of mammalian membrane-bound ADAMs contain the signature catalytic site motif HEXXHXXGXXHD (where X denotes any amino acid). The function of the proteinase-inactive ADAMs remains unclear. Aside from sheddase activity, ADAMs function in cell–cell and cell–matrix adhesion. The domains that are carboxy terminal to the M domain of ADAMs have been shown to exhibit adhesive activities in tissue culture.[37–39] ADAMs have been associated with numerous disease conditions including rheumatoid arthritis, Alzheimer's disease, heart disease, and cancer.[36,40,41] ADAM33 has been genetically linked to asthma and bronchial hyperresponsiveness in Caucasians.[42]

Disintegrins are small proteins (40–90 amino acids) that are generated, albeit not exclusively,[43] by proteolytic processing of larger precursor P-II SVMPs that are composed of M and D domains.[44,45] They typically possess an Arg-Gly-Asp (RGD) recognition sequence on an extended loop (disintegrin loop) that has been shown to inhibit platelet aggregation *via* integrin binding.[46,47] ADAMs are unique among the cell-surface proteins in that they possess a disintegrin-like sequence, which suggests that integrins are common receptors for ADAMs.[12,18,27,48] However, the RGD sequence in the ADAMs disintegrin-loop is usually replaced by XXCD, and therefore, the adhesive properties of the D domain are controversial.

AMINO ACID SEQUENCE INFORMATION

The VAP1 cDNA encodes a protein of 610 amino acid residues (EMBL database: AB042840). Mature VAP1 is a disulfide-bonded homodimer of polypeptide chains of 423 residues each. The signal sequence and the prodomain, which precede the M domain, are cleaved by posttranslational processing, and the mature protein contains only the MDC domain. The MDC domains of human ADAMs exhibit 30–40% sequence identity with VAP1.[49]

The prodomain of VAP1 contains a cysteine-containing sequence, PKMCGVT, which is thought to maintain the proteinase in a latent state, and is activated by a cysteine-switch mechanism.[50] The cysteine-containing sequence is conserved among the adamalysin/reprolysin/ADAM family proteins and the matrix metalloproteinases (MMP) of the metzincin clan of metalloproteinases. The mechanism of removal of the prodomain of VAP1 has not been clarified. The activation of some ADAMs has been shown to involve their own proteinase activity, while the others are believed to be activated by proprotein convertases (e.g. furin) in the secretary pathway.

PROTEIN PRODUCTION, PURIFICATION, AND MOLECULAR CHARACTERIZATION

VAP1 can be purified from the lyophilized powder of *C. atrox* venom by conventional liquid chromatography.[51] In the amino terminus of the M domain, Glu184 is modified to its pyro-form, and a carbohydrate chain is linked to the residue Asn218.[49]

VAP1 has a unique dimeric structure, and most adamalysin/reprolysin/ADAM family proteins do not appear to form VAP1-type dimers, as they lack the consensus QDHSK sequence (residues 320–324 in VAP1) and Cys365.[49] The consensus sequence and a cysteine residue at this position are found in other apoptotic P-III SVMPs, such as HV-1 (habu snake vascular-apoptosis-inducing protein-1),[4] halysase,[5] and VLAIP (*Vipera lebetina* apoptosis-inducing protein).[6] The VAP1-type dimers are categorized as the P-IIIb subclass of SVMPs, to distinguish them from the monomeric P-IIIa SVMPs.[10]

METAL CONTENT AND COFACTORS

There are one zinc and two calcium ions bound per VAP1 monomer, as shown by X-ray crystallography.[49] On the basis of the structures of VAP1 and the related proteins, and amino acid sequence alignment, the canonical ADAM MDC domains contain one zinc ion and three calcium ions. No other cofactors are present.

ACTIVITY AND INHIBITION TESTS

VAP1 degrades fibrinogen *in vitro*,[24] although the cleavage site(s) has not been identified. After incubation with either ethylenediaminetetraacetic acid (EDTA) or ethyleneglycol bis (2-aminoethyl ether) tetraacetic acid (EGTA), the ability of VAP1 to degrade fibrinogen and induce apoptosis in VECs is severely impaired.[24] Hydroxamic acid derivatives, such as GM6001 has been given as (*N*-[(2*R*)-2-(hydroxamidocarbonylmethyl)-4-methylpentanoyl]-L-tryptophan methylamide) also inhibit VAP1-induced VEC apoptosis. Therefore, the metalloproteinase activity of VAP1 appears to be involved in the induction of apoptosis by VAP1. Most of the hemorrhagic SVMPs degrade basal membrane component proteins[11]; however, the degradation activity of VAP1 toward those proteins *in vitro* is very weak.

The 12 human ADAMs (ADAM8, 9, 10, 12, 15, 17, 19, 20, 21, 28, 30, and 33) contain a catalytic signature sequence (HEXXHXXGXXHD), and most of them (with the exception of ADAM20, 21, and 30) have been shown to be proteolytically active.[12,17,18]

X-RAY AND NMR STRUCTURES

The first member of the adamalysin/reprolysin/ADAM family of proteinases for which the X-ray structure was determined was adamalysin II, a P-I SVMP from *Crotalus adamantus*.[52,53] Since then, crystal structures of seven P-I SVMPs have been published.[54–60] The structures of several disintegrins have been determined by X-ray crystallography[61–63] and NMR.[64–68] Although the crystallization papers of two P-III SVMPs, Jararhagin from *Bothrops jararaca* and AaH-IV from *Agkistrodon acutus* venoms, are available,[69,70] the three-dimensional structures have not been reported. The structures of seven mammalian proteins are currently available – the M domains of human ADAM17[71] and ADAM33,[72] the DC domains of bovine ADAM10,[73] the M domain of human ADAMTS-5,[74] and the MD domains of human ADAMTS-1,[23] ADAMTS-4, and ADAMTS-5.[75]

VAP1 was the first P-III SVMP structure to be resolved by X-ray crystallography.[49] The crystal structures of VAP1 have revealed an MDC domain architecture, which is shared by the mammalian ADAMs. Crystal structures of three different crystal forms of catrocollastatin/VAP2B, an apoptotic, monomeric class (P-IIIa) of SVMP[3,7] that has platelet-aggregation inhibitory activity,[76] have been determined.[77] A comparison of the six catrocollastatin/VAP2B structures and the structures of VAP1 reveals a dynamic, modular architecture of the MDC domains that may be important for the functions of adamalysin/reprolysin/ADAM family proteins.[77] The third MDC-containing SVMP for which the crystal structure was solved is RVV-X,[78] an unusual metalloproteinase that belongs to the P-IV class of SVMPs. Two C-type lectin-like chains are added posttranslationally to the C domain of P-III class SVMPs.[10,79–81] Although no mammalian ADAM MDC-domain crystal structures are currently available, electron microscopy of negative-stained recombinant ADAM12 with its prodomain revealed a four-leaf-clover shape, in which three of the four leaves represented the MDC domains.[82] Table 1 summarizes the adamalysin/reprolysin/ADAM family proteins currently entered into the Protein Data Bank.

Crystallization

VAP1 was crystallized in two distinct crystal forms using the sitting or hanging drop vapor diffusion methods.[49,51] Crystals were obtained with a reservoir solution that contained 15% polyethyleneglycol (PEG) 8000 and 100 mM sodium cacodylate at pH 6.5, with (orthorhombic form) or without (tetragonal form) 20 mM cobaltous chloride hexahydrate. The orthorhombic crystals belonged to space group $P2_12_12_1$ with $a = 86.7$ Å, $b = 93.3$ Å, $c = 137.7$ Å and one VAP1 dimer in the asymmetric unit. The tetragonal crystals belonged to space group $P4_12_12$ with $a = b = 93.9$ Å, $c = 244.8$ Å and one VAP1 dimer per asymmetric unit. Inhibitor-bound crystals were prepared by adding GM6001 to the drop with the orthorhombic crystal at a final concentration of 0.33 mM, followed by a 12-h incubation. Native structures were determined from crystals in the two distinct space groups at 2.5 Å resolution, and GM6001-bound structure was determined at 3.0 Å resolution.[49]

Like other proteins, adamalysin/reprolysin/ADAM family proteins are more prone to crystallize with inhibitors, which not only increase the thermal stability of the proteins[74] but also provide additional contacts with neighboring molecules in the crystalline lattice.[51,77,78]

MDC domains form a 'C shape'

The MDC domain architecture of VAP1 is shown in 3D structure and Figure 2(a) and (b). The M domains in the dimer are related by a noncrystallographic twofold axis, such that their active sites point in opposite directions, and an interchain disulfide bridge is formed between symmetry-related Cys365 residues. Each monomer has an almost identical structure except for the subdomain orientations. The M domain is followed by the D domain, which is further divided into two structurally distinct subsegments, the 'shoulder' (D_s) and the 'arm' (D_a) segments. The D_s segment protrudes from the M domain close to Ca^{2+} binding site I (see below), opposite the catalytic zinc ion. The C domain is subdivided into 'wrist' (C_w) and 'hand' (C_h) segments. Because of the curved structure of the D_s/D_a/C_w/C_h segments, with the concave surface facing

Table 1 Selection of the 3D structures of ADAM/adamalysin/reprolysin family proteins currently deposited in the PDB

Protein	Domains	Method	PDB code	Reference
Snake venom proteins				
VAP1	MDC (homodimer)	X ray	2ERO, 2ERP, 2ERQ	49
Catrocollastatin/VAP2B	MDC	X ray	2DW0, 2DW1, 2DW2	75
RVV-X (russellysin)	MDC + 2CLPs	X ray	2E3X	76
Adamalysin II	M (P-I SVMP)	X ray	1AIG, 2AIG, 3AIG	52, 53
Atrolysin C	M (P-I SVMP)	X ray	1ATL, 1HTD	54
Acutolysin A	M (P-I SVMP)	X ray	1BSW, 1BUD	55
BaP1	M (P-I SVMP)	X ray	1ND1	56
H2	M (P-I SVMP)	X ray	1WNI	57
TM-3	M (P-I SVMP)	X ray	1KUF, 1KUG, 1KUI, 1KUK	58
Acutolysin C	M (P-I SVMP)	X ray	1QUA	59
FII	M (P-I SVMP)	X ray	1YP1	60
Trimestatin	Disintegrin	X ray	1J2L	61
Schistatin	Disintegrin (homodimer)	X ray	1RMR	62
Disintegrin (*Echis carinatus*)	Disintegrin (heterodimer)	X ray	1TEJ	63
Disintegrin (*Echis carinatus*)	Disintegrin (homodimer)	X ray	1Z1X	Unpublished
Kistrin	Disintegrin	NMR	1N4Y	67
Rhodostmin	Disintegrin	NMR	2PJF	Unpublished
Echistatin	Disintegrin	NMR	1RO3, 2ECH	65
Flavoridin	Disintegrin	NMR	1FVL	66
Obtustatin	Disintegrin	NMR	1MPZ	64
Salmosin	Disintegrin	NMR	1L3X	68
Mammalian proteins				
ADAM33	M	X ray	1R54, 1R55	72
ADAM17 (TACE)	M	X ray	1BKC	71
ADAM10	DC	X ray	2AO7	73
ADAMTS-5	M	X ray	3B8Z	74
ADAMTS-1	MD*	X ray	2JIH, 2V4B	23
ADAMTS-4	MD*	X ray	2RJP, 3B2Z	75
ADAMTS-5	MD*	X ray	2RJQ	75

* The use of disintegrin-like (D) domain in the nomenclature of ADAMTS is a misnomer.[23] The D-domain in ADAMTSs appears no structural similarity to the D-domain of ADAMs and SVMPs, and thus is represented as "D*".

the M domain, the overall appearance of the MDC domains is a C-shaped configuration. The distal portion of the C_h segment comes close to and faces the catalytic zinc ion in the M domain.

Metalloproteinase domain

The VAP1 M domain has as an oblate ellipsoidal shape with a notch in its flat side that creates a relatively small 'lower' domain and an 'upper' main molecular body in the 'standard' orientation,[15,52,85] wherein the active-site cleft extends horizontally across the M-domain surface to bind peptide substrates from left to right (Figure 2b). The catalytic zinc atom is located at the bottom of the cleft. The amino-terminal upper domain has a central core consisting of highly twisted five-stranded β-sheets and five α-helices. The amino-terminal h0 helix located on the h5 helix is unique to VAP1, and is not found, to date, in the

structures of other family members. The curved β-sheets are parallel, with the exception of s4-strand, which faces the active-site cleft, and is sandwiched between helices h2 and h4 on the concave side and helix h3 on the convex side. The short helix h1 is located at an edge of the β-sheet. A topology diagram of the M domain is shown in Figure 2(c). The secondary structural arrangement is similar to other metzincins, such as astacin[85] and human neurophil collagenase (MMP-8),[86] except for a large insertion of helix h3 and the loop between strand s2 and helix h3. This insertion contributes to calcium binding site I (see below), which is unique in the adamalysin/reprolysin/ADAM family proteinases. The carboxy-terminal lower domain consists of helix h5 and an irregularly folded region. This irregular region is presumably important for substrate recognition because it forms, in part, the wall of the S1′ crevice, contains the 'Met-turn', and is stabilized by two conserved disulfide bridges (Cys350–Cys374 and Cys352–Cys357). A third highly conserved disulfide bridge (Cys310–Cys390)

Figure 2 Ribbon structure of VAP1. (a) VAP1 dimer viewed from the twofold axis. The h0 helix, M domain, linker, D_s, D_a, C_w, C_h segments, and HVR are shown in red, yellow, gray, cyan, pink, gray, light green, and blue, respectively. Zinc and calcium ions are represented as red and black spheres, respectively. The carbohydrate moieties linked to Asn218 the calcium-mimetic Lys202 and bound GM6001 (in green) are in ball–stick representations; (b) stereo view of the VAP1 monomer in the standard orientation, nearly perpendicular to the view in (a); (c) topology diagram of the VAP1 M domain. Figures were generated using the MOLSCRIPT[83] and RASTER3D[84] programs.

connects the two subdomains close to Ca^{2+} binding site I. The M domain of VAP1 can be superposed with those of human ADAM33[72] and ADAM17[71] (Figure 3).

Arm structure

The VAP1 D domain is linked to the M domain by a short linker that allows variable orientation between the M domain and the D_s segment. The D_s and D_a segments consist largely of a series of turns and two short regions of antiparallel β-sheet, and constitute an elongated C-shaped arm structure together with the amino-terminal region of the C domain, the C_w segment (Figure 4(a)). The C_w segment consists of a pair of antiparallel β-strands and loops. It packs against the D_a segment on one side and against the carboxy-terminal β-sheet of the C_h segment on the other. There are three disulfide bridges

in the D_s segment, three in the D_a segment, and one in the C_w segment. The subsegments are connected by single disulfide bridges. The number and spacing of the cysteine residues involved in these disulfide bridges are highly conserved among adamalysin/reprolysin/ADAM family proteins (Figure 4(c)).[10,44,49,77] Because there are few secondary structural elements, the disulfide bridges, together with bound calcium ions (see below), are essential for the structural rigidity of each segment of the C-shaped arm structure.

As predicted from its amino acid sequence, the structure of the D_a segment is similar to that of the RGD-containing disintegrin trimestatin (root mean square deviation (rmsd) of 1.24 Å),[61] with the exception of the disintegrin loop and the carboxy terminus of the D_a segment (Figure 4(b)). These two regions in disintegrins are highly mobile and are candidate sites for integrin binding.[65–67] Using isolated D domains or portions of them, numerous

Figure 3 Stereo view of the superimposition of the M domains of VAP1 (yellow), ADAM33 (cyan), and ADAM10 (pink). The calcium ion bound to site I and the zinc ion in ADAM33 are represented by black and red spheres, respectively. The h0 helix in VAP1 is colored red.

Figure 4 Arm structure of VAP1 (a) stereo diagram of the arm structure. The D_s, D_a, and C_w segments are in cyan, pink, and light green, respectively. The residues involved in calcium ion coordination and the disulfide bridges are shown in red and green, respectively. The carbonyl oxygen atoms of the residues that are involved in calcium coordination are underlined. Calcium ions are represented as black spheres. The disintegrin-loop (DECD) is in blue; (b) superimposition of the D_s segments of VAP1 and trimestatin (1J2L). Trimestatin and its RGD loop residues are shown in red and blue, respectively; and (c) amino acid sequence alignment of VAP1, trimestatin, and human ADAMs. The cysteinyl residues and conserved residues are shaded in pink and yellow, respectively. Disulfide bridges, secondary structures, and the boundary of the segments are shown schematically. The calcium binding sites are boxed in red, and the residues involved in calcium ion coordination are indicated. The National Center for Biotechnology Information (NCBI, http://www.ncbi.nlm.nih.gov/) accession numbers for the sequences are BAB18307 for VAP1, AAC59672 for VAP2B (catrocollastain/VAP2B), NP_003807 for ADAM9, AAC08703 for ADAM12, NP_075525 for ADAM19, NP_079496 for ADAM28, Z48579 for ADAM10, U69611 for ADAM17, and 1J2L for trimestatin. Figures were generated using the MOLSCRIPT[83] and RASTER3D[84] programs.

ADAMs, and P-III SVMPs have been shown to interact with integrins.[12,18,47,48] However, in VAP1, a bound calcium ion at site III forms a structural core that stabilizes the disintegrin-loop that is packed against the C_w segment. A disulfide bond (Cys468–Cys499) further stabilizes the continuous structure, which suggests that there is little intersegment flexibility. Cys468 is conserved among mammalian ADAMs and P-III SVMPs, which always contain a C domain. The structures of the DC domains of bovine ADAM10,[73] catrocollastain/VAP2B,[77] and RVV-X[78] also show a continuous D_a/C_w structure. These observations suggest that the disintegrin loop in ADAMs and P-III SVMPs is unavailable for protein binding due to steric hindrance.

Metal site geometries

Catalytic site (Zn^{2+})

VAP1 has a zinc-binding consensus sequence (HEXXHXXGXXH), which is characteristic of the metzincin superfamily.[15,16] The zinc ion is situated at the bottom of the catalytic cleft, and is tetrahedrally coordinated by the Nε2 atoms of the three consensus histidines, His335, His339, and His345, with bond distances of 2.0–2.2 Å. The coordination of the catalytic zinc atom is almost the same as in other members of this family. In GM6001-bound VAP1, the zinc ion is pentacoordinated by the two hydroxamate oxygen atoms and the Nε2 atoms of the three histidines (Figure 5).

Ca^{2+} binding site in the M domain (Ca^{2+} site I)

The MDC domain contains three potential Ca^{2+} binding sites. The structures of the M domain of ADAM33[72] and

Figure 5 Stereo diagram of the catalytic zinc (pink sphere) of the VAP1–GM6001 complex (PDB code 2ERQ). The hydroxamic acid group of bound GM6001 and three histidine ligands are shown, along with the Zn–N/O distances (angstrom). The figure was generated using PyMOL.[87]

Figure 6 Stereo diagram of calcium binding site I of VAP1 (gray) superposed on that of catrocollastain/VAP2B (blue). The Ca^{2+}/N–O distances (angstrom) are indicated. The figure was generated using PyMOL.[87] The ammonium group of Lys202 in VAP1 occupies the position of the calcium ion in catrocollastatin/VAP2B.

of other P-I SVMPs[52,53,55] suggest that most ADAMs have a Ca^{2+} binding site (designated Ca^{2+} binding site I) that is in opposition to the active-site cleft close to the crossover point of the amino-terminal and carboxy-terminal segments of the M domain. In catrocollastatin/VAP2B, this Ca^{2+} ion is coordinated by the side chains of Asp285, Asn391, and Glu201, the backbone carbonyl oxygen of Cys388, and two water molecules in a pentagonal bipyramidal arrangement.[77] The three side chains that coordinate the Ca^{2+} ion are largely conserved among ADAMs and SVMPs. However, in VAP1, Glu and Asn are replaced by Lys202 and Lys392, respectively, and the distal ammonium group of Lys202 substitutes for the Ca^{2+} ion (Figure 6). Replacement of the calcium-coordinating glutamate residue with lysine is also observed in several ADAMs (e.g. human ADAMs16, 25, and 38–40). The high degree of conservation of residues involved in calcium binding and the presence of mimetic calcium binding might reflect the importance of this region for the structural link between the M and D_s domains. A protective role for calcium against auto proteolysis in the linker region has also been reported,[45,53,88] and the linker region is usually removed from P-I SVMPs posttranslationally.[89] ADAM17[71] and, presumably, ADAM10 do not possess this calcium binding site. These two ADAMs are not typical members of the mammalian family of ADAMs. They also lack Ca^{2+} binding site III, and lack an EGF domain.

Ca^{2+} sites in the D_s- and D_a segments

The structure of both the D_s and D_a segments revealed Ca^{2+} binding sites[49] that were not predicted by protein sequence. In the D_s segment, side-chain oxygen atoms of residues Asn408, Glu412, Glu415, and Asp418, and main-chain oxygen atoms of Val405 and Phe410 are

(a)

(b)

Figure 7 Stereo diagram of bound calcium ions in the (a) D_s segment (site II) and in the (b) D_a segment (site III) of VAP1. The Ca^{2+}–O distances (angstrom) are indicated. The figure was generated using PyMOL.[87]

involved in pentagonal bipyramidal coordination (hepta-coordination) of Ca^{2+} binding site II (Figure 7(a)). Of note, these residues are strictly conserved among all known mammalian ADAMs and P-III SVMPs.[49,77] Side-chain oxygen atoms of Asp469, Asp472, and Asp483, and the main-chain carbonyl oxygen atoms of Met470 and Arg484 coordinate the binding of a Ca^{2+} ion at the corners of a pentagonal bipyramid, and constitute Ca^{2+} binding site III in the D_a segment (Figure 7(b)). These residues are highly conserved among mammalian ADAMs, with the exception of ADAM10 and ADAM17.[49,77]

Hand (C_h segment) structure and hypervariable region (HVR)

The core of the carboxy-terminal region of the VAP1 C domain, the C_h segment, is an α/β fold structure that consists of two antiparallel β-strands packed against two of the three α-helices, and five disulfide bonds (Cys511–Cys561, Cys526–Cys572, Cys539–Cys549, Cys556–Cys598, and Cys592–Cys603) (Figure 8(a)). The C_h segment of VAP1 has a novel and unique fold with no

structural homology to other known proteins, with the exception of the corresponding segment of ADAM10[73] and ADAMTS-1[23] (see below).

The loop encompasses residues 562–583, and extends across the central region of the C_h segment. It is the region in which the ADAM sequences are most divergent and variable in length (11–55 aa) (Figure 8(e)). We have designated this the hypervariable region (HVR).[49] In all the crystal forms of VAP1 and catrocollastatin/VAP2B, the HVR is involved in crystal packing, and forms a short antiparallel β-strand in the center that participates in a 'handshake' with the HVR of a neighboring molecule.[49,77] The structure of the HVR is stabilized mainly by interchain interactions. However, while there are no main chain–main chain hydrogen bonds between residues 574–584 and the remainder of the C_h segment, a water-mediated hydrogen bond network helps stabilize the HVR structure. Therefore, it appears that the HVR β-strand might be formed by an induced fit mechanism upon the association of the C_h segment, and that the conserved disulfide bridge (Cys526–Cys572) stabilizes the structure when the HVR is isolated in solution. Some ADAMs possess a putative fusion peptide sequence in this segment that is typical of viral fusion proteins[27,28]; however, its role in the actual fusion process has not been experimentally demonstrated.

The HVR is located at the distal end of the C-shaped MDC domain, and points toward the M-domain catalytic site, with a distance of ~4 nm between them. It has been suggested that the C domain is an adhesion domain with potential protein–protein and protein–matrix binding surfaces. However, most of the studies that implicate this region in heterologous interactions have not identified specific regions of the C domain that are involved, and the molecular mechanism of recognition is not well understood. Different ADAMs and SVMPs have distinct HVR sequences, which results in their having distinct surface features that may play a role in binding specificity. The VAP1 structure indicates that the HVR may interact with other proteins, bringing them toward the M-domain catalytic site where they can interact directly with the catalytic cleft. These observations suggest that the HVR of both ADAMs and SVMPs could be an exosite for the cleavage of certain cell-surface molecules; that is, it may directly interact with target molecules or their associated proteins that are processed by the catalytic site. The D domain is located opposite and apart from the catalytic site, and thus, might function primarily as a scaffold that positions the catalytic site and the exosite in the proper position and orientation.

Comparison to the related structures

ADAM 10 and ADAMTS-1 C_h domains

ADAM10 and ADAM17 show less sequence similarity, particularly in the C domain, to the other canonical

Figure 8 Structures of the hand segment (C$_h$ segment) of VAP1 and human ADAM10. (a) Ribbon diagram of the VAP1 C$_h$ segment in stereo. The HVR is shown in blue. The common scaffold of VAP1, ADAM10, and ADAMTS-1 is shown in cyan, and the segment lacking in ADAM10 is shown in light green. Disulfide bridges are indicated; (b) topology diagram of the C$_h$ segment of VAP1; (c) ribbon representation of the C$_h$ segment of ADAM10 in stereo. The HVR is shown in red. The numbering of the amino acids of ADAM10 (bovine) were changed to that of human; (d) superimposition of the C$_h$ segments of VAP1 and ADAM10. The colors are as described for (a) and (c); and (e) structure-based alignment of the C$_h$ segments of SVMPs, human ADAMs, and human ADAMTSs. Secondary structure of VAP1 and the disulfide bridges are represented schematically.

ADAMs. A comparison of the bovine ADAM10 DC domain structure (ADAM10$_{D+C}$)[73] and that of VAP1 reveals that these two proteins share a continuous D$_a$/C$_w$ structure and C$_h$ segment scaffold[49] (Figure 8(a–c)). The crystal structure of the MD domains of the human ADAMTS-1 has recently been determined, and it shows that the previously named disintegrin-like domain of ADAMTS-1 appears to be very similar in structure to the C$_h$ segment of VAP1 (rmsd of 1.1 Å for 52 Cα atom positions), despite low sequence identity (~16%) between the two molecules.[23] The locations of the four disulfide bonds within the C$_h$ segment are conserved among VAP1, ADAM10, and ADAMTS-1, which enabled us to align the

three sequences. Figure 8(e) shows the sequence alignment of a selected subset of human ADAMs, ADAMTSs, and SVMPs. ADAM10 and ADAMTS-1 lack helix h8 and the variable loop that protrudes from VAP1, and have different HVR structures (the amino-terminal region of the HVR of ADAMTS-1 is disordered and has not been included in the model[23]). ADAMTSs lack the entire D$_s$/D$_a$/C$_w$ segment, and their C$_h$ segment is connected to the M domain by a connector loop (22 residues in ADAMTS-1) that wraps around the back of the M domain, resulting in a drastically different position of the C$_h$ segment relative to the M domain compared to VAP1. ADAM10 also has a different spatial arrangement of the M and C$_h$

Figure 9 Mobility of the subdomains of VAP1, ADAM10, and catrocollastatin/VAP2B. (a) Superimposition of the D_a segments of ADAM10 and VAP1. The D_s/D_a/C_w segments and helix h7 helix of VAP1 and ADAM10 are shown in blue and red, respectively. The C_h segments of VAP1 and ADAM10 are shown in cyan and pink, respectively. The arrow indicates the pivot point between the C_w and C_h segments. Bound calcium ions in VAP1 are shown as black spheres. Superposition of (b) the M domain and; (c) the C_h segments of the six structures of catrocollastatin/VAP2B and VAP1 monomer structure. Two representative catrocollastatin/VAP2B molecules are shown in blue and red, the other four catrocollastatin/VAP2B molecules are shown in gray, and VAP1 is in green. The zinc ion bound to the red molecule is shown as a yellow sphere. The calcium ions bound to the red and the blue catrocollastain/VAP2B molecules and VAP1 are shown as red, blue, and green spheres, respectively.

domains, primarily due to a different orientation between the C_w and C_h segments (Figure 9(a)). The possibility that different ADAMs have distinct C_w/C_h orientations remains to be determined. While most of the membrane-bound ADAMs have an EGF module between the C domain and the transmembrane segment, the ADAM10 C domain is separated from the cell membrane by only 26 residues, which are likely to be disordered.[73]

Catrocollastatin/VAP2B

The structures of catrocollastatin/VAP2B determined in three different crystal forms[77] are the first reported structures of a member of the monomeric class of MDC-domain-containing proteins of the adamalysin/reprolysin/ADAM family. The overall structure of catarocollastatin/VAP2B showed good agreement with each monomer of VAP1, and the structure of each segment was nearly identical between the molecules (Figure 9(b) and (c)). However the relative orientation of the subdomains was quite variable. Comparison of the six catrocollastatin/VAP2B monomer structures and the four VAP1 monomer structures derived from different crystal forms revealed a dynamic, modular architecture of the MDC domain of this family of proteins.[77] The largest difference was observed when the M domains of the six catrocollastatin/VAP2B molecules were superimposed (Figure 9(b)). The arm portion was rotated by approximately 13° relative to the M domain, bringing about a 15-Å displacement at the distal end of the C_h segment. A bulky hydrophobic residue (Leu, Phe, or Tyr) at position 408 is highly conserved among adamalysin/reprolysin/ADAM family proteins. The side chain of Leu408 in catrocollastatin/VAP2B functions as a universal joint (shoulder joint) that allows the D_s segment to adopt various orientations with respect to the M domain.[77] Intrinsic flexibility may be important for fine-tuning substrate recognition, and adjusting the spatial alignment of the catalytic and adhesion sites during the catalysis.

Structure of RVV-X

The coagulation factor X activator from Russell's viper venom (RVV-X, russellysin) is a unique metalloproteinase of the P-IV class of SVMPs that is composed of an MDC-domain-containing heavy chain and two C-type lectin-like light chains.[10,79–81] RVV-X specifically activates factor X by cleaving the Arg194–Ile195 bond in factor X, which is also cleaved by physiological convertases.[90] Cleavage removes the heavily glycosylated amino-terminal 52 residues (active peptide, or AP) of the factor X heavy chain, which results in exposure of the active site. Activated factor X (factor Xa) in turn converts prothrombin to thrombin, which ultimately leads to formation of a hemostatic plug.

The crystal structure of RVV-X resembles a hook–spanner–wrench configuration, in which the MD domains constitute a hook, and the rest of the molecule forms a handle (Figure 10(a)).[77] The two homologous light chains have a fold similar to the carbohydrate-recognition domain (CRD) of rat mannose binding protein (MBP),[91] but they form an intertwined dimer, in which the central portion of each chain projects toward the adjoining subunit. The RVV-X heavy chain has a unique cysteine residue (Cys389) in the middle of the HVR. Cys389 forms a disulfide bond with the carboxy-terminal cysteine residue of one of the light chains, light chain A (LA). In addition to

(a) (b)

Figure 10 Structure of RVV-X and the factor-Xa docking model. (a) Crystal structure of RVV-X. Each segment of the RVV-X heavy chain is colored as described for VAP1 in Figure 2. Light chain A and B are colored in orange and magenta, respectively. The disulfide bridge between Cys389 in the heavy chain and Cys133 in light chain A, the carbohydrate moieties (in green) linked to asparagine residues, and GM6001 (in magenta) are shown in ball-and-stick representations. Bound calcium and zinc ions are represented as black and red spheres, respectively; (b) factor Xa docking model in stereo. The molecular surface of RVV-X is colored as for (a). Factor Xa is shown in ribbon representation. Ile195 (in stick representation) and the amino-terminal region of the factor Xa heavy chain are shown in magenta. Because the structure of the factor X zymogen is currently unavailable, the model was constructed on the basis of the factor-Xa crystal structures (1XKA and 1IOD).[78] In the factor Xa structure, the amino terminus of the heavy chain is buried within the protein. However, in the zymogen, the intact scissile peptide bond (Arg194–Ile195) must be situated on the molecular surface, as in the equivalent segments of other serine proteinase zymogen structures.

this interchain disulfide bond, the HVR and surrounding residues are engaged in multiple hydrophobic interactions and hydrogen bonds, which further stabilize the continuous C_h/LA structure. The RVV-X structure represents the first example of HVR-mediated protein–protein interactions in the adamalysin/reprolysin/ADAM family proteins.

The structure of the RVV-X light chains is quite similar to that of the factor X-binding protein (X-bp) from *Deinagkistrodon actus* venom, as determined in complex with the γ-carboxyglutamic acid (Gla) domain of factor X.[92] This structural similarity and the previous biochemical observations[81] suggest that the concave cleft created between the two light chains in RVV-X may function as an exosite for factor X. A 6.5 nm separation between the catalytic site and a putative Gla-domain-binding exosite suggests the docking model for factor X (Figure 10(b)).[78] The active-site zinc atom and Ile195 of factor Xa are 16 Å apart because the two molecules are positioned as rigid bodies without any contacts. Intrinsic flexibility between the segments of the RVV-X heavy chain, and conformational changes upon association of RVV-X and factor X zymogen, may allow the catalytic

site of RVV-X to interact directly with the bond between Arg194–Ile195 of factor X in solution. The relatively large separation between the catalytic site and the exosite may explain the high specificity of RVV-X for factor X.

The VAP1 structure suggests a model in which the HVR constitutes an exosite that captures target or associated proteins that are then processed by the catalytic site.[49] The RVV-X structure[78] is consistent with this model and provides additional insights into the molecular basis of target recognition and proteolysis by ADAM/adamalysin/reprolysin proteinases. The fold adaptation of the RVV-X structure is also a good example of evolutionary gain of function by multi-subunit proteins for the binding of ligands.

FUNCTIONAL ASPECTS

C-domain-mediated protein–protein interactions

ADAM family proteins are widely distributed and constitute major membrane-bound sheddases that are involved in the proteolysis of cell-surface-protein ectodomains fo

cell–cell communications. As such, they have emerged as potential therapeutic targets for various disease conditions. The P-III SVMPs are the most potent hemorrhagins and constitute key toxins in venom-induced pathologies. Thus, they are important targets for antivenom therapeutics. However, the physiological targets of ADAMs and SVMPs and the molecular mechanism of target recognition are poorly understood. The structures of VAP1 and related proteins highlight the potential roles of the C domain in protein–protein interactions.

There is mounting experimental evidence that C domains mediate protein–protein interactions. Peptides encompassing the HVR and the hydrophobic ridge from jararhagin and atrolysin-A (P-III SVMPs from *C. atrox* venom) interfere with platelet interaction and collagen binding.[93] Catrocollastatin-C and jararhagin-C, which are proteolytic products (DC-domain fragments) of catrocollastatin/VAP2B and jararhagin, respectively, have been shown to inhibit collagen-induced platelet aggregation.[94,95] Jararhagin-C also activates early events in the inflammatory response, such as leukocyte rolling and proinflammatory cytokine release.[96] Recombinant atrolysin-A C domain (A/C) specifically binds collagen type I and von Willebrand factor (vWF), and blocks collagen–vWF interactions.[97,98] It also binds to the von Willebrand factor A (VWA)-domain-containing extracellular matrix (ECM) proteins collagen XII and XIV, and matrilins 1, 3, and 4.[99] Binding of vWF in solution to immobilized A/C was inhibited by ristocetin, and preincubation of platelets with A/C abolished ristocetin/vWF-induced platelet aggregation, which indicates that the interaction of A/C with vWF is mediated by the VWA1 domain.[100] Two peptide sequences have been identified in the C domain of jararhagin that bind to vWF and block C-domain binding.[101] On the basis of the structures of VAP1 and catrocollastain/VAP2B, the Jar6 peptide (corresponding to catrocollastatin/VAP2B residues [547]PCAPEDVKCG[556]) is located on the surface of the C domain, and thus could play a role in protein–protein interactions. ADAM12 interacts with cell-surface syndecan through its C domain and mediates integrin-dependent cell spreading.[37] The DC domain of ADAM13 has been implicated in cell migration events,[102] and binds to the ECM proteins laminin and fibronectin.[38] It should be noted, however, that most of these studies do not identify a specific region of the C domain that is involved in these interactions, and so the molecular mechanisms of recognition remain to be elucidated.

Several studies have indicated that the ADAMs' C domain can influence proteolytic activity. The C domain of ADAM13 was found to be the major determinant of specific developmental events that are mediated by the proteolytic activity of ADAM13.[103] Ectodomain shedding of interleukin-1 R-II by ADAM17 (TACE) requires the DC domains, whereas tumor necrosis factor (TNF) and p75 tumor necrosis factor receptor (TNFR) shedding by ADAM17 requires only the tethered M domain.[104] The

acidic surface pocket in the ADAM10 C domain serves as a binding site for the ephrin-A5/EphA3 complex in ADAM10-mediated ephrin-A5 proteolysis.[22] Jararhagin cleaves vWF at sites adjacent to the VWA1 domain, and digestion is completely inhibited by the A/C and catrocollastatin-C.[100]

ACKNOWLEDGEMENTS

The author is indebted to T. Igarashi, Y. Ohishi, M. Tomisako, and S. Araki, who made essential contributions to the elucidation of the structures of VAP1, catrocollastatin/VAP2B, and RVV-X, and to H. Mori for support and encouragement. The financial support of the Ministry of Education, Science, Sports, and Culture, Grant-in-aid for Scientific Research B-19370047-2007, and Health and Labor Science Research Grants, and grants from the Mitsubishi Pharma Research Foundation and the Astellas Foundation for Research on Metabolic Disorders are kindly acknowledged.

REFERENCES

1 S Araki, T Ishida, T Yamamoto, K Kaji and H Hayashi, *Biochem Biophys Res Commun*, **190**, 148–53 (1993).

2 S Masuda, S Araki, T Yamamoto, K Kaji and H Hayashi, *Biochem Biophys Res Commun*, **235**, 59–63 (1997).

3 S Masuda, H Hayashi and S Araki, *Eur J Biochem*, **253**, 36–41 (1998).

4 S Masuda, H Hayashi, H Atoda, T Morita and S Araki, *Eur J Biochem*, **268**, 3339–45 (2001).

5 WK You, HJ Seo, KH Chung and DS Kim, *J Biochem (Tokyo)*, **134**, 739–49 (2003).

6 K Trummal, K Tonismagi, E Siigur, A Aaspollu, A Lopp, T Sillat, R Saat, L Kasak, I Tammiste, P Kogerman, N Kalkkinen and J Siigur, *Toxicon*, **46**, 46–61 (2005).

7 S Masuda, H Maeda, JY Miao, H Hayashi and S Araki, *Endothelium*, **14**, 89–96 (2007).

8 I Tanjoni, R Weinlich, MS Della-Casa, PB Clissa, RF Saldanha-Gama, MS de Freitas, C Barja-Fidalgo, GP Amarante-Mendes and AM Moura-da-Silva, *Apoptosis*, **10**, 851–61 (2005).

9 JB Bjarnason and JW Fox, *Methods Enzymol*, **248**, 345–68 (1995).

10 JW Fox and SM Serrano, *Toxicon*, **45**, 969–85 (2005).

11 JM Gutierrez, A Rucavado, T Escalante and C Diaz, *Toxicon*, **45**, 997–1011 (2005).

12 JM White, L Bidges, D DeSimone, M Tomczuk and T Wolfsberg, in NM Hooper and U Lendeckel (eds.), *The ADAM Family of Proteases*, Springer, Dordrecht (2005).

13 K Kuno, N Kanada, E Nakashima, F Fujiki, F Ichimura and K Matsushima, *J Biol Chem*, **272**, 556–62 (1997).

14 BL Tang and W Hong, *FEBS Lett*, **445**, 223–25 (1999).

15 FX Gomis-Ruth, *Mol Biotechnol*, **24**, 157–202 (2003).

16 W Bode, FX Gomis-Ruth and W Stockler, *FEBS Lett*, **331**, 134–40 (1993).

17 DF Seals and SA Courtneidge, *Genes Dev*, **17**, 7–30 (2003).

18 JM White, *Curr Opin Cell Biol*, **15**, 598–606 (2003).

19 T Nakamura, H Abe, A Hirata and C Shimoda, *Eukaryot Cell*, **3**, 27–39 (2004).

20 BJ Gilpin, F Loechel, MG Mattei, E Engvall, R Albrechtsen and UM Wewer, *J Biol Chem*, **273**, 157–66 (1998).

21 CM Roberts, PH Tani, LC Bridges, Z Laszik and RD Bowditch, *J Biol Chem*, **274**, 29251–59 (1999).

22 GC Jones and GP Riley, *Arthritis Res Ther*, **7**, 160–69 (2005).

23 S Gerhardt, G Hassall, P Hawtin, E McCall, L Flavell, C Minshull, D Hargreaves, A Ting, RA Pauptit, AE Parker and WM Abbott, *J Mol Biol*, **373**, 891–902 (2007).

24 S Masuda, T Ohta, K Kaji, JW Fox, H Hayashi and S Araki, *Biochem Biophys Res Commun*, **278**, 197–204 (2000).

25 S Araki, S Masuda, H Maeda, MJ Ying and H Hayashi, *Toxicon*, **40**, 535–42 (2002).

26 J Maruyama, H Hayashi, J Miao, H Sawada and S Araki, *Toxicon*, **46**, 1–6 (2005).

27 CP Blobel, TG Wolfsberg, CW Turck, DG Myles, P Primakoff and JM White, *Nature*, **356**, 248–52 (1992).

28 T Yagami-Hiromasa, T Sato, T Kurisaki, K Kamijo, Y Nabeshima and A Fujisawa-Sehara, *Nature*, **377**, 652–56 (1995).

29 RA Black, CT Rauch, CJ Kozlosky, JJ Peschon, JL Slack, MF Wolfson, BJ Castner, KL Stocking, P Reddy, S Srinivasan, N Nelson, N Boiani, KA Schooley, M Gerhart, R Davis, JN Fitzner, RS Johnson, RJ Paxton, CJ March and DP Cerretti, *Nature*, **385**, 729–33 (1997).

30 ML Moss, SL Jin, ME Milla, DM Bickett, W Burkhart, HL Carter, WJ Chen, WC Clay, JR Didsbury, D Hassler, CR Hoffman, TA Kost, MH Lambert, MA Leesnitzer, P McCauley, G McGeehan, J Mitchell, M Moyer, G Pahel, W Rocque, LK Overton, F Schoenen, T Seaton, JL Su, J Warner, D Willard and JD Becherer, *Nature*, **385**, 733–36 (1997).

31 J Rooke, D Pan, T Xu and GM Rubin, *Science*, **273**, 1227–31 (1996).

32 H Qi, MD Rand, X Wu, N Sestan, W Wang, P Rakic, T Xu and S Artavanis-Tsakonas, *Science*, **283**, 91–94 (1999).

33 D Pan and GM Rubin, *Cell*, **90**, 271–80 (1997).

34 N Prenzel, E Zwick, H Daub, M Leserer, R Abraham, C Wallasch and A Ullrich, *Nature*, **402**, 884–88 (1999).

35 CP Blobel, *Nat Rev Mol Cell Biol*, **6**, 32–43 (2005).

36 M Asakura, M Kitakaze, S Takashima, Y Liao, F Ishikura, T Yoshinaka, H Ohmoto, K Node, K Yoshino, H Ishiguro, H Asanuma, S Sanada, Y Matsumura, H Takeda, S Beppu, M Tada, M Hori and S Higashiyama, *Nat Med*, **8**, 35–40 (2002).

37 K Iba, R Albrechtsen, B Gilpin, C Frohlich, F Loechel, A Zolkiewska, K Ishiguro, T Kojima, W Liu, JK Langford, RD Sanderson, C Brakebusch, R Fassler and UM Wewer, *J Cell Biol*, **149**, 1143–56 (2000).

38 A Gaultier, H Cousin, T Darribere and D Alfandari, *J Biol Chem*, **277**, 23336–44 (2002).

39 A Zolkiewska, *Exp Cell Res*, **252**, 423–31 (1999).

40 MJ Duffy, DJ Lynn, AT Lloyd and CM O'Shea, *Thromb Haemost*, **89**, 622–31 (2003).

41 ML Moss and JW Bartsch, *Biochemistry*, **43**, 7227–35 (2004).

42 P Van Eerdewegh, RD Little, J Dupuis, RG Del Mastro, K Falls, J Simon, D Torrey, S Pandit, J McKenny, K Braunschweiger, A Walsh, Z Liu, B Hayward, C Folz, SP Manning, A Bawa, L Saracino, M Thackston, Y Benchekroun, N Capparell, M Wang, R Adair, Y Feng, J Dubois, MG FitzGerald, H Huang, R Gibson, KM Allen, A Pedan, MR Danzig, SP Umland, RW Egan, FM Cuss, S Rorke, JB Clough, JW Holloway, ST Holgate and TP Keith, *Nature*, **418**, 426–30 (2002).

43 D Okuda, H Koike and T Morita, *Biochemistry*, **41**, 14248–54 (2002).

44 LA Hite, JD Shannon, JB Bjarnason and JW Fox, *Biochemistry*, **31**, 6203–11 (1992).

45 H Takeya, S Nishida, N Nishino, Y Makinose, T Omori-Satoh, T Nikai, H Sugihara and S Iwanaga, *J Biochem (Tokyo)*, **113**, 473–83 (1993).

46 TF Huang, JC Holt, H Lukasiewicz and S Niewiarowski, *J Biol Chem*, **262**, 16157–63 (1987).

47 JJ Calvete, C Marcinkiewicz, D Monleon, V Esteve, B Celda, P Juarez and L Sanz, *Toxicon*, **45**, 1063–74 (2005).

48 JP Evans, *Bioessays*, **23**, 628–39 (2001).

49 S Takeda, T Igarashi, H Mori and S Araki, *EMBO J*, **25**, 2388–96 (2006).

50 F Grams, R Huber, LF Kress, L Moroder and W Bode, *FEBS Lett*, **335**, 76–80 (1993).

51 T Igarashi, Y Oishi, S Araki, H Mori and S Takeda, *Acta Crystallogr, Sect F: Struct Biol Cryst Commun*, **62**, 688–91 (2006).

52 FX Gomis-Ruth, LF Kress and W Bode, *EMBO J*, **12**, 4151–57 (1993).

53 FX Gomis-Ruth, LF Kress, J Kellermann, I Mayr, X Lee, R Huber and W Bode, *J Mol Biol*, **239**, 513–44 (1994).

54 D Zhang, I Botos, FX Gomis-Ruth, R Doll, C Blood, FG Njoroge, JW Fox, W Bode and EF Meyer, *Proc Natl Acad Sci USA*, **91**, 8447–51 (1994).

55 W Gong, X Zhu, S Liu, M Teng and L Niu, *J Mol Biol*, **283**, 657–68 (1998).

56 L Watanabe, JD Shannon, RH Valente, A Rucavado, A Alape-Giron, AS Kamiguti, RD Theakston, JW Fox, JM Gutierrez and RK Arni, *Protein Sci*, **12**, 2273–81 (2003).

57 T Kumasaka, M Yamamoto, H Moriyama, N Tanaka, M Sato, Y Katsube, Y Yamakawa, T Omori-Satoh, S Iwanaga and T Ueki, *J Biochem (Tokyo)*, **119**, 49–57 (1996).

58 KF Huang, SH Chiou, TP Ko, JM Yuann and AH Wang, *Acta Crystallogr, Sect D: Biol Crystallogr*, **58**, 1118–28 (2002).

59 X Zhu, M Teng and L Niu, *Acta Crystallogr, Sect D: Biol Crystallogr*, **55**, 1834–41 (1999).

60 Z Lou, J Hou, X Liang, J Chen, P Qiu, Y Liu, M Li, Z Rao and G Yan, *J Struct Biol*, **152**, 195–203 (2005).

61 Y Fujii, D Okuda, Z Fujimoto, K Horii, T Morita and H Mizuno, *J Mol Biol*, **332**, 1115–22 (2003).

62 S Bilgrami, S Tomar, S Yadav, P Kaur, J Kumar, T Jabeen, S Sharma and TP Singh, *J Mol Biol*, **341**, 829–37 (2004).

63 S Bilgrami, S Yadav, P Kaur, S Sharma, M Perbandt, C Betzel and TP Singh, *Biochemistry*, **44**, 11058–66 (2005).

64 M Paz Moreno-Murciano, D Monleon, C Marcinkiewicz, JJ Calvete and B Celda, *J Mol Biol*, **329**, 135–45 (2003).

65 V Saudek, RA Atkinson and JT Pelton, *Biochemistry*, **30**, 7369–72 (1991).

66 H Senn and W Klaus, *J Mol Biol*, **232**, 907–25 (1993).

67 M Adler, RA Lazarus, MS Dennis and G Wagner, *Science*, **253**, 445–48 (1991).

68 J Shin, SY Hong, K Chung, I Kang, Y Jang, DS Kim and W Lee, *Biochemistry*, **42**, 14408–15 (2003).

69 DH Souza, HS Selistre-de-Araujo, AM Moura-da-Silva, MS Della-Casa, G Oliva and RC Garratt, *Acta Crystallogr, Sect D: Biol Crystallogr*, **57**, 1135–37 (2001).

70 J Zang, Z Zhu, Y Yu, M Teng, L Niu, Q Huang, Q Liu and Q Hao, *Acta Crystallogr, Sect D: Biol Crystallogr*, **59**, 2310–12 (2003).

71 K Maskos, C Fernandez-Catalan, R Huber, GP Bourenkov, H Bartunik, GA Ellestad, P Reddy, MF Wolfson, CT Rauch, BJ Castner, R Davis, HR Clarke, M Petersen, JN Fitzner,

DP Cerretti, CJ March, RJ Paxton, RA Black and W Bode, *Proc Natl Acad Sci USA*, **95**, 3408–12 (1998).

72 P Orth, P Reichert, W Wang, WW Prosise, T Yarosh-Tomaine, G Hammond, RN Ingram, L Xiao, UA Mirza, J Zou, C Strickland, SS Taremi, HV Le and V Madison, *J Mol Biol*, **335**, 129–37 (2004).

73 PW Janes, N Saha, WA Barton, MV Kolev, SH Wimmer-Kleikamp, E Nievergall, CP Blobel, JP Himanen, M Lackmann and DB Nikolov, *Cell*, **123**, 291–304 (2005).

74 HS Shieh, KJ Mathis, JM Williams, RL Hills, JF Wiese, TE Benson, JR Kiefer, MH Marino, JN Carroll, JW Leone, AM Malfait, EC Arner, MD Tortorella and A Tomaselli, *J Biol Chem*, **283**, 1501–07 (2007).

75 L Mosyak, K Georgiadis, T Shane, K Svenson, T Hebert, T McDonagh, S Mackie, S Olland, L Lin, X Zhong, R Kriz, EL Reifenberg, LA Collins-Racie, C Corcoran, B Freeman, R Zollner, T Marvell, M Vera, PE Sum, ER Lavallie, M Stahl and W Somers, *Protein Sci*, **17**, 16–21 (2008).

76 Q Zhou, JB Smith and MH Grossman, *Biochem J*, **307**(Pt 2), 411–17 (1995).

77 T Igarashi, S Araki, H Mori and S Takeda, *FEBS Lett*, **581**, 2416–22 (2007).

78 S Takeda, T Igarashi and H Mori, *FEBS Lett*, **581**, 5859–64 (2007).

79 H Takeya, S Nishida, T Miyata, S Kawada, Y Saisaka, T Morita and S Iwanaga, *J Biol Chem*, **267**, 14109–17 (1992).

80 DC Gowda, CM Jackson, P Hensley and EA Davidson, *J Biol Chem*, **269**, 10644–50 (1994).

81 T Morita and GS Bailey (eds.), *Enzymes from Snake Venom*, Alaken, Fort Collins, CO (1998).

82 UM Wewer, M Morgelin, P Holck, J Jacobsen, MC Lydolph, AH Johnsen, M Kveiborg and R Albrechtsen, *J Biol Chem*, **281**, 9418–22 (2006).

83 PJ Kraulis, *Acta Crystallogr, Sect D: Biol Crystallogr*, **24**, 946–50 (1991).

84 EA Merritt and ME Murphy, *Acta Crystallogr*, **D50**, 869–79 (1994).

85 W Bode, FX Gomis-Ruth, R Huber, R Zwilling and W Stocker, *Nature*, **358**, 164–67 (1992).

86 W Bode, P Reinemer, R Huber, T Kleine, S Schnierer and H Tschesche, *EMBO J*, **13**, 1263–69 (1994).

87 WL DeLano, *The PyMOL User's Manual*, DeLano Scientific, San Carlos, CA (2002).

88 T Nikai, K Taniguchi, Y Komori, K Masuda, JW Fox and H Sugihara, *Arch Biochem Biophys*, **378**, 6–15 (2000).

89 JW Fox and JB Bjarnason, *Methods Enzymol*, **248**, 368–87 (1995).

90 KG Mann, *Chest*, **124**, 4S–10S (2003).

91 WI Weis, R Kahn, R Fourme, K Drickamer and WA Hendrickson, *Science*, **254**, 1608–15 (1991).

92 H Mizuno, Z Fujimoto, H Atoda and T Morita, *Proc Natl Acad Sci USA*, **98**, 7230–34 (2001).

93 AS Kamiguti, P Gallagher, C Marcinkiewicz, RD Theakston, M Zuzel and JW Fox, *FEBS Lett*, **549**, 129–34 (2003).

94 Y Usami, Y Fujimura, S Miura, H Shima, E Yoshida, A Yoshioka, K Hirano, M Suzuki and K Titani, *Biochem Biophys Res Commun*, **201**, 331–39 (1994).

95 K Shimokawa, JD Shannon, LG Jia and JW Fox, *Arch Biochem Biophys*, **343**, 35–43 (1997).

96 PB Clissa, M Lopes-Ferreira, MS Della-Casa, SH Farsky and AM Moura-da-Silva, *Toxicon*, **47**, 591–96 (2006).

97 LG Jia, XM Wang, JD Shannon, JB Bjarnason and JW Fox, *Arch Biochem Biophys*, **373**, 281–86 (2000).

98 SM Serrano, LG Jia, D Wang, JD Shannon and JW Fox, *Biochem J*, **391**, 69–76 (2005).

99 SM Serrano, J Kim, D Wang, B Dragulev, JD Shannon, HH Mann, G Veit, R Wagener, M Koch and JW Fox, *J Biol Chem*, **281**, 39746–56 (2006).

100 SM Serrano, D Wang, JD Shannon, AF Pinto, RK Polanowska-Grabowska and JW Fox, *FEBS J*, **274**, 3611–21 (2007).

101 AF Pinto, RM Terra, JA Guimaraes and JW Fox, *Arch Biochem Biophys*, **457**, 41–46 (2007).

102 D Alfandari, H Cousin, A Gaultier, K Smith, JM White, T Darribere and DW DeSimone, *Curr Biol*, **11**, 918–30 (2001).

103 KM Smith, A Gaultier, H Cousin, D Alfandari, JM White and DW DeSimone, *J Cell Biol*, **159**, 893–902 (2002).

104 P Reddy, JL Slack, R Davis, DP Cerretti, CJ Kozlosky, RA Blanton, D Shows, JJ Peschon and RA Black, *J Biol Chem*, **275**, 14608–14 (2000).

Lyases

Cadmium-carbonic anhydrase

Yan Xu[†], Claudiu T Supuran[‡] and François MM Morel[†]

[†]Department of Geosciences, Princeton University, Princeton, NJ, USA
[‡]Dipartmento di Chimica, University of Florence, Sesto Fiorentino, Italy

FUNCTIONAL CLASS

Enzyme; carbonic anhydrase (CA): carbonate hydrolyase, EC 4.2.1.1; cambialistic enzyme that can use either Zn or Cd as its cofactor.

CA catalyzes the reversible hydration of carbon dioxide. Currently, CA is categorized into five classes of CAs, α, β, γ, δ, and ζ, which have no sequence homology between them, implying their independent origins. α-, β-, and γ-CAs are mostly present in animals, plants and bacteria, respectively.[1] δ- and ζ-CAs are so far only reported in microalgae.[2,3]

OCCURRENCE

The only known ζ-CA is a cadmium-CA (CDCA1), which is originally isolated from a marine diatom, *Thalassiosira weissflogii* and its homolog gene is found in *T. pseudonana* genome.[2,5] Partial homolog gene sequences are also found using degenerate primers in a number of marine diatom species, *T. oceanica*, *T. rotula*, *Skeletonema costatum*, *Dictylum brightwellii*, *Chaetoceros calcitrans*, *Phaeodactylum tricornutum*, *Nitzchia cf. pusilla*, and *Asterionellopsis glaciallis*, and in several aquatic environments, New Jersey coast, Arabian Sea coast, Lake Carnegie of New Jersey, and the Equatorial Pacific Ocean.[6,7] Attempt to find the homolog gene in marine green algae and coccolithophores using the same primers has not succeeded.[7]

BIOLOGICAL FUNCTION

CA is a key enzyme involved in the acquisition of inorganic carbon for photosynthesis in phytoplankton.[8] Most phytoplankters operate a carbon concentrating mechanism (CCM) to increase the CO_2 concentration at the site of fixation by ribulose-1,5-bisphosphate carboxylase oxygenase (RubisCO) several folds over its external concentration, allowing the enzyme to function efficiently.[9] Marine diatoms possess both external and internal CAs.[10] It has been hypothesized in the model diatom *T. weissflogii* that the external CA catalyzes the dehydration of HCO_3^- to CO_2 to increase the gradient of the CO_2 diffusion from the external medium to the cytoplasm, and the internal CA in the cytoplasm catalyzes the rehydration of CO_2 to HCO_3^- to prevent the leakage of CO_2 to the external medium again.[11] It is not known yet where CDCA1 is localized in *T. weissflogii* or other diatoms.

The *cdca* gene expression is very sensitive to pH/pCO_2$. Both the transcript and protein abundance are significantly higher at high pH/low pCO_2$ than those at low pH/high pCO_2$ in *T. weissflogii*, as well as in natural assemblages in New Jersey coast.[5,6] The expression level is also regulated by Zn and Cd availability in *T. weissflogii* culture medium

3D Structure Schematic representation of CDCA1 repeat 2 from *Thalassiosira weissflogii*. Two lobes of the structure are colored green and purple. The Cd atom is shown as a red sphere. PDB code: 3BOB. Prepared with the program PyMOL.[4]

```
CDCA_R1  --------------NQSNTSSSTSKASLTPDQIVAALQERGWQAEIVTEFSLLNEMVDVDPQGILKCVDGRGSDNTQFC  65
CDCA_R2  -------------------------SISPAQIAEALQGRGWDAEIVTDASMAGQLVDVRPEGILKCVDGRGSDNTRMG  275
CDCA_R3  -------------------------SITPPQIVSALRGRGWKASIVKASTMSSELKRVDPQGILKCVDGRGSDNTQFG  485
Tp_CDCA  MCMHVDLQVAMSSILSKLTGKDDTSAPPLTPKDIVAALQSRGWEAEIISASSISQDMVEVDPAGILKCVDGRGSDNTRMA  80
                                                                              *

CDCA_R1  GPKMPGGIYAIAHNRGVTTLEGLKQITKEVASKGHVPSVHGDHSSDMLGCGFFKLWVTGRFDDMGYPRPQFDADQGAKAV  145
CDCA_R2  GPKMPGGIYAIAHNRGVTSIEGLKQITKEVASKGHLPSVHGDHSSDMLGCGFFKLWVTGRFDDMGYPRPQFDADQGANAV  355
CDCA_R3  GPKMPGGIYAIAHNRGVTTLEGLKDITREVASKGHVPSVHGDHSSDMLGCGFFKLWLTGRFDDMGYPRPEFDADQGALAV  565
Tp_CDCA  GPKMPGGIYAIAHNRGTTSVDGLKEITKEVASKGHVPSVHGDHSADMLGCGFFRLWVTGEFDSMGYPRPEFDADQGAAAV  160
                                         *             *

CDCA_R1  ENAGGVIEMHHGSHAEKVVYINLVENKTLEPDEDDQRFIVDGWAAGKFGLDVPKFLIAAAATVEMLGGPKKAKIVIP    222
CDCA_R2  KDAGGIIEMHHGSHTEKVVYINLLANKTLEPNENDQRFIVDGWAADKFGLDVPKFLIAAAATVEMLGGPKNAKIVVP    432
CDCA_R3  RAAGGVIEMHHGSHEEKVVYINLVSGMTLEPNEHDQRFIVDGWAASKFGLDVVKFLVAAAATVEMLGGPKKAKIVIP    642
Tp_CDCA  KESGGVIEMHHGSHTEKVVYINLVENKTLEPDENDQRFIVDGWAAIKFNLDVVKFLVAAAATVEMLGGPRIAKIVVA    237
```

Figure 1 Sequence alignment of CDCA1 three repeats and Tp-CDCA. The metal-binding residues are indicated with asterisks.

(Xu, unpublished data). In the absence of Cd, the CDCA protein abundance increases with Zn availability; in the presence of Cd and a limiting amount of Zn, the protein abundance increases with Cd availability.

AMINO ACID SEQUENCE INFORMATION

The amino acid sequence of CDCA1 has been determined in *T. weissflogii*, which contains a triple repeat with about 85% identity between repeats.[2] A homolog sequence has been identified in the genome of *T. pseudonana*, which contains only a single repeat (Figure 1). The complete sequence of CDCA1 is not yet available but the sequence of the mature protein including the amino-terminus has been determined. The full-length Tp-CDCA has only 15 amino acids at the amino-terminus preceding the homologous sequence of CDCA1. Since the CDCA sequence has no homology to that of any known CAs, it represents a new class of CA, the ζ class.

- CDCA1 (*Thalassiosira weissflogii*), 642 amino acid residues (AA), derived from cDNA. Genbank accession number AY772014.
- Tp-CDCA (*Thalassiosira pseudonana*), 237 AA, derived from DNA. *Thalassiosira pseudonana* genome[12] protein ID 25840.

PROTEIN PRODUCTION, PURIFICATION, AND MOLECULAR CHARACTERIZATION

CDCA1 was first isolated from *T. weissflogii* culture grown under 100 ppm CO_2, 3 pM Zn′ and 45 pM Cd′ (Zn′ and Cd′ represent the unchelated concentrations of Zn and Cd in the medium). The cell lysate was first subjected to sequential ammonium sulfate precipitation. The fraction from 70% ammonium sulfate precipitation was then loaded to a butyl hydrophobic interaction chromatography (HIC) column twice. The fractions with CA activity were pooled and loaded to a TSK-diethylaminoethyl cellulose (DEAE) ion-exchange column and eluted with a NaCl gradient.

Finally, pooled CA containing fractions from the ion-exchange column were subjected to native polyacrylamide gel electrophoresis (PAGE), and the pure CDCA1 was eluted from the excised band with CA activity.[2,5]

Full-length CDCA1, each single repeat of CDCA1, and Tp-CDCA were also cloned into a pET15b expression vector and expressed in *E. coli* strain BL21 (DE3). The recombinant proteins were purified by metal (Ni^{2+}) affinity chromatography and gel filtration.[13]

CDCA1 has a molecular mass of approximately 69 kDa and possibly possesses an internal pseudo threefold symmetry. Each single repeat of CDCA1, when expressed in *E. coli*, is also fully active. Tp-CDCA has a molecular mass of 25.5 kDa.

METAL CONTENT AND COFACTORS

CDCA1 is a cambialistic enzyme which can incorporate either Cd or Zn in the active site.[13] The recombinant CDCA1 and Tp-CDCA have one Cd or Zn atom in each repeat depending on the concentrations of Cd and Zn added in *E. coli* growth medium before the induction of the expression. Both Cd- and Zn-bound CDCA are active enzymes. The metal content of CDCA1 in *T. weissflogii* is also dependent on Cd and Zn concentrations in the growth medium (Xu, unpublished data).

Cu-substituted CDCA1 repeat 2 was obtained by adding Cu in the buffer during crystallization (Xu, unpublished data). The activity of the Cu form was not tested. However, partial-Cu-substituted CDCA1 (about 50% Cu and 50% Zn) was obtained by adding Cu in *E. coli* growth medium right before induction of protein expression and the Cu-incorporated CDCA1 was probably inactive (Thompson, unpublished data). Co can also substitute Cd/Zn in CDCA1. Partial-Co-substituted CDCA1 (about 50% Co and 50% Zn) was also obtained by adding Co in *E. coli* growth medium right before induction. The specific activity of Co-CDCA1 was roughly one-third of that of Zn-CDCA1 (Thompson, unpublished data).

ACTIVITY TEST

CA activity was measured by ^{18}O exchange from triply labeled CO_2 ($^{13}C^{18}O^{18}O$) in a membrane-inlet mass spectrometer.[13] The constants k and k' were calculated from the slope, λ, of the line $\ln(\text{mass }49)$ versus time (corrected for the uncatalyzed blank) by the equation $2\lambda = k + k' - [(k + k')^2 - 4/3kk']^{1/2}$ and the ratio $k/k' = [HCO_3^-]/[CO_2]$ at the pH of interest.[14] The assay solution contained $0.4\,mM$ total dissolved inorganic carbon, $25\,mM$ 4-(2-hydroxyethyl)piperazine-1-ethanesulfonic acid (HEPES), $0.1\,M$ $NaSO_4$ at pH 8 and $20\,°C$. For the activity measured at different pHs, 2-(N-morpholino)ethanesulfonic acid (MES) was used for pHs between 6 and 7, HEPES for pHs between 7 and 8.5, N, N-bis(2-hydroxyethyl)glycine (BICINE) for pH 9, and 2-(cyclohexylamino)ethanesulfonic acid (CHES) for pH 9.5.

SPECTROSCOPY

X-ray absorption near-edge spectroscopy was performed for CDCA1 purified from *T. weissflogii*.[2] Two tetrahedral, thiolate-coordinated species, $[Cd(SPh)_4](Me_4N_2)$ and cadmium phytochelatin, and two octahedral species, $[Cd(H_2O)_6]^{2+}$ and $[Cd(imidazole)_6](NO_3)_2$, were used as the standards. The spectrum of CDCA1 is very similar to that of the tetrahedral species suggesting that the metal site has a tetrahedral geometry and that the cadmium ion is bound by two or more thiolates. The spectrum also indicates that the active site contains an activated water molecule.

X-RAY STRUCTURES OF CDCA1 REPEATS

Crystallization and structure determination

The crystal structures of the Cd-bound CDCA1 repeat 1 (PDB code: 3BOH) and repeat 2 (PDB codes: 3BOB and 3BOE), the Zn-bound repeat 2 (PDB code: 3BOC), and the apo-form of repeat 1 (PDB code: 3BOJ) have been determined.[13] Crystals were produced using the hanging-drop vapor-diffusion method. Protein solutions of $10\,mg\,mL^{-1}$ containing $20\,mM$ tris, pH 8.0, $2\,mM$ dithiothreitol (DTT), $150\,mM$ NaCl were used for crystallization. The Cd-bound repeat 1 was crystallized in $1.2\,M$ NaH_2PO_4, $1.4\,M$ K_2HPO_4, and $0.1\,M$ sodium acetate, pH 3.5. The metal-free repeat 1 was crystallized in $0.5\,M$ NaH_2PO_4, $1.4\,M$ K_2HPO_4, and $0.1M$ sodium acetate, pH 4.5. The Zn-bound and Cd-bound repeat 2 were crystallized in $0.1\,M$ sodium citrate, pH 5.5 and 20% (w/v) polyethylene glycol (PEG) 3350. Cd-loaded repeat 2 bound to acetate was crystallized in the presence of $200\,mM$ sodium acetate with $0.1\,M$ sodium citrate pH 5.5 and 20% (w/v)

PEG3350. The repeat 2 was crystallized in space group $P2_12_12$ with typical cell dimensions $a = 64.3\,Å$, $b = 78.2\,Å$, $c = 37.1\,Å$, and $\alpha = \beta = \gamma = 90°$. The metal-free repeat 1 was crystallized in space group $P2_12_12$ with cell dimensions $a = 46.3\,Å$, $b = 59.2\,Å$, $c = 79.6\,Å$, and $\alpha = \beta = \gamma = 90°$. The Cd-bound repeat 1 was crystallized in space group C2 with cell dimensions $a = 125.3\,Å$, $b = 43.7\,Å$, $c = 76.9\,Å$, and $\alpha = \gamma = 90°$, $\beta = 92.5°$.

The structure of the Cd-bound CDCA1 repeat 2 was determined using Cd single wavelength anomalous diffraction (SAD) at a wavelength ($1.61\,Å$) away from the inaccessible Cd edge, from a signal of approximately 5 electrons in 209 amino acids. The single Cd site was found and initial phases calculated using SHELX.[15] The model was refined to an R-factor of 0.168 and an R_{free} of 0.194 at $1.45\,Å$. The root mean square deviation of bond lengths and angles for the final model was $0.0083\,Å$ and $1.55°$ respectively. Other structures were solved by molecular replacement.

Overall description of structure

The structures of CDCA1 repeat 1 and 2 have been reported, each repeat functioning as a functional unit, although the structure of the full-length CDCA1 is not yet available.[13] The structure of CDCA1 repeat 2 contains seven α-helices and nine β-strands forming an overall ellipsoidal shape (see 3D Structure). Two β-sheets constituted by seven β-strands are located in the center of the structure, containing four and three β-strands respectively. All seven α-helices are located on one side of the β-sheets. The structure can be divided into two lobes, each constituted by a β-sheet and several α-helices. There is a deep cleft leading to the active site pocket between the two lobes.

Although the overall fold of CDCA1 repeats does not share similarity with other CAs, a single molecule of these repeats can be superimposed with a functional dimer of the β-CA from *Pisum sativum*.[16] The three-stranded lobe of CDCA1 repeat 2 containing three metal-binding residues, Cys263, His315, and Cys325 and the conserved Asp–Arg pair resembles a monomer of the β-CA dimer containing corresponding residues, while the four-stranded lobe of CDCA1 repeat 2 containing the substrate binding residues, Phe393, Leu421, and Thr417 resembles another monomer of the β-CA dimmer containing corresponding residues. A hydrophobic channel with an inner diameter of 4–5 Å is connected to the bottom of the funnel-shaped active site pocket, suggesting it may be the entry or escape route for the reaction substrate or product.

Metal site geometry

In Cd-bound CDCA1 repeat 2, Cd resides at the bottom of a funnel-shaped active site pocket and is tetrahedrally

Figure 2 The active site of Cd-bound CDCA1 repeat 2. PDB code: 3BOE. Prepared with the program PyMOL.

coordinated by three conserved residues, Cys263, His315, and Cys325, and a water molecule with distances of 2.46 Å, 2.34 Å, and 2.51 Å, respectively, between Cd and the metal-binding atoms of these residues (Figure 2). A second water molecule also contributes to binding of Cd, and a third water molecule forms hydrogen bonds to these two water molecules. In Zn-bound CDCA1 repeat 2, Zn is coordinated in the same manner except that the distances between Zn and the metal-binding atoms of the three coordinating residues are reduced by approximately 0.16–0.19 Å. The Cd-bound CDCA1 repeat 1 has identical metal coordination as in repeat 2. In addition, the locations of the catalytic metal ion and its tetrahedrally bound residues and water molecule are very similar between CDCA1 and the β-CA in *P. sativum*. When a substrate analog, acetate, is bound to CDCA1 repeat 2, acetate replaces one of the two water molecules that were hydrogen-bonded to the metal ion (Figure 2).[13]

FUNCTIONAL ASPECTS

Enzyme kinetics

The kinetic properties of the full-length CDCA1 and repeats have been determined by ^{18}O exchange.[13] Both showed pH dependence with higher catalytic efficiency at higher pH. The Zn-bound CDCA1 is a very efficient CA, whose k_{cat}/K_m is even higher than CAII, which is known as the most catalytically efficient CA. k_{cat}/K_m of the Zn-bound full-length CDCA1 ranges from $3.2 \times 10^7\,M^{-1}\,s^{-1}$ to $8.6 \times 10^8\,M^{-1}\,s^{-1}$ for CO_2 hydration between pH 6.5 and 9.5, while k_{cat}/K_m of the Cd-bound full-length CDCA1 from $2.0 \times 10^6\,M^{-1}\,s^{-1}$ to $1.5 \times 10^8\,M^{-1}\,s^{-1}$.

Metal exchange

Both the full-length CDCA1 and single repeats can naturally incorporate either Cd or Zn as the catalytic metal depending on the metal availability.[13] *In vitro* metal exchange experiments were carried out between CDCA1 and nitrilotriacetic acid (NTA)-Zn/Cd or phytochelatin-Zn/Cd. Zn-bound CDCA1 spontaneously exchanges Zn for Cd when Cd is complexed by either NTA or phytochelatin. Cd-bound CDCA1 only exchanges Cd for Zn when Zn is complexed by phytochelatin but not by NTA. The rate of metal exchange is similar between the full-length CDCA1 and repeat 2. However, Co or Cu bound to phytochelatin cannot exchange with Zn or Cd in CDCA1 (Thompson, unpublished data). Such efficient incorporation of Cd and facile metal exchange between Zn and Cd was not observed in the β-CA from another diatom, *Phaeodactylum tricornutrum*, although it has the same metal-coordination residues.

The structural basis for metal exchange in CDCA1 has been elucidated by comparison of the Cd-bound and metal-free CDCA1 repeat1 (Figure 3).[13] The linker region between the metal-binding residues His105 and Cys115 seems to provide sufficient flexibility, so that the active site takes on an open conformation with two Cys residues moving away from their metal-coordination position, when the metal is absent.

CDCA1 inhibitors

The inhibition of the catalytic activity of CDCA1 by anions was examined for CO_2 hydration reaction (Table 1, Supuran, unpublished data). The set of anions tested showed similar inhibition behavior, with K_Is mostly in

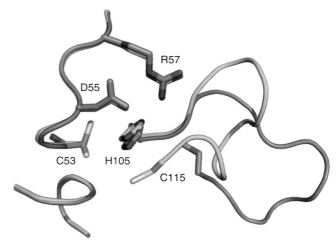

Figure 3 Comparison of the active site conformation between the metal-free CDCA1 repeat 1 (magenta) and the Cd-bound CDCA1 repeat 1 (green). PDB code: 3BOH and 3BOJ. Prepared with the program PyMOL.

Table 1 Inhibition constants of anionic inhibitors against CDCA1 repeat 1 and human isozymes hCA II, for the CO_2 hydration reaction, at 20 °C

Inhibitor	Cd-R1 (mM)	Zn-R1 (mM)	hCA II (mM)[a]
F^-	0.53	0.36	>300
Cl^-	0.76	0.41	200
Br^-	0.85	0.53	63
I^-	1.12	0.61	26
CNO^-	0.10	0.11	0.03
SCN^-	0.089	0.10	1.6
CN^-	0.11	0.10	0.02
N_3^-	0.84	0.11	1.5
HCO_3^-	0.12	0.10	85
CO_3^{2-}	0.13	0.11	73
NO_3^-	0.82	0.21	35
NO_2^-	0.88	0.58	63
HS^-	0.70	0.15	0.04
HSO_3^-	0.63	0.34	89
SO_4^{2-}	0.48	0.24	>200
H_2NSO_3H[b]	0.010	0.072	0.39
$H_2NSO_2NH_2$	0.065	0.060	1.13
$PhB(OH)_2$ (phenylboronic acid)	0.69	0.61	23.1
$PhAsO_3H_2$[b] (phenylarsonic acid)	0.60	0.52	49.2

[a] Data from reference [17].
[b] As sodium salt.

the range of 0.1–1.1 mM for CDCA1 repeat 1 and similar inhibition constants between the Cd- and Zn-bound CDCA1 and between different repeats. The most effective anion inhibitor was H_2NSO_3H and the least effective anion inhibitor I^- for both the Cd- and Zn-bound CDCA repeat 1. The anion inhibition profiles of CDCA1 were somewhat different from hCA II, which in general have higher K_1s, and anions like F^-, Cl^-, HCO_3^-, HSO_3^-, and SO_4^{2-} are very weak inhibitors to hCA II but not to CDCA1.

REFERENCES

1 BC Tripp, K Smith and JG Ferry, *J Biol Chem*, **276**, 48615–18 (2001).

2 TW Lane, MA Saito, GN George, IJ Pickering, RC Prince and FMM Morel, *Nature*, **435**, 42 (2005).

3 SB Roberts, TW Lane and FMM Morel, *J Phycol*, **33**, 845–50 (1997).

4 WL DeLano, *The PyMOL Molecular Graphics System*, Available on the World Wide Web: http://www.pymol.org (2002).

5 TW Lane and FMM Morel, *Proc Natl Acad Sci USA*, **97**, 4627–31 (2000).

6 H Park, PJ McGinn and FMM Morel, *Aquat Microb Ecol*, **51**, 183–93 (2008).

7 H Park, B Song and FMM Morel, *Environ Microbiol*, **9**, 403–13 (2007).

8 M Badger, *Photosynth Res*, **77**, 83–94 (2003).

9 A Kaplan and L Reinhold, *Annu Rev Plant Phys*, **50**, 539–70 (1999).

10 S Burkhardt, G Amoroso, U Riebesell and D Sultemeyer, *Limnol Oceanogr*, **46**, 1378–91 (2001).

11 FMM Morel, EH Cox, AML Kraepiel, TW Lane, AJ Milligan, I Schaperdoth, JR Reinfelder and PD Tortell, *Funct Plant Biol*, **29**, 301–308 (2002).

12 EV Armbrust, JA Berges, C Bowler, BR Green, D Martinez, NH Putnam, SG Zhou, AE Allen, KE Apt, M Bechner, MA Brzezinski, BK Chaal, A Chiovitti, AK Davis, MS Demarest, JC Detter, T Glavina, D Goodstein, MZ Hadi, U Hellsten, M Hildebrand, BD Jenkins, J Jurka, VV Kapitonov, N Kroger, WWY Lau, TW Lane, FW Larimer, JC Lippmeier, S Lucas, M Medina, A Montsant, M Obornik, MS Parker, B Palenik, GJ Pazour, PM Richardson, TA Rynearson, MA Saito, DC Schwartz, K Thamatrakoln, K Valentin, A Vardi, FP Wilkerson and DS Rokhsar, *Science*, **306**, 79–86 (2004).

13 Y Xu, L Feng, PD Jeffrey, YG Shi and FMM Morel, *Nature*, **452**, 56–61 (2008).

14 DN Silverman, *Methods Enzymol*, **87**, 732–52 (1982).

15 G Sheldrick, *Patterson Interpretation and the use of Macro-molecular Delta-F Data*, Daresbury, UK (1991).

16 MS Kimber and EF Pai, *EMBO J*, **19**, 1407–418 (2000).

17 CT Supuran, *Nat Rev Drug Discov*, **7**, 168–81 (2008).

Peptidyl-α-hydroxyglycine α-amidating lyase (PAL)

Eduardo E Chufán[§], Betty Eipper[‡], Richard Mains[‡] and Mario L Amzel[§]

[‡] Neuroscience and Molecular, Microbial, and Structural Biology, University of Connecticut Health Center, Farmington, CT 06030, USA

[§] Department of Biophysics and Biophysical Chemistry, Johns Hopkins School of Medicine, Johns Hopkins University, Baltimore, MD 21205, USA

FUNCTIONAL CLASS

Enzyme; EC 4.3.2.5; carbinolamide N−C lyase containing a catalytic zinc(II) and a structural calcium(II); also known as *peptidylamidoglycolate lyase* (*PGL*).

Peptidyl-α-hydroxyglycine α-amidating lyase (PAL) catalyzes the stereospecific N-dealkylation of peptidyl-(S)-α-hydroxyglycine compounds to generate the α-amidated peptides and glyoxylate (Scheme 1).[1–3] This is the second and final reaction in the activation of neuropeptides and peptides hormones; the first reaction, after processing of the precursors, is the α-hydroxylation of the glycine-extended peptides catalyzed by the copper-containing peptidylglycine α-hydroxylating monooxygenase (PHM, EC 1.14.17.3).[4–6]

PAL exhibits wide substrate specificity, i.e. peptides with any amino acid next to the α-hydroxyglycine moiety have been shown to be substrates of PAL.[7] Even nonpeptidic compounds having a terminal carboxylate group with a hydroxyl at the α-carbon position, such as α-hydroxyhippuric acid or ureidoglycolate, are substrates of PAL.[8,9]

OCCURRENCE

PAL is encoded with PHM as a single transcript, yielding the bifunctional enzyme peptidylglycine α-amidating monooxygenase (PAM). PAM is highly expressed in atrial myocytes, endocrine tissues such as the pituitary, and neuronal tissues, and, to a lesser extent, in other tissues such as muscle cells, airway and olfactory epithelium, endothelial cells, and astrocytes.[2,10,11] Amidated peptides have been detected in tumors (e.g. small-cell lung carcinoma cells) and therefore PAM and PAL activity may contribute to tumor growth.[12]

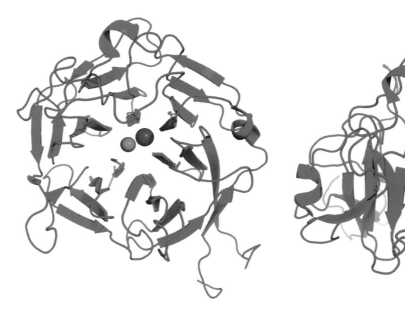

3D Structure Schematic representation of the *Rattus norvegicus* PALcc (cc, catalytic core). The structure is a six-blade β-propeller; the C-terminal and the N-terminal (His-tag) form a 'latch' that ties the structure together. The Zn(II) (red ball) and the Ca(II) (blue ball) are 11 Å apart, on the axis of the propeller. The figure was produced using the program PyMOL. PDB Code: 3FVZ.[36]

Scheme 1 Catalytic reaction carried out by PAL.

BIOLOGICAL FUNCTION

The physiological role of PAL is to catalyze the second and final reaction in the amidation of bioactive peptides at the acidic medium of the trans-Golgi network and secretory granules of neural and endocrine tissues. This process is a ubiquitous posttranslational modification of relevant neuropeptides such as neuropeptide Y or substance P, and hormone peptides such as oxytocin, vasopressin, gastrin, or calcitonin.[2]

AMINO ACID SEQUENCE INFORMATION

As mentioned above, in many species such as human, rat, and *Xenopus*, PAL is encoded with PHM in the same mRNA to produce the bifunctional protein enzyme PAM.[13,14] In PAM, PAL is located at the C-terminal to the PHM domain, usually separated from PHM by a segment called *exon A* (or *exon 16* in rat). Exon A is noncatalytic and is not present in some isoforms as a result of alternative splicing. In other species such as *Xenopus laevis*, the gene does not encode an exon A-like region. A transmembrane domain (exon 25) follows the PAL segment; however, it is found deleted in some isoforms.[2] If the transmembrane domain is deleted, PAM behaves as a soluble protein.[2] Besides being expressed with PHM, PAL is also expressed as a single protein in some species such as *Drosophila* and *Caenorhabditis elegans*.

- *Homo sapiens* (*Human*), AMD_HUMAN, 973 amino acids (AA) PAM, 323 AA PAL (residues 495–817), 4 isoforms produced by alternative splicing, Swiss-Prot ID code (SWP) P19021.[15–18]
- *Bos Taurus* (*bovine*), AMD_BOVIN, 972 AA PAM, 323 AA PAL (residues 495–817), SWP P10731.[19,20]
- *Rattus norvegicus* (*Rat*), AMD_RAT, 976 AA PAM, 323 AA PAL (residues 498–820), 7 isoforms produced by alternative splicing, SWP P14925.[4,21–23]
- *Mus musculus* (*Mouse*), AMD_MOUSE, 979 AA PAM, 326 AA PAL (residues 498–823), SWP P97467.[24]
- *Xenopus laevis* (*African clawed frog*), AMD1_XENLA, 935 AA PAM, 322 AA PAL (residues

391–712), 2 isoforms produced by alternative splicing, SWP P08478.[25]
- *Xenopus laevis* (*African clawed frog*), AMD2_XENLA, 875 AA PAM, 322 AA PAL (residues 395–716), SWP P12890.[26]
- *Caenorhabditis elegans*, AMDL_CAEEL, 663 AA PAM, 363 AA PAL (residues 301–663), SWP P83388.[27,28]
- *Caenorhabditis elegans*, PAL_CAEEL, 350 AA, SWP P91268.[27,28]
- *Drosophila melanogaster* (*Fruit fly*), PAL1_DROME, 541 AA, SWP Q9V5E1.[29,30]
- *Drosophila melanogaster* (*Fruit fly*), PAL2_DROME, 406 AA, 2 isoforms produced by alternative splicing, SWP Q9W1L5.[29,30]

Soluble PAL can be generated from the bifunctional membrane PAM precursor by tissue-specific endoproteolytic cleavage.[31] The peptidyl-α-hydroxyglycine α-amidating lyase catalytic core (PALcc) was defined to include residues 498–820 of the rat PAM.[7,32]

PROTEIN PRODUCTION, PURIFICATION, AND CHARACTERIZATION

Rat His$_6$-PAL catalytic core is overexpressed in stably transfected Chinese hamster ovary (CHO) cells. Following concentration by ammonium sulfate precipitation, purification is accomplished by hydrophobic interaction column followed by gel filtration.[8,33]

PAL optimal activity is observed at pH 5–6.5. PAL kinetics follows a Michaelis–Menten mechanism; using α-N-acetyl-Tyr-Val-α-hydroxyglycine as a substrate, purified rat PALcc and purified bovine PAL yielded K_m values of 33 ± 6 and $38 \pm 13\,\mu M$, with turnover numbers (k_{cat}) of 380 ± 40 and $220\,s^{-1}$, respectively.[7,34]

METAL CONTENT OF PAL

PAL contains equimolar amounts of Zn(II) and Ca(II) as determined by inductively coupled plasma (ICP) optical emission spectroscopy and later confirmed by X-ray

crystallography.[8,33] At a concentration between 0.5 and 1 mM, metal chelators ethylenediaminetetraacetic acid (EDTA) and ethylene glycol tetraacetic acid (EGTA) produce 50% inhibition of PAL activity. Further investigations with these chelators showed that the metals play an important role in PAL's thermostability as well as its sensitivity to trypsin.[7] After removing the metals, the activity can be restored with several metal ions such as Mn^{2+}, Co^{2+}, Ni^{2+}, Cd^{2+}, Ca^{2+}, and Zn^{2+}, probably occupying the same position as Zn^{2+} in the catalytic site of the enzyme (see crystallographic studies below).[7,33,35]

X-RAY STRUCTURE

In 2009, the X-ray crystal structure of the *Rattus norvegicus* PALcc and the complex PALcc with α-hydroxyhippuric acid (a nonpeptidic PAL substrate) were determined at a resolution of 2.35 and 2.50 Å, respectively (PDB accession codes 3FVZ and 3FW0).

Crystallization

The protein crystallizes in space group $P2_12_12_1$ (cell dimension $a = 52.2$ Å, $b = 75.1$ Å, and $c = 97.5$ Å), either in the presence of equimolar amounts of Zn(II) and Fe(III) (0.1 M NaAc pH 4.8 with 0.2 mM $ZnAc_2$ and 0.2 mM $FeCl_3$) or in the absence of metal (0.1 M NaAc pH 4.6 with 9–12% polyethyleneglycol 8000). Interestingly, Fe(III) is found coordinated by the His-tag when the protein is crystallized in the presence of metals, but the His-tag remains ordered even when it crystallizes in the absence of metal.[33]

Overall structure

PAL folds as a six-blade β-propeller containing two metal binding sites, one structural and one catalytic (3D Structure). The structural metal site contains calcium(II) located at the middle of the central cavity. It is bound to three different β-strands of the protein through a monodentate aspartate (Asp787; Ca–O distance 2.45 Å) and two main-chain carbonyls (Val520 and Leu587; distances 2.5 and 2.3 Å) conferring additional stability to the structure. The catalytic site is formed by a zinc(II) situated at the bottom of the propeller's cup; several other residues accompany the Zinc(II) (see below). The propeller presents extensive loops at the top and at the bottom of the structure; one of these loops is 20 residues long, much longer than the other loops, and it is believed that it provides a surface to interact with the PHM domain.[33]

The zinc catalytic site

The Zinc(II) ion is coordinated by three histidine residues (distance Zn–Nε, all three 2.1 Å) at the corners of a very distorted tetrahedron (angles between 95° and 104°). The fourth position is occupied by an acetate ligand in the crystal structure (distance Zn–O, 2.0 Å), but another ligand, most likely a water molecule, probably occupies this position under physiologic conditions in the absence of substrate.[37] During the crystallographic studies, it was observed that the Zn(II) ion can be easily replaced by Hg(II); however, Ca(II) could not be displaced by Hg(II) under the conditions of the experiment (1 mM $HgAc_2$).

The $Zn(His)_3$ motif is found in many other enzymes.[33] Nevertheless, other residues located around the $Zn(His)_3$ make the PAL active site ideally designed to bind and catalyze extended α-hydroxyglycine compounds (Figure 1). An arginine (Arg533) anchors the substrate through a bidentate salt bridge to the terminal carboxylate group that orients the substrate for efficient catalysis. A methionine (Met784) makes the reaction stereospecific, preventing binding of *R*-stereoisomer substrates.[33] An essential tyrosine (Tyr654) acts as the catalytic base accepting the proton from the substrate as an initial step in the reaction. A second

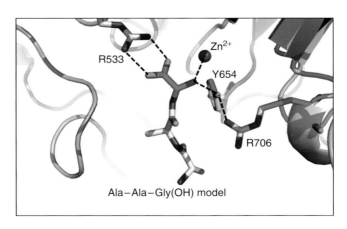

Figure 1 PAL-tripeptide [Ala–Ala–Gly(OH)] model complex built on the basis of the X-ray structure of PALcc-α-hydroxyhippuric acid. The most relevant interactions between the protein and the tripeptide are indicated.

arginine at the active site (Arg706) helps Tyr654 to act as a base through a hydrogen bond contact that, in addition, lowers the pK_a of the tyrosine. Moreover, in this scenario, the *N*-dealkylation reaction proceeds through a simple mechanism (described below). The zinc(II) ion also contributes to lowering of the pK_a of Tyr654.

COMPLEX PAL SUBSTRATE

Taking advantage of the observation that replacing the Zn(II) by Hg(II) renders the enzyme inactive, PAL Hg(II) was crystallized with the substrate α-hydroxyhippuric acid. The electron density map clearly showed the complete substrate molecule indicating that the substrate binds but does not undergo the reaction when Hg(II) is the metal at the active site.

CATALYTIC MECHANISM

Nonenzymatic hydrolysis of PAL substrates occurs spontaneously at pH values higher than 7,[20,38] strongly suggesting that the lyase mechanism proceeds via base-catalyzed deprotonation of the substrate's α-hydroxyl group. The X-ray crystal structures of PAL, alone and in complex with the substrate, showed a tyrosine residue (Tyr654) with its OH strategically located at a distance of 3.2 Å from the catalytic Zn(II) ion. The PAL–substrate complex revealed that the substrate binds to the active site with the α-hydroxyl group coordinated with the Zinc(II) ion forming hydrogen bonds to the OH-group of Tyr654. Site-directed mutagenesis studies indicated that this tyrosine plays an essential role in catalysis.[8] Therefore, mutagenesis, biochemical, and structural data support a mechanism in which Tyr654 is the catalytic base used for substrate deprotonation. The proximity of the positive charges from Arg706 (hydrogen-bonded to Tyr654) and the Zn(II) polarizing the tyrosine O–H bond, and thus reducing its pK_a, can explain why Tyr654 is an efficient catalytic base for hydroxyl deprotonation. After deprotonation, the Tyr654 probably delivers the proton to the leaving NH group.

ACKNOWLEDGEMENTS

We acknowledge the National Science Foundation (NSF) (grant MCB-0450465, L.M.A.) and National Institutes of Health (NIH) (grant DK32949, B.A.E. and R.E.M.) for financial support.

REFERENCES

1 BA Eipper, DA Stoffers and RE Mains, *Ann Rev Neurosci*, **15**, 57–85 (1992).

2 ST Prigge, RE Mains, BA Eipper and LM Amzel, *Cell Mol Life Sci*, **57**, 1236–59 (2000).

3 DS Ping, AG Katopodis and SW May, *J Am Chem Soc*, **114**, 3998–4000 (1992).

4 ST Prigge, AS Kolhekar, BA Eipper, RE Mains and LM Amzel, *Science*, **278**, 1300–5 (1997).

5 JP Klinman, *J Biol Chem*, **281**, 3013–16 (2006).

6 A Crespo, MA Marti, AE Roitberg, LM Amzel and DA Estrin, *J Am Chem Soc*, **128**, 12817–28 (2006).

7 AS Kolhekar, J Bell, EN Shiozaki, L Jin, HT Keutmann, TA Hand, RE Mains and BA Eipper, *Biochemistry*, **41**, 12384–94 (2002).

8 M De, J Bell, NJ Blackburn, RE Mains and BA Eipper, *J Biol Chem*, **281**, 20873–82 (2006).

9 AG Katopodis and SW May, *Biochemistry*, **29**, 4541–48 (1990).

10 BA Eipper, SL Milgram, EJ Husten, HY Yun and RE Mains, *Protein Sci*, **2**, 489–97 (1993).

11 CD Oldham, CZ Li, PR Girard, RM Nerem and SW May, *Biochem Biophys Res Commun*, **184**, 323–29 (1992).

12 L Scopsi, R Lee, M Gullo, P Collini, EJ Husten and BA Eipper, *Appl Immunohistochem*, **6**, 120–32 (1998).

13 I Kato, H Yonekura, M Tajima, M Yanagi, H Yamamoto and H Okamoto, *Biochem Biophys Res Commun*, **172**, 197–203 (1990).

14 SN Perkins, EJ Husten and BA Eipper, *Biochem Biophys Res Commun*, **171**, 926–32 (1990).

15 J Glauder, H Ragg, J Rauch and JW Engels, *Biochem Biophys Res Commun*, **169**, 551–58 (1990).

16 K Tateishi, F Arakawa, Y Misumi, AM Treston, M Vos and Y Matsuoka, *Biochem Biophys Res Commun*, **205**, 282–90 (1994).

17 M Satani, K Takahashi, H Sakamoto, S Harada, Y Kaida and M Noguchi, *Protein Expr Purif*, **28**, 293–302 (2003).

18 HY Yun, HT Keutmann and BA Eipper, *J Biol Chem*, **269**, 10946–55 (1994).

19 BA Eipper, LP Park, IM Dickerson, HT Keutmann, EA Thiele, H Rodriguez, PR Schofield and RE Mains, *Mol Endocrinol*, **1**, 777–90 (1987). DOI: 10.1210/mend-1-11-777.

20 AG Katopodis, DS Ping, CE Smith and SW May, *Biochemistry*, **30**, 6189–94 (1991).

21 DA Stoffers, CB Green and BA Eipper, *Proc Natl Acad Sci U S A*, **86**, 735–39 (1989).

22 DA Stoffers, L Ouafik and BA Eipper, *J Biol Chem*, **266**, 1701–7 (1991).

23 BA Eipper, CBR Green, TA Campbell, DA Stoffers, HT Keutmann, RE Mains and L Ouafik, *J Biol Chem*, **267**, 4008–15 (1992).

24 J Villen, SA Beausoleil, SA Gerber and SP Gygi, *Proc Natl Acad Sci U S A*, **104**, 1488–93 (2007). DOI: 10.1073/pnas.0609836104.

25 Y Iwasaki, T Kawahara, H Shimoi, K Suzuki, O Ghisalba, K Kangawa, H Matsuo and Y Nishikawa, *Eur J Biochem*, **201**, 551–59 (1991).

26 K Ohsuye, K Kitano, Y Wada, K Fuchimura, S Tanaka, K Mizuno and H Matsuo, *Biochem Biophys Res Commun*, **150**, 1275–81 (1988).

27 The C. elegans Sequencing Consortium, *Science*, **282**, 2012–18 (1998). DOI: 10.1126/science.282.5396.2012.

28 H Kaji, J-i Kamiie, H Kawakami, K Kido, Y Yamauchi, T Shinkawa, M Taoka, N Takahashi and T Isobe, *Mol Cell Proteomics*, **6**, 2100–09 (2007). DOI: 10.1074/mcp.M600392-MCP200.

29 MD Adams, SE Celniker, RA Holt, CA Evans, JD Gocayne, PG Amanatides, SE Scherer, PW Li, RA Hoskins, RF Galle, RA George, SE Lewis, S Richards, M Ashburner, S N Henderson, GG Sutton, JR Wortman, MD Yandell, Q Zhang, LX Chen, RC Brandon, Y-HC Rogers, RG Blazej, M Champe, BD Pfeiffer, KH Wan, C Doyle, EG Baxter, G Helt, CR Nelson, GL Gabor Miklos, JF Abril, A Agbayani, H-J An, C Andrews-Pfannkoch, D Baldwin, RM Ballew, A Basu, J Baxendale, L Bayraktaroglu, EM Beasley, KY Beeson, PV Benos, BP Berman, D Bhandari, S Bolshakov, D Borkova, MR Botchan, J Bouck, P Brokstein, P Brottier, KC Burtis, DA Busam, H Butler, E Cadieu, A Center, I Chandra, JM Cherry, S Cawley, C Dahlke, LB Davenport, P Davies, Bd Pablos, A Delcher, Z Deng, AD Mays, I Dew, SM Dietz, K Dodson, LE Doup, M Downes, S Dugan-Rocha, BC Dunkov, P Dunn, KJ Durbin, CC Evangelista, C Ferraz, S Ferriera, W Fleischmann, C Fosler, AE Gabrielian, NS Garg, WM Gelbart, K Glasser, A Glodek, F Gong, JH Gorrell, Z Gu, P Guan, M Harris, NL Harris, D Harvey, TJ Heiman, JR Hernandez, J Houck, D Hostin, KA Houston, TJ Howland, M-H Wei, C Ibegwam, M Jalali, F Kalush, GH Karpen, Z Ke, JA Kennison, KA Ketchum, BE Kimmel, CD Kodira, C Kraft, S Kravitz, D Kulp, Z Lai, P Lasko, Y Lei, AA Levitsky, J Li, Z Li, Y Liang, X Lin, X Liu, B Mattei, TC McIntosh, MP McLeod, D McPherson, G Merkulov, NV Milshina, C Mobarry, J Morris, A Moshrefi, SM Mount, M Moy, B Murphy, L Murphy, DM Muzny, DL Nelson, DR Nelson, KA Nelson, K Nixon, DR Nusskern, JM Pacleb, M Palazzolo, GS Pittman, S Pan, J Pollard, V Puri, MG Reese, K Reinert, K Remington, RD Saunders, F Scheeler, H Shen, BC Shue, I n-Kiamos, M Simpson, MP Skupski, T Smith, E Spier, AC Spradling, M Stapleton, R Strong, E Sun, R Svirskas, C Tector, R Turner, E Venter, AH Wang, X Wang, Z-Y Wang, DA Wassarman, GM Weinstock, J Weissenbach, SM Williams, T Woodage, KC Worley, D Wu, S Yang, QA Yao, J Ye, R-F Yeh, JS Zaveri, M Zhan, G Zhang, Q Zhao, L Zheng, XH Zheng, FN Zhong, W Zhong, X Zhou, S Zhu, X Zhu, HO Smith, RA Gibbs, EW Myers, GM Rubin and JC Venter, *Science*, **287**, 2185–95 (2000). DOI: 10.1126/science.287.5461.2185.

30 M Han, D Park, PJ Vanderzalm, RE Mains, BA Eipper and PH Taghert, *J Neurochem*, **90**, 129–41 (2004).

31 BA Eipper, SL Milgram, EJ Husten, HY Yun and RE Mains, *Protein Sci*, **2**, 489–97 (1993).

32 AS Kolhekar, AS Quon, CA Berard, RE Mains and BA Eipper, *J Biol Chem*, **273**, 23012–18 (1998).

33 EE Chufan, M De, BA Eipper, RE Mains and LM Amzel, *Structure*, **17**, 965–73 (2009). DOI: S0969-2126(09)00219-6 [pii] 10.1016/j.str.2009.05.008.

34 BA Eipper, SN Perkins, EJ Husten, RC Johnson, HT Keutmann and RE Mains, *J Biol Chem*, **266**, 7827–33 (1991).

35 K Takahashi, S Harada, Y Higashimoto, C Shimokawa, H Sato, M Sugishima, Y Kaida and M Noguchi, *Biochemistry*, **48**, 1654–62 (2009). DOI: 10.1021/bi8018866.

36 WL DeLano, 'The PyMOL Molecular Graphics System', DeLano Scientific LLC, San Carlos, CA (2002).

37 DS Auld, *Biometals*, **14**, 271–313 (2001).

38 H Bundgaard and AH Kahns, *Peptides*, **12**, 745–48 (1991).

SR-like protein ZRANB2

Robyn E Mansfield and Joel P Mackay

School of Molecular Bioscience, University of Sydney, Sydney, NSW, 2006, Australia

FUNCTIONAL CLASS

RNA-binding protein with likely involvement in pre-mRNA splicing; contains two zinc fingers in which the zinc ion plays a structural role.

OCCURRENCE

ZRANB2 (zinc finger Ran-binding domain-containing protein 2) is highly conserved between vertebrates, and the N-terminal ZnF domains are also conserved in nematodes. ZRANB2 is ubiquitously expressed with a slight elevation in some tissues early in development.[2–5]

BIOLOGICAL FUNCTION

The limited functional data available for ZRANB2 points to a role in pre-mRNA splicing. Pre-mRNA splicing is the process whereby noncoding introns are excised from the initial pre-mRNA transcript of a gene, to produce a mature messenger RNA (mRNA) from which a protein can be translated. The splicing reaction is catalyzed by the spliceosome – a large, dynamic assembly of five small nuclear ribonucleoproteins (U1, U2, U4, U5, and U6 snRNPs) and up to 300 additional proteins.[6,7] The exons from a gene can often be re-ligated in a number of different combinations by the process of alternative splicing, which is regulated by numerous other splicing factors and enables the production of multiple proteins from a single gene. Serine/arginine-rich (SR) proteins are a well-characterized family of splicing factors implicated in diverse roles in constitutive and alternative splicing.[8] They share a common domain structure, with an N-terminal RNA-binding domain, most commonly comprised of two RNA-recognition motifs (RRMs), and a C-terminal arginine/serine-rich (RS) domain. The RS domain is widely accepted as a protein-interaction domain that is able to heterodimerise with other RS domain-containing proteins, although some evidence suggests that it can also bind RNA with limited specificity.[9–11]

ZRANB2 is similar to the SR family of splicing factors, in that it contains a C-terminal RS domain and two

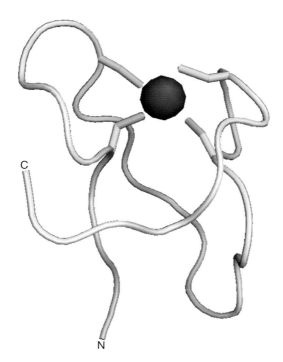

3D Structure Schematic representation of the first zinc finger from ZRANB2. The zinc ion is shown in brown and the zinc-ligating cysteine residues are shown in yellow. PDB code: 1N0Z. Produced using the program PyMOL.[1]

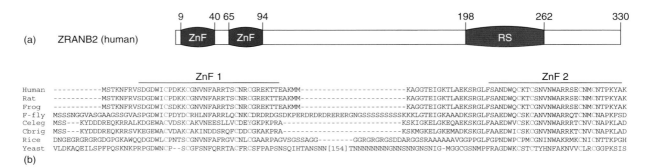

(a) ZRANB2 (human)

```
                     ZnF 1                                                              ZnF 2
Human  -----------MSTKNFRVSDGDWICPDKKCGNVNFARRTSCNRCGREKTTEAKMM---------------------KAGGTEIGKTLAEKSRGLFSANDWQCKTCSNVNWARRSECNMCNTPKYAK
Rat    -----------MSTKNFRVSDGDWICPDKKCGNVNFARRTSCNRCGREKTTEAKMM---------------------KAGGTEIGKTLAEKSRGLFSANDWQCKTCSNVNWARRSECNMCNTPKYAK
Frog   -----------MSTKNFRVSDGDWICSDKKCGNVNFARRTSCNRCGREKTTEAKMM---------------------KAGGTEIGKTLAEKSRGLFSANDWQCKTCGNVNWARRSECNMCNTPKYAK
F-fly  MSSSNGGVASGAAGSSGVASPGDWICPDYDCRHLNFARRLQCNKCDRDRDGSDKPERDRDRDRERERGNGSSSSSSSSSKKKLGTEIGKAAADKSRGLFSAEDWQCSKCANVNWARRQTCNMCNAPKFSD
Celeg  MSS---KYDDDREQKRRALKDGEWACVDSKCAKVNEESLLVCDEYGKPKPRA------------------------KSKIGKELGKEQAEKSKGLFAAEDWVCSKCGNVNWARRRTCNVCNAPKLAD
Cbrig  MSS---KYDDDREQKRRSVKEGEWACVDAKCAKINDDSRQFCDDCGKAKPRA------------------------KSKMGKELGKEMADKSKGLFAAEDWICSKCGNVNWARRKTCNVCNAPKLAD
Rice   DNGEGRGRGRGDGPGKAWQQDGDWLCPNTSCGNVNFAPRGVCNLCGAARPAGVSGSSAGG--------GGRGRGRGSDDARGGSRAAAAAAVGGPPGLFGPNDWPCPMCGNINWAKRMKCNICNTTKPGH
Yeast  VLDKAQEILSPFPQSKNKPRPGDWNCP--SCGFSNFQRRTACFRCSFPAPSNSQIHTANSNN[154]TNNNNNNNNGNNSNNGNSNIG-MGGCGSNMPFRAGDWKCSTCTYHNFAKNVVCLRCGGPKSIS
```
(b)

Figure 1 ZRANB2 protein. (a) Schematic diagram of the domain structure of ZRANB2. (b) Sequence alignment of the ZnF region of ZRANB2 across a variety of species. All sequences start from residue 1 except that for yeast, which starts at residue 336. Zinc-ligating cysteines are shown in red. Genbank accession codes: NM_203350 (*Homo sapiens*, 320 AA), NM_031616 (*Rattus norvegicus*, 330 AA), NM_001090673 (*Xenopus laevis*, 344 AA), NM_137848.2 (*Drosophila melanogaster*, 282 AA), NM_062039 (*Caenorhabditis elegans*, 345 AA), CBG19634 (*Caenorhabditis briggsae*, 326 AA), XM_477574 (*Oryza sativa*, 501 AA) and NC_001136.9 (*Saccharomyces cerevisiae*, 719 AA).

RNA-binding zinc finger (ZnF) domains at the N-terminus (Figure 1).[12] ZRANB2 has been shown by yeast two-hybrid and immunoprecipitation to bind splicing factors U1-70K and U2AF$_{35}$, which associate with the 5′ and 3′ splice sites of pre-mRNAs, respectively. By immunofluorescence microscopy, ZRANB2 has been found to colocalize with splicing factors U1-70K and SC35, but not with the Sm proteins that are present in all snRNPs, suggesting a role in alternative splicing or in a subset of splicing reactions rather than a global role in constitutive splicing.[13] Furthermore, the overexpression of ZRANB2 in human embryonic kidney (HEK293) cells alters the proportions of alternative splice forms produced from the human transformer-2-β1 (Tra2-β1) reporter gene, which indicates a role in splice site selection.[13] Finally, each individual ZnF of ZRANB2 binds an RNA sequence resembling the 5′ splice site (AGGUAA).[14] From this evidence, it is possible that ZRANB2 could act by binding directly to a subset of 5′ splice sites, thus preventing recognition of those sites by the spliceosome and promoting exon skipping. Further research will be required to establish the function of ZRANB2 in splicing, specify the genes involved, and determine the biological outcomes of this splicing activity.

AMINO ACID SEQUENCE INFORMATION

All available 3D structures of ZRANB2 involve the ZnFs from *Homo sapiens*. As mentioned above, ZRANB2 is highly conserved between vertebrates, and the ZnF domains are also conserved in nematodes. It is notable, however, that the first ZnF of the *Caenorhabditis elegans* protein is missing in one of the zinc-binding cysteines and is disordered in solution.[14] GenBank accession codes and number of amino acid residues (AA) are given in the legend of Figure 1, for ZRANB2 from a representative subset of species.

PROTEIN PRODUCTION AND PURIFICATION

Owing to the mostly unstructured nature of ZRANB2, only the N-terminal ZnFs have been successfully expressed and purified to date. Recombinant *Escherichia coli* expression systems are available for each ZnF from human ZRANB2, as well as a construct containing both ZnFs and the natural linker residues.[12,14]

NMR STRUCTURES

The three-dimensional structures of each of the human ZRANB2 ZnFs (ZnF1 and ZnF2) have been solved by NMR spectroscopy.[12,14] Each ZnF comprises two distorted β-hairpins crossing at an angle of approximately 80° relative to each other. Each hairpin provides two of the cysteines for coordinating a zinc ion (Figure 2). A close-up of the ZnF2 zinc ligation site is shown in Figure 3. The structures fall into the zinc ribbon class of zinc-binding domains.

Figure 2 Solution structures of the ZRANB2 ZnFs. The domains of ZnF1 (PDB code 1N0Z) and ZnF2 (PDB code 2K1P) are shown in ribbon format, with zinc-coordinating cysteine side chains displayed in yellow and the zinc ions shown as brown spheres. Produced using the program PyMOL.[1]

Figure 3 Zinc coordination geometry in ZnF2 of ZRANB2 (PDB code 2K1P). The zinc ion is shown as a brown sphere and distances are given in angstroms. Similar distances between the sulfur and zinc atoms (2.2–2.4 Å) were observed in the NMR structure of ZnF1 (PDB code 1N0Z) and the X-ray structure of ZnF2 in complex with RNA (PDB code 3G9Y). Produced using the program MOLMOL.[15]

Domains with homology to these ZnFs have been observed in more than 100 other functionally diverse proteins,[16] and are known collectively as Ran-binding protein 2 (RanBP2)-type ZnFs. This domain type occurs in one to eight copies per protein, and has been found to exhibit binding to a range of substrates in different proteins. In the nuclear pore complex proteins NUP358 and NUP153, the RanBP2 ZnFs are able to bind RanGDP via an $L_{11}/V_{12}/A_{23}$ motif.[17,18] In contrast, in the NPL4 (nuclear protein localization protein 4) and TAB2 (TGF-β-activated kinase 1-binding protein 2) ZnFs, this motif is changed to $T_{11}/F_{12}/(M/V)_{23}$ (highlighted in magenta, Figure 4) and facilitates binding to ubiquitin.[16,19] The RNA-binding ability of the ZRANB2 ZnFs was first discovered in the *Xenopus* ortholog (CSR4), when a portion of this protein containing the two ZnFs was selected from an oocyte expression library through its ability to bind an RNA probe.[4] A similar RNA-binding ability has also been demonstrated for the RanBP2-type ZnF of TLS/FUS (translated in liposarcoma protein).[20]

PROTEIN-RNA COMPLEX STRUCTURE

An X-ray structure of the second ZnF from human ZRANB2 in complex with a 6-nt RNA (AGGUAA) has been determined to a resolution of 1.4 Å.[14] Single crystals were grown over 2 weeks from solutions containing

Figure 5 Structure of the complex between ZnF2 and RNA. Overview of the crystal structure (PDB code 3G9Y) showing sequence-specific recognition of the central GGU motif. ZnF2 is shown as a green ribbon, RNA-contacting side chains are shown as sticks, and the zinc ion as a sphere. The RNA is displayed in pink stick format. Produced using the program PyMOL.[1]

2.2 M malic acid, 0.1 M bis-tris propane pH 7.0 and pH 7.2.[21] The lattice was hexagonal, space group $P6_522$ or $P6_122$, with unit cell parameters $a = 54.52$, $b = 54.52$, and $c = 48.07$ Å. Each asymmetric unit contained one monomeric complex. The structure of ZnF2 in complex with RNA is very similar to the structure of the free domain with a backbone overlay giving a root mean square deviation of 1.2 Å. Recognition of the central GGU bases is clearly defined and unambiguous. The aromatic side chain of Trp79 inserts between the two guanines, and base specificity is conferred by extensive hydrogen bond contacts (direct and water-mediated) involving the side chains of Arg81, Arg82, Asp68, Asn76, and Asn86, and the backbone amides or carbonyls of Arg81, Trp79, Val77, and Ala80 (Figure 5). Asn78 and Cys85 also contribute indirectly to base specificity via a hydrogen bonding network that serves to orient Asn76 such that the polarity of its side chain is complementary to uracil. All ZnF2 residues that contribute to recognition of GGU are identical in ZnF1, with the exception of Trp79 which is conservatively replaced by a phenylalanine (Phe25) in ZnF1. This suggests that ZnF1 is likely to display a similar mode of recognition for these nucleotides.

```
O95218|ZRANB2 F1 9-41        SDGDWICPDKKCGNVNFARRTSCNRCGREKTT
O95218|ZRANB2 F2 65-95       SANDWQCK--TCSNVNWARRSECNMCNTPKYA
P35637|TLS/FUS 422-454       RAGDWKCPNPTCENMNFSWRNECNQCKAPKPD
P49790|NUP153 F2 722-752     VIGTWDCD--TCLVQNKPEAIKCVACETPKPG
P49792|NUP358 F3 1479-1509   KEGQWDCS--ACLVQNEGSSTKCAACQNPRKQ
Q8TAT6|NPL4 580-608          TAAMWACQ--HCTFMNQPGTGHCEMCSLPRT-
Q9NYJ8|TAB2 664-693          EGAQWNCT--ACTFLNHPALIRCEQCEMPRHF
```

Figure 4 Sequence alignment of RanBP2-type ZnFs from different human proteins. RanGDP-binding residues are shown in green and ubiquitin-binding residues in magenta. Zinc-ligating cysteine residues are highlighted in yellow, and SwissProt accession codes are given on the left.

REFERENCES

1 WL DeLano, *The PyMOL Molecular Graphics System*, Available at http://www.pymol.org (2002).

2 DJ Adams, L van der Weyden, A Kovacic, FJ Lovicu, NG Copeland, DJ Gilbert, NA Jenkins, PA Ioannou and BJ Morris, *Cytogenet Cell Genet*, **88**, 68–73 (2000).

3 EA Karginova, ES Pentz, IG Kazakova, VF Norwood, RM Carey and RA Gomez, *Am J Physiol*, **273**, F731–38 (1997).

4 M Ladomery, R Marshall, L Arif and J Sommerville, *Gene*, **256**, 293–302 (2000).

5 M Nakano, K Yoshiura, M Oikawa, O Miyoshi, K Yamada, S Kondo, N Miwa, E Soeda, Y Jinno, T Fujii and N Niikawa, *Gene*, **225**, 59–65 (1998).

6 MS Jurica and MJ Moore, *Mol Cell*, **12**, 5–14 (2003).

7 TW Nilsen, *Bioessays*, **25**, 1147–49 (2003).

8 CF Bourgeois, F Lejeune and J Stevenin, *Prog Nucleic Acid Res Mol Biol*, **78**, 37–88 (2004).

9 KJ Hertel and BR Graveley, *Trends Biochem Sci*, **30**, 115–18 (2005).

10 H Shen and MR Green, *Mol Cell*, **16**, 363–73 (2004).

11 H Shen, JL Kan and MR Green, *Mol Cell*, **13**, 367–76 (2004).

12 CA Plambeck, AH Kwan, DJ Adams, BJ Westman, L van der Weyden, RL Medcalf, BJ Morris and JP Mackay, *J Biol Chem*, **278**, 22805–811 (2003).

13 DJ Adams, L van der Weyden, A Mayeda, S Stamm, BJ Morris and JE Rasko, *J Cell Biol*, **154**, 25–32 (2001).

14 FE Loughlin, RE Mansfield, PM Vaz, AP McGrath, S Setiyaputra, R Gamsjaeger, ES Chen, BJ Morris, JM Guss and JP Mackay, *Proc Natl Acad Sci USA*, **106**, 5581–86 (2009).

15 R Koradi, M Billeter and K Wuthrich, *J Mol Graph*, **14**, 51–55, 29–32 (1996).

16 B Wang, SL Alam, HH Meyer, M Payne, T.L Stemmler, DR Davis and WI Sundquist, *J Biol Chem*, **278**, 20225–34 (2003).

17 MM Higa, SL Alam, WI Sundquist and KS Ullman, *J Biol Chem*, **282**, 17090–100 (2007).

18 NR Yaseen and G Blobel, *Proc Natl Acad Sci USA*, **96**, 5516–21 (1999).

19 SL Alam, J Sun, M Payne, BD Welch, BK Blake, DR Davis, HH Meyer, SD Emr and WI Sundquist, *EMBO J*, **23**, 1411–21 (2004).

20 Y Iko, TS Kodama, N Kasai, T Oyama, EH Morita, T Muto, M Okumura, R Fujii, T Takumi, S Tate and K Morikawa, *J Biol Chem*, **279**, 44834–40 (2004).

21 FE Loughlin, M Lee, JM Guss and JP Mackay, *Acta Crystallogr Sect F Struct Biol Cryst Commun*, **64**, 1175–77 (2008).

Zinc transporter YiiP from *Escherichia coli*

Dax Fu

Department of Biology, Brookhaven National Laboratory, Upton, NY 11973, USA

FUNCTIONAL CLASS

Purified YiiP in the reconstituted proteoliposomes catalyzes a transmembrane zinc-for-proton exchange according to reaction scheme (1):

$$Zn^{2+}_{(in)} + H^+_{(out)} \Longleftrightarrow Zn^{2+}_{(out)} + H^+_{(in)} \qquad (1)$$

YiiP is a selective metal transporter for Zn^{2+} and Cd^{2+}.[1] *In vivo* transport data suggested that YiiP may function as a Fe^{2+} efflux transporter.[2] Thus, YiiP is named *FieF*, for ferrous iron efflux.

OCCURRENCE

YiiP is an integral membrane protein found in the cytoplasmic membrane of *E. coli*.[3] Transcription of chromosomal *yiiP* gene is inducible by Zn^{2+} and Fe^{2+} in a concentration-dependent manner.[2] YiiP belongs to the protein family of cation diffusion facilitator (CDF).[4] Members of the CDF family occur at all phylogenetic levels from bacteria to archaea and eukaryotes.[5] Most eukaryotic CDFs are localized in various intracellular organelle membranes, such as vacuoles of plants and yeasts,[6,7] and the Golgi of animals.[8,9]

BIOLOGICAL FUNCTION

CDFs are proton-driven metal transporters, catalyzing metal effluxes from the cytoplasm to the extracellular medium or into intracellular membrane compartments.[10–13] The spectrum of known metal ion substrates for CDFs includes Zn^{2+}, Cd^{2+}, Co^{2+}, Fe^{2+}, Ni^{2+}, and Mn^{2+}.[14–19] Bacterial CDFs are generally involved in resistance to toxic metal exposure.[20] The functional role of YiiP is implicated by cell growth under metal stress conditions. A double deletion of *yiiP* and the ferrous iron uptake regulator *fur*, increased iron sensitivity, whereas an overexpression of

3D Structure Schematic representation of a YiiP homodimer. TMD is colored in cyan, CTD in green, and zinc atoms in purple. PDB code: 3H90. Prepared with the program PyMol (http://www.pymol.org/).

yiiP restored iron tolerance, accompanied by a decrease in Fe^{2+} accumulation in the cells.[2] The observed YiiP-dependent phenotypes suggested that YiiP is involved in iron detoxification *in vivo*.[2] However, a ^{55}Fe-uptake assay showed that YiiP catalyzed active uptake of Zn^{2+}, but not Fe^{2+}, into everted membrane vesicles in a proton-dependent manner.[2] *In vitro* fluorimetry-based transport assay for purified YiiP also indicated that YiiP transported Zn^{2+} and Cd^{2+} into reconstituted proteoliposomes.[1] In corroboration with this observation, inductively coupled plasma mass spectroscopic measurements showed that YiiP transported Zn^{2+} and Cd^{2+}, but rejected Fe^{2+} (Lin and Fu, unpublished data). A second *E. coli* CDF, zinc-induced transporter B (ZitB), confers zinc resistance to a zinc-sensitive *E. coli* strain.[3] Purified ZitB catalyzes a 1:1 stoichiometric zinc-for-proton exchange in reconstituted proteoliposomes.[10] Thus, ZitB likely is a zinc-specific efflux transporter both *in vivo* and *in vitro*. Additional examples of bacterial CDFs are the heavy metal ion transporter CzcD from *Ralstonia* sp. and cadmium-zinc resistance protein B (CzrB) from *Thermus thermophilus*. CzcD mediates Zn^{2+}, Co^{2+} and Cd^{2+} resistance[14], while heterologous expression of CzrB in *E. coli* increases resistance to Zn^{2+} and Cd^{2+}, but not to Co^{2+}.[21]

Yeast CDFs from *Saccharomyces cerevisiae* comprise five homologs. The zinc and cobalt tolerance proteins, ZRC1 and COT1 transport cytoplasmic Zn^{2+}, Cd^{2+}, and Co^{2+} into vacuoles for storage and detoxification.[22,23] A third *S. cerevisiae* CDF, MSC2, is involved in zinc homeostasis of the nucleus and endoplasmic reticulum.[24,25] The rest two CDFs, MFT1 and MFT2, are Fe^{2+} transporters located in the mitochondrial membrane.[26] Plant CDFs are now called MTPs, for metal tolerance proteins, following a new naming system.[27] *Arabidopsis thaliana* contains twelve MTPs. They exhibit specific cellular and subcellular distributions with distinct metal specificities and affinities.[28] For example, multiple MTPs are found in vacuolar membranes,[5] wherein they are energized by a proton gradient to pump Zn^{2+} against its concentration gradient into the vacuole.[29] The activities of MTPs render high levels of metal tolerance in hyperaccumulator strains. In mammals, all characterized CDFs transport Zn^{2+}, and so these proteins are named ZnT, for zinc transporter.[30] Ten mammalian ZnT homologs (ZnT1–10) form family 39 in the classification of solute carrier proteins (SLC39).[31] Among them, ZnT1 is a zinc homeostatic protein, transporting excess cytoplasmic zinc out of cells.[30] Emerging evidence suggests that ZnT1 may be involved in cross talk with cellular calcium homeostasis,[32] and in the regulation of a Ras-signalling pathway.[33] ZnT1 is the only mammalian CDF found in the cytoplasmic membrane. All other ZnTs are localized intracellularly, shuttling Zn^{2+} into intracellular and secretory vesicles. For examples, ZnT3 is responsible for replenishing zinc-rich synaptic vesicles after zinc release at glutamatergic synapses.[34,35] ZnT5 functions as a Zn^{2+}/H^+ antiporter for vesicular zinc sequestration into the trans-Golgi subcompartment.[13] ZnT8 is exclusively expressed in pancreatic insulin-producing beta cells.[36] A genomewide association study established an association between a single nucleotide polymorphism marker on the human *znT8* gene and genetic susceptibility to type-2 diabetes.[37] The phenotype of ZnT8-null transgenic mice showed that ZnT8 is required for zinc-insulin crystallization within secretory vesicles.[38] Taken together, mammalian CDFs seem more involved in cellular signaling and regulation than survival-dependent zinc homeostasis.

AMINO ACID SEQUENCE INFORMATION

Escherichia coli (stain K12), YiiP, or FieF, 300 amino acids, translation of DNA sequence, SWP P69380.

PROTEIN PRODUCTION AND PURIFICATION

Recombinant *E. coli* expression was used for large-scale production of YiiP in an expression strain, BL21 (DE3) pLysS. The expression plasmid was constructed on the basis of a commercial vector, pET15b (Novagen, Darmstadt, Germany) with an inserted YiiP sequence fused in frame to a thrombin proteolytic cleavage site, followed by a C-terminal six-histidine affinity tag. YiiP expression was under the control of a T7 *lac* promoter.[39] The expression host cells were first cultivated under catabolite repression of the *lac* operon by glucose. As the cells grew to higher densities, lactose in the culture medium gradually took over glucose to induce YiiP overexpression. At an optimal glucose-to-lactose ratio,[40] the lactose-induced cell culture typically reached an optical density (OD_{600}) of 4–6 absorbance units.

Purification of YiiP consisted of membrane vesicle preparation, detergent solubilization, initial affinity purification, and a final polish by size-exclusion high-performance liquid chromatography (HPLC).[41] Harvested cells were lysed using an ice-chilled microfluidizer press-cell. The resulting membrane vesicles were collected by ultracentrifugation, and then solubilized using dodecyl-maltoside (DDM) at a detergent to cell-mass ratio of 1:5 (w/w). YiiP-TB-His was less than 0.5% of the total protein in the detergent crude extract. The low-abundance starting material necessitated a stringent purification procedure, but an excessive detergent-wash would cause protein denaturation because of over-delipidation. A delicate balance between protein purity and delipidation had to be optimized on the basis of readouts of two UV detectors that monitored the entire purification process as follows: YiiP-TB-His was first passed through a diethylaminoethyl (DEAE) anion exchange column, and then loaded to a nickel nitrilotriacetic acid affinity column, on which the immobilized YiiP-TB-His was washed free of contaminants at an elevated imidazole concentration. The washed

YiiP-TB-His was eluted by 500 mM imidazole, which was removed immediately from the protein sample by desalting. At this point, a typical protein yield was 30 mg per liter of cell culture. The resulting YiiP-TB-His was dialyzed against a bulk solution containing 5% polyethylene glycol (PEG) 35K as osmotic absorbent to concentrate the protein sample inside a dialysis cassette.[42] Thrombin was added at a ratio of 0.5 units per mg of YiiP-TB-His to cleave the histidine-tag. For the final HPLC purification, concentrated YiiP (\sim15 mg mL^{-1}) was incubated briefly with 5 mM ethylenedinitrilotetraacetic acid (EDTA) before injecting into a size-exclusion column pre-equilibrated with a mobile phase containing 0.05% DDM. The HPLC-polished sample was collected, concentrated to 15–20 mg mL^{-1}, and then dialyzed against a buffer containing 100 mM NaCl, 10 mM Na-citrate, 0.05% (w/v) undecyl-maltoside (UDM), 20% (w/v) glycerol, and 0.5 mM tris(2-carboxyethyl)phosphine, pH 5.5. DDM/UDM detergent exchange was complete after a 2-week dialysis at 4 $^{\circ}$C.

MOLECULAR CHARACTERIZATION

The proteolytic cleavage of the His-tag was confirmed by matrix-assisted laser desorption/ionization time-of-flight mass spectrometry and by Western-blot analysis using an antibody specific to the polyhistidine peptide. YiiP could be concentrated up to 20–25 mg mL^{-1} without compromising its monodispersity, as judged by dynamic light-scattering measurement. The mono-modal scattering profile suggested that YiiP and its associated detergents and lipids formed a homogenous micellar species. Analytical size-exclusion HPLC showed that YiiP eluted as a major mono-disperse species with a retention time corresponding to an apparent molecular weight of 190 kDa. The oligomeric state of the purified YiiP in the detergent-lipid micelles was determined by simultaneous measurements of ultraviolet (UV) absorption, light-scattering (LS), and differential refractive index (RI) of the YiiP peak fraction.[43] This UV-LS-RI method gave absolute protein mass irrespective of the size, shape, and lipid-detergent constituent of the micelles. When YiiP was solubilized in four types of maltoside detergents, the protein mass distribution in the micelles was found to be within a narrow range matching the predicted mass of a YiiP homodimer.[44] The subunit organization of YiiP in the lipid bilayer was visualized by electron microscopy of two-dimensional YiiP crystals in negative stain. A projection structure calculated from measurable optical diffractions to 25-Å resolution revealed a dumbbell-shaped homodimer profile.[44] The dimeric assembly of YiiP in the native cytoplasmic membrane was confirmed by cross-linking analysis.[44]

Metal binding to the purified YiiP was characterized by isothermal titration calorimetric analysis.[41] Zn^{2+} titrations exhibited a characteristic exothermic-to-endothermic transition, suggesting the presence of at least two sets of independent Zn^{2+} binding sites. The zinc titration data indicated a binding stoichiometry of 2.34 Zn^{2+} equivalents per YiiP monomer, but the multiphase of the Zn^{2+} binding isotherm precluded a reliable fitting of the binding parameters. Cd^{2+} titrations yielded a pure exothermic isotherm that could be fitted to a two-site model with $K_{a1} = 8.70 \pm 0.45\,\mu M^{-1}$, $n_1 = 1.2 \pm 0.1$, $\Delta H_1 = -6.5 \pm 0.1\,kcal\,mol^{-1}$; $K_{a2} = 0.30 \pm 0.05\,\mu M^{-1}$, $n_2 = 0.84 \pm 0.05$, and $\Delta H_2 = -6.1 \pm 0.7\,kcal\,mol^{-1}$. A Zn^{2+}/Cd^{2+} competition assay showed that Cd^{2+} binding specifically abolished the exothermic zinc heat component. It appeared that both Cd^{2+} sites overlap with the two exothermic Zn^{2+} sites. The enthalpy change of Cd^{2+} binding to a common binding site was found to be linearly related to the ionization enthalpy of the pH buffer with a slope corresponding to the release of 1.23 H$^+$ upon each Cd^{2+} binding.[41]

ACTIVITY TEST

YiiP with only 300 residues alone can transport zinc in response to cytoplasmic zinc binding. Activity was assayed using HPLC-purified YiiP reconstituted into proteoliposomes. A zinc-selective fluorescent indicator, Fluozin-1, was used to monitor zinc influx elicited by mixing of proteoliposomes with zinc on a stopped-flow apparatus.[10] The specific activity of YiiP was estimated on the basis of a calibration of the Fluozin-1 fluorescence signal to the actual zinc flux, giving a turnover number of 12 s^{-1}.

X-RAY STRUCTURE

Crystallization

YiiP crystals were grown at 20 $^{\circ}$C in hanging drops from an equal volume mixture of protein (\sim10 mg mL^{-1}) and a reservoir solution containing 100 mM Na-citrate (pH 6.0), 5 mM ZnSO$_4$, 3 mM Fos-Choline-12, 100 mM NaCl, 200 mM (NH4)$_2$SO$_4$, 10% (v/v) PEG400, 15–20% (w/v) PEG2000, 4% (w/v) benzamidine, 10% (w/v) glycerol, and 4% (v/v) 1,3-propanediol. Crystals reached a full size of about 150 μm \times 50 μm \times 20 μm within 2 months. The lattice is orthorhombic, space group P222$_1$ with the following unit cell dimensions: $a = 106.7$ Å, $b = 110.8$ Å, and $c = 130.7$ Å. Each asymmetric unit contains two YiiP monomers that belong to two different physiological homodimers. YiiP crystals exhibited a large variation in X-ray diffraction quality. Only a small fraction of YiiP crystals diffracted to 3.8 Å. The first YiiP structure was solved by multiple isomorphous replacement and anomalous scattering phasing using diffraction datasets collected from a native and 12 heavy atom derivatized crystals.[45] Mercury derivatization of the YiiP crystals yielded a second crystal form. The space group is P2$_1$ with $a = 105.7$ Å, $b = 130.7$ Å, $c = 115.8$ Å, $\beta = 93.3^{\circ}$. Each asymmetric unit

contains four YiiP monomers that form two physiological homodimers. The best P2$_1$ crystals diffracted to 2.9 Å. A refined YiiP structure was obtained at this resolution by single isomorphous replacement and anomalous scattering phasing aided by molecular replacement.[42]

Overall description of the structure

The YiiP crystal structure reveals a Y-shaped dimeric architecture arranged around a twofold axis oriented perpendicular to the membrane plane.[45] Each monomer comprises an N-terminal transmembrane domain (TMD), followed by a C-terminal domain (CTD) that protrudes into the cytoplasm (3D Structure). Two CTDs of a YiiP homodimer juxtapose each other in parallel to form a major dimerization contact. At the CTD and TMD juncture, highly conserved intersubunit salt bridges[42] and hydrophobic contacts form another dimerization contact, from which two TMDs swing outward and plunge into the membrane. The resulting Y-shaped architecture dramatically differs from most cylindrically shaped membrane proteins. The uniquely oriented TMDs in the lipid bilayer are expected to cause significant hydrophobic mismatches. The deformation energy of a stressed lipid bilayer may in turn impact YiiP conformations.[46] How much of the native conformation is preserved in the YiiP crystal structure has yet to be evaluated.

Each TMD contains six transmembrane helices (TM1-6), fully consistent with earlier topology mapping data, showing that the polypeptide chain of YiiP traverses the cytoplasmic membrane six times with both the N- and C-terminus in the cytoplasm.[1] The overall organization of TM1–6 can be grouped into two subdomains: TM1, TM2, TM4, and TM5 form a compact four-helix bundle, whereas the remaining TM3 and TM6 crossover in an antiparallel configuration outside the bundle (Figure 1). TM3 is tilted away from TM2; consequently, one side of the TM3–TM6 pair embraces TM5 at one corner of the rectangle-shaped four-helix bundle, whereas the other side projects highly conserved hydrophobic residues into the TMD–TMD interface to seal the bottom of the V-shaped void (3D Structure).[45] The orientation of the TM3–TM6 pairs is stabilized by four interlocked salt bridges formed between Lys77 of TM3 and Asp207 from a short loop that connects TM6 to the CTD.[42] These highly conserved charged residues are arranged in a circular fashion to form a (Lys77–Asp207)$_2$ charge-interlock that bundles together the cytoplasmic ends of two TM3–TM6 pairs at the dimer interface as well as at the domain interface between TMD and CTD (3D Structure).

Among the six TMs, TM5 is conspicuously short in length, accounting for four helical turns from residue Gln145 to Met159. This short helix is largely sequestered within TMD, thereby giving rise to one extracellular and one intracellular cavity on either side of the membrane

Figure 1 Topology diagram of a YiiP monomer. α-Helices and β-strands are represented by cylinders and arrows, respectively. SA is the active site for zinc transport. The labeling of the secondary structure elements is adopted from Ref. 45.

(Figure 2). The extracellular cavity is accessible from the bulk solvent and exposed to the membrane outer leaflet. This cavity spans nearly half of the membrane thickness, and is lined with negatively charged residues that provide a favorable electrostatic environment for a bound zinc ion near the bottom of the cavity. On the other hand, the intracellular cavity is relatively shallow. The two cavities from different sides of the membrane point toward each other within the membrane, but no connecting channel exists between them. The hydrophobic seal between the two cavities is stabilized by two highly conserved salt bridges, Glu79–Arg11 and Glu200–Arg148 within the intracellular cavity. They anchor the TM3–TM6 pair to the four-helix bundle in a manner reminiscent of the interhelical salt bridges in the rhodopsin subfamily of G-protein coupled receptors,[47–49] and lactose permease LacY,[50] wherein the salt bridges act as molecular switches to lock protein conformations that can be released by substrate binding.[51–53]

In each TMD, TM1 to TM6 are linked together by three extracellular loops, denoted as EL1 to EL3, and two intracellular loops, IL1 and IL2 (Figure 1). An additional intracellular loop, IL3, connects TM6 to CTD. IL1 extends toward the dimer interface and forms a dimerization contact with IL3 from the neighboring subunit.[45] IL2 is situated at the entrance to the intracellular cavity. In YiiP,

Figure 2 Cross section of a YiiP homodimer viewed from the membrane plane. One subunit is shown in ribbon representation, and the other in solvent-accessible surface with TM1 and TM2 removed to reveal embedded TM5(yellow patch) and a bound zinc ion (purple sphere) at the bottom of the extracellular cavity. Solid lines depict the membrane boundaries, dashed lines outline the cavity boundaries, and arrows indicate the openings of the cavities.

IL2 connects TM4 and TM5 with only four residues from position 141 to 144. Many CDF members contain an extended IL2 that harbors a metal binding motif with multiple histidine residues. Thus, IL2 is often referred to as the *histidine-rich loop*.[4] Functional studies showed that deletion of the histidine-rich loop of AtMTP1 stimulated Zn^{2+} transport activity,[11] and the loss of the histidine-rich loop in TgMTP1 conferred Ni^{2+} specificity.[19] These results suggest that the histidine-rich loop plays a role in regulating transport activity and selectivity. On the extracellular membrane surface, all three extracellular loops adopt extended conformations with full exposure to solvent. However, EL3 in the membrane-bound YiiP may adopt a different conformation that protects an S171C mutation in EL3 from thiol-specific labeling.[1] The potential conformational difference between the detergent-solubilized and membrane-bound YiiP has yet to be evaluated.

The CTD of YiiP adopts an open α–β fold with two α helices (H1–2) on one side of the domain and a three-stranded mixed β-sheet (S1–3) on the other side (3D Structure and Figure 1). The CTD exhibits an overall structural similarity with the copper metallochaperone, human ATX homolog 1 (Hah1),[54] although there is no sequence homology between YiiP and Hah1. This

structural similarity to metallochaperone proteins places CTD into the same structural category as a possible Zn^{2+} receiving domain.[55] The second important feature of CDT is represented by a charge-rich CTD–CTD interface stretching from the $(Lys77–Asp207)_2$ charge-interlock at the TMD–CTD juncture to the tip of the CTD, which extends 30 Å into the cytoplasm.[42] The electrostatic repulsion between two CTDs is neutralized by zinc binding at the CTD–CTD interface (see below).

Zinc sites

The crystal structure of YiiP was determined in complex with four coordinated Zn^{2+} (Z1–Z4) in each monomer (Figure 2). Z1–Z4, together with protein ligands and water molecules that participate in their first coordination shells, constitute three distinct Zn^{2+} binding sites, termed SA, SB, and SC, respectively. The multisite operation of YiiP does not fall into the single-site, alternating-access paradigm ascribed to LacY, glycerol-3-phosphate transporter (GlpT), Na^+/H^+ antiporter (NhaA), Na^+/Cl^--dependent leucine transporter (LeuT), and many other secondary membrane transporters.[50,56–58] Rather, recent progress in structural analyses of Ca^{2+}, Mg^{2+}, and Zn^{2+} transporters[59–65] has begun to coalesce into a new paradigm based on a common two-modular architecture. In this model, a cytoplasmic metal-sensing domain regulates the activity of a transmembrane metal-transporting domain in response to the fluctuation of metal concentrations around a homeostatic set point.[66]

Z1 in SA is tetra-coordinated by highly conserved Asp45 and Asp49 from TM2, and His153 and Asp157 from TM5 (Figure 3). They form a coordination system with four-ligand groups (Asp45 Oδ1, Asp49 Oδ2, His153 Nε2, and Asp157 Oδ2) positioned at the vertexes of a nearly ideal tetrahedron.[42] Tetrahedral coordination is preferred for Zn^{2+} and Cd^{2+}, as opposed to octahedral coordination

Figure 3 Drawing of the active site (SA) for zinc transport with bond distances as indicated.

that is preferred for most other divalent cations.[67] The observed tetrahedral coordination in the crystal structure is consistent with an earlier finding that SA can bind Zn^{2+} and Cd^{2+}, but not Fe^{2+}, Mg^{2+}, Ca^{2+}, Mn^{2+}, Co^{2+}, or Ni^{2+}.[1] SA exhibits three features well suited to rapid on–off switching of zinc coordination as expected for a zinc transporter. First, all coordinating residues in SA are completely unconstrained, and thus no making or breaking of outer-shell interactions is needed for Zn^{2+} binding and release during a transport cycle.[68] Second, each of the three Asp-carboxylates in SA is mono-coordinated, leaving an uncoordinated carboxylate oxygen ligand free of outer-shell interaction. These "dangling" carboxylate oxygens can potentially be rearranged to enter the coordination shell, resulting in a highly adaptable inner-shell arrangement with varied coordination geometries and numbers.[69] The resultant conformational flexibility of SA may contribute to a rapid Zn^{2+} turnover rate of YiiP, which is several orders of magnitudes faster than Zn^{2+} exchange rates for typical zinc metalloproteins. Third, SA is confined exclusively between TM2 and TM5. A small interhelix shift between TM2 and TM5 can lead to a large readjustment of the zinc coordination geometry either in favor of zinc binding or release (Figure 1), thereby allowing for allosteric regulation of zinc coordination through protein conformational changes.[42]

Z2 in SB is five-coordinated by two His-imidazoles, a bidentate Asp-carboxylate, and a water molecule that takes up the fifth coordinate (Figure 4). The presence of a coordinated water molecule is characteristic of zinc coordination in hydrolytic zinc enzymes,[70] but its functional role in a membrane transporter is unclear. All Z2 coordinating residues are located within an intracellular loop (IL1) that connects TM2 and TM3. The IL1 conformation is stabilized by SB outer-shell interactions through an intraloop hydrogen bond between His75

Figure 5 Drawing of the binuclear zinc binding site, SC.

Nδ1 and main-chain carbonyl of Pro66, while another outer-shell hydrogen bond is made between His71 Nϵ2 and Gln203 Oϵ1 from TM6 of the neighboring subunit. This intersubunit outer-shell interaction contributes to dimeric association.

Z3 and Z4 are 3.8 Å apart in the binuclear SC at the CTD–CTD interface (3D Structure). The carboxylate groups of a conserved D285 bridges Z3 and Z4. Additional coordination residues to Z3 are His232 and His248, and those to Z4 are His283 and His261 from the neighboring subunit (Figure 5). These residues are tucked into the dimer interface in a cleft capped by two coordinated water molecules. The positive charges on the two Zn^{2+} ions in SC balance the strong electronegativity at the CTD–CTD interface, thereby stabilizing dimeric association.[42] All coordinating residues, with the exception of the bridging D285, are highly constrained through extensive outer-shell interactions. His232, His248, and His261 each donates a hydrogen bond to a carboxylate provided by Glu250, Asp233, and Asp265, respectively. His283, on the other hand, donates a hydrogen bond to Gln284 of the neighboring subunit. Each of those outer-shell residues can potentially accept additional hydrogen bonds from neighboring protein donors or water molecules to further expend the outer-shell interactions at the CTD–CTD interface. The resulting network of outer-shell interactions allows for effective coupling of Zn^{2+} binding to inter-CTD conformational changes.[42]

FUNCTIONAL ASPECTS

Roles of three zinc sites

The functional roles of SA, SB, and SC were characterized by mutation-function analysis. SA is located at the bottom of the extracellular cavity (Figure 2). A D49A or D157A mutation to SA disrupted metal binding and completely abolished transport activity, indicating that SA is the active site for zinc transport.[1,71] SA was found to be

Figure 4 Drawing of the zinc binding site, SB. (Reproduced from Ref. 45. © American Association for the Advancement of Science, 2007).

highly selective for Zn^{2+} and Cd^{2+}, but not for Fe^{2+} and other divalent cations.[1] SB is localized to the TM2–TM3 connecting loop on the cytoplasmic membrane surface. Disruption of zinc binding to SB by a D68A mutation had little effect on zinc transport activity, suggesting that SB is not directly involved in zinc transport. SC is located at the CTD–CTD interface. A H232A mutation abolished zinc binding to SC, impaired a zinc-induced inter-CTD conformational change, allosterically affected zinc binding to a reporter cysteine in SA, and reduced the rate of zinc transport.[42] These data collectively suggested that SC may serve as a zinc concentration sensor, while its extensive outer-shell constraints enable a tight coupling of zinc binding to an inter-CTD conformational change.[42]

Transport kinetics

Stopped-flow measurements of the transmembrane zinc flux were performed using reconstituted proteoliposomes encapsulated with a fluorescent zinc indicator, Fluozinc-1.[1] The rate of the fluorescence rise k_{obs} increased in a hyperbolic manner as a function of the Zn^{2+} concentration. This kinetic behavior is consistent with a two-step process shown in the following scheme[10]:

$$M + T_1 \underset{k_{-1}}{\overset{k_1}{\rightleftharpoons}} MT_1 \overset{k_2}{\longrightarrow} T_2 + M \qquad (2)$$

where T_1 and T_2 are different conformational states of YiiP, and M is the metal substrate. The first step is a rapid equilibrium with a binding constant k_{-1}/k_1, followed by a rate-limiting conformational transition from T_1 to T_2 with a rate constant k_2. The relationship among k_1, k_{-1} and k_2 is defined by $K_m = (k_2 + k_{-1})/k_1$. Application of the steady-state condition to the MT_1 species gives equation (3):

$$1/K_{obs} = 1/k_3 + (K_m/k_3)/[M] \qquad (3)$$

Linear regression of $1/K_{obs}$ as a function of $1/[M]$ yielded a k_3 value of $34 \pm 5\ s^{-1}$ and a K_m value of $310 \pm 32\ \mu M$.[1]

Mechanism

Zn^{2+} is a densely charged ion with very high electron affinity. Consequently, release of zinc from its ligand groups often occurs over a period of hours.[67] It is a significant challenge to move a zinc ion across the membrane barrier and move it rapidly on a 10–100 ms timescale. The YiiP crystal structure is characterized by a pair of cavities that extend into the lipid bilayer from opposite membrane surfaces (Figure 2). Water of hydration within the cavities would significantly reduce the free energy barrier to Zn^{2+} diffusion in the low dielectric

Figure 6 Proposal for a Zn^{2+}/H^+ antiport mechanism.

environment of the inner membrane.[72] From an energetic standpoint, zinc transport would occur at a breaching point within the hydrophobic seal that narrowly separates the two cavities. This hydrophobic seal is stabilized by highly conserved salt bridges in the intracellular cavity. Another essential component of the zinc transport reaction is proton antiport. In the absence of proton, zinc transport is arrested despite an imposing Zn^{2+} gradient. The coupling of zinc transport and proton antiport seems obligatory in all CDF members characterized thus far.[2,10,12,13] Since Cd^{2+} binding to YiiP was shown to displace proton with a ~1: 1 exchange stoichiometry,[41] we propose a stoichiometric Zn^{2+}/H^+ antiport model consisting of three minimum steps (Figure 6). In step 1, an Arg residue initially is engaged in a salt bridge in the intracellular cavity. Zinc binding from the cytoplasm deprotonates the arginine residue to release a proton into the cytoplasm. The unprotonated guanidine group of arginine can act as a metal ligand for zinc binding.[73] At the same time, a proton from the periplasm releases a coordinated-zinc from SA in the extracellular cavity by a Zn^{2+}/H^+ exchange. During step 2, the loss of a stabilizing salt bridge leads to a conformational change that opens an intercavity 'channel'. The Arg-coordinated zinc ion passes through the 'channel' to enter SA where it deprotonates coordinating residues. The proton released from SA simultaneously moves across the intercavity 'channel' to reprotonate the Arg residue. In step 3, YiiP re-establishes the salt bridge to close the intercavity seal, thereby completing a Zn^{2+}/H^+ antiport cycle. The role of Arg residue in proton transport has been well documented in the proton transport pathway of bacteriorhodopsin.[74]

Regulation of activity

The crystal structure of YiiP suggests that zinc release from SC would entail unbalanced electronegativity at

Periplasm

Cytoplasm

Figure 7 Schematic drawing of the proposed zinc-regulated zinc transport mechanism. The red-cross at the TMD-CTD juncture represents the charge-interlock that acts as the pivotal point for a hinge-like motion between two CTDs.

the CTD–CTD interface, causing two juxtaposed CTDs to swing apart by electrostatic repulsion in a hingelike motion pivoting around the (Lys77–Asp207)$_2$ charge-interlock (Figure 7).[42] This charge-interlock is strategically situated at the CTD–TMD juncture, well positioned to transmit inter-CTD conformational changes into TMD, wherein the charge-interlock also stabilizes the orientation of TM3–TM6 pair, which in turn, is linked sterically to the TM5–TM2 orientation in association with the coordination geometry of SA (Figure 7). Therefore, SC of CTD, the charger-interlock at the CTD–TMD interface, and SA of TMD may define a regulatory pathway for allosteric regulation of zinc transport activity by cytoplasmic zinc binding. The charge-interlock is among the most conserved structural elements in YiiP, suggesting a common allosteric mechanism for all CDF family members. A single R325W mutation in human ZnT8 has been linked to the risk of type 2 diabetes.[37] Homology modeling of ZnT8 localizes the R325W mutation to the CTD interface. This mutation is more than 50-Å away from SA, and thus it is unlikely to have a direct effect on the active site for zinc transport. Rather, R325W may impair the allosteric pathway that transmits the activation signal of cytoplasmic zinc binding to the distant active site in ZnT8.[42]

Comparison with related structures

The CTD of YiiP is nearly identical to the CTD of the Zn^{2+}/Cd^{2+} efflux transporter CzrB from *T. thermophilus*. A ~100 amino acid soluble fragment of CzrB was crystallized with and without zinc. The crystal structures were solved to 1.7 Å resolution for the apo-form and 1.8 Å resolution for the zinc-bound form.[75] Both structures reveal a dimeric subunit assembly, but the inner-dimer conformation changes dramatically upon zinc binding. The two CzrB subunits are snapped together by zinc binding in a manner similar to dimeric CTD association in the full length YiiP structure. In the apo-form, the two CzrB subunits seem to undergo a hinge-like *en bloc* motion, opening up the dimer interface at one end of the molecule that is expected to interact with TMD in the full length CzrB. Cα-trace

superposition of a CTD of YiiP with one CzrB fragment, either in apo- or zinc-bound form (PDB codes: 3BYP, 3BYR), yielded a root mean square deviation less than 1.2 Å for 78 common Cα atoms among three proteins.[42] However, despite the overall structural similarity among individual CTDs, the highly conserved (Lys77–Asp207)$_2$ charge-interlock is missing in the CzrB fragment. Since this charge-interlock stabilizes CTD–CTD dimeric association in YiiP, the lack of a critical dimeric association in the CzrB fragment structures raises the question as to the functional relevance of the observed conformational change. Each subunit of the CzrB fragment is associated with four zinc ions (Z1–4). The first three were found at or close to the interface between two subunits. They are likely present *in vivo* while Z4 only exists in the crystal lattice. Z1 and Z3 are tetrahedrally coordinated whereas Z2 is hexacoordinated with classic octahedral geometry. It is noted that Z1 and Z2 are 4.9 Å apart, homologous with the two coordinated zinc ions in the binuclear zinc site (SC) of YiiP.

The CTD of YiiP shares a striking structural similarity to metallochaperones, a class of metal binding proteins involved in intracellular metal trafficking.[76] Metallochaperones deliver metal ions to specific target proteins, which also contain one or multiple metallochaperone-like domains that serve as metal acceptors.[77] Both donor and acceptor proteins are characterized by a CXXC metal binding sequence.[78] The intermolecular metal transfer occurs by docking of the chaperone to the target protein to form a metal-bridged heterodimer complex, in which the metal ion is coordinated simultaneously by two CXXC motifs in close proximity at the protein interface.[54] In human, the well-characterized metal transfer pairs are metallochaperone Hah1 and its targets, ATP7A and ATP7B,[79] both are metal-transporting P-type ATPases involved in intracellular copper homeostasis.[80] Mutations of ATP7A and ATP7B cause Menkes syndrome and Wilson's disease.[81] Interestingly, ATP7A and ATP7B, each contains six metallochaperone-like domains,[82] but only a few of them can accept copper from the Hah1 donor.[83,84] In yeast, the prototypical metallochaperone-target pair is the copper chaperone, anti-oxidant 1 (Atx1), and the corresponding

Cu(I)-transporting ATPase, Ccc2.[85] In bacteria, the Cu-chaperone, CopZ delivers Cu(I) to the corresponding Cu(I)-ATPase, CopA.[86] At present, a zinc-specific metallochaperone has yet to be identified. Nevertheless, a zinc-transporting ATPase from *E. coli*, ZntA, contains an N-terminal metallochaperone-like domain.[87] The CXXC motif in ZntA likely is involved in Zn^{2+} transfer.[88]

The crystal structure of a Hah1-Cd^{2+}-Hah1 homodimer revealed atomic details of Cd^{2+} coordination at the dimer interface.[54] Structurally, a Hah1 monomer is built up from two βαβ motifs linked together by a hairpin loop corresponding to the S1–S2 connection in the CTD of YiiP (Figure 1). To a first approximation, the topologies of the Hah1 βαβ–βαβ fold and the αβ–βαβ fold in the CTD of YiiP are identical except that the first β-strand in Hah1 is missing in YiiP. The structural core of the CTD from H1 to H2 (αβ–βα) can be superimposed onto the equivalent portion in Hah1 (αβ–βα) with a root mean square deviation of 1.8 Å for 42 common Cα positions (Figure 8).[45] The last β-strand in the CTD diverges significantly from that of Hah1 because the missing first β-strand is required to hold the last β-strand in position through an antiparallel packing interaction. Despite the overall structural similarity, CDT of YiiP has neither a CXXC metal binding sequence nor an overall sequence homology with Hah1. Thus, their structural similarity may arise independently of each other through convergent evolution at the structural level.

Proposed protein interaction

A model of a metallochaperone–YiiP complex is proposed on the basis of the crystal structures of YiiP and Hah1 homodimers.[45] Superposition of a Hah1 monomer and a CTD allows placement of a second Hah1 structure onto a putative docking position (Figure 8).[45] As shown in Figure 9, the docked metallochaperone fits snugly between TMD and CDT with a putative Zn^{2+} transfer site

Figure 8 Superposition of a CTD (green) and a Hah1 monomer (magenta). The orange sphere represents a cadmium ion located at the metal transfer site of a Hah1 homodimer. PDB code: 1FE0.

Figure 9 Docking of Hah1 onto YiiP.

positioned right at the entrance to the intracellular cavity. In this model, a zinc-loaded metallochaperone would directly deliver its cargo into the intracellular cavity to initiate the zinc transport cycle. The docking of the metallochaperone blocks much of the solvent accessibility to the intracellular cavity, thereby preventing back flow of Zn^{2+} into the cytoplasm. The histidine-rich loop found in many CDF homologs is located in close proximity to the Zn^{2+} transfer site, and thus may play an important role in mediating the Zn^{2+} delivery process. According to this model, the metallochaperone–YiiP docking is only possible when two CTDs are clamped together by binuclear zinc binding to SC at the CTD interface. Therefore, cytoplasmic Zn^{2+} binding may be a prerequisite for docking of a zinc-loaded metallochaperone.

ACKNOWLEDGEMENTS

This work is supported by the National Institute of Health (R01 GM065137), and Office of Basic Energy Sciences, Department of Energy (DOE KC0304000). BNL is managed by Brookhaven Science Associates for the Department of Energy.

REFERENCES

1 Y Wei and D Fu, *J Biol Chem*, **280**(40), 33716–24 (2005).

2 G Grass, M Otto, B Fricke, CJ Haney, C Rensing, DH Nies and D Munkelt, *Arch Microbiol*, **183**(1), 9–18 (2005).

3 G Grass, B Fan, BP Rosen, S Franke, DH Nies and C Rensing, *J Bacteriol*, **183**(15), 4664–67 (2001).

4 I Paulsen and MJ Saier, *J Membr Biol*, **156**(2), 99–103 (1997).

5 B Montanini, D Blaudez, S Jeandroz, D Sanders and M Chalot, *BMC Genomics*, **8**, 107 (2007).

6 DJ Eide, *Biochim Biophys Acta*, **1763**(7), 711–22 (2006).

7 JL Hall and LE Williams, *J Exp Bot*, **54**(393), 2601–13 (2003).

8 LA Lichten and RJ Cousins, *Annu Rev Nutr*, **29**, 153–76 (2009).

9 T Kambe, Y Yamaguchi-Iwai, R Sasaki and M Nagao, *Cell Mol Life Sci*, **61**(1), 49–68 (2004).

10 Y Chao and D Fu, *J Biol Chem*, **279**(13), 12043–50 (2004).

11 M Kawachi, Y Kobae, T Mimura and M Maeshima, *J Biol Chem*, **283**(13), 8374–83 (2008).

12 CW MacDiarmid, MA Milanick and DJ Eide, *J Biol Chem*, **277**(42), 39187–94 (2002).

13 E Ohana, E Hoch, C Keasar, T Kambe, O Yifrach, M Hershfinkel and I Sekler, *J Biol Chem*, **284**(26), 17677–86 (2009).

14 A Anton, C Grosse, J Reissmann, T Pribyl and D.H Nies, *J Bacteriol*, **181**(22), 6876–81 (1999).

15 A Anton, A Weltrowski, CJ Haney, S Franke, G Grass, C Rensing and DH Nies, *J Bacteriol*, **186**(22), 7499–507 (2004).

16 E Delhaize, T Kataoka, DM Hebb, RG White and PR Ryan, *Plant Cell*, **15**(5), 1131–42 (2003).

17 H Lin, A Kumanovics, JM Nelson, DE Warner, DM Ward and J Kaplan, *J Biol Chem*, **283**(49), 33865–73 (2008).

18 D Munkelt, G Grass and DH Nies, *J Bacteriol*, **186**(23), 8036–43 (2004).

19 MW Persans, K Nieman and DE Salt, *Proc Natl Acad Sci USA*, **98**(17), 9995–10000 (2001).

20 DH Nies, *FEMS Microbiol Rev*, **27**(2–3), 313–39 (2003).

21 S Spada, JT Pembroke and JG Wall, *Extremophiles*, **6**(4), 301–8 (2002).

22 DS Conklin, JA McMaster, MR Culbertson and C Kung, *Mol Cell Biol*, **12**(9), 3678–88 (1992).

23 CW MacDiarmid, MA Milanick and DJ Eide, *J Biol Chem*, **278**(17), 15065–72 (2003).

24 CD Ellis, F Wang, CW MacDiarmid, S Clark, T Lyons and DJ Eide, *J Cell Biol*, **166**(3), 325–35 (2004).

25 L Li and J Kaplan, *J Biol Chem*, **276**(7), 5036–43 (2001).

26 L Li and J Kaplan, *J Biol Chem*, **272**(45), 28485–93 (1997).

27 P Maser, S Thomine, JI Schroeder, JM Ward, K Hirschi, H Sze, IN Talke, A Amtmann, FJ Maathuis, D Sanders, JF Harper, J Tchieu, M Gribskov, MW Persans, DE Salt, SA Kim and ML Guerinot, *Plant Physiol*, **126**(4), 1646–67 (2001).

28 CM Palmer and ML Guerinot, *Nat Chem Biol*, **5**(5), 333–40 (2009).

29 Y Kobae, T Uemura, MH Sato, M Ohnishi, T Mimura, T Nakagawa and M Maeshima, *Plant Cell Physiol*, **45**(12), 1749–58 (2004).

30 R Palmiter and S Findley, *EMBO J*, **14**(4), 639–49 (1995).

31 RJ Cousins, JP Liuzzi and LA Lichten, *J Biol Chem*, **281**(34), 24085–89 (2006).

32 S Levy, O Beharier, Y Etzion, M Mor, L Buzaglo, L Shaltiel, LA Gheber, J Kahn, AJ Muslin, A Katz, D Gitler and A Moran, *J Biol Chem*, **284**(47), 32434–43 (2009).

33 T Jirakulaporn and AJ Muslin, *J Biol Chem*, **279**(26), 27807–15 (2004).

34 TB Cole, HJ Wenzel, KE Kafer, PA Schwartzkroin and RD Palmiter, *Proc Natl Acad Sci USA*, **96**(4), 1716–21 (1999).

35 RD Palmiter, TB Cole, CJ Quaife and SD Findley, *Proc Natl Acad Sci USA*, **93**(25), 14934–39 (1996).

36 F Chimienti, S Devergnas, F Pattou, F Schuit, R Garcia-Cuenca, B Vandewalle, J Kerr-Conte, L Van Lommel, D Grunwald, A Favier and M Seve, *J Cell Sci*, **119**(Pt 20), 4199–206 (2006).

37 R Sladek, G Rocheleau, J Rung, C Dina, L Shen, D Serre, P Boutin, D Vincent, A Belisle, S Hadjadj, B Balkau, B Heude, G Charpentier, TJ Hudson, A Montpetit, AV Pshezhetsky, M

Prentki, BI Posner, DJ Balding, D Meyre, C Polychronakos, P Froguel, *Nature*, **445**(7130), 881–85 (2007).

38 K Lemaire, MA Ravier, A Schraenen, JW Creemers, R Van de Plas, M Granvik, L Van Lommel, E Waelkens, F Chimienti, GA Rutter, P Gilon, PA in't Veld and FC Schuit, *Proc Natl Acad Sci USA*, **106**(35), 14872–77 (2009).

39 FW Studier and BA Moffatt, *J Mol Biol*, **189**(1), 113–30 (1986).

40 FW Studier, *Protein Expr Purif*, **41**(1), 207–34 (2005).

41 Y Chao and D Fu, *J Biol Chem*, **279**(17), 17173–80 (2004).

42 M Lu, J Chai and D Fu, *Nat Struct Mol Biol*, **16**(10), 1063–67 (2009).

43 Y Hayashi, H Matsui and T Takagi, *Methods Enzymol*, **172**, 514–28 (1989).

44 Y Wei, H Li and D Fu, *J Biol Chem*, **279**, 39251–59 (2004).

45 M Lu and D Fu, *Science*, **317**(5845), 1746–48 (2007).

46 OS Andersen, and RE Koeppe, 2nd, *Annu Rev Biophys Biomol Struct*, **36**, 107–30 (2007).

47 V Cherezov, DM Rosenbaum, MA Hanson, SG Rasmussen, FS Thian, TS Kobilka, HJ Choi, P Kuhn, WI Weis, BK Kobilka and RC Stevens, *Science*, **318**(5854), 1258–65 (2007).

48 E Pebay-Peyroula, G Rummel, JP Rosenbusch and EM Landau, *Science*, **277**(5332), 1676–81 (1997).

49 SG Rasmussen, HJ Choi, DM Rosenbaum, TS Kobilka, FS Thian, PC Edwards, M Burghammer, VR Ratnala, R Sanishvili, RF Fischetti, GF Schertler, WI Weis and BK Kobilka, *Nature*, **450**(7168), 383–87 (2007).

50 J Abramson, I Smirnova, V Kasho, G Verner, HR Kaback and S Iwata, *Science*, **301**(5633), 610–15 (2003).

51 O Mirza, L Guan, G Verner, S Iwata and HR Kaback, *EMBO J*, **25**(6), 1177–83 (2006).

52 X Yao, C Parnot, X Deupi, VR Ratnala, G Swaminath, D Farrens and B Kobilka, *Nat Chem Biol*, **2**(8), 417–22 (2006).

53 Y Yin, MO Jensen, E Tajkhorshid and K Schulten, *Biophys J*, **91**(11), 3972–85 (2006).

54 AK Wernimont, DL Huffman, AL Lamb, TV O'Halloran and AC Rosenzweig, *Nat Struct Biol*, **7**(9), 766–71 (2000).

55 LA Finney and TV O'Halloran, *Science*, **300**(5621), 931–36 (2003).

56 Y Huang, MJ Lemieux, J Song, M Auer and DN Wang, *Science*, **301**(5633), 616–20 (2003).

57 C Hunte, E Screpanti, M Venturi, A Rimon, E Padan and H Michel, *Nature*, **435**(7046), 1197–202 (2005).

58 A Yamashita, SK Singh, T Kawate, Y Jin and E Gouaux, *Nature*, **437**(7056), 215–23 (2005).

59 DW Hilgemann, *Nature*, **344**(6263), 242–45 (1990).

60 GM Besserer, M Ottolia, DA Nicoll, V Chaptal, D Cascio, KD Philipson and J Abramson, *Proc Natl Acad Sci USA*, **104**(47), 18467–72 (2007).

61 S Eshaghi, D Niegowski, A Kohl, D Martinez Molina, SA Lesley and P Nordlund, *Science*, **313**(5785), 354–57 (2006).

62 M Hattori, Y Tanaka, S Fukai, R Ishitani and O Nureki, *Nature*, **448**(7157), 1072–75 (2007).

63 VV Lunin, E Dobrovetsky, G Khutoreskaya, R Zhang, A Joachimiak, DA Doyle, A Bochkarev, ME Maguire, AM Edwards and CM Koth, *Nature*, **440**(7085), 833–37 (2006).

64 J Payandeh and EF Pai, *EMBO J*, **25**(16), 3762–73 (2006).

65 M Hilge, J Aelen and GW Vuister, *Mol Cell*, **22**(1), 15–25 (2006).

66 DH Nies, *Science*, **317**(5845), 1695–96 (2007).

67 J Frausto da Silva and R Williams, *The Biological Chemistry of the Elements-The Inorganic Chemistry of Life*, Oxford University Press, pp 315–33 (2001).

68 W Maret and Y Li, *Chem Rev*, **109**(10), 4682–707 (2009).

69 SF Sousa, PA Fernandes and MJ Ramos, *J Am Chem Soc*, **129**(5), 1378–85 (2007).

70 BL Vallee and DS Auld, *Proc Natl Acad Sci USA*, **87**(1), 220–24 (1990).

71 Y Wei and D Fu, *J Biol Chem*, **281**(33), 23492–502 (2006).

72 DA Doyle, J Morais Cabral, RA Pfuetzner, A Kuo, JM Gulbis, SL Cohen, BT Chait and R MacKinnon, *Science*, **280**(5360), 69–77 (1998).

73 L Di Costanzo, LV Flores Jr and DW Christianson, *Proteins*, **65**(3), 637–42 (2006).

74 H Luecke, HT Richter and JK Lanyi, *Science*, **280**(5371), 1934–37 (1998).

75 V Cherezov, N Hofer, DM Szebenyi, O Kolaj, JG Wall, R Gillilan, V Srinivasan, CP Jaroniec and M Caffrey, *Structure*, **16**(9), 1378–88 (2008).

76 AC Rosenzweig and TV O'Halloran, *Curr Opin Chem Biol*, **4**(2), 140–47 (2000).

77 DL Huffman and TV O'Halloran, *Annu Rev Biochem*, **70**, 677–701 (2001).

78 F Arnesano, L Banci, I Bertini, S Ciofi-Baffoni, E Molteni, DL Huffman and TV O'Halloran, *Genome Res*, **12**(2), 255–71 (2002).

79 LW Klomp, SJ Lin, DS Yuan, RD Klausner, VC Culotta and JD Gitlin, *J Biol Chem*, **272**(14), 9221–26 (1997).

80 ED Harris, *Annu Rev Nutr*, **20**, 291–310 (2000).

81 DW Cox and SD Moore, *J Bioenerg Biomembr*, **34**(5), 333–38 (2002).

82 S Lutsenko, RG Efremov, R Tsivkovskii and JM Walker, *J Bioenerg Biomembr*, **34**(5), 351–62 (2002).

83 D Achila, L Banci, I Bertini, J Bunce, S Ciofi-Baffoni and DL Huffman, *Proc Natl Acad Sci USA*, **103**(15), 5729–34 (2006).

84 LA Yatsunyk and AC Rosenzweig, *J Biol Chem*, **282**(12), 8622–31 (2007).

85 RA Pufahl, CP Singer, KL Peariso, SJ Lin, PJ Schmidt, CJ Fahrni, VC Culotta, JE Penner-Hahn and TV O'Halloran, *Science*, **278**(5339), 853–56 (1997).

86 C Rensing, B Fan, R Sharma, B Mitra and BP Rosen, *Proc Natl Acad Sci USA*, **97**(2), 652–56 (2000).

87 C Rensing, B Mitra and BP Rosen, *Proc Natl Acad Sci USA*, **94**(26), 14326–31 (1997).

88 L Banci, I Bertini, S Ciofi-Baffoni, LA Finney, CE Outten and TV O'Halloran, *J Mol Biol*, **323**(5), 883–97 (2002).

Zinc-binding protein ZnuA

Thomas J Smith[†] and Himadri B Pakrasi[‡]

[†] Donald Danforth Plant Science Center, 975 North Warson Road, St. Louis, MO 63132, USA
[‡] Department of Biology, Campus Box 1137, Washington University, St. Louis, MO 63130, USA

FUNCTIONAL CLASS

Binding protein; ATP-binding cassette (ABC) zinc importer.

Zinc uptake (Znu)A is a high-affinity, periplasmic zinc (Zn^{2+})-binding protein, which is a component of a three-protein ABC transport system.

OCCURRENCE

ZnuA belongs to the 'Cluster 9'[1] ABC-type transport proteins that are involved in the uptake of transition-metal ions. In *Synechocystis* 6803, the *znu* operon includes the *znuA*, *znuB*, and *znuC* genes that encode the periplasmic Zn-binding protein, the integral membrane protein component, and the cytoplasmic ABC domain, respectively (3D Structure).

BIOLOGICAL FUNCTION

First identified in *Escherichia coli*, the *znu* system has been shown to be important for scavenging and transporting Zn^{2+}.[3] Inactivation of genes that encode homologs of *znuA* has resulted in decreased growth rates and virulence in several pathogenic bacteria.[4–6]

AMINO ACID SEQUENCE INFORMATION

ZnuA belongs to a large group of solute-binding proteins associated with the ABC metal transport systems.[1] Within this homologous group of proteins, the functional distinction is less clear (e.g. Zn^{2+} *versus* Mn^{2+} transport). However, among those with clearly identified transport ligands, there seems to be a good correlation between the transport of zinc and the presence of an acid/histidine-rich loop adjacent to the ligand binding pocket.[1,7–9] Below is the sequence information for *Synechocystis* 6803 ZnuA and several of the other likely zinc-binding proteins.

- *Synechocystis* sp. PCC 6803: Periplasmic binding protein component of an ABC-type zinc uptake transporter, 338 amino acids (AA), translation of cDNA sequence, BAA17110 NCBI.[10]
- *E. coli* str. K12 substr. MG1655: Zinc transporter subunit: periplasmic binding component of ABC superfamily, 310 AA, translation of cDNA sequence, NP_416371 NCBI.[11]

3D Structure Structure of ZnuA and overview of the ZnuABC metal transport system. On the left is a ribbon diagram of wild-type ZnuA colored from blue to red as the chain extends from the amino to the carboxyl terminus. The bound zinc atom is represented by a mauve sphere, and the three chelating His residues and one water molecule are also shown. On the right is a diagrammatic representation of the ZnuABC transport system created using the program CHIMERA[2] using the structure of full-length ZnuA (PDB ID 1pq4).

- *Desulfovibrio desulfuricans* G20: ABC-type metal ion transport system, periplasmic component/surface adhesin, 366 AA, translation of cDNA sequence, ZP_00129856 NCBI.
- *Wolinella succinogenes*: Adhesion protein, 293 AA, translation of cDNA sequence CAE10146 NCBI.[12]

PROTEIN PRODUCTION AND PURIFICATION

Expression and purification of recombinant ZnuA

Four different heterologous expression constructs were made to express ZnuA. The N-terminus of ZnuA contains a hydrophobic membrane anchor. Therefore, in all cases, primers were designed to eliminate the first 27 residues of the mature ZnuA protein. In the first study,[8] the genomic DNA encoding residues 28–339 were amplified by polymerase chain reaction (PCR) from *Synechocystis* 6803 genomic DNA and inserted into pET41a (Novagen) in frame with the N-terminal glutathione transferase gene using EcoR I and Xho I restriction sites. In subsequent studies, ZnuA, as well as the Δ158–173 and Δ138–173 (Table 1) mutants, were inserted into the pGEX-4T-1 expression vector.

All of the various constructs were transformed into *E. coli* BL21 (DE3) strain. ZnuA expression was induced with isopropyl-ß-D-thiogalactopyranoside (IPTG) and the cells were harvested by centrifugation and lysed by sonication or using a French press. In all cases, the expressed protein was found in the soluble fractions and purified using the glutathione S-transferase (GST) tag on the protein and glutathione sepharose 4B affinity chromatography. Peak fractions were pooled, and enterokinase was used to remove the GST. The digested material was then passed over a glutathione sepharose column to remove uncleaved fusion protein and GST.

Preparation of apo wild-type and mutant ZnuA

Zinc was removed from wild-type and mutant ZnuA as previously described[13] with minor modifications. Purified ZnuA protein was diluted to a concentration of 2 mg mL^{-1}, and then dialyzed against 0.1 M sodium acetate (pH 4.6), 10 mM 1,10-phenanthroline overnight with four buffer changes. Atomic absorption spectroscopy was used to confirm that the zinc had been removed from the protein.

X-RAY STRUCTURE

Crystallization of ZnuA

For crystallization experiments, the protein was concentrated to 10 mg mL^{-1} using Amicon Centricons. The protein was crystallized using the vapor diffusion method and a hanging drop apparatus at room temperature. The drops were composed of 5 μL protein and 5 μL of reservoir solution (1.5–2.5 M ammonia sulfate). Crystals grew to dimensions of $0.2 \times 0.2 \times 0.4 \, mm^3$ within 1 week. In the case of the Δ138–173 mutant form of ZnuA, the protein was concentrated to 15 mg mL^{-1} using Amicon Centricons and crystallized using the vapor diffusion method at room temperature. The reservoir solution contained 100 mM β-alaninediacetic acid (ADA), pH 6.5, and 1.8–2.0 M ammonium sulfate. Crystals grew to dimensions of $0.2 \times 0.3 \times 0.1 \, mm^3$.

Diffraction data collection and structure determination

Diffraction data from native crystals of ZnuA were collected at room temperature on a Proteum R Smart 6000 CCD detector connected to a Bruker-Nonius FR591 rotating anode X-ray generator. Diffraction intensities were integrated, merged, and scaled using the Proteum software suite. Reflections were observed to a resolution of 1.7 Å, but data was integrated and scaled to 1.9 Å. The crystals belong to the space group P2$_1$ with unit cell dimensions of $a = 64.99 \, \text{Å}$, $b = 78.40 \, \text{Å}$, $c = 68.50 \, \text{Å}$, and $\beta = 117.81°$. From Matthews coefficient V_M calculations, it was determined that there were two molecules in each asymmetric unit ($V_M = 2.4 \, \text{Å}^3 \, Da^{-1}$).

Table 1 Sequences of the flexible loop deletion mutants of ZnuA

The middle segment represents those residues that were disordered in the structure of the wild-type ZnuA.[8] The short segments that are underlined represent residues that were used as linker regions in the constructs and are not found in the wild-type sequence. Numbering used for all constructs corresponds to the wild-type sequence.

The initial structure of wild-type ZnuA was determined by molecular replacement.[8] Because of the limited sequence identities between ZnuA and those of the previously determined structures PsaA (23%; PDB ID 1psz) and TroA (27%; PDB ID 1toa), several starting models were generated and a molecular replacement solution was found using AMORE.[14] Using CNS for all subsequent refinement, this model was subjected to rigid-body refinement followed by energy minimization and simulated annealing with noncrystallographic restraints with reflection data between 20 and 3.0 Å. The model was then subjected to cycles of simulated annealing, energy minimization, and B-factor refinement, with the resolution being increased by 0.1 Å at each step to the final resolution of 1.9 Å. The program 'O'[15] was used for model building, and the electron density was twofold averaged at times with the program RAVE[16] to help break model phase bias. Zinc atoms were placed at the expected zinc-binding sites since electron density peaks were observed that had amplitudes more than 8σ above the mean value. A zinc ion was added to the model and its B-factor refined to ~15 Å2, while the average thermal factor for the residues binding to the zinc are ~12 Å2. The identity of the metal moiety was further corroborated by atomic absorption spectroscopy.

The structures of the Δ138–173 mutant in the presence and absence of zinc were determined by molecular replacement using the program MOLREP[17] and the structure of wild-type zinc-bound form of ZnuA.[8] CNS[18] was used for all subsequent refinement, and the program 'O'[19] was used to make adjustments to the model. Upon refinement of this structure, it was apparent that zinc was not present as it had been in the case of full-length ZnuA.[8] Therefore to prepare a zinc-bound form of this deletion mutant, 50 mM zinc acetate was added to all of the cryoprotectant solutions. Even though zinc was not included in the initial refinement model, it was immediately apparent that zinc was bound and that there were concomitant conformational changes in the immediate vicinity of the bound zinc.

COMPLEX STRUCTURES

The overall structure of ZnuA is very similar to the previous structures of the periplasmic domains of the ABC metal transporters PsaA[20] and TroA.[13,21] PsaA stands for pneumococcal surface antigen A, and TroA is a related periplasmic protein from *Treponema palladium*. ZnuA has a 'C clamp' shape that is composed of two $(\beta/\alpha)_4$ domains related by pseudo twofold symmetry (3D Structure). Also, like the other metal transporters, the two domains are linked by a 33-residue α-helix. This helix is likely to restrain domain flexibility compared to the extended β-strand found in the ABC transporters for larger solutes.[22]

Unlike TroA and PsaA, ZnuA possesses a highly charged, 36-residue insert (residues 138–173) located between β2-1

ZnuA (+Zn^{2+})
Δ138–173 ZnuA (apo)

Δ138–173 ZnuA (+Zn^{2+})
Δ138–173 ZnuA (apo)

Figure 1 Structures of apo and zinc-bound Δ158–173 ZnuA compared to wild-type ZnuA created using the program CHIMERA.[2] The left ribbon diagram shows a comparison of the full-length ZnuA (blue) with the apo form of Δ158–173 ZnuA (red). The bound zinc in the wild-type ZnuA structure is represented by the mauve sphere. The black arrow denotes the location of the flexible loop in the wild-type form of ZnuA. Note that the deletion of this loop does not affect the conformation of the polypeptide leading into, or returning from, this flexible region. On the right is a comparison of the structure of the Δ158–173 ZnuA mutant in the presence (green) and absence (red) of bound zinc. Note that the structure of ZnuA remains relatively unchanged as zinc binds.

and β2-1 (using the TroA topology nomenclature[13,21]) in the N-terminal domain (3D Structure and Figure 1). This insert is mostly disordered in the crystal structure and it was possible to build only 13 residues of this loop in spite of several cycles of refinement and real-space density averaging. Disorder in this region is not surprising because of its highly charged nature and the fact that both the secondary structure prediction algorithm PHD[23] and the fold recognition program DALI[24] suggested that the loop has a random-coil secondary structure.

The fact that character and location of the loop are conserved among the ZnuA proteins suggests an important role for this feature. The charged mobile nature of this loop (12 acid and 8 histidine residues) makes it tempting to speculate that it may play some role in acquiring metals in the periplasmic space. It may be that this loop helps to sequester metal ions in the area immediately around the metal-binding cleft via weak interactions. However, the fact that this loop is absent in the other ABC metal transporters suggests that it is not necessary for transporting all metals. Alternatively, this charged loop might be used for ZnuA/ZnuB interactions. However, the sequences of

the membrane channel domains are well conserved among all of the 'Cluster 9' ABC transporters and there is no obvious unique region of charged residues in ZnuB that would complement this loop.

The other region of the protein that exhibited significant disorder was the N-terminus. The first 27 residues of the N-terminus, proposed to be the membrane anchor domain, had been removed when the *znuA* gene was moved into the heterologous expression system, and the following 19 residues were also not included in the model owing to poorly defined electron density. This is also not surprising since it is likely that this region is a flexible tether connecting the metal-binding domain to the membrane anchor.

To address the possible role of this flexible loop adjacent to the metal-binding site, the loop was deleted (Δ138–173) and the structure was determined in the presence and absence of zinc (Figures 1 and 2). Comparison of these two structures with the wild-type form of ZnuA allows direct comparison of the flexible loop conformation in the presence and absence of bound metal. As shown in Figure 1, there are apparent conformational differences between the structures of the full-length and the Δ138–173 mutant forms of ZnuA. However, it is also clear that the structure of the protein main chain leading into and out of the flexible loop appears to be unchanged by the deletion (arrow A). Further, it was particularly striking was that the backbone conformation of Δ138–173 ZnuA did not change significantly upon zinc binding. From the analysis of the crystal packing, it seemed more than likely that the differences between the deletion mutant and intact form of ZnuA were more due to crystal contacts than the deletion of the flexible loop *per se*.

The above results suggest that the zinc-binding site remains fixed whereas the domains of the whole protein are rather plastic. Indeed, the residues in contact with the bound zinc are essentially identical regardless of the

presence of the flexible loop (Figure 2). This suggests that the zinc-binding environment is unaffected by either the loop deletion or by the differences in domain conformations. While the solute-binding domains from other ABC transport systems often undergo large motion during the binding and release of ligand, it appears that ZnuA does not, and, in fact, the metal-binding conformation remains unchanged during significant domain movement. This suggests a different structural mechanism for ligand release than that found in other ABC transport systems.

The metal-binding site lies in the cleft between the two domains and is comprised of three histidine residues (AA numbers 83, 179, and 243) and a water molecule arranged as a trigonal pyramid with the solvent occupying the apical position (Figure 2). The histidines interact via their Nε2 nitrogen atoms. The orientations of these histidines are strengthened by additional interactions with the free Nδ1 on the imidazole rings; His179 (Nδ1) interacts with Asp177 (Oδ1) and His243 (Nδ1) interacts with Glu261 (Oδ1). The water molecule that forms the fourth coordination ligand interacts with Ser245. However, this interaction is probably weak since, according to the electron density, the side chain for Ser245 has two clear orientations of which only one interacts with the water. Besides Ser245, this water molecule is in a nonpolar cavity (Figure 2). This implies that the solvent is brought into this region by the metal ion during the process of binding and may act to shield the charge of the zinc from the hydrophobic residues.

A crucial aspect of the metal ion coordination site in ZnuA is the altered conformation of Asp313 compared to the other metal transporters. This aspartate is highly conserved among all the Cluster 9 ABC-type transporters and forms the fourth coordination site in TroA[21] and PsaA.[20] In ZnuA, Asp313 is oriented away from the metal-binding cavity and forms hydrogen bonds with several external water molecules. This difference in architecture

Figure 2 Structural details of the zinc-binding site in the presence (left) and absence (right) of metal. On the right are some of the interactions between ZnuA and the bound zinc ion (green sphere). When the metal is released (right), only His179 remains relatively unchanged and a number of water molecules enter into the site. These figures were created using the program PyMOL.[25]

is due to differences in the residues upstream from this aspartate compared to TroA and PsaA. Interestingly, the ZnuA from *E. coli* replaces the water molecule with a nonconserved E59 that binds in a monodentate manner.[9,26] This disagrees with our initial proposal that the specificity of ZnuA for zinc over manganese might be governed by the lack of a fourth protein coordination residue; zinc is often found bound to proteins via three histidine residues but manganese was never found bound to this configuration. The interaction with Glu59 in *E. coli* ZnuA has an unknown biological role but is likely to enhance binding affinity. It should be noted that even though theoretically Cu^{2+} is also able to bind to a histidine-rich site, the normal $His–Zn^{2+}$ bonding distances are slightly longer than $His–Cu^{2+}$ and therefore more subtle differences in ligation environments may also affect metal specificity.

The zinc in the TroA is bound in a pentavalent manner with three His and one Asp residues. This environment can bind Fe^{2+}, Mn^{2+}, and Zn^{2+}, with Mn^{2+} being the slightly favored metal.[27] The metal–protein distances in TroA are all >2.2 Å[21] and are actually more typical of protein–Mn^{2+} interactions than of zinc. While this might negatively impact zinc binding, it is likely that the pentavalent nature of this site compensates for these longer bonding distances. A similar broad metal specificity has been observed with Irt1, a metal transporter in plants.[28] PsaA is the only structure determined to date with a 2 His + 1 Glu + 1 Asp architecture.[20] However, proteins with the similar 2 His + 2 acid configurations can support both Zn^{2+} and Mn^{2+} binding. More recently, the analysis of the MntABC permease (Mnt stands for manganese transport) from *Neisseria gonorrhoeae* also demonstrated that the metal-binding protein can bind either zinc or manganese.[29] From these results, it seems likely that *Synechocystis* ZnuA may be the most specific for Zn^{2+} transport by virtue of the 3-His chelating environment. However, it should also be remembered that the relative concentrations of these two metals would also greatly impact which metal is transported by the various ABC systems.

The highly charged and mobile loop between β2-1 and β2-1 is apparently unique to the Zn^{2+}-binding proteins. ZnuA proteins from various organisms have inserts of differing lengths but with similar chemical characteristics, whereas this region is absent in the Mn^{2+} metal-binding proteins. What is particularly interesting is that ZntA[30–32] and ZIP4[33,34] are cytoplasmic zinc transporters that do not belong to the same class as ZnuA but have a very similar charged extension. In the case of ZntA, the *N*-terminus is rich in His and Cys residues, which would be expected to interact with zinc at some level. Deletion of this extension affects the kinetics of zinc export but does not abrogate activity.[32] It seems possible that, since free zinc is at such low concentrations in the periplasm and cytoplasm,[35] these charged loops in the zinc transporters are necessary to chaperone the zinc to the metal-binding cleft. It follows that this element might not be needed in the manganese transporters

since free manganese concentrations are significantly higher than that of zinc.[35]

To dissect the possible role of this loop with regard to zinc binding to the high-affinity site, two ZnuA mutants were created. The first construct represented a 'half loop' deletion where residues 158–173 were replaced with a shorter PYTDK linker (called Δ158–173 ZnuA). The second construct (called Δ138–173 ZnuA) replaced the entire flexible loop (residues 138–173) with the much shorter loop (PGRL) that is found the other group 9 ABC solute-binding domains. While both proteins expressed to relatively high levels and were readily purified, crystals were obtained only with the full-loop deletion mutant (Δ138–173 ZnuA).

As noted above, this deletion did not, by itself, appear to significantly affect the protein conformation. However, deletion of this flexible loop facilitated crystallization of the apo form of ZnuA so that the conformational changes associated with metal binding could be determined. While the backbone of Δ138–173 ZnuA remains largely unaffected by zinc binding, there are striking changes in the zinc-binding site (Figure 2). Zinc bound to Δ138–173 ZnuA is essentially identical to that observed in wild-type ZnuA even with regard to the water molecule associated with zinc and, compared to the apo form, relatively few water molecules elsewhere in this metal-binding pocket. When zinc is released, two of the three histidines (His83 and His243) sweep out of the binding pocket, while His179 remains relatively fixed. The metal–His179 interaction is replaced by a hydrogen bond with a new water molecule. In the presence of zinc, His243 is hydrogen bonded to both Glu261 and the zinc atom. In the absence of zinc, the side chains of His243 and Glu261 move out of the metal-binding pocket and maintain that hydrogen bond. Glu290 moves in to replace the His243–zinc hydrogen bond. In this new orientation, Glu290 also forms a hydrogen bond with Ser245. As His83 leaves the metal-binding pocket, Asp81 moves in with two associated water molecules. Overall, the removal of zinc from the binding pocket causes a marked increase in hydration but, unlike many other solute-binding proteins from various ABC transporters, it is not associated with significant changes in domain conformation.

FUNCTIONAL ASPECTS

The structures of the Δ138–173 ZnuA mutant in the presence and absence of zinc strongly suggested that the effects of deleting this large, flexible loop were limited to the immediate vicinity and did not affect the metal-binding site. Nevertheless, we initially proposed that the loop might affect binding by chaperoning the metal to the high-affinity site.[8] To see whether the deletion affected the intrinsic affinity of ZnuA for Zn^{2+}, ITC was performed on wild-type and the two loop mutants Δ158–173 and Δ138–173.

Figure 3 Isothermal titration calorimetry (ITC) analysis of zinc binding. Shown here are the ITC results of zinc binding to full-length, Δ138–173, and Δ158–173 forms of ZnuA (left to right). In each panel, the top figure shows the raw ITC data and the bottom figures show the same data along with the curve-fitting results. The curve-fitting results are summarized in the table at the bottom of the figure.

Isothermal titration calorimetry (ITC)

Samples of ZnuA that had been stripped of zinc were analyzed using on a MicroCal VP-ITC titration calorimeter. Zinc chloride was dissolved in the same degassed buffer that the proteins were dialyzed against, and protein concentration was adjusted to 1–3 mM. The protein samples ranging in concentrations from 0.02 to 0.035 mM were placed in the reaction cell, and the reference cell was filled with deionized water. Control experiments to determine the heat absorbed due to dilution of the zinc solution were carried out with identical injections in the absence of protein. These values were then used to normalize the ZnuA binding data. The titration data were curve-fitted to models that assumed either one or two classes of noninteracting binding sites using a nonlinear least-squares algorithm in the MicroCal Origin software package. The binding enthalpy change ΔH, association constant K_a, and the binding stoichiometry n were all refined during the least-squares minimization process.

The binding of zinc to wild-type ZnuA cannot be described by a single class of sites model. As shown in Figure 3, the binding fits well to a model with two classes of sites with disassociation constants of ~10 and 10 000 nM. The number of zinc molecules bound per class

of sites is not a reliable number, since the enthalpies of the various interactions are not measured independently. This is made evident by the fact that there is only one high-affinity site, yet the curve fitting suggests that there are two. Nevertheless, it is interesting to note that the ratio of the low-affinity sites to high-affinity sites is approximately 3. These results are in contrast to those of the Δ138–173 form of ZnuA. Here the data is very well described by a model assuming only a single class of high-affinity zinc-binding sites. When the error of the curve fitting is accounted for, the binding constant for this one site is very close to that of the high-affinity site of wild-type ZnuA. Therefore, this demonstrates that the intrinsic affinity for zinc binding to the high-affinity site is unaffected by the deletion of the flexible loop. This also suggests that the loop itself does not appear to facilitate the acquisition of zinc in the high-affinity site at least *in vitro*. From the chemical nature of the flexible loop, it seems likely that there are multiple binding sites for zinc on the flexible loop. Indeed, when half the loop is deleted (Δ158–173 ZnuA), there are still two classes of binding sites but now the ratio of low- to high-affinity sites has decreased to approximately 1. Further, the association constants for both classes of sites are consistent with both wild-type and Δ138–173 ZnuA. Therefore, the data suggests that the loop has multiple binding sites for

zinc but that the affinity of these sites for zinc are two to three orders of magnitude weaker than for the high-affinity site. This is consistent with recent result on the ZnuA from *E. coli.*[9] Finally, neither full nor partial deletion of this loop appears to have significant effects on the ability of the high-affinity site to bind zinc *in vitro*.

CONCLUDING REMARKS

Previously, the structure of a homologous metal-binding protein TroA was determined in the presence[21] and absence[13] of the bound metal. In that case, it was suggested that, upon the release of bound metal, the metal-binding site 'collapses' such that Asp66 (TroA sequence) shifts toward one of the chelating histidines, His68. It was suggested that this, in turn, caused the imidazole ring of His68 to flip and facilitates the release of bound metal. It should be noted that these two forms of TroA crystallized in two different space groups with inherently different crystal lattice contacts, and what we have observed with ZnuA is that such packing constraints can affect apparent domain conformation.

The effect of metal release is quite different in the case of Δ138–173 ZnuA. In this case, the domains did not appear to move significantly upon zinc binding or release. However, there was a rather large conformational difference between the full-length and Δ138–173 mutant forms of ZnuA. While it might be suggested that the deletion itself caused the conformational difference, this seems highly unlikely since the structure of the ZnuA at either side of the flexible loop was unaffected by the truncation. Further, the truncation did not have a significant affect on the high-affinity zinc-binding site (Figure 3). It is highly likely that the conformational differences between the structures of full-length ZnuA and Δ138–173 ZnuA are due to crystal packing forces. This suggests that ZnuA is more plastic than previously thought, and yet the zinc-binding site itself appears to be mostly unaffected by these conformational changes (Figure 2).

There are, however, a number of large changes in side chains lining the zinc-binding pocket upon the release of zinc. Only one histidine remains in its original conformation (His179), while the other two (His83 and His243) rotate out of the metal-binding pocket to be replaced by a number of water molecules and acidic residues. Since zinc can bind relatively well to two histidines, perhaps this movement is necessary to facilitate zinc release. What remains unclear, however, is what triggers zinc release to the ZnuB pore. The apparently plasticity of ZnuA may imply that, unlike other ABC transporters, the transmembrane pore may not be signaling metal release via imposition of conformational changes in the solute-binding domain. Perhaps for this class of ABC transporters, zinc release from ZnuA may be more of a passive event with the intracellular ATPase driving large conformational changes in the ZnuB pore more than ZnuA. For example, the ATPase may cause a conformational change in ZnuB, which opens up a binding site with higher affinity than that found in ZnuA or a direct opening to the cytoplasm where the free zinc concentration is extremely low.

The results presented here begin to narrow down the possible functions of the flexible loop that is rich in histidine and acidic residues (residues 138–173). This feature is found in all of the group 9 zinc transporters, and yet was completely disordered in the structure of full-length ZnuA.[8] What is now clear is that this loop likely has multiple zinc-binding sites with an affinity at least 100-fold weaker than the high-affinity site. We had previously suggested that the loop might 'chaperone' zinc to the high-affinity site perhaps by increasing the pool of zinc around the high-affinity site. However, at least *in vitro*, deletion of the loop does not seem to affect zinc binding.

It is possible that this loop is regulating ZnuABC-mediated transport. High levels of zinc are toxic to the cell and therefore the intracellular concentrations need to be tightly regulated. To this end, there is clear transcriptional regulation of the *znuA* operon. However, such regulation does not address the potential problem of rapid increases in zinc concentration in the extracellular milieu, which might overwhelm the cell before transcriptional regulation can respond. It is possible that this low-affinity zinc-binding loop is actually a 'sensor.' At very low concentrations of zinc, only the high-affinity site will bind the metal. It may be that at concentrations 100-fold higher than that needed for binding to the high-affinity site, zinc associates with the flexible loop and may actually lend structure to at least portions of the loop. This might block zinc transport by preventing association of ZnuA with ZnuB. It could even be that zinc associating with the loop could aggregate two or more copies of ZnuA on the cell membrane and block zinc transport.

ACKNOWLEDGEMENTS

This work was supported by funds from the US Department of Energy Office of Basic Energy Sciences to HBP and by the US Environmental Protection Agency to TJS.

REFERENCES

1 JP Claverys, *Res Microbiol*, **152**, 231–43 (2001).

2 EF Pettersen, TD Goddard, CC Huang, GS Couch, DM Greenblatt, EC Meng and TE Ferrin, *J Comput Chem*, **25**, 1605–12 (2004).

3 SI Patzer and K Hantke, *Mol Microbiol*, **28**, 1199–210 (1998).

4 CY Chen and SA Morse, *FEMS Microbiol Lett*, **202**, 67–71 (2001).

5 A Dintilhac, G Alloing, C Granadel and JP Claverys, *Mol Microbiol*, **25**, 727–39 (1997).

6 DA Lewis, J Klesney-Tait, SR Lumbley, CK Ward, JL Latimer, CA Ison and EJ Hansen, *Infect Immun*, **67**, 5060–68 (1999).

7 K Hantke, *Biometals*, **14**, 239–49 (2001).

8 S Banerjee, B Wei, M Bhattacharyya-Pakrasi, HB Pakrasi and TJ Smith, *J Mol Biol*, **333**, 1061–69 (2003).

9 LA Yatsunyk, JA Easton, LR Kim, SA Sugarbaker, B Brian, RM Breece, II Vorontsov, DL Tierney, MW Crowder and AC Rosenzweig, *J Biol Inorg Chem*, **13**, 271–88 (2008).

10 T Kaneko, A Tanaka, S Sato, H Kotani, T Sazuka, N Miyajima, M Sugiura and S Tabata, *DNA Res*, **2**, 153–66 (1995).

11 M Riley, T Abe, MB Arnaud, MK Berlyn, FR Blattner, RR Chaudhuri, JD Glasner, T Horiuchi, IM Keseler, T Kosuge, H Mori, NT Perna, GI Plunkett, KE Rudd, MH Serres, GH Thomas, NR Thomson, D Wishart and BL Wanner, *Nucleic Acids Res*, **34**, 1–9 (2006).

12 C Baar, M Eppinger, G Raddatz, J Simon, C Lanz, O Klimmek, R Nandakumar, R Gross, A Rosinus, H Keller, P Jagtap, B Linke, F Meyer, H Lederer and SC Schuster, *Proc Natl Acad Sci USA*, **100**, 11690–95 (2003).

13 Y-H Lee, MR Dorwart, KRO Hazlett, RK Deka, MV Norgard, JD Radolf and CA Hasemann, *J Bacteriol*, **184**, 2300–4 (2002).

14 J Navaza, *Acta Crystallogr*, **A50**, 157–63 (1994).

15 GJ Kleywegt and TA Jones, in S Bailey, R Hubbard and D Waller (eds.), *From First Map to Final Model*, SERC Daresbury Laboratory, Daresbury, UK, pp 59–66 (1994).

16 GJ Kleywegt and TA Jones, *Acta Crystallogr*, **D55**, 941–44 (1999).

17 A Vagin and A Teplyakov, *J Appl Crystallogr*, **30**, 1022–25 (1997).

18 AT Brunger, PD Adams, GM Clore, P Gros, RW Grosse-Kunstleve, J-S Jiang, J Kuszewski, N Nilges, NS Pannu, RJ Read, LM Rice, T Simonson and GL Warren, *Acta Crystallogr D*, **54**, 905–21 (1998).

19 TA Jones, J-Y Zou and SW Cowan, *Acta Crystallogr A*, **47**, 110–19 (1991).

20 MC Lawrence, PA Pilling, VC Epa, AM Berry, AD Ogunniyi and JC Paton, *Structure*, **6**, 1553–61 (1998).

21 Y-H Lee, R Deka, MV Norgard, JD Radolf and CA Hasemann, *Nat Struct Biol*, **6**, 628–33 (1999).

22 FA Quiocho and PS Ledvina, *Mol Microbiol*, **20**, 17–25 (1996).

23 B Rost, *Methods Enzymol*, **266**, 525–39 (1996).

24 L Holm and C Sander, *J Mol Biol*, **233**, 123–38 (1993).

25 WL DeLano, *The PyMOL Molecular Graphics System*, DeLano Scientific LLC, Palo Alto, CA (2008).

26 H Li and G Jogl, *J Mol Biol*, **368**, 1358–66 (2007).

27 KRO Hazlett, F Rusnak, DG Kehres, SW Bearden, CJ La Vake, ME La Vake, ME Maguire, RD Perry and JD Radolf, *J Biol Chem*, **278**, 20687–94 (2003).

28 YO Korshunova, D Eide, WG Clark, ML Guerinot and HB Pakrasi, *Plant Mol Biol*, **40**, 37–44 (1999).

29 KHL Lim, CE Jones, RN vanden Hoven, JL Edwards, ML Falsetta, MA Apicella, MP Jennings and AG McEwan, *Infect Immun*, **76**, 3569–76 (2008).

30 L Banci, I Bertini, S Ciofi-Baffoni, LA Finney, CE Outten and TV O'Halloran, *J Mol Biol*, **323**, 883–97 (2002).

31 Z Hou and B Mitra, *J Biol Chem*, **278**, 28455–61 (2003).

32 A Mitra and R Sharma, *Biochemistry*, **40**, 7694–99 (2001).

33 G Grass, MD Wong, BP Rosen, RL Smith and C Rensing, *J Bacteriol*, **184**, 864–66 (2002).

34 DJ Eide, *Pflugers Arch*, **447**(5), 796–800 (2004).

35 LA Finney and TV O'Halloran, *Science*, **300**, 931–36 (2003).

Other Zinc Proteins

BAK

Tudor Moldoveanu[†], Qian Liu[‡], Douglas R Green[†] and Kalle Gehring[‡]

[†]Department of Immunology, St. Jude Children's Research Hospital, Memphis, TN, USA
[‡]Department of Biochemistry, McGill University, Montreal, Quebec, Canada

FUNCTIONAL CLASS

Outer mitochondrial (OM) and endoplasmic reticulum (ER) transmembrane protein; B cell lymphoma (*BCL*)-2 homologous *antagonist/killer* or BAK; Proapoptotic BCL (B cell lymphoma)-2 family protein that drives the mitochondrial pathway of apoptosis, binds and is inhibited by zinc, and undergoes oxidative modifications.

BAK[1–3] integrates upstream cell death signals to regulate mitochondrial outer membrane permeabilization (also known as *MOMP*) in the intrinsic apoptotic pathway. This 24-kDa proapoptotic BCL-2 family protein is anchored to target membranes *via* a 3-kDa *C*-terminal transmembrane (TM) region. Out of 13 paralogs in the human genome, BAK and its functional relative BAX (B cell lymphoma-2-associated X protein)[4] are the two BCL-2 family proteins absolutely indispensable for MOMP.[5,6]

OCCURRENCE

BCL-2 family proteins are found in mammals, their associated viruses, fruit flies, and nematodes; so far they have not been identified in single-cell organisms.[7] BAK

and BAX have been best characterized in mammals, where they are expressed at various levels in all tissue types from the developing embryo to the aging adult.[8] Antiapoptotic BCL-2 family proteins including BCL-2 and BCL-x_L (BCL-2-like isoform 1) and many B cell lymphoma-2 homology 3 (BH3)-only proapoptotic proteins are coexpressed with BAK and BAX.[9] Acting together, these proteins function as a life and death intracellular rheostat[10] to determine the inactive or active MOMP status of cells.[11] In all cells, BAK is localized to the cytosolic face of OM/ER membranes, whereas BAX is cytosolic, soluble, and translocates to the outer mitochondrial membrane (OMM) when activated.[12]

BIOLOGICAL FUNCTION

The physiological role of BAK (and BAX) is to drive the mitochondrial pathway of apoptosis through protein–protein–membrane interactions.[13,14] This pathway is engaged intrinsically by the p53-DNA damage response system[15] and by several kinase networks,[16] or extrinsically through death receptor-mediated signaling[17] that upregulates and/or mobilizes sequestered BAK/BAX-activating BH3-only proteins to exert proapoptotic functions at

3D Structure Schematic representation of the monomer structure of BAK showing the conserved BH1-3 regions, PDB code: 2IMS. This figure and Figures 1–7 were prepared with the program PyMOL.[46]

the mitochondria. BAK directly mediates the release of apoptogenic factors from the mitochondrial intermembrane space by forming porelike structures within the OMM.[18]

The 'globular' 21-kDa portion of BAK is postulated to exist in several different conformations including an inactive soluble, an activated soluble, and activated membrane-bound. The latter represent intermediates of a putative porelike structure, which releases proteins as small as the 12-kDa cytochrome (cyt) c and as large as the 116-kDa trimeric serine protease Htra2 (high temperature requirement gene A-like serine peptidase 2), to promote apoptosis. BAK is tightly inhibited ($IC_{50} < 1 \mu M$) by all antiapoptotic BCL-2 proteins (BCL-2, BCL-X_L, BCL-2-like isoform 2 or BCL-w, myeloid cell leukemia sequence 1 (MCL-1) and BCL-2-related protein A1), presumably by sequestration of the activated intermediate states and the pore via the BAK BH3 region, but in $vivo$, MCL-1 and BCL-X_L represent the primary and secondary BAK inhibitor, respectively.[19] The inhibited BAK complexes (e.g. MCL-1–BAK) can be dissociated by excess proapoptotic BH3-only proteins, which compete for the BH3 binding pocket of the antiapoptotics to release active BAK. Preactivated, antiapoptotic-inhibited BAK species are readily observed in tumors or transformed cells,[20,21] whereas in healthy cells BAK is thought to exist mostly in the free inactive form, which requires activation by a select class of BCL-2 proteins known as the *direct activator BH3-only proteins*,[11] including BID (B cell lymphoma-2 homology-3 interacting domain death agonist), BIM (BCL-2-like isoform 11 apoptosis facilitator), and, potentially, PUMA (p53 upregulated modulator of apoptosis).[22]

An emerging role in the regulation of mitochondrial morphology and morphogenesis has been recently attributed to BAK[23] and BAX.[24] Both seem to modulate mitochondrial network dynamics by interacting with members of the family of large guanosine triphosphatases (GTPases) mitofusins (Mfn) including Mfn1 and Mfn2. It is not conclusive whether this function is required for MOMP and apoptosis.[25]

AMINO ACID SEQUENCE INFORMATION

Homo sapiens (human), BAK has 211 amino acid residues (AA), accession number (#): Q16611. All accession numbers are from the NCBI protein data base.

Human BAX has 192 AA, #: Q07812.
Human BCL-X_L has 233 AA, #: CAA80661.
Human BCL-2 has 239 AA, #: NP_000624.
Human BCL-w has 193 AA, #: AAB09055.
Human MCL-1 has 350 AA, #: AAF64255.
Human BID has 195 AA, #: CAG30275.
Human BIM has 195 AA, #: NP_619527.

PROTEIN PRODUCTION, PURIFICATION, AND MOLECULAR CHARACTERIZATION

Native BAK is an integral membrane protein that assumes various membrane-bound conformations. Its isolation from natural sources is hampered by extremely low levels of expression and by heterogeneous aggregation/oligomerization during detergent solubilization of mitochondria-containing heavy membrane (HM) fractions. The HM fractions[26,27] are readily used to test BAK activity in its natural membrane environment in MOMP assays that monitor mitochondrial intermembrane protein release (e.g. cyt c release).

To date, only BAX has been expressed in heterologous bacterial systems and purified as a soluble full-length protein.[28] To remain soluble, BAX packs intramolecularly its C-terminal TM tail within its own putative BH3 pocket. All other BCL-2 family proteins that have been successfully produced in bacterial expression systems are TM-truncated (ΔTM) derivatives that can be purified as soluble monomers. BAK–ΔTM constructs have been expressed by engineering several tags at the N-terminus to yield ~1 mg of protein from 1 L of *E. coli* (BL21 DE3).[29] The shortest FLAG-tag (the DYKDDDDK octapeptide) construct also contained a C-terminal His$_6$ tag to facilitate purification. A thrombin-releasable GST (glutathione S-transferase) tag helped increased the yields of several GST–BAK–ΔTM constructs. As the first step of purification, the protein was affinity bound to either Ni-NTA (nitrilotriacetic acid) or glutathione resin. Tag removal for the FLAG–BAK–ΔTM construct was performed using several calpain proteases, which released the N-terminal residues up to and including AA 15 and the His$_6$ tag, essentially producing a stable BAK fragment free of exogenous sequences. The BAK–ΔTM proteins were typically purified to homogeneity by FPLC (fast protein liquid chromatography) on gel filtration and anion exchange resins and store well at $-80\,^\circ$C.

METAL CONTENT AND COFACTORS

BCL-2 family proteins had not been associated with metal binding until a Zn^{2+} ion was detected in the crystal structure of BAK.[29] This site in BAK was confirmed by NMR (nuclear magnetic resonance) spectroscopy as well as through mutagenesis and activity assays. Interestingly, several unique zinc sites were also identified in the crystal structure of MCL-1-BIM BH3 complex (PDB code 2PQK), but these have not yet been confirmed by other methods. BCL-2 family proteins do not contain or bind any cofactors.

ACTIVITY TEST

Purified BAK (and BAX) has been tested *in vitro* for MOMP activity by monitoring cyt c release from the

intermembrane space of purified mitochondria by probing the supernatants and pellets using Western blotting[29] or ELISA (enzyme-linked immunosorbent assay). Endogenous BAK isolated beginning with HM fractions either from cultured cells, livers, or hearts requires incubation with direct activator proteins tBID,[30] BIM,[31] or p53[32] to release cyt c. Among BAK–ΔTM proteins tested *in vitro*, only the calpain-proteolyzed B cell lymphoma-2 homologous antagonist/killer (cBAK) is active in MOMP assays.[29] cBAK activity is comparable to that of recombinant BAX–ΔTM but is significantly less ($\leq 10\times$) active than full-length BAX. This reflects the importance of the TM regions in high affinity targeting to the OMM, but argues against the TM being essential for MOMP activity. Natural sources of BAK-free mitochondria are livers from floxed out-BAX$^{-/-}$/BAK$^{-/-}$ mice[33] or BAX$^{-/-}$/BAK$^{-/-}$ mouse embryonic fibroblasts (MEFs).[5] *In vivo* endogenous BAK activity can be tested in BAX$^{-/-}$ MEFs[34] using green fluorescent protein (GFP)-labeled cyt c and monitoring by microscopy the release from mitochondria induced by various apoptotic agents (e.g. staurosporine, etoposide, and FAS or tumor necrosis factor receptor superfamily member 6 ligand).[35] Alternatively, engineered BAK can be reintroduced transiently or stably in BAX$^{-/-}$/BAK$^{-/-}$ MEFs to reconstitute the cell's intrinsic apoptotic pathway.[36]

SPECTROSCOPY

The binding of BAK BH3 peptides to antiapoptotic proteins has been monitored by intrinsic tryptophan fluorescence (IWF) spectroscopy, as a detectable fluorescence increase upon complexation.[37] Alternatively, for the protein–peptide complex pairs that showed poor IWF changes, fluorescence polarization was used to monitor binding of a fluorescently tagged peptide to BCL-2 proteins.[38] NMR spectroscopy of BCL-x$_L$,[37,39] BCL-w,[40] MCL-1,[41] and BAK[29] were used to detect and map the interactions with various BH3 peptides. Specific chemical shifts within the BH3 pocket represent fingerprints of the structural changes for BH3 peptide–BCL-2 protein pairs. BAK interaction with BIM BH3, a known direct activator, occurs at the putative BAK BH3 pocket, but is very weak compared with the peptide complexes of all antiapoptotic proteins.[29]

X-RAY STRUCTURES

Human BAK

Crystallization of recombinant protein

The cBAK version of BAK–ΔTM has been crystallized in the Zn^{2+}-bound state.[29] The protein was concentrated to 10–15 mg mL^{-1} in 20 mM 4-(2-hydroxyethyl)-1-peperazineethanesulfonic acid (HEPES) (pH 6.8) and 1 mM DTT (dithiothreitol). Rodlike crystals of dimensions 0.2 mm \times 0.2 mm \times 0.5 mm were grown in PEG (polyethylene glycol) 3350 (15–30%) as precipitant, a pH range of 4.0–6.0 and 1–50 mM zinc acetate (ZnOAc) or ~0.2 M ammonium fluoride (NH$_4$F) as additives, using the hanging drop vapor diffusion method. Both additives produced crystals of space group C2 that diffracted better than 1.5 Å, with unit cell parameters $a = 57.5$ Å, $b = 53.7$ Å, $c = 58.3$ Å, $\beta = 115.0$ Å, and one molecule per asymmetric unit. A selenium methionine (Se-Met) derivative of cBAK was required for single anomalous dispersion (SAD) structure determination from the ZnOAc crystals.

Overall description of the structure

cBAK is composed of eight tightly packed helices assembled into a globular domain around the central core helix α5 to adopt the canonical BCL-2 family topology[42] (3D Structure).[29] With the exception of the loops that connect the unique one-turn helix α2, all loop regions turn sharply (≤ 5 AA) into the following helix. The seven-turn helix α1 is the longest among the BCL-2 family structures. Helix α3 is unusual as it bends at its center around helix α5 to produce an uninterrupted seven-turn helix, rather than two shorter helices connected by a stretched out loop observed for BAX[28] and all antiapoptotic BCL-2 proteins except MCL-1.[43] Helices α4–α8 are very similar in length and positioning to other family members. Functional studies have identified three BH regions 1–3, numbered chronologically according to their identification, and occasionally (incorrectly) referred to as *domains*.[44] Helix α3 contains the BH3 region (AA 74–88); helices α4–α5 contain the BH1 region (AA 117–136); and helices α7–α8 contain the BH2 region (AA 169–181; 3D Structure).[45] The BH regions represent the most conserved residues in the protein family and they combine on one face to define and delimit the BH3 pocket and determine the overall fold of the BCL-2 family. Deletion of any one of the regions has been performed in many functional studies and is predicted to have major consequences on the protein fold, stability, and, ultimately, function. One way of visualizing the globular cBAK structure is by considering two helical bundles that are circularized by a C-terminal hook to form a thick donut-shaped fold with the core helix α5 filling the center (Figure 1).[29] The N-terminal bundle (N-bundle) contains α1–α2 and the first three turns of α3. The hingelike central turn of α3 precedes the C-terminal bundle (C-bundle) composed of the last three turns of α3 and helices α4–α6. The hook region consists of helices α7–α8 that consolidate an extended hydrophobic core involving both bundles as well as the three functional BH regions. The hook ends where the putative BH3 pocket typically begins.

BAK BH3 pocket occlusion

The BH3 pocket is partially occluded in BAK by the unique conformation of helix α3.[29] Helix α3 wraps more tightly

Figure 1 Stereo view of the BAK monomer. The BAK monomer can be considered to be composed of two helical bundles, the *N*-bundle (purple) and the *C*-bundle (blue), that are separated by a hinge region (red) and circularized by the BH2 hook region (yellow). The *C*-bundle contains most of the residues of the putative BH3 pocket, which is occluded in BAK. The obstructing side chains of Tyr89 and Arg88 are shown.

than in all BCL-2 proteins around the core α5 to stack the side chains of Tyr89 and Arg88 within the center of the pocket (Figure 1). The pocket remains accessible, but is significantly narrower above (*N*-bundle) and below (*C*-bundle) the occlusion. The Tyr89 side chain resembles a scoop at the center of the pocket, and in this conformation, it cannot undergo side chain rotations to free the pocket and accommodate BH3 peptides as seen in BCL-X$_L$[47] and BCL-2.[48]

Zn^{2+}-dependent BAK homodimerization

In the crystals produced either with ZnOAc (PDB code 2IMS) or NH$_4$F (2IMT) as additives, the cBAK monomer shares a crystal contact with a symmetry-related monomer at a face opposite to the BH3 pocket. This contact defines a symmetrical twofold interface mediated by helices α4 and α6 to produce a BAK homodimer (Figure 2).[29] At the *C*-terminal end of α6, the interface is exclusively stabilized by four coordinations to a Zn^{2+} ion at a special position on the twofold crystallographic *a* axis. In each monomer, the coordinating ligands Asp160 OD2 and His164 NE2 on turn 3 and 4 of α6 are 2.1 and 2.0 Å, respectively, from the Zn^{2+} ion (Figure 2). This quaternary protein interface leads to a tetrahedral coordination geometry, as typically observed for Zn^{2+} binding sites.[49] Compared with structural Zn^{2+} binding sites that can be predicted easily by sequence alignments of

Figure 2 The Zn^{2+}-bound BAK homodimer structure. It shows an extensive symmetrical dimerization interface involving helices α4 and α6. Dimerization is mediated by Zn^{2+} (magenta sphere) coordination at one end of the interaction surface. At the other end, steric complementarity is enhanced by a hydrogen bonding network. BH1-3 regions are colored as in the 3D structure. Side chains involved at the interface are displayed and labeled.

coordinating residues observed in representative domains (e.g. baculovirus inhibitor of apoptosis protein (IAP) repeat (BIR – baculovirus IAP repeat) domain[50]), quaternary zinc sites have only been identified fortuitously by crystallographic studies as mediators of multisubunit interfaces (e.g. nitric oxide synthases[51]). Interestingly, in the NH_4F crystal, Zn^{2+} was not added during crystallization and the last step of cBAK purification was performed in buffers containing 5 mM ethylenediaminetetraacetic acid (EDTA). This suggests the trace presence of the element in one of the crystallization components, but more importantly it indicates that, as Asp160 and His164 become appropriately charged at pH 4.0–6.0, the affinity in the crystal of cBAK for Zn^{2+} must be substantial.

The homodimerization interface extends at the N-terminal end of helix α6, where complementary surfaces become buried between the first two turns of α6 and the last two turns of α4 (Figure 2). The interface is stabilized by van der Waals interactions mapped at the phenolic ring of Tyr108 from monomer 1, which stacks with the guanidine group of Arg156 from monomer 2. Centrally at the interface, the side chains of Gln153 on α6 are found only 1.5 Å from the *a* axis. In addition, Gln153 OE1 stabilizes Arg156 NH2 intramolecularly through hydrogen bonding (2.7 Å). Arg156 NH1 salt bridges to the intermolecular Glu105 OE2 *via* a 3.0-Å bond.

Oxidized human BAK

Crystallization of recombinant protein

Oxidation of recombinant BAK protein to disulfide-bonded homodimers in the absence of reducing agent was first obtained during *in vitro* assays that tested the Zn^{2+}-mediated homodimerization observed in the crystal structure (TM unpublished). BAK–ΔTM contains two cysteine residues but in cBAK, the N-terminal Cys14 is released by calpain proteolysis between AA 15 and 16. cBAK therefore contains only Cys166, which is responsible for disulfide bond formation in BAK–ΔTM. Oxidized cBAK$_o$ was produced from purified cBAK, washed free of reducing agents, by spontaneous slow oxidation at concentrations of ~5–10 mg mL^{-1} at 4 °C or by fast overnight oxidation induced using 1 mM $CuSO_4$. Oxidized cBAK$_o$ was then purified away from monomeric cBAK using gel filtration chromatography and stored in 20 mM HEPES (pH 6.8) at −80 °C. Two oxidized cBAK$_o$ crystals were grown using the hanging drop vapor diffusion method in mother liquor containing 2.5–3.3 M NaOAc as precipitant at pH 5.0–6.0. The original crystals were obtained from 10 mg mL^{-1} purified cBAK$_o$ dimer as 0.3 mm × 0.3 mm × 0.5 mm heterogeneous rods and diffracted to 3.0 Å. They were assigned to the space group C222$_1$ with unit cell parameters $a = 69.2$ Å, $b = 114.7$ Å, $c = 131.6$ Å, having three cBAK

monomers (1–3) in the asymmetric unit. Differently packed 0.5 mm × 0.5 mm × 0.5 mm hexagonal pyramid crystals were produced from cBAK monomers induced to oxidize in the crystallization drop by supplementing 10 mg mL^{-1} cBAK monomer in the DTT-free protein solution with 1 mM $CuSO_4$ prior to crystallization. They were assigned to space group P6$_5$22 with cell dimensions $a = 62.4$ Å, $b = 62.4$ Å, $c = 138.3$ Å with one monomer (A) in the asymmetric unit and diffracted better than 2.0 Å. Identical P6$_5$22 crystals with unit cell dimensions $a = 62.8$ Å, $b = 62.8$ Å, $c = 138.1$ Å were grown at the Structural Genomics Consortium (Stockholm) in 22% PEG3350, 20% glycerol, 0.2 M sodium sulfate, 2 mM tris(2-carboxyethyl) phosphine hydrochloride (TCEP), 0.3 M NaCl, and 20 mM HEPES pH 7.5. Surprisingly, the oxidized dimer formed during crystallization even in the presence of the reducing agent TCEP suggesting that the packing of BAK in these crystals forces the positioning of Cys166 for disulfide bond formation.

Structure of oxidized cBAK$_o$

Three different oxidized cBAK$_o$ dimers have been captured in the C222$_1$ (two) and P6$_5$22 crystals (one; Figure 3). Monomers of each cBAK$_o$ dimer are disulfide bonded at Cys166. The disulfide bond permits relative flexibility of monomers within the dimers such that the overlaps of dimer 1–2′ and 3–3′ from the C222$_1$ crystal onto the A–A′ dimer from the P6$_5$22 crystal had rmsd (root-mean-square deviations) values of 2.0 Å (2194 atoms) and 2.7 Å (2261 atoms), respectively. All primed (′) monomers are from adjacent asymmetric units. In contrast, overlaps of monomers from the cBAK$_o$ crystals onto the original Zn^{2+}-bound cBAK monomer (2IMT) showed rmsd of 0.8 Å for 1170 atoms from monomer A (P6$_5$22), and 1.2, 0.9, and 1.1 Å for 1196, 1164, and 1178 atoms from monomers 1, 2, and 3 (C222$_1$), respectively. The occlusion of the BH3 pocket was observed in all five crystallographic monomers, as well as in the BAK derivative solved by the Structural Genomics Consortium (PDB code 2JCN).

Reflecting the flexibility of the Cys166 disulfide bond, the dimerization interface captured by the three dimers varies and involves alternative hydrogen bonding networks (Figure 3). The 1–2′ dimer is the most asymmetric dimer and is stabilized by three hydrogen bonds: Gln173 NE2–2.9 Å–His165′ ND1, Arg169 NH2–2.8 Å–Glu24′ OE1, and Glu24 OE1–3.0 Å–His164′ ND1. The 3–3′ dimer is symmetric, but stabilized only by a pair of symmetric 3.2 Å hydrogen bonds between Arg169 NE and His164′ O. The A–A′ dimer is the most tightly packed with five pairs of intramolecular hydrogen bonds at the interface: Arg169 NH1–3.0 Å–His164′ O, Trp170 NE1–3.2 Å–Glu120′ O, His164 O–3.3 Å–Arg169′ NE, Glu120 OE1–2.8 Å–Arg174′ NH2, and Glu120 O–3.2 Å–Trp170′ NE1 (Figure 3).

Figure 3 Structures of the 1–2', 3–3', and A–A' oxidized cBAK$_o$ homodimers and the intermolecular interfaces (pink) centered around the Cys166-mediated disulfide bond (orange). Oxidative dimerization prevents the Zn^{2+} half sites, D160 and H164, from coordinating Zn^{2+} as shown in Figure 2. Selected residue side chains are shown and labeled. Hydrogen bonds are represented as dashes.

cBAK$_o$ packing in the C222$_1$ and P6$_5$22 crystals

Examination of the cBAK$_o$ crystals reveals similar packing of monomers along the corresponding 2$_1$ and 6$_5$ screw axes (Figure 4). The C222$_1$ crystal form presents a more compacted packing along the 2$_1$ axis (c edge), which produces slightly larger a and b edge dimensions. In both crystals, every BAK molecule along the screw axes is a monomer of disulfide-bonded cBAK$_o$ dimers. Interestingly, both crystals use the occluded BH3 pocket from the C-bundle side of monomer 2 (or 3 or A2) to accommodate the short α2 from the N-bundle of monomer 1 (or 2 or A1, respectively). Viewed perpendicular to the screw axes, the three-monomer C222$_1$ asymmetric unit and three one-monomer asymmetric units of the P6$_5$22 crystal resemble

Figure 4 Crystal packing for oxidized BAK. The packing for the P6$_5$22 (purple) and the C222$_1$ crystal (green) is shown perpendicular (above) and along the corresponding screw axis (below). In both crystals, the packing is very similar being mediated by the short helix α2 (red) of the N-bundle interacting with the BH3 pocket just below the occlusion in the C-bundle. The asymmetric units contain three different monomers (1–2–3; C222$_1$) and one monomer A (P6$_5$22). Each is disulfide bonded at position Cys166 to another monomer from a unique asymmetric unit to generate a disulfide-bonded crystal.

a large circumference made up of BAK molecules that present their C-termini on roughly the same side, pointing toward a hypothetical membrane. Whether this packing has any functional or physiological relevance for full-length BAK integrated with a TM anchor into the mitochondrial membranes remains to be tested. Identical packing was also selected in the presence of reducing agent, which might interfere with disulfide bond formation, suggesting that the α2 to C-bundle packing might be a driving force for oxidation.

FUNCTIONAL ASPECTS

Comparison of BAK to BCL-2 family proteins

BAK is less than 25% identical to any BCL-2 family protein. Examination of structure-based sequence alignments suggests that the C-bundle and hook regions are more structurally conserved than the N-bundle. This

observation is illustrated by structural comparisons of the C-bundle and hook between BAK (2IMS, AA 107–181)[29] and other BCL-2 family structures (Figure 5). BCL-X_L (1MAZ, AA 119–196)[47] (first item in structure explaining parentheses is the respective PDB code) was overlapped with rmsd of 1.4 Å (467 atoms), BCL-2 (1G5M, AA 126–206)[48] with rmsd of 1.5 Å (441 atoms), BAX (1F16, AA 88–163)[28] with rmsd of 1.8 Å (446 atoms), BCL-w (1MK3, AA 74–170)[52] with rmsd of 2.9 Å (439 atoms), MCL-1 (1WSX, AA 223–307)[43] with rmsd of 1.7 Å (426 atoms), BCL-X_L–BAK BH3 complex (1BXL, AA 119–196)[37] with rmsd of 1.9 Å (467 atoms), and MCL-1–BIM BH3 complex (2NL9, AA 223–307)[41] with rmsd of 1.6 Å (207 atoms). All structures were oriented with the BH3 pocket shown vertically, as defined by the BIM BH3 peptide (transparent surface representation in Figure 5(b)) from the MCL-1–BIM BH3 complex

(not shown).[41] For all structures, except BCL-X_L, the alignment shows the potential clashes/interactions at the BH3 pocket with the same BIM BH3 peptide. For free BCL-X_L (1MAZ), the BH3 peptide from the BCL-X_L–BAK BH3 complex (1BXL) was used instead. In the alignment, the core helix α5 shows the best overlap, followed by α6 and the hook region. Helices α3–α4 show the largest deviations. These helices in antiapoptotic proteins must rearrange to accommodate incoming BH3 peptides as amphipathic helices within mostly preformed pockets (Figures 5(a) and 6(a)). In particular, α2–α3 typically melt and recoil to significantly different conformations in the free and bound states (Figure 6). In antiapoptotic proteins, the BH3 pockets are mostly found in open unrestricted conformations (Figure 5(a)). In BAX, the BH3 pocket contains the C-terminal hydrophobic tail, which blocks access (Figure 5(c)). This similar arrangement was also

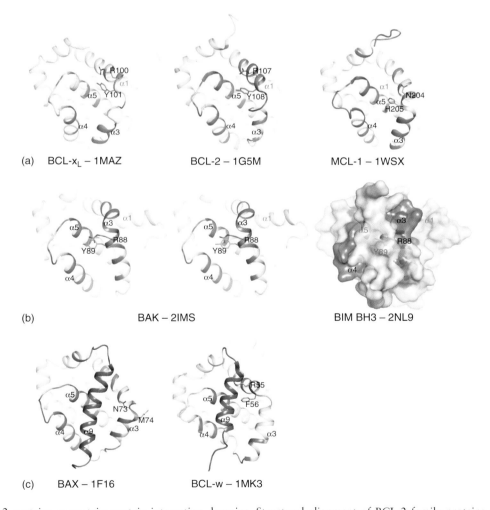

Figure 5 BCL-2 proteins as protein–protein interaction domains. Structural alignment of BCL-2 family proteins was performed for the C-terminal bundle and hook region to compare the conformations assumed by the BH3 pocket in BCL-2 proteins in the absence of BH3 peptide: (a) open, (b) occluded, and (c) C-terminal tail (red) blocked states. The BIM BH3 surface (pink), shown onto the surface representation of BAK, was aligned to illustrate the hypothetical interactions/clashes at the BH3 pockets. These are highlighted as yellow regions on a white background and occur along helices α2–α5. The BAK cartoon is represented in stereo view. In the other structures, the residues corresponding to the Arg88 and Tyr89 of BAK are displayed as orange side chains and labeled. The PDB codes are shown.

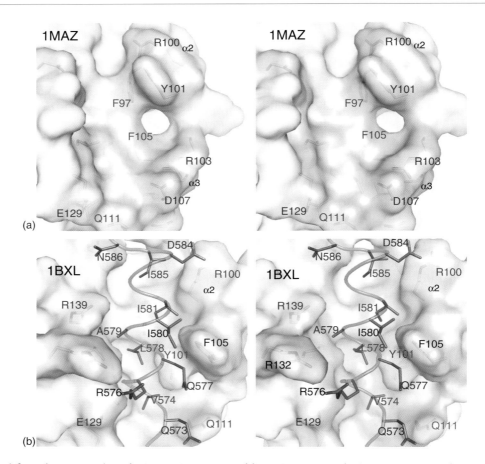

Figure 6 Induced-fit to the BH3 pocket of BCL-X_L. Stereo view of free BCL-X_L (a) and BAK BH3–BCL-X_L (b) was aligned to show the prototypical induced-fit mechanism of binding between an unstructured BH3 peptide, when free in solution, and the accommodating BH3 pocket. The pocket undergoes extensive rearrangements to bind and fold the peptide into an amphipathic helix. The right side of the pocket rearranges significantly by unfolding the lower helix α3 (free state) and refolding it to a longer helix α2 to deepen and delimit the pocket. Select residues are displayed and marked. Unlike BAK BH3 pocket, the pocket in BCL-X_L is opened as the conserved Arg100-Tyr101 do not occlude it.

observed for BCL-w,[52,53] but its C-terminal helix trapped in the BH3 pocket was more loosely attached (Figure 5(c)). In BAK, the BH3 pocket is occluded by the shift of helix α3 much closer to the core α5 (Figure 5(b)). Helix α1 of the N-bundle contributes to the occlusion from underneath the pocket by spanning the entire length of the protein to bridge the hook on one side and the BH3-containing helix α3 on the other. No other BCL-2 protein structure has the C-terminal extension in helix α1 that protrudes as far next to α3 as observed in BAK.

The BCL-2 family proteins can be grouped into three classes: those that have evolved BH3 pockets that are open for strong BH3 peptide binding, those whose pocket is fully blocked by C-terminal helices to prevent peptide binding, and those such as BAK, where the pocket is partially occluded to prevent strong BH3 binding. The proapoptotic effector proteins BAK and BAX have evolved different structural strategies to distinguish them from the antiapoptotic homologs on the basis of BH3 peptide affinity.

BAK binding to BCL-2 family proteins

BAK BH3 peptide binding to BCL-X_L, elucidated by NMR spectroscopy (1BXL), was the archetype of complexes between BH3 peptides and antiapoptotic proteins.[37] BH3 peptides are typically unstructured in solution, but when bound to the receptor BH3 pocket they assume an amphipathic helical conformation and orient opposite to the C-termini of BAX and BCL-w. BAK BH3 is unique and much more flexible in solution because of two glycine residues in addition to the Gly-Asp motif conserved in most BH3 proteins. The folding of BAK BH3 follows an induced-fit mechanism with the BH3 pocket undergoing major shifts, unwinding, and recoiling rearrangements at helices α2–α5 (Figures 5(a) and 6). Ultimately, the BH3 pocket accommodates the hydrophobic side of the BH3 helix with Val74, Leu78, Ile81, and Ile85 engaging its deepest sites. A salt-bridge interaction is mapped at the periphery of the pocket between Asp84 of BAK and Arg100 of BCL-X_L. Since the original analysis presented a decade ago, several variations

of the same theme confirmed conformational changes at the level of both peptides and BH3 pockets to induce and fit an amphipathic 3–7 turn α helix in heterogenous pockets.[39–41,54] The mechanisms of peptide sequestration at the BH3 pockets of antiapoptotics necessitate major conformational changes to expose the BH3 peptide of BAK,[29] BAX,[28] or BID.[55,56] Most of the other proapoptotic BCL-2 paralogs are intrinsically unfolded proteins that undergo binding-induced folding at target BH3 pockets.[57] It is difficult to predict the conformational changes in the absence of structural analysis of activated/active BAK and BAX forms. The inhibitory Zn^{2+}-mediated homodimerization interface, remotely positioned with respect to the BH3 region, is predicted to minimally influence the reorganization of the BH3 region upon activation. Instead, it may block membrane insertion of the activated BAK.

BAK as a Zn^{2+}-inhibited redox sensor

The Zn^{2+}-mediated homodimer and the oxidized homodimer structures reveal features of a common regulatory mechanism.[29] In mammals, including humans, primates, and canines, BAK has evolved a conserved Zn^{2+} binding patch encompassing residues Asp160, His164, and His165 at the C-terminus of helix α6 and Cys166, the hingelike residues that link α6 to α7 of the hook region (Figure 7). In rodents, the zinc patch has been preserved at α6, Cys166 was replaced by a tyrosine residue, and a conserved cysteine residue was added one helical turn away on the N-terminal side of Asp160. The Zn^{2+} binding patch is inhibitory both in humans and mice as MOMP by BAK is blocked at <1 μM Zn^{2+}. The inhibition was shown with endogenous BAK present in HM mitochondria from mouse liver, $BAX^{-/-}$ MEFs, and human KB oral carcinoma cell lines. In addition, human cBAK was shown to be inactivated by ~5 μM Zn^{2+} using mitochondria from $BAX^{-/-}/BAK^{-/-}$ MEFs. In the same genetic background, the mutation H164A in cBAK precluded the Zn^{2+}-mediated MOMP inhibition. Therefore, Zn^{2+} can induce an inhibited state of BAK by producing dormant BAK homodimers outside the OMM unable to drive MOMP even in the presence of excessive amounts of direct activator proteins (e.g. truncated tBID).

In the oxidized $cBAK_o$ homodimer, the proximity of Cys166 to the half Zn^{2+} sites in the Zn^{2+} homodimer excludes the cBAK monomers from ever achieving the inhibited dormant state (Figures 2, 3 and 7). Moreover, $cBAK_o$ is equally active in MOMP compared to cBAK and it is much less sensitive to Zn^{2+} inhibition. $cBAK_o$ showed a similar trend for MOMP in the presence of Zn^{2+} as the BAX control, which represented the nonspecific binding of BCL proteins to HM mitochondria because BAX does not contain a similar Zn^{2+} site. Compared with cBAK (5 μM), more than 20 μM Zn^{2+} is necessary for significant attenuation of $cBAK_o$ MOMP activity (TM unpublished). The effect of oxidation on endogenous BAK has not yet been resolved. Nevertheless, the structural features observed next to the Cys166 suggest the emergence of a redox-sensitive site, typically found within 6 Å from acid–base residue pairs that help lower the pK_a of the cysteine making it more nucleophilic.[58] The thiol group of Cys166 is 3.7 and 3.9 Å from NH1 and NH2 of Arg169 and 5.2 Å from the Glu24 OE1, making this acid–base pair important for BAK redox signaling and regulation. $cBAK_o$ represents one of several possible reversible redox-signaling modifications that Cys166 can undergo. In rodents, similar redox modifications can be extended to the tyrosine residue, whereas the unique cysteine on helix α6 could mediate disulfide bond formation. Oxidation of BAX into disulfide-bonded dimers has been reported to result in its translocation to mitochondria in the absence of apoptosis.[59] Given that mitochondria are constantly exposed to oxidative insults as byproducts of metabolism, it is not surprising that the MOMP effectors have evolved features that allow them to sense the levels of reactive oxygen/nitrogen species by undergoing reversible modifications and to respond during pathophysiologies.

CONCLUDING REMARKS

Ever since their discovery in the early 1990s, BAK and BAX regulation has been extremely puzzling mechanistically.[21] Their properties both as soluble and membrane-associated/integrated proteins have made it extremely difficult to obtain structural information related to their MOMP

Figure 7 Stereo representation of the putative Zn^{2+}-dependent redox center in BAK. Side chains with affinity for zinc and acid–base pairs that may help regulate the nucleophilicity of Cys166 are displayed and labeled. The redox center in either the Zn^{2+}-bound or oxidized state does not structurally compromise the BH3 pocket on the face opposite to the Zn^{2+}-mediated quaternary interface.

active state that ultimately kills cells through mitochondrial apoptogenic protein release. Both proteins have been postulated to form membrane-bound dimers and higher order oligomers that potentially coalesce into a porelike structure, but none of these states have been homogeneously trapped and formally characterized. It is extremely intriguing that the cBAK$_O$ dimer is functional in MOMP assays, suggesting that the oxidation into dimers is tolerated during activation, oligomerization, and pore-formation. It is possible that a membrane-bound cBAK$_O$-like dimer represents the building block of both oligomers and the pore, even in the absence of oxidation. The Zn^{2+} binding site has perhaps evolved to add another level of regulation outside of membranes to keep BAK, a potent cell killer, in check.

REFERENCES

1 T Chittenden, EA Harrington, R O'Connor, C Flemington, RJ Lutz, GI Evan and BC Guild, *Nature*, **374**, 733–36 (1995).

2 SN Farrow, JH White, I Martinou, T Raven, KT Pun, CJ Grinham, JC Martinou and R Brown, *Nature*, **374**, 731–33 (1995).

3 MC Kiefer, MJ Brauer, VC Powers, JJ Wu, SR Umansky, LD Tomei and PJ Barr, *Nature*, **374**, 736–39 (1995).

4 ZN Oltvai, CL Milliman and SJ Korsmeyer, *Cell*, **74**, 609–19 (1993).

5 T Lindsten, AJ Ross, A King, WX Zong, JC Rathmell, HA Shiels, E Ulrich, KG Waymire, P Mahar, K Frauwirth, Y Chen, M Wei, VM Eng, DM Adelman, MC Simon, A Ma, JA Golden, G Evan, SJ Korsmeyer, GR MacGregor and CB Thompson, *Mol Cell*, **6**, 1389–99 (2000).

6 MC Wei, WX Zong, EH Cheng, T Lindsten, V Panoutsakopoulou, AJ Ross, KA Roth, GR MacGregor, CB Thompson and SJ Korsmeyer, *Science*, **292**, 727–30 (2001).

7 NN Danial and SJ Korsmeyer, *Cell*, **116**, 205–19 (2004).

8 AM Ranger, BA Malynn and SJ Korsmeyer, *Nat Genet*, **28**, 113–18 (2001).

9 S Shimohama, S Fujimoto, Y Sumida and H Tanino, *Biochem Biophys Res Commun*, **252**, 92–96 (1998).

10 SJ Korsmeyer, JR Shutter, DJ Veis, DE Merry and ZN Oltvai, *Semin Cancer Biol*, **4**, 327–32 (1993).

11 JE Chipuk, L Bouchier-Hayes and DR Green, *Cell Death Differ*, **13**, 1396–402 (2006).

12 M Germain and GC Shore, *Sci STKE*, **2003**, 10 (2003).

13 DR Green and G Kroemer, *Science*, **305**, 626–29 (2004).

14 G Kroemer, L Galluzzi and C Brenner, *Physiol Rev*, **87**, 99–163 (2007).

15 M Schuler and DR Green, *Trends Genet*, **21**, 182–87 (2005).

16 D Morgensztern and HL McLeod, *Anticancer Drugs*, **16**, 797–803 (2005).

17 KC Zimmermann, C Bonzon and DR Green, *Pharmacol Ther*, **92**, 57–70 (2001).

18 D Spierings, G McStay, M Saleh, C Bender, J Chipuk, U Maurer and DR Green, *Science*, **310**, 66–67 (2005).

19 SN Willis, L Chen, G Dewson, A Wei, E Naik, JI Fletcher, JM Adams and DC Huang, *Genes Dev*, **19**, 1294–305 (2005).

20 JM Adams and S Cory, *Curr Opin Immunol*, **19**, 488–96 (2007).

21 RJ Youle and A Strasser, *Nat Rev Mol Cell Biol*, **9**, 47–59 (2008).

22 H Kim, M Rafiuddin-Shah, HC Tu, JR Jeffers, GP Zambetti, JJ Hsieh and EH Cheng, *Nat Cell Biol*, **8**, 1348–58 (2006).

23 C Brooks, Q Wei, L Feng, G Dong, Y Tao, L Mei, ZJ Xie and Z Dong, *Proc Natl Acad Sci*, **104**, 11649–54 (2007).

24 M Karbowski, KL Norris, MM Cleland, SY Jeong and RJ Youle, *Nature*, **443**, 658–62 (2006).

25 RJ Youle and M Karbowski, *Nat Rev Mol Cell Biol*, **6**, 657–63 (2005).

26 E Bossy-Wetzel and DR Green, *Methods Enzymol*, **322**, 235–42 (2000).

27 IS Goping, A Gross, JN Lavoie, M Nguyen, R Jemmerson, K Roth, SJ Korsmeyer and GC Shore, *J Cell Biol*, **143**, 207–15 (1998).

28 M Suzuki, RJ Youle and N Tjandra, *Cell*, **103**, 645–54 (2000).

29 T Moldoveanu, Q Liu, A Tocilj, M Watson, G Shore and K Gehring, *Mol Cell*, **24**, 677–88 (2006).

30 MC Wei, T Lindsten, VK Mootha, S Weiler, A Gross, M Ashiya, CB Thompson and SJ Korsmeyer, *Genes Dev*, **14**, 2060–71 (2000).

31 WX Zong, T Lindsten, AJ Ross, GR MacGregor and CB Thompson, *Genes Dev*, **15**, 1481–86 (2001).

32 JI Leu, P Dumont, M Hafey, ME Murphy and DL George, *Nat Cell Biol*, **6**, 443–50 (2004).

33 C Hetz, P Bernasconi, J Fisher, AH Lee, MC Bassik, B Antonsson, GS Brandt, NN Iwakoshi, A Schinzel, LH Glimcher and SJ Korsmeyer, *Science*, **312**, 572–76 (2006).

34 CM Knudson, KS Tung, WG Tourtellotte, GA Brown and SJ Korsmeyer, *Science*, **270**, 96–99 (1995).

35 JC Goldstein, NJ Waterhouse, P Juin, GI Evan and DR Green, *Nat Cell Biol*, **2**, 156–62 (2000).

36 L Galluzzi, N Zamzami, T de La Motte Rouge, C Lemaire, C Brenner and G Kroemer, *Apoptosis*, **12**, 803–13 (2007).

37 M Sattler, H Liang, D Nettesheim, RP Meadows, JE Harlan, M Eberstadt, HS Yoon, SB Shuker, BS Chang, AJ Minn, CB Thompson and SW Fesik, *Science*, **275**, 983–86 (1997).

38 LD Walensky, AL Kung, I Escher, TJ Malia, S Barbuto, RD Wright, G Wagner, GL Verdine and SJ Korsmeyer, *Science*, **305**, 1466–70 (2004).

39 AM Petros, DG Nettesheim, Y Wang, ET Olejniczak, RP Meadows, J Mack, K Swift, ED Matayoshi, H Zhang, CB Thompson and SW Fesik, *Protein Sci*, **9**, 2528–34 (2000).

40 AY Denisov, G Chen, T Sprules, T Moldoveanu, P Beauparlant and K Gehring, *Biochemistry*, **45**, 2250–56 (2006).

41 PE Czabotar, EF Lee, MF van Delft, CL Day, BJ Smith, DC Huang, WD Fairlie, MG Hinds and PM Colman, *Proc Natl Acad Sci*, **104**, 6217–22 (2007).

42 AM Petros, ET Olejniczak and SW Fesik, *Biochim Biophys Acta*, **1644**, 83–94 (2004).

43 CL Day, L Chen, SJ Richardson, PJ Harrison, DC Huang and MG Hinds, *J Biol Chem*, **280**, 4738–44 (2005).

44 T Chittenden, C Flemington, AB Houghton, RG Ebb, GJ Gallo, B Elangovan, G Chinnadurai and RJ Lutz, *EMBO J*, **14**, 5589–96 (1995).

45 JA Herberg, S Phillips, S Beck, T Jones, D Sheer, JJ Wu, V Prochazka, PJ Barr, MC Kiefer and J Trowsdale, *Gene*, **211**, 87–94 (1998).

46 WL DeLano, http://www.pymol.org (2004).

47 SW Muchmore, M Sattler, H Liang, RP Meadows, JE Harlan, HS Yoon, D Nettesheim, BS Chang, CB Thompson, SL Wong, SL Ng and SW Fesik, *Nature*, **381**, 335–41 (1996).

48 AM Petros, A Medek, DG Nettesheim, DH Kim, HS Yoon, K Swift, ED Matayoshi, T Oltersdorf and SW Fesik, *Proc Natl Acad Sci*, **98**, 3012–17 (2001).

49 DS Auld, *Biometals*, **14**, 271–313 (2001).

50 GS Salvesen and CS Duckett, *Nat Rev Mol Cell Biol*, **3**, 401–10 (2002).

51 CS Raman, H Li, P Martasek, V Kral, BS Masters and TL Poulos, *Cell*, **95**, 939–50 (1998).

52 AY Denisov, MS Madiraju, G Chen, A Khadir, P Beauparlant, G Attardo, GC Shore and K Gehring, *J Biol Chem*, **278**, 21124–28 (2003).

53 MG Hinds, M Lackmann, GL Skea, PJ Harrison, DC Huang and CL Day, *EMBO J*, **22**, 1497–507 (2003).

54 X Liu, S Dai, Y Zhu, P Marrack and JW Kappler, *Immunity*, **19**, 341–52 (2003).

55 JJ Chou, H Li, GS Salvesen, J Yuan and G Wagner, *Cell*, **96**, 615–24 (1999).

56 JM McDonnell, D Fushman, CL Milliman, SJ Korsmeyer and D Cowburn, *Cell*, **96**, 625–34 (1999).

57 MG Hinds, C Smits, R Fredericks-Short, JM Risk, M Bailey, DC Huang and CL Day, *Cell Death Differ*, **14**, 128–36 (2007).

58 DT Hess, A Matsumoto, SO Kim, HE Marshall and JS Stamler, *Nat Rev Mol Cell Biol*, **6**, 150–66 (2005).

59 M D'Alessio, M De Nicola, S Coppola, G Gualandi, L Pugliese, C Cerella, S Cristofanon, P Civitareale, MR Ciriolo, A Bergamaschi, A Magrini and L Ghibelli, *FASEB J*, **19**, 1504–06 (2005).

CALCIUM

Calmodulin interactions with Ca$_V$1 and Ca$_V$2 voltage-gated calcium channel IQ domains

Eun Young Kim[†], Felix Findeisen[†] and *Daniel L Minor[†,‡,§,§§]*

[†] Cardiovascular Research Institute, University of California, San Francisco, CA 94158-2330, USA
[‡] Departments of Biochemistry and Biophysics, and Cellular and Molecular Pharmacology, University of California, San Francisco, CA 94158-2330, USA
[§] California Institute for Quantitative Biomedical Research, University of California, San Francisco, CA 94158-2330, USA
[§§] Physical Biosciences Division, Lawrence Berkeley National Laboratory, Berkeley, CA 94720, USA

FUNCTIONAL CLASS

Calcium binding protein: Calmodulin (CaM) is a bilobed, 16.7-kDa calcium binding protein involved in intracellular Ca^{2+} signaling[1] and is a member of a larger family of calcium sensor proteins.[1,2] CaM contains two pairs of independently folded domains[3,4] that each contain two Ca^{2+} binding motifs known as *EF hands*,[5,6] each of which can bind a single Ca^{2+} ion. Ca^{2+} binding to the EF-hand pairs causes a conformational change in the individual lobes, which exposes a phenylalanine and methionine-rich hydrophobic pocket[7,8] that allows Ca^{2+}/CaM to interact with more than 300 different target proteins in a variety of binding modes.[1,8,9] CaM directly modulates numerous types of ion channels.[10]

Ion channel: Voltage-gated calcium channels (Ca$_V$s)[11,12] are transmembrane ion channels found throughout metazoan life[11,13–15] and are members of the superfamily of voltage-gated ion channels[16,17] that constitutes the third most abundant set of genes in the human genome.[17] There are two Ca$_V$ functional classes that have diverse physiological and pharmacological properties: high-voltage-activated Ca$_V$s (Ca$_V$1s and Ca$_V$2s),[11] which open in response to strong membrane depolarization (\sim+30 to +50 mV), and low-voltage-activated Ca$_V$s (Ca$_V$3s), which open in response to weaker membrane depolarization (\sim−55 to −20 mV).[18,19] The high-voltage-activated class is further divided on the basis of both pharmacology and functional properties into L-type (Ca$_V$1s)[13,20] and non-L-type (Ca$_V$2s)[13,21,22] channels (Table 1).

The Ca$_V$1 and Ca$_V$2 functional unit comprises four separate subunits (Figure 1(a) and (b)) that have a total molecular mass >0.5 MDa[28] and include a transmembrane, pore-forming subunit (Ca$_V\alpha_1$) that contains four homologous repeats composed of six transmembrane segments each (Figure 1(b)) and that sets many of the functional and pharmacological properties of the channel[11,13] (Table 1); a cytoplasmic subunit (Ca$_V\beta$) that shapes channel inactivation properties and regulates plasma membrane expression[29]; a membrane-anchored subunit (Ca$_V\alpha_2\delta$) that is the receptor for antiepileptic and antinociceptive drugs[30]; and calmodulin (CaM).[31] CaM acts as an intrinsic calcium sensor that endows the channels with strong calcium-dependent responses known as *calcium-dependent inactivation* (*CDI*) and *calcium-dependent facilitation* (*CDF*).[32,33] The central site of the CaM interactions that govern CDI and CDF is an IQ domain present in the Ca$_V\alpha_1$ C-terminal cytoplasmic tail (Figure 1(c)).[24,26,27,34–37] Interactions between

(a) Ca^{2+}/CaM–Ca$_V$1.2 IQ domain (b) Ca^{2+}/CaM–Ca$_V$2.3 IQ domain

3D Structure Cartoon representation of Ca^{2+}/CaM complexes with the IQ domains from representative Ca$_V$1 (a) 2BE6 and Ca$_V$2 (b) 3DVK. Ca^{2+}/CaM N-lobe and C-lobe are displayed in green and blue, respectively. The white spheres are calcium ions. All structural figures were prepared using PyMOL.[101]

Table 1 Ca$_V$ nomenclature and Ca^{2+}/CaM–IQ domain complexes

Native channel	Pore-forming Ca$_V\alpha_1$ subunit				Ca^{2+}/CaM–IQ domain complexes				
	Classification		Resolution (Å)	Peptide length (amino acids)	Residues	IQ numbers	Source	PDB code	References
	Alphabetical	Numerical							
L-type	α_{1S}	Ca$_V$1.1	1.94	21	1522–1542	I1529/Q1530	Human	2VAY	23
	α_{1C}	Ca$_V$1.2	2.00	34	1611–1644	I1624/Q1625	Human	2BE6	24
			1.45	21	1655–1685	I1672/Q1673	Human	2F3Y	25
			1.60	21	IQ → AA mutant 1655–1685	I1672A/Q1673A	Human	2F3Z	25
	α_{1D}	Ca$_V$1.3				N/A			
	α_{1F}	Ca$_V$1.4				N/A			
Non-L-type P/Q-type	α_{1A}	Ca$_V$2.1	2.60	25	1963–1984	I1971/M1972	Rabbit	3DVM	26
			2.60	21	1960–1980	I1967/M1968	Human	3BXK	27
N-type	α_{1B}	Ca$_V$2.2	2.35	25	1855–1876	I1863/F1864	Rabbit	3DVE	26
			2.80	25	1853–1876	I1863/F1864	Rabbit	3DVJ	26
R-type	α_{1E}	Ca$_V$2.3	2.30	25	1818–1839	I1826/M1827	Rat	3DVK	26
			2.20	21	1819–1839	I1826/M1827	Human	3BXL	27

Figure 1 Voltage-gated calcium channel structure and IQ domain comparison. (a) Cartoon diagram of a Ca$_V$1 or Ca$_V$2 channel. The four homologous transmembrane domains of Ca$_V$α$_1$ are indicated. Ca$_V$β is shown in blue and interacts with its high-affinity binding site on the I–II intracellular loop known as the α-*interaction domain* (AID). CaM is shown bound to the C-terminal cytoplasmic tail at the site of the IQ domain. The Ca$_V$α$_2$δ membrane-associated subunit is shown in orange and green. (b) Topology of the pore-forming Ca$_V$α$_1$ subunit. Positions of the Ca$_V$β/AID complex (PDB: 1T0J)[38] and Ca^{2+}/CaM–IQ domain (PDB: 2BE6)[24] complexes are shown. (c) Comparison of the IQ domain sequences from Ca$_V$1 and Ca$_V$2 channels. Positions of main anchors are indicated by the asterisks. Colors indicate contacts to the N-lobe (green), C-lobe (blue), or both (purple). Sequence positions relative to Ile(0) of the IQ motif is shown.

OCCURRENCE

CaM is found in all eukaryotic cells[39–42] and is one of the most highly conserved protein sequences known[8,40,42] (see reference 43 for a detailed comparison of CaM sequences). In mammalian cells, a single isoform of CaM is encoded by multiple genes.[42,44]

Ca$_V$s are present in all metazoans.[13] Besides numerous vertebrate examples, phylogenetic comparison indicates that Ca$_V$s are ancient molecules that have features conserved between mammals and invertebrates such as sea squirts,[15] *Drosophila*,[45,46] *Caenorhabditis elegans*,[47,48] coral,[49] and jellyfish.[50] The different Ca$_V$ subtypes have

particular tissue and subcellular distributions. Ca$_V$1.1 is most abundant in skeletal muscle[13] and is directly coupled to the ryanodyne receptor intracellular calcium-release channel.[51] Ca$_V$1.2 is present in the brain, heart, smooth muscle, and endocrine cells.[13,20,52,53] Ca$_V$1.3 is important in sensory cells, such as cochlear hair cells and photoreceptors, neuroendocrine cells, the sinoatrial node of the heart, and neurons.[13,20,52–54] Ca$_V$1.4 is largely restricted to the retina.[13,20,55,56] Ca$_V$2.1, Ca$_V$2.2, and Ca$_V$2.3 are found throughout the central and peripheral nervous systems.[13,21,22,57] In particular, Ca$_V$2.1 and Ca$_V$2.2 play key roles in the modulation of neurotransmitter release.[21,22] Ca$_V$s have a multitude of splice variants. In a number of cases, the resulting amino acid differences have been shown to provide functional diversification that may tailor Ca$_V$ function to particular environments and specialized cell types.[56,58,59]

BIOLOGICAL FUNCTION

Ca$_V$s are the molecules that define excitable cells.[16] Calcium ion influx has two major effects: it depolarizes the cell membrane and increases the intracellular concentration of calcium ions which can act as chemical signal effectors.[39] Therefore, Ca$_V$s act as a nidus for cross talk between electrical and chemical signals. Consequently, they have prominent roles in the function of nerve and muscle[11,13,21,57] and also play important roles in hormone secretion from adrenal[52] and pancreatic cells.[53] Mutations in Ca$_V$s are linked to a wide range of human diseases and syndromes that include hypokalemic periodic paralysis (Ca$_V$1.1)[55]; cardiac arrhythmias and autism (Ca$_V$1.2)[60]; stationary night blindness (Ca$_V$1.4)[55,56]; and migraine (Ca$_V$2.1).[61] Because of their critical role in human physiology, both L-type[62,63] and non-L-type channels[64,65] are the targets for a wide range of drugs. These include dihydropyridines, phenylalkylamines, diltiazem, and mibefradil that are used to treat cardiovascular diseases including angina, arrhythmias, congestive heart failure, and hypertension,[66–68] and drugs for epilepsy and chronic pain.[69–71]

AMINO ACID SEQUENCE INFORMATION

Calmodulin (CaM)

- *Saccharomyces cerevisiae*: isoform 1 (canonical CaM), 147 amino acid residues (AA), SWISSPROT Id code (SWP) P06787.[72]
- *Homo sapiens*: isoform 1, 148 AA, SWP P62158.[73]
- *Chlamydomonas reinhardtii*: isoform 1, 162 AA, SWP P04352.[74]
- *Arabidopsis thaliana*: plant isoform 2, 148 AA, SWP P25069.[75]
- *Arabidopsis thaliana*: plant isoform 4, 148 AA, SWP P25854.[76]

- *Arabidopsis thaliana*: plant isoform 6, 148 AA, SWP Q03509.[76]

Voltage-gated calcium channel Ca$_V$α1 subunit

- *Homo sapiens*: Ca$_V$1.1 (α1S), 1873 AA, SWP Q13698.[77–79]
- *Homo sapiens*: Ca$_V$1.2 (α1C), isoform 1 (canonical, there are 35 isoforms), 2221 AA, SWP P13936.[80]
- *Homo sapiens*: Ca$_V$1.2 (α1C), isoform 20 (α1C77), 2138 AA, SWP P13936-20.[80–82]
- *Homo sapiens*: Ca$_V$1.3 (α1D), isoform Neuronal-type, 2161 AA, SWP Q01668.[83]
- *Homo sapiens*: Ca$_V$1.3 (α1D), isoform Beta-cell-type, 2181 AA, SWP Q01668-2.[84]
- *Homo sapiens*: Ca$_V$1.4 (α1F), isoform 1, 1977 AA, SWP O60840.[85]
- *Homo sapiens*: Ca$_V$1.4 (α1F), isoform 2, 1966 AA, SWP O60840-2.[85]
- *Homo sapiens*: Ca$_V$2.1 (α1A), isoform 1 (canonical, there are 7 isoforms), 2505 AA, SWP O00555.[86]
- *Oryctolagus cuniculus*: Ca$_V$2.1 (α1A), isoform BI-2 (canonical, there are 5 isoforms), 2424 AA, SWP P27884.[87]
- *Homo sapiens*: Ca$_V$2.2 (α1B), isoform α1B-1 (canonical, there are 2 isoforms), 2339 AA, SWP Q00975.[88]
- *Oryctolagus cuniculus*: Ca$_V$2.2 (α1B), 2339 AA, SWP Q05152.[89]
- *Homo sapiens*: Ca$_V$2.3 (α1E), isoform 1 (canonical, there are 3 isoforms), 2313 AA, SWP Q15878.[90]
- *Rattus norvegicus*: Ca$_V$2.3 (α1E), 2222 AA, SWP Q07652.[91]
- *Homo sapiens*: Ca$_V$3.1 (α1G), isoform 5 (canonical, there are 14 isoforms), 2377 AA, SWP O43497.[92,93]
- *Homo sapiens*: Ca$_V$3.2 (α1H), isoform 1 (canonical, there are 2 isoforms), 2353 AA, SWP O95180.[94]
- *Homo sapiens*: Ca$_V$3.3 (α1I), isoform 1 (canonical, there are 4 isoforms), 2223 AA, SWP Q9P0X4.[95,96]

PROTEIN PRODUCTION, PURIFICATION, AND MOLECULAR CHARACTERIZATION

Because they are large multicomponent membrane protein complexes (∼0.5 MDa), little is known about the three-dimensional structure of complete Ca$_V$s. Presently, the best data available on complete channels are low-resolution (∼30 Å) electron microscopy reconstructions.[97–100] This level of structural definition reveals only the gross shape of the channel and is inadequate for developing detailed mechanistic insights. Recent crystallographic studies have yielded the first high-resolution structures of the complexes of Ca^{2+}/CaM with the C-terminal tail IQ domains of Ca$_V$1 and Ca$_V$2 subtypes (3D Structure).[23–27] These structure determination efforts have relied on either

recombinant complexes produced by coexpression in *Escherichia coli*[24,26] or *in vitro* complexes made from recombinant CaM expressed in *E. coli* and synthetic Ca$_V$ IQ domain peptides.[23,25,27]

For coexpression production of Ca^{2+}/CaM–IQ domain complexes,[24,26] the IQ domain is expressed as a C-terminal fusion to a construct that bears in sequence a hexahistidine tag, maltose binding protein (MBP), and tobacco etch virus (TEV) protease site (termed HMT fusions for *His$_6$ –maltose binding protein–TEV cleavage site*). HMT fusions permit the use of two, orthogonal affinity steps (metal affinity chromatography and amylose affinity chromatography) that selectively bind the hexahistidine tag and MBP, respectively. Along with the HMT fusion, untagged CaM is expressed from a second plasmid.[24,26] This approach allows the *in vivo* formation of the complex and has often been the key method for making soluble, well-behaved samples as many channel domains that interact with CaM are poorly soluble on their own.

After initial metal affinity and amylose binding affinity chromatography steps to isolate the expressed complexes, the HMT tag is removed with a specific protease, polyhistidine-tagged TEV protease.[102] Following TEV cleavage, application of the digested sample to a metal affinity purification step removes both the protease and uncleaved protein from the cleaved target material in a single step. The resulting Ca^{2+}/CaM–IQ domain complexes are then further purified using ion exchange and size-exclusion chromatography.

For complexes produced *in vitro*,[23,25,27] recombinantly expressed CaM is typically purified from the expression host using some type of hydrophobic interaction resin (ex reference 103). This method exploits the fact that Ca^{2+}/CaM binds tightly to such matrices and can be released upon the addition of a divalent chelator such as EDTA (ethylene diamine tetraacetic acid) or EGTA (ethylene glycol tetraacetic acid). Combination of purified CaM, purified synthetic peptide, and calcium ions are used to make the Ca^{2+}/CaM–IQ domain complexes that are then purified further by a gel-filtration step.[23,25,27]

X-RAY AND NMR STRUCTURE

Both calcium-free 'apo-CaM' and Ca^{2+}/CaM (Figures 2 and 3) have been the subject of numerous NMR and X-ray crystallographic studies that have investigated apo-CaM and Ca^{2+}/CaM structure alone and in complexes with a wide range of targets.[1,7,41] These studies have set the general framework for understanding how CaM acts as a calcium-sensitive switch and how it can recognize such a diverse set of protein targets. NMR studies of apo-CaM (PDB: 1CFD, 1DMO)[104,105] demonstrate that the N-lobe and C-lobe, which are tethered by a short (residue 77–80) interdomain linker, act as independent domains and have similar folds bearing two EF-hand Ca^{2+} binding motifs each (Figure 2). Upon Ca^{2+} binding, both lobes undergo a structural transformation that opens a phenylalanine- and methionine-rich hydrophobic pocket in each lobe (Figures 2 and 3). The interdomain linker is flexible in the absence of target binding[106,107] and has been seen to adopt a variety of different conformations once Ca^{2+}/CaM binds a target.[1,7,41]

The highest resolution structure of Ca^{2+}/CaM reported is at 1.0 Å (PDB: 1EXR) and is of an extended conformation in which the two lobes are separated by a long α-helix[108] (Figure 2). The crystals for these studies were grown at 4 °C from a solution containing 5 mM CaCl$_2$, 50 mM sodium cacodylate (pH 5.0), and 20% methylpentanediol (MPD) equilibrated over a reservoir of 50 mM sodium cacodylate (pH 5.0), 50% MPD. They were triclinic, space group $P1$ with $a = 25.02$ Å, $b = 29.42$ Å, $c = 52.76$ Å, $\alpha = 89.54°$, $\beta = 86.10°$, $\gamma = 82.39°$, and had one molecule per asymmetric unit. This high-resolution structure reveals

Figure 2 Structure of apo-CaM (PDB: 1CFD),[105] and Ca^{2+}/CaM in the extended (PDB: 1EXR)[108] and compact (PDB: 1PRW)[109] conformations. N-lobe and C-lobe are colored green and blue, respectively. Positions of the EF-hand domains are indicated.

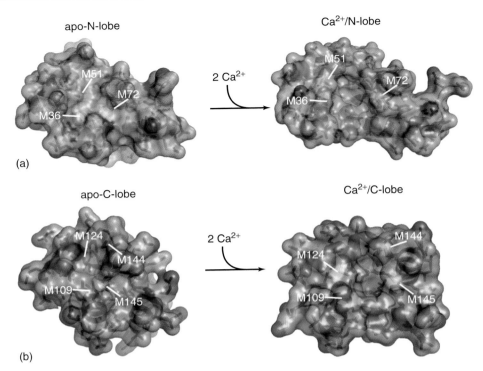

apo-N-lobe

Ca^{2+}/N-lobe

2 Ca^{2+}

(a)

apo-C-lobe

Ca^{2+}/C-lobe

2 Ca^{2+}

(b)

Figure 3 Ca^{2+}-dependent conformational changes expose hydrophobic pockets used for target recognition. (a and b) show views of the N-lobe (a) and C-lobe (b) hydrophobic pockets in the calcium-free (apo-state) and calcium-bound state. Structures are from (PDB: 1EXR).[108] The positions of methionine residues that are important in forming the target binding pocket are indicated.

numerous alternative conformations for residues in the binding pockets and disorder on a wide range of length scales. These unusual structural features suggest that Ca^{2+}/CaM has a large number of structural substates.[108] This high internal disorder is thought to be a crucial factor in the ability of Ca^{2+}/CaM to bind such a diverse range of targets. A crystal structure of a compact form of Ca^{2+}/CaM reported at 1.7 Å resolution (PDB: 1PRW)[109] further demonstrates the great flexibility of the interdomain linker (Figure 3). The crystals for these studies were centered monoclinic, space group $C2$, $a = 63.32$ Å, $b = 35.75$ Å, $c = 68.03$ Å, $\alpha = \gamma = 90.00°$, $\beta = 117.19°$, contained one molecule in the asymmetric unit, and were grown from 40% polyethylene glycol (PEG) 6000, 50 mM sodium acetate (pH 5.6), and 10 mM CaCl$_2$.

CaM EF-hand calcium binding architecture, ion selectivity, and ion binding affinity

The basis for Ca^{2+} recognition by CaM is the EF-hand loop[5,6] (Figure 4). This extremely well-studied calcium binding motif was first identified in the E and F helices of the calcium binding protein parvalbumin[110] and is found in many calcium binding proteins.[5,6,42] The canonical EF-hand loop is composed of a sequence of 12 residues that start with an aspartate and end with a glutamate. Six amino acid positions, denoted X, Y, Z, −X, −Y, and

−Z contribute interactions to the pentagonal bipyramidal coordination of the bound calcium ion (Figure 4(a and b)). In Ca^{2+}/CaM, Ca^{2+} is hepta-coordinated by six EF-hand residues and a water molecule (Figure 4(b)). The residues at EF-hand positions X, Y, Z, and −Z use side-chain oxygen atoms to coordinate the calcium ion directly. In contrast, the −X position coordinates the Ca^{2+} ion indirectly via a water molecule and the −Y residue contributes the coordination oxygen directly from its backbone carbonyl. Consequently, the amino acid identities at the −X and −Y positions are more varied (Figure 4(a)).[5] EF hands most often occur in pairs. This arrangement allows for cooperative binding of calcium ions[5] and is the basic architecture in both CaM lobes (Figure 4).

Inside the cell, the concentration of Mg^{2+}, the element just above calcium in the IIA group of the periodic table, is ∼0.5–2 mM, and presents the EF hands with a 10^2–10^4-fold excess over the Ca^{2+} concentration.[111] Thus, how EF hands achieve ion specificity has been an important question. NMR studies have demonstrated that Mg^{2+} can bind to CaM EF hands. Nevertheless, this interaction fails to cause conformational changes that alter the hydrophobic binding pocket and results in a CaM conformation that is very similar to apo-CaM.[112] Further, even though the CaM EF hands are likely to have some partial occupancy of Mg^{2+} inside the cell, the presence of up to 1 mM Mg^{2+} has no impact on EF-hand Ca^{2+} affinity.[112,113] The basis for the ion selectivity arises from the fact that Mg^{2+} is

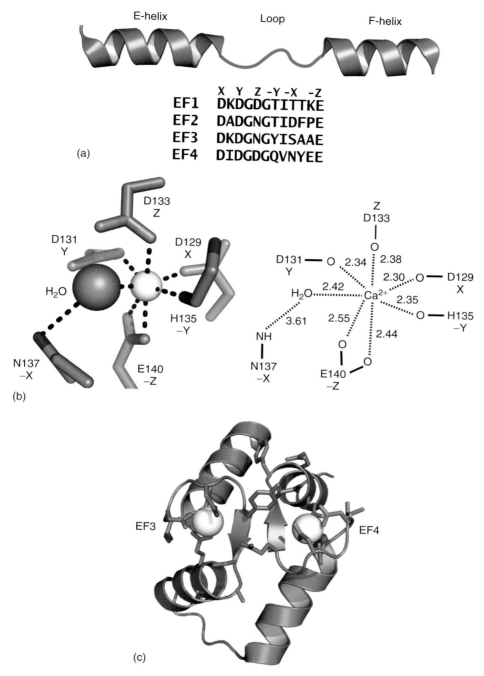

Figure 4 Ca^{2+} ion coordination by CaM EF hands. (a) EF-hand sequences for each of the four CaM EF hands from human CaM. Residues contributing to Ca^{2+} coordination are indicated. (b) View of Ca^{2+} coordination by EF4 in (PDB: 1EXR).[108] Ca^{2+} coordination distance, in angstroms, are shown schematically on the right. (c) CaM Ca^{2+}/C-lobe EF-hand pair.

much smaller, rarely uses neutral oxygen donors such as carbonyl and side-chain hydroxyls as ligands, always forms regular octahedral coordination spheres with a coordination number of six, and has a higher energetic cost of dehydration[16,111] due to its smaller ionic radius (0.65 Å and 0.99 Å for Mg^{2+} and Ca^{2+}, respectively[16]).

In the absence of targets, both CaM lobes act independently and bind calcium ions with positive cooperativity within the lobe.[114] The calcium affinities are in the range of 0.5–5 µM[113,114] with the C-lobe having ~10-fold tighter binding than N-lobe and slower binding kinetics.[115,116] Notably, both the kinetic and thermodynamic calcium binding properties can change greatly due to target engagement.[117–125] In particular, CaM binding to Ca$_V$1 and Ca$_V$2 IQ domains has been reported to increase the apparent Ca^{2+} affinity by ~20–100-fold.[23,126] Thus,

there is a clear interplay between the target and CaM that can tune the calcium response of specific complexes.

Ca^{2+}/CaM – Ca$_V$1 and Ca$_V$2 IQ domain complexes

The IQ motif, (I/L/V)QXXXRXXXX(R/K), named for the isoleucine–glutamine (IQ) pair, is a Ca^{2+}/CaM and apo-CaM binding motif found in diverse proteins including molecular motors, voltage-gated calcium channels, voltage-gated sodium channels, and phosphatases.[127–129] All Ca$_V$1s and Ca$_V$2s have an IQ motif located in the C-terminal cytoplasmic tail ~150–180 residues C-terminal to the last transmembrane segment (IVS6) (Figure 1). This site functions as the principal Ca^{2+}/CaM binding site and has been shown to be crucial for both CDI and CDF in both Ca$_V$1 and Ca$_V$2s.[24,26,27,34,35,37,130–132]

To simplify comparisons, and because the Ca$_V$ IQ sequences have different numbering schemes depending on the organism of origin and particular splice variant used, the IQ domain positions are designated by their relative position in the sequence with respect to the central isoleucine, Ile(0), with negative and positive numbers signifying the position of each residue N-terminal or C-terminal with reference to Ile(0), respectively (Figure 1(c)).

Ca$_V$1 IQ complexes

The first structures of Ca^{2+}/CaM–Ca$_V$ IQ domain complexes were reported using the IQ domains of the L-type channel Ca$_V$1.2[24,25] (Figure 5). These structures were not only the first description of Ca^{2+}/CaM bound to a Ca$_V$ IQ domain but were also the first description of a Ca^{2+}/CaM–IQ domain complex from any source. The Ca^{2+}/CaM–Ca$_V$1.2 IQ domain structures (PDB: 2BE6, 2F3Y)[24,25] showed that Ca^{2+}/CaM wraps around an α-helix formed by the IQ domain (Figure 5). For 2BE6, crystals of the complex were monoclinic, space group P2$_1$, $a = 84.73$ Å, $b = 37.24$ Å, $c = 86.86$ Å, $\alpha = \gamma = 90.00°$, $\beta = 97.77°$, contained three complexes in the asymmetric unit, and were grown from 20–30% PEG 3350, 0.1 M Bis–Tris (pH 6.5). The crystals used in 2F3Y were centered monoclinic, space group C2, $a = 86.20$ Å, $b = 30.96$ Å, $c = 63.94$ Å, $\alpha = \gamma = 90.00°$, $\beta = 114.54°$, contained one complex in the asymmetric unit, and were

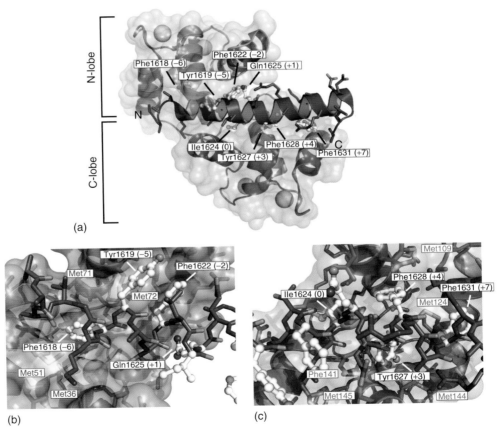

Figure 5 (a) Structure of the Ca^{2+}/CaM–Ca$_V$1.2 IQ peptide complex (PDB: 2BE6).[24] Ca^{2+}/N-lobe and Ca^{2+}/C-lobe are shown in green and blue, respectively. Ca$_V$1.2 IQ domain is shown in firebrick and the aromatic anchor positions are white and shown in ball-and-stick representation. The 'IQ' positions are labeled. (b) Close-up view of the Ca^{2+}/N-lobe-Ca$_V$1.2 IQ domain interactions. (c) Close-up view of the Ca^{2+}/C-lobe–Ca$_V$1.2 IQ domain interactions.

grown from 32% PEG 4000, 50 mM MgCl$_2$, 50 mM Tris (pH 8.3).

In the 2BE6 structures,[24] which have longer IQ domains, the IQ helix has a ~10° bend, centered on Ile1624(0). The structures uncovered two key, unanticipated features. First, the complex revealed a parallel binding mode in which Ca^{2+}/N-lobe was bound to the N-terminal portion of the IQ helix, whereas Ca^{2+}/C-lobe was bound to the C-terminal end. Previously, only one other Ca^{2+}/CaM-α-helical peptide complex had shown this type of binding orientation, that of the Ca^{2+}/CaM-dependent kinase kinase.[133,134] All other examples of Ca^{2+}/CaM–peptide complexes adopted an antiparallel arrangement with respect to Ca^{2+}/CaM and the bound helical peptide. Second, the structures revealed that each Ca^{2+}/CaM lobe interacts with three principle aromatic residues, termed *aromatic anchors* arranged on opposite faces of the IQ helix (Figures 1(c) and 5).

In the Ca^{2+}/CaM–Ca$_V$1.2 IQ domain complex, Phe1618(−6), Tyr1619(−5), and Phe1622(−2) form the aromatic anchors that interact with Ca^{2+}/N-lobe (Figure 5(b)). In 2BE6, two conformations of the Ca^{2+}/N-lobe were observed (denoted, Chain A and Chain C). These use the same set of aromatic anchors but tilt and shift the position of Ca^{2+}/N-lobe to make a slightly more compact structure in the one from Chain C. Tyr1627(+3), Phe1628(+4), and Phe1631(+7) form the aromatic anchors that interact with Ca^{2+}/C-lobe (Figure 5(c)). From the IQ hallmark residues, Ile1624(0) is completely buried by interactions with Ca^{2+}/C-lobe and Gln1625(+1) interacts with both Ca^{2+}/N-lobe and Ca^{2+}/C-lobe. The key contacts are similar in both PDB: 2BE6, 2F3Y. Additionally, Fallon et al.[25] determined the structure of an IQ domain mutant (PDB: 2F3Z) that incorporated the IQ → AA change at positions 0 and +1. These crystals were isomorphic to 2F3Y and grown in the same crystallization conditions. In Ca$_V$1.2, the IQ → AA double mutant eliminates CDI and causes strong CDF,[135] but does not alter the ability of Ca^{2+}/CaM to bind the IQ domain.[135,136] The structure of this mutant complex is essentially identical to the wild-type complex (root mean square deviation for Cα atoms, r.m.s.d.$_C$ = 0.530).

Ca$_V$1.1 channels are unusual. Their principle role is to act in skeletal muscle as the voltage-sensing subunit for the intracellular ryanodyne receptor.[16] This action requires a physical link between Ca$_V$1.1 and the ryanodyne receptor but does not require calcium permeation through Ca$_V$1.1.[137–141] Nevertheless, Ca$_V$1.1 subunits do have some form of CDI[142] and an IQ domain that is capable of binding Ca^{2+}/CaM.[23,143] The 1.94-Å resolution structure of Ca^{2+}/CaM–Ca$_V$1.1 IQ domain complex[23] (PDB: 2VAY) reveals a parallel binding conformation that is very similar to that observed in the Ca$_V$1.2 complexes (Table 2). These crystals were centered monoclinic, space group C2, a = 84.92 Å, b = 34.67 Å, c = 62.98 Å, α = γ = 90.00°, β = 113.59°, contained one complex in the asymmetric unit, and were grown in 32% PEG 3500, 50 mM MgCl$_2$,

50 mM Tris. This crystal habit and growth conditions are very similar to those of 2F3Y and 2F3Z. Of the four residues that are not conserved between Ca$_V$1.1 and Ca$_V$1.2 (positions +3, +8, +11, and +13) (Figure 1(c)), only the anchor position residue Ca$_V$1.1 His1532(+3) and Ca$_V$1.2 Tyr1627(+3) make substantial contacts with Ca^{2+}/CaM. Structural analysis shows that Ca$_V$1.1 His1532 (+3) occupies the same Ca^{2+}/C-lobe binding pocket as Ca$_V$1.2 Tyr1627(+3). This change requires only a minor rearrangement of the side chains that line the pocket.[23] Introduction of the Y → H(+3) change into the Ca$_V$1.2 IQ domain is sufficient to reduce Ca^{2+}/CaM binding. Simultaneous introduction of Y(+3) → H(+3) and K(+8) → M(+8) into Ca$_V$1.2 eliminates CDI.[143]

Ca$_V$2 IQ complexes

The determination of Ca^{2+}/CaM–Ca$_V$ IQ domain complexes from Ca$_V$2.1, Ca$_V$2.2, and Ca$_V$2.3 at 2.6, 2.35, and 2.30 Å resolution (PDB: 3DVM, 3DVE, and 3DVK), respectively, revealed that unlike the Ca$_V$1.2 and Ca$_V$1.1 Ca^{2+}/CaM-IQ domain complexes, all three Ca$_V$2 IQ domain complexes are antiparallel (Figure 6). The Ca$_V$2.1 complex crystals (3DVM) were primitive hexagonal, space group P6$_1$22, a = b = 44.0 Å c = 337.9 Å, α = β = 90.00°, γ = 120.00°, contained one complex in the asymmetric unit and were grown in 25% PEG 3350, 0.1 M Bis–Tris (pH 6.5). Crystals of the Ca$_V$2.2 and Ca$_V$2.3 complexes (3DVE and 3DVK) were primitive hexagonal, space group P6$_1$22, had unit-cell dimensions of a = b = 44.3 Å, c = 344.7 Å, α = β = 90.00°, γ = 120.00°, and a = b = 44.3 Å, c = 337.9 Å, α = β = 90.00°, γ = 120.00°, respectively. Each contained one complex in the asymmetric unit and were grown from 25 to 30% PEG 2000 monomethylether (MME), 0.1 M Bis–Tris (pH 6.5).

Rather than just a simple exchange of binding positions, the Ca$_V$2 antiparallel complexes also show a translation of Ca^{2+}/CaM toward the N-terminal end of the IQ helix (Figure 7). This shift is consistent with the loss of the aromatic anchor at the +7 position, which is a small hydrophilic residue in all of the Ca$_V$2 IQ domains (Figure 1(c) and 7). As a consequence of the more N-terminally located binding of Ca^{2+}/CaM, Ca^{2+}/N-lobe is anchored by four main residues: methionine (−1), isoleucine (0), and the aromatics at positions (+3) and (+5). Ca^{2+}/C-lobe, which is bound to the N-terminal end of the IQ helix, is anchored by only two major positions, (−6) and (−2).

While the Ca$_V$2.1 and Ca$_V$2.3 complexes are essentially identical (r.m.s.d.$_C$ = 0.598), the Ca$_V$2.2 complex displayed some structural differences (r.m.s.d.$_C$ = 2.02 for superposition using Ca$_V$2.2 and Ca$_V$2.3 Ca^{2+}/N-lobes and IQ domains), namely, a slightly altered IQ helix pose and a relative displacement of the Ca^{2+}/C-lobe toward the center of the IQ helix. These differences

Table 2 Structure comparison of Ca^{2+}/CaM-IQ domain complexes

Native channel	Pore-forming $Ca_{v}\alpha_1$ subunit	L-type α_{1S}, $Ca_v1.1$, 2VAY	L-type α_{1C}, $Ca_v1.2$, 2BE6, Chain A	L-type α_{1C}, $Ca_v1.2$, 2BE6, Chain C	L-type α_{1C}, $Ca_v1.2$, 2F3Y	L-type α_{1C}, $Ca_v1.2$, 2F3Z, IQ→AA	P/Q-type α_{1A}, $Ca_v2.1$, 3DVM	P/Q-type α_{1A}, $Ca_v2.1$, 3BXK	N-type α_{1B}, $Ca_v2.2$, 3DVE	N-type α_{1B}, $Ca_v2.2$, 3DVJ	R-type α_{1E}, $Ca_v2.3$, 3DVK	R-type α_{1E}, $Ca_v2.3$, 3BXL
L-type	α_{1S}, $Ca_v1.1$, 2VAY[23]	–	–	–	–	–	–	–	–	–	–	–
	α_{1C}, $Ca_v1.2$, 2BE6, Chain A[24]	0.831	–	–	–	–	–	–	–	–	–	–
	α_{1C}, $Ca_v1.2$, 2BE6, Chain C[24]	1.140	0.738	–	–	–	–	–	–	–	–	–
	α_{1C}, $Ca_v1.2$, 2F3Y[25]	0.684	0.848	1.061	–	–	–	–	–	–	–	–
	α_{1C}, $Ca_v1.2$, 2F3Z, IQ → AA[25]	0.847	0.821	1.154	0.602	–	–	–	–	–	–	–
P/Q-type	α_{1A}, $Ca_v2.1$, 3DVM[26]	1.917	2.037	1.990	1.869	1.885	–	–	–	–	–	–
	α_{1A}, $Ca_v2.1$, 3BXK[27]	1.478	0.868	0.643	1.319	1.507	2.356	–	–	–	–	–
N-type	α_{1B}, $Ca_v2.2$, 3DVE[26]	2.128	2.164	2.077	2.156	2.182	1.514	2.405	–	–	–	–
	α_{1B}, $Ca_v2.2$, 3DVJ, HM → TV[26]	2.141	2.125	2.221	2.177	2.188	1.402	2.451	0.447	–	–	–
R-type	α_{1E}, $Ca_v2.3$, 3DVK[26]	2.141	1.983	1.923	1.779	1.810	0.598	2.285	1.699	1.576	–	–
	α_{1E}, $Ca_v2.3$, 3BXL[27]	1.836	1.309	0.938	1.311	1.476	2.136	0.621	2.109	2.175	2.069	–

Black numbers indicate superposition based on Ca^{2+}/C-lobe and IQ domain. Green numbers indicate superposition based on Ca^{2+}/N-lobe and IQ domain. Blue numbers indicate superposition based on Ca^{2+}/C-lobe-IQ domain with Ca^{2+}/N-lobe-IQ domain. In all cases, the lobe used for superposition is the one bound to the C-terminal site of the IQ domain. All values are for r.m.s.d.$_C$.

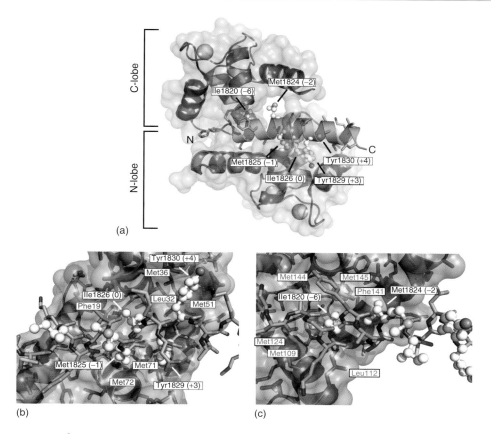

(a)

(b) (c)

Figure 6 (a) Structure of Ca^{2+}/CaM–Ca$_V$2 IQ peptide complex (PDB: 3DVK).[26] Ca^{2+}/N-lobe and Ca^{2+}/C-lobe are shown in green and blue, respectively. Ca$_V$2.3 IQ domain is shown in orange and the aromatic anchor positions are white and shown in ball-and-stick representation. (b) Close-up view of the Ca^{2+}/N-lobe-Ca$_V$2.3 IQ domain interactions. (c) Close-up view of the Ca^{2+}/C-lobe-Ca$_V$2.3 IQ domain interactions.

cause less burial of Met1862 (−1), more Ca^{2+}/N-lobe interactions to Phe1864(+1) than made in Ca$_V$2.1 and Ca$_V$2.3 to Met1972/1827(+1), and a more central position of Ile1863(0) in the Ca$_V$2.2 complex. In all structures, the Tyr(+4) side-chain hydroxyl makes a water-mediated hydrogen bond with the Ca^{2+}/N-lobe.

In addition to the above structures, complexes of Ca^{2+}/CaM with Ca$_V$2.1 and Ca$_V$2.3 IQ peptides shorter than those described above (Table 1) were also reported (PDB: 3BXK and 3BXL, respectively).[27] The Ca$_V$2.1 complex crystals were centered monoclinic, space group C2, had unit-cell dimensions of $a = 80.65$ Å, $b = 80.43$ Å, $c = 63.84$ Å, $\alpha = \gamma = 90.00°$, $\beta = 97.56°$, contained two complexes in the asymmetric unit, and were grown from 2.3 M ammonium sulfate, 0.15 M sodium tartrate, and 0.05 M sodium citrate (pH 5.5). The Ca$_V$2.3 complex crystals were centered tetragonal, space group $I4_1 22$, had unit-cell dimensions of $a = b = 124.61$ Å, $c = 74.02$ Å, $\alpha = \beta = \gamma = 90.00°$, contained one complex in the asymmetric unit, and were grown from 2.1 M ammonium sulfate and 0.05 M sodium citrate (pH 5.0).

Strikingly, the structures of these complexes are very similar to the parallel Ca$_V$1.2 complex using the short

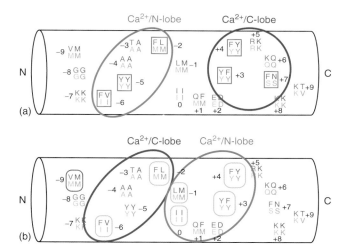

(a)

(b)

Figure 7 Comparisons of the anchor positions used by the individual Ca^{2+}/CaM lobes in the parallel Ca$_V$1.2 complex (a) and antiparallel Ca$_V$2 complexes (b). Ca^{2+}/N-lobe and Ca^{2+}/C-lobe are shown in green and blue, respectively. Sequences from Ca$_V$1.2, Ca$_V$2.1, Ca$_V$2.2, and Ca$_V$2.3 are shown in red, yellow, purple, and orange, respectively. Red boxes indicate the aromatic anchors in the Ca$_V$1.2 complex. Yellow ovals indicate the anchor positions used in the Ca$_V$2 complexes. Purple oval shows an additional contact to Ca^{2+}/C-lobe in the Ca$_V$2.2 complex.

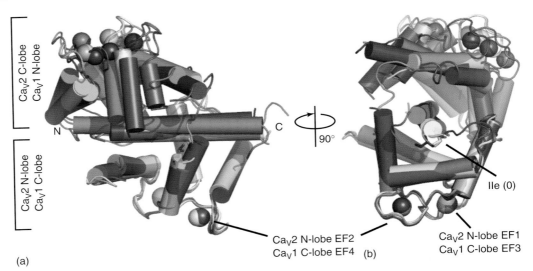

Figure 8 Comparison of the Ca^{2+}/CaM–Ca$_V$1.2 and Ca^{2+}/CaM–Ca$_V$2 parallel and antiparallel structures using superposition of Ca^{2+}/C-lobe–Ca$_V$1.2 and Ca^{2+}/N-lobe–Ca$_V$2s. Structures are colored as follows: Ca^{2+}/CaM–Ca$_V$1.2 IQ domain (firebrick), Ca^{2+}/CaM–Ca$_V$2.1 IQ domain (yellow), Ca^{2+}/CaM–Ca$_V$2.2 IQ domain (purple), Ca^{2+}/CaM–Ca$_V$2.3 IQ domain (orange). (a) Side view. All IQ helices have the same orientation. (b) Axial view from the C-terminus of the IQ domain.

peptide reported by Fallon *et al.*[25] The ability of Ca^{2+}/CaM to bind similar peptide sequences in opposite orientations is striking. It should be noted, however, that the shorter peptides lack four residues that contribute to interactions with the C-lobe in the antiparallel complexes, particularly the residue at (−9), and adoption of the antiparallel pose on the short peptide would place the positively charged IQ peptide N-terminus near the C-lobe. Notably, the peptide length is not an issue for Ca$_V$1.2 binding as the 2BE6 structures contain a peptide that begins at position (−12).

Comparison of parallel and antiparallel binding modes

In both the parallel Ca$_V$1- and antiparallel Ca$_V$2–Ca^{2+}/CaM IQ domain complexes, each Ca^{2+}/CaM lobe interacts with an extensive network of residues from the IQ helices. One common element in the Ca$_V$1 and Ca$_V$2 complexes is that the occupant of the N-terminal binding site, Ca^{2+}/N-lobe for Ca$_V$1s and Ca^{2+}/C-lobe for Ca$_V$2s, buries much less surface area than the occupant of the C-terminal binding site (Ca^{2+}/N-lobe vs Ca^{2+}/C-lobe: Ca$_V$1.1 1209 Å2, 1630 Å2; Ca$_V$1.2 1450 Å2, 1819 Å2; Ca$_V$2.1 1652 Å2, 921 Å2; Ca$_V$2.2 2026 Å2, 1224 Å2; Ca$_V$2.3 1673 Å2, 950 Å2; respectively). Aside from the helix direction, the constellation of anchor points has major differences (Figure 7). In all antiparallel Ca$_V$2 complexes, Ca^{2+}/CaM binds further toward the IQ helix N-terminal end, a change that is consistent with the lack of an aromatic residue at (+7), a position that is a key anchor for Ca^{2+}/C-lobe in the Ca$_V$1 complexes. Four aromatic anchor positions used by the Ca$_V$1.2 IQ α-helix to bind Ca^{2+}/CaM, positions (−6), (−2), (+3) and

(+4), are also used as anchors in the Ca^{2+}/CaM–Ca$_V$2 IQ helix complexes. Ca^{2+}/C-lobe binds two of these, (−6) and (−2), neither of which are aromatic residues in Ca$_V$2s but that retain nonpolar character, whereas Ca^{2+}/N-lobe uses the two aromatics at (+3) and (+4). The more N-terminal location of Ca^{2+}/N-lobes in the Ca$_V$2 complexes results in the (−1) and (0) positions occupying a very central position in the Ca^{2+}/N-lobe binding site (Figures 6(a) and 7(b)).

Ca^{2+}/N-lobe and Ca^{2+}/C-lobe share a high degree of structural similarity.[43] This is evident if one superposes the Ca^{2+}/C-lobe of the Ca$_V$1.2 parallel complex onto Ca^{2+}/N-lobe of the antiparallel Ca$_V$2 complexes (Figure 8). This superposition preserves the IQ helix direction and shows that Ca^{2+}/CaM wraps around the IQ helix by using different amounts of lobe separation along the helix. Comparison of all of the structures is shown in Table 2. The largest degree of separation is found in the Ca$_V$1.2 complex. The relative position of the N-terminally located lobe with respect to the IQ helix axis is delimited by the two conformations seen for Ca^{2+}/N-lobe in the Ca$_V$1.2 structure (Figure 8(b)).

FUNCTIONAL ASPECTS

The processes of CDI and CDF provide opposing ways for Ca$_V$s to autoregulate activity.[28,32,33] Both depend on the interaction of Ca^{2+}/CaM with the IQ domain. Elegant experiments using CaM mutants impaired in calcium binding at specific lobes have demonstrated that the individual lobes cause CDI in a manner that is exchanged between Ca$_V$1 and Ca$_V$2 isoforms. In Ca$_V$1.2, the C-lobe governs CDI[37] (Figure 9(a)), whereas in

$Ca_V2.1$[34,35] (Figure 10(a)), $Ca_V2.2$,[36] and $Ca_V2.3$[36] the N-lobe governs CDI. Further, the C-lobe has been shown to control $Ca_V2.1$ CDF.[34,35] Functional analysis based on the $Ca_V1.2$ structure deepened the mystery further. Elimination of the interactions between the N-lobe anchors Phe1618(-6), Tyr1619(-5), and Phe1622(-2) by a triple alanine mutation (TripleA), abolished $Ca_V1.2$ CDF and Ca^{2+}/N-lobe binding[24] (Figure 9(b)). This result suggests a complete inversion of lobe-specific roles between $Ca_V1.2$ and $Ca_V2.1$ (Figure 11(a)).

The high level of sequence similarity among the Ca_V1 and Ca_V2 IQ domains (Figure 1(c)) and the inversion of lobe-specific functions (Figure 11(a)), pushed the desire to understand how the same molecule, Ca^{2+}/CaM, could affect different processes using different lobes and yet interact with a highly conserved portion of the pore-forming subunit. The antiparallel orientation revealed in the Ca^{2+}/CaM complexes with the longest Ca_V2 IQ domains, together with the observation that structure-based alanine mutations that eliminate the binding of the C-lobe to the IQ domain also greatly reduce CDF[26] (Figure 10(b)) indicates a clear structural basis for the swap of lobe-specific roles. These data suggest that the Ca_V1 and Ca_V2 IQ domains contain dedicated CDF binding sites and that the occupant of those sites is exchanged between Ca_V1 and Ca_V2 isoforms (Figure 11). The observed inversion of structural polarity provides an attractive explanation for the inversion of lobe-specific roles (Figure 11(b)) (however, see reference 27 for alternative scenarios). The observation that the occupant of the N-terminal site in both Ca_V1 and Ca_V2 IQ domains makes fewer contacts and binds more weakly, suggests that these physical properties are also key to the CDF mechanism.

Despite the advances in understanding the structural interactions of Ca^{2+}/CaM with Ca_V IQ domains, the view remains limited. It is unclear how the channel senses the conformation changes on the IQ domain and how these are linked to changes in the behavior of the channel pore. Further, apo-CaM binds the Ca_V C-terminal tails of both L-type and non-L-type Ca_Vs[31,37,130,144–147] and is thought to be essential for the ability of Ca_Vs to decode different types of calcium signals[148]; however, the exact binding site and details of the interactions remain controversial. At least three-candidate Ca_V C-terminal tail regions have been proposed: the IQ domain,[136,146,149] and two regions in the 'pre-IQ' region that are termed the *A-peptide*[149] and *C-peptide* regions.[136,145,149,150]

As there is a substantial amount of the Ca_V mass in the cytoplasm, ~150 kDa,[28] other elements from the intracellular regions of the channel are likely to have some role in both CDI and CDF. Functional data point toward potential roles for interaction of the Ca^{2+}/CaM IQ domain with the putative EF hand proximal to transmembrane segment IV6,[27,151] elements in the N-terminal[148,152,153] and the C-terminal $Ca_V\alpha_1$ cytoplasmic domains,[154–157] and the $Ca_V\beta$ subunit.[149,158,159] Additionally, the large,

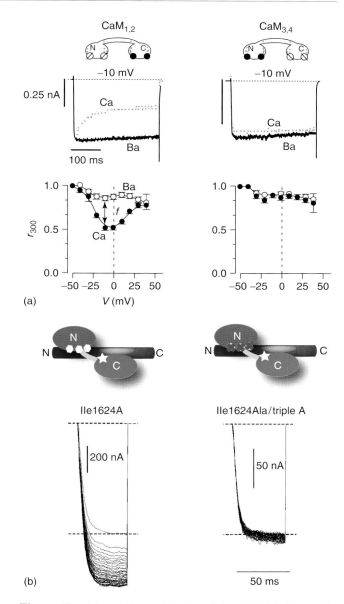

Figure 9 Calmodulin modulation of $Ca_V1.2$ (a) Lobe-specific CaM mutants defective in Ca^{2+} binding, $CaM_{1,2}$ (defective N-lobe), and $CaM_{3,4}$ (defective C-lobe) demonstrate the importance of C-lobe for $Ca_V1.2$ CDI. Top shows response of $Ca_V1.2$ to a depolarization to -10 mV when Ca^{2+} (gray) or Ba^{2+} (black) is the charge carrier. Bottom shows the residual current at 300 ms for both charge carriers (from reference 37). (b) Elimination of Ca^{2+}/N-lobe aromatic anchors abolishes $Ca_V1.2$ CDF. Experiments show the response of $Ca_V1.2$ to a 3-Hz pulse train (50 ms steps to $+20$ mV from a holding potential of -90 mV) and are done in the background of the I1624A mutant that unmasks CDF. Cartoons show the positions of the Ca^{2+}/N-lobe aromatic anchors (hexagons) and I1624A (star). (Reproduced with permission from Ref. 24. © Nature.)

dodecameric protein kinase, CaMKII has been shown to be a key element in both $Ca_V1.2$[160–164] and $Ca_V2.1$[165] CDF. Exactly how this large complex engages the channel remains unknown.

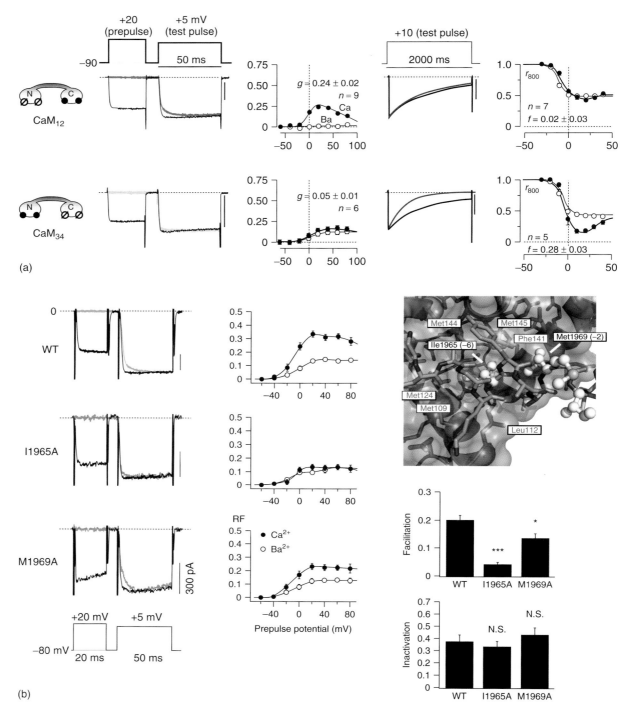

Figure 10 Calmodulin modulation of Ca$_V$1.2. (a) Lobe-specific CaM mutants defective in Ca^{2+} binding, CaM$_{12}$ (defective N-lobe), and CaM$_{34}$ (defective C-lobe) demonstrate the importance of N-lobe for Ca$_V$2.1 CDI and C-lobe for Ca$_V$2.1 CDF. Left shows response of Ca$_V$2.1 to a depolarization to +5 mV following a prepulse to +20 mV and a measure of relative facilitation when Ca^{2+} (gray) or Ba^{2+} (black) is the charge carrier. Right shows response to a +10 mV pulse and inactivation at 800 ms for both charge carriers (from reference 34). (b) Elimination of Ca^{2+}/C-lobe anchors demonstrates importance for Ca$_V$2.1 CDF. Left shows response of Ca$_V$2.1 and I1965(−6) and M1969(−2) anchor mutants to protocols similar to (a). Right shows positions of (−6) and (−2) anchors and the alanine mutant effects on facilitation and inactivation. (Reproduced with permission from Ref. 26. © Elsevier.)

The acquisition of high-resolution structural views of the interactions of Ca^{2+}/CaM with various Ca$_V$1 and Ca$_V$2 IQ domains has provided significant insight into the complex mechanisms that control Ca$_V$ activity-dependent modulation. Nevertheless, the IQ domain is too far from the pore-lining segments in primary sequence to postulate

	CDI	CDF
Ca$_V$1.2 (L-type)	C-lobe	N-lobe
(a) Ca$_V$2.1 (P/Q type)	N-lobe	C-lobe

Figure 11 Functional and structural correlates of Ca^{2+}/CaM interactions with Ca$_V$1 and Ca$_V$2 IQ domains. (a) Lobe-specific roles in Ca$_V$1.2 and Ca$_V$2.1 CDI and CDF. (b) Diagrams of the orientations of Ca^{2+}/CaM on the Ca$_V$1 and Ca$_V$2 IQ domains and the roles of the individual lobes.

a simple model for how the Ca^{2+}/CaM IQ domain complexes mediate CDI and CDF. Thus, defining the exact arrangement of the channel intracellular components and the state dependence of interactions remains an important challenge for future work.

REFERENCES

1 M Ikura and JB Ames, *Proc Natl Acad Sci U S A*, **103**, 1159–64 (2006). DOI: 0508640103 [pii] 10.1073/pnas.0508640103.

2 RD Burgoyne, *Nat Rev Neurosci*, **8**, 182–93 (2007). DOI: nrn2093 [pii] 10.1038/nrn2093.

3 TN Tsalkova and PL Privalov, *J Mol Biol*, **181**, 533–44 (1985). DOI: 0022–2836(85)90425-5 [pii].

4 L Masino, SR Martin and PM Bayley, *Protein Sci*, **9**, 1519–29 (2000). DOI: 10.1110/ ps.9.8.1519.

5 JL Gifford, MP Walsh and HJ Vogel, *Biochem J*, **405**, 199–221 (2007). DOI: BJ20070255 [pii] 10.1042/BJ20070255.

6 Z Grabarek, *J Mol Biol*, **359**, 509–25 (2006). DOI: S0022-2836(06)00447-5 [pii] 10.1016/j.jmb.2006.03.066.

7 KP Hoeflich and M Ikura, *Cell*, **108**, 739–42 (2002).

8 AP Yamniuk and HJ Vogel, *Mol Biotechnol*, **27**, 33–57 (2004). DOI: MB:27:1:33 [pii] 10.1385/MB:27:1:33.

9 KL Yap, J Kim, K Truong, M Sherman, T Yuan and M Ikura, *J Struct Funct Genomics*, **1**, 8–14 (2000).

10 Y Saimi and C Kung, *Annu Rev Physiol*, **64**, 289–311 (2002).

11 WA Catterall, *Annu Rev Cell Dev Biol*, **16**, 521–55 (2000).

12 EA Ertel, KP Campbell, MM Harpold, F Hofmann, Y Mori, E Perez-Reyes, A Schwartz, TP Snutch, T Tanabe, L Birnbaumer, RW Tsien and WA Catterall, *Neuron*, **25**, 533–35 (2000). DOI: S0896-6273(00)81057-0 [pii].

13 WA Catterall, E Perez-Reyes, TP Snutch and J Striessnig, *Pharmacol Rev*, **57**, 411–25 (2005). DOI: 57/4/411 [pii] 10.1124/pr.57.4.5.

14 MC Jeziorski, RM Greenberg and PA Anderson, *J Exp Biol*, **203**, 841–56 (2000).

15 Y Okamura, H Izumi-Nakaseko, K Nakajo, Y Ohtsuka and T Ebihara, *Neurosignals*, **12**, 142–58 (2003). DOI: 10.1159/ 000072161 NSG2003012003142 [pii].

16 B Hille, *Ion Channels of Excitable Membranes*, 3rd edn, Sinauer Associates, Inc., Sunderland, MA (2001).

17 FH Yu, V Yarov-Yarovoy, GA Gutman and WA Catterall, *Pharmacol Rev*, **57**, 387–95 (2005).

18 K Talavera and B Nilius, *Cell Calcium*, **40**, 97–114 (2006). DOI: S0143-4160(06)00080-7 [pii] 10.1016/j.ceca.2006.04.013.

19 MC Iftinca and GW Zamponi, *Trends Pharmacol Sci*, **30**, 32–40 (2009). DOI: S0165-6147(08)00242-3 [pii] 10.1016/j.tips.2008.10.004.

20 I Calin-Jageman and A Lee, *J Neurochem*, **105**, 573–83 (2008). DOI: JNC5286 [pii] 10.1111/j.1471–4159.2008.05286.x.

21 HW Tedford and GW Zamponi, *Pharmacol Rev*, **58**, 837–62 (2006).

22 WA Catterall and AP Few, *Neuron*, **59**, 882–901 (2008). DOI: S0896-6273(08)00752-6 [pii] 10.1016/j.neuron.2008.09.005.

23 DB Halling, DK Georgiou, DJ Black, G Yang, JL Fallon, FA Quiocho, SE Pedersen and SL Hamilton, *J Biol Chem*, (2009). DOI: M109.013326 [pii] 10.1074/jbc.M109.013326.

24 F Van Petegem, FC Chatelain and DL Minor Jr, *Nat Struct Mol Biol*, **12**, 1108–15 (2005).

25 JL Fallon, DB Halling, SL Hamilton and FA Quiocho, *Structure*, **13**, 1881–86 (2005).

26 EY Kim, CH Rumpf, Y Fujiwara, ES Cooley, F Van Petegem and DL Minor Jr, *Structure*, **16**, 1455–67 (2008).

27 MX Mori, CW Vander Kooi, DJ Leahy and DT Yue, *Structure*, **16**, 607–20 (2008).

28 F Van Petegem and DL Minor, *Biochem Soc Trans*, **34**, 887–93 (2006).

29 AC Dolphin, *J Bioenerg Biomembr*, **35**, 599–620 (2003).

30 A Davies, J Hendrich, AT Van Minh, J Wratten, L Douglas and AC Dolphin, *Trends Pharmacol Sci*, **28**, 220–28 (2007).

31 GS Pitt, *Cardiovasc Res*, **73**, 641–47 (2007).

32 K Dunlap, *J Gen Physiol*, **129**, 379–83 (2007).

33 DB Halling, P Aracena-Parks and SL Hamilton, *Sci STKE*, **2006**, er1 (2006).

34 CD DeMaria, TW Soong, BA Alseikhan, RS Alvania and DT Yue, *Nature*, **411**, 484–89 (2001).

35 A Lee, H Zhou, T Scheuer and WA Catterall, *Proc Natl Acad Sci U S A*, **12**, 12 (2003).

36 H Liang, CD DeMaria, MG Erickson, MX Mori, BA Alseikhan and DT Yue, *Neuron*, **39**, 951–60 (2003).

37 BZ Peterson, CD DeMaria, JP Adelman and DT Yue, *Neuron*, **22**, 549–58 (1999).

38 F Van Petegem, KA Clark, FC Chatelain and DL Minor Jr, *Nature*, **429**, 671–75 (2004).

39 DE Clapham, *Cell*, **131**, 1047–58 (2007).

40 CB Klee, TH Crouch and PG Richman, *Annu Rev Biochem*, **49**, 489–515 (1980). DOI: 10.1146/annurev.bi.49.070180. 002421.

41 A Crivici and M Ikura, *Annu Rev Biophys Biomol Struct*, **24**, 85–116 (1995).

42 S Nakayama and RH Kretsinger, *Annu Rev Biophys Biomol Struct*, **23**, 473–507 (1994). DOI: 10.1146/annurev.bb.23. 060194.002353.

43 ZA Ataman, L Gakhar, BR Sorensen, JW Hell and MA Shea, *Structure*, **15**, 1603–17 (2007).

44 R Fischer, M Koller, M Flura, S Mathews, MA Strehler-Page, J Krebs, JT Penniston, E Carafoli and EE Strehler, *J Biol Chem*, **263**, 17055–62 (1988).

45 JT Littleton and B Ganetzky, *Neuron*, **26**, 35–43 (2000). DOI: S0896-6273(00)81135-6 [pii].

46 W Zheng, G Feng, D Ren, DF Eberl, F Hannan, M Dubald and LM Hall, *J Neurosci*, **15**, 1132–43 (1995).

47 RY Lee, L Lobel, M Hengartner, HR Horvitz and L Avery, *EMBO J*, **16**, 6066–76 (1997).

48 WR Schafer and CJ Kenyon, *Nature*, **375**, 73–78 (1995). DOI: 10.1038/375073a0.

49 D Zoccola, E Tambutte, F Senegas-Balas, JF Michiels, JP Failla, J Jaubert and D Allemand, *Gene*, **227**, 157–67 (1999).

50 MC Jeziorski, RM Greenberg, KS Clark and PA Anderson, *J Biol Chem*, **273**, 22792–99 (1998).

51 SL Hamilton, II Serysheva, *J Biol Chem*, **284**, 4047–51 (2009). DOI: R800054200 [pii] 10.1074/jbc.R800054200.

52 A Marcantoni, P Baldelli, JM Hernandez-Guijo, V Comunanza, V Carabelli and E Carbone, *Cell Calcium*, **42**, 397–408 (2007). DOI: S0143-4160(07)00101-7 [pii] 10.1016/j.ceca.2007. 04.015.

53 SN Yang and PO Berggren, *Endocr Rev*, **27**, 621–76 (2006). DOI: er.2005-0888 [pii] 10.1210/er.2005-0888.

54 J Striessnig, A Koschak, MJ Sinnegger-Brauns, A Hetzenauer, NK Nguyen, P Busquet, G Pelster and N Singewald, *Biochem Soc Trans*, **34**, 903–9 (2006). DOI: BST0340903 [pii] 10.1042/BST0340903.

55 J Striessnig, HJ Bolz and A Koschak, *Pflugers Arch*, (2010). DOI: 10.1007/s00424-010-0800-x.

56 CJ Doering, JB Peloquin and JE McRory, *Channels (Austin)*, **1**, 3–10 (2007). DOI: 3938 [pii].

57 RM Evans and GW Zamponi, *Trends Neurosci*, **29**, 617–24 (2006).

58 P Liao, HY Zhang and TW Soong, *Pflugers Arch*, **458**, 481–87 (2009). DOI: 10.1007/s00424-009-0635-5.

59 AC Gray, J Raingo and D Lipscombe, *Cell Calcium*, **42**, 409–17 (2007). DOI: S0143-4160(07)00076-0 [pii] 10.1016/j.ceca. 2007.04.003.

60 P Liao and TW Soong, *Pflugers Arch*, **460**(2), 353–9 (2010). DOI: 10.1007/s00424-009-0753-0.

61 D Pietrobon, *Pflugers Arch*, **460**(2), 375–93 (2010). DOI: 10.1007/s00424-010-0802-8.

62 DJ Triggle, *Curr Pharm Des*, **12**, 443–57 (2006).

63 DJ Triggle, *Biochem Pharmacol*, **74**, 1–9 (2007).

64 E Bourinet and GW Zamponi, *Curr Top Med Chem*, **5**, 539–46 (2005).

65 CJ Doering and GW Zamponi, *J Bioenerg Biomembr*, **35**, 491–505 (2003).

66 JP Benitah, AM Gomez, J Fauconnier, BG Kerfant, E Perrier, G Vassort and S Richard, *Basic Res Cardiol*, **97**, I11–18 (2002).

67 AA Grace and AJ Camm, *Cardiovasc Res*, **45**, 43–51 (2000).

68 AA Kochegarov, *Cell Calcium*, **33**, 145–62 (2003).

69 DJ Dooley, CP Taylor, S Donevan and D Feltner, *Trends Pharmacol Sci*, **28**, 75–82 (2007).

70 KS Elmslie, *J Neurosci Res*, **75**, 733–41 (2004).

71 N Klugbauer, E Marais and F Hofmann, *J Bioenerg Biomembr*, **35**, 639–47 (2003).

72 TN Davis, MS Urdea, FR Masiarz and J Thorner, *Cell*, **47**, 423–31 (1986). DOI: 0092-8674(86)90599-4 [pii].

73 EJ Wawrzynczak and RN Perham, *Biochem Int*, **9**, 177–85 (1984).

74 WE Zimmer, JA Schloss, CD Silflow, J Youngblom and DM Watterson, *J Biol Chem*, **263**, 19370–83 (1988).

75 V Ling, I Perera and RE Zielinski, *Plant Physiol*, **96**, 1196–202 (1991).

76 MC Gawienowski, D Szymanski, IY Perera and RE Zielinski, *Plant Mol Biol*, **22**, 215–25 (1993).

77 K Hogan, PA Powers and RG Gregg, *Genomics*, **24**, 608–9 (1994). DOI: S0888-7543(84)71677-6 [pii] 10.1006/geno. 1994.1677.

78 P Ruth, A Rohrkasten, M Biel, E Bosse, S Regulla, HE Meyer, V Flockerzi and F Hofmann, *Science*, **245**, 1115–18 (1989).

79 T Tanabe, H Takeshima, A Mikami, V Flockerzi, H Takahashi, K Kangawa, M Kojima, H Matsuo, T Hirose and S Numa, *Nature*, **328**, 313–18 (1987). DOI: 10.1038/328313a0.

80 NM Soldatov, *Proc Natl Acad Sci U S A*, **89**, 4628–32 (1992).

81 NM Soldatov, A Bouron and H Reuter, *J Biol Chem*, **270**, 10540–43 (1995).

82 RD Zuhlke, A Bouron, NM Soldatov and H Reuter, *FEBS Lett*, **427**, 220–24 (1998). DOI: S0014-5793(98)00425-6 [pii].

83 ME Williams, DH Feldman, AF McCue, R Brenner, G Velicelebi, SB Ellis and MM Harpold, *Neuron*, **8**, 71–84 (1992). DOI: 0896-6273(92)90109-Q [pii].

84 S Seino, L Chen, M Seino, O Blondel, J Takeda, JH Johnson and GI Bell, *Proc Natl Acad Sci U S A*, **89**, 584–88 (1992).

85 TM Strom, G Nyakatura, E Apfelstedt-Sylla, H Hellebrand, B Lorenz, BH Weber, K Wutz, N Gutwillinger, K Ruther, B Drescher, C Sauer, E Zrenner, T Meitinger, A Rosenthal and A Meindl, *Nat Genet*, **19**, 260–63 (1998).

86 M Hans, A Urrutia, C Deal, PF Brust, K Stauderman, SB Ellis, MM Harpold, EC Johnson and ME Williams, *Biophys J*, **76**, 1384–400 (1999). DOI: S0006-3495(99)77300-5 [pii] 10.1016/S0006-3495(99)77300-5.

87 Y Mori, T Friedrich, MS Kim, A Mikami, J Nakai, P Ruth, E Bosse, F Hofmann, V Flockerzi, T Furuichi, K Mikoshiba, K Imoto, T Tanabe and S Numa, *Nature*, **350**, 398–402 (1991). DOI: 10.1038/350398a0.

88 ME Williams, PF Brust, DH Feldman, S Patthi, S Simerson, A Maroufi, AF McCue, G Velicelebi, SB Ellis and MM Harpold, *Science*, **257**, 389–95 (1992).

89 Y Fujita, M Mynlieff, RT Dirksen, MS Kim, T Niidome, J Nakai, T Friedrich, N Iwabe, T Miyata and T Furuichi, D Furutama, K Mikoshiba, Y Mori and KG Beam, *Neuron*, **10**, 585–98 (1993). DOI: 0896-6273(93)90162-K [pii].

90 T Schneider, X Wei, R Olcese, JL Costantin, A Neely, P Palade, E Perez-Reyes, N Qin, J Zhou and GD Crawford, *Recept Channels*, **2**, 255–70 (1994).

91 TW Soong, A Stea, CD Hodson, SJ Dubel, SR Vincent and TP Snutch, *Science*, **260**, 1133–36 (1993).

92 S Mittman, J Guo and WS Agnew, *Neurosci Lett*, **274**, 143–46 (1999). DOI: S0304394099007168 [pii].

93 E Perez-Reyes, LL Cribbs, A Daud, AE Lacerda, J Barclay, MP Williamson, M Fox, M Rees and JH Lee, *Nature*, **391**, 896–900 (1998). DOI: 10.1038/36110.

94 LL Cribbs, JH Lee, J Yang, J Satin, Y Zhang, A Daud, J Barclay, MP Williamson, M Fox, M Rees and E Perez-Reyes, *Circ Res*, **83**, 103–9 (1998).

95 S Mittman, J Guo, MC Emerick and WS Agnew, *Neurosci Lett*, **269**, 121–24 (1999). DOI: S0304394099003195 [pii].

96 JH Lee, AN Daud, LL Cribbs, AE Lacerda, A Pereverzev, U Klockner, T Schneider and E Perez-Reyes, *J Neurosci*, **19**, 1912–21 (1999).

97 II Serysheva, SJ Ludtke, MR Baker, W Chiu and SL Hamilton, *Proc Natl Acad Sci U S A*, **99**, 10370–75 (2002).

98 MC Wang, G Velarde, RC Ford, NS Berrow, AC Dolphin and A Kitmitto, *J Mol Biol*, **323**, 85–98 (2002).

99 M Wolf, A Eberhart, H Glossmann, J Striessnig and N Grigorieff, *J Mol Biol*, **332**, 171–82 (2003).

100 MC Wang, RF Collins, RC Ford, NS Berrow, AC Dolphin and A Kitmitto, *J Biol Chem*, **279**, 7159–68 (2004). DOI: 10.1074/jbc.M308057200 M308057200 [pii].

101 http://www.pymol.org/.

102 RB Kapust, J Tozser, JD Fox, DE Anderson, S Cherry, TD Copeland and DS Waugh, *Protein Eng*, **14**, 993–1000 (2001).

103 R Gopalakrishna and WB Anderson, *Biochem Biophys Res Commun*, **104**, 830–36 (1982). DOI: 0006-291X(82)90712-4 [pii].

104 M Zhang, T Tanaka and M Ikura, *Nat Struct Biol*, **2**, 758–67 (1995).

105 H Kuboniwa, N Tjandra, S Grzesiek, H Ren, CB Klee and A Bax, *Nat Struct Biol*, **2**, 768–76 (1995).

106 J Trewhella, *Cell Calcium*, **13**, 377–90 (1992).

107 G Barbato, M Ikura, LE Kay, RW Pastor and A Bax, *Biochemistry*, **31**, 5269–78 (1992).

108 MA Wilson and AT Brunger, *J Mol Biol*, **301**, 1237–56 (2000). DOI: 10.1006/jmbi.2000.4029 S0022-2836(00)94029-4 [pii].

109 JL Fallon and FA Quiocho, *Structure*, **11**, 1303–7 (2003). DOI: S0969212603002053 [pii].

110 RH Kretsinger and CE Nockolds, *J Biol Chem*, **248**, 3313–26 (1973).

111 JJRF da Silva and RJP Williams, *The Biological Chemistry of the Elements*, Oxford University Press, Oxford (1991).

112 S Ohki, M Ikura and M Zhang, *Biochemistry*, **36**, 4309–16 (1997). DOI: 10.1021/bi962759m bi962759m [pii].

113 SR Martin, L Masino and PM Bayley, *Protein Sci*, **9**, 2477–88 (2000). DOI: 10.1110/ ps.9.12.2477.

114 S Linse, A Helmersson and S Forsen, *J Biol Chem*, **266**, 8050–54 (1991).

115 P Bayley, P Ahlstrom, SR Martin and S Forsen, *Biochem Biophys Res Commun*, **120**, 185–91 (1984). DOI: 0006-291X(84)91431-1 [pii].

116 A Teleman, T Drakenberg and S Forsen, *Biochim Biophys Acta*, **873**, 204–13 (1986). DOI: 0167-4838(86)90047-6 [pii].

117 PM Bayley, WA Findlay and SR Martin, *Protein Sci*, **5**, 1215–28 (1996). DOI: 10.1002/pro.5560050701.

118 TS Ulmer, S Soelaiman, S Li, CB Klee, WJ Tang and A Bax, *J Biol Chem*, **278**, 29261–66 (2003). DOI: 10.1074/jbc. M302837200 M302837200 [pii].

119 CY Huang, V Chau, PB Chock, JH Wang and RK Sharma, *Proc Natl Acad Sci U S A*, **78**, 871–74 (1981).

120 NT Theoharis, BR Sorensen, J Theisen-Toupal and MA Shea, *Biochemistry*, **47**, 112–23 (2008). DOI: 10.1021/bi7013129.

121 TR Gaertner, JA Putkey and MN Waxham, *J Biol Chem*, **279**, 39374–82 (2004). DOI: 10.1074/jbc.M405352200 M405352200 [pii].

122 JA Putkey, Q Kleerekoper, TR Gaertner and MN Waxham, *J Biol Chem*, **278**, 49667–70 (2003). DOI: 10.1074/jbc. C300372200 C300372200 [pii].

123 JA Putkey, MN Waxham, TR Gaertner, KJ Brewer, M Goldsmith, Y Kubota and QK Kleerekoper, *J Biol Chem*, **283**, 1401–10 (2008). DOI: M703831200 [pii] 10.1074/jbc.M703831200.

124 JD Johnson, C Snyder, M Walsh and M Flynn, *J Biol Chem*, **271**, 761–67 (1996).

125 BB Olwin and DR Storm, *Biochemistry*, **24**, 8081–86 (1985).

126 DJ Black, DB Halling, DV Mandich, SE Pedersen, RA Altschuld and SL Hamilton, *Am J Physiol Cell Physiol*, **288**, C669–76 (2005).

127 AR Rhoads and F Friedberg, *Biochem J*, **11**, 331–40 (1997).

128 M Bahler and A Rhoads, *FEBS Lett*, **513**, 107–13 (2002).

129 LA Jurado, PS Chockalingam and HW Jarrett, *Physiol Rev*, **79**, 661–82 (1999).

130 GS Pitt, RD Zühlke, A Hudmon, H Schulman, H Reuter and RW Tsien, *J Biol Chem*, **276**, 30794–802 (2001).

131 N Qin, R Olcese, M Bransby, T Lin and L Birnbaumer, *Proc Natl Acad Sci U S A*, **96**, 2435–38 (1999).

132 RD Zühlke, GS Pitt, K Deisseroth, RW Tsien and H Reuter, *Nature*, **399**, 159–62 (1999).

133 H Kurokawa, M Osawa, H Kurihara, N Katayama, H Tokumitsu, MB Swindells, M Kainosho and M Ikura, *J Mol Biol*, **312**, 59–68 (2001).

134 M Osawa, H Tokumitsu, MB Swindells, H Kurihara, M Orita, T Shibanuma, T Furuya and M Ikura, *Nat Struct Biol*, **6**, 819–24 (1999).

135 RD Zühlke, GS Pitt, RW Tsien and H Reuter, *J Biol Chem*, **275**, 21121–29 (2000).

136 W Tang, DB Halling, DJ Black, P Pate, JZ Zhang, S Pedersen, RA Altschuld and SL Hamilton, *Biophys J*, **85**, 1538–47 (2003).

137 MF Schneider and WK Chandler, *Nature*, **242**, 244–46 (1973).

138 E Rios and G Brum, *Nature*, **325**, 717–20 (1987). DOI: 10.1038/325717a0.

139 J Schredelseker, M Shrivastav, A Dayal and M Grabner, *Proc Natl Acad Sci U S A*, **107**, 5658–63 (2010). DOI: 0912153107 [pii] 10.1073/pnas.0912153107.

140 CM Wilkens, N Kasielke, BE Flucher, KG Beam and M Grabner, *Proc Natl Acad Sci U S A*, **98**, 5892–97 (2001). DOI: 10.1073/pnas.101618098 101618098 [pii].

141 C Proenza, CM Wilkens and KG Beam, *J Biol Chem*, **275**, 29935–37 (2000). DOI: 10.1074/jbc.C000464200 C000464200 [pii].

142 K Stroffekova, *Pflugers Arch*, **455**, 873–84 (2008). DOI: 10.1007/s00424-007-0344-x.

143 J Ohrtman, B Ritter, A Polster, KG Beam and S Papadopoulos, *J Biol Chem*, **283**, 29301–11 (2008). DOI: M805152200 [pii] 10.1074/jbc.M805152200.

144 MG Erickson, BA Alseikhan, BZ Peterson and DT Yue, *Neuron*, **31**, 973–85 (2001).

145 MG Erickson, H Liang, MX Mori and DT Yue, *Neuron*, **39**, 97–107 (2003).

146 LY Lian, D Myatt and A Kitmitto, *Biochem Biophys Res Commun*, **353**, 565–70 (2007).

147 HG Wang, MS George, J Kim, C Wang and GS Pitt, *J Neurosci*, **27**, 9086–93 (2007). DOI: 27/34/9086 [pii] 10.1523/JNEUROSCI.1720-07.2007.

148 MR Tadross, IE Dick and DT Yue, *Cell*, **133**, 1228–40 (2008).

149 J Kim, S Ghosh, DA Nunziato and GS Pitt, *Neuron*, **41**, 745–54 (2004).

150 C Romanin, R Gamsjaeger, H Kahr, D Schaufler, O Carlson, DR Abernethy and NM Soldatov, *FEBS Lett*, **487**, 301–6 (2000).

151 M de Leon, Y Wang, L Jones, E Perez-Reyes, X Wei, TW Soong, TP Snutch and DT Yue, *Science*, **270**, 1502–6 (1995).

152 IE Dick, MR Tadross, H Liang, LH Tay, W Yang and DT Yue, *Nature*, **451**, 830–34 (2008).

153 T Ivanina, Y Blumenstein, E Shistik, R Barzilai and N Dascal, *J Biol Chem*, **275**, 39846–54 (2000).

154 A Lee, ST Wong, D Gallagher, B Li, DR Storm, T Scheuer and WA Catterall, *Nature*, **399**, 155–59 (1999).

155 JT Hulme, V Yarov-Yarovoy, TW Lin, T Scheuer and WA Catterall, *J Physiol*, **576**, 87–102 (2006).

156 A Singh, D Hamedinger, JC Hoda, M Gebhart, A Koschak, C Romanin and J Striessnig, *Nat Neurosci*, **9**, 1108–16 (2006).

157 C Wahl-Schott, L Baumann, H Cuny, C Eckert, K Griessmeier and M Biel, *Proc Natl Acad Sci U S A*, **103**, 15657–62 (2006).

158 F Findeisen, DL Minor Jr, *J Gen Physiol*, **133**, 327–43 (2009). DOI: jgp.200810143 [pii] 10.1085/jgp.200810143.

159 T Cens, M Rousset, JP Leyris, P Fesquet and P Charnet, *Prog Biophys Mol Biol*, **90**, 104–17 (2006).

160 W Yuan and DM Bers, *Am J Physiol*, **267**, H982–93 (1994).

161 ME Anderson, AP Braun, H Schulman and BA Premack, *Circ Res*, **75**, 854–61 (1994).

162 A Hudmon, H Schulman, J Kim, JM Maltez, RW Tsien and GS Pitt, *J Cell Biol*, **171**, 537–47 (2005).

163 CE Grueter, SA Abiria, I Dzhura, Y Wu, AJ Ham, PJ Mohler, ME Anderson and RJ Colbran, *Mol Cell*, **23**, 641–50 (2006).

164 TS Lee, R Karl, S Moosmang, P Lenhardt, N Klugbauer, F Hofmann, T Kleppisch and A Welling, *J Biol Chem*, **281**, 25560–67 (2006).

165 X Jiang, NJ Lautermilch, H Watari, RE Westenbroek, T Scheuer and WA Catterall, *Proc Natl Acad Sci U S A*, **105**, 341–46 (2008).

Calx-β domains

Mark Hilge

Radboud University Nijmegen, Nijmegen, The Netherlands

FUNCTIONAL CLASS

Ca^{2+} binding motif; a domain formed by 110–150 amino acids (AAs) with up to four Ca^{2+} ions bound. Calx-β domains are most closely related to C2 domains.

On the basis of an alignment of AA sequences related to the *Drosophila melanogaster* exchanger (Calx), Schwarz and Benzer defined a stretch of approximately 75 residues as the Calx-β motif.[1] The exact domain boundaries (3D structure) of this motif were recently established by a report[2] describing the structures of two Ca^{2+} binding domains, CBD1 and CBD2, in the Na^+/Ca^{2+} exchanger (NCX). Generally, Calx-β domains are structural or regulatory domains that bind Ca^{2+} ions with affinities of 10^{-7}–10^{-4} M. The presence of a few key residues in the Ca^{2+} binding sites not only determines Ca^{2+} affinities in Calx-β domains but also is decisive whether Ca^{2+} binding is accompanied by a pronounced conformational change.

OCCURRENCE

Calx-β domains are presently found in over 750 deposited sequences of often unrelated proteins, including tandem repeats in NCX,[1,2] multiple copies in the very large G-protein-coupled receptor 1 (VLGR1),[5,6] extracellular matrix (ECM) proteins ranging from marine sponges to humans,[7–9] a single copy in integrin β4,[1] as well as one[10] or two[11] copies in bacteria or lower eukaryotes, respectively. Spatially, Calx-β domains in VLGRs[5,6] and some ECM proteins (Fraser syndrome causing ECM protein 1 (FRAS1), FRAS1-related ECM protein 2 (FREM2), and ECM3)[12] are located in the ectodomains of these molecules, whereas in NCX and integrin β4, they contribute to their cytosolic part. In contrast, Calx-β domains in the *Microciona prolifera* aggregation factor protein 3C (MAFp3C)[7] as well as in ECM proteins FREM1 and FREM3 are soluble.[12]

3D Structure Schematic representation of the primary Ca^{2+} binding domain (CBD1)[2,3] in the Na^+/Ca^{2+} exchanger, forming the structural basis for Calx-β domains, PDB code: 2DPK. Secondary structure elements of the originally defined Calx-β motif are colored yellow and the new elements red. Ca^{2+} ions are shown in pink. The seven β-strands that form a β-sandwich topology are labeled (A–F). All figures were prepared with the program PyMOL.[4]

BIOLOGICAL FUNCTION

The physiological role of Calx-β domains, with the exception of the Ca^{2+} binding domains CBD1 and CBD2 in NCX, is still under debate. In NCX, CBD1 and CBD2 act as sensors for cytosolic Ca^{2+} and thereby regulate Na^+/Ca^{2+} exchange across the plasma membrane. In this process, CBD1 plays the role of the primary Ca^{2+} sensor (K_d 100–400 nM), while CBD2 binds Ca^{2+} ions only at comparably high Ca^{2+} concentrations (1–10 μM). In contrast to the strictly conserved Ca^{2+} binding sites of CBD1, variability in CBD2 arises from alternative splicing of mRNA exchanger transcripts[13–15] and the existence of three NCX isoforms (NCX1, NCX2, and NCX3)[16–18] that are tissue-specifically expressed.[19]

Since Ca^{2+} concentrations in the ECM are several orders of magnitude higher than in the cytoplasm, Calx-β domains in VLGR1 and ECM proteins hardly function as Ca^{2+} sensors. Instead, it is much more likely that tight Ca^{2+} binding is necessary for stability reasons or the formation of scaffolds that allow interactions with other ECM proteins.

AMINO ACID SEQUENCE INFORMATION

- *Canis familiaris* (dog) NCX1, first Ca^{2+} binding domain CBD1, contains 130 AA residues.[16]
- *Canis familiaris* (dog) NCX1, second Ca^{2+} binding domain CBD2, variable length depending on splice form; CBD2-AD, containing mutually exclusive exon A and cassette exon D, contains 149 AA; SWISS-PROT accession code: P23685.[16]
- Human VLGR1, first of 35 copies of Calx-β domains, contains 117 AA; EMBL accession code: AF055084.[5]

- *Lytechinus variegatus* (sea urchin) ECM3, a FREM2 homolog, first of five copies of Calx-β domains, contains 113 AA; EMBL accession code: AF287478.[8]
- Human integrin β4, single Calx-β domain, contains 118 AA; SWISS-PROT accession code: P16144.[1]
- *Physarum polycephalum*, first of two copies of Calx-β domains in membrane-anchored β-glycosidase, contains 111 AA; EMBL accession: Q3V6T3.[11]

Figure 1 shows the alignment of the listed sequences with the exception of the first Calx-β domain of *P. polycephalum* that displays only very little homology with the other sequences.

PROTEIN PRODUCTION, PURIFICATION, AND MOLECULAR CHARACTERIZATION

CBD1 and CBD2 of canine NCX1 can be recombinantly expressed in *Escherichia coli* as individual or tandem domains. Purification of these domains was achieved by an N-terminal His-tag and anion-exchange chromatography.[2] Depending on the number of Ca^{2+} ions bound, constructs may occur in multiple conformational states that can be visualized on native polyacrylamide gels. Expression of constructs encompassing Calx-β domains 8–9 (residues 940–1132) as well as 6–9 (residues 706–1132) of VLGR1 was also reported.[5] Both constructs have been shown to bind Ca^{2+}.

METAL CONTENT

CBD1[3] and CBD2[2,20] bind four and two Ca^{2+} ions, respectively. The single Calx-β domain in integrin β4 is

Figure 1 Sequence alignment of representative Calx-β domains: CBD1 and CBD2-AD of canine NCX1, the first Calx-β domain of ECM3 from sea urchin, the first Calx-β domain in VLGR1, and the single Calx-β domain in integrin β4. Conserved residues that coordinate Ca^{2+} ions in CBD1 and CBD2 are marked with an asterisk, while filled circles indicate structurally important residues. Secondary structure elements of CBD1 and CBD2 are displayed above the sequences with the original Calx-β motif[1] in yellow and the new elements in red.

special in the sense that all structurally important, but only four out of nine in CBD1 Ca^{2+} coordinating residues are maintained. The presence of basic and apolar instead of the acidic residues as well as cytosolic Ca^{2+} concentrations of approximately 10^{-7} M make it rather unlikely that this Calx-β domain binds Ca^{2+} ions. While Ca^{2+} binding domains of NCX and Calx-β domains 6–9 of VLGR1 do bind lanthanides[2,5] such as Eu^{2+}, Yb^{3+}, and Gd^{3+}, no extensive analyses with Calx-β domains were so far performed to determine their abilities to bind ions other than Ca^{2+}.

ISOTHERMAL TITRATION CALORIMETRY

To further characterize Ca^{2+} binding, isothermal titration calorimetry (ITC) measurements on wild-type CBD1 and CBD2 as well as on several mutants were performed,[2] which revealed K_d values of 100–400 nM for CBD1 and 1–10 μM for CBD2, respectively. The determined dissociation constants show relatively large standard deviations that are presumably related to the existence of more than one Ca^{2+} binding site with similar affinities. In addition, CBD1, the primary Ca^{2+} sensor in NCX, can only

be measured at low concentrations (~5 μM) due to the extensive conformational changes upon Ca^{2+} binding that tend to result in aggregation. Nevertheless, ITC-derived K_d values for the individual Ca^{2+} binding sites are consistent with the averaged values obtained from electrophysiological measurements.[21–23]

NMR AND X-RAY STRUCTURES

Overall description of representative Calx-β structures

The first structures of CBD1 and CBD2-AD, containing mutually exclusive exon A and cassette exon D, of canine NCX1 were determined by NMR spectroscopy[2] (Figure 2(a) and (b)). Both domains display the immunoglobulin fold that is, amongst others, also found in C2 domains, cadherins, and fibronectins. The two antiparallel β-sheets constitute a β-sandwich with one β-sheet containing strands A, B, and E, and the other containing strands C, D, F, and G. In the individual domains, the long FG loop, residues 468–482 in CBD1 and residues 599–627 in CBD2, are largely unstructured and absent

(a)　　　　　　　　　　　　　　　　　　　　(b)

Figure 2 (a) Superposition of the 20 NMR-derived structures of Ca^{2+} bound CBD1 (red, residues 371–500) and CBD2 (green, residues 501–650), PDB codes: 2FWS and 2FWU, respectively. Structurally important residues are highlighted yellow as ball-and-stick representation. The orientation is approximately $180°$ rotated around the vertical axis with respect to the situation in (b) and 3D Structure. The unstructured FG loop was removed for clarity. (b) CBD1 chemical shift changes between the Ca^{2+}-free and bound forms of CBD1 mapped onto its molecular structure suggest unfolding of the Ca^{2+} binding sites in the absence of Ca^{2+}. Unchanged resonances are shown in red, while strongly shifted and disappearing resonances are shown in orange and yellow, respectively.

in most other Calx-β domains. Both domains contain a β-bulge in strand A (Figure 2(b)), but only CBD2 displays a second β-bulge in strand G. CBD1 instead, possesses a *cis*-proline at a structurally similar position. Superposition of CBD1 and CBD2 (Figure 2(a)) resulted in an average rmsd of 1.3 Å (on 104 Cα positions) with the biggest differences observed for the BC, CD, and the FG loops as well as for parts of the first acidic segment (residues 446–454 and 577–582, respectively). Residues Ile374/Phe505, Phe376/507, Tyr422/Phe553, Phe431/562, Phe456/587, and Leu460/Ile591 form the core of the two domains and are likely important for stability (Figure 2(a)). In particular, orthologous Phe456 and Phe587 show distinct chemical shift values for their $H^{\delta 1,2}$ and $H^{\varepsilon 1,2}$ protons, reflecting the inability of their aromatic rings to rotate freely.

X-ray structures

Recently, structures of virtually identical constructs of CBD1 and CBD2-AD were also determined by X-ray crystallography at 2.5 Å[3] and 1.7 Å resolution.[20] Because of the lack of any useful constraints for the bound Ca^{2+} ions, especially in the absence of Ca^{2+} free solution structures, Ca^{2+} binding sites are better resolved in the later published X-ray structures. For instance, in the initial CBD1 NMR structure, only two Ca^{2+} ions were implemented, while the corresponding X-ray structure clearly revealed the presence of four Ca^{2+} ions.[3] Besserer *et al.*[20] also reported a structure of a Ca^{2+} free form of CBD2-AD that was, however, obtained from crystals grown at pH 4.9. In comparison, Ca^{2+} binding sites of an unpublished solution structure of CBD2-AD look different. All available structural data on Calx-β domains are summarized in Table 1.

Table 1 Available structural information on Calx-β domains

	Method	Residues	pH	PDB code	State
CBD1	NMR	371–509	7.0	2FWS	Ca^{2+} bound[2]
	X ray	370–509	7.5	2DPK	Ca^{2+} bound[3]
CBD2-AD	NMR	501–657	7.0	2FWU	Ca^{2+} bound[2]
	X ray	501–659	6.3	2QVM	Ca^{2+} bound[20]
	X ray	501–659	4.9	2QVK	'Ca^{2+} free'[20]

Calcium binding sites geometries

Besides the structurally conserved AAs, many Ca^{2+} coordinating residues of CBD1 and CBD2 are maintained throughout most Calx-β domains (Figure 1). The largest contribution to the Ca^{2+} binding sites in CBD1 and CBD2 originates from two acidic segments located in the EF loop and at the C-terminus of the domains (3D Structure, Figure 3(a) and (b)). In both domains, Ca^{2+} binding sites are complemented by a conserved glutamate (Glu385/516) and an aspartate (Asp421/552) in the AB and CD loop, respectively. However, as a consequence of the lack of acidic residues corresponding to Glu454, Asp499, and Asp500 as well as the presence of surrounding basic residues (especially Lys585), Ca^{2+} binding sites in CBD2 are considerably less negative than those of CBD1. Dramatic chemical shift differences in $[^1H,^{15}N]$ heteronuclear single quantum coherence (HSQC) spectra of the Ca^{2+} free and bound forms (Figure 2(b)) fueled the hypothesis that the high density of negative charges in CBD1 is responsible for a large conformational change upon binding and release of Ca^{2+} ions, while changes in CBD2 were predicted to be comparably modest.[2] Concomitantly, reduction of the number of acidic residues in CBD2 also results in lower affinities for Ca^{2+}. Furthermore, the markedly different behavior of the domains in the absence of Ca^{2+} could be attributed to the orthologous residues Glu454 in CBD1

(a)	CBD1	(b)	CBD2-AD

Figure 3 Ca^{2+} coordination in CBD1 (a) and CBD2-AD (b) as determined by X-ray crystallography, PDB codes: 2DPK and 2QVM, respectively. Ca^{2+} ions are shown in pink, whereas water molecules are represented as red spheres. Explicit distances between atoms of the domains and the bound Ca^{2+} ions are listed in Table 2.

Table 2 Interactions of CBD1 and CBD2-AD with bound Ca^{2+} ions

Atom 1	Atom 2		Distance (Å)
CBD1			
Ca1	D421	OD1	2.8
		OD2	2.7
	E451	OE2	2.5
	E454	OE1	2.9
		OE2	2.6
Ca2	D421	OD2	2.5
	E451	OE1	2.7
		OE2	2.9
	Wat	1	2.3
	Wat	15	2.5
	Wat	16	2.3
Ca3	E385	OE1	2.7
		OE2	2.7
	D447	OD2	2.4
	I449	O	2.4
	E451	OE1	2.6
	D498	OD1	2.4
	D500	OD2	2.4
Ca4	D446	OD2	2.3
	D447	O	2.3
	D499	OD1	2.3
	D500	OD1	2.5
		OD2	2.8
Calcium ions			
Ca1	Ca2		4.3
	Ca3		6.9
	Ca4		10.4
Ca2	Ca3		4.3
	Ca4		6.7
Ca3	Ca4		3.9
CBD2			
Ca1	E516	OE1	2.52
		OE2	2.45
	D578	OD1	2.39
	E580	O	2.37
	E648	OE1	2.54
		OE2	2.64
	Wat	8	2.44
	Wat	15	2.41
Ca2	D552	OD1	2.33
	D578	OD2	2.33
	Wat	6	2.52
	Wat	9	2.49
	Wat	11	2.38
	Wat	26	2.50
	Wat	30	2.38
Calcium ions			
Ca1	Ca2		5.47

REFERENCES

1 EM Schwarz and S Benzer, *Proc Natl Acad Sci USA*, **94**, 10249–54 (1997).

2 M Hilge, J Aelen and GW Vuister, *Mol Cell*, **22**, 15–25 (2006).

3 DA Nicoll, MR Sawaya, S Kwon, D Cascio, KD Philipson and J Abramson, *J Biol Chem*, **281**, 21577–81 (2006).

4 WL DeLano, *The PyMOL Molecular Graphics System*, DeLano Scientific, San Carlos, CA (2002).

5 H Nikkila, DR McMillan, BS Nunez, L Pascoe, KM Curnow and PC White, *Mol Endocrinol*, **14**, 1351–64 (2000).

6 DR McMillan, KM Kayes-Wandover, JA Richardson and PC White, *J Biol Chem*, **277**, 785–92 (2002).

7 X Fernandez-Busquets and MM Burger, *J Biol Chem*, **272**, 27839–47 (1997).

8 PG Hodor, MR Illies, S Broadley and CA Ettensohn, *Dev Biol*, **222**, 181–94 (2000).

9 L McGregor, V Makela, SM Darling, S Vrontou, G Chalepakis, C Roberts, N Smart, P Rutland, N Prescott, J Hopkins, E Bentley, A Shaw, E Roberts, R Mueller, S Jadeja, N Philip, J Nelson, C Francannet, A Perez-Aytes, A Megarbane, B Kerr, B Wainwright, AS Woolf, R Winter and PJ Scambler, *Nat Genet*, **34**, 203–8 (2003).

10 T Kaneko, S Sato, H Kotani, A Tanaka, E Asamizu, Y Nakamura, N Miyajima, M Hirosawa, M Sugiura, S Sasamoto, T Kimura, T Hosouchi, A Matsuno, A Muraki, N Nakazaki, K Naruo, S Okumura, S Shimpo, C Takeuchi, T Wada, A Watanabe, M Yamada, M Yasuda and S Tabata, *DNA Res*, **3**, 109–36 (1996).

11 A Maekawa, M Hayase, T Yubisui and Y Minami, *Int J Biochem Cell Biol*, **38**, 2164–72 (2006).

12 I Smyth, X Du, MS Taylor, MJ Justice, B Beutler and IJ Jackson, *Proc Natl Acad Sci USA*, **101**, 13560–65 (2004).

13 P Kofuji, WJ Lederer and DH Schulze, *J Biol Chem*, **269**, 5145–49 (1994).

14 SL Lee, AS Yu and J Lytton, *J Biol Chem*, **269**, 14849–52 (1994).

15 BD Quednau, DA Nicoll and KD Philipson, *Am J Physiol*, **272**, C1250–61 (1997).

16 DA Nicoll, S Longoni and KD Philipson, *Science*, **250**, 562–65 (1990).

17 Z Li, S Matsuoka, LV Hryshko, DA Nicoll, MM Bersohn, EP Burke, RP Lifton and KD Philipson, *J Biol Chem*, **269**, 17434–39 (1994).

18 DA Nicoll, BD Quednau, Z Qui, YR Xia, AJ Lusis and KD Philipson, *J Biol Chem*, **271**, 24914–21 (1996).

19 B Linck, Z Qiu, Z He, Q Tong, DW Hilgemann and KD Philipson, *Am J Physiol*, **274**, C415–23 (1998).

20 GM Besserer, M Ottolia, DA Nicoll, V Chaptal, D Cascio, KD Philipson and J Abramson, *Proc Natl Acad Sci USA*, **104**, 18467–72 (2007).

21 M Ottolia, KD Philipson and S John, *Biophys J*, **87**, 899–906 (2004).

22 C Dyck, A Omelchenko, CL Elias, BD Quednau, KD Philipson, M Hnatowich and LV Hryshko, *J Gen Physiol*, **114**, 701–11 (1999).

23 J Dunn, CL Elias, HD Le, A Omelchenko, LV Hryshko, and J Lytton, *J Biol Chem*, **277**, 33957–62 (2002).

and Lys585 in CBD2 (Figure 3(a) and (b)). Strikingly, their mutants, Glu454Lys and Lys585Glu, largely allowed to interchange the functionality of the domains.[2]

Human factor VIII

Jacky Chi Ki Ngo, Mingdong Huang[†], David A Roth[‡], Barbara C Furie[†] and Bruce Furie[†]*

*Department of Biochemistry, The Chinese University of Hong Kong, Hong Kong, China
[†]Marine Biological Laboratory, Woods Hole MA, Beth Israel Deaconess Medical Center and Harvard Medical School, Boston, MA, USA
[‡]Wyeth Research, Cambridge, MA, USA

FUNCTIONAL CLASS

Procofactor; procoagulant component; metal-ion-dependent plasma protein containing multiple calcium and copper atoms per molecule; contains domains that are related to ceruloplasmin.

Factor VIII is synthesized as a single chain precursor protein, which is then processed into a heavy and light chain before secretion into the blood. The two chains form a heterodimer where they are noncovalently associated in the presence of calcium/manganese and copper ions.[1–3] At sites of vascular injury, factor VIII is activated to factor VIIIa through limited proteolysis by thrombin or factor Xa.[4–6] Factor VIIIa then forms a complex with factor IXa on the membrane surfaces and converts factor X into factor Xa during blood coagulation.[7,8]

OCCURRENCE

The 186 kb human factor VIII gene is composed of 26 exons and located on the X chromosome.[9–11] Factor VIII mRNA is detected in numerous tissues including liver, spleen, kidney, and lymph nodes.[12–15] Although transplantation studies have suggested that different organs such as lung and spleen contribute to the production of factor VIII in the circulation, liver is believed to be the major site of factor VIII synthesis.[16–19] Expression of factor VIII is low and its concentration in blood plasma is approximately 0.3 nM.[20,21] Once synthesized and secreted into the circulation, factor VIII interacts with von Willebrand factor (vWF) to form a high affinity complex.[22–25] Each molecule of factor VIII binds approximately one molecule of vWF monomer.[26,27] However, the stoichiometry of the complex

3D Structure Schematic representation of the heterodimer structure of human B domain-deleted factor VIII. The A1 and A2 domains of the heavy chains are depicted in dark and light gray, respectively; the A3, C1, and C2 domains of the light chain in red, orange and yellow, respectively. The copper ions are denoted in blue spheres and calcium ion in green sphere. The carbohydrate moieties are represented by pink meshes. PDB ID: 3CDZ. This and other figures are prepared by the program PyMOL.[28] (Reproduced from. Ref. 57 © Elsevier, 2008.)

in vivo is one molecule of factor VIII per 50 molecules of vWF due to the low expression of factor VIII.[25]

BIOLOGICAL FUNCTION

Factor VIII is an important plasma protein that participates in blood coagulation. The deficiency or defect of the protein causes hemophilia A, an X-linked inherited hemorrhagic disorder.[29-31] Factor VIII circulates as a procofactor and remains bound to vWF. Upon initiation of the blood coagulation cascade, it becomes activated to factor VIIIa by factor Xa or thrombin and is released from vWF.[5,6,32] Factor VIIIa then binds specifically to activated cell membranes and serves as a cofactor to the serine protease factor IXa to form the tenase complex. The tenase complex converts the zymogen factor X to factor Xa.[8,33,34] The binding of factor VIIIa to factor IXa increases the catalytic efficiency of factor IXa by several orders of magnitude.[7,35,36] This reaction in consequence leads to the large second burst of thrombin production during clot formation. The tenase complex is downregulated by proteolytic inactivation of factor VIIIa *via* the activated protein C pathway or by spontaneous dissociation of the heavy and light chains.[37-39]

AMINO ACID SEQUENCE INFORMATION

Homo sapiens: signal peptide, 19 amino acid residues (AA); mature factor VIII, 2332 AA. SWISSPROT ID code (SWP) P00451.

PROTEIN PRODUCTION AND PURIFICATION

Concentrates of factor VIII were originally obtained from plasma by cryoprecipitation or precipitation with agents such as ethanol, AAs or AA analogs, or ethylene glycol, followed by partial fibrinogen removal using bentonite or fuller's earth and gel filtration.[40-45] In 1982, Fay *et al.* described a new method to further purify factor VIII to near homogeneity using calcium dissociation and differential size and charge chromatography.[46] However, because of its low concentration in plasma, only minute amount of purified factor VIII could be obtained.

Recombinant factor VIII protein was not routinely produced until the gene of human factor VIII was cloned and characterized in 1984.[9,10,47] Currently, there are several commercially available factor VIII preparations that are derived from human plasma or produced by recombinant technology. These products are either full length factor VIII or B- domain-deleted factor VIII. Since the B domain was found to be dispensable for the biological activity of factor VIII and was sensitive to proteolytic attack by serine proteases during purification

and storage, some recombinant proteins were expressed with the deletion of most or the entire B domain.[48-55] Furthermore, the deletion of the B domain increases the production yield of factor VIII without compromising its biological activity. Licensed recombinant factor VIII products are produced either in cultures of a baby hamster kidney (BHK) cell line or transfected Chinese hamster ovary (CHO) cells. However, different purification protocols exist for these different factor VIII products. Two different deletion constructs of recombinant factor VIII were used for the crystallographic studies, including the construct for the licensed B-domain-deleted recombinant factor VIII product that completely excludes the B domain and links the heavy and light chains through a 14-residue linker (741-754) (Wyeth Pharmaceuticals, Inc., Philadelphia, PA, USA).[56-58] For this latter B-domain-deleted factor VIII preparation (Wyeth Pharmaceuticals, Inc., Philadelphia, PA, USA), factor VIII expression and purification were slightly modified from the protocol described previously.[56,57] In brief, recombinant proteins were expressed by cultivating CHO cells with the factor VIII cDNA in medium free of human serum albumin. Factor VIII was first purified by ion exchange chromatography, followed by peptide ligand affinity chromatography with TN8.2 Sepharose, hydrophobic interaction, and size exclusion.[58,59]

MOLECULAR CHARACTERIZATION

Nascent factor VIII is a single polypeptide chain containing a signal peptide and the mature protein with domain structure arranged as A1-*a1*-A2-*a2*-B-*a3*-A3-C1-C2, where *a1*, *a2*, and *a3* are short acidic peptides that separate the different domains.[9,11] The three A domains of factor VIII are homologous to each other (~30% homology) and share sequence homology with the A domains of factor V and the copper-binding protein ceruloplasmin.[60] The C domains belong to the discoidin domain family and are highly similar to each other and share 42% sequence identity.[10] They also share similarities with the C domains of factor V, the galactose oxide lipid-binding domain, lectin discoidin I, and milk fat globule proteins from human and murine.[61-66] On the other hand, the sequence of B domain shares no homology with any known protein. Before secretion into plasma, factor VIII is cleaved at the B domain and processed into a heterodimer comprising a heavy chain of varying molecular masses between 90 and 200 kDa, in combination with a light chain of 80 kDa. The heavy chain (residues 1-740) consists of A1, A2 domains, *a1*, *a2* peptides, and variable lengths of B domain (residues 741-1648) in different forms of factor VIII; the light chain (residues 1649-2332) consists of A3, C1, and C2 domains and *a3* peptide.[49,67] Eight disulfide bridges have been identified in the heavy and light chains, including Cys153-Cys179, Cys248-Cys329, Cys528-Cys554, Cys630-Cys711, Cys1832-Cys1858,

Cys1899–Cys1903, Cys2021–Cys2169, and Cys2174–Cys2326. It is not known whether the cysteines in the B-domain are linked.[68] Factor VIII contains 25 potential N-linked glycosylation sites, of which 20 are located within the B domain.[69,70] In addition, factor VIII is posttranslationally modified in the acidic *a1*, *a2*, and *a3* peptide regions with sulfation at Tyr346, 718, 719, 723, 1664, and 1680. These sulfated regions affect procoagulant activity of factor VIII and its interaction with thrombin and vWF.[71,72]

METAL CONTENT OF FACTOR VIII

The A domains of human factor VIII share high homology with ceruloplasmin and, therefore, the molecule appears to contain three potential copper-binding sites based on its primary sequence and structural predictions.[9,73,74] Atomic absorption spectroscopy of both purified plasma-derived and recombinant factor VIII detected one mole of copper ion per mole of protein.[75,76] In contrast, electron paramagnetic resonance (EPR) spectroscopy on the recombinant factor VIII heterodimer could not detect any copper ion. Only after the dissociation of the heavy and light chains by incubation with ethylenediaminetetraacetic acid (EDTA) could a significant copper ion signal be measured, suggesting that the ion might be protected in a reduced diamagnetic form.[77,78] The study by Tagliavacca *et al.* also suggested that the ion is important for enhancing the affinity between the heavy and light chains of the heterodimer.[77] The recent crystal structures of factor VIII reveal two copper ions instead of one, each coordinated within the A1 and A3 domains.[58,79]

Generation of cofactor activity of factor VIII requires the presence of divalent metal ions such as calcium or manganese ions and it was proposed that the factor VIII contains two calcium-binding sites.[80–85] Yet, three calcium ions were identified in one crystal structure, while only one was identified in the other B-domain-deleted factor VIII structure.[58,79]

COFACTOR ACTIVITY ASSAYS

Factor VIII is a nonenzymatic protein; its cofactor activity is usually determined by one-stage clotting assays that are based upon the ability of factor VIII to shorten the prolonged activated partial thromboplastin time (APTT) of factor VIII-deficient plasma.[86] Briefly, phospholipids and negatively charged surface activators, such as kaolin, are added to citrated plasma to activate the contact factors and generate factor XIa. Calcium ions are added next to activate factor IX to factor IXa by factor XIa. Factor IXa then forms the tenase complex with factor VIIIa to convert factor X to factor Xa, which subsequently leads to thrombin activation. The time required for fibrin clot formation by thrombin is measured and used to plot a double logarithmic graph with log factor VIII activity *versus* log clotting time. The activity

of the factor VIII sample understudied can then be derived from a standard curve measured from known factor VIII activity.

The chromogenic assay is another standard approach designed to assay factor VIII cofactor activity by measuring the factor VIII-dependent generation of factor Xa from factor X using chromogenic substrates.[87–89] In this assay, the factor VIII sample under study is first activated by thrombin, then added to purified factor IXa and excess factor X in the presence of phospholipids and calcium ions. The amount of factor Xa generated is determined from the hydrolysis of a selective chromogenic substrate (e.g., Spectrozyme Xa) at 405 mM and is directly proportional to the factor VIII activity.

X-RAY STRUCTURES

Crystallization

Human factor VIII with different B-domain deletions has been crystallized. The first reported factor VIII crystals were obtained by Shen *et al.* and consist of A1, A2, A3, C1, C2 domains and residues 1563–1648 of the B domain (henceforth referred to as *factor VIII(sB)*).[79] The crystals were grown in 8–12% polyethylene glycol (PEG) 8000, 100–300 mM NaCl, and 50 mM Tris–HCl (pH 6.5–7.5) using the hanging drop reverse-vapor diffusion method. The lattice was tetragonal, space group $P4_12_12$, with $a = b = 134.8$ Å and $c = 358.4$ Å, and contained one molecule per asymmetric unit. The structure was refined to 3.7 Å.

The second crystal form of factor VIII comprises A1, A2, A3, C1, and C2 domains with residues 1–754 linked to residues 1649–2332 (Wyeth) (referred to as *factor VIII(ΔB)*).[58] The crystals were obtained from a solution containing 7% PEG 3350, 10% ethanol, and 100 mM Tris–HCl (pH 8.5) using hanging drop vapor diffusion at 25 °C. The crystals were also crystallized in $P4_12_12$ space group with $a = b = 134.113$ Å, $c = 349.760$ Å, and one molecule per asymmetric unit. The factor VIII(ΔB) structure was solved at 3.98 Å.

Overall description of structure

Factor VIII is a large molecule with dimensions of approximately 120 Å × 75 Å × 55 Å (3D Structure). Although the constructs being used in the two crystallographic studies are different, the two structures adopt very similar overall conformations with a root mean square deviation (rmsd) of 1.2 Å for 970 core residues (Figure 1). Three A domains are arranged into a triangular heterotrimer, where A1 and A3 domains serve as the base and stack on top of the globular C2 and C1 domains, respectively. All three A domains contain a large loop that protrudes in the same plane and

Orange: factor VIII(ΔB)
Blue: factor VIII(sB)

Figure 1 Superimposition of the carbon backbone of factor VIII(ΔB) (orange, PDB ID: 3CDZ) and factor VIII(sB) (blue, PDB ID: 2R7E). The overall conformations of both structures are nearly identical.

forms a deep cleft at the center of the trimer. The secondary structures of factor VIII are mostly β-strands with minimal α-helical content. Each A domain consists of two connected β-barrels and are structurally homologous to each other. Their folds resemble that of the cupredoxin-type domain. The C domains share high structural similarity and their folding is of a distorted β-barrel. Their overall folds are nearly identical to that of the high-resolution factor VIII C2 domain crystal structure.[90] The acidic peptides (*a1*, *a2*, and *a3*) between the A domains are present in both constructs, but they are mostly flexible and disordered in the crystal structures. The B domain region retained in the construct of factor VIII(sB) is also disordered and not modeled. The front side of the molecule, where most of the suggested binding sites for factor IXa exist, appears to be

relatively planar. Both structures observed three glycosylation sites at Asn239, Asn1810, and Asn2118, respectively. All of the tyrosines that undergo sulfation reside within the disordered regions. While the factor VIII(ΔB) crystal structure showed eight disulfide bridges that correspond to those determined or proposed previously, Cys1899 and Cys1903 within the A3 domain are not covalently linked in the factor VIII(sB) structure, resulting in a different conformation of the A3 protrusion. In addition, only three metal ions are observed in the factor VIII(ΔB) structure in contrast to five in factor VIII(sB). One significant conformational difference between the two factor VIII structures exists between residues 557 and 572 of the A2 domain. In the factor VIII(ΔB) structure, this region adopts a loop conformation that extends toward the front plane of the molecule and is solvent-exposed, although the tip of the loop appears to be 'pinned down' by a symmetry-related molecule (Figure 2). In contrast, this region forms a reverse turn and is bent backward in the factor VIII(sB) structure where it is partly shielded by residues 360–372 and 720–725 of the *a1* and *a2* acidic peptides, respectively (Figure 2). Table 1 summarizes the difference observed between the two factor VIII structures.

Copper site geometry

Sequences of both A1 and A3 domains of factor VIII show that they contain the four canonical ligands (His, Cys, His, Met) for a type 1 copper-binding site. These residues adopt structurally identical positions as in the primary structure of the copper-binding protein ceruloplasmin and are putative copper-binding sites in factor VIII. In accordance with this, both crystal structures of factor VIII show that the two mononuclear copper ions are each coordinated by two histidines and a cysteine in a distorted trigonal planar structure as observed in other type 1 copper site. However, the methionine residues are not properly oriented and are too distant (>4 Å) to form the weaker axial ligand at all sites (Figures 3 and 4).[91–93] The copper ion in the

Orange: factor VIII(ΔB)
Blue: factor VIII(sB)

a.a. 360–372
a.a. 557–572
a.a. 720–725
a.a. 557–572

90°

a.a. 360–372
a.a. 720–725
a.a. 557–572
a.a. 557–572

Figure 2 Conformational difference in the region between residues 557 and 572. This region is solvent exposed in the factor VIII(ΔB) structure (orange), while it forms a reverse turn that bends backward and is buried under the regions 360–372 and 720–725 in the factor VIII(sB) structure (blue).

Table 1 Summary of differences between the structures of factor VIII(sB) and factor VIII(ΔB)

	Factor VIII(sB)	Factor VIII(ΔB)
Amino acid sequence (mature factor VIII numbering)	1–741, 1563–2332	1–754, 1649–2332
Modeled residues	1–214, 222–334, 360–725, 1689–2332	1–16, 44–210, 224–333, 377–713, 1691–1713, 1725–2332
Number of copper ions	2	2
Number of calcium ions	3	1
Number of glycosylation sites	3	3
Number of disulfide bonds	7	8
Regions with significant different conformations	555–572, 1890–1917	

A1 domain is coordinated by two nitrogens of His265 and His315 and the sulfur of Cys310 at an average of 2.1 Å (Figure 3). The A3 domain copper site is defined by His1954, Cys2000, and His2006 (Figure 4). Similar tricoordinate sites have been observed in the domain 2 of ceruloplasmin and certain laccase isozymes.[94,95] These sites usually have a relatively high reduction potential that could keep the copper ion in a permanently reduced state, thus explaining the result of the EPR study performed by Tagliavacca *et al.*[77,94,96] Intriguingly, Ile312 at the A1 copper site and Ile2002 at the A3 copper site are both located in close proximity to the copper ions in the factor VIII(sB) structure – approximately 2.3 and 2.8 Å, respectively, in contrast to 4.4 and 3.5 Å in the factor VIII(ΔB) (compare Figures 3(a) with 3(b) and 4(a) with 4(b), respectively). These residues are positioned opposite to the canonical methionines and occupy the reciprocal axial ligand positions, despite the fact that isoleucine cannot be considered as a copper ligand. This is similar to the type 1 copper sites of Cot A laccase from *Bacillus subtilis* and laccase from *Trametes versicolor*.[97–99] In the case of Cot A laccase, the isoleucine at the corresponding position plays a role in enzymatic activity.[97] Whether these aliphatic residues play any role in factor VIII cofactor activity remains to be elucidated. Furthermore, it is unclear whether the observed variations in the orientation of ligand residues in the two structures are the result of different proteins being crystallized or errors in model building due to intermediate resolutions (3.7 and 3.98 Å, respectively).

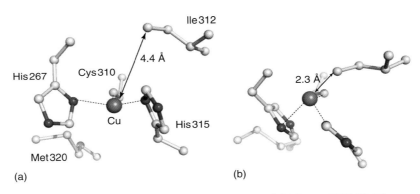

Figure 3 Copper coordination at the A1 domain of (a) factor VIII(ΔB) and (b) factor VIII(sB). The copper ion is liganded to two histidines and one cysteine. The distance between the metal and the noncanonical isoleucine residue is indicated.

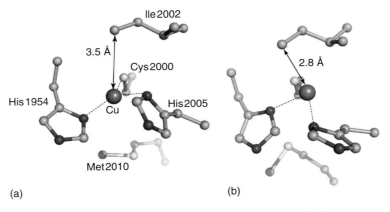

Figure 4 Copper coordination at the A3 domain of (a) factor VIII(ΔB) and (b) factor VIII(sB).

A putative interdomain type 2 copper site, predicted to be formed by His99 of A1, His1957 of A3 domain, and an oxygen atom of a water molecule hydrogen-bonded to Tyr105 and Ala100, is previously proposed to enhance interchain affinity of the heavy and light chains of factor VIII.[73,80,100,101] The crystal structures show that these ligand residues are structurally conserved to those in other type 2 copper sites, but no copper ion is observed at this site in either structure.

Calcium site geometry

Divalent ions such as Ca^{2+} or Mn^{2+} are required in addition to the copper ions to regenerate cofactor activity after reconstitution of factor VIII from isolated chains.[78,85,102,103] Consistent with the site-directed mutagenesis study by Wakabayashi *et al.*, both factor VIII crystal structures reveal a common calcium-binding site between residues 110 and 126 in the A1 domain.[83] In the factor VIII(ΔB) structure, the calcium ion is coordinated by the carboxyl groups of Glu110, Asp116, Asp125, Asp126, and the backbone carbonyls of Lys107 and Glu122 (Figure 5). Side chains of both Asp125 and Asp126 are in proper orientation to provide bidentate carboxylate ligation, suggesting the coordination number of this calcium ion could be close to eight. However, the precise coordination number and geometry of the calcium ion cannot be deduced from the structure because of limited resolution. A second calcium-binding site is observed in the factor VIII(sB) crystal structure and the divalent ion is coordinated by the amide group of Asn538 and carboxyl group of Asp542 of the A2 domain. Although not described, the model of factor VIII(sB) also contains a third calcium ion in the A1 domain juxtaposed to the first calcium and liganded by the carboxyl

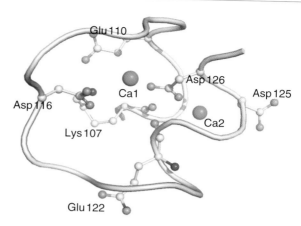

Figure 6 Two adjacent A1 calcium-binding sites in the structure of factor VIII(sB). The ligands to the metal ions cannot be predicted from the X-ray data. The residues responsible for calcium binding in the factor VIII(ΔB) structure are shown.

group of Asp126 (Figure 6). It is unclear whether this site represents a true calcium-binding site or it is responsible for the manganese binding described before.[83]

Comparison with factor V

Factor V is a procofactor in the prothrombinase complex that plays an analogous role as factor VIII in the tenase complex. Factor VIII and factor V share nearly 40% sequence homology and same domain arrangement.[9,60,62] The two proteins undergo similar activation and inactivation pathways during the course of blood coagulation.[39,104,105] Although the structure of factor V has not been solved, a crystal structure of activated protein C-inactivated factor Va, factor Vai, from bovine is available for partial comparison with human factor VIII.[61] The factor Vai structure only contains A1, A3, C1, and C2 domains. These adopt similar conformations and spatial arrangement as the corresponding domains in factor VIII (average rmsd of 1.6 Å over 524 core residues) (Figure 7). Both factor VIII and factor V depend on metal ions such as copper and calcium for subunit association and cofactor activity.[106–108] However, the canonical residues for type 1 copper site in factor VIII are absent in factor V. The single copper ion observed in the factor Vai structure occupies a site different from those in factor VIII and is liganded within the buried interdomain surface between A1 and A3 domains. Despite its location, the ligands (His1802, His1804, and Asp1844) to the copper ion are contributed solely by the A3 domain, and the metal does not bridge the heavy and light chains together through direct contacts. One calcium ion was observed in A1 domain of the factor Vai structure and its location is identical to that found in the structure of factor VIII. The ligands to the calcium are also partially conserved in both structures.

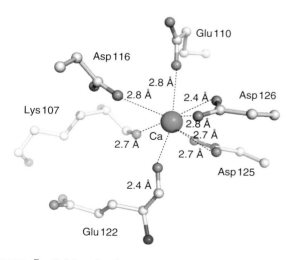

Figure 5 Calcium-binding site at the A1 domain of factor VIII(ΔB). The ion is coordinated by up to eight ligands. The distances between the calcium and ligands are indicated. The average calcium–ligand distance is longer than normal probably owing to model building errors at intermediate resolution.

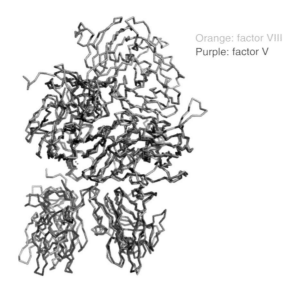

Orange: factor VIII
Purple: factor V

Figure 7 Overlay of the carbon backbone of factor VIII and factor V. Factor VIII is shown in orange and factor V in purple. (Reproduced from. Ref. 57. © Elsevier, 2008.)

FUNCTIONAL ASPECTS

Implications of conformational differences

Factor VIII is activated through limited proteolytic cleavage by thrombin or factor Xa at three sites – Arg372, Arg740, and Arg1689, yielding a noncovalently linked heterodimer with the B domain removed.[32,109,110] The activation of factor VIII alters its conformation and enhances its binding with the serine protease factor IXa. Several putative factor IXa-interacting sites have been suggested and mapped onto the factor VIII(ΔB) structure, including residues 558–565, 707–712, and 1811–1819.[58,111–117] These sites span the front surface of the factor VIII(ΔB) model and are mostly solvent exposed. Furthermore, they are spatially complementary to the corresponding interaction sites on factor IXa.[58]

When the same putative sites are mapped onto the factor VIII(sB) structure, however, it shows that one of these sites – residues 558–568 – is blocked from interacting with factor IXa. In the factor VIII(sB) structure, extra electron densities were observed and modeled for residues 360–376 from the *a*1 acidic peptide and residues 714–725. These two regions interact with each other and cooperatively anchor the reverse turn between residues 557 and 572 toward the back side of the molecule and shield the putative factor IXa-binding site (Figure 2). This structural difference between the two crystal structures might be a crystallographic artifact. However, an alternative explanation is that the extra 85 residues of the small B domain region retained in the factor VIII(sB) structure might have stabilized residues 714–725, which in turn fix the regions between residues 360–376 and 557–572 in conformations that mimic the procofactor form of factor VIII. On the other hand,

since the entire B domain is truncated in the factor VIII(ΔB) construct, it might represent the activated form of factor VIII, in which the B domain is removed during activation and exposing the 558–568 region for factor IXa binding.

Roles of metal ions

High sequence and structural homologies between the A domains of factor VIII and ceruloplasmin suggest that they evolved from a common ancestor.[9,95,118] Both copper-binding sites in factor VIII are conserved in ceruloplasmin. Yet, unlike ceruloplasmin, there is no evidence that factor VIII is redox-active. Instead, the copper ions along with calcium ions play important roles in the binding affinity of the heavy and light chains and the specific activity of the cofactor. Neither calcium nor copper ions, however, are coordinated at the interchain surface to directly bridge the two chains together. All three metal ions appear to contribute to interdomain interactions and cofactor activity indirectly by maintaining the structural integrity of the interface between different domains. In fact, the peptide backbone of the residues that coordinate the A1 copper forms part of the binding surface for the A2 domain. The loop comprising the A3 copper ligands forms partial interactive surface for A1 domain binding (Figure 8). In the absence of copper binding, these regions might adopt different conformations and disrupt the interdomain surfaces, interfering interchain binding and impacting on the specific cofactor activity. This is supported by reports that the chelation of metal ions by incubating the protein with EDTA resulted in heavy and light chain dissociation.[77,119]

Likewise, the calcium ion in the A1 domain might exert similar function by stabilizing the binding interface between domains and indirectly enhance the cofactor activity of factor VIII.[80,81] The C2 domain is essential for the association of factor VIII with membrane surfaces.[120,121]

Figure 8 Surface rendition of the interdomain surfaces formed by the copper-binding sites. The regions that coordinate the metal ions in A1 and A3 domains are denoted dark gray and red, respectively.

Figure 9 Surface rendition of the interdomain surfaces formed by the calcium-binding site. The calcium-binding region forms the major binding interface between A1 and C2 domains.

However, it is loosely tethered to the molecule and there are few direct contacts between the C2 and A1 domains, which cover only an average of 286 Å of solvent-accessible surface area. The major residues that are involved in the interaction are located within the calcium-binding loop in the A1 domain (Figure 9).[83] It is reasonable to speculate that the binding of a calcium ion at this site helps to maintain a proper interface between the two domains, which in turn modulates the conformation of the C2 domain and enhances the affinity of the factor VIIIa molecule for the anionic phospholipids surfaces for maximal cofactor activity.[80,121,122] Furthermore, residues from the A1 calcium-binding loop make extensive contacts with the A3 domain, which may assist the packing between the two domains to promote cofactor activity.[81,85] On the other hand, the region that binds the second calcium ion in the factor VIII(sB) structure does not involve in interdomain interaction and the role of this ion is unclear. The role of the second calcium at the A1 domain also remains to be elucidated.

Despite the absence of a copper ion at the interface of the A1 and A3 domains of both crystal structures, the functional role of the type 2 copper-binding site on factor VIII stability or activity remains uncertain. First, it should be noted that the heavy chain/light chain reconstitution assays employed in previous studies monitored the contribution of the copper ions to interchain affinity and specific activity using factor Xa generation assay, which required the proteolytic activation of factor VIII. Therefore, there is no direct evidence for the role of a type 2 copper ion in the procofactor form of factor VIII.[80,100,101] Second, the concentrations of factor VIII being used during the crystallization studies (\sim55 mM of factor VIII(sB) and 275 mM of factor VIII(ΔB)) are several orders of magnitude higher than the K_d for heavy chain/light chain binding in the absence of copper (\sim50 nM).[101] Therefore, the association of the two chains in the protein crystal may no longer require the occupancy of the type 2 copper site.

REFERENCES

1 PJ Fay, *Int J Hematol*, **83**, 103–8 (2006).

2 PJ Lenting, JA van Mourik and K Mertens, *Blood*, **92**, 3983–96 (1998).

3 B Furie and BC Furie, *Cell*, **53**, 505–18 (1988).

4 D Eaton, H Rodriguez and GA Vehar, *Biochemistry*, **25**, 505–12 (1986).

5 P Lollar, GJ Knutson and DN Fass, *Biochemistry*, **24**, 8056–64 (1985).

6 LW Hoyer and NC Trabold, *J Lab Clin Med*, **97**, 50–64 (1981).

7 G van Dieijen, G Tans, J Rosing and HC Hemker, *J Biol Chem*, **256**, 3433–42 (1981).

8 GE Gilbert and AA Arena, *J Biol Chem*, **271**, 11120–25 (1996).

9 GA Vehar, B Keyt, D Eaton, H Rodriguez, DP O'Brien, F Rotblat, H Oppermann, R Keck, WI Wood, RN Harkins, EG Tuddenham, RM Lawn and DJ Capon, *Nature*, **312**, 337–42 (1984).

10 J Gitschier, WI Wood, TM Goralka, KL Wion, EY Chen, DH Eaton, GA Vehar, DJ Capon and RM Lawn, *Nature*, **312**, 326–30 (1984).

11 JJ Toole, JL Knopf, JM Wozney, LA Sultzman, JL Buecker, DD Pittman, RJ Kaufman, E Brown, C Shoemaker, EC Orr, G Amphlett, WB Foster, M Lou Coe, GJ Knutson, DN Fass and RM Hewick, *Nature*, **312**, 342–47 (1984).

12 MG Zelechowska, JA van Mourik and T Brodniewicz-Proba, *Nature*, **317**, 729–30 (1985).

13 KL Wion, D Kelly, JA Summerfield, EG Tuddenham and RM Lawn, *Nature*, **317**, 726–29 (1985).

14 B Elder, D Lakich and J Gitschier, *Genomics*, **16**, 374–79 (1993).

15 B Levinson, S Kenwrick, P Gamel, K Fisher and J Gitschier, *Genomics*, **14**, 585–89 (1992).

16 JH Lewis, FA Bontempo, JA Spero, MV Ragni and TE Starzl, *N Engl J Med*, **312**, 1189–190 (1985).

17 WE Hathaway, MM Mull, JH Githens, CG Groth, TL Marchioro and TE Starzl, *Transplantation*, **7**, 73–75 (1969).

18 CA Owen Jr., EJ Bowie and DN Fass, *Br J Haematol*, **43**, 307–15 (1979).

19 E Shaw, JC Giddings, IR Peake and AL Bloom, *Br J Haematol*, **41**, 585–96 (1979).

20 AE Preston and A Barr, *Br J Haematol*, **10**, 238–45 (1964).

21 AE Preston, *Br J Haematol*, **10**, 110–14 (1964).

22 P Lollar, DC Hill-Eubanks and CG Parker, *J Biol Chem*, **263**, 10451–55 (1988).

23 A Leyte, MP Verbeet, T Brodniewicz-Proba, JA Van Mourik and K Mertens, *Biochem J*, **257**, 679–83 (1989).

24 P Lollar, *Mayo Clin Proc*, **66**, 524–34 (1991).

25 AJ Vlot, SJ Koppelman, MH van den Berg, BN Bouma and JJ Sixma, *Blood*, **85**, 3150–57 (1995).

26 AJ Vlot, SJ Koppelman, JC Meijers, C Dama, HM van den Berg, BN Bouma, JJ Sixma and GM Willems, *Blood*, **87**, 1809–16 (1996).

27 P Lollar and CG Parker, *J Biol Chem*, **262**, 17572–76 (1987).

28 WL Delano, *The PyMOL Molecular Graphics System*, DeLano Scientific LLC, San Carlos, CA, USA, (2002).

29 B Furie and BC Furie, *Semin Hematol*, **27**, 270–85 (1990).

30 SE Antonarakis, *Curr Stud Hematol Blood Transfus*, 73–77 (1991).

31 SE Antonarakis, *Adv Hum Genet*, **17**, 27–59 (1988).

32 DD Pittman and RJ Kaufman, *Proc Natl Acad Sci U S A*, **85**, 2429–33 (1988).

33 P Neuenschwander and J Jesty, *Blood*, **72**, 1761–70 (1988).

34 GE Gilbert and AA Arena, *J Biol Chem*, **270**, 18500–5 (1995).

35 K Mertens, A van Wijngaarden and RM Bertina, *Thromb Haemost*, **54**, 654–60 (1985).

36 MB Hultin and Y Nemerson, *Blood*, **52**, 928–40 (1978).

37 PJ Fay, TL Beattie, LM Regan, LM O'Brien and RJ Kaufman, *J Biol Chem*, **271**, 6027–32 (1996).

38 PJ Fay and FJ Walker, *Biochim Biophys Acta*, **994**, 142–48 (1989).

39 PJ Fay, TM Smudzin and FJ Walker, *J Biol Chem*, **266**, 20139–145 (1991).

40 EJ Hershgold, JG Pool and AR Pappenhagen, *J Lab Clin Med*, **67**, 23–32 (1966).

41 EJ Hershgold, AM Davison and ME Janszen, *J Lab Clin Med*, **77**, 185–205 (1971).

42 BH Wagner, WD McLester, M Smith and KM Brinkhous, *Thromb Diath Haemorrh*, **11**, 64–74 (1964).

43 B Blomback, M Blomback and I Struwe, *Thromb Diath Haemorrh*, **7**, (Suppl), 172–85 (1962).

44 SL Marchesi, NR Shulman and HR Gralnick, *J Clin Invest*, **51**, 2151–61 (1972).

45 L Kass, OD Ratnoff and MA Leon, *J Clin Invest*, **48**, 351–58 (1969).

46 PJ Fay, SI Chavin, D Schroeder, FE Young and VJ Marder, *Proc Natl Acad Sci U S A*, **79**, 7200–4 (1982).

47 WI Wood, DJ Capon, CC Simonsen, DL Eaton, J Gitschier, B Keyt, PH Seeburg, DH Smith, P Hollingshead, KL Wion, E Delwart, EG Tuddenham, GA Vehar and RM Lawn, *Nature*, **312**, 330–37 (1984).

48 JJ Toole, DD Pittman, EC Orr, P Murtha, LC Wasley and RJ Kaufman, *Proc Natl Acad Sci U S A*, **83**, 5939–42 (1986).

49 LO Andersson, N Forsman, K Huang, K Larsen, A Lundin, B Pavlu, H Sandberg, K Sewerin and J Smart, *Proc Natl Acad Sci U S A*, **83**, 2979–83 (1986).

50 P Meulien, T Faure, F Mischler, H Harrer, P Ulrich, B Bouderbala, K Dott, M Sainte Marie, C Mazurier, ML Wiesel, H Van de Pol, JP Cazenave, M Courtney and A Pavirani, *Protein Eng*, **2**, 301–6 (1988).

51 N Sarver, GA Ricca, J Link, MH Nathan, J Newman and WN Drohan, *DNA*, **6**, 553–64 (1987).

52 DL Eaton, WI Wood, D Eaton, PE Hass, P Hollingshead, K Wion, J Mather, RM Lawn, GA Vehar and C Gorman, *Biochemistry*, **25**, 8343–47 (1986).

53 DD Pittman, EM Alderman, KN Tomkinson, JH Wang, AR Giles and RJ Kaufman, *Blood*, **81**, 2925–35 (1993).

54 N Bihoreau, P Paolantonacci, C Bardelle, MP Fontaine-Aupart, S Krishnan, J Yon and JL Romet-Lemonne, *Biochem J*, **277**(Pt 1), 23–31 (1991).

55 P Lind, K Larsson, J Spira, M Sydow-Backman, A Almstedt, E Gray and H Sandberg, *Eur J Biochem*, **232**, 19–27 (1995).

56 RK Eriksson, C Fenge, E Lindner-Olsson, C Ljungqvist, J Rosenquist, AL Smeds, A ostlin, T Charlebois, M Leonard, BD Kelley and A Ljungqvist, *Semin Hematol*, **38**, 24–31 (2001).

57 H Sandberg, A Almstedt, J Brandt, E Gray, L Holmquist, U Oswaldsson, S Sebring and M Mikaelsson, *Thromb Haemost*, **85**, 93–100 (2001).

58 JC Ngo, M Huang, DA Roth, BC Furie and B Furie, *Structure*, **16**, 597–606 (2008).

59 BD Kelley, J Booth, M Tannatt, QL Wub, R Ladner, J Yuc, D Potter and A Ley, *J Chromatogr A*, **1038**, 121–30 (2004).

60 WR Church, RL Jernigan, J Toole, RM Hewick, J Knopf, GJ Knutson, ME Nesheim, KG Mann and DN Fass, *Proc Natl Acad Sci U S A*, **81**, 6934–37 (1984).

61 TE Adams, MF Hockin, KG Mann and SJ Everse, *Proc Natl Acad Sci U S A*, **101**, 8918–23 (2004).

62 WH Kane and EW Davie, *Proc Natl Acad Sci U S A*, **83**, 6800–4 (1986).

63 JL Pellequer, AJ Gale, JH Griffin and ED Getzoff, *Blood Cells Mol Dis*, **24**, 448–61 (1998).

64 S Baumgartner, K Hofmann, R Chiquet-Ehrismann and P Bucher, *Protein Sci*, **7**, 1626–31 (1998).

65 D Larocca, JA Peterson, R Urrea, J Kuniyoshi, AM Bistrain and RL Ceriani, *Cancer Res*, **51**, 4994–98 (1991).

66 JD Stubbs, C Lekutis, KL Singer, A Bui, D Yuzuki, U Srinivasan and G Parry, *Proc Natl Acad Sci U S A*, **87**, 8417–21 (1990).

67 RJ Kaufman, LC Wasley and AJ Dorner, *J Biol Chem*, **263**, 6352–62 (1988).

68 BA McMullen, K Fujikawa, EW Davie, U Hedner and M Ezban, *Protein Sci*, **4**, 740–46 (1995).

69 T Hironaka, K Furukawa, PC Esmon, T Yokota, JE Brown, S Sawada, MA Fournel, T Minaga and A Kobata, *Arch Biochem Biophys*, **307**, 316–30 (1993).

70 KF Medzihradszky, MJ Besman and AL Burlingame, *Anal Chem*, **69**, 3986–94 (1997).

71 DA Michnick, DD Pittman, RJ Wise and RJ Kaufman, *J Biol Chem*, **269**, 20095–102 (1994).

72 A Leyte, HB van Schijndel, C Niehrs, WB Huttner, MP Verbeet, K Mertens and JA van Mourik, *J Biol Chem*, **266**, 740–46 (1991).

73 S Pemberton, P Lindley, V Zaitsev, G Card, EG Tuddenham and G Kemball-Cook, *Blood*, **89**, 2413–21 (1997).

74 Y Pan, T DeFay, J Gitschier and FE Cohen, *Nat Struct Biol*, **2**, 740–44 (1995).

75 N Bihoreau, S Pin, AM de Kersabiec, F Vidot and MP Fontaine-Aupart, *Eur J Biochem*, **222**, 41–48 (1994).

76 N Bihoreau, S Pin, AM de Kersabiec, F Vidot and MP Fontaine-Aupart, *C R Acad Sci III*, **316**, 536–39 (1993).

77 L Tagliavacca, N Moon, WR Dunham and RJ Kaufman, *J Biol Chem*, **272**, 27428–34 (1997).

78 DN Fass, GJ Knutson and JA Katzmann, *Blood*, **59**, 594–600 (1982).

79 BW Shen, PC Spiegel, CH Chang, JW Huh, JS Lee, J Kim, YH Kim and BL Stoddard, *Blood*, **111**, 1240–47 (2008).

80 H Wakabayashi, ME Koszelak, M Mastri and PJ Fay, *Biochemistry*, **40**, 10293–300 (2001).

81 H Wakabayashi, KM Schmidt and PJ Fay, *Biochemistry*, **41**, 8485–92 (2002).

82 H Wakabayashi, Z Zhen, KM Schmidt and PJ Fay, *Biochemistry*, **42**, 145–53 (2003).

83 H Wakabayashi, J Freas, Q Zhou and PJ Fay, *J Biol Chem*, **279**, 12677–84 (2004).

84 O Nordfang and M Ezban, *J Biol Chem*, **263**, 1115–18 (1988).

85 PJ Fay, *Arch Biochem Biophys*, **262**, 525–31 (1988).

86 RD Langdell, RH Wagner and KM Brinkhous, *J Lab Clin Med*, **41**, 637–47 (1953).

87 S Rosen, *Scand J Haematol Suppl*, **40**, 139–45 (1984).

88 MJ Seghatchian and M Miller-Andersson, *Med Lab Sci*, **35**, 347–54 (1978).

89 G Carlebjork, U Oswaldsson and S Rosen, *Thromb Res*, **47**, 5–14 (1987).

90 KP Pratt, BW Shen, K Takeshima, EW Davie, K Fujikawa and BL Stoddard, *Nature*, **402**, 439–42 (1999).

91 I Bento, C Peixoto, VN Zaitsev and PF Lindley, *Acta Crystallogr D Biol Crystallogr*, **63**, 240–48 (2007).

92 A Messerschmidt and R Huber, *Eur J Biochem*, **187**, 341–52 (1990).

93 A Romero, H Nar, R Huber, A Messerschmidt, AP Kalverda, GW Canters, R Durley and FS Mathews, *J Mol Biol*, **236**, 1196–211 (1994).

94 EI Solomon, UM Sundaram and TE Machonkin, *Chem Rev*, **96**, 2563–605 (1996).

95 I Zaitseva, V Zaitsev, G Card, K Moshkov, B Bax, A Ralph and P Lindley, *J Biol Inorg Chem*, **1**,, 15–23 (1996).

96 TE Machonkin, HH Zhang, B Hedman, KO Hodgson and EI Solomon, *Biochemistry*, **37**, 9570–78 (1998).

97 P Durao, Z Chen, CS Silva, CM Soares, MM Pereira, S Todorovic, P Hildebrandt, I Bento, PF Lindley and LO Martins, *Biochem J*, **412**, 339–46 (2008).

98 FJ Enguita, LO Martins, AO Henriques and MA Carrondo, *J Biol Chem*, **278**, 19416–25 (2003).

99 T Bertrand, C Jolivalt, P Briozzo, E Caminade, N Joly, C Madzak and C Mougin, *Biochemistry*, **41**, 7325–33 (2002).

100 PJ Fay and PV Jenkins, *Blood Rev*, **19**, 15–27 (2005).

101 H Wakabayashi, Q Zhou, K Nogami, C Ansong, F Varfaj, S Miles and PJ Fay, *Biochim Biophys Acta*, **1764**, 1094–101 (2006).

102 PJ Fay, PJ Haidaris and TM Smudzin, *J Biol Chem*, **266**, 8957–62 (1991).

103 K Sudhakar and PJ Fay, *Biochemistry*, **37**, 6874–82 (1998).

104 LM O'Brien, M Mastri and PJ Fay, *Blood*, **95**, 1714–20 (2000).

105 M Kalafatis, MD Rand, RJ Jenny, YH Ehrlich and KG Mann, *Blood*, **81**, 704–19 (1993).

106 TM Laue, R Lu, UC Krieg, CT Esmon and AE Johnson, *Biochemistry*, **28**, 4762–71 (1989).

107 LS Hibbard and KG Mann, *J Biol Chem*, **255**, 638–45 (1980).

108 KG Mann, CM Lawler, GA Vehar and WR Church, *J Biol Chem*, **259**, 12949–51 (1984).

109 JL Newell and PJ Fay, *J Biol Chem*, **282**, 25367–75 (2007).

110 MS Donath, PJ Lenting, JA van Mourik and K Mertens, *J Biol Chem*, **270**, 3648–55 (1995).

111 PJ Fay and D Scandella, *J Biol Chem*, **274**, 29826–30 (1999).

112 PJ Lenting, JW van de Loo, MJ Donath, JA van Mourik and K Mertens, *J Biol Chem*, **271**, 1935–40 (1996).

113 PJ Lenting, MJ Donath, JA van Mourik and K Mertens, *J Biol Chem*, **269**, 7150–55 (1994).

114 PJ Fay, T Beattie, CF Huggins and LM Regan, *J Biol Chem*, **269**, 20522–27 (1994).

115 PJ Fay and K Koshibu, *J Biol Chem*, **273**, 19049–54 (1998).

116 SP Bajaj, AE Schmidt, A Mathur, K Padmanabhan, D Zhong, M Mastri and PJ Fay, *J Biol Chem*, **276**, 16302–9 (2001).

117 A Mathur and SP Bajaj, *J Biol Chem*, **274**, 18477–86 (1999).

118 N Takahashi, TL Ortel and FW Putnam, *Proc Natl Acad Sci U S A*, **81**, 390–94 (1984).

119 O Nordfang, *Eur J Haematol Suppl*, **49**, 1–28 (1989).

120 ME Nesheim, DD Pittman, JH Wang, D Slonosky, AR Giles and RJ Kaufman, *J Biol Chem*, **263**, 16467–70 (1988).

121 EL Saenko, D Scandella, AV Yakhyaev and NJ Greco, *J Biol Chem*, **273**, 27918–926 (1998).

122 EL Saenko, M Shima and AG Sarafanov, *Trends Cardiovasc Med*, **9**, 185–92 (1999).

MAGNESIUM

The CorA Mg^{2+} channel

Michael E Maguire

Department of Pharmacology, School of Medicine, Case Western Reserve University, Cleveland, OH, 44106-4965, USA

FUNCTIONAL CLASS

Ion channels; divalent cation ion channels; metal ion transport (MIT) family, TC 1.A.35 according to the transport classification database.[1] The primary functional classification is as a Mg^{2+} (influx) ion channel,[2,3] termed CorA (gene product of *corA*) after the phenotype of the original mutation found in *Escherichia coli* and *Salmonella enterica* serovar Typhimurium.[4,5] A subfamily of this family putatively mediates the efflux of Zn^{2+},[6] and additional functional subfamilies may exist.[7,8]

OCCURRENCE

CorA ion channels are widespread in prokaryotic organisms. From the many genome sequences available for bacteria and archaea, ~50% of bacteria and ~20% of archaea have a CorA homolog. There are relatively few CorA homologs in the marine metagenome, where the MgtE (gene product of *mgtE*) Mg^{2+} transporter predominates. A smaller percentage in each kingdom has the putative Zn^{2+} efflux paralog ZntB (gene product of *zntB*).[6,7] The family is ubiquitous in eukaryotes as the mitochondrial Mrs2 Mg^{2+} channel (gene product of *mrs2*).[2] The protein in all cases is found in the cell membrane or the inner membrane of the mitochondrion. Additional paralogs involved in Al^{3+} resistance and possibly resistance to other heavy metals are found in yeast and plants (Alr1/2, gene products of *alr1/2*),[8–10] although it is not known how widespread these paralogs are distributed in the eukaryotes. Plants in particular may have multiple paralogs (AtMrs2, gene products of *Atmrs2* genes), most with additional functions other than Mg^{2+} influx.[11,12] At least in the bacteria, CorA appears to be ubiquitously expressed and is the primary provider of cytosolic Mg^{2+}.

BIOLOGICAL FUNCTION

The CorA ion channel mediates the influx of Mg^{2+}. This appears to be its primary function in all organisms. In bacteria, CorA can also mediate the influx of Co^{2+} and Ni^{2+}.[4,5] These cations are only taken up at extracellular

3D Structure Ribbon representation of the *Thermotoga maritima* CorA (PDB code: 2BBJ) rendered using PyMOL 1.1 (www.PyMOL.org) with each of the five monomers of the homopentamer in a different color.

concentrations that are toxic; thus, physiologically CorA serves as the primary source of cellular Mg^{2+}. Nonetheless, since the cellular requirement for Co^{2+} and Ni^{2+} is very low in many bacteria, it is possible that much of that requirement could be met by 'leakage' of these ions into the cell via CorA. It is not clear if the eukaryotic members of the CorA family can mediate the flux of cations other than Mg^{2+}. In the bacteria, very high extracellular concentrations of Mg^{2+} will elicit Mg^{2+} efflux.[13] This does not appear to be physiologically relevant, and electrophysiological studies on the mitochondrial Mrs2 homolog suggest that eukaryotic channels cannot mediate efflux of Mg^{2+}.[2]

The physiological effect of disruption of the CorA Mg^{2+} channel depends on whether the organism in question has additional Mg^{2+} influx systems. In the bacteria, a small percentage of species carrying CorA also carry an additional unrelated Mg^{2+} influx system, MgtE, which is also possibly an ion channel. In these species, mutation of the *corA* gene would not lead to a Mg^{2+} deficiency, at least under laboratory growth conditions. In some species of *enterobacteria* and *firmicutes*, the Mgt P-type ATPases (gene products of *mgtA* or *mgtB*) are present in addition to CorA. These systems mediate the influx of Mg^{2+} at the expense of ATP. Again, in these species, mutation of *corA* does not lead to Mg^{2+} deficiency under laboratory growth conditions. If the Mgt and CorA systems are simultaneously mutated, the resulting bacteria become dependent on high concentrations of Mg^{2+} for growth ($\geq 10\,mM$).[14] Lower Mg^{2+} concentrations do not however lead to cell death. Cells lacking both Mgt and CorA systems remain viable for long periods of time and readily grow when sufficient Mg^{2+} is supplied. In such situations, the bacteria presumably obtain sufficient Mg^{2+} that 'leaks' in nonselectively through other ion transporters.

AMINO ACID SEQUENCE INFORMATION

CorA is expressed as a protein of about 310–380 amino acids depending on the organism. All bacterial CorAs appear to be synthesized without an N-terminal signal peptide. CorA proteins form homooligomeric pentamers in the membrane. The basic topology of the protein is a 250–290 amino acid N-terminal domain residing in the cytosol – the first transmembrane segment – a nine amino acid external (periplasmic) loop – the second transmembrane segment – and a cytosolic C-terminal segment of six amino acids (3D Structure). Eukaryotic Mrs2 homologs have additional ∼50 amino acids at the C terminus and ∼75–100 amino acids as an N-terminal extension. The Alr homologs have an N-terminal extension as large as 500 amino acids. This extension is likely involved in chelating heavy metal cations. In general, each organism has a single gene encoding CorA or Mrs2 proteins. It is

not known if isoforms exist although this seems unlikely. Many bacteria and archaea carry CorA paralogs, e.g. ZntB, sometimes as many as three additional genes. The function of these paralogs has not been determined. Alr homologs may be present as 1–3 distinct genes. Plants, as noted above, may have multiple paralogs encoded in their chromosomes. It is likely that most of these paralogs are Mrs2-like mitochondrial Mg^{2+} channels expressed in a tissue-specific manner, although localization in other cellular membranes or transport of other cations cannot be excluded currently. A representative list of CorA and Mrs2 proteins is given in Table 1. A comprehensive alignment and phylogenetic analysis has been published by Knoop *et al.*[8]

All CorA family members have two C-terminal transmembrane TM domains (Figure 1). A canonical CorA protein has an N-terminal cytosolic soluble domain of about 270 amino acids, primarily α helical. This is followed by (i) TM1, (ii) a nine amino acid loop in the extracellular periplasmic space of bacteria and archaea or in the intermembrane space of mitochondria, (iii) TM2, and (iv) a six amino acid highly positively charged C-terminal cytosolic sequence. Initial topology studies indicated three TM segments,[15] but additional topology studies indicated only two TM segments[16]; the crystal structures (see below) definitively show that the CorA family has two TM segments. Initial studies suggested that CorA was at least a homotetramer and possibly a homopentamer[17]; again, the crystal structures show that CorA is a homopentamer.

The TM segments in all CorA proteins have no charged amino acids,[8,18] indicating that electrostatic bonding is not required for membrane passage of cation, whether Mg^{2+}, Zn^{2+} or potentially other cations. The five amino acids at the C-terminal/extracellular end of TM1 form a signature sequence for CorA. This sequence, YGMNF, does not appear to be present in any other protein currently in the database. The nine amino acid sequence in the extracellular or extramitochondrial space that follows YGMNF is distinctive in the bacteria and many archaea, but less so in eukaryotes. In the bacteria, for CorA homologs that mediate Mg^{2+} influx, this sequence is (E/K)(Y/F)MPEL(K/E)(Y/F)X with the amino acids 1 and 7 being of opposite charge. For putative ZntB homologs, however, this sequence contains relatively small amino acids, few if any charged or aromatic amino acids and usually several glycine residues, all indicative of minimal structural constraints. In all CorA family members, prokaryotic or eukaryotic, several initial amino acids in the cytosol following TM2 almost always contain three and sometimes four lysine or arginine residues within the first 6–8 amino acids. These residues are likely important for function given their position in the crystal structures (see below). The N- and C-terminal extended sequences of the eukaryotic Mrs2 channels are of unknown function, although a reasonable speculation is that they are involved in protein–protein interactions.

Table 1 Representative list of CorA and Mrs2 proteins

Accession number	Species	Length	Alignment probability[a]	Percent identity	Function[b]
		Bacteria			
P0A2R8	*Salmonella typhimurium*	316	NA	NA	Yes
P0A2R9	*Salmonella typhi*	316	e-173	97–100[c]	
Q5PKM1	*Salmonella paratyphi A*	316	e-173	97–100	
Q329Z2	*Shigella dysenteriae*	316	e-173	97	
P0ABI4	*Escherichia coli K12*	316	e-173	97	Yes
Q6CZH4	*Erwinia carotovora*	316	e-160	88	
Q0WAH3	*Yersinia pestis*	316	e-160	88	
Q8D2T1	*Wigglesworthia glossinidia*	315	e-135	75	
Q4QLP6	*Haemophilus influenzae*	315	e-121	70	
A4BPS9	*Nitrococcus mobilis*	315	e-90	54	
Q1LIV2	*Ralstonia metallidurans*	320	e-70	45	
A4Y7P7	*Shewanella putrefaciens*	315	e-65	42	
BAB49763	*Mesorhizobium loti*	324	e-51	37	
NP 384425	*Sinorhizobium meliloti*	329	e-45	34	
NP253955	*Pseudomonas aeruginosa PA01*	326	e-41	31	Yes
Q9PPI1	*Campylobacter jejuni*	327	e-38	29	
AAD08385	*Helicobacter pylori*	318	e-30	26	Yes
AAD35646	*Thermotoga maritima*	351	e-15	25	Yes
ACA90903	*Burkholderia cenocepacia*	325	e-13	24	
AA005567	*Staphylococcus epidermis*	315	e-12	22	
AAY91127	*Pseudomonas fluorescens*	323	e-06	22	
AAN59474	*Streptococcus mutans*	314	e-04	22	
		Archaea			
AAM05128	*Methanosarcina acetivorans*	356	e-17	24	
BAA29213	*Pyrococcus horikoshii*	323	e-17	25	Yes
AAB90452	*Archaeoglobus fulgidus*	351	e-12	21	Yes
Q58439	*Methanocalcococcus jannaschii*[d]	317	e-09	20	Yes
ABN07876	*Methanocorpusculum labreanum*	314	e-05	21	
		Eukaryotes (Mrs2)			
CAA89979	*Saccharomyces cerevisiae*	470	NA[e]	NA/(4/25)[f]	Yes
Q5A970	*Candida albicans*	468	e-106	51	
EAL22736	*Cryptococcus neoformans*	492	e-47	30	
AAG45213	*Arabidopsis thaliana*	459	e-17	24	
EDL86489	*Rattus norvegicus*	434	e-16	24	
AAK38615	*Homo sapiens*	443	e-15	24/(4/20)	Yes

[a] From precalculated Blast alignments at http://www.ncbi.nlm.nih.gov/ run against the *S. typhimurium* CorA for both bacteria and archaea.

[b] Function denotes that the protein has been shown to transport Mg^{2+} either by direct transport assay in the Mg^{2+} transport deficient strain of *S. typhimurium* or by complementation of that strain for growth without supplemental Mg^{2+}. The *Homo sapiens* Mrs2 has been shown to complement the *mrs2* mutant of *S. cerevisiae* but has not been tested in *S. typhimurium*. The *S. typhimurium* CorA also complements the *mrs2* mutant of *S. cerevisiae*. Function of CorA homologs as Mg^{2+} influx systems has also been demonstrated by complementation of the Mg^{2+} transport deficient strain of *S. typhimurium* for *Bacillus subtilis* (YfiQ), *Deinococcus radiodurans*, *Haemophilus influenzae*, and *Mycobacterium tuberculosis*.

[c] For most bacterial and archaeal species shown, 'percent identity' is calculated for the full length of the protein (\sim315 amino acids).

[d] Previously *Methanococcus jannaschii*.

[e] From precalculated Blast alignments at http://www.ncbi.nlm.nih.gov/ run against the *S. cerevisiae* Mrs2.

[f] The percent identity of the Mrs2 homolog compared to *S. cerevisiae*. For *S. cerevisiae* and *H. sapiens*, the numbers in parentheses are the percent identity and percent similarity respectively of Mrs2 versus *S. typhimurium* CorA calculated for 60 amino acids centering on the loop connecting TM1 and TM2. There is no significant sequence similarity between the remainder of the N-terminal segment of CorA versus Mrs2. However, as discussed in the text, the predicted secondary structures and predicted 3D structures of Mrs2 and CorA are identical and each functionally complements the other.

Figure 1 Membrane topology of the CorA family of proteins.

PROTEIN PRODUCTION, PURIFICATION, AND MOLECULAR CHARACTERIZATION

Full-length CorA proteins from numerous bacteria have been purified by expression in *E. coli*. Both bacterial and archaeal CorA channels have been expressed in this manner and purified.[19–22] It has been demonstrated that the archaeal *Methanococcus jannaschii* CorA and the CorA from hyperthermophile *Thermotoga maritima* can be expressed in *S. Typhimurium* with retention of function.[23,24] All purifications have involved a cleavable 6X-His tag at the N terminus, extraction from the membrane by various detergents, usually dodecylmaltoside, and purification on a Ni^{2+}-nitriloacetic acid column as with other His-tagged proteins. A subsequent single step of further purification by fast protein liquid chromatography (FPLC) has generally been required. Purification of a eukaryotic homolog has not yet been reported.

The expression of CorA in *E. coli* has generally given only modest yields of $0.5–1\,mg\,l^{-1}$ protein. Coexpression of the chaperones DnaJ and DnaK has been reported to improve the yield.[25] Dodecyl maltoside extraction clearly allows the homopentamer to stay assembled as evidenced by the crystal structures. Whether extraction with other detergents yields homopentameric protein is not known.

The N-terminal soluble domain of ~270 amino acids has also been expressed.[19,22] Cross-linking experiments demonstrate that the soluble domain can assemble into at least a homotetramer and most likely a homopentamer even in the absence of the membrane domain.[17,24] Reconstitution studies show that the purified, assembled CorA protein retains function.[24] The purified CorA protein seems to be structurally stable for at least a week at $4\,°C$ and can be frozen at -20 or $-80\,°C$.

ACTIVITY AND INHIBITION TESTS

There is virtually no sequence identity between the soluble domain of the bacterial or archaeal CorA channels and the soluble domain of eukaryotic Mrs2 proteins. However, Mrs2 proteins have significant similarity with CorA in the 55–60 amino acids from the beginning of TM1 to the C terminus of CorA. That this sequence similarity is meaningful has been shown by the ability of *S. cerevisiae* Mrs2 to complement a mutation in *S. typhimurium* CorA. Likewise, the *S. typhimurium* CorA can complement an Mrs2 mutation in *S. cerevisiae*. Likewise, an archaeal or extremophile CorA can complement a CorA mutation in *S. typhimurium*. Such genetic complementation has been, in most cases, verified by the demonstration of functional transport of either $^{63}Ni^{2+}$ or Mg^{2+}. Thus, the activity of a putative CorA channel can be initially determined the expression in a *corA* mutant strain of *S. typhimurium* (or *E. coli*).

Proper assembly of heterologously expressed or of purified CorA protein can be verified by cross-linking with formaldehyde, which should give at least a tetrameric and usually a pentameric band.[17] In *S. typhimurium*, these oligomeric bands are often doublets. This appears to be due to cross-linking between Cys191 residues on adjacent monomers.[17] Similarly, when the large N-terminal soluble domain is expressed without its membrane domain, the soluble protein appears to fold properly and assemble into a pentamer. Thus the membrane domain is not absolutely required for assembly.

The function of CorA has been measured in three ways. Most of the characterization has involved measurement of the uptake of $^{28}Mg^{2+}$ or $^{63}Ni^{2+}$ in intact cells, most commonly in *S. typhimurium*.[26,27] Recently, Mrs2 has been overexpressed and characterized by patch clamping of giant liposomes fused with detergent-solubilized mitochondrial membranes.[2] In addition, flux of Mg^{2+} has been determined in *S. typhimurium* or with reconstituted CorA in liposomes using a fluorescent Mg^{2+}-sensitive dye, Mag-Fura2.

Measurement of uptake in intact cells with radioisotopes has been extensively documented in bacteria either by measurement of native CorA uptake in *S. typhimurium* or after expression of a heterologous CorA homolog in *E. coli* or *S. typhimurium*.[4,5] Initially, measurements used $^{28}Mg^{2+}$, a short-lived high-energy isotope. In the mid-1980s, this isotope became prohibitively expensive, and further work used $^{63}Ni^{2+}$ as a surrogate.[15,28–31] Influx properties and kinetic parameters measured with either isotope appear identical. Limited studies using $^{57}Co^{2+}$ or $^{60}Co^{2+}$ also give comparable properties. Uptake of $^{28}Mg^{2+}$ by the *S. typhimurium* CorA is linear for only $<30\,s$ at $37\,°C$ and $<90\,s$ at room temperature. In contrast, uptake of $^{63}Ni^{2+}$ (and Co^{2+}) is linear for $>10\,min$ at $37\,°C$ and for at least 15–20 min at room temperature. The rate of uptake in intact cells at $4\,°C$ is detectable but very low. Uptake is apparently dependent on the

membrane potential and not on ATP,[15,18,32-34] although this has only been definitively demonstrated through the electrophysiological measurements of Mrs2.[2] In intact *S. typhimurium*, the concentrations of extracellular cation that gives a half-maximal rate of influx are 10–15 μM for Mg^{2+}, 20 μM for Co^{2+}, and 200 μM for Ni^{2+}. With the *S. typhimurium* CorA, Mn^{2+} inhibits noncompetitively with a $K_i > 30\,\mu$M. Ca^{2+} inhibits with a $K_i > 10$ mM. Neither cation is transported. Fe^{2+}, Fe^{3+}, Zn^{2+}, Sr^{2+}, and Ba^{2+} do not appear to inhibit significantly, although this is difficult to determine because at high extracellular concentrations (>1 mM), these cations can be acutely toxic or cause extensive cell aggregation.[4,5,35]

Single channel patch clamp studies of yeast Mrs2 elegantly demonstrate a Mg^{2+}-selective channel with a high conductance of ~150 pS.[2] Ni^{2+} is also permeable with a conductance of ~45 pS. The yeast Mrs2 is not permeable to Ca^{2+} or Mn^{2+} but, unlike *S. typhimurium* CorA, it is also not permeable to Co^{2+}. $LaCl_3$ did not inhibit Mg^{2+} conductance. The channel is sensitive to the concentration of Mg^{2+} in the matrix (equivalent of bacterial cytosol), showing a reversal potential of +20 mV and a reduced open-time probability. This is consistent with the presence of bound Mg^{2+} ions in the cytosolic domain (see below).

The Mg^{2+} cation when hydrated is the largest of all cations with a diameter of almost 5 Å (Table 2).[36-38] In contrast, the atomic (unhydrated) ion is only about 0.65 Å in diameter. Cation hexaammines are analogs of the hydrated cation.[39] They are stable compounds containing an ammine ($-NH_3$) or other moiety covalently bound to a di- or trivalent cation, most commonly Co, Ru, and Ni. Mg^{2+} is invariably hexacoordinate as are the cation hexaammines. Their size is dependent on the cation, its charge, and the specific moiety attached. Co^{3+}, Ru^{3+}, and Ru^{2+} all form hexaammines with a diameter of approximately 5 Å, while Ni^{2+} hexaammine has a diameter closer to 6 Å. The Co^{3+}, Ru^{3+}, and Ru^{2+} hexaammines all inhibit the uptake of $^{63}Ni^{2+}$ by *S. typhimurium* and *M. jannaschii* CorA with K_is of 1–3 μM, even more potent than Mg^{2+} itself.[39] In contrast, the larger Ni^{2+} hexaammine does not inhibit at concentrations up to 1 mM. Inhibition of the *T. maritima* CorA has also been demonstrated.[24] Co^{3+} hexaammine can also selectively inhibit the yeast Mrs2 Mg^{2+} channel, whether measured electrophysiologically or via a Mg^{2+}-selective dye.[33,34,39] The Yeast Alr homologs

are also inhibited by Co^{3+} hexaammine.[9,40] (It is not known if the ZntB homolog can be inhibited.) Several conclusions can be drawn from these results.[3,39] First, all CorA homologs likely interact with extracellular Mg^{2+} in the same manner, at the entrance to the pore itself and/or the external loop between TM1 and TM2. Second, the initial binding of the Mg^{2+} cation involves the still fully hydrated ion. This is apparently unique among ion channels and transporters, where the initial binding site for cation involves at least partial dehydration. Third, the initial binding of cation to the extracellular domain of the channel does not discriminate charge since both +2 and +3 cations inhibit essentially equivalently. Finally, the initial external binding site for Mg^{2+} must accommodate a large 5-Å diameter cation but cannot accommodate anything larger. Presumably, initial interaction of the channel with the large fully hydrated cation forms at least part of the selectivity of the channel, since all other hydrated (biological) cations are much smaller.

X-RAY STRUCTURES OF CorA

Crystallization

The crystal structure of the full-length and soluble domain of *T. maritima* CorA (PDB codes: 2BBJ, 2BBH) was determined initially by Lunin *et al.*[19] at a resolution of 3.9 Å for the full-length protein and 1.85 Å for the soluble domain, both in the presence of Mg^{2+}. Subsequently, two other groups determined full-length crystal structures (PDB codes: 2IUB, 2HN2) at resolutions of 2.9–3.4 Å, one in the presence of Ca^{2+} and one in the presence of Mg^{2+} and Co^{2+}.[20-22] In addition, Payandeh and Pai[22] determined a crystal structure of the soluble domain of *Archaeoglobus fulgidus* CorA without divalent cation (PDB code: 2HN1).

In all cases, an N-terminal His-tagged protein was expressed in *E. coli* using T7 polymerase or inducible arabinose expression systems. Lunin *et al.*[19] solubilized CorA from a crude membrane fraction in a buffer of 50 mM 4-(2-hydroxyethyl)-1-piperazineethanesulfonic acid (HEPES), pH 7.5, 0.5 M NaCl, 5% (v/v) glycerol, 10 mM imidazole, and 1% (w/v) dodecyl maltoside (DDM) before purification by Ni^{2+} affinity chromatography. Eshaghi *et al.*

Table 2 Properties of Mg^{2+} compared with other biological cations[36,38]

Ion	Intracellular concentration		Size		Coordination number	Rate of exchange of waters of hydration (per second)
	Total (mM)	Free (mM)	Ionic radius (Å)	Hydrated radius (Å)		
Na^+	15	8–10	0.95	2.75	6	10^9
K^+	140	120	1.38	2.32	6	10^9
Ca^{2+}	3	0.0001–0.001	0.99	2.95	6, 7, 8, or 9	10^8
Mg^{2+}	30	0.3–1.0	0.65	4.76	6	10^5

solubilized CorA again from a crude membrane fraction using 1% (w/v) Cymal-6 in 20 mM sodium phosphate, pH 7.4, 300 mM NaCl, 20 mM imidazole.[20] Payandeh and Pai solubilized an unfractionated cell lysate in 50 mM Tris, pH 8.0, 300 mM NaCl, 5 mM imidazole, 10 mM β mercaptoethanol, and 2% (w/v) DDM.[21,22] Protease inhibitors were added in all purification schemes. Eshaghi *et al.* as well as Payandeh and Pai further purified protein over a Superdex 200 column, while Lunin *et al.* did not further purify the protein after Ni^{2+} affinity chromatography. Yields ranged from 1–6 mg protein from 1 l of culture but were generally at the lower end of that range.

All three groups used hanging-drop vapor diffusion methods with 0.1–0.3 M MgCl$_2$, Mg(NO$_3$)$_2$, or CaCl$_2$, buffered with 0.1 M HEPES, pH 7.0, or Tris, pH 8.0. Additives were polyethylene glycol 400, 1500, 2000, or 3350. Eshaghi *et al.* included 1.5% (v/v) *n*-octyl-β-D-glucoside and 0.1 M NaCl. Crystallization of selenomethionine derivatives was essentially identical.

Lunin *et al.*[19] and Payandeh and Pai[21,22] used selenomethionine incorporation to obtain an anomalous dataset for phasing. The former group reported that lower selenomethionine concentration gave better crystallization presumably because the larger selenomethionine molecule was present in multiple copies within the pentameric membrane domain, disrupting it sufficiently to obviate crystallization. Eshaghi *et al.*[20] soaked crystals in cobalt acetate to obtain an anomalous dataset. In contrast, Payandeh and Pai[21] reported that addition of Co^{2+} resulted in crystal twinning.

Structure

The three crystal structures of the full-length CorA reported are essentially identical and are quite unlike the structure of other membrane proteins. The channel is apparently in a closed form and is a homopentamer shaped like a funnel with the stem of the funnel in the membrane and the bowl of the funnel in the cytosol (3D Structure and Figure 2(a) and (b)). The five monomers are slightly twisted around each other. The pore is formed completely by TM1, which is inserted in the membrane at a slight angle (Figure 2(a) and (b)). The five TM2 segments that lie well outside are essentially orthogonal to the membrane and serve to bring the highly positively charged C terminus back into the cytosol (Figure 3). On the basis of the structures, the function of TM2 appears merely to connect the external loop to TM1 and to bring the C terminus back into the cytosol. Whether it actively participates in opening and closing of the channel remains to be seen.

The soluble domain of CorA comprises a relatively compact domain consisting of a seven-stranded antiparallel β sheet flanked on each side by three α helices all external to the pore (Figure 2). The three N-terminal α helices are relatively short while on the other side of the β sheet, α$_4$ is short but α$_5$ and α$_6$ are about 40 Å in length. This entire domain is external to the extremely long (~100 Å) α$_7$ helix. This long helix forms most of the internal face of the funnel although the α$_6$ helix contributes at the top of the funnel.

There are several unique features of the CorA structure. First, the external mouth of the pore formed by TM1 is apparently closed by the asparagine of the YGMNF

(a) (b)

Figure 2 (a) Ribbon representation of CorA homopentamer as seen from the cytosol. From the N terminus, the α$_1$, α$_2$, and α$_3$ helices are shown in yellow, the seven-stranded β sheet in blue, the α$_4$, α$_5$, and α$_6$ helices in red, and the α$_7$ stalk helix ending in TM1 in green and TM2 in magenta. TM2 is mostly hidden in this view. (b) Side view of the CorA monomer colored as in part (a). In this view, the α$_3$ helix is mostly hidden and TM2 in magenta is seen followed by the C-terminal cytosolic six amino acid tail in dark blue. Figures prepared using PyMOL 1.1.

Figure 3 The TM segments of the *T. maritima* CorA are shown as cylinders with the cytosolic portion of the protein removed. The pore, in the closed form, is formed completely from the five TM1 segments which lie at a slight angle to the plane of the membrane. The helices are not shown connected because the nine amino acid extracellular (periplasmic) loops are not resolved in any crystal structure. The TM2 segments are essentially perpendicular to the plane of the membrane. Figure prepared using PyMOL 1.1.

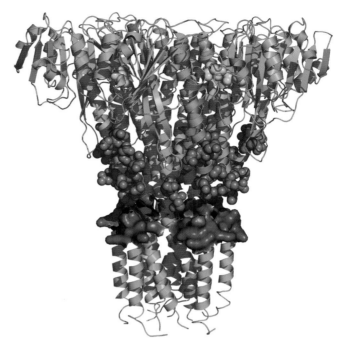

Figure 4 Ribbon representation of the *T. maritima* CorA homopentamer with important residues highlighted. The 'basic sphincter' formed by the C-terminal lysines and two additional lysines from the back side of the α_7 helix are shown as a surface in blue. The 10 aspartate and glutamate residues at the membrane-proximal ends of the α_5 and α_6 helices are shown as spheres in red. The two aspartate residues (D89 and D253 in *T. maritima* CorA) that bind Mg^{2+} and appear to hold the $\alpha\beta\alpha$ domain of one monomer to the α_7 helix of the adjacent monomer are shown in lavender. Figure prepared using PyMOL 1.1.

motif. It is held in place by apparent π–π interactions between the aromatic residues of the YGMNF motif, with the Y of one monomer stacking with the F of the adjacent monomer. On the cytosolic end of the pore, the side chains of two bulky nonpolar residues, one turn apart on the α helix, appear to point into the pore narrowing it considerably. In the *T. maritima* CorA, these are L294 and M291. In other CorAs, these residues differ but are always nonpolar and bulky. These amino acids were suggested to be good candidates to form 'gates' for Mg^{2+} flow through the channel. Lunin *et al.*[19] suggested that the asparagine of the YGMNF motif might help determine cation selectivity, but aspects of the structure determined by Payandeh and Pai[22] may not support this supposition.

The second unusual feature of CorA is a collection of positively charged residues, lysines in T maritima CorA and lysines and arginines in other CorA's. These residues form a donut-shaped ring around the outside of the funnel just at the cytosolic membrane surface (Figure 4). In *T. maritima* the ring is composed of four lysines at the C terminus and two additional lysines on the outside face of the funnel contributed from the α_7 helix. This feature is present in all CorAs with the C-terminal six amino acids virtually always containing three or four lysines or arginines. The positively charged amino acids from the α_7 helix are likewise highly conserved. This concentration of residues results in a ring of 30 lysines just where the cytosolic funnel becomes the stem within the membrane. This extremely high concentration of positive charge would likely form a considerable barrier to the movement of Mg^{2+} through the pore even though all of the lysines are external to the pore.

Third, this ring of positive charge is apparently countered by the membrane-proximal ends of the α_5 and α_6 helices. Of the last 10 residues in each helix, half are aspartate or glutamate. In the pentamer, this provides 50 negatively charged residues immediately above the ring of lysines (Figure 4). While the sequences of the α_5 and α_6 helices are not well conserved, the concentration of negatively charged residues on their membrane-proximal ends is conserved.

Fourth, all three crystal structures show apparent Mg^{2+} ions bound in the cytosolic domain between an aspartate of the α_3 helix of one monomer and the α_7 helix of the adjacent monomer, giving a total of five bound Mg^{2+} ions. In *T. maritima* CorA, these are D89 and D253 (Figures 4 and 5). These two residues likewise appear to be highly conserved, although poor sequence conservation in the soluble domain makes definitive alignment impossible.

The CorA Mg^{2+} channel

Figure 5 Close-up of the CorA cytosolic Mg^{2+} binding site. Residue D89 (pink) of one monomer (blue) coordinates with a Mg^{2+} ion (red) which also coordinates with D253 (pink) of the adjacent monomer (dark blue). The remaining monomers are all colored gray. Some helices are identified for orientation. The bond lengths from the carbonyls of each aspartate residue to the Mg^{2+} ion are indicated. (The bar is not to scale because of the viewing angle.) Four water molecules fill out the remainder of the Mg^{2+} coordination shell. As discussed in the text, in addition to Mg^{2+} being the only cation present, the identity of the Mg^{2+} ion is inferred from the short bonds lengths and the roughly 90° bond angles of the coordination sphere. Figure prepared using PyMOL 1.1.

Payandeh and Pai[22] have identified some additional putative metal binding sites that may also be physiologically relevant, although the coordination and predicted affinities of these additional sites suggest that at typical cytosolic 'free' Mg^{2+} concentrations of ~0.5 mM these sites are not likely to be occupied. Further studies will be necessary to determine whether all of these apparent bound cations have a function.

Finally, the interior face of the funnel, formed largely by the α_7 helix, is lined with concentric rings of polar or negatively charged residues beginning at the membrane interface and continuing through the entire length of the funnel's interior (Figure 6). Almost every turn of the α_7 helix has a polar or negatively charged residue pointing into the interior space of the funnel. In *T. maritima* these are, from the membrane outward, S284, S280, D277, S273, D270, E266, D263, and Y255. The 'gaps' on either side of the ring formed by Y255 are potentially filled by E320, S233, and D238 of the α_6 helix at the very top of the funnel. Some basic residues in the $\alpha6$ and $\beta4$ segments may serve to partially neutralize this negative charge. It is worth noting that in the soluble domain structure of the *A. fulgidus* these basic residues are pulled away from the funnel, leaving it highly negative. Such rings of polar and negatively charged amino acids lining the pore appear well conserved in other CorAs. The concentric rings would clearly be able to interact with Mg^{2+} entering the pore and may be a mechanism both to 'accelerate' Mg^{2+} out of the funnel and to prevent Mg^{2+} from reentering the pore.[19,22]

(a) (b)

Figure 6 Polar and charged residues lining the inside face of the CorA funnel. The cytosolic portions of the most of the α_6 and α_7 helices of the *T. maritima* CorA are shown as ribbons in green. The charged and polar residues that line the inner wall of the funnel formed by α_6 and α_7 are represented as spheres with alternate rings represented in red (S284, D277, D270, D263, and Y255) and pink (S280, S273, E266, and E230). Residues S233, D238, and E246 are not colored for clarity, and two of the five monomers have been removed to allow better visualization of the successive rings of charged and polar residues ascending the funnel. Figure prepared using PyMOL 1.1.

Mechanism

The three crystal structures to date are all apparently of a closed form of the channel. Without further studies and especially without the structure of an open form of the channel, it is not possible to outline a potential mechanism with significant experimental support. Overall, it would appear that the asparagine of the YGMNF motif at the external end of the pore likely forms a primary barrier to cation entry. There is disagreement concerning the role of the extracellular loop. This loop and especially the MPEL motif are extremely well conserved over a broad range of CorA homologs, and the motif was initially postulated to interact with Co^{3+} hexaammine and to be responsible for initial binding of Mg^{2+}. In contrast, Payandeh and Pai[22] noted that Co^{3+} hexaammine inhibits both the *M. jannaschii* and *S. typhimurium* CorA channels[39] even though the sequence of the external loop differs in eight of nine amino acids and has little charge. This would imply that the inhibitor more likely interacts with the YGMNF motif or even that it enters the pore and is blocked by the 'gate' formed by the leucine and methionine residues at the cytosolic end of the pore. More recent work has been interpreted to suggest that the external loop may be required for proper folding and stability but not for cation binding or flux.[24]

The overall mechanism implied by the crystal structures is that the cytosolic Mg^{2+} bound between D89 and D253 has a major role in opening the channel. If the Mg^{2+} ions bound at this site were to dissociate, this would free the αβα domain of one monomer to move away from the α$_7$ helix of the adjacent monitor, potentially opening the pore through propagation of movement through the very long α$_7$ helix. This is a feasible mechanism in terms of Mg^{2+}. In CorA, the Mg^{2+} bound between D89 and D253 would coordinate at two sites by the negatively charged oxygen of the carboxyl group. The remaining four sites appear to all be occupied by water. From enzyme studies and other structural studies, bound Mg^{2+} ions between two such aspartate residues would be predicted to demonstrate a dissociation constant of 0.3–0.5 mM. Thus Mg^{2+} would be binding, dissociating, and rebinding to this site fairly rapidly. The probability that all five of the bound Mg^{2+} ions would be dissociated simultaneously is relatively small but hardly negligible. When this happens, it would allow all the αβα domains to rotate away from the α$_7$ helix simultaneously opening CorA somewhat like the iris of a camera. This is precisely what is seen in the *A. fulgidus* soluble domain structure obtained in the absence of divalent cation.[22] The rotation would cause/allow movement of the α$_7$ helix propagating through the protein to the pore formed by its distal end. Considerable additional data support a primary role for the Mg^{2+} bound between the monomers in the cytosol.[22,24]

A conserved proline residue in TM1 near the center of the pore has been suggested to be involved in gating.[24]

The long-range movement of the α$_7$ helix would alter the 'kink' induced by a proline residue, thus potentially opening the pore or altering packing of the TM1 and TM2 helices. Mutations in this TM1 proline in *T. maritima* CorA appear to 'open' the pore in a 'gain of function' mutation. In contrast, mutation of the equivalent proline in TM1 of *S. typhimurium* CorA decreases apparent V_{max} twofold without change in the apparent affinity for Mg^{2+}.[41] Interestingly, despite no change in Mg^{2+} affinity, the apparent affinities of this proline mutant for Ni^{2+} and Co^{2+} are shifted to the right by about fivefold. In addition, mutation of the proline had no effect on the cooperativity measured for ^{63}Ni^{2+} uptake (Hill coefficient >2). Thus, the role of the highly conserved proline in TM1 is unclear. Further, the work of Payandeh and Pai[24] has clearly demonstrated a role for the α$_5$ and α$_6$ helices consistent with their movement during opening of the pore. In contrast, it is currently unclear whether the lysine ring at the cytosol–membrane interface interacts with the negatively charged residues of the α$_5$ and α$_6$ helices or whether it moves significantly during opening.

Overall, the crystal structures and currently available mutational data are consistent with closure of the pore by the asparagine of the YGMNF motif. Opening of this gate and dissociation of the bound Mg^{2+} ions on the cytosolic site between α7- and α3-helices of adjacent monomers allows movement of the α5- and α6-helices and rotation of the monomers slightly away from each other, thus relieving the block at the cytosolic end of the pore and allowing Mg^{2+} entry. Among the many issues not yet clear are the role of the external loop between TM1 and TM2, how the asparagine block at the external end of the pore is relieved, and the function of the lysine ring.

Structure of other members of the CorA family

More than one branch of the CorA family is apparent after alignment of the hundreds of CorA homologs in GenBank.[8,18] Some species have multiple apparent orthologs. Many of these apparent CorA family members share only minimal sequence identity with *S. typhimurium* or *T. maritima* CorA. Further, it is highly likely that not all of these function to mediate Mg^{2+} influx. Thus two questions simultaneously arise: what range of functions is present in this family and do all homologs, regardless of function, share a similar funnel-shaped structure?

The only CorA ortholog whose function has been investigated is ZntB in *S. typhimurium*, which has about 25% sequence identity with the *S. typhimurium* CorA. On the basis of the cation accumulation assays, ZntB putatively functions as a Zn^{2+} efflux system.[6] The secondary structures of CorA and ZntB are predicted to be essentially identical, and both are completely compatible with the crystal structures from *T. maritima*. Thus it was suggested that ZntB has the same overall structure as CorA.[3] Similar

Figure 7 Ribbon representation of the soluble domain of the *Vibrio parahaemolyticus* ZntB homolog (PDB code: 3BHC) viewed from the cytosol. Each monomer is shown in a different color. Figure prepared using PyMOL 1.1.

comparison of Mrs2 proteins to the bacterial homologs also predicts an essentially identical structure.[3] This hypothesis has recently been confirmed by the deposit of the coordinates (PDB code: 3BHC) of the soluble domain of a ZntB ortholog from *Vibrio parahaemolyticus* (Figure 7). This soluble domain has the same overall homopentameric funnel shape, a long central α helix equivalent to the α₇ helix of CorA, and a similar αβα domain that potentially interacts with the α₇ helix of an adjacent monomer. Thus, the CorA family represents yet another example of a basic structure being adapted for multiple purposes.

Unresolved problems

Clearly, an open form of the CorA Mg²⁺ channel is required to make substantial further progress on the mechanism of Mg²⁺ movement through CorA. But there are substantial issues concerning CorA that have not been answered or even addressed by the current structures. Two examples can be described. The first involves cross-linking of single cysteine substitutions within either TM1 or TM2 with the identical residue on another monomer. With some substitutions, cross-linking is spontaneous; with others cross-linking is readily induced by addition of copper-phenanthroline. Within TM1, such cross-linking seems feasible and potentially explainable given the crystal structures. However, the TM2 helices are much further apart. It is not clear how they could ever be close enough to form a disulfide bond between monomers. Even if they

move during opening of the pore and passage of Mg²⁺, they would generally move relative to TM1, but would not likely come much closer to another TM2.

Second, there is a mismatch between the symmetry of the channel and the Mg²⁺ cation. The channel is homopentameric, but the Mg²⁺ ion is hexacoordinate and strongly prefers coordination to oxygen. The apparent pore of the channel does not contain charged amino acids, indicating that the primary interactions of Mg²⁺ as it traverses the pore must be with backbone carbonyl groups. Since Mg²⁺ strongly prefers a bond angle very close to 90°, it is not possible for Mg²⁺ to coordinate three or more bonds to the symmetric homopentamer without markedly distorting the preferred octahedral coordination geometry, an energetically very costly process. Even coordinating two bonds of the Mg²⁺ octahedral coordination sphere to the homopentamer would likely involve bond angles significantly different than 90°. Coordination of Mg²⁺ to water, which then coordinates with the backbone carbonyls, may be feasible, but would imply a much larger pore diameter than seen in other ion channels.

ACKNOWLEDGEMENTS

The work from the author's laboratory was supported by a grant from the National Institutes of Health (GM39447).

REFERENCES

1 MH Saier Jr, *Microbiol Mol Biol Rev*, **64**, 354–411 (2000).

2 R Schindl, J Weghuber, C Romanin and RJ Schweyen, *Biophys J*, **93**, 3872–83 (2007).

3 ME Maguire, *Curr Opin Struct Biol*, **4**, 432–38 (2006).

4 MD Snavely, JB Florer, CG Miller and ME Maguire, *J Appl Bacteriol*, **171**, 4761–66 (1989).

5 SP Hmiel, MD Snavely, CG Miller and ME Maguire, *J Appl Bacteriol*, **168**, 1444–50 (1986).

6 AJ Worlock and RL Smith, *J Appl Bacteriol*, **184**, 4369–73 (2002).

7 ME Maguire, *Front Biosci*, **11**, 3149–63 (2006).

8 V Knoop, M Groth-Malonek, M Gebert, K Eifler and K Weyand, *Mol Genet Genomics*, **274**, 205–16 (2005).

9 GJ Liu, DK Martin, RC Gardner and PR Ryan, *FEMS Microbiol Lett*, **213**, 231–37 (2002).

10 A Graschopf, JA Stadler, MK Hoellerer, S Eder, M Sieghardt, SD Kohlwein and RJ Schweyen, *J Biol Chem*, **276**, 16216–22 (2001).

11 L Li, AF Tutone, RS Drummond, RC Gardner and S Luan, *Plant Cell*, **13**, 2761–75 (2001).

12 I Schock, J Gregan, S Steinhauser, R Schweyen, A Brennicke and V Knoop, *Plant J*, **24**, 489–501 (2000).

13 MM Gibson, DA Bagga, CG Miller and ME Maguire, *Mol Microbiol*, **5**, 2753–62 (1991).

14 SP Hmiel, MD Snavely, JB Florer, ME Maguire and CG Miller, *J Appl Bacteriol*, **171**, 4742–51 (1989).

15 RL Smith, JL Banks, MD Snavely and ME Maguire, *J Biol Chem*, **268**, 14071–80 (1993).

16 M Rapp, D Drew, DO Daley, J Nilsson, T Carvalho, K Melen, JW De Gier and G Von Heijne, *Protein Sci*, **13**, 937–45 (2004).

17 MA Warren, LM Kucharski, A Veenstra, L Shi, PF Grulich and ME Maguire, *J Appl Bacteriol*, **186**, 4605–12 (2004).

18 DG Kehres, CH Lawyer and ME Maguire, *Microb Comp Genomics*, **43**, 151–69 (1998).

19 VV Lunin, E Dobrovetsky, G Khutoreskaya, R Zhang, A Joachimiak, DA Doyle, A Bochkarev, ME Maguire, AM Edwards and CM Koth, *Nature*, **440**, 833–37 (2006).

20 S Eshaghi, D Niegowski, A Kohl, MD Martinez, SA Lesley and P Nordlund, *Science*, **313**, 354–57 (2006).

21 J Payandeh and EF Pai, *Acta Crystallograph Sect F Struct Biol Cryst Commun*, **62**, 148–52 (2006).

22 J Payandeh and EF Pai, *EMBO J*, **25**, 3762–73 (2006).

23 RL Smith, E Gottlieb, LM Kucharski and ME Maguire, *J Appl Bacteriol*, **180**, 2788–91 (1998).

24 J Payandeh, C Li, M Ramjeesingh, E Poduch, CE Bear and EF Pai, *J Biol Chem*, **283**, 11721–33 (2008).

25 Y Chen, J Song, SF Sui and DN Wang, *Protein Expr Purif*, **32**, 221–31 (2003).

26 RD Grubbs, MD Snavely, SP Hmiel and ME Maguire, *Methods Enzymol*, **173**, 546–63 (1989).

27 ME Maguire, in H Schatten and A Eisenstark (eds.), *Salmonella: Methods and Protocols*, Humana Press, Totowa, NJ (2007).

28 RL Smith, LJ Thompson and ME Maguire, *J Appl Bacteriol*, **177**, 1233–38 (1995).

29 T Tao, MD Snavely, SG Farr and ME Maguire, *J Appl Bacteriol*, **177**, 2654–62 (1995).

30 DE Townsend, AJ Esenwine, J George III, D Bross, ME Maguire and RL Smith, *J Appl Bacteriol*, **177**, 5350–54 (1995).

31 ME Maguire, *J Bioenerg Biomembr*, **24**, 319–28 (1992).

32 J Weghuber, F Dieterich, EM Froschauer, S Svidova and RJ Schweyen, *FEBS J*, **273**, 1198–209 (2006).

33 EM Froschauer, M Kolisek, F Dieterich, M Schweigel and RJ Schweyen, *FEMS Microbiol Lett*, **237**, 49–55 (2004).

34 M Kolisek, G Zsurka, J Samaj, J Weghuber, RJ Schweyen and M Schweigel, *EMBO J*, **22**, 1235–44 (2003).

35 KM Papp and ME Maguire, *J Appl Bacteriol*, **186**, 7653–58 (2004).

36 ME Maguire and JA Cowan, *Biometals*, **15**, 203–10 (2002).

37 JA Cowan, *Chem Rev*, **98**, 1067–87 (1998).

38 JA Cowan, *The Biological Chemistry of Magnesium*, VCH Publishers, New York (1995).

39 LM Kucharski, WJ Lubbe and ME Maguire, *J Biol Chem*, **275**, 16767–73 (2000).

40 JM Lee and RC Gardner, *Curr Genet*, **49**, 7–20 (2006).

41 MA Szegedy and ME Maguire, *J Biol Chem*, **274**, 36973–79 (1999).

The MgtE Mg^{2+} transporter

Michael E Maguire

Department of Pharmacology, School of Medicine, Case Western Reserve University, Cleveland, OH, 44106-4965, USA

FUNCTIONAL CLASS

Cation transporter; divalent cation transporter and/or channel; MgtE family TC #9.A.19 according to the Transport Classification Database[1] and SLC41 family according to the Human Genome Organization Database (http://www.gene.ucl.ac.uk/nomenclature). The primary functional classification is as a Mg^{2+} (influx) ion transporter.[2,3] The transporter is termed MgtE for Mg^{2+} transport with E denoting that this was the fifth prokaryotic gene related to Mg^{2+} transport to be identified.[2–4]

OCCURRENCE

The MgtE class of Mg^{2+} ion transporter is widespread in the bacteria, with over 50% of current genomic sequences exhibiting a homolog. MgtE is particularly widespread in *Chlamydia*, Firmicutes, and cyanobacteria but a few occurrences are found in cytophaga-flexibacter-bacteroides (CFB) group bacteria, δ-, and γ-proteobacteria. Interestingly, MgtE homologs are greatly overrepresented in the current marine metagenome with about 1800 sequences compared to less than 200 for CorA, the other primary prokaryotic Mg^{2+} channel. Like CorA, MgtE is the primary provider of cytosolic Mg^{2+} in those organisms that carry it. A few prokaryotes appear to carry both CorA and MgtE. MgtE homologs (SLC41 family) are also widespread in eukaryotes especially throughout the metazoa and fungi, but MgtE is apparently absent from plants where CorA homologs appear to predominate.

BIOLOGICAL FUNCTION

In those organisms carrying only MgtE, the growth phenotype (if any) resulting from mutation of *mgtE* (gene

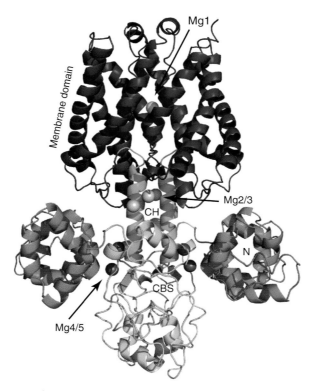

3D Structure A ribbon representation of a side view of homodimeric MgtE from *Thermus thermophilus* in the plane of the membrane is shown (PDB code 2YVX).[6] The membrane domain is colored in dark blue, the 'connecting α helices' in light blue, the CBS domains in beige, and the N domains in red. Bound Mg^{2+} ions are shown as spheres (see text for discussion). Mg1 within the TM domain is wheat-colored, Mg2 and Mg3 are shown in gray, and Mg4 and Mg5 are shown in purple. This and similar following figures were drawn using PyMOL 1.1.[18]

encoding MgtE protein) has not been determined. In parallel with the phenotype of mutations of *corA* (gene encoding CorA protein), the expectation would be that most organisms would show no Mg^{2+} dependence for growth because of the presence of some type of secondary Mg^{2+} influx system. Other phenotypes have only been reported in *Aeromonas hydrophila*, where mutation of *mgtE* markedly decreases adherence of the bacteria to mammalian cells.[5] It also decreases the ability of the strain to form biofilm. The strain is not, however, dependent on increased extracellular Mg^{2+} for growth since *Aeromonas* sp. are among the minority of bacteria that also carry a CorA.

AMINO ACID SEQUENCE INFORMATION

MgtE is somewhat larger than CorA at about 440–490 amino acids. It forms a symmetrical homodimer of about 100 kDa in the membrane (3D Structure and Figure 1).[6] From the N terminus, MgtE contains a large helical domain followed by duplicated CBS (cystathionine-β-synthase) domains (see below). The N domain has weak sequence similarity but significant structural identity to FliG (Figure 2), a membrane-bound component of the bacterial flagellum that is part of the motor assembly.[7,8] The N domain also has some similarity to the C-terminal domain of human FancF, one of the Fanconi anemia proteins that form a nuclear core complex required for monoubiquitination of certain proteins.[9,10] CBS domains are thought to be involved in dimerization but may bind a potentially regulatory nucleotide.[10] Following the CBS domains, an apparent α-helix connects each monomer to 5 transmembrane (TM) segments per monomer, giving a total of 10 in the dimer. The entire TM domain is at the C terminus as with CorA.

Figure 2 Comparison of the MgtE N domain structure to FliG. The soluble fragment of FliG consists of two α-helical bundles connected by a linking α helix. The N domain of MgtE is a superbundle of 10 α helices. Because the published FliG structure is a fragment,[7,8] and the helix bundle is apparently opened compared to MgtE, each of the two smaller FliG α helix bundles were compared to MgtE independently. The comparison of the most N-terminal bundle of the FliG (PDB code 1LKV, purple) with that of the most N-terminal region of the N domain of the *Enterococcus faecalis* MgtE (PDB code 2OUX, blue) overlaid using Cn3D (www.ncbi.nlm.nih.gov) is shown. The gray sphere is the equivalent of Mg4 from the MgtE structure. A comparison of the more C-terminal α-helical bundle from FliG to the remainder of the *E. faecalis* MgtE N domain shows a similar conservation of structure. Comparison of FliG with *T. thermophilus* MgtE gives similar results.

While the SLC41 homologs in eukaryotes have substantial sequence similarity throughout the TM domain, both the gene structure and soluble domain sequence differ significantly. In SLC41 proteins, the N-terminal soluble domain is short, about 100 amino acids, and does not exhibit significant sequence similarity to either N or CBS domains of MgtE. In addition, while the bacterial MgtE apparently forms a homodimer with a total of 10 TM segments, SLC41 contains the same (homologous) 10 TM segments tandemly fused into a single gene. This does not however preclude association of the eukaryotic homologs with additional proteins that may contain either or both the N and CBS domains. Indeed, Kolisek *et al.* have reported that human SLC41A1 forms heteromeric complexes up to 1000 kDa in size as assayed by blue native gel electrophoresis (see discussion below).[11]

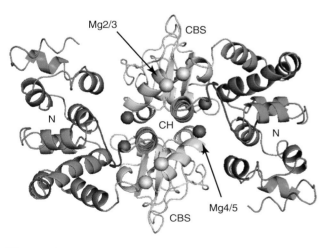

Figure 1 The soluble cytosolic domain of *T. thermophilus* MgtE is shown viewed from the membrane toward the cell. The TM domain is removed. Color coding is the same as that in the 3D Structure.

PROTEIN PRODUCTION, PURIFICATION, AND MOLECULAR CHARACTERIZATION

Full-length MgtE proteins from *T. thermophilus*, *Bacillus subtilis*, *Bacillus firmus* OF4, and *Providencia stuartii* can be expressed in *Escherichia coli* and/or *Salmonella enterica* serovar typhimurium with retention of function.[2,3,5,6] Full-length MgtE proteins from *T. thermophilus*, *Thermatoga maritima*, *Thermobifida fusca*, *B. subtilis*, *Pyrococcus horikoshii*, *Methanosarcina mazei* and *Methanothermobacter thermautotrophicus* have been purified after expression in *E. coli* C41 (DE3) but only that from *T. thermophilus* has been successfully crystallized.[6,12,13] Purification was achieved by the use of a Prescission Protease cleavable 6X-His tag at the N terminus. Cells were sonicated in 50 mM HEPES (4-(2-hydroxyethyl)-1-piperazineethanesulfonic acid) buffer, pH 7.0 with 150 mM NaCl, 3 mM β-mercaptoethanol, and protease inhibitors. After isolation of a membrane fraction, solubilization was achieved in 50 mM HEPES, pH 7.0, 150 mM NaCl, 20 mM imidazole, and 2% (w/v) dodecylmaltoside (DDM). After column washes with buffer containing 50 mM HEPES, pH 7.0, 150 mM NaCl and 0.1% DDM, protein was eluted with 50 and 300 mM imidazole. A subsequent single step of purification by size exclusion chromatography on a Superdex 200 column was performed. The column was equilibrated in 20 mM HEPES, pH 7.0, and 150 mM NaCl with 0.1% DDM, 0.25% decylmaltoside, 0.2% $C_{12}E_8$, or 1.25% octylglucoside. Crystals were obtained from the protein in DDM but not protein in other detergents. The expression of MgtE in *E. coli* from *T. thermophilus*, *Thermotoga maritima*, and *Thermobifida fusca* gave modest yields of $0.2–1 \, mg \, l^{-1}$ protein.

The MgtE N-terminal soluble domain of ~250 amino acids has also been expressed independently of the membrane domain and crystallized in the presence or absence of Mg²⁺. The soluble domain appears to form a homodimer when expressed independently, consistent with the full-length structure.[6,13]

ACTIVITY AND INHIBITION TESTS

Cation flux through MgtE has been characterized for the proteins from *B. firmus* OF4 and *P. stuartii* using $^{57}Co^{2+}$ since $^{28}Mg^{2+}$ is not available.[2,3] MgtE properties in the two species are essentially identical. In both species, the concentration that gives maximal uptake is 70 μM Co²⁺. Mg²⁺ inhibits $^{57}Co^{2+}$ uptake by MgtE with a K_i of 50 μM. Sr²⁺, Mn²⁺, Ca²⁺, and Zn²⁺ inhibit with K_is ranging from 20 to 80 μM. Zn²⁺ is the most potent. It is unlikely that MgtE transports these latter cations, however, since overexpression of MgtE in *S. typhimurium* does not lead to increased toxicity from these cations, but this has not been definitively demonstrated. In contrast to the CorA Mg²⁺ channel, Ni²⁺ is not transported by MgtE, and Ni²⁺

does not inhibit uptake of $^{57}Co^{2+}$. Physiologically, MgtE is considered a Mg²⁺ uptake system primarily due to its ability to restore growth on media containing no added Mg²⁺ to a *S. typhimurium* strain devoid of Mg²⁺ transporters[2,3]; without complementation by MgtE, the strain requires >5 mM extracellular Mg²⁺ for growth.

In eukaryotes, the mouse SLC41A1 and SLC41A2 proteins have been expressed in *Xenopus laevis* oocytes[14,15] and reported to give inwardly directed cation currents with the permeability profile of $Mg^{2+} \geq Sr^{2+} \geq Fe^{2+} \geq Ba^{2+} \geq Cu^{2+} \geq Zn^{2+} \geq Co^{2+} > Cd^{2+}$. However, this is unlikely to be the true permeation profile both because the method used, two-electrode voltage clamp, does not control for intracellular ion content and because the order of the permeation profile reported does not correspond in any way with the size or the electrical and chemical properties of the cations tested. More recently, Kolisek *et al.* have overexpressed human SLC41A1 in human embryonic kidney (HEK) 293 cells and in the Mg²⁺-transport-deficient strain of *S. typhimurium*.[11] The SLC41A1 protein complements the Mg²⁺ growth requirement of the *S. typhimurium* strain, indicating that SLC41A1 is functionally capable of Mg²⁺ influx. In HEK293 cells overexpressing SLC41A1, the transporter localizes to the plasma membrane; however, whole cell patch clamp experiments did not show inwardly directed Mg²⁺-dependent currents. Instead, in the presence of an outwardly directed Mg²⁺ gradient, expression of SLC41A1 led to a decrease in intracellular free Mg²⁺ as well as a decrease in total intracellular Mg²⁺. In addition, outwardly directed Cl⁻ currents were activated. Their blockade by a Cl⁻ inhibitor did not alter the apparent Mg²⁺ efflux. The selective CorA Mg²⁺ channel inhibitor cobalt(III) hexaammine[16] did not inhibit these effects of SLC41A1 expression.[11] (Interestingly, these same experiments demonstrated that the inhibitor could block transient receptor potential melastatin-related (TRPM) 7 Mg²⁺-dependent currents.) Overall, the data of Kolisek *et al.* provide strong evidence that SLC41A1 functions as a Mg²⁺ efflux system. It is not known if the bacterial MgtE transporters can mediate Mg²⁺ efflux as well as influx.[11]

These data raise the interesting question of whether MgtE/SLC41 proteins are all ion channels or all carrier/transporters or whether both mechanisms exist, depending on the specific family member and cell type each is expressed in. Moreover, although the large Cl⁻ currents associated with the SLC41A1 Mg²⁺ efflux in HEK293 cells could be blocked without affecting Mg²⁺ flux, outward movement of Mg²⁺ would require energy, presumably in the form of a counter- or cotransported cation, since there is no evidence that MgtE/SLC41A1 is an ATPase. Kolisek *et al.* speculated that when SLC41A1 is expressed in the Mg²⁺-transport-deficient strain of *S. typhimurium* it acts as an ion channel, mediating Mg²⁺ influx because it lacks the additional proteins forming the apparent complex.[11] They further suggest that it is the apparent association with additional heteromeric partners in eukaryotes that results

in SLC41A1 acting functionally as a Mg^{2+} efflux system. This could also potentially explain the inwardly directed Mg^{2+} currents seen when the mouse SLC41A1 protein was expressed in *Xenopus* oocytes[14,15] since the heteromeric partner proteins would not be present. Expression in oocytes would thus be functionally equivalent to expression of SLC41A1 in *S. typhimurium* where it mediates Mg^{2+} influx. While this is a quite reasonable hypothesis, further work will be needed to determine if this is a correct scenario, whether heteromeric partners of SLC41A1 exist, and if such partners exist whether they are homologous with the N and CBS domains seen in bacterial MgtE systems.

X-RAY STRUCTURES OF MgtE

Crystal structures have been reported[6,12,13] for the *T. thermophilus* full-length MgtE (3.5-Å resolution, PDB code 2YVX), for its soluble domain in the presence and absence of Mg^{2+} (2.3 and 3.9-Å, PDB codes 2YVY and 2YVZ, respectively), and for the soluble domain of the *E. faecalis* MgtE in the presence of Mg^{2+} (2.2 Å resolution, PDB code 2OUX). All structures show similar pictures of subdomain structure although in the soluble domain structure without Mg^{2+}, N and CBS domains are significantly rotated from each other compared to the structure in the presence of Mg^{2+}.

Crystallization

The *E. faecalis* MgtE soluble domain (residues 2–285) was expressed in *E. coli* BL21 (DE3), but further details of the purification protocol have not been published. It was crystallized by vapor diffusion at 298 °K from 0.1 M HEPES, pH 7.5, 25% (w/v) polyethylene glycol (PEG) 3350, and 0.2 M $MgCl_2$. The *T. thermophilus* MgtE crystallized as tetragonal bipyramidal crystals after 2 weeks with 26–32% (w/v) 2-methyl-2,4-pentanediol (MPD), 40 mM magnesium acetate and 100 mM 2-(N-morpholino)-ethanesulfonic acid (MES), pH 6.0. Crystals of protein incorporating selenomethionine were obtained after seeding with native crystals under similar conditions except that MPD was 32–34%. Reproducibility of crystal

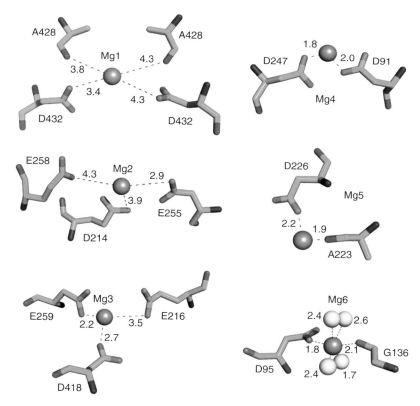

Figure 3 Bound Mg^{2+} ions in the MgtE crystal structure. The residues coordinating each of the bound Mg^{2+} ions in the full-length MgtE structure (Mg1–Mg5) and the soluble domain MgtE structure with Mg^{2+} (Mg2–Mg4 and Mg6) are shown. Amino acid backbones are in light green, oxygen atoms of carboxyl groups are in lavender, backbone nitrogen atoms are in blue, backbone carbonyl atoms are in red, Mg^{2+} atoms in light blue and water molecules (Mg6) in pale blue. The numbers denote the distance in angstroms from the indicated oxygen atom to the bound Mg^{2+}. In the full-length crystal structure, additional pockets of density around each bound Mg^{2+} are presumably water molecules around Mg1–Mg5, but the resolution of the crystal structure was not sufficient to assign the density as water. The higher resolution of the soluble domain structure allowed definition of waters around Mg6.

formation was markedly improved by addition of 0.1 vol of a 10 mg ml^{-1} *E. coli* phospholipid polar extract followed by centrifugation to remove any insoluble material.[12,13]

Structure

From the N terminus, MgtE contains a rather globular N domain (for N terminus) composed of a right-handed superhelix containing 10 short α helices followed by duplicated CBS domains. In the homodimer, these soluble domains form a symmetrical structure. This soluble domain is linked to the TM domain by a 'connecting α helix' orthogonal to the membrane. The 5 TM segments of each monomer again form a symmetrical and intimate association with each other, resulting in overall twofold symmetry (3D Structure and Figure 1). Each TM segment is at a substantial angle to the plane of the membrane. The external third of TM2 does not appear to be strongly α helical. At the external face of the membrane, two short α helices (termed H1b helices), one from each monomer, lie parallel to the membrane surface and were postulated by Hattori *et al.* to form part of the recognition/binding site for Mg^{2+}.[6,17] These H1b helices would appear to shield the nonhelical portion of TM2 at the outer face from the aqueous phase.

The full-length crystal structure of MgtE contains several areas of density interpreted as bound Mg^{2+} ions. This interpretation was based on Mg^{2+} being the only divalent cation present and more rigorously by the apparent hexacoordinate nature of the bonds and the short bond lengths are characteristic of Mg^{2+}.[6] One Mg^{2+} (Mg1) appears in the presumed ion conductance pathway within the membrane between the two TM5 segments apparently interacting with conserved Asp432 residues and the main chain carbonyl groups of the nearby Ala428, also in TM5 (3D Structure, wheat-colored sphere, and Figure 3). Two additional Mg^{2+} cations per monomer (Mg2 and Mg3) are located between the cytosolic and membrane domains, about 6 Å apart (3D Structure and Figure 1, gray spheres, and Figure 3). Mg2 is liganded to Asp214 in one CBS domain and to Glu255 and Glu258 in the 'connecting α helix'. Mg3 interacts with Glu216 in the CBS domain, Glu259 in the 'connecting α helix' and Asp418 in a short connecting loop between the TM5 α helix and a short cytosolic α-helix (H4b) between TM4 and TM5. These acidic residues are generally conserved in the MgtE family. Both of these bound Mg^{2+} ions would serve to bridge the cytosolic and TM domains, potentially locking the transporter in a closed form. Two additional Mg^{2+} ions per monomer (Mg4 and Mg5) are located at the interface between the N and CBS domains and appear to serve to stabilize the interaction of the N and CBS domains (3D Structure and Figure 1, purple spheres, and Figure 3). The positioning of two Mg^{2+} ions between the 'connecting α helices' and the TM domain and of two additional Mg^{2+} ions between the N and CBS domains suggests

Figure 4 Proposed movement of connecting helices and TM segments. The MgtE homodimer is shown with both N domains, both TM3 and TM4 segments, and one CBS domain removed. The CBS domain is colored rose, the connecting helices light green, TM1 lavender, H1b and TM2 helices blue and TM5 light blue. Mg1 is wheat, Mg2 and Mg3 light green and Mg4 and Mg5 purple. (Some Mg^{2+} ions are partially hidden in this view.) The arrows show proposed directions of movement during opening of the pore according to Hattori *et al.*[6,17] The cytosolic end of TM2 (A) is proposed to move away from its cognate TM2. The membrane proximal end of each CH (B) is proposed to move outward to a relatively large degree while the N-terminal end of each CH (C) is proposed to move outward to a lesser degree. The cytosolic end of TM5 (D) is proposed to move outward away from each other and toward the cytosolic end of TM2. The combined movement of the CH and TM2 would likely bring the cytosolic end of TM1 inward (E), closer to TM2.

that the presence or absence of bound Mg^{2+} at these sites would possibly regulate Mg^{2+} movement through the ion conductance pore within the membrane. This further suggests that regulation of Mg^{2+} flux through both MgtE and the CorA Mg^{2+} channel is controlled similarly, by Mg^{2+} ions bound to specific sites in the cytosolic portion of the transporter/channel. The implication is that Mg^{2+} flux is controlled by the cytosolic-free Mg^{2+} concentration with the cytosolic domains of MgtE and CorA acting as 'Mg^{2+} sensors'.

In the structure of the Mg^{2+}-bound soluble domain of *T. thermophilus* MgtE, bound Mg^{2+} ions corresponding to those discussed above were observed, except Mg1

Figure 5 Cartoon structure of MgtE showing proposed domain movements during Mg^{2+} flux. This drawing is based on the model shown in Figure 4C, D of Hattori *et al.*[6] The bound Mg^{2+} ions are shown as numbered light purple circles, while the additional unnumbered light purple circles in the cytosol represent relative concentration of cytosolic-free Mg^{2+}. The various domains are labeled as in previous figures. In (a) Mg2/3 and Mg4/5 hold the CH to the TM domain and the N to the CBS domain, respectively. However, as cytosolic Mg^{2+} decreases, these bound Mg^{2+} ions may dissociate from MgtE. Loss of Mg2/3 would free the connecting helices from the TM domain, putatively allowing TM2 to move outward changing the angle of TM5 relative to the membrane (b). Concomitantly, the loss of Mg4/5 would allow the N domain to swing out markedly pulling the CBS domains apart, which in turn separates the connecting helices opening the pore for entry of Mg1.

that would not have been observed in a soluble domain structure since their liganding residues involve the TM domain. Interestingly, while Mg5 was not observed in the soluble domain structure, another Mg^{2+} (Mg6) was bound nearby at a resolution sufficient to show coordinating water molecules (Figure 3). The soluble domain structure from *E. faecalis* also contained similar bound Mg^{2+} residues, supporting their relevance.

The functional importance of the bound Mg^{2+} in the cytosolic domain of MgtE is further suggested by the structure of the cytosolic domain determined in the absence of Mg^{2+}. In the Mg^{2+}-free structure, the N domain and the CBS domain structures were essentially equivalent in the presence and absence of Mg^{2+} (root-mean-square deviations (rmsd) ≈ 1 Å), but the relationship of the two domains to each other was markedly altered. In the Mg^{2+}-free state, the N domain rotates and swings apart from the CBS domain by about 120°. Moreover, the relative structure of the dimeric CBS domains within each monomer alters significantly (rmsd ≈ 3.8 Å). In turn, this suggests that in the intact protein movement of the 'connecting α helices' would occur. Hattori *et al.*[6,17] speculated that Mg2, Mg3, Mg4 and potentially Mg5 binding leads to tight dimerization of the CBS domains, bringing the 'connecting α-helices' together and closing the ion conductance pore (3D Structure, Figures 1, 4, and 5). In the absence of bound Mg^{2+}, the CBS domain dimerization is loosened leading to rotation of

the CBS domain relative to the N domain coupled with an approximately 20° movement of the 'connecting α-helices' away from each other (Figure 4, light green arrows, and Figure 5). This combination leads to a proposed slight lateral separation of TM2 in one monomer from its cognate TM2 in the other monomer (Figure 4, blue double-headed arrow, and Figure 5) and to a larger outward movement of the cytosolic ends of the two TM5 helices (Figure 4, light blue arrows, and Figure 5) accompanied by straightening of TM1 and movement of its cytosolic end toward TM2 (Figure 4, blue arrows, and Figure 5). Movement of TM5 is proposed to open the cytosolic end of the membrane pore to allow Mg^{2+} flux (Figure 5).

Unresolved problems in MgtE function and structure

The overall structure of MgtE is compatible with either a channel or carrier/transporter mechanism. As noted above, both mechanisms are possible, even likely, depending on the specific family member. Unlike the CorA Mg^{2+} channel, which has concentric rings of polar and negatively charged residues along the length of the inner wall of the cytosolic 'funnel' that could interact with the Mg^{2+} cation as it exits the membrane pore, MgtE has no apparent similar set of residues. Since CorA cannot mediate Mg^{2+} efflux except under certain nonphysiological conditions,[19] CorA would clearly seem to be a Mg^{2+} influx system while MgtE might

Table 1 Representative list of MgtE and SLC41A proteins

Accession number	Species	Length	Alignment probability	Percent identity[a]	Function[b]
MgtE homologs[c]					
CAB13187	MgtE (YkoK) *B. subtilis*	451	NA	NA	Yes
YP_078614	*Bacillus licheniformis*	451	>E-150	87	
BAB04230	*Bacillus halodurans*	452	5E-147	57	
NP_692145	*Oceanobacillus iheyensis* HTE831	459	8E-99	40	
ZP_02168784	*Bacillus selenitireducens* MLS10	453	6E-95	42	
YP_301866	*Staphylococcus saprophyticus*	461	3E-89	38	
AAO04295	*Staphylococcus epidermidis*	461	5E-88	38	
YP_040395	*Staphylococcus aureus* MRSA252	461	3E-87	37	
AAO82375	*E. faecalis* V583	453	9E-80	36	
AAA64954	*B. firmus* OF4	312	7E-79	48	Yes
ACA98283	*Synechococcus* sp. PCC 7002	456	6E-75	34	
ZP_01189247	*Halothermothrix orenii* H 168	464	3E-73	37	
ZP_01623485	*Lyngbya* sp. PCC 8106	454	5E-73	34	
YP_536192	*Lactobacillus salivarius*	455	2E-72	36	
AAO35912	*Clostridium tetani*	450	9E-71	35	
YP_322942	*Anabaena variabilis*	466	2E-70	32	
EDT27535	*Clostridium perfringens*	445	6E-70	31	
YP_144326	*T. thermophilus*	450	1E-69	34	Yes
AAL95673	*Fusobacterium nucleatum*	449	2E-67	32	
EDG11603	Marine metagenome	465	6E-68	33	
AAD36237	*T. maritima*	446	7E-68	31	
EBL37520	Marine metagenome	452	2E-67	33	
AAQ00836	*Prochlorococcus marinus*	468	9E-66	33	
ZP_01733910	*Flavobacteria bacterium*	450	3E-65	31	
YP_682299	*Roseobacter denitrificans*	463	4E-63	31	
NP_102935	*Mesorhizobium loti*	470	1E-62	28	
EBH31769	Marine metagenome	480	4E-62	30	
ZP_02854209	*Natranaerobius thermophilus*	458	5E-62	32	
AAK87334	*Agrobacterium tumefaciens*	475	8E-62	29	
ABB38629	*Desulfovibrio desulfuricans*	460	2E-61	31	
EBF82944	Marine metagenome	449	2E-60	32	
ZP_02042094	*Ruminococcus gnavus*	450	3E-60	29	
ZP_01308304	*Oceanobacter* sp. RED65	451	3E-60	28	
ABA58256	*Nitrosococcus oceani*	447	1E-59	31	
EAY54275	*Shewanella putrifaciens*	457	2E-59	30	
EDC79856	Marine metagenome	470	2E-59	31	
CAM74419	*Magnetospirillum gryphiswaldense*	465	2E-58	29	
EDN11845	*Vibrio cholerae*	453	2E-58	29	
ZP_02523136	*Bacillus cereus*	442	4E-58	31	
ZP_02094720	*Peptostreptococcus micros*	464	9E-58	28	
ECW74980	Marine metagenome	460	2E-57	30	
CAL15989	*Alcanivorax borkumensis*	454	2E-57	28	
AAS14102	*Wolbachia* endosymbiont of *Drosophila melanogaster*	456	8E-57	25	
NP_812953	*Bacteroides thetaiotaomicron*	446	3E-55	28	
YP_915183	*Paracoccus denitrificans*	485	5E-54	26	
NP_283269	*Neisseria meningitidis*	484	8E-54	27	
YP_033025	*Bartonella henselae*	458	2E-51	27	
YP_685660	Uncultured methanogenic archaeon	443	3E-51	25	
EBK84828	Marine metagenome	410	8E-51	31	
ABR85234	*Pseudomonas aeruginosa*	482	7E-50	25	
ABF89290	*Myxococcus xanthus*	439	3E-49	30	
AAN34049	*Brucella suis*	465	6E-49	28	
CAE43079	*Bordetella pertussis*	490	9E-48	25	
AAC44715	*Borrelia burgdorferi*	454	3E-47	29	

Table 1 *(continued)*

Accession number	Species	Length	Alignment probability	Percent identity[a]	Function[b]
YP_224524	*Corynebacterium glutamicum*	436	7E-47	30	
ABY72855	*Rickettsia rickettsii*	456	3E-46	27	
ZP_02550777	*Mycobacterium tuberculosis*	460	4E-46	27	
AAM84967	*Yersinia pestis* KIM	491	1E-45	25	
ZP_02960904	*Providencia stuartii*	486	2E-45	25	Yes
CAA15029	*Rickettsia prowazeki*	456	3E-45	26	
ABS21071	*B. cereus* subsp. *cytotoxic*	442	2E-42	25	
YP_857335	*A. hydrophila*	447	9E-42	26	Yes
AAZ18442	*Psychrobacter arcticus*	467	1E-40	24	
YP_891872	*Campylobacter fetus*	453	3E-39	26	
ECS78106	Marine metagenome	320	3E-39	30	
ECW28501	Marine metagenome	231	2E-25	32	
SLC41A homologs [d]					
AAI16282	SLC41A1 [*Mus musculus*]	512	NA	NA	Yes
CAH92071	SLC41A1 [*Pongo abelii*]	513	>E-180	97	
XP_001091472	SLC41A3 [*Macaca mulatta*]	513	>E-180	97	
CAH56217	SLC41A1 [*Homo sapiens*]	513	>E-180	97	
XP_536105	SLC41A1 [*Canis familiaris*]	514	>E-180	97	
XP_001490814	SLC41A1 [*Equus caballus*]	514	>E-180	96	
XP_613469	SLC41A1 [*Bos taurus*]	514	>E-180	95	
XP_001365656	SLC41A1 [*Monodelphis domestica*]	514	>E-180	93	
XP_417968	SLC41A1 [*Gallus gallus*]	515	>E-180	86	
XP_682785	SLC41A1 [*Danio rerio*]	531	>E-180	80	
CAF96952	SLC41A1 [*Tetraodon nigroviridis*]	557	>E-180	74	
NP_115524	SLC41A2 [*H. sapiens*]	490	2E-172	67	
XP_001509059	SLC41A1 [*Ornithorhynchus anatinus*]	573	4E-172	67	
NP_001086569	SLC41A1 [*Xenopus laevis*]	561	1E-169	65	
EAW97753	SLC41A2 isoform CRA_b [*H. sapiens*]	528	4E-142	58	
XP_394279	SLC41A1 [*Apis mellifera*]	573	1E-130	52	
NP_776290.1	SLC41A isoform 3 [*M. musculus*]	488	5E-124	54	
AAC04427	K07H8.2a [*Caenorhabditis elegans*]	507	3E-104	49	
AAF46385	SLC41A protein isoform D [*D. melanogaster*]	679	1E-96	46	
XP_311188	AGAP000663-PA [*Anopheles gambiae*]	457	2E-93	44	
AAW45812	SLC41A1 [*Cryptococcus neoformans*]	610	5E-41	30	
XP_756366	UM00219.1 [*Ustilago maydis*]	697	3E-31	32	
NP_142650	PH0703 [*Pyrococcus horikoshii* OT3]	397	3E-15	24	
ABN57482	MgtE [*Methanoculleus marisnigri*]	398	7E-14	24	
AAB89753	MgtE [*Archaeoglobus fulgidus*]	336	5E-11	23	
EBK34299	Marine metagenome	341	6E-9	22	
NP_147008	MgtE [*Aeropyrum pernix*]	386	1E-5	22	
YP_001737310	MgtE [*Candidatus Korarchaeum cryptofilum*]	383	1E-3	21	
AAU25018	MgtE [*B. licheniformis*]	372	6E-2	25	
BAA24475	YfhI [*B. subtilis*]	399	6E-2	23	

[a] For most comparisons shown, 'percent identity' is calculated for the full-length of the protein: ≈450 amino acids for bacterial and archaeal MgtE and ≈520 amino acids for SLC41A1. For a few proteins with lower homology, only partial sequences are available, and 'percent identity' refers to identity over the available sequence. Comparison of SLC41A1 with prokaryotic MgtE is over the membrane domain only since SLC41A1 proteins do not have the N and CBS domains.

[b] Function denotes that the protein has been shown to transport Mg^{2+} either by direct transport assay in the Mg^{2+}-transport-deficient strain of *S. typhimurium* or by complementation of that strain for growth without supplemental Mg^{2+}.

[c] From precalculated Blast alignments at http://www.ncbi.nlm.nih.gov/run against the *B. subtilis* MgtE (*ykoK* gene).

[d] From precalculated Blast alignments at http://www.ncbi.nlm.nih.gov/run against the *M. musculus* SLC41A1.

be capable of either Mg^{2+} influx or efflux depending on the specific protein, specific cell type, and any interacting protein partners.

The proposed role of the bound Mg^{2+} ions in the cytosolic domain of MgtE, while reasonable, is currently speculative and needs to be explored by site-directed

mutagenesis and additional structure studies. Further, the movement of the CBS domain versus the N domain over $\approx 120°$ in the Mg^{2+}-free soluble structure seems extremely large. While this could be physiologically relevant, without further data it seems possible that this is a crystallization artifact due to the absence of Mg^{2+} and/or the membrane domain. Further structural studies, perhaps of proteins carrying mutations at the Mg^{2+}-binding sites, will be necessary to answer these and similar questions.

Finally, the physiological role(s) of MgtE are currently ambiguous. Minimal phenotypic data are available on the consequences of mutation or loss of MgtE or SLC41 in any cell system. That these systems are of physiological importance in Mg^{2+} homeostasis in both bacterial and eukaryotic systems is indicated by their regulation. In *B. subtilis*, a Mg^{2+} riboswitch in the 5′ untranslated region of the *mgtE* gene controls expression of MgtE protein, an indication that intracellular Mg^{2+} concentrations control expression of the channel/transporter.[20] Likewise, in mice fed with a low Mg^{2+} diet, SLC41A1 expression is significantly increased in kidney, colon, and heart.[14] That other systems mediating Mg^{2+} flux contribute to Mg^{2+} homeostasis seems almost certain, but the MgtE/SLC41 family appears to have an important role in intracellular Mg^{2+} homeostasis in both Bacteria and eukaryotes.

ACKNOWLEDGEMENTS

The work from the author's laboratory was supported by NIH grant GM39447. The author is grateful to Mr. M. Hattori and Professor O. Nureki for fruitful discussions on MgtE.

REFERENCES

1 MH Saier Jr, *Microbiol Mol Biol Rev*, **64**, 354–411 (2000).

2 RL Smith, LJ Thompson and ME Maguire, *J Bacteriol*, **177**, 1233–38 (1995).

3 DE Townsend, AJ Esenwine, J George III, D Bross, ME Maguire and RL Smith, *J Bacteriol*, **177**, 5350–54 (1995).

4 ME Maguire, *Front Biosci*, **11**, 3149–63 (2006).

5 S Merino, R Gavin, M Altarriba, L Izquierdo, ME Maguire and JM Tomas, *FEMS Microbiol Lett*, **198**, 189–95 (2001).

6 M Hattori, Y Tanaka, S Fukai, R Ishitani and O Nureki, *Nature*, **448**, 1072–75 (2007).

7 PN Brown, CP Hill and DF Blair, *EMBO J*, **21**, 3225–34 (2002).

8 SA Lloyd, FG Whitby, DF Blair and CP Hill, *Nature*, **400**, 472–75 (1999).

9 F Leveille, E Blom, AL Medhurst, P Bier, EH Laghmani, M Johnson, MA Rooimans, A Sobeck, Q Waisfisz, F Arwert, KJ Patel, ME Hoatlin, H Joenje and JP de Winter, *J Biol Chem*, **279**, 39421–30 (2004).

10 P Kowal, AM Gurtan, P Stuckert, AD D'Andrea and T Ellenberger, *J Biol Chem*, **282**, 2047–55 (2007).

11 M Kolisek, P Launay, A Beck, G Sponder, N Serafini, M Brenkus, EM Froschauer, H Martens, A Fleig and M Schweigel, *J Biol Chem*, **283**, 16235–47 (2008).

12 M Hattori, Y Tanaka, S Fukai, R Ishitani and O Nureki, *Acta Crystallogr Sect F Struct Biol Cryst Commun*, **63**, 682–84 (2007).

13 Y Tanaka, M Hattori, S Fukai, R Ishitania and O Nureki, *Acta Crystallogr Sect F Struct Biol Cryst Commun*, **63**, 678–81 (2007).

14 A Goytain and GA Quamme, *Physiol Genomics*, **21**, 337–42 (2005).

15 A Goytain and GA Quamme, *Biochem Biophys Res Commun*, **330**, 701–5 (2005).

16 LM Kucharski, WJ Lubbe and ME Maguire, *J Biol Chem*, **275**, 16767–73 (2000).

17 M Hattori and O Nureki, *Tanpakushitsu Kakusan Koso*, **53**, 242–48 (2008).

18 WL Delano, http://www.pymol.org (2008).

19 MM Gibson, DA Bagga, CG Miller and ME Maguire, *Mol Microbiol*, **5**, 2753–62 (1991).

20 CE Dann III, CA Wakeman, CL Sieling, SC Baker, I Irnov and WC Winkler, *Cell*, **130**, 878–92 (2007).

SODIUM AND POTASSIUM

The sodium potassium ATPase

Maria Nyblom, Jens Preben Morth and Poul Nissen

Center for Membrane Pumps in Cells and Disease – PUMPKIN, Danish National Research Foundation, Department of Molecular Biology, Aarhus University, Denmark

FUNCTIONAL CLASS

Enzyme, E C 3.6.3.9, sodium potassium transporting ATPase (Na^+, K^+-ATPase) belongs to the family of P-type ATPases. This class of proteins recognizes various substrates, from cations to lipids. They share an overall resemblance in topology and general mechanism for energy conversion into substrate transport. The P-type designation refers to the phosphorylation of a highly conserved aspartate residue during the catalytic cycle. At the expense of one adenosine triphosphate (ATP) molecule, the Na^+, K^+-ATPase exports three Na^+-ions from the cytoplasm to the extracellular side of cells, while at the same time it transports two K^+-ions in the opposite direction.

The transport cycle

The transport cycle of the Na^+, K^+-ATPase switches between two principal conformational states, $E1$ and $E2$. The reaction is schematically described by the Post–Albers cycle (Figure 1).[1] In the $E1$ conformation, three cytoplasmic Na^+-ions are allowed to bind. Subsequently, a conserved aspartic acid residue is phosphorylated from bound ATP, upon which the $[Na_3]E1P$ phosphoenzyme complex is formed. In this state, the sodium ions are occluded inside the membrane-spanning region of the protein. Then the enzyme undergoes conformational changes into the $E2P$ state allowing the three Na^+-ions to be released to the extracellular side and giving access for two K^+-ions to bind to the enzyme. At this intermediate energy step, potassium

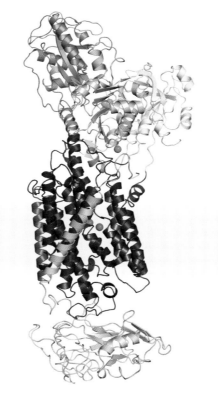

3D Structure Architecture of the α, β, γ-complex of the potassium-occluded $[K_2]E2 \cdot Pi$ form of the Na^+, K^+-ATPase. The catalytic α-subunit is shown in four colors: the intracellular A-, N-, and P-domain are colored yellow, light red, and light blue, respectively, and the transmembrane domain is shown in dark blue (the approximate position of the membrane is indicated in light blue). The β-subunit and the γ-subunit are shown in beige and red, respectively. Two rubidium ions, congeners for potassium ions, and one MgF_4^{2-} molecule (a phosphate analog) are bound to the enzyme and these are shown in magenta and green. PDB entry used in this and all subsequent figures: 3KDP. Present figure and all proceeding structural representations were generated using PyMOL.[58]

Figure 1 The Post–Albers scheme describing the various states the enzyme undergoes during its transport cycle. The dotted arrows show the forward reaction: Briefly, three sodium ions from the cell interior bind to a high-affinity site in the $E1$ state. Ion binding triggers phosphorylation of the enzyme by ATP, generating the phosphorylated $E1P$ state. The phosphorylated $E2P$ state then forms, which has a reduced affinity for the sodium ions allowing them to escape to the extracellular side. Two potassium ions bind from the outside of the cell and, on hydrolysis of the phosphorylated Asp, the enzyme releases the counter ions to the intracellular side and rebinds three sodium ions. The cycle is completed and the enzyme is prepared to recommence the enzymatic reaction. As a net result of this process, an electrochemical gradient is created over the membrane, which supplies energy for secondary transporters as well as maintains the resting potential in cells.

binding stimulates dephosphorylation which is coupled to occlusion. The reaction cycle is completed when the K^+-ions are released to the cytoplasm, stimulated by the binding of ATP.

OCCURRENCE

The P-type ATPases can be found in various membranes of animal, plant, fungal, bacterial, and archaeal cells. The Na^+, K^+-ATPase is specific for animal cells where it generates the electrochemical gradients for the two substrate ions in the plasma membrane. It was originally described in 1957,[2] and is one of the best characterized P-type ATPases. Open reading frames with resemblance to the Na^+, K^+-ATPase have also been found in a few microorganisms.[3]

BIOLOGICAL FUNCTION

The Na^+ and K^+ gradients across the plasma membrane are important for maintaining the resting potential of most animal tissues as well as for electrical excitability of e.g. muscle and nerve cells. The sodium gradient is the primary energy source for secondary transporters that are responsible for cellular uptake of ions, nutrients, neurotransmitters, and intracellular pH. Maintenance of the salt

balance across the plasma membrane is directly involved in the regulation of cell volume and osmolality. The protein has also been implicated to be involved in signal transduction that can stimulate various cellular responses.[4] Na^+, K^+-ATPase activity represents an astonishing 20–30% of total ATP turnover in humans to perform all these tasks.[5]

AMINO ACID SEQUENCE INFORMATION

The P-type ATPases share common sequence characteristics. Their catalytic core (the α-subunit) is divided into four principal domains: Three cytoplasmic segments and one transmembrane (TM) segment (see 3D Structure representation for orientation). The phosphorylation (P) domain is the most preserved among the four principal domains.[6] It contains a conserved motif, DKTGTLT, in which the aspartate (Asp369) is reversibly phosphorylated during the catalytic cycle. Opposed to the P-domain, the actuator (A) domain does not contain any ion or cofactor binding sites, so its role in the transport cycle was not obvious until the first X-ray structures of the family were determined.[7–11] Nevertheless, it contains a small motif, TGE, which is conserved through the P-type ATPases. These residues have been shown to be responsible for dephosphorylation of the aspartate during the reaction cycle.[12,13] The third cytoplasmic domain, the nucleotide binding (N) segment, is a large sequence insert in the P-domain. Its size and

residues vary within the superfamily more than that of the other cytoplasmic domains.[6] The residues Phe475, Lys480, Lys501, Glu216, and Arg544 (pig α1 numbers) in this domain are believed to be responsible for confining the nucleotide and mediating the γ-phosphate to the aspartate. The TM domain of the Na$^+$, K$^+$-ATPase α-subunit is formed by 10 α-helical segments. During the transport cycle, a half channel is formed between helices 1–6, with access to the cytoplasmic side. Upon sodium binding, these helices rearrange for occlusion and reopen to form another half channel with access to the extracellular environment in which the sodium ions are released and potassium ions are taken up. In the fourth helical segment, there is a universally conserved proline, in all P-type ATPases, which breaks the α-helix half way through the membrane where the ions bind. The overall topology of the pump is complex with TM segments 1 through 3 linked to the A-domain and TM segments 4 and 5 linked to the P-domain followed by the TM segments 6 through 10.

The functional pump is a multisubunit complex

The minimal functional unit of the Na$^+$, K$^+$-ATPase consists of two subunits: The α-subunit, which contains the A-, N-, P-, and TM-domains, and the β-subunit, which is important for the stability and trafficking of the pump and unique to the K$^+$-counter-transporting P-type ATPases. The α-subunit has a molecular mass of approximately 112 kDa, and is homologous to single subunit ATPases (such as the sarco(endo)plasmic reticulum Ca^{2+}-ATPase (SERCA)). In contrast, the β-subunit consists of a single TM helix with a large soluble domain on the extracellular side of the membrane, and the molecular weight can vary between 40 and 60 kDA, due to diverse glycosylation in different tissues. This subunit is believed to work as a chaperone, and facilitates the correct packing and membrane distribution of the newly synthesized α-subunit. The relationship between the subunits protects the α-chain against cellular degradation.[14,15] Frequently, the Na$^+$, K$^+$-ATPase also contains a third polypeptide of a protein belonging to the FXYD family (also known as the γ-subunit for the Na$^+$, K$^+$-ATPase). When associated with the $\alpha\beta$-complex, the FXYD subunit regulates the pumping activity in a tissue- and isoform-specific way.[16,17]

Specifically, the recently structurally determined complexes from pig and shark were from the complexes of subunits with sequence entry codes P05024, P05027, and Q58K79 (pig) and Q4H132, C4IX13, and Q70Q12 (shark), respectively (UniProtKB/Swiss-Prot database entries).

Various isoforms

The complexity is further increased by the presence of four different isoforms of the α-subunit (α1, α2, α3, and α4)[18–20]

and three β-isoforms[15] that have been found in humans. The expression of various isoforms is greatly tissue specific. The α1 is ubiquitously expressed[21] and highly abundant in kidney, from which it has been purified in high quantities[22] (also for the recently determined structure[23]). Both α2 and α3 isoforms are found in nervous tissues. However, α3 is mainly expressed in neurons, and therefore most likely plays an important role in neurotransmission.[24,25] The α4 isoform is expressed predominantly in sperm where it contributes to motility of the sperm.[20,26,27] Seven members of the FXYD family have been identified in mammals.[28] These 1-TM proteins are distributed mainly in heart, skeletal muscle, kidney, stomach, and brain, and in these tissues they have been associated with the Na$^+$, K$^+$-ATPase.

PROTEIN PRODUCTION, PURIFICATION, AND MOLECULAR CHARACTERIZATION

Extraction and purification from natural sources

The Na$^+$, K$^+$-ATPase has traditionally been purified from natural sources for molecular characterization, and especially the kidney is very enriched in the α1 isoform. Most of the procedures consist of steps for separation of the plasma membranes from other cell organelles. The membrane is then treated with low levels of the detergent sodium dodecylsulfate (SDS) and ATP at pH 7.5,[22] which removes contaminating proteins while the Na$^+$, K$^+$-ATPase is maintained and protected inside the membrane. Preparative procedures must be carefully monitored by activity assays to maintain the highest possible activity. The presence of ATP in the preparation (or adenosine diphosphate (ADP)) protects the protein and preserves the activity of the pump.[22] The SDS-treated microsome fraction is then subjected to density gradient centrifugation, typically using 10–45% sucrose, and fractions with the highest activity are collected.

Overproduction of the Na$^+$, K$^+$-ATPase

There are several expression systems used for studying the Na$^+$, K$^+$-ATPase. The α,β-complex has been overproduced in *Saccharomyces cerevisiae* foremost to perform functional and biochemical studies on the whole yeast cells or the extracted membranes.[29] Furthermore, the *Xenopus* oocyte system has been extensively used for expression of the pump to investigate its function and regulation.[30] In a more large-scale production of the pump, the methylotropic yeast *Pichia pastoris*, has been very successful in generating active protein.[31,32]

Purification and stability of recombinant protein

It has been shown that the Na$^+$, K$^+$-ATPase has strict demands on the lipid environment and during purification

(of recombinant protein) specific lipids have to be added for the protein to remain active.[32] It appears as if the activity depends not only on which phospholipid that is present but also on what type of ions that are used in the buffer during relipidation. For example, the acid phospholipid dioleoylphosphatidylserine preserves the activity of the enzyme in both a Na^+-containing as well as a K^+ buffer.[32] Furthermore, the type of phospholipid is important as acidic types are required for the pump activity and phosphatidylserine is better than phosphatidylinositol.[33]

Stability properties of recombinant Na^+, K^+-ATPase have also been tested when the third subunit, the regulatory protein FXYD1, has been added to the sample. This subunit associates readily with the α,β-complex and it stabilizes the pump and protects it effectively against thermal inactivation.[34]

Activity assay

There are a range of colorimetric assays for measuring the activity of the P-type ATPases. Typically, these assays estimate the inorganic phosphate that is released during the catalytic cycle. In direct methods, the free phosphate reacts to form a compound that is quantified by absorption. These methods vary in the type of light-absorbing compound that is used. For instance, the Baginski[35] procedure is a highly sensitive and a commonly used assay for membrane-bound Na^+, K^+-ATPase activity measurements. The protocol is one of many that has been modified from the historical Fiske–Subbarow method for measuring inorganic phosphate.[36] In the Baginski assay, free phosphate reacts with ammonium molybdate and a reducing agent (ascorbic acid), which forms a blue measurable color. Another way of measuring the activity of ATPases is the malachite green assay which uses the same principle as Baginsky.[37] However, in indirect procedures, the release of free phosphate is measured by enzyme-coupled reactions that utilize the absorption of NADH.[38] All three above mentioned assays quantify genuine ATP hydrolytic activity, as opposed to the *para*-nitrophenylphosphate (pNPP) assay, which measures the hydrolysis of this compound to *para*-nitrophenol mediated by ATPases.[39] This reaction is believed to mimic the dephosphorylation reaction of the pump (E2P to E2). When raising the pH, the para-nitrophenol deprotonates and forms a quantifiable colorant.

Inhibitors

In the past, many natural products from plants and animals have been used to cure or prevent diseases. A few of them have been shown to be inhibitors of ion transporters, including the P-type ATPases. The group of cardiotonic steroids (cardiac glycosides) are well-known inhibitors of the Na^+, K^+-ATPase and some of these compounds are used in the treatment of congestive heart failure and cardiac arrhythmia. For example, digoxin is a cardiotonic steroid and comes from the flowering plant foxglove (*Digitalis purpurea*),[40] as well as the bufadienolides, which are secreted as toxins from animals such as some toads, snakes, and fireflies.[41] The function of these inhibitors in the treatment of heart failure is to bind to the extracellular side and produce a local increase in intracellular Na^+. This in turn slows down the secondary active transport of Ca^{2+} out of the cell which increases the contractility of the heart muscle. However, there are also endogenous compounds inside the cell that exert the same effect on the Na^+, K^+-ATPase as the cardiotonic steroids,[42] and this indicates that the mechanism of these types of compounds is more complicated.

X-RAY STRUCTURE OF THE SODIUM POTASSIUM ATPASE

The first crystal structure of a P-type ATPase was the SERCA and it was solved in 2000.[7] Since then, numerous structures of this enzyme in several conformations have followed, which has clarified the reaction mechanism of the entire superfamily of P-type ATPases.[9–11,43] When the X-ray structure of the Na^+, K^+-ATPase was solved in 2007,[23] it was the first model of a multisubunit P-type ATPase. The overall topology of the α-subunit of Na^+, K^+-ATPase was demonstrated to be highly similar to SERCA, but the details of the ion-binding sites and the positions of the two extra subunits were not known. Hitherto, there are three structures of the Na^+, K^+-ATPase (one for the pig enzyme and two of protein purified from the shark enzyme) and in all structures MgF_4^{2-} has been bound to the enzyme to achieve what is believed to be the $[K_2]E2 \cdot P_i$ potassium-occluded state[23,44,45]; the step following dephosphorylation in the enzymatic reaction cycle between the nonoccluded K_2E2P and the occluded $[K_2]E2$ state (Figure 1).

Crystallization

The pig Na^+, K^+-ATPase structure was obtained from crystals of octaethyleneglycol mono-n-dodecylether ($C_{12}E_8$) solubilized enzyme. The protein mixture was mixed in a 1:1 ratio with precipitating solution containing 14% polyethylene glycol 2000 monomethyl ether (PEG-2000mme), 200 mM choline chloride, 4 mM dithiothreitol (DTT), 4% glycerol, and 4% 2-methyl-2,4-pentanediol (MPD). In addition, 0.1–0.35% n-dodecyl-β-D-maltoside (β-DDM) was added for crystallization. The initial precipitate was removed by centrifugation and hanging drop experiments were set up. Crystals appeared after 3–4 days at $19\,^{\circ}C$ and they grew to the approximate size of $600 \times 200 \times 50\,\mu m$. The shark enzyme crystals were also obtained from ($C_{12}E_8$) solubilized enzyme. However, this

protein needed the lipid phosphatidylcholine to be added to the solution before crystallization.[44,45] Another difference was that those crystals were obtained following dialysis and took 1–2 months to form.

Crystals of Na+, K+-ATPase

The first model of the Na+, K+-ATPase from pig was determined from crystals with space group symmetry $P2_12_12_1$ and unit-cell dimensions $a = 68.93$ Å, $b = 261.5$ Å, and $c = 333.8$ Å and about 75% solvent, from which 3.5 Å resolution data could be collected (PDB ID 3B8E) (PDB, Protein Data Bank, www.pdb.org).[23] The asymmetric unit of these crystals contained two αβγ complexes. The crystals of the shark enzyme belonged to the C2 space group with unit-cell parameters of $a = 223.8$ Å, $b = 50.9$ Å, $c = 163.8$ Å, and $\beta = 105.1°$ with about 60% solvent.[44] These crystals supported diffraction to 2.4 Å (PDB ID 2ZXE).[44] Crystals obtained in the same way were used to achieve a low-affinity bound state of the Na+, K+-ATPase inhibitor ouabain, by soaking the crystals with the inhibitor prior to flash freezing.

Overall architecture of the α-subunit

The full heteromonomeric αβγ complex has an estimated length of around 160 Å and a width of 80 Å (perpendicular to and in the plane of the membrane, respectively). It is dominated by the α-subunit (of about 1000 residues), which adopts a similar structural organization as SERCA. As expected, the α-subunit comprises of 10 TM α-helices and a large cytoplasmic and relatively compact headpiece, which includes the actuator, the phosphorylation, and the nucleotide binding domains. These main domains are conserved throughout the P-type ATPase family, and deletions and insertions are mainly restricted to the extracellular loops or stretches of residues that connect conserved secondary structures in the cytoplasmic domains.

All three A-, N-, and P-domains are fairly globular. They are arranged in space with the P-domain in the center above the membrane-spanning region and the two other soluble domains flanking on each side (see 3D Structure representation). The spatially well-separated cytoplasmic domains, unrestricted for large conformational changes, are unexpected; both the A- and P-domains are divided up in two parts in the sequence and the N-domain is inserted into the P-domain. Information about the structural rearrangements that take place during the enzymatic cycle is reasonable to deduct from the structural work for SERCA. The nucleotide binding domain (N-domain) recognizes the adenosine moiety of the ATP molecule and upon nucleotide binding the N-domain closes in on the P-domain, and this positions the gamma-phosphate for nucleophilic attack on Asp369 (pig enzyme), which leads to the

intermediate phosphoacyl group. In the *E2* conformation, the actuator domain (A-domain) positions glutamic acid in the TGE-motif to coordinate a water molecule that will perform a nucleophilic attack on the phosphoacyl group, which will lead to dephosphorylation. Albeit well documented from several characterized conformations of SERCA, it is important from a mechanistic point of view to recognize that there is a nearly 30 Å distance between the nucleotide binding site in the N-domain (Lys501) and the phosphorylation site in the P-domain (Asp369), and an even greater distance from Asp369 to the two visualized ion-binding sites in the membrane (about 45 Å) (Figure 2). As a consequence, for phosphorylation of Asp369 to occur in the *E1* state the N-domain must approach the P-domain, as seen in SERCA.[43]

Figure 2 Cartoon emphasizing the spatial distances of the major events during the transport cycle: the phosphorylation/dephosphorylation in the P-domain; the potential ion channel pathways on the cytoplasmic and extracellular side, respectively; and the occluded ions in the active site cavity in the transmembrane domain (the third putative sodium site in white). The potassium and sodium ions are shown in magenta and green, respectively. Furthermore, a third potassium ion weakly bound to Asp740, in the $[K_2]E2 \cdot P_i$ potassium-occluded state, is displayed (the ion indicated by a circle colored magenta; for details see Figure 4). The intracellular side is located on the top and the membrane is shown in faded gray.

The architecture of the TM region of the α-subunit is homologous to the one observed in SERCA. With the exception of TM7–TM10 (TM8 is not even conserved within the members of closely related pumps such as the Na$^+$, K$^+$- and H$^+$, K$^+$-ATPases), the amino acid sequence is well conserved within the P-type ATPase family. The high degree of sequence similarity is especially true for TM4 and TM6, which unwind in the middle of the membrane-spanning region accommodating the ion-binding sites (see details below). The P-domain sequence starts at the C-terminal end of TM4 and ends at the beginning of TM5 that stretches all through the membrane like a spine. This and the complex topology linking TM segments to the cytoplasmic domains explain, in part, how the phosphorylation site at the P-domain is associated with the transport route through the membrane. The TM1–TM3 are sequentially connected with the A-domain and TM1 shows a characteristic 90° kink near the cytoplasmic surface of the membrane, where it comes into contact with TM3 and in this way the energy released from ATP hydrolysis may be transferred to mechanical movement.[23] Residues in TM3 have also been suggested to take part in the cytosolic ion exit/entry pathway.[46] The remaining TM7–TM10 are clustered on one side of the TM1–TM6 core with only small soluble loops on either side of the membrane. Interestingly, these four helices lack counterparts in the bacterial type I P-type ATPases and with the first high-resolution structure of the α,β,γ-complex new functional features for these helices have emerged (see below). In this part of the TM domain, TM7 (relatively unwound) and the cytoplasmic end of TM10 are different from what has been displayed in SERCA.

The β- and γ-subunit

The structure of the Na$^+$, K$^+$-ATPase also visualized, for the first time, the large soluble domain of the β-subunit on the extracellular side of the membrane covering the short loops of the α-subunit. The β-subunit is highly glycosylated and anchored to the membrane through one TM helix that is tilted 32° from the membrane normal, almost parallel to TM7, and in a position adjacent to TM7 and TM10. Indeed, the β-TM hydrogen bonds

Figure 3 Details of the potassium/rubidium ion-binding sites in the transmembrane domain of the alpha subunit. The transmembrane helices involved in the coordination of the ions (TM4–6) are indicated. The residues stabilizing the ions (in magenta) are shown in orange. Ligands (binding distances are indicated in parentheses) for site *one* are side-chain oxygen of Ser775 (3.0 Å), Asn776 (2.8 Å), and Asp804 (2.6 Å), and main-chain carbonyl of Thr772 (3.2 Å). Site *two* is stabilized by four residues (binding distances are indicated in parentheses): side chains of Asn776 (3.0 Å) and Asp804 (3.2 Å), as well as main-chain carbonyls of Val322 (3.0 Å) and Val325 (3.0 Å). Side chain of Glu779 and main chain of Ala323 are slightly too far for binding to the ion in site *two* (binding distances 3.6 Å and 4.0 Å, respectively), but these residues have been shown to contribute to the ion-binding site in the structure of the shark enzyme.[44] (a) View in the plane of the membrane (intracellular side is located on the top). (b) View from the intracellular side.

with these two helices (only at the near cytoplasmic side for TM10) of the α-subunit, primarily between aromatic residues. However, the details on how the extracellular fraction of the β-subunit interacts with the α-subunit were fully resolved in the recent structure of the shark enzyme: a complex saltbridge network that involves residues from the loop between TM7 and TM8.[44]

In the X-ray structure of the pig enzyme, the position of the regulatory γ-subunit could also be identified. This subunit consists of a single TM segment and only a small extracellular N-terminus. The γ-TM is almost perpendicular to the membrane and is nearly exclusively interacting with TM9 from the α-subunit, in a distal arrangement relative to the center of the TM domain.[44] The N-terminus contains the conserved FXYD motif which gives this family of proteins their name. These residues are extended toward the extracellular domain of the β-subunit and form key interactions, with both the α- and β-chains, which could explain the stability effect this subunit has

on the full complex. Taken together, the location of the β- and γ-subunits clarifies the importance of TM7–TM10, which typically are not included in the conserved "core" of the P-type ATPases, but which contain the important C-terminal element of the α-subunit (see below).[23,47]

The details of the two K⁺ sites

The two potassium ion-binding sites, located in the structure (porcine enzyme) by using Rb^+ as a congener for K^+, are positioned between TM helices, TM4, TM5, and TM6, in the α-subunit, with only 4 Å apart (Figure 3). Side chains of Ser775 (TM5), Asn776 (TM5), and Asp804 (TM6), together with contribution from the main-chain of Thr772, are the donating ligands to the ion for binding in site *one*. Site *two* is situated slightly closer to the extracellular side and it involves Asn776, Glu779, and Asp804 as well as three main-chain carbonyls on TM4. It is possible that Glu327 (TM4) does not bind directly

Figure 4 Close view of a third potassium/rubidium ion (shown in magenta) weakly bound at Asp740 (shown in cyan) in the P-domain (light blue) of the $[K_2]E2 \cdot P_i$ potassium-occluded state. Visualized is also the phosphate analog $MgF_4{}^{2-}$ (green), at the phosphorylation site Asp369 (cyan), locking the enzyme in this particulate state and a free Mg^{2+} ion (yellow). Adjacent to the phosphorylation site, Glu214 (cyan) of the TGE-motif in the A-domain (light yellow) is situated, which assists in the dephosphorylation of the aspartate. The intracellular side of the enzyme is up in the figure and part of transmembrane helices TM4 and TM5 are shown in dark blue.

to the second potassium ion, but is rather involved in controlling the extracellular gate (together with Leu97 in TM1); these residues have been biochemically shown to influence the potassium ion-binding on the extracellular side as well as the release to the cytosolic side.[46,48,49] Closer to the cytosolic side, the membrane-spanning helix TM1 makes a 90° bend at the N-terminal part and leans toward TM3, right before Leu97. It is believed that the cytosolic exit pathway for the potassium ions leads past these residues in TM1 and TM3. This kink feature can also be seen in the plant plasma membrane H^+-ATPase[50] and Ca^{2+}-ATPase SERCA suggesting a common structural motif among P-type ATPases. In addition to the two K^+ binding site participating in the actual transport, a third K^+ cytoplasmic site was identified by anomalous difference Fourier map analysis of the structure (Figure 4). Mutational analysis has implicated this site to be involved in activation of dephosphorylation of the enzyme.[51]

Interestingly, almost identical residues as the ones that contribute to the binding of K^+ in Na^+, K^+-ATPase are found at the equivalent positions in SERCA, albeit small differences exist. Furthermore, many of the corresponding amino acids provide oxygen ligands for Ca^{2+} binding in the E1 forms of SERCA. As a consequence, they are also candidates for coordinating two of the three Na^+ in the E1 form of the Na^+, K^+-ATPase. This would mean that there is an overlap in binding of the transported ions between the E1 and the E2 form and this supports the consecutive transport model in which Na^+ is released on the extracellular side in exchange for K^+ that is transported in the opposite way through the same occlusion cavity. The position of binding of the last Na^+ ion is, however, less clear from the $[K_2]E2 \cdot P_i$ models. Nevertheless, mutagenesis and biochemical studies have indicated that residues Tyr771 (TM5),[52] Thr807 (TM6),[53] Gln923 (TM8), and Glu954 (TM9)[54–56] may ligand the ion (Figure 5). Detailed description of this putative site will however have to await further experimental, structural data.

The importance of the C-terminus

In the last 15 residues of the C-terminus, the Na^+, K^+-ATPase has three arginines and two well-conserved sequences, the PGG and KETYY motifs (deletion of the latter reduces the Na^+ affinity[23]). The structure revealed

Figure 5 Arrangement of transmembrane helices (numbering of helices indicated) and residues believed to be involved in the third sodium binding site (highlighted in orange). The two included potassium/rubidium ions (magenta) display the relative position of the third putative sodium ion-binding site (two of the sodium ions are bound at the same position as the potassium ions). The intracellular side of the enzyme is up in the figure.

that this part of the protein, positioned at the end of TM10, makes a 90° turn arranging the stretch of residues at the membrane interface and in close proximity to the intracellular fraction of TM5, the loop between TM8 and TM9, and the ion-binding sites. However, a hypothesis on voltage-sensory function of the arginine cluster in the C-terminal segment[23] has not been verified by mutational studies using electrophysiology.[57] Interestingly, mutations and deletions at the C-terminus have a profound and specific effect on Na$^+$ affinity, which is similar to mutations at the putative third Na$^+$ site. How this communication takes place and relates to a regulatory function of the C-terminus may be revealed from further structural studies, in particular, on mutated forms obtained from suitable overexpression systems.

REFERENCES

1 RL Post, C Hegyvary and S Kume, *J Biol Chem*, **247**(20), 6530–40 (1972).

2 JC Skou, *Biochim Biophys Acta*, **23**(2), 394–401 (1957).

3 B De Hertogh, AC Lantin, PV Baret and A Goffeau, *J Bioenerg Biomembr*, **36**(1), 135–42 (2004).

4 SV Pierre and Z Xie, *Cell Biochem Biophys*, **46**(3), 303–16 (2006).

5 PL Jorgensen, KO Hakansson and SJ Karlish, *Annu Rev Physiol*, **65**, 817–49 (2003).

6 W Kuhlbrandt, *Nat Rev Mol Cell Biol*, **5**(4), 282–95 (2004).

7 C Toyoshima, M Nakasako, H Nomura and H Ogawa, *Nature*, **405**(6787), 647–55 (2000).

8 S Hua, H Ma, D Lewis, G Inesi and C Toyoshima, *Biochemistry*, **41**(7), 2264–72 (2002).

9 C Toyoshima, H Nomura and T Tsuda, *Nature*, **432**(7015), 361–68 (2004).

10 TL Sorensen, JV Moller and P Nissen, *Science*, **304**(5677), 1672–75 (2004).

11 C Olesen, TL Sorensen, RC Nielsen, JV Moller and P Nissen, *Science*, **306**(5705), 2251–55 (2004).

12 F Portillo and R Serrano, *EMBO J*, **7**(6), 1793–98 (1988).

13 DM Clarke, TW Loo and DH MacLennan, *J Biol Chem*, **265**(24), 14088–92 (1990).

14 S Lutsenko and JH Kaplan, *Biochemistry*, **32**(26), 6737–43 (1993).

15 K Geering, *J Bioenerg Biomembr*, **33**(5), 425–38 (2001).

16 AG Therien and R Blostein, *Am J Physiol Cell Physiol*, **279**(3), C541–66 (2000).

17 H Garty and SJ Karlish, *Annu Rev Physiol*, **68**, 431–59 (2006).

18 GE Shull, J Greeb and JB Lingrel, *Biochemistry*, **25**(25), 8125–32 (1986).

19 VL Herrera, JR Emanuel, N Ruiz-Opazo, R Levenson and B Nadal-Ginard, *J Cell Biol*, **105**(4), 1855–65 (1987).

20 OI Shamraj and JB Lingrel, *Proc Natl Acad Sci USA*, **91**(26), 12952–56 (1994).

21 G Blanco and RW Mercer, *Am J Physiol*, **275**(5 Pt 2), F633–50 (1998).

22 PL Jorgensen, *Biochim Biophys Acta*, **356**(1), 36–52 (1974).

23 JP Morth, BP Pedersen, MS Toustrup-Jensen, TL Sorensen, J Petersen, JP Andersen, B Vilsen and P Nissen, *Nature*, **450**(7172), 1043–49 (2007).

24 V Hieber, GJ Siegel, DJ Fink, MW Beaty and M Mata, *Cell Mol Neurobiol*, **11**(2), 253–62 (1991).

25 KM McGrail, JM Phillips and KJ Sweadner, *J Neurosci*, **11**(2), 381–91 (1991).

26 AL Woo, PF James and JB Lingrel, *J Biol Chem*, **275**(27), 20693–99 (2000).

27 AL Woo, PF James and JB Lingrel, *Mol Reprod Dev*, **62**(3), 348–56 (2002).

28 K Geering, *J Bioenerg Biomembr*, **37**(6), 387–92 (2005).

29 B Horowitz, KA Eakle, G Scheiner-Bobis, GR Randolph, CY Chen, RA Hitzeman and RA Farley, *J Biol Chem*, **265**(8), 4189–92 (1990).

30 G Crambert, U Hasler, AT Beggah, C Yu, NN Modyanov, JD Horisberger, L Lelievre and K Geering, *J Biol Chem*, **275**(3), 1976–86 (2000).

31 D Strugatsky, KE Gottschalk, R Goldshleger, E Bibi and SJ Karlish, *J Biol Chem*, **278**(46), 46064–73 (2003).

32 E Cohen, R Goldshleger, A Shainskaya, DM Tal, C Ebel, M le Maire and SJ Karlish, *J Biol Chem*, **280**(17), 16610–18 (2005).

33 H Haviv, E Cohen, Y Lifshitz, DM Tal, R Goldshleger and SJ Karlish, *Biochemistry*, **46**(44), 12855–67 (2007).

34 Y Lifshitz, E Petrovich, H Haviv, R Goldshleger, DM Tal, H Garty and SJ Karlish, *Biochemistry*, **46**(51), 14937–50 (2007).

35 ES Baginski, PP Foa and B Zak, *Clin Chem*, **13**(4), 326–32 (1967).

36 EG Spokas and BW Spur, *Anal Biochem*, **299**(1), 112–16 (2001).

37 PP van Veldhoven and GP Mannaerts, *Anal Biochem*, **161**(1), 45–48 (1987).

38 KW Anderson and AJ Murphy, *J Biol Chem*, **258**(23), 14276–78 (1983).

39 L Beauge, G Berberian and M Campos, *Biochim Biophys Acta*, **773**(1), 157–64 (1984).

40 PJ Hauptman and RA Kelly, *Circulation*, **99**(9), 1265–70 (1999).

41 L Krenn and B Kopp, *Phytochemistry*, **48**(1), 1–29 (1998).

42 JM Hamlyn, MP Blaustein, S Bova, DW DuCharme, DW Harris, F Mandel, WR Mathews and JH Ludens, *Proc Natl Acad Sci USA*, **88**(14), 6259–63 (1991).

43 C Olesen, M Picard, AM Winther, C Gyrup, JP Morth, C Oxvig, JV Moller and P Nissen, *Nature*, **450**(7172), 1036–42 (2007).

44 T Shinoda, H Ogawa, F Cornelius and C Toyoshima, *Nature*, **459**(7245), 446–50 (2009).

45 H Ogawa, T Shinoda, F Cornelius and C Toyoshima, *Proc Natl Acad Sci USA*, **106**(33), 13742–47 (2009).

46 AP Einholm, JP Andersen and B Vilsen, *J Biol Chem*, **282**(33), 23854–66 (2007).

47 MS Toustrup-Jensen, R Holm, AP Einholm, VR Schack, JP Morth, P Nissen, JP Andersen and B Vilsen, *J Biol Chem*, **284**(28), 18715–25 (2009).

48 B Vilsen and JP Andersen, *Biochemistry*, **37**(31), 10961–71 (1998).

49 AP Einholm, M Toustrup-Jensen, JP Andersen and B Vilsen, *Proc Natl Acad Sci USA*, **102**(32), 11254–59 (2005).

50 BP Pedersen, MJ Buch-Pedersen, JP Morth, MG Palmgren and P Nissen, *Nature*, **450**(7172), 1111–14 (2007).

51 VR Schack, JP Morth, MS Toustrup-Jensen, AN Anthonisen, P Nissen, JP Andersen and B Vilsen, *J Biol Chem*, **283**(41), 27982–90 (2008).

52 B Vilsen, D Ramlov and JP Andersen, *Ann N Y Acad Sci*, **834**, 297–309 (1997).

53 B Vilsen, *Biochemistry*, **34**(4), 1455–63 (1995).

54 H Ogawa and C Toyoshima, *Proc Natl Acad Sci USA*, **99**(25), 15977–82 (2002).

55 C Li, O Capendeguy, K Geering and JD Horisberger, *Proc Natl Acad Sci USA*, **102**(36), 12706–11 (2005).

56 T Imagawa, T Yamamoto, S Kaya, K Sakaguchi and K Taniguchi, *J Biol Chem*, **280**(19), 18736–44 (2005).

57 JP Morth, H Poulsen, MS Toustrup-Jensen, VR Schack, J Egebjerg, JP Andersen, B Vilsen and P Nissen, *Philos Trans R Soc Lond B Biol Sci*, **364**(1514), 217–27 (2009).

58 WL DeLano, *The PyMOL Molecular Graphics System*, DeLano Scientific, Palo Alto, CA, (2002), http://www.pymol.org.

Potassium channels

Michael J Lenaeus and Adrian Gross

Department of Molecular Pharmacology and Biological Chemistry, Northwestern University Medical School,
303 East Chicago Avenue, Chicago, IL 60611, USA

FUNCTIONAL CLASS

Potassium channels are unusual metalloproteins. They are not enzymes in the traditional sense of the word and are not captured in the EC classification scheme. Their primary function is to allow for the movement of potassium ions across the cell membrane.[1] The ion movement is passive and its net direction depends on the electrochemical gradient of potassium across the membrane. Potassium channels accomplish their physiological role(s) by combining two notable functional properties: exquisite selectivity for potassium over other cations (specifically sodium) and extremely high potassium ion throughput. These seemingly contradictory properties are made possible by the unique structure of the selectivity filter of the channel.[2]

OCCURRENCE

Potassium channels are ubiquitous in nature and are thought to be essential to life. Potassium channels are the phylogenetic founders of a superfamily of structurally related ion channels that include sodium and calcium channels, nucleotide-gated ion channels, and glutamate receptors (glutamate-gated ion channels). At the cellular level, potassium channels are located in the cell membrane.

BIOLOGICAL FUNCTION

Potassium channels are membrane proteins that lower the energy barrier for potassium ions to move across membranes.[1] As potassium ions move through the channel, positive charge is transferred from the high potassium side of the membrane (inside) to the low potassium side (outside). Each moving ion changes the membrane potential in the direction of the potassium equilibrium potential (about $-100\,mV$, inside negative). However, the equilibrium potential is never reached because of the presence of additional ion permeabilities in the cell membrane that depolarize (reduce) the membrane potential. In most cells, the membrane potential settles near $-70\,mV$; this is called *resting potential of the cell membrane*. At this potential, the influx and the outflux of ions are balanced and the number of ions moving across the membrane at any given time is very small. Excitable cells have additional depolarizing channels, notably voltage-dependent sodium channels, that can trigger the opening of additional voltage-gated potassium channels. This leads to an increased potassium efflux from the cell, which brings the membrane potential back to its resting range. The gate to the ion pathway can also be regulated by a number of voltage-independent means, including ligand-dependent mechanisms that allow cells

(a) (b)

3D Structure Schematic representation of the potassium channel pore domain. The pore domain is a homotetramer assembled from four identical subunits and arranged around a central fourfold symmetry axis. (a) Top view and (b) side view. The gray spheres are potassium ions. PDB code: 1K4C. This figure was made using the program WebLab ViewerPro.

to couple potassium flux to a variety of biochemical signals.[1] Given this very general and central role, it is not surprising that potassium channels are involved in numerous physiologically important functions, including muscle contraction, secretion, and signal transduction. Potassium channels are also increasingly being recognized as important drug targets.[3]

AMINO ACID SEQUENCE INFORMATION

The amino acid (AA) sequences of many potassium channels are known. The presence of the short-sequence TVGYG, called the *signature sequence*, is so characteristic of these proteins that its presence is sufficient to designate an unknown protein sequence as a putative potassium channel. The following list highlights a few potassium channels that are of particular historical, functional, or structural importance (the first two sequences are from EMBL-Bank and the others from UniProtKB data bases).

- *Loligo opalescens* (squid), SkKv1A, 488 AA residues, translation of mRNA (AAB02884).[4]
- *Drosophila melanogaster* (fruit fly), Shaker, 656 AA, translation of mRNA (CAA29917).[5]

- *Streptomyces lividans*, KcsA, 160 AA, translation of genomic DNA (P0A334).[6]
- *Aeropyrum pernix*, KvAP, 295 AA, translation of genomic DNA (Q9YDF8).[7]
- *Rattus norvegicus*, Kv1.2, 499 AA, translation of cDNA (P19024).[8]
- *Methanothermobacter thermautotrophicus*, MthK, 336 AA, translation of genomic DNA (O27564).[9]
- *Homo sapiens*, hERG, 1159 AA, translation of genomic DNA (Q12809).[10]

RELATIONSHIPS

The minimal structural unit necessary to achieve selective potassium movement across the cell membrane is the potassium channel pore domain, a tetrameric protein assembly of ~20 kDa size (3D Structure). The structure of the pore domain and of the signature sequence are highly conserved, indicating that all potassium channels achieve permeation through the same basic mechanism.[2,11–15]

Potassium channels are the phylogenetic founders of a large superfamily of structurally related ion channels (Figure 1). These proteins share a common tetrameric architecture with a central ion conduction pathway. It is

Figure 1 Phylogenetic relationships between different ion channels. The potassium channel pore domain is shown as a dark gray box. It corresponds to the structure of the KcsA potassium channel. Recruitment of additional gating domains leads to functionally distinct channels. The voltage-sensing domain is shown as a light gray box. Ligand binding domains are shown as intracellular and extracellular additions. The concatenation of subunits allows for the breaking of fourfold symmetry. Only a subset of the phylogenetic family is shown.

thought that the selectivity filters of these related proteins are tuned for the respective ionic species.

Gating domains, such as those required to impart voltage- or ligand-dependent gating, are thought to represent evolutionarily separate domains that have been recruited by the pore domain.[9,16]

PROTEIN PRODUCTION AND PURIFICATION

Potassium channels are found only in small numbers in native membranes. The lack of an abundant natural source of native protein and the initially limited success of heterologous overexpression of eukaryotic channels made biochemical and structural studies very difficult. The discovery of potassium channels in bacteria and their successful overexpression were instrumental for the many recent biochemical and structural advances of the field.[6] The expression and purification of bacterial potassium channels follow well-established techniques for heterologous overexpression in *Escherichia coli* and tag-based affinity chromatography. As is typical for membrane proteins, the channel is first removed from the membrane by detergent solubilization and detergent must be maintained throughout purification and crystallization in order to preserve the structural integrity of the channel. Recent progress has extended high-level overexpression to some eukaryotic channels in yeast.[17]

METAL CONTENT

Potassium channels bind potassium ions at or near the selectivity filter (Figure 2). It is a fundamental property of the channel that there are more potential binding sites than bound ions,[14] as strong mutual repulsion between ions prevents the simultaneous filling of all sites. As potassium ions travel through the channel, they are progressively dehydrated before they enter the selectivity filter and then subsequently rehydrated when they leave the filter. The channel, thus, binds potassium ions of different hydration states at different locations along the permeation pathway.[2] Fully hydrated potassium ions bind at the two entrances to the selectivity filter, that is, in the external vestibule above the filter and in the water-filled cavity below it. Closer to the selectivity filter, these hydrated ions are first partially dehydrated at the transition sites and then fully dehydrated as they enter the selectivity filter proper and bind at the first of the four internal sites. The number of ions inside the filter is concentration dependent and increases with the increase in potassium concentration.[2,12,14] At low potassium concentrations, a single ion is thought to be bound to the filter and shared equally between two of the four potassium binding sites within the filter. This state of the filter is thought to be nonconductive.[2] As

Figure 2 Potassium binding sites near the selectivity filter. The selectivity filter of two opposing subunits is shown in stick representation. Carbon, nitrogen, and oxygen atoms are represented in gray, blue, and red, respectively. Potassium ions are shown as green spheres. There are four binding sites inside the filter and two additional binding sites on either side of the filter. This figure was made using the program WebLab ViewerPro.

the potassium concentration is raised, a second ion enters the filter and the two ions are shared equally between all four binding sites. This doubly occupied filter structure is thought to represent the conductive state of the filter.[2] The conformational change between a closed, singly occupied state and an open, doubly occupied state is believed to be an essential property of the selectivity filter. The work required to move the selectivity filter from the closed to the open state reduces the effective ion binding affinity of the selectivity filer, thus allowing an ion to bind with large specificity but fairly low affinity.[14] This property, together with the mutual repulsion between the two bound ions, is instrumental to achieving high permeation rates through the channel. The same property is also important for gating of the channel (see below).

ACTIVITY AND INHIBITION TESTS

The activity of potassium channels is typically determined in electrophysiology experiments as a current flowing across the membrane. Such experiments have traditionally been done under voltage-clamp conditions that allow the precise control of membrane potential and, thereby, the opening and closing of voltage-dependent potassium channels.[1]

Under this scenario, the behavior of a channel or current is investigated by altering the membrane potential and observing the potassium current that results. It is also possible to record ion flow through a single channel in real time[18] and to determine the activity of potassium channels by using ion flux assays that incorporate radioactive tracer ions.[19]

Potassium channels can be blocked by ions that bind at potassium binding sites, but do not themselves permeate the channel as effectively as does potassium. Barium, sodium, and tetraethylammonium (TEA) are classic examples of blockers that act in this manner.[1] The three blockers bind at different potassium binding sites and, thus, generate functionally distinct blockades. Barium is a divalent potassium analog that binds more tightly to the selectivity filter than potassium, thus preventing potassium from permeating in either direction.[20–22] Sodium blockade is typically observed when a sodium ion enters the channel from the inside solution and binds to a nonselective site in the cavity.[23,24] Since sodium can leave the channel only toward the inside, it prevents the outward, but not inward, flow of potassium through the channel. TEA acts as an analog to potassium at the dehydration transition step and binds tightly to the transition sites located on either side of the selectivity filter.[25–27] In addition, potassium channels are targeted by toxins produced by a number of venomous animals.[28] These toxins are typically small proteins that recognize functionally critical parts of the channel.

X-RAY STRUCTURE OF KCSA AND OTHER CHANNELS

Crystallization

The first high-resolution structure of a potassium channel was determined in the laboratory of Roderick MacKinnon.[11] The crystals of the N-terminal portion of the prokaryotic potassium channel KcsA (K channel from Streptomyces lividans) were grown in the presence of lauryldimethylamine-oxide (LDAO) with polyethylene glycol 400 (PEG400) as the precipitant. The KcsA potassium channel structure comprises the pore domain of the channel (3D Structure). The crystals were monoclinic, space group C2, with $a = 128.8$ Å, $b = 68.9$ Å, $c = 112.0$ Å, $\beta = 124.6°$, and two channels per asymmetric unit. The crystals diffracted X-rays anisotropically to between 2.5 and 3.5 Å Bragg spacings. The structure was solved through multiple isomorphus replacement with mercury binding to cysteine residues introduced by mutagenesis and was refined with data to 3.2 Å. The structure showed the presence of three ions in single file bound to the selectivity filter. A second, higher resolution, crystal form was obtained a few years later with the use of a Fab fragment raised against the KcsA channel.[2] The Fab–KcsA complex crystallized in the presence of decylmaltoside (DM) with PEG400 as the precipitant. The crystals were of the tetragonal space group I4, with one KcsA subunit–Fab complex per asymmetric unit. The structure was refined to 2.0 Å resolution. This crystal form can be grown at different concentrations of potassium. The high potassium form showed seven partially occupied potassium binding sites arranged in single file ($a = b = 155.3$ Å and $c = 76.3$ Å), whereas the low potassium form showed only three ion binding sites in single file, of which two appeared to be occupied by potassium ($a = b = 155.3$ Å and $c = 75.7$ Å).

Recently, a number of lines of evidence have suggested that portions of voltage-dependent potassium channel structures may be distorted by detergent solubilization and there has been a suggestion that these more complex potassium channels be crystallized in the presence of lipids or lipidlike detergents.[29,30] The pore domain, however, seems to be unaffected by detergent solubilization and its overall structure has been highly reproducible both across evolutionary distant origin and distinct crystallization conditions.

Overall description of the pore domain structure

The four subunits of the potassium channel pore are arranged around a central symmetry axis that coincides with the pathway of the channel. The dimensions of the pore are roughly $40 \times 40 \times 60$ Å (3D structure). Each KcsA subunit forms two transmembrane helices and a pore helix and consists of approximately 100 residues. The eight transmembrane helices of the channel shield a central aqueous pathway from the surrounding hydrophobic membrane environment. The overall architecture of the transmembrane helices has been likened to an upside-down teepee.[11] The selectivity filter is placed in the wide upper part of the teepee and consists of a unique structure built from the signature sequences (TVGYG) and the pore helices of the four subunits. The width of the aqueous pathway changes substantially along the channel. The pathway is very narrow at the level of the selectivity filter and widens substantially in the middle (the cavity), before narrowing again on the inside of the channel.

Conformational changes

The channel undergoes two conformational changes during gating: one related to intracellular potassium gaining access to the cavity and the other related to potassium flux through the selectivity filter proper. Structures of different channels [KcsA (closed), MthK (open), KvAP (open), and Kv1.2 (open),[2,9,11,31,32]] believed to represent different gating states suggest that the first gating transition occurs at the lower isthmus of the conduction pore below the cavity (Figure 3). In the closed state, the inner helices are straight

Figure 3 Conformational changes during gating as derived from structures of different potassium channels. Sketch of the potassium pore domain depicting two of the four subunits. The inner helices and the selectivity filter are highlighted. The ion pathway can be closed at two levels: at the level of the selectivity filter and at the level of the helix bundle. Green indicates an open structure and red a closed structure. The MthK structure is thought to be conducting, and the KcsA structures are closed. The black circles in MthK refer to conserved glycine residues that may act as hinges during gating.

and constrict the ion pathway to a width smaller than the size of a hydrated potassium ion, thus preventing potassium from entering the cavity. Upon opening of the channel, the inner helices break at a well-conserved glycine residue acting as a hinge and splay open sideways. This conformational change opens the cavity to the inside solution and allows the entry of hydrated potassium ions and their eventual passage through the selectivity filter. It is believed that this opening mechanism is conserved in all potassium and related ion channels.[31,33] Gating modifiers such as voltage sensors and ligand binding domains act by changing the relative stability of the two gating states in response to cellular stimuli.

The second conformational change of the channel occurs at the level of the selectivity filter. This change has been linked to the process of slow (or C-type) inactivation, a mechanism of channel closure that can occur even when the activation gate on the inside of the channel remains open.[34–36] Two structures of KcsA observed at different potassium concentrations (150 vs 20 mM K) are thought to approximate the two main structures that the selectivity filter can adopt during function.[2] The development of the low potassium structure has been linked to the breaking of a conserved hydrogen bond network centered around an interaction between Glu71 and Asp80.[37] Since one of

the two structures is nonconductive, transitions between them can present themselves functionally as gating events, though the significance of this structural transition for gating remains controversial.

Potassium site geometries

High-resolution structures of KcsA have shown that the structure of the selectivity filter consists of four extended strands of the sequence TVGYG with the carbonyl oxygen atoms of the main chain facing inward. This fourfold symmetric assembly generates a regular array of stacked oxygen ligands with each level consisting of four ligands distributed on the edges of a square.[2,12] Potassium ions bind between two stacks of ligands in a dehydrated state and are surrounded by eight oxygen atoms from the protein that have been prepositioned to select for potassium over sodium or other cations. The selectivity filter consists of four very similar such binding sites (usually numbered 1–4). The innermost site deviates from the above architecture because it is formed by four carbonyl atoms and four threonine side-chain oxygen atoms. The geometry of the ion coordination at all sites is that of a double prism with four oxygen atoms above the ion and four below it. This geometry is similar to that found in the potassium-selective antibiotic nonactin.[38]

Structures in the presence of channel blockers

Barium is a divalent potassium analog and binds preferentially at the innermost selective potassium site within the selectivity filter.[22] Because its off-rate from the site is very slow, barium acts as a blocker of potassium permeation. Quaternary ammonium compounds (QAs) represent the most extensively studied group of potassium channel blockers. QAs bind selectively to either side of the ion pore by mimicking a partially dehydrated potassium ion that cannot permeate. Several structures of KcsA in complex with QAs have been determined.[25–27,39] The structures show that QAs act as potassium analogs at the dehydration transition step during permeation.[25]

FUNCTIONAL ASPECTS

The mechanism of potassium permeation must allow for the fulfillment of the two key attributes of potassium permeation: high potassium selectivity and a nearly diffusion-limited rate of ion permeation. To simultaneously achieve these seemingly contradictory properties, the channel must (i) overcome the high energy of transition of an ion moving from the solution into a membrane environment, (ii) select for potassium over sodium and other competing ions, and (iii) bind potassium with an affinity low enough to allow rapid permeation.

The energetic cost of potassium entering the membrane environment is overcome mainly by the creation of an aqueous cavity in the middle of the lipid bilayer, allowing hydrated ions to be stabilized in what would otherwise be a very low dielectric environment.[11] Furthermore, the channel stabilizes cations in the bilayer by orienting the four pore helices with their amino terminal ends pointed toward the cavity and, thereby, imposing a negative electrostatic potential that attracts and stabilizes cations in the cavity.[11,40] The combination of these two effects generates a favorable ion binding site in the cavity and compresses the membrane electric field from ~30 Å (width of the membrane) to ~10 Å (width of the selectivity filter).

High selectivity is accomplished by the prepositioning of carbonyl and/or hydroxyl oxygen atoms in the selectivity filter.[2,12,15] This mechanism allows for about 1000-fold selection of potassium over sodium.[1] There is an additional selection mechanism operating in the cavity itself, but its selectivity is orders of magnitude lower than the process that occurs in the selectivity filter.[23,24]

Rapid permeation is thought to occur through a combination of factors. First, the AA composition of the pore domain generates a negative surface potential at the channel entryway, promoting a local increase in the cation concentration.[11] Second, transit time is reduced by the inert hydrophobic lining of the pore between the internal vestibule and the selectivity filter.[11] Third, the two proposed permeation states of the filter (see below) are energetically well balanced in the case of potassium, maximizing permeation.[12] Fourth, the transition rate is increased by the electrostatic repulsion between potassium ions and by the energetic cost of maintaining the high potassium state of the selectivity filter.[13,14] The combination of these

factors permits potassium permeation rates close to the diffusion limit.

The leading permeation model[12,13] assumes that the selectivity filter shuttles between two energetically equivalent states, the 1–3 and 2–4 states (Figure 4). An ion's transit through the selectivity filter begins with its passage from the cavity site to the dehydration transition site located below the selectivity filter (i.e., the binding site of tetrabutylammonium (TBA) site). The ion is then dehydrated by the channel machinery and enters the filter by binding at the fourth site and 'pushing' an ion/water queue toward the extracellular surface *via* electrostatic repulsion. This transition allows the development of the 2–4 state and subsequent entry of new potassium ions or water molecules will bring about the 1–3 state, the 2–4 state, the 1–3 state, and so on.[41] In each of two states, the selectively filter binds the same queued series of ions and water molecules, but the queue is shifted by one position. This process can be interrupted by cessation of ion flow (i.e., closing of the intracellular gate or block) or by a conformational change in the selectivity filter (i.e., breaking of the Glu71-Asp80 hydrogen bond network and subsequent development of a low potassium state). The movement of ions is entirely passive and can occur in both directions depending on the relative local potassium concentrations and the direction of the electric field.

ACKNOWLEDGEMENTS

This work was supported by NIH grant GM58568 to A.G.

REFERENCES

1 B Hille, *Ion Channels of Excitable Membranes*, Sinauer, Sunderland (2001).

2 Y Zhou, JH Morais-Cabral, A Kaufman and R MacKinnon, *Nature*, **414**, 43–48 (2001).

3 JW Ford, EB Stevens, JM Treherne, J Packer and M Bushfield, *Prog Drug Res*, **58**, 133–68 (2002).

4 JJ Rosenthal, RG Vickery and WF Gilly, *J Gen Physiol*, **108**, 207–19 (1996).

5 TL Schwarz, BL Tempel, DM Papazian, YN Jan and LY Jan, *Nature*, **331**, 137–42 (1988).

6 H Schrempf, O Schmidt, R Kummerlen, S Hinnah, D Muller, M Betzler, T Steinkamp and R Wagner, *Embo J*, **14**, 5170–78 (1995).

7 V Ruta, Y Jiang, A Lee, J Chen and R MacKinnon, *Nature*, **422**, 180–85 (2003).

8 D McKinnon, *J Biol Chem*, **264**, 8230–36 (1989).

9 Y Jiang, A Lee, J Chen, M Cadene, BT Chait and R MacKinnon, *Nature*, **417**, 515–22 (2002).

10 T Itoh, T Tanaka, R Nagai, T Kamiya, T Sawayama, T Nakayama, H Tomoike, H Sakurada, Y Yazaki and Y Nakamura, *Hum Genet*, **102**, 435–39 (1998).

11 DA Doyle, JM Cabral, RA Pfuetzner, A Kuo, JM Gulbis, SL Cohen, BT Chait and R MacKinnon, *Science*, **280**, 69–77 (1998).

Figure 4 Two-state model of ion permeation. The selectivity filter is shown schematically with ions numbered 1–4. The schematic shows the different hydration states of potassium ions along the permeation pathway. Oxygen ligands are indicated by red crosses (water) or circles (carbonyl or hydroxyl). The two states of the selectivity filter (1/3 and 2/4) are occupied alternatively during permeation. A dehydration transition site for potassium is observed experimentally on the outside of the channel, but not on the inside.

12 JH Morais-Cabral, Y Zhou and R MacKinnon, *Nature*, **414**, 37–42 (2001).

13 S Berneche and B Roux, *Nature*, **414**, 73–77 (2001).

14 Y Zhou and R MacKinnon, *J Mol Biol*, **333**, 965–75 (2003).

15 SY Noskov, S Berneche and B Roux, *Nature*, **431**, 830–34 (2004).

16 Y Murata, H Iwasaki, M Sasaki, K Inaba and Y Okamura, *Nature*, **435**, 1239–43 (2005).

17 DN Parcej and L Eckhardt-Strelau, *J Mol Biol*, **333**, 103–16 (2003).

18 OP Hamill, A Marty, E Neher, B Sakmann and FJ Sigworth, *Pflugers Arch*, **391**, 85–100 (1981).

19 L Heginbotham, L Kolmakova-Partensky and C Miller, *J Gen Physiol*, **111**, 741–49 (1998).

20 J Neyton and C Miller, *J Gen Physiol*, **92**, 569–86 (1988).

21 J Neyton and C Miller, *J Gen Physiol*, **92**, 549–67 (1988).

22 Y Jiang and R MacKinnon, *J Gen Physiol*, **115**, 269–72 (2000).

23 CM Nimigean and C Miller, *J Gen Physiol*, **120**, 323–35 (2002).

24 Y Zhou and R MacKinnon, *Biochemistry*, **43**, 4978–82 (2004).

25 MJ Lenaeus, M Vamvouka, PJ Focia and A Gross, *Nat Struct Mol Biol*, **12**, 454–59 (2005).

26 S Yohannan, Y Hu and Y Zhou, *J Mol Biol*, **366**, 806–14 (2007).

27 JD Faraldo-Gomez, E Kutluay, V Jogini, Y Zhao, L Heginbotham and B Roux, *J Mol Biol*, **365**, 649–62 (2007).

28 S Mouhat, N Andreotti, B Jouirou and JM Sabatier, *Curr Pharm Des*, **14**, 2503–18 (2008).

29 SY Lee, A Lee, J Chen and R MacKinnon, *Proc Natl Acad Sci U S A*, **102**, 15441–446 (2005).

30 SB Long, X Tao, EB Campbell and R MacKinnon, *Nature*, **450**, 376–82 (2007).

31 Y Jiang, A Lee, J Chen, V Ruta, M Cadene, BT Chait and R MacKinnon, *Nature*, **423**, 33–41 (2003).

32 SB Long, EB Campbell and R MacKinnon, *Science*, **309**, 897–903 (2005).

33 Y Jiang, V Ruta, J Chen, A Lee and R MacKinnon, *Nature*, **423**, 42–48 (2003).

34 S Grissmer and M Cahalan, *Biophys J*, **55**, 203–6 (1989).

35 KL Choi, RW Aldrich and G Yellen, *Proc Natl Acad Sci U S A*, **88**, 5092–95 (1991).

36 S Berneche and B Roux, *Structure*, **13**, 591–600 (2005).

37 JF Cordero-Morales, V Jogini, A Lewis, V Vasquez, DM Cortes, B Roux and E Perozo, *Nat Struct Mol Biol*, **14**, 1062–69 (2007).

38 M Dobler, JD Dunitz and BT Kilbourn, *Helv Chim Acta*, **52**, 2573–83 (1969).

39 M Zhou, JH Morais-Cabral, S Mann and R MacKinnon, *Nature*, **411**, 657–61 (2001).

40 B Roux and R MacKinnon, *Science*, **285**, 100–102 (1999).

41 S Berneche and B Roux, *Proc Natl Acad Sci U S A*, **100**, 8644–48 (2003).

The nucleobase-cation-symport-1 family of membrane transport proteins

Simone Weyand[†], Pikyee Ma[‡], Massoud Saidijam[‡§], Jocelyn Baldwin[‡], Oliver Beckstein[§§], Scott Jackson[‡], Shun'ichi Suzuki[‡¶], Simon G Patching[‡], Tatsuro Shimamura[†], Mark SP Sansom[§§], So Iwata[†], Alexander D Cameron[†], Stephen A Baldwin[‡] and Peter JF Henderson[‡]

[†] Biochemistry Department, South Kensington Campus, Imperial College London University, London SW7 2AZ, UK
[‡] Astbury Centre for Structural Molecular Biology, Institute of Membrane and Systems Biology, University of Leeds, Leeds LS2 9JT, UK
[§] School of Medicine, Hamedan University of Medical Sciences, Hamedan, Iran
[§§] Structural Bioinformatics and Computational Biochemistry Unit, Department of Biochemistry, University of Oxford, South Parks Road, Oxford OX13QU, UK
[¶] Ajinomoto Co. Inc., Kawasaki-ku, Kawasaki, Kanagawa 2108681, Japan

FUNCTIONAL CLASS

The nucleobase-cation-symport-1 (NCS-1) family of membrane transport proteins consists of over 1000 homologous proteins derived from gram-negative and gram-positive bacteria, archaea, yeasts, fungi, and plants.[1,2]

3D Structure Schematic representation of the structure of the Mhp1 hydantoin transport protein from *Microbacterium liquefaciens*.[4] (a) The Mhp1 structure is viewed in the plane of the membrane. The figure is based on the high-resolution structure of the Mhp1 without benzyl hydantoin. The proposed position of the substrate in the Mhp1-benzyl hydantoin complex structure is shown as a reference. A sodium ion is also shown as a blue sphere. (b) View from the 'OUT' side of the membrane. Reproduced by permission of the American Association for the Advancement of Science. The programs used to make these and all the structural figures are described in references [4,5] and their supplementary information. (*continued overleaf*)

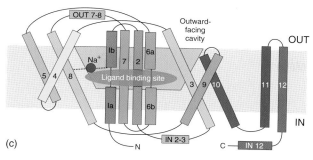

(c)

3D Structure (*continued*) (c) Mhp1 topology. The positions of the substrate and the cation binding sites are depicted as a brown ellipsoid and blue circle, respectively. The membrane is shown in gray and the outward-facing cavity observed in the structure is highlighted in light blue. The horizontal helices on the 'IN' and 'OUT' sides of membrane are indicated as 'IN' and 'OUT'. TMs 3 and 8 are packed onto each other in three-dimensional space.

INTRODUCTION

Until now, membrane transport proteins have been classified into families and superfamilies according to their functions and statistically determined similarities of their amino acid sequences.[1–3] The transport classification (TC) database,[1,2] [TCDB is the classification system approved by the International Union of Biochemistry and Molecular Biology (IUBMB) analogous to the Enzyme Commission (EC) classification of enzymes], puts sodium- or proton-linked transporters of nucleobases, nucleosides, allantoin derivatives, and vitamins in the NCS-1 family. The NCS-1 family is categorized as 2.A.39, i.e. the functional Class 2, 'electrochemical potential-driven transporters'; group A 'porters (uniporters, symporters, antiporters)'; subfamily number 39. Within this family are evolutionary clusters, further classified according to the similarities of their amino acid sequences. The Microbacterium hydantoin permease, 'Mhp1', the only member of the NCS-1 family for which the structure has been determined,[4–6] belongs to cluster 3 and is so designated 2.A.39.3.5.

However, despite the classification system, recent crystal structures of secondary active membrane transport proteins, thought to be unrelated because of the diversity of their amino acid sequences, unexpectedly reveal a similar protein fold.[7–12] The nucleobase-cation-symporter (NCS-1) family must therefore be regarded as related to the 'neurotransmitter:sodium-symporter family' (NSS, 2.A.22), the 'solute:sodium-symporter family' (SSS, 2.A.21), the 'betaine–carnitine–choline' family (BCCT, 2.A.15), and the 'amino acid–polyamine–organocation' family (APC, 2.A.3), with the probability of more such structural similarities being uncovered.[13–16] All the proteins in all of these families are now informally known as the *LeuT superfamily*, in recognition of the first paradigm structure determined by Gouaux and colleagues.[7]

The NCS-1 family should therefore be regarded as part of a much larger group of membrane transport proteins. A number of these, including Mhp1, couple movement of Na$^+$ to movement of the organic solute, and hence a metal is involved in the transport function.

OCCURRENCE

Members of the NCS-1 family are widely distributed in eubacteria and fungi (Figure 1).[2,3,16,17] Genes encoding family members have also been identified in green plants and archaea[2,3] (Figure 1), although no functional characterization of such proteins has yet been reported. Unlike the distantly related NCS-2 family, no NCS-1 family transporters have yet been identified in metazoans.

BIOLOGICAL FUNCTION

The generalized transport reaction (Figure 2) catalyzed by transport proteins of the NCS-1 family is[1]

Nucleobase or vitamin (out) + cation (out)

→ Nucleobase or vitamin (in) + cation (in)

The cations have so far been identified as Na$^+$ or H$^+$ (Figure 2). Mhp1 is sodium containing but other members appear to work with protons. The organic substrates are generally involved in salvage pathways for nucleobases and capture of related compounds like vitamins. Examples include aromatic hydantoins, allantoin, cytosine, uridine, nicotinamide, and thiamine (Figure 3).

The physiological role of the NCS-1 family appears to be in the uptake of small molecules either as an energy source or for supply of cofactors and biosynthetic precursors. Several members of the NCS-1 family from bacteria[2,3] and from fungi[16,17] have been functionally characterized, revealing that the family as a whole exhibits diverse permeant selectivity. In the bacteria, the best-characterized family member, Mhp1 from *Microbacterium liquefaciens*, is a hydantoin transporter, with a preference for permeants with a hydrophobic substituent at position 5

Figure 1 Unrooted phylogenetic tree illustrating relationships between selected NCS-1 family members from eubacteria (black), archaea (red), green plants (green), and fungi (blue). Transporters that have been functionally characterized are indicated by the names used in the literature, followed by species designation (Sc, *Saccharomyces cerevisiae*; Sp, *Schizosaccharomyces pombe*; Ca, *Candida albicans*; An, *Aspergillus nidulans*; Ec, *Escherichia coli*; Ml, *Microbacterium liquefaciens*) and are boxed. Other putative transporters are indicated by their UniProt accession numbers. The alignment was made using Clustal X[18] and then manually adjusted using BioEdit,[19] and the phylogenetic tree was created using the neighbor-joining method.[20]

of the hydantoin such as 5-indolyl methyl hydantoin (IMH) and 5-benzyl hydantoin (BH), and a selectivity for the L-isomer over the D-isomer.[6] Other characterized bacterial NCS-1 family members are the transporters for allantoin in *Bacillus subtilis* (designated PucI)[21] and for cytosine in *Escherichia coli* (designated CodB[22]); neither allantoin nor cytosine (Figure 3) is a substrate for Mhp1. The active transport of the permeants by the NCS-1 family is driven by the transmembrane cation gradient of Na$^+$ or H$^+$, with a stoichiometry that probably varies with individual proteins, depending upon the presence or absence of positive or negative charges in the organic substrate.[13,14] However, the molecular mechanism by which transport is energized in these proteins remains to be determined (see below).

In fungi, members of the NCS-1 family have variously been identified as transporters of nucleobases, nucleosides, coenzymes, and vitamins; the designated phenotype names containing three letters and a number[17] are used in the following summary of their activities. Phylogenetically, they fall into two distinct subfamilies (Figure 1). One subfamily is typified by the well-characterized transporter Fcy2p of *Saccharomyces cerevisiae*, which transports the purine nucleobases adenine, guanine, and hypoxanthine, together with the pyrimidine nucleobase cytosine.[23] Its close homologues in *S. cerevisiae* Fcy21p and Fcy22p are likely to have similar permeant selectivities,[24] and functionally similar transporters have also been identified in *Aspergillus nidulans* (FcyB)[25] as well as in *Candida*

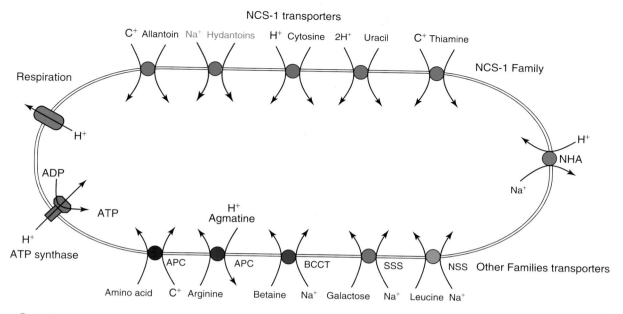

Figure 2 Scheme for the energized transport of substrates of the NCS-1 and LeuT superfamily proteins. The large oval represents the cytoplasmic membrane of a microorganism. In bacteria, a transmembrane electrochemical gradient of protons is generated by respiration or ATP hydrolysis, as shown on the left. In higher organisms, a transmembrane gradient of sodium ions would be generated by a Na^+, K^+-ATPase. The gradient may be used to drive proton/sodium antiport, sodium-nutrient symport, and substrate/substrate antiport secondary active transport systems shown around the circumference, with NCS-1 family members along the top and other LeuT superfamily members along the bottom. Each is a single protein indicated by a circle.

Figure 3 Substrates of the NCS-1 family of membrane transport proteins.

albicans (Fcy21p).[26] In contrast to these nucleobase transporters, subfamily member Tpn1p of *S. cerevisiae* instead transports vitamin B_6 (pyridoxine, and probably also pyridoxal and pyridoxamine).[27] Each of the yeast transporters also represents a route of uptake for the clinically used antifungal agent 5-fluorocytosine (5FC; Ancotil®), while Fcy2p, Fcy21p, and Fcy22p also transport the toxic adenine analogue 8-azaadenine.[24] The importance of Fcy2p for this process is highlighted by the fact that nonsense mutations in the homologous transporter FCY2 have been shown to be responsible for 5FC resistance in clinical isolates of *Candida lusitaniae*.[28]

Several lines of evidence indicate that these fungal transporters are proton symporters, rather than cotransporting organic permeants and sodium ions. These include investigations of Fcy2p incorporated into proteoliposomes harboring cytochrome *c* oxidase, where transport of cytosine was demonstrated to be driven solely by the ΔpH component of the proton-motive force.[29] Additional evidence for proton symport by Fcy2p has been provided by investigations of the effects of pH on the binding of nucleobases to yeast plasma membranes containing the overexpressed protein.[30]

Members of the second subfamily of functionally characterized NCS-1 transporters from fungi have been identified as transporters of an even more structurally diverse family of permeants than the first, ranging in size from uracil to thiamine. The best-characterized member of the family, Fur4p from *S. cerevisiae*, is a uracil transporter.[31] Functionally similar homologues have also been described from *Schizosaccharomyces pombe* (Fur4p)[32] and from *A. nidulans* (FurD).[33] In contrast, the *S. cerevisiae* protein Dal4p, which is 68% identical in sequence to Fur4p, transports allantoin,[34] as does the FurA protein from *A. nidulans*.[35]

Interestingly, phylogenetic analyses have suggested that within this subfamily of fungal transporters, convergent evolution toward uracil and allantoin transport activity has occurred multiple times independently.[35] Also part of the fungal transporter subfamily related to Fur4p is the nucleoside transporter Fui1p of *S. cerevisiae*, which is selective for uridine rather than uracil.[36,37] More distantly related members of the subfamily are the *S. cerevisiae* transporters Thi7p and Nrt1p, which primarily transport thiamine and nicotinamide riboside respectively, although thiamine is also a low-affinity permeant of Nrt1p.[38,39] Nicotinamide riboside is a precursor of NAD^+ and plays a key role in calorie restriction-mediated life span extension in yeast.[40]

In the same way as for the Fcy2p-related subfamily of fungal NCS-1 transporters, Fur4p and its homologues appear to function as proton-linked symporters. Investigations of proton and uracil uptake in yeast cells overexpressing Fur4p and genetically deficient in uracil metabolism revealed a likely stoichiometry of two protons per uracil at pH 6.5.[41] In contrast, electrophysiological analysis of Fui1p expressed in *Xenopus* oocytes demonstrated that uridine uptake was dependent on proton cotransport with a 1:1 stoichiometry.[42]

AMINO ACID SEQUENCE INFORMATION

The alignments of the predicted amino acid sequences of the NCS-1 transporter family have been extensively analyzed by Saier,[1,2] Paulsen[3] and others.[18–20,43] In Figure 1, we generated a partial phylogenetic tree to illustrate the evolutionary relationships between the prokaryote and eukaryote members of the family, and in Figure 4 some of these are aligned to reveal the positions of conserved residues that may be critical for function. The examples chosen are deliberately restricted to those where functional information is available. Residues highlighted in red are completely conserved and the roles of many of these in the transport mechanism are discussed later. Similarly, residues identified as important in transport by mutagenesis of fungal transporters are indicated in the alignments.

FUNCTIONAL ASPECTS

Transport assays

Radioisotope-labeled substrates are generally obtained from commercial sources, but labeled hydantoins and allantoin have been prepared in-house.[44] After dilution to an appropriate specific activity, the uptakes of labeled compounds into bacterial or yeast cells harboring the protein (see below) can be assayed.[45] The amounts of substrates taken into cells are measured using either induced or uninduced cells, and the differences between the uptakes by each type of cells are regarded as the effect caused by the induced transport protein. In the case of the hydantoins, corrections needed to be made to account for the tendency of the hydrophobic ligand to adhere to the filter.[6]

To determine the sensitivity of uptake to the substrate concentrations, the concentrations of ^3H-L-indolylmethyl hydantoin or ^3H-L-benzyl hydantoin were varied between 0.1 and 250 μM. The amount of uptake at 15 s, 2 min, 3 min, 5 min, and 10 min after the initiation of each reaction are convenient time points for sampling. By including an excess of unlabeled compound before the addition of the labeled substrate, the specificity of an NCS-1 protein for ligands can be determined.[6] In the case of Mhp1, this was L-indolylmethyl-hydantoin > L-benzyl hydantoin > D-indolylmethyl hydantoin > D-benzyl hydantoin > D,L isobutyl hydantoin; other substrates of NCS-1 family transporters – allantoin, cytosine, uracil, thiamine, adenine, and guanine – were inactive with Mhp1.[6]

For the determination of the effect of NaCl, the assay buffer can be changed to include 140 mM KCl and 10 mM NaCl instead of 150 mM KCl, or increasing proportions of NaCl. To measure the effect of uncoupling agents, 2 mM dinitrophenol (DNP) or 0.02 mM cyanocarbonyl-m-chlorophenylhydrazone (CCCP), can be added to the reaction mixture 3 min before the initiation of the reaction. For determining the optimal pH for the uptakes, the buffers were 10 mM potassium acetate for pH 4.0; 5 mM morpholino ethane sulfonate for pH 4.9, 6.1, 6.6, 7.1, 7.9; 10 mM tris-(hydroxymethyl)aminomethane-HCl for pH 8.0; and 10 mM glycine–NaOH pH 10.0 in each assay buffer. The initial rate of uptake at each pH is calculated by the amount of uptake in the first 15 s of reaction.

Fluorimetry

When proteins are irradiated with light of wavelength 285 nm, tryptophan residues can fluoresce at 348 nm to an extent dependent on their environment in the protein. In the case of purified Mhp1, either sodium ions or benzyl hydantoin quench this fluorescence in a dose-dependent manner, and the effect is synergistic (Figure 5).[4] It is most likely that Trp117 and Trp220 (Figure 4) are the key residues involved in the fluorescence change of Mhp1. The decrease in the fluorescence peak at 348 nm was expressed as a percentage of the peak height, and a hyperbolic fit made to the titration curves (Figure 5). The apparent ΔF_{max} for NaCl was 11.8 ± 1.1 and the apparent K_d was $1.15\,mM \pm 0.28\,mM$ and for NaCl, in the presence of 2 mM benzyl hydantoin, the apparent ΔF_{max} was 18.8 ± 1.2 and the apparent K_d was $0.15\,mM \pm 0.04\,mM$. In further experiments, no indication was found that chloride ions interacted with

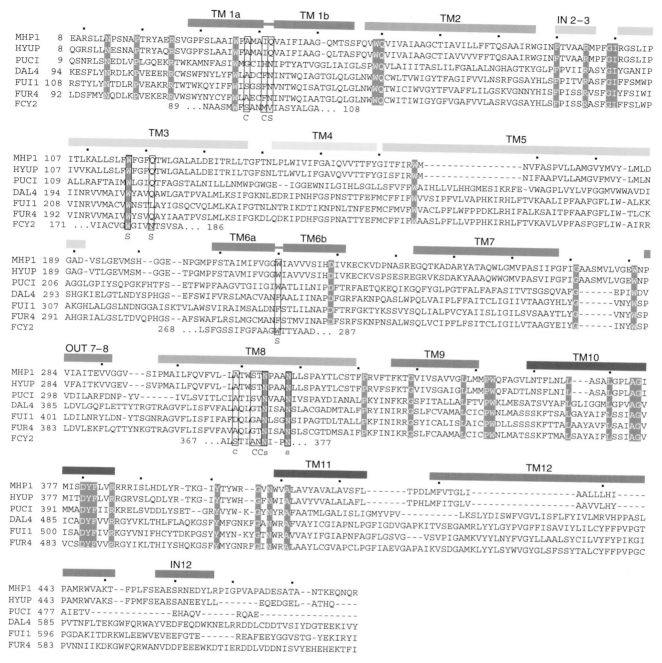

Figure 4 Amino acid sequence alignment of the NCS-1 family transporters. Amino acid sequence alignment of *Microbacterium liquefaciens* Mhp1 with HYUP (Q9F467), a transporter protein of *Arthrobacter aurescens*, PUCI (P94575), allantoin transporter of *Bacillus subtilis*, DAL4 (Q04895), allantoin transporter of *Saccharomyces cerevisiae*, FUI1 (P38196), uridine transporter of *S. cerevisiae*, FUR4 (P05316), uracil transporter of *S. cerevisiae* and FCY2 (P17064), purine-cytosine transporter from *S. cerevisiae*, using TCOFFEE (http://tcoffee.vital-it.ch/cgi-bin/Tcoffee/tcoffee_cgi/index.cgi). Because the overall alignment of FCY2 with other homologues has some ambiguity, the figure shows only the residues involved in the substrate and cation binding. These residues can be aligned unambiguously and are discussed in the main text. Strictly conserved residues are highlighted in red and the alpha helices are indicated as boxes. (TM, transmembrane helix; IN, horizontal helix on the inside of the membrane; OUT, horizontal helix on the outside of the membrane). 'c' and 'C' indicate those residues involved in cation binding through the main-chain carbonyl oxygen or through the side chain, respectively. 's' indicates the residues involved in substrate binding.

the protein. This assay is invaluable for determining the retention of binding activity by the purified protein, and for measuring the influence of a mutation in a residue(s)

on the binding activity. Importantly, the synergism of the binding of cation and substrate revealed by the fluorescence measurements demonstrates the coupling of

Figure 5 Quenching of tryptophan fluorescence in Mhp1 by NaCl. Purified Mhp1 protein ($0.14\,\mathrm{mg\,mL^{-1}}$ final concentration) in 10 mM KPi, pH 7.6, 0.05% DDM at 18 °C was stirred for 4 min and the indicated concentrations of NaCl were titrated into the solution (circles). Two minutes after each addition, a fluorescence spectrum was scanned through 300–400 nm with an excitation wavelength of 285 nm. The titration with NaCl was repeated, but in the presence of 2 mM benzyl hydantoin (triangles). Benzyl hydantoin does not emit fluorescence in the absence of protein. The decrease in the fluorescence peak at 348 nm was expressed as a percentage of the peak height, and the experiments were repeated in triplicate. The binding parameters (see text) were deduced from unweighted least squares fits of the measurements to a rectangular hyperbola using the program ULTRAFIT.

the ligand binding that is a feature of the alternating-access mechanism.

PROTEIN PRODUCTION AND PURIFICATION

Gene cloning

An expression vector useful for the production of any bacterial NCS-1 protein was constructed by using the vector pTTQ18 (Figure 6).[46–50] For example, *M. liquefaciens* AJ 3912 was used as gene source for production of the Mhp1 protein. The gene-designated *hyuP* encoding the Mhp protein was amplified from the chromosomal DNA of the organism by polymerase chain reaction (PCR) using the following primers:

hyuP upstream primer with *Eco*RI site,

5′-CGTCAATGAATTCGACACCCATCGAAGAGG-CT−3′;

hyuP downstream primer with *Pst*I site,

5′-TCCTTCTCCTGCAGGGTACTGCTTCTCGGT-GGG−3′.

The amplified fragment was then digested with *Eco*RI and *Pst*I, and inserted between the corresponding sites of plasmid JLC1, an expression vector originally including a glucose transporter gene *gluP* that had been excised by *Eco*RI–*Pst*I digestion. Most importantly, the vector has been engineered to include an RGSH$_6$-tag fused in-frame with the gene at the C-terminus.[47,48] Then the *E. coli* BLR host strain (Novagen) was transformed with the vector thus constructed (pSHP11). This recombinant strain (*E. coli*/pSHP11) was used as the MhpH$_6$ protein producer. The success of the amplified expression of MhpH$_6$,[6] and

Figure 6 Cloning strategy for NCS-1 membrane proteins using plasmid pTTQ18-His$_6$. The process starts (top left) with a PCR reaction (see text) using genomic DNA from the target organism and is completed by transforming the new vector into the *E. coli* host (bottom right).[47,49]

Figure 7 Expression of bacterial NCS-1 genes in *E. coli*. Thirteen NCS-1 genes from both Gram-negative and Gram-positive bacteria (Ma, 2010) were cloned into plasmid pTTQ18-His$_6$ and expressed in *E. coli* BL21(DE3) cells. The cells cultured in Luria Broth medium were induced with 0.5 mM isopropyl-β Dthiogalacoside (IPTG) when $A_{680\,nm}$ reached 0.4–0.6 and harvested 3 h post induction. Total membranes were prepared by water lysis,[49] and samples (15 μg) were analyzed by SDS-PAGE (a) and Western blotting (b).

other proteins,[46–50] was measured by direct observation of Coomassie-stained membrane preparations from induced and uninduced host cells accompanied by parallel Western blots detecting the (His)$_6$ epitope tag on the protein (Figure 7).

This strategy has been extended to explore the expressibility of a wide range of bacterial NCS-1 proteins (Figure 7). Out of 13 genes from both Gram-negative and Gram-positive organisms carried through to tests of protein expression, 4 yielded sufficient amplification of protein expression to be taken forward to purification, stability, and crystallization trials. Note that this success rate is not high, and could perhaps be improved by employing other promoters (e.g. *araC*[51]) or different vector/host organism (e.g. *L. lactis*).[51]

Culture media and conditions

Small volume

A culture medium-1 containing 10 g L^{-1} D-glucose, 5 g L^{-1} yeast extracts, 5 g L^{-1} peptone, 10 g L^{-1} NaCl (pH 7.0) was used for the cultivation of *M. liquefaciens* to obtain a source of chromosomal DNA. The strain was cultured in this medium at 30 °C for 18 h. For the cultivation of *E. coli*/pSHP11, a culture medium containing 20 mM glycerol, 10 g L^{-1} peptone, 5 g L^{-1} yeast extract, and 5 g L^{-1} NaCl, or M9 medium containing 20 mM glycerol, 0.2% (w/v)

casamino acid, 6 g L^{-1} Na$_2$HPO$_4$, 3 g L^{-1} KH$_2$HPO$_4$, 1 g L^{-1} NH$_4$Cl, 0.5 g L^{-1} NaCl, 2 mM MgSO$_4$, and 0.2 mM CaCl$_2$ was used. Carbenicillin was added into media at a concentration of 0.2 mg mL^{-1} to maintain selection for the β-lactamase-encoding plasmids when required. Refreshed *E. coli*/pSHP11 was inoculated into 2 mL of medium-1 and cultured at 37 °C for 16 h. A 1-mL portion of the culture broth was inoculated into 50 mL of fresh M9-casamino acid/carbenicillin medium and cultured at 37 °C. When the absorbance at 600 nm reached approximately 0.4 cm^{-1}, a final concentration of 0.2 mM isopropyl-β-D-galactopyranoside inducer was added into the culture medium. Then the culture was continued at 27 °C for an extra 12 h or at 30 °C for an extra 4–6 h.

Larger volumes

These conditions can be scaled up to 500 mL in a 2-L flask incubation, or to 30-L and 100-L scale in laboratory fermenters. Membranes containing overexpressed protein can be prepared by explosive decompression using a French Press or Constant Cell DisruptorTM.[49] In each case, the cells harvested by centrifugation were washed first with 0.2 M Tris-HCl buffer (pH 8.0) and then used for the preparations. Inner and outer membrane fractions were further prepared from French press membranes by sucrose density gradient centrifugation.[49]

Solubilization and purification of NCS-1 proteins

MhpH$_6$ is here used as an example. The inner membrane fraction of *E. coli*/pSHP11 adjusted to approximately 5 mg mL^{-1} of protein was incubated in 20 mM Tris-HC1 buffer (pH 8.0) including 20 mM imidazole, 20% (v/v) glycerol, 0.3 M NaC1, and 1% (w/v) *n*-dodecyl-β-D-maltoside (DDM) on ice for 1 h. The supernatant obtained after centrifugation at 160 000*g* for 30 min was used as the soluble fraction; the precipitate was suspended in the same volume of H$_2$O as the supernatant and used as the insoluble fraction. The supernatant obtained above was incubated with Ni-nitrilotriacetate (NiNTA) agarose (Qiagen, Hilden, Germany) pre-equilibrated with buffer W containing 20 mM Tris-HC1 (pH 8.0), 20 mM imidazole, 10% (v/v) glycerol, and 0.05% (w/v) DDM at 4 °C for 3 h. The resin was separated from unbound protein solution by centrifugation and then washed with 10 times its volume of buffer W. The washed resin was then packed in a small column and the absorbed proteins were eluted by the addition of 200 mM imidazole (pH 8.0), 20% (v/v) glycerol, and 0.05% (w/v) DDM. The eluted fractions were examined by sodium dodecylsulfate polyacrylmide gel electrophoresis (SDS-PAGE) and the pure fractions of MhpH$_6$ used for further experiments. For many proteins, an additional purification step with size exclusion gel filtration is desirable, remembering that the size of the protein is increased by its associated detergent micelle. In any case, size exclusion chromatography on an analytical scale is very important to test the monodispersity of the protein preparation before crystallization trials.

Through all the purification steps, the molecular mass of MhpH$_6$ was observed at about 36 kDa.[6] This is lower than the predicted mass of 54,584 Da, but such anomalous migration in SDS-PAGE is often observed with membrane proteins.[46–50] Importantly, the N-terminal amino acid sequence of the purified MhpH$_6$ was determined for 10 residues as MNSTPIEEAR, corresponding exactly to what was expected from the nucleotide sequence in the constructed plasmid. Coupled with the integrity of the RGSH$_6$ C-terminal end of the protein shown by the Western blot, this verifies that the purified polypeptide chain of MhpH$_6$, or any other similar protein, is intact. Electrospray ionization mass spectrometry can also be used to check the integrity of the purified protein, but stringent procedures are required to remove the detergent and any sodium ions first.[51,52]

This basic procedure is useful for any of the overexpressed bacterial NCS-1 proteins, with some modifications for fine-tuning of detergent, salt, and glycerol concentrations, and the precise concentrations of imidazole used in the prewash and elution steps for each individual protein. These modifications are important; in our experience, each protein behaves differently, despite any apparent similarities in amino acid sequence or other properties.

MOLECULAR CHARACTERIZATION OF NCS-1 TRANSPORT PROTEINS

Metal-substrate coupling

Although the NCS-1 family members are secondary active transporters, the mechanism of metal–substrate coupling remains unclear. Several of the yeast transporters have been reported as proton symporters,[17,26,30] and direct binding experiments have revealed an increased affinity of the *S. cerevisiae* transporter Fcy2 for hypoxanthine upon protonation of a residue with an apparent pK_a of 3.8.[26] Electrophysiological measurements on the *S. cerevisiae* transporter FuiI, expressed in *Xenopus* oocytes, demonstrated that uridine uptake was dependent on proton cotransport, with a 1:1 stoichiometry.[27] In the case of Mhp1, sodium dependency was not evident in whole-cell-uptake experiments, and uptake was inhibited by the uncoupler dinitrophenol, suggesting possible energization by the electrochemical proton gradient.[6] However, using fluorimetry, the apparent affinity of sodium binding to purified Mhp1 is increased by benzyl hydantoin (Figure 5) and the apparent affinity of benzyl hydantoin binding was substantially increased by sodium, indicating that the binding of the two is tightly coupled.[4] Moreover, examination of the Mhp1 structure clearly reveals a possible cation binding site,[45] equivalent to sites observed and assigned as sodium binding sites in LeuT$_{Aa}$[7] and the Na$^+$-galactose transport protein from *Vibrio parahaemolyticus* designated vSGLT (vibrio sodium glucose transporter).[8] To investigate the role of this site, we have examined the effects on function of mutating residues predicted to contribute side-chain hydroxyls to sodium binding (i.e. Mhp1 residues Ser312 and Thr313). Consistently, mutation of these residues to alanine and isoleucine, respectively, prevented the enhancement by Na$^+$ of the fluorescence quench due to benzyl hydantoin. It is, of course, possible that this site can alternatively accommodate hydrated protons.

X-RAY CRYSTAL STRUCTURES

The protein was crystallized in three different conformational states.

Outward-open form

Mhp1 protein was purified to homogeneity (see above) in a final buffer of 10 mM Tris-HCl (pH 8.0), 2.5% glycerol, and 0.5% nonyl-β-D-maltoside, concentrated to 20–30 mg mL^{-1} and sedimented briefly at 100 000*g* to remove aggregated protein. The best crystals appear after 5–7 days as needle clusters. They have cell dimensions of $a = 79.7$ Å, $b = 101.1$ Å, and $c = 113.8$ Å, and belong

to space group $P2_12_12_1$ and grew at $18\,^\circ$C with 31–33% polyethyleneglycol (PEG) 300, 100 mM NaCl, and 100 mM Na-phosphate (pH 7.0) in the reservoir solution.[4,53] The resulting needlelike crystals[53] yielded diffraction data that ultimately revealed the structure of the outward-open form of the protein.[4]

Outward-occluded form

These crystals were obtained in the same conditions as above but with benzyl hydantoin added to the protein.[4,53]

Inward-open form

Protein expressed from *E. coli* cultured in minimal media in the presence of selenomethionine gave rise to hexagonal crystals of space group $P6_1$ with $a = b = 173.9\,\text{Å}$, and $c = 74.5\,\text{Å}$ in addition to the orthorhombic crystals seen above.[5] The crystals grew at $4\,^\circ$C in 24–28% PEG300, 100 mM NaCl, and 100 mM Bicine pH9.0. The hexagonal crystals showed the protein to be in an inward-open state.[5] In the electron density maps, we observed an elongated electron-dense feature in the sodium binding site.[5] The possibility of the density representing a Na$^+$ ion could be excluded due to the density, shape, and peak height. Anomalous diffraction experiments failed to reveal the nature of the density. One interesting hypothesis is that this molecule traps Mhp1 in the inward-facing conformation.

Overview

Overall, the use of a low molecular weight PEG together with a high sodium concentration and a suitable detergent (small micelle) triggers this protein to crystallize well. The orthorhombic crystals disclosed the protein to be in an outward-facing open or outward-facing occluded state, whereas hexagonal crystals contained this transporter in the inward-facing open conformation. It appears that the shift of temperature and pH and the presence of the unidentified molecule encourage the protein toward an equilibrium between both conformations.

The quality of the crystals generally varied significantly between different protein batches. Consequently, a strategy for screening of the individual crystals at the beamline is needed in order to find the best candidates for data collection.

Overall description of the structure

The Mhp1 transporter comprises 12 transmembrane helices (3D Structure). The first 10 helices form a structural motif, which is conserved in this superfamily of proteins found to contain the 'LeuT fold'.[13,14] The arrangement consists of helices 1–5 and 6–10, which show an inverted repeat with a twofold axis approximately parallel to the membrane. The 12 transmembrane helices can be grouped into three segments, which are referred to as the *4-helix bundle* (transmembrane helices (TMs) 1 and 2 and their symmetry partners 6 and 7), the hash motif, which is another 4-helix bundle with the appearance of a hash sign (TMs 3 and 4 with TMs 8 and 9) and the C-terminal TMs 11 and 12.[5] The first two motifs are linked by TM 5, and the nonmembrane helices IN 2–3 and OUT 7–8; TM 10 links the hash motif with the C-terminal TMs 11 and 12 (3D Structure). Within helices 5 and 10 there are significant movements during conformational changes, so they are also referred to as *flexible helices*.

Metal binding site

It is important to remember that Na$^+$ is difficult to resolve by X-ray crystallography, its density being similar to that of H$_3$O$^+$. Nevertheless, finding potential chelating elements ($-$C=O, $-$OH) arranged in space in such a way as to present an ideal coordinating site for Na$^+$,[4,5] taken with biochemical evidence of the participation of Na$^+$ in binding (Figure 5),[4] is accepted as sufficient identification of a binding site for this cation.

The proposed Na$^+$ binding site in Mhp1 is located at the interface of TMs 1 and 8.[4,5] In both the outward-open and outward-occluded structures, the cation is modeled to interact with the carbonyl oxygen atoms of Ala 38 and Ile 41 in TM1 and of Ala 309 in TM8 and with the -OH groups of Ser 312 and Thr 313 in TM8 (Figure 8). In the inward-facing structure,[5] on the other hand, TM8 has moved \sim4.5 Å away from TM1 so that the Na$^+$ binding site is no longer intact (Figure 8), which is reminiscent of the situation in the inward-facing vSGLT structure.[8]

Molecular dynamics simulations of sodium binding

The dynamic behavior of a Na$^+$ ion in the Na-site was assessed by extended molecular dynamics (MD) computer simulations, which provide time-resolved atomic detail, based only on the crystal structures as inputs.[5] The three conformations of Mhp1 were simulated in a nativelike membrane composed of a 4:1 molar ratio of 1-palmitoyl-2-oleoylphosphatidylethanolamine (POPE) and 1-palmitoyl-2-oleoylglycero-3-phosphoglycerol (POPG) lipids. The simulated time was typically in excess of 100 ns.

In the occluded conformation with benzyl hydantoin present, the Na$^+$ ion is tightly coordinated by the liganding oxygen atoms (Figure 9(a)). The typical ion–oxygen distance is 2.2–2.3 Å with fluctuations of 0.1 Å or less seen in simulations. A very long 1-μs simulation

Figure 8 Metal and substrate binding sites[4]. (a) Mhp1 (PDB accession code: 2JLN). The sodium ion and the bound benzyl hydantoin in the vicinity are colored in blue and magenta, respectively. (b) LeuT$_{Aa}$ (PDB accession code: 2A65). The two sodium ions and the leucine in the vicinity are colored in blue and magenta, respectively. (c) vSGLT (PDB accession code: 3DH4). The sodium ion and the galactose in the vicinity are colored in blue and magenta, respectively. TMs 2, 4, 7, and 9 of vSGLT are equivalent to the TMs 1, 3, 6, and 8 of Mhp1 and LeuT$_{Aa}$, respectively. The coloring scheme of the ribbon is as in Figure 1. (Reproduced by permission of the American Association for the Advancement of Science.)

Figure 9 Coordination of the Na$^+$ ion in the Na-site and definition of ion–oxygen distances analyzed in MD simulations. The view looks at the Na-site approximately along the center plane of the membrane onto the bundle[5] (red) and the hash motif[5] (yellow), with the Na$^+$ ion in blue. (a) Occluded conformation. (b) Inward-facing open conformation.

shows that the ion is symmetrically coordinated by Ala38:O and Thr313:O$_\gamma$ (bridging TM1 and TM8), Ala309:O and Ser312:O$_\gamma$ (on TM8), and Ile41:O (TM1) (Figure 10).

Simulations of the outward-facing open conformation and the occluded conformation without substrate indicated

that Na$^+$ would generally bind in a similar manner with distances of about 2.2 and 2.3 Å and the Na$^+$–Ile41:O distance varying between these values. In some simulations, the Na$^+$ ion was released into the extracellular bulk solution, indicating that sodium binding itself is not

Figure 10 Distribution of ion–oxygen distances of a Na$^+$ ion in the Na binding site, derived from a 1-μs MD simulation with substrate. For Na$^+$ bound to Mhp1, typical binding lengths are between 2.2 and 2.3 Å with standard deviation 0.1 Å (Beckstein and Sansom, unpublished).

particularly tight and might be intimately related with the hydration properties of the binding cavity.

Modeling a Na$^+$ ion into the metal site of the inward-facing conformation (Figure 9(b)) yields ion–oxygen distances between 2 and 7 Å, resulting in three or fewer contacts (distances less than 6 Å) as opposed

to five contacts (all distances <3 Å) in the occluded and outward-facing conformation. Thus, the perturbed metal site does not appear to present an ideal sodium-liganding environment. A structurally similar site geometry was observed for vSGLT in the inward-facing conformation.[8] MD simulations of vSGLT had suggested that a Na$^+$ ion in the site would be only very weakly bound.[54] Similar simulations for Mhp1 in the inward-facing conformation revealed that the ion would not be able to find a stable binding position.[5] Instead of forming five contacts to oxygen ligands, it would at most come close to only three of the oxygen atoms that define the binding site. Because the ion is not sufficiently shielded from solvent in the inward-facing site geometry, water molecules substitute for protein oxygen atoms and solvate the ion, thus energetically stabilizing the charged particle in the low dielectric environment near the center of the membrane (Figure 11(a)). The hydrated ion diffuses rapidly (within less than 2 ns) through a wide aqueous pathway between the bundle, TM5, and the hash motif into the intracellular solution (Figure 11(b)).

The observed atomic Cα root mean square (rms) fluctuations of 0.5 Å for rigid secondary structural elements to 4 Å for mobile loops and rms deviations from the starting structure of 1.5–3 Å after 100 ns are comparable with simulations of other high-resolution membrane proteins. Hence, we conclude from both structural and dynamic considerations that the Na$^+$ binding site is intact in the outward-facing and occluded forms and disrupted in the inward-facing form. The presence of benzyl hydantoin in its binding site blocks the primary pathway of the sodium ion to the extracellular side in the simulations and thus couples Na$^+$ binding with substrate binding as also shown in the fluorescence-quenching experiments[4] (Figure 6). Recent simulations of sodium release from vSGLT come to the

Figure 11 Na-site in the inward-facing open conformation. (a) Mhp1 embedded in a 4:1 POPE : POPG bilayer. A Na$^+$ ion (magenta) was modeled into the Na-site. Transmembrane helices 1,8,4,5 are involved in Na$^+$-coordination or Na$^+$-release. (b) Na$^+$-release trajectory as seen in an MD simulation that started with the conformation (a). The Na$^+$ ion moves along the yellow pathway into the bulk solution on the intracellular side. Water enters the protein and the lipid head group region up to the surface show in blue.

same conclusions for this structural homologue of Mhp1.[54] The MD simulations show that the metal site in Mhp1 can bind a Na^+ ion in the outward-facing conformation but will readily release an ion in the inward-facing conformation and thus open a pathway for substrate egress into the cytoplasm.

Substrate binding site

The location of the substrate in the Mhp1 molecule was identified in electron density maps of the Mhp1 crystals with benzyl hydantoin.[4] An L-shaped density was clearly observed at a position almost identical to that of the leucine in the $LeuT_{Aa}$ structure and close to that of the galactose in vSGLT (Figure 8). This site is located at the breaks in the discontinuous TMs 1 and 6 and facing TMs 3 and 8 (Figure 8). It coincides with the foot of the outward-facing cavity, which is composed of the neighboring surfaces of TMs 1, 3, 6, 8, and 10, and allows access of the substrate to the binding site (Figure 8). The structure of L-5-benzyl hydantoin taken from the Cambridge Structural Database (accession code CIJYOK) was consistent with the shape of this density and the molecule was placed between Trp117 (TM3) and Trp220 (TM6) without requiring any modifications of torsion angles.

The hydantoin moiety forms a π-stacking interaction with the indole ring of Trp117 and is within hydrogen

(a) Outward open	(b) Outward occluded	(c) Inward open
(d)	(e)	(f)

Figure 12 Comparisons of the outward-facing, occluded, and inward-facing conformations of Mhp1. (a) Arrangement of the transmembrane helices (TMs) in the Mhp1 outward-open structure, viewed parallel to the membrane. (b) Same as (a) but for the Mph1 outward-occluded structure. (c) Same as (a) but for the Mhp1 inward-open structure. The green rod indicates the axis about which the hash motif rotates in relation to the bundle. (d) Slice through the surface of the Mhp1 substrate-free structure, viewed parallel to the membrane, showing the outward-facing cavity. The Connolly surface of Mph1 is shown in yellow (calculated with a probe radius of 2 Å). The ribbon representation of Mhp1 is shown in the same colors as in the first Figure of the structure on page 1. (e) Same as (d) but for the Mhp1 outward-occluded structure. Bound benzyl hydantoin is shown. Note that the outward-facing cavity shown in (a) is now blocked and the substrate is occluded from the 'OUT' side of the membrane. (f) Same as (d) but for the inward-open structure.

bonding distance of Asn318 and Gln121 (Figure 8). Trp117 and Asn318 are conserved among all the transporters in the family and Gln121 only varies in the uridine transporter, Fui1 (Figure 4). Another conserved residue, Asn314, is within hydrogen bonding distance of Asn318 such that it may hold the asparagine side chain in position to interact with the substrate. The benzyl group of the substrate is situated next to Trp220 and Gln42. The side chain of Trp220 moves into the binding site with respect to its position in the substrate-free structure and forms a π-stacking interaction with the benzyl moiety.

Potential interactions between the metal and substrate binding sites

Mhp1 has one cation binding site located between helices 1 and 8, which could be identified in both the outward-open and outward-occluded states. The 5-benzyl hydantoin and sodium binding sites are close together constituted by the arrangement of TMs 1, 3, 6, and 8 (Figure 8). The outward-occluded conformation, which was cocrystallized with 5-benzyl hydantoin, gave detailed insight into the binding mode of the benzyl hydantoin. The two crucial tryptophans 117 and 220 turn out to be most essential for substrate binding and for its passage from the extracellular space to the cytoplasm. These residues are located in TMs 3 and 6, which are pointing toward each other and sandwich the substrate in between the side chains supported by π electron stacks. This binding is stabilized by the neighboring residues on TMs 3 and 8 (Gln121 on TM 3 and Asn318 on TM8). A comparison of the active site of the occluded state with the outward-open and inward-open conformations reveals that the side chains of Trp117 and Trp220 are displaced toward the ligand.[4,5] These small movements are part of a much larger movement of the hash motif containing helices 3,4,8,9 relative to the bundle containing helices 1,2,6,7 that opens a cavity in Mhp1 to connect substrate and sodium binding sites to the inside of the cell, leading particularly to an accompanying collapse of the Na^+ binding site.[5] As a result, the Na^+ and substrate are released into the cavity and can pass through into the cytoplasm.

Conformational states and molecular mechanism

The Mhp1 protein has been solved in three different conformational states by X-ray crystallography (Figure 12).[4,5] The outward-facing open state and the occluded state show very high similarity, whereas neither of those conformations superimposes well with the inward-facing open state, leaving the question, whether or not there is only one occluded state. The significant movements within all three structures appear to be an overall rigid body rotation

of the hash motif (helices 3,4,8,9) relative to the bundle (helices 1,2,6,7). The C-terminus (helices 11,12), moves relatively little in comparison. In general, the mechanism can be visualized as a gating system. The transition between the states can be described as the interplay of a buried thick gate, an external thin gate, and an internal thin gate. The thick gate regulates the conformational change from the outward-facing occluded state to the inward-facing open state and obstructs the ligand binding site toward the intracellular space, when open to the outside. In contrast, the external thin gate comprises only some residues in helix 10, which orchestrate the opening and closing of the outward-facing substrate and Na^+ binding sites. A complementary region of residues in helix 5 comprises the internal thin gate, which allows opening and release of substrate and Na^+ toward the inside when the external thin gate and thick gates are closed to the outside. The interplay of these events to effect transport are illustrated schematically in Figure 13. During the conformational changes, the occluded state of the protein always prevents net movement of either cation or substrate without the other – their movement is 'coupled'.

While three conformations of Mhp1 have been resolved, the complete process of transport is likely to involve as many as eight intermediate states (Figure 13). Of course, some of these may be unstable and short-lived, and so unlikely to be detected with available biophysical techniques. Nevertheless, establishing the number of these and the kinetic constants for their interconversions is the next stage in understanding the molecular mechanism of Mhp1, and defining the differences between members of the NCS-1 family itself and other families of the

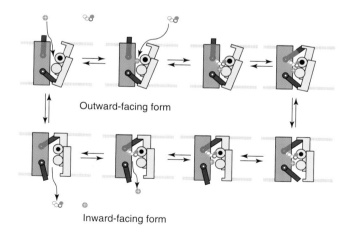

Outward-facing form

Inward-facing form

Figure 13 Schematic illustration of the possible conformations of an NCS-1 membrane transport protein. The bundle[5] helices 1,2,6,7 are in red. The hash motif[5] helices 3,4,8,9 forming the internal thick gate[5] are in yellow; the external thin gate[5] containing part of helix 10 is in blue. The internal thin gate[5] containing part of helix 5 is also in blue. The rotation axis of the thick gate, running approximately parallel to TM3, is shown as a filled black circle on TM3.

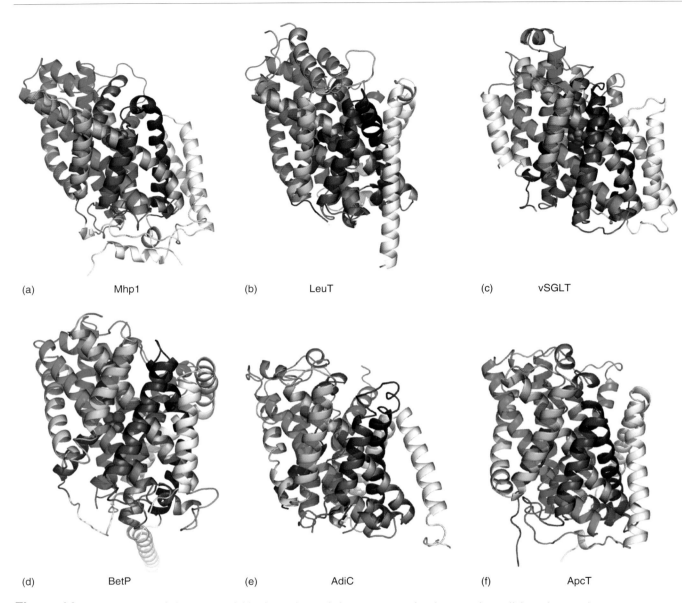

Figure 14 Comparisons of the protein fold of members of the LeuT superfamily viewed parallel to the membrane. (a) Structure of Mhp1 (PDB accession code: 2JLN.pdb). The transmembrane helices (TMs) 11 and 12 are colored in gray. (b) Structure of LeuT$_{Aa}$ (2A65.pdb). TMs 11 and 12 are colored in gray. (c) Structure of vSGLT (3DH4.pdb). TMs 1, 12, and 13 are colored in gray. (d) Structure of the betaine or proline transporter BetP (2WIT.pdb). (e) Structure of the arginine/agmatine transporter AdiC (3HQK.pdb). (f) Structure of an amino acid or polyamine transporter Apc(3GIA.pdb). The coloring scheme of the other helices is as in the structure on page 1.

LeuT superfamily. These are the objectives of future studies.[13,14]

FURTHER UNDERSTANDING OF THE RELATIONSHIPS OF STRUCTURE TO FUNCTION

The similarities of the overall structural folds of proteins of the NCS-1 family with those of the NSS, SSS, APC, and other emerging families of transport proteins (Figure 14) might imply that the overall molecular mechanism of cation–substrate uptake, translocation, and release are similar. However, the variations in the precise nature of the substrate, the nature of the cation involved (Na^+, H^+, or none), and the process of antiport or symport, are just as indicative of an evolutionary flexibility. Understanding these subtle similarities and variations in substrate recognition, number and nature of cations involved, symport versus antiport versus facilitated diffusion, are the key areas for future examination and elucidation. It is clear that the NCS-1 family is not an isolated one, but, like mankind, includes relatives with differences that are, in fact, superficial, and overlay similarities that are very deep.

ACKNOWLEDGEMENTS

This work was funded by the BBSRC (grant no. BB/C51725 and BB/G020043/1) and the EU (European Drug Initiative for Channels and Transporters, EDICT grant 201924). The authors are grateful for the use of the Membrane Protein Laboratory (MPL) funded by the Wellcome Trust (grant no.062164/Z/00/Z) at the Diamond Light Source Limited. PJFH received personal funding from the Leverhulme Trust, SW, from a European Molecular Biology Organization long-term fellowship, and TS from a Grant-in-Aid for Scientific Research (B) (grant no. 21370043). We appreciate the additional support of the Ajinomoto Company Incorporated. A part of this work was also supported by a grant from the ERATO Iwata Human Receptor Crystallography Project from the Japan Science and Technology Agency (JST).

REFERENCES

1 MH Saier Jr, *Microbiol Mol Biol Rev*, **64**, 354–411 (2000).

2 MH Saier Jr, CV Tran, RD Barabote, *Nucl Acids Res*, **34**, 181–86 (2006).

3 Q Ren and IT Paulsen, *Mol Micro Biotech*, **12**, 165–79 (2007).

4 S Weyand, T Shimamura, S Yajima, S Suzuki, O Mirza, K Krusong, EP Carpenter, NG Rutherford, JM Hadden, J O'Reilly, P Ma, M Saidijam, SG Patching, RJ Hope, HT Norbertczak, PCJ Roach, S Iwata, PJF Henderson and AD Cameron, *Science*, **322**, 709–13 (2008).

5 T Shimamura, S Weyand, O Beckstein, NG Rutherford, JM Hadden, D Sharples, MPS Sansom, S Iwata, PJF Henderson and AD Cameron, *Science*, **328**, 470–73 (2010).

6 S Suzuki and PJF Henderson, *J Bacteriol*, **188**, 3329–36 (2006).

7 A Yamashita, SK Singh, T Kawate, Y Jin and E Gouaux, *Nature*, **437**, 215–23 (2005).

8 S Faham, A Watanabe, GM Besserer, D Cascio, A Specht, BA Hirayama, EM Wright and J Abramson, *Science*, **321**, 810–14 (2008).

9 S Ressl, ACT van Scheltinga, C Vonrhein, V Ott and C Ziegler, *Nature*, **458**, 47–52 (2009).

10 PL Shaffer, A Goehring, A Shankaranarayanan and E Gouaux, *Science*, **325**, 1010–14 (2009).

11 Y Fang, H Jayaram, T Shane, L Kolmakova-Partensky, F Wu, C Williams, Y Xiong and C Miller, *Nature*, **460**, 1040–43 (2009).

12 X Gao, L Zhou, X Jiao, F Lu, C Yan, X Zeng, J Wang and Y Shi, *Nature*, **63**, 828–32 (2010).

13 J Abramson and EM Wright, *Curr Opin Struct Biol*, **19**, 425–32 (2009).

14 H Krishnamurthy, CL Piscitelli and E Gouaux, *Nature*, **459**, 347–55 (2009).

15 JS Lolkema and DJ Slotbloom, *Mol Membr Biol*, **22**, 177–89 (2005).

16 G Diallinas, *Mol Membr Biol*, **26**, 356–70 (2009).

17 A Pantazopoulou and G Diallinas, *FEMS Microbiol Rev*, **31**, 657–75 (2007).

18 JD Thompson, TJ Gibson, F Plewniak, F Jeanmougin and DG Higgins, *Nucl Acids Res*, **25**, 4876–82 (1997).

19 TA Hall, *Nucl Acids Symp Ser*, **41**, 95–98 (1999).

20 N Saitou and M Nei, *Mol Biol Evol*, **4**, 406–25 (1987).

21 AC Schultz, P Nygaard and HH Saxild, *J Bacteriol*, **183**, 3293–302 (2001).

22 S Danielsen, M Kilstrup, K Barilla, B Jochimsen and J Neuhard, *Mol Microbiol*, **6**, 1335–44 (1992).

23 T Ferreira, D Brethes, B Pinson, C Napias and J Chevallier, *J Biol Chem*, **272**, 9697–702 (1997).

24 JP Paluszynski, R Klassen, M Rohe and F Meinhardt, *Yeast*, **23**, 707–15 (2006).

25 A Vlanti and G Diallinas, *Mol Microbiol*, **68**, 959–77 (2008).

26 S Goudela, H Tsilivi and G Diallinas, *Mol Membr Biol*, **23**, 291–303 (2006).

27 J Stolz and M Vielreicher, *J Biol Chem*, **278**, 18990–996 (2003).

28 M Florent, T Noel, G Ruprich-Robert, SB Da, V Fitton-Ouhabi, C Chastin, N Papon and F Chapeland-Leclerc, *Antimicrob Agents Chemother*, **53**, 2982–90 (2009).

29 B Pinson, C Napias, J Chevallier, PJ van den Broek and D Brethes, *J Biol Chem*, **272**, 28918–24 (1997).

30 D Brethes, C Napias, E Torchut and J Chevallier, *Eur J Biochem*, **210**, 785–91 (1992).

31 R Jund, E Weber and MR Chevallier, *Eur J Biochem*, **171**, 417–24 (1988).

32 J deMontigny, ML Straub, R Wagner, ML Bach and MR Chevallier, *Yeast*, **14**, 1051–59 (1998).

33 S Amillis, Z Hamari, K Roumelioti, C Scazzocchio and G Diallinas, *Mol Membr Biol*, **24**, 206–14 (2007).

34 HS Yoo, TS Cunningham and TG Cooper, *Yeast*, **8**, 997–1006 (1992).

35 Z Hamari, S Amillis, C Drevet, A Apostolaki, C Vagvolgyi, G Diallinas and C Scazzocchio, *Mol Microbiol*, **73**, 43–57 (2009).

36 MF Vickers, SY Yao, SA Baldwin, JD Young and CE Cass, *J Biol Chem*, **275**, 25931–38 (2000).

37 R Wagner, J deMontigny, P deWergifosse, JL Souciet and S Potier, *FEMS Microbiol Lett*, **159**, 69–75 (1998).

38 F Enjo, K Nosaka, M Ogata, A Iwashima and H Nishimura, *J Biol Chem*, **272**, 19165–70 (1997).

39 PA Belenky, TG Moga and C Brenner, *J Biol Chem*, **283**, 8075–79 (2008).

40 SP Lu, M Kato and SJ Lin, *J Biol Chem*, **284**, 17110–19 (2009).

41 AA Eddy and P Hopkins, *Biochem J*, **336**, 125–30 (1998).

42 J Zhang, KM Smith, T Tackaberry, XJ Sun, P Carpenter, MD Slugoski, MJ Robins, LPC Nielsen, I Nowak, SA Baldwin, JD Young and CE Cass, *J Biol Chem*, **281**, 28210–21 (2006).

43 Q Ren and IT Paulsen, *TransportDB*, (2010) http://www.membranetransport.org/.

44 SG Patching, *J Label Compd Radiopharm*, **52**, 401–4 (2009).

45 PJF Henderson and AJS Macpherson, *Meth Enzymol*, **125**, 387–429 (1986).

46 A Ward, J O'Reilly, NG Rutherford, SM Ferguson, CK Hoyle, SL Palmer, JL Clough, H Venter, H Xie, GJ Litherland, GEM Martin, JM Wood, PE Roberts, MAT Groves, W-j Liang, A Steel, BJ McKeown and PJF Henderson, *Biochem Soc Trans*, **27**, 893–99 (1999).

47 M Saidijam, G Psakis, JL Clough, J Meuller, S Suzuki, CK Hoyle, SL Palmer, SM Morrison, MK Pos, RC Essenberg, MCJ Maiden, A Abu-bakr, SG Baumberg, MJ Stark, A Ward, J O'Reilly, NG Rutherford, MK Phillips-Jones and PJF Henderson, *FEBS Lett*, **555**, 170–75 (2003).

48 A Ward, CJ Hoyle, SE Palmer, J O'Reilly, JK Griffith, KM Pos, SJ Morrison, B Poolman, M Gwynne and PJF Henderson, *J Mol Microbiol Biotechnol*, **l3**, 193–200 (2001).

49 A Ward, NJ Sanderson, J O'Reilly, NG Rutherford, B Poolman, M Gwynne and PJF Henderson, in SA Baldwin (ed.), *Membrane Transport: A Practical Approach*, Oxford University Press, New York, pp 141–66 (2000).

50 G Psakis, M Saidijam, K Shibayama, J Polaczek, KE Bettaney, JM Baldwin, SA Baldwin, RJ Hope, L-O Essen, RC Essenberg and PJF Henderson, *Mol Microbiol*, **71**, 391–403 (2009).

51 S Surade, M Klein, PC Stolt-Bergner, C Muenke, A Roy and H Michel, *Protein Sci*, **15**, 2178–89 (2006).

52 L Jones, SA Baldwin, PJF Henderson and AE Ashcroft, *Rapid Commun Mass Spec*, **24**, 1–9 (2010).

53 T Shimamura, S Yajima, S Suzuki, NG Rutherford, J O'Reilly, PJF Henderson and S Iwata, *Acta Crystallog*, **F64**, 1172–74 (2008).

54 J Li and E Tajkhorshid, *Biophys J*, **97**, L29 (2009).

MERCURY

The organomercurial lyase MerB

Paola Di Lello[†,‡], Julien Lafrance-Vanasse[†] and James G Omichinski[†]

[†]Département de Biochimie, Université de Montréal, Montréal, Québec, Canada
[‡]Current address: Roche Research Center, Hoffman-La Roche Inc., 340 Kingsland Street, Nutley, NJ 07110, USA

FUNCTIONAL CLASS

Enzyme; lyase; EC 4.99.1.2; an alkylmercury lyase or organomercurial lyase commonly known as *MerB*.

MerB catalyzes the protonolysis of the carbon–mercury bond in organomercurials, yielding ionic mercury and the corresponding hydrocarbon (see Scheme 1). MerB is active on a large variety of substrates ranging from simple alkyl compounds like methylmercury, which is the most naturally abundant organomercurial, to polyaromatic heterocyclic compounds like merbromin.[3,4] MerB also catalyzes the cleavage of the carbon–tin bond in select organostannanes like tetravinyltin, but in a less efficient manner.[5]

OCCURRENCE

The organomercurial lyase MerB is a cytosolic protein found in gram-positive and gram-negative bacterial strains that display resistance to both ionic mercury and organomercurial compounds.[6–9] The mercury resistance is due to a dedicated set of genes that are regulated together by the *mer* operon.[10,11] The *mer* operon occurs in most cases on transferable genetic elements such as transposons or plasmids, and it is not part of the native genome. The activation of the *mer* operon occurs only in response to the presence of compounds containing mercury, which bind to the DNA-bound MerR and activate expression of the *mer* operon.[12] The composition of the *mer* operon can vary dramatically between different bacterial strains, but resistance to organomercurial requires the presence of two enzymes, the lyase MerB and the mercuric reductase MerA.[9]

BIOLOGICAL FUNCTION

MerB belongs to a group of proteins that confers organomercurials with resistance to specific bacteria containing the *mer* operon.[9,13] The mercury detoxification

3D Structure Ribbon representation of the mercury-bound form of the organomercurial lyase MerB. PDB code: 3F0O. The core domain of the protein is colored in dark blue, the amino-terminal region of the protein is colored in teal, and the mercury ion is represented as a gray sphere. This representation and all other structural representations were prepared using PyMOL[1] unless noted otherwise. (Reproduced from Ref. 2. © American Society for Biochemistry and Molecular Biology, 2009.)

$$R'\text{-Hg-SR} \xrightarrow{\text{MerB}} R'H + Hg^{2+} + SR^-$$

Scheme 1

$$Hg^{2+} \xrightarrow[\substack{NADPH \quad\quad NADP^+}]{MerA} Hg^0$$

Scheme 2

system developed by these microorganisms consists in transforming toxic mercury from organomercurials or inorganic mercuric salts into elemental mercury.[6] The advantage to the bacteria is that elemental mercury is chemically inert, less toxic, and passively eliminated from the bacteria through volatilization.[7] The transformations are achieved through the action of two enzymes, MerA and MerB. The mercuric ion reductase MerA catalyzes the reduction of ionic mercury to the less toxic elemental mercury, using reduced nicotinamide adenine dinucleotide phosphate (NADPH) as source of electrons and flavin adenine dinucleotide (FAD) as cofactor.[14] The organomercurial lyase MerB cleaves the mercury–carbon bond in organomercurials releasing ionic mercury that is subsequently reduced to elemental mercury by MerA (Scheme 2).[3,4]

Bacteria carrying the *merB* gene, which encodes for the organomercurial lyase MerB, are usually referred to as *broad spectrum* because they are resistant to both organic and inorganic mercury compounds.[9] On the contrary, bacteria lacking the gene encoding for MerB have a *narrow-spectrum* resistance to mercury; they can survive in the presence of inorganic mercury salts but not organomercurials.

Relationships

The *merB* gene is expressed from the *mer* operon of all bacteria resistant to organomercurial compounds, but it occurs more commonly in gram-positive bacteria than in gram-negative bacteria.[9] The first reports of bacterial degradation of organomercurial compounds were from the gram-negative mercury-resistant *Pseudomonas* strain K62.[13,15] Subsequent studies demonstrated that this particular strain contained two distinct forms of the MerB protein and both forms were capable of degrading a broad range of organomercurial compounds.[7,16–18] The most extensively studied form of the MerB protein comes from the *E. coli* strain carrying the IncM plasmid, R831b.[19] Blast analysis of the R831b MerB sequence against the UniProtKB database identified 65 complete protein sequences that are organomercurial lyases (as of January 2010). The majority of the 65 related MerB sequences contain about 210–220 amino acids. ClustalW alignment of these 65 sequences reveals that they are highly

conserved, and that the most significant differences occur at the amino-terminal end of the protein. In addition, the two cysteines required for substrate binding (Cys96 and Cys159 in the R831b sequence) are conserved in all 65 sequences.[8] Furthermore, the aspartic acid residue that constitutes the third residue of a catalytic triad involved in carbon–mercury bond cleavage is conserved in 61 of the 65 sequences (Asp99 in the R831b sequence). The four sequences missing the crucial aspartic acid, all contain a serine residue in the equivalent position (UniProtKB/SwissProt: Q9WWL2, Q7DJP9, Q7DJN2, and Q7DHE2; see Figure 1) and this difference leads to a slight change in substrate specificity and overall activity.[20]

The 65 MerB sequences from the UniProtKB database can be divided into 27 groups, on the basis of their sequence identity (>90%) and the relationship among these groups is illustrated by the phylogenetic tree reported in Figure 2. The R831b MerB sequence from *Escherichia coli* belongs to the largest group and it is closely related to the majority of known MerB sequences, including those found in *Pseudomonas* K62, *Staphylococcus aureus* and certain strains of *Bacillus cereus* (Figure 2, left side of the tree). The four sequences from *B. cereus*, *Bacillus megaterium*, *Clostridium butyricum*, and *Bacillus* sp. (strain RC607), which have a serine in place of the conserved aspartic acid in the active site, all cluster in the same group and they are among the sequences most distantly related to R831b from *E. coli* (Figure 2, right side of the tree).

It should be noted that the phylogeny of MerB does not correlate with the phylogeny of the organisms in which this protein was found. In fact, there are examples of closely related MerB sequences derived from distantly related gram-positive and gram-negative bacteria.[8]

To date, no protein that is functionally homologous to MerB has been identified in any other known organisms. However, a structural homolog recently discovered is the copper-binding protein NosL, one of the accessory proteins of the nitrous oxide reductase (Nos) gene cluster.[22]

Figure 1 Sequence alignment of MerB. Eight representative MerB protein sequences taken from the ClustalW alignment[21] highlighting the sequence conservation within the two regions (89–103 and 157–169) containing the three key active site residues (Cys96, Asp99, and Cys159 in the R831b sequence) involved in carbon–mercury bond cleavage. The three residues are completely conserved in all known MerB sequences with the only exceptions being four sequences that contain a serine substitution in the Asp99 position.

Figure 2 MerB unrooted phylogenetic tree. MerB protein sequences from various bacteria were first clustered on the basis of their sequence identity (>90%) and then aligned using the ClustalW program.[21] For each group, one representative bacterial strain is reported. For groups containing more than one sequence, the corresponding number of sequences is also indicated.

Despite the low sequence identity (<20%) and the different biological function, NosL and MerB share a similar tertiary fold.[23]

AMINO ACID SEQUENCE INFORMATION

The sequence information for the two original MerB proteins isolated from *Pseudomonas* strain K62,[16,17] the sequence from the IncM plasmid R831b[19] and two sequences containing an active site serine residue as opposed to the more typical aspartic acid residue are summarized below as examples.

- *Pseudomonas* sp. K62, GeneBank (GB): AB013925, UniProtKB/Swiss-Prot (UP/SP): Q9Z3Y8, 212 amino acid (AA)[24]
- *Pseudomonas* sp. K62, GB: D83080, UP/SP: O07303, 212 AA[25]
- *Escherichia coli* plasmid R831b, GB: U77087, UP/SP: P77092, 212 AA[19]
- *Bacillus megaterium*, GB: AB027307, UP/SP: Q7DJN2, 209 AA[20]

- *Bacillus* sp. Strain RC607, GB: AF138877, UP/SP: Q9WWL2, 209 AA[26]

PROTEIN PRODUCTION, PURIFICATION, AND MOLECULAR CHARACTERIZATION

The MerB protein was initially purified from mercury-resistant bacteria strains grown in the presence of an organomercurial compound to induce native expression of MerB through the plasmid-based *mer* operon.[7,16,17] Two native forms of MerB were purified from the mercury-resistant *Pseudomonas* K-62 strain carrying the plasmid pMR26[16,17] and a third native form was purified from the *E. coli* K12 strain J53-1 carrying the plasmid R831b.[7] All of the native forms displayed activity toward a variety of organomercurial substrates although the rate of activity varied with both the enzyme source and the nature of the organomercurial substrate.[7,16,17]

The most extensively characterized MerB is the one encoded by the R831b plasmid and subsequent purifications were performed using this form of MerB generated using recombinant *E. coli* expression systems to overproduce the proteins from a T7 promoter.[2–4,7,8,19,27–30] In

addition to the wild-type sequence, recombinant MerB has been produced with a 6-Histidine tag as well as with [2]H-, [15]N-, and [13]C-labeling for heteronuclear NMR studies.[8,28]

The expression and purification protocols vary depending on the construct used. Typically, the frozen cells are lysed and the insoluble components are removed by ultracentrifugation. The protein of interest is then purified from the cleared lysate with two steps of cation-exchange chromatography at different pH values followed by a final purification step on a size-exclusion column. The histidine-tagged MerB is purified in three steps: an initial nickel-chelating column, followed by a cation-exchange column, and the final purification by size-exclusion chromatography.

MerB from the R831b plasmid is a 23-kDa monomeric protein that is localized almost exclusively in the cytosol.[8] It contains four cysteine residues and three of the four cysteines are highly conserved in all other known MerB sequences.[8] The sulfhydryl groups of two of the conserved cysteine residues (Cys96 and Cys159 in R831b) play critical roles in binding the mercury moiety of the organomercurial substrate, whereas the third conserved cysteine (Cys117 in R831b) has a structural role.[2,8,29] Mutations of any of the three highly conserved cysteine residues lead to either a significant decrease in enzymatic activity (Cys96 and Cys159) or to improper folding (Cys117).[8]

METAL CONTENT AND COFACTORS

MerB has no bound cofactors, however, it has been shown that for full *in vitro* activity the enzyme requires the presence of thiols in solution, but the nature and concentration of the buffer thiols can have dramatically different effects.[3,4] Several endogenous thiols (MerA, cysteine, glutathione) have been shown to increase the rate of the enzymatic protonolysis, whereas others such as dithiothreitol (DTT) can function as inhibitors.[3,8,27] It is thought that the thiols play a fundamental role both in substrate binding and mercury release. First, the rapid substitution of the organomercurial salt counterions by the buffer thiol produces the organomercurial thiolate (R-Hg-SR′) that is thought to be the actual substrate for the enzyme. In addition, two equivalents of a thiol are postulated to be essential for release of the ionic mercury product from the active site thiols (Cys96 and Cys159 in R831b) following cleavage of the carbon–mercury bond.[3,4]

Although wild-type MerB does not contain any bound metals, it is able to bind ionic mercury in a 1:1 (protein:metal) ratio.[3] In the crystal state, the ionic mercury produced following cleavage of organomercurial substrates binds MerB in the active site in a planar-trigonal conformation that involves two sulfur atoms from the side chains of Cys96 and Cys159 and one oxygen atom from a water molecule present in the active site.[2]

ACTIVITY TESTS

The activity of MerB has been directly assayed by measuring either the release of the hydrocarbon products from the organomercurial or the generation of volatilized elemental mercury following reduction of the ionic mercury product.[3,4,16,17] Hydrocarbon product formation has been determined by a number of techniques including gas chromatographic analysis, UV analysis and high-performance liquid chromatography (HPLC) analysis.[3,4,6–8,16,17] The choice of analysis is in part dictated by the organomercurial substrate that is used. Measuring the amount of volatilized elemental mercury generated requires both a [203]Hg-labeled substrate and an agent to reduce the ionic mercury (either purified MerA or SnCl$_2$).[6,7] Alternatively, MerB activity has also been measured indirectly, using radioisotope assays in which the rate of consumption of a radiolabeled ([14]C or [203]Hg) organomercurial substrate is monitored.[8,16,17] Specific activity is given as units per milligram of MerB, where one unit is defined as the number of nanomoles of either the hydrocarbon[1] or ionic mercury produced per minute of reaction with the substrate methylmercury.[7] The specific activity of the purified recombinant MerB was reported to be 60 U mg^{-1}.[3]

SPECTROSCOPY

UV–vis absorption

MerB shows the typical UV–vis spectrum of a polypeptide chain containing tyrosine and tryptophan residues and no bound cofactors, with two maxima at 220 nm and 280 nm and a shoulder at 290 nm. No absorbance above 300 nm is observed.[3]

X-ray absorption

X-ray absorption spectroscopy (XAS) was performed on the MerB–Hg–DTT complex to characterize the ligands coordinated to the bound mercury.[27] Curve fitting analysis of the extended X-ray absorption fine structure (EXAFS) for the MerB–Hg–DTT complex indicated a coordination sphere of Hg–S$_3$ as indicated by the goodness-of-fit and Debye-Waller values. The Hg–S bond distances (2.42 ± 0.02 Å) are in agreement with other mercury-thiolate compounds with a coordination number of 3.

THREE-DIMENSIONAL STRUCTURES OF MERB

NMR sample

Samples for NMR studies contained 1.0–1.5 mM of MerB ([15]N- or [15]N/[13]C-labeled) in NMR buffer (10 mM sodium

phosphate pH = 7.5, 10 mM NaCl, 7.5 mM DTT, and 1 mM EDTA (ehylenediaminetetraacetic acid)) and 90% H_2O /10% D_2O or 99.9% D_2O. For measurements of residual dipolar couplings (RDC) the protein was oriented using Pf1 phage (11 mg mL^{-1}).[29]

NMR structure

The three-dimensional structure of MerB in solution is characterized by the presence of six α-helices and three antiparallel β-sheets arranged into a unique fold (Figure 3(a)).[29] The closest structural homolog identified to date is the copper-binding protein NosL (PDB codes 2HPU and 2HQ3), which has a backbone root mean square deviation (r.m.s.d.) of 3.0 Å with respect to the main core of MerB.[23] From a structural point of view, MerB shows two apparently distinct sections, the amino-terminal region and the main core of the protein. The amino-terminal region of MerB adopts a highly helical fold with three α-helices located between residues 26–32 (α1), 39–46 (α2), and 50–58 (α3), followed by a short and highly twisted β-sheet (Sheet A) involving residues 65–66 (β1) and 70–71 (β2). This short β-sheet is packed against the loop connecting helices α1 and α2. The αααββ topology that characterizes the amino-terminal region of MerB is further stabilized by a number of hydrophobic interactions involving the side chains of α1, α2, and α3 (Figure 3(a)). In the main core of the protein, a second five-stranded β-sheet (Sheet B) is formed by residues 83–87 (β3), 90–94 (β4), 111–116 (β5), 123–128 (β6), and 133–137 (β7), whereas three shorter strands, β8 (residues 142–145), β9 (residues 163–165), and

β10 (residues 185–188), form the third antiparallel β-sheet (Sheet C). The two major β-sheets (B and C) are oriented almost perpendicular to each other and this overall fold is stabilized by hydrophobic interactions involving residues from β5, β6, and β9. An additional α-helix (α5), formed by residues 168–176, packs against the three-stranded β-sheet (Sheet C), whereas a sixth α-helix (α6) is located at the carboxy-terminus of the protein and it extends between residues 189–204 (Figure 3(a)).

The pairwise r.m.s.d. for the ensemble of the 20 lowest energy structures of the amino-terminal region (residues 26–58 and 64–72) is 0.70 ± 0.20 Å (backbone atoms) and 1.64 ± 0.18 Å (heavy atoms), whereas for the main core (residues 83–94, 105–145, 162–177, and 185–202), it is 0.61 ± 0.14 Å (backbone atoms) and 1.39 ± 0.13 Å (heavy atoms). The amino-terminal region of MerB (residues 26–72), although well characterized within the local elements of secondary structure, is less precisely defined with respect to the main core of the protein by the NMR data set. This is because of the limited number of NMR restraints involving this region and the main core of the protein. As a result, the global pairwise r.m.s.d. for the amino-terminal region and main core taken together increases to 1.26 ± 0.35 Å for the backbone atoms and 1.87 ± 0.28 Å for all the heavy atoms (Figure 3(b)).

As already mentioned, the limited number of NMR restraints causes portions of the amino-terminal region as well as the main core (residues 73–82, 95–104, 146–161, and 178–184) to be poorly defined. However, for the two regions encompassing residues 73–82 and 95–104, the chemical shift index (CSI) prediction as well as the amide exchange and dynamics data suggest the presence of

(a) (b)

Figure 3 NMR structure of MerB (a) Ribbon model of one representative structure of MerB from the ensemble of the 20 lowest energy structures. (b) Overlay of the 20 lowest energy structures. The structures were superimposed using the backbone atoms C′, Cα, and N of residues 26–58, 64–72, 83–94, 105–145, 162–177, and 185–202. The figures were prepared using MOLMOL.[31] (Reproduced from Ref. 29. © American Chemical Society, 2004.)

a stable fold.[29] The consensus CSI predicts a β-strand involving residues 76–78 and the hydrogen–deuterium exchange data indicate that several amide protons of residues in the two regions are protected from exchange with the solvent, either as a result of a direct involvement in hydrogen bonds formation or as being part of the protein core. Supporting these results, dynamics data indicate the absence of backbone flexibility on fast timescales (pico- to nanoseconds). Although the CSI predicts an α-helix conformation for several amino acids in the long loop between residues 146 and 161, the NOEs (Nuclear Overhauser Effects) typical of this type of secondary structure are absent. In addition, the dynamics data indicate backbone flexibility, thus pointing to a conformational heterogeneity for this region.

Overall the NMR studies provide an accurate description of the structural features of MerB in solution. However, for residues 1–25, for which very limited resonance assignment was achieved, no structural information was derived from the NMR data. Interestingly, this region is predicted to adopt an α-helical conformation based on the primary sequence and an α-helix spanning residues 3–14 is indeed observed in the X-ray structure of the MerB (see description below).[2] It is possible that the amino-terminal α-helix is also present in the solution structure of MerB, but under the experimental conditions used for the NMR studies it was not observed. In fact, at high pH values (7.5) the rapid amide proton exchange could have been the cause of the dramatic reduction observed in signal intensity. Another possibility is that the amino-terminal α-helix is only partially formed in solution and in rapid exchange between different conformational states. This would lead to severe line broadening and compromise the structural information derived by the NMR studies. In this respect, the crystal structure of free MerB may provide a more complete picture of the overall fold of the protein.

X-RAY STRUCTURE

Crystallization

Crystals of the free form were prepared with the recombinant MerB originating from the R831b plasmid. Crystals were grown by vapor diffusion from a solution buffered at pH 5.5 containing polyethylene glycol monomethyl ether (PEG 2000 MME), potassium bromide, and sodium acetate. The crystals diffracted to a resolution of 1.76 Å and formed the monoclinic space group $P2_1$ with unit cell dimensions $a = 38.7$ Å, $b = 90.0$ Å, $c = 52.2$ Å, and $\beta = 100.5°$. MerB forms a homodimer in the unit cell, with a twofold noncrystallographic symmetry between the two identical subunits. Nevertheless, experimental evidences show that MerB is a monomer in solution.[3,29]

Overall structure

The crystal structure of MerB (Figure 4), solved at 1.76 Å resolution (Table 1), is highly similar to the solution structure described above (Figure 3). The structure of the free form is shown schematically in the 3D structure. The topologies are identical and the independent alignments of the amino-terminal region and the main core give low r.m.s.d. values. However, the most significant differences occur in the amino-terminal region (Figure 4(a) and (b)). First, the crystal structure is more compact and the amino-terminal region is closer to the main core of the protein (Figure 4(b)). Second, in the crystal structure residues 3–14 form an α-helix and this helix is positioned over the active site establishing hydrophobic interactions with many residues of the main core of the protein. In contrast, under the experimental conditions chosen, these first 25 amino acids that are clearly defined in the crystal structure could not be defined in the NMR solution structure (Figure 4(a)).

Another important difference between the crystal structure and the NMR structure occurs in the large loop (residues 146–161) adjacent to the active site. Very few NMR restraints were determined for this loop in the NMR experiments and it is not well defined in the solution structure. As discussed above, this was probably because of the highly dynamic nature of this region. In the crystal structure, this loop clearly forms a short α-helix that is stabilized through hydrophobic interactions with the amino-terminal helix formed by residues 3–14 (Figure 4(b)).

It has been postulated that differences between the solution NMR and the crystal structures might be the key

Table 1 List of all MerB structures including metal complexes and mutants. The PDB codes are from January 2010

Protein	Form	Technique	Resolution (Å)	PDB code	Reference
WT	Free	NMR	–	1S6L	29
WT	Free	X-ray	1.76	3F0O	2
WT	Hg (from a PHMBA soak)	X-ray	1.64	3F0P	2
WT	Hg (from a MeHg soak)	X-ray	1.98	3F2F	2
C160S	Free	X-ray	1.78	3F2G	2
C160S	Hg (from a PHMBA soak)	X-ray	2.00	3F2H	2
WT	Hg (from cocrystallization)	X-ray	1.88	3FN8	PDB

PHMBA, p-(hydroxymercuri) benzoate.

Figure 4 Comparison of NMR and crystal structures of MerB. Ribbon representations of the NMR solution structure (a) and the X-ray crystal structure (b) of the free form of MerB (Reproduced from Ref. 29. © American Chemical Society, 2004 and Reproduced from Ref. 2. © American Society for Biochemistry and Molecular Biology, 2009, respectively.) The differences between the two structures are highlighted in yellow. In the NMR structure (a), the highlighted region encompasses residues 146–161 (loop) and in the crystal structure (b) the highlighted regions encompass residues 1–21 (helix) and residues 146–161 (loop).

for a more comprehensive understanding of the catalytic mechanism of MerB. In solution, the amino-terminal helix (residues 3–14) and the loop 146–161 are highly mobile, so that MerB could easily access an "open" conformation in the absence of a ligand. The crystal structure shows a thermodynamically stabilized form in a "closed" conformation that could be adopted in the presence of ligands or products. The change between an open and a closed

conformation is supported by NMR mapping studies of the MerB–Hg–DTT complex.[27,29] If racemic DTT is used to prepare the MerB–Hg–DTT complex, one observes several residues of MerB giving pairs of peaks of equal intensity in the (^1H–^{15}N)-HSQC (heteronuclear single quantum coherence spectroscopy) spectra. In contrast, if optically active L-DTT is used, only one member of each pair of peaks remains. These peaks correspond to the amino acids that are

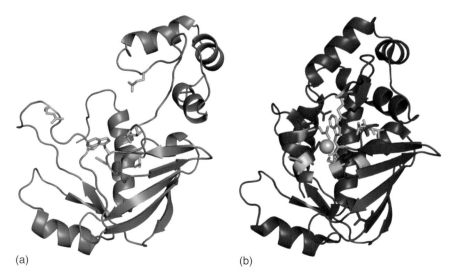

Figure 5 Location of the residues near DTT in the MerB–Hg–DTT complex. (a) Ribbon representation of the NMR solution structure of MerB (green) with the side chains of residues Glu64, Leu76, Thr77, Trp95, Cys96, Thr100, Arg155, and Cys160 highlighted (orange). These highlighted residues display two peaks in the 2D (^1H–^{15}N HSQC) spectrum of the MerB–Hg–DTT complex formed with racemic DTT. (Reproduced from Ref. 27 and Ref. 29. © American Chemical Society, 2004.) (b) The same residues listed in (a) are colored in orange in the X-ray structure of the MerB–Hg complex. (Reproduced from Ref. 2. © American Society for Biochemistry and Molecular Biology, 2009.)

in proximity of the DTT molecule in the MerB–Hg–DTT complex. Mapping these amino acids onto the NMR structure (Figure 5(a)) and crystal structure (Figure 5(b)) highlights the location of the DTT binding site. In the NMR structure, DTT appears to bind a quite large area of the protein, but in the crystal structure these same residues define a much smaller binding site that is close to the catalytic site. This difference is consistent with the hypothesis that the amino-terminal region (residues 1–25) as well as the loop 146–161 of MerB are in exchange between an open and a closed conformation in solution, but are trapped in a closed conformation in the crystal structure. This hypothesis could also explain how MerB protects its surroundings from the toxic mercury product.

Active site structure

The high resolution of the crystal structure clearly defines the active site and the residues important for catalytic activity.[2] As predicted from mutagenesis studies, Cys96 and Cys159 are both present in the active site with their sulfur atoms pointing toward each other (Figure 6).[8] Surprisingly, the side chains of the residues creating the immediate pocket around the two catalytically important cysteines for the most part do not contain any charged or labile protons. One exception is Asp99, which is adjacent to Cys96 with one of the oxygen atoms of its carboxyl group within 3.5 Å of the sulfur atom (Figure 6). This spatial proximity suggests that Asp99 could have a crucial function in catalysis. The other striking characteristic is the hydrophobic nature of the majority of the side chains present in the active site.

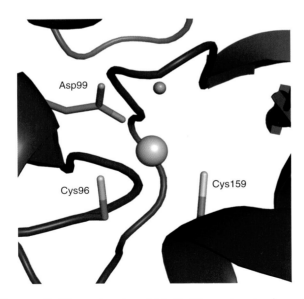

Figure 6 The active site of MerB. The active site from the mercury-bound form of MerB demonstrating the relative location the three residues in the catalytic triad (Cys96, Asp99, and Cys159). (Reproduced from Ref. 2. © American Society for Biochemistry and Molecular Biology, 2009.)

The active site is almost completely buried inside the core of the protein and it appears to be rather inaccessible to the solvent. This suggests that substrate binding would require a fairly dramatic conformational change of either the amino-terminal helix (residues 3–14) or the large loop encompassing residues 146–161.

FUNCTIONAL ASPECTS

Role of other components of the *mer* system

As mentioned earlier, the bacterial resistance to organomercurials and ionic mercury resides in a series of proteins with specific roles in the detoxification pathway. The genes encoding for these proteins are clustered in a plasmid-carried operon, and although the organization of the genes may vary in different bacteria, the common ones, found in all operons, encode for the mercuric ion transport proteins MerP and MerT, the mercuric reductase MerA, the regulatory protein MerR, and, in the "broad spectrum" bacteria, the lyase MerB (Figure 7).

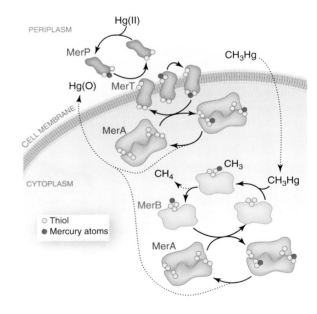

Figure 7 The *mer* system. The proteins of the *mer* system depend on thiols for high-affinity binding to mercury compounds. Ionic mercury (Hg(II)) is bound in the periplasmic space by MerP and then transferred to MerT for transport across the membrane. In the cytosol, Hg(II) is transferred from MerT to MerA. MerA reduces Hg(II) to elemental mercury (Hg(0)), which is volatile and easily eliminated. Methylmercury (CH$_3$Hg) directly enters the cytosol, where it binds to MerB. MerB uses thiols to cleave the carbon–mercury bond. This cleavage generates methane and Hg(II). The latter remains bound to MerB until it is transferred to MerA for reduction to Hg(0). (Reproduced from Ref. 32. © American Association for the Advancement of Science, 2007.)

The regulatory protein MerR binds to the operator region of the *mer* operon repressing its own transcription as well as that of the detoxification genes.[33] MerR is a dimeric protein that is extremely sensitive and selective for binding ionic mercury.[34] MerR can form an asymmetric complex at nanomolar concentrations of ionic mercury. The ionic mercury is coordinated to the sulfur atoms of three cysteine residues of MerR, one from first monomer and the other two from the second monomer.[35,36] Upon binding to mercury, MerR induces a conformational change in the MerR–DNA–RNAP complex allowing the preassociate RNA polymerase (RNAP) to initiate transcription of the detoxification genes.[37]

MerP and MerT are the two proteins involved in transporting mercury inside the cell (Figure 7).[38] MerP is a small periplasmic protein (72 amino acids) that plays an important role as an ionic mercury scavenger.[39] MerP also protects periplasmic and membrane proteins from binding ionic mercury.[40] Structural studies show that this protein binds ionic mercury through two cysteine residues forming a complex in which the mercury is bicoordinated to two sulfur atoms and in a close to linear conformation.[41] Following the binding of ionic mercury, MerP specifically interacts with the integral membrane protein MerT to facilitate mercury transport across the cell membrane.[42]

MerT is the second major player in ionic mercury uptake. Although no structural information is available to date, it is thought that this protein helps mercury translocation through the cell membrane using two pairs of cysteines, one predicted to be in a transmembrane region accessible from the periplasmic side and the other one predicted to be located in a loop on the cytoplasmic side of the inner membrane (Figure 7). Recent studies also suggest a direct transfer of ionic mercury from MerT to MerA.[43] Organomercurials, because of their hydrophobicity, are permeable to the cell membrane and they can easily enter the cytosol without a dedicated transport system.

Once the ionic mercury and/or organomercurial salts are in the cytoplasm, the actual detoxification steps take place; the lyase MerB cleaves the organomercurials into mercuric ion, and the corresponding aliphatic/aromatic compound and the mercuric ion reductase MerA reduces the ionic mercury to elemental mercury. As observed with the transfer of ionic mercury between MerP to MerT and MerT to MerA,[42,43] MerB is able to transfer the mercuric ion directly to MerA without prior release.[27] All of these direct transfers of the ionic mercury between the various components of the *mer* system would serve to limit the interactions of the ionic mercury with protein sulfhydryls and thus minimize possible adverse reactions within the organism (Figure 7).

Substrate specificity of MerB

Initial *in vitro* mechanistic studies using purified recombinant protein and an extensive array of organomercurial compounds demonstrated that MerB cleaves carbon–mercury bonds through a concerted S_E2 (electrophilic substitution) mechanism.[4] In this mechanism, the proton attacks the carbon atom of the carbon–mercury bond from the same side as the mercury atom. This type of mechanism proceeds with retention of stereochemistry about the α-carbon atom, and electron-donating groups on the α-carbon can generally enhance the enzymatic activity. In contrast, slower rates are observed with β-substituted compounds, and this is most likely due to steric reasons. For the substrates tested, turnover numbers in the range $1–240\,min^{-1}$ were measured. The enzyme is relatively insensitive to the structure of the substrate and one observes relatively similar K_m (0.5 to 3.0 mM) and V_{max} (turnover numbers between $1–30\,min^{-1}$) values for a wide range of structurally diverse organomercurial compounds. The biggest difference seen was a significant rate enhancement for substituted alkenyl mercurials and this is most likely due to a stabilization of a transition state by the C2 methyl substituent. In addition, there was no correlation observed between the rate of chemical protonolysis, the bond strength, and the enzymatic rates observed.

Role of thiols on MerB activity *in vitro*

The *in vitro* studies with MerB demonstrated a need for the presence of an exogeneous monothiol in order to have enzyme turnover and most physiological thiols such as cysteine and glutathione promoted turnover.[3,27] In contrast, dithiols are unable to promote turnover and DTT inhibits turnover even in the presence of excess monothiols.[3,27] The inhibition of MerB by DTT is most likely due to the formation of a stable MerB–Hg–DTT complex involving the two sulfhydryls present on DTT.[27] In addition, MerB turnover rates *in vitro* are increasing even at exogenous monothiol concentrations as high as 20 mM, and it is postulated that exogenous thiols play a role in substrate binding, product release, and in preventing nonspecific binding of the ionic mercury product to the protein.[3]

FUNCTIONAL DERIVATIVES

X-ray structure of the MerB-Hg complex

Crystallization and complex formation

The structures of several MerB–Hg complexes were determined by soaking MerB crystals in a solution of an organomercurial with or without exogenous thiols.[2] Two of the structures have been published, one at 1.64 Å resolution and the other at 1.97 Å resolution (Table 1). Soaking the MerB crystals with multiple combinations of organomercurial and thiols always resulted in the same

MerB–Hg species without exception. These experiments proved that the crystal form of MerB was still catalytically active and that mercury product release could be a rate-limiting step in the reaction. Another crystal structure of a MerB–Hg complex has also been deposited in the Protein Data Bank (code 3FN8), but the details of the structure determination have not been published. According to the information in the database, MerB was incubated with ionic mercury prior to crystallization and the crystals diffracted to 1.88 Å (Table 1).

In all of the crystals containing the MerB–Hg complex, the space group is the same (P2$_1$) and the unit cell parameters do not vary much in comparison to the free form. All MerB–Hg complexes are highly similar to each other. The only difference is in the 3FN8 structure, which contains a molecule of glycerol in the active site, whereas a bound water molecule is found in all of the other crystal structures of MerB (Table 1).

Mercury site geometry

In the structures of the MerB–Hg complex, one mercury ion is bound to the active site of MerB and no trace of the hydrocarbon moiety of the organomercurial substrate is observed.[2] The mercury is in the center of a planar-trigonal geometry coordinated to two sulfur atoms, one from Cys96 and one from Cys159, and an oxygen atom from a water molecule (Figure 6). The distances from the mercury to the three coordinating atoms are 2.3 Å, 2.4 Å, and 2.6 Å, respectively and the angles formed by the three coordinated groups are all around 120°. A similar geometry has been suggested for the MerR–Hg complex on the basis of mutational analysis.[35] In MerR, mercury is bound by three sulfur atoms, two from one molecule of MerR and the third sulfur atom from a second molecule of MerR. This is in contrast to what is observed in the structures of the MerP–Hg complex[41] and synthetic compounds mimicking MerB's cleavage step,[44–46] where mercury is either in a linear-bicoordinate geometry coordinated to two sulfur atoms (MerP–Hg) or in a pseudotetrahedral geometry (synthetic compounds).

X-ray structures of cysteine mutants

Three cysteine mutants (Cys96Ser, Cys159Ser, and Cys160Ser) have been crystallized and all of them had virtually identical structures as the free form of wild-type MerB (Table 1). Unlike the crystals with wild-type MerB,[2] the crystals formed by the Cys96Ser and Cys159Ser mutants displayed no catalytic activity when exposed to organomercurial agents and this is consistent with in vitro enzymatic studies of these two mutants. Furthermore, there was also no evidence for substrate binding with either of these two cysteine mutants, which supports the theory that these

two cysteine residues play a role in both substrate binding and catalytic activity.[8] On the other hand, the Cys160Ser mutant formed a mercury-bound complex following exposure to organomercurial compounds and this demonstrated that the mutant was still catalytically active (Table 1). This result was also consistent with in vitro enzymatic assays and demonstrates that Cys160 is not absolutely essential for substrate binding or catalytic activity.[8]

Mechanism of carbon–mercury bond cleavage

Extensive biochemical and structural studies have helped gain a better understanding of the catalytic mechanism for MerB. On the basis of these experiments, it was proposed that the process begins with the binding of organomercurial compound by an endogenous thiol to generate the substrate. The substrate then binds to two nucleophilic moieties present in MerB and this results in displacement of the bound endogenous thiol and the formation of a trigonally coordinated mercury species. Mutational studies demonstrated that the two nucleophiles used by MerB to activate the organomercurial substrate for protonolysis are sulfhydryl groups from two strictly conserved cysteines (Cys96 and Cys159 in the MerB from the R831b)[8] and this was subsequently supported by structural studies.[2,29] On the basis of the crystal structures of free and mercury-bound MerB,[2] it was proposed that the organomercurial substrate initially binds to Cys96 that is located at the amino-terminal of an α-helix, in proximity of Asp99 (Figure 8(a)). Owing to the helix dipole, the pK_a of Cys96 is most likely lower than what is typically observed for a cysteine residue. This lowering of the pK_a could facilitate deprotonation of the sulfyhdryl group of Cys96 by Asp99 and lead to the formation of a nucleophilic thiolate that binds the organomercurial substrate in the first step of the catalytic process (Figure 8(b)). The subsequent or concomitant attack of a second thiolate from the other conserved cysteine (Cys159) leads to the displacement of the exogenous thiol and to the formation of the activated MerB/R–Hg adduct, which is characterized by the trigonally coordinated mercury atom (Figure 8(b)). Once the trigonally coordinated mercury intermediate is formed, the activated carbon is easily protonated by Asp99 (Figure 8(b)). The final step of the reaction involves the release of the hydrocarbon product. In this mechanism, Asp99 plays an essential function in the catalysis; it serves as a proton mediator by first deprotonating the sulfhydryl group of Cys96 and then donating this proton back to the organomercurial carbon moiety in the final step of the protonolysis (Figure 8(b)).

Using the crystal structure as a starting point for quantum chemical calculations, two similar mechanisms have been proposed.[30] In the first mechanism, the Cys96 thiolate first binds the substrate followed by the binding of the Cys159 thiolate. However, the calculations predict that Asp99

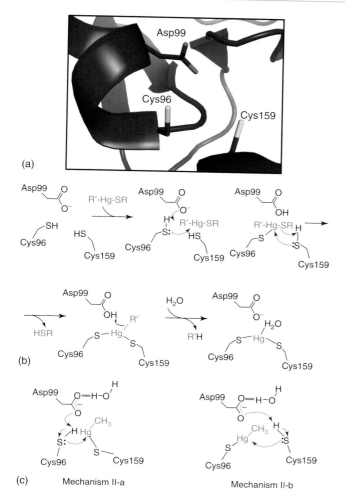

(a)

(b)

(c) Mechanism II-a Mechanism II-b

Figure 8 Mechanism of carbon–mercury bond cleavage (a) Ribbon representation of the active site in the crystal structure of free MerB. (Reproduced from Ref. 2. © American Society for Biochemistry and Molecular Biology, 2009.) The side chain of the three residues (Cys96, Asp99, and Cys159) involved in the catalytic process are highlighted in sticks. (b) Mechanism of carbon–mercury bond cleavage based on the crystallographic analysis of MerB (wild-type and cysteines mutants). (Reproduced from Ref. 2. © American Society for Biochemistry and Molecular Biology, 2009.) (c) Alternative mechanisms proposed for the initial steps of the catalysis. (Reproduced from Ref. 30. © American Chemical Society, 2009.)

would mediate the deprotonation of Cys159 instead of Cys96, in a concerted, water-assisted process (Figure 8(c)). In the second proposed mechanism, the calculations predict that the Cys159 thiolate is involved in the initial binding to the substrate and that Asp99 extracts the proton from Cys96 leading to the formation of a second thiolate that attacks the mercury atom and activates the carbon–mercury bond for protonolysis (Figure 8(c)).

Despite the subtle differences in the initial steps of the catalysis, all of the proposed mechanisms agree on the crucial role of the catalytic triad consisting of Cys96, Cy159, and Asp99. The role for the carboxylate group of

Asp99 serving a function in carbon–mercury bond cleavage is consistent with studies demonstrating that carboxylate bases are able to assist in organomercurials protonolysis *in vitro*.[47]

Likewise, the formation of the mercury species trigonally coordinated by two sulfur atoms and one carbon atom is supported by studies examining the general properties of carbon–mercury bonds. Quantum mechanical calculations predict that when the coordination number for mercury is greater than two, the carbon–mercury bond polarity ($C^{\delta-}$–$Hg^{\delta+}$) is enhanced, and this makes the carbon more susceptible to protonation.[48–50] These predictions are confirmed by experimental studies demonstrating the high rate of protonolysis of the carbon–mercury bond in synthetic alkyl compounds like [Tm^{But}]HgR [alkyl mercury tris(2-mercapto-1-*t*-butylimidazolyl)hydroborato], in which mercury forms a pseudotetrahedral coordinated structure.[44–46]

The last step of the reaction mechanism is the release of the product mercury. Currently, the two proposed mechanisms for the release of the ionic mercury are by endogenous thiols or by direct shuttling to MerA. Although both mechanisms have been shown to occur *in vitro*, the direct shuttling of the reactive ionic mercury is more logical for the ultimate survival of the organism and it is also supported by a number of *in vitro* observations. First, it is clear from the X-ray studies that passive diffusion of the ionic mercury from the active site is slow.[2] Second, *in vitro* kinetic studies demonstrated that MerB activity was still increasing with cysteine concentration up to 20 mM and in most cases this is significantly above normal physiological levels.[3,4,8] Third, experiments demonstrated that it was very difficult to remove DTT from the active site of the MerB–Hg–DTT complex using endogenous thiols such as cysteine or glutathione, but the direct shuttling of ionic mercury from the MerB–Hg–DTT complex to MerA was faster than free ionic mercury binding to MerA.[27] Further experiments aimed at understanding the mechanism by which the ionic mercury product from MerB is transferred to MerA are crucial to exploiting the full potential of MerA and MerB in bioremediation efforts to clean up methylmercury contamination.

ACKNOWLEDGEMENTS

J.G.O. is supported by a grant from the Natural Science and Engineering Council of Canada, J.L.-V. is a recipient of a predoctoral fellowship from the FQRNT, and P.D.L is recipient of a Postdoctoral Fellowship from the CIHR.

REFERENCES

1 WL DeLano, *The PyMOL Molecular Graphics Systems*, DeLano Scientific, Palo Alto, CA (2002).

2 J Lafrance-Vanasse, M Lefebvre, P Di Lello, J Sygusch and JG Omichinski, *J Biol Chem*, **284**, 938–44 (2009).

3 TP Begley, AE Walts and CT Walsh, *Biochemistry*, **25**, 7186–92 (1986).

4 TP Begley, AE Walts and CT Walsh, *Biochemistry*, **25**, 7192–200 (1986).

5 AE Walts and CT Walsh, *J Am Chem Soc*, **110**, 1950–53 (1988).

6 J Schottel, A Mandal, D Clark, S Silver and RW Hedges, *Nature*, **251**, 335–37 (1974).

7 JL Schottel, *J Biol Chem*, **253**, 4341–49 (1978).

8 KE Pitts and AO Summers, *Biochemistry*, **41**, 10287–96 (2002).

9 T Barkay, SM Miller and AO Summers, *FEMS Microbiol Rev*, **27**, 355–84 (2003).

10 WJ Jackson and AO Summers, *J Bacteriol*, **151**, 962–70 (1982).

11 AO Summers, *Annu Rev Microbiol*, **40**, 607–34 (1986).

12 NL Brown, JV Stoyanov, SP Kidd and JL Hobman, *FEMS Microbiol Rev*, **27**, 145–63 (2003).

13 K Furukawa and K Tonomura, *Agr Biol Chem*, **35**, 604–10 (1971).

14 B Fox and CT Walsh, *J. Biol. Chem.*, **257**, 2498–503 (1982).

15 K Furukawa and K Tonomura, *Biochim Biophys Acta*, **325**, 413–23 (1973).

16 T Tezuka and K Tonomura, *J Biochem*, **80**, 79–87 (1976).

17 T Tezuka and K Tonomura, *J Bacteriol*, **135**, 138–43 (1978).

18 P Brunker, D Rother, R Sedlmeier, J Klein, R Mattes and J Altenbuchner, *Mol Gen Genet*, **251**, 307–15 (1996).

19 HI Ogawa, CL Tolle and AO Summers, *Gene*, **32**, 311–20 (1984).

20 CC Huang, M Narita, T Yamagata and G Endo, *Gene*, **239**, 361–66 (1999).

21 JD Thompson, DG Desmond, G Higgins and TJ Gibson, *Nucleic Acids Res*, **22**, 4673–4680 (1994).

22 P Wunsch, M Herb, H Wieland, UM Schiek and WG Zumft, *J Bacteriol*, **185**, 887–96 (2003).

23 LM Taubner, MA McGuirl, DM Dooley and V Copie, *Biochemistry*, **45**, 12240–52 (2006).

24 M Kiyono and H Pan-Hou, *Biol Pharm Bull*, **22**, 910–14 (1999).

25 M Kiyono, T Omura, M Inuzuka, H Fujimori and PH Hidemitsu, *Gene*, **189**, 151–57 (1997).

26 Y Wang, M Moore, HS Levinson, S Silver, C Walsh and I Mahler, *J Bacteriol*, **171**, 83–92 (1989).

27 GC Benison, P Di Lello, JE Shokes, NJ Cosper, RA Scott, P Legault and JG Omichinski, *Biochemistry*, **43**, 8333–45 (2004).

28 P Di Lello, GC Benison, JG Omichinski and P Legault, *J Biomol NMR*, **29**, 457–58 (2004).

29 P Di Lello, GC Benison, H Valafar, KE Pitts, AO Summers, P Legault and JG Omichinski, *Biochemistry*, **43**, 8322–32 (2004).

30 JM Parks, H Guo, C Momany, LY Liang, SM Miller, AO Summers and JC Smith, *J Am Chem Soc*, **131**, 13278–85 (2009).

31 R Koradi, M Billeter and K Wüthrich, *J Mol Graph*, **14**, 51–55 (1996).

32 JG Omichinski, *Science*, **317**, 205–6 (2007).

33 AO Summers, *J Bacteriol*, **174**, 3097–101 (1992).

34 DM Ralston and TV O'Halloran, *P Natl Acad Sci USA*, **87**, 3846–50 (1990).

35 JD Helmann, BT Ballard and CT Walsh, *Science*, **247**, 946–48 (1990).

36 LM Utschig, JW Bryson and TV O'Halloran, *Science*, **268**, 381–85 (1995).

37 AZ Ansari, JE Bradner and TV O'Halloran, *Nature*, **374**, 371–75 (1995).

38 NV Hamlett, EC Landale, BH Davis and AO Summers, *J Bacteriol*, **174**, 6377–85 (1992).

39 S Silver and M Walderhaug, *Bacterial Plasmid-mediated Resistances to Mercury, Cadmium and Copper*, Springer-Verlag, Berlin (1995).

40 SM Miller, *Essays Biochem*, **34**, 17–30 (1999).

41 RA Steele and SJ Opella, *Biochemistry*, **36**, 6885–95 (1997).

42 AP Morby, JL Hobman and NL Brown, *Mol Microbiol*, **17**, 25–35 (1995).

43 E Rossy, O Seneque, D Lascoux, D Lemaire, S Crouzy, P Delangle and J Coves, *FEBS Lett*, **575**, 86–90 (2004).

44 J Melnick and G Parkin, *Science*, **317**, 225–27 (2007).

45 JG Melnick, K Yurkerwich and G Parkin, *Inorg Chem*, **48**, 6763–72 (2009).

46 H Strasdeit, *Angew Chem Int Edit*, **47**, 828–30 (2008).

47 E Gopinath and TC Bruice, *J Am Chem Soc*, **109**, 7903–905 (1987).

48 V Barone, A Bencini, F Totti and MG Uytterhoeven, *J Phys Chem*, **99**, 12743–50 (1995).

49 M Wilhelm, S Deeken, E Berssen, W Saak, A Lützen, R Koch and H Strasdeit, *Eur J Inorg Chem*, **2004**, 2301–12 (2004).

50 B Ni, JR Kramer, RA Bell and NH Werstiuk, *J Phys Chem A*, **110**, 9451–58 (2006).

List of Contributors

Dietmar Abt
Universität Konstanz, Konstanz, Germany

Mario L Amzel
Department of Biophysics and Biophysical Chemistry, Johns Hopkins School of Medicine, Johns Hopkins University, Baltimore, MD 21205, USA

Susana LA Andrade
Institut für Mikrobiologie und Genetik, Georg-August-Universität Göttingen, Göttingen, Germany

Svetlana V Antonyuk
Molecular Biophysics Group, Daresbury Laboratory, Warrington, Cheshire WA4 4AD, UK

Margarida Archer
Instituto de Tecnologia Química e Biológica, Universidade Nova de Lisboa, Av. República, 2780-157, Oeiras, Portugal

Matteo Ardini
Department of Biochemical Sciences "A. Rossi Fanelli", "Sapienza" University of Rome, Italy

Fabio Arnesano
Department of Pharmaceutical Chemistry, University of Bari, Bari, Italy

Sally J Atkinson
EaStCHEM, School of Chemistry, University of Edinburgh, West Mains Road, Edinburgh, UK

Lucas J Bailey
Department of Biochemistry, University of Wisconsin Madison, WI 53706, USA

Jocelyn Baldwin
Astbury Centre for Structural Molecular Biology, Institute of Membrane and Systems Biology, University of Leeds, Leeds LS2 9JT, UK

Stephen A Baldwin
Astbury Centre for Structural Molecular Biology, Institute of Membrane and Systems Biology, University of Leeds, Leeds LS2 9JT, UK

Lucia Banci
Magnetic Resonance Center (CERM) and Department of Chemistry, University of Florence, Florence, Italy

Danas Baniulis
Department of Biological Sciences, Purdue University, West Lafayette, IN 47907, USA

Kevin J Barnham
Department of Pathology, University of Melbourne, Parkville, Victoria 3010, Australia
and
Bio21 Molecular Science and Biotechnology Institute, University of Melbourne, Victoria 3010, Australia
and
Mental Health Research Institute of Victoria, Parkville, Victoria 3052, Australia

Mark Bartlam
Tianjin Key Laboratory of Protein Science, College of Life Sciences, Nankai University, Tianjin 300071, China

Vladimir V Barynin
The Krebs Institute, Department of Molecular Biology and Biotechnology, University of Sheffield, Firth Court, Western Bank, Sheffield S10 2TN, UK

Ulrich Baumann
Departement für Chemie und Biochemie, Universität Bern, Berne, Switzerland

Oliver Beckstein
Structural Bioinformatics and Computational Biochemistry Unit, Department of Biochemistry, University of Oxford, South Parks Road, Oxford OX13QU, UK

Derk Bemeleit
Gene Center and Center for Integrated Protein Science, Department of Chemistry and Biochemistry, Ludwig-Maximilians-University Munich, Feodor-Lynen-Str. 25, 81377 Munich, Germany

Isabel Bento
Instituto de Tecnologia Química e Biológica, Universidade Nova de Lisboa, Av. da República, 2781-901 Oeiras, Portugal

Michela Bertero
Centre for Genomic Regulation, Barcelona, Spain

Christoph Bieniossek
Departement für Chemie und Biochemie, Universität Bern, Berne, Switzerland
and
Institute of Biophysics and Molecular Biology, Swiss Federal Institute of Technology, Zurich, Switzerland

Jacek Biesiadka
Institut für Chemie und Biochemie–Kristallographie, Freie Universität Berlin, Takustrasse 6, 14195 Berlin, Germany

Andrew N Bigley
Department of Chemistry, Texas A&M University, College Station, TX, USA

Leah C Blasiak
Department of Chemistry, Massachusetts Institute of Technology, Cambridge, MA 02139, USA

Matthias Boll
Institute of Biochemistry, University of Leipzig, Leipzig, Germany

Florence Bonnot
Laboratoire de Chimie et Biologie des Métaux, IRTSV-CEA, CNRS, Université J. Fourier, 17 rue des Martyrs, 38054 Grenoble, France

Dominique Bourgeois
Institut de Biologie Structurale Jean-Pierre Ebel, CEA, CNRS, Université Joseph Fourier, 41 rue Jules Horowitz, 38027 Grenoble, France

Konstantin M Boyko
A.N. Bach Institute of Biochemistry of Russian Academy of Sciences, Moscow, Russian Federation

Fabrizio Briganti
Dipartimento di Chimica, Università di Firenze, Via della Lastruccia 3, I-50019 Sesto Fiorentino (FI), Italy

Chiara Bruckmann
EaStCHEM, School of Chemistry, University of Edinburgh, West Mains Road, Edinburgh, UK

Luigi Bubacco
Department of Biology, University of Padova, Via Ugo Bassi 58b, 35121, Padova, Italy

Thomas Büchert
Universität Konstanz, Konstanz, Germany

Wolfgang Buckel
Laboratorium für Mikrobiologie, Fachbereich Biologie, Philipps-Universität Marburg, Germany

Alexander D Cameron
Biochemistry Department, South Kensington Campus, Imperial College London University, London SW7 2AZ, UK

Gerard W Canters
Leiden Institute of Chemistry, Leiden University, Gorlaeus Laboratories, Einsteinweg 55, 2333 CC Leiden, The Netherlands
and
Leiden Institute of Physics, Leiden University, Huygens Laboratory, Niels Bohrweg 2, 2333 CA Leiden, The Netherlands

Roberto Cappai
Department of Pathology, University of Melbourne, Parkville, Victoria 3010, Australia
and
Centre for Neuroscience, University of Melbourne, Victoria 3010, Australia
and
Bio21 Molecular Science and Biotechnology Institute, University of Melbourne, Victoria 3010, Australia
and
Mental Health Research Institute of Victoria, Parkville, Victoria 3052, Australia

Jenna K Capyk
Department of Biochemistry and Molecular Biology, University of British Columbia, Vancouver, British Columbia, Canada

Maria Arménia Carrondo
Instituto de Tecnologia Química e Biológica, Universidade Nova de Lisboa, Oeiras, Portugal

Christine Cavazza
Institut de Biologie Structurale, Grenoble, France

Pierpaolo Ceci
C.N.R. Institute of Molecular Biology and Pathology, Rome, Italy

Eric Chabriere
Université Henri Poincaré, Nancy, France

Stephen K Chapman
EaStCHEM, School of Chemistry, University of Edinburgh, West Mains Road, Edinburgh, UK

Eduardo E Chufán
Department of Biophysics and Biophysical Chemistry, Johns Hopkins School of Medicine, Johns Hopkins University, Baltimore, MD 21205, USA

David Cobessi
Institut de Biologie Structurale, CNRS-CEA-Université
Joseph Fourier, 41, Rue Jules Horowitz, 38027 Grenoble
Cedex-1, France

Carlos Contreras-Martel
Institut de Biologie Structurale, Grenoble, France

Joseph A Cotruvo Jr.
Department of Chemistry, Massachusetts Institute of
Technology, Cambridge, MA, USA

William A Cramer
Department of Biological Sciences, Purdue University,
West Lafayette, IN 47907, USA

Harry A Dailey
Biomedical and Health Sciences Institute, Department of
Biochemistry and Molecular Biology, Department of
Microbiology, University of Georgia, Athens, GA
30602, USA

Muriel Delepierre
Unité de Résonance Magnétique Nucléaire des
Biomolécules, CNRS URA 2185, Institut Pasteur,
Paris, France

Holger Dobbek
Labor für Proteinkristallographie/Biochemie, Universität
Bayreuth, Germany
and
Institut für Biologie, Strukturbiologie/Biochemie,
Humboldt-Universität zu Berlin, Berlin, Germany

Catherine L Drennan
Department of Chemistry, Massachusetts Institute of
Technology, Cambridge, MA 02139, USA
and
Department of Biology, Massachusetts Institute of
Technology, Cambridge, MA 02139, USA

Jérôme Dupuy
Laboratoire de Cristallographie et de Cristallogenèse des
Protéines, Institut de Biologie Structurale J.P. Ebel,
CEA-CNRS-UJF, UMR 5075, Grenoble, France
and
Stevens Laboratory – SR105, Scripps Research Institute,
La Jolla, California 92037, USA

Robert R Eady
Molecular Biophysics Group, Daresbury Laboratory,
Warrington, Cheshire WA4 4AD, UK

Oliver Einsle
Institut für Mikrobiologie und Genetik,
Georg-August-Universität Göttingen, Göttingen, Germany

Betty Eipper
Neuroscience and Molecular, Microbial, and Structural
Biology, University of Connecticut Health Center,
Farmington, CT 06030, USA

Lindsay D Eltis
Department of Biochemistry and Molecular Biology,
University of British Columbia, Vancouver, British
Columbia, Canada
and
Department of Microbiology and Immunology, University
of British Columbia, Vancouver, British Columbia,
Canada

Ulrich Ermler
Max-Planck-Institut für Biophysik, Frankfurt, Germany

Jorge C Escalante-Semerena
Department of Bacteriology, University of Wisconsin,
Madison, WI 53706, USA

Marta Ferraroni
Dipartimento di Chimica, Università di Firenze, Via della
Lastruccia 3, I-50019 Sesto Fiorentino (FI), Italy

Felix Findeisen
Cardiovascular Research Institute, University of
California, San Francisco, CA 94158-2330, USA

David Fischer
Universität Konstanz, Konstanz, Germany

Juan C Fontecilla-Camps
Laboratoire de Cristallographie et de Cristallogenèse des
Protéines, Institut de Biologie Structurale J.P. Ebel,
CEA-CNRS-UJF, UMR 5075, Grenoble, France

Farhad Forouhar
Department of Biological Sciences, Northeast Structural
Genomics Consortium, Columbia University, New York,
NY, USA

Brian G Fox
Department of Biochemistry, University of Wisconsin
Madison, WI 53706, USA

Carlos Frazão
Instituto de Tecnologia Química e Biológica, Universidade
Nova de Lisboa, Oeiras, Portugal

Peter Friedrich
Laboratorium für Mikrobiologie, Fachbereich Biologie,
Philipps-Universität Marburg, Germany

Günter Fritz
Universitätsklinikum Freiburg, Freiburg, Germany

Dax Fu
Department of Biology, Brookhaven National Laboratory, Upton, NY 11973, USA

Barbara C Furie
Marine Biological Laboratory, Woods Hole MA, Beth Israel Deaconess Medical Center and Harvard Medical School, Boston, MA, USA

Bruce Furie
Marine Biological Laboratory, Woods Hole MA, Beth Israel Deaconess Medical Center and Harvard Medical School, Boston, MA, USA

Kalle Gehring
Department of Biochemistry, McGill University, Montreal, Quebec, Canada

Douglas R Green
Department of Immunology, St. Jude Children's Research Hospital, Memphis, TN, USA

Adrian Gross
Department of Molecular Pharmacology and Biological Chemistry, Northwestern University Medical School, 303 East Chicago Avenue, Chicago, IL 60611, USA

S Samar Hasnain
Molecular Biophysics Group, Daresbury Laboratory, Warrington, Cheshire WA4 4AD, UK

Peter JF Henderson
Astbury Centre for Structural Molecular Biology, Institute of Membrane and Systems Biology, University of Leeds, Leeds LS2 9JT, UK

Karolin Herrmanns
Universität Konstanz, Konstanz, Germany

Mark Hilge
Radboud University Nijmegen, Nijmegen, The Netherlands

Rolf Hilgenfeld
Institute of Biochemistry, Center for Structural and Cell Biology in Medicine (CSCM), University of Lübeck, Ratzeburger Allee 160, Lübeck, Germany

Russ Hille
Department of Biochemistry, University of California, Riverside, CA 92521, USA

Karl-Peter Hopfner
Gene Center and Center for Integrated Protein Science, Department of Chemistry and Biochemistry, Ludwig-Maximilians-University Munich, Feodor-Lynen-Str. 25, 81377 Munich, Germany

Yilin Hu
Department of Molecular Biology and Biochemistry, University of California, Irvine, CA, USA

Mingdong Huang
Marine Biological Laboratory, Woods Hole MA, Beth Israel Deaconess Medical Center and Harvard Medical School, Boston, MA, USA

Andrea Ilari
C.N.R. Institute of Molecular Biology and Pathology, Rome, Italy

So Iwata
Biochemistry Department, South Kensington Campus, Imperial College London University, London SW7 2AZ, UK

Nadia Izadi-Pruneyre
Unité de Résonance Magnétique Nucléaire des Biomolécules, CNRS URA 2185, Institut Pasteur, Paris, France

Scott Jackson
Astbury Centre for Structural Molecular Biology, Institute of Membrane and Systems Biology, University of Leeds, Leeds LS2 9JT, UK

Jae-Hun Jeoung
Labor für Proteinkristallographie/Biochemie, Universität Bayreuth, Germany

Jacky Chi Ki Ngo
Department of Biochemistry, The Chinese University of Hong Kong, Hong Kong, China

Nicole Koropatkin
Donald Danforth Plant Science Center, 975 North Warson Road, St. Louis, MO 63132, USA

Wolfgang Köster
VIDO-Vaccine & Infectious Diseases Organization, University of Saskatchewan, Saskatoon, Saskatchewan, Canada

Karla D Krewulak
Structural Biology Research Group, Department of Biological Sciences, University of Calgary, Calgary, Alberta, Canada

Peter MH Kroneck
Universität Konstanz, Konstanz, Germany

Julien Lafrance-Vanasse
Département de Biochimie, Université de Montréal, Montréal, Québec, Canada

Katja Lammens
Gene Center and Center for Integrated Protein Science, Department of Chemistry and Biochemistry, Ludwig-Maximilians-University Munich, Feodor-Lynen-Str. 25, 81377 Munich, Germany

William N Lanzilotta
Biomedical and Health Sciences Institute, Department of Biochemistry and Molecular Biology, Department of Microbiology, University of Georgia, Athens, GA 30602, USA

Thomas J Lawton
Departments of Biochemistry, Molecular and Cell Biology and of Chemistry, Northwestern University, Evanston, IL, USA

Anne Lecroisey
Unité de Résonance Magnétique Nucléaire des Biomolécules, CNRS URA 2185, Institut Pasteur, Paris, France

Paola Di Lello
Département de Biochimie, Université de Montréal, Montréal, Québec, Canada
and
Current address: Roche Research Center, Hoffman-La Roche Inc., 340 Kingsland Street, Nutley, NJ 07110, USA

Michael J Lenaeus
Department of Molecular Pharmacology and Biological Chemistry, Northwestern University Medical School, 303 East Chicago Avenue, Chicago, IL 60611, USA

Su Ling Leong
Department of Pathology, University of Melbourne, Parkville, Victoria 3010, Australia
and
Bio21 Molecular Science and Biotechnology Institute, University of Melbourne, Victoria 3010, Australia
and
Mental Health Research Institute of Victoria, Parkville, Victoria 3052, Australia

Xin Li
Tianjin Key Laboratory of Protein Science, College of Life Sciences, Nankai University, Tianjin 300071, China

Qian Liu
Department of Biochemistry, McGill University, Montreal, Quebec, Canada

Bernhard Loll
Institut für Chemie und Biochemie–Kristallographie, Freie Universität Berlin, Takustrasse 6, 14195 Berlin, Germany
and
Max–Planck Institute for Medical Research, Department of Biomolecular Mechanisms, Jahnstrasse 29, 69120 Heidelberg, Germany

Emanuela Lonardi
Leiden Institute of Chemistry, Leiden University, Gorlaeus Laboratories, Einsteinweg 55, 2333 CC Leiden, The Netherlands

Ricardo O Louro
Instituto de Tecnologia Química e Biológica, Universidade Nova de Lisboa, Av. da República, 2781-901 Oeiras, Portugal

Pikyee Ma
Astbury Centre for Structural Molecular Biology, Institute of Membrane and Systems Biology, University of Leeds, Leeds LS2 9JT, UK

Joel P Mackay
School of Molecular Bioscience, University of Sydney, Sydney, NSW, 2006, Australia

Michael E Maguire
Department of Pharmacology, School of Medicine, Case Western Reserve University, Cleveland, OH, 44106-4965, USA

Richard Mains
Neuroscience and Molecular, Microbial, and Structural Biology, University of Connecticut Health Center, Farmington, CT 06030, USA

Robyn E Mansfield
School of Molecular Bioscience, University of Sydney, Sydney, NSW, 2006, Australia

Berta M Martins
Laboratorium für Mikrobiologie/Proteinkristallographie, ENB Macromolecular Science, Universität Bayreuth, Germany

Paola E Mera
Department of Bacteriology, University of Wisconsin, Madison, WI 53706, USA

Albrecht Messerschmidt
Structural Proteomics, Max-Planck-Institut für Biochemie, Martinsried, Germany

Jeroen R Mesters
Institute of Biochemistry, Center for Structural and Cell Biology in Medicine (CSCM), University of Lübeck, Ratzeburger Allee 160, Lübeck, Germany

Jacques Meyer
Institut de Recherches en Technologies et Sciences du Vivant, CEA-Grenoble, Grenoble, France

Kunio Miki
Department of Chemistry, Graduate School of Science, Kyoto University, Kyoto, Japan

Daniel L Minor
Cardiovascular Research Institute, University of California, San Francisco, CA 94158-2330, USA
and
Departments of Biochemistry and Biophysics, and Cellular and Molecular Pharmacology, University of California, San Francisco, CA 94158-2330, USA
and
California Institute for Quantitative Biomedical Research, University of California, San Francisco, CA 94158-2330, USA
and
Physical Biosciences Division, Lawrence Berkeley National Laboratory, Berkeley, CA 94720, USA

Tudor Moldoveanu
Department of Immunology, St. Jude Children's Research Hospital, Memphis, TN, USA

François MM Morel
Department of Geosciences, Princeton University, Princeton, NJ, USA

Jens Preben Morth
Center for Membrane Pumps in Cells and Disease – PUMPKIN, Danish National Research Foundation, Department of Molecular Biology, Aarhus University, Denmark

Jean-Marc Moulis
Laboratoire de Chimie et Biologie des Métaux, Institut de Recherches et Technologies du Vivant, Université J. Fourier, UMR CNRS 5249, CEA-Grenoble, France

Christopher G Mowat
EaStCHEM, School of Chemistry, University of Edinburgh, West Mains Road, Edinburgh, UK

Gerd Multhaup
Freie Universitaet Berlin, Institut fuer Chemie/Biochemie, Thielallee 63, D-14195 Berlin, Germany

Satish K Nair
Center for Biophysics and Computational Biology, University of Illinois at Urbana-Champaign, 600 South Mathews Avenue, Urbana, IL 61801, USA
and
Department of Biochemistry, University of Illinois at Urbana-Champaign, 600 South Mathews Avenue, Urbana, IL 61801, USA

Takeshi Nishino
Department of Biochemistry and Molecular Biology, Nippon Medical School, Tokyo, Japan

Poul Nissen
Center for Membrane Pumps in Cells and Disease – PUMPKIN, Danish National Research Foundation, Department of Molecular Biology, Aarhus University, Denmark

Vincent Nivière
Laboratoire de Chimie et Biologie des Métaux, IRTSV-CEA, CNRS, Université J. Fourier, 17 rue des Martyrs, 38054 Grenoble, France

Maria Nyblom
Center for Membrane Pumps in Cells and Disease – PUMPKIN, Danish National Research Foundation, Department of Molecular Biology, Aarhus University, Denmark

James G Omichinski
Département de Biochimie, Université de Montréal, Montréal, Québec, Canada

Emil F Pai
Departments of Biochemistry, Medical Biophysics, and Molecular Genetics, University of Toronto, Toronto, Ontario, Canada
and
Division of Cancer Genomics & Proteomics, Ontario Cancer Institute, Princess Margaret Hospital, Toronto, Ontario, Canada

Himadri B Pakrasi
Department of Biology, Campus Box 1137, Washington University, St. Louis, MO 63130, USA

Kristian Parey
Max-Planck-Institut für Biophysik, Frankfurt, Germany

Simon G Patching
Astbury Centre for Structural Molecular Biology, Institute of Membrane and Systems Biology, University of Leeds, Leeds LS2 9JT, UK

Inês AC Pereira
Instituto de Tecnologia Química e Biológica, Universidade Nova de Lisboa, Av. República, 2780-157, Oeiras, Portugal

Christine M Phillips
Department of Chemistry, Massachusetts Institute of Technology, Cambridge, MA, 02139, USA

Antonio J Pierik
Institut für Zytobiologie, Philipps-Universität Marburg, Marburg, Germany

Konstantin M Polyakov
Engelhardt Institute of Molecular Biology of Russian Academy of Sciences, Moscow, Russian Federation

Vladimir O Popov
A.N. Bach Institute of Biochemistry of Russian Academy of Sciences, Moscow, Russian Federation

Zihe Rao
Tianjin Key Laboratory of Protein Science, College of Life Sciences, Nankai University, Tianjin 300071, China
and
National Laboratory of Biomacromolecules, Institute of Biophysics, Chinese Academy of Sciences, Beijing 100101, China

Frank M Raushel
Department of Chemistry, Texas A&M University, College Station, TX, USA

Ivan Rayment
Department of Biochemistry, University of Wisconsin, Madison, WI 53706, USA

Graeme A Reid
Institute of Structural and Molecular Biology, University of Edinburgh, Edinburgh, UK

Markus W Ribbe
Department of Molecular Biology and Biochemistry, University of California, Irvine, CA, USA

Maria Luisa Rodrigues
Instituto de Tecnologia Química e Biológica, Universidade Nova de Lisboa, Av. República, 2780-157, Oeiras, Portugal

Amy C Rosenzweig
Departments of Biochemistry, Molecular Biology and Cell Biology and Chemistry, Northwestern University, Evanston, IL, USA

David A Roth
Wyeth Research, Cambridge, MA, USA

Katarzyna Rudzka
Department of Biophysics and Biophysical Chemistry, Johns Hopkins School of Medicine, Johns Hopkins University, Baltimore, MD 21205, USA

Wolfram Saenger
Institut für Chemie und Biochemie–Kristallographie, Freie Universität Berlin, Takustrasse 6, 14195 Berlin, Germany

Tatiana N Safonova
A.N. Bach Institute of Biochemistry of Russian Academy of Sciences, Moscow, Russian Federation

Massoud Saidijam
Astbury Centre for Structural Molecular Biology, Institute of Membrane and Systems Biology, University of Leeds, Leeds LS2 9JT, UK
and
School of Medicine, Hamedan University of Medical Sciences, Hamedan, Iran

S Saif Hasan
Department of Biological Sciences, Purdue University, West Lafayette, IN 47907, USA

Mark SP Sansom
Structural Bioinformatics and Computational Biochemistry Unit, Department of Biochemistry, University of Oxford, South Parks Road, Oxford OX13QU, UK

Leonid Sazanov
Medical Research Council Mitochondrial Biology Unit, Cambridge CB2 0XY, UK

Isabelle J Schalk
Institut de Recherche de l'Ecole de Biotechnologie, Université de Strasbourg-CNRS, Bd Sebastien Brandt, BP 10413, F67412 Illkirch Cedex, France

Alexander Schiffer
Universität Konstanz, Konstanz, Germany

Grazyna B Seiffert
Universität Konstanz, Konstanz, Germany

Tatsuro Shimamura
Biochemistry Department, South Kensington Campus, Imperial College London University, London SW7 2AZ, UK

Thomas J Smith
Donald Danforth Plant Science Center, 975 North Warson Road, St. Louis, MO 63132, USA

Cláudio M Soares
Instituto de Tecnologia Química e Biológica, Universidade Nova de Lisboa, Av. da República, 2781-901 Oeiras, Portugal

Simonetta Stefanini
Department of Biochemical Sciences "A. Rossi Fanelli", "Sapienza" University of Rome, Italy

Julia Steuber
Universität Hohenheim, Stuttgart, Germany

Natalie C Strynadka
Department of Biochemistry and Molecular Biology, University of British Columbia, Vancouver, British Columbia, Canada

JoAnne Stubbe
Department of Chemistry, Massachusetts Institute of Technology, Cambridge, MA, USA
and
Department of Biology, Massachusetts Institute of Technology, Cambridge, MA, USA

Fei Sun
National Laboratory of Biomacromolecules, Institute of Biophysics, Chinese Academy of Sciences, Beijing 100101, China

Claudiu T Supuran
Dipartimento di Chimica, University of Florence, Sesto Fiorentino, Italy

Shun'ichi Suzuki
Astbury Centre for Structural Molecular Biology, Institute of Membrane and Systems Biology, University of Leeds, Leeds LS2 9JT, UK
and
Ajinomoto Co. Inc., Kawasaki-ku, Kawasaki, Kanagawa 2108681, Japan

Soichi Takeda
Department of Cardiac Physiology, National Cardiovascular Center Research Institute, Osaka, Japan

Miguel Teixeira
Instituto de Tecnologia Química e Biológica, Universidade Nova de Lisboa, Oeiras, Portugal

Felix tenBrink
Universität Konstanz, Konstanz, Germany

Armand WJW Tepper
Leiden Institute of Chemistry, Leiden University, Gorlaeus Laboratories, Einsteinweg 55, 2333 CC Leiden, The Netherlands

Sarah J Thackray
EaStCHEM, School of Chemistry, University of Edinburgh, West Mains Road, Edinburgh, UK

Tamara V Tikhonova
A.N. Bach Institute of Biochemistry of Russian Academy of Sciences, Moscow, Russian Federation

Liang Tong
Department of Biological Sciences, Northeast Structural Genomics Consortium, Columbia University, New York, NY, USA

João B Vicente
Instituto de Tecnologia Química e Biológica, Universidade Nova de Lisboa, Oeiras, Portugal

Hans J Vogel
Structural Biology Research Group, Department of Biological Sciences, University of Calgary, Calgary, Alberta, Canada

Anne Volbeda
Laboratoire de Cristallographie et de Cristallogenèse des Protéines, Institut de Biologie Structurale J.P. Ebel, CEA-CNRS-UJF, UMR 5075, Grenoble, France

Karl Volz
Department of Microbiology and Immunology, University of Illinois at Chicago, Chicago, Illinois, 60612-7334, USA

William Walden
Department of Microbiology and Immunology, University of Illinois at Chicago, Chicago, Illinois, 60612-7334, USA

Satoshi Watanabe
Department of Chemistry, Graduate School of Science, Kyoto University, Kyoto, Japan

Simone Weyand
Biochemistry Department, South Kensington Campus, Imperial College London University, London SW7 2AZ, UK

James W Whittaker
Department of Science and Engineering, Oregon Health and Science University, 20000 N.W. Walker Road, Beaverton, OR 97006, USA

Nicolas Wolff
Unité de Résonance Magnétique Nucléaire des Biomolécules, CNRS URA 2185, Institut Pasteur, Paris, France

Yan Xu
Department of Geosciences, Princeton University, Princeton, NJ, USA

Eiki Yamashita
Department of Biological Sciences, Purdue University, West Lafayette, IN 47907, USA

Eun Young Kim
Cardiovascular Research Institute, University of California, San Francisco, CA 94158-2330, USA

Jin Zhang
Laboratorium für Mikrobiologie, Fachbereich Biologie, Philipps-Universität Marburg, Germany

Huimin Zhao
Department of Chemical and Biomolecular Engineering, University of Illinois at Urbana-Champaign, 600 South Mathews Avenue, Urbana, IL 61801, USA
and
Center for Biophysics and Computational Biology, University of Illinois at Urbana-Champaign, 600 South Mathews Avenue, Urbana, IL 61801, USA

PDB-Code Listing

1A16 Aminopeptidase P from E. Coli with the Inhibitor Pro-Leu; *M. C. J. Wilce, C. S. Bond, P. E. Lilley, N. E. Dixon, H. C. Freeman, J. M. Guss*

1AAP X-Ray Crystal Structure of the Protease Inhibitor Domain of Alzheimer's Amyloid Beta-Protein Precursor; *T. R. Hynes, M. Randal, L. A. Kennedy, C. Eigenbrot, A. A. Kossiakoff*

1ACO Crystal Structure of Aconitase with Transaconitate Bound; *C. D. Stout*

1AIG Photosynthetic Reaction Center from Rhodobacter Sphaeroides in the D+Qb-Charge Separated State; *M. H. Stowell, T. M. McPhillips, D. C. Rees, S. M. Soltis, E. Abresch, G. Feher*

1AMI Steric and Conformational Features of the Aconitase Mechanism; *H. Lauble, C. D. Stout*

1AMJ Steric and Conformational Features of the Aconitase Mechanism; *H. Lauble, C. D. Stout*

1AMP Crystal Structure of Aeromonas Proteolytica Aminopeptidase: A Prototypical Member of the Co-Catalytic Zinc Enzyme Family; *B. Chevrier, C. Schalk, H. D'Orchymont, J. M. Rondeau, D. Moras, C. Tarnus*

1AOZ Refined Crystal Structure of Ascorbate Oxidase at 1.9 Angstroms Resolution; *A. Messerschmidt, R. Ladenstein, R. Huber, M. Bolognesi, L. Avigliano, R. Petruzzelli, A. Rossi, A. Finazzi-Agro*

1AS7 Structure of Alcaligenes Faecalis Nitrite Reductase at Cryo Temperature; *M. E. Murphy, S. Turley, E. T. Adman*

1ATL Structural Interaction of Natural and Synthetic Inhibitors with the Venom Metalloproteinase, Atrolysin C (Form-D); *D. Zhang, I. Botos, F. X. Gomis-Ruth, R. Doll, C. Blood, F. G. Njoroge, J. W. Fox, W. Bode, E. F. Meyer*

1AW0 Fourth Metal-Binding Domain of the Menkes Copper-Transporting ATPase, NMR, 20 Structures; *Gitschier, W. J. Fairbrother*

1B0J Crystal Structure of Aconitase with Isocitrate; *S. J. Lloyd, H. Lauble, G. S. Prasad, C. D. Stout*

1B0K S642A:Fluorocitrate Complex of Aconitases; *J. Lloyd, H. Lauble, G. S. Prasad, C. D. Stout*

1B0M Aconitase R644Q:Fluorocitrate Complex; *S. J. Lloyd, H. Lauble, G. S. Prasad, C. D. Stout*

1B0P Crystal Structure of Pyruvate-Ferredoxin Oxidoreductase from Desulfovibrio Africanus; *E. Chabriere, M. H. Charon, A. Volbeda*

1B2V Heme-Binding Protein A; *P. Arnoux, R. Haser, N. Izadi, A. Lecroisey, C. Wandersman, M. Czjzek*

1BA4 The Solution Structure of Amyloid Beta-Peptide (1-40) in a Water-Micelle Environment. Is the Membrane-Spanning Domain Where We Think It Is? NMR, 10 Structures; *M. Coles, W. Bicknell, A. A. Watson, D. P. Fairlie, D. J. Craik*

1BE7 Clostridium Pasteurianum Rubredoxin C42S Mutant; *M. Maher, J. M. Guss, J. M. Wilce, A. G. Wedd*

1BKC Catalytic Domain of TNF-Alpha Converting Enzyme (Tace); *K. Maskos, C. Fernandez-Catalan, W. Bode*

1BSW Acutolysin A from Snake Venom of Agkistrodon Acutus at pH 7.5; *W. Gong, X. Zhu, S. Liu, M. Teng, L. Niu*

1BUD Acutolysin A from Snake Venom of Agkistrodon Acutus at pH 5.0; *W. Gong, X. Zhu, S. Liu, M. Teng, L. Niu*

1BVB Heme-Packing Motifs Revealed by the Crystal Structure of Cytochrome c554 from Nitrosomonas Europaea; *T. M. Iverson, D. M. Arciero, B. T. Hsu, M. S. Logan, P. A. B. Hooper, D. C. Rees*

1BXL Structure of Bcl-Xl/Bak Peptide Complex, NMR, Minimized Average Structure; *M. Sattler, H. Liang, D. Nettesheim, R. P. Meadows, J. E. Harlan, M. Eberstadt, H. Yoon, S. B. Shuker, B. S. Chang, A. J. Minn, C. B. Thompson, S. W. Fesik*

1BXV Reduced Plastocyanin from Synechococcus Sp.; *T. Inoue, H. Sugawara, S. Hamanaka, H. Tsukui, E. Suzuki, T. Kohzuma, Y. Kai*

1BY3 FhuA from E. Coli; *K. P. Locher, B. Rees, R. Koebnik, A. Mitschler, L. Moulinier, J. P. Rosenbusch, D. Moras*

1BY5 FhuA from E. Coli, with its Ligand Ferrichrome; *K. P. Locher, B. Rees, R. Koebnik, A. Mitschler, L. Moulinier, J. P. Rosenbusch, D. Moras*

1C51 Photosynthetic Reaction Center and Core Antenna System (Trimeric), Alpha Carbon Only; *O. Klukas, W. D. Schubert, P. Jordan, N. Krauss, P. Fromme, H. T. Witt, W. Saenger*

1C96 S642A:Citrate Complex of Aconitase; *S. J. Lloyd, H. Lauble, G. S. Prasad, C. D. Stout*

1C97 S642A:Isocitrate Complex of Aconitase; *S. J. Lloyd, H. Lauble, G. S. Prasad, C. D. Stout*

1C1H Crystal Structure of Bacillus Subtilis Ferrochelatase in Complex with N-Methyl Mesoporphyrin; *D. Lecerof, M. Fodje, A. Hansson, M. Hansson, S. Al-Karadaghi*

1CC7 Crystal Structure of the Atx1 Metallochaperone Protein; *A. C. Rosenzweig, D. L. Huffman, M. Y. R. Pufahl, A. Hou, T. V. O. A. K. Wernimont*

1CC8 Crystal Structure of the Atx1 Metallochaperone Protein; *A. C. Rosenzweig, D. L. Huffman, M. Y. R. Pufahl, A. Hou, T. V. O. A. K. Wernimont*

1CFD Calcium-Free Calmodulin; *H. Kuboniwa, N. Tjandra, S. Grzesiek, H. Ren, C. B. Klee, A. Bax*

1CJN Structure of Ferredoxin, NMR, Minimized Average Structure; *H. Hatanaka, R. Tanimura, S. Katoh, F. Inagaki*

1CPZ Copper Chaperone of Enterococcus Hirae (Apo-Form); *R. Wimmer, T. Herrmann, M. Solioz, K. Wuthrich*

1CX8 Crytal Structure of the Ectodomain of Human Transferrin Receptor; *C. M. Lawrence, S. Ray, M. Babyonyshev, R. Galluser, D. W. Borhani, S. C. Harrison*

1DKH Crystal Structure of the Hemophore HasA, pH 6.5; *P. Arnoux, R. Haser, N. Izadi-Pruneyre, A. Lecroisey, M. Czjzek*

1DKO Crystal Structure of Tungstate Complex of Escherichia Coli Phytase at pH 6.6 with Tungstate Bound at the Active Site and with Hg^{2+} Cation Acting as an Intermolecular Bridge; *D. Lim, S. Golovan, C. W. Forsberg, Z. Jia*

1KVI — Solution Structure of the Reduced Form of the First Heavy Metal Binding Motif of the Menkes Protein; *T. M. DeSilva, G. Veglia, S. J. Opella*

1KVJ — Solution Structure of the Cu(I) Bound Form of the First Heavy Metal Binding Motif of the Menkes Protein; *T. M. DeSilva, G. Veglia, S. J. Opella*

1L3X — Solution Structure of Novel Disintegrin Salmosin; *J. Shin, S. Y. Hong, K. Chung, I. Kang, Y. Jang, D. S. Kim, W. Lee*

1L5J — Crystal Structure of E. Coli Aconitase; *B. C. H. Williams, T. J. Stillman, V. V. Barynin, S. E. Sedelnikova, Y. Tang, J. Green, J. R. Guest, P. J. Artymiuk*

1LKV — Crystal Structure of the Middle and C-Terminal Domains of the Flagellar Rotor Protein FliG; *P. N. Brown, C. P. Hill, D. F. Blair*

1LV7 — Crystal Structure of the AAA Domain of FtsH; *S. Krzywda, A. M. Brzozowski, C. Verma, K. Karata, T. Ogura, A. J. Wilkinson*

1M1N — Nitrogenase MoFe Protein from Azotobacter Vinelandii; *O. Einsle, F. A. Tezcan, S. L. Andrade, B. Schmid, M. Yoshida, J. B. Howard, D. C. Rees*

1M2A — Crystal Structure at 1.5 Angstroms Resolution of the Wild Type Thioredoxin-Like [2Fe-2S] Ferredoxin from Aquifex Aeolicus; *A. P. Yeh, X. I. Ambroggio, S. L. A. Andrade, O. Einsle, C. Chatelet, J. Meyer, D. C. Rees*

1M2B — Crystal Structure at 1.25 Angstroms Resolution of the Cys55Ser Variant of the Thioredoxin-Like [2Fe-2S] Ferredoxin from Aquifex Aeolicus; *A. P. Yeh, X. I. Ambroggio, S. L. A. Andrade, O. Einsle, C. Chatelet, J. Meyer, D. C. Rees*

1M2D — Crystal Structure at 1.05 Angstroms Resolution of the Cys59Ser Variant of the Thioredoxin-Like [2Fe-2S] Ferredoxin from Aquifex Aeolicus; *A. P. Yeh, X. I. Ambroggio, S. L. A. Andrade, O. Einsle, C. Chatelet, J. Meyer, D. C. Rees*

1MAZ — X-Ray Structure of BCL-XL, An Inhibitor of Programmed Cell Death; *S. W. Muchmore, M. Sattler, H. Liang, R. P. Meadows, J. E. Harlan, H. S. Yoon, D. Nettesheim, B. S. Chang, C. B. Thompson, S. L. Wong, S. L. Ng, S. W. Fesik*

1MDV — Key Role of Phenylalanine 20 in Cytochrome c3: Structure, Stability and Function Studies; *A. Dolla, P. Arnoux, I. Protasevich, V. Lobachov, M. Brugna, M. T. Giudici-Orticoni, R. Haser, M. Czjzek, A. Makarov, M. Bruschi*

1MJG — Crystal Structure of Bifunctional Carbon Monoxide Dehydrogenase/Acetyl-CoA Synthase(CODH/ACS) from Moorella Thermoacetica (F. Clostridium Thermoaceticum); *T. I. Doukov, T. M. Iverson, J. Seravalli, S. W. Ragsdale, C. L. Drennan*

1MK3 — Solution Structure of Human Bcl-W Protein; *A. Y. Denisov, M. S. Madiraju, G. Chen, A. Khadir, P. Beauparlant, G. Attardo, G. C. Shore, K. Gehring*

1MMO — Crystal Structure of a Bacterial Non-Haem Iron Hydroxylase that Catalyses the Biological Oxidation of Methane; *A. C. Rosenzweig, C. A. Frederick, S. J. Lippard, P. Nordlund*

1MPZ — NMR Solution Structure of Native Viperidae Lebetina Obtusa Protein; *M. P. Moreno-Murciano, D. Monleon, C. Marcinkiewicz, J. J. Calvete, B. Celda*

1MWP — N-Terminal Domain of the Amyloid Precursor Protein; *J. Rossjohn, R. Cappai, S. C. Feil, A. Henry, W. J. McKinstry, D. Galatis, L. Hesse, G. Multhaup, K. Beyreuther, C. L. Masters, M. W. Parker*

1MZ4 — Crystal Structure of Cytochrome c550 from Thermosynechococcus Elongatus; *C. A. Kerfeld, M. R. Sawaya, H. Bottin, K. T. Tran, M. Sugiura, D. Cascio, A. Desbois, T. O. Yeates, D. Kirilovsky, A. Boussac*

1N0Z — Solution Structure of the First Zinc-Finger Domain from ZNF265; *C. A. Plambeck, A. H. Y. Kwan, D. J. Adams, B. J. Westman, L. van der Weyden, R. L. Medcalf, B. J. Morris, J. P. Mackay*

1N2Z — 2.0 Angstrom Structure of BtuF, the Vitamin B12 Binding Protein of E. Coli; *E. L. Borths, K. P. Locher, A. T. Lee, D. C. Rees*

1N4A — The Ligand Bound Structure of E. Coli BtuF, the Periplasmic Binding Protein for Vitamin B_{12}; *N. K. Karpowich, P. C. Smith, J. F. Hunt, Northeast Structural Genomics Consortium (NESG)*

1N4D — The Ligand-Free Structure of E. Coli BtuF, the Periplasmic Binding Protein for Vitamin B_{12}; *N. K. Karpowich, P. C. Smith, J. F. Hunt*

1N4Y — Refined Structure of Kistrin; *A. M. Krezel, J. Krane, M. S. Dennis, R. A. Lazarus, G. Wagner*

1ND1 — Amino Acid Sequence and Crystal Structure of BaP1, a Metalloproteinase from Bothrops as per Snake Venom that Exerts Multiple Tissue-Damaging Activities; *L. Watanabe, J. D. Shannon, R. H. Valente, A. Rucavado, A. Alape-Giron, A. S. Kamiguti, R. D. Theakston, J. W. Fox, J. M. Gutierrez, R. K. Arni*

1NEK — Complex II (Succinate Dehydrogenase) from E. Coli with Ubiquinone Bound; *V. Yankovskaya, R. Horsefield, S. Tornroth, C. Luna-Chavez, H. Miyoshi, C. Leger, B. Byrne, G. Cecchini, S. Iwata*

1NIS — Crystal Structure of Aconitase with Trans-Aconitate and Nitrocitrate Bound; *H. Lauble, M.C. Kennedy, H. Beinert, C. D. Stout*

1NIT — Crystal Structure of Aconitase with Trans-Aconitate and Nitrocitrate Bound; *H. Lauble, M.C. Kennedy, H. Beinert, C. D. Stout*

1O9I — Crystal Structure of the Y42F Mutant of Manganese Catalase from Lactobacillus Plantarum at 1.33 A Resolution; *V. V. Barynin, M. M. Whittaker, J. W. Whittaker*

1OAO — NiZn[Fe$_4$S$_4$] and NiNi[Fe$_4$S$_4$] Clusters in Closed and Open Alpha Subunits of Acetyl-CoA Synthase/Carbon Monoxide Dehydrogenase; *C. Darnault, A. Volbeda, E. J. Kim, P. Legrand, X. Vernede, P. A. Lindahl, J. C. Fontecilla-Camps*

1OCR — Bovine Heart Cytochrome c Oxidase in the Fully Reduced State; *T. Tsukihara, M. Yao*

1OGY — Crystal Structure of the Heterodimeric Nitrate Reductase from Rhodobacter Sphaeroides; *P. Arnoux, M. Sabaty, J. Alric, B. Frangioni, B. Guigliarelli, J. M. Adriano, D. Pignol*

1ON4 — Solution Structure of Soluble Domain of Sco1 from Bacillus Subtilis; *E. Balatri, L. Banci, I. Bertini, F. Cantini, S. Ciofi-Baffoni, Structural Proteomics in Europe (SPINE)*

1OPM — Oxidized (Cu^{2+}) Peptidylglycine Alpha-Hydroxylating Monooxygenase (PHM) with Bound Substrate; *S. T. Prigge, A. S. Kolhekar, B. A. Eipper, R. E. Mains, L. M. Amzel*

Index

Contents of Volumes 1, 2 and 3

Volume 1

Volume 2

COPPER . 1149

Volume 3